D0569415

TIMELINES

~ OF THE ARTS AND LITERATURE

TIME
～ OF THE ARTS

JUN 0 9 1995

JUN 0 9 1995

LINES
AND LITERATURE

DAVID BROWNSTONE AND IRENE FRANCK

HarperCollins*Publishers*

STERLING LIBRARY
MADISON STATE COLLEGE
MADISON NC 86637

TIMELINES OF THE ARTS AND LITERATURE. Copyright © 1994 by David M. Brownstone and Irene M. Franck. All rights reserved. Printed in the United States of America. No part of this book may be used or reproduced in any manner whatsoever without written permission except in the case of brief quotations embodied in critical articles and reviews. For information, address HarperCollins Publishers, Inc., 10 East 53rd Street, New York, NY 10022.

HarperCollins books may be purchased for educational, business or sales promotional use. For information, please write: Special Markets Department, HarperCollins Publishers, Inc., 10 East 53rd Street, New York, NY 10022.

FIRST EDITION

Library of Congress Cataloging-in-Publication Data
Brownstone, David.
 Timelines of the arts and literature / David Brownstone & Irene Franck. — 1st ed.
 p. cm.
 Includes index.
 ISBN 0-06-270069-3
 1. Arts—Chronology. I. Franck, Irene M. II. Title.
NX447.5.B76 1994
700'.2'02—dc20 93-11603

94 95 96 97 98 ❖/RRD 10 9 8 7 6 5 4 3

R
700.202
B825t

World Almanac Educ 27 55

5-25-95

Timelines of the Arts and Literature offers a detailed chronology of the cultural side of human history, from the Magdalenian cave paintings, Venus figurines, and early pipes, rattles, drums, and bull-roarers to Louis Armstrong, *Gone With the Wind*, the Beatles, and thousands of other people, works, movements, and ideas that make up the cultural life of our own time.

We have included an extremely broad and diverse range of cultural forms in this work, in such areas as painting, fiction, classical and popular music, film, poetry, theater, television, sculpture, belles-lettres, photography, dance, opera, and architecture, also touching on such areas as variety, the circus, and the minor arts. These are organized in the following major cultural classifications:

In early centuries (up through 1499), these are:

- Literature, including fiction, poetry, biography, and belles-lettres.
- Visual Arts, including painting, sculpture, photography, architecture, graphics, design, and a considerable range of other visual forms.
- Performing Arts, including theater, variety, music, and dance.

From 1500 on, the Performing Arts category is broken into two parts:

- Theater and Variety, including drama, musical theater, and other live spoken and mimed forms, as in vaudeville and the circus.
- Music and Dance, including popular and classical music, opera, and ballet; popular songs originating in film, theater, and variety will be carried here.

From 1920, a new category is introduced:

- Film and Broadcasting, including movies, radio, and television.

We have also included a general category called "World Events," which includes a quite selective set of highlight events, to help set the wider contexts within which cultural life developed.

The book runs chronologically from the earliest period to the latest. In early times, entries are grouped into time periods, such as centuries and later decades, as the amount of material warrants. From 1500 on, the information is carried year-by-year.

Using the headings at the top of the page as a guide, you can easily find the year or time period you are seeking. If you want to know what was happening culturally around the time of Columbus, for example, you can look at the period 1490–1499. If you want to know what cultural events occurred in 1776, you need only look under that year. Alternatively, if you know a person's name (e.g., author, actor, playwright, or composer), you can find related entries directly through the Index, useful if you do not know the relevant dates for the person you are seeking.

For some thousands of key people, we have included death date entries, which include birth dates, where they are known. For ease of use, we have kept abbreviations to a minimum, using only these: b. for born, d. for died, c. for century, and ca. for circa, in addition to the standard BC and AD. For example:

d. John Lennon, British musician, member of the Beatles (b. 1940); he was murdered by crazed fan Mark Chapman in New York City, on December 8. Earlier that year, he and Yoko Ono had released their album *Double Fantasy*.

Where a birth or death date is not known, we have generally used "?", for example:

d. Ibn Da'ud, Islamic poet (?-910), who compiled the poetry anthology *Kitab az-zahrah* (*Book of the Flower*).

Where only a general time period is known, we say simply "active," for example:

Zeuxis, Greek painter (active late 5th c. BC), who specialized in panel paintings, building on Apollodorus's use of light and shade in modeling figures.

Note that in such cases, commonly in the early period, where there are not separate entries on dated works, we often add brief comments on the person's career or, in special cases like John Lennon's, about some aspect of their life or death.

Our thanks to our editor, Robert A. Kaplan, who has so capably seen the book through the production process; to Mary Racette, who was so helpful with the organization of the material; and as always to the librarians throughout the northeastern library network, in particular to the staff of the Chappaqua Library—Director Mark Hasskarl; the expert reference staff, including Martha Alcott, Teresa Cullen, Carolyn Jones, Paula Peyraud, Mary Platt, and Carolyn Reznick; and the circulation staff, including Marilyn Coleman, Lois Siwicki, and Jane McKean—who are ever-helpful in fulfilling our research needs.

David Brownstone
Irene Franck

100,000–5000 BC

LITERATURE

Markings on bones indicate probable use of numbering systems in northwestern and north central Europe (ca. 30,000 BC).

Early "proto-languages" believed to be spoken (ca. 12,000 BC). One, which theorists call Nostratic (Latin for "our language"), may have been ancestral to the Indo-European, Altaic, Elamo-Dravidian, Uralic-Yukaghir, Korean, and Afro-Asiatic languages, including Semitic, Berber, Chadic, and Egyptian.

Other posited "super-language" groups (ca. 12,000 BC) include Eurasiatic, including Japanese and Ainu, possibly related to Korean and Altaic; Sino Caucasian or Dene-Caucasian, including Sino-Tibetan, Eskimo-Aleut, Etruscan, and Basque; Amerind, including the Native American tongues; Indo-Pacific and Austric, spoken in the Indian and Pacific oceans; and language groups spoken in Africa: Nilo-Saharan, Niger-Kordofanian, and Khoisan.

Clay tokens used in Mesopotamia (Iraq) to record numbers of livestock and measures of grain, practices that would lead to numbering and writing systems (8000 BC).

VISUAL ARTS

Earliest known ornament, a decorative amulet, made from a piece of mammoth's tooth by a Neanderthal (ca. 100,000 BC); found in Hungary.

People began to make wall paintings and rock engravings in caves, in Eurasia, notably in France, Spain, central Europe, and the Urals (ca. 35,000 BC or earlier), and perhaps nearly as early in Africa. Among the oldest paintings are outlines of hands and crude line drawings, mostly portraying animals, especially bison and mammoths. Surviving pigments include ochres, manganese oxides, charcoal, and iron carbonate, giving primarily shades of red, yellow, and black.

Eurasian and African peoples created numerous small carvings (*mobilier,* or portable art) from bones, antlers, and stones, most with abstract designs; some portraying animals but also "Venus" figurines: small statues of faceless pregnant women with large breasts and buttocks (ca. 35,000 BC or earlier).

Evidence of fired clay objects in Czechoslovakia (from ca. 30,000–25,000 BC), although ceramics would not be used to make pots for possibly another 20,000 years.

Beads, bracelets, and pendants were worn by humans (ca. 30,000–25,000 BC).

"Golden Age" of Ice Age cave paintings, often with relief sculptures as well (ca. 15,000–10,000 BC), as at Altamira, Spain (caves rediscovered in 1868, the paintings in 1879), and at Lascaux, with its great "Hall of Bulls," some painted with an "airbrush" (blowing-tube), in France's Dordogne Valley (rediscovered in 1940).

Houses of sun-dried brick, without mortar, built in Jericho, (from ca. 10,000–9000 BC); transition from round to rectangular structures taking place.

Cloth was being woven in the Near East (from ca. 7000–6000 BC).

Pottery made of fired clay used in the Middle East, as at Jericho and Jarmo (probably after 7000 BC), and the Far East, as at Spirit Cave, Thailand, and Hsienjentung, China (both ca. 6800 BC); cultures developed characteristic shapes and decorative patterns.

Earliest known use of metal, hammered copper in objects found in Cayönü Tepesi, southern Turkey (ca. 7000 BC).

People in Jericho created plaster "portraits" on the skulls of their dead, also making nearly life-size human figures (before 6000 BC).

Rock art flourished in Sahara, especially southern Fezzan, during moister periods (ca. 5600–4000 BC and 3500–2500 BC).

PERFORMING ARTS

One of the earliest ritual instruments, probably by the Upper Paleolithic era, was the bull-roarer (thunderstick or whizzer), possibly used in hunting rites; found in virtually all known societies (possibly ca. 50,000 BC or even earlier).

Music was probably produced by humans, as evidenced in what is now France by cave paintings, cave footprints, seemingly those of dancers, and carved bones that appear to be wind and percussion instruments (25,000–20,000 BC).

At *Les Trois Frères,* an Upper Paleolithic cave in

Ariège, France, named for the three brothers who discovered it in 1912, reached only by a tortuous journey by underground river, wall paintings include some of the relatively rare representations of humans. One shows a man dubbed the "sorcerer," wearing a bison mask and skin; with one foot lifted and the tail of his animal skin curved as if in movement, he appears to be dancing. An engraving shows another man wearing an antlered head and also a tail, both highlighted in black paint. Many observers interpret such figures as evidence that these peoples were engaged in early rituals, involving theatrical skills such as dance, probably music, and mime (15,000 BC or earlier).

Also at *Les Trois Frères* is a painting of a man appearing to hold a hunting bow to his mouth, possibly the earliest depiction of a musical bow (15,000 BC or earlier).

Instruments believed to be in use among many cultures of the Upper Paleolithic were worn rattles, gourd rattles, scrapers, whistles, and didjeridu (an indigenous Australian wind instrument) (by 10,000 BC).

Instruments believed to be in use among many cultures of the Early Neolithic were slit drum, stamping tube, drum, musical bow, flute, panpipes, and conch (after 10,000 BC).

Instruments believed to be in use among cultures of the Later Neolithic were the xylophone, bamboo jew's harp, and reed pipe (before 7000 BC).

Instruments believed to be in use among cultures of the Early Metal Age were the metal bell, friction drum, idiochord zither, and horn (after 7000 BC).

WORLD EVENTS

Ritual burials performed among Neanderthal peoples, the oldest known being at La Ferrassie, in France's Dordogne valley, where bodies were buried in uniform position and orientation (as early as 100,000 BC).

Stone lamps used, in a variety of forms and designs (ca. 79,000 BC).

Neanderthal burials involved ritual preparation, with horns specially arranged around the bodies (as in Teshik Tash in Russia) and in at least one case being buried with flowers (in Shanidar Cave, Iraq) (ca. 60,000 or earlier).

Humans began to settle Australia, coming by sea from New Guinea, evidence of early boats in use (ca. 50,000 BC or earlier).

Neanderthal peoples (*Homo sapiens neanderthalensis*) replaced by, or merged with, modern humans (*Homo sapiens sapiens*) (ca. 40,000 BC).

Possible use of bows and arrows in Europe, but perhaps first in Africa (ca. 25,000–20,000 BC).

Nomadic hunters using stone tools reached Americas, possibly not the first to do so (ca. 15,000 BC; perhaps 30,000 BC or even earlier).

Dog domesticated in Near East (ca. 11,000 BC).

Hunter-gatherers on Anatolian Plateau, Nile Valley uplands (ca. 10,000–5000 BC).

Wheat (einkorn and emmer) and barley cultivated at Jericho, in Jordan River valley (ca. 10,000 BC).

Folsom culture made fine chipped spear points in America (ca. 10,000 BC).

Beginnings of Mayan astronomy in Central America (ca. 9000–8000 BC).

Sheep domesticated in Iraq (ca. 8650 BC) and goats in Iran (ca. 8200 BC).

People of Jericho and other early cities worshiped "Mother Goddess" (ca. 8000 BC).

Earliest evidence of pig domestication, in Turkey (ca. 7200 BC).

Catal Hüyük in Turkey had settled agricultural communities (by ca. 7700 BC).

City of Jericho became the first known permanent walled settlement (by ca. 7500 BC).

Evidence of possible domestication of ricelike grains and other plants at Spirit Cave, Thailand (ca. 6800 BC).

Oldest known woven mats found, from Beidha, in Jordan (from ca. 7000–6000 BC); basketry probably began much earlier.

Farmers and herders expanded from the Near Eastern uplands into the Mesopotamian valleys (7000–6000 BC).

Agriculture spread to Greece, Crete, Italy, southern France, and Iberia (ca. 6000 BC).

Plant cultivation began in Mexico (by 6000 BC).

Britain cut off from mainland by rising sea levels (ca. 6000 BC).

Farming extended up Nile Valley beyond second cataract (by 5500 BC).

Techniques of irrigation developed in Mesopotamia (ca. late 6th millennium BC).

5000–3000 BC

LITERATURE

Indo-European, the family ancestral to most languages from Scotland to India, was spoken in Eurasia (5000 BC).

Indo-European languages had split into a dozen branches (by 4000 BC); Germanic, Italic, Greek, Celtic, Baltic, Slavic, Armenian, Iranian, Albanian, and Indic would by the Middle Ages have spun off a variety of other languages; two branches (Anatolian and Tocharian) no longer survive.

Individually patterned seals used as "signatures" in Mesopotamia, precursors to writing (4000 BC).

Sumerians of southern Mesopotamia (Iraq) developed an early form of writing called *cuneiform*, using writing instruments with sharp points and points shaped like a wedge (*cuneus*), to incise standardized symbols, actually abstracted pictograms, in wet clay (mid-4th millennium BC).

Hieroglyphics developed in Egypt (ca. 3300 BC).

Writing in Mesopotamia began to run horizontally, rather than in the earlier vertical columns (by 3200 BC).

People of Elam, east of Mesopotamia, developed a geometric-style script (ca. 3200 BC).

Papyrus and hieroglyphics in use by Egypt's First Dynasty (ca. 3100–2890 BC); surviving documents record the first ruler known by name: King Narmer.

VISUAL ARTS

Tombs of large stones (*megaliths*) and massive "passage graves" built in Europe (ca. 4500 BC).

Techniques of copper smelting and casting developed in Anatolia and the Levant (after 4500 BC).

Egyptians developed faience, a glaze made from glass and copper (from ca. 4500 BC), not widely adopted.

Seals used in western Asia (by ca. 4000 BC), often finely engraved and inscribed objects, often cylinders.

Gold was being smelted in Egypt and Sumeria, generally for ornamental use (ca. 4000 BC).

Pottery kiln developed in Mesopotamia (ca. 4000 BC or earlier).

Evidence of metalworking at Non Nok Tha, northern Thailand (ca. 4000 BC).

Ziggurat at Warka, Mesopotamia (Iraq), religious tower consisting of successively smaller mud-brick cubes, or stories, topped by a temple; demonstrated knowledge of columns, domes, arches, and vaults (late 4th millennium BC).

Fired bricks were developed in Mesopotamia (ca. 3500 BC).

Potter's wheel developed, probably in Mesopotamia (ca. 3400 BC).

New Grange passage grave built in Ireland (ca. 3300 BC).

Pottery making developed in the Americas, first probably in coastal Ecuador (as early as ca. 3200 BC).

White Temple at Uruk, so-called for its whitewashed sides (ca. 3200–3000 BC).

Bronze first made, from copper and tin, in the Near East (ca. 3100 BC).

PERFORMING ARTS

Musical instruments of many kinds played in Mesopotamia (ca. 3500 BC); in the classification later made by Erich von Hornbostel and Curt Sachs (ca. 1914) these included: *membranophones*, with sounds coming from stretched membranes, such as drums; *chordophones*, stringed instruments, such as zithers or harps; *aerophones*, wind instruments with sounds formed by vibrating air, as in end-blown or side-blown (transverse) flutes; and *idiophones*, in which the sounds come from the material of the instrument itself when struck, as in a xylophone or bell; hit together, as with cymbals or castanets; shaken, as with a rattle or gourd; or plucked, as with a jew's harp.

WORLD EVENTS

Southern Mesopotamia first settled (before ca. 5000 BC).

Farming spread to Continental Europe, first along coasts, river valleys, and main routes (5000–4000 BC).

Farming probably began in northern China (before 5000 BC).

Settled communities formed along Chilean and Peruvian coasts of South America (by 5000 BC).

Polished stone tools in use in North America (from ca. 5000 BC).

Ur was founded by the Sumerians (ca. 4000 BC).

Polished stone tools and handmade pottery used in Continental Europe (from ca. 4000 BC).

Evidence of domesticated grains at Homutu, China (ca. 4000 BC).

Beginnings of Bronze Age, as major civilizations began to rise in great arc that included Mesopotamia, the eastern Mediterranean, and the Indus Valley (ca. 3500–3000 BC).

Minoan civilization began to rise in Crete (ca. 3500 BC).

Mining and trade of flint began in England and Belgium (by 4000 BC).

Cart wheel developed, probably on the Russian steppes or in Mesopotamia (by ca. 3400 BC).

Egypt's First Dynasty (ca. 3100 BC).

3000–2500 BC

LITERATURE

Collections of clay tablets carrying cuneiform writing were common in Near East; pictographs gradually transformed into symbols that represent syllables, a key event in development of modern writing (from early 3rd millennium).

In Egypt, speedier writing with a rush pen led to a more cursive form of writing (ca. 3000–2600 BC).

Pictograms used in Indus Valley (ca. 3000 BC).

Sumerian script adopted by Babylonians–Assyrians in Mesopotamia and with modifications spread throughout Southwest Asia (after ca. 2800 BC).

Epic of Gilgamesh, ancient Sumerian poetic cycle (2700–1400 BC), its demigod hero probably based on Gilgamesh, ruler of Uruk (ca. 2700 BC).

PERFORMING ARTS

Highly formalized religious pageants held in Ur, in Mesopotamia (3000–2000 BC).

Trained, perhaps professional dancers were attached to Egyptian temples (as early as 3000 BC).

Bells in use in Southeast Asia (before 3000 BC).

Pipes in use in China (ca. 2700 BC); Chinese emperor Huang Di reportedly sent Ling Lun to the western mountains for bamboo pipes to simulate the call of the phoenix (2697 BC).

Instruments played in Mesopotamia include arched harps, lyres, and divergent reed pipes (by 2600 BC).

Instruments played in Egypt include temple clappers, end-blown flutes, and parallel reed pipes (by 2600 BC).

VISUAL ARTS

Copper worked around Great Lakes in North America (before 3000 BC).

Beautifully painted pottery produced in Japan (from before 3000 BC).

Pottery and ceramic figures made in Colombia (ca. 3000 BC), including the oldest known representation of an animal from the Americas.

First version of Stonehenge was constructed on England's Salisbury Plain (2900–2800 BC).

Architecture in Mesopotamia included corbeled arches and domes (2800–2700 BC).

Cycladic islanders made stylized, abstract statues (ca. 2800 BC).

Silk was made in China; origin of sericulture traditionally credited to the wife of Emperor Huang Di (ca. 2700 BC).

Funeral complex built at Saqqara (ca. 2650–2600 BC), designed by Imhotep, Egyptian physician and architect, the first known by name; oldest of the pyramids, together considered one of the "Seven Wonders of the World."

Great Pyramid of Giza (ca. 2600–2480 BC), largest of the pyramids, built as a tomb for Egyptian pharaoh Cheops (Khufu).

Both sand casting and hollow casting (lost-wax or cire-perdue method) used for bronze working in Mesopotamia (ca. 2600 BC).

Earliest reference to gardens as an art form, in Egypt (ca. 2580 BC).

Sphinx, massive statue of a lion with a man's head, near Pyramids of Giza, Egypt (ca. 2550 BC).

WORLD EVENTS

Rise of great cities of Mohenjo-daro and Harappa in the Indus Valley (ca. 3000–1500 BC).

Chinese farmers expanded into the fertile Huang (Yellow) and Wei river valleys (by 3000 BC).

Sumerian people of Ur traded on the Persian Gulf seacoast, from Dilmun and Bahrain on the west

side of the Gulf to northern India. Egyptians traded south to Punt, beyond the Red Sea (ca. 3000 BC).

Weights and measures took standard forms in Egypt and Mesopotamia (ca. 3000 BC).

Possible trade between Crete and Egypt (ca. 3000 BC).

Farming and herding widespread in Bronze Age civilizations (ca. 3000 BC).

Egyptians and peoples of Mesopotamia used reed boats and plows (ca. 3000 BC).

Tyre was founded (traditional date 2750 BC).

Gilgamesh, ruler of Uruk (ca. 2675 BC).

2500–2000 BC

LITERATURE

Limited form of writing, so far undeciphered, developed in Indus civilization centered on Mohenjo-daro and Harappa (ca. 2500–1600 BC); possibly precursor to Indian script of 3rd century BC.

Earliest surviving examples of writing on papyrus, also leather, from Egypt's Fifth Dynasty (ca. 2494–2345 BC).

Linen mummy wrappings inscribed with passages from the religious collection *Book of the Dead* survive from Egypt's Sixth Dynasty (ca. 2345–2181 BC).

Enheduanna (active ca. 2300 BC), Assyrian princess, priestess, and poet, the earliest writer whose name and work survive.

Earliest surviving examples of Egyptian inscriptions on wooden writing boards, from the Middle Kingdom (2134–1789 BC).

VISUAL ARTS

Sumerians of Mesopotamia produced limestone sculptures of rounded figures, often in conventional positions, as with folded hands (ca. 2500 BC).

Chinese began carving jade, for decorative objects and also for symbols of rank and power (mid-3rd millennium BC).

Potter's turntable used in China (ca. 2500).

Bronze head, probably King Sargon, made by Akkadians (ca. 2380–2223 BC).

Great Ziggurat at Ur, with staircases ascending to the top (ca. 2200 BC); among the finest, largest, and best-preserved Mesopotamian ziggurats.

Eighty bluestones were set up at Stonehenge, England, in two concentric circles around a huge Altar Stone (2200–2100 BC); possibly an ancient observatory.

Pottery of the Yang-shao culture made in China (ca. 2200–1700 BC).

Statue of Gudea, from Sumeria, now in the Louvre (ca. 2100 BC).

PERFORMING ARTS

Religious rituals in Egypt involved sophisticated acting and dancing, apparently with professional performers, some imported from elsewhere, notably Ethiopia (ca. 25th c. BC or earlier).

Professional dancers employed by royal courts in China and India (as early as 2500 BC).

Under Emperor Shun (2255–2206 BC), according to tradition, the five notes of the Chinese scale were set and given "social value," and musical instruments were divided into eight classes; the five-stringed zither and panpipes were also said to be invented.

Under Emperor Yu (2205–2198 BC), a new musical system (*Ta-Hia*) was reportedly developed.

WORLD EVENTS

Trading center existed at Troy, entrance to Asia (2500–2300 BC).

Voyagers from the Cycladic Islands may have reached Iberia (ca. 2500 BC).

Earliest surviving complete seagoing ship, from pyramid of Cheops (Khufu) in Egypt (ca. 2530 BC), though ships with sails and deck cabins in use as early as 4000 BC.

Maize hybridized for greater yield in Meso-America (after 2500 BC); in South America, beans, squash, and gourds cultivated.

Indo-European speakers north of the Black Sea and on into Asia had domesticated the horse (ca. 2300 BC).

Chinese observers reported the earliest known sighting of a comet (2296 BC).

Egyptian Middle Kingdom; capital was at Thebes (ca. 2100–1600 BC).

Codified laws in Ur: the laws of Ur-Nammu (ca. 2100 BC).

2000–1500 BC

LITERATURE

Schools for scribes operated in Egypt and Mesopotamia (by early 2nd millennium BC).

Writing on Crete, mostly stone inscriptions, using pictorial script (ca. 2000–1500 BC).

First known pharmacopeia completed by Sumerians at Ur (ca. 2000 BC).

Egyptian scribes began writing in horizontal lines, instead of vertical columns, during Twelfth Dynasty (ca. 1999–1786 BC).

Consonant-only North Semitic alphabet of approximately 30 letters developed along Asia's Mediterranean coast (ca. 1800–1300 BC); basis for most others, ancient and modern.

Development of still-undeciphered Linear A script on Crete, apparently part pictorial and part syllabic (ca. 1700 BC).

Decline of writing in India with collapse of Indus civilization and Aryan invasions (ca. 1600–1500 BC).

Earliest surviving examples of Chinese writing on tortoiseshell and animal bones, called "oracle bones," from the Shang period (ca. 1520–1030 BC); about 2,500 script signs in use.

VISUAL ARTS

Some metal objects appear in western Asia, but apparently from meteoric iron, not smelted (before 2000 BC).

Evidence of metalworking in the Andes (ca. 2000 BC).

Techniques of working in copper, bronze, and gold spread into the Eurasian heartland (by ca. 2000 BC).

Scandinavians produced rock engravings of humans, animals, and objects such as boats, plows, and later chariots and carts (ca. 2nd millennium BC).

Minoan palaces at Knossos and Phaestos linked to the labyrinth and the legendary Minotaur, destroyed in catastrophe on Crete (ca. 1700 BC).

Pottery and metalwork placed in the Mycenae Shaft Graves (ca. 1600 BC), later found by Heinreich Schliemann.

Temple of Amon at Karnak built; planned and begun under Ramses I (1320–1318 BC), later completed, then expanded (ca. 1570–1085 BC).

Temple of Amon-Mut-Khonsu at Luxor begun, later many times expanded (ca. 1570–1200 BC).

PERFORMING ARTS

Ritual pageants in the Middle East, notably Babylon, require substantial acting and dancing skills, though presumably by amateurs (2000–1000 BC).

Instruments played in Mesopotamia include vessel rattles, frame drums, angular harps, and long lutes (by 2000 BC).

Instruments played in Egypt include barrel drums and lyres (by 2000 BC).

Possible panpipes found in Russian archaeological site, but might have been blown individually, as in some later Eastern European cultures (before 2000 BC).

Egyptian documents records performances of a now-lost religious drama, *Abydos Passion Play*, about the death of the god Osiris, and his family's efforts to revive him (1887–1849 BC); possibly only one of many such sacred plays, some possibly employing professional performers.

WORLD EVENTS

Egypt traded east on the Spice Route for cinnamon (used in embalming) and other spices and goods (ca. 2000 BC).

Chariots were used in war in Mesopotamia (by ca. 2000 BC).

Traders on the European Amber Routes developed a continentwide trading system, with amber from northern Europe traded as far south as northern Italy (ca. 2000 BC).

Silk probably traded for jade west across Asia on the Silk Road (as early as 2000 BC).

Indo-European-speaking peoples—Iranians, Hittites, Greeks, Celts, Cimmerians, Slavs, and Balts—expanded into Europe, Iran, and the Near East, fighting from horses and chariots (ca. 2000 BC).

Abraham settled in southern Palestine, probably migrating from Mesopotamia (ca. 2000 BC).

Hsia kingdom in China (legendary dates ca. 2000–1520 BC).

Crete became a major Mediterranean trading center, its capital Knossos (ca. 2000 BC).

Indo-European speakers—the Achean Greeks—began migrating from north of the Black Sea into Greece (ca. 1900 BC).

Babylon's first dynasty (ca. 1894–1595 BC).

Sumerian law code of Lipi-Ishtar promulgated (ca. 1870 BC).

Hammurabi, ruler of Babylon, created a body of laws, the historic Code of Hammurabi (1792 BC).

Babylonian Creation and Flood myths recorded (ca. 1750 BC).

Civilizations of the Indus Valley were conquered by Aryans (Indo-Europeans) from the north (ca. 1700 BC or earlier).

1500–1000 BC

LITERATURE

Rgveda (*Rigveda*), collection of 1,028 hymns in Sanskrit, the earliest known Indian text and the oldest major work in any Indo-European language.

Story of Ahikar, Near Eastern wisdom literature (1500–500 BC).

Development of syllabic Linear B script on Crete (ca. 1450–1200 BC), at Knossos; not deciphered until 1953.

First five books of the Old Testament written: *Genesis*, *Exodus*, *Leviticus*, *Numbers*, and *Deuteronomy*, collectively called the *Pentateuch* or (among Jews) the *Torah* (ca. 1400 or 1200 BC); credited to Moses.

Joshua, book of the Old Testament, written; credited to Joshua (ca. 1350 or 1150 BC).

Tablet of Abydos showed Egyptian Pharaoh Sethos I making offerings to 76 ancestors, named in hieroglyphics (ca. 1309–1291 BC).

Phoenicians (Canaanites) developed a 22-letter, all-consonant, right-to-left, horizontal script, forerunner of the modern Western alphabet, and spread it around the Mediterranean as they established colonies (ca. 1300–300 BC).

The Poem of Baal, Canaanite epic poem (1300 BC).

Veda of the Formulas (*Yajurveda*), Sanskrit texts of India's early Vedic rituals (ca. 1200 BC).

Artharvaveda, collection of spoken Sanskrit Vedic religious rituals (ca. 1200 BC).

Inscriptions found on bronze vessels in China's Zhou period (1134–250 BC).

Judges and *Ruth*, books of the Old Testament of the Bible, written; authors unknown (ca. 11th c. BC).

Veda of the Chants (*Samaveda*), early Sanskrit texts (ca. 1100 BC).

VISUAL ARTS

Thutmose III erected in Heliopolis, Egypt, an obelisk called Cleopatra's Needle; its shadow is used to calculate the time, season, and solstices (ca. 1500–1451 BC); he also expanded the temple at Karnak.

China's Lung-Shan culture developed their distinctive black pottery (ca. 1500 BC).

Chinese developed bronze-casting techniques, making ritual bronze vessels in a variety of shapes, sometimes imitating pottery, often with animal motifs (by 1500 BC).

Tapestry weaving in linen in Egypt (ca. 1500 BC).

Mortuary temple of Queen Hatshepsut built by Senmut at Deir el Bahari, Egypt (ca. 1480 BC).

Glass was made in Mesopotamia and Egypt (ca. 1400 BC).

Treasury of Atreus, Mycenae, Crete (ca. 1350 BC), with its fine corbeled vault and its relief carvings, some now in museums in London and Athens.

Iron objects made, but rare and highly valued, like the iron dagger (and its gold counterpart) found in Tutankhamen's tomb (ca. 1323 BC).

Temple at Abydos begun under Egyptian pharaoh Seti I (1318–1304 BC).

Abu-Simbel, two Egyptian temples and a statue of Ramses II (rescued in the 1960s from the Aswan High Dam), were built during Ramses II's reign (1304–1237 BC); the temples at Karnak and Luxor were also much expanded and Abydos completed.

Earliest known Chinese stone sculptures (ca. 1300 BC), small marble figures, from the Shang dynasty.

Ziggurat at Choga Zambil, Elam, built by King Untash-napirisha, with fine early arches (ca. 13th c. BC).

Scandinavian artisans were making and exporting bronze vessels and decorative objects (from ca. 1200 BC).

Ironworking techniques developed, presumably in Near East, and spread quickly (ca. 1200 BC).

Beginning of Geometric period in Greek art (ca.

1100–800 BC), primarily involving terracotta fig-urines in naive style, especially of horses.

Chinese develop elegant style and refinement of carving in jade working under the Chou dynasty (ca. 1027–256 BC).

PERFORMING ARTS

Secular professional dancers employed in Egypt, primarily as entertainers for nobility (by ca. 1500 BC).

Instruments played in Mesopotamia include angular (horizontal) harps and small cymbals (by 1500 BC).

Instruments played in Egypt include angular harps, long lutes, divergent reed pipes, short trumpets, frame drums, and rods (sistrum) (by 1500 BC).

Two Egyptian lyres survive, in the Louvre, from the Eighteenth Dynasty (ca. 1500 BC).

Clay tablets in Babylonia include instructions on tuning harps (ca. 1500 BC).

Strings probably of sheep gut found on Egyptian lute (from ca. 1500 BC).

Earliest known trumpets, from the tomb of King Tutankhamen, one of silver, the other of brass and gold (ca. 1350 BC).

Bronze bells were being cast in China (ca. 1200 BC).

Chinese ode describes dancing rites with orchestral accompaniment (ca. 1122 BC); another mentions bells and drums (ca. 1135 BC).

China adopted a seven-note scale for some ritual music (ca. 1116 BC).

Sheng, a free-reed mouth organ, played in China (from at least ca. 1100 BC).

Tuned bells played in China, their fixed-interval relations being important to music theory (from ca. 1050 BC).

WORLD EVENTS

Egyptian trade with Punt began, with an expedition sent by Queen Hatshepsut (ca. 1500 BC).

Arabian camel was domesticated (ca. 1500–1300 BC).

Age of Iron began, as iron weapons replaced bronze in warfare (ca. 1500 BC).

Greeks take Crete, forming merged Mycenean culture (ca. 1500 BC).

Permanent communities settled on North America's northwest coast (by ca. 1500 BC).

Hittites took and sacked Babylon (ca. 1495 BC).

Mycenean Greeks invaded and took Crete (ca. 1400 BC).

Moses led the Exodus from Egypt (ca. 1350 BC).

Pharaoh Tutantkhamen (Tutankhaten) was buried in the tomb reopened in 1922 (ca. 1347–1339 BC).

Mycenean Greeks probably took Troy after a long siege, as recounted in Homer's *Iliad* (ca. 1300–1200 BC).

Dorians began to move into Greece from the north (ca. 1250 BC).

Hebrews conquered Palestine (ca. 1250–1200 BC).

Acropolis, plateau above Athens, first fortified (ca. 1200 BC).

Scythians began to move into areas north of the Caucasus (ca. 1200–700 BC).

Peoples of the Sea attack and defeat Hittites and Ugarit, but are defeated by Egyptians (ca. 1200 BC).

Nebuchadnezzar I reigned in Babylon (1124–1103 BC).

Agadir (Cadiz) and Utique (Utica) were founded by the Phoenicians (ca. 1100 BC).

Tiglath-pileser I of Assyria conquered Syria (ca. 1100 BC).

Phoenician colonies founded on Cyprus and Rhodes (ca. 1050 BC).

Western (Early) Chou period in China (ca. 1030–722 BC).

Saul became king of Israel, and warred with his neighbors, defeating among others the Philistines (ca. 1020–1000 BC).

1000–900 BC

LITERATURE

Greeks adopted the Phoenician all-consonant alphabet and modified it by using unneeded symbols for vowels, including "a" called "aleph" (ca. 1000 BC).

Several books of the Old Testament written, including *Job,* author unknown; *Psalms,* largely by David; *Proverbs, Ecclesiastes,* and *Song of Solomon,* all linked with Solomon; and *1 and 2 Samuel,* author unknown (ca. 10th c. BC or later).

In China, multiple copies of inscriptions from relief-cut stamping seals were taken, laying the basis for later block printing (ca. 1st millennium BC).

Brahmana, sacred texts on Vedic rituals (ca. 1000–800 BC).

Book of Odes, collection of over 300 Chinese songs (ca. 1000–700 BC).

VISUAL ARTS

Purple dyes—the "royal purple"—made from the shellfish murex were introduced by the Phoenicians (1000–951 BC).

Bronze-working techniques used in Indochina, probably learned from China (ca. 1000 BC).

Adena culture of Ohio carved stone pipes to represent human figures (ca. 1000–200 BC).

Temple of Solomon built in Jerusalem (ca. 950 BC).

PERFORMING ARTS

Instruments mentioned in *Psalms* in the Bible include the trumpet (*shofar*), vertical harp (*psaltery*), lyre (*cithara*), frame drum (*timbrel* or *tof*), cymbals (*mtziltayim*), various stringed instruments, and an unknown instrument, *'ugab*, possibly a type of flute (ca. 10th c. BC or later).

Qin, a long zither, and *xiao*, an end-blown flute, used in China (before 1000 BC).

WORLD EVENTS

David became king of Israel, campaigned against several neighbors, including the Philistines. Israelites took Jerusalem, moved Ark of the Covenant there (ca. 1000 BC).

Amber from northern Europe was being traded along the Vistula River and far into the eastern Mediterranean (ca. 1000 BC).

Solomon became king of Israel; during his reign Israel developed substantial trade east and south, and possibly traded far east into southern Asia for spices. Solomon's Temple was also built (ca. 961–922 BC).

900–800 BC

LITERATURE

"Great seal" script developed in Chinese calligraphy under the Zhou Emperor Xuan Wang (827–781 BC).

VISUAL ARTS

Huge human heads with "baby" faces were sculpted from basalt by peoples of the Yucutan's Olmec culture (from ca. 850).

Palace of Assurnasirpal II at Nimrud, Assyria (ca. 883–859 BC).

First known arched bridge was built in Smyrna (Izmir), Turkey (ca. 850–801 BC).

PERFORMING ARTS

Quena or *kena*, a notched flute, played in South American Andes, in Peru and Chile (by ca. 900 BC).

Companies of dancers, mimes, acrobats, and jugglers toured Greece (as early as 9th c. BC), as their successors would do through the Renaissance, and as circuses still do.

Large bronze horns, called *lur*, used in Scandinavia; burial in pairs, always at the same angle, suggest ritual use (900–500 BC).

WORLD EVENTS

Celtic tribes continued to move across Europe, reaching Britain (ca. 900 BC).

Shalmaneser III became ruler of Assyria, and took Syria and much of Middle East (858–824 BC).

Etruscans settled in central Italy (ca. 850–800 BC).

Carthage was founded by the Phoenicians, becoming their western Mediterranean trading center (ca. 814 BC).

800–700 BC

LITERATURE

Iliad, on the Trojan War, and *Odyssey*, probably a sequel, on the wanderings of Ulysses; credited to Homer, greatest of Greek's epic poets, presumably based on earlier oral versions (ca. 800 BC).

Several books of the Old Testament of the Bible written, named for their presumed authors—*Isaiah, Hosea, Joel, Amos, Jonah,* and *Micah* (ca. 8th c. BC).

Upanisads, Sanskrit texts of the teachings of India's Vedic sages (ca. 800–500 BC), and *Aranyakas*, Sanskrit Vedic texts (ca. 800–600 BC).

Earliest surviving inscriptions of the Greek alphabet (ca. 8th c. BC).

Etruscans of northern Italy developed their own version of the Greek alphabet (ca. 800 BC).

Babylonians wrote catalogs of stars (ca. 800 BC).

Book of Documents records the line of China's Shang kings (8th c. BC).

VISUAL ARTS

Olmec peoples built pyramids in La Venta, Tabasco, Mexico (800–751 BC).

Beginning of Archaic period in Greek art (ca. 800–480 BC), with sculpture, public architecture, and early painting, especially of vases, with figures characteristically shown smiling.

Palace of Sargon II at Khorsabad, Assyria (late 8th c. BC).

Palace of Sennacherib at Nineveh, Assyria (ca. 705–681 BC).

PERFORMING ARTS

Art of mime practiced in Greece, as evidenced by fragmentary vase paintings and manuscripts (ca. 800 BC).

Clay bells played in Greece (from ca. 8th c. BC).

WORLD EVENTS

Cimmerians moved into Iran (ca. 800 BC).

Chinese Eastern Chou dynasty began, capital at Loyang (ca. 771–256 BC).

Rome was founded (ca. 753 BC).

Olympic Games were established (ca. 776 BC).

Corfu was founded by Corinth (753 BC).

Cumae was founded by Greeks, near Naples; oldest Greek colony on Italian mainland (ca. 750 BC).

Tiglath-pileser III became ruler of Assyria (744 BC).

Syracuse was founded by Corinth, as the Greek world began to expand strongly into the western Mediterranean (ca. 733 BC).

Israel fell to the Assyrians, under Sargon (722 BC).

Syria and Cilicia fell to Sargon of Assyria (ca. 720).

Tarentum was founded by Greeks (ca. 708 BC).

Sennacherib became king of Assyria (ca. 704–681 BC).

700–600 BC

LITERATURE

Theogony, introducing the main Greek gods and their genealogies, and *Works and Days*, including the story of Pandora's box, both by early Greek poet Hesiod (active ca. 700 BC).

Two books of the Old Testament of the Bible written, named for their presumed authors— *Nahum* and *Habakkuk* (ca. 7th c. BC).

Aramaic script came into widespread use in the Near East, forming the basis for the Square Hebrew script and various Western Asian scripts (by 7th c. BC).

Demotic script evolved from hieratic script in Egypt.

Archilochus, Greek poet who wrote many elegies, noted for their innovation in poetic meter (ca. 680–ca. 640 BC).

Avesta, sacred book of Zoroastrians and Parsees (before 628 BC to ca. 4th c. AD); the oldest part, five hymns called the *Gathas*, traditionally credited to Zoroaster himself.

Zephaniah, book from the Old Testament of the Bible, written; named for its presumed author (before 621 BC).

VISUAL ARTS

Hanging Gardens of Babylon, roof gardens that were one of the "Seven Wonders of the World," built by Nebuchadnezzar II (ca. 630–562 BC).

Greek temple to Apollo, at Delphi, home of the Delphic Oracle (by 7th c. BC), and site of Olympic (Panhellenic) Games every four years from 582 BC; abandoned after 4th century AD, later partly restored.

Earliest known examples of Animal Style, small, portable, decorative depictions of animals in natural media, such as bone or horn, or in gold (ca. 650 BC), from Temir Gora on the Taman Peninsula; especially associated with the Scythians.

PERFORMING ARTS

Greeks had two main kinds of lyre, the personal-size *lyra*, and the *kithara* used by professionals and in contests (from 7th c. BC).

WORLD EVENTS

Kingdom of the Medes was founded (ca. 700).

Byzantium was founded (ca. 660 BC).

Kingdom of Lydia was founded (ca. 687 BC).

Scythians invaded Armenia (680 BC).

Egypt was conquered by the Assyrians (671 BC).

Jimmu Tenno became the legendary first Japanese emperor, his capital near Kyoto (ca. 660 BC).

Cyrus I became king of Persia (640–600 BC).

Judah became an independent state, winning freedom from Assyria (ca. 629–628 BC).

Babylon won its independence from Assyria (626 BC).

Draco (the Lawgiver) created the first Athenian code of laws (621 BC).

Nineveh fell; Babylon and Media divided what remained of Assyria (612 BC).

600–500 BC

LITERATURE

First five books of the Bible, the *Pentateuch* or *Torah*, translated into Aramaic by various scholar-translators (6th–5th c. BC); the Babylonian *Targum* (translation) was credited to Onkelos.

Several books of the Old Testament of the Bible written: *1* and *2 Kings*, author unknown; *Jeremiah* and *Lamentations*, both credited to Jeremiah; and three books named for their presumed authors: *Ezekiel*, *Daniel*, and *Obadiah* (ca. 6th c. BC).

Aesop's Fables, moralistic folktales (ca. 6th c. BC) usually with animal characters, credited to possibly legendary Greek writer Aesop.

Astadhyayi, Sanskrit Vedic grammar (ca. 600 BC).

Poems by Buddhist nuns (*theris*) written (from ca. 6th c. BC); later collected in the *Therigatha* (ca. 80 BC).

Earliest surviving inscription in Latin (6th c. BC).

d. Sappho, Greek woman poet from the island of Lesbos (active ca. 610 BC–ca. 580 BC), whose hymns and songs—including poems criticizing uneducated women—survive only in fragments.

d. Alcaeus, Greek lyric poet (ca. 620 BC–ca. 580 BC), whose songs were edited by Aristophanes and Aristarchus, but survive only in fragments.

Lao Tzu (Lao-Tse), Chinese philosopher and founder of Taoism (active ca. 570 BC), whose name means "Master Tzu"; thought to have taught Confucius and credited with writing *Tao-te ching* (*The Classic of the Way and Its Power*), oldest of the Taoist works (collected ca. 3rd–4th c. BC).

Two books of the Old Testament written: *Haggai* (520 BC) and *Zechariah* (ca. 520–500 BC).

The Survey of the Earth, Hecataeus of Miletus's lost geographical work (ca. 510 BC).

VISUAL ARTS

Greeks began to carve marble statues (by ca. 600 BC), often of naked young males (*kouroi*), but also fully clad women (*kourai*).

Temple of Hera, Olympia, earliest surviving Doric-style temple (before 600 BC).

First map of the world, inscribed on clay, made at Nineveh (ca. 600 BC).

Huai style developed in China, characterized by elaborate, intertwining motifs (ca. 600 BC).

Temple of Artemis (Diana), shrine built at Ephesus by Chersiphron for Croesus, King of Lydia (ca. 560–546 BC), one of the "Seven Wonders of the Ancient World"; later burned (4th c. BC), rebuilt, then destroyed in 3rd century AD, though fragments survive.

Temple of Hera, at Samos, by Greek architect Theodorus of Samos and possibly his son Rhoecus (ca. 560 BC).

Bronze casting by lost-wax method introduced into Greece (mid-6th c. BC), according to tradition by Theodorus, Rhoecus, and craftsmen of Samos.

"Basilica" of Paestum, in southern Italy, an early Doric Greek temple (ca. 530 BC).

Monument at Behistun, celebrating Darius's ascension to the throne of Persia with an inscription in Old Persian, Elamite, and Babylonian (ca. 521 BC).

Palace at Persepolis, with its Hall of a Hundred Columns and numerous sculptured reliefs, built (518–ca. 460 BC) employing artisans and styles from throughout the vast Persian Empire; largely destroyed by Alexander the Great (ca. 331 BC).

First known attempt to beautify a city by planting trees, by Cimon in Athens (ca. 512–449 BC).

PERFORMING ARTS

Arion of Corinth credited with making a distinct literary form of choral lyrics called *dithyrambs* (ca. 600 BC), which Aristotle regarded as the source from which Greek tragedy developed.

Panpipes depicted on urns in northeast Italy, widely played by Etruscans and Greeks (by 6th c. BC), remaining popular in folk music around the world.

Thespic of Icaria, Greek poet and playwright, began his career (ca. 560 BC); he was the first to present spoken dialogue on stage, in what had been all-choral works, and so is regarded as the first professional actor and the founder of drama. He also adopted various disguises, including a linen mask.

Earliest depiction of a Chinese *sheng* (mouth organ) (551 BC).

Thespis of Icaria performed and won first prize at the first Great Dionysia, a spring Athens theatrical contest (ca. 534 BC); all of Thespis's plays have been lost.

Phrynichus won first prize for tragedy in Athens's Great Dionysia for a now-lost play (511 BC).

Athens instituted official competitions for choral lyrics called *dithyrambs* (509 BC); they would continue as a significant art form through the 4th century BC.

WORLD EVENTS

Phoenician sailors probably traveled around Africa (ca. 600 BC).

Greeks founded Massalia (Marseilles) (ca. 600 BC).

Avars moved out of central Asia as far west as Hungarian plain (ca. 600 BC).

Solon, Archon of Athens, made many legal and institutional reforms (594–593 BC).

Judah revolted against Babylonian rule; Jerusalem fell after a long siege; Solomon's Temple was destroyed; thousands of Jews were deported to Babylon, beginning the Babylonian Captivity (ca. 587 BC).

Croesus became king of Lydia (560–546 BC).

Cyrus II (the Great) became king of Persia (559–530 BC).

Cyrus II took Lydia in the course of building the Persian Empire, ultimately reaching from India to the Mediterranean (547 BC).

Cyrus II of Persia took Babylon; Jews set free to return from their exile (539 BC).

Cambyses succeeded Cyrus as Persian emperor, then conquered Egypt and North Africa (530 BC).

Darius took power in Persia, in the following decade attacking Scythia, and taking Thrace and many of the Greek Asia Minor colonies (521–512 BC).

Roman Republic established after revolutions toppled Tarquin (ca. 509 BC).

500–476 BC

LITERATURE

The five Confucian Classics (all ca. 500 BC): *I Ching* (*Classic of Changes* or *Book of Changes*), religious, philosophical, and folk writings; *Shu Ching* (*Classic of History* or *Book of Documents*), Chinese court historical materials; *Shih Ching* (*Classic of Poetry* or *Book of Odes*), first anthology of Chinese poetry; *Li chi* (*Record of Rites*), rituals and stories; and *Ch'un Ch'iu* (*Spring and Autumn Annals*), a chronology of the history (722–481 BC) of Confucius's home area of Lu.

Left-to-right horizontal script became firmly established in Greek writing, setting the modern Western pattern (5th c. BC).

Square Hebrew script adopted for the writing of the Scriptures, reportedly by Judaic reformer Ezra (5th–4th c. BC).

Several books of the Old Testament of the Bible written: *1* and *2 Chronicles*, author unknown, and three credited to their presumed authors: *Ezra*, *Nehemiah*, and *Esther* (ca. 5th c. BC).

Lieh Tzu, author of *Lieh Tzu*, a Chinese Taoist work (active ca. 500 BC).

Hieroglyphic writing and mathematical–astronomical almanac developed in Central America by Olmec peoples (by ca. 500 BC), providing basis for later Mayan writing.

Indian and Southeast Asian Buddhists and Jains reportedly wrote down their scriptures on palm leaf, wood, and bamboo (by ca. 500 BC).

Anacreon's main work, including lyric poems, love songs, and elegies, some fragments of which survive in part (ca. 500 BC).

Earliest stelae (stone monuments) inscribed with hieroglyphics in Mexico (ca. 500 BC).

VISUAL ARTS

Temple of Zeus Olympios at Agrigento in Sicily, early Greek Doric temple (ca. 500–470 BC).

Apollo of Veii, life-size Etruscan terracotta statue, now at Rome's Villa Giulia (ca. 500 BC).

Art of making mosaics developed by Romans (ca. 5th c. BC).

La Tène style of decoration used on Celtic weapons and ornaments (from 5th c. BC).

Chinese make small wooden sculptures for ritual use (ca. 5th c. BC).

Beginning of Classical period in Greek art (ca. 480–323 BC), the great age of sculpture and architecture, and later painting, especially emphasizing beauty of proportion.

Apollodorus, Athenian painter (active 5th c. BC), described by Pliny as being the first to use light and shade in modeling figures.

PERFORMING ARTS

Shih Ching (*Classic of Poetry*), one of five Confucian Classics (ca. 500 BC); a poetry anthology that is also a classic of music, its text including 305 Chinese songs, some dating back to 1000–700 BC.

Epicharmus, earliest and best-known writer of mime plays (active early 5th or late 6th c. BC); a Greek Sicilian, probably from Syracuse.

Instruments used in South and Central America include rattles, drums, and flutes (by 500 BC).

Bronze bells used in Greece (by ca. 500 BC).

Aeschylus won his first known prize, for a now-lost tragedy (484 BC).

WORLD EVENTS

Expanding Hsiung-nu (later Huns) pushed the Yüeh-chih (Scythians) west across the steppe along the Eurasian Steppe Route (the "Earth Girdle"); they in turn forced the Cimmerians into Europe (ca. 500 BC).

Revolt of Ionian Greek cities in Asia Minor was crushed by Persians (ca. 499–494 BC).

Persians lost much of their invasion fleet in a storm while headed for the Greek mainland, and aborted a planned invasion (492 BC).

Persian fleet and army invaded Greece, and took Eretria, but were defeated at the Battle of Marathon, on Attica, returning to Persia (490 BC).

d. Siddhartha Gautama (ca. 563–ca. 483 BC) known as the Buddha, founder of Buddhism (ca. 563–ca. 483 BC); first Buddhist Council met at Rajagaha (483 BC).

Massive Persian army led by Xerxes crossed Helle-spont (Dardanelles) on bridge of ships, took Athens after Greek resistance at Thermopylae. Persian fleet was destroyed at Salamis; Xerxes retreated to Persia, but left large force in Greece (480 BC).

Greeks decisively defeated remaining Persian force in Greece at Plataea (479 BC). Greeks also burnt drydocked Persian fleet at Cape Mycales, freeing Greek cities in Asia Minor to successfully revolt.

Warring States period in China (480–221 BC).

Hamilcar of Carthage invaded Sicily (ca. 480 BC).

475–451 BC

LITERATURE

d. Simonides of Ceos, Greek poet (ca. 556–ca. 468 BC), who won numerous prizes for his choral lyrics (*dithyrambs*). He was credited with adding four letters to the Phoenician-derived Greek alphabet.

Pythian, Pindar's latest surviving poem (ca. 462).

VISUAL ARTS

Delphi Charioteer, bronze statue, originally with chariot and horses, commissioned by Polyzalus of Gela after his victory at the Olympic games (after 474 or 478 BC).

PERFORMING ARTS

Aeschylus won first prize at Athens's Great Dionysia with *The Persians* (472 BC), set during the Greek victory over the Persians at Salamis, where he himself had fought; a major innovation to the theater was his introduction of a second actor to the stage. His earliest surviving tragedy, it was part of a tetralogy including *Phineus*, *Glaucus of Potniae*, and *Prometheus*.

d. Phrynichus, Greek tragic poet and playwright (ca. 540–ca. 470 BC), who first introduced female characters to the stage; his works, lost except for fragments, included *Alcestis*, *The Sack of Miletus*, and *Phoenician Women*.

The Suppliant Maidens, Aeschylus's tragedy on mythological themes; the surviving play was part of a tetralogy on the legend of Danaus and his 50 daughters, including *Egyptians*, *Daughters*

of Danaus, and *Amymone* (probably after 468 BC).

Sophocles won first prize in Athens's Great Dionysia, defeating the great Aeschylus, with a now-lost play (468 BC).

Seven Against Thebes, Aeschylus's tragedy, won first prize at Athens's Great Dionysia (467 BC); the history of a legendary Theban royal house was part of the tetralogy that included *Laius*, *Oedipus*, and *Sphinx*, now lost but for fragments.

The Oresteia, Aeschylus's great tragedies on the royal house of Atreus: *Agamemnon*, *The Libation Bearers*, *Eumenides*, and *Proteus*; the tetralogy won first prize at Athens's Great Dionysia (458 BC); the first three survive.

Aeschylus's trilogy on political and mythological themes, *Prometheus Bound*, *Prometheus Unbound*, and *Prometheus the Fire-Bearer*; only the first play survives (ca. 458–456 BC).

d. Aeschylus, Greek playwright, who introduced the second (and possibly third) actor into the Greek theater and reduced the size of the chorus in tragedies from perhaps 50 to 12–15; seven of his approximately 90 classic plays survive (525–456 BC).

Euripides entered his first Dionysia at Athens (455 BC).

WORLD EVENTS

Greek fleet destroyed a Persian fleet off Pamphylia (468 BC).

Preparation for the Peloponnesian Wars began, as Sparta, Corinth, Thebes, and Aegina allied themselves against Athens (462 BC).

Hippocrates opened his pioneering medical school at Cos (ca. 460–367 BC).

b. Democritus, Greek philosopher (ca. 460–ca. 361 BC).

Temple of Delphi was destroyed by fire (458 BC).

450–426 BC

LITERATURE

Malachi (450–425 BC), the last book of the Old Testament, written.

d. Bacchylides, Greek choral lyric poet (ca. 524–ca. 450 BC).

Herodotus's *History*, a lively, occasionally fanciful portrait of the Greeks' known world and its recent history (ca. 445–425 BC).

d. Pindar, Greek choral lyric poet (518–438 BC), whose odes and songs much influenced later poets.

d. Empedocles, Greek philosopher (ca. 493–ca. 433 BC), author of *On Nature* and *Purifications*, verses on cosmology and matter.

VISUAL ARTS

Parthenon, Athens's main temple to its patron goddess, Athena, erected on the Acropolis, the plateau overlooking the city (447–ca. 432 BC), by architects Ictinus and Callicrates, with notable sculptures by Phidias, some now in the British Museum as the "Elgin marbles."

Phidias, Athenian sculptor (active mid-5th c. BC); among his statues were *Athena*, at the Parthenon; the bronze work *Athena Promachos*; and *Zeus*, in the temple of Zeus at Olympia's sacred grove, one of the "Seven Wonders of the Ancient World," destroyed in the 5th c. AD.

Polygnotus of Thasos, Greek painter (active ca. 450 BC).

d. Polyclitus of Argos or Sikyon, Greek sculptor (active ca. 450–420 BC), known for his descriptions of the proportions that constitute ideal male beauty.

Temple of Hephaistos, Athens (ca. 449–444 BC).

Propylaea, Mnesicles's monument forming the entrance to Athens's Acropolis (437–432 BC).

PERFORMING ARTS

Ajax, Sophocles's tragedy set during the siege of Troy (ca. 442 BC), probably his earliest surviving play.

Antigone, Sophocles's tragedy of Antigone, Creon, and the dead Polyniece, involving the conflict between private and public duty (ca. 442–440 BC); basis of several modern plays.

Euripides won his first top prize at Athens's Dionysia (441 BC).

Alcestis, Euripides's tragicomedy based on a folktale; his earliest surviving datable play, originally part of a tetralogy (438 BC).

Trachiniae (*Women of Trachis*), Sophocles's tragedy (ca. 437–429 BC).

Oedipus the King (*Oedipus Tyrannus*), Sophocles's

powerful tragedy on the legend of the Theban king Oedipus, who unknowingly killed his father and married his mother (ca. 430 BC).

Medea, Euripides's tragedy of the revenge of Medea on Jason (431 BC).

Hippolytus, Euripides's tragedy of sexual passion involving Theseus, his young wife Phaedra, and her stepson Hippolytus, which won first prize at the Athens Dionysia (428 BC).

The Children of Heracles (ca. 427–429 BC), one of Euripides's series of "political" plays against the backdrop of the Peloponnesian war.

Aristophanes's first two plays, both now lost: *Banqueters* (427 BC) and *Babylonians* (426 BC), the latter satirical comedy sparking condemnation by the Athenan Council.

WORLD EVENTS

Phoenician fleet was defeated by Athenians off Cyprus (450 BC).

Spartan-led army moved on Attica; Athens–Sparta peace treaty (446 BC).

Peloponnesian Wars began, with invasion of Attica (431–421 BC).

425–401 BC

LITERATURE

d. Herodotus, Greek historian (ca. 484–ca. 420 BC).

Athenian Greeks passed a law to standardize the letters of the alphabet (403 BC), basis of the modern Western alphabet; among the new letters added were *phi* (Φ), *chi* (χ), *psi* (ψ), and *omega* (Ω).

d. Thucydides, Greek historian (ca. 460/455–ca. 402/399 BC); his *History of the Peloponnesian War*, on the conflict between Athens and Sparta (431–404 BC), was incomplete at his death.

VISUAL ARTS

Erechtheum, a temple on Athens's Acropolis, probably used by several cults (421–406 BC).

Zeuxis, Greek painter (active late 5th c. BC), who specialized in panel paintings, building on Apollodorus's use of light and shade in modeling figures.

PERFORMING ARTS

The Acharnians (*Acharniana*), Aristophanes's antiwar comedy (425 BC), his earliest surviving play, which won first prize at the Athens Dionysia.

Euripides's tragedy *Andromache* (ca. 425–423 BC).

The Knights, Aristophanes's comedy ridiculing the demagogue Cleon, which won first prize at the Athens Dionysia (424 BC).

Hecuba, Euripides's tragedy about a Trojan widow's revenge on the loss of her sons (ca. 424 BC).

Euripides's political play *Suppliant Women* (ca. 424–420 BC).

Cyclops, Euripides's satiric play (ca. 423 BC), based on Homer's tale.

The Clouds, Aristophanes's comedy of a simpleton going to Socrates's school; one of his most famous plays, unsuccessful at first (423 BC).

The Wasps, Aristophanes's play satirizing trial by mass jury (422 BC); it came in second in the Athens Dionysia.

Heracles, Euripides's bitter tragedy of Heracles and his enemy Hera (ca. 422–416 BC).

Peace, Aristophanes's play, which won second prize at Athens's Great Dionysia (421 BC).

Ion, Euripides's play (ca. 421–411 BC).

Agathon, Greek tragic poet, won the first of his two victories at the Athens Dionysia (416 BC), for an unknown play; his celebration party was described in Plato's *Symposium*, and he was satirized in Aristophanes's *Thesmophoriazusae* (*Women at the Festival*).

The Trojan Women, Euripides's play (415 BC), about the aftermath of a massacre by the Athenians.

Electra, Sophocles's tragedy (ca. 414 BC) about Electra's revenge on the murderers of her father, Agamemnon, on his return from the wars.

The Birds, Aristophanes's escapist comedy–fantasy, which placed second at the Athens Dionysia (414 BC).

Iphigenia in Tauris, Euripides's romantic drama about priestess Iphigenia saving her brother Orestes and his friend (ca. 414–411 BC).

Some enslaved Athenian prisoners of war in Sicily won their freedom by performing plays of Euripides (413 BC), according to Plutarch.

Helena, Euripides's rare comedy–drama (412 BC).

Lysistrata, Aristophanes's comedy about women using sex to force an end to war (411 BC).

Phoenician Women, Euripides's tragedy of Thebes under attack (411–409 BC).

Thesmaphoriazousae (*Women at the Festival*), Aristophanes's comedy (411 BC) about women's revenge on Euripides for his "slander" of them in *Lysistrata*.

Philoctetes, Sophocles's play, won first prize in the Athens Dionysia (409 BC).

Orestes, a sequel to *Electra*; one of Euripides's most popular plays (ca. 408 BC).

Euripides's plays *Ion* and *Heracles* (408 BC).

Two posthumously produced plays by Euripides, produced by his son, Euripides, won first prize at the Athens Dionysia: *The Bacchantes* (*Bacchae*) (ca. 407 BC), his masterpiece depicting the coming of the god Dionysus to Thebes; and *Iphigenia at Aulis* (ca. 408–406 BC), possibly finished by someone else, his tragedy of Agamemnon sacrificing his daughter.

Oedipus at Colonus, Sophocles's tragedy of the old blind hero–king (ca. 406 BC), first produced posthumously in 402 BC.

d. Sophocles, Greek playwright (ca. 496–406 BC), whose classic works are central in world theater, though only 7 of perhaps 123 plays survive; he (or Aeschylus) introduced the third actor into Greek drama, was reportedly the first to use painted scenery, and was the first playwright who did not always act in his own works. He won first prize in the Athens Dionysia 24 times.

d. Euripides, Greek playwright, the first great realist in drama (480–406 BC), who shocked both contemporaries and many later audiences.

The Frogs, Aristophanes's play about Dionysus's return to earth as a tragic playwright (406 BC); it not only won first prize but was, unusually, played a second time.

WORLD EVENTS

Failed siege of Syracuse sapped Athenian strength, bringing closer defeat by Sparta (414 BC).

Carthaginian invasion of Sicily began the long Greek–Carthage wars (ca. 409 BC).

Sparta ultimately defeated Athens; after Athenian surrender, Spartans occupied Athens and took much of remaining empire (405 BC).

Artaxerxes II became king of Persia (404–358 BC).

400–375 BC

LITERATURE

Mahabharata, Indian poem in Sanskrit, the world's longest epic, developed over centuries (by ca. 400 BC–ca. 200/400 AD), to more than 100,000 couplets; includes the *Bhagavadgita* (*Song of the Lord*) and a version of the *Ramayana*.

Greek poet Simias wrote poetry in the shape of objects, such as an egg or a bird in flight (4th c. BC).

Earliest surviving example of shorthand, from the Acropolis, in Athens (ca. 4th c. BC).

d. Socrates, Greek philosopher (ca. 469 BC–ca. 399 BC), sentenced to death by the citizens of Athens.

Plato founded his Academy in Athens (ca. 387–370 BC). Most of his major works were probably written before this, including *Apology*, his defense of Socrates against the charges for which he was sentenced to death; the early Socratic dialogues on knowledge, truth, and virtue, such as *Crito*, *Euthyphro*, *Hippias Minor*, *Laches*, and *Lysis*; and the more mature dialogues, such as *Gorgias*, *Meno*, *Protagoras*, *Phaedo*, *Symposium*, *Phaedrus*, and *Republic*.

Xenophon's *Anabasis*, an account of Greek mercenaries—the Ten Thousand—serving under Cyrus of Persia, and their dramatic retreat to the Black Sea (after 386 BC).

VISUAL ARTS

Teotihuacán (City of the Gods), complex containing the huge Pyramids of the Sun and Moon, near Mexico City (ca. 400 BC).

Greek sculptors, according to Pliny, developed the practice of *indirect carving*, where the artist first works in another material, then does the actual cutting of stone to match that (late 4th c. BC).

PERFORMING ARTS

Ecclesiazusae (*Women in Parliament*), Aristophanes's comedy (392 BC), focusing on communal sharing

and equality between sexes, ideas soon taken up seriously in Plato's *Republic*.

Plutus, Aristophanes's last surviving play (388 BC), a revision of an earlier work.

d. Aristophanes, Greek playwright (ca. 450–ca. 380 BC).

WORLD EVENTS

Celts moved across Europe; large bands crossed the Alps, fighting their way south into Italy (ca. 400 BC).

Celts moving south in Italy defeated the Roman army and took Rome. Gauls moving south took, sacked, and burned Rome (ca. 390 BC).

Hippocrates, teaching the independent practice of medicine at Cos, originated the Hippocratic oath (ca. 400 BC).

Xenophon led retreat of Greek army of the Ten Thousand, after their defeat by the Persians at Cunaxa (400 BC).

Carthaginians laid siege to Syracuse; Greek cities came to aid of Syracuse, forced Carthaginian withdrawal (397–396 BC).

Syracusan army led by Dionysius took the offensive against Carthaginian settlements in Sicily (ca. 380–375 BC).

Temple of Asclepius was built in Epidaurus (ca. 380–375 BC).

375–351 BC

LITERATURE

Chuang Tzu (*Master Chuang*), Chinese Taoist text (369–286 BC).

Plato's *Theaetetus* (368 BC) and other late works, including *Parmenides*, *Politicus*, *Sophistes*, *Philebus*, *Timaeus*, and *Laws* (ca. 368–348 BC).

d. Xenophon, Greek historian (ca. 430–ca. 354 BC), best known for his *Hellenica*, intended to complete Thucydides's *History of the Peloponnesian War*, and also cover earlier Greek history.

VISUAL ARTS

Theodorus of Phocaea, Greek architect (active early 4th c. BC), credited with building the bee-

hive-shaped Tholos at Delphi.

Mausoleum of Halicarnassus (355–330 BC), tomb of Mausolus, King of Caria, built by Pythius, with Satyrus; including sculptures by Praxiteles and Scopas; one of the "Seven Wonders of the Ancient World," it was destroyed in an earthquake (ca. 1400 AD).

PERFORMING ARTS

Greek chorus, originally amateurs, had become professional players, like the main actors; all were male (by 4th c. BC).

Zheng, a long zither, used in China (by 4th c. BC).

WORLD EVENTS

Philip of Macedon began his conquest of Greece (359–336 BC).

War between Rome and the Etruscan League won by Rome (356 BC).

Chinese observers made the first recorded sighting of a supernova (352 BC).

350–326 BC

LITERATURE

d. Plato, Greek philosopher and writer (ca. 428–ca. 348 BC).

Aristotle produced or began major works: *De anima*, on thought and sensation, perhaps the first work of psychology; *Organon*, on logic; *Historia animalium*, on biology; *Physics*; *Metaphysics*; *Politics*; *Rhetoric*; *Nichomachean Ethics*; and *Eudemian Ethics* (ca. 347–ca. 335 BC). He also became tutor to Macedonian prince Alexander, later called "The Great" (342 BC).

Aristotle ran a school, named the Lyceum after the nearby grove Apollo Lyceius (335–ca. 323 BC); his works from then included *Protrepticus* and *Constitutions of Cities*, and possibly *Poetics*, his still-influential classic of literary criticism.

VISUAL ARTS

Praxiteles, Athenian sculptor (active mid-4th c. BC); among his works are *Hermes* (340 BC), his famous

statue from the temple of Hera at Olympia, and the *Cnidian Aphrodite* and *Sauroctonus* (both ca. 350 BC).

Greek amphitheater at Epidaurus (ca. 350 BC), revealing not only architectural skills but command of acoustics.

Celtic chiefs began building Maiden Castle in south Dorset, one of the great fortified castles of Britain (350–341 BC).

Choragic Monument of Lysicrates, Athens (335–334 BC), the epitome of late Classical architecture.

Demeter of Cnidus, marble Greek statue (ca. 330 BC) found at Cnidus, perhaps originally accompanied by a figure of Persephone, as in a similar bronze sculpture retrieved from the sea in 1953.

Gardens were planted to beautify the Temple of Hephaistus in Athens (ca. 330 BC).

WORLD EVENTS

Persians took Egypt, ending the last Egyptian-born dynasty (30th) and beginning the 31st dynasty (343 BC).

Philip of Macedon completed his conquest of Greece, joining all in a league of semiautonomous states dominated by Macedon (338 BC).

d. Philip of Macedon, assassinated; he was succeeded by his son, Alexander the Great (336 BC).

Alexander began his campaign of conquest, crossing the Hellespont (Dardanelles) to defeat the Persians in a series of battles that took him deep into Persia; Alexander also took Egypt and much of the southeastern Mediterranean coast (334–332 BC).

Alexander founded Alexandria, Egypt (331 BC).

Alexander fought his way east, taking Persepolis, Persia's capital, then taking much of south-central Asia (331–329 BC).

Alexander attacked and took much of northern India (327–326 BC).

Praxagoras, Greek physician (active second half of 4th c. BC).

325–301 BC

LITERATURE

Arthashastra, Indian treatise on government and economics credited to Kautalya (active ca. 322–298 BC).

d. Aristotle, Greek philosopher and scientist (384–322 BC).

d. Demosthenes, Greek orator (384–322 BC).

VISUAL ARTS

Beginning of Hellenistic period in Greek art (ca. 323–27 BC), a period of more diverse styles, building on the Classical.

Apollo Belvedere, best-known statue of the Greek god Apollo, from Classical or Hellenistic era; today known only from a Roman marble copy (ca. 323 BC).

Nicias, Greek painter (active ca. late 4th c. BC), best known for his painting of the sculptures of Praxiteles (their original state, not the white marble of surviving statues).

PERFORMING ARTS

Lü Pu-We, Chinese musical theorist (active ca. 320 BC), author of the earliest surviving Chinese musical writings, including descriptions of large orchestras and many instruments; and the combining of poetry, music, and dance.

Misanthrope (*Dyscolus*), Menander's only surviving complete play, which took first prize at the Athens Dionysia (316 BC); a copy was rediscovered only in 1958, from an Egyptian papyrus.

Menander's comedies *Hero* (314 BC); *Shorn Girl* (ca. 310 BC); and *Woman from Samos* (308 BC).

Guild of professional musicians in Rome conducted a notable labor strike (311 BC).

WORLD EVENTS

d. Alexander the Great (356–323 BC); his empire was divided between his contending generals.

Chandragupta Maurya founded India's Maurya dynasty (ca. 322 BC).

Ptolemy, formerly Alexander's general, took Egypt and Syria (320–319 BC).

Seleucid dynasty was founded by Seleucus Nicator, who took Babylon (312 BC).

300–276 BC

LITERATURE

Term "alphabet" came into use, so called because the

first two Greek letters were *alpha* (A) and *beta* (B) (3rd c. BC).

Great library, the *Mouseion*, established at Alexandria, Egypt, by Ptolemy I (built ca. 300–250 BC).

"Little seal" script developed in Chinese calligraphy (ca. 3rd c. BC).

Hsün Tzu, Hsün Ch'ing's Chinese Confucian work (ca. 300 BC).

Ch'u Yüan's poem *Heaven Questions* (ca. 300 BC).

d. Menander, Greek comic poet (ca. 342/341–ca. 293/289 BC).

VISUAL ARTS

Small animal and human figures cast in bronze in China (by 3rd c. BC), beginnings of Chinese sculpture "in the round."

Temples of plastered masonry built by Mayans at their ceremonial center of Tikal, Guatemala (by ca. 300 BC).

Temple platform built by Mayans at Uaxactún, Guatemala (ca. 300 BC).

Colossus of Rhodes (ca. 290 BC), a 100-foot-high statue of the sun god, overlooking the harbor of Rhodes, created by Chares of Lindus; one of the "Seven Wonders of the Ancient World," it was partly destroyed in an earthquake (ca. 225 BC), then broken up for scrap (ca. 7th c.).

Hopewell culture of the American Midwest (Ohio, Michigan, Wisconsin) developed a distinctive style of carving mica and copper sheets, and incising bone (ca. 300 BC–500 AD).

Apelles, Greek painter (active ca. 356–336 BC), whose works included portraits of Philip of Macedon and his son, Alexander the Great, at the Temple of Artemis, Ephesus; and *Aphrodite Rising from the Sea* (*Aphrodite Anadyomene*), in Cos.

PERFORMING ARTS

Artists of Dionysus, organizations of actors, musicians, mask makers, writers, and stagehands, was formed in the ancient Greek theater. The oldest guild was in Athens (ca. late 4th c. BC), but after ca. 290 BC several others were established, including guilds in Egypt and the Ionian-Hellespontic region.

The Arbitration, Menander's play (ca. 300 BC).

Apollonius of Perga credited with developing mechanical musical instruments, including singing birds (3rd c. BC).

d. Menander, Greek comic poet and playwright (341–290 BC) whose 100 or more comedies were noted for their wit and ingenious plots, regarded as the height of the "New Comedy."

WORLD EVENTS

Museum of Alexandria was built, and became the center of Greek mathematics and a wide range of other scholarly and artistic work (ca. 300–291 BC).

Antioch was founded (300 BC).

d. Mauryan emperor Chandragupta (ca. 321–ca. 297 BC); fresh conquests under Bindusara expanded the empire in northern India.

Rome was at war with the Gauls and their Samnite allies (295 BC).

Etruria and the Gauls were at war (284 BC).

275–251 BC

LITERATURE

Earliest surviving examples of a distinctive Indian script, edicts of Emperor Ashoka (272–231 BC), inscribed in rock; it would later spread with Buddhism into central and Southeast Asia.

d. Epicurus, Greek philosopher (341–271 BC), best known for his *On Nature*.

VISUAL ARTS

Pharos, noted lighthouse built by Sostratus for Ptolemy II (ruled ca. 283–246 BC) on Pharos Island, off Alexandria, Egypt; one of the "Seven Wonders of the Ancient World," it was partly destroyed in the 9th century and toppled in an earthquake (ca. 13th c.).

Earliest surviving sculptures in Amaravati style on Ceylon (3rd c. BC).

WORLD EVENTS

First Punic War began between Rome and Carthage (264–241 BC).

Syracuse besieged by Romans (263 BC).

Carthaginian fleet defeated by Romans off Mylae (260 BC).

Asoka succeeded Bindusara as Mauryan emperor (273 BC).

Buddhism brought to Ceylon by Indians (269–232 BC).

250–226 BC

LITERATURE

Old Testament of the Bible began to be translated into Greek (ca. 250 BC), probably in Alexandria, reportedly by 70 scholars, and so called the *Septuagint* (Greek for 70); basis of the Christian Bible.

Dead Sea Scrolls, fragments of various books of the Bible, hidden in caves at Qumran, in the Judaean Desert; found in the 1940s (ca. 250 BC–2nd c. AD).

d. Theocritus, Greek poet (ca. 310/300–ca. 260/250 BC).

d. Apollonius Rhodius, Alexandrian scholar and epic poet (ca. 295–after 247 BC), best known for his *Argonautica*.

d. Callimachus, Greek poet and scholar (ca. 305–ca. 240 BC), known for his four books of elegies, including *Lock of Berenice*, and his *Pinakes*, the first known systematic library catalog, in 120 books.

VISUAL ARTS

Great Stupa at Sanchi, built in Bhopal, India, by Mauryan Emperor Ashoka to house a relic of Buddha (ca. 240 BC); enlarged under the Andrha dynasty (72–25 BC); sculptured reliefs became common on buildings and monuments.

Dying Gaul, Greek statue presumed to be from Pergamum, known now only from a Roman copy, in the Capitoline Museum (late 3rd c. BC).

Celtic style of art, emphasizing stylized plant and geometric forms, probably developed from early Greek styles, developed in British Isles (during 3rd c. BC).

PERFORMING ARTS

First known example of an organ, the *hydraulis*, invented by Alexandrian engineer Ktesibios, who also developed mechanical singing birds (ca. 246 BC).

d. Theocritus, Greek poet, from Syracuse; also a writer of mime plays.

WORLD EVENTS

Sarmatians moving out of Asia pushed Scythians south into the Crimea (ca. 250 BC).

First Punic War ended with Roman victory; Sicily became a Roman province (241 BC).

Rome took Sardinia and Corsica from Carthage, making them Roman provinces (238 BC).

Chinese astronomers made first sighting and recording of Halley's comet (240 BC).

225–201 BC

LITERATURE

The great Chinese book burning, accompanied by executions of intellectuals, ordered by Emperor Huang Di (213 BC).

Meng Tian credited with inventing the brush used in Chinese calligraphy (before 209 BC).

Chinese developed script signs indicating sound as well as meaning or general concept, under the Han dynasty (206 BC–221 AD).

d. Gnaeus Naevius, Roman dramatist and epic poet (ca. 270–ca. 201 BC), author of *Bellum Punicum*, a history of the First Punic War.

VISUAL ARTS

Qin Shih Huang Di Tomb, burial site of the first emperor and unifier of China, Qin Shih Huang Di (Ch'in Shih Huang Ti), who died in 210 BC and was buried with thousands of life-size terracotta soldiers to guard him; discovered near Xian (Sian) in 1974.

Bridge at Martorell, Spain, with 130-foot center arch; oldest surviving bridge of substantial length (ca. 219 BC).

Under the Han dynasty (206 BC–220 AD), Chinese artists developed an extraordinarily lifelike and lively way of depicting animals, in jade or bronze sculptures or pottery.

Earliest known pottery house-models from Chinese tombs (ca. 202 BC).

PERFORMING ARTS

Titus Maccius Plautus produced numerous Roman comedies (*fabulae palliatae*), many of which survive, the best known being *Miles Gloriosus, the Braggart Warrior* (probably 204 BC), basis for the Elizabethan stock character, and *The Menaechmi* (ca. 215 BC), involving confusion of identical twins, basis for William Shakespeare's *The Comedy of Errors*. Others include *The Comedy of Asses* (ca. 217 BC), *The Merchant* (ca. 214 BC), *Cistellaria* (probably 204 BC), and *The Casket* play (ca. 202 BC).

Emperor Huang Di ordered the destruction of all music and musical instruments, along with books, in the period aptly named "Burning of the Books" (ca. 212 BC).

d. Lucius Livius Andronicus, Roman playwright (ca. 284–204 BC).

WORLD EVENTS

State of Ch'in became dominant, and unified China for the first time, with Chang'an its capital; Huang Ti (the Yellow Emperor) built a national road system, unified fortifications into the Great Wall, and set the centralized administration pattern that would be characteristic throughout Chinese history (221–207 BC).

Romans defeated Celts in northern Italy (225 BC).

Hannibal took command of Carthaginian forces in Spain (221–218 BC).

Second Punic War began; Hannibal crossed the Alps and took the war to Italy in series of victories; at Cannae, he destroyed a Roman army (218 BC).

Carthaginian army led by Hasdrubal defeated by Romans in northern Italy; Romans invaded and conquered Carthaginian Spain (207–206 BC).

Second Punic War ended with Hannibal's defeat at Zama (202 BC).

Western Han dynasty in China (202 BC–9 AD).

200–176 BC

LITERATURE

Persians developed the Avestan script (from Aramaic) and used it in recording the Zoroastrian scriptures; the script would later spread to the Sogdian and Turkic peoples of central Asia.

Great library at Pergamum founded by Attalus I and Eumenes II (ca. 200 BC).

Earliest surviving texts from Central America's Mayan civilization (ca. 200–100 BC).

Manu (*Manusmrti*), Indian treatise on religious law and social obligation (probably compiled ca. 200 BC–200 AD).

Moche people of Peru, predecessors of the Incas, developed various symbolic methods of information storage, including painted or marked beans (ca. 200 BC–900 AD).

Yogasutra, basic text of the yoga (ca. 200 BC).

Antipater of Sidon published a travel guidebook (ca. 200 BC) containing the most influential list of the "Seven Wonders of the Ancient World."

Rosetta Stone engraved in hieroglyphics and other scripts in honor of Ptolemy V of Egypt; when deciphered in 1822, it provided the key to understanding hieroglyphics (196 BC).

VISUAL ARTS

Nike of Samothrace, a marble statue of winged Victory, erected in Samothrace (ca. after 200 BC); now in the Louvre, headless.

Stabian Baths built in Pompeii; earliest known concrete dome (ca. 2nd c. BC).

Earliest of the Buddhist cave-temples in western India, at Ajanta (ca. 200 BC).

Boethus, Greek sculptor (active ca. 200 BC); no original works survive, only possible copies.

Sculptured stupa at Sanchi, India (2nd c. BC–1st c. AD).

PERFORMING ARTS

Aulularia (*The Pot of Gold*), Titus Maccus Plautus's comedy (ca. 194 BC), based on a lost Greek play by Menander; it was the source of Molière's *L'Avare*, also influencing numerous other plays.

Titus Maccius Plautus produced numerous plays, including *Pseudolus* (191 BC), *Stichus* (200 BC), *The Haunted House* (ca. 196 BC), *The Persian* (ca. 195 BC), *The Rope*, (ca. 194 BC), *Curculio* (ca. 193 BC), *Epidicus* (ca. 191 BC), *The Bacchides* (ca. 189 BC), *The Captives* (ca. 188 BC), *Casina* (185 BC), and others harder to date: *Rudens, Mostellaria, Menaechmi, Captivi,* and *Amphitruo* (all ca. 200

BC). Several of his plays, combined, were the source of the musical *A Funny Thing Happened on the Way to the Forum* (1962).

d. Titus Maccus Plautus, Roman playwright (ca. 254–184 BC), most famous for his comedies freely adapted from Greek originals, thereby helping to create a distinctively Roman style.

Shadow-play theaters were popular in the Far East (from at least 200 BC), as were puppet theaters.

WORLD EVENTS

Menander (Milinda), first ruler of the Indo-Greek Dynasty; he held Punjab, but failed to gain the Ganges valley (ca. 180–160 or ca. 160–140 BC).

Philip V of Macedon defeated by Romans (197 BC).

Yellow Turban Uprising in China (186 BC).

Palestine taken by Antiochus III (198 BC).

Second Rome–Macedon War (200–197 BC).

175–151 BC

LITERATURE

· Nicander, Greek poet (active ca. late 2nd c. BC), known for his poems on scientific topics, such as *Theriaca* (*On Poisonous Animals*) and *Alexipharmaca* (*Antidotes to Poison*).

b. Dionysius Thrax, Greek grammarian (b. ca. 166 BC–?).

VISUAL ARTS

Great Altar of Zeus dedicated at Pergamum (early 2nd c. BC); saved from destruction in 1876; now in the Berlin Museum.

Olympeion, temple to Zeus Olympius at Athens, begun in Doric style by several architects under Pisastratus, abandoned at his death, and completed in Corinthian style under Roman Emperor Hadrian (174 BC–131 AD).

PERFORMING ARTS

d. Terence (Publius Terentius Afer), Roman playwright (ca. 190–159 BC), a freed slave. Six of his plays survive: *Girl from Andros* (*Andria*) (166 BC), basis for Richard Steele's 1722 play *The Conscious Lovers*;

Hecyra (*The Mother-in-Law*) (165 BC), *The Self-Punisher* (*Heauton timoroumenos*) (163 BC), *Phormio* (161 BC), *The Eunuch* (161 BC), and *Adelphi* (*The Brothers*) (160 BC).

WORLD EVENTS

Third Rome–Macedon War; Macedonians defeated, their country divided into four republics (171–167 BC).

Maccabaean revolt against Antiochus IV (167 BC).

150–126 BC

LITERATURE

Nash Papyrus, an Egyptian copy of the *Decalogue* and *Deuteronomy*, the only premedieval copy of matter from the Hebrew Bible before the Dead Sea Scrolls were discovered in the 1940s (ca. 150 BC).

VISUAL ARTS

Laocoon, sculpture group of Trojan priest Laocoon and his two sons being squeezed to death by snakes; Pliny described it as being in Emperor Titus's palace, and the sculptors as Hagesander, Polydorus, and Athenodorus of Rhodes; now in the Vatican museum (mid-2nd c. BC).

PERFORMING ARTS

Emperor Wu (141–87 BC) founded the Imperial Office of Music, to collect all kinds of music, to supervise music (apparently including musical plays), and to oversee maintenance of proper pitch in music.

d. Marcus Pacuvius, Roman playwright (ca. 220–130 BC), a leading Roman dramatist among the first to focus on tragedy, as in his *Iliona* and *Chryses*; only fragments survive.

WORLD EVENTS

Chang Ch'ien took the first known Chinese mission to the West, across Asia, to Bactra in central Asia (Afghanistan) (ca. 128 BC).

Third Punic War; Carthage taken by Romans and destroyed; (149–146 BC).

Fourth Rome–Macedon War; Macedonia became a Roman province (148 BC).

125–101 BC

LITERATURE

d. Polybius, Greek historian (ca. 203–ca. 120 BC).

VISUAL ARTS

Temple of Apollo at Delphi built (120 BC).
Earliest known full-size Chinese statue in the round (117 BC), showing a fallen soldier and his horse.

PERFORMING ARTS

Arched harps were played in India (ca. 2nd c. BC–9th c. AD).

WORLD EVENTS

Han Chinese troops and traders moved out into central Asia, beginning to establish the Silk Road (105–100 BC).

100–76 BC

LITERATURE

Ramayana, Indian romantic epic poem central to Indian culture, the story of prince Rama and his wife Sita (ca. 100 BC–ca. 100 AD).
Biblical Books of the Prophets were translated into Aramaic in Palestine, then probably in Babylonia; editing was credited to scholar–translator Jonathan ben Uzziel (ca. 1st c. BC–1st c. AD).
Scandinavian inscriptions called *runes* began to be used, with an alphabet called *futhark* (after the initial letters of the names of its characters; ca. 1st c. BC).
The Art of Grammar, the first Greek Grammar (ca. 100 BC); Dionysius Thrax's text would be influential through the Renaissance and even into the 19th century.
Book of Rites (*Li chi*), Chinese classic (100 BC).
Egyptians began to use a phonetic alphabet (ca. 100 BC).

d. Ssu-ma Ch'ien, Chinese annalist (ca. 145–ca. 86 BC), whose great work was *Shih-chi* (*Historical Records*), a monumental and enormously influential history of China from the legendary Yellow Emperor (ca. 2697 BC) on.
Therigatha, poems by Indian Buddhist nuns (*theris*), first written down, some dating back to the 6th century BC; perhaps the earliest known anthology of women's literature (ca. 80 BC).

VISUAL ARTS

Venus de Milo, marble statue of Aphrodite, perhaps the most famous of all Greek Classical statues (ca. 100 BC); rediscovered in Melos in 1820, now in the Louvre.
Africans produced mature rock and cave paintings and engravings, most notable in central Tanzania, Zimbabwe (Rhodesia), and South and Southwest Africa (from ca. 100 BC), often recording hunting and other everyday activities; developments from much older painting traditions.
Battersea Shield (ca. 100 BC), a Celtic shield decorated in La Tène style, found near Battersea, England.
Rock-cut Buddhist sanctuary at Bhaja, India (ca. 1st c. BC), imitating style of older wooden structures.
Buddhist cave-temples at Karli, India (80 BC).
Roman amphitheater, in typical oval shape, built at Pompeii (ca. 80 BC).
Tabularium built in Rome (78 BC).

PERFORMING ARTS

Natya'sastra, Hindu treatise on Indian performing arts, treating music, drama, and dance not as a separate but a single art form, outlining the stylized forms and gestures used by performers (ca. 100); it also included the earliest known classification of instruments, into stringed, hollow, covered, and solid instruments. Attributed to Bharata, it is thought to have originated at least by 100 BC, though further developed until ca. 800 AD.
d. Lucius Accius, Roman playwright (ca. 170–85 BC), son of a former slave, one of Rome's most famous tragic playwrights; only fragments of his work survive.
d. Titus Quintius Atta, Roman playwright (d. 77 BC), famed for his comedies of daily life, especially his

depiction of women; only fragments of his work survive.

WORLD EVENTS

Establishment of Chinese government service examination system (ca. 100 BC).

Romans led by Sulla took Greece, portions of Asia Minor (87–83 BC).

Sulla's return to Rome generated civil war; he emerged as Roman dictator (83–80 BC).

75–51 BC

LITERATURE

Cicero's *4 Catilinarian Orations* (63 BC); also his *De oratore* (55 BC), on oratory, and *De republica* (*Republic*) (51 BC), on political philosophy.

Linen used for writing in Roman Empire, the result being *libri lintei* (linen books) (1st c. BC–1st c. AD).

Acta Diurna began daily publication in Rome.

Julius Caesar's *De Bello Gallico* (*Commentaries on the Gallic War*) (ca. 58/57–ca. 51/44 BC).

Earliest record of a full shorthand system, credited to Marcus Tullius Tiro (58 BC); later widely used throughout Europe.

d. Lucretius (Titus Lucretius Carus), Roman philosophical poet (ca. 95–ca. 55 BC), whose only known work was *De rerum natura*, a poem exploring the nature of the natural world, unfinished at his death.

VISUAL ARTS

Earliest paintings in the cave-temples at Ajanta, India (early 1st c. AD).

Gardens of Lucullus created in Rome (after 64 BC).

First stone amphitheater built in Rome, by Pompey (ca. 55 BC).

PERFORMING ARTS

Tuba, a straight trumpetlike instrument 3–4 feet long, was the most popular of all Roman horn-type instruments made of hammered bronze with a cup mouthpiece (1st c. BC); possibly ancestral to medieval trumpets. Its sound is unknown, but had

been represented in the 3rd century BC by the poet Ennius as "taratantara."

Lituus, a Roman trumpetlike instrument of Etruscan origin, used generally at funerals and other ceremonial rites (in use through 1st c. BC).

WORLD EVENTS

Massive slave revolt in Italy, led by Spartacus (73 BC).

Third Mithriadatic War (74–63 BC), ended with Roman victory; Seleucid Dynasty ended, and independent Judaea taken by Rome (63 BC).

Caesar, Pompey, and Crassus formed the First Triumvirate (60 BC).

Caesar's conquest of Gaul began (58–51 BC).

Caesar invaded Britain (55–54 BC).

Roman army destroyed by Parthians at Carrhae; Crassus killed (53 BC).

Syria invaded by the Parthians (51 BC).

50–26 BC

LITERATURE

d. Cicero (Marcus Tullius Cicero), Roman orator and statesman (106–43 BC); among his late works were *14 Philippics* (delivered against Antony 44–43 BC), *Laws*, *De officiis*, *De finibus*, and *Brutus*.

Virgil's *Bucolics* (*Pastoral Poems*, or *Eclogues*) (ca. 42 BC).

Contents of the library of Pergamum added to the library at Alexandria, making it the world's greatest (ca. 40–31 BC).

Horace's major poetic works, *Satires I* (ca. 35 BC) and *Satires II* and *Epodes* (both ca. 30 BC).

Dionysius of Halicarnassus, Greek scholar and writer (active 30–8 BC), best known for his *Roman Antiquities* and his letters and essays *Scripts rhetorica*.

Virgil's *Georgics* (29 BC).

Augustan Age, a golden age of Roman literarature, began with reign of Augustus (27 BC–14 AD).

VISUAL ARTS

Nero's Golden House, Rome, built by Severus (mid-1st c. BC) after Rome's 64 BC fire, known for its ostentation; later the site of public baths, then the Colosseum.

Temple of Male Fortune, Rome (mid-1st c. BC).

Circular Roman temples built (probably 1st c. BC), one by the Tiber in Rome (later the Church of Sta. Maria del Sole), the other the Temple of Vesta at Tivoli, model for the Bank of England.

Gardens of Sallust created on Rome's Pincian Hill (after 44 BC).

Triumphal arch at Orange, in southern France (ca. 30 BC).

d. Vitruvius Pollio, Roman architect (ca. 70–ca. 27 BC), most famous for his *De Architectura*, a treatise on architecture and engineering, also discussing astronomy, acoustics, sundials, and waterwheels; the key source of knowledge about Roman construction until the Renaissance.

Pantheon, Rome's notable circular temple to all the gods, built (27–25 BC).

End of Hellenistic period in Greek art (began ca. 323 BC).

PERFORMING ARTS

Circus Maximus built in Rome, the first and largest of the Roman circuses (modeled on the Greek hippodrome); an oval stadium with tiered seats, with a reported capacity of 150,000, intended for horse racing or spectacles such as gladiators fighting each other or wild animals, rather than for plays (ca. 50 BC).

WORLD EVENTS

Civil war in Rome, as Caesar crossed the Rubicon and took Italy (49 BC).

Caesar defeated Pompey at Pharsalus and campaigned in Egypt; library at Alexandria burned (48–47 BC).

Caesar became Roman dictator (47–44 BC).

Julius Caesar assassinated in the Roman Senate (March 15, 44 BC).

Mount Etna in Sicily began a series of major eruptions (44 BC).

Mark Antony and Octavian defeated Caesar's assassins, Brutus and Cassius, at Philippi (42 BC).

Herod was named Judaean king by the Romans (40 BC).

Cleopatra married Mark Antony (37 BC).

Mark Antony was defeated by Octavian at Actium (31 BC).

Mark Antony and Cleopatra committed suicide (30 BC).

Octavian, now Augustus, became emperor of Rome (27BC–14 AD).

25–1 BC

LITERATURE

Horace's poetic works *Odes I–III* (23 BC); letters, *To Florus* (20–17 BC) and *Epistles I* (20 BC); and *Ars Poetica* (20–17 BC), the most important Roman critical work, on guidelines for success in writing poetry.

d. Virgil (Publius Vergilius Maro), Roman poet (70–19 BC), whose last great work, the epic poem *Aeneid*, through Trojan hero Aeneas linking Rome with Homer.

d. Sextus Propertius, Roman elegiac poet (ca. 54/48–ca. 16 BC).

Ovid's elegies to a mistress *Amores* (after 16 BC).

Horace's letters *Epistles II* (ca. 14 BC) and *Odes IV* (13 BC).

d. Horace, Latin lyric poet and satirist (65–8 BC).

Ovid's *Heroides*, letters and poems written as by women to their husbands or lovers (ca. 2 BC).

VISUAL ARTS

Maison Carrée Nîmes, now in France (ca. 19 BC), with its Roman Corinthian columns.

Ara Pacis (*Altar of Peace*) set up by Augustus on Rome's Campus Martius (13–9 BC).

PERFORMING ARTS

Office of Music, which had been collecting popular music and songs, especially those from central Asia, closed by Chinese government (7 BC).

WORLD EVENTS

Romans defeated Nubians, expanded area of Roman control in Egypt (22 BC).

Herod began to rebuild the Temple at Jerusalem (ca. 20 BC).

Tiberius campaigned north into Germany; Roman occupation extended to the Danube (12–9 BC).

1–24 AD

LITERATURE

On the Sublime (Peri Hupsous), a work relating poetic excellence to the depth of poets' thoughts and emotions (ca. 1st c.); credited to Longinus.

Kamasutra of Vatsyayana, Hindu text on the techniques of erotic love (ca. 1st c.).

Syriac script and language, based on earlier Phoenician, became a main medium for early Christian documents (from 1st c.).

Ovid's elegies *Fasti* and tales *Metamorphoses* (both 2–8); and his poems *Ars amatoria* (before 8), and *Epistulae ex Ponto* and *Tristia* (both 8–17/18).

Roman alphabet developed its mature form, with 22 letters of the Greek alphabet plus G, Y, and Z (ca. 1st c.). Distinctive Roman capital letters also developed.

d. Livy (Titus Livius), Roman historian (59 BC–17 AD), whose main work was *History of Rome*.

d. Ovid (Publius Ovidius Naso), Roman poet (43 BC–17 AD).

VISUAL ARTS

Pont du Gard, three-tiered aqueduct at Nîmes, now in France (ca. 14).

Temple of the Sun, Palmyra, Syria (ca. 1 AD).

Chinese built suspension bridges of cast iron (1–9 AD).

PERFORMING ARTS

Lituus, an Etruscan-Roman ceremonial trumpetlike instrument with a hooked bell, passed out of use in Rome (by 1st c.); its name was then sometimes used to refer to a small ox-horn-shaped instrument popularly called a *bucina*.

New Testament references indicate that two or more pipers were commonly hired to play at Jewish funerals (1st–3rd c.).

WORLD EVENTS

Massive uprising in Germany destroyed occupying Roman army; Roman frontier swept back to the Rhine (9).

Jewish Zealots rose against the Roman occupiers of Judaea (7).

Red Eyebrows peasant rising in China (18).

25–49 AD

LITERATURE

Silk widely used as medium for writing in China by Eastern Han period (25–220).

Two books of the New Testament written: *Galatians* (ca. 48), credited to Paul, and *James* (ca. 45–48), credited to James.

VISUAL ARTS

La Tène art had a final late bloom in Britain before the Roman conquest (before 43); it would continue in Ireland.

PERFORMING ARTS

Buccina, a small horn, similar to a swineherd's cowhorn but sometimes in bronze, used by the Roman army for camp signals at first but later for regular use, especially among the cavalry (from 1st c.); sometimes called *bucina* or *lituus*.

WORLD EVENTS

Pontius Pilate became procurator of Roman-occupied Judaea (26–37).

Jesus Christ crucified in Judaea (ca. 28–33).

St. Paul converted to Christianity (ca. 36).

Caligula ruled in Rome (37–41); killed by the Praetorian Guard, he was succeeded by Claudius (41–54).

St. Peter became the first pope (ca. 42–67).

Roman armies led by Emperor Claudius invaded and in the following three decades took and held much of what is now southeastern England (43).

Thrace became a Roman province (46).

Messalina was executed after a failed plot to assassinate Claudius (48).

50–74 AD

LITERATURE

A'svaghosa, first known writer of classical Sanskrit poetry (ca. 1st c.).

Several books of the New Testament written, credited to Paul: *Romans* (ca. 58), *1 Corinthians* (ca. 56), *2 Corinthians* (ca. 57), *1 Thessalonians* (ca. 50–51), and *2 Thessalonians* (ca. 51).

First three of the four *Gospels* describing the life of Jesus written, named for their authors: *Matthew* (ca. 60–80), *Mark* (ca. 60), and *Luke* (ca. 65).

Other New Testament books written in this period were *Acts* (ca. 65), credited to Luke; *Ephesians*, *Philippians*, and *Colossians* (all ca. 60–61), *1 Timothy* (ca. 64), *2 Timothy* and *Titus* (both ca. 64–66), *Philemon* (ca. 61), all credited to Paul; *Hebrews* (ca. 60–70), possibly by Paul or Apollos; *1 Peter* and *2 Peter* (both ca. 64), credited to Peter; and *Jude* (ca. 64–70), credited to Jude.

d. Lucan (Marcus Annaeus Lucanus), Latin epic poet (39–65).

d. Seneca (Lucius Annaeus Seneca, the Younger), Roman writer, philosopher, orator, and statesman (4 BC–65 AD), whose philosophical essays include *Ad Marciam de consolatione* and *De brevitate vitae*.

VISUAL ARTS

Potter's wheel began to be used in Japan (during 1st c.).

Rome's multistory apartment houses (*insulae*) laid out on a geometric plan, around public squares and with arcaded streets, as Rome was rebuilt after a fire (64).

Orthodox Jewish law in Israel temporarily prohibited all representational art, not only human sculptures, but also animals and art on flat surfaces (from 66).

PERFORMING ARTS

Seneca (the Younger) wrote a number of tragedies (ca. 50–65), at least eight of which survive, based on earlier Greek tragedies: *Hercules Furens*, *Troades*, *Phaedra*, and *Medea* (all based on Euripides); *Phoenissai* (on Euripides and Sophocles); *Oedipus* (on Sophocles); *Agamemnon* (on Aeschylus); and *Thyestes* (on Sophocles, Euripides, and others).

St. Paul, in his *Ephesians* and *Colossians* (ca. 60–61), recommends that Christians should glorify their Lord with "psalms, hymns, and spiritual songs"; but in *1 Corinthians* (ca. 56) he pronounced, "The voice of woman leads to licentiousness," presumably seeking to continue the earlier Jewish tradition of prohibiting women's religious singing.

Gospel of *Mark* (ca. 60) described singing of *Hallel* at the conclusion of the Passah meal; probable precursor of the *Alleleuia* long associated with Easter week.

With Buddhism from India, Chinese adopted Indian chanting style, while monks adopted the Chinese zither (from ca. 61–62).

Instrumental music was prohibited in Jewish synagogues (by 70).

WORLD EVENTS

Romans founded Londinium (London) (50).

Claudius was assassinated; succeeded by Nero (54–68).

Boudicca (Boadicaea) led a failed revolt against Roman rule in Britain (61).

Rome was at war with Parthia; Roman army defeated (62).

Massive fire in Rome burned for nine days and destroyed much of the city. Under Nero, the persecution of Christians grew in Rome (64).

Buddhist missionaries arrived in China (65).

Jewish revolt in Palestine (66–73).

Nero committed suicide, after having been deposed (68).

Titus Flavius Vespasianus became Roman emperor (69).

Destruction of the Jewish Temple in Jerusalem, after Titus besieged and took the city (70).

Further Han Chinese expansion into central Asia; much of Turkestan fell (73).

75–99 AD

LITERATURE

d. Pliny the Elder (Gaius Plinius Secundus), Roman writer (23–79) whose major works included *History of the German Wars*, now lost, and *On Natural History* (ca. 78).

Tacitus's *Dialogus de oratoribus* (ca. 80).

Thebaid, Publius Papinius Statius's epic (92).

Several books of the New Testament written, all credited to John: *John*, the last of the four Gospels (ca. 95); *1, 2, 3 John* (ca. 90–95); and *Revelation* (ca. 95).

d. (Flavius) Josephus (Joseph ben Matthias), Jewish historian (ca. 37/38–ca. 95), whose main works were *Jewish War*, written in Aramaic, and *Jewish Antiquities*, a history of Jewish people, written in Greek.

d. Publius Papinius Statius, Latin epic poet (ca. 45–ca. 96).

VISUAL ARTS

Palace complex build by Rabirius for Domitian on the Palatine in Rome (late 1st c.).

Colosseum, Rome's greatest amphitheater, in typical oval shape, dedicated (ca. 69–79); it could hold 50,000 spectators.

Arch of Titus, with a single opening, erected in Rome (after 81) celebrating his conquest of Judaea.

Apollodorus of Damascus (active 97–130); among his works, all in Rome, were Baths of Trajan, Trajan's Forum, and Trajan's Column, with its spiral reliefs depicting the Dacian wars; he also wrote a treatise, *Engines of War*.

PERFORMING ARTS

Book of *Revelation* (ca. 95) contains extensive references to instrumental music, including what some have called musical fantasies.

Cornu, a curving bronze horn of Etruscan origin, played in the Roman Empire, in two sizes (by 1st c.), the smaller popular in military settings. The larger was sometimes used along with an organ (*hydraulis*) to signal changes of scene or events in amphitheaters; examples were preserved at Pompeii. The cornu was revived in France after the 1789 Revolution, then called the *tuba curva*.

WORLD EVENTS

Pompeii and Herculaneum were destroyed by a massive volcanic eruption of Mount Vesuvius (79).

Domitian became Roman emperor (81–96) and began a series of campaigns in Dacia (Romania) (ca. 82).

Roman army led by Agricola defeated the Caledonian army at Mons Graupius, in the Scottish High-

lands, as Agricola fought his way north (83).

Trajan became Roman emperor (98–117).

100–124

LITERATURE

Mishnah, compilation of Jewish law, credited to Rabbi Judah the Patriarch (codified 100).

Elegies of Ch'ü, Chinese anthology of poetry (compiled 2nd c.).

Gaius Petronius Arbiter, Latin satirist (active probably 1st c. AD), author of *Satyricon*.

In China, number of script signs increased to about 9,000 (by ca. 100).

Tacitus's *Histories* (104–109).

Paper reportedly invented by Cai Lun, a eunuch serving Han Emperor Wu Di, according to Chinese records (105).

Periplus of the Erythraean Sea, describing the trade route between East African and Arabian ports on the Red Sea and India (ca. 106).

Chinese-style writing brought to Korea by Chinese conquerors (109); it would be the official script through the 7th c..

Juvenal's *16 Satires*, attacking degenerate Roman society (110–130).

d. Tacitus (Cornelius Tacitus), Italian writer (ca. 56–ca. 120), author of *Annals* (ca. 117).

VISUAL ARTS

Rome's Pantheon rebuilt, with its magnificent dome (ca. 100–125); in 7th century converted to Santa Maria dei Martiri church.

Flying Horse of Gansu, Han bronze statue, from a Chinese general's tomb in Wu-wei (ca. 100); a prime example of Han skill at depicting animals. From the same tomb came the oldest surviving example of a scroll painting, *Admonitions of the Imperial Preceptress*.

Temple of Ed Deir, Petra, in Jordan; one of a serious of temples, tombs, and other structures cut out of rock (ca. 2nd c.).

Potters working in Egypt and Syria perfected lead glazes (ca. 1st–2nd c.), widely adopted.

Earliest of the Meso-American pyramids, at Cuilcuilco (ca. 1st–2nd c.).

PERFORMING ARTS

Oe Tadafusa's *Book of Puppeteers* was the first work to describe the life of professional touring puppeteers in the Far East (ca. 100).

Celtic peoples used a trumpetlike instrument called a *karynx* (a term related to the Latin *cornu* and Germanic *horn*); possibly the bronze instrument about three feet long, ending in a boar or wolf's head, depicted on some Gaulish coins and on Trajan's Column (before 117).

Syrian jugglers and acrobats were in China; entertained at the royal court (ca. 120).

WORLD EVENTS

Trajan completed the Roman conquests of Dacia (Romania) and Arabia (101–106).

Rome and Parthia were at war; Rome took Mesopotamia and Armenia (114–117).

Hadrian became Roman emperor (117–138).

Romans built Hadrian's Wall across Britain from Newcastle-upon-Tyne to Carlisle (120).

125–149

LITERATURE

Ch'u Elegies, Chinese poetry anthology (125).

d. Plutarch, Greek writer (ca. 46–ca. 127), whose main work was *Parallel Lives* (probably before 120), biographies of great figures; much translated, and especially influential during the Renaissance, as on Shakespeare.`

Aquila, a convert to Judaism, translated the Hebrew Bible into Greek, under the direction of Rabbi Akiba (ca. 130).

d. Epictetus, Stoic philosopher (ca. 55–135).

History of Rome, the major work of Greek historian Appian (active ca. 140).

d. Juvenal, Roman satirist (ca. 60–ca. 130/140).

VISUAL ARTS

Hadrian's villa at Tivoli, displaying various styles of Roman architecture (ca. 123).

Temple of Baal built in Palmyra, Syria (131).

PERFORMING ARTS

Christian church began to dispute whether instrumental music was appropriate for use in the church (by ca. 150), inspired by earlier Jewish prohibitions in synagogues; arguments would rage until the 6th century.

WORLD EVENTS

Failed Jewish revolt in Palestine, led by Bar-Cochba; Jews exiled from Palestine, and dispersed (131–135).

Antoninus Pius became Roman emperor (138–161).

150–174

LITERATURE

Description of Greece, 10-volume work by Pausanias, Greek traveler and writer (active ca. 150 AD).

Geographica, an atlas of the world known to the Greeks (ca. 150), by Ptolemy (Claudius Ptolemaeus) (active 121–151).

Lucius Apuleius, Latin writer (active ca. 155), best known for his *The Golden Ass* (*Metamorphoses*), a satirical romance based on a Greek story; the only Latin "novel" to survive whole (2nd c. AD).

VISUAL ARTS

Temple of Baalbek built, in what is now Lebanon (after ca. 150).

PERFORMING ARTS

The Little Clay Cart (*The Toy Cart* or *Mrcchakatika*), Indian Sanskrit play, possibly by Sudraka (ca. 150); a production in translation was mounted at New York's Neighborhood Playhouse in 1924.

WORLD EVENTS

Marcus Aurelius became Roman emperor (161–180), succeeding Antonine.

Plague spread throughout the Roman Empire (165–167).

Roman merchants reached China; first direct Chinese–Roman contact (166).

Marcomanni, Quadi, and Vandals crossed Roman frontier on middle Danube (167).

175–199

LITERATURE

Two new Greek translations of the Hebrew Bible were made, by Theodotion and Symmachus, respectively (late 2nd c.).

d. Lucian, Greek writer (ca. 115–ca. 180), best known for his *A True History*, a parody of travel writings; *How to Write History*; and numerous tales.

Chinese-style writing introduced to Vietnam by King Siyoung (186).

VISUAL ARTS

Basilica Porcia, a city meeting hall, added to the Roman Forum by Cato the elder (ca. 184 BC).

Roman amphitheater built at Verona (ca. 190).

PERFORMING ARTS

Christians developed their distinctive monophonic unison liturgical chant, generally without instrumental accompaniment, primarily in five major centers: Syria, Egypt, Armenia, Rome, and later Byzantium (after 313). Styles were derived partly from Jewish synagogue chants, especially the antiphonal singing between a precentor and a responding choir, with folk influences as well (2nd–3rd c.).

Clement of Alexandria (ca. 150–215?), Christian church father in Egypt, composed numerous hymns, including *Hymn on Christ*, perhaps the earliest Christian poem.

WORLD EVENTS

d. Marcus Aurelius (121–180); succeeded by his son Commodus.

Yellow Turban rising in China (184).

Commodus assassinated (192); Septimius Severus emerged from struggle for sucession as emperor (193–211).

200–224

LITERATURE

Scots arriving from Ireland brought their Gaelic language to the west coast of what is now Scotland (3rd–5th c.).

Ts'ao Chih, Chinese lyric poet (ca. 200).

Earliest surviving Psalter, or Psalm book, a papyrus roll from Egypt (3rd c.).

Huang-lah (*Emperor's Mirror*), first known Chinese encyclopedia (ca. 220).

VISUAL ARTS

Buddhist art in Gandhara (northern India) began to be influenced by Hellenistic art from the Near East (2nd c.); it would ultimately affect art in central Asia, China, and Japan.

Arch of Septimius Severus erected in Rome (203), to celebrate his victories over the Parthians.

Earliest surviving Christian meetinghouse, at Dura Europos, in Syria (ca. 200–230).

Baths of Caracalla built in Rome (ca. 215).

PERFORMING ARTS

Bhasa, earliest Indian Sanskrit playwright known by name; among the 13 surviving works (as early as ca. 200) credited to him are seven based on episodes in the epic *Mahabharata*; two on the epic *Ramayana*; a romantic Romeo and Juliet–type play, *Avimaraka*; the unfinished or partial *The Poverty of Carudatta* (*Daridra-Carudatta*); and two semihistorical works, *The Minister's Vows* and *The Dream of Vasavadatta* (*Svapnavasavadatta*), the most famous of the group; they are called the Trivandrum plays, after the city where the manuscripts were found; Bhasa was praised by Kalidasa in his play *Malavika and Agnimitra*.

WORLD EVENTS

Hsiung-nu nomads smashed through China's Great Wall, destroying the northern cities (ca. 200).

Pressure on Rome grew as new waves of peoples pushed out of Asia; Roman armies fought the Alemanni and Goths in the Balkans (213–214).

Caracalla succeeded Severus as Roman emperor after the death of Severus while campaigning in Britain (211).

Parthian forces expelled the Romans from Mesopotamia (217).

Three Kingdoms period in China (221–265).

225–249

LITERATURE

Alexandrian theologian Origen, working at Caesarea, produced a version of the Bible in six columns (230–249), called the *Hexapla* ("sixfold"), showing the Hebrew text, the Hebrew text in Greek letters, and four Greek translations, including the *Septuagint*.

d. Dio Cassius, Greek historian (ca. 155–ca. 235), whose main work was *Roman History*.

VISUAL ARTS

Bronze used for sculpture in China (from ca. 3rd c.).

Meso-American cultures developed monumental architecture, sculpture, wall frescoes, and polychrome pottery (from 3rd c.).

PERFORMING ARTS

Military musicians of Rome formed a mutual protection and compensation guild; these were primarily trumpeters and horn players who signaled military movements and also provided music for funerals, victory celebrations, and marches (early 3rd c.).

WORLD EVENTS

Period of great instability began in Rome (from 235), until the rule of Diocletian (284).

Artaxerxes of Persia defeated the Parthians (226).

Shapur I became Persian emperor (241–271).

250–274

LITERATURE

d. Hsi K'ang, Chinese scholar, poet, musician and painter (223–263), most famous as leader (with Juan Chi) of the artistic group called the Seven

Sages of the Bamboo Grove.

Library at Alexandria partly burned when Palmyra's Queen Zenobia invaded Egypt (269).

Bible translated into Coptic (ca. 274).

Parts of the New Testament appeared in Latin, Coptic, and Syriac, as Christianity spread in the Roman world (mid-3rd c.).

VISUAL ARTS

Romans became expert in use of concrete for construction and decoration (2nd c.).

Sculpture at Naqsh-i-rustam, depicting Sassanian Persian King Shapur I victorious over Roman emperor Valerian (3rd c.).

PERFORMING ARTS

Women's choruses sang in churches in Syria (mid-3rd c.), and many others evidently opposed the ban on women's religious singing based on St. Paul's comments.

WORLD EVENTS

Macedonia and Thrace attacked by invading Goths (251).

Goths and Alemanni attacked Romans on the Danube, while Franks broke through Roman defenses on the Rhine (256).

Shapur of Persia took Antioch and Syria (256).

Alemanni pushing west moved over the Alps into northern Italy (260).

Western Chin dynasty in China (265–317).

275–299

LITERATURE

Korean scholars brought Chinese-style writing to Japan (285; possibly as late as 405).

Earliest known Mayan calendar stone, from Tikal, Guatemala (292).

VISUAL ARTS

Triumphal arch at Porta Nigra at Trier, now in France (late 3rd or early 4th c.).

PERFORMING ARTS

Bishop Paulus of Samosata (ca. 230–290) routinely led women's religious choirs, though only fragments survive of the hymns that were sung.

Oxyrynchos Hymn, an early Christian hymn, written in Greek notation (late 3rd c.), virtually the last musical notation until the late 6th century; fragments discovered in 1922.

WORLD EVENTS

Diocletian became Roman emperor, ending the preceding chaotic period (284–305).

300–324

LITERATURE

Many Chinese encyclopedias compiled; Lu Pu-wei's was the first, but the best known was *Shan Hai Ching* (*Book of the Mountains and Seas*) (ca. 3rd c.)

Formal style of Chinese calligraphy developed; called *kai shu*, or the "model" or "normal" script, it would remain standard (4th c.).

Celtic peoples of the British Isles used a cryptic alphabet called the Ogham script for writing (ca. 4th–7th c.).

Great library at Byzantium founded by Constantine (ca. 300).

Ch'u Elegies, credited in part to Chinese poet Ch'ü Yüan (ca. 313).

Lady Wei Shao wrote the first treatise on calligraphy (320).

VISUAL ARTS

Palace of Diocletian (built ca. 300), regarded as the last great work of Roman architecture, in what is now Split, in Croatia.

Baths of Diocletian built in Rome (306); later incorporated into the Church of Sta. Maria degli Angeli under the direction of Michelangelo.

Development of "basilica" style of church, an oblong building with a nave and two or more aisles, such as the Basilica Nova of Maxentius (completed 313) and the Old St. Peter's and Lateran Basilica (after 313); developed from the Roman basilica, a town meeting hall, it would gradually replace "house-style" churches.

Arch of Constantine erected in Rome (ca. 315), actually a triple arch incorporating parts of the earlier, but then-destroyed Arch of Trajan.

Beginning of Mayan classical period (ca. 300–900); early stone carvings, in distinctive Mayan style, often as relief sculptures (ca. 320).

PERFORMING ARTS

Alleluia (*Hallelujah*), from the Hebrew for "Praise Jahweh," the traditional religious refrain or response was in use among both Eastern and Western Christians (by ca. 300). Western (Latin) and Eastern (Byzantine) Christians had developed different musical and liturgical styles, sometimes assigned names or numbers and arranged in groups, often associated with particular religious holidays or seasons. Among Byzantine Christians, the word *alleluia* was often accompanied by 2–3 psalm verses (alleluïarion), a pattern that may have influenced later Latin use.

WORLD EVENTS

Constantine became Roman emperor (306).

Constantine took Italy, ultimately winning the battle of Milvian Bridge (312); in full power, he declared Christianity the Roman state religion (313).

Constantine renamed and rebuilt Byzantium as Constantinople (324).

325–349

LITERATURE

Earliest known Mayan calendar stone, from Uaxactún, Guatemala (328).

VISUAL ARTS

Scenes of Christ's Passion, his activities from his entry into Jerusalem on Palm Sunday until his death and burial, began to be depicted in Christian sculpture, especially on sarcophagi (during 4th c.).

PERFORMING ARTS

Synod of Laodicea ruled that only officially appointed psalmists could officiate regularly in churches, and that only texts from the Scriptures could be chanted (ca. 343–380).

WORLD EVENTS

First General Council of the Catholic Church organized at Nicaea (325).

Constantinople became the capital of the Roman Empire (330).

Samudra Gupta conquered much of northern India (ca. 335–380).

350–374

LITERATURE

Aelius Donatus wrote a text *Ars grammatica* (*Art of Letters*) used for centuries; medieval texts were called *donets* after him (ca. 350).

Bishop Wulfilas (Ulfilas) credited with developing the Gothic script, into which he translated the Bible (mid-4th c.); the New Testament and fragments of the Old are the main surviving fragments of Gothic literature.

VISUAL ARTS

Two massive carved, gilt, and painted figures of Buddha in a cave-monastery hewn from a cliff face in Bamiyan, Afghanistan (ca. 350); inspiration for many similar statues across Asia to China.

Persian palace at Sarvistan (ca. 350).

Among the earliest surviving depictions of Christ and the Apostles, on a sarcophagus for Junius Bassus (c. 359), now in the Vatican.

PERFORMING ARTS

d. St. Hilary of Poitiers, among the earliest Western European hymn writers (310–367).

The terms *cornu* and *bucina* were reversed by a copyist's error in Vegetius's *Epitoma rei militaris*, resulting in later confusion of the two different types of horns used in late Roman times (ca. 4th c.).

WORLD EVENTS

Huns moving west arrived north of the Black Sea, moved further west into Europe (ca. 350).

Alemanni, Franks, and Saxons attacked Gaul (355).

Persia and Rome were at war (359–361).

Roman rule slipped in Britain, as Picts, Caledonians, and others came over Hadrian's Wall and raided from the sea (ca. 360–370).

Huns defeated the Ostrogoths in southern Russia; Ostrogoths pushed west (ca. 370).

375–399

LITERATURE

Arabic script developed, based on Aramaic, though not at first widely used (late 4th and 5th c.).

St. Jerome's *Life of Paul the Monk* (376).

St. Jerome collated various translations of the Bible into an authorized version (382–404); both the Old and New testaments (plus disputed books, the Apocrypha) appeared for the first time in a single language, Latin; this *Latin Vulgate* ("common version") would be used through the Middle Ages and beyond.

St. Jerome's *Against Helvidius* (383).

Library at Alexandria, greatest in the ancient world, burned and partly consumed (ca. 390).

St. Jerome's *Of Illustrious Men* (392), *Against Jovinian* (393), and *On the Trinity* (*De Trinitate*) (399–419).

Confessiones (*The Confessions*), St. Augustine's great spiritual autobiography (397–401); also his *De doctrina Christiana* (*Christian Instruction*) (397–428).

In Europe, more rounded writing script, called *uncials*, was developed, still using all-capital letters (by 399).

VISUAL ARTS

Church of S. Salvatore built in Spoleto, Italy (late 4th c.).

Durga temple at Aihole, India (ca. 5th c.); typical of the Gupta period (320–600 AD), being small and made with a flat roof and no mortar.

PERFORMING ARTS

Ambrosian chant repertory, a repertory of chants and accompanying music that came to prominence in Milan, under St. Ambrose (ca. 340–397), possibly preserving some earlier forms of chants; the only early medieval chant repertory surviving the 8th-century official Church adoption of the Gregorian chant.

St. Ambrose (ca. 340–397) of Milan was among those influential Christian church figures who spoke out against the early prohibition of women in religious singing; instead he stressed the participation of the whole community, men and women, in religious singing.

Peregrinatio, Etheriae Silviae's description of her trip to Jerusalem, described a nun's choir (late 4th c.), an example of the segregated male and female choirs found in some monasteries and communities; it also first mentions the *Kyrie Eleison* chant, and other Latin and Greek hymns, notably *Bright light, full of holy splendour*.

Roman tuba, a straight 3–4-foot-long trumpetlike instrument, continued popular in the Byzantine Empire, where they were often played in military settings (late 4th c.).

WORLD EVENTS

Ostrogoths moved west across the Danube, fighting Roman armies (376).

Theodosius I became Roman emperor (378–395).

Shapur III became emperor of Persia (383–388).

Armenia was partitioned between Rome and Persia (384).

Northern Wei dynasty in China (386–535).

Chandra Gupta II extended Gupta dominance into western India (388).

Roman army led by Stilicho held the Roman Danube frontier against an army of Huns, Goths, Alans, and others (392).

Alaric became king of the Visigoths (395–410).

Visigoths took Thrace, Macedonia, and Greece (395).

400–424

LITERATURE

Daphnis and Chloë, Greek pastoral poem credited to Longus (4th–5th c.).

Mahanama's *Mahavamsa*, the Great Chronicle of Ceylon (compiled 5th c.).

St. Augustine's religious work *Against Vigilantius* (406).

Sanskrit writer Kalidasa produced several poems, including the epics *Raghuvam'sa*, about the legendary hero Rama, and *Kumarasambhava*; and the lyrics *Meghaduta*, *Rtusamhara*, and *Srngaratilaka* (all ca. 400).

Optional punctuation marks—dots and dashes above or below letters—were added to the all-consonant Hebrew script, as an aid in pronunciation (ca. 5th–6th c.).

St. Jerome completed his Latin translation of the Old Testament (404).

d. Claudian (Claudius Claudianus), Latin poet (ca. 370–404).

De Civitate Dei (*The City of God*), St. Augustine's exploration of the conflict between the City of God and the Earthly City (*Civitas Terrena*) (413–426); also his *On Nature and Grace* (*De natura et gratia*) (415).

d. St. Jerome (Eusebius Hieronymus), Christian Latin writer (ca. 348–420). Among his late works were *Against the Pelagians* (415), *Enchiridion to Laurentius on Faith, Hope, and Love* (421), *On Christian Learning* (426), and *Retractions* (426).

VISUAL ARTS

Life-size bronze sculpture of St. Peter, in St. Peter's in Rome (5th c.); among the last major bronze sculptures in the round until the Italian Renaissance.

Wall paintings in the Koguryo royal tombs near the Yalu River, at Toug-kou, Korea (ca. 4th–5th c.).

Copper-casting techniques used in Nazca culture of Peru (ca. 400).

d. Ku K'ai-Chih, Chinese Taoist landscape painter (ca. 345–ca. 405).

PERFORMING ARTS

Three surviving plays attributed to Kalidasa: *Malavika and Agnimitra* (*Malavikagnimitra*), a comedy of court life; *Vikrama and Urvashi* (*Vikramorvasiya*), a mythological drama; and *Shakuntala* (*Abhijnana' sakuntala*, sometimes *The Recovered Ring*), his masterpiece, an epic love story (all ca. 400).

d. Kalidasa, Indian poet and playwright (373?–415?) the most celebrated of all the dramatists working in Sanskrit; believed to have been associated with the court of Chandragupta II in central India.

Te Deum, early hymn, probably written by Nicetas of Remesia (ca. 400).

First Council of Toledo (400) forbade women—even "consecrated virgins or widows"—from singing antiphons or other religious music, except in the presence of a bishop or priest; an attempt to suppress "singing circles."

St. John of Chrysostom praised the private singing of hymns, as soothing to mothers, children, workers, and weary travelers, indicating popular acceptance of hymns, even where not formally used in churches, especially the Rome-based Western Christian church (before 407).

WORLD EVENTS

Visigoths led by Alaric invaded Italy, but were repulsed (401–403); attacked Italy again (408).

Most Roman troops began withdrawal from Britain (410).

Visgoths took and sacked Rome (410).

Visigoths begin their conquest of Spain (414).

(Liu) Sung dynasty in China (420–479).

425–449

LITERATURE

d. T'ao Ch'ien (Tao Yüan-ming), Chinese nature poet (ca. 365–427), most of whose work is now lost.

d. St. Augustine (of Hippo), early Christian church father, philosopher, and writer (354–430).

d. Hsieh Ling-yün, Chinese nature poet (385–433).

d. St. Mesrob (Mashtots), Christian translator (ca. 361–ca. 440), who is credited with developing an Armenian alphabet and translating parts of the Bible into Armenian and Georgian.

VISUAL ARTS

Among the earliest representations of Christ on the cross, in an ivory carving now in the British Museum (early 5th c.).

Early Christian churches in Cilicia (now Turkey), at Kandirli and Cambazli (early 5th c.).

Prime example of early abstract or symbolic representation of crucifixion, in carved reliefs on the doors of Rome's Sta. Sabina (ca. 432); the dominant style of portrayal before the 5th century.

PERFORMING ARTS

St. Augustine described *alleluia* or *jubili* chants of the Christian church as the summit of religious ecstasy (before 430 BC).

WORLD EVENTS

Nestorius became patriarch of Constantinople (428–431).

Vandals led by Genseric took Roman Africa (429).

St. Patrick began the conversion of Ireland to Christianity (432).

Attila became head of the Hunnish confederacy (433).

Vandals took Mauretania and Numidia, and expanded their conquests in North Africa (435).

Vandals took Carthage (439).

Rome and the Huns were at war (441–449).

Angles, Saxons, and Jutes migrated into Britain, pushing Picts and Caledonians north and west (from ca. 449).

450–474

LITERATURE

Mayan calendar stone; the earliest found at Copán, Guatemala (460).

VISUAL ARTS

Most cave temples at Ajanta, India, built (400–500), with extensive paintings and sculptures and a temple carved into the stone face fronting the cave; some caves were much older.

Earliest surviving Hindu temples in India (from ca. 450 c.).

PERFORMING ARTS

China adopted the Persian harp and various central Asian drums and cymbals (before mid-5th c.).

WORLD EVENTS

Huns attacked Italy, threatened Rome (452).

d. Attila the Hun (406?–453); Hunnish confederacy collapsed, and with it the immediate threat to Rome (453).

Vandals led by Gaiserica took and sacked Rome (455).

475–499

LITERATURE

Oldest surviving Anglo-Saxon inscriptions of a Germanic form of runic script brought to England (by ca. 480).

VISUAL ARTS

Church of S. Lorenzo, Milan (late 5th c.).

Church of St. John in Studion, Constantinople (late 5th c.).

PERFORMING ARTS

Dancing was officially made part of China's Confucian ceremonies (485).

Christians, probably in eastern Syria, developed *neumes*, a form of musical notation for their liturgical chants (late 5th c.), not representing individual notes, but whole phrases and motifs, given precise value only by being assigned a specific "mode"; later adopted by the Byzantine (Eastern), Western (Latin), and Armenian churches.

WORLD EVENTS

Western Roman Empire dissolved (ca. 475).

Theodoric became king of Ostrogothic Italy, his capital at Ravenna (493–526).

Chi dynasty in China (470–502).

500–524

LITERATURE

In Europe, writing style changed from the all-capitals *uncial* script to the *half-uncial* (*semi-uncial*), a step toward lowercase letters (early 6th c.).

Wen-hsin tiao-lung (*Carving of the Literary Dragon*), first recorded full-scale Chinese work of literary criticism, by Liu Hsieh (ca. 500).

Kiratarjuniya, Indian epic poem, credited to Bharavi, based on a story in the *Mahabharata* (ca. 500).

In China, number of script signs increased to about 18,000 (by 500 AD).

Venatius Fortunatus, Bishop of Poitiers, wrote *De Sancta Cruce*, a poem in the shape of a cross, introducing "picture writing" to Christian Europe (ca. 500).

Benedictine Order founded the library and publishing monastery at Luxeuil, France (514).

d. Boethius (Ancius Manlius Severinus), Roman philosopher (ca. 480–ca. 524), who wrote his *De consolatione philosophiae* (*The Consolation of Philosophy*) while in a Roman prison awaiting execution for treason.

VISUAL ARTS

Hsieh Ho's *Ku-hua p'in-lu*, a key work of Chinese art criticism (6th c.).

Vienna Genesis, among the earliest illuminated (handwritten, ornamented, and illustrated) manuscripts, from the Greek world (6th c.).

Rock-cut cave-temples at Lung-men, Honan province, and Mai-chi-san, in Kansu (Gansu) province, China (from ca. 6th c.).

Parthenon of Athens was gutted by the Byzantines for conversion to a Christian church (ca. 6th c.).

Wall paintings of animals in tomb at Uhyon-ni, near Pyong-yang, Korea (ca. 6th c.).

Basilica of S. Apollinare Nuovo, Ravenna, Italy (510–520).

Dioscorides, illuminated manuscript (ca. 512), now in Vienna.

PERFORMING ARTS

De Institutione Musica, a work central to medieval music theory in Europe, by Roman philosopher Boethius (ca. 524).

Under Emperor Ou-ti (502–549), China developed spectacles called *pé-kî* ("a hundred diversions").

Rote, a stringed instrument probably descended from the lyre, in use in Europe (6th–14th c.).

Red pottery panpipes played in Peru, in the Nazca period (ca. 500).

WORLD EVENTS

Srivijaya (Sumatra) began its seven-century domination of the eastern Indian Ocean (ca. 500).

Persia was at war with Rome (503–505).

Persia began a long war against the invading White Huns (503–513).

As the Huns moved east, out of Europe, they were replaced by other invaders; Lombards took their place in Transylvania (ca. 505).

Wu Ti became emperor of China's Liang Dynasty (502–549); he converted to Buddhism (517).

Justin I became eastern Roman emperor (518–527).

525–549

LITERATURE

Benedictine Order founded the library and publishing monastery at Monte Cassino, Italy (529).

d. Imru'u'l-Qais (Imru'u'l-Qais ibn Hujr), Arab poet (ca. 540), the most notable pre-Islamic Arab poet, credited with creating the *qasidah*, a form of classical ode.

VISUAL ARTS

Earliest surviving illustrated manuscripts of the Gospels, *Rossano Gospels*, from Antioch (early 6th c.).

Theodoric's Tomb in Ravenna, Italy, built before his death (526); main architectural work of the "Migration Period" of invasions.

S. Vitale, Ravenna, Italy, built in Byzantine style (ca. 526–547).

Domed churches of St. Hripsime at Etchmiadzin, Armenia, and Dzhvari at Mtskheta, Georgia, built (early 6th c.).

Santa Sophia (Hagia Sophia, or Sacred Wisdom) church in Constantinople designed by Anthemios of Tralles (532), selected for the job by eastern Roman Emperor Justinian, and built with his collaborator and successor Isidorus of Miletus.

S. Apollinare in Classe, Ravenna, Italy, built in Byzantine style (ca. 536–550).

PERFORMING ARTS

Earliest references to the *Octoechos* (ca. 515–531), a system of relating eight tones or modes, developed by the Byzantine Christians for representing their liturgical chants; later adopted by Western (Latin) Christians.

Octoechos, a collection of hymns and religious poems, compiled by Severus, Patriarch of Antioch, and Paulus of Edessa; grouped according to the Octoechos system of musical modes to which they were to be sung (before 538).

d. Theodora, Byzantine actress (ca. 500–548) and (from 525) wife of Emperor Justinian.

WORLD EVENTS

Justinian I (the Great) became eastern Roman emperor (527–565).

Byzantium was at war with the Vandals, Goths, and Ostrogoths; Byzantine general Belisarius took North Africa, Italy, Sicily, and Dalmatia (533–548).

Justinian Code completed (534), a historic set of laws forming the basis of most European legal systems.

Possibly legendary King Arthur of Britain said to have been killed at a battle at Camlan (ca. 537).

Monte Cassino monastery founded (529).

Plato's Academy in Athens was ordered closed by the Byzantines (529).

550–574

LITERATURE

Chinese-style writing widely used by educated elite in Japan, with the adoption of Buddhism as the official religion (mid-6th c.).

VISUAL ARTS

Basilica of S. Apollinare in Classe (ca. 550).

Cathach of St. Columba, an illuminated manuscript, in the Royal Irish Academy (late 6th c.).

PERFORMING ARTS

Fortunatus of Poitiers described Parisian musicians,

with young people playing various pipes, and others playing trumpets, cymbals, and frame drums and singing poems to lyre accompaniment; he also noted that "barbarians" to the north sang to a lyrelike instrument as well (6th c.).

WORLD EVENTS

Buddhism was introduced into Japan (ca. 552).
Byzantine forces took much of southern coastal Spain (550).
St. Columba founded Celtic Christian center at Iona (563).
Justin II became eastern Roman emperor (565–578).
Lombards attacked Italy, took much of north; attacked Gaul (568–575).

575–599

LITERATURE

Y Gododdin, the only surviving work in the Cumbric (Brythonic) language, once spoken in Scotland and Wales (late 6th c.).
Techniques of block printing developed in China, probably during the Sui dynasty (581–818) or early T'ang dynasty (618–907).
Benedictine Order founded the library and publishing monastery at Canterbury, England (597).

VISUAL ARTS

Buddhism, introduced from China via Korea, began to affect Japanese art (ca. 575); most Japanese sculptures were made after this.
Gospels of Rabula, early illuminated manuscript from Syria (586).

PERFORMING ARTS

China was entertained by central Asian ensembles ("the Seven Orchestras") (581); and Turkish princess-bride brought with her to China a musician who played the short lute and introduced Persian modes to China (586).
Whole repertories of liturgical chants and music had developed among Christians; the best known because later officially adopted was the Gregorian chant, so-named because tradition held that it

developed during the time of Pope Gregory (590–604), though it may not have developed until the 8th century.

WORLD EVENTS

Persians took southern Arabia (ca. 575).
Sui dynasty in China; country once again unified (581–618).
Chosroes II became emperor of Persia (590–628).

600–624

LITERATURE

The Bible, Latin, and then-current forms of writing, including use of the vellum codex and the quill pen, were spread across Europe by Christian missionaries; monasteries often included scriptoria, where monks worked in teams as scribes, illuminators (illustrators), and bookbinders (ca. 7th–8th c.).
Codex Hilleli, Rabbi Hillel ben Moses ben Hillel's authoritative version of the Hebrew Bible, now lost (ca. 600).
Runic script suppressed in the British Isles, replaced by the Roman alphabet (ca. 600).
Literature began to be written in the Irish language (ca. 7th c.).
Benedictine Order founded the library and publishing monastery at Bobbio, Italy (614).
Song-tsen-gam-po introduced writing from India and use of pen and ink from China (620–649); basis for later Tibetan script.

VISUAL ARTS

Christian panel paintings, of the Virgin Mary and the saints, first became common, in both Italy and Byzantium (7th c.).
Two prime examples of early Gospel books, illuminated manuscripts of the Gospels, these containing decorated pages and portraits of the Evangelists: Book of Durrow, now in Dublin's Trinity College, and Lindisfarne Gospels, in the British Museum (both ca. 600).
Large bronze statue of an emperor, possibly Heraclius, at Barlotte, Italy (7th c.).
Kuratsukuri-no-Tori, Japanese sculptor (active ca.

600–630), best known for his bronze triad in Nara's Horyu-ji monastery.

Pulguk-sa Temples near Kyong-ju, Korea, built (7th–8th c.).

Anglo-Saxon church at Reculver, Kent, England (7th c.).

Hindu temple of Deogarh built in central India (ca. 600–700).

St. Paul's Cathedral, London, founded (604).

Li Ch'un built the Great Stone Bridge over the Chiao Shui River in China (ca. 610–619); the first example of a segmental arch bridge, it survives intact.

Golden Age of Chinese art began with the T'ang dynasty (618–906), including influences from Persia; most notably, Chinese potters developed the first porcelains, including those with a grayish-green glaze called celadon.

PERFORMING ARTS

Tuned sets of gongs, called *gamelan*, in wide use in Southeast Asia (probably by 7th c. AD).

Central Asian music was played at Chinese T'ang dynasty imperial court (619–907).

WORLD EVENTS

China reunified under the T'ang dynasty (618–906).

Chinese Grand Canal built (605–610).

Muhammad and his followers made their Hegira (migration) to Jathrib (Medina) (622).

Scandinavians invaded Ireland (ca. 620).

Slavs moved into southern Europe (ca. 600).

Harsha ruled Kanauj, in northern India (606).

Heraclitus became eastern Roman emperor (610–641).

Persians attacked in Syria, Asia Minor, and Egypt, taking much of the Middle East (611–626).

Monasteries of St. Gall and Bobbio founded (ca. 612).

Constantinople besieged unsuccessfully by the Avars and Slavs (616–626).

Alexandria was taken by the Persians, who then occupied all Egypt (618–619).

625–649

LITERATURE

Koran (Quran), sacred book of Islam, first written

down from oral versions following the death of Mohammed (after 632). Arabic script spread with Islam, since reading in the original Arabic was required; calligraphy became a major Islamic art form, as representational art was barred.

Chinese-style writing and paper-manufacturing techniques spread widely in Japan after establishment of a centralized administration based on Confucian principles (645).

d. Bana, Sanskrit author and poet (606–647), whose main works were a novel, *Kadambari*, and a history, *Harsacarita*, honoring his patron, King Harsha, himself a playwright.

VISUAL ARTS

Church of S. Agnese, Rome (ca. 630).

Japan's "Golden Age" of sculpture began during the Nara period (646–784), especially after 725.

PERFORMING ARTS

Muhammad initiated the Muslim *adhan* ("call to prayer") (622).

d. Yu Che-nan, Chinese musician (558–638); among his zither works was *Moonlight on the Hsiun Yang River*.

d. Harsha, Sanskrit playwright and king of northern India (ca. 590–ca. 647), author of *Nagananda* (*The Joy of the Serpents*), on Buddhist religious themes, and two other plays, *Ratnavali* and *Priyadarsika*.

d. Chinese emperor Tai Tsung, reportedly writer of *The Battle Line Smashing Song* (649).

WORLD EVENTS

Muhammad took Mecca, making it the religious center of Islam (630).

Muslims completed their conquest of Arabia (631).

d. Prophet Muhammad (ca. 570–632), founder of Islam.

Muslim Arabs began their long path of conquest, taking most of Syria and Iraq (633–637).

Muslims defeated the Byzantines at the Yarmak River, then completing their conquest of Syria (636).

Muslims defeated Persians at Qadisiya (637).

Jerusalem fell to the Arabs (638).

Expanding into central Asia, Chinese forces defeated the Eastern Turks (639).

Muslim armies took Persia (640–643).

Muslim armies took Egypt (641), Alexandria resisting until 642.

Persians defeated at Nineveh by Byzantines (627).

Chinese Buddhist pilgrim Hsüan Tsang visited India, writing about his travels (ca. 630).

Celtic Christian center founded on Lindisfarne (Holy Island) (635).

650–674

LITERATURE

Dandin, Indian author (active 7th c.), whose major work was *History of the Ten Princes* (*Dasakumaracarita*).

Caedmon (active 658–680) produced the first known Anglo-Saxon translations of parts of the Bible; he also wrote the poem *Hymn of Caedmon* (ca. 670).

Benedictine Order founded the library and publishing monastery at Wearmouth, England (674).

VISUAL ARTS

Massive reliefs of Hindu mythology carved into cliffs, near Mamallapuram, India (ca. 650).

Chinese art fell under Indian influence with the introduction of Buddhism (by ca. 661).

Tradition held that sculpture was introduced into Tibet by King Srong Tsan Gampo's two wives, one Chinese, the other Nepalese (ca. 7th c.).

d. Yen Li-Pên, Chinese painter (?–673), court artist to T'ang emperor T'ai-tsung; noted for his wall paintings, most now lost.

PERFORMING ARTS

Hote to stauro (*When to the cross they nailed the Lord*), the Good Friday hymn, probably written by Sophronius, Patriarch of Jerusalem (during 7th c.).

Octoechos, the 6th-century collection of hymns and religious poems, definitively edited by Jacob of Edessa (before 675).

WORLD EVENTS

Jewish kingdom of Khazaria controlled the western end of Silk Road (ca. 650–700).

Chinese defeated the Western Turks, expanding further into central Asia (656).

Umayyad caliphate founded, its capital Damascus (661).

Khurasan conquered by Arabs (663–671).

Bulgarians moved into the Balkans (ca. 670–680).

Callincus, Syrian-Jewish architect, invented Greek fire during sea battle off Constantinople (673).

Muslims unsuccessfully besieged Constantinople (674–678).

675–699

LITERATURE

The Wanderer and *The Seafarer*, two anonymous Old English poems (as early as 7th c.).

Kakinomoto Hitomaro, first celebrated Japanese poet (active ca. 680–710).

Benedictine Order founded the library and publishing monastery at Jarrow, England (681).

d. Caedmon, English religious poet (?–680).

VISUAL ARTS

Dome of the Rock, Muslim mosque, built on Jerusalem's Temple Mount (from 687), on the site of earlier Jewish temples, later much altered (ca. 1561); traditionally the site where Abraham was to sacrifice Isaac and Mohammed rose to heaven, so sacred to Jews, Christians, and Muslims.

PERFORMING ARTS

'Azza al-Mayla' and Jamila were famous late 7th-century Arabian singers and instrumentalists of Mecca (ca. 675).

Great age of Ethiopian religious poetry and hymns, many gathered in two collections: *Deggua* and *Meeraf* (late 7th c.).

Zheng, long Chinese zither, used in court ensembles or for solos (before 8th c. AD).

d. Chinese emperor Kao Tsung, reportedly writer of *Music of Grand Victory* (683).

WORLD EVENTS

Justinian II became eastern Roman emperor (685–695; 705–711).

Justinian II defeated by Arabs near Sebastopolis, Cilicia (692).

Muslim forces took Carthage (698).

Empress Wu ruled China (690–705).

700–724

LITERATURE

Beowulf, epic derived from Norse mythology, about the eponymous hero's battles, notably with the monster Grendel; the first major work in any vernacular European language (700).

Lindisfarne Gospels produced in the monastery of Britain's Lindisfarne Island, written in Latin by Bishop Eadfrith (ca. 700).

Sisupalavadha, Magha's epic poem, based on a story in the *Mahabharata* (ca. 700).

Earliest surviving example of a block-printed text (ca. 704–751), a Buddhist incantation (*dharani*) sealed into Korea's Pulguk-sa temple in 751.

d. Aldhelm, Anglo-Saxon scholar (ca. 639–709), Bishop of Sherborne, credited with translating the Psalms into Anglo-Saxon.

Koji-ki (*Records of Ancient Matters*), exploring Japanese myths of origin (ca. 712).

d. 'Umar ibn Abi Rabi'ah, Islamic poet of Mecca (644–ca. 720), a developer of the *ghazal*, or love poem.

Nihon shoki (*Chronicles of Japan*), one of Japan's earliest literary works (ca. 720).

Benedictine Order founded the library and publishing monastery at Reichenau, Germany (724).

VISUAL ARTS

Book of Kells, now in Dublin's Trinity College, an illuminated manuscript of the Gospels, containing illustrated scenes (ca. 700).

Hindu shore-temples of Mamallapuram and Kanchipuram built in India (ca. 700).

Echternach Gospels, an illuminated manuscript, inParis's Bibliothèque Nationale (ca. 700).

Pagoda of Yakushi-ji built at Nara, Japan (ca. 700).

Wild Goose (Great Gander) Pagoda, Xian (Ch'ang-an), China (ca. 704), tower honoring Buddhist pilgrim Hsüan-tsang.

Great Mosque, Damascus, created (706–715) from what had been a Roman temple, then Christian church; first known instance of a tower (*minaret*) being used by the *muezzin* to give the call to prayer.

Potala, the Dalai Lama's palace in Lhasa, Tibet, begun (8th c.).

d. Li Ssu-Hsun, Chinese painter and statesman (b. 651), credited with developing the "blue-and-green" style of landscape painting; often regarded as the founder of the "northern school" of Chinese painting.

Han Kan, Chinese painter (active ca. 720–ca. 780), famed for his paintings of horses, two of which survive.

Yakushi Nyorai, bronze sculpture of Buddha and other figures (ca. 720), at Yakushi-ji, Nara, Japan.

PERFORMING ARTS

'Cham, Tibetan dance form, adapted by Indian teacher Padmasambhava, as he brought Buddhism to Tibet (ca. 700).

Burmese harp, the *saùng* or *saùng-gauk*, was depicted among Buddhists in Burma and India (from at least 7th c. AD); possibly derived from the arched harps of early Egypt.

Long zither, the *koto*, and a type of lute, the *biwa*, developed in Japan, probably from Chinese ancestors (early 8th c.).

Bells cast using "lost-wax" method in Italy (ca. 700).

Formation of the Japanese national music bureau, the *gagakuryo* (702).

Koji-ki, a history citing the mythical origins of Japanese music (713).

WORLD EVENTS

Irish settlers reached Iceland (ca. 700).

Buddhism spread into Tibet and Nepal (ca. 700–800).

Muslim forces moving into central Asia took Balkh and Bokhara (705).

Muslim forces took Cappadocia (707).

Muslim forces continuing their Asian conquests took Samarkand, Khiva, and Baluchistan (710).

Muslim forces took Sind (711–712).

Muslim forces began their invasion and long occupation of Spain (711–713).

Muslim forces unsuccessfully besieged Constantinople (716–717).

Rhodes occupied by the Muslims (717–718).

Tibet and the Muslim allied themselves against China (717).

Pelayo of Asturias defeated Muslims at Covadonga, beginning to turn the tide of Muslim advance in the West (718).

Japanese established their first capital city, at Nara (710).

Hsüan-tsung became emperor of China (713–755).

725–749

LITERATURE

Venerable Bede's *An Ecclesiastical History of the English People* (*Historia Ecclesiastica Gentis Anglorum*), a history of England from Caesar's invasion in 55 BC (731); he also translated parts of the Bible into Anglo-Saxon (before 735).

Orhon inscriptions, two monuments (732, 735), outlining early history of central Asian Turkic peoples; discovered in 1893 in Orhon Valley, northern Mongolia.

Benedictine Order founded the library and publishing monastery at Fulda, Germany (744).

VISUAL ARTS

In Byzantine Empire, Iconoclastic (Image-Breaking) movement began, destroying depictions of religious figures (8th–9th c.).

Minaret at Kairouan, Tunisia, completed (727), modeled on a church tower, from which many early minarets were converted.

Free-standing and rock-cut temples built at Ellura, India (8th c.).

Parasuramesvara, Hindu temple in India, built (ca. 8th c.).

PERFORMING ARTS

Chinese Emperor Ming Huang (713–756) had at his court six "standing" and eight "sitting" orchestras, employing over 500 musicians.

Genjoraku, a Japanese court dance (*bugaku*), reportedly on Indian Vedic themes; also Indonesian music performed in Japan (ca. 736).

Earliest surviving "alleluia" verses, sung in responso-

rial chants during Mass in the Christian church, perhaps generally (as later) sung before the Gospel, except during Lent, and strongly linked with Easter; melodies have not survived (8th c.).

WORLD EVENTS

Charles Martel stopped the Muslim advance near Poitiers (732).

Khazar forces routed Muslim army in the Caucasus (730).

Muslim forces took Khazar capital of Atil, then withdrew south of the Caucasus (ca. 738–740).

Byzantine forces defeated the Muslims at Akroinon (740).

750–774

LITERATURE

d. John of Damascus, Byzantine theologian (ca. 675–ca. 750), known for his dogmatic treatise *Fountain of Knowledge*.

Chinese papermakers taken captive in Chinese–Muslim Battle of the Talas River (751) near Samarkand, then a papermaking center for next century.

d. Ibn al-Muqaffa', Arab translator of Persian classics (?–ca. 756).

Manyo-shu, Japanese poetry anthology of the Nara period (ca. 759).

Korean and Japanese wood-block printing (ca. 760).

Japanese Empress Shotoku ordered the printing of one million Buddhist incantations (*dharani*) to stave off a rebellion; it took six years (764–770).

d. Li Po, Chinese court poet (701–762).

d. Tu Fu, Chinese poet (712–770).

VISUAL ARTS

Earliest known campanile, or bell tower, attached to St. Peter's in Rome (mid-8th c.).

Shoso-in, Japanese imperial repository of royal art and household objects, established (8th c.).

Cave sanctuary at Sokkul-am, North Kyongsang province, Korea, founded by statesman Kim Taesong (ca. 752), containing a larger-than-life-size statue of Buddha, and reliefs of his disciples.

Original abbey church of St. Denis built, in France (ca. 754–775).

Great Hall of the Toshodaiji built at Nara, Japan (759).

d. Wu Tao-Tzu, Chinese painter (ca. 700–ca. 760), most famous of the early Chinese painters, noted for his Buddhist wall paintings, all now lost but known from many copies; credited with developing figure painting, a new calligraphic style (*mo chu*), and a technique for printing silk (sêng chüan).

PERFORMING ARTS

Bhavabhuti, Indian playwright (ca. 750), author of the classic Sanskrit dramas *Malati and Madhava*, *The History of Rama*, and *Rama's Later History*.

Emperor Ming Huang established the first Chinese acting academy, at Chang-an, in his pear garden; Chinese actors since have been known as "the children of the pear garden" (ca. 750).

First known organ in western Europe was a gift from Emperor Constantine IV to France's King Pepin, father of Charlemagne (757).

d. Wang Wei, Chinese musician (699–759); among his works was the zither work *The Last Battle of Hiang Yu*; he was also a painter, noted for his landscape work.

WORLD EVENTS

Chinese defeated by Muslims and Tibetans at the Battle of the Talas River, marking the high tide of Chinese expansion into western Asia (751).

Umayyad caliphate fell; replaced by Abbasid caliphate (750).

Pépin le Bref (the Short) became the first Carolingian king of France (752).

Abd al-Rahman I founded the Emirate of Córdoba (756–961).

Gopala, king of Bengal, founded the Pala dynasty (ca. 760).

Pépin le Bref took Aquitaine (760–768).

Caliph al-Mansur founded Baghdad (762).

Charlemagne, son of Pépin le Bref, became Frankish king (768).

Charlemagne began his long series of campaigns against the Saxons (772–804).

Charlemagne conquered the Lombards (774).

Indian numeral system was introduced into the Arab world; basis of Arabic numerals used today (ca. 771).

775–799

LITERATURE

d. Otomo Yakamochi, Japanese poet (718–785).

Charlemagne ordered the development of a new standard writing script (789); the Caroline or Carolingian minuscule—credited to Alcuin of York, Abbot of St. Martin's, Tours—first introduced small (lowercase) letters.

VISUAL ARTS

Tassilo Chalice in Kremsmünster, a notable example of Carolingian artistry (ca. 777–788).

Earliest datable *tjandi*, a combined Buddhist temple and funerary monument, in Indonesia (778).

Church of S. Maria, Cassino (ca. 780–790).

Mosque at Cordoba, Spain, built (786–990).

Abbey church at Fulda built, modeled on Rome's Old St. Peter's (ca. 790–819).

PERFORMING ARTS

Japanese professionals and amateurs played 13-stringed *gaku-so*, in chamber ensembles and individually (Heian period, 782–1184).

In the Western (Latin) Christian church, various types of liturgical singing and music were repressed in Charlemagne's Frankish Empire, in favor of a unified style called the Gregorian chant (late 8th c.), which may have been developed then, though traditionally linked with Pope Gregory (590–604). Western Christians also adopted, for the Gregorian chant, the Byzantine method of organizing plainchants by symmetrical groups of modes.

Hymns first began to be adopted within the Rome-based Western (Latin) Christian church (late 8th c.), though long common in the East.

WORLD EVENTS

Charlemagne was defeated by forces of Abd-al-Rahman at Roncesvalles; destruction of Roland's rearguard became the stuff of legend (778).

Leo IV the Khazar became Byzantine emperor (775–780).

Constantine VI became Byzantine emperor (780–797).

Irene, widow of Constantine VI, became empress of Byzantium (797–802).

Harun al-Rashid became Abbasid Caliph (786–809).

Lindisfarne was raided by the Vikings (793).

Heian-kyo (Kyoto) became the capital of Japan (794).

Iona Abbey was destroyed by Danish Vikings. Norwegian Vikings raided in Ireland (795).

800–824

LITERATURE

Elder or *Poetic Edda*, Icelandic collection of early Scandinavian mythology (9th–12th c.).

Vikings took a Nordic form of runic script with them as they expanded throughout Europe (ca. 800–1050).

d. Alcuin, medieval Latin writer (d. 804).

d. Hasan ibn Hani' Abu Nuwas, Arab poet (762–ca. 815), a favorite poet at the court of Caliph Harun al-Rashid; Nuwas appears as a character in *The Arabian Nights*.

Benedictine Order founded the library and publishing monastery at Corvey, Germany (822).

d. Han Yü, Chinese essayist (768–824), author of *Yüan-tao* (*On the True Way*).

VISUAL ARTS

Temple of Borobudur, beautifully sculptured Buddhist monuments, built in Java (ca. 800); regarded as one of the "wonders of the Orient" (restored 1907–1911).

Islamic potters began to produce distinctive fine wares, under Chinese influence, and also made use of the old but little-used faience technique (from ca. 9th c.).

Bronze-casting techniques used in South America, probably developed in Bolivia and spread to Peru and Argentina (ca. 800–900), later to Ecuador by the Incas.

Utrecht Psalter, early illustrated manuscript, containing miniatures and ornaments in outline, in plain ink or color (816–835).

Gold altar (*paliotto*) at S. Ambrogio in Milan (ca. 824–859), one of the first examples of early goldsmith artistry.

Church at Steinbach, Germigny-des-Près, built by Einhard (ca. 800), containing a surviving mosaic.

Church of S. Maria, Cosmedin (early 9th c.).

Great Temple, Bhubanesvar, India (9th c.).

Hindu temples, Orissa (800–1200).

Chang Hsüan, Chinese painter of the T'ang court (active early 8th c.).

PERFORMING ARTS

Formation of the Japanese Big Song Hall (*Outa dokoro*), a national music bureau for Japanese-composed music (ca. 9th c.).

Manikkavacakar's *Tiruvacakam*, a collection of hymns to Siva (ca. 9th c.).

Arabic treatise described the system for producing music "automatically," later used in the barrel organ or player piano (9th c.).

Harps depicted in Europe, France, Ireland, Scotland, and Wales, as well as in Byzantium (from 9th c.).

Tergensee (Germany) *Antichrist*, a German religious play, in Latin (ca. 800).

Earliest notations of liturgical music in Europe, though without designation of precise pitch (9th c.).

WORLD EVENTS

Scandinavian Viking raiders (Danes, Normans, and Norwegians) mounted powerful raids against and settled in France, the British Isles, and Ireland, while Swedish Varangian Vikings (Rus) traded and conquered south on the Russian River routes (ca. 800–900).

Charlemagne was crowned western Roman emperor by Pope Leo III in Rome (800).

Cambodia became an independent kingdom, its capital near Angkor (802–1432).

Charlemagne completed the Frankish conquest of Saxony (804).

Treaty of peace between Tibet and China (821).

825–849

LITERATURE

Chinese law banned unofficial printing of calendars (835).

Japanese monk reported seeing 1,000 printed copies of a *sutra* (Buddhist writing) in China (839).

Earliest known surviving writings in French, the *Strasbourg Oaths* (842); first example of a Neo-Latin, or vernacular, language.

d. Abu Tammam, Syrian poet (804–845), author of two Bedouin poetry anthologies, both titled *Hamasah* (*Poems of Bravery*).

VISUAL ARTS

Church in octagonal style built at Aachen, begun by Charlemagne (ca. 825).

Original St. Mark's (San Marco) built in Venice (829); later rebuilt.

Great Mosque of Kairouan, Tunisia, the first great African mosque, built (836) on the site of an earlier mosque.

Byzantine Christian church formally supported having holy images in churches, resolving the "Iconoclast controversy," leading to a revival of Byzantine Christian art (843).

Much Buddhist art destroyed, after Buddhism was banned in China (845).

PERFORMING ARTS

First organ known to be produced in western Europe, built by a Venetian priest for the Frankish palace at Aachen (826); but most other organs for centuries would be used in religious settings, and then only for special occasions, not as part of regular services.

WORLD EVENTS

Muslims took most of Sicily, including Palermo (827–831).

Muslim forces raided in southern France and Italy, with Arab colonies founded in southern Italy (838–842).

London was sacked by Danish Vikings (836).

Norman raids intensified in France; Orléans sacked; Paris attacked (838).

Danish Vikings founded Dublin, Ireland (840).

850–874

LITERATURE

Earliest known translations of parts of the Bible into

Old Church Slavonic, in Moravia, credited to Byzantine Christian missionary brothers Cyril and Methodius, who reportedly developed script for the purpose, basis for the Cyrillic alphabet (ca. 863).

Diamond Sutra, oldest dated complete printed book known (868), a scroll of a Buddhist holy work, sealed in the Cave of the Thousand Buddhas near China's old Silk Road in the 11th century; rediscovered by a Chinese monk (ca. 1904) and then taken out of China by Marc Aurel Stein.

Evangelienbuch (*Book of the Gospels*), by Otfrid of Weissenburg (870).

d. al-Jahiz (Uthman 'Amr ibn Bahr ibn Mahbub al'Jahiz), Arab writer and Muslim theologian (ca. 776/780–868/869), Iraqi grandson of a Black slave, whose best-known works were *The Book of Eloquence and Exposition* and *The Book of Animals*.

VISUAL ARTS

Great Mosque of Samarra, Iraq, built (ca. 850); largest of the early mosques, noted for its minaret with spiral external staircase.

Utrecht Psalter, illuminated manuscript (9th c.).

Mosque of Bu Fatata, Susa, Tunisia, built (850–851).

PERFORMING ARTS

First use of the term *organum*, referring to nonunison singing in church; the term is unrelated to organs, not used to accompany singing in this period (ca. 860).

WORLD EVENTS

Antiforeign rioting in Canton; 120,000 people reported massacred (ca. 850).

Norse ships reached Iceland (ca. 850).

Norse settlers reached Iceland in considerable numbers (ca. 870).

Danish Vikings settled in northern England, establishing colonies (the Danelaw) (ca. 870).

Alfred the Great became king of Wessex (in England) (871–899).

Basil I the Macedonian became emperor of Byzantium (867–886).

875–899

LITERATURE

Anglo-Saxon Chronicles, historical chronicles begun under King Alfred in various monasteries, the first extended work written in English (ca. 891–1154).

Cairo Prophets Codex, the oldest surviving version of parts of the Old Testament, by Moses ben Asher in Tiberias.

d. Ibn Quataybah, Persian writer (828–889), author of *'Uyun al-akhbar* (*Fountains of Stories*).

VISUAL ARTS

Indravarman, Cambodian architect (active ca. 877–889).

Prah Koh, a complex of six tower shrines, built by Indravarman for the Cambodian funerary cult of Jaravarman.

Mosque of Ibn Tulun built in Cairo by Admad ibn Tulun (ca. 876–879).

Temple at Bakong built on an artificial mountain by Indravarman on Cambodia's Roluos plain.

PERFORMING ARTS

Hucbald's *De Harmonica Institutione* (ca. 880), the earliest known systematic work on musical theory, treating everything from intervals and tones to scales and modes.

When conditions allowed long-distance travel, troupes of entertainers would tour Europe, bringing new instruments and styles from Italy and the Byzantine Empire into the rest of Europe, including knowledge of organ building and bell founding (9th c.).

WORLD EVENTS

Magyars migrated from north of Caspian Sea onto the Hungarian plain (ca. 895).

Vikings attacked Paris (875).

Viking attack on Wessex defeated by forces of Alfred the Great (876).

Byzantine forces captured the Cilician Gates, moved to reconquer southen Italy (876).

900–924

LITERATURE

Anglo-Danish simplified pidgin language developed in England between speakers of Old English and Old Danish, basis for modern English (ca. 10th–11th c.).

Bhagavata-Purana, an Indian epic poem, a history and celebration of the lord Krsnu (ca. 900).

Barlaam and Josaphat, Christian romance (900).

Calligraphy became virtually a cult during the Heian period in Japan (ca. 10th c.).

Leningrad Codex of the Latter Prophets, an authoritative version of parts of the Old Testament (916).

d. Ibn al-Mu'tazz, Islamic poet (?–908), who helped formalize the rules of Islamic poetry.

d. Ibn Da'ud, Islamic poet (?–910), who compiled the poetry anthology *Kitab az-zahrah* (*Book of the Flower*).

VISUAL ARTS

Chludov Psalter, an illustrated Psalm book, one of the earliest known; now in Moscow's Historical Museum (ca. 900).

Illuminated manuscripts: *Joshua Rotulus*, from the Vatican, and *Nicander* and *Paris Psalter*, both in Paris's Bibliothèque Nationale (ca. 900).

Meso-American palace at Uxmal; also Codz-Pop (Palace of the Masks), at Kabah (both ca. 9th–10th c.).

Prambanan, a *tjandi* (combination temple and funerary monument), built in Indonesia by King Daksha (ca. 915), with many reliefs illustrating the *Ramayana*; partially restored in 20th century.

Original monastery church at Cluny begun (916–917); now called Cluny I, it survived as the Abbey Sacristy.

PERFORMING ARTS

Beginning of the great age of liturgical music–drama in the Christian church of western Europe (early 10th c.–late 13th c.).

Hrotsvitha, a German nun, a playwright whose works included *Abraham*, *Calimachus*, *Gallicanus I* and *II*, *Paphnutius*, *Sapientia*, and *Dulcitius* (ca. 900).

Musica enchiriadis, an instruction book for singers, widely used in Europe (ca. 900).

Abu al-Faraj al-Isbahani's *Kitab al-Aghani* (*Book of Songs*) (ca. 900).

Arichanda, Indian Buddhist drama; a Tamil-language classic (ca. 900).

Transverse (horizontally held, side-blown) flutes used in Byzantium, possibly from Asia (10th c.).

WORLD EVENTS

Magyar raiders attacked and greatly damaged Moravia, beginning a long series of attacks on central and western Europe (ca. 900).

Hausa Dynasty began in Nigeria (ca. 900–1911).

Leo of Tripoli, headquartered in Crete, attacked Constantinople (904).

Tang period ended in China; Five Dynasty period began (907–960).

Rus (Varangian Swedish Vikings) forces attacked Constantinople (907).

Fatimid Caliphate founded in North Africa (909).

Abbey of Cluny founded by William of Aquitaine (910).

Athelstan, king of England; York and Northumbria conquered (925–939).

Leo of Tripoli decisively defeated off Lemnos by Byzantine war fleet (917).

925–949

LITERATURE

First known Arabic translation of the Hebrew Bible made by Sa'adia ben Joseph for Jews living in Muslim countries (before 942).

Aleppo Codex, an authoritative version of the full Old Testament, by Solomon ben Buya'a, edited by Aaron ben Moses ben Asher (930).

Walter of Aquitaine, Eckhard of St. Gall's epic (930).

d. Rudaki (Abu 'Abdollah Ja'fer ebn Mohammad), Persian poet (ca. 859–ca. 940) whose work in the new Persian style was central to the development of modern Persian literature.

d. as-Sanawbari, Aleppo-based landscape and garden poet (?–945).

d. Ki Tsurayuki, Japanese poet and diarist (ca. 870–946), chief editor of the *Kokin-wakashu* (*Kokinshu*) poetry anthology.

VISUAL ARTS

Mausoleum of the Samanids, Bukhara, Transoxiana (first half of 10th c.).

Embroidered stole and maniple of Frithestan, bishop of Winchester, England, among the earliest surviving church vestments (before 932).

PERFORMING ARTS

Earliest surviving melodies for *alleluia* liturgical chants (10th c.); the earliest surviving verses are from the 8th century, often with the word *alleluia* followed by 2–3 psalms.

d. Hucbald, French monk, composer, and musical theorist (ca. 840–930), noted for his choir instruction and his treatises on musical theory.

WORLD EVENTS

Byzantines attacked Muslims in Syria, beginning reconquest (931).

Foreign merchants expelled from China (925).

Bulgars unsuccessfully besieged Constantinople (926).

Otto I became Holy Roman Emperor (936–73).

950–974

LITERATURE

d. al-Farabi (Alpharabius or Muhammad ibn Muhammad ibn Tarkhan ibn Uzalagh al-Farabi), Aleppo-based central Asian philosopher and writer (ca. 878–ca. 950), teacher of Aristotle's works.

First known text in Italian (960), relating to a lawsuit.

d. Ahmad ibn al-Husain al-Mutanabbi, Arab poet (915–965), a key figure in the "Modern" school of Islamic poetry.

d. Abu al-Faraj al-Isbahani, Islamic writer (?–967), editor of the poetry-and-prose anthology *Kitab al-aghani* (*Book of Songs*).

VISUAL ARTS

Benedictional of St. Aethelwold, an illuminated manuscript, now in the British Museum (active ca. 950).

Tibetan Buddhist artists made the earliest *thangkas*, painted or embroidered banners carried in religious processions (during 10th c.).

Huang Ch'üan, Chinese flower and bird painter (active ca. 950).

Chinese potters made some of their finest and most elegant ceramics during the Sung dynasty, often working in teams in large workshops (960–1278).

Surviving Sassanian Persian silk weaving, depicting elephants, camels, and peacocks (ca. 960); now in the Louvre.

Cairo's al-Azhar Mosque built by the Fatimid rulers of Egypt (970–972).

PERFORMING ARTS

Earliest surviving documentation of liturgical music–drama, *Quem quaeritis*, in two different versions from St. Gall and Limoges, both rudimentary Easter scenes (*tropes*), with dialogue and music portraying the scene at the tomb, with assurances of the Resurrection, ending with the *Te Deum* (mid-10th c.); Christmas dramas quickly followed.

Bowing of stringed instruments depicted in documents from Spain (before 950) and the Byzantine Empire (10th c.); earliest description of bowing from an Arabic treatise of al-Farabi (before 950).

d. Wang Fo, Chinese musician (?–959), who developed a new theory of notes.

WORLD EVENTS

Rus sacked Itil, destroying Khazarian power (950).

Buddhism persecuted in China (from 955).

Northern Sung dynasty in China (960–1126).

Crete and Cyprus were taken by Byzantium (965).

Pechenegs besieged Kiev (ca. 968).

Fatimids took Egypt, built Cairo as their capital (969–973).

Seljuk Turks moving out of central Asia invaded Persia (ca. 970).

975–999

LITERATURE

Minamoto Shitagau's *The Tale of the Hollow Tree* (*Utsubo monogatari*) (983).

Fihrist (*Index*) of Arabic literature, compiled by bookseller Ibn an-Nadim (988).

The Battle of Maldon, anonymous heroic Old English poem, celebrating a fight against the Danes (after 991).

Publication started of Persian scholar and statesman al-Khwarizm's *Mafatih al-'Ulum* (*Key to the Sciences*) (995–997).

VISUAL ARTS

Central Asian Buddhist monks, refugees from Chinese persecution, brought their art styles to Tibet (after 975).

Menology of Basil II, an illuminated manuscript, in the Vatican (976–1025).

Gospel Book of Egbert of Trier (*Codex Egberti*), illuminated manuscript containing illustrations of New Testament scenes (980).

Second church at Cluny (Cluny II) consecrated (981).

Bronze doors of Mainz Cathedral (late 10th c.).

Gospel books, illustrated (illuminated) manuscripts of the Gospels, became popular in Europe (before 1000).

PERFORMING ARTS

Earliest known full-fledged liturgical music–drama, *Winchester Troper* (ca. 980), another version of the Easter scene at the tomb, with dialogue sung through and annotations as to action, costumes, and props.

Qanun, a plucked stringed instrument, in wide use in the Middle East (before 10th c.).

WORLD EVENTS

Norse settlers reached Greenland (ca. 980), and soon reached the North American mainland .

Syria and Palestine were taken by Byzantium (975).

Otto II was defeated by Muslim forces in southern Italy (982).

Basil II conquered Bulgaria (986–1018).

Hugh Capet became king of France, beginning Capet dynasty (987–1126).

Vladimir of Kiev converted to Christianity (989).

Sultan Mahmud occupied Peshawar, took the Punjab, and sacked many great Hindu cities (991).

1000–1009

LITERATURE

Chansons de geste ("songs of deeds"), French metrical romances celebrating the deeds of knights both historical and legendary, composed by French medieval poets (*trouvères*) and sung by traveling entertainers and court minstrels (11th and early 12th c.).

Thousand Stories, Persian collection of Persian and Indian tales; basis for the later *Arabian Nights* (by 1000 BC).

Kathasaritsagara, Indian poet Somadeva's collection of folktales in Sanskrit (11th c.).

Gothic script developed in northern Europe (by 11th c.); the more condensed script would be used in Gutenberg's first books.

In China, number of script signs increased to about 27,000 (by 1000 AD).

Library Dar al-Hikmah (House of Wisdom) established in Cairo by Caliph al-Hakim (1005).

d. Ahmad ibn al-Hussain al-Hamadhani, Arab writer (967–1007), noted for his verse stories; nicknamed Badi al-Zaman (Wonder of the Age).

VISUAL ARTS

Bamberg Apocalypse (written in Reichenau, ca. 1000).

Caedmon, an illuminated manuscript illustrated only with outlined miniatures in plain ink, not colored illustrations (ca. 1000).

Ta Keo, a huge, pyramidal mountain-temple, built in Cambodia under Suryavarman I (ca. 1000).

Miniature painting developed in Meso-America (by 1000).

Original Cathedral of Notre-Dame, Chartres, begun (ca. 1000); later rebuilt after a fire (1194).

Great basilica-style cathedrals at Ani, Armania, and Sveti-Tskoveli, Mtskheta, Georgia, built (ca. 1000).

Chinese developed their version of perspective, called the technique of "the far and the near" (by 11th c.).

Cairo's Al-Hakim Mosque built by the Fatimid rulers of Egypt (1002–1003).

Gunbad-i-Kabus, over 200-foot-high tower in Iran (1006–1007).

PERFORMING ARTS

Micrologus, Guido of Arezzo's basic and widely used book of music theory (ca. 1000), not only describing different kinds of music but developing the basic Western system of musical notation, as well as the use of syllables for sight-singing, such as "ut, re, mi, fa, sol, la."

Earliest surviving hymnbooks from the Slavonic Church of Russia, written in Byzantine-style notation (11th c.).

WORLD EVENTS

Christian pilgrimages became widespread in Europe (ca. 1000).

King Olaf of Sweden became a Christian, introducing of Christianity into Scandinavia (1000).

Sri vijayan power grew, with the conquest of East Java (1006).

St. Stephen became king of Hungary (1001).

Henry II became Holy Roman Emperor (1002–1024).

Polish forces occupied Bohemia (1003–1004).

Suryavarman I became king of Cambodia (1002–1050).

Robert the Pious conquered Burgundy (1003–1016).

First Normans reached Sicily (1009).

1010–1019

LITERATURE

Firdawsî's epic poem *Shâh-nâma* (*Book of the Kings*), a history of Persia in over 50,000 couplets, based on earlier works (ca. 1010).

VISUAL ARTS

Bronze doors of the cathedral at Hildesheim, showing scenes from the Old and New Testaments (1015).

Lingaraja, a Hindu temple, built in Bhuvanesvara, India (ca. 1000).

PERFORMING ARTS

Crwth (in English, crouth or crowd), a bowed stringed instrument, used in Wales and also on the Continent (ca. 11th c.).

WORLD EVENTS

Cnut (Canute) of Denmark became king of England (1016).

First Normans reached southern Italy (1016).

Poland invaded Russia, taking Kiev (1018).

1020–1029

LITERATURE

The Tale of Genji (*Genji monogatari*), Lady Murasaki Shikibu's tale of the life and loves of Prince Genji; the first and greatest of Japanese literary works, perhaps the world's first complete novel (ca. 1020).

d. Firdawsî (Mansûr Abu'l-Qâsim Firdawsî), Persian epic poet (ca. 935/941–ca. 1020).

VISUAL ARTS

Artisans from Constantinople brought the Byzantine style to Kiev (ca. 11th c.).

Distinctive Pueblo style of pottery, called Classic Mimbres, developed in American Southwest (ca. 1000–1200).

PERFORMING ARTS

Guido of Arezzo called to Rome by Pope John XIX to teach his new methods of musical notation and training of singers and musicians (ca. 1028).

WORLD EVENTS

Castile and León were taken by Sancho of Navarre; his son Ferdinand became Ferdinand I, the first king of Castile (1029).

Druze sect was organized (1021).

1030–1039

LITERATURE

al-Biruni's *History of India* (*Ta'rikh al-Hind*) (1030).

d. Murasaki Shikibu, Japanese novelist and diarist (ca. 980–ca. 1030).

d. Avicenna (Ibn Sina or Husain ibn Abdullah), Islamic physician and philosopher (980–1037), who compiled much-translated works on medicine, science, and philosophy.

VISUAL ARTS

Santa Sophia Church, Kiev, begun (1037).

PERFORMING ARTS

d. Guido of Arezzo, Italian monk and music theorist (b. ca. 991–d. after 1033), who first developed the Western pattern of musical notation, using the staff, and the practice of sight-singing using syllables.

WORLD EVENTS

Caliphate in Spain fragmented into many small kingdoms (1030).

Henry I became king of France (1031–1060).

Duncan I became king of Scotland (1034–1040).

Henry III became Holy Roman Emperor (1037–1056).

1040–1049

LITERATURE

Chinese alchemist and smith Bi Sheng credited with producing movable type from baked clay, later to be replaced by wood, metal, even porcelain in printing (ca. 1045).

d. al-Biruni (Abu ar-Rayhan Muhammad ibn Ahmad al-Biruni), Islamic scholar (973–1048), who worked in history, mathematics, geography, astronomy, and the natural sciences.

VISUAL ARTS

Codex Aureus, an illuminated manuscript decorated primarily with gold leaf (1045–1046).

PERFORMING ARTS

Oldest surviving manuscripts of Old Roman, the Roman version of Gregorian chant (ca. 11th–13th c.), later replaced by the more melodic Gregorian chant as developed originally in Charlemagne's Frankish Empire.

WORLD EVENTS

Edward the Confessor became king of England (1042–1066).

Russians besieged Constantinople; the Russian fleet was destroyed by Greek fire (1043).

Mandingo Empire of Jenne founded (ca. 1043).

Anawratha became the first king of Pagan (Burma) (1044–1077).

1050–1059

LITERATURE

Chanson de Roland (*Song of Roland*), French medieval romance, telling of the destruction of Charlemagne's rearguard by Saracen Muslims at the late 8th-century battle of Roncesvalles in the Pyrenees; Roland (or Orlando) would figure in many ballads (ca. 1050).

d. Ibn Janah of Córdoba (Abu al-Walid Marwan ibn Janah or Rabbi Jonah), Spanish-Jewish grammarian working in Arabic (ca. 990–1050), writer of the first known complete Hebrew grammar, *Kitab al-luma*.

d. Ahmad ibn 'Abdullah, al-Ma'arri Abu'l-'Ala, blind Syrian poet of the "Modern" school (973–1058), noted for his early poems *Sparks from Flint and Steel*.

VISUAL ARTS

Saint-Savin-sur-Gartempe, Poitevin abbey church, France, built (before 1050), noted for its Romanesque wall paintings; later enlarged (ca. 1100).

Building of Westminster Abbey began (1052).

d. Jocho, Japanese sculptor (?–1057).

PERFORMING ARTS

Victimae Paschali, a liturgical music–drama portraying the Eastern scene at the tomb (11th c.); much adapted.

Pope Leo IX composed the *Office of St. Gregory the Great* (1054), a liturgical work that was adopted in various abbeys, such as St. Martin at Cologne, then under Abbot Aaron Scotus.

d. Aaron Scotus, Scottish Benedictine abbot and theorist (ca. 1000–1052), who wrote three influential treatises on singing, especially relating to the Gregorian chant.

WORLD EVENTS

Pechenegs moved into western Russia, pressed by other Turkish speakers out of central Asia (ca. 1050).

Great Schism period began, between the Eastern and Western churches (1054).

Seljuk Turks took Baghdad (1055).

Beginning of the Almoravid dynasty; Almoravids began their conquests in Morocco and Algeria (1056–1147).

1060–1069

LITERATURE

d. 'Ali ibn Ahmad Ibn Hazm, Arab writer (994–1064), best known for his *Tawq al-hamamah* (*The Ring of the Dove*).

VISUAL ARTS

Bayeux Tapestry, Anglo-Saxon embroidery illustrating in a series of "cartoons" the story of the Norman Conquest, probably made at Canterbury for William the Conqueror's brother Odo, bishop of Bayeux (1066–1077).

Pisa Cathedral begun by Buscheto (Busketus) in Pisa, Italy (1063–1118).

Montecassino built in Italy (1066).

Theodore Psalter, an illuminated manuscript, in the British Museum (1066).

PERFORMING ARTS

Earliest surviving documentary records of the Ambrosian chant, the early medieval liturgical chant and music repertory centered on Milan, first prominent under St. Ambrose (ca. 340–397); Ambrosian was the only early medieval chant to survive the 8th-century general adoption of the Gregorian chant (ca. 11th c.).

WORLD EVENTS

Harold of England defeated the Norwegians at Stamford Bridge, but was defeated and killed by the Normans at Hastings; England fell to the Normans and William the Conqueror became king of England (1066).

1070–1079

LITERATURE

Chronography, Michael Psellus's history (1078).
d. Ibn Zaydun of Córdoba, Spanish Muslim lyric poet (?–1071).

VISUAL ARTS

Church of Santiago de Compostela built, in northwest Spain (ca. 1075–1188); the supposed burial site of St. James (Iago) the Great, much visited by medieval pilgrims from at least 844.

PERFORMING ARTS

Carved ivory horn called an *oliphant* (elephant) in use in Europe, many made by Arab artisans in southern Italy (before 1100); in the *Chanson de Roland*, the hero trumpets on an oliphant to signal Charlemagne.

WORLD EVENTS

Serbia became an independent nation (1071).
Marrakesh founded as capital by Abu Bakr b. Umar (1070).
Seljuk Turks took Syria and Palestine (1070).
Seljuk Turks defeated the Byzantines at Manzikart, and took Asia Minor (1071).

1080–1089

LITERATURE

First known European papermaking mill established by Muslims at Játiva, Spain; from there and Sicily papermaking techniques would spread to Europe (ca. 1085).
Domesday Book (*Doomsday* or "Day of Judgment"), a census record and survey of England—its people, livestock, and land values—compiled under William the Conqueror (1086).
d. Khwajah 'Abd Allah al-Ansari, Persian Muslim religious writer (?–1088).

VISUAL ARTS

Dome of Malik Shah, Masjid-i Jami, Isfahan, Iran (1080).
Cathedral at Salerno consecrated (1084).
Shwé Zigon, Burmese stupa, built by Kyanzittha (1084–1112).
S. Nicola at Bari, Italy, begun (after 1087), showing Norman influence.
Third church at Cluny (Cluny III) begun (1088); an influential example of the Romanesque style.

PERFORMING ARTS

Medieval trumpets, often played in pairs, developed in Europe and the Islamic world, both probably descended from the earlier Roman tuba, a straight 3–4-foot-long trumpetlike instrument. Islamic versions were sometimes curved, folded, even collapsible, but the new European instruments remained straight, and were 3–6 feet long, generally with a pommel at the base of the bell, but with simply a widened end for a mouthpiece, not a separate cup (from ca. 11th c.).

WORLD EVENTS

Henry IV of Germany took Rome (1083).
Rome was sacked by the Normans (1084).
Christian Spanish forces took Toledo (1085).
Alexius I Comnenus became Byzantine emperor (1081–1118).

1090–1099

LITERATURE

d. Michael Psellus, Byzantine philosopher–historian (1018–1096/1097).

VISUAL ARTS

Earliest datable use of rib vaults, in Durham Cathe-

dral (ca. 1093); soon to be part of the Gothic style.

St. Mark's (San Marco), Venice's famed 11th-century basilica, completed and consecrated (1094), replacing earlier shrine.

S. Abbondio consecrated at Como, Italy (1095).

Cathedral of Modena, Italy, begun (1099).

PERFORMING ARTS

Troubadours active in Provence (by ca. 1100), center of a widespread vernacular singing movement; single performers dominated, such as solo harpers or fiddlers (*vieleurs*), but sometimes the troubadour would be accompanied by a minstrel (*jongleur*).

Side-blown (transverse) flutes played in western Europe, especially Germany (by the 12th c.).

WORLD EVENTS

First Crusade began (1095): Peter the Hermit led Crusader forces from France (1096), fought the Seljuk Turks (1097), campaigned in Asia Minor and besieged Antioch (1097–1098), and took Jerusalem (1099).

Massacres of Jews in France and Germany accompanied the First Crusade (1096).

El Cid took Valencia (1094–1099).

d. Rodrigo Díaz de Vivar (El Cid), Spanish military leader and national hero (ca. 1043–1099).

Assassin movement founded at Alamut, Persia (1090).

Pechenegs unsuccessfully besieged Constantinople (1090–1091).

Order of Knights of St. John (Hospitallers) of Jerusalem was founded (1098).

1100–1109

LITERATURE

Prthviraj Rasu, Chand Bardai's epic Hindi poem, on historical themes (ca. 1100).

Iramavatarum (*Rama's Incarnation*), an interpretation of the *Ramayana*, by Tamil poet Kampan (ca. 1100).

VISUAL ARTS

New basilica of S. Ambrogio, Milan (ca. 1100).

Jannatha, a Hindu temple, built at Puri in India (ca. 1100).

Ananda, temple by Kyanzittha built in India (ca. 1105).

d. Su Tung-p'o, Chinese poet, essayist, and painter (b. 1036), known for his calligraphy and bamboo paintings.

d. Li Lung-mien or Li Kung-lin (originally Li Po-shih), Chinese artist and art critic (b. 1049).

d. Mi Fei, Chinese painter and calligrapher (1051–1107), famed for his calligraphy and his writings on art theory, who developed the "ink splashing" (*p'o-mo*) technique of depicting form.

PERFORMING ARTS

Gatagovinda, Indian epic poem in Sanskrit, about Krishna and Radha; often the basis of drama (ca. 1100).

The Bridegroom (*Sponsus*), early French vernacular play, written in Latin (ca. 1100).

Large kettledrums played in royal bands in the Middle East (from at least 12th c.).

Tambourines, at first without jingles, began to be used in Europe, derived from earlier ones from the Middle East (ca. 12th c.).

WORLD EVENTS

Norwegians led by Magnus III invaded Ireland (1103).

Louis VI became king of France, making many towns answerable only to the crown, rather than to their former feudal lords (1108–1137).

Crusaders took several coastal cities, including Beirut and Sidon (1109–1110).

1110–1119

VISUAL ARTS

Angkor Wat, extensive Indian-influenced Hindu shrine including many temples built in Cambodia by Khmer under King Suryavarman II (ca. 1112–1153), rediscovered in 1861 and partly restored.

Bronze font at S. Barthélemy, Liège, France (ca. 1115).

Church at St. Lazare, Autun, France (1116–1132); a notable example of Romanesque style.

Cathedral begun at Parma (after 1117).

South Pagoda, Fang-shan, Hopei, China (1117).

PERFORMING ARTS

First known examples of wheel-operated instruments ancestral to the hurdy-gurdy (12th c.).

WORLD EVENTS

Almoravids continued to attack in Spain and Portugal; Lisbon fell (1110).

Baldwin I of Jerusalem attacked Egypt (1118).

1120–1129

LITERATURE

William of Malmesbury's *Gesta regum Anglorum* (*Chronicle of the Kings of England*) (ca. 1120–1128), a key source of information about early England.

d. Mas'ud-e Sa'd-e Salman, Muslim poet (?–1121), who wrote many prison poems and died a political prisoner in Lahore.

VISUAL ARTS

St. *Albans Psalter*, an illuminated manuscript (ca. 1120), with illustrations of Old and New Testament scenes, from Hildesheim Cathedral.

Present building at Vézelay, abbey of the Magdalen, built (ca. 1120–1150); a key abbey on France's pilgrimage route.

Great Mosque completed in Isfahan (1121), showing influence of Persian style.

Hangchow became center for making China's fine Kuan porcelain, especially celadonware (after 1127).

PERFORMING ARTS

German version of the *Quem quaeritis* liturgical music–drama portraying the Easter scene at the tomb (early 12th c.).

WORLD EVENTS

Jurchen forces took Peking (Beijing), ended

Northern Sung dynasty (1125–1126); Southern Sung dynasty began (1127–1279).

Order of Knights Templar founded (ca. 1120).

Byzantium was at war with Venice (1122–1126).

First Lateran General Council of the Catholic Church convened (1123).

1130–1139

LITERATURE

Pierre Abélard's *Historia calamitatum* (ca. 1134), which sparked a famous series of letters between him and Héloïse; once her teacher, he had been castrated on discovery of their secret marriage (ca. 1118).

History of the Kings of Britain (*Historia regum Britanniae*) (ca. 1137), Geoffrey of Monmouth's account of the founding of England, a key source of legends about King Arthur, King Lear, and other figures.

Alexanderlied, German epic poem about Alexander the Great, translated from the French (ca. 1130).

Libro de buen amor (*Book of Good Love*), Juan Ruiz's poetry collection (1130).

d. 'Omar Khayyâm, Persian poet and mathematician (1048?–1131?), best known for his poetic work *Rubáiyát*, translated into English by Edward Fitzgerald in 1859.

d. Sana'i (Abu al-Majd Maj-dud ibn Adam), Persian mystical poet (1050–1131), author of the epic *Hadiqeh ol-haqiqat* (*Orchard of Truth*), in approximately 10,000 verses.

d. Ibn Khafajah, Spanish Muslim landscape and garden poet (?–1139).

VISUAL ARTS

Cistercian Order brought elements of the Gothic style to churches in England (from ca. 1130).

Cormac's Chapel, Cashel, Ireland (1134).

d. Li T'ang, Chinese painter (1049–1130), credited the technique of using dry-ink brush strokes to depict texture of rocks.

d. Chinese emperor Hui-tsung (Hu Tsung), painter and calligrapher (1082–1135).

PERFORMING ARTS

Earliest reference in medieval records to a bagpipe (12th c.).

WORLD EVENTS

Civil war in England, between Empress Matilda and King Stephen (1139).

Louis VII became king of France (1137–1180); he married Eleanor of Aquitaine (1137).

Roger II became king of Sicily (1130–1154).

Conrad III became Holy Roman Emperor (1138–1152).

Alfonso I became the first king of Portugal (1139).

1140–1149

LITERATURE

Poema de mío Cid (*Poema del Cid* or *Song of My Lord*), earliest surviving Spanish epic poem (anonymous; ca. 1140), relating the efforts of Rodrigo (Ruy) Díaz de Vivar (ca. 1043–1099) to halt Moorish expansion on the Iberian Peninsula; source for many later works.

Alexiad, Anna Comnena's history of the reign of her father, Byzantine Emperor Alexius I (after 1148).

d. Pierre Abélard, French philosopher, theologian, and ill-fated lover of Héloïse (1079–1142).

d. William of Malmesbury, English historian and monk (ca. 1090–ca. 1143); his late work included *Historia novella* (*Modern History*) (1142).

d. Ari Thorgilsson, Icelandic writer and historian (ca. 1067–1148), whose works include *Book of the Icelanders* (*Libellus Islandorum Islendingabók*) and *Book of Settlements* (*Landnámbók*).

VISUAL ARTS

First section of the Abbey of St.-Denis, near Paris, built, inspired by Abbot Suger (1129–1151; whole completed 13th c.); regarded as the first truly Gothic structure.

Shaftesbury Psalter, an illustrated Psalm book (ca. 1140–1150), now in the British Museum.

Cappella Palatina, Palermo, Roger II of Sicily's royal chapel (ca. 1140), showing Islamic influence in decoration.

PERFORMING ARTS

Minnesang, tradition of courtly lyrics and secular songs in the vernacular, at its height in Germany (ca. 1150–1200); based on Provence's troubadour tradition.

WORLD EVENTS

Second Crusade was led by Conrad III of Germany and Louis VII of France (1147–1148).

Crusaders unsuccessfully besieged Damascus (1148).

Assassin sect built its strength, headquartered in Syria (ca. 1140).

Order of the Teutonic Knights was founded (1143).

Alfonso VII took Córdoba (1144).

Norman forces took Tripoli (1146).

1150–1159

LITERATURE

Sicilian geographer Idrisi's book *Kitab nuzhat al-mushtaq fi ikhtiraq al-afaq* (*The Delight of Him Who Wishes to Traverse the Regions of the World*) (1154).

Eisteddfod, national meeting of bards, established in modern form in Wales (12th c.).

'*Bharata Yuddha*, 722-stanza Old Javanese *kakawin* (12th c.).

Oldest surviving texts in Middle English (12th c.).

d. Anna Comnena, Byzantine historian (1083–ca. 1153).

d. Li Ch'ing-chao, Chinese woman poet (1084–ca. 1151).

d. Geoffrey of Monmouth, English cleric and chronicler (ca. 1100–1154).

VISUAL ARTS

Sicilian geographer Idrisi's world map (1154).

b. Benedetto Antelami, Italian sculptor (ca. 1150–?); among his works was the marble panel, *Descent from the Cross*, at Parma Cathedral (after 1150).

Lambeth Bible and *Winchester Bible*, illuminated manuscripts, illustrated with miniatures (ca. mid-12th c.).

Islamic potters developed a fine, brittle ware modeled after Chinese porcelain, painted with animated figures, in *minai* style (second half of 12th c.).

Giralda tower built by Muslims in Seville, Spain (1159).

PERFORMING ARTS

The Play of Adam (*Jeu d'Adam*), French play on biblical themes (ca. 1150).

WORLD EVENTS

Henry of Anjou married Eleanor of Aquitaine, after her divorce from Louis VII of France (1152).

English civil war ended by treaty between Henry of Anjou and King Stephen (1153).

Henry of Anjou became Henry II, king of England (1154–1189).

Christian forces of Aragon took much of northern Spain (1150–1153).

Frederick I "Barbarossa" ("Red Beard") succeeded Conrad III as Holy Roman Emperor (1152–1190).

1160–1169

LITERATURE

d. Theodore Prodromus, Byzantine poet (?–ca. 1166).

d. Abraham Ben Meir Ibn Ezra, Hebrew poet and scholar (1093–1167).

VISUAL ARTS

Notre-Dame de Paris, notable Gothic cathedral on the Ile de la Cité, designed (1163); the famed rose windows were added later (1250–1320); finished 14th century.

WORLD EVENTS

Thomas à Becket became archbishop of Canterbury (1162).

Frederick Barbarossa took and sacked Milan (1162).

Frederick Barbarossa took Rome (1167).

Saladin became the first ruler of Egypt's Ayyubid dynasty (1169–1193).

1170–1179

LITERATURE

Chrétien de Troyes, French poet (active ca. 1170s), author of *Erec et Enide* (ca. 1170), *Cligès* (ca. 1176), and *Yvain* and *Lancelot* (both ca. 1177–79).

Eilhart von Oberg's *Tristant und Isolde* (ca. 1170).

Ilyâs ibn Yûsuf Nizâmî's poetic work *The Treasury of Secrets* (ca. 1175).

Aeneid, Heinrich von Veldeke's German court epic (ca. 1175–1186).

Marie de France, earliest known French woman poet (active late 12th c.).

VISUAL ARTS

Cathedral of Notre-Dame at Laon designed (1170); regarded as the first Gothic building to break totally with the Romanesque style.

Leaning Tower of Pisa, the bell tower or campanile next to Pisa Cathedral, begun (1173); a major tourist site because of its unintended tilt.

Canterbury Cathedral begun by William of Sens (1175) and completed by William the Englishman (1185); first fully Gothic building in England.

Nicolas of Verdun, goldsmith, metalworker, enameler, and sculptor (active late 12th–early 13th c.).

Korean potters developed distinctive Sanggam pottery, with inlaid celadon (late 12th c.).

Unkei, Japanese sculptor (active 1175–1218).

PERFORMING ARTS

Visitatio Sepulchri, an Eastern liturgical music–drama, adding to the traditional Christ and three Marys (played by women) Matthew, Mark, and John (second half of 12th c.); earliest version discovered in Ripoll, Spain.

WORLD EVENTS

Norman marcher lords invaded Ireland from Britain, led by Richard Fitzgilbert de Clare, called Strongbow (1170).

Thomas à Becket was murdered at Canterbury (1170); later canonized (1173).

Eleanor of Aquitaine led an insurrection against her husband, Henry II of England (1172).

Pierre Waldo founded the Waldensian sect (ca. 1173).

Saladin took Syria (1174).

Muslim conquest of India of India began (ca. 1175–1340).

Frederic Barbarossa was defeated by the Lombard League at Legnano (1176).

1180–1189

LITERATURE

Farîd al-Dîn 'Attâr, Persian physician and mystic poet (active ca. 1180–1120), whose major work was *Tadhkirat al-Awilyâ*, tales and sayings of Muslim mystic saints.

Ilyâs ibn Yûsuf Nizâmî's poetic romances *Khusraw and Shîrîn* (1180) and *Laylâ and Majnûn* (1188).

Oldest Olafs saga helga (*First Saga of St. Olaf*), among the oldest Icelandic sagas (1180).

Gesta Danorum (*The Deeds of the Danes* or *Historica Danica*), Saxo Grammaticus's work on Danish kings, historical and legendary, including the Hamlet legend; written in Latin (1185).

VISUAL ARTS

Wells Cathedral begun (ca. 1180); early example of English Gothic or Early English style.

Nicolas of Verdun's pulpit frontal, Klosterneuburg, Austria, completed (1181).

Angkor Thom, including the temple complex, the Bayon, built under Khmer King Jayavarman VII (ca. 1181–13th c.).

PERFORMING ARTS

Trouvère songs originated in northern France (late 12th c.), especially influencing England.

WORLD EVENTS

Saladin took Jerusalem (1187), by then having reconquered all but a few coastal cities still held by the Crusaders.

d. Henry II of England (1133–1189); succeeded by Richard I (the Lionhearted, or *Coeur de Lion*).

Third Crusade was led by Frederic Barbarossa of Germany, Philip Augustus of France, and Richard I of England (1189–1193).

Jews were expelled from France (1182).

1190–1199

LITERATURE

Nibelungenlied, High German epic poem (probably 1190 or 1200), basis for Richard Wagner's *Ring* operas.

Ilyâs ibn Yûsuf Niâmî's *The Book of Alexander* (*Iskandar-nâma*), on Alexander the Great, in two parts (1191; ca. 1200); also his *Haft Paykar* (*The Seven Portraits*) (1197).

d. Saigyo-hosi, Japanese poet (1118–1190), known for his poetry collections, notable *Senzaishu* and *Shinkokinshu*.

d. Herrad von Landsperg, Abbess of Hohenburg (?–1195), creator of the illuminated manuscript *Hortus deliciarum*, reportedly the first encyclopedia to be compiled by a woman.

d. Averooës (Ibn Rushd or Abu al-Walid Muhammad ibn Admad ibn ez), Arab philosopher and Marrakech court physician (1126–1198), most notable for his works on Aristotle.

VISUAL ARTS

Nicolas of Verdun's *Shrine of the Three Kings*, Cologne Cathedral (ca. 1190–1200).

Cathedral of Notre-Dame, Chartres, rebuilt after a fire (from 1194) in the High Gothic style lauded by Henry Adams.

Original building of the Louvre built by Philip Augustus (ca. 1190) as a fortress and storehouse for royal treasures.

Lincoln Cathedral begun (1192); an example of English Gothic or Early English style.

Kutb Mosque (Quwwat al-Islam), built in Delhi by Kutb al-din Aibak (1193); the earliest surviving Islamic building in India.

Cathedral of S. Étienne, Bourges begun (ca. 1195), its Gothic design made as early as 1170.

Benedetto Antelami's *Reliefs*, doors of Baptistry, Parma (begun in 1196).

Ma Yüan, Chinese painter (active ca. 1190–1224), most famous of the Ma family of painters.

PERFORMING ARTS

Vartapet Khatjatur, Taron, Armenia, wrote the Christian hymn *hor-hurd horin* (*O deep marvel*), sung while the priest is dressing for Mass (1191).

Early Arab shadow plays (ca. 1200 or earlier), folk dramas stressing comic and risqué elements.

Earliest known example of a medieval fiddle, smaller

than modern violins, found at Novogorod, Russia (ca. 1190).

WORLD EVENTS

Muhammed Ghori took the Ganges Valley (1191).

Third Crusade ended, with peace agreement between Saladin and the Crusaders (1192).

Returning from the Third Crusade, Richard I of England was taken and held by Leopold of Austria and then Henry VI (1192–1194).

King Richard of England defeated Philip Augustus of France at Fréteval (1194).

d. Richard I, king of England (1157–1199); succeeded by King John.

1200–1209

LITERATURE

Kanjur (*Translated word*) and *Tanjur* (*Translated treatises*), Tibetan Buddhist religious works (ca. 1200).

Aucassin et Nicolette (*Aucassin and Nicolette*), an anonymous French romance (*chante-fable*), alternating prose and verse (early 13th c.).

L'Escoufle, Jean Renart's narrative romantic poem (ca. 1200).

Parzifal, Wolfram von Eschenbach's poem about the Keeper of the Holy Grail (early 13th c.); basis for Richard Wagner's 1882 opera.

Shota Rustaveli, Georgian bard (active ca. 1200), whose main work was the romantic epic *Vepkhistqaosani* (*The Man in the Panther's Skin*).

Hadewijch, Dutch poet (late 12th and early 13th c.).

d. Nezami of Ganjeh, poet (ca. 1141–1203 or 1217), author of the *Khamseh* (*Quintuplet*).

Genghis (Chingiz) Khan made Uighur his central Asian empire's official script, developed from the Middle Persian (1206).

d. Ilyâs ibn Yûsuf Nizâmî, Persian poet (1140–1209).

VISUAL ARTS

Bamberg Cathedral built (ca. 1200–1237).

Building of Dublin Castle begun (1200–1208).

Monastic churches built in Serbia at Studenica, Milesevo, and Sopo'cani, in the style of the Raska School (13th c.)

Mosque at Tabriz, Persia, built (1204).

Nicolas of Verdun's St. Mary Shrine, Tournai Cathedral (1205).

Moorish potters brought to Spain, especially Andalusia, techniques of making golden luster pottery (by 13th c.), which became popular throughout Europe, and also faience glazes.

Sun temple, Orissan temple at Konarak, India, with hundreds of sculptures, including the Sun God's chariot (ca. 1200); now in ruins.

Etowah people of Georgia represented humans and birds on copper sheets (ca. 1200–1400).

Peoples of the Mississippi River basin made distinctive pottery with geometric and curvilinear designs (ca. 1200–1400).

PERFORMING ARTS

Auto Sacramental, Spanish term for a religious play (*auto*), which derived from the Latin liturgical drama, the earliest known text in the vernacular being the *Auto de los reyes magos* (ca. 1200).

Jalal ad-Din ar-Rumi founded the whirling Mawlawi (Dervish) order, in Anatolia (ca. 1200).

Jean Bodel's *Jeu de Saint Nicolas* (*The Play of St. Nicholas*), early French miracle play (ca. 1200).

Ordo ad visitandum sepulchrun, Latin-Czech Christian religious drama (ca. 1200).

Saragaku, popular variety companies, played in Japan, foreshadowing the advent of the 14th-century Noh theater (ca. 1200).

Sangitaratnakara, Sarngadeva's work in Indian musical theory (ca. 1200).

Vorau (Germany) passion play *Isaak and Rebecca* (ca. 1200).

A small portable organ, often called the *portative*, was in use in Europe (ca. 13th–15th c.).

In Europe organs began to be used in alternation with singing in religious settings, though not as accompaniment to singing (during 13th c.).

Small pear-shaped fiddles were being replaced by larger fiddles with a slight "waist" (ca. 13th c.).

Metal strings used in some lutes in Arab countries (at least to 13th c.).

World Events

Temujin made himself Chingis (Genghis) Khan, ruler of all the Mongols (1206), then began the series of conquests that would ultimately result in the *Pax Mongolica*, consolidating and extending his hold on Mongolia (1207).

Chingis Khan conquered the Khitans (1209).

Fourth Crusade began (1201–1204).

Crusaders took and sacked Constantinople, founding the Latin Empire (1204).

Slave Dynasty was founded in northern India (1206–1526).

Simon de Montfort began a long series of attacks (Crusades) against the Albigenses in southern France (1209–1229).

1210–1219

Literature

Tristan und Isolde, Gottfried von Strassburg's German version of the Celtic epic, which later influenced Wagner (ca. 1210).

Gudrun, German epic poem (ca. 1210).

The Council of Paris forbade teaching Aristotle's natural philosophy (1210), because of its supposed stress on materialism.

d. Kamo (no) Chomei, Japanese critic and essayist (1153/1155–1216), best known for his *Hojoki* (*An Account of My Hut*), an account of his life as a hermit (1212).

d. Saxo Grammaticus, Danish historian (ca. 1150–after 1216).

d. Judah ben Samuel (Yehuda the Hasid or the Hasid of Regensburg), German-Jewish mystic (?–1217), author of the mystical Hebrew work *Sefer Hasidim*.

Visual Arts

Aleppo citadel built in Syria by Ayyubid Sultan Malik Zahir Gazi (ca. 1210).

Cathedral of Notre-Dame, Reims (1210–ca. 1300), and Cathedral of Notre-Dame, Amiens (1220–ca. 1269), built by architect Robet de Luizarches; both noted examples of the French Gothic style.

d. Liang K'ai, Chinese painter (ca. 1140–1210), noted for his "abbreviated brush" wet-ink technique (*chien-pi*).

Performing Arts

d. Jean Bodel, French playwright, poet, and composer (*trouvère*) (ca. 1167–1210), author of the first French miracle play; also noted for his *pastourelles*, *fabliaux*, and *chansons de geste*.

World Events

King John of England signed *Magna Carta* at Runnymede (1215).

Mongol forces attacked China, but broke off the attack to turn west (1211).

Mongols conquered the Tarim basin, eastern Turkestan, western Turkestan, Afghanistan, and part of Persia (1217–1221).

Frederick II became the king of Germany and Sicily (1212–1250).

Spanish and Portuguese forces decisively defeated Muslim forces at Las Navas de Tolosa (1212).

Fifth Crusade began (1217–1221).

1220–1229

Literature

Icelandic writer Snorri Sturluson wrote the *Younger* or *Prose Edda* (*Snorra Edda*), a collection of early Scandinavian mythology (before 1223) and *Heimskringla* (*Orb of the World*), on the lives of the early Norwegian kings (1223–1235).

Cantico di frate sole (*Canticle of the Sun*), St. Francis of Assisi's poem in Italian (1125).

Tristram's saga, Icelandic saga written for King Haakon IV of Norway (1226).

King Horn, an early English verse romance (ca. 1225).

Farid od-Din 'Attar, Persian mystical writer (active ca. 1180–ca. 1220), author of the poetic allegory *Mantiq al-Tayr* (*Conference of the Birds*).

Visual Arts

Mosque of Alaeddin Kaykubad, built in Konya, Anatolia (Turkey) (ca. 1220).

Salisbury Cathedral built in England (1220–ca. 1270).

Basilica of St. Francis at Assisi built in Italy (1228–1253), showing French influence.

WORLD EVENTS

Mongols, led by Chingis Khan, raided northern India (1222).
Mongols raided into Russia (1223).
d. Chingis Khan (ca. 1155–1227); Mongols conquered Hsi-Hsia (1227).
Ogöta became Great Khan of the Mongols, making Karakorum the Mongol capital (1229–1241).
Sixth Crusade (1227–1229). Crusaders won Jerusalem by terms of a peace agreement (1229).
Padua University was founded (1222).

1230–1239

LITERATURE

Roman de la Rose (*Romance of the Rose*), Guillaume de Lorris's medieval French poem, modeled on Ovid's *The Art of Love* (ca. 1230).
James I of Aragon ordered the burning of all copies of the Bible in "romance," the common Spanish language (1233).

VISUAL ARTS

Villard d'Honnecourt's sketchbook on the elements of drawing (ca. 1235).

PERFORMING ARTS

Carmina Burana, collection of pious and impious verses (early 13th c.), made famous by Carl Orff's 1937 cantata based on them.
Rubebe, a small pear-shaped fiddle, mentioned first in the *Romance of the Rose* (ca. 1230).
d. Walther von der Vogelweide, German poet and Minnesinger (1170?–1230?).

WORLD EVENTS

Mongols completed their conquest of the Chin empire (1232–1234).
Mongols overran Russia; then retired to Don basin (1237–1238).

Mongols took Moscow (1238).
Teutonic Order moved to Prussia (1230).

1240–1249

LITERATURE

d. Muhammad ibn 'ali Ibn al-'Arabi, Arab mystical writer (1165–1240), author of the treatises *Fusus al-Hikam* and *Meccan Revelations* and numerous mystical odes.
d. Snorri Sturluson, Scandinavian-Icelandic historian and writer (1178?–1241).

VISUAL ARTS

Matthew Paris's illuminated historical manuscripts *Chronica Majora* and *Liber additamentorum* (both ca. 1240).

PERFORMING ARTS

d. Neidhart von Reuental, German poet and knight (ca. 1180–ca. 1240), noted for his courtly verses on rural life to folk-song-like melodies; called Neidhart Fuchs ("the Fox").

WORLD EVENTS

Mongols took Kiev (1240).
Mongols raided deep into Europe, their victories in Silesia (Leignitz) and Mohi (Hungary) opening Europe to the Atlantic; but then turned back (1241), after the death of Ogöta Khan (1185–1241).
Franciscan monk John de Piano Carpini reached the Mongol camp capital at Karakorum (1245).
Alexander Nevsky's forces defeated the Teutonic Order on Lake Peipus (1242).
Seventh Crusade began (1248–1250).

1250–1259

LITERATURE

Koreans developed movable type and adopted an alphabetical script, replacing the Chinese one previously used (during 13th c.).

Secret History of the Mongols, an epic chronicle of (Chingis) Khan and his successors (mid-13th c.).

Poetria, Jean de Garlande's discussion of poetic technique and choice of style (mid-13th c.).

Libro de Alexandre, Spanish epic poem on Alexander the Great (1st half of 13th c.).

Sa'di's poetic works *Bûstân* (*The Orchard*) (1257) and *Gulestân* (*Rose Garden*) (1258).

St. Thomas Aquinas's theological treatise *Summa [de Veritate Catholicae Fidei] contra Gentiles* (1259–1264).

First known royal Norman proclamation in English, as well as Latin and French (1258).

VISUAL ARTS

Amida Buddha, statue over 42 feet high, at Kotoku-in, Kamakura, Japan (mid-13th c.), paid for by contributions collected by monk Joko.

Cathedral of Utrecht begun (1254).

Mu Ch'i, Chinese painter (active mid-13th c.), noted for his use of the "ink splashing" (*p'o-mo*) and "splayed brush" styles, whose work much influenced Japanese painting.

Nicola Pisano, Italian sculptor (active 1258–1278).

d. Matthew Paris, English artist and historiographer (ca. 1200–1259).

PERFORMING ARTS

Earliest known mention of a *guitarra*, but not in its modern form, in a Spanish document (13th c.)

Meister Alexander, poet–composer of (mainly) *Sprüche* and Minnesang; from south Germany (active ca. 1250–1290).

Sumer is icumen in (*Summer Canon*), the only documented version of a medieval rota, or round, probably written in Reading, England (ca. 1250).

The Easter Play of Muri, early Swiss religious play, in German (ca. 1250).

The Sorrows of Han (*Han Kung ch'iu*), Ma Chih-yuan's Chinese play; an early classic, possibly predating the golden age that began late in the 13th century (ca. 1250).

Citole and gittern, two similar plucked stringed instruments, in widespread use in Europe (ca. 1250–1350).

Wang Shih-fu (Wang Te-hsin), Chinese playwright (ca. 1250–1337?).

WORLD EVENTS

Möngke became the Great Khan of the Mongols (1251–1259).

Mongols took eastern Tibet and Nan-Chao (1252).

Mongols took much of southwestern China (1257).

Mongols sacked Baghdad; took Korea (1258).

Crusader army was defeated at al-Mansura, and Louis IX was captured; later ransomed (1250).

1260–1269

LITERATURE

d. Jalâl al-Dîn (also called Rûmî or Mawlânâ [Our Master]), Persian mystic poet (1207–1273), founder of the "Dancing Dervishes"; his major works included the poetry collections *Dîvâni-i Shams-i Tabrîz*, in honor of mystic Shams al-Dîn of Tabriz, and *Mathnawî-i Ma'nawî*, on the basic ideas of mysticism.

VISUAL ARTS

St. Urbain at Troyes, France, built (1262).

Giovanni Pisano, Italian sculptor (active 1265–1314).

PERFORMING ARTS

The Miracle of Theophile, Rutebeuf's French miracle play (1261).

Yü hai (*Sea of Jade*), Chinese encyclopedia (ca. 1267).

WORLD EVENTS

Kublai Khan became Great Khan of Mongols; Mongols ruled China (1260–1368); beginning of *Pax Mongolica*, century-long rule of Mongols over much of Asia (1260).

Nicolò and Maffeo Polo traded in central Asia, visited Kublai Khan at Khanbaligh (1260).

Civil war in England; Prince Edward defeated Simon de Montfort (1263–1265).

1270–1279

LITERATURE

Icelandic Codex Regius manuscript, including the 9th–12th c. *Poetic Edda* (ca. 1270).

Völsunga saga, tales from Icelandic and Scandinavian history and legend (1270).

Kublai Khan adopted the Tibetan-based Passepa as his official court script (1272).

Ibn Khallikan's *Biographical Dictionary* (1274).

Gunnlaugs Saga, an anonymous Norse prose narrative, in which the hero visits the court of Ethelred the Unready (late 13th c.).

Roman de la Rose (*Romance of the Rose*) extended by Jean de Meun.

d. Jalâl al-Dîn (Rûmî or Mawlânâ [Our Master]), Persian mystic, poet, and founder of the "Dancing Dervishes" (1207–1273).

d. St. Thomas Aquinas, Italian scholastic theologian and philosopher (ca. 1225–1274).

VISUAL ARTS

St. Nazaire at Carcassonne, France, built (ca. 1270).

Cimabue's *Crucifix*, S. Domenico, Arezzo (before 1272).

Giovanni Pisano's sculptures: external decoration of the Baptistery, Pisa (1278–1285), and *Fontana Maggiore*, Perugia, Italy, sculpture (with Nicola Pisano) (1278).

Byzantine-style church of Metekhi, at Tbilisi, Georgia, built (ca. 1278).

Pietro Cavallini, Italian painter (active 1273–1308), realist painter known for his murals, most now destroyed.

PERFORMING ARTS

d. Der Tannhäuser, German Minnesinger (ca. 1205–ca. 1270), whose songs speak of travel, as in the fifth Crusade (1228–1233).

First mention of the lute in Europe, in France, at first played with device employing quills, in the Arab style (ca. 1270).

Jerome of Moravia, a Dominican monk in Paris, wrote a treatise on the techniques of tuning and playing the fiddle (after 1272).

Kuan Han-ch'ing, Chinese playwright of the Yuan theater golden age (active ca. 1275–1300), who wrote more than 60 plays, of which 18 have survived.

Cantigas de Santa Maria (late 13th c.), compiled under direction of Alfonso el Sabio (the wise), described and depicted 38 different instruments, often played individually, as had been the medieval style, rather than in concert.

Earliest known mention of the pipe and tabor, in which a person plays a pipe with one hand and with the other beats a drum hanging from the opposite arm; still used in European folk dancing, including revivals such as the Morris dance (late 13th c.).

Adam de la Halle's *Le Jeu de la feuillée* (*The Play of the Leafy Bower [Canopy]*) (ca. 1276), a French play, considered the first French comedy.

WORLD EVENTS

Marco Polo reached China, with Nicolò and Maffeo Polo (1276–1292).

Mongols completed their conquest of south China (1276–1279).

Mamluks attacked remaining Assassin strongholds (1274).

d. Louis IX, later St. Louis (1214–1270), king of France, while attacking Tunis during the Eighth Crusade.

d. Henry III (1207–1272), king of England; succeeded by Edward I.

Mongols raided Japan, withdrew after encountering heavy resistance (1274).

1280–1289

LITERATURE

d. Ibn Khallikan (Ahmad ibn Muhammad ibn Khallikan), Arab biographer (1211–1282).

d. Alfonso X (Alfonso the Learned), King of Castile and Léon (1221–1284); author of the *Crónica General*, a history of Spain to 711, and the poetry collection *Songs to the Virgin* (1221–1284).

d. Fakr-ud-Din 'Iraqi, Persian poet noted for his love poetry (?–1289).

VISUAL ARTS

Alfonso Psalter, an illuminated manuscript, exempli-

fying the move from stylized decoration to more naturalistic leaf work (ca. 1284).

Giovanni Pisano's sculptural decoration of the facade, Siena Cathedral (1284).

Frescoes, Upper Church of S. Francesco, Assisi, attributed to Cimabue (1288–1290).

PERFORMING ARTS

Many Chinese scholars turned to writing plays, resulting in a "golden age" of drama, after the Yüan dynasty (1280–1368) of the Mongols abolished the civil service.

New seven-note central Asian scale introduced to China under Kublai Khan (1280).

Adam de la Halle's musical play *Le Jeu de Robin et Marion* (ca. 1283), sometimes considered the earliest comic opera.

d. Alfonso el Sabio, Spanish monarch, patron, and poet (1221–1284).

d. Adam de la Halle, French playwright, poet, and composer (*trouvère*) (ca. 1245–ca. 1285); called Adam le Bossu (the Hunchback).

WORLD EVENTS

Mongol invasion of Japan failed; most of invasion fleet destroyed by a typhoon in the sea of Japan (1281).

French under Charles of Anjou expelled from Sicily (the Sicilian Vespers); Peter of Aragon became king of Sicily (1282).

Wales conquered by Edward I of England (1282).

Teutonic Knights conquered Prussia (1283).

War between Mongols and Champa (1283).

1290–1299

LITERATURE

La vita nuova (*The New Life*), Dante Alighieri's poems and prose, about his love for Beatrice, as a precursor to divine love (ca. 1293).

d. Sa'di (Musharrif al-Dîn b. Muslih [Mosleh] od-Din Sa'di), Persian poet (ca. 1215–1292?).

VISUAL ARTS

Altarpiece *Madonna of Sta. Trinita* (*Madonna*

Enthroned with St. Francis) and *Large Crucifix* for Sta. Croce, Florence, attributed to Cimabue (all 1290–1295).

Wells Cathedral built in England (ca. 1290–ca. 1340).

Orvieto Cathedral begun (1290); its facade is from the 14th century.

Pietro Cavallini's mosaic *Life of the Virgin*, at Sta. Maria in Trastavere (1291), showing use of vertical axis perspective.

Crucifix, Giotto's fresco cycle (ca. 1295–1300).

Florence Cathedral begun, with Arnolfo di Cambio as master mason (1296).

Giovanni Pisano's pulpit, S. Andrea, Pistoia, Italy (1298–1301).

Fresco cycle *Life of St. Francis*, Upper Church of S. Francesco at Assisi (1297–ca. 1305), traditionally attributed to Giotto.

Bristol Cathedral begun in England (1298).

d. Ch'ien Hsüan, Chinese painter, calligrapher, and poet (1235–ca. 1290).

PERFORMING ARTS

d. Safi ad-Din, Muslim music theorist (?–1294).

WORLD EVENTS

Muslim forces retook Acre, ending the Crusader state of Jerusalem (1291).

Failed Mongol invasion of Java (1293).

Marco Polo completed his travels, returning to Europe (1295).

Jews were expelled from England (1290).

1300–1309

LITERATURE

Dante Alighieri's *De vulgari eloquentia* (*Of Common Eloquence*), written in Latin but urging the use of the vernacular Italian for literary works (1304–1306); he is regarded as the creator of "Standard Italian."

The White Book of Rhydderch, collection of Welsh stories that includes the *Mabinogion* (ca. 1300–1325).

Parts of the Bible, *Genesis* and *Kings*, translated into the Old Norwegian language, under the title *Stjórn* ("guidance" [of god]) (ca. 1200).

First work of Irish literature in English, the *Kildare Poems* (ca. 14th c.).

The Great Deeds of King Gesar, Destroyer of Enemies (*Rgal-po Ge-sar dgra'dul gyi rtogs-pa brjod-pa*), Tibetan epic (ca. 1300).

Heike-monogatari, Japanese historical romance (1300).

Amir Khosrow, Persian-Indian poet (active ca. 1300).

Kaviraja Madhava Kandali, Assamese poet (active ca. 1300) who translated the *Ramayana* from Sanskrit into Assamese.

Lalla, Kashmiri woman poet (active ca. 1300).

Robert Mannying's verse *Handlying Synne* (ca. 1303).

d. Rudiger Manesse (?–1304), compiler of the *Codex Manesse*, a collection of early German *Minnesang* works.

El caballero Cifar (*The Knight Cifar*), the first Spanish novel, an anonymous romance of chivalry (1305).

VISUAL ARTS

Giotto's fresco cycle *The Lives of the Virgin and Christ* (1305–1308) at the Arena Chapel in Padua; the accompanying depictions of the Virtues and Vices are the first known examples of *grisaille* (gray monotone) painting; also his panel painting *The Madonna in Glory* (ca. 1305–1310).

Alhambra, palace-citadel of the Sultans in Granada (1309–1354), outstanding example of Moorish architecture; named for its surrounding red-clay fortifications (Arabic *al-hamra* meaning "red house").

Venice's Doge's Palace, with its facade on the water; much painted by later artists (ca. 1309).

St. John the Evangelist, Cimabue's mosaic in the Duomo of Pisa (1301–1302).

Giovanni Pisano's pulpit in the Cathedral, Pisa (1302–1311), and his statue *Madonna and Child with Two Acolytes* (ca. 1305).

b. Andrea di Cione, Florentine artist (active ca. 1308–ca. 1368).

Altneuschule, one of the oldest surviving synagogues, built in Gothic style, in Prague (14th c.)

Gothic designs for pottery were developed by Hispano-Moorish potters at Paterna near Valencia, Spain (during 14th c.).

Books of Hours, prayer books for private devotions, usually for aristocrats, became popular (ca. 14th–15th c.).

d. Arnolfo di Cambio, Italian sculptor and mason (?–1302?).

d. Cimabue (Cenni di Peppi), Italian painter (ca. 1240–ca. 1305), mentioned in Dante's *Divine Comedy*.

PERFORMING ARTS

The Circle of Chalk (*Hui lan chi*), Chinese drama attributed to Li Ch'ien-fu (ca. 1300); basis for Bertolt Brecht's *Caucasian Chalk Circle* (1945).

The Little Orphan of the Family of Tchao (*Chao Li jang fei*), Chi Chun-hsiang's Chinese play, often translated in the West from the 18th century on (ca. 1300).

Ars Nova (*New Art*), Philippe de Vitry's widely used book of musical theory (ca. 1300).

Eccerinis, Alberto Mussato's verse tragedy, in Latin (ca. 1300).

An Heir in His Old Age (*Lao Sheng Erh*), Wu Han Ch'en's Chinese play (ca. 1300).

Abele spelen (*Seemly plays*), early Dutch secular plays (ca. 1300).

Vienna Passion, early passion play (ca. 1300).

Lucidarium, Marchetto da Padova's treatise (1309–1318).

Age of the Meistergesang in Germany (flourished ca. 14th–17th c., esp. 16th c.), a tradition of songwriting and performance by members of city-controlled guilds, some of which would survive into the 20th century.

Shawn or *hautboy*, a wind instrument ancestral to the oboe, was popular in Europe especially for ceremonial occasions outdoors or in large buildings (ca. 14th–17th c.); developed in different sizes, it probably derived from the Middle Eastern *surna* late in the Crusades.

Small snare drum played with two sticks in use in Europe, later joined by fife in military music, first by German and Swiss soldiers (ca. 14th c.).

Oldest record of codes for hunting horns, in France (14th c.).

WORLD EVENTS

Robert Bruce became king of Scotland; warred with England (1306).

Wenceslaus of Bohemia became king of an almost fully united Poland (1300–1305).

Pope Boniface VIII issued papal bull *Unam Sanctum*, claiming maximum papal powers (1302).

Knights Templar expelled from Syria, ending Crusader occupation (1302).

French defeated by the Flemings at Courtrai (1303).

Jews expelled from France (1306).

Knights Templar were attacked in France and effectively destroyed (1307); later made official by Pope Clement V (1312).

1310–1319

LITERATURE

The Divine Comedy (*La Divinia Commedia*), Dante Alighieri's great allegorical epic poem (1314), with the narrator touring Hell and Purgatory guided by the spirits of Virgil and his ideal love, Beatrice; also Dante's *De monarchia* (*On Monarchy*) (ca. 1313) and *Eclogues* (ca. 1319). His writing in Tuscan, not Latin, sped acceptance of vernacular Italian.

Wang Chen published a history of Chinese technology, composed using movable wooden blocks as a form of type (ca. 1310).

Mongol Empire made its official script Kalika, an adaptation of Uighur and forerunner of modern Mongolian (1310).

Eufemiavisorna (*The Songs of Euphemia*), Swedish medieval poetry collection (1312).

Pomerium, treatise by Marchetto da Padova (1318–1326).

VISUAL ARTS

Giotto's fresco cycle in two chapels in Sta. Croce, Florence (ca. 1310–1330), all now in ruined state.

Giovanni Pisano's tomb of Margaret of Luxembourg (1311) and his statue *Madonna della Cintola* (ca. 1312).

Simone Martini's mural *The Virgin in Majesty* (1315).

Chinese painting came to be closely allied with writing (from ca. 14th c.), especially poetry, being called "poetry without words."

Great enclosure at Zimbabwe (14th–16th-c.), now in ruins.

PERFORMING ARTS

d. Frauenlob (Heinrich von Meissen), influential German Minnesiger (ca. 1250–1318), known for his courtly and lyric songs (*Spruch*).

WORLD EVENTS

Scots forces led by Robert Bruce defeated English forces led by Edward II at Bannockburn (1314).

Knights of St. John took Rhodes (1310).

Council of Vienna; papal bull *Vox in excelso*: Order of Knights Templar suppressed (1312).

Kublai Khan restored the Chinese civil service examination system (1315).

Philip V became king of France (1316).

1320–1329

LITERATURE

Divan of Hafiz, collected odes of the Persian Muslim poet Hafiz, on topics such as love, nature, and the impermanence of human existence (1326).

d. Dante Alighieri, Italian poet (1265–1321), whose supreme work was *The Divine Comedy* (*La Divinia Commedia*).

VISUAL ARTS

Start of illustration of the Persian painting Demotte *Shah-nameh* (1320–1360); its surviving miniatures were scattered worldwide.

Lady Chapel and Octagon built at Ely, in England (1321–1353).

Church of Gracanica built in Serbia (ca. 1320).

Monastic church built at Decani, Serbia (1327), where probably the largest expanse of medieval fresco painting survives.

d. Meng-Fu Chao, Chinese painter (1254–1322).

PERFORMING ARTS

The Chester Plays, a cycle of 25 anonymous Corpus Christi plays on Christian religious themes (ca. 1325), traditionally staged over three successive days from "pageant wagons" in Chester, England.

d. Kuan Han-ch'ing, Chinese classical playwright (1241?–1320?). Of his 60 or more plays, only 14 survive, including *Tou-o-yüan* (*Injustice Suffered by Tou-o*).

Johannes de Muris's works on musical theory *Ars nove musice* (ca. 1321), *Musica pratica* (ca. 1322), and *Musica speculativa* (ca. 1323).

Play of the Wise and Foolish Virgins, passion play from

Eisenach, Germany (1322).

d. Yunus Emre, Turkish mystical singer and Sufi philosopher (?–ca. 1321), whose best-known works were influential verse in traditional Anatolian forms.

d. Marchetto da Padova, Italian theorist and composer (1274–after 1326).

WORLD EVENTS

Edward II of England deposed; succeeded by Edward III (1327).

Janissaries, Turkish military guard, founded (1326).

Ivan I became grand duke of Russia (1329).

1330–1339

LITERATURE

Petrarch's *Prayers* (1335–1338); also his poetic works *Africa* (1338) and *De viris illustribus* (1338–1339).

Yoshida Kenko's *Tsurezure-gusa* (*Essays in Idleness*) (1330 or later).

Giovanni Boccaccio's poem *Diana's Hunt* (1334).

Robert Mannying's *The Story of England* (ca. 1338).

Papermaking factory established in Troyes, France (1338).

VISUAL ARTS

Taddeo Gaddi's best-known works, all for S. Croce, Florence: panel paintings *Life of Christ* (ca. 1330), frescoes *Last Supper* (undated) in the refectory, and *Life of the Virgin* (1338) at the Baroncelli chapel.

Simone Martini's painting *Annunciation* (1333).

d. Giotto (Giotto di Bondone), Italian painter (1267–1337).

PERFORMING ARTS

First performances of the St. Gall passion play (ca. 1330).

d. Wang Shih-fu (Wang Te-hsin), Chinese playwright (ca. 1250–1337?), regarded as the greatest playwright under the Yüan dynasty. Of his 14 or more plays, only 3 survive, including the widely known *Romance of the Western Chamber* (*Hsi hsiang chi*).

WORLD EVENTS

Edward III defeated Scottish forces at Halidon Hill (1333).

Edward III of England reinstated the long-standing English claim to the French throne, beginning the Hundred Years' War (1337–1457).

Poland and the Teutonic Knights were at war (1330–1332).

Casimir III (the Great) became king of Poland (1333–1370).

Restrictions on Jews were lifted in Poland; migration of Jews from other European countries increased (1334).

Ottoman Turks took Nicaea (1331).

Grenoble University was founded (1339).

1340–1349

LITERATURE

Petrarch's poetic works *Secretum meum* (1342–1343), *Epistolae sine nomine* (written 1342–1358), *De vita solitaria* (1346), and *De otio religioso* (1347); and prose works *Rerum memorandarum libri* (1343–1345), *Bucolicum carmen* (1346–1348; 1364), and *Salmi penitenziali* (1347).

Giovanni Boccaccio's prose romance *Ameto* (1341); also his poetic works *Amoroso visione* (1342–1343) and *Ninfale Fiesolano* (1346).

English replaced Latin as the language of instruction in English schools (ca. 1348), except Oxford and Cambridge.

d. Manuel Philes, Byzantine poet (ca. 1275–ca. 1345).

d. Robert Mannyng, English poet and chronicler (ca. 1264–ca. 1340).

VISUAL ARTS

d. Simone Martini, Sienese painter (ca. 1285–1344); his most notable late work was the painting *Christ Reproved by His Parents* (1342).

Prague Cathedral begun by Matthias of Arras (1344); after his death (1353), work continued under Peter Parler.

Romance of Alexander, an illuminated manuscript, illustrated with numerous marginal pictures, not always linked with the text (1344).

Ponte Vecchio, two-story arched bridge across Flo-

rence's Arno River, completed by Taddeo Gaddi, connecting the Uffizi, Pitti, and other palaces (1345).

PERFORMING ARTS

Surviving manuscript of *The Romance of Alexander* (1344) shows a wide variety of medieval instruments, including bagpipe, tabor (drum), nakers (small kettledrums), cymbals, handbells, fiddle, portable organ, psaltery (a stringed instrument), and citole (a stringed instrument).

WORLD EVENTS

Beginning of the Black Plague in Europe, probably spread by infected rats carried in Italian ships (1346–1347).

Hundred Years' War: British army led by Edward III decisively defeated a French army three times its size at Crécy, British infantry armed with longbows destroying the French cavalry (1346).

British forces destroyed a French fleet at Sluys (1340).

Holy League between the pope, Cyprus, the Knights of Rhodes, and Venice (1343).

Stephen III Dushan became emperor of Serbia (1346).

Calais fell to the British after a siege (1346–1347).

Black Plague began to take a massive death toll in Egypt and neighboring countries (1348).

Prague University founded (1348).

1350–1359

LITERATURE

The Decameron, Giovanni Boccaccio's influential collection of 100 stories, told over 10 days ("deca"–"hemera") by people who had fled to the hills above Florence to escape the Black Death (1351–1353).

The Bruce, John Barbour's epic Scottish poem focusing on Robert Bruce and the struggle for Scottish independence (1350).

Petrarch's poetic works *Epistolae metricae* (1350) and *De remediis utriusque fortunae* (1354); and prose works *Invectivarum contra medicum quendam libri iv* (1352–1355), *Invectiva contra quendam magni status hominem sed nullius scientiae aut virtutis* (1355), and

Itinerarium Syriacum (*Itinerarium breve de Janua usque ad Jerusalem et Terram Sanctam*) (ca. 1358).

Augsburg Bible, a German translation, was circulating (by 1350).

Jan van Ruysbroeck's *Die chierheit der gheestliker brulocht* (*The Adornment of the Spiritual Marriage*) (1350).

Shih Naj-an, Chinese novelist (probably active 14th c.).

Prapancha, Javanese author (active 14th c.).

d. Yoshida Kenko, Japanese writer (1283–1350).

d. Janabai, Indian woman poet (ca. 1298–ca. 1350).

VISUAL ARTS

Sanctuary of Besakih, temple structure, built on Gnung Agung Mountain, in Bali (14th c.).

d. Huang Kung-Wang, Chinese painter (1269–1354), one of the "Four Great Landscape Masters" of the Yüan dynasty, who with Ni Tsan introduced the innovative dry-ink and slanting-brush technique.

d. Wu Chên, Chinese painter (1280–1354), one of the "Four Great Landscape Masters" of the Yüan dynasty, famed for his paintings of bamboo, such as *Bamboos in the Wind*.

Andrea di Cione's frescoes *Hell*, *Last Judgment*, and *Triumph of Death* (all ca. 1350); also his altarpiece *The Redeemer* (1354–1357).

Illuminated manuscripts *Liber Viaticus of Johann von Neumarkt* and *Queen Mary's Psalter* (both ca. 1350).

Madrassa of Sultan Hasan built in Cairo under the Ayyubids (1356).

d. Jehan Pucelle, French painter (ca. 1300–ca. 1355).

PERFORMING ARTS

Stringed instrument called a *gusli* depicted in Russia, common in rural homes (ca. 1350).

WORLD EVENTS

English defeated by Scots at Nesbit (1355).

English forces led by the Black Prince (Edward) defeated French forces led by John II at Poitiers (1356).

Peasant uprising in France (the Jacquerie) (1358).

Muslim traveler Ibn Battuta returned to Tangier,

after a quarter century of travel to India, Ceylon, and the Far East (1350).

Ottoman Turks took Gallipoli (1354).

Ottoman Turks took Adrianople (1357).

Charles IV issued the Golden Bull, defining the powers of rulers of the Holy Roman Empire (1356).

1360–1369

LITERATURE

Geoffrey Chaucer's long poem *The Book of the Duchess*, based on French sources such as *Romance of the Rose*, probably written at the death of Blanche, wife of John of Gaunt, Chaucer's patron (1369).

Piers Plowman (*The Vision of William Concerning Piers Plowman*) (ca. 1362–1387), a long satirical poem in Middle English, attributed to William Langland or Langley (ca. 1332–ca. 1400).

Giovanni Boccaccio's poem *Corbaccio* (1366).

Petrarch's poetry *Senilium rerum libri* (1361–1374).

English language first used officially in Parliament (ca. 1362), replacing French, though legal records still kept in Latin.

Statutes of Kilkenny ineffectually attempted to legislate continued use of English names and language among Anglo-Norman settlers in Ireland (1366).

VISUAL ARTS

Finest Chinese potters and their kilns were centered in the city of Ching-te Chen in Southeast China, at the command of the first Ming ruler (after 1368); in this period, elaborately painted porcelain became common.

Papal palace at Avignon, France, was decorated with painted tiles made by Hispano-Moorish potters (1362).

Jean de Bondol (Jean de Bruges), Flemish painter and miniaturist (active ca. 1368–1381).

d. Taddeo Gaddi, Florentine painter (ca. 1300–ca. 1366).

PERFORMING ARTS

Trumpets began to be made with U-bends, rather than being completely straight; some early styles had the bell bend one way and the mouthpiece bent another, in an S-shape (before 1400).

WORLD EVENTS

Tamerlane conquered Transoxiana (1364–1370).

Tamerlane took Samarkand (1369).

Ming dynasty began in China, its capital at Peking (1368–1644).

Philip the Bold became duke of Burgundy (1363).

Charles V became king of France (1364–1380).

Cracow University was founded (1364).

Macedonia won its independence from Serbia (1366).

Peasant rebellions in France (1366–1369).

1370–1379

LITERATURE

Sir Gawain and the Green Knight, a major Middle English poem on the Arthurian legend, written anonymously by the "Pearl Poet," whose other works included *The Pearl*, *Purity* (or *Cleanliness*), and *Patience* (ca. 1370).

The Travels of Sir John Mandeville, describing fictional African and Asian travels, possibly translated from French or Latin works into English (ca. 1371).

Shui-hu Chuan (*Story of the Water Margin*, translated by Pearl Buck as *All Men Are Brothers*), Chinese picaresque novel by Shih Naj-an, with Lo Kuanchung as coauthor or reviser (late 14th c.).

Geoffrey Chaucer's long poem *The House of Fame* (ca. 1379–1380).

Giovanni Boccaccio gave notable lectures on postclassical writings, especially by Dante (1373–1374).

Wood-block printing appeared in Europe (by ca. 1375).

d. Petrarch (Francesco Petrarca), Italian scholar, poet, and Humanist (1304–1374), whose last works included *Invectiva contra eum qui maledixit Italiae*.

d. Ibn Battuta (Muhammad ibn Abdullah ibn Battuta), Arab traveler and geographer (1304–ca. 1377), known for his accounts of journeys from Africa to China, Crimea to the Maldive Islands.

VISUAL ARTS

d. Ni Tsan, Chinese artist (1301–1374), one of the

"Four Great Landscape Masters" of the Yüan dynasty, best known for his bamboo paintings; with Huang Kung-Wang, he introduced the innovative dry-ink and slanting-brush technique.

Angers Apocalypse (ca. 1375), a huge tapestry (originally 470 feet long) made for the Duke of Anjou from cartoons designed by Jean de Bondol; only two-thirds survives.

Theophanes the Greek's frescoes at the Church of the Transfiguration, Novgorod, his best-known work (1378).

PERFORMING ARTS

First known chromatic keyboards with raised keys for sharps, used on organs (end of 14th c.).

Metal strings began to be used in European lutes, especially in Germany where metalworking techniques had developed (late 14th c.); adopted from earlier Arab use.

The Wakefield Plays (*Towneley Manuscript*), Corpus Christi cycle of 32 English religious plays (ca. 1375–1400).

First record of a double harp, in Spain (1378).

d. Guillaume de Machaut, French composer and poet (ca. 1300–ca. 1377), known for his influential use of the Ars Nova musical style, especially in settings for his own poems.

WORLD EVENTS

French fleet defeated a British fleet off New Rochelle (1372).

Tamerlane attacked Khwarizm (Khiva) (ca. 1370–1380).

Ottoman Turk Sultan Murad I defeated the Serbs at the Marica, taking Macedonia and southern Serbia (1371).

Dimitri Donskoy defeated Tartar forces on the Don (1378).

Robert II became king of Scotland (1371–1390).

Great Schism of the Western Christian church began (1378).

1380–1389

LITERATURE

The Canterbury Tales (ca. 1387–1400), Geoffrey

Chaucer's longest and best-known work, a highlight of English literature, with members of an April pilgrimage to Canterbury each telling a tale; 24 of the originally planned tales were written. Also from this period are his poems *The Parliament of Fowls* (ca. 1382), *Troilus and Criseyde* (1385), and the unfinished *The Legend of Good Women* (1386).

d. John Wycliffe, Bible translator (ca. 1320–1384), best known for producing (with others) the first English translation of the Bible (ca. 1382), which became widely popular, most often as read aloud to congregations.

John Gower's poem *Confessio Amantis* (ca. 1386–1390).

Wenzel Bible, a German-language version of the Old Testament (ca. 1389–1400).

d. Hafiz (Shams-ud-Din Muhammad), Persian Muslim (Sufi) lyric poet (ca. 1300–ca. 1388/1390).

VISUAL ARTS

d. Wang Mêng, Chinese artist (1308–1385), last of the "Four Great Landscape Masters" of the Yüan dynasty.

Milan Cathedral begun by contentious artisans from Lombardy, Germany, and France (1386).

Mosque of Sultan Barquq, Cairo, built (1384).

PERFORMING ARTS

d. Kan-ami Kiyotsugo (1333–ca. 1384), Japanese *Noh* playwright and manager, father of Zeami Motokiyo, both key figures in the development of the *Noh* theater.

Carillons used to sound the hour, often with tunes struck by puppets, in Brussels and Louvain (by 1381).

Earliest known surviving Renaissance recorder (ca. 1388), from Holland.

Monk of Salzburg, German composer and poet (active late 14th c.), of both religious and secular songs.

WORLD EVENTS

Tamerlane conquered Persia (1381–1387).

Ottoman Turk forces decisively defeated the Serbs at Kossovo (Field of the Blackbirds), with Serbian nobility destroyed (1389).

Tamerlane raided into Afghanistan and Kurdistan (1385–1395).

Leopold III of Austria was defeated and killed by the Swiss at Sempach (1386).

Wat Tyler led a peasant revolt in England (1381).

English defeated Scotish forces at Otterburn (1388).

Danes defeated Albert of Sweden at Falköping; Sweden was then joined with Denmark (1389).

Heidelberg University was founded (1386).

1390–1399

LITERATURE

In northern Europe, a new writing style developed, called *scrittura umanistica* (Humanistic script), setting the pattern for modern Western typestyles, including capitals, lowercase letters, and italic (from late 14th c.).

Papermaking techniques established in Nuremberg, Germany (1390).

Korea established a government printing house (ca. 1395).

Henry IV became the first English king for whom English was his native language (1399).

d. John Barbour, Scottish poet (1316?–1395).

VISUAL ARTS

Trebon Altarpiece, from Bohemia; an example of the International Gothic style (ca. 1390).

Golden Pavilion (*Kinkaku-ji*), built in Kyoto, Japan, by Shogun Askikaga Yoshimitsu (1397).

Kyungbok-gung Palace built in Seoul, Korea (1395); rebuilt 1867.

PERFORMING ARTS

Paulus, Pier Paolo Vergerio's early Italian Renaissance tragedy (1390).

First recorded mention of a harpsichord (*clavicimbalum*) (1397).

Bagpipes called *cornamusa* in use in Catalonia (by 1390).

d. Francesco Landini, blind Italian composer, poet, and performer, known for his mastery of the organ and other instruments (ca. 1325–ca. 1397).

WORLD EVENTS

Tamerlane invaded Russia (1390).

Tamerlane conquered Georgia and Mesopotamia (1393–1395).

Tamerlane raided and took much of northern India, occupying Delhi, and returning home (1398–1399).

Intensified persecution of Jews in Spain; massacres caused many Jews to publicly renounce and secretly adhere to Judaism (1391).

Sultan Bayazid unsuccessfully besieged Constantinople (1391).

Ottoman Turks took Bulgaria (1393).

Ottoman Turks decisively defeated Crusaders at Nicopolis (1395).

Union of Denmark, Sweden, and Norway (1397).

1400–1409

LITERATURE

Yung-lo ta-tian (*Great Handbook*), reportedly the largest encyclopedia ever compiled, in China (ca. 1400).

Printing with movable metal type, made of bronze, began in Korea (by ca. 1403).

Beginning of the Great Vowel Shift in English, as pronunciation of Middle English vowels changed to their modern sounds (ca. 1400–ca. 1600).

Srikrsna-kirtana (*Praise of the Lord Krsna*), Baru-Candidas's Bengali narrative poem (ca. 1400).

Johann von Tepl's German story *Ackermann aus Böhmen* (*The Plowman from Bohemia*) (ca. 1400).

Life of Yoshitsune, Japanese fictionalized epic history (ca. 1400).

Rimado de palacio (*Poem of Palace Life*), by Pedro López de Ayala, chancellor of Castile (ca. 1400).

An Oxford synod forbade translation or use of the Bible in English (1408), forcing much production abroad.

d. Geoffrey Chaucer, English poet (ca. 1343–1400).

d. Lo Kuan-chung, Chinese writer (ca. 1330–ca. 1400), whose work includes *San Kuo chih yen-i* (*Romance of the Three Kingdoms*).

d. Ibn Khaldun ('Abd al-Rahman ibn Muhammad Ibn Khaldun), Tunis-born Muslim philosopher and historian (1332–1406), whose main work was *The Book of Examples*, a Muslim history, with its notable introduction, *The Muqaddimah*,

on the philosophy of history.

d. John Gower, English poet (ca. 1325–ca. 1408).

VISUAL ARTS

Donatello's classical bronze sculpture *David* (1408–1409), originally in the court of the Medici Palace, and *St. John the Evangelist*, sculpture (1408–1415).

Jacopo della Quercia's tomb of Ilaria del Carretta, wife of the ruler of Lucca (ca. 1406).

Gur-i Amir, Timur's Mausoleum, Samarkand (1405).

Fortress–monastery at Monasija, Serbia, built in Morava School style (ca. 1407).

Très Riches Heures du duc de Berry, one of the most elaborately illustrated and best-known "Books of Hours" for private devotions (early 15th c.); now in Chantilly's Musée Condé.

Hispano-Moorish potters developed brightly painted blue or blue-and-purple wares (15th c.), which influenced the development of majolica ware.

d. Theophanes the Greek, Byzantine painter (ca. 1330/1340–ca. 1405).

PERFORMING ARTS

Zeami Motokiyo's Japanese *Noh* plays *The Robe of Feathers* (*Hagoromo*), *Aoi-no-ue*, and *Atsumori* (all ca. 1400).

The York Plays (*Ashburnham Manuscript*), Corpus Christi cycle of 32 English religious plays (ca. 1400).

Les Miracles de Notre Dame, French miracle play collection (ca. 1400).

Organization of the French passion play production group Confrérie de la Passion (1402).

A type of transverse flute—a *Pfeife* (*fife*)—used with a drum during marching by Swiss soldiers (15th c.).

Bridge builder Thang-stong rgyal-po reportedly introduced the Indian morality play to Tibet (ca. 1400).

Misteri d'Elch, an anonymous Assumption play, an early Spanish religious work (ca. 1400).

Clavichord, one of the earliest stringed keyboard instruments, in use in Europe (by 15th c.).

Europeans adopted the Arab *naqqara*, a pair of small kettledrums tied together, at first primarily in military settings; predecessors of the modern orchestral tympani (15th c.).

Tromba marine, a tall stringed instrument that stands

on the floor, in use in western Europe (from 15th–early 18th c.), surviving in some folk music, especially in Bohemia.

Nyckelharpa, a fiddle with keys, a folk instrument in use in Sweden (by 15th c.), and later also in Demark and northern Germany.

WORLD EVENTS

Henry IV decisively defeated supporters of Richard II at Cirencester (1400).

Owen Glendower led a revolt against English rule in Wales (1402–1409).

Scots invaded England, but were defeated at Nesbit Moor (1402).

Henry IV defeated the northern English rebel army of the Percys at Shrewsbury (1403).

Civil war in Germany (1400).

Tamerlane invaded Syria (1400).

Tamerlane took Baghdad (1401).

Tamerlane defeated the Ottoman Turks at Angora, took Anatolia, and then returned to Samarkand (1402).

d. Tamerlane (Timur the Lame, or Tamberlaine) (1336–1405), on his way to attack China.

John Hus began preaching and winning adherents in Prague (1402).

Chinese fleet led by Cheng Ho made the first of seven Indian Ocean trips, reaching Arabia (1405).

Chinese took Ceylon (1408–1411).

1410–1419

LITERATURE

John Lydgate's *Troy Book* (1412–1420), based on Guido delle Colonne's *Historia Troiana*; also Lydgate's poetic works *Complaint of the Black Knight* (ca. 1410) and *Temple of Glass* (ca. 1410).

Translation of the Bible into Valencian Catalan was destroyed by the Inquisition (1417).

VISUAL ARTS

Donatello's sculptures of standing figures for niches in cathedrals, including *St. Mark* (1411–ca. 1415) and *St. George* (1415–1420); also his *Crucifix* (ca. 1410–1415).

Filippo Brunelleschi designed Florence's *Ospedale*

degli Innocenti (*Foundling Hospital*), sometimes called the first Renaissance building (1419; built 1422–1444).

Jacopo della Quercia's sculpture *Fonte Gaia* (1419), a fountain decorated with figures in relief.

Rohan Hours, illustrated private devotional book (ca. 1419).

b. Enguerrand Charonton, French painter (1410–?; active at Avignon ca. 1447–1461).

PERFORMING ARTS

Agincourt Song, for two voices and three-part chorus, commemorating the English victory at the Battle of Agincourt, when it was probably written (1415).

Earliest known Renaissance book on dance, Domenico da Piacenza's *On the Art of Dancing and Directing* (1416).

De proportionibus musicae, Johannes Ciconia's treatise (1411).

d. Johannes Ciconia, Liégeois composer and theorist (1335/1373–1412).

WORLD EVENTS

d. Henry IV (Bolingbroke) (1366–1413), king of England; he was succeeded by Henry V.

English forces led by Henry V decisively defeated the French at Agincourt (1415).

Henry V took Normandy (1417–1419).

Polish and Lithuanian forces decisively defeated the Teutonic Knights at Tannenberg (1410).

Catholic General Council of Constance convened (1414).

John Hus was burnt for heresy at Constance (1415).

Council of Constance elected Pope Martin V (1417).

Hussite wars began in Bohemia (1419–1436).

Portuguese captured fortress of Ceuta (opposite Gibraltar), on the Moroccan coast (1415).

Chinese fleet under Cheng Ho visited Mogadishu, Barawa, and Malindi (1417–1419).

1420–1429

LITERATURE

The Kingis Quair, a long Scottish poem, written by King James I of Scotland while in an English prison (1424), not published until 1783.

John Lydgate's poem *The Story of Thebes* (1420–1444).

Earliest known dated translation of the Hebrew Bible into Judeo-German, or Yiddish (1421).

VISUAL ARTS

Filippo Brunelleschi began work on his masterpiece, the Dome of Florence Cathedral (1420–1436); other works from this decade, all in Florence, include: Barbadori Chapel, Sta. Felicita (ca. 1420), Palazzo di Parte Guelfa (facade and grand salon) (ca. 1420), Basilica of S. Lorenzo (1421–1429, 1441–1460s), Old Sacristy, S. Lorenzo (1421–1428), and Pazzi Chapel in the Sta. Croce cloister (begun 1429, but completed by others in the 1460s).

The Trinity (ca. 1427), Masaccio's painting, the earliest known work based on Brunelleschi's rules of central perspective.

d. Masaccio (Tommaso Giovanni di Mone Massaccio), Florentine artist (1401–1428); among the works of his last years were the paintings *Giovenale Triptych* (1422), *Madonna and Child with St. Anne* (ca. 1424), *Prayer in the Garden and the Communion of St. Jerome* (ca. 1425–1427), *SS. John the Baptist and Jerome* (ca. 1426), *St. Julian's Story* (1427), and frescoes for the Brancacci Chapel, Sta. Maria del Carmine, Florence (ca. 1424–1428).

Donatello's standing figure *Lo Zuccone* (*Baldpate*) (1423–1425) for Florence Cathedral; also his sculptures *Pazzi Madonna* (ca. 1422), Siena Baptistry (1423–1429), *St. Louis Tabernacle* (1423), *Tomb of John XXIII* (effigy) (1425–1427), *Annunciation Tabernacle* (1428–1433), and the relief *The Ascension with Christ Giving the Keys to St. Peter* (1427–1430).

Fra Angelico's paintings *Madonna of the Star* (*Madonna della Stella*) (1425–1430), *Madonna with Child and Two Angels* (1425–1430), *The Dead Christ with Saints* (1425–1428), *Madonna and Child* (1428–1430), *The Coronation of the Virgin* (1428), and *The Martyrdom of St. Peter* (1429).

Offering Hall at the Altar of Heaven (*Ch'i-nien-tin*) built in Peking (Beijing) (1420); reconstructed 1889.

Gentile da Fabriano's altarpiece *Adoration of the Magi* (1423) and polyptych *Quaratesi* (1425).

Lorenzo Ghiberti's bronze doors for the Baptistry of Florence (1424).

Jacopo della Quercia's reliefs, portal of S. Petronio, Bologna (1425); his last notable work.

The Miracle of the Snow, Masolino da Panicale's triptych painting (ca. 1428–1431).

Buxheimer St. Christopher, an early European block print, a precursor to printing (ca. 1423).

d. Nanni di Banco, Italian sculptor (ca. 1385/90–1421).

d. Gentile da Fabriano, Italian painter (ca. 1370–1427).

PERFORMING ARTS

The Castle of Perseverance, an English morality play (1425).

Music began to be written with not just tones but also notations as to the values of the notes and fingerings, first for organ in Italy (ca. 1420).

WORLD EVENTS

Henry V married Catherine of France (1420).

d. Henry V (1387–1422), king of England; he was succeeded by nine-month-old Henry VI (1422).

France, with Scottish support, at war with England (1423–1429).

Joan of Arc relieved Orléans, besieged by the English (1429).

Civil war in Germany (1423).

Ottoman Turk Sultan Murad II unsuccessfully besieged Constantinople (1422).

John VIII Palaeologos became eastern Roman emperor (1425–1448).

1430–1439

LITERATURE

Laurens Janszoon Coster may have produced printed books in Holland (ca. 1430).

Johann Gutenberg was experimenting with movable type (as early as 1436) and had a press built to his specifications (by 1438).

Leon Battista Alberti's dialogue *Della famiglia* (1435–1444).

Sri Rahula, Sinhalese poet (active 1430–1460).

VISUAL ARTS

David, Donatello's sculpture (ca. 1430–1435), his second major sculpture of the giant-slayer, and the first nude statue known since classical times; also Donatello's sculpture *Cantoria* (1433–1439).

Fra Angelico's frescoes on religious life at San Marco, Florence (1438–1450), buildings for his Dominican order.

Fra Angelico's paintings *The Coronation of the Virgin* (1430–1435), *The Last Judgment* (1430–1433), *The Madonna of Humility* (1430–1433), *The Death and Assumption of the Virgin* (ca. 1434), *Virgin and Child with Angels, Saints and Donor* (ca. 1435), *Lamentation* (1436), and *The Annunciation* (ca. 1436).

Fra Angelico's altarpiece paintings *Linaiuoli Altarpiece* (1433), *Sta. Trinita Altarpiece* (ca. 1433), and *Annalena Altarpiece* (*Triptych: Madonna and Child with Saints and Angels*) (ca. 1437).

Filippo Brunelleschi's architectural works, all in Florence: Sta. Maria degli Angeli, Florence (1434–1437, unfinished), S. Spirito church, (1436–1480s), and the lantern (from 1435) and tribunes (from 1439) for Florence Cathedral.

Della pittura (*On Painting*), Leon Battista Alberti's book, describing the laws of perspective in painting (1436); also his *De pictura praestantissima* (1435).

The Reform of the Carmelite Rule, Fra Filippo Lippi's fresco, Sta. Maria del Carmine, Florence; one of his earliest paintings (1432).

Fra Filippo Lippi's *Annunciation* (ca. 1438), a notable early use of the principles of perspective, at S. Lorenzo, Florence; also his paintings *Madonna of Humility* (ca. 1432), *Madonna and Child Enthroned*, (ca. 1437), and *The Virgin and Child Between SS. Frediano and Augustin* (1437).

Ghent Altarpiece (*The Adoration of the Lamb*) (1432), completed by Jan van Eyck, probably started by his brother Hubert.

The Marriage of Giovanni Arnolfini and Giovanna Cenami (*Arnolfini and his Wife*), Jan van Eyck's work, painted for their marriage (1434); much reproduced in textbooks.

Jan van Eyck's early 1430s paintings *Portrait of a Young Man* (*Tymotheas*) (1432); *A Man in a Turban* (ca. 1433), possibly a self-portrait; *The Annunciation* (ca. 1434); *Madonna with Canon van*

der Paele (1434–1436); Cardinal Albergati (ca. 1435); and The Lucca Madonna (ca. 1435–1436).

Jan van Eyck's late 1430s paintings The Goldsmith Jan de Leeuwe (1436), Madonna with Chancellor Rolin, (ca. 1436), Portrait of Baulduyn de Lannoy (ca. 1436–1437), St. Barbara (1437), Triptych (1437), Madonna at the Fountain (1439), and Margaret van Eyck (1439).

The Altarpiece of the Virgin, Rogier van der Weyden's Miraflores Altarpiece (ca. 1435–1440s).

Rogier van der Weyden's early 1430s paintings Madonna and Child in a Niche (ca. 1432), Annunciation (ca. 1435), Descent from the Cross (ca. 1435–1440), and St. Luke Painting the Virgin (ca. 1435).

Convent of S. Marco rebuilt by Michelozzi Michelozzo (ca. 1436–1443).

d. Andrei Rublev, Russian religious painter (ca. 1360–ca. 1430), whose masterpiece was the icon of the Old Testament Trinity, at his monastery of Troitsky-Sergieva.

d. Jacopo della Quercia, Italian sculptor (ca. 1374–1438).

PERFORMING ARTS

Guillaume Dufay's motet Nuper rosarum flores (1436).

d. Thomas Damett, English composer (1389/1390–1436).

WORLD EVENTS

Joan of Arc burnt for heresy at Rouen (1431).

Chinese fleet led by Cheng Ho visited Bengal and then the Middle East, entering the Red Sea (1431–1432).

Portuguese sailors rounded Cape Bojador (the Bulging Cape), on the West African coast (1433).

d. James I (1394–1437), king of Scotland, assassinated; succeeded by James II.

Council of Basle ended the schism between Eastern and Western Christian churches (1431–1439).

1440–1449

LITERATURE

Korean King Sejong traditionally credited with

development of a new syllabic/phonetic alphabet (on-mun) (1446).

Marqués de Santillana's Preface and Letter to the Constable of Portugal, first known Spanish-language work of literary criticism (1449).

Leon Battista Alberti's dialogue Della tranquillità dell'animo (1441–1442).

El laberinto de fortuna (The Labyrinth of Fortune), Juan de Mena's epic historical–allegorical poem (1444).

d. Laurens Janszoon Coster (ca. 1370–ca. 1440), Dutchman who may have produced printed books before Gutenberg.

VISUAL ARTS

Donatello's high altar for S. Antonio, Padua (1446–1450); Gattamelata, the equestrian monument of Erasmo da Narni (1447–1453); and the sculpture Crucifix (1444–1447).

Leon Battista Alberti's Palazzo Rucellai, Florence (ca. 1445–1451; completed by 1460) and Tempio Malatestiano, Rimini, created from the original Gothic church of S. Francesco (1447–1450).

Fra Angelico's frescoes at Cappella di Niccolò V (1448–1450).

Fra Filippo Lippi's early 1440s paintings The Annunciation (ca. 1442), The Coronation of the Virgin (1441–1447), The Madonna Enthroned with Saints (1441–1442), and Virgin and Child (1441–1442).

Fra Filippo Lippi's late 1440s paintings Coronation of the Virgin (ca. 1445), Adoration of the Magi (ca. 1445–1447), and St. Bernard's Vision of the Virgin (1447).

Fra Filippo Lippi's Alessandrai Altarpiece, St. Lawrence Enthroned with SS. Cosmo and Damian and Alessandro Alessandri and Two of His Sons; St. Benedict; St. Anthony Abbott (ca. 1442–1447).

Michelozzi Michelozzo's Medici Palace (1444–1459), now called the Palazzo Medici-Riccardi, built for Cosimo de' Medici.

Piero della Francesca's panel paintings The Baptism of Christ (ca. 1440–1445) and Madonna della Misericordia (1445–1462).

Andrea di Bartolo di Bargilla's frescoes of the Last Supper and Passion scenes, at the monastery of Sta. Apollonia (1444–1450); also his Frescoes of Famous Men and Women (ca. 1449).

Chih-hua-ssu temple completed in Peking (Beijing), China (1444).

Domenico Veneziano's paintings *Carnesecchi Madonna* (ca. 1440) and *St. Lucy Altarpiece* (ca. 1445).

Andrea Mantegna's frescoes at Ovetari Chapel (1448–1455).

Filarete completed the bronze doors at St. Peter's, Rome (1445).

Petrus Christus's painting *Portrait of Edward Grymestone* (1446).

Agostino di Duccio's reliefs at Modena Cathedral (1442).

Triumphal arch in Castelnuovo, Naples, Italy, erected for Alfonso I of Aragon (1443).

Enguerrand Charonton, French painter (active at Avignon ca. 1447–1461).

Tai Chin, Chinese painter (active ca. 1446).

Jaime Huguet, Spanish painter (active 1448–1492).

Stefan Lochner, German painter (active 1442–1451).

d. Jan van Eyck, Belgian painter (ca. 1395–1441).

d. Filippo Brunelleschi, Italian architect (1377–1446), often said to have "discovered" rules of perspective.

d. Masolino da Panicale, Italian painter (ca. 1383–1447?).

Performing Arts

d. Zeami Motokiyo, the greatest of all Japanese *Noh* playwrights (1363–1443), author of approximately 100 plays and a wide range of essays on the theater; son of Kan-ami Kiyotsugo, both key figures in the development of the *Noh* theater.

d. Leonel Power, English composer (ca. 1370/1385–1445), known for his masses and motets; long associated with Cambridge's Christ Church Priory.

The First Joy of Mary, Dutch mystery play (ca. 1448).

Play and Festival of Abraham and Isaac, Feo Belcari's Italian mystery play (1449).

First known mention of pedals being used on organs, in the *Ileborgh Codex*, from Germany (1448).

b. Guglielmo Ebreo (Guillaume le Juif or William the Jew of Pesaro), Jewish-Italian dancing master (b. before 1400–?).

d. N. (Nicholas?) Sturgeon, English composer (?–1454), whose works include mass movements and a motet possibly composed to celebrate the Agincourt victory (1415).

World Events

Portuguese sailors brought home their first Black African slaves, beginning the Atlantic slave trade (1441).

Final Crusade; Ottoman Turks ultimately defeated the Crusaders at Varna (1443–1444).

French won Normandy back from English (1449–1450).

First Dalai Lama appointed ruler of Tibet (ca. 1447).

Frederick III became Holy Roman Emperor (1440–1493).

Constantinople was again besieged by the Ottoman Turks (1441).

John Hunyadi, Hungarian hero, defeated the Ottomans in Transylvania (1442).

Skanderbeg (George Kastrioti) led temporarily successful Albanian wars of independence (1443–1468).

Frederick of Brandenburg seized Berlin, making it his capital (1448).

Ottoman Turk Sultan Murad II defeated John Hunyadi at the second Battle of Kossovo (1448).

1450–1459

Literature

In Mainz, Germany, Johannes Gutenberg developed the first movable-type printing press in Europe, with a screw press, on which he printed his first work—the 42-line Bible, each two-column page being 42 lines long—changing the course of Western civilization by making printed matter readily available to all (1452–1456).

Mainz Psalter (1457), the second book known to be printed by movable type, probably started by Gutenberg, but identified as published by Johann Fust (who had financed, then foreclosed on Gutenberg) and Peter Schöffer, Fust's son-in-law and heir.

The Arabian Nights' Entertainments (*A Thousand and One Nights*), a collection of tales narrated by Scheherazade, introducing characters such as Ali Baba and Sinbad; written in Arabic from older Persian, Indian, and Arabic sources, probably edited in Cairo (ca. 1450), later much translated.

Early Modern English developed (by ca. 1450).

Vidyapati, Indian poet (active ca. 15th c.).

d. John Lydgate, English poet and priest (ca. 1360–ca. 1451).

VISUAL ARTS

Donatello's full-length sculptures *St. Mary Magdalen* (1454–1455), in wood, and *Judith and Holofernes* (1456–1457), in bronze.

Piero della Francesca's panel painting *St. Jerome Penitent* (1450), panels from the altarpiece of S. Agostino in Sansepolcro (1454–1469), and later panels *St. Augustine, Flagellation of Christ, St. Michael, St. Nicholas of Tolentino, St. Simon the Apostle* (all late 1450s).

The Deposition in the Tomb, among Rogier van der Weyden's finest paintings, now in the Prado (ca. 1450); also his paintings *Braque Triptych* (ca. 1450), *Madonna and Child with Four Saints* (ca. 1450), *Seven Sacraments Triptych* (ca. 1451–1455), and *Crucifixion* (ca. 1455).

Rogier van der Weyden's altarpieces *Last Judgment Altarpiece* (ca. 1450), *Bladelin Altarpiece* (ca. 1455), and *St. John Altarpiece* (ca. 1455).

Leon Battista Alberti began work on his *De re aedificatoria*, the first architectural work of the Renaissance (1452–1472; publication completed 1485).

Piero della Francesca's frescoes *Sigismondo Malatesta Before St. Sigismund* (1451) and *The Legend of the True [Holy] Cross* (ca. 1452–ca. 1466), in the choir of S. Francesco at Arezzo; also his *Flagellation*, now at Urbino (ca. 1465–1467).

Andrea Mantegna's *St. Luke Polyptych, The Man of Sorrows with the Virgin and Saints* (1454); also his paintings *The Agony in the Garden* (ca. 1450), *The Virgin with Sleeping Child* (ca. 1450), *Madonna Enthroned with Saints* (1456–1459), *The Crucifixion* (1456–1459), and *St. Sebastian* (ca. 1459).

Giovanni Bellini's paintings *Annunciation, Virgin and Child, Christ Blessing,* and *Transfiguration* (all ca. 1450).

Jean Fouquet's painting *Diptych of Melun* (ca. 1450); also his *Book of Hours*, for his patron Étienne Chevalier (1450–1460).

Enguerrand Charonton's paintings *Virgin of Mercy* (1452) and *Coronation of the Virgin* (1454).

Fra Filippo Lippi's frescoes for the Prato Cathedral, *Scenes from the Lives of SS. Stephen and John the Baptist* (1452–ca. 1465); also his paintings *Madonna with Child and Scenes from the Life of Mary* (1452), *The Virgin Enthroned and Two Saints* (1453), *The Adoration of the Child with St. Hilary* (ca. 1455), and *Seven Saints* (1458–1460).

Andrea di Bartolo di Bargilla'a fresco *St. Julian*, at SS. Annunziata (1454–1455).

Leon Battista Alberti's varicolored marble-inlaid facade for the S. Maria Novella, Florence (1456–1470).

Madonna with Two Saints, Petrus Christus's painting, the first dated northern European painting to show use of perspective (1457).

Benozzo di Lese Gozzoll's decorations for the chapel at the Medici Palace (1459).

Agostino di Duccio's sculptural reliefs, Tempio Malatestiano, Rimini (ca. 1450–1457).

Brightly painted majolica ware was developed in Italy (mid-15th c.), under Islamic influence, and many factories were established (mid-16th c.).

d. Fra Angelico (Guido di Pietro Angelico), Italian painter and Dominican monk (1400–1455).

d. Lorenzo Ghiberti, Italian sculptor (1378–1455).

d. Andrea di Bartolo di Bargilla, Florentine painter (ca. 1423–1457).

PERFORMING ARTS

Mystère de la Passion, Arnoul Greban's early French passion play, considered one of the best, presented in four days of performance (ca. 1453–1454).

Ordinalia, a trilogy of Cornish miracle plays, including *Origo Mundi, Passio Domini,* and *Ressurectio Domini* (ca. 1450).

Details of harpsichord construction and playing technique described in a French manuscript by musician Henri Arnaut (ca. 1454).

Recorders in treble and tenor sizes, being played in groups, depicted in Italian paintings (ca. 1450).

The lute was featured in the *Arabian Nights* (ca. 1450), its roots going back deep into the Middle Ages, probably to Iraq.

Des Türken Vasnachtspil, Hans Rosenplüt's play (1456).

d. John Dunstable, English composer (ca. 1390–ca. 1453), key exponent of the "English manner," who strongly influenced later Continental composers.

WORLD EVENTS

Ottoman Turks led by Muhammad II took Constantinople, cutting off European trade to the East and pushing European motives to explore west across the Atlantic to reach the Indies (1453).

Richard of York defeated a Lancastrian army at St. Albans, then captured Henry VI, beginning the Wars of the Roses (1455–1485).

English, Bretons, and Basques were fishing off Iceland and Greenland (ca. 1450).

Portuguese sailors discovered the Cape Verde Islands (1456).

French retook all English-occupied territory, except Calais (1451–1453).

Poland defeated the Teutonic Knights (1454–1456).

John Hunyadi raised the Ottoman Turk siege of Belgrade (1456).

Ottoman Turks took Thrace (1456).

Ottoman Turks took Athens (1457).

Ottoman Turks took Serbia (1459).

Glasgow University was founded (1451).

Pope Nicholas V founded the Vatican Library (1450).

1460–1469

LITERATURE

Mainz continued as Europe's center of printing, among its main works being *Catholicon* (1460), a Latin dictionary–encyclopedia written by Johann Balbus and printed in Mainz, possibly by Johannes Gutenberg.

In Bamberg, Germany, Albrecht Pfister printed *Edelstein* (1461), regarded as the first illustrated book, with the woodcut illustrations printed by separate impressions.

Mainz was sacked and burned (1462), and printers fled, taking knowledge of printing technology to other European cities.

Printing was established at Subiaco (near Rome), in the Benedictine monastery of Santa Scholastica (1465), Lactantius's *De Divinis Institutionibus* being the first dated Italian printed book. German-trained printers Conrad Sweynherm and Arnold Pannartz developed a type from the more open *scrittura umanisticaa* (Humanistic script), basis of the modern roman type.

Mentel Bible, the first printed in German, was published in Strasbourg (by 1466).

Printing began in Cologne, Germany (1466).

d. Johannes Gutenberg, German goldsmith (ca. 1394/1400–ca. 1468) who developed movable-type printing in Europe.

Printing began in Rome proper and Augsburg, Germany (1468).

Le Morte d'Arthur, Thomas Malory's classic English prose rendition of the King Arthur legends, originally eight separate romances (1469), not unified until 1485.

Printing established in Venice (1469).

VISUAL ARTS

Andrea Mantegna's paintings *Portrait of Cardinal Lodovico Mezzarota* and *The Adoration of the Shepherds* (both ca. 1460); *St. Sebastian*, *The Death of the Virgin*, and *Triptych with the Adoration of the Magi, the Circumcision, and the Ascension* (all ca. 1465); and *The Dead Christ* (ca. 1466).

Piero della Francesca's paintings *Portraits of Federico da Montefeltro, Duke of Urbino and of His Wife, Battista Sforza*, now in the Uffizi (ca. 1465).

Piero della Francesca's fresco *Resurrection* (ca. 1463) and painting *Hercules* (ca. 1460–1466).

d. Donatello (Donato di Niccolo), Italian sculptor (ca. 1386–1466). His most notable late work was the high-relief sculptures for twin pulpits, S. Lorenzo, Florence (from ca. 1460).

Fra Filippo Lippi's paintings *The Virgin Adoring the Child* (ca. 1460), *The Adoration of the Child with St. Bernard* (ca. 1463), and *The Madonna and Child with Two Angels* (ca. 1465).

d. Fra Filippo Lippi, Italian artist and Carmelite monk (1406–1469); among his final works were the choir and apse frescoes, Spoleto Cathedral (begun 1467–1469).

Giovanni Bellini's paintings *Pietà with Virgin and St. John*, *The Agony in the Garden*, and *The Blood of the Redeemer* (all ca. 1460).

Leon Battista Alberti's S. Sebastiano, Mantua (1460–1470) and Rucellai Chapel, Florence (1467); also his books *De statua* (ca. 1464) and *De iciarchia* (1468).

Jaime Huguet's paintings *Epiphany* and *Consecration of St. Augustine* (1463–1486).

Andrea del Verrocchio's sculptures *Tombstone for Cosimo de'Medici* (1465–1467), *Christ and St. Thomas* (1467–1483), and *Candelabrum* (1468).

Blue Mosque, Tabriz, built (1465).

Hugo Van Der Goes's painting *Fall and Lamentation* (ca. 1468).

Sandro Botticelli's paintings *The Madonna of the Guides of Faenza* (ca. 1468) and *Judith and Holofernes* (ca. 1469).

d. Rogier van der Weyden, French artist (ca. 1400–1464); among his final works was his *Columba Altarpiece* (ca. 1460–1464).

d. Filarete, Florentine sculptor and architect (ca. 1400–ca. 1469).

d. Domenico Veneziano, Italian painter (ca. 1400–1461).

PERFORMING ARTS

Antonio Cornazano's *The Book of the Art of the Dance* (1465 or 1455).

English morality play *Despair* (1466).

La representación del Nacimiento de Nuestro Señor, Gómez Manrique's play (written 1467–1481).

The N-Town Plays (*Hegge Manuscript*), English Corpus Christi cycle of 42 plays (1468).

First depictions of trombones (*sackbuts*), probably developed in Italy or Flanders; the first brass instrument capable of playing the full range of notes, and the main deep-toned wind instruments for centuries (from at least 15th c.).

Oldest known reference to the virginal, a plucked keyboard instrument, in Czechoslovakia (ca. 1460).

The *regal*, a small organ using reeds, popular as a transportable instrument in Europe (mid-15th–late 17th c.).

d. Gilles de Bins dit Binchois, Franco-Flemish composer (ca. 1400–1460).

WORLD EVENTS

Wars of the Roses: Edward defeated Lancastrians at Mortimer's Cross and Henry VI at Towton Moor, deposing Henry VI and succeeding him as Edward IV (1461).

Gibraltar was taken by Castile (1462).

Ivan III (the Great) became grand duke of Muscovy (1462–1505).

Venice and the Ottoman Turks were at war (1463–1479).

Ottoman Turks took Trebizond (1462).

Ottoman Turks took Herzegovina (1465–1466).

Isabel of Castile married Ferdinand of Aragon (1469).

Lorenzo de Medici became ruler of Florence (1469–1492).

1470–1479

LITERATURE

First printed book to have page numbers, a version of St. Augustine's *De civitate Dei* (*The City of God*), published in Venice (1470).

Nicolas Jenson (working in Venice 1470–1480) developed influential roman typestyles, as well as Greek types (for quotations) and gothic fonts, used primarily in medical and historical works.

Printing started in Paris by three German printers invited to the Sorbonne (1470), and by decade's end was established also in Toulouse, Angers, Vienne, Poitiers, and Lyons.

First printed Bible in Italian, translated from the Latin Vulgate by Niccolò Malermi, published in Venice (1471).

d. Thomas Malory, English writer (1408–1471).

Printing began in Florence (1472), but calligraphic production remained predominant there.

Boccaccio's *De Claris Mulieribus* printed in Ulm, Germany, illustrated with woodcuts based on French illuminated handwritten manuscripts (1473).

Earliest confirmed Dutch book printed in Utrecht (1473), though some may have been earlier, even before Gutenberg; printing also found in Deventer, Delft, Gouda, and elsewhere.

First Belgian press established at Alost (1473), and at Louvain, Bruges, Brussels, and Audenarde by 1480.

In Spain, printing started in Valencia (1474), and spread to Saragossa, Tortosa, Seville, Barcelona, and Lerida by 1480.

First printed book in English, *Recuyell of the Historyes of Troye* (1475), produced in Brussels by William Caxton.

The Japanese royal court had its own type foundry, for large-scale printing (late 15th c.).

Journey Across Three Seas, Afanasy Nikitina's story of travels in India and Persian by a 15th-century Russian trader (ca. 1475).

Printer William Caxton established his press near Westminster Abbey in London (1476), where his

first dated printed work was *The Dictes or Sayings of the Philosophers* (1477). Some letters unique to Old English were dropped, since printers were using continental typefaces; spelling would gradually be standardized.

First printed Hebrew version of the *Psalms*, with rabbinic commentary, produced in Italy (1477).

France's first illustrated book, *Le Mirouer de la Rédemption*, printed at Lyons (1478).

Versions of the Bible in Spanish, rather than the approved Latin, were banned in Castile, Leon, and Aragon (1479–1504).

VISUAL ARTS

Leonardo da Vinci's early paintings *The Annunciation*, now in the Uffizi, Florence (ca. 1472–1477); also *Madonna and Child* (ca. 1474), *Portrait of a Young Lady (Ginevra de'Benci)* (ca. 1475–1478), and *Madonna Benois* (1478–after 1500).

Giovanni Bellini's paintings *Coronation of the Virgin* (*Madonna and Child*), *Madonna with Sleeping Child*, *Madonna with Standing Child*, *Madonna with the Greek Inscription*, and *St. Jerome* (all ca. 1470); *Portrait of Georg Fugger* (1474); and *St. Vincent Ferrer Polyptych* (ca. 1475).

Piero della Francesca's paintings *Senigallia Madonna* and *The Madonna with Child, Angels, Saints and Federico da Montefeltro, Duke of Urbino* (both 1470s) and *Madonna with Child and Saints* (ca. 1472–1474).

Sandro Botticelli's paintings *Fortitude* (1470), *St. Sebastian* (1474), *The Adoration of the Magi* (ca. 1475), *The Primavera (Allegory of Spring)* (1477–1478), and *Giuliano de' Medici* (1478).

Andrea del Verrocchio's paintings *Baptism of Christ* (ca. 1474–1475) and *Madonna and Child with Saints* (1478–1479); also his Tomb of Piero and Giovanni de' Medici (1472); relief *Beheading of St. John the Baptist* and terracotta work *Giuliano de'Medici* (both 1478–1479); and sculpture *Putto with Dolphin* (ca. 1479).

Andrea del Verrocchio's sculptures *Lady with Primroses*, and *Monument of Cardinal Niccolò Forteguerri* (both 1476), *David* (before 1476), and his terracotta relief *Madonna and Child* (ca. 1477/78).

Andrea Mantegna's painting *The Mourning over the Dead Christ* (ca. 1475?); also his fresco of the Camera degli Sposi, Palazzo Ducale, Mantua (1473–1474).

Domenico Ghirlandaio's frescoes over Vespucci Altar, Church of Ognissanti, Florence (ca. 1472–1473) and *Life of Sta. Fina* (1475).

Hans Memling's early 1470s paintings *Portinari Triptych* and *The Martyrdom of St. Sebastian* (both ca. 1470), *Portrait of Gilles Joye* (1472), *The Last Judgment* (ca. 1473), and *Christ Surrounded by Angel Musicians* (ca. 1475).

Hans Memling's late 1470s paintings *Adoration of the Magi* and *Mystic Marriage of St. Catherine of Alexandria* (both 1479); and *The Deposition*, *The Mystic Marriage of St. Catherine of Alexandria*, *The Virgin and Child*, *Triptych: The Virgin and Child with Saints and Donors*, and altarpiece *The Adoration of the Shepherds* (all ca. 1475).

Leon Battista Alberti's S. Andrea, Mantua (ca. 1470) and SS. Annunziata, Florence (designed ca. 1470).

Domenico Ghirlandaio's fresco *SS. Barbara, Jerome and Anthony Abbot* (early 1470s).

Donato Bramante's frescoes for the facade of the Palazzo del Podestà, Bergamo (1477).

Benedetto da Maiano's portrait bust *Pietro Mellini* (1474); also his altar, Sta. Fina, Cathedral of S. Gimignano (ca. 1475).

Hugo van der Goes's *Portinati Altarpiece* (ca. 1475–1476).

Capitoline Museum established in Rome by Pope Sixtus IV (1471); the oldest known civic art collection.

Mosque of Qait Bey built in Cairo under the Ayyubids (1472).

Building carved from rock face at Malinalco, Mexico, by Aztecs (ca. 1476–1520).

d. Leon Battista Alberti, architect, mathematician, painter, and scholar (1404–1472).

d. Michelozzi Michelozzo, Florentine architect and sculptor (1396–1472), favorite architect of Cosimo de' Medici.

d. Petrus Christus, Dutch painter (ca. 1420–ca. 1472/1473).

d. Paolo Uccello, Florentine painter (1397–1475).

d. Antonello da Messina, Italian painter (ca. 1430–1479).

PERFORMING ARTS

Viol—a stringed instrument shaped like a guitar, tuned like a lute, and played with a bow—developed in Spain, probably in Valencia (1470s).

Guitar assumed characteristic modern form in Spain (late 15th c.), though with only five or four strings (paired).

Johannes Tinctoris's *Terminorum musicae deffinitorium*, the oldest printed music dictionary (ca. 1475).

In Europe, lutes came to be played more often with the fingertips, rather than with a device employing quills, Arab style (late 15th c.).

d. Hans Rosenplüt, German poet and playwright (ca. 1400–ca. 1470).

d. Arnoul Greban, French musician, organist, and playwright (ca. 1420–ca. 1471), choirmaster at Notre-Dame in Paris (ca. 1147–1452), best known for his passion play *Mystère de la Passion* (ca. 1453–1454).

d. Conrad Paumann, blind German composer and organist (ca. 1410–1473).

d. Guillaume Dufay, French composer (ca. 1398–1474).

WORLD EVENTS

Edward IV driven into exile, but returned to defeat the Yorkists at Barnet and Margaret at Tewkesbury, taking back his kingdom (1471).

Edward IV and the Hanseatic cities signed the Peace of Utrecht (1474).

Portuguese moving south on the African coast took Tangier and reached the Niger (1471).

Castile established the Inquisition, intensifying the persecution of Jews, Muslims, and dissenters (1478).

Poland and Hungary were at war (1472).

Songhai became an independent state (1473).

Ottoman Turk Sultan Muhammad II invaded Wallachia, but was rebuffed by the forces of Stephen the Great of Moldavia (1474–1475).

England instituted the Court of the Star Chamber (1478).

Ivan III took Nizhny Novgorod (1478).

Castile and Aragon joined in single state (1479).

Venice and the Ottoman Turks temporarily made peace, signing the Treaty of Constantinople (1479).

1480–1489

LITERATURE

First printed Hebrew version of the *Pentateuch* or *Torah*, the first five books of the Bible, with rabbinic commentary, produced in Italy (1482).

Orlando innamorato (*Orlando in Love*), Matteo Maria Boiardo's Italian poem (1483).

William Caxton printed *Le Morte d'Arthur* (1485), combining Sir Thomas Malory's eight separate King Arthur romances into a unified narrative.

First printed Hebrew version of the Books of the Prophets, from the Bible, with rabbinic commentary, produced in Italy (1485–1486).

Hortus Sanitatis, an herbal extensively illustrated with woodcuts, printed by Peter Schöffer, Gutenberg's sucessor (1485).

First printed Hebrew version of the Hagiographa of the Bible, with rabbinic commentary, produced in Italy (1486–1487).

First printed edition of the full Hebrew Bible produced in Soncino, Italy (1488).

First complete Czech-language Bible published in Prague (1488).

d. Surdas, blind Indian Hindu poet (d. 1563).

d. Luigi Pulci, Italian poet (1432–1484) who wrote the comic epic *Morgante* (1483).

VISUAL ARTS

Sistine Chapel, the pope's chapel in the Vatican and later site of Michelangelo's noted frescoes, built (1473–1487).

Sandro Botticelli's frescoes in the Sistine Chapel, the Vatican (1481–1482).

Sandro Botticelli's early 1480s paintings *Madonna of the Eucharist* (1481), *The Adoration of the Magi* (1482), and *Virgin and Child with St. John the Baptist and St. John the Evangelist* (1484–1485).

Sandro Botticelli's late 1480s paintings *Mars and Venus*, *Pallas and the Centaur*, *The Birth of Venus*, and *The Madonna of the Magnificat* (all ca. 1485); *The Madonna of the Pomegranate* (ca. 1487); and *The Annunciation* (1488–1490).

Leonardo da Vinci's paintings *St. Jerome* (ca. 1480), *The Adoration of the Magi* (1481), and *The Virgin of the Rocks* (1483).

Piero della Francesca's painting *The Nativity* (ca. 1480).

Andrea Mantegna's *Triumph of Caesar*, a series of nine massive paintings, each nine feet square (ca. 1484–1486), now at the Orangery at Hampton Court; also his *The Madonna of the Caves* (ca. 1484?).

Domenico Ghirlandaio's early 1480s frescoes *Last Supper*, *St. Jerome*, and *Madonna and Child Enthroned, with SS. Michael, Raphael, Justus, and Zenobius* (all ca. 1480); *Christ Calling the First Apostles* and *Christ Calling SS. Peter and Andrew* (both 1481–1482); *Roman Heroes* (1482); and *Scenes from the Life of St. Francis* (1482–1485).

Domenico Ghirlandaio's late 1480s frescoes *Adoration of the Shepherds* (1485), *Madonna and Saints* (1485–1494), *Scenes from the Lives of the Virgin and St. John the Baptist* (1486–1490), and *Adoration of the Magi* and *Giovanna Tornabuoni* (both 1488).

Sta. Maria presso S. Satiro, Milan, Donato Bramante's first major work, begun (ca. 1480); also his plan for Pavia Cathedral (1488), only the crypt actually following his design.

Giovanni Bellini's paintings *Enthroned Madonna from S. Giobbe*, *Resurrection*, *St. Francis in Ecstasy*, and *Transfiguration* (all ca. 1480); *Madonna degli Alberetti* (1487); and *Madonna with Doge Agostino Barbarigo* (1488).

Hans Memling's early 1480s paintings *Madonna and Child with Angels* (ca. 1480–1485), *Scenes from the Life of Christ and the Virgin* (ca. 1480), *The Descent from the Cross* (1480), *Moreel Triptych* (1484), and *Bathsheba* (ca. 1485).

Earliest surviving miniatures by Persia's great painter Kamal Ud-din Bihzad (1486–1495).

Hans Memling's late 1480s paintings *St. Benedict*, *The Virgin and Child*, *Portrait of Benedetto Portinari*, and *Diptych with Madonna and Martin van Nieuwenhove* (all 1487), and *St. Ursula Shrine* (1489).

Piero di Cosimo's paintings *Vulcan and Aeolus* (1486) and *The Visitation with Two Saints* (ca. 1487).

Filippino Lippi's painting *Vision of St. Bernard* (ca. 1486).

Kamal Ud-din Bihzad's illustrations for Sa'di's *Bustan* (before 1488); now in Cairo's National Library.

d. Andrea del Verrocchio, Italian sculptor (1435–1488); among his last works was the sculpture *Bartolomeo Colleoni* (1483–1488).

d. Hugo van der Goes, Flemish painter (ca. 1440–1482); among his last works was *In the Death of the Virgin* (ca. 1480).

d. Agostino di Duccio, Italian sculptor (1418–1481).

d. Jean Fouquet, French painter (ca. 1420–ca. 1481), most noted for his work as an illuminator.

PERFORMING ARTS

Colascione, a long-necked lute (similar to an old-style bouzouki), brought to Italy by a Turkish prisoner; it was adopted and renamed the tambura (ca. 1480).

Crumhorn, a double-reeded wind instrument with a hooked bottom, widely used in Europe (ca. 1480–1650).

Carillon with manual keyboard for playing bells developed (ca. 1480 or later).

Orpheus, Angelo Poliziano's Italian pastoral drama (1480).

Play of Frau Jutta, Dietrich Schernberg's German morality play (1480).

Musica practica, Bartolomeo Ramos de Pareia's treatise (1482).

WORLD EVENTS

Portuguese sailor Bartholomeu Dias rounded the Cape of Good Hope, a milestone in the great age of European exploration and conquest (1487).

d. Edward IV (1442–1483), king of England, precipitating a succession crisis, from which Richard III emerged as usurper of the throne after probably murdering the two young princes in the Tower of London; contested by Henry Tudor (1483).

Henry Tudor defeated Richard III at Bosworth (1485); Richard was killed during the battle. Henry Tudor became Henry VII of England, founder of the Tudor dynasty (1485–1603).

Ivan III (the Great) proclaimed himself the first "Czar of all the Russias" (1480–1505).

Crimean Khan took Kiev (1482).

Charles VIII became king of France, succeeding Louis XI (1483).

1490–1499

LITERATURE

Aldus Manutius began his Aldine Press in Venice

(1494), with a series of Greek classics and other scholarly works, and illustrated works such as Colonna's *Hyperotomachia Poliphili* (1499); his printer's mark was the dolphin and anchor.

Second edition of the full Hebrew Bible, printed in Naples, Italy (1491–1493).

d. William Caxton, first English printer (ca. 1422–1491).

Antonio de Nebrija's *Gramática de la lengua castellana* (*Grammar of the Castilian language*), the first grammar of a modern European language.

Chronik der Sachsen, printed by Peter Schöffer (1492).

Spanish paper quality declined, as Christian workers replaced more highly skilled Muslim artisans (1492).

d. Jâmî (Nûr al-Dîn 'Abd al-Rahmân Jâmî), Persian poet, scholar, and mystic (1414–1492), whose main work was *Haft Awrang* (*Seven Thrones*), seven long poems, the two most popular being *Salâmân and Absâl* and *Yûsuf and Zulaykhâ*.

d. Angelo Poliziano (Politian), writer and critic (1454–1494), whose major work, *Miscellaneorum centuria* (*A Century of Miscellanies*), laid the basis of modern textual criticism in literature (before 1494).

Third printed edition of the full Hebrew Bible, printed in Brescia, Italy (1494).

Livre d'Heures printed Philippe Pigouchet at Paris (1498), using high-quality woodcuts and type to imitate French calligraphy and miniature painting.

Papermaking techniques established in Wiener-Neustadt, Austria (1498).

Complete Bible translated into the Slavic language (1499).

VISUAL ARTS

Michelangelo's sculptures, the magnificent *Pietà* (ca. 1499), *Battle of the Centaurs* and *Madonna of the Stairs* (both ca. 1492), *Crucifixion* (before 1494), and *Bacchus* (1497).

The Last Supper, Leonardo da Vinci's dramatic painting (1495–1497) in the Refectory of Sta. Maria delle Grazie, Milan.

Leonardo da Vinci's paintings *Lady with an Ermine* and *The Musician* (both ca. 1490), *The Virgin of the Rocks* (1494–1508), and his cartoon *The Virgin*

and Child with St. Anne (1499); also his decoration of the Sala delle Asse, Castello Sforzesco, Milan (1498).

Parnassus, one of Andrea Mantegna's most notable paintings (1497); now in the Louvre.

Andrea Mantegna's engravings *Bacchanal and Battle of the Sea Gods* (both ca. 1490); and *The Entombment* and *The Risen Christ Between St. Andrew and Longinus* (both 1490s).

Andrea Mantegna's painting *St. Sebastian* (ca. 1490–1500), *Madonna della Victoria* (1495).

Giovanni Bellini's painting *Madonna and Child with St. Paul and St. George*, *Madonna of the Pomegranate*, and *Portrait of a Young Man* (all ca. 1490); *The Allegory of the Souls in Purgatory* (1490s).

Sandro Botticelli's paintings *Coronation of the Virgin* (1490), *St. Augustine in His Cell* and *The Calumny of Apelles* (both ca. 1495), and *The Story of Virginia Romana* and *The Tragedy of Lucretia* (both ca. 1499).

Albrecht Dürer's paintings *Self-Portrait* (1493), *Dresden Altarpiece* and *Frederick the Wise* (both 1496), *Mater Dolorosa* (1496–1497), and *Self-Portrait* (1498); also his woodcut cycle *Apocalypse* (1498).

Donato Bramante designed the Canons' Cloister at S. Ambrogio and *tribuna* of Sta. Maria delle Grazie, both in Milan (1492).

Giorgione's paintings *Judgment of Solomon* and *Trial of Moses* (both ca. 1495–1500).

Piero de Cosimo's painting *Death of Procris* (ca. 1490).

Vittore Carpaccio's cycle of paintings *Scenes from the Life of St. Ursula* (1490s).

Gerard David's painting *The Judgment of Cambyses* (1498).

d. Piero della Francesca, Italian artist (ca. 1420–1492).

d. Domenico Ghirlandaio (Domenico Bigordi), Italian fresco painter (ca. 1448–1494); among his final works was the fresco *The Visitation* (1491).

d. Hans Memling, Flemish painter (1430–1494); among his final works were the paintings *Resurrection* (ca. 1490) and *Passion Triptych* (*Crucifixion panel*) (1491).

d. Benedetto da Maiano, Italian sculptor (1442–1497); among his final works was the altar, S. Bartolo, S. Agostino at S. Gimignano (1494).

d. Benozzo di Lese Gozzoll, Italian painter (ca. 1421–1497).

d. Antonio Pollaiuolo, Italian sculptor, painter, and artisan (ca. 1431–1498); among his last works were the tombs of Pope Sixtus IV (1493) and Pope Innocent VIII (ca. 1495).

d. Alesso Baldovinetti, Italian painter and mosaicist (ca. 1426–1499).

d. Geertgen Tot Sint Jans, Dutch painter (ca. 1460–ca. 1490).

PERFORMING ARTS

De musica, treatise by Adam von Fulda (1490).

John Browne, English composer (active ca. 1490).

Henry Medwall, early English playwright (active 1490–1514).

Mary of Nijmegen, Dutch miracle play (ca. 1490).

Viols were brought to Italy from Spain by Valencian pope Rodrigo Borgia (1492).

Akhak kwebon (*Music Handbook*), the first such Korean book known (1493).

Elckerly (*Everyman*), Dutch morality play (1495).

Fulgens and Lucrece, Henry Medwall's play, probably acted in 1497.

Ottaviano die Petrucci used movable type to set and print music (1498).

Celestina, Fernando de Rojas's play (1499).

Musical theorists and instrument builders established the general pattern for tuning of intervals between notes that cannot be changed by a player during a performance, as on a keyboard instrument (ca. 1500).

Sliding mouthpiece used on unkeyed trumpets in Germany (probably from before 16th c.)

Small instrumental groups, including often three trombones with cornets for high parts, used in church to accompany choirs (probably before 1500).

Vina, the classic Indian instrument of a wooden tube with two large gourds attached reached its present design (by 16th c.).

d. Gómez Manrique, Spanish poet and playwright (1412–ca. 1490).

d. Bartolomeo Ramos de Pareia, Spanish composer and music theorist (ca. 1440–ca. 1491).

d. Antoine Busnois, French composer (ca. 1430–1492).

d. Henry Abyndon, English musician (ca. 1420–1497).

d. Johannes Ockeghem, Franco-Flemish composer (ca. 1410–1497).

WORLD EVENTS

Ferdinand of Spain and the Catholic church expelled the Jews from Castile and Aragon (1492).

Granada fell to Christian Spanish forces (1492).

Christopher Columbus, sailing out of Palos, Spain, reached the Caribbean, beginning the European conquest of the Americas (1492).

Henry VII of England besieged Boulogne (1492).

Columbus made his second voyage to the Caribbean (1493).

French forces invaded Italy (1494).

Aberdeen University was founded (1495).

Portuguese Jews and Muslims were forcibly converted to Christianity or expelled (1496).

John Cabot landed on the North American mainland, establishing British claims (1497).

Vasco da Gama sailed around Africa to Calicut, India, beginning the age of direct European contact and colonization of South Asia and the Far East (1498).

Columbus made his third voyage to the Caribbean (1498).

Niccolò Machiavelli became secretary to the government of Florence (1498–1512).

1500

LITERATURE

Amadis de Gaula, Garci Rodriquez de Montalvo's Spanish romance of chivalry (16th c.).

Script based on the Roman alphabet introduced to Vietnam by Portuguese missionaries (16th c. or earlier).

Hubb Khatun, Kashmiri woman poet (ca. 1500).

VISUAL ARTS

Sandro Botticelli's paintings *Magdalene at the Foot of the Cross* (ca. 1500) and *Scenes from the Life of St. Zenobius* (ca. 1500–1505).

Albrecht Dürer's paintings *Lamentation of Christ* (ca. 1500), *Portrait of a Young Man*, and *Self-Portrait*.

Book of Hours of Ane of Brittany, Jean Bourdichon's illuminated work (ca. 1500).

Triumph of Virtue, Andrea Mantegna's painting (ca. 1500).

Leonardo da Vinci's painting *Virgin and Child with St. Anne*.

Giovanni Bellini's painting *The Feast of the Gods* (ca. 1500).

Donato Bramante designed the Cloister, Sta. Maria della Pace, Rome (1500–1504).

The Adulteress Brought Before Christ, Giorgione's painting (ca. 1500).

Piero de Cosimo's painting *The Discovery of Wine* (ca. 1500).

Nimatnamah, cookery book containing the earliest known Indian Islamic paintings (ca. 1500).

Peoples at Key Marco in Florida produced distinctive wood carvings of human figures (ca. 1500).

THEATER & VARIETY

A Play About Duke Karl, Who Is Now Our Emperor, Dutch play by Jan Smeken.

Ataka, Kwanze Kojiro Nobumitsu's *Noh* play (ca. 1500); based on the *Life of Yoshitsune* (ca. 1400).

Everyman (*Den Spieghel der Salicheit van Elckerlijc*), Dutch morality play (ca. 1500).

MUSIC & DANCE

Main bagpipe repertory of laments and *piobaireachd* (*pibroch*), also called *céol mòr* ("great music"), developed in Scottish Highlands (from ca. 1500), especially by the MacCrimmon family.

d. Antonio Cornazano, Italian dancing master (1431–ca. 1500).

Earliest known music written for lute, in Venice (ca. 1500).

Zampogna, a large bagpipe, depicted in Italy (from 16th c.).

WORLD EVENTS

Pedro Alvares Cabral landed in what is now Brazil, claiming it for Portugal, and beginning the long Spanish–Portuguese dispute in that region.

Genoa was taken without a battle by Louis XII.

1501

LITERATURE

Marko Maruli's *Judita*, a Croatian epic dealing with the long struggle for freedom from Turkish domination.

Aldus Manutius's Aldine Press introduced italic type, designed by Francesco Griffo of Bologna, in editions of Virgil and Juvenal.

d. Nawâ'î (Mir 'Ali Shîr), Turkish poet (b. 1441).

VISUAL ARTS

Michelangelo's sculptures *David* and *Madonna and Child* (both 1501–1504).

Raphael's *Altarpiece: the Crucified Christ with the Virgin Mary, Saints and Angels* (Mond Crucifixion), and his paintings *An Allegory* (*Vision of a Knight*), *St. Michael*, *Three Graces*, and *Coronation of the Virgin* (all ca. 1501).

Leonardo da Vinci's painting *Madonna with Yarnwinder*.

Giovanni Bellini's painting *Doge Leonardo Loredan* (ca. 1501).

Mystic Nativity, Sandro Botticelli's painting.

d. Francesco di Giorgio, Italian painter, sculptor, and architect (b. 1439–ca. 1501).

MUSIC & DANCE

Earliest known surviving example of a *vihuela*, a Spanish Renaissance stringed instrument ancestral to the guitar and probably the viol (ca. 1500).

WORLD EVENTS

African slaves arrived in Hispaniola, beginning the slave trade in the New World.

French forces took Naples.

1502

LITERATURE

Printing began in Turkey.

VISUAL ARTS

Albrecht Dürer's painting *Salvator Mundi*.

Wisdom Overcoming the Vices, Andrea Mantegna's painting.

Lucas Cranach the Elder's paintings *St. Francis Receiving the Stigmata* (ca. 1502) and *St. Jerome in Penitence*.

Donato Bramante's *Tempietto*, S. Pietro in Montorio, Rome.

Pyramid at El Tepozteco built in Mexico by Aztecs (ca. 1502–1520).

MUSIC & DANCE

d. Francesco d'Ana, Italian composer and organist (b. ca. 1460).

WORLD EVENTS

Columbus made his fourth voyage to the Caribbean.

Montezuma II became ruler of the Aztec empire (1502–1520).

Vasco da Gama again journeyed to Calicut, India (1502-1503).

1503

LITERATURE

William Dunbar's poem, *The Thistle and the Rose*.

The Nutbrown Maid, an anonymous poem, first published.

Thomas More's poem A *Lamentation of Queen Elizabeth*.

VISUAL ARTS

Mona Lisa (*La Gioconda*), Leonardo da Vinci's painting of the woman with the enigmatic smile; also his painting *Battle of Anghiari* (1503–1506).

Michelangelo's sculptures *Madonna and Child* (*The Pitti Madonna*) and *The Madonna and Child with the Infant St. John* (*Taddei Tondo*); and his painting *Holy Family* (*Doni Madonna*) (all ca. 1503).

Matthias Grünewald's paintings *Lindenhardt Altarpiece* and *Mocking of Christ* (ca. 1503).

Christ on the Cross, Lucas Cranach the Elder's painting.

Madonna with St. Peter Martyr, Lorenzo Lotto's painting.

Mariotto Albertinelli's painting *Visitation*.

THEATER & VARIETY

Comedy of Dorothea, Danish vernacular play.

WORLD EVENTS

Aragonese forces pushed the French out of Naples.

Gonçalo Coelho explored the coast of Brazil.

1504

LITERATURE

Arcadia, Jacopo Sannazaro's influential pastoral romance.

VISUAL ARTS

Rest on the Flight into Egypt, Lucas Cranach the Elder's painting.

Albrecht Dürer's paintings *The Adoration of the Magi* and *The Paumgärtner Altarpiece*, Munich; and his engraving *Adam and Eve*.

Giorgione's paintings *Madonna and Child in a Landscape*, *Madonna and Child with SS. Francis and Liberale*, and *Portrait of a Youth* (all ca. 1504).

Raphael's *The Marriage of the Virgin*.

Fra Baccio Della Porta Bartolommeo's painting *Vision of St. Bernard* (1504–1507).

d. Filippino Lippi, Italian painter (b. ca. 1457).

THEATER & VARIETY

The Life of St. Meriasek, Cornish saint's play.

MUSIC & DANCE

Tibetan dance form *'cham* spread with Tibetan Buddhism into the rest of east central Asia (ca. 1500).

WORLD EVENTS

Hernán Cortés arrived in Cuba.

Ottoman Turks annexed Moldavia and Wallachia.

1505

LITERATURE

John Skelton's poem *Phillip Sparrow* (by 1505).

VISUAL ARTS

Esterházy Madonna, Raphael's painting (ca. 1505–1507); also his paintings *The Madonna of the Goldfinch*, *Portrait of Agnolo Doni*, *Portrait of Maddalena Doni*, and *The Madonna and Child with St. John* (*Madonna del Prato*) (all ca. 1505).

Ober St. Veit Altarpiece, Albrecht Dürer's painting (1505–1506).

Donato Bramante's *Belvedere courtyard* of the Vatican (ca. 1505); new choir, Sta. Maria del Popolo (1505–1509); and plans for rebuilding St. Peter's (1505–1506), all in Rome.

Giorgione's paintings *Boy with an Arrow*, *Fugger Youth*, *Judith*, *Madonna and Child with SS. Roch and Anthony of Padua*, *Shepherd with a Flute*, and *The Tempest* (all ca. 1505).

Giovanni Bellini's paintings *The Madonna of the Meadow* (ca. 1505) and *Enthroned Madonna with Four Saints*.

MUSIC & DANCE

Earliest depiction of a violin, not yet in modern form, in Italy (1505–1508).

d. Adam von Fulda, German composer and theorist (b. ca. 1445).

d. Jacob Obrecht, Netherlands composer (b. ca. 1450).

WORLD EVENTS

Francisco d'Almeida took Kilwa and Mombasa, establishing a Portuguese fort at Kilwa.

1506

VISUAL ARTS

Albrecht Dürer's paintings *Portrait of a Young Man*, *Young Jesus with the Doctors*, and *The Feast of the Rose Garlands*.

Ansidei Madonna, Raphael's painting (ca. 1506).

Titian's earliest known painting, *Votive Picture of Jacopo Pesaro* (ca. 1506).

Giorgione's paintings *Antonio Broccardo* (ca. 1506) and *Laura*.

Lorenzo Lotto's painting *St. Jerome*.

Lucas Cranach the Elder's *St. Catherine Altarpiece*.

d. Andrea Mantegna, Italian painter (b. 1431).

MUSIC & DANCE

d. Alexander Agricola, Franco-Netherlands singer and composer (b. ca. 1446), working mainly in Italian and French courts.

WORLD EVENTS

Madagascar was explored by the Portuguese, moving in force into the Indian Ocean.

1507

LITERATURE

"America" (presumably the Latin version of Italian explorer Amerigo Vespucci's name) first appeared on a map by German cartographer Martin Waldseemüller, referring to the region now named Brazil.

Elijah Levita's verse romance *Bove-Buch*.

VISUAL ARTS

Adam and Eve, Albrecht Dürer's painting.

Raphael's paintings *The Deposition of Christ* and *La Belle Jardinière*.

The Baptism of Christ, Gerard David's painting.

Massys's *Altarpiece of St. Anne*, Brussels (1507–1509).

MUSIC & DANCE

d. Richard Davy, English composer (ca. 1465–ca. 1507), choirmaster at Oxford's Magdalen College (from 1483).

WORLD EVENTS

Failed Portuguese attack on Hormuz.

1508

LITERATURE

William Dunbar's poem *Lament of the Makaris* (ca. 1508).

Printing began in Romania.

VISUAL ARTS

Michelangelo's frescoes on the Sistine Chapel ceiling and upper walls, in the Vatican (1508–1512); part would be destroyed by Michelangelo himself when painting *The Last Judgment* (1536–1541).

Albrecht Dürer's painting *Martyrdom of the Ten Thousand* and engraving *Agony in the Garden*.

Andrea Del Sarto's painting *Madonna* (ca. 1508).

Giorgione's paintings *Adoration of the Shepherds*, *Epiphany*, *Portrait of a Young Man*, *The Holy Family*, and *Nude Woman* (all ca. 1508).

Raphael's paintings *Stanza della Segnatura* (1508–1511) and *The Niccolini-Cowper Madonna*.

Mohammed and the Monk, Lucas van Leyden's painting.

Matthias Grünewald's painting *The Crucifixion* (before 1508).

Massys's painting *Lamentation* (1508–1511).

Donato Bramante's *Palazzo dei Tribunali*, Rome.

THEATER & VARIETY

Lodovico Ariosto's play *La cassaria* opened in Ferrara.

WORLD EVENTS

Portuguese Indian Ocean fleet defeated by Indian fleet and allies off Chaul.

Vatican, Austria, France, and Spain allied against Venice.

1509

LITERATURE

Desiderius Erasmus's satire *The Praise of Folly* (*Moriae encomium*).

VISUAL ARTS

Rock gardens of the Daisen-in, among the most famous of Japan's "dry" landscape gardens, established in Daitoku-ji, Kyoto, probably by Abbot Kogaku (ca. 1509).

Albrecht Dürer's engravings *Man of Sorrows* and the series *Small Passion* (1509–1511).

Andrea Del Sarto's painting *Five Episodes from the Life of S. Filippo Benizzi* (1509–1510).

d. Shên Chou, Chinese painter and calligrapher (1427–1509), one of the four Ming master painters, of the Suchou school.

THEATER & VARIETY

Ludovico Ariosto's play *I suppositi* opened in Ferrara.

MUSIC & DANCE

William Cornysh was the leading figure in the court plays and entertainments of England's King Henry VIII (1509–before 1523).

WORLD EVENTS

Henry VIII became king of England; married Catherine of Aragon.

Portuguese weaponry destroyed a massive fleet from allied Indian Ocean countries; with sea mastery, the Portuguese moved to fully monopolize trade and plant colonies in the region.

Sebastian Cabot reached Hudson Bay.

Spain expanded on the North African coast, taking Oran.

1510

LITERATURE

Garci Rodriquez de Montalvo's romance *Las sergas de Esplandián*.

VISUAL ARTS

Titian's paintings *Gipsy Madonna* (ca. 1510), *The Concert* (1510–1512), and frescoes *Three Miracles of St. Anthony of Padua* (1510–1511).

Giorgione's paintings *Self-Portrait as David*, *Sleeping Venus*, *La Vecchia* (*The Old Woman*), *Pastoral Concert*, and *The Three Philosophers* (all ca. 1510).

Noli Me Tangere, Andrea Del Sarto's painting.

Correggio's painting *The Mystic Marriage of St. Catherine* (1510–1514).

Giovanni Bellini's painting *Madonna*.

The Holy Kinship, Lucas Cranach the Elder's painting (ca. 1510–1512).

Ecce Homo, Lucas van Leyden's painting.

Donato Bramante's House of Raphael, Rome (formerly Palazzo Caprini) (ca. 1510).

Mariotto Albertinelli's painting *Annunciation*.

Alejo Fernandez's painting *Virgen de la Rose* (1510–1520).

d. Sandro Botticelli, Italian painter (b. 1445).

THEATER & VARIETY

Gil Vicente's *Auto da Fé*.

MUSIC & DANCE

Virginals of polygonal design made in Italy (from 1510s); rectangular forms were also made later in the century.

WORLD EVENTS

Afonso d'Albuquerque became viceroy in India, pursuing Portuguese aims in the Indian Ocean; Portuguese took Goa.

1511

VISUAL ARTS

Andrea Del Sarto's paintings *Procession of the Magi*, *Baptism of Christ*, and *The Archangel Raphael, Tobias, St. Leonard, and a Donor*; also his fresco series *The History of St. John the Baptist* (ca. 1511–1526).

Adoration of the Trinity, Albrecht Dürer's painting.

Triumph of Galatea, Raphael's painting (1511–1513).

Matthias Grünewald's painting *St. Cyriakus and St. Lawrence* (1511–1513).

d. Giorgione (Giorgione da Castelfranco), Italian painter (b. ca. 1477).

THEATER & VARIETY

Play of William Tell, Swiss pre-Lent carnival play (*Fastnachtsspiel*).

MUSIC & DANCE

First known European book to describe what sets of instruments should be used to perform what types of musical works; by Virdung.

Spiegel der Orgelmacher und Organisten, Arnolt Schlick's treatise on organ building and playing.

d. Antoine de Févin, French composer (ca. 1470–1511/1512).

d. Johannes Tinctoris, Franco-Flemish music theorist and composer (ca. 1435–1511?).

WORLD EVENTS

Afonso d'Albuquerque took Malacca.

Babur took Samarkand.

Poland and Russia were at war (1511–1522).

1512

VISUAL ARTS

Titian's paintings *Young Man with Cap and Gloves*, *Sacred and Profane Love* (both 1512–1515), and *Gentleman in Blue* (*Ariosto*) (ca. 1512).

Andrea Del Sarto's paintings *Marriage of St. Catherine* (1512–1513) and *Annunciation*.

Albrecht Dürer's painting *Portrait of Charlemagne* (1512–1513); also his engraving *Ecce Homo*.

Raphael's painting *Stanza d'Eliodoro* (1512–1514).

Salome, Alonso Berruguete's painting (ca. 1512).

Jacob Cornelisz van Oostsanen's *Adoration of the Shepherds*.

MUSIC & DANCE

Earliest reference to the melody *Hey, tutti tattie*, later combined with Robert Burns's 1793 poem to become the unofficial Scottish anthem *Scots wha ha'e wi' Wallace bled*.

Shawn bands became popular, playing stately music, sometimes supplemented by cornet and trombone (ca. 16th–mid-17th c.).

WORLD EVENTS

Battle of Ravenna; French driven out of Italy.

England and France were at war (1512–1513).

1513

LITERATURE

The Prince (*Il Principe*), Niccolò Machiavelli's contro-

versial treatise on how to gain, hold, and wield political power, with Cesare Borgia as a model prince, written from exile.

Thomas More's *The History of Richard III*.

VISUAL ARTS

Sistine Madonna, Raphael's famous altarpiece painting, with Mother and Child floating among the clouds; also his *Chigi Chapel* (ca. 1513–1514).

Albrecht Dürer's engravings *Knight, Death and the Devil* and *St. Jerome in His Study*.

Andrea Del Sarto's paintings *Holy Family* (ca. 1513), *Birth of the Virgin* (ca. 1513–1514), and *Portrait of a Young Woman* (*Lucrezia del Fede*) (1514–1515).

Domenico di Pace Beccafumi's *The Trinity*.

St. Jerome with St. Christopher and St. Augustine, Giovanni Bellini's painting.

THEATER & VARIETY

Eclogue of Plácida and Vitoriano, Juan del Encina's early Spanish Renaissance play (ca. 1513).

Niccolò Machiavelli's comedy–satire *La Mandragola* (*The Mandrake*) (1513–1520).

MUSIC & DANCE

Larger snare drums had developed, as later depicted in Rembrandt's *The Night Watch*; also techniques had developed for holding down the drumhead directly, rather than perforating it for stringing cords (ca. 1500).

WORLD EVENTS

Vasco Núñez de Balboa crossed the Isthmus of Panama, and reached the Pacific.

Juan Ponce de León landed in Florida.

1514

LITERATURE

Complutensian Polyglot, a multivolume Christian version of the Bible, containing the Hebrew Bible, along with Greek, Latin, and some Aramaic translations, edited under the direction of Spain's Cardinal Ximenes and printed in Alcala (1514–1517; released 1522).

VISUAL ARTS

Albrecht Dürer's engraving *Melencholia I*.

Correggio's paintings *Adoration of the Kings* (ca. 1514), *Christ Taking Leave of His Mother* (1514–1517), *Four Saints* (1514–1517), *Madonna of St. Francis* (1514), and *Campori Madonna* (1514–1517).

Lucas Cranach the Elder's paintings *Duchess Katharina von Mecklenburg* and *Duke Henry the Pious*.

Raphael's *Stanza dell'Incendio* (1514–1517).

St. Catherine Receiving the Stigmata, Domenico di Pace Beccafumi's painting (ca. 1514).

d. Donato Bramante, Italian architect (b. 1444).

THEATER & VARIETY

Giovanni Rucellai's tragedy *Oreste*.

The Last Judgment (*Theocrisis*), Gian-Francesco Conti's French morality play.

WORLD EVENTS

Peace of London ended the French–English war.

Peasant revolts in Hungary.

Polish–Russian War; Russians took Smolensk after a siege.

1515

LITERATURE

Scottish Field, an anonymous poem better known as *The Battle of Flodden* (ca. 1515).

Magnificence, John Skelton's poem (written 1515-1516).

Printing began in Greece.

d. Aldus Manutius (Teobaldo ["Aldo"] Mannucci), Italian scholar and publisher (1449–1515), founder of the Aldine Press, Venice.

VISUAL ARTS

Andrea Del Sarto's paintings included *Christ the Redeemer*, *Holy Family* (both ca. 1515), and *The Stories of St. Joseph the Jew* (1515–1516).

Titian's paintings included *The Three Ages of Man*,

Salome, and *Flora* (all ca. 1515).

Lucas Cranach the Elder's paintings included *The Nativity* and *Virgin and Child with St. Anne* (both ca. 1515–1520).

Rescue of Andromeda, Piero de Cosimo's painting.

d. Mariotto Albertinelli, Florentine painter (b. 1474).

d. Vincenzio Foppa, Italian painter (b. 1427).

THEATER & VARIETY

Pamphilus Gengenbach's morality play *Das Spiel von den zehn Altern*.

MUSIC & DANCE

Hans Judenkünig's first *Lutebook* (ca. 1515–1519).

d. Antoine Brumel, French composer (b. ca. 1460).

WORLD EVENTS

Francis I of France attacked Milan, defeating the Milanese army at Marignano, and then taking Milan and Genoa.

Ottoman Turks took Algeria and Tunisia (1515).

1516

LITERATURE

Erasmus, working as scholar–editor for Basel-based publisher Johann Froben, oversaw publication of the New Testament in Greek, making it widely available to scholars for the first time, along with Erasmus's Latin translation.

Erasmus's *Colloquies*; Johann Froben sold 24,000 copies in just a few months; by contrast, the contemporary publisher Vespasiano used 55 writers for two years to produce 200 handwritten books.

Printed version of the full Hebrew Bible, with rabbinic commentary, edited by Felix Pratensis and published by Daniel Bomberg in Venice (1516–1517).

Ludovico Ariosto's poem *Orlando Furioso*.

John Skelton's poem *Elinour Rumming (Visitors to the Ale-House)* (ca. 1517).

Thomas More's *Utopia*, a political work analyzing England's ills, then describing a place free of such problems; the name literally means "nowhere," from the Greek *ou* ("not") and *topos* ("a place"), and spawned many other utopias.

VISUAL ARTS

Raphael's works included *Palazzo Pandolfini*, Florence, and *S. Eligio degli Orefici* (both ca. 1516); his *Tapestry cartoons* for Leo X (ca. 1516); and his painting *Portrait of Balthasar Castiglione*.

Isenheim Altarpiece, Matthias Grünewald's painting (before 1516).

Titian's painting *Assumption* (1516–1518).

Madonna with Child and St. John, Andrea Del Sarto's painting.

Lucas Cranach the Elder's painting *A Princess of Saxony* (ca. 1516–1518).

Neptune and Amphitrite, Jan Gossaert's painting.

d. Giovanni Bellini, Venetian painter (ca. 1430–ca. 1516).

d. Hieronymus Bosch, artist of Brabant (b. 1450).

THEATER & VARIETY

Giovanni Rucellai's tragedy *Rosmunda*.

MUSIC & DANCE

Isagoge in musicen, Heinrich Glarean's treatise on the elements of music.

WORLD EVENTS

Juan Díaz de Solis discovered the River Plate.

Ottoman Turks took Syria.

1517

LITERATURE

Ludovico Ariosto's *Satire* (1517–1525).

VISUAL ARTS

Andrea Del Sarto's paintings included *Disputation on the Trinity*, *Holy Family*, and *Portrait of a Young Man* (all 1517–1518); *The Virgin and Child with St. John the Baptist and Two Angels* (ca. 1517); and *Madonna of the Harpies*.

Correggio's frescoes for Camera di S. Paolo, Parma (1517–1520).

St. John the Baptist, Leonardo da Vinci's painting (before 1517).

Transfiguration, Raphael's painting (1517–ca. 1520).

Pedro Machuca's *Madonna del suffragio*.

Monastic cathedral built at Curtea-de-Arges, Moldavia (Romania) (ca. 1517).

d. Fra Baccio Della Porta Bartolommeo, Italian painter (b. 1472 or 1475).

THEATER & VARIETY

Gil Vicente's plays *Auto da Alma* and his *Barcas* trilogy: *Barca do Glória*, *Barca do Inferno*, and *Barca do Purgatório* (all 1517–ca. 1519).

MUSIC & DANCE

d. Gaspar van Weerbeke, Netherlands composer (ca. 1445–ca. 1517).

d. Heinrich Isaac, Flemish composer (b. ca. 1450).

WORLD EVENTS

Martin Luther's 95 Theses, posted at Wittenberg, began the Protestant Reformation.

Portuguese traders arrived at Canton.

1518

LITERATURE

First printed copy of the *Septuagint*, the early Greek translation of the Old Testament, published by Aldine Press; the *Complutensian Polyglot* was printed first (1514–1517), but not released until 1522.

d. Kabir, Indian poet (b. 1440).

VISUAL ARTS

Raphael's paintings included *St. Michael Vanquishing Satan* and *The Holy Family of Francis I*.

Titian's painting *Worship of Venus* (1518–1519).

Charity, Andrea Del Sarto's painting.

Albrecht Altdorfer's altar for S. Florian near Linz.

Jacopo Carucci Pontormo's painting *Joseph in Egypt* (1518–1519).

Reclining River Nymph at the Fountain, painting by Lucas Cranach the Elder.

MUSIC & DANCE

Choralis constantinus, Heinrich Isaac's posthumous three-volume collection published (after 1517).

d. Loyset Compère, French composer (b. ca. 1445).

WORLD EVENTS

Ottoman Turks defeated insurrections in Anatolia and Syria, further consolidating their hold on both countries.

Portuguese established a fort at Colombo, Ceylon.

Khair-ed-Din took power in Algiers, expelling Spanish occupation forces.

1519

LITERATURE

John Skelton's poem *Colin Clout* (ca. 1519).

VISUAL ARTS

d. Leonardo da Vinci, Florentine artist, scientist, and quintessential Renaissance figure (b. 1452).

Titian's altarpiece the *Pesaro Family*, Sta. Maria dei Frazi, Venice (1519–1526).

Michelangelo's sculpture *Christ Bearing the Cross* (1519–1520).

Hans Holbein the Younger's paintings *The Last Supper*, *The Flagellation*, and *Portrait of Bonifacius Amerbach* (1519–1520).

Matthias Grünewald's paintings included *Miracle of the Snow*, *The Small Crucifixion*, and *Virgin of Stuppach*.

Chambord, the French chateau, built (from 1519).

MUSIC & DANCE

Viols were taken from Italy to England, by Henry VIII, and to Germany (before 1520).

WORLD EVENTS

Ferdinand Magellan began his around-the-world voyage (1519–1521), rounding Cape Horn,

making the first known crossing of the Pacific; after his death (1521), one ship of five completed the journey.

Hernán Cortés began the conquest of Mexico (New Spain).

1520

LITERATURE

Celebrated Chronicle, a Burmese history.
John Skelton's poem *A Garland of Laurel* (ca. 1520).

VISUAL ARTS

Michelangelo began the Medici Chapel, which was to contain the tombs of four Medici family members (1520–1534); it would include his magnificent sculpture *Moses* (after 1513).
Pietà, Andrea Del Sarto's painting (ca. 1520).
Correggio's works included the frescoes on the cupola of S. Giovanni Evangelista, Parma, and the paintings *Ecce Homo*, *Madonna of St. Sebastian*, *Mystic Marriage of St. Catherine*, *Noli Me Tangere*, and *The Sojourn in Egypt* (1520–1526).
Titian's paintings included the *Bacchus and Ariadne*, *Man with a Glove*, and *Madonna and Saints with a Donor* (1520–1523).
d. Raphael (Raffael Sanzio), a major figure of the Italian Renaissance (b. 1483).

THEATER & VARIETY

Ludovio Ariosto's play *Il negromante*.
Pastoral, play by Angelo Boelco (Il Ruzzante).

MUSIC & DANCE

Fundamentum, Hans Buchner's work on keyboard notation and techniques for organ.

WORLD EVENTS

Montezuma murdered by the Spanish.
Pope Leo X excommunicated Martin Luther.

1521

LITERATURE

John Skelton's poem *Speak, Parrot* (written ca. 1521; first published 1554).

VISUAL ARTS

Albrecht Dürer's paintings *Lorenz Sterck* and *St. Jerome*.
Francesco Mazzola Parmigianino's painting *The Marriage of St. Catherine*.
Hans Holbein the Younger's painting *Dead Christ*.
Lucas Cranach the Elder's painting *Martin Luther as St. George* (ca. 1521).
d. Jean Bourdichon, French painter and illuminator (b. ca. 1457).
d. Piero di Cosimo, Italian painter (ca. 1462–1521?).

THEATER & VARIETY

Pamphilus Gengenbach's *The Corpse-Eaters*, a powerful indictment of the Catholic church.

MUSIC & DANCE

d. Arnolt Schlick, German organist and composer (b. ca. 1460).
d. Josquin Desprez, northern French composer (b. ca. 1440).
d. Robert Fayrfax, English composer (b. 1464).

WORLD EVENTS

Anabaptist movement was founded in Wittenberg.
d. Ferdinand Magellan (Ferñao de Magalhaes), Portuguese explorer (b. ca. 1480), killed in the Philippines.

1522

LITERATURE

Martin Luther's translation of the New Testament, based on Erasmus's Greek Testament, printed in Wittenberg, with illustrations by Lucas Cranach the

Elder; the Old Testament, based on the Hebrew Bible, appeared later in sections (1522–1534).

VISUAL ARTS

Andrea Del Sarto's paintings *Assumption of the Virgin* and *Madonna della Scala*.

Matthias Grünewald's paintings *Christ Bearing the Cross* and *Crucifixion*.

Titian's *Resurrection Altarpiece*.

Chiu Ying, Chinese painter (active 1522–1560).

THEATER & VARIETY

Gil Vicente's play *Dom Duardos*.

The Woman of Ancona, play by Angelo Boelco (Il Ruzzante).

MUSIC & DANCE

d. Jean Mouton, French composer, a key motet composer of the early 16th century. He wrote over 100 motets, approximately 15 masses, and over 20 chansons (b. 1459?).

WORLD EVENTS

Hernán Cortés appointed governor and captain-general of New Spain (Mexico).

England and France were at war.

Ottoman Turks took Rhodes.

1523

LITERATURE

New French version of the New Testament, probably by Jacques Lefèvre d'Étaples (Faber Stapulensis) published in Paris; the Old Testament appeared in 1528 in Antwerp, so the two were called the *Antwerp Bible*.

Die Wittenbergisch Nachtigall (*The Nightingale of Wittenberg*), Hans Sachs's allegorical poem praising Martin Luther.

VISUAL ARTS

Michelangelo designed the Biblioteca Lauranziana

(Laurentian Library), S. Lorenzo, Florence (1523–1559).

Correggio's paintings *Madonna of St. Jerome* and *Il Giorno*.

Titian's paintings *The Andrians* (1523–1524) and *Federico II Gonzaga, Duke of Mantua* (ca. 1523).

Hans Holbein the Younger's painting *Portrait of Erasmus* (1523–1524).

Matthias Grünewald's painting *The SS. Erasmus and Mauritius*.

d. Gerard David, Flemish painter.

THEATER & VARIETY

Gil Vicente's comedy–satire *Farsa de Inés Pereira*.

MUSIC & DANCE

Hans Judenkünig's second *Lutebook*.

Toscanello, Pietro Aaron's treatise on musical practice.

Marco Antonio Cavazzoni wrote a volume of keyboard music.

d. Juan de Anchieta, Spanish composer (b. 1462).

d. William Cornysh, English composer.

WORLD EVENTS

Babur took the Punjab.

Pedro de Alvaro conquered Guatemala for Spain.

1524

LITERATURE

Printed version of the full Hebrew Bible, with rabbinic commentary, edited by Jacob ben Hayim ibn Adonijah and published in four volumes by Daniel Bomberg in Venice (1524–1525); highly influential into the 20th century.

Danish-language translation of Luther's New Testament, prepared by Christiern Vinter and Hans Mikkelsen, published in Wittenberg.

VISUAL ARTS

d. Joachim de Patenier (or Patinir), Flemish painter (b. ca. 1485).

THEATER & VARIETY

Giangiorgio Trissino's *Sofonisba*, a classical tragedy after Livy, but in the Greek style.
d. Bartolomé de Torres Naharro, Spanish playwright who worked largely in Italy (b. ca. 1485).

MUSIC & DANCE

Martin Luther's *Kirchenlieder* (*Church-Songs*), including the great hymn *A Mighty Fortress Is Our God* (*Ein feste Burg ist unser Gott*).

WORLD EVENTS

Giovanni Verrazano reached Newfoundland and Belle Isle, and reportedly realized that North America was a continent.
Peasant revolts in Germany, led by Thomas Münzer.
Spain founded the Council of the Indies.

1525

LITERATURE

William Tyndale produced a new English version of the New Testament, working directly from the Greek, printed on the Continent, since proscribed in England.
Printer–publisher Geoffroy Tory introduced the more open Italian typestyles into France in works such as *Horae*.

VISUAL ARTS

Correggio's paintings *Holy Family with St. James* and *Madonna of the Bowl* (both ca. 1525).
Jan Mostaert's painting *Landscape of the West Indies* (ca. 1525–1530).
Matthias Grünewald's painting *Mourning over the Body of Christ* (before 1525).
Titian's painting *Venus Anadyomene* (ca. 1525).
d. Vittore Carpaccio, Italian painter (ca. 1460–ca. 1525/1526).

THEATER & VARIETY

Niccolò Machiavelli's *Clizia*.
d. Giovanni Rucellai, Italian playwright (b. 1475).
d. Pamphilus Gengenbach, printer and playwright (b. ca. 1480).

MUSIC & DANCE

In western Europe, flutes were made in sets of three sizes—treble, alto-tenor, and bass (early 16th c.).
Cittern, a plucked, metal-string instrument, in widespread use (ca. 16th–mid-17th c.).

WORLD EVENTS

Ottoman Turks decisively defeated Hungarians at Mohacs, control of the Hungarian plain opening the way into central Europe; Louis II of Hungary killed.
German peasant revolts failed.

1526

LITERATURE

Jacob van Liesvelt of Antwerp published a Dutch translation of the Bible, the first modern vernacular version to segregate out disputed writings called the Apocrypha.
Jacopo Sannazaro's epigrams and elegies *Eclogae piscatoriae*; also his Christian epic *De partu virginis*.
First Swedish-language version of the New Testament, based primarily on Luther's, was published at Stockholm.

VISUAL ARTS

Albrecht Dürer's engraving *Erasmus of Rotterdam* and his painting *Four Apostles*.
Hans Holbein the Younger's paintings included *Sir Thomas More*, *Magdalena Offenburg as Venus*, and *Virgin with the Family of the Burgomaster Jakob Meyer* (*Darmstadt Madonna*).
Lucas Cranach the Elder's paintings included *Adam and Eve*, *Cardinal Albrecht of Brandenburg as St. Jerome*, and *David and Bathsheba*.

Correggio's *Assumption of the Virgin*, on the cupola of Parma Cathedral (1526–1530).

Giulio Romano's Palazzo del Tè, Mantua.

Lucas van Leyden's triptych *Last Judgment*.

Titian's painting *Entombment* (1526–1532).

Tradition of pleasure gardens brought to India by Babar (1526–1530).

THEATER & VARIETY

Pietro Aretino's comedy–satire *La Cortigiana*.

MUSIC & DANCE

d. Hans Judenkünig, German lutenist, leading Viennese lute composer (b. ca. 1450).

WORLD EVENTS

Babur invaded northern India, defeating Indian forces at Panipat (Ibrahim Shah killed), and then took Delhi, founding the Mughal dynasty.

Spanish made their first settlement on the South Carolina coast.

1527

LITERATURE

d. Niccolò di Bernardo dei Machiavelli, Florentine writer and statesman (b. 1469).

VISUAL ARTS

Andrea Del Sarto's paintings included *The Last Supper*, *Holy Family with the Infant St. John*, and *The Sacrifice of Abraham*.

Hans Holbein the Younger's paintings included *Portrait of Lady Guildford* and *Sir Henry Guildford*, and *Portrait of William Warham, Archbishop of Canterbury*.

Alejo Fernandez's altarpiece *Lamentation of Christ*, Seville Cathedral.

THEATER & VARIETY

The Estrella Range, Gil Vicente's play.

MUSIC & DANCE

d. Heinrich Finck, German composer (b. 1444–1445), who worked in Poland and Lithuania, as well as Germany.

WORLD EVENTS

Rome was taken and sacked by imperial troops commanded by Charles de Bourbon; many Renaissance artworks stolen and some destroyed.

Atahuallpa succeeded Huayna Capac as Inca ruler.

Ferdinand III became king of Bohemia and Hungary.

1528

LITERATURE

Erasmus published *De recta Latini Graecique sermonis pronuntiatione* (*On the Correct Pronunciation of Latin and Greek*), a highly controversial and influential work.

VISUAL ARTS

Andrea Del Sarto's paintings included *Abraham's Offering*, *Charity*, *Madonna with Six Saints*, and *Self-Portrait*.

Hans Holbein the Younger's paintings included *Portrait of Nicolas Kratzer*, *Portrait of Sir Thomas Godsalve and His Son Sir John*, and *Portrait of the Artist's Wife with Katharina and Philipp*.

Domenico di Pace Beccafumi's *The Mystic Marriage of St. Catherine*.

Fontainebleau, quintessential French chateau of François I, built (from 1528).

d. Albrecht Dürer, German painter (b. 1471).

d. Matthias Grünewald, German artist (b. ca. 1460).

THEATER & VARIETY

Ruzzante Come Back from the War and *La Moschetta* (*The Coquette*), plays by Angelo Boelco (Il Ruzzante).

MUSIC & DANCE

d. Francisco de Peñalosa, Spanish singer and com-

poser (b. ca. 1470), who sang at the papal chapel in Rome (from 1517).

WORLD EVENTS

Francisco Pizarro became Spanish governor of Peru.

Henry VIII actively pressed for a divorce from Catherine of Aragon.

1529

LITERATURE

England's Henry VIII was the first European monarch to censor the press, issuing a list of banned books including Thomas More's *Utopia*.

French printer Geoffroy Tory published *Champs Fleury*, an influential work on letter design.

d. Baldassar Castiglione, Italian writer (b. 1478).

d. John Skelton, English poet (b. ca. 1460).

VISUAL ARTS

Lucas Cranach the Elder's paintings included *The Stag Hunt of the Elector Frederick the Wise* and *Portrait of Dr. J. Scheyring*.

Andrea Del Sarto's painting *The Sacrifice of Isaac, Prisoner of an Angel* (ca. 1529).

Albrecht Altdorfer's painting *Battle of Issus*.

THEATER & VARIETY

Ludovico Ariosto's play *La lena*.

Christ Crucified (*Christus Xylonicus*), Nicholas Barthélémy's French morality play.

MUSIC & DANCE

d. Juan del Encina, Spanish poet, dramatist, and composer (1468–ca. 1529), who worked at Spanish pope's court in Rome.

WORLD EVENTS

Thomas More became lord chancellor of England, after Henry VIII had sacked Cardinal Wolsey.

Ottoman Turks besieged and came very close to taking Vienna.

1530

LITERATURE

William Tyndale's new English-language translations of the Old Testament began to appear, book by book.

John Palsgreave's *Lesclarcissement de la Langue Françoyse*, the first French grammar, published in England.

Geoffroy Tory was named *Imprimeur du roi*, printer to the French king.

d. Babur (Zahir ud-Din Muhammad), founder of India's Mughal dynasty, poet, and diarist (1483–1530), who wrote a much-translated *Autobiography*.

d. Jacopo Sannazaro, Italian poet (b. 1456), the year his *Rime* appeared.

d. William Dunbar, Scottish poet (ca. 1465–ca. 1530).

VISUAL ARTS

d. Andrea Del Sarto (born Andrea d'Agnolo), Florentine painter and draftsman (b. 1486), a major figure of the Italian Renaissance; among his last works was *Portraits of the Artist and His Wife, Lucrezia* (ca. 1530).

Correggio's paintings included *Leda* and *The Virtues* (both ca. 1530s).

Lucas Cranach the Elder's paintings included *Apollo and Diana in a Wooded Landscape*, *Hercules and Antaeus*, *The Judgment of Paris*, and *Venus and Cupid*.

Titian's paintings included *Madonna and Child with SS. John the Baptist and Catherine of Alexandria* and *Madonna and Child with St. Catherine and a Rabbit*.

Francesco Mazzola Parmigianino's painting *Madonna with St. Zachary, the Magdalen and St. John* (ca. 1530).

d. Quentin (Massys or Matsys or Messys), Flemish artist (b. 1465–1466).

THEATER & VARIETY

John Heywood's *The Playe called the foure P.P.; a newe and a very mery enterlude of a palmer, a pardoner, a potycary, a pedlar*, a group of four vignettes (ca. 1530).

The Comedy of Flora, play by Angelo Boelco (Il Ruzzante).

MUSIC & DANCE

Jean Courtois, Franco-Flemish composer (active 1530–1545).
Luys de Narváez, Spanish composer and vihuelist (active 1530–1550).

WORLD EVENTS

Charles V became Holy Roman Emperor.
Malta taken by the Knights of St. John of Jerusalem.

1531

LITERATURE

Le Miroir d l'âme pécheresse, Marguerite de Navarre's first publication, a religious poem condemned by Paris's Sorbonne Faculty of Theology for spreading Luther's doctrines.

VISUAL ARTS

Lucas Cranach the Elder's paintings *Feat of Herod* and *The Old Lover*.

MUSIC & DANCE

Pietro Paolo Borrono, Italian composer and lutenist (active 1531–1549).

WORLD EVENTS

Civil war between Swiss Protestant and Catholic cantons; Huldrych Zwingli was killed at Battle of Kappel.
Henry VIII proclaimed himself head of the Church in England.

1532

LITERATURE

Luigi Alamanni's satire, *Opere toscane* (1532–1533).
d. Tulsidas (Tulsi Das) of Rajapur, Indian poet, best

known for his *Ramacaritmana*, based on the *Ramayana* (d. 1623).

VISUAL ARTS

Michelangelo's sculpture *Victory* (ca. 1532–1534).
Correggio's painting *The School of Love* (ca. 1532).
Hans Holbein the Younger's paintings included *Erasmus in the Roundel*, *Hans of Antwerp*, and *Portrait of the Merchant Georg Gisze*.
Lucas Cranach the Elder's paintings *The Payment* and *Venus*.

THEATER & VARIETY

Étienne Joselle, French Renaissance poet and playwright (d. 1573).

MUSIC & DANCE

Musica instrumentalis deudsch, Martin Agricola's treatise on musical instruments, describing many now unknown or much changed.
Earliest known example of carillon with manual keyboard for playing bells, from Bruges.

WORLD EVENTS

Pizzaro attacked the Inca Empire, taking Atahuallpa prisoner at Cajamarca.
Thomas More resigned as England's lord chancellor.

1533

LITERATURE

d. Ludovico Ariosto, Italian poet (b. 1474).
d. Geoffroy Tory, French typographer and printer (ca. 1480–ca. 1533).

VISUAL ARTS

The Last Judgment, Michelangelo's painting on the ceiling of the Sistine Chapel of the Vatican (1533–1541), one of the central works of the Renaissance, actually painted over some of his earlier frescoes (1508–1512).
Titian's painting *Alfonso d'Avalos, Marques del Vasto*.
Hans Holbein the Younger's paintings included

Derick Born, *Dirk Tybis of Duisburg*, and *Jean de Dinteville and Georges de Selve (The Ambassadors)*.

Jacob Cornelisz van Oostsanen's *Self-Portrait*.

d. Lucas van Leyden, Dutch painter (b. 1494).

THEATER & VARIETY

d. Lodovico Ariosto, Italian poet and playwright (b. 1474).

Pietro Aretino's play *The Sea Captain*.

John Heywood's *The Play of the Wether* and *The Play of Love*.

WORLD EVENTS

Pope Clement VII excommunicated Henry VIII of England, who had Archbishop Cranmer grant his divorce from Catherine of Aragon and married Anne Boleyn.

Cartagena, Colombia, founded.

1534

LITERATURE

Ragionamenti, Pietro Aretino's bawdy exploration of the courtesan's world (1534–1536).

Cambridge University Press founded.

Printing began in the New World in Mexico.

German-language Roman Catholic Bible published in Mainz, by Johann Dietenberger based on earlier work by Heironymus Emser and on Luther's Old Testament; this became the standard German Catholic version.

Publication of Lutheran Bible complete (begun 1522).

VISUAL ARTS

Titian's painting *The Presentation of the Virgin in the Temple* (1534–1538).

d. Correggio (Antonio Allegri Correggio), Italian painter (b. 1494).

MUSIC & DANCE

Viola developed in northern Italy, especially for playing dances (1530s).

WORLD EVENTS

Jacques Cartier landed at Chaleur Bay, on the New Brunswick coast, beginning the French exploration and colonization of North America.

Pope Clement VII invalidated the marriage of Henry VIII and Anne Boleyn.

1535

LITERATURE

First printed English version of the complete Bible, translated by English bishop Miles Coverdale, and first to segregate the Apocrypha; printed in either Zurich or Cologne, but later editions had royal approval for printing in England.

First French Protestant version of the Bible appeared, translated by Pierre-Robert Olivétan and printed at Serrières, near Neuchâtel.

Sejarah Melayu (The Malay Annals) (ca. 1535).

d. Thomas More, English lawyer–statesman, humanist scholar, and author (b. 1478), executed by King Henry VIII.

VISUAL ARTS

Hans Holbein the Younger's work included the woodcut for the title page of *Coverdale's Bible*, the woodcut *Erasmus im Gehüs*, and the painting *Portrait of Charles de Solier, Sieur de Morette*.

Titian's painting *Doge Andrea Gritti* (1535–1538).

d. Kamal Ud-din Bihzad, Persian painter (b. ca. 1460).

MUSIC & DANCE

Bass shawn (*Basspommer*), six feet tall, developed in Germany.

Depiction of a small cello in G. Ferrari's angel frescoes in the church at Saronno, near Milan (ca. 1535).

d. Bartolomeo Tromboncino, Italian composer (ca. 1470–ca. 1535).

WORLD EVENTS

Jacques Cartier again voyaged to North America, traversing the St. Lawrence River as far as Ottawa, and founding Montreal.

Lima and Buenos Aires were founded.

1536

LITERATURE

Thomas Wyatt's poems *In Mourning Wise, Mine Own John Poyntz, If Walker Care,* and *Who List His Wealth and Ease Retain* (all ca. 1536).

d. Desiderius Erasmus, Dutch scholar and philosopher (b. 1466).

VISUAL ARTS

Hans Holbein the Younger's portrait paintings included *Henry VIII, Jane Seymour,* and *Sir Richard Southwell.*

Titian's painting *Francesco Maria della Rovere, Duke of Urbino* (1536–1538).

THEATER & VARIETY

d. Gil Vicente, Portuguese playwright (b. ca. 1465), regarded as the founder of Portuguese drama.

MUSIC & DANCE

Luis de Milán's *Libro de música de vihuela de mano intitulado El maestro,* the first collection of music for vihuela (and therefore guitar).

WORLD EVENTS

Henry VIII had Anne Boleyn beheaded; he then married Jane Seymour.

Hundreds of smaller English monasteries were shut down by Parliament.

1537

LITERATURE

New English translation of the Bible appeared, called *Matthew's Bible* after supposed translator Thomas Matthew (probably actually John Rogers), drawing heavily on the Tyndale and Coverdale Bibles.

Pietro Aretino's *Letters,* commenting on contemporary Italian life (1537–1557).

MUSIC & DANCE

Costanzo Festa published his first book of madrigals for three voices.

d. Paul Hofhaimer, Austrian organist and composer, the most notable organist of his day (b. 1549).

WORLD EVENTS

d. Jane Seymour (b. 1509?), third wife of Henry VIII; died after giving birth to Edward VI.

Ignatius Loyola was ordained.

1538

LITERATURE

Hans Holbein's *Dance of Death* was printed in Lyon, using blocks cut in Basel.

To suppress "naughty printed books," British government required that each book be licensed before printing and prohibited importation of books in English printed abroad.

VISUAL ARTS

Hans Holbein the Younger's works included the woodcut *Dance of Death,* the woodcuts in *Icones historiarum Veteris Testamenti* and the painting *Christina of Denmark, Duchess of Milan.*

Titian's painting *Venus of Urbino* (1538–1539).

Paris Bordone's painting *Presentation of the Ring of St. Mark to the Doge.*

d. Albrecht Altdorfer, German painter (b. ca. 1485).

THEATER & VARIETY

John Bale's *Kynge Johan,* the first English historical play.

Francisco de Sá de Miranda's comedy *Os vilhalpandos* (ca. 1538).

MUSIC & DANCE

Luys de Narváez wrote music for solo vihuela, including fantasias, variations, and arrangements of vocal pieces and songs.

d. Hans Buchner, German organist and composer (b. 1483).

WORLD EVENTS

Bogotá, Colombia, was founded.

Truce of Nice, a 10-year truce mediated by the Vatican, between France and the Holy Roman Empire.

1539

LITERATURE

New English-language Bible printed in Paris, dubbed the *Great Bible* for its large page size; banned in England under the Catholic Queen Mary, it was restored under Elizabeth I.

Thomas Wyatt's poem *Tagus, Farewell* (ca. 1539).

France's King Francis I ordered that French, not Latin, become the language used in the law.

First complete Swiss Bible was published.

VISUAL ARTS

Alonso Berruguete's work included his alabaster and wood carvings for Toledo Cathedral (1539–1547).

Francesco Mazzola Parmigianino's painting *Madonna with SS. Stephen and John the Baptist and a Donor*.

THEATER & VARIETY

Wit and Science, John Redford's English morality play.

MUSIC & DANCE

Manuals describing recorder fingering and technique were written in Europe (1530s).

WORLD EVENTS

Fernando de Soto began the conquest of Florida for Spain.

Henry VIII married Anne of Cleves.

Larger monasteries shut down in England, by the second Act of Dissolution.

1540

LITERATURE

David Lindsay's Scottish poem on abuses of political life, *Ane Pleasant Satyre of the Thrie Estatis*.

Thomas Wyatt's poem *The Pillar Perished Is* (ca. 1540).

First Icelandic version of the New Testament, prepared by Oddur Gottskálksson from the *Latin Vulgate* and Luther's translation, published in Roskilde, Denmark.

VISUAL ARTS

Andrea Palladio began several works, including the Palazzo Civena, Vicenza (1540–1546); Villa Godi, Lonedo (ca. 1540–1542); Villa Marcello, Bertesina (ca. 1540–1544); and Villa Pisani, Bagnolo (1540s–1560s).

Titian's paintings included *Jupiter and Antiope* (*Venus of El Pardo*) (ca. 1540–1560) and *The Englishman* (1540–1545).

Tintoretto's paintings included *Madonna and Child with Six Saints* and *Supper at Emmaus* (ca. 1540).

Hans Holbein the Younger's works included the miniatures *Anne of Cleves*, *Charles Brandon*, and *Portrait of Mrs. Pemberton* (ca. 1540).

Mausoleum of Sultan Sher Shah, Sahsaram, India, built (1540–1545).

d. Francesco Mazzola Parmigianino, Italian painter and etcher (b. 1503).

THEATER & VARIETY

Ralph Roister Doister, Nicholas Udall's play (ca. 1540).

WORLD EVENTS

After the annulment of his marriage to Anne of Cleves, Henry VIII married Catherine Howard.

Francisco Vásquez de Coronado reached the Grand Canyon; his expedition introduced the horse into North America.

1541

LITERATURE

Thomas Wyatt's poems *Sighs Are My Food* and *Lucks, My Fair Falcon* (ca. 1541).

First complete Bible in any Scandinavian language, the *Gustav Vasa Bible* published in Stockholm, Sweden.

Hungarian version of the New Testament, based on the Greek, published by János Sylvester (Erdõsi) at Sárvár.

THEATER & VARIETY

Celestina (*La comedia de Calisto y Melibea*), Fernando de Rojas's play (before 1541).
Pietro Aretino's *La Talanta*.
Giovanni Battista Giraldi's *Orbecche*.
d. Fernando de Rojas, Spanish novelist (b. ca. 1465).

MUSIC & DANCE

Martin Agricola's *Sangbuchlein*, one of the earliest collections of German Protestant songs.
d. Hans Kotter, German organist and composer (b. ca. 1485).

WORLD EVENTS

Hernando de Soto's expedition reached the Mississippi; he died of fever en route.

1542

LITERATURE

d. Thomas Wyatt, English poet (b. ca. 1503).

VISUAL ARTS

Michelangelo's late paintings included *Conversion of St. Paul* (1542–1545) and *Crucifixion of St. Peter* (1542–1540).
Titian's paintings included *Christ Before Pilate*, *Clarice Strozzi*, and *Pope Paul III Without Cap*.

THEATER & VARIETY

d. Angelo Boelco, Padua-based Italian actor and playwright (ca. 1502–1542), who created the popular commedia dell'arte rural comedian Ruzzante, and so was known as Il Ruzzante.
Pietro Aretino's *Lo Ipocrito*.

MUSIC & DANCE

Francesco Cavalli's opera *La virtù de' strali d'Amore.*

Cipriano de Rore wrote 10 books of Italian madrigals (1542–1566).
d. Ludwig Senfl, Swiss composer active in Germany (b. ca. 1486).

WORLD EVENTS

Henry VIII had Catherine Howard beheaded.
Juan Cabrillo sailed north along the Pacific Coast of North America, from Navidad to what is now the Oregon border.
Portuguese reached Japan (ca. 1542–1543).

1543

LITERATURE

First printed translation of the Hebrew Bible in Judeo-German, or Yiddish, by Michael Adam, published in Constance (1543–1544).
De Historia Stirpum, Leonhard Fuchs's botanical work, published in Basel.

VISUAL ARTS

Titian's paintings included *The Vendramin Family* (1543–1547) and *Three Old Testament Subjects* (1543–1544).
d. Hans Holbein the Younger, German painter (b. 1497).
d. Alejo Fernandez, Spanish painter (b. ca. 1470).

THEATER & VARIETY

Giovambattista Biraldi Cinthio's tratise *Concerning the Writing of Comedies and Tragedies*.
Giovanni Battista Giraldi's *L'Altile*.

WORLD EVENTS

Henry VIII married Catherine Parr.
Nicolas Copernicus's *On the Revolutions of Celestial Bodies*, published in the year of his death.

1544

VISUAL ARTS

Tintoretto's painting *Apollo and Marsyas* (1544–1545).

RETA E. KING LIBRARY
CHADRON STATE COLLEGE
CHADRON, NE 69337

THEATER & VARIETY

Jephthah or the Vow (*Jephthes sive votem*), George Buchanan's morality play.

MUSIC & DANCE

Cipriano de Rore wrote 80 sacred motets in five books (1544–1563; 1595).

WORLD EVENTS

England and Scotland were at war; the English took Edinburgh.

1545

VISUAL ARTS

Benvenuto Cellini's statue *Perseus*.
Tintoretto's paintings included the *St. Demetrius Altarpiece* (ca. 1545) and his *Portrait of a Young Man*.
Titian's painting *Pietro Aretino* (ca. 1545).
Andrea Palladio's works included the Palazzo Thiene, Vicenza (ca. 1545–1550) and the Villa Poiana, Poiana Maggiore (ca. 1545–1550).
d. Hans Baldung (Hans Grien or Grün), German painter (b. ca. 1484).

MUSIC & DANCE

d. Costanzo Festa, Italian composer and singer (b. ca. 1490).
d. John Taverner, English composer (b. ca. 1490); subject of a 1972 opera by Peter Maxwell Davies.

WORLD EVENTS

Scottish forces defeated the English at Ancrum Moor.

1546

LITERATURE

Index expurgatorius (*Index of forbidden books*) first published in Spain.
Epitaphium, Hans Sachs's poem on Martin Luther's death.

Religious reformer John Calvin published a celebrated new edition of Pierre-Robert Olivétan's 1535 French Protestant Bible.
La coltivazione, Luigi Alamanni's poem on rustic life.

VISUAL ARTS

Tintoretto's *Self-Portrait* (ca. 1546).
Titian's paintings included *Paul III and His Grandsons Ottavio and Cardinal Alessandro Farnese* and *Christ Crowned with Thorns* (1546–1550).
Present structure of the Louvre built, designed by Pierre Lescot (from 1546); the old building was demolished.
d. Giulio Romano, Italian architect and painter (b. ca. 1499).

THEATER & VARIETY

Orazio, Pietro Aretino's tragedy.

MUSIC & DANCE

Antonio Rotta's volume *Intabolatura*.
Alonso Mudarra's *Tres libros de musica*.
Giulio Abondanta, Italian lutenist and composer (active ca. 1546–1587).
d. Fridolin Sicher, Swiss organist (b. 1490).

WORLD EVENTS

Spain took Mexico's Yucatán Peninsula.

1547

LITERATURE

Marguerite de Navarre's poetry *Les Marguerites*.

VISUAL ARTS

Michelangelo completed the facade of Rome's *Palazzo Farnese*.
Tintoretto's paintings included his *Last Supper*, *Christ Washing the Feet of the Apostles*, *Portrait of a Man*, and *Christ and the Adulteress* (ca. 1547).
d. Sebastiano del Piombo, Italian painter (b. ca. 1485).

THEATER & VARIETY

Giovanni Battista Giraldi's *Epizia*.

MUSIC & DANCE

Dodecachordon, Heinrich Glarean's treatise, which much influenced Renaissance musical thought.

Enríquez de Valderrábano's book *Libro de música de vihuela, intitulado Silva de sirenas*.

d. Jean Richafort, Franco-Flemish composer (ca. 1480–ca. 1547).

d. John Redford, English composer and organist (?–1547?).

WORLD EVENTS

d. Henry VIII (b. 1491), king of England; succeeded by Edward VI.

Ottoman Turks took Aden.

1548

VISUAL ARTS

Titian's paintings included *The Emperor Charles V at Mühlberg, Giovanni Battista Castaldo*, and *Martyrdom of St. Lawrence* (1548–1557).

Paolo Veronese painted the *Bevilacqua-Lazise Altarpiece*.

Tintoretto's paintings included *Esther Before Ahasuerus* and *S. Marco Freeing the Slave*.

Andrea Palladio's design for the Basilica, Vicenza, was accepted (completed 1617).

THEATER & VARIETY

Théâtre de l'Hôtel de Bourgogne (built 1548).

MUSIC & DANCE

d. Sixt Dietrich, German composer (b. ca. 1493).

WORLD EVENTS

La Paz, Bolivia, founded.

Sigismund II became king of Poland (1548–1572).

1549

LITERATURE

Book of Common Prayer introduced for public worship by Anglican Christians, introducing phrases such as "to have and to hold" and "in sickness and in health"; *First* and *Second Prayer Books* (1549, 1552) compiled by Thomas Cranmer for Britain's King Edward VI.

Thomas Wyatt's poem *Psalm 130* (1549).

d. Marguerite de Navarre, French writer and queen of Navarre (b. 1492).

VISUAL ARTS

Tintoretto's paintings included *St. Martial with SS. Peter and Paul, S. Rocco Among the Plague-Stricken*, and *St. Augustine Healing the Plague-Stricken* (ca. 1549).

MUSIC & DANCE

d. Antonio Rotta, the most notable Italian lutenist of his day (b. ca. 1495).

WORLD EVENTS

English religious observance limited by First Act of Uniformity.

France recovered Boulogne from England, as part of a peace agreement ending hostilities.

Portuguese government and Jesuits began the lasting settlement of Brazil.

1550

LITERATURE

Pierre de Ronsard's *Odes* (*Les Quatre Premiers Livres des Odes*), regarded as France's first great lyric poetry, modeled after Horace and Pindar.

Printing began in Ireland.

Hamzah Fansuri, Malay Sufi poet (active ca. 1550–1600).

Christian III Bible, a Danish version of the complete text, published in Copenhagen.

Louvain Bible, a new French Roman Catholic version, published.

VISUAL ARTS

Titian's paintings included his portrait of *Philip II* (1550–1551), *Venus and Cupid with an Organist* (ca. 1550), a *Self Portrait* (ca. 1550), and *Venus with a Mirror* (1550–1555).

Andrea Palladio's works included the Basilica Chiericati, Vicenza; the Villa Thiene, Quinto (ca. 1550); the Villa Rotondo, Vicenza (1550–1551); and the Villa Emo, Franzolo (late 1550s).

Paolo Veronese's paintings included *Christ Among the Doctors* (ca. 1550), *Presentation in the Temple* (mid-1550s), *The Anointment of David* (mid-1550s), and *The Holy Family with the Infant St. John and St. George* (late 1550s).

Tintoretto's paintings included *Miracle of the Loaves and Fishes* (late 1550s), *St. George and the Dragon* (ca. 1550), and *Susanna Bathing* (ca. 1550).

Benvenuto Cellini's bust of *Bindo Altoviti* (ca. 1550).

Lucas Cranach the Elder's *Self-Portrait*.

Giorgio Vasari's biographical work *Lives of the Most Excellent Painters, Sculptors, and Architects* (1550; enlarged ed. 1568).

Sulaymaniyeh Cami, Mosque of Sultan Sulayman, Istanbul, founded.

d. Ch'iu Ying (ca. 1500–1550), one of the four Ming master painters, of the Suchou school.

THEATER & VARIETY

Francisco de Sá de Miranda's *Cleopatra*, the first Portuguese classical tragedy (ca. 1550).

Professional commedia dell'arte companies began to be formed (ca. 1550).

Giovanni Maria Cecchi's *Assiuolo*.

Thomas Preston, English playwright (active 16th c.).

MUSIC & DANCE

Mulliner Book, English manuscript of keyboard music copied by T. Mulliner, liturgical organ pieces, dances, and arrangements, including pieces by John Redford, Thomas Tallis, and others (ca. 1550–1575).

Spanish guitar became widely popular in other European countries (ca. 16th c.).

Enríquez de Valderrábano, Spanish composer and vihuelist (active ca. 1550).

d. Pietro Aaron, Italian music theorist and composer (ca. 1480–ca. 1550).

In France, groups of instruments, often all strings, were being organized, the previous common practice being for instruments to be played solo or with voice (ca. 1550s).

WORLD EVENTS

Ottoman Turks advanced south in Africa, conquering as far as Third Cataract (ca. 1550).

Julius III became pope.

1551

VISUAL ARTS

Paolo Veronese's painting *Portrait of Francesco Franceschini*.

Tintoretto's paintings included *Portrait of a Young Lady* and *Knight of Malta* (both ca. 1551).

d. Domenico di Pace Beccafumi, Italian painter (b. ca. 1489); his later works included the paintings *Christ in Limbo* and *The Birth of the Virgin* (both before 1551).

THEATER & VARIETY

Beginning of production of Jesuit plays (ca. 1551).

WORLD EVENTS

Austria tightened hold on Hungary and Transylvania.

Ottoman Turks moved further west in North Africa, taking Tripoli.

1552

LITERATURE

Pierre de Ronsard's *Amours* (*Les Amours de Cassandre*), love poems in Petrarchan sonnet form.

Second *Book of Common Prayer* issued in England.

VISUAL ARTS

Michelangelo's sculpture *Rondanini Pietà* (1552–1564), his last work.

Titian's painting *Giovanni Francesco Acquaviva, Duke of Atri*.

Tintoretto's painting *Presentation of the Virgin in the Temple*.

Paolo Veronese's painting *Temptation of St. Anthony*.

Agnolo Tori di Cosimo di Moraino Bronzino's painting *Christ in Limbo*.

Alonso Berruguete's carvings on the *tomb of Cardinal Tavera*.

THEATER & VARIETY

Ane Pleasant Satyre of the Thrie Estaitis, David Lyndsay's Scottish morality play.

Étienne Joselle's *Cléopâtre captive*.

MUSIC & DANCE

d. Philippe Verdelot, French composer (ca. 1470/1480–before 1552).

WORLD EVENTS

Rhodes was taken by the Ottoman Turks.

Russians led by Ivan IV continued their expansion, besieging and taking Kazan.

1553

LITERATURE

First Polish-language version of the New Testament, prepared by Lutheran Greek scholar Jan Seklucjan, published in Königsberg.

Printer Robert Estienne (Stephanus) published a notable new edition of Pierre-Robert Olivétan's 1535 French Protestant Bible.

Pierre de Ronsard's poetry *Livret de Folâtries*.

Printing began in Russia.

VISUAL ARTS

Paolo Veronese's work included his paintings at Venice's ducal palace (1553–1554), and his painting *St. Mary Magdalene Laying Aside Her Jewels* (ca. 1553–1554).

Tintoretto's painting *Portrait of a Woman in Black* (ca. 1553).

Titian's paintings included *Venus and Adonis* and *Danae with Nursemaid* (both 1553–1554).

Andrea Palladio's Villa Pisani, Montagnana (ca. 1553–1555).

d. Francesco de'Rossi Salviati, Italian painter (b. 1510).

d. Lucas Cranach the Elder, German painter (b. 1472).

THEATER & VARIETY

Old Fortunatus, Thomas Dekker's play; a sequel to a play by Hans Sachs, based on a German folktale.

Gammer Gurton's Needle, William Stevenson's play, one of the earliest English comedies (ca. 1553).

MUSIC & DANCE

Diego Ortiz's *Trattado de glosas*, the first printed ornamentation manual for bowed string instruments; including some 24 viol pieces.

d. Cristóbal de Morales, Spanish composer (b. ca. 1500).

WORLD EVENTS

British sea captain Richard Chancellor rounded the North Cape and reached Archangel.

d. Edward VI (b. 1537), king of England; in the succession crisis that followed, Mary I emerged as queen.

1554

LITERATURE

Pierre de Ronsard's poetic works *Le Bocage* and *Les Mélanges*.

VISUAL ARTS

Andrea Palladio's work included the Villa Badoer, Fratta Polesine (1554–1563), and the Villa Chiericati, Vancimuglio (1554–1557).

Titian's paintings included *Trinity (La Gloria)*, and *Perseus and Andromeda* (1554–1556).

Hans Eworth's painting of *Queen Mary*.
Sacrifizio, Agostino Beccari's Italian pastoral drama.

MUSIC & DANCE

Costanzo Festa published his four-part *Magnificat*.
Giovanni Palestrina published his mass, *Ecce sacerdos magnus*.
Miguel de Fuenllana's *Orphénica lyra*.

WORLD EVENTS

England swung back to Catholic and Vatican dominance under Mary I, as Protestant dissent continued to grow, fanned by persecution, including legal killings of "heretics." Lady Jane Grey was executed. Mary married Philip of Spain.

1555

LITERATURE

Pierre de Ronsard's poetic works *Continuation des amours* (1555) and *Les Hymnes*, reflecting awe at the universe (1555–1556).
d. David Lyndsay, Scottish poet and playwright (ca. 1490–ca. 1555).

VISUAL ARTS

Paolo Veronese's work included the ceiling paintings and frescoes at S. Sebastiano, Venice (1555–1558), and his painting *Transfiguration* (1555–1556).
Tintoretto's paintings included *Joseph and Potiphar's Wife* (ca. 1555), *Portrait of a Venetian Gentleman*, and *The Finding of Moses*.
Titian's painting *Lavinia with Fan* (1555–1560).
Andrea Palladio's Villa Barbaro, Maser (ca. 1555–1559).
Hans Eworth's portrait of *Lady Dacre* (ca. 1555).
d. Jan Mostaert, Dutch painter (b. ca. 1556).

THEATER & VARIETY

Euphrosyne, Portuguese playwright Jorge Ferreire de Vasconcelos's drama.
Luíz Vaz de Camoes's *Filodemoa*.

MUSIC & DANCE

Earliest known use of microtonal keyboards, with intervals smaller than those on the standard piano or organ keyboard, in Italy (ca. 1555).

WORLD EVENTS

Bishops Latimer and Ridley were burnt as heretics by Catholics at Oxford.
English Muscovy Company was founded, trading by sea on the Northeast Passage to Russia.

1556

LITERATURE

Printing began in India by Portuguese Jesuits in Goa.
d. Luigi Alamanni, Italian poet (b. 1495).
d. Pietro Aretino, Italian writer (b. 1492).

VISUAL ARTS

Paolo Veronese's paintings included *Portrait of Countess Nani* (*La Belle*) (ca. 1556) and *Portrait of a Lady and Her Daughter* (ca. 1556).
Pieter Bruegel the Elder's painting *The Adoration of the Kings* (ca. 1556).
Tintoretto's paintings included *Portrait of a Gentleman with a Gold Chain* (ca. 1556–1560) and *Portrait of Jacopo Sansovino* (ca. 1556).
d. Lorenzo Lotto, Italian painter (b. ca. 1480).

THEATER & VARIETY

d. Pietro Aretino, Italian author and playwright (b. 1492).
d. Burkard Waldis, anti-Catholic German playwright (b. ca. 1490).

MUSIC & DANCE

d. Martin Agricola, German music theorist and composer (b. 1486).

WORLD EVENTS

Ivan IV took Astrakhan.

Ottoman Turks took Tripoli from the Knights of St. John.

1557

LITERATURE

Britain's Queen Mary granted the Stationers' Company a virtual monopoly on printing, and ruled that the person who first registers a book there held all rights to it, the beginning of copyright.

Spanish Inquisition's *Index of Forbidden Books* banned the Bible in the vernacular Spanish, in force into the 18th century.

Thomas Wyatt's poems *Farewell, Love, My Lute Awake!* and *They Flee from Me*.

Library of the Escorial founded in Madrid, based on the library of Philip II.

Protestant exiles in Geneva printed a new English-language version of the New Testament, followed by the Old Testament in 1560; together called the *Geneva Bible* or *Breeches Bible* (since Adam and Eve were shown clothed), it was the first English-language Bible to exclude the Apocrypha, and supplanted the *Great Bible*.

VISUAL ARTS

Michelangelo designed the dome of St. Peter's, Rome (1557–1558).

d. Jacopo Carucci Pontormo, Italian painter (b. 1494).

MUSIC & DANCE

d. Thomas Crecquillon, Franco-Flemish composer (b. ca. 1480/1500).

WORLD EVENTS

France and the Vatican were at war; French attacked in Italy.

French and English were at war; English and Spanish allies defeated French at St. Quentin.

Portuguese consolidated hold on East Africa.

1558

LITERATURE

Marguerite de Navarre's short stories, *Heptaméron*, published posthumously (1558–1559).

VISUAL ARTS

Titian's work included the painting *Crucifixion*.

THEATER & VARIETY

Étienne Joselle's *Didon*.

d. Francisco de Sá de Miranda, Portuguese playwright (b. 1485), a key figure in the Portuguese Renaissance.

MUSIC & DANCE

Giaches de Wert wrote 230 madrigals and other secular vocal works, in 16 books (1558–1608).

d. Clément Janequin, French composer (ca. 1485–ca. 1558).

WORLD EVENTS

d. Mary I (b. 1516), queen of England; often called "Bloody Mary."

Elizabeth I became queen of England.

Shane O'Neill became lord of Tyrone.

1559

LITERATURE

The Mirror for Magistrates, a collection of verse tragedies about great figures in English history, by different authors; most notable was Thomas Sackville's *Induction*, a prime example of early Elizabethan verse.

Pope Paul IV banned all printing or reading of the Bible in the vernacular, except with church permission, barring Catholic translation for the next two centuries.

Index of forbidden books published by the Sacred Congregation of the Roman Inquisition; it

continued until 1966.

Thomas Wyatt's poem *Sometime I Fled the Fire.*

VISUAL ARTS

Titian's paintings included *The Rape of Europa* (ca. 1559–1562), *Diana and Callisto,* and *Entomb-ment.*

Pieter Bruegel the Elder's paintings included *The Fight Between Carnival and Lent* and *The Nether-landish Proverbs.*

Tintoretto's painting *The Pool of Bethesda.*

THEATER & VARIETY

Mirror of the True Priesthood, Mihály Sztáray's Hungarian play.

WORLD EVENTS

British explorer Anthony Jenkinson visited Persia and Bokhara.

Spanish and allied fleet was decisively defeated by Ottoman Turks at Algiers.

1560

LITERATURE

Count Jan Ungnad published a new translation of the New Testament at Urach, printed in both the Serbian and Croatian scripts.

VISUAL ARTS

Titian's paintings included his *Venus and the Lute Player* and *Magdalen* (both ca. 1560), and the *Annunciation* (1560–1565).

El Greco's painting *Christ Cleansing the Temple* (1560–1565).

Andrea Palladio's work included the refectory of Venice's S. Giorgio Maggiore (1560–1562) and the Villa Cornaro, Piombino Dese (ca. 1560–1565).

Paolo Veronese's paintings included *The Pilgrims of Emmaus, Feast in the House of the Pharisee* (both ca. 1560) and *Christ and Centurion* (1560s).

MUSIC & DANCE

Christoph Praetorius wrote various chorale motets

and occasional pieces (d. 1587).

First major works written for viols (1560s).

Person-high double basses depicted in Italian and German pictures (1560s).

d. Gasparo Alberti, Italian composer (ca. 1480–ca. 1560).

d. Loys Bourgeois, French composer and theorist (b. ca. 1510).

d. Marco Antonio Cavazzoni, Italian composer (ca. 1490–ca. 1560).

WORLD EVENTS

As piracy increased in the Caribbean, the Spanish established a maritime convoy system, with armed fleets periodically making the Atlantic voyage.

1561

LITERATURE

Baldassar Castiglione's *The Courtier* (*Il libro del corte-giano* or *The Book of the Courtier*), dialogues on the ideal courtier and standards of culture and courtesy.

VISUAL ARTS

Paolo Veronese's paintings included the *Baptism of Christ, The Preaching of John the Baptist* (ca. 1561), and the works at Villa Barbaro, Maser (ca. 1561).

Michelangelo's Porta Pia, Rome.

d. Alonso Berruguete, Castilian sculptor and painter (b. ca. 1488).

d. Lancelot Blondeel, Flemish artist (b. 1496).

THEATER & VARIETY

Gorboduc, or Ferrex and Porrex, tragedy by Thomas Norton and Thomas Sackville.

César, Jacques Grêvin's French tragedy.

Giulio Cesare Scaligero's treatise *The Seven Books of the Poetics.*

MUSIC & DANCE

Giacomo Gorzanis produced four lutebooks (1561–ca. 1575).

Antonio Scandello's *St. John Passion.*

d. Luis de Milán, Spanish musician (b. ca. 1500).

WORLD EVENTS

Denmark and Sweden were at war (1561–1568).
Philip II made Madrid capital of Spain.

1562

LITERATURE

Rinaldo, Torquato Tasso's romantic epic poem about the adventures of Rinaldo, a medieval hero almost as famous as his cousin Roland (Orlando).

VISUAL ARTS

Accademia del Disegno was founded in Florence by Duke Cosimo de' Medici.

Paolo Veronese's paintings included the *Sacra Conversazione* (ca. 1562), *The Marriage at Cana* (1562–1563), and *The Consecration of St. Nicholas*, *The Martyrdom of SS. Primo and Feliciano*.

Pieter Bruegel the Elder's paintings included *The Suicide of Saul*, *The Triumph of Death* (ca. 1562), and *View of Naples* (ca. 1562–1563).

Tintoretto's paintings included his *The Last Judgment*, *Finding of the Body of St. Mark*, and *The Law and the Golden Calf* (all ca. 1562).

Titian's painting *Madonna and Child in Evening Landscape* (1562–1565).

MUSIC & DANCE

d. Claudin de Sermisy, French composer (b. ca. 1490).
d. Wolff Heckel, German lutenist and composer (b. ca. 1515).

WORLD EVENTS

First Huguenot War: French Huguenots rebelled after the massacre at Vassy; beginning of the long Protestant–Catholic civil wars in France.

John Hawkins made his first voyage to the Caribbean.

1563

LITERATURE

John Foxe's *Actes and Monuments of These Latter Perilous Days*, popularly called *The Book of Martyrs*, the stories of contemporary Protestant martyrs; he began it from exile (1554–1559) while Catholic Queen Mary was on the English throne.

Printing began in Palestine.

Brest Bible, a Protestant Polish translation sponsored by Prince Radziwill, published.

d. Surdas, blind Indian Hindu poet (b. 1483), whose works are collected in the *Sursagar*.

VISUAL ARTS

Giovanni Bologna's *Fountain of Neptune* (1563–1566).
Pieter Bruegel the Elder's painting *The Tower of Babel*.

THEATER & VARIETY

d. John Bale, Bishop of Ossory in Ireland (b. 1495), a Catholic priest turned Protestant, author of several anti-Catholic plays.

MUSIC & DANCE

Intavolatura di laudo, Vincenzo Galilei's book of madrigals.

d. Hans Neusidler, German composer and lutenist, a key figure in early German lute music (b. ca. 1508–1509).

d. Heinrich Glarean, Swiss musical theorist and poet (b. 1488).

WORLD EVENTS

First Huguenot War: Orléans surrendered after a Catholic siege; Peace of Amboise ended the civil war with temporary suspension of the persecution of Huguenots.

1564

LITERATURE

Index of Prohibited Books published by the Vatican.

VISUAL ARTS

d. Michelangelo (Michelangelo de Lodovico Buonarroti Simoni), Italian sculptor, painter, and architect (b. 1475), one of the central figures of the Renaissance.

Tintoretto began his ceiling paintings at Venice's Scuola Grande di S. Rocco, Venice (1564–1581).

Pieter Bruegel the Elder's paintings included *The Adoration of the Kings* and *The Way to Calvary*.

WORLD EVENTS

Burmese forces took but could not hold Laos (1564–1565).

1565

LITERATURE

Pierre de Ronsard's *Élégies, mascarades et bergerie,* lyrical poems dedicated to Queen Elizabeth I and meant for court entertainment.

VISUAL ARTS

Andrea Palladio's work included the Palazzo Valmarana, Vicenza (1565–1566), and Venice's S. Francesco della Vigna (ca. 1565).

Paolo Veronese's painting *The Martyrdom of St. George* (ca. 1565).

Tintoretto's paintings included *Crucifixion.*

THEATER & VARIETY

Lodovico Dolce's *Marianna.*

MUSIC & DANCE

Spanish music theorist and composer Tomas Santa Maria published a treatise describing a numbering system for keyboard fingering and described techniques for playing fast passages, especially with scales.

Diego Ortiz wrote a book of sacred music.

d. Cipriano de Rore, Flemish composer (b. ca. 1515–1516).

d. Jacques Buus, Flemish composer (b. ca. 1500).

WORLD EVENTS

Miguel Lopez de Lagazpi found a practical route east from the Philippines to Panama, beginning the Manila trade; Spain then occupied the Philippines.

Spanish fleet took Malta.

Spanish founded a colony at St. Augustine, Florida.

1566

VISUAL ARTS

Paolo Veronese's painting *St. Jerome in the Wilderness.*

Antoine Caron's painting *Massacres under the Triumvirate.*

Giovanni Bologna's work included his fountains *Hercules and the Centaur* and *Samson and a Philistine* (both ca. 1566).

Pieter Bruegel the Elder's paintings included *The Sermon of St. John the Baptist* and *The Wedding Dance.*

d. Lambert Lombard, Flemish painter, engraver, and architect (b. 1505).

THEATER & VARIETY

The Czech Comedy About a Money-bag and Lazarus, Pavel Kyrmezer's play.

MUSIC & DANCE

Congregazione dei Musici di Roma, a society founded in Rome, that held meetings to discuss and perform music (ca. 1566); later renamed Accademia di S Cecilia (ca. 1839).

Andrea Gabrieli's *Madrigali a 5, Book I.*

Giaches de Wert wrote over 150 sacred pieces, in three books (1566–1581).

WORLD EVENTS

Ottoman Turks invaded Hungary.

Unsuccessful revolt in Ulster, Ireland.

1567

VISUAL ARTS

Tintoretto's paintings included *S. Rocco in Prison* and *Jacopo Strada* (1567–1568).

Bartolommeo Ammanati's work included the Ponte Sta. Trinità, Florence (1567–1570).

Pieter Bruegel the Elder's paintings included *Peasant Wedding* and *The Conversion of St. Paul.*

MUSIC & DANCE

Giovanni Palestrina's masses *De Beata Virgine* and *Papae Marcelli*.

WORLD EVENTS

Mary of Scotland abdicated; succeeded by James VI.
Second Huguenot civil war in France (1567–1568).

1568

LITERATURE

Antwerp-based Christophe Plantin printed the *Bibla Regia* for Philip II of Spain, an eight-volume work printed in five languages—Hebrew, Greek, Aramaic, Latin, and Syriac—and so called the *Polyglot Bible* (1568–1572). Besides 13 sets on vellum for the King, 1,200 copies were printed on paper for public sale.
Bishops' Bible, a new English translation, intended to supplant the *Geneva Bible*.
d. Sankaradeva, Assamese poet (?–1568).

VISUAL ARTS

Pieter Bruegel the Elder's paintings included *The Cripples*, *The Magpie on the Gallows*, *The Parable of the Blind*, and *The Storm at Sea*.
Tintoretto's paintings included *Descent of Christ into Limbo* and *Doge Alvise Mocenigo and Family Before the Madonna and Child* (ca. 1573).
New edition of Andreas Vesalius's classic work on anatomy, *De humani corporis fabrica*, published with illustrations by Stevenszoon Van Calcar.

THEATER & VARIETY

Robert Garnier's plays *Porcie* and *Hippolyte* (ca. 1568).
d. Lodovico Dolce, Italian playwright and translator (b. 1508).

MUSIC & DANCE

d. Miguel de Fuenllana, Spanish composer and vihuelist (b. ca. 1500).
Fronimo, a treatise on lute playing.

WORLD EVENTS

Mary of Scotland fled to England, and was there imprisoned by Elizabeth I.
Oda Nobunaga took control of much of central Japan, ruling from Kyoto.
Ottoman Turk forces took Yemen.
Second Huguenot civil war in France ended, but after a few months the Third Huguenot War began (1568–1570).

1569

LITERATURE

The Doubt of Future Foes, poem by England's Queen Elizabeth (ca. 1569).

VISUAL ARTS

Agnolo Tori di Cosimo di Moraino Bronzino's painting *Martyrdom of S. Lorenzo*.
d. Pieter Bruegel the Elder, Flemish painter (b. ca. 1525), nicknamed "Peasant Bruegel."

THEATER & VARIETY

Cambyses King of Persia, Thomas Preston's play (ca. 1569).
Christux Judex (*The King of the Jews*), Stefano Tuccio's Jesuit play.
d. António Ferreira, Portuguese playwright (b. 1528).

MUSIC & DANCE

Kortholt and *sordun*, both double-reed wind instruments, used in Europe (ca. 1570–1650).

WORLD EVENTS

First Desmond revolt in Ireland (1569–1573).
French Catholics defeated Huguenots at Jarnaca.

1570

VISUAL ARTS

El Greco's paintings *Christ Healing the Blind* and

Giulio Clovio (both ca. 1570), and *Boy Lighting a Candle* (1570–1575).

Paolo Veronese's paintings *Marriage of St. Catherine* (late 1570s) and *The Family of Darius Before Alexander* (ca. 1570).

Tintoretto's painting *The Virgin and Child Adored by SS. Mark and Luke* (ca. 1570–1580).

Titian's paintings *Christ Crowned with Thorns* (1570–1576), *Nymph and Shepherd* (ca. 1570), *Triple Portrait Mask, Allegory of Prudence* (ca. 1570), and *The Flaying of Marsyas* (ca. 1570–1576).

I Quattro Libri dell' Architettura, Andrea Palladio's influential theoretical work.

MUSIC & DANCE

d. Andrea Amati, Italian violin maker, active in Cremona (before 1511–1570/1580), who developed the modern violin, basis for the whole violin family; he was succeeded by his sons, Antonio and Girolao, and grandson Nicolò.

Giovanni Palestrina's mass *L'Homme armé*.

Andrea Gabrieli's *Madrigali a 5, Book II*.

Guillaume Costeley's *Chansons* published in a collected edition.

d. Diego Ortiz, Spanish theorist and composer (b. ca. 1510).

d. Johann Walter, German composer (b. 1496).

WORLD EVENTS

Amnesty granted to French Huguenots as part of the peace agreement ending the Third Huguenot War.

Francis Drake made his first pirate raid on Spanish shipping in the Caribbean.

Venice and the Ottoman Turks were at war (1570–1573).

1571

LITERATURE

Biblioteca Laurenziana founded, based on the library of Lorenzo the Magnificent; the building was designed by Michelangelo.

VISUAL ARTS

Titian's painting *Tarquin and Lucretia*.

Bartolommeo Ammanati's fountain with marble *Neptune* and bronze *Nymphs*, at Florence's Piazza della Signoria (1571–1575).

d. Benvenuto Cellini, Florentine goldsmith and sculptor (b. 1500).

MUSIC & DANCE

Luzzasco Luzzaschi wrote seven books of five-part madrigals (1571–1604).

Orgel oder Instrument Tabulatur, Elias Nikolaus Ammerbach's book of organ tablature.

d. Giovanni Animuccia, Italian composer (b. ca. 1500).

WORLD EVENTS

At Lepanto, Venetian and Spanish fleets decisively defeated the Ottoman Turks, ending unrestrained Ottoman dominance in the eastern Mediterranean.

Khan of the Crimea attacked Moscow.

Spanish forces captured and killed Tupac Amaru, "the last Inca."

1572

LITERATURE

Os Lusíadas, Luíz Vaz de Camões's epic poem on Portuguese history.

Pierre de Ronsard's unfinished epic poem *La Franciade* (*Les Quatre Premiers Livres de La Franciade*).

Printer John Day introduced roman type into England, where it gradually replaced gothic type.

VISUAL ARTS

d. Agnolo Tori di Cosimo di Moraino Bronzino, Italian painter (b. 1503).

d. François Clouet, French painter (b. before 1510).

THEATER & VARIETY

Jean de la Taille's *Saül le furieux*.

MUSIC & DANCE

Giovanni Palestrina's motet *Assumpta est Maria*.

d. Christopher Tye, English composer (b. ca. 1505).
d. Claude Goudimel, French composer (b. 1514–1520), known for his psalms and *chansons*.

WORLD EVENTS

Fourth Huguenot War in France began with the St. Bartholomew's Day massacre of Huguenots in Paris (1572–1574).
Dutch War of Independence began.

1573

VISUAL ARTS

Paolo Veronese's paintings included his *Adoration of the Kings* and *Feast in the House of Levi.*

THEATER & VARIETY

Aminta, Torquato Tasso's pastoral drama.
The New Comedy About a Widow, Pavel Kyrmezer's play.
d. Étienne Joselle, French Renaissance poet and playwright (b. 1532).
d. Giovanni Battista Giraldi, Italian humanist (b. 1504).

MUSIC & DANCE

Camerata founded in Florence by Giovanni d' Bardi and others, whose aim was to recreate the classic Greek fusion of music and theater, from which flowed the development of the opera.
Catherine de Medici sponsored the *Ballet de Polonais*, a dance spectacle for Polish ambassadors visiting France.

WORLD EVENTS

Fourth Huguenot War in France ended, and Fifth Huguenot War began.

1574

LITERATURE

Tulsi Das began his major Hindi poem *Ramcaritmanas* (*The Holy Lake of the Acts of Rama*).

VISUAL ARTS

El Greco painted his *Pietà* (1574–1576).
d. Giorgio Vasari, Italian painter and architect (b. 1511), best known for his biographies of Renaissance artists.

THEATER & VARIETY

Jean de la Taille's *The Rivals.*

MUSIC & DANCE

Oldest known surviving viola, built for the French royal violin band by Andrea Amati.
Vincenzo Galilei's book of madrigals, in four volumes.
Andrea Gabrieli's *Madrigali a 6, Book I.*
Christoph Praetorius published a music textbook.

WORLD EVENTS

Francis Drake made his second pirate raiding voyage to the Caribbean.
Henry III became king of France, succeeding Charles IX.

1575

LITERATURE

Movable metal type for printing was introduced into Japan, from both Korea and Portugal (late 16th c.), though it largely died out in the 17th century.
Torquato Tasso's epic *Gerusalemme liberata* (*Jerusalem Delivered*).

VISUAL ARTS

El Greco's paintings included his *Annunciation* (1575–1576) and *Vincentio Anastagi* (ca. 1575).
Paolo Veronese's ceiling paintings at Venice's ducal palace (1575–1577).
Titian's painting of *St. Jerome.*

THEATER & VARIETY

First *kabuki* company was formed, by a Japanese woman, Okuni.

MUSIC & DANCE

Cantiones sacrae, anthology of Latin motets by Thomas Tallis and Wililam Byrd, under a license granted to them by Elizabeth I.

Andrea Gabrieli's *Madrigali a 3*.

Earliest known keyboard instrument played by friction, not percussion: the *geigenwerk*, built by Hans Haiden of Nuremberg (late 16th c.); Leonardo da Vinci had earlier designed one, never built.

d. Annibale Padovano, Italian composer (b. 1527).

d. Giacomo Gorzanis, blind Italian composer and lutenist (b. ca. 1520–d. 1575–1579).

WORLD EVENTS

Akbar took Bengal.

Fifth Huguenot War: Huguenots defeated by Catholics at Battle of Dormans.

1576

LITERATURE

d. Hans Sachs, German poet and dramatist (b. 1494), a singing shoemaker who also appears as a character in Richard Wagner's 1868 opera *Die Meistersinger von Nürnberg*.

VISUAL ARTS

d. Titian (Tiziano Vecellio), Italian painter (b. ca. 1480), one of the central figures of the Italian Renaissance.

Andrea Palladio designed Venice's Church of Il Redentore.

MUSIC & DANCE

First known mention of the *racket*, a double-reed wind instrument, made up to ca. 1640.

d. Hans Sachs, singing shoemaker (1494–1576), who figured in Richard Wagner's 1868 opera *Die Meistersinger von Nürnberg*.

WORLD EVENTS

Fifth Huguenot War ended, with some concessions to Huguenots.

Warsaw University was founded.

1577

LITERATURE

Raphael Holinshed's *The Chronicles of England, Scotland, and Ireland*, a main source of material for Elizabethan dramatists, including Shakespeare, on supposed early English historical figures such as King Lear, Macbeth, and Cymbeline.

VISUAL ARTS

El Greco's paintings included his *Assumption of the Virgin*, *Espolio* (1577–1579), *St. Sebastian* (1577–1578), and his *Trinity* (1577–1579).

Giovanni Bologna's Apennine fountain (1577–1581).

MUSIC & DANCE

Serpent, a deep-toned, sinuously curved wind instrument, was played in Europe (probably from late 16th c.).

WORLD EVENTS

Francis Drake began his voyage around the world (1577–1580).

Sixth Huguenot civil war was fought in France.

1578

LITERATURE

Sonnets pour Hélène, Pierre de Ronsard's final collection of love poetry.

VISUAL ARTS

El Greco's painting *Knight Taking an Oath* (1578–1580).

d. Jean Bullant, French architect (b. ca. 1520).

THEATER & VARIETY

Luigi Groto's play *Adriana*, a telling of the Romeo

and Juliet story; like Shakespeare's play, based on an earlier story.

MUSIC & DANCE

Andrea Gabrieli's *Cantiones sacrae a 6–16*.

WORLD EVENTS

Portuguese seaborne forces attacking Morocco were decisively defeated at the Alcazar.

Muhammed Khudabanda became Shah of Persia.

1579

LITERATURE

The Shepheardes Calender, Edmund Spenser's collection of 12 pastoral poems and dialogues, one for each month.

Euphues, the Anatomy of Wit, John Lyly's best-known work.

Kralice Bible, a six-volume version prepared by Jan Blahoslav, published at Kralice; it would become the standard Czech Protestant Bible.

VISUAL ARTS

Andrea Palladio's work included the Teatro Olimpico, Vicenza (1579–1580).

MUSIC & DANCE

Theorbo, a large lute for playing accompaniments, in use in Europe (ca. late 16th–mid-18th c.).

WORLD EVENTS

Dutch Republic established by the Treaty of Utrecht.

Francis Drake, reaching California on his around-the-world vogage, claimed it for England.

Poland and Russia were at war.

1580

LITERATURE

Michel de Montaigne's *Essais (Essays)*, a series of discursive explorations on human concerns, developed the modern personal essay, the term referring to a "trial" or "assay" of an idea, judgment, or experience.

Philip Sidney's *An Apology for Poetrie*, the prime critical work of the Elizabethan age (ca. 1580; published posthumously 1595); and his *Astrophel and Stella* sonnet sequence, with "Stella" being Penelope Devereux and "Astrophel" ("star–lover," from the Greek) being Sidney (written 1580–1584; published 1591).

d. Wu Ch'eng-en, Chinese novelist (b. ca. 1510), whose main work was *Hsi-yu chi* (*Journey to the West*; in Arthur Waley's translation, *Monkey*), based on the 7th-century journey of Chinese priest Hsüan Tsang (Tripitaka) to India for sacred Buddhist texts.

d. Luís Vaz de Camoes, Portuguese poet and playwright (b. ca. 1525).

Jan Kochanowski's poetic works *Lyricorum libellus* and *Treny*.

VISUAL ARTS

d. Andrea Palladio, Italian architect (b. 1508), a central figure in Italian Renaissance architecture.

El Greco's paintings included his *Martyrdom of St. Maurice* (1580–1582) and *Crucifixion with Donors* (ca. 1580).

Tintoretto's painting *A Battle Between Turks and Christians* (1580s).

THEATER & VARIETY

Robert Garnier's *Les Juives* (ca. 1580).

d. John Heywood, English playwright (b. ca. 1497), author of many interludes that were precursors to Elizabethan comedy.

MUSIC & DANCE

Andrea Gabrieli's *Madrigali a 6, Book II*.

Luca Marenzio's *Madrigals: Book I for 5 voices*.

Date of a surviving example of the 16th-century stringed instrument *orpharion*, built by its reported inventor, John Rose of London.

d. Alonso Mudarra, Spanish vihuelist and composer (b. ca. 1510).

d. Antonio Scandello, Italian composer (b. 1517).

WORLD EVENTS

Francis Drake returned to England after completing his around-the-world voyage in his last remaining ship, the *Golden Hind*.

French religious wars continued, with Seventh Huguenot War.

Dutch colonists first settled in Guiana.

Failed insurrection against Akbar in Bengal.

Spain took Portugal (1580–1640).

1581

LITERATURE

First complete Bible in Slavic, based on the 1499 translation, printed in Ostrog.

VISUAL ARTS

Tintoretto's painting *Ariadne, Bacchus, and Venus*.

THEATER & VARIETY

Los amantes (*The Lovers*), Andrés Rey de Artieda's play.

MUSIC & DANCE

Catherine de' Medici organized the *Ballet Comique de la Reyne Louise*, a spectacle in drama, dance, songs, and music; sometimes regarded as the first true ballet.

Luca Marenzio's *Madrigals: Book I for 6 voices* and *Book II for 5 voices*.

Vincenzo Galilei's *Dialogo*.

WORLD EVENTS

Akbar took Afghanistan.

Russian exploration and conquest of Siberia and rest of northwest Asian mainland well under way.

Russo-Polish War: Poles under King Stephen Báthory invaded Russia.

1582

LITERATURE

First Roman Catholic New Testament in the French vernacular appeared; initiated by the cardinal of Reims, and translated primarily at Douai, so called the *Reims-Douai Bible*; the Old Testament followed in 1609–1610.

Richard Hakluyt's *Divers Voyages Touching the Discovery of America*, the first of his accounts of English exploration.

VISUAL ARTS

Agostino Carracci's painting *Communion of St. Francis* (1582–1583).

Bartolommeo Ammanati's Jesuit College in Rome (ca. 1582–1585).

THEATER & VARIETY

Giordano Bruno's *Il Candelaio* (*The Candle-Maker*), the philosopher's only play (ca. 1582).

Robert Garnier's *Bradamante*.

MUSIC & DANCE

Giovanni Palestrina's masses *Lauda Sion* and *O magnum mysterium*.

Luca Marenzio's *Madrigals: Book III for 5 voices*.

WORLD EVENTS

Pope Gregory XIII introduced the Gregorian calendar.

Toyotomi Hideyoshi assassinated Oda Nobunaga, then completed the unification of Japan (1582–1590).

University of Würtzburg founded.

1583

VISUAL ARTS

Paolo Veronese's painting *The Magdalen*.

Annibale Carracci's paintings *The Butcher's Shop* (ca. 1583) and *The Crucifixion and Saints*.

Giovanni Bologna's statuary group *Rape of the Sabines*.

Ludovico Carracci's paintings included *Mystical Marriage of a Saint* (ca. 1583), *Portrait of a Youth* (ca. 1583), *St. Francis Adoring the Crucifix* (1583–1584), and *The Baptism of Christ* (ca. 1583).

THEATER & VARIETY

Beginning of the Lucerne, Switzerland, Easter passion play.

MUSIC & DANCE

Costanzo Festa published his book of litanies for double choir.

Orazio (Tiberio) Vecchi's *Madrigals*.

Francis Cutting, English composer and lutenist (active 1583–ca. 1603).

WORLD EVENTS

Akbar built the fortress at Allahabad.

British founded the Newfoundland colony.

University of Edinburgh founded.

1584

LITERATURE

A *New Courtly Sonnet of the Lady Greensleeves*, anonymous poem that became a traditional folk song.

Oxford University Press founded.

Printing began in Peru.

First complete Bible in the Slovenian language, prepared by Jurij Dalmatin from Luther's work, printed at Wittenberg.

First complete Icelandic Bible, translated primarily by Gudbrandur Thorláksson, published at Hólar.

d. Jan Kochanowski, Polish poet (b. 1530).

VISUAL ARTS

Juan de Herrera completed the massive Escorial, Philip II of Spain's palace, monastery, and associated structures.

Agostino Carracci's paintings included *Adoration of the Shepherds* and *Bacchus and Ariadne* (1584–1585).

Giovanni Paolo Lomazzo's work on art theory, *Trattato dell' Arte de la Pittura*.

THEATER & VARIETY

Allegiance to Solomon, by Danish playwright Hieronymus Ranch.

John Lyly's earliest plays, *Campaspe* and *Sapho and Phao*, were first performed.

MUSIC & DANCE

Giovanni Palestrina's *29 motets*, based on the *Song of Solomon*.

Luca Marenzio's *Madrigali spirituali for 5 voices*, *Madrigals: Book II for 6 voices*, and *Madrigals: Book IV for 5 voices*.

Vincenzo Galilei's *Pieces for 2 viols*.

WORLD EVENTS

Siberia was annexed by expanding Russia.

Walter Raleigh explored the coast of Virginia.

d. Ivan IV (b. 1530), czar of Russia, called "Ivan the Terrible"; succeeded by his son Feodor, but Boris Godunov effectively ruled Russia.

1585

LITERATURE

Miguel de Cervantes's first novel, *La Galatea*, a pastoral romance.

d. Pierre de Ronsard, French poet (b. 1524).

VISUAL ARTS

Annibale Carracci's paintings included *Deposition*, *The Baptism of Christ*, and *The Triumph of Truth*.

El Greco's paintings included his *Christ Carrying the Cross* and *St. Louis of France* (both 1585–1590).

Ludovico Carracci's paintings included *The Annunciation* (ca. 1585) and *The Vision of St. Anthony of Padua* (ca. 1585).

Juan de Herrera began the Valladolid cathedral.

Mosque at Isfahan, Persia, built.

THEATER & VARIETY

Admiral's Men, the English acting company, first appeared at Court; their patron was Lord Howard.
John Lyly's *Galatea*.
d. Luigi Groto, Italian playwright and poet (b. 1541).

MUSIC & DANCE

Luca Marenzio's *Madrigals for 4 voices* and *Madrigals: Book III for 6 voices*.
Giovanni Croce's *Il primo libro de madrigali a 5 voci*.
Requiem for Ronsard's funeral, by Jacques Mauduit.
Giovanni Gabrieli's *Madrigali a 6 voci o istrumenti*.
d. Andrea Gabrieli, Italian composer (b. 1533).
d. Thomas Tallis, English composer (b. ca. 1505).

WORLD EVENTS

First Roanoke, Virginia, colony established and failed.
Eighth Huguenot civil war in France ended with defeat of Huguenots (1585–1598).
Elizabeth I sent an army led by the Earl of Leicester to support the Protestant Dutch.

1586

LITERATURE

Les Derniers Vers de P. de Ronsard, Pierre de Ronsard's final poems, published posthumously.
d. Philip Sidney, English poet (b. 1554).

VISUAL ARTS

El Greco's painting *Burial of the Conde de Orgaz* (1586–1588).
Agostino Carracci's painting *Madonna with Child and Saints*.

MUSIC & DANCE

Jacques Mauduit's *Chansonettes*.
Luca Marenzio's *Madrigals: Book IV for 6 voices*.

WORLD EVENTS

Akbar took Kashmir, faced growing rebellion in Afghanistan.

Mary of Scotland was tried for treason in England.
Philip II of Spain developed his planned Armada, for the coming invasion of England.

1587

LITERATURE

Humayun Nama, Gul-Badan Begum's history of the reign of her brother, Mughal ruler Humayun.

VISUAL ARTS

Annibale Carracci's paintings included his *Self-Portrait and Portrait of the Father and Nephew Antonio* (1587–1588) and *The Assumption*.
Ludovico Carracci's painting *The Conversion of St. Paul* (ca. 1587–1588).
Paolo Veronese's painting *St. Pantaleon Healing a Sick Boy*.

THEATER & VARIETY

Dido, Queen of Carthage, Christopher Marlowe's play, written with Thomas Nashe (ca. 1587); and Marlowe's *Tamburlaine the Great*.
Actresses were first allowed to work on the Spanish stage.
The Spanish Tragedy, Thomas Kyd's play (ca. 1587).
António Ferreira's *Tragédia de Doña Inêz de Castro*.
d. Giovanni Maria Cecchi, Italian playwright (b. 1518).
George Peele's *David and Bethsabe* (ca. 1587).

MUSIC & DANCE

Claudio Monteverdi's *Madrigal Book 1*.
Alfonso Ferrabosco I produced two books of five-voice madrigals.
Giovanni Gabrieli's *Concerti a 6–16 voci* and *Madrigali e ricercari a 4*.
Vincenzo Galilei's book of madrigals in five volumes.
Luca Marenzio's *Madrigals for 4, 5, & 6 voices*.

WORLD EVENTS

Francis Drake attacked and sacked Cadiz.
Mary of Scotland was beheaded by the English.

Ottoman Turks invaded Persia (1587–1590).

Second Roanoke, Virginia, colony established; later vanished without a trace.

1588

LITERATURE

Bible translated into Welsh by Bishop Morgan, helping the language survive.

Characterie: an Arte of Shorte, Swifte, and Secrete Writing by Character, Timothy Bright's work on shorthand.

Pandosto, the Triumph of Time, Robert Greene's romantic prose narrative; basis for Shakespeare's *The Winter's Tale*.

Briefe and True Report of the New-Found Land of Virginia, by British geographer Thomas Hariot.

VISUAL ARTS

Tintoretto's paintings included *Glorification of S. Rocco* and *Paradise* (1588–1590).

Annibale Carracci's paintings *St. Roch Giving Alms* (1588–1595) and *Enthroned Madonna with St. Matthew*.

Federico Barocci's painting *Madonna del Rosario* (1588–1591).

Ludovico Carracci's frescoes *History of Rome*, Palazzo Salem, Bologna (1588–1592); also his painting *Madonna dei Bargellini*.

d. Paolo Veronese, Venetian painter (b. 1528).

THEATER & VARIETY

d. Richard Tarleton, Elizabethan clown (?–1588), who may have originated the role of Yorick in *Hamlet*.

Christopher Marlowe's *Doctor Faustus*.

John Lyly's *Endymion the Man in the Moon*.

Robert Greene's *Doctor Faustus* (ca. 1588).

The Misfortunes of Arthur, Thomas Hughes's play, performed before Elizabeth I at Greenwich, February 28.

MUSIC & DANCE

Psalmes, Sonets, & songs of sadnes & pietie, William Byrd's songs, psalms, and madrigals.

Orchésographie, Thoinot Arbeau's illustrated dance manual.

Giovanni Croce's *Canzonette a 4 voci*.

d. Alfonso Ferrabosco I, Italian composer, influential in bringing Italian music to England (1543–ca. 1588).

WORLD EVENTS

England was attacked by the Spanish Armada, which was decisively defeated by the English off Calais; while retreating, gales destroyed much of the remaining Spanish fleet.

Boris Godunov formally became Regent of Russia (1588–1598).

1589

LITERATURE

Richard Hakluyt's *Principal Navigations, Traffics, Voyages, and Discoveries of the English Nation*.

The Arte of English Poesie, credited to George Puttenham, notable for suggesting that English could serve for poetry as well as Latin or Greek.

Thomas Lodge's poem *Glaucus and Scilla*.

Robert Greene's pastoral romance *Menaphon* (*Greene's Arcadia*).

THEATER & VARIETY

William Shakespeare's *Henry VI, Part II* and *Henry VI, Part III* (1589–1591).

Edward Alleyn starred in Christopher Marlowe's *The Tragical History of Dr. Faustus* and *Tamburlaine the Great* (ca. 1589).

Robert Greene's *The Honorable History of Friar Bacon and Friar Bungay* (1589).

John Lyly's *Midas* and *Mother Bombie*.

Pieter Corneliszoon Hooft's tragedy *Achilles en Polyxena*.

MUSIC & DANCE

William Byrd's *Cantiones Sacrae* (1589–1591) and *Songs of Sundrie Natures*, songs, psalms, and madrigals.

Giovanni Gabrieli's *Ecclesiasticae cantiones a 4–6 v.*

Andrea Gabrieli's *Madrigali a 5, Book III*.

Orazio (Tiberio) Vecchi's *Madrigals*.

First recorded mention of the *chitarrone*, a large, tall lute, possibly invented by Antonio Naldi; in common use in early 17th- century Italy.

WORLD EVENTS

d. Henry III (b. 1551), king of France, assassinated; resulting succession crisis eventuated in accession of Henry IV, the first Bourbon king of France.

d. Catherine de' Medici (b. 1519), queen of France's Henry II, and a power behind three sons who became kings.

Failed British seaborne attack on Lisbon.

1590

LITERATURE

Books 1–3 of Edmund Spenser's epic poem, *The Faerie Queene*, an allegory of virtue, with Gloriana (the Faerie Queene) referring to Queen Elizabeth I (and to Glory); only six of a projected 12 books were published (1590–1596), plus two additional cantos (1609).

Thomas Lodge's prose romance *Rosalynde, Euphues's Golden Legacie*.

Printing began in Japan.

Walter Raleigh's poem *Sir Walter Ralegh to the Queen* (early 1590s).

First complete Hungarian Bible published at Vizsoly; widely adopted by Protestants.

Alagiyavanna, Sinhalese poet (active 1590–1620).

VISUAL ARTS

El Greco's paintings included his *Christ at Gethsemane, Holy Family with St. Anne*, and *Holy Family with the Magdalen* (all 1590–1595).

Caravaggio's painting *Rest on the Flight into Egypt* (ca. 1590).

Giovanni Paolo Lomazzo's work on art theory, *Idea del Tempio della Pittura*.

THEATER & VARIETY

Edward Alleyn starred in Christopher Marlowe's *The Jew of Malta* (ca. 1590).

George Peele's *The Old Wives' Tale* (ca. 1590).

John Lyly's *Love's Metamorphosis* (1590).

The Faithful Shepherd, Giambattista Guarini's play (1590).

d. Robert Garnier, French Renaissance playwright (b. ca. 1545).

MUSIC & DANCE

Jam Christus astra ascenderat, Giovanni Palestrina's mass.

Giovanni Croce's *Il primo libro de madrigali a 6 voci* and *Mascharate piacevole et ridicolose*.

William Byrd's *The First Sett of Italian Madrigalls*.

Claudio Monteverdi's *Madrigal Book 2*.

"Golden Age" of lute music, in Europe (1590–1630).

d. Blasius Ammon, Austrian composer (b. ca. 1560).

d. Gioseffo Zarlino, Italian theorist and composer (b. 1517).

d. Lodovico Agostini, Italian composer (b. 1534).

d. Melchior Neusidler, German lutenist and composer (b. 1531), son of Hans Neusidler.

WORLD EVENTS

Civil war in France, between Henry IV and the Catholic League over the succession.

Akbar took southern Sind.

Galileo's *On Motion*.

Ottoman Turk–Persian war ended the Treaty of Constantinople.

1591

LITERATURE

d. St. John of the Cross (San Juan de la Cruz; Juan de Yepes y Alvarez), Spanish mystic and poet (1542–1591), best known for his mystical poems about the soul's attempt to find union with God.

Edmund Spenser's poetic works *Complaints* and *Daphnaïda*.

First known grammar written in one language about another: Richard Percivall's *Bibliotheca Hispanica, Containing a Grammar, with a Dictionarie in Spanish, English, and Latine*.

VISUAL ARTS

Agostino Carracci's paintings *Assumption of the Virgin* and *The Communion of St. Jerome* (both 1591–1593).

Ludovico Carracci's painting *Madonna and Child with St. Francis, St. Joseph and Donors*.

d. Jost Amman, Swiss engraver and illustrator (b. 1539).

THEATER & VARIETY

William Shakespeare's *Henry VI, Part I* (1591–1592).

Edward Alleyn starred in Greene's *Orlando Furioso*, based on Aristo (ca. 1591).

George Peele's *Edward I*.

MUSIC & DANCE

My Ladye Nevells Booke, William Byrd's keyboard collection.

Luca Marenzio's *Madrigals: Book V for 6 voices*.

d. Jacobus de Kerle, South Netherlands composer (b. 1531–1532).

d. Vincenzo Galilei, Italian theorist and composer (b. ca. 1520).

WORLD EVENTS

Akbar annexed Sind.

Henry IV of France was excommunicated by the Vatican; part of the continuing war of succession.

Trinity College, Dublin, founded.

1592

LITERATURE

Samuel Daniel's sonnet sequence *Delia* and first-person narrative poem *The Complaint of Rosamund*.

d. Michel Eyquem de Montaigne, French essayist (b. 1533).

d. Urfi, Persian Muslim poet working in India (?–1592).

VISUAL ARTS

Ludovico Carracci's paintings included *Supper in the House of Simon*, *The Martyrdom of St. Ursula*, *The Preaching of the Baptist Flora* (1592–1593), and *La Dea Opi* (1592–1593).

Agostino Carracci's paintings included *Pluto Madonna with SS. Luke and Catherine* and *The Assumption of the Virgin*.

d. Bartolommeo Ammanati, Italian architect and sculptor (b. 1511).

d. Jacopo da Ponte Bassano, Italian painter (b. 1517–1518).

THEATER & VARIETY

William Shakespeare's *Richard III* (1592–1593), with the title role created by Richard Burbage; and *The Comedy of Errors*.

Christopher Marlowe's *Edward II*.

d. Robert Greene, English playwright (b. ca. 1560) known for his portrayals of Elizabethan London's "low life."

MUSIC & DANCE

Claudio Monteverdi's *Madrigal Book 3*.

Giovanni Croce's *Il secondo libro de madrigali a 5 voci*.

Richard Alison, English composer (active 1592–1606).

d. Alessandro Striggio, Italian composer (b. ca. 1540).

WORLD EVENTS

Failed Japanese invasion of Korea.

Johannes Kepler's *Mysterium cosmographicum* (*The Mystery of the Universe*) (1596).

1593

LITERATURE

William Shakespeare's long poem *Venus and Adonis*, dedicated to Henry Wriothesley, Earl of Southampton; in this period, he also began writing his famous sonnet sequence, not published until 1609.

Michael Drayton's poetic work *Idea, the Shepherd's Garland*.

Walter Raleigh's poems *Praised Be Diana's Fair and Harmless Light*, *Like to a Hermit Poor*, and *Like Truthless Dreams*.

New Polish-language Roman Catholic Bible, prepared by Jakób Wujek, published, becoming the standard.

d. Christopher Marlowe, English poet and dramatist (b. 1564).

VISUAL ARTS

Tomb of Akbar, Sikandara (1593–1613).

Rome's Accademia di S. Luca was founded; Federigo Zuccaro was its first president.

Caravaggio's paintings included *Boy Bitten by a Lizard*, *Boy with a Basket of Fruit*, and *The Young Bacchus*.

Annibale Carracci's painting *Christ at the Tomb*.

d. Giuseppe Arcimboldo, Milanese painter (b. 1537) noted for grotesques formed from plants and animals.

THEATER & VARIETY

William Shakespeare's *The Taming of the Shrew* and *Titus Andronicus* (1593–1594).

John Lyly's *The Woman in the Moon*.

MUSIC & DANCE

Thomas Morley's *Canzonets for Three Voices*.

Raffaella Aleotti's *Sacrae cantiones*.

WORLD EVENTS

Austria and the Ottoman Turks were again at war (1593–1601).

Henry IV of France converted to Roman Catholicism.

Lutheranism became the Swedish state religion.

1594

LITERATURE

William Shakespeare's poem *The Rape of Lucrece*, on the Roman woman Lucretia who, after publicly acknowledging being raped by the king's son, stabs herself because of the dishonor to herself and her family.

Michael Drayton's sonnet sequence *Idea's Mirror*.

The Unfortunate Traveller, Thomas Nashe's "low-life" tale.

VISUAL ARTS

d. Tintoretto (Jacopo Robusti Tintoretto), Italian artist (b. 1518), a major Renaissance figure; one of his late works was his *The Last Supper* (1594).

Caravaggio's paintings included his *The Fortune-teller* (*La Zingara*) and *The Sacrifice of Isaac* (1594–1596).

Agostino Carracci's painting *Christ and the Adultress* (ca. 1594).

THEATER & VARIETY

William Shakespeare's *Romeo and Juliet*, *Love's Labour's Lost*, and *The Two Gentlemen of Verona* (1594–1595).

Chamberlain's Men founded, the acting company that originated most of William Shakespeare's plays; its leading actor was Richard Burbage. Played at London's Theater (1594–1599), and then at the Globe; later renamed *King's Men*.

d. Thomas Kyd, English playwright (b. 1558).

MUSIC & DANCE

Chansons by Jan Pieterszoon Sweelinck.

Giovanni Croce's *Nove pensieri musicali a 5 voci* (*Book III of Madrigals*).

Carlo Gesualdo's *Madrigals for 5 voices* (20), *Books I* and *II*.

Thomas Morley's *Madrigals for Four Voices*.

Luca Marenzio's *Madrigals: Book VI for 5 Voices*.

d. Giovanni Palestrina, Italian composer (b. 1525).

d. Orlande Lassus, Franco-Flemish composer (b. ca. 1530–1531).

WORLD EVENTS

Dutch expedition to Indian Ocean began Dutch penetration and ultimate conquest of the East Indies (Indonesia).

Henry IV was crowned king of France.

Ottoman Turks advanced in central Europe, crossing into Hungary.

1595

LITERATURE

Edmund Spenser's *Amoretti*, a sonnet sequence on

courtship, and *Epithalamion*, a marriage ode.

Robert Southwell's religious poem *The Burning Babe*.

Samuel Daniel's verse work *The Civil Wars* (1595–1605).

d. Torquato Tasso, Italian poet (b. 1544).

VISUAL ARTS

El Greco's paintings included his *View of Toledo* (ca. 1595), *St. Jerome as Cardinal* (1595–1600), and *St. Francis Kneeling in Meditation* (1595–1600).

Annibale Carracci's painting *Hercules at the Crossroad*.

THEATER & VARIETY

William Shakespeare's *Richard II* and *A Midsummer Night's Dream* (1595–1596).

MUSIC & DANCE

Thomas Morley's *Balletts for Five Voices*, *Canzonets for Two Voices*, and *Dialogue for Seven Voices*.

Luca Marenzio's *Madrigals: Book VI for 6 Voices* and *Madrigals: Book VII for 5 Voices*.

Carlo Gesualdo's *Madrigals for 5 Voices (20)*, *Book III*.

Giovanni Croce's *Triaca musicale*.

d. Thoinot Arbeau, French writer (b. 1520).

WORLD EVENTS

France and Spain were at war.

Uprisings against the English in Ulster prepared the way for the coming major uprising (1595–1604).

Spanish fleet attacked Cornwall and southwestern England.

1596

LITERATURE

Edmund Spenser's poetic works *Prothalamion*, celebrating a double marriage; *Foure Hymnes*, two written much earlier; and *The Faerie Queene*, books 4–6.

Walter Raleigh's *The Discovery of the Empyre of Guiana*.

VISUAL ARTS

Caravaggio's paintings included his *Lute Player*, *Basket of Fruit*, *The Magdalene*, and *The Supper at Emmaus* (1596–1598).

d. Pellegrino Tibaldi, Italian painter, sculptor, and architect (b. 1527).

THEATER & VARIETY

William Shakespeare's *King John* and *The Merchant of Venice* (1596–1597).

MUSIC & DANCE

Carlo Gesualdo's *Madrigals for 5 Voices (20, 1 for 6)*, *Book IV*.

Costanzo Festa's *Te Deum* published.

Thomas Campion's *Three songs*.

d. Giaches de Wert, Flemish composer (b. 1535).

WORLD EVENTS

Widening Protestant–Catholic wars in Europe, as England, France, and the Dutch formally allied themselves against Spain.

Dutch vessels reached Sumatra. First Dutch treaty in Indonesia, with Prince of Bantam.

1597

LITERATURE

Essays, Francis Bacon's explorations of wide-ranging philosophical and religious concerns; the original 10 essays were expanded to 38 (1612), then 58 (1625).

Come Away, Come, Sweet Love, anonymous poem, set to lute music by John Dowland.

Michael Drayton's *England's Heroical Epistles*.

VISUAL ARTS

d. Juan de Herrera, Spanish architect (b. 1530).

THEATER & VARIETY

William Shakespeare's *Henry IV, Part I* and *Henry IV, Part II* (1597–1598).
d. George Peele, English playwright (b. ca. 1558).
d. Stefano Tuccio, Sicilian playwright (b. 1540).

MUSIC & DANCE

Thomas Morley's *Canzonets for Six Voices.*
Giovanni Gabrieli's *Symphoniae sacrae* and *Sonata pian e forte.*
L'Amfiparnaso, Orazio (Tiberio) Vecchi's madrigal–comedy.
Thomas Weelkes's *Madrigals.*
Giovanni Croce's *Motetti a quattro voci.*
Simone Molinaro produced nine books of sacred works (1597–1616).
Giovanni Gabrieli's *Sacrae symphoniae, Book I.*
d. Elias Nikolaus Ammerbach, German organist and arranger (b. ca. 1530).

WORLD EVENTS

Japan intensified its anti-Christian persecutions.
Persians expanded into central Asia, taking Uzbekistan.
Second failed Japanese invasion of Korea.

1598

LITERATURE

George Chapman published his translation of *Seven Books of the Iliad*; the complete translation of Homer's *Iliad* appeared in 1611; it was the work celebrated in Keats's 1816 sonnet.
Lope de Vega's epic poem *La dragontea,* attacking Sir Francis Drake and England, and pastoral novel *La arcadia,* inspired by Jacopo Sannazaro's *Arcadia* (1504).
Francis Bacon's poem *The Life of Man.*

VISUAL ARTS

Caravaggio's paintings included his *The Calling of St. Matthew, The Martyrdom of St. Matthew,* and *St. Matthew and the Angel* (all 1598–1601).
Ludovico Carracci's painting *Martyrdom of S. Angelo* (ca. 1598).

Agostino Carracci's painting *Portrait of Giovanna Parolini-Guicciardini.*

THEATER & VARIETY

William Shakespeare's *Henry V* and *Much Ado About Nothing* (1598–1599).
Ben Jonson's *Every Man in His Humour* presented by the Chamberlain's Men, with William Shakespeare in an acting role.
Giovanni Battista Guarini's *Il pastor fido.*

MUSIC & DANCE

Dafne, the first completely sung opera; music by Jacopo Peri and Jacopo Corsi, libretto by Ottavio Rinuccini.
Thomas Weelkes's *Balletts and Madrigals.*
Luca Marenzio's *Madrigals: Book VIII for 5 voices.*
Luzzasco Luzzaschi published a motet volume.
Five strings (each paired) became standard on guitars (ca. 1600).

WORLD EVENTS

Boris Godunov became czar of Russia (1598–1605).
Unsuccessful rising in Ulster, led by Hugh O'Neill, with Spanish alliance (1598–1602).

1599

LITERATURE

The Passionate Pilgrim, a volume of 20 poems published under William Shakespeare's name, but most believed to be by others.
Lope de Vega's verse work *El Isidro,* about the patron saint of Madrid.
Mateo Alemán's novel *Guzmán de Alfarache* (1599–1604).
Honoring his English queen, John Davies wrote a series of 26 acrostic poems spelling out "Elisabetha Regina."
d. Edmund Spenser, English writer (b. 1599).

VISUAL ARTS

d. Wen Cheng-ming (ca. 1500–1599), one of the four Ming master painters, of the Suchou school.

THEATER & VARIETY

William Shakespeare's *As You Like It* and *Julius Caesar* (1599–1600).

Richard and Cuthbert Burbage built the Globe Theater, which was then occupied by the Chamberlain's Men; site of much of Shakespeare's work.

All Fools, George Chapman's play.

John Marston's *Antonio and Mellida* (ca. 1599).

John Marston's *Antonio's Revenge*.

Thomas Dekker's *The Shoemaker's Holiday*.

MUSIC & DANCE

Simone Molinaro's *Lutebook*.

Luca Marenzio's *Madrigals: Book IX for 5 voices*.

Richard Alison's *Psalmes of David*.

d. Francisco Guerrero, Spanish composer of 18 masses and some 150 motets (b. 1528).

d. Jacob Regnart, South Netherlands composer (b. 1540–1545).

WORLD EVENTS

British East India Company founded.

Second failed Spanish invasion never reached England, due to weather.

1600

LITERATURE

The Passionate Shepherd to His Love, Christopher Marlowe's famous poem beginning "Come live with me and be my love," much imitated, and also parodied, as by John Donne in *The Bait*.

If All the World and Love Were Young, Walter Raleigh's poem.

Chin P'ing Mei, Chinese novel.

Hikayat Hang Tuah, Malay quasi-historical novel (15th c.).

Mira Bai, celebrated Indian *bhakti* (devotional) woman poet (active ca. 1600).

d. George Puttenham, English writer (b. 1532).

VISUAL ARTS

El Greco's paintings included his *Cardinal Don Fernando Niño de Guevara* (ca. 1600), *St. Dominic*

(1600–1605), *St. Francis and Brother Leo Meditating on Death* (1600–1605), and *St. Ildefonso* (1600–1603).

Ludovico Carracci's painting *The Martyrdom of St. Ursula*.

Annibale Carracci's painting *The Assumption* (1600–1601).

d. Antoine Caron, French painter (b. ca. 1520).

d. Giovanni Paolo Lomazzo, Italian painter (b. 1538).

THEATRE & VARIETY

William Shakespeare's *Hamlet*, with Richard Burbage creating the title role; and *The Merry Wives of Windsor* (1600–1601).

The Chamberlain's Men premiered Ben Jonson's *Cynthia's Revels*.

John Day's *The Blind Beggar of Bethnal Green*, also known as *Thomas Strowd*.

Robert Armin's *Foole upon Foole, or Six Sortes of Sottes*.

d. Giordano Bruno, Italian philosopher and playwright (b. 1548), author of *Il Candelaio*.

Erophile, by Cretan playwright Georgios Hortatsis (ca. 1600).

MUSIC & DANCE

Thomas Weelkes's *Madrigals for Five Voices* and *Madrigals for Six Voices*.

Il Rapimento di Cefalo, Giulio Caccini's stage work.

Thomas Morley's *Airs to the Lute*.

WORLD EVENTS

Attacking Dutch forces in Indonesia consolidated their hold on the spice trade.

Tokugawa Ieyau won the decisive Battle of Sekigahara, completing the unification of Japan.

Poland and Sweden were at war (1600–1611).

Spanish destroyed Dutch fleet in Manila harbor.

1601

LITERATURE

Mysterious poem *The Phoenix and the Turtle*, attributed to William Shakespeare, published with some poems by Robert Chester under the title *Loves Martyr: Or Rosalin's Complaint*.

Thomas Campion's poems My Sweetest Lesbia, When to Her Lute Corinna Sings, and I Care Not For These Ladies.

VISUAL ARTS

Annibale Carracci's painting Christ Appearing to St. Peter on the Appian Way ("Domine, Quo Vadis?") (ca. 1601).

Caravaggio's paintings included his The Crucifixion of St. Peter and The Conversion of St. Paul.

Ludovico Carracci's painting The Assumption.

THEATER & VARIETY

William Shakespeare's Twelfth Night and Troilus and Cressida (1601–1602).

Thomas Dekker's Satiromastix was presented by the Chamberlain's Men.

The Poetaster, Ben Jonson's play.

d. Thomas Nashe, English pamphleteer and playwright (b. 1567).

MUSIC & DANCE

Tu es Petrus, Giovanni Palestrina's mass.

Book of Airs, Thomas Campion's songs to be sung to the lute (composed with Philip Rosseter).

Luzzasco Luzzaschi published a book of madrigals for one to three sopranos with keyboard accompaniment.

Giovanni Croce's Canzonette a 3 voci.

WORLD EVENTS

Decisive Dutch victory over a Portuguese fleet off Bantam, in the East Indies, defined Dutch power in the region.

English forces decisively defeated the Ulster rebels and their Spanish allies at Kinsale.

Matteo Ricci, Jesuit priest, was at the Chinese court; highly esteemed as an astronomer (1601–1613).

1602

LITERATURE

Thomas Campion's Observations on the Art of English

Poesie, espousing the use of classical meter in poetry.

Lope de Vega's verse work, La hermosura de Angelica, his sequel to Ariosto's Orlando Furioso (1516).

Bodleian Library at Oxford University opened.

Printing began in the Philippines.

VISUAL ARTS

Caravaggio's painting The Deposition of Christ (1602–1604).

Peter Paul Rubens's painting Rubens and His Friends at Mantua (ca. 1602).

d. Agostino Carracci, Italian painter (b. 1557).

THEATER & VARIETY

William Shakespeare's All's Well That Ends Well (1602–1603).

George Chapman's May-Day.

Theseus and Ariadne, Pieter Hooft's drama.

Henry Chettle's The Tragedy of Hoffman (ca. 1602).

MUSIC & DANCE

Euridice, the first opera for which the score is still complete; music by Jacopo Peri and Giulio Caccini; libretto by Ottavio Rinuccine.

Concerti Ecclesiastici, Lodovico Viadana's work for one to four voices.

Le nuove musiche, Giulio Caccini's song.

d. Thomas Morley, English composer (b. 1557–1558).

WORLD EVENTS

Manchus began their runup to the conquest of China, attacking Chinese cities in Manchuria (ca. 1602).

Turkey and Persia were at war (1602–1612).

Tycho Brahe's Introduction to the New Astronomy, published posthumously.

1603

LITERATURE

Samuel Daniel's A Defence of Rhyme, arguing that English poetry should be based on the natural rhythms of English, not on Latin or Greek.

Thomas Dekker's pamphlet, *The Wonderful Year*, describing a London plague year.

Weep You No More, Sad Fountains, anonymous poem (ca. 1635).

d. Gul-Badan Begum, Indian writer (b. 1523), sister of Mughal ruler Humayun.

VISUAL ARTS

Annibale Carracci's work included his frescoes at Rome's Palazzo Farnese (1603–1604), and his paintings *The Dead Christ Mourned* (*The Three Maries*) (ca. 1603) and *Pietà*.

El Greco's work included his altars, sculpture, and paintings for the Hospital de la Caridad (1603–1605).

Giovanni Bologna's bronze doors at Pisa Cathedral.

Caravaggio's painting *Madonna with Pilgrims* (*Madonna di Loreto*).

Hendrick de Keyser's work included Amsterdam's South Church (1603–1614).

Peter Paul Rubens's painting *Duke of Lerma*.

THEATER & VARIETY

Sejanus, Ben Jonson's play.

Thomas Heywood's *A Woman Killed with Kindness*.

d. William Kempe, Elizabethan clown and player of jigs (?–1603).

MUSIC & DANCE

Claudio Monteverdi's *Madrigal Book 4*.

Carlo Gesualdo's *Sacrae Cantiones for 5 voices, Book I* and *Sacrae Cantiones for 6 and 7 voices, Book I*.

Book of tunes for violin published in Nuremberg, indicating the instrument's popularity for everyday music, especially dancing (ca. 1600).

d. Philippe de Monte, Flemish composer (b. 1521).

WORLD EVENTS

d. Elizabeth I (b. 1533), queen of England; succeeded by James VI of Scotland, who ruled England as James I, the first of the Stuart kings.

French explorer Samuel de Champlain made his first voyage to North America, exploring the St. Lawrence as far as the Lichine Rapids.

1604

LITERATURE

James I ordered a new English translation of the Bible, which would become the *King James Version*.

First published dictionary in English: Robert Cawdrey's *Table Alphabeticall*.

Adi Granth (*First Book*), poetry collected by Arjun, Sikh Guru; issued mainly in Punjabi.

Lope de Vega's prose work *El peregrino en su patria* (*The Pilgrim, or the Stranger in his own Country*).

VISUAL ARTS

Annibale Carracci's paintings included *Christ and the Samaritan at the Well* (ca. 1604–1605), *Entombment* (ca. 1604), *Flight into Egypt* (ca. 1604), and *Martyrdom of St. Stephen* (ca. 1604).

Ludovico Carracci's painting *The Divine Providence* (ca. 1604–1605).

Golden Temple (Darbar Sahib or Harimandir), chief Sikh house of worship and pilgrimage shrine, built in Amritsar (ca. 1604).

THEATER & VARIETY

William Shakespeare's *Othello*; the title role was created by Richard Burbage.

d. Isabella Canali Andreini, leading commedia dell'arte actress (b. 1562), with her husband Francesco Andreini comanager and costar of the Gelosi troupe, and mother of actor Giovanni Battista Andreini.

George Chapman's *Bussy d'Ambois* and *All Fools* (ca. 1604).

John Marston's *The Malcontent* and *The Dutch Courtesan*.

Samuel Daniel's *Philotas*.

Thomas Heywood's *The Wise Woman of Hogsdon*.

Thomas Middleton's *The Phoenix*.

MUSIC & DANCE

Lachrimae, John Dowland's seven pavans, for viol consort and lute, including the noted *Semper Dowland semper dolens*.

Michael East's *First Set of Madrigals*.

d. Claudio Merulo, Italian composer (b. 1533).

d. Emanuel Adriaenssen, South Netherlands lutenist and composer (b. ca. 1554).

d. Giovanale (Giovanni) Ancina, Italian composer (b. 1545).

WORLD EVENTS

Boris Godunov defeated the forces of Dimitri, claimant to the Russian throne.

French East India Company was founded.

Port Royal (Annapolis) was founded in Nova Scotia.

1605

LITERATURE

Don Quixote, part 1 of Miguel de Cervantes's novel, *El ingenioso hidalgo don Quijote de la Mancha*, the universal tale of the idealistic Don Quixote de la Mancha tilting at windmills, with his faithful squire Sancho Panza and his adopted lady, Dulcinea.

Francis Bacon's *The Advancement of Learning* (*The Two Bookes of Francis Bacon of the Proficience and Advancement of Learning Divine and Humane*), a philosophical treatise on the state of knowledge and nature of learning; later greatly expanded (1623).

News publication *Mercure de France* began appearing annually in France; later taken over by Cardinal Richelieu.

VISUAL ARTS

Caravaggio's paintings included his *Death of the Virgin* and *Madonna dei Palafrenieri* (*Madonna of the Serpent*) (both 1605–1606).

El Greco's paintings included *Agony in the Garden* and *Jerónimo de Cevallos* (both 1605–1610).

Peter Paul Rubens's painting *Circumcision*.

Place Royale (Place des Vosges) begun in Paris.

India's ruler, Akbar, built Humayun's tomb and the palace city of Fatchpur Sikri, abandoned at Akbar's death (1605).

THEATER & VARIETY

William Shakespeare's *King Lear*, *Macbeth*, and *Mea-*

sure for Measure (1605–1606).

Ben Jonson's *Volpone*, which premiered at the Globe; his *Eastward Ho!*, a satire to which James I took offense; imprisoning Jonson for a time; and Jonson's *The Masque of Blackness*.

Thomas Middleton's comedy *A Trick to Catch the Old One*.

Pieter Corneliszoon Hooft's pastoral play *Granida*.

MUSIC & DANCE

Gradualia, William Byrd's motets.

Claudio Monteverdi's *Madrigal Book 5*.

L'organo suonarino, Adriano Banchieri's treatise on bass figures and liturgical chant.

Francis Pilkington wrote a collection of lute songs.

d. Orazio (Tiberio) Vecchi, Italian composer (b. 1550).

WORLD EVENTS

d. Boris Godunov (b. ca. 1551), czar of Russia; in the succession crisis that followed, his son Feodor was assassinated and Dimitri briefly held the throne.

Guy Fawkes's Gunpowder Plot, an alleged attempt to blow up the Parliament and assassinate James I.

First French settlement in North America, the Habitation, at Port Royal (Annapolis), Nova Scotia.

d. Akbar (b. 1542), Mughal emperor of India; succeeded by Jahangir.

1606

VISUAL ARTS

Ludovico Carracci's paintings included *Apostles at the Tomb of the Virgin* (1606–1609).

THEATER & VARIETY

William Shakespeare's *Antony and Cleopatra* (1606–1607).

Francesco Andreini's *Le Bravure del Capitan Spavento da Vall'Inferna*, Part I.

Francis Beaumont and John Fletcher's play *The Woman Hater*.

John Day's *Isle of Gulls.*

Thomas Middleton's *A Mad World, My Masters.*

d. John Lyly, English novelist and playwright (b. ca. 1554).

MUSIC & DANCE

Michael East's *Second Set of Madrigals.*

d. Guillaume Costeley, French composer (b. ca. 1530).

WORLD EVENTS

Dutch began commercial and political penetration of Borneo.

Executions of Guy Fawkes and others involved in Gunpowder Plot.

1607

LITERATURE

First Protestant Bible in Italian, by Hebrew and Greek scholar Biovanni Diodati, published in Geneva; it remained standard into the 20th century.

VISUAL ARTS

Caravaggio's paintings included his *St. Jerome, Ecce Homo, Madonna of the Rosary, The Seven Works of Mercy,* and *The Supper at Emmaus.*

El Greco's paintings included his *Immaculate Conception* (1607–1614).

Annibale Carracci's painting *Pietà* (ca. 1607).

Battistello's painting *Liberation of St. Peter.*

THEATER & VARIETY

William Shakespeare's plays *Coriolanus* and *Timon of Athens* (1607–1608).

Francis Beaumont's play *The Knight of the Burning Pestle.*

The Revenger's Tragedy, Cyril Tourneur's play.

Thomas Heywood's *The Rape of Lucrece.*

Thomas Middleton's *Your Five Gallants.*

MUSIC & DANCE

La Favola D'Orfeo (*The Legend of Orpheus*), Claudio

Monteverdi's opera, libretto by Alessandro Striggio, first performed privately and then at the Court Theater, Mantua, February 1607, with Castrato Giovanni Gualberto as Orfeo.

Thomas Campion's *Songs for a Mask at the marriage of Sir James Hay.*

Giovanni Croce's *Il quarto libro de madrigali a 5 et 6.*

d. Luzzasco Luzzaschi, Italian composer (b. 1545).

WORLD EVENTS

English colonists arriving on the *Discovery, Goodspeed,* and *Sarah Constant* founded first permanent colony at Jamestown, Virginia.

"Flight of the Earls," the fleeing of leading Irish rebels from Ulster, followed by an intensified "plantation" of Protestant settlers in Ulster.

1608

LITERATURE

John Smith's pamphlet *A True Relation of such occurrences and accidents of noate as hath hapned in Virginia since the first planting of that Collony.*

d. Thomas Sackville, English poet (b. 1536).

VISUAL ARTS

El Greco's painting *The Fifth Seal of the Apocalypse* (1608–1614).

Caravaggio's paintings included his *Salome Receives the Head of St. John the Baptist, The Burial of St. Lucy, Portrait of Alof de Wignacourt,* and *Sleeping Cupid.*

Himeji Castle completed, in Japan's Hyogo prefecture.

d. Giovanni Bologna, Italian sculptor (b. 1529).

THEATER & VARIETY

William Shakespeare's *Pericles* (1608–1609).

John Fletcher's *The Faithfull Shepheardesse* (1608–1609).

Francis Beaumont and John Fletcher's *Phylaster, The Coxcombe,* and *The Maides Tragedy* (1608–1611).

John Day's *The Parliament of Bees.*

Tyre et Sidon, Jean de Schelandre's tragedy.

d. Jean de la Taille, French playwright (b. 1540).

MUSIC & DANCE

Arianna, Claudio Monteverdi's opera, libretto by Ottavio Rinuccini, premiered at Teatro della Corte, Mantua, May 28.

Il ballo delle ingrate, Claudio Monteverdi's ballet.

Girolamo Frescobaldi published an early volume of madrigals and began what would be 12 volumes of keyboard music (1608–1614).

Dafne, Marco da Gagliano's opera.

Thomas Weelkes's *Airs or Fantastic Spirits*.

WORLD EVENTS

Samuel de Champlain founded Quebec City.

Emperor Rudolf V of Austria abdicated; succeeded by his brother Matthias.

1609

LITERATURE

William Shakespeare's *Sonnets*, 154 verses forming the finest sonnet sequence in English, published (written 1593–1601); the identity of the "Dark Lady" and of "W.H." to whom the sonnets are dedicated are unknown, as is the authorship of another poem in the same volume, *A Lover's Complaint*.

Two additional cantos to Edmund Spenser's *The Faerie Queene*, published posthumously; on mutability, so called the *Mutabile Cantos*.

First regularly published newspaper in Western world, *Avisa Relation oder Zeitung*, began appearing, produced by Johan Carolus of Strasbourg.

Lope de Vega's verse works *Arte nuevo de hacer comedias en este tiempo* and *Jerusalén conquistada*.

Francis Bacon's *De Sapientia Veterum*.

VISUAL ARTS

Peter Paul Rubens's paintings included his *Adoration of the Magi* and *Rubens with His First Wife, Isabella Brant, Amidst Honeysuckle* (ca. 1609).

Caravaggio's paintings included his *The Adoration of the Shepherds* and *The Resurrection of Lazarus*.

El Greco's painting *Fray Feliz Hortensio Paravicino*.

d. Annibale Carracci, Italian painter (b. 1560).

THEATER & VARIETY

William Shakespeare's *Cymbeline* (1609–1610).

Ben Jonson's *Masque of Queens Celebrated from the House of Fame*, staged by Inigo Jones at Court on Twelfth Night; and Jonson's *Epicoene* and *The Captaine*.

MUSIC & DANCE

Pammelia, the first English printed collection of rounds and catches, by Thomas Ravenscroft.

Ayres, Alfonso Ferabosco's book of lute songs.

d. Christoph Praetorius, German composer (?–1609).

d. Giovanni Croce, Italian composer (b. ca. 1557).

d. Giovanni Giacomo Gastoldi, Italian composer (b. ca. 1550).

WORLD EVENTS

Henry Hudson, exploring the northeastern coast of North America, discovered New York harbor, and sailed up the Hudson River.

Galileo invented the telescope.

Massive expulsions of Muslims from Spain.

Russia and Poland were at war (1609–1618).

Samuel de Champlain accompanied Indians into the lake later named for him.

1610

LITERATURE

Printing began in Lebanon and Bolivia.

Earliest surviving publication in Manx Gaelic, a translation of the Book of Common Prayer.

VISUAL ARTS

El Greco's paintings included his *View and Plan of Toledo* and *Laocoön* (1610–1614).

d. Caravaggio (Michelangelo Merisi da Caravaggio), Italian painter (b. 1573).

THEATER & VARIETY

William Shakespeare's *The Winter's Tale* (1610–1611).

Ben Jonson's *The Alchemist*.

John Fletcher's *Monsieur Thomas, Valentinian*, and

The Faithful Shepherdess (1610–1616), the latter after the Giambattista Guarini play *The Faithful Shepherd*.

John Marston's *The Insatiate Countess*.

Thomas Dekker's *If It Be Not Good, the Devil Is in It*.

Thomas Heywood's *The Fair Maid of the West*.

MUSIC & DANCE

Full Fadom Five Thye Father Lies and *Come Away, Come Away Death*, songs from Shakespeare's *The Tempest*.

Michael East's *Third Book*.

WORLD EVENTS

Galileo further developed the telescope and used it for pioneering explorations of the sky.

Henry Hudson discovered Hudson's Bay.

1611

LITERATURE

King James or *Authorized Version* published; sponsored by King James I, 47 translators in teams at Oxford, Cambridge, and Westminster had worked to produce a new English translation more faithful to the Bible's original languages. It remains the best-known Bible of the English-speaking world, its enormously resonant phrases having become a deep part of language and civilization, even to the irreligious.

George Chapman completed his translation of Homer's *Iliad* into English.

John Donne's long elegiac poem *An Anatomy of the World*, the first of two together called *The Anniversaries*.

VISUAL ARTS

Palais and Jardin (Garden) du Luxembourg built (1611–1620).

THEATER & VARIETY

William Shakespeare's *The Tempest* (1611–1612).

Francis Beaumont and John Fletcher's *A King and No King* and *Cupids Revenge*.

John Fletcher's plays *Bonduca* (1611–1614) and *The Womans Prize* (1611?).

Thomas Middleton's *A Chaste Maid in Cheapside*.

Tirso de Molina's *The Man in Green Breeches*.

d. Robert Armin, English Elizabethan writer and clown (b. ca. 1568).

MUSIC & DANCE

Carlo Gesualdo's *Madrigals for 5 voices (21), Book V* and *Madrigals for 5 voices (23), Book VI*; also his *Responsoria for 6 voices*.

Parthenia, William Byrd's keyboard collection (ca. 1611).

Courtly Masquing Ayres, John Adson's dances.

Paul Peuerl produced three instrumental collections (1611–1625).

d. Tomás Luis de Victoria, Spanish composer (b. 1548).

WORLD EVENTS

Denmark and Sweden were at war.

Russo-Polish War: Polish and Swedish forces fought their way deep into Russia.

1612

LITERATURE

John Donne's long elegiac poem *Of the Progresse of the Soule*, the second of two together called *The Anniversaries*.

Lope de Vega's pastoral novel, *Pastores de Belén*.

VISUAL ARTS

El Greco's painting *Adoration of the Shepherds* (1612–1614).

Peter Paul Rubens's painting *Deposition Triptych* (1612–1614).

Masjid-i Shah, Great Mosque of Shah Abbas, built in Isfahan (1612–1620).

d. Federico Barocci, Italian painter (b. 1526).

THEATER & VARIETY

William Shakespeare's *Henry VIII* (1612–1613).

John Webster's *The White Devil* (ca. 1612).

Gerbrand Adriaansz Bredero's *Griane* and *The Farce of the Cow*.

Samuel Coster's comedy *Teewis the Peasant*.

Tirso de Molina's *The Bashful Man at Court* (ca. 1612).

d. Giovanni Battista Guarini, Italian playwright (b. 1537).

d. Giovanni Pellesini, Italian actor (b. ca. 1526).

MUSIC & DANCE

The Fitzwilliam Virginal Book, William Byrd's noted keyboard collection (1612–1619).

Jan Pieterszoon Sweelinck's *Italian Madrigals* and *chansons*.

d. Giovanni Gabrieli, Italian composer (b. ca. 1553–1556).

d. Hans Leo Hassler, German composer (b. 1564).

WORLD EVENTS

Dutch settlement that would become New Amsterdam began, with the arrival of two Dutch ships and development of trade.

John Rolfe began growing tobacco in Virginia.

Samuel de Champlain became governor of New France.

1613

LITERATURE

Miguel de Cervantes's *Novelas ejemplares* (*Exemplary Novels*), 12 short stories.

Pieter Corneliszoon Hooft's *Geeraerdt van Velzen*, based on stories of King Floris V's murder by a subject.

d. Mateo Alemán, Spanish novelist (1547–after 1643).

VISUAL ARTS

Peter Paul Rubens's paintings included *The Rockox Altarpiece* (1613–1615) and *The Toilet of Venus* (ca. 1613–1615).

Salomon de Brosse's work included his chateau at Coulommiers.

Anthony Van Dyck painted a *Self-Portrait* (ca. 1613).

Start of construction of Oxford's Bodleian Library (1613–1618).

THEATER & VARIETY

John Webster's *The Duchess of Malfi*.

Thomas Middleton's *No Wit No Help Like a Woman's*.

Francis Beaumont and John Fletcher's *The Scornful Ladie* (1613–1617).

Giovann Battista Andreini's *Adamo*.

Gerbrand Adriaensz Bredero's farce *Klucht van den Molenaar*.

Pieter Hooft's history play *Geeraerdt van Velsen*.

d. Andrés Rey de Artieda, Spanish playwright (b. 1549).

MUSIC & DANCE

Thomas Campion's book *A New Way of Making Four parts in Counterpoint*; also his *Songs for a Mask at the Marriage of Princess Elizabeth*; *Songs for a Mask at the Marriage of Robert, Earl of Somerset*; and *First and Second Books of Airs* (ca. 1613).

Francis Pilkington's *First set of madrigals* (1613–1614).

John Ward's *Madrigals*.

Paul Peuerl's volume of songs.

d. Carlo Gesualdo, Prince of Venosa, Italian composer (b. 1561).

WORLD EVENTS

English began trading in Japan.

English colonial forces took and destroyed the French settlement at Port Royal, Nova Scotia.

Michael Romanov became czar of Russia, the first of the Romanov dynasty.

1614

LITERATURE

Miguel de Cervantes's verse allegory *Viaje del Parnaso* (*The Voyage to Parnassus*).

d. Mateo Alemán, Spanish novelist (b. 1547).

VISUAL ARTS

Peter Paul Rubens acted as illustrator for numerous works by the Antwerp publishing house of Christophe Plantin, including *Breviarium Romanum*.

Hendrick de Keyser's tomb of William the Silent (1614–ca. 1621).

d. El Greco (Domenikos Theotocopoulous), Greek painter, sculptor, and architect (b. 1541), working in Spain; a major figure of the Renaissance.

THEATER & VARIETY

Ben Jonson's *Bartholomew Fair*.

Lope Félix de Vega Carpio's play *The Commander of Ocañ*.

Bretislaus, New Comedy, Czech play in Latin by Jan Campanus Vodhansky.

Samuel Coster's drama *Ithys*.

MUSIC & DANCE

Cartella musicale, Adriano Banchieri's writings on harmony, rhythm, and vocal ornamentation.

Giulio Caccini's *Nuove musiche e nuova maniera di scriverle*.

Claudio Monteverdi's *Madrigal Book 6*.

Thomas Ravenscroft treatise *Briefe Discourse*.

d. Felice Anerio, Italian composer (b. ca. 1560).

WORLD EVENTS

Danish East India Company founded.

Dutch East India Company founded.

Poland and the Ottoman Turks were at war (1614–1621).

Swedish forces took Novgorod from the Russians.

Czar Michael defeated the Cossacks at Rostokino.

1615

LITERATURE

Don Quixote, part 2 of Miguel de Cervantes's novel, *El ingenioso hidalgo don Quijote de la Mancha*.

George Chapman, English translation of Homer's *Odyssey*.

Weekly newspaper began publication in Frankfurt, Germany.

VISUAL ARTS

Peter Paul Rubens's paintings included *The Holy Family* (ca. 1615).

Salomon de Brosse's work included his chateaus of Blérancourt and Luxembourg.

THEATER & VARIETY

Miguel de Cervantes's *Ocho comedias, y ocho entremenses nuevos*, drama.

MUSIC & DANCE

Giovanni Gabrieli's *Sacrae symphoniae, Book II*; also his *Canzione e sonate a 3–22*, and *Sonata* for three violins.

Johann Hieronymus Kapsberger's *Sinfonie a quattro*.

d. Simone Molinaro, Italian composer (b. ca. 1565).

WORLD EVENTS

Samuel de Champlain explored west to Lake Huron.

The Dutch took the Moluccas from the Portuguese.

William Baffin explored deep into the Arctic.

Duke of Savoy invaded Milan.

1616

LITERATURE

John Smith's *A Description of New England: or the Observations and Discoveries of Captain John Smith. . .*

Tz'enah u-Re'na, a Yiddish version of the Hebrew Bible, published in Lublin by Jacob ben Isaac Ashkenazi of Janów.

d. Miguel de Cervantes, Spanish writer (b. 1547).

d. Richard Hakluyt, English scholar and clergyman (b. 1553).

VISUAL ARTS

Frans Hals's paintings included *The Merry Company* (ca. 1616–1617) and *Banquet of Officers of the Civic Guard of St. George at Haarlem*.

Inigo Jones began his work on the Queen's House at Greenwich (1616–1635).

Peter Paul Rubens's paintings included *Judith with the Head of Holofernes* (1616–1618) and *The Last Judgment*.

Anthony Van Dyck's painting *Portrait of Jan Vermeulen*.

Majid-i Shah (Royal) Mosque built in Isfahan

(1616–1630), an example of the Persian-style cruciform mosque, in the shape of a cross.

THEATER & VARIETY

d. William Shakespeare, English playwright, poet, and actor (b. 1564), the world-renowned Bard.

Francis Beaumont and John Fletcher's *Loves Pilgrimage* (ca. 1616).

John Fletcher's play *The Mad Lover*.

d. Francis Beaumont, English playwright (b. 1584), with John Fletcher a major figure in the Elizabethan theater.

MUSIC & DANCE

Tirsi e Clori, Claudio Monteverdi's ballet.

Shamisen, a long lute, was the most widely played instrument during Japan's Edo period (ca. 1615–1868), often with voice, or *koto*, a long zither, and *shakuhachi*, a flute.

WORLD EVENTS

Galileo was warned by the Inquisition not to teach the Copernican doctrine that the earth revolved around the sun.

Jurchen chief Nurhachu proclaimed himself the Later Chin Emperor.

William Baffin discovered Baffin Bay.

1617

LITERATURE

John Donne's *Holy Sonnets*, including *Death Be Not Proud* and *Batter My Heart, Three Person'd God*; written after the death of his wife (1617), but published posthumously (1633).

Miguel de Cervantes's verse–romance novel, *Los trabajos de Persiles e Sigismunda* (*The Travels of Persiles and Sigismunda*), published posthumously.

Pieter Corneliszoon Hooft's work about the origins of Holland, *Baeto oft Oorsprong der Holanderen*.

VISUAL ARTS

Anthony Van Dyck's painting *Carrying of the Cross* (ca. 1617).

Andrea Palladio completed the Basilica, Vicenza.

Gregório Fernandez's sculpture *Pietà*.

Jacob Jordaens's painting *Crucifixion*.

Ludovico Carracci's painting *St. Peter Repenting*.

THEATER & VARIETY

Gerbrand Adriaansz Bredero's *The Spanish Brabanter*.

John Fletcher's *The Chances* (ca. 1617).

Juan Ruiz de Alarcón y Mendoza's *Walls Have Ears*.

Lope Félix de Vega Carpio's *The King and the Farmer* (*El villano en su rincón*) and *The Lady Nit-Wit* (*La dama boba*).

Samuel Coster's drama *Iphigenia*.

MUSIC & DANCE

Thomas Campion's *Third and Fourth Books of Airs* (ca. 1617).

Glockenspiel in use in Europe (ca. 17th c.).

Jew's harp manufacture centered in Molln, Austria, where it was popular for serenading (from 17th c.).

WORLD EVENTS

Francis Bacon was appointed Lord Keeper of England.

Russo-Swedish war was ended by Treaty of Stolbovo.

1618

LITERATURE

Courante Uyt Italian, Duytslandt was Holland's first newspaper (1618–1658), expanding from its original single sheet (printed on both sides) to larger weekly issues with the Thirty Years' War.

Elzevir family began publishing.

d. Gerbrand Adriaensz Bredero, Dutch poet and playwright (b. 1585).

VISUAL ARTS

Diego Velázquez's paintings included *Christ in the House of Martha and Mary* (ca. 1618) and *Old Woman Frying Eggs*.

Epiphanius of Evesham's tomb of Edmund West.

François Mansart's chateau of Coulommiers.

Hendrick de Keyser's statue of Erasmus.

Jacob Jordaens's painting *Adoration of the Shepherds*.

Salomon de Brosse's palace at Rennes, for the Breton Parlement.

Anthony Van Dyck's *Portrait of Cornelis van der Geest* (ca. 1618–1620).

THEATER & VARIETY

The Loyall Subject, John Fletcher's play.

Samuel Coster's drama *Isabella*.

Lope Félix de Vega Carpio's *El perro del hortelano* (*The Gardener's Dog*).

Francesco Andreini's *Le Bravure del Capitan Spavento da Vall'Inferna*, Part II.

Gerbrand Adriaansz Bredero's *The Dumb Knight*.

Guíllen de Castry o Bellvés's *La mocedades del Cid*.

d. Gerbrand Adriaansz Bredero, Flemish playwright (b. 1585).

MUSIC & DANCE

Michael Praetorius produced his key document on early musical instruments, *Syntagma Musicum* (1618–1620).

Musette de cour, a small bagpipe, was developed for use in elegant society (17th–18th c.).

d. Giulio Caccini, Italian composer and singer (b. ca. 1545).

WORLD EVENTS

Massive all-Europe Thirty Years' War began in Bohemia, triggered by the Defenestration of Prague, the murder of two Austrian envoys; Bohemia and Austria went to war, followed by most of Europe (1618–1648).

Walter Raleigh was executed in England.

1619

LITERATURE

d. Samuel Daniel, English poet and dramatist (b. ca. 1562).

VISUAL ARTS

Diego Velázquez's paintings included his *Adoration of*

the Magi and *Water Seller of Seville* (ca. 1619).

Gian Lorenzo Bernini's sculpture *Aeneas, Anchises and Ascanius Fleeing Troy*.

Inigo Jones began his Banqueting House at Whitehall (1619–1621).

Anthony Van Dyck's painting *The Entry into Jerusalem* (ca. 1619).

d. Ludovico Carracci, Italian painter (b. 1555).

THEATER & VARIETY

Samuel Coster's drama *Polyxena*.

John Fletcher and Philip Massinger's *The Custome of the Country*, *Sir John van Olden Barnavelt*, and *The Little French Lawyer* (1619–1623).

John Fletcher's *The Humorous Lieutenant*, *Women Pleas'd*, and *The Island Princesse* (ca. 1619–1621).

Lope Félix de Vega Carpio's *All Citizens Are Soldiers* (*Fuente ovejuna*).

d. Richard Burbage, English actor (ca. 1567), the first of the great English actors, who originated many of Shakespeare's main roles, including Richard III, Lear, Hamlet, and Othello.

d. Samuel Daniel, English poet and playwright (b. 1563), author of several masques.

MUSIC & DANCE

Claudio Monteverdi's *Madrigal Book 7*, and the madrigal *Chiome d'oro*.

Michael East's *Fourth Book*.

Heinrich Schütz's *Psalmen Davids*, 26 psalms.

Jan Pieterszoon Sweelinck's *Motets*.

d. Francis Tregian, English musician (b. 1574).

WORLD EVENTS

First Black African slaves arrived in Virginia, and were sold at Jamestown.

Virginia House of Burgesses was established at Jamestown.

1620

LITERATURE

Francis Bacon's *Novum Organum* (*New Instrument*), outlining his inductive method of examining experience to reach conclusions resulting in new

knowledge; part 2 of his projected *Instauratio Magna* (*Great Renewal*) project.

Francis Quarles's poem *A Feast for Worms*.

d. Thomas Campion, British poet and musician (b. ca. 1567).

VISUAL ARTS

Frans Hals's paintings included his *Nurse and Child* (ca. 1620) and *Portraits of Paulus van Beresteyn and His Wife*.

Peter Paul Rubens's paintings included *Le Chapeau de Paille* (ca. 1620) and *Thomas Howard, Earl of Arundel, with His Wife Alathea Talbot*.

Gian Lorenzo Bernini's sculpture *Neptune and Triton* (ca. 1620).

Anthony Van Dyck's painting *The Taking of Christ* (ca. 1620–1621).

Gian-Francesco Barbieri's painting *St. William Receiving the Habit*.

Hendrick de Keyser began his West Church at Amsterdam.

THEATER & VARIETY

John Fletcher and Philip Massinger's *The False One*.

Philip Massinger's *The Duke of Milan*.

MUSIC & DANCE

Composers began to specify which instruments should play which parts of a musical composition (by 1620s).

Miserere, psalm setting by Gregorio Allegri (ca. 1620).

Kettledrums began to be used in orchestras (during 17th c.).

Triple harp known in Italy (17th c.).

WORLD EVENTS

English Pilgrim settlers aboard the *Mayflower* landed at Provincetown, Massachusetts; originated the Mayflower Compact; and established the Plymouth, Massachusetts, colony.

Thirty Years' War: Battle of White Hill.

1621

LITERATURE

Robert Burton's highly influential *The Anatomy of Melancholy*, exploring mental and philosophical states and the human condition.

First news publication in England produced by John Archer, who was quickly jailed by censors; earlier English-language news sheets had been produced in Holland.

Lope de Vega's prose work *Las fortunas de Diana* in *la filomena* (1621).

VISUAL ARTS

Gian Lorenzo Bernini's sculpture *Pluto and Proserpina* (1621–1622).

Anthony Van Dyck's paintings included *Isabella Brant, Wife of P. P. Rubens* and a *Self Portrait* (both ca. 1621).

Gian-Francesco Barbieri's *Aurora*, a ceiling fresco at the Villa Ludovisi.

d. Ambrosius Bosschaert, Flemish painter (b. 1573).

d. Hendrick de Keyser, Dutch architect and sculptor (b. 1565).

THEATER & VARIETY

Ben Jonson's play *The Metamorphos'd Gypsies*.

Francis Beaumont, John Fletcher, and Philip Massinger's *Thierry and Theodoret*.

John Fletcher and Philip Massinger's *The Double Marriage*.

John Fletcher's *The Pilgrim* and *The Wild-Goose Chase*.

Philip Massinger's *The Maid of Honor*.

Thomas Middleton's tragedy *Women Beware Women*.

d. Antoine de Montchrétien, French playwright (b. ca. 1575).

MUSIC & DANCE

d. Michael Praetorius, German composer and music theorist (ca. 1571–1621).

d. Jan Pieterszoon Sweelinck, Netherlands composer and organist at Amsterdam's Old Church, also a noted organ teacher (b. 1562).

WORLD EVENTS

Dutch West India Company was chartered.

Holland and Spain were again at war, after expiration of their 12-year truce.

Huguenot rebellion in France.

1622

LITERATURE

Francis Bacon's *Historia Ventorum* and *The Historie of the Raigne of King Henry the Seventh*.

Mourt's Relation, a journal of the *Mayflower* voyage and the Plymouth Colony, probably based on those of Edward Winslow and William Bradford.

Weekly News began publishing in London.

VISUAL ARTS

Frans Hals's painting *Man with Arms Crossed*.

Gian Lorenzo Bernini's sculpture *Apollo and Daphne* (1622–1624).

Peter Paul Rubens's paintings included *Marie de Médicis* (ca. 1622–1625), part of his Médicis cycle.

Anthony Van Dyck's paintings included portraits of *François Duquesnoy* (1622–1623) and *Sir Robert Shirley*.

Esaias van de Velde's painting *The Ferry*.

Francesco Borromini designed Rome's S. Andrea della Valle church (ca. 1622).

THEATER & VARIETY

Francis Beaumont, John Fletcher, and Philip Massinger's *The Beggars Bush* (1622).

John Fletcher and Philip Massinger's *The Prophetesse*, *The Sea Voyage*, and *The Spanish Curate* (all 1622), and *The Lovers Progress* (1623–1634).

Tirso de Molina's *Prudence in Woman* (ca. 1622).

Giovann Battista Andreini's *La Centaura*.

MUSIC & DANCE

Thomas Tomkins's secular works *Songs of 3, 4, 5, and 6 parts*.

Italian musicians brought to Russia stringed instru-

ments that became the popular Ukrainian banduras (early 17th c.).

WORLD EVENTS

English and Persian forces took Hormuz from the Portuguese.

Failed Powhatan Indian uprising in Virginia.

Anglo-Dutch fleet blockaded Mozambique.

French Huguenot rebellion ended with peace agreement.

1623

LITERATURE

First complete collection of Shakespeare's works, called the First Folio, published in England by Nathanial Butter, Nicholas Bourne, and Thomas Archer.

Francis Bacon's *De Dignitate et Augmentis Scientiarium*, an expansion of his *The Advancement of Learning* (1605) to form part 1 of his projected *Instauratio Magna* (*Great Renewal*) project; also his *Historia Vitae et Mortis* (1623).

d. Tulsidas (Tulsi Das) of Rajapur, Indian poet, author of *Ramacaritmana*, based on the *Ramayana* (b. 1532).

VISUAL ARTS

Inigo Jones began the Queen's Chapel, St. James's (1623–1668).

Gian Lorenzo Bernini's sculpture *David* (1623–1624).

François Mansart's work included the chateau of Berny and the facade of the Church of the Feuillants in Paris (1623–1629).

Anthony Van Dyck's paintings *Marchesa Elena Grimaldi* and *Wife of Marchese Nicola Cattaneo* (ca. 1623).

Esaias van de Velde's painting *Winter Scene*.

THEATER & VARIETY

Philip Massinger's *The Bondman*.

MUSIC & DANCE

Resurrection History, Heinrich Schütz's vocal work.

Jacques Mauduit's *Psalms*.

d. Thomas Weelkes, English composer and organist (b. 1576).

d. William Byrd, English composer (b. 1542).

WORLD EVENTS

European–Japanese trade was sharply curtailed, as Japanese persecution of Christians increased.

Long civil war began in Vietnam (1623–1673).

Persian forces took Baghdad from the Ottoman Turks (1623–1638).

1624

LITERATURE

John Donne's *Devotions upon Emergent Occasions*, prose meditations on the human condition, written during a grave illness, containing famous passages such as "No man is an island" and "for whom the bell tolls."

Lope de Vega's prose works *Guzmán el bravo*, *La Circe*, *La desdicha por la honra*, and *La prudente venganza*.

John Smith's *The Generall Historie of Virginia, New England, and the Summer Isles*, including his description of Pocahontas.

Good News from New England, Edward Winslow's description of the Plymouth Colony.

VISUAL ARTS

Frans Hals's painting *The Laughing Cavalier*.

Anthony Van Dyck's paintings included his *Madonna of the Rosary* (ca. 1624–1628) and his *Portrait of Emanuel Philibert*.

Peter Paul Rubens's painting of *Vladislav Sigismund IV, King of Poland*.

Gian Lorenzo Bernini began his baldachin, above the high altar at St. Peter's in Rome (1624–1633); and his sculpture *Santa Bibiana* (1624–1626).

José de Ribera's painting *Martyrdom of St. Bartholomew*.

Pietro Berrettini da Cortona's frescoes at Rome's Santa Bibiana (1624–1626).

Louis XIII's hunting lodge began to be developed into the Royal Palace of Versailles.

THEATER & VARIETY

d. Francesco Andreini, Italian playwright and actor, with his wife Isabella Canali Andreini comanager and costar of the Gelosi commedia dell'arte troupe, and father of actor Giovanni Battista Andreini (b. 1548).

John Fletcher's plays *Rule a Wife and Have a Wife* and *A Wife for a Month*.

Philip Massinger's *The Renegado*.

Tirso de Molina's *Damned for Lack of Faith* (ca. 1624).

MUSIC & DANCE

Il Combattimento di Tancredi e Clorinda, Claudio Monteverdi's dramatic cantata.

Will Forster's Book, William Byrd's keyboard collection, published posthumously.

Francis Pilkington's *Second Set of Madrigals*.

WORLD EVENTS

Dutch settled at Pernambuco, Brazil (1624–1654).

English colonists settled Barbados (1624–1625).

Portuguese and Dutch at war in Brazil (Sugar War) (1624–1658).

Thirty Years' War: Battle of Breda (1624–1625).

1625

LITERATURE

Francis Bacon's *Apophthagmes New and Old* and *The Translation of Certaine Psalmes into English Verse*.

Charles I suppressed all news sheets in England.

d. Giambattista Marino, Italian poet (b. 1569).

d. Thomas Lodge, English poet, playwright, and prose writer (b. 1558?).

VISUAL ARTS

Frans Hals's paintings included his *St. Matthew and the Angel* (ca. 1625), *Portrait of Aletta Hanemans*, and *Portrait of Jacob Pieters Olycan*.

Juan Bautista Mayno's painting *The Recovery of Bahia in 1625*.

Peter Paul Rubens's painting *Lot Fleeing from Sodom*.

Anthony Van Dyck's painting *Paola Adorno, Marchesa Brignole Sale, and Her Son* (ca. 1625).

Dutch potters in Delft began to imitate imported blue-and-white Chinese porcelain (ca. 1625).

Ninna-ji Temple built at Kyoto, Japan (first half of 17th c.).

d. Jan Brueghel, Flemish painter (b. 1568), nicknamed "Velvet" Brueghel.

THEATER & VARIETY

A New Way to Pay Old Debts, Philip Massinger's best-known work, with Sir Giles Overreach, his best-known character.

Pedro Calderón de la Barca's *Devotion to the Cross* (*La devoción de la cruz* (ca. 1625).

Francis Beaumont, John Fletcher, and Philip Massinger's *Loves Cure All*.

John Fletcher and Philip Massinger's *The Elder Brother* (1625) and *A Very Woman* (1625–1634).

d. John Fletcher, English playwright (b. 1579).

MUSIC & DANCE

d. Orlando Gibbons, English composer and organist at the Westminster Abbey, who composed many madrigals, motets, fantasies, anthems, and much keyboard music (b. 1583).

d. Paul Peuerl, German composer, organist, and organ builder (1570–after 1625).

WORLD EVENTS

d. James I (b. 1566), king of England (and James VI of Scotland); succeeded by Charles II.

Dutch settled New Amsterdam (New York City).

Huguenots again rebelled in France (1625–1626).

Nurhachi established the Manchu capital at Mukden.

1626

LITERATURE

Francisco Gómez de Quevedo y Villegas's novel *La historia de la vida del Buxcón*.

d. Francis Bacon, English writer, philosopher, and statesman (b. 1561).

VISUAL ARTS

Frans Hals's paintings included *Portrait of Isaac Abrahams* and *Young Man Holding a Skull* (*Hamlet*) (ca. 1626–1628).

Rembrandt van Rijn's paintings included *The Angel and the Prophet Balaam* and *Tobit and Anna with the Kid*.

José de Ribera's painting *Drunken Silenus*.

Nicolas Poussin's paintings included *The Assumption of the Virgin* (ca. 1626) and *The Triumph of David* (ca. 1626).

Pieter de Molyn's painting *The Sand Dune*.

Anthony Van Dyck's painting *Giovanni Vicenzo Imperiale*.

d. Salomon de Brosse, French architect (b. 1571).

THEATER & VARIETY

James Shirley's *The Maid's Revenge*.

Philip Massinger's *The Roman Actor*.

d. Edward Alleyn, English actor (b. 1566).

MUSIC & DANCE

Violons du Roi, a string ensemble of 6 violins, 12 violas, and 6 cellos, established in France; others followed.

Oldest known national hymn, from the Netherlands, with music by an unknown composer (by 1626) to a poem by Philip van Marnix (ca. 1590).

d. John Dowland, English composer and lutenist (b. 1563?).

d. John Coperario (born Cooper), English viola da gambist, lutenist, and composer (b. ca. 1575).

d. John Danyel, English composer (b. 1564).

WORLD EVENTS

Charles I of England dissolved Parliament.

French Huguenot rebellion ended with the Peace of New Rochelle.

Protestant peasant revolts in Austria (1626–1628).

1627

LITERATURE

Lope de Vega's verse work *Corona trágica*.

VISUAL ARTS

Rembrandt van Rijn's paintings included *The Flight into Egypt* and *The Money-Changers*, and a drawn *Self-Portrait* (ca. 1627–1628).

Frans Hals's paintings included his *Banquet of Officers of the Civic Guard of St. George at Haarlem*, and *Verdonck* (ca. 1627).

Anthony Van Dyck's painting *Portrait of Peter Stevens*.

Hall of Supreme Harmony (*T'ai-ho-Tien*) built in Inner City of Peking (Beijing); later restored and rebuilt under the Ch'ing dynasty.

THEATER & VARIETY

John Ford's *'Tis Pity She's a Whore*.

Pedro Calderón de la Barca's *La cisma de Igalaterra* (ca. 1627).

Philip Massinger's *The Great Duke of Florence*.

d. Thomas Middleton, English playwright (b. ca. 1570).

MUSIC & DANCE

Heinrich Schütz's *Dafne*, the first German opera; text by Martin Opitz, based on Ottavio Rinuccini's libretto for the 1598 Italian opera.

d. Jacques Mauduit, French composer (b. 1557).

d. Lodovico Viadana, Italian composer (b. ca. 1560).

WORLD EVENTS

Another Huguenot rising in France, with British allies, but the British failed to relieve the siege of New Rochelle by sea.

1628

VISUAL ARTS

Diego Velázquez's painting *Los Borrachos* (*The Topers*) or *The Triumph of Bacchus* (ca. 1628–1629).

Frans Hals's paintings included *Gypsy Girl*, *Peeckelhaering*, and *The Merry Toper* (all ca. 1628–1630).

Rembrandt van Rijn painted a *Self-Portrait* (ca. 1628).

Gian Lorenzo Bernini's tomb of Urban VIII (1628–1647).

José de Ribera's painting *Martyrdom of St. Andrew*.

Nicolas Poussin's painting *The Martyrdom of St. Erasmus* (1628–1629).

Peter Paul Rubens's painting *Philip II of Spain* (ca. 1629–1629).

Anthony Van Dyck's painting *Portrait of Anna Wake, Wife of Peter Stevens*.

THEATER & VARIETY

James Shirley's *The Witty Fair One*.

John Ford's *The Lover's Melancholy*.

Pedro Calderón de la Barca's *El purgatorio de San Patricio* (*The Purgatory of St. Patrick*) (ca. 1628).

Richard Brome's *The City Wit; or, the Woman Wears the Breeches*.

MUSIC & DANCE

Earliest reference to the melody later popularized as the setting for Sir Walter Scott's *Bonnie Dundee*.

Heinrich Schütz's *Becker Psalter*.

Johann Hieronymus Kapsberger's *Cantiones sacrae*.

Marco da Gagliano's *La Flora*.

d. Alfonso Ferrabosco II (b. 1628), English composer, lutenist, viol player, and singer at the courts of Elizabeth I and James I; son of Alfonso Ferrabosco I.

d. Gregor Aichinger, German composer (b. ca. 1564–1565).

d. Peter Philips, English composer (b. 1560–1561).

WORLD EVENTS

British again failed to relieve New Rochelle; the few remaining Huguenots surrendered.

English Parliament (third under Charles I) convened.

Salem, Massachusetts, was founded.

1629

LITERATURE

Elzevir publishers began to produce popular small-format editions of books, quickly imitated by others.

Francis Quarles's poetic work *Argalus and Parthenia*.

VISUAL ARTS

Rembrandt van Rijn's works included his paintings *Christ at Emmaus* (ca. 1629), *The Tribute Money,* and a *Self-Portrait* (ca. 1629); also an etched *Self-Portrait Bareheaded.*

Francesco Borromini and Gian Lorenzo Bernini, Rome's Barberini Palace (1629–1631).

Gian Lorenzo Bernini's sculpture *St. Longinus* (1629–1638).

Anthony Van Dyck's painting *Rinaldo and Armida.*

Gerard Seghers's painting *The Assumption of the Virgin.*

THEATER & VARIETY

Okuni and other women were barred from the kabuki stage (1629–1868).

Ben Jonson's *The Newe Inne, or The Light Heart.*

John Ford's *The Broken Heart.*

Niccolò Barbieri's *L'Inavertito.*

Pedro Calderón de la Barca's *La dama duende Casa con dos puertas, mala es de guardar;* and *El principe constante.*

Richard Brome's *The Northern Lass.*

MUSIC & DANCE

Post horns, brass instruments, were played to announce arrival and departure of mail coaches (from early 17th c.); their sound was often imitated in musical compositions.

WORLD EVENTS

Charles I dissolved the English Parliament and ruled without it (1629–1640).

French Huguenot rebellion ended; Huguenots were once again assured of religious freedom.

Polish–Swedish war ended, with Truce of Altmark; Sweden took Livonia and some territory in Prussia.

1630

LITERATURE

John Smith's autobiography *The True Travels, Adventures, and Observations of Captaine John Smith in Europe, Asia, Africa, and America, from . . . 1593 to 1629. . . .*

Lope de Vega's verse work *Laurel de Apolo.*

Disputed biblical writings called the Apocrypha dropped from the *King James* or *Authorized Version* of the Bible.

VISUAL ARTS

Diego Velázquez's paintings included *Joseph's Bloody Coat Brought to Jacob* and *The Forge of Vulcan.*

François Mansart's Hotel Bouthillier, Paris.

Anthony Van Dyck's paintings included his *Christ on the Cross* (ca. 1630), *Philippe Le Roy, Seigneur de Ravels, Samson and Delilah* (ca. 1630), and *Prince Ruprecht of the Palatinate* (ca. 1630–1631).

Frans Hals's paintings included *Malle Babbe* (ca. 1630–1633), *Nicolaes Hasselaer* (ca. 1630–1633), and *Portrait of a Man.*

Peter Paul Rubens's *Ildefonso Altarpiece* (1630–1632).

Gerard Seghers's painting *The Adoration of the Magi.*

Nicolas Poussin's painting *The Plague at Ashdod* (1630–1631).

Gregório Fernandez's sculpture *Baptism of Christ.*

Salomon van Ruysdael's painting *River Landscape* (ca. 1630).

d. Esaias van de Velde, painter (b. 1591).

THEATER & VARIETY

Pedro Calderón de la Barca's *La cena de Baltasar (Belshazzar's Feast)* (ca. 1630).

Tirso de Molina's *The Trickster of Seville and the Stone Guest* (ca. 1630).

b. John Heminge, English actor, a member of the Chamberlain's Men and probably the first to play Falstaff (b. ca. 1556).

MUSIC & DANCE

Girolamo Frescobaldi's *Arie musicali,* in two volumes.

d. Giovanni Battista Fontana, Italian composer and violinist (d. 1630).

d. Thomas Simpson, English composer (b. 1582).

d. William Brade, English instrumentalist and composer (b. 1560).

WORLD EVENTS

Boston was founded by English settlers of Massachusetts Bay Colony.

Sugar War in Brazil: Dutch on the offensive against the Portuguese.

1631

LITERATURE

Nouvells Ordinaires de Divers Endroits (later *Gazette*) began publishing in France; the weekly survived as an official news publication for over 150 years.

Francis Quarles's poem *History of Samson*.

d. John Donne, English poet (b. ca. 1572).

d. Michael Drayton, English poet (b. 1563).

d. John Smith, British explorer and travel writer (b. 1580).

VISUAL ARTS

Taj Mahal built near Agra, India (ca. 1631–1650); a central work of Indian architecture, commissioned by Mughal emperor Shah Jahan as a mausoleum for his favorite wife, Mumtaz Mahal.

Rembrandt van Rijn's work included his paintings *Rembrandt's Mother* and *Presentation of Christ in the Temple*, and his drawings *Seated Old Man*.

Francesco Borromini began St. Peter's church in Rome (with Bernini and Baldacchino) (1631–1633).

Claude's painting *Landscape with River*.

Diego Velázquez's painting *Christ on the Cross* (ca. 1631).

Frans Hals's painting *A Burgomaster* (ca. 1631–1633).

José de Ribera's painting *St. Peter* (1631–1632).

Anthony Van Dyck's painting *Marie de Raet*.

THEATER & VARIETY

Pierre Corneille's *Clitandre* and *La Veuve* (1631–1632).

James Shirley's *Love's Cruelty* and *The Traitor*.

Georges de Scudéry's *Le Trompeur puni*.

Pedro Calderón de la Barca's *De una causa dos efectos* (ca. 1631–1632).

d. Alexandre Hardy, the earliest French playwright (ca. 1575–ca. 1631); an extraordinarily prolific writer, he wrote an estimated 600–700 plays.

d. Guíllen de Castro y Bellvís, Spanish playwright (b. 1569).

MUSIC & DANCE

(Johannes) Christoph Demantius's *St. John Passion*.

WORLD EVENTS

Thirty Years' War: Battle of Breitenfeld.

Prague fell to Savoy forces.

Insurrection against Portuguese rule in Mombasa.

1632

LITERATURE

John Milton's poetic companion pieces, *L'Allegro*, a pastoral idyll, and *Il Penseroso*, a celebration of contemplation and melancholy.

Danzig Bible, a revision of the 1553 *Brest Bible* prepared by Daniel Mikkolajewski and Jan Turnowski, was burned by Catholics; reprinted in Germany, it became standard for Evangelical Protestants.

Lope de Vega's autobiographical novel in dialogue, *La Dorotea*.

Francis Quarles's poetry *Divine Fancies*.

VISUAL ARTS

Rembrandt van Rijn's works included *The Noble Slav* and the five paintings in *The Passion Cycle* (ca. 1632–1639); and the etching *The Raising of Lazarus* (ca. 1632).

Gian Lorenzo Bernini's sculpture *Cardinal Scipione Borghese*.

François Mansart's Convents of the Visitation, in Paris (1632).

Peter Paul Rubens's painting *The Garden of Love* (1632–1634).

Epiphanius of Evesham's tomb of Lord Teynham.

THEATER & VARIETY

Pierre Corneille's *La Galerie du palais*.

James Shirley's *Hyde Park*.

Pedro Calderón de la Barca's *La banda y la flor*.

Philip Massinger's *The City Madam*.

d. Thomas Dekker, English playwright (ca. 1572–ca. 1632).

MUSIC & DANCE

Jean-Baptiste Lully (Giovanni Battista Lulli), Italian-born French composer (d. 1687), considered the founder of French opera; a student of Pierre Beauchamps.

Walter Porter's *Madrigals* published.

WORLD EVENTS

English colonists settled on Antigua and Barbuda.

Peace treaty of St. Germain-en-Laye between English and French ceded Quebec back to France.

Russia and Poland were at war (1624–1632).

Thirty Years' War: Battle of Lützen.

1633

LITERATURE

John Donne's poems were first published, including *Go and Catch a Falling Star* (Song), *A Valediction: Forbidding Mourning*, *Twicknam Garden*, *The Canonization*, and his *Holy Sonnets*.

d. George Herbert, English poet (b. 1593); his major work was *The Temple*, an influential volume of religious poems including *The Collar* and *The Sacrifice* (1633).

VISUAL ARTS

Rembrandt van Rijn's works included the paintings *Portrait of Saskia* (ca. 1633–1634), *Portrait of Johannes Uytenbogaert*, and *The Shipbuilder and His Wife*; and the drawing *Watchdog Asleep in His Kennel* (ca. 1633).

Frans Hals's paintings included *Pieter van den Broecke*, *Portrait of a Man in His Thirties*, and *Portrait of an Elderly Lady*.

Nicolas Poussin's painting *The Adoration of the Magi*.

d. Epiphanius of Evesham, English sculptor (b. 1570).

THEATER & VARIETY

Pierre Corneille's *La Place Royale* and *La Suivante*.

James Shirley's *The Gamester*.

Pedro Calderón de la Barca's *Amar después de la muerte* (*Love After Death*), and *Devotion to the Cross*.

Philip Massinger's *The Guardian*.

MUSIC & DANCE

d. Jacopo Peri, Italian composer, instrumentalist, and singer, a key figure in the development of opera as a distinct form.

d. Jehan Titelouze, French composer (b. ca. 1562).

WORLD EVENTS

Galileo was forced by the Catholic Inquisition to deny the Copernican teaching that the earth moves around the sun.

Wallenstein defeated Swedish army at Steinau, in Silesia.

1634

LITERATURE

Ben Jonson's influential *English Grammar*, published posthumously.

Lope de Vega's verse work *La gatomaquia*.

d. George Chapman, English poet, scholar, translator, and playwright (b. ca. 1559).

VISUAL ARTS

Rembrandt van Rijn's works included the paintings *Portrait of Maerten Soolmans*, *Portrait of Saskia as Flora*, and a *Self-Portrait* (1634); and the etching *The Angel Appearing to the Shepherds*.

Claude's painting *Harbour Scene*.

Diego Velázquez's paintings included his *The Surrender of Breda*, *Equestrian Portrait of Philip IV*, *Equestrian Portrait of Olivares*, and *Equestrian Portrait of Prince Baltasar Carlos* (all ca. 1634–1635).

Francisco Zurbarán's paintings included *The Defence of Cadiz* and *The Labours of Hercules*.

Anthony Van Dyck's painting *Lamentation for Christ*.

THEATER & VARIETY

John Milton's masque *Comus* was presented at Ludlow Castle on September 29.

Annual Oberammergau, Bavaria passion play began.

John Ford's history play *Perkin Warbeck*.

Ruiz de Alarcón's *Change for the Better* and *The Truth Suspected*.

d. George Chapman, English poet and playwright (b. ca. 1560).

d. John Marston, English playwright (b. ca. 1575).

d. John Webster, English playwright (b. ca. 1580)), author of *The White Devil* and *The Duchess of Malfi*.

MUSIC & DANCE

Henry Lawes's *Comus*, music for masque by John Milton.

d. Adriano Banchieri, Italian composer and theorist (b. 1568).

WORLD EVENTS

Jean Nicolet explored the Great Lakes region, as far west as Green Bay.

Thirty Years' War: Battle of Nördlingen.

1635

LITERATURE

Académie Française—made up of "50 immortals"—established to maintain a dictionary of French and make judgments about usage, grammar, and vocabulary.

Francis Quarles's poetry, *Emblems*.

Christ Was the Word That Spake It, anonymous poem (ca. 1635).

d. Lope de Vega (Lope Félix de Vega Carpio), Spanish writer (b. 1562).

VISUAL ARTS

Rembrandt van Rijn's works included the paintings *Aristotle Contemplating the Bust of Homer*, *Rembrandt and Saskia* (ca. 1635), *The Abduction of Ganymede*, and *The Sacrifice of Abraham*; and his drawings *Saskia in Bed*, *a Woman Sitting at Her Feet* and *Saskia Looking Out of a Window* (ca. 1635).

Peter Paul Rubens's paintings included *The Rape of the Sabines*, *Venus and Adonis* (ca. 1635), *Bathsheba*

Receiving David's Letter (ca. 1635), *Christ on the Cross* (1635–1640), and *The Massacre of the Innocents* (ca. 1635–1639).

Nicolas Poussin's paintings included *The Rape of the Sabine Women* (ca. 1635) and *The Triumph of Neptune* (ca. 1635).

Diego Velázquez's paintings included *Lady with a Fan* (ca. 1635–1640) and *Prince Baltasar Carlos as Huntsman* (1635–1636).

Frans Hals's painting *Portrait of a Woman*.

Jacques Lemercier began the Sorbonne, Paris.

Anthony Van Dyck's painting *Prince Thomas of Savoy* (ca. 1635).

Red Fort built in Agra, India (ca. 1635).

THEATER & VARIETY

Lope Félix de Vega Carpio's *The King the Greatest Alcalde* (*El mejor alcalde, el rey*) and *Por la puente, Juana*.

Pierre Corneille's tragedy *Médée*.

Pedro Calderón de la Barca's *La vida es sueño* (*Life Is a Dream*), *A secreto agravio, secreta venganza* (*Secret Vengeance for Secret Insult*), *El gran teatro del mundo* (*The Great Theater of the World*), and *El médico de su honra* (*The Surgeon of His Honour*).

Georges de Scudéry's *La Comédie des comédiens* and *La Mort de César*.

Isaac de Benserade's *Cléopâtre*.

James Shirley's *The Lady of Pleasure*.

d. Jean de Schelandre, French playwright (b. ca. 1585).

MUSIC & DANCE

Arie musicali, Domenico Anglesi's collection of songs for voice and continuo.

Girolamo Frescobaldi's *Fiori musicali*.

d. Thomas Ravenscroft, English editor, composer, and music theorist (b. ca. 1582).

WORLD EVENTS

Ottoman Turks took Erivan from Persians.

Saxony left the Thirty Years' War with Peace of Prague, signed with the Holy Roman Empire.

1636

VISUAL ARTS

Rembrandt van Rijn's works included the paintings *Danaë* and *The Blinding of Samson*; the drawings *A Row of Trees in an Open Field* (ca. 1636) and *A Woman Carrying Child Downstairs*; and the etching *The Return of the Prodigal Son*.

Alonso Cano's painting *St. John's Vision* (ca. 1636).

Claude's painting *View of the Campo Vaccino*.

Jan van Goyen's painting *River Scene*.

Peter Paul Rubens's painting *The Kermesse* (ca. 1636–1638).

d. Tung Ch'i-Ch'ang, Chinese painter, calligrapher, and essayist (b. 1555).

d. Gregório Fernandez, Spanish sculptor (b. ca. 1576).

THEATER & VARIETY

Pierre Corneille's *L'Illusion comique*.

Thomas Killigrew's *The Princess; or, Love at First Sight* and *Claracilla*.

MUSIC & DANCE

Volgendo il ciel, Claudio Monteverdi's ballet (1636?).

Harmonie universelle, Marin Mersenne's illustrated compendium on musical instruments, published in Paris.

WORLD EVENTS

Harvard College was founded.

Pequot Indian War in Massachusetts (1636–1637).

Providence, Rhode Island, was founded by democratic dissenter Roger Williams.

1637

LITERATURE

Lycidas, John Milton's elegy on the death of his friend Edward King.

In England, *A Decree of Starre-Chamber Concerning Printing* limited the number of print shops and type foundries.

VISUAL ARTS

Frans Hals's paintings included *The Company of Captain Reynier Reael and Lieutenant Cornelis Michielsz. Blaeuw* and *Willem van Heythuyzen* (ca. 1637–1639).

Francesco Borromini's Oratory of St. Philip Neri, Rome.

Nicolas Poussin's painting *The Adoration of the Shepherds* (ca. 1637).

Rembrandt van Rijn's drawing *Elephant*.

Anthony Van Dyck's paintings included *Charles I in Three Positions* and *Cupid and Psyche* (both ca. 1637).

André Le Nôtre was named royal gardener to Louis XIV.

d. Giovanni Battista Caracciolo (Battistello), Neapolitan painter (b. ca. 1570).

d. Honnami Koetsu, Japanese painter and calligrapher (b. 1558).

THEATER & VARIETY

Pierre Corneille's *Le Cid* premiered at the Marais Theater, with Montdory in the title role; Corneille's most notable play, and a landmark in the history of the French theater.

Pedro Calderón de la Barca's *El mágico prodigioso* (*The Wonder-Working Magician*) and *Las tres justicias en una* (*Three Judgments at a Blow*).

d. Ben Jonson, English playwright, poet, and grammarian (b. 1572).

Jean de Rotrou's *Les Sosies*.

MUSIC & DANCE

Johann Vierdanck published an instrumental collection.

Earliest known dated spinet, a small version of the harpsichord, made by Zenti of Viterbo, Italy; spinets soon replaced virginals for use in the home.

Ancient Society of College Youths, a change-ringing society, founded in London.

WORLD EVENTS

Shimabara Revolt, revolt of Christian Japanese against the Tokugawa Shogunate, ended with the

siege and fall of Hara; Portuguese expelled from Japan, which then was closed to the West (1637–1638).

Pequot War: New England colonial forces massacred and scattered the small remainder of the Pequot people.

1638

LITERATURE

After the total ban on English news sheets was lifted (imposed 1625), Nathaniel Butter and Nicholas Bourne were granted sole right to print the news in England.

Francis Quarles's poetry *Hieroglyphics*.

First New Testament in contemporary Greek published by Maximus of Gallipoli, probably printed at Geneva.

VISUAL ARTS

Rembrandt van Rijn's works included the paintings *Samson's Wedding Feast*, *Stormy Landscape*, *The Risen Christ Appearing to Mary Magdalen*, and *The Stony Bridge* (ca. 1638); and the drawing *Woman Seen from Behind Wearing a North Holland Costume* (ca. 1638).

Anthony Van Dyck's paintings included *Charles I, King of England*, *Charles I and Henrietta Maria with Their Children*, *King Charles on Horseback* (all by 1638), and *Portrait of Thomas Killigrew and Thomas Carew*.

Francesco Borromini began the church of S. Carlo alle Quattro Fontane, in Rome (1638–1641).

Inigo Jones completed the design of the rebuilt St. Paul's Church, in London.

Peter Paul Rubens's paintings included *Hélèna Fourment with Fur Cloak* (ca. 1638–1640), *The Brazen Serpent* (ca. 1638), *The Judgment of Paris* (1638–1639), and *The Three Graces* (ca. 1638–1640).

Diego Velázquez's painting *Duke of Modena*.

THEATER & VARIETY

Pedro Calderón de la Barca's *La Niña de Gómez Arias* (ca. 1638).

MUSIC & DANCE

Claudio Monteverdi's *Madrigali guerrieri et amorosi*.

d. Francis Pilkington, English composer (b. ca. 1638).

d. John Ward, English composer (b. 1571).

d. Nicolas Formé, French composer (b. 1567).

WORLD EVENTS

Dutch occupied Indian Ocean island of Mauritius.

Establishment of Swedish settlement at Fort Christiana, Delaware.

Hara castle fell; Nagasaki was left open as Japan's only trading port.

1639

LITERATURE

Printing began in North America, with the founding of Stephen Day's press in Cambridge, Massachusetts, the first publication being *The Oath of a Free Man*; no copy survives.

Andreas Gryphius's lyric poetry *Sonn- und Feiertagssonette*.

The royal publisher—the Imprimerie Royale, or Typographia Regia—was established by French King Louis XIII at Cardinal Richelieu's suggestion.

VISUAL ARTS

Rembrandt van Rijn's works included the paintings *Rembrandt's Mother* and *Maria Trip*; the etchings *Rembrandt Leaning on a Stone-Sill*, *The 100 Guilder Print*, and *The Death of the Virgin*, and the drawing *Staatliche Uylenburch*.

Peter Paul Rubens painted a *Self-Portrait*.

Pietro Berrettini da Cortona completed his fresco *Allegory of Divine Providence and Barberini Power*.

THEATER & VARIETY

Pedro Calderón de la Barca's *No hay cosa como callar*.

d. John Ford, English playwright (b. 1586).

d. Juan Ruiz de Alarcón y Mendoza, Spanish playwright (b. 1580).

MUSIC & DANCE

First Set of Psalmes, 20 pieces by William Child.

WORLD EVENTS

Thirty Years' War: Battle of the Downs; massive defeat of Spanish fleet by Dutch.
Scotland and England were at war (First Bishops' War), won by Scots Covenanters.
French peasant rebellion in Normandy.

1640

LITERATURE

First book and oldest surviving printed work produced in North America, by Stephen Day in Cambridge, Massachusetts: *Bay Psalm Book* (*The Whole Booke of Psalms Faithfully Translated into English Metre*), by various Massachusetts ministers, including Richard Mather, Thomas Welde, and John Eliot.
Printing began in Iran.

VISUAL ARTS

Rembrandt van Rijn's works included the paintings *Self-Portrait at the Age of 34* and *The Visitation*; and the etching *View of Amsterdam* (ca. 1640).
Claude's paintings included *The Burial of St. Serapia* and *The Finding of Moses* (both ca. 1640).
Eustache le Sueur's painting *The Presentation of the Virgin* (1640–1645).
François Mansart's work included the Chapel of the Dames de Saint-Marie, Paris.
Frans Hals's painting *The Violinist (Daniel van Aken Playing the Violin* (ca. 1640).

THEATER & VARIETY

Floridor starred at the Marais Theater in the title role of Pierre Corneille's *Horace*.
Diogenes Cynicus Alive Again, by Comenius (Amos Komensky).
Pedro Calderón de la Barca's *El Alcalde de Zalamea* (*The Mayor of Zalamea*), *El Joséf de las mujeres*, and *No siempre lo peor es cierto* (ca. 1640).

d. John Day, English playwright (b. ca. 1640).
d. Philip Massinger, English playwright (b. 1583).

MUSIC & DANCE

Della musica dell'eta nostrà, Pietro Della Valle's discourse on music.
Gli amore d'Apollo e di Dafne, Francesco Cavalli's opera.
d. Giles Farnaby, English composer (b. ca. 1563).
d. John Adson, English composer, court musician, and music teacher to Charles I (b. ca. 1600).
d. Agostino Agazzaria, Italian composer and writer (b. ca. 1578).

WORLD EVENTS

Dutch besieged Malacca.
English Short Parliament met, dissolved; Long Parliament convened.
Scottish forces took much of northern England.
France took Tortuga, in the West Indies.
French attacked in northern Spain, in support of new Catalan republic.

1641

VISUAL ARTS

Pompa Introitus Ferdinandi, illustrated by Peter Paul Rubens, published after Rubens's death by Antwerp-based publisher Christophe Plantin.
Diego Velázquez's painting *The Coronation of the Virgin* (ca. 1641–1642).
Rembrandt van Rijn's painting *The Mennonite Minister Cornelis Claesz Anslo Conversing with a Woman*.
Simon Vouet's painting *The Presentation*.
d. Peter Paul Rubens, German painter (b. 1640).
d. Anthony Van Dyck, Flemish painter (b. 1599).

THEATER & VARIETY

Floridor starred at the Marais Theater in the title role of Pierre Corneille's *Cinna*.
James Shirley's *The Cardinal*.
Lope Félix de Vega Carpio's play *The Knight from Olmedo* (*El caballero de Olmedo*).
Richard Brome's *A Jovial Crew, or, the Merry Beggars*.
Thomas Killigrew's *The Parson's Wedding*.

Abraham the Patriarch, by Comenius (Amos Komensky).

d. Niccolò Barbieri, actor and playwright of the commedia dell'arte (b. 1576).

d. Thomas Heywood, English actor and playwright (b. ca. 1570).

MUSIC & DANCE

Il ritorno d'Ulisse in patria, Claudio Monteverdi's opera, libretto by Giacomo Badoaro, premiered in Venice in February.

Giovanni Battista Fontana's collection of sonatas—6 for violin (or cornet) and bass, 12 for 2 violins and bass (sometimes with bassoon or cello)—published posthumously.

Didone, Francesco Cavalli's opera.

Johann Vierdanck wrote a volume of sacred concertos and an instrumental collection.

John Barnard, English music editor (b. 1591; active ca. 1641).

WORLD EVENTS

Dutch forces attacked Angola.

Father Isaac Jogues and Charles Raymbault explored west in North America as far as Sault St. Marie.

Rebelling Irish Catholics defeated English at Drogheda, massacred Protestants in Ulster.

Dutch took Malacca from Portuguese.

1642

LITERATURE

First publication of France's royal publisher, the Imprimerie Royale: *De Imitatione Christi*.

Printing began in Finland.

d. John Suckling, English poet (b. 1609).

VISUAL ARTS

Rembrandt van Rijn's paintings included his famous *Nightwatch* and *The Reconciliation of David and Absalom*.

Bartolomé Murillo's painting *Virgin of the Rosary* (ca. 1642).

Francesco Borromini began the Roman church S. Ivo della Sapienza (1642–1660).

François Mansart's work included the chateau of Maisons.

Gian Lorenzo Bernini's Triton Fountain (1642–1643).

Nicolas Poussin's painting *The Seven Sacraments* (first series).

William Dobson's painting *Unknown Officer with a Page*.

d. Guido Reni, Italian painter (b. 1575).

THEATER & VARIETY

Floridor starred at the Marais Theater in the title role of Pierre Corneille's *Polyeucte*.

James Shirley's *The Sisters*.

d. Marc Lescarbot, French lawyer and playwright (b. ca. 1570).

MUSIC & DANCE

L'Incoronazione di Poppea (*The Coronation of Poppea*), Claudio Monteverdi's opera; libretto by Giovanni Busenello; opened at Teatro di Giovanni e Paolo, Venice.

Cello (violoncello), at first called *violoncino*, came into use (ca. 1642).

WORLD EVENTS

First English Civil War began; London rose against Charles I; Battle of Edgehill.

Montreal was founded by Paul de Chomedey.

Thirty Years' War: Second Battle of Breitenfeld.

Abel Tasman discovered New Zealand.

1643

LITERATURE

Thomas Browne's *Religio Medici* (*A Doctor's Religion*), a private exploration of the author's attempt to find inclusive, sustaining faith; published only after pirated editions began to circulate.

Andreas Gryphius's poetry *Sonette*.

Printing began in Norway.

VISUAL ARTS

Jan Van Goyen's painting *View of Leyden*.

Rembrandt van Rijn's etching *The Three Trees.*
William Dobson's paintings *Charles, Prince of Wales* (ca. 1643) and *The First Lord Byron* (ca. 1643).

THEATER & VARIETY

Pierre Corneille's tragedy *Le Mort de Pompée* and comedy *Le Menteur.*

MUSIC & DANCE

Egisto, Francesco Cavalli's opera.
Johann Vierdanck published a volume of sacred concertos.
d. Claudio Monteverdi, Italian composer (b. 1567).
d. Girolamo Frescobaldi, Italian composer and organist (b. 1583).
d. Marco da Gagliano, Italian composer (b. 1582).

WORLD EVENTS

Thirty Years' War: Battle of Rocroi; sea battle of Kolberg.

1644

LITERATURE

John Milton's *Areopagitica* published (1644), the text of his 1643 speech before the British Parliament for freedom of the press, against licensing of printed materials by censors; the title refers to the Areopagus, the Great Council of Athens, before whom Greek citizens spoke.
John Cotton's *The Keyes of the Kingdom of Heaven,* Congregational guide.
Western-style printing began in China.
d. Francis Quarles, English poet (b. 1592).

VISUAL ARTS

Diego Velázquez's painting *Philip IV at Fraga.*
José de Ribera's painting *St. Jerome.*
Nicolas Poussin's painting *The Seven Sacraments* (second series, 1644–1648).

THEATER & VARIETY

François Tristan l'Hermite's *La Mort de Sénèque.*

d. Antonio Mira de Amescua, Spanish playwright (b. ca. 1574).

MUSIC & DANCE

Ormindo, Francesco Cavalli's opera.

WORLD EVENTS

Manchu dynasty began in China, after Peking fell to rebel General Li Tzu-Cheng, and Manchus then attacked, taking and holding Peking (1644–1911).
First English Civil War: Battle of Marston Moor.
Second Powhatan Indian war in Virginia.

1645

LITERATURE

John Milton's *Poems,* collecting his early works.

VISUAL ARTS

Rembrandt van Rijn's work included the paintings *A Girl at the Window* and *The Holy Family with Angels,* the drawing *Young Man Pulling a Rope,* and the etching *Six: Bridge.*
Bartolomé Murillo's paintings included *S. Diego of Alcalá Feeding the Poor* (1645–1646), and *Ecstasy of St. Diego of Alcalá.*
Francesco Borromini began the vault at Rome's Palazzo Pamphili (1645–1650).
Aelbert Cuyp's painting *Castle by a River Bank.*
Gian Lorenzo Bernini's sculpture *The Ecstasy of St. Teresa* (1645–1652).
Alessandro Algardi's tomb of Leo XI at St. Peter's, Rome (ca. 1645).
Diego Velázquez's painting *Mars* (ca. 1645–1648).
Frans Hals's painting *Portrait of a Young Man* (ca. 1645).

THEATER & VARIETY

Pierre Corneille's *Théodore* and *Rodogune* starred Floridor, at the Marais Theater.
Jean de Rotrou's *Le Véritable Saint-Genest.*
Pedro Calderón de la Barca's *El pintor de su deshonra* (*The Painter of His Own Dishonor*) (ca. 1645).

MUSIC & DANCE

d. William Lawes, English composer (b. 1602).

WORLD EVENTS

Oliver Cromwell's New Model Army defeated the Royalist forces of Charles I at the decisive battle of Naseby.

1646

LITERATURE

Richard Crashaw's poems *Steps to the Temple*, its title referring to its inspiration, George Herbert's *The Temple* (1633).

John Cotton's catechism for children *Milks for Babes, Drawn out of the Breasts of Both Testaments*.

Hypocrisie Unmasked, Edward Winslow's defense of the Plymouth Colony.

VISUAL ARTS

Rembrandt van Rijn's work included the paintings *The Holy Family* and *Winter Landscape*, the etchings *Study of Two Male Nudes and Baby Learning to Walk* and *Jan Cornelis Sylvius Preacher*, and the drawing *Study for Etched Portrait of J. C. Sylvius*.

Building of Pearl Mosque begun by Shah Jahan, inside Red Fort at Agra, India (1646–1653).

Francesco Borromini began the Collegio di Propaganda Fide, Rome (1646–1667).

Claude's paintings included *Hagar and the Angel* and *The Embarkation of Ulysses*.

d. William Dobson, English painter (b. 1610).

THEATER & VARIETY

Pierre Corneille's *Héraclius* starred Floridor, at the Marais Theater.

Audo do fidalgo aprendiz (*The Apprentice Nobleman*), Francisco Manuel de Melo's play (ca. 1646).

Joost van den Vondel's *Maria Stuart*.

Andreas Gryphius's *Leo Arminius*.

MUSIC & DANCE

d. Raffaella Aleotti, Italian composer (1570–after 1646).

d. Johann Vierdanck, German composer (b. ca. 1605).

WORLD EVENTS

Charles I surrendered to the Scots.

Long Maratha–Mughal wars in the Indian Deccan began (1646–1707).

Mughal campaign against the Uzbeks and others in Transoxiana failed; army retreated to Kabul (1646–1647).

1647

LITERATURE

The Simple Cobler of Aggawam, satire against religious toleration by Aggawan (now Ipswich), Massachusetts, clergyman Nathaniel Ward.

d. Pieter Corneliszoon Hooft, Dutch poet (b. 1581).

VISUAL ARTS

Rembrandt van Rijn's works included the paintings *Susanna and the Elders*, and *Rest on the Flight into Egypt*; and the etching *Jan Six*.

Salomon van Ruysdael's painting *Ferry*.

Alonso Cano's painting *Miracle of the Well* (ca. 1647).

THEATER & VARIETY

Andreas Gryphius's tragedy *Cardenio and Celinde*.

d. Pieter Cornelisz Hooft, Flemish playwright (b. 1581).

MUSIC & DANCE

Northumbrian bagpipes, a version of the small French *musette*, were played in northern Britain (17th c.).

WORLD EVENTS

English Parliament imprisoned Charles I after he

attempted to escape, while negotiations between Charles and Parliament continued.

Failed rebellion against Spanish rule in Naples (Masaniello's Rebellion; 1647–1648).

1648

LITERATURE

Robert Herrick's poem *To the Virgins, to Make Much of Time*, with its admonition, "Gather ye rosebuds while ye may," expressing the 17th–century Cavalier's version of the Latin *carpe diem* ("seize the day") philosophy; also Herrick's pastoral love poems *Corinna's Going A-Maying* and *Delight in Disorder*.

VISUAL ARTS

Academy of Painting and Sculpture was founded in Paris.

Gian Lorenzo Bernini began his sculpture *Fountain of the Four Rivers* (1648–1651).

Jacob van Campen began the Royal Palace, Amsterdam.

Rembrandt van Rijn's etching *Self-Portrait Drawing at a Window* and drawing *View of the Amstel River* (ca. 1648).

Francisco Zurbarán's painting *The Adoration of the Shepherds*.

Nicolas Poussin's paintings included *Landscape with Diogenes* and *Holy Family on the Steps*.

Gerard Terborch the Younger's painting *The Oath of the Peace Treaty between the Dutch and Spanish at Munster*.

THEATER & VARIETY

Pedro Calderón de la Barca's *El jardin de Falerina*.

d. Francisco de Rojas Zorrilla, Spanish playwright (b. 1607).

d. Tirso de Molina, Spanish ecclesiastic and playwright (b. ca. 1571).

MUSIC & DANCE

Kern-Sprüche, Johann Rosenmüller's book of German concertos.

d. Marin Mersenne, French mathematician and scholar of musical instruments (b. 1588).

WORLD EVENTS

Second English Civil War began, with Scottish invasion of England in support of Charles I; Scots defeated at Preston by Cromwell.

Treaty of Westphalia ended the Thirty Years' War.

Bogdan Chmielnicki led a Cossack rising in the Ukraine against Polish rule; his forces massacred an estimated 200,000–250,000 Jews during the rising (1648–1654).

1649

LITERATURE

English poet John Milton became Latin secretary to Puritan leader Oliver Cromwell, assisted from 1657 by poet Andrew Marvell.

Richard Lovelace's poem on the liberty of the soul, *To Althea from Prison*, best known for the lines "Stone walls do not a prison make / Nor iron bars a cage."

Samuel Green took over Stephen Day's press in Cambridge, Massachusetts, still the only press in North America.

d. Richard Crashaw, English metaphysical poet (b. 1612).

VISUAL ARTS

Rembrandt van Rijn's works included the drawings *Turn in the Amstel River near Kostverloren Estate* and *View of the River IJ near Amsterdam* (both ca. 1649–1650).

Diego Velázquez's painting *Portrait of Juan de Poareja* (1649–1650).

Eustache le Sueur's painting *St. Paul at Ephesus*.

François Mansart's Hotel Nevers, Paris (1649–1650).

d. Juan Bautista Mayno, Spanish painter (b. 1578).

d. Simon Vouet, French painter (b. 1590).

THEATER & VARIETY

Andreas Gryphius's history play *Charles Stuart*.

Jean de Rotrou's *Cosroës*.

MUSIC & DANCE

Orontea, Antonio Cesti's opera.
Giasone, Francesco Cavalli's opera.

WORLD EVENTS

English Civil War: Charles I executed by Parliament; Oliver Cromwell became protector of the new English Commonwealth; Cromwell defeated Irish forces, adopting a scorched-earth policy in Ireland.
French Civil Wars of the Fronde began (1649–1653).

1650

LITERATURE

Andrew Marvell's *To His Coy Mistress*, a poem urging consummation of a love, for "at my back I always hear / Time's wingèd chariot hurrying near"; also his *An Horatian Ode upon Cromwell's Return from Ireland*.
Anne Bradstreet's *The Tenth Muse Lately Sprung Up in America*, the first original work of verse written and published in North America.
Henry Vaughan's poem *Silex Scintillans* (1650–1655).

VISUAL ARTS

Rembrandt van Rijn's painting *The Man with the Golden Helmet* (ca. 1650) and etching *The Shell*.
Diego Velázquez's painting included *Portrait of Pope Innocent X* and *Views of the Villa Medici, Rome* (ca. 1650).
Frans Hals's painting *Portrait of Isabella Coymans, Wife of Stephanus Geraerdts* (ca. 1650–1652).
Alessandro Algardi's relief at St. Peter's *Pope Leo driving Attila from Rome*.
Claude's painting *Sacrifice at Delphi*.
Georges de la Tour's paintings *St. Sebastian* and *The New-Born Child* (both ca. 1650).
Jan Van Goyen's painting *Winter Landscape*.
Nicolas Poussin painted a *Self-Portrait*.
d. Iwasa Matabei, called Shoi or Katsumochi, Japanese genre painter (b. 1578), credited with founding the *ukiyo-e* movement.

THEATER & VARIETY

Daniel Caspar von Lohenstein's *Ibrahim Bassa*.
None But the King, Francisco de Rojas Zorrilla's play.
d. Jean de Rotrou, French playwright (b. 1609).

MUSIC & DANCE

Carillon building at its height, the finest makers being the Dutch Hemony brothers (b. ca. 1609 and 1619).
Pierre Beauchamp made his debut as a ballet dancer.
Spitzharfe, a kind of upright psaltery, common in German homes (ca. 1650–1750).

WORLD EVENTS

Scotland and England were at war; Cromwell defeated the Scots and Charles II; Edinburgh surrendered.

1651

LITERATURE

d. Abu Talib Kalim, Indian (Mughal) court poet (?–1651).

VISUAL ARTS

Diego Velázquez's painting *The Toilet of Venus* (*The Rokeby Venus*) (ca. 1651).
Rembrandt van Rijn's work included the etchings *Clement de Jonghe* and *The Goldweigher's Field*.
Claude's painting *Pastoral Landscape*.
d. Abraham Bolemaert, Dutch painter (b. 1564).
d. Gerard Seghers, Flemish painter (b. 1591).

THEATER & VARIETY

d. Luis Quiñones de Benavente, Spanish playwright (b. ca. 1593).

MUSIC & DANCE

Calisto, Francesco Cavalli's opera; libretto by Giovanni Faustini.
Rosinda, Francesco Cavalli's opera.
Claudio Monteverdi's *Madrigal Book 9*.

d. Domenico Gabrielli, Italian composer (d. 1690).

d. Johann Hieronymus Kapsberger, German composer (b. ca. 1580).

d. Heinrich Albert, German composer (b. 1604).

WORLD EVENTS

Tokugawa Iyetsuna became Shogun of Japan (1651–1680).

Irish forces surrendered to the English at Limerick.

1652

LITERATURE

When I Consider How My Light Is Spent, John Milton's poem, with its famous conclusion, "They also serve who only stand and wait."

d. John Cotton, British-born Massachusetts religious leader and writer (b. 1584), father-in-law of Increase Mather.

VISUAL ARTS

Rembrandt van Rijn's work included the paintings *Portrait of Nicolaes Bruyningh* and a *Self-Portrait*; the etchings *Christ Preaching* (*La Petite Tombe*) (ca. 1652) and *Faust*; and the drawings *St. Jerome Reading in a Landscape* and *The Amstel River at the Omval* (ca. 1652).

Diego Velázquez's painting *Queen Mariana of Austria* (1652–1653).

Francesco Borromini's S. Agnese in Agone church, Rome.

d. Inigo Jones, English architect and stage designer (b. 1573).

d. Georges de la Tour, French painter (b. 1593).

d. José de Ribera, Spanish painter (b. 1591).

THEATER & VARIETY

Pedro Calderón de la Barca's *Lo que va del hombre a Dios* and *No hay más fortuna que Dios* (ca. 1652).

MUSIC & DANCE

Eritrea, Francesco Cavalli's opera.

Kern-Sprüche, Johann Rosenmüller's second book of German concertos (1652–1653).

d. Gregorio Allegri, Italian composer (b. 1582).

d. Pietro Della Valle, Italian theorist and composer (b. 1586).

WORLD EVENTS

Failed Taiwanese rising against Dutch rule.

First Anglo-Dutch War began (1652–1654).

1653

LITERATURE

Izaak Walton's *The Compleat Angler, or the Contemplative Man's Recreation*.

VISUAL ARTS

Rembrandt van Rijn's etching *The Three Crosses*.

Diego Velázquez's painting *The Infanta Margarita in a Pink Dress* (1653–1654).

Francesco Borromini began the exterior of S. Andrea delle Fratte, Rome (1653–1665).

Nicolas Poussin's painting *Christ and the Woman Taken in Adultery*.

Claude's painting *Landscape with the Adoration of the Golden Calf*.

Pieter de Hooch's painting *Backgammon Players* (ca. 1653).

THEATER & VARIETY

Pedro Calderón de la Barca's *La Hija del aire*.

d. Richard Brome, English playwright (b. ca. 1590).

MUSIC & DANCE

La Nuit, Jean-Baptiste Lully's ballet, opened February 25; as he (and other amateurs) would for decades, France's Louis XIV danced in the ballet, here appearing as the sun, and so later called the Sun King.

Cupid and Death, James Shirley's masque, with music probably by Christopher Gibbons.

The Czech Lute, Adam Václav Michna's hymnal.

WORLD EVENTS

Chinese "pirate" rising in south China waters led by Koxinga against Manchus (1653–1662).

Cromwell dissolved the Rump Parliament.

First Anglo-Dutch War; sea battle off Scheviningen.

1654

VISUAL ARTS

Rembrandt van Rijn's paintings included A Woman Bathing in a Stream (ca. 1654), Bathsheba Holding King David's Letter, and Jan Six.

Gian Lorenzo Bernini began his sculpture Constantine (1654–1670).

Nicolas Poussin's painting The Exposing of Moses.

d. Alessandro Algardi, Italian sculptor (b. 1595).

d. Jacques Lemercier, French architect (b. 1585).

d. Paulus Potter, Dutch painter and etcher (b. 1625).

THEATER & VARIETY

School as Amusement, by Comenius (Amos Komensky).

François le Metel de Boisrobert's La Belle Plaideuse.

François Tristan l'Hermite's Le Parasite.

Joost van den Vondel's Lucifer.

Nikolaus Avancini's Curae Caesarum.

d. Giovanni Battista (Giovanbattista) Andreini (ca. 1578–ca. 1654), Italian actor known as Lelio; son of Francesco and Isabella Andreini, who played with them in the Gelosi commedia dell'arte troupe.

MUSIC & DANCE

Jean-Baptiste Lully's ballets Les Proverbes, first presented February 17, and Le Temps, presented November 30.

Xerse, Francesco Cavalli's opera.

Sacra et litaniae, Adam Václav Michna's hymnal.

WORLD EVENTS

Ordinance of Union joined England, Ireland, and Scotland.

Russia and Poland were at war (1654–1656).

1655

LITERATURE

Altan tobchi (The Golden Button), history of the Mongols.

d. Edward Winslow, English-born Puritan (b. 1595).

VISUAL ARTS

Rembrandt van Rijn's works included the paintings The Polish Rider (ca. 1655) and Titus at His Desk; the drawings Jael and Sisera, Portrait of a Man (both ca. 1655–1660), and Sleeping Woman (ca. 1655); and the etching Thomas Jacobszoon Haringh.

Diego Velázquez's painting Las Hilanderas (The Spinners; ca. 1655).

Nicolas Poussin's painting The Arcadian Shepherds (ca. 1655).

François Mansart began his remodeling of the Hotel Carnavalet, Paris (1655–1661).

THEATER & VARIETY

d. François Tristan l'Hermite, French playwright (b. ca. 1602).

MUSIC & DANCE

Jean-Baptiste Lully's ballets Les Plaisirs, presented February 4, and Les Bienvenus, presented at Compiègne May 30.

Francesco Cavalli's operas Erismena and Statira (both 1655–1656).

WORLD EVENTS

Araucanian resistance to the Spanish continued in southern Chile.

First Northern War began between Poland and Sweden; ultimately grew to involve many European countries (1655–1660).

1656

LITERATURE

Weckelycke Courant van Europa founded; Holland's oldest surviving newspaper, becoming *Nieuwe Haarlemsche Courant.*

VISUAL ARTS

Rembrandt van Rijn's work included the paintings *Jacob Blessing the Sons of Joseph, Portrait of Dr. Arnold Tholinx,* and *The Anatomical Lesson of Dr. Joan Deyman;* a drawn *Self-Portrait;* and the etching *Arnold Tholinx* (ca. 1656).

Gian Lorenzo Bernini began the piazza and colonnade at St. Peter's, Rome (1656–1667).

Bartolomé Murillo's painting *Vision of St. Anthony.*

Claude's painting *The Sermon on the Mount.*

Diego Velázquez's painting *Las Meninas (The Maids of Honour).*

Jan Vermeer's painting *A Girl Asleep* (ca. 1656).

Nicholas Fouquet built the French chateau Vaux-le-Vicomte.

d. Jan van Goyen, Dutch painter (b. 1596).

THEATER & VARIETY

William Davenant's *The Siege of Rhodes.*

MUSIC & DANCE

Jean-Baptiste Lully introduced two new ballets, *Psyché et la puissance de l'amour,* presented January 16, and *Les Galanteries du temps,* presented February 14; as head of France's royal music department, he also began to insist that all players of the same instruments use the same bowing patterns (from 1656).

The Siege of Rhodes, first all-sung English opera, with libretto by William Davenant.

d. Thomas Tomkins, Welsh composer (b. 1572).

WORLD EVENTS

Catholics and Protestants were at war in Switzerland (Villmergen War).

Dutch astronomer Christiaan Huygens identified the rings of Saturn.

Dutch forces took Colombo from the Portuguese.

1657

LITERATURE

Andreas Gryphius's poetic work *Kirchhofsgedanken.*

d. Hâjji Khalfa, Ottoman polymath and encyclopedist (b. 1609).

VISUAL ARTS

Rembrandt van Rijn's works included the paintings *Portrait of Titus Reading* (ca. 1657) and a *Self-Portrait;* the etching *Abraham Francen;* and the drawing *Christ on the Mount of Olives.*

Gian Lorenzo Bernini began his sculpture *Cathedra Petri* (1657–1666).

Jan Vermeer's paintings included *Lady Reading a Letter at an Open Window* and *Officer and Laughing Girl* (both ca. 1657).

d. Jacob van Campen, Dutch architect and painter (b. 1595).

MUSIC & DANCE

Jean-Baptiste Lully's ballets *L'Amour malade,* presented January 16, and *Les Plaisirs troublés,* presented February 14.

Alcidiane, Jean-Baptiste Lully's ballet.

La Dori, Antonio Cesti's opera.

WORLD EVENTS

Denmark attacked Sweden, joining the First Northern War.

War of succession began among the four sons of Mughal Emperor Shah Jahan (1657–1659).

1658

LITERATURE

d. Richard Lovelace, English poet (b. 1618).

VISUAL ARTS

Jan Vermeer's paintings included *Girl Drinking Wine*

with a Gentleman (ca. 1658–1660), The Kitchen-Maid (ca. 1658), The Little Street (ca. 1658), and Young Woman with a Water Jug (ca. 1658–1660).

Rembrandt van Rijn's works included a painted Self-Portrait, the etching Negress Lying Down, and the drawing Female Nude Seated on a Stool (ca. 1658).

Pieter de Hooch's paintings included A Woman and Her Maid in a Court (1658), Courtyard, and The Pantry (ca. 1658).

THEATER & VARIETY

On October 24, Molière appeared for the first time before Louis XIV and his court at the Louvre as an actor in Corneille's Nicomède; he also wrote Les Préciuses ridicules.

William Davenant's The Spaniards in Peru.

WORLD EVENTS

d. Oliver Cromwell (b. 1599), lord protector of England; succeeded by his son Richard Cromwell.

Russia and Poland were at war (1658–1667).

1659

VISUAL ARTS

Rembrandt van Rijn's works included the painting Portrait of Titus and the etching Jupiter and Antiope.

Diego Velázquez's paintings included Mercury and Argus (ca. 1659) and Prince Felipe Próspero.

Francesco Borromini began the Biblioteca Alessandrina in S. Ivo della Sapienza, Rome (1659–1661).

Pieter de Hooch's painting A Mother Beside a Cradle (1659–1660).

THEATER & VARIETY

Brécourt (Guillaume Marcoureau) starred in his own play, La Feinte Mort de Jodelet.

Nikolaus Avancini's Pietas victrix sive Flavius Constantinus Magnus de Maxentio dyranno victor.

The Victory of Devotion, large-scale Jesuit play produced in Vienna.

William Davenant's Sir Francis Drake.

MUSIC & DANCE

La Raillerie, Jean-Baptiste Lully's ballet, presented at the Louvre, Paris, February 19.

d. Walter Porter, English composer (b. ca. 1587? or ca. 1595).

WORLD EVENTS

Richard Cromwell resigned as lord protector of England; the Long Parliament reconvened.

Treaty of the Pyrenees ended the war between France and Spain.

1660

LITERATURE

Samuel Pepys's Diary, a document intended to be private and written in shorthand (1660–1669), but deciphered in 1825, when parts were first published.

Astraea Redux, John Dryden's poem celebrating England's Charles II.

VISUAL ARTS

Frans Hals's painting Man in a Slouch Hat (ca. 1660–1666).

Jan Vermeer's paintings included A Lady at the Virginals with a Gentleman Listening and View of Delft (both ca. 1660).

Nicolas Poussin's painting The Four Seasons (1660–1664).

Rembrandt van Rijn's paintings included Hendrickje Stoffels and St. Peter's Denial.

Willem Van De Velde the Younger's painting The Cannon Shot (ca. 1660).

d. Diego Velázquez, Spanish painter (b. 1599).

THEATER & VARIETY

Molière's comedy Sganarelle, ou le cocu imaginaire.

Pedro Calderón de la Barca's Celos, aun del aire matan, and La púrpura de la rosa.

d. Paul Scarron, French playwright and novelist (b. 1610).

MUSIC & DANCE

At the direction of Jean-Baptiste Lully, the old *hautbois* or *shawn* was redesigned to make it more suitable for playing together with other instruments; this was the beginning of the modern oboe (ca. 1660s–1680s). Lully also barred trombones and cornets from royal music groups.

Early types of bassoon developed, first in France (ca. 1660s).

Bands playing harmonized music, generally made up of oboes and bassoons, began to be used in military settings such as parades, first in France, then Britain and Germany; previously fife and drum had accompanied foot soldiers, and trumpets and kettledrums cavalry (1660s).

WORLD EVENTS

Long Parliament offered the English crown to the son of Charles I; he accepted and became Charles II (1660–1685).

English Royal Society was founded.

1661

LITERATURE

Puritan missionary John Eliot translated the Bible into the language of Massachusetts's Algonquin Indians, printed two years later.

VISUAL ARTS

Rembrandt van Rijn's works included the paintings *The Conspiracy of Claudius Civilis* and *Portrait of Himself as St. Paul*; and the drawing *Study for the Conspiracy of Claudius Civilis*.

Claude's painting *The Rest on the Flight to Egypt*.

First of three major reconstructions of Versailles designed by Louis le Vau (1661, 1669, 1671).

d. Daniel Seghers, Flemish painter (b. 1590).

d. Pieter de Molyn, Dutch painter (b. 1595).

THEATER & VARIETY

Actresses were allowed on stage in England; previously men had played all roles.

Molière's *The School for Husbands* premiered in Paris in June; he also presented the court entertainment *Les Fâcheux (The Bores)*, in which Louis XIX danced.

Lincoln's Inn Fields Theater opened in London.

Daniel Caspar von Lohenstein's *Cleopatra*.

Pedro Calderón de la Barca's *Eco y Narciso*.

MUSIC & DANCE

Jean-Baptiste Lully's ballets *L'Impatience*, presented at the Louvre, Paris, February 19, and *Les Saisons*, presented at Fontainebleau, July 30. That year he founded the Royal Academy of the Dance, which eventually became the Paris Opéra.

Thomas Greeting published a manual called *Pleasant Campanion for the Flagelet* (a kind of flute).

d. Louis Couperin, French composer, head of a family of musicians, some (like himself) organist at St. Gervais in Paris (b. ca. 1626).

WORLD EVENTS

The Restoration began in England as Cavalier Parliament was installed (1661–1667).

Portugal and Spain were at war (1661–1668).

Sweden and Russia ended their war with the Peace of Kardis.

1662

LITERATURE

Michael Wigglesworth's poem *The Day of Doom*.

Saghang Sechen's *Erdeni-yin tobchi (The Jeweled Button)*, central Asian work.

Revised *Book of Common Prayer*, banned under the Commonwealth, restored to use by Anglican Christians.

VISUAL ARTS

Christopher Wren began Oxford University's Sheldonian Theater (1662–1669).

Jan Vermeer's paintings included *A Woman Weighing Gold* (ca. 1662–1663), *Young Lady with a Pearl Necklace* (1662–1663), and *Young Woman Reading a Letter* (ca. 1662–1663).

Rembrandt van Rijn's painting *The Sampling Officials of the Drapers' Guild (Staalmeesters)*.

Francesco Borromini began the Re Magi chapel of the Propaganda Fide, Rome (1662–1664).

THEATER & VARIETY

Molière's *The School for Wives* premiered in Paris.
Marie-Catherine-Hortense Desjardins's *Manlius*.
Pierre Corneille's *Sertorius*.
d. François le Metel de Boisrobert, French playwright (b. 1592).

MUSIC & DANCE

Ercole amante, Francesco Cavalli's opera.
Triple harp largely replaced older single harp in Wales (during 17th c.).

WORLD EVENTS

Koxinga took Taiwan from the Dutch.
Persecution of nonconformists accelerated in England.

1663

LITERATURE

Samuel Butler's *Hudibras*, a long poem satirizing Puritan hypocrisy and intolerance, published in three parts (1663, 1664, 1678).
Roger L'Estrange, under license to Charles II after restoration of the British monarchy, began publication of the newspaper *Publick Intelligencer*.
First Bible printed in North America: John Eliot's 1661 *Massachusetts Indian Bible*, published by Samuel Green and Marmaduke Johnson at Cambridge.

VISUAL ARTS

Rembrandt van Rijn's painting *Homer*.
Christopher Wren began the Pembroke College Chapel at Cambridge University (1663–1665), among his first buildings.
Claude's painting *Tobias and the Angel*.
Gian Lorenzo Bernini began the Scala Regia, at the Vatican (1663–1666).
Jan Steen's paintings *The Morning Toilet* and *Merry Company*.
Pieter de Hooch's painting *At the Linen Closet*.

THEATER & VARIETY

Andreas Gryphius's *Horribilicribrifax, or Choosing Lovers*.
Belleroche's *Le Baron de la Crasse*.
London's Drury Lane Theater opened as the Theater Royal, with a production of Francis Beaumont and John Fletcher's *The Humorous Lieutenant*.
Edmé Boursault's *Le portrait du peintre*.

MUSIC & DANCE

Jean-Baptiste Lully's ballets *Les Arts*, presented at the Palais Cardinal, Paris, January 8; *Les Nopces de village*, presented Vincennes, October 3; and his comedy–ballet *L'Impromptu de Versailles*, presented at Versailles, October 14.
L'Impromptu de Versailles, Jean-Baptiste Lully's comedy, presented at the Palais-Royal, Paris, November 4.
d. Biagio Marini, Italian composer (b. 1587).
d. Heinrich Scheidemann, German composer (b. ca. 1595).

WORLD EVENTS

Ottoman Turk forces attacked Hungary, bringing war between Austria and Turkey (1663–1664).
Dutch forces took Malabar.
Blaise Pascal's *On the equilibrium of liquids*, published posthumously.

1664

LITERATURE

Jean de La Fontaine's *Contes et nouvelles en vers* (*Tales and Novels in Verse*).
d. Andreas Gryphius, German poet and dramatist (b. 1616).

VISUAL ARTS

Rembrandt van Rijn's painting *Lucretia* (ca. 1664).
Claude's painting *Landscape with Psyche at the Palace of Cupid* (*The Enchanted Castle*).
Christopher Wren's Sheldonian Theater, Oxford.
Frans Hals's painting *Governors of the Old Men's Home at Haarlem*.

Jan Vermeer's painting *The Lacemaker* (ca. 1664–1665).

Nicolas Poussin's painting *Apollo and Daphne*.

Alonso Cano's sculpture *Madonna of Bethlehem*.

d. Francisco Zurbarán, Spanish painter (b. 1598).

THEATER & VARIETY

Molière wrote *Tartuffe* and presented the court entertainment *Le Mariage forcé*, in which Louis XIV danced.

Jean Racine's *La Thébaïde ou les frères ennemis*.

Molière's *Le Tartuffe, ou l'imposteur*.

Philippe Quinault's tragedy *Astrate roi de Tyr*.

Sir George Etherege's *The Comical Revenge; or, Love in a Tub*.

d. Andreas Gryphius, German baroque playwright (b. 1616).

d. Theophilus Bird, English actor (b. 1608).

MUSIC & DANCE

Jean-Baptiste Lully's comedy–ballets *Le Mariage forcé*, presented at the Louvre, Paris, January 29, and *Les Amours desguisés*, presented at the Palais-Royal, Paris, February 15.

Scipione affricano, Francesco Cavalli's opera.

Heinrich Schütz's *Christmas History*.

Earliest printed notations of music for samisen, koto, and flute, traditional accompaniment (with drums) for Japan's *kabuki* theater, in the *Shichiku shoshinshu*.

WORLD EVENTS

Austrians defeated Ottoman Turk forces at St. Gotthard; Treaty of Eisenberg ended the Austro-Turkish war.

France and Britain attacked North African pirates in the Barbary Wars (1664–1669).

Second Anglo-Dutch War began (1664–1667); English took Dutch New Netherlands colony, renaming it New York.

1665

LITERATURE

Henry Muddiman began publication of a single-sheet, twice-weekly *Oxford Gazette* in Oxford, to which the English Court had repaired during the Great Plague; soon becoming the *London Gazette*, it would also become a major news source for the North American colonists, shipped and reprinted.

John Bunyan's religious allegory *The Holy City, or the New Jerusalem*.

VISUAL ARTS

Jan Vermeer's paintings included his *Allegory of Painting, Head of a Young Girl, The Girl with a Red Hat*, and *Young Girl with a Flute* (all ca. 1665).

Rembrandt van Rijn's paintings included *The Bridal Couple* (*The Jewish Bride*) (ca. 1665) and *Portrait of Gerard de Lairesse*.

Aelbert Cuyp's painting *Hilly Landscape with Cows and Shepherds*.

Gian Lorenzo Bernini's sculpture of *Louis XIV*.

Meindert Hobbema's painting *The Water Mill*.

d. Giovanni Benedetto Castiglione (Il Grechetto), Italian painter (b. ca. 1610).

d. Nicolas Poussin, French painter (b. 1594).

THEATER & VARIETY

Molière's *Don Juan* and *L'Amour médecin*.

Daniel Caspar von Lohenstein's *Agrippina* and *Epicharis*.

Marie-Catherine-Hortense Desjardins's *Le Favory*.

d. Samuel Coster, Dutch playwright and physician (1579–1665?).

d. Lope de Rueda, Spain's first actor–manager and popular playwright (b. ca. 1605).

MUSIC & DANCE

Jean-Baptiste Lully's ballet *La Naissance de Vénus*, presented at the Palais-Royal, Paris, January 26; also his ballet *L'Amour médecin*.

WORLD EVENTS

London was struck by the Great Plague, which killed an estimated 65,000–75,000 people.

Réunion Island was occupied by the French.

Second Anglo-Dutch War; Dutch war fleet defeated off Lowestoft (1665–1667).

1666

VISUAL ARTS

Jan Vermeer's painting *The Letter* (ca. 1666).
d. François Mansart, French architect (b. 1598).
d. Frans Hals, Dutch painter (b. 1581–1585).
d. Gian-Francesco Barbieri, Italian painter (b. 1591).

THEATER & VARIETY

Molière's *Le Misanthrope* and *Le Médecin malgré lui*.
John Dryden's *Secret Love, or the Maiden Queen*.
Daniel Caspar von Lohenstein's *Sophonisbe*.
Jean Racine's *Alexandre le Grand*.
Philippe Quinault's comedy *La Mère coquette*.
d. James Shirley, English playwright (b. 1596).
d. Francisco Manuel de Melo, Portuguese writer and diplomat (b. 1608).

MUSIC & DANCE

Les Muses, Jean-Baptiste Lully's ballet, presented at Saint-Germain, December 2.
Heinrich Schütz's *St. Matthew, St. Luke and St. John Passions*.
Accademia Filarmonica society established in Bologna, Italy.

WORLD EVENTS

Cossacks rebelled against Russian rule (1666–1671).
England and France were at war.
Great Fire of London.

1667

LITERATURE

Paradise Lost, John Milton's epic poem on humanity's loss of Eden, from "Man's first disobedience and the fruit / of that forbidden tree"
John Dryden's *Annus Mirabilis* (*The Year of Wonders*) a poem on the events of 1666, especially the London fire and the war with the Dutch.

VISUAL ARTS

Jan Vermeer's painting *A Lady Writing a Letter, with Her Maid* (ca. 1667).
Claude's painting *The Rape of Europa*.
Gian Lorenzo Bernini began his sculpture *Angels* (1667–1669).
Jan Steen's painting *The Feast of St. Nicholas* (ca. 1667).
d. Francesco Borromini, Italian architect (b. 1599).
d. Alonso Cano, Spanish sculptor, painter, and architect (b. 1601).

THEATER & VARIETY

John Dryden's *The Indian Emperour*.
Jean Racine's *Andromaque*, from the Euripides play.
Pierre Corneille's *Attila*.
d. Georges de Scudéry, French playwright (b. 1601).

MUSIC & DANCE

Jean-Baptiste Lully's comedy–ballets *Pastorale comique*, presented at Saint-Germain, January 5, and *Le Sicilien, ou l'amour peintre*, presented at the Palais-Royal, Paris, June 10.
d. Johann Jacob Froberger, German composer and the leading German keyboard player of his day (b. ca. 1616).

WORLD EVENTS

England took the Cape Colony from the Dutch.
Peace of Breda brought end of wars between England, Holland, and France; Acadia was returned to France.
War of the Devolution began between France and Spain (1667–1668).

1668

LITERATURE

Fables choisies, mises en vers (*Selected Fables, Set in Verse*), Jean de La Fontaine's spirited versions of ancient and modern tales (1668–1694).
John Dryden's critical work *Of Dramatick Poesie*.

VISUAL ARTS

Rembrandt van Rijn's paintings included *Family Group* (ca. 1668) and *The Return of the Prodigal Son* (ca. 1668–1669).

Gian Lorenzo Bernini began his sculpture *Gabriele Fonseca* (1668–1675).

Jan Vermeer's painting *The Astronomer*.

Guarino Guarini's works included the chapel of the Holy Shroud at Turin Cathedral and the Theatine Church of S. Lorenzo (1668–1687).

THEATER & VARIETY

Molière's *Le Misanthrope* and *L'Avare*.

George Etherege's comedy *She Would If She Could*.

The Mulberry-Garden, Charles Sedley play.

d. William Davenant, English playwright, poet, and theater manager (b. 1606).

MUSIC & DANCE

Le Carnaval (Mascarade royale), Jean-Baptiste Lully's ballet, presented at the Tuileries, Paris, January 18.

Principles of change ringing, the English-developed systematic ringing of peals of bells, first described in C. R. Fabian Stedman's book *Tintinnabula*.

Musica Deo sacra, posthumously published collection of Thomas Tomkins's sacred music.

Il pomo d'oro, Antonio Cesti's opera.

WORLD EVENTS

Dutch took Macassar, further extending their hold in Indonesia.

England and Holland became allies against France.

Reflecting telescope invented by Isaac Newton.

Spain formally recognized Portuguese independence.

1669

LITERATURE

Jean de La Fontaine's poetic work *Les Amours de Psiché et de Cupidon* (*The Loves of Pysche and Cupid*).

Johann Jakob von Grimmelshausen's novel *Der abenteuerliche Simplicissimus Teutsch*.

VISUAL ARTS

d. Rembrandt Harmensz van Rijn, greatest of the Dutch painters (b. 1606); two very late works were the paintings *Simeon Holding the Christ Child in the Temple* and a *Self-Portrait*.

Jan Vermeer's paintings included *Allegory of the Faith* (ca. 1669–1670) and *Der Astronom* (sometimes called *The Geographer*).

d. Pietro Berrettini da Cortona, Italian painter and architect (b. 1596).

THEATER & VARIETY

Jean Racine's *Les Plaideurs* and *Britannicus*.

Pedro Calderón de la Barca's *Fieras afemina amor* and *La estatua de Prometeo*.

MUSIC & DANCE

Jean-Baptiste Lully's ballet *Flore*, presented at the Tuileries, Paris, February 13; the music for his ballet *La Jeunesse* also dates from 1669.

Royal Academy of Music founded in Paris; merged with the Royal Academy of the Dance, it would become the Paris Opéra.

d. Antonio Cesti, Italian composer (b. 1623).

d. Domenico Anglesi, Italian composer (b. ca. 1610).

WORLD EVENTS

Don John of Austria led a rebellion in Catalonia.

Ottoman forces took Crete from the Venetians.

1670

LITERATURE

Comtesse de La Fayette's novels *La Princesse de Montpensier* and *Zaïde*.

Increase Mather's *Life and Death of That Reverend Man of God, Mr. Richard Mather*.

VISUAL ARTS

Christopher Wren's works included the St. Mary Aldermanbury church (1670–1676); St. Mary-le-Bow church, Cheapside (1670–1677); and

the St. Michael's Church, Cornhill (1670–1672).

Jan Vermeer's painting *A Young Woman Standing at a Virginal* (ca. 1670).

d. Bartholomeus van der Helst, Dutch painter (b. 1613).

d. Louis le Vau, French architect (b. 1612).

d. Salomon van Ruysdael, Dutch landscape painter (b. ca. 1600).

THEATER & VARIETY

Molière's *Le Bourgeois gentilhomme* was presented at the French Court.

Marie Desmares Champmeslé created title role in Jean Racine's *Bérénice*.

John Dryden's *Tyrannick Love, or the Royal Martyr*.

Aphra Behn's *The Forc'd Marriage; or, the Jealous Bridegroom*.

MUSIC & DANCE

Le Bourgeois gentilhomme, Jean-Baptiste Lully's comedy–ballet, presented at Chambord, October 14, then at the Palais-Royal, Paris, November 23; also Lully's ballet *Les amants magnifiques*.

Le Sort d'Andromède, Marc-Antoine Charpentier's pastorale (ca. 1670).

d. Patrick Mòr MacCrimmon, Scottish bagpiper and composer (ca. 1595–ca. 1670), of the noted MacCrimmon family of bagpipers; best known for his *Lament for the Children*.

WORLD EVENTS

English colonists founded Charleston, South Carolina.

Henry Morgan's pirates took Panama City.

Stenka Razin led a failed Cossack revolt in Russia (1670–1671).

1671

LITERATURE

John Milton's *Paradise Regained*, a sequel to *Paradise Lost* in four books, and *Samson Agonistes*, Milton's final great poem, with Samson's blindness echoing Milton's own.

VISUAL ARTS

Gian Lorenzo Bernini began the Tomb of Alexander VII (1671–1678).

Christopher Wren's work included the churches of St. Lawrence Jewry (1671–1677) and St. Magnus the Martyr (1671–1676).

THEATER & VARIETY

Molière's *Psyché* and *Les Fourberies de Scapin*.

John Dryden's *An Evening's Love, or the Mock-Astrologer*.

William Wycherley's *Love in a Wood; or, St. James's Park*.

Elkanah Settle's *Cambyses, King of Persia* and *The Empress of Morocco*.

MUSIC & DANCE

Jean-Baptiste Lully's tragedy–ballet *Psyché*, presented at the Tuileries, Paris, January 17, and his comedy–ballet *Le Comtesse d'Escarbagnas* (with *Le Ballet des ballets*), presented at Saint-Germain, December 2.

WORLD EVENTS

Poland and the Ottomans were at war (1671–1676).

1672

LITERATURE

John Bunyan's *A Confession of My Faith, and a Reason of My Practice*.

d. Anne Bradstreet, American writer (b. ca. 1612).

VISUAL ARTS

Christopher Wren's work included St. Stephen's church, Walbrook (1672–1679).

d. English architect and stage designer John Webb, long associated with Inigo Jones (b. 1611).

THEATER & VARIETY

John Dryden's *The Conquest of Granada by the Spaniards*; and his critical work *Of Heroick Plays*.
Molière's *Les Femmes savantes*.
Jean Racine's *Bajazet*.
William Wycherley's *The Gentleman Dancing-Master*.
Thomas Shadwell's *Epsom Wells*.

MUSIC & DANCE

Académie Royale de Musique, Paris, established by Jean-Baptiste Lully.
Jean-Baptiste Lully's comedy–ballet *Le Comtesse d'Escarbagnas*, presented at the Palais-Royal, Paris, July 8, and his pastorale (pasticcio) *Les Festes de l'Amour et de Bacchus*, presented at the Opéra, Paris, November 15.
d. Heinrich Schütz, German composer (b. 1585).
d. Jacques Champion, Sieur de Chambonnières, French composer and harpsichordist, son of Jacques Champion (b. 1601–1602).

WORLD EVENTS

France invaded Holland, beginning a war that quickly involved many European countries (1672–1679).
Third Anglo-Dutch War was an inconclusive naval war that was part of the larger French–Dutch and general European wars (1672–1674).
Russia and the Ottoman Turks were at war (1672–1681).

1673

THEATER & VARIETY

d. Molière (Jean-Baptiste Poquelin), French playwright and actor (b. 1622); he died while playing the title role in his play *The Imaginary Invalid*.
Charles Chevillet Champmeslé's one-act farce *Crispin Chevalier*.
Daniel Caspar von Lohenstein's *Ibrahim Sultan*.
Jean Racine's *Mithridate*.
John Dryden's *Marriage A-la-Mode*.

MUSIC & DANCE

Cadmus et Hermione, Jean-Baptiste Lully's opera presented at the Opéra, Paris, April 27.
The Empress of Morocco, Matthew Locke's dramatic musical work.
d. Johann Rudolf Ahle, German composer (b. 1625).

WORLD EVENTS

Louis Joliet and Jacques Marquette reached the northern Mississippi River.
John Sobieski of Poland defeated the Ottoman Turks at Khorzim.

1674

LITERATURE

d. John Milton, English poet (b. 1608).
d. Robert Herrick, English poet (b. 1591).
d. Margaret Cavendish, English writer (b. ca. 1624).

VISUAL ARTS

Gian Lorenzo Bernini's sculpture *Ludovica Albertoni* (ca. 1674).
d. Jan Lievens, Dutch painter (b. 1607).
d. Philippe de Champaigne, Flemish painter (b. 1602).

THEATER & VARIETY

Pedro Calderón de la Barca's *La nave del mercader* and *La viña del Señor*.

MUSIC & DANCE

Jean-Baptiste Lully's opera *Alceste, ou Le Triomphe d'Alcide*, presented at the Opéra, Paris, January 19.
d. Matthias Weckmann, German composer and organist (b. ca. 1619).

WORLD EVENTS

England left the war against Holland, with the Treaty of Westminster.
French–Dutch War: Battle of Senef.
John Sobieski became king of Poland (1674–1696).

1675

LITERATURE

John Wilmot, Earl of Rochester's poem A *Satire Against Mankind*.

John Foster began printing in 1675, as only the second North American publisher.

VISUAL ARTS

Christopher Wren began St. Paul's Cathedral (1675–1709).

Claude's paintings included *The Arrival of Aeneas at Pallanteum* and *The Origin of Coral*.

Guarino Guarini's church of S. Filippo, Turin.

Jan Steen's painting *Serenade*.

John Bushnell's tomb of Viscount Mordaunt, at Fulham church.

d. Jan Vermeer, Dutch painter (b. 1632).

THEATER & VARIETY

William Wycherley's *The Country Wife* premiered at London's Theater Royal.

Jean Racine's *Iphigénie*.

Pedro Calderón de la Barca's *El nuevo hospicio de pobres*.

Thomas Otway's *Alcibiades*.

Thomas Shadwell's *The Libertine*.

MUSIC & DANCE

Jean-Baptiste Lully's opera *Thésée*, presented at Saint-Germain, January 12, and at Paris in April; also his 1668 ballet *Le Carnaval* (*Mascarade royale*), was revived in a different version at the Opéra, Paris, October 17.

Psyche, Matthew Locke's dramatic musical work.

First known purely musical use of horns, previously only for hunting, in an anonymous Czech sonata (ca. 1670s).

Tenor oboe first made, in France, especially for use in military bands (ca. 1670).

WORLD EVENTS

King Philip's War: southern New England Indian peoples were destroyed by English forces (1675–1676).

English Royal Observatory was established at Greenwich.

French peasants rebelled in Brittany.

1676

LITERATURE

d. Johann Jakob Christoffel von Grimmelshausen, German novelist (b. 1625).

d. Jean Desmarets de Saint-Sorlin, French novelist, poet, and playwright (b. 1595).

VISUAL ARTS

Christopher Wren's work included Trinity College Library, Cambridge University.

THEATER & VARIETY

Edward Ravenscroft's *The Wrangling Lovers; or, the Invisible Mistress*.

Sir George Etherege's *The Man of Mode*.

Thomas Otway's *The Cheats of Scapin* and *Don Carlos*, a tragedy in rhymed verse.

Thomas Shadwell's *The Virtuoso*.

William Wycherley's *The Plain-Dealer*.

MUSIC & DANCE

Atys, Jean-Baptiste Lully's opera, libretto by Philippe Quinault, presented at Saint-Germain, January 10, and at Paris in April.

Laetatus sum, Heinrich von Biber's motet.

Campanologia, C. R. Fabian Stedman's work on bell ringing, called *change ringing*.

d. Adam Václav Michna, Czech composer (b. ca. 1600).

d. Francesco Cavalli, Italian composer (b. 1602).

d. Nicolaus A Kempis, Flemish composer (b. ca. 1600).

WORLD EVENTS

Bacon's Rebellion of Americans against English rule: Jamestown, Virginia, destroyed.

Feodor III became czar of Russia (1676–1682).

French–Dutch War: Battle of Lund; sea battle off Öland.

1677

VISUAL ARTS

Christopher Wren's work included Christ Church, Newgate Street, (1677–1687), SS. Anne and Agnes parish church, Gresham Street (1677–1680), and St. Peter's parish church, Cornhill (1677–1681), all in London.

d. Aert van der Neer, Amsterdam painter (b. 1603–1604).

THEATER & VARIETY

John Dryden's *All for Love* premiered at London's Theater Royal.

Marie Desmares Champmeslé created title role in Racine's *Phèdre*.

Aphra Behn's comedy *The Rover, or The Banished Cavaliers, Part I.*

John Crowne's *The Destruction of Jerusalem by Titus Vespasian.*

MUSIC & DANCE

Isis, Jean-Baptiste Lully's opera, presented at Saint-Germain, January 5, and at Paris, April 19.

Earliest description and depiction of a baroque recorder, from Italy.

d. Matthew Locke, English composer (b. ca. 1621–1622).

WORLD EVENTS

Failed Hungarian insurrection against Austrian rule (1677–1682).

French–Dutch War: sea battle between Danish and Swedish fleet at Kioge Bay.

Innsbruck University was founded.

1678

LITERATURE

John Bunyan's *Pilgrim's Progress from This World to That Which Is to Come*, a prose allegory published in two parts (1678, 1684), following Christian and his meetings with Sloth, Hypocrisy, and many other figures en route to the Celestial City.

Comtesse de La Fayette's novel *La Princesse de Clèves.*

Anne Bradstreet's *Poems.*

d. Andrew Marvell, English poet (b. 1621).

VISUAL ARTS

Bartolomé Murillo's painting *The Immaculate Conception.*

Guarino Guarini began the Palazzo Carignano (1679–after 1683).

Jules Hardouin-Mansart assumed direction of the extensions to Versailles.

d. Jacob Jordaens, Flemish painter (b. 1593).

d. Karel Dujardin, Dutch painter and etcher (b. 1622).

THEATER & VARIETY

Aphra Behn's comedy *Sir Patient Fancy.*

Pedro Calderón de la Barca's *El día mayor de los días* and *El pastor fido.*

Thomas Otway's *Friendship in Fashion.*

MUSIC & DANCE

Psyché, Jean-Baptiste Lully's opera, presented at the Opéra, Paris, April 19.

First mention of the banjo, or *banja*, in the Antilles.

d. Antonio Maria Abbatini, Italian composer (b. ca. 1609–1610).

d. John Jenkins, English composer, lutenist, and lyra viol player (b. 1592).

WORLD EVENTS

Persecution of Catholics intensified in England, with the "Popish Plot."

Sweden and Russia were at war (1678–1679).

1679

LITERATURE

Strange Songs from a Chinese Studio (*Liao-cai chih-i*), P'u Sung-ling's collection of 431 stories.

d. Thomas Hobbes, English philosopher (b. 1588).

VISUAL ARTS

d. Jan Steen, Dutch painter (b. 1625).

THEATER & VARIETY

Aphra Behn's *The Feign'd Curtizans; or, a Night's Intrigue.*
John Dryden's *Troilus and Cressida.*
Thomas Otway's *The History and Fall of Caius Marius.*
d. Joost van den Vondel, Flemish playwright (b. 1587).

MUSIC & DANCE

Bellérophon, Jean-Baptiste Lully's opera, presented at the Opéra, Paris, January 31.
Pantaleon, a large dulcimer, invented by Pantaleon Hebenstreit (1667–1750), reportedly at the request of Louis XIV.

WORLD EVENTS

Daniel Duluth explored west as far as northern Minnesota.
Act of Habeas Corpus in England.
Failed Scots Covenanter rising ended by British forces led by James Scott, duke of Monmouth, at Bothwell Bridge.
France and Austria ended their war with the Treaty of Nijmegen.

1680

LITERATURE

John Bunyan's allegory *The Life and Death of Mr. Badman.*
Evliyâ Chelebi's *Seyât-nâme (Book of Travels).*
d. John Wilmot, Earl of Rochester, British poet and courtier (b. 1647).

VISUAL ARTS

Christopher Wren designed the St. Mary-le-Bow steeple, and began St. Clement Danes, both in London.
d. Gian Lorenzo Bernini, Italian sculptor (b. 1598).
d. Peter Lely, Dutch-English portrait painter (b. 1618).

THEATER & VARIETY

La Comédie-Française was founded.
Aphra Behn's comedy *The Rover, or The Banished Cavaliers: Part II.*
Thomas Otway's *The Orphan; or, the Unhappy Marriage* and *The Soldier's Fortune.*

MUSIC & DANCE

Proserpine, Jean-Baptiste Lully's opera, presented at Saint-Germain, February 3, and at Paris, November 15.
Henry Purcell's instrumental works, *Chacony in G Minor* and 13 *Fantasies.*
Le Retour du printemps, *idylle sur la convalescence du roi*, Marc-Antoine Charpentier's pastorale (ca. 1680).
Esther, Nicolaus Adam Strungk's opera.

WORLD EVENTS

Pueblo Indian uprising in New Mexico against Spanish rule.
Tokugawa Tsunayoshi became shogun of Japan (1680–1709).

1681

LITERATURE

Andrew Marvell's posthumously published poems *The Definition of Love*, on the impossibility of fulfilling passion's expectations, and *The Garden*, bringing "a green thought in a green shade."
Absalom and Achitophel, John Dryden's political satire in verse, attacking Puritan machinations against the Catholic Duke of York (later James II).
First Portuguese-language version of the New Testament, by João Ferreira d'Almeida, published in Amsterdam.

VISUAL ARTS

Christopher Wren began Tom Tower, at Christ Church, Oxford University (1681–1682); and his St. Mary's Abchurch (1681–1686).
d. Antoine le Pautre, French architect (b. 1621).
d. Gerard Terborch the Younger (b. 1617).

THEATER & VARIETY

Aphra Behn's *The Roundheads; or, the Good Old Cause.*
John Dryden's *The Spanish Fryar.*
Edward Ravenscroft's *The London Cuckolds.*
d. Pedro Calderón de la Barca, Spanish playwright (b. 1600).
d. John Lacy, English actor and playwright.

WORLD EVENTS

Charles II dissolved Parliament.
Pennsylvania was founded by Quaker William Penn, by British royal grant.
Persecution of Huguenots in France again further intensified.

1682

LITERATURE

Religio Laici (*A Layman's Faith*), John Dryden's poetic defense of Anglicanism, and *The Medall: A Satyre against Sedition*, about political moves against the Catholic Duke of York (later James II).
Ihara Saikaku's novel *Koshoku ichidai otoko* (*The Life of an Amorous Man*).
Johann Beer's novel *Teutsch Winternächte.*
John Bunyan's allegory *The Holy War.*
First printing press established in Jamestown, Virginia, by William Nuthead.

VISUAL ARTS

d. Claude (Claude Gellée, Le Lorrain, or Claude Lorraine), French painter (b. 1600); his final year included the painting *Landscape with Ascanius Shooting the Stag of Sylvia.*
Christopher Wren began Chelsea Hospital, Chelsea (1682–1685) and St. James's church, Piccadilly (1682–1684), both in London.
Luca Giordano's ceiling at the Salon of Florence's Medici-Riccardi Palace.
d. Bartolomé Esteban Murillo, Spanish painter (b. 1617).

THEATER & VARIETY

Thomas Betterton and Elizabeth Barry opened in

London in Thomas Otway's *Venice Preserved.*
Aphra Behn's *The City-Heiress, or, Sir Timothy Treat-all.*

MUSIC & DANCE

Jean-Baptiste Lully's opera *Persée,* presented at the Opéra, Paris, April 18.
Rejoice in the Lord Always, Henry Purcell's verse anthem (ca. 1682).
12 dance suites by Johann Rosenmüller.
Newly designed oboe, then called *hautbois* or *hautboy,* adopted in Britain and Germany (ca. 1680s).
Orchestra came into use (1680s) in France, referring to an assemblage of instruments being played together; early groups were all strings, then joined by bassoons and oboes, often doubling with flutes.

WORLD EVENTS

Robert LaSalle reached the mouth of the Mississippi, claiming the river basin for France.
Algiers was shelled by French ships, in the continuing war with North African pirates.
First rebellion of the Russian palace guard, the Streltsy.
First sighting of Halley's comet by Edmund Halley.

1683

LITERATURE

Johann Beer's novel *Kurtzweilige Sommertäge.*
d. Evliyâ Chelebi, Ottoman Turk traveler (b. 1614).

VISUAL ARTS

Ashmolean Museum at Oxford University opened.
d. Pieter de Hooch, Dutch painter (b. 1629).
d. Guarino Guarini, Italian architect (b. 1624).

THEATER & VARIETY

Thomas Otway's *The Atheist; or, the Second Part of the Soldier's Fortune.*
Edme Boursault's comedy *Le Mercure galant.*
Edward Ravenscroft's *Dame Dobson; or, the Cunning Woman.*

d. Cosmé Peréz, Spanish comic actor (b. ca. 1585).

d. Daniel Caspar von Lohenstein, German playwright (b. 1635).

d. Marie-Catherine-Hortense Desjardins, French playwright (b. 1632).

d. Thomas Killigrew, English playwright and theater manager (b. 1612).

MUSIC & DANCE

Henry Purcell's two choral works *Odes for St. Cecilia's Day*, including the one beginning "Welcome to all the pleasures"; also instrumental works *Sonatas of III Parts*.

Phaéton, Jean-Baptiste Lully's opera, presented at Versailles, January 9, and at Paris, April 27.

WORLD EVENTS

Turning of tide in long Ottoman Turk attack on Europe: Turkish forces unsuccessfully besieged Vienna, were decisively defeated and expelled from Austria and Hungary by European alliance.

Formosa (Taiwan) taken by the Manchus.

German Mennonites founded Germantown, Pennsylvania.

1684

LITERATURE

John Dryden's *MacFlecknoe, or a Satyr upon the True-Blew-Protestant Poet* (1684), directed against a would-be successor as poet laureate, and *Miscellany Poems* (1684–1694).

Increase Mather's *An Essay for the Recording of Illustrious Providences*, popularly called *Remarkable Providences*.

THEATER & VARIETY

d. Pierre Corneille, French playwright (b. 1606).

MUSIC & DANCE

Amadis de Gaule, Jean-Baptiste Lully's opera, presented at the Opéra, Paris, January 18.

Begin the Song, John Blow's work for St. Cecilia's Day.

d. Johann Rosenmüller, German composer (b. ca. 1619).

WORLD EVENTS

Austria, Poland, and Venice formed the Holy League, against the Ottoman Turks.

French took and annexed Luxembourg.

1685

LITERATURE

John Dryden's poem *Threnodia Augustalis: a Funeral–Pindarique Poem Sacred to the Happy Memory of King Charles II.*

Printing introduced to Philadelphia, Pennsylvania, by William Bradford.

VISUAL ARTS

Christopher Wren began St. Andrew by the Wardrobe Church, London (1685–1693).

Godrey Kneller's *Self-Portrait*.

THEATER & VARIETY

Chikamatsu Monzaemon play *Kagekiyo Victorious* (*Shusse Kagekiyo*).

Charles Chevillet Champmeslé's *Le Florentin*.

Jean-Galbert de Campistron's tragedies *Alcibiade* and *Andronic*.

Michel Baron's *Le Rendez-vous des Tuilleries*.

d. Brécourt, French actor and playwright (b. 1638).

d. Thomas Otway, English playwright (b. 1652).

MUSIC & DANCE

Henry Purcell's choral work *Ode for St. Cecilia's Day*.

Idylle sur la paix, Jean-Baptiste Lully's divertissement presented at Sceaux, July 16, and his ballet *Le Temple de la paix*, at Fontainebleau, October 20; both were shown in Paris, in November.

Roland, Jean-Baptiste Lully's dramatic opera presented at Versailles, January 8, and at Paris, March 8.

John Blow's masque *Venus and Adonis* (by 1685) and his anthem *God Spake Sometime in Visions*.

Albion and Albanius, John Dryden's opera.
Shichiku taizen, music for samisen, koto, and flute, published in Japan.

WORLD EVENTS

Failed Monmouth's Rebellion in England followed by Royalist reign of terror.
Russian–Chinese border clashes in central Asia as Russians pushing into Asia encountered newly resurgent Chinese under Manchus.
d. Charles II (b. 1630), king of England; succeeded by James II.

1686

LITERATURE

Ihara Saikaku's novel *Koshoku gonin onna* (*Five Women Who Loved Love*).
John Dryden's poem *To the pious Memory of . . . Mrs. Anne Killigrew, . . . An Ode*.

VISUAL ARTS

Christopher Wren's St. Margaret Lothbury church (1686–1690) and St. Michael Paternoster Royal church (1686–1694).

THEATER & VARIETY

Michel Baron's *L'Homme à bonne fortune*.
d. Nikolaus Avancini, Austrian playwright (b. 1611).

MUSIC & DANCE

Armide, Jean-Baptiste Lully's dramatic opera, based on Torquato Tasso's poem *Gerusalemme Liberata*; libretto by Philippe Quinault.
Marc-Antoine Charpentier's dramatic musical work *Les arts florissants*.

WORLD EVENTS

League of Augsburg formed, composed of Austria, the Palatinate, Saxony, Spain, and Sweden.
Russia joined Holy League, widening the massive European alliance against the Ottoman Turks.

1687

LITERATURE

The Hind and the Panther, John Dryden's poetic defense of Catholicism; also his *A Song for St. Cecilia's Day*.
Kim Man-jung's Chinese novel *Cloud Dream of the Nine* (*Ku-un-mong*), a satire against the institution of concubines (1687–1688).
d. Charles Cotton, English poet and translator (b. 1630).

VISUAL ARTS

Parthenon was heavily damaged by shelling from Venetian forces then besieging Turkish-occupied Athens.
Godfrey Kneller's painting *The Chinese Convert*.

THEATER & VARIETY

Bellamira; or, the Mistress, Charles Sedley's play.
William Penkethman opened in Aphra Behn's *Harlequin*; she also wrote *Emperor of the Moon*.
Florent Carton Dancourt's *Le Chevalier à la mode*.
d. Nell Gwynn, English actress (b. 1650).

MUSIC & DANCE

San Sigismondo re di Borgogna, Domenico Gabrieli's oratorio.
Domenico Gabrielli's *Ricercari* for solo cello, one of the earliest works written for the cello.
First recorded mention of the *chalumeau* (*chalimo*), a single-reed wind instrument ancestral to the clarinet.
d. Jean-Baptiste Lully (Giovanni Battista Lulli), Italian-born French composer, considered the founder of French opera (b. 1632).

WORLD EVENTS

Isaac Newton's *Principia*, a central work of modern science, propounded the theory of gravitation.
Ottoman Turks were defeated by Austrians at Mohacs.
James II dissolved English Parliament.

1688

LITERATURE

First English novel by a woman: *Oroonoko, or the History of the Royal Slave*, Aphra Behn's antislavery work; also her *The Fair Jilt*.

Charles Perrault's *Parallèles des Anciens et des Modernes* (*Parallels between the Ancients and the Moderns*).

Ihara Saikaku's novel *Nippon Eitai-gura*.

d. John Bunyan, English writer and preacher (b. 1628).

VISUAL ARTS

d. Joachim von Sandrart, German art historian, engraver, and painter.

THEATER & VARIETY

The Palace of Eternal Youth (*Ch'ang sheng tien*), Chinese lyric play, by Hung Shen, set in the Tang (8th c.) court.

Charles Chevillet Champmeslé's *La Coupe enchantée*.

Florent Carton Dancourt's *La Maison de campagne*.

Thomas Shadwell's *The Squire of Alsatia*.

d. Philippe Quinault, French playwright and librettist (b. 1635).

MUSIC & DANCE

David et Jonathas, Marc-Antoine Charpentier's dramatic opera.

Pierre Jaillard, called Bressan, emigrated from France to become a noted recorder maker in England.

WORLD EVENTS

"Glorious Revolution" in England: William of Orange became Protestant ruler of England, as James II abdicated and fled into exile.

War of the Grand Alliance began, allying much of Europe against France (1688–1697).

Antislavery movement began to take shape in British America, as Quakers opposed slavery.

1689

LITERATURE

Kim Man-jung's Chinese novel, *Story of Lady Sa* (*Sassi namjong-gi*) (1689–1692).

Cotton Mather's *Memorable Providences, Relating to Witchcrafts and Possessions*.

Charles Cotton's *Poems on Several Occasions*.

d. Aphra (Afra) Behn, British writer, the first professional woman writer (b. 1640).

VISUAL ARTS

Meindert Hobbema's painting *The Avenue at Middelharnis*, widely regarded to be his masterpiece.

Jules Hardouin-Mansart began work on the chapel at Versailles (1689–1703).

THEATER & VARIETY

Jean Racine's *Esther*.

Thomas Shadwell's *Bury Fair*.

MUSIC & DANCE

Dido and Aeneas, Henry Purcell's only true opera, libretto by Nahum Tate, first performed at Josias Priest's Boarding School for Girls, London.

Jean-Henri D'Anglebert's *Pièces de clavecin*.

WORLD EVENTS

James II, with French allies, led a failed Irish insurrection against the new Protestant English government (1689–1691).

King William's War, the first major conflict in the long British–French war for North America; part of European War of the Grand Alliance (1689–1697).

Peter the Great took power in Russia.

Russo-Chinese border war ended with Treaty of Nerchinsk.

1690

LITERATURE

First American paper mill established by printer

William Bradford and Mennonite bishop William Rittinghausen near Philadelphia, Pennsylvania.

First American newspaper, *Public Occurrences Both Forreign and Domestick*, published in Boston by Benjamin Harris; killed by the colony's governor and council after one issue.

VISUAL ARTS

d. Yün Shou-P'ing, Chinese landscape and flower painter (b. 1663).

d. Abraham van Beyeren, Dutch painter (b. 1620–1621).

d. Charles Lebrun, French painter and decorator (b. 1619).

THEATER & VARIETY

Edme Boursault's *Ésope à la ville*.

John Dryden's *Amphitryon* and *Don Sebastian, King of Portugal*.

d. Belleroche, French actor (b. ca. 1630).

MUSIC & DANCE

Marc-Antoine Charpentier's pastorales *Le Jugement de Pan*, *La Fête du Ruel*, and *Actéon* (all ca. 1690).

Dioclesian, Henry Purcell's semiopera (with not all parts sung).

d. Domenico Gabrielli, Italian composer (b. 1651).

d. Giovanni Legrenzi, Italian composer and organist (b. 1626).

WORLD EVENTS

Irish War: English and allied forces defeated Irish–French forces at the decisive Battle of the Boyne; many Irish soldiers fled into exile, becoming "Wild Geese."

August Kelsey explored west out of York Factory as far as the Saskatchewan River.

British founded Calcutta.

1691

THEATER & VARIETY

Jean Racine's *Athalie*.

Jean-Galbert de Campistron's *Tiridate*.

d. Isaac de Benserade, French poet and playwright (b. 1613).

d. George Etherege, English playwright (b. 1634).

MUSIC & DANCE

King Arthur, or The British Worthy, Henry Purcell's semiopera to John Dryden's libretto, premiered in London.

Domenico Gabrieli's solo cantatas.

d. Jean-Henri D'Anglebert, French composer and keyboard player (b. 1635).

WORLD EVENTS

Irish War: English forces defeated remainder of Irish army at Aughrim. Limerick was besieged and fell.

Austrian forces decisively defeated the Ottoman Turks at Szálankemén.

Venetian forces captured the island of Chios.

1692

LITERATURE

William Congreve's novel *Incognita; or, Love and Duty Reconcil'd*.

Ihara Saikaku's novel *Seken Mune-san-yo*.

Cotton Mather's tales *Political Fables*.

THEATER & VARIETY

John Dryden's play *Cleomenes, The Spartan Heroe*.

d. Johannes Velten, German actor (b. 1640).

MUSIC & DANCE

Henry Purcell's masque *The Fairy Queen*, based on Shakespeare's 1595 *A Midsummer Night's Dream*; also his choral work *Ode for St. Cecilia's Day*, opening "Hail bright, Cecilia."

La Noce de village, Marc-Antoine Charpentier's pastorale.

WORLD EVENTS

Salem, Massachusetts, witch trials.
War of the Grand Alliance: English fleet defeated French at La Hogue; Battle of Steenkerke.

1693

LITERATURE

Some Fruits of Solitude, William Penn's religious and moral maxims.
Work began on the influential *romain du roi*, a complete set of 82 fonts of type for Louis XIV, created by Philippe Grandjean but completed long after his death by assistants Jean Alexandre and Louis Luce (1693–1745).
Cotton Mather's *The Wonders of the Invisible World*, on the Salem witch trials.
William Bradford established a press in New York.
d. Ihara Saikaku, Japanese novelist and *haiku* poet (b. 1642).
d. Comtesse de La Fayette (Marie Madeleine de la Vergne), French novelist (b. 1634).

VISUAL ARTS

José de Churriguera's high altar at the church of S. Esteban, Salamanca.
J. P. and D. Elers, brothers in Staffordshire, England, developed unglazed red stoneware for everyday use (ca. 1693–1698).
d. Micolaes Maes, Dutch painter (b. 1634).

THEATER & VARIETY

Mrs. Bracegirdle opened in London in William Congreve's *The Double Dealer*; George Powell opened in Congreve's *The Old Bachelour*.

MUSIC & DANCE

Marc-Antoine Charpentier's opera *Médée*.
Heinrich von Biber's 32-part *Vesperae*.
Music was being written for newer French (orchestral) horns of a deeper tone (by 1700).

WORLD EVENTS

Failed Ottoman Turk attack on Belgrade.
French attacks on Mohawks restrain Iroquois attacks on French-Canadian settlements.
Virginia's College of William and Mary founded.
War of the Grand Alliance: Battle of Neerwinden.

1694

LITERATURE

In Britain, the Licensing Act against which John Milton had spoken in *Areopagitica* (1643) expired without renewal, ending official censorship of the press.
Jean Racine's *Cantiques spirituels* (*Spiritual Hymns*).
d. (Matsuo) Basho, Japanese writer (b. 1644), best known for his journal *Oku no hosomichi* (*The Narrow Road of Oku*).

VISUAL ARTS

Johann Bernhard Fischer von Erlach's Church of the Trinity, Salzburg (1694–1702).

THEATER & VARIETY

Edward Ravenscroft's *The Canterbury Guests*.
John Dryden's *Love Triumphant*.
Thomas Southerne's *The Fatal Marriage*, based on the Aphra Behn novel.

MUSIC & DANCE

Henry Purcell's ode *Come Ye Sons of Art*.
Tomaso Giovanni Albinoni's opera *Zenobia*.
Elisabeth-Claude Jacquet de la Guerre's opera *Cephale et Procris*.

WORLD EVENTS

French raiders from St. Dominque struck at English Jamaica.
Venetian–Turkish naval engagement off Kata Batun.

1695

LITERATURE

William Congreve's A *Pindarique Ode, Humbly Offer'd to the King on his Taking Namure* and the pastoral *The Mourning Muse of Alexis*.
d. Henry Vaughan, Welsh-born English poet (b. 1622).
d. Jean de la Fontaine, French scholar and poet (b. 1621).
d. Sor Juana Inés de la Cruz, Mexican poet and playwright (b. 1651?).

VISUAL ARTS

Johann Fischer von Erlach began the Palace of Prince Eugen, Vienna (1695–1698).
d. Hishikawa Moronobu, Japanese illustrator (ca. 1625–ca. 1695), credited with developing the characteristic *ukiyo-e* woodcut print.

THEATER & VARIETY

Florent Carton Dancourt's *Les Vendanges de Suresnes*.
William Congreve's *Love for Love* opened in London's Lincoln's Inn Fields Theater.
Thomas Southerne's *Oroonoko*, based on the Aphra Behn novel, opened in London.

MUSIC & DANCE

d. Henry Purcell, English composer (b. 1659); works produced in his last year include the semioperas *The Indian Queen* and *The Tempest*.
Les Plaisirs de Versailles, Marc-Antoine Charpentier's pastorale (ca. 1695).
Domenico Gabrieli's motets for contralto *Vexillum pacis*.

WORLD EVENTS

Breslau University founded.
Mustafa II became Ottoman Turk sultan (1695–1703).
Russia and Turkey were at war; Peter the Great attacked Azov (1695–1700).
War of the Grand Alliance: besieged Namur fell to the forces of William III.

1696

LITERATURE

William Congreve's *Letters upon Several Occasions*.
d. Marie de Rabutin-Chantal Sévigné, the most famous of European letter writers (b. 1626).

VISUAL ARTS

Christopher Wren began Greenwich Hospital.
Johann Bernhard Fischer von Erlach's University Church at Salzburg (1694–1707).
d. Abate Filippo Baldinucci, Florentine artist and art historian (b. 1624).

THEATER & VARIETY

Colley Cibber's *Love's Last Shift; or, the Fool in Fashion*.
Edward Ravenscroft's *The Anatomist; or, the Sham Doctor*.
John Vanbrugh's *The Relapse; or, Virtue in Danger*.

MUSIC & DANCE

George Frideric Handel's *Six Sonatas for Two Oboes and Continuo* (ca. 1696).
Henry Purcell's *Eight Harpsichord Suites*, published posthumously.
Ode on the Death of Mr. Henry Purcell, John Blow's tribute to his late student.
Il Trionfo di Camilla, Giovanni Bononcini's opera.
d. Vincenzo Albrici, Italian composer (b. 1696).

WORLD EVENTS

Russia took Kamchatka, continuing its eastern imperial expansion.
Russo-Turkish War: Peter the Great took Azov from the Turks.

1697

LITERATURE

Mother Goose Tales (Les Contes de ma mère l'Oye), Charles Perrault's versions of many famous folk-

tales, including *The Sleeping Beauty, Little Red Riding-Hood, Blue Beard, Cinderella, Tom Thumb,* and *Puss in Boots.*
John Dryden's poem *Alexander's Feast.*

THEATER & VARIETY

William Congreve's *The Mourning Bride.*
Edward Ravenscroft's tragedy *The Italian Husband.*
John Dennis's *A Plot and No Plot.*
The Provok'd Wife, John Vanbrugh's play, was produced (written 1690–1692).

MUSIC & DANCE

Antonio Stradivari had developed the form of his classic violins (ca. 1700).
Henry Purcell's instrumental works, 10 *Sonatas of IV Parts*, published posthumously.
d. William Child, English composer (b. 1606).

WORLD EVENTS

Prince Eugene defeated Ottoman Turks at Zenta.

1698

LITERATURE

William Congreve's *Amendments of Mr. Collier's False and Imperfect Citations*, and his poem *The Birth of the Muse.*

THEATER & VARIETY

George Farquhar's *Love and a Bottle.*
d. Marie Desmares Champmeslé, French actress (b. 1643).

MUSIC & DANCE

d. Andrea Guarneri, Italian violin maker, active in Cremona (b. 1626); who (with Francesco Ruggeri) developed the form of the modern cello; he had been trained by Nicolò Amati, and was succeeded by his sons, Pietro and Giuseppe, and most notably his nephew, Giuseppe "Del Gesu" Guarneri.

WORLD EVENTS

Second Streltsy (Russian palace guard) Rebellion; crushed by Peter the Great.
Russia, Poland, and Denmark formed an alliance against Sweden.

1699

LITERATURE

Frederick III, elector of Brandenburg, instructed that two copies of every book published in his principality be deposited in the state library, a forward-looking practice adopted only much later in many other countries.

VISUAL ARTS

John Vanbrugh designed Castle Howard (1699–1726).
d. Jan Hackaert, Dutch landscape painter (b. 1628).

THEATER & VARIETY

George Farquhar's *The Constant Couple.*
d. Jean Racine, French playwright (b. 1639).

MUSIC & DANCE

British organs began to have pedals (late 17th–early 18th c.), the Continental practice brought in with the Restoration by returning or immigrant organ builders, notably "Father" Smith from Holland (d. 1708), who made the organs for Westminster Abbey and St. Paul's Cathedral.

WORLD EVENTS

Holy League and Ottoman Turks ended their war with the treaty of Karlowitz.
Omani forces took Zanzibar.

1700

LITERATURE

Arani-mal, Kashmiri woman poet (active ca. 1700).
d. John Dryden, English poet (b. 1631).
d. Johann Beer, German novelist (b. 1655).

VISUAL ARTS

China's Imperial Summer Palace at Beijing and the Marble Pagoda in the western hills near Beijing were built (early 18th c.).

d. André Le Nôtre, French landscape gardener (b. 1613), who designed the parks at Vaux-le-Vicomte and Versailles.

THEATER & VARIETY

William Congreve's *The Way of the World.*

Charles-Rivière Dufresny's *Esprit de contradiction.*

d. Armande-Grésinde-Claire-Élisabeth Béjart, French actress (b. 1641).

b. Charles Macklin, Irish actor (d. 1797).

MUSIC & DANCE

Academy of Vocal Music, later the Academy of Ancient Music, formed in London, to revive early church music, with fortnightly concerts in season (early 18th c.).

Théâtre Royal de la Monnaie opened in Brussels.

d. Nicolaus Adam Strungk, German composer (b. 1640).

WORLD EVENTS

Great Northern War began, pitting Russia, Poland, Denmark, and Prussia against Sweden (1700–1721).

Charles II of Sweden defeated Peter the Great of Russia at Narva.

1701

LITERATURE

A *Serious Proposal to the Ladies for the Advancement of Their True and Greatest Interest*, Mary Astell's early call for women's education.

Daniel Defoe's poem *The True-Born Englishman.*

VISUAL ARTS

d. John Bushnell, English sculptor (b. ca. 1605).

THEATER & VARIETY

William Congreve's masque *The Judgement of Paris.*

d. Edme Boursault, French playwright (b. 1638); produced that year was the play *Ésope à la cour.*

Nicholas Rowe's *The Ambitious Step-Mother.*

d. Charles Chevillet Champmeslé, French actor and playwright (b. 1642).

MUSIC & DANCE

Heinrich von Biber's *Missa Sancti Henrici.*

Earliest known church barrel organ, in Derbyshire, England (ca. 1700).

WORLD EVENTS

Great Northern War: Battle of Dünamünde.

University of Venice founded.

1702

LITERATURE

Daniel Defoe's *The Shortest Way with the Dissenters*, a satirical work attacking ecclesiastical intolerance, for which he was fined and imprisoned.

Elizabeth Mallet and later also Samuel Buckley began publishing *The Daily Courant*, the first daily newspaper in England, continuing for 30 years.

Magnalia Christi Americana, Cotton Mather's religious history of New England.

Médailles sur les Événements du Règne de Louis-le-Grand, the first publication set in *romain du roi*, a typestyle created (1693) by Philippe Grandjean.

VISUAL ARTS

Godrey Kneller's portraits of the Kitkat Club, a series designed to be hung in the club's meeting room (ca. 1702–1717).

Andrea Bozzo began his decoration of Vienna's Liechtenstein Palace.

THEATER & VARIETY

Colley Cibber's *She Would and She Would Not.*

Charles-Rivière Dufresny's *Le Double Veuvage.*

MUSIC & DANCE

Rodrigo in Algeri, Tomaso Giovanni Albinoni's opera, staged in Naples.

The Italian name "trombone" began to replace the English and French name *sackbut* or *saqueboute* (during 18th c.), by which the instrument had been known since the late 15th century.

Side snare drums had shrunk to roughly modern size (early 18th c.).

Uilleann pipes developed in Ireland (during 18th c.); also used in Scotland.

WORLD EVENTS

Camisard insurrection of French Protestants began (1702–1705).

d. William III (b. 1650), king of England; succeeded by his daughter, Queen Anne.

Great Northern War: Swedish forces took Warsaw.

War of the Spanish Succession began, in the Americas called Queen Anne's War (1702–1713).

1703

LITERATURE

William Congreve's *A Hymn to Harmony* and *The Tears of Amaryllis for Amyntas: A Pastoral*.

d. Samuel Pepys, English politician, best known for his *Diary* (b. 1533).

d. Charles Perrault, French writer and critic (b. 1628).

VISUAL ARTS

Jules Hardouin-Mansart completed the chapel at Versailles (1689–1703).

THEATER & VARIETY

Chikamatsu Monzaemon's *Sonezaki shinju* (*Love Suicides at Sonezaki*).

George Powell opened in Nicholas Rowe's *The Fair Penitent*.

MUSIC & DANCE

Matsu no ha, a book of music for samisen, koto, and flute, published in Japan.

Horns began to join strings, oboes, and bassoons in orchestras (18th c.).

WORLD EVENTS

Great Northern War: Charles II campaigned successfully in Poland.

Rakoczi Rebellion; failed insurrection against Austrian rule in Hungary (1703–1711).

1704

LITERATURE

A Tale of a Tub . . . , Jonathan Swift's allegorical satire ridiculing religious extremists of *all* persuasions; also *Discourse Concerning the Mechanical Operation of the Spirit* and *The Battle of the Books*, a mock-heroic satire on the comparative merits of ancient and modern literature.

The first English-language translation of *The Arabian Nights' Entertainment* (*A Thousand and One Nights*); also Antoine Galland began preparing his 12-volume French version (1704–1717).

John Campbell began publishing *Boston News-Letter*, the first continuing American newspaper (1704–1722).

Joseph Addison's poem *The Campaign*.

d. Hung Sheng, Chinese poet and dramatist (b. 1646).

VISUAL ARTS

Johann Fischer von Erlach began his series of designs for Vienna's Schönebrunn Palace (ca. 1704).

THEATER & VARIETY

The Lute Song (*Romance of the Lute*; *P'i pa chi*), Chinese play, by Kao Tse-ch'eng.

Colley Cibber's *The Careless Husband*.

John Dennis's *Liberty Asserted*.

d. Henry Harris, English actor (b. 1634).

MUSIC & DANCE

Appalachian dulcimer, a kind of fretted zither, developed in Appalachian Mountains, especially Kentucky and Alabama (ca. 18th c.).

First depictions of balalaikas (18th c.), possibly developed from older central Asian instruments.

Japanese bowed instrument, *kokyu*, developed (18th c.).

College of piping in existence in Dunvagen, Scotland (18th c.).

Small, portable, hand-turned street organs came into popular use (early 18th c.).

d. Marc-Antoine Charpentier, French composer (b. 1645–1650).

d. Heinrich Ignaz Franz von Biber, Bohemian composer, also a violin virtuoso (b. 1664).

WORLD EVENTS

War of the Spanish Succession: British and Austrian forces led by John Churchill, Duke of Marlborough, defeated the French and Bavarians at Blenheim.

British took Gibraltar.

Deerfield (Massachusetts) Massacre, by French and Indian forces during Queen Anne's War.

First Javanese War of Succession (1704–1708).

1705

LITERATURE

Daniel Defoe's *The Review*, originally titled *A Weekly Review of the Affairs of France*, offering opinion on current topics, began appearing three times a week (1705–1713).

VISUAL ARTS

John Vanbrugh designed Blenheim Palace (1705–1720), home of the Churchill family, built to honor the Duke of Marlborough.

d. Chu Ta, Chinese ink painter (b. ca. 1630).

d. Luca Giordano, Italian decorative painter (b. 1634).

THEATER & VARIETY

Susannah Centlivre's *The Gamester*.

John Dennis's *Gibraltar; or, the Spanish Adventure*.

John Vanbrugh's *The Confederacy*.

Nicholas Rowe's *Ulysses*.

Prosper Jolyot de Crébillon's *Idoménée*.

MUSIC & DANCE

Almira, George Frideric Handel's opera, book by F. C. Feustking, premiered at Hamburg, January 8.

d. Pierre Beauchamp(s), French dancer, choreographer, and ballet master (1636–ca. 1705), who choreographed numerous operas and plays, including those of Molière. He is credited with developing (or codifying) the five classic positions in ballet, and also a system of dance notation.

WORLD EVENTS

Barcelona was taken by the British.

Failed rebellion of Bashkirs in southern Russia (1705–1711).

Moscow University founded.

1706

LITERATURE

William Congreve's *A Pindarique Ode on the Victorious Progress of Her Majesties Arms*.

VISUAL ARTS

Jean Jouvenet's *Miraculous Draught of Fishes*.

THEATER & VARIETY

George Farquhar's *The Recruiting Officer*.

Chikamatsu Monzaemon's *Gonza the Lancer* (*Yari no Gonza*).

d. Mlle. De Brie, French actress (b. ca. 1630).

MUSIC & DANCE

d. Johann Pachelbel, German composer and organist (b. 1653), best known for his *Canon* in D.

WORLD EVENTS

War of the Spanish Succession: British led by Marlborough defeated the French at Ramillies.

Formal union between England and Scotland.

1707

VISUAL ARTS

Johann Fischer von Erlach built the Palais Clam Gallas, Prague (1707–1712).
d. Willem van de Velde, Dutch marine painter (b. 1633).

THEATER & VARIETY

George Farquhar's *The Beaux' Stratagem*.
d. George Farquhar, Irish-born playwright (b. 1678).

MUSIC & DANCE

George Frideric Handel's opera *Il Trionfo del Tempo e del Disinganno* and choral work *Dixit Dominus*.
Der Carneval von Venedig, Reinhard Keiser's opera.
Principes de la flute traversiere, Jacques Hotteterre's manual on playing the flute.

WORLD EVENTS

Kondrati Bulavin led a failed Don Cossack revolt against Russian rule (1707–1708).

1708

LITERATURE

Jonathan Swift's satirical work *An Argument Against Abolishing Christianity*.

VISUAL ARTS

d. Jules Hardouin-Mansart, French architect (b. 1646).

THEATER & VARIETY

Electra, Prosper Crébillon's play.
Chikamatsu Monzaemon's *Tamba Yosaka* (*Yosaku from Tamba*).

MUSIC & DANCE

La Resurrezione, George Frideric Handel's oratorio.
d. James Talbot, British professor and historian of musical instruments (b. 1664), who described in detail all musical instruments in use in London during his day.
d. John Blow, English composer (b. 1649).

WORLD EVENTS

War of the Spanish Succession: major French defeat by Allied forces at Oudenarde.
Algerian forces took Oran from Spain.

1709

LITERATURE

Richard Steele's *The Tatler* began appearing three times a week, written by Steele and others, including Joseph Addison, as if from various London coffeehouses (1709–1711).
In Britain, the Copyright Act formally recognized authors' rights, protecting them for a set time.
Jonathan Swift's poem *A Description of the Morning*.

VISUAL ARTS

Antoine Watteau's painting *L'île de Cythère* (1709–1712).
d. Meindert Hobbema, the last of the great 17th-century Dutch landscape painters (b. 1638).

THEATER & VARIETY

Peter the Great founded the St. Petersburg Imperial Theater.
Alain René Le Sage's *Turcaret* opened at the Comédie Française on February 14.
John Dennis's *Appius and Virginia*.
Susannah Centlivre's *The Busie Body*.
d. Saint Dmitri of Rostov, Russian playwright (b. 1651).
d. Thomas Corneille (Corneille de l'Isle), French playwright (b. 1625).
d. Jean-Francois Regnard, French playwright (b. 1655).

MUSIC & DANCE

Agrippina, George Frideric Handel's opera, libretto by Vincenzo Grimani; opened in Venice, December 26.
A report described a new instrument developed by

Bartolomeo Cristofori as *"gravicembalo* (harpsichord) *con piano e forte"*; the latter phrase, referring to the player's ability to play both soft and loud, became the instrument's name: *pianoforte* or *piano*. Early models generally had four octaves.

d. Giuseppe Torelli, Italian composer (b. 1658).

WORLD EVENTS

Great Northern War: Peter the Great of Russia decisively defeated Charles XII of Sweden at Poltava.

War of the Spanish Succession: British and Austrians defeated French at Malplaquet; besieged Tournai fell.

Afghanistan and Persia were at war (1709–1711).

1710

LITERATURE

Jonathan Swift's poem *A Description of a City Shower*; he also began keeping his private *Journal to Stella*, letters addressed to a friend, identified as Esther Johnson.

John Arbuthnot's *The History of John Bull* introduced "John Bull" as the personification of England (ca. 1710).

VISUAL ARTS

Interior decoration of the chapel at Versailles was completed; begun by Jules Hardouin-Mansart (1689).

Johann Fischer von Erlach built the Palais Trautson, Vienna (1710–1716).

Thomas Archer began St. Philip's Church, Birmingham, England (1710–1715).

THEATER & VARIETY

Aaron Hill's *The Walking Statue; or, the Devil in the Wine Cellar*.

d. Thomas Betterton, English actor (b. ca. 1635).

MUSIC & DANCE

First recorded mention of the clarinet, believed to have been developed by Nuremberg woodwind maker J. C. Denner (1655–1707) or his son Jakob (1681–1785).

Semele, William Congreve's unacted opera.

WORLD EVENTS

British forces took Port Royal, Nova Scotia.

George Berkeley's *Principles of Human Knowledge*.

South Sea Company was formed in England.

Turkey and Russia were at war (1710–1711).

1711

LITERATURE

Alexander Pope's poem *An Essay on Criticism*, which brought him early fame, with maxims such as "A little learning is a dangerous thing" and "To err is human, to forgive divine."

The Spectator, successor to *The Tatler*, written and published by Richard Steele and Joseph Addison, using the device of fictional authors from a small club (1711–1712).

VISUAL ARTS

d. Jean Jouvenet, French painter (b. 1644).

THEATER & VARIETY

The Courier for Hell (*Meidono Hikyatu*), Chikamatsu Monzaemon play.

Prosper Jolyot de Crébillon's *Rhadamiste et Zénobie*.

MUSIC & DANCE

Rinaldo, George Frideric Handel's opera, book by Giacomo Rossi; opened at the Haymarket, London, February 24.

Tolomeo et Alessandro, overo La corona disprezzata, Domenico Scarlatti's opera.

WORLD EVENTS

Afghan–Persian war ended with the decisive defeat of Persian army besieging Kandahar.

Russia lost Azov to the Turks in the peace agreement ending the Russo-Turkish war.

Tuscarora Indian war in North Carolina (1711–1713).

1712

LITERATURE

The Rape of the Lock, Alexander Pope's mock-heroic poem about the feud that arises from the filching of a lock of hair; the original two cantos were later expanded to five (1714).

John Arbuthnot's essay *The Art of Political Lying*.

The Spacious Firmament on High, Joseph Addison's hymn.

VISUAL ARTS

Antoine Watteau's paintings included *Ceres (Summer)*, *Jupiter et Antiope*, *L'Accordée de village*, *La Conversation*, and *La Perspective* (all 1712–1715).

Thomas Archer began St. Paul's Church, Deptford, London (1712–1715).

Nicholas Hawksmoor designed the Clarendon Building, Oxford University, and St. Alphege Church, Greenwich (1712–1714).

d. Jan van der Heyden, Dutch painter (b. 1637).

MUSIC & DANCE

Tetide in Sciro, Domenico Scarlatti's opera.

WORLD EVENTS

Hostilities ended in the War of the Spanish Succession; peace negotiations began at Utrecht.

Second Villmergen War between Catholics and Protestants in Switzerland.

1713

LITERATURE

Alexander Pope's verses, *Ode for Musick* and *Windsor-Forest*.

Anne Finch, Countess of Winchilsea's poem A *Nocturnal Reverie*, praised by William Wordsworth; also her *To the Nightingale*.

Real Academia (Royal Academy), modeled on France's, founded in Spain to protect the Spanish language.

VISUAL ARTS

Francis Bird's monument of *Dr. Ernest Grabe*.

THEATER & VARIETY

Joseph Addison's blank-verse tragedy *Cato*.

Merope, Francesco Scipione's tragedy.

Joseph Addison's *Cato of Utica*.

d. Elizabeth Barry, England's first star actress, a tragedian of the first rank (b. 1658).

d. John Crowne, English Restoration playwright (b. 1640?).

MUSIC & DANCE

Utrecht (Te Deum and Jubilate), George Frideric Handel's choral work.

d. Archangelo Corelli, Italian composer and violinist (b. 1653).

WORLD EVENTS

Peace of Utrecht formally ended the War of the Spanish Succession; it also ended Queen Anne's War in North America; British took Acadia (Nova Scotia) from French, regained Newfoundland and Hudson's Bay.

1714

LITERATURE

Maha Ya-zawingyi (Great Chronicle), Burmese history by U Kala (active 1714–1733).

Thomas Parnell's poem A *Hymn to Contentment*.

VISUAL ARTS

Antoine Watteau's paintings included *L'Amour désarmé* (1714–1716) and *Le Bal Champêtre* (1714–1715).

James Gibbs's church of St. Mary-le-Strand, Westminster (1714–1717).

Thomas Archer began St. John's Church, Smith Square, London (1714–1758).

d. Tao Chi, Chinese painter, calligraphist, and poet (b. 1667), who wrote on the theory of painting.

THEATER & VARIETY

d. Takemoto Gidayu (?–1714), collaborator of Chikamatsu Monzaemon in the development of the Osaka *bunraku* puppet theater.

Nicholas Rowe's *The Tragedy of Jane Shore* opened in London February 2.

Susannah Centlivre's *The Wonder, a Woman Keeps a Secret*.

d. George Powell, English actor (b. 1668).

MUSIC & DANCE

Christmas Concerto, Archangelo Corelli's concerto grosso in G minor.

Domenico Scarlatti's opera *Narciso*.

Antonio Vivaldi's opera *Orlando*.

WORLD EVENTS

d. Anne (b. 1665), queen of England; succeeded by George I of Hanover, the first of the Hanoverian line.

Failed revolt against Turkish rule in Montenegro.

Turkey was at war with a European alliance that included Venice, Austria, and Russia (1714–1718).

1715

LITERATURE

Histoire de Gil Blas de Santillane, Alain René Lesage's picaresque novel.

d. P'u Sung-ling, Chinese story writer and novelist (b. 1640) who wrote the story collection *Liaochai-chih-i*.

VISUAL ARTS

Giovanni Battista Tiepolo's painting *The Sacrifice of Isaac* (*The Sacrifice of Abraham*) (1715–1716).

Antoine Watteau's painting *La Gamme d'Amour* (ca. 1715).

Colen Campbell's folio *Vitruvius Britannicus*.

THEATER & VARIETY

The Battles of Coxinga (*Kokusenya Kassen*), Chikamatsu Monzaemon's play premiered at the Osaka puppet theater November 26.

Charles-Rivière Dufresny's *La Coquette du village*.

Nicholas Rowe's *Lady Jane Grey*.

MUSIC & DANCE

George Frideric Handel's opera *Amadigi* (*di Gaula*).

Domenico Scarlatti's opera *Ambleto*.

WORLD EVENTS

Failed Jacobite rebellion against English rule in Scotland (1715–1716).

Yamasee Indian War in the Carolinas (1715–1718).

1716

VISUAL ARTS

Antoine Watteau's paintings included *Harlequin and Columbine* (*Voulez-vous triompher des belles?*), *The French Comedy* (*L'Amour au théâtre français*), *The Italian Comedy* (*L'amour au théâtre italien*) (ca. 1716), *Assemblée dans un parc* (1716–1717), *L'Indifférent* (ca. 1716), *La Finette* (ca. 1716), *Les Deux Cousines* (1716–1717), and *Gilles and His Family* (*Sous un habit de Mezzetin*) (1716–1718).

Johann Bernhard Fischer von Erlach began the Church of St. Charles (Karlskirche), Vienna.

Melchor Pére Holguín's painting *Entry of Viceroy Fray Diego Morcillo Rubio de Aunón into Potosi*.

THEATER & VARIETY

d. William Wycherley, English playwright (b. 1640).

MUSIC & DANCE

Brockes' Passion, George Frideric Handel's choral work (ca. 1716).

Juditha triumphans, Antonio Vivaldi's oratorio.

WORLD EVENTS

Mongolian forces took Tibet from the Manchus.

Tokugawa Yoshimune became shogun of Japan; began to open slightly to the west (1716–1745).

Turkish forces took Belgrade.

1717

LITERATURE

Alexander Pope's poetic works, *Eloisa to Abelard* and *Verses to the Memory of an Unfortunate Lady*.

VISUAL ARTS

Antoine Watteau's paintings included *The Embarkation for Cythère* and *The Music-Party* (1717–1718).
Giovanni Battista Tiepolo's painting *Repudiation of Hagar* (1717–1719).
William Kent's painting of the ceiling in S. Giuliano in Rome.

MUSIC & DANCE

Water Music, George Frideric Handel's orchestral work to entertain British King George I's river party on the Thames; also his choral works *11 Chandos Anthems*.
The Loves of Mars and Venus, John Weaver's ballet-without-words (*ballet d'action*), a form derived from earlier English masques.

WORLD EVENTS

Austrian forces took back Belgrade from the Ottoman Turks.
Britain, France, and Holland formed a Triple Alliance.

1718

LITERATURE

Psalterium Americanum, Cotton Mather's translation of the Psalms.
d. Thomas Parnell, Irish priest and poet (b. 1679).

VISUAL ARTS

Antoine Watteau's paintings included *Fêtes venitiennes* (ca. 1718), *Mezzetin* (1718–1719), and *The Champs-Élysées* (1718–1719).
Colen Campbell began his remodeling of Burlington House (1718–1719).

THEATER & VARIETY

The Uprooted Pine (*Nebiki no Kabumatsu*), Chikamatsu Monzaemon play.
Susannah Centlivre's *A Bold Stroke for a Wife*.
d. Nicholas Rowe, English playwright (b. 1674).

WORLD EVENTS

Mongol forces defeated Manchu army sent to take Tibet.
Turks lost Belgrade and Hungary to Austria by terms of the Treaty of Passarowitz, ending their current war.
War of the Quadruple Alliance began, pitting Austria, France, Britain, and the Netherlands against Spain (1718–1720).

1719

LITERATURE

Robinson Crusoe, Daniel Defoe's tale of a mariner's existence shipwrecked on an island with his companion and servant "Man Friday"; the first novel to appear serially (1719–1720).
Isaac Watts's poem *Man Frail and God Eternal*, best known as the hymn beginning "Our God, our help in ages past."
Postmaster William Brooker began publishing the *Boston Gazette*, America's second continuing newspaper, continued by five succeeding postmasters; under Brooker (1719–1721), it was printed by James Franklin, assisted by his then-apprenticed younger brother, Benjamin.
d. Joseph Addison, English poet, essayist, and critic (b. 1672).

VISUAL ARTS

d. Jan Weenix, Dutch landscape and still-life painter (b. 1640), many of whose works involved hunting.
d. William Talman, English architect (b. 1650).

MUSIC & DANCE

Henry Carey's song *The Ballad of Sally in Our Alley* (before 1719).
Antonio Vivaldi's opera *Teuzzone*.

Germans developed a new form of oboe, the *oboe d'amore*, first named by Johann Sebastian Bach in the score for his *St. John Passion*; but it became obsolete by the 1770s.

WORLD EVENTS

British South Sea Company grew to great size, as investments poured in.

Failed Jacobite rising in Scotland.

Javanese War of Succession (1719–1723).

Russia and Sweden were at war.

Trieste was made a free port.

1720

LITERATURE

d. Anne Finch, Countess of Winchilsea (pen name, Ardelia), British writer (b. 1661).

VISUAL ARTS

Antoine Watteau's paintings included *La Toilette, The French Comedians, Gilles* (1720–1721), *Italian Comedians, L'enseigne de Gersaint* (ca. 1720–1721), and *Le Rendez-vous de chasse* (ca. 1720).

Nicholas Hawksmoor began St. George's Church, Bloomsbury, London.

Giovanni Battista Tiepolo's paintings included his *Glory of St. Theresa* (ca. 1720) and *The Madonna of Carmelo and the Souls of Purgatory* (ca. 1720).

THEATER & VARIETY

Harlequin Polished by Love, Pierre Marivaux's play, was presented by the Italian Comedians company in Paris.

MUSIC & DANCE

George Frideric Handel's opera *Radamisto* opened at the Royal Academy of Music, a London opera company he headed (1720–1728); also Handel's choral work *Acis and Galatea*, and *Suites de pièces* for harpsichord (both ca. 1720).

Johann Sebastian Bach's *Chromatic Fantasia and Fugue* (ca. 1720).

Antonio Vivaldi's opera *Tito*.

Terpsichore, Jean-Féry Rebel's dance symphony.

Horns were added to oboes and bassoons in European military bands (1720s).

So-called "Turkish music," featuring bass drum, cymbals, and triangle, became popular in Europe, as instruments became available, after Turkey's losses in eastern Europe (1720s).

WORLD EVENTS

Manchu forces took Tibet from the Mongols, also taking Turgan and Urumchi in Mongolia.

British "South Sea Bubble" burst, with huge losses to investors.

1721

LITERATURE

James Franklin published the short-lived but influential *New England Courant* in Boston, provided news and features such as the "Do-Good Papers" contributed by his younger brother and apprentice, Benjamin.

Thomas Parnell's poems *A Night Piece on Death* and *Song*, published posthumously.

VISUAL ARTS

d. Antoine Watteau, French painter (b. 1684); a late work was *Le Jugement de Paris*.

d. Grinling Gibbons, Dutch-English sculptor (b. 1648), notable for his small wood carvings, while also working in marble and bronze forms.

THEATER & VARIETY

Chikamatsu Monzaemon's *Shinju Ten no Amijima* (*The Love Suicides at Amijima*); presented first in the puppet theater, the work became a staple in the repertory of the *kabuki* theater; he also presented *The Woman-Killer and the Hell of Oil* (*Onnogoroshi Abura Jigoku*).

Charles-Rivière Dufresny's *Le Mariage fait et rompu*.

MUSIC & DANCE

Johann Sebastian Bach's *Brandenburg Concertos Nos. 1–6*.

Georg Philipp Telemann's opera *Der geduldige Socrates*.

WORLD EVENTS

Paraguayan revolt against Spanish rule began (1721–1735).

Swedish–Russian war ended with the Peace of Nystadt, granting Russian major territorial gains.

France annexed the Indian Ocean island of Mauritius.

1722

LITERATURE

Two major works by Daniel Defoe: *Moll Flanders*, the picaresque, supposedly autobiographical novel of her "Fortunes and Misfortunes"; and *A Journal of the Plague Year*, a fictional account of the London Plague of 1665.

VISUAL ARTS

James Gibbs began the Church of St. Martin's-in-the-Fields (1722–1726), and the Senate House at Cambridge.

Colen Campbell began Mereworth Castle, Kent (ca. 1722–1725).

THEATER & VARIETY

Pierre Carlet de Chamblain de Marivaux's *La Surprise de l'amour*.

Ludvig Holberg's *Jean de France* and *Mester Gert Westphaler*.

MUSIC & DANCE

Johann Sebastian Bach's keyboard works 6 *English Suites* and 6 *French Suites* (both ca. 1722), and his monumental *Das wohltemperiete Klavier*, '48' (*The Well-Tempered Clavier*; 1722, 1742).

Giuseppe Guarneri began making violins (1722–1723).

Tomaso Giovanni Albinoni's opera *I veri amici*.

WORLD EVENTS

Afghan forces completed their conquest of Persia, taking Isfahan.

Turkish forces invaded Persia, taking large portions of northern Persia, but failing to take Isfahan (1722–1727).

1723

LITERATURE

d. Increase Mather, New England Puritan cleric and writer (b. 1639).

VISUAL ARTS

Nicholas Hawksmoor began Christchurch, Spitalfields, London (1723–1729).

d. Johann Bernhard Fischer von Erlach, Austrian architect (b. 1656); a late work was his Vienna Court Library (*Hofbibliothek*), completed by his son.

Francis Bird's tomb of the Duke of Newcastle.

d. Christopher Wren, English architect (b. 1632).

THEATER & VARIETY

Pierre Carlet de Chamblain de Marivaux's *La Double Inconstance* (1723).

d. Jean-Galbert de Campistron, French playwright (b. 1656).

d. Susannah Centlivre, English playwright and actress (b. 1667).

MUSIC & DANCE

Johann Sebastian Bach's great choral works the *Magnificat* and *Jesu meine Freude* (1723?); also his keyboard works 15 *Inventions* and 15 *Sinfonias*.

George Frideric Handel's opera *Ottone*.

Johann Joseph Fux's opera *Costanza e Fortezza* (*Constancy and Courage*).

WORLD EVENTS

Russia took Baku from Persia by the terms of the Russo-Persian peace treaty of St. Petersburg.

1724

LITERATURE

The Braes of Yarrow, William Hamilton of Bangour's poem.

Parentator, a biography of Increase Mather by his son, Cotton Mather.

An Thou Were My Ain Thing, Allan Ramsay's poem.

VISUAL ARTS

Giovanni Battista Tiepolo's painting *The Force of Eloquence* (ca. 1724–1725).

James Gibbs's Fellows' Building at King's College, Oxford (1724–1749).

Melchor Pére Holguín's painting *Four Evangelists*.

William Hogarth's engraving *Masquerades and Operas*.

THEATER & VARIETY

d. Charles-Rivière Dufresny, French playwright (b. 1654).

d. Elkanah Settle, English playwright (b. 1648).

MUSIC & DANCE

George Frideric Handel's operas *Julius Cesare* premiered at the Haymarket, London, February 20, and *Tamerlano* (*Tamburlaine*) opened at King's Theater, London, October 31; libretto for both by Nicola Haym.

St. John Passion, Johann Sebastian Bach's choral work.

Antonio Vivaldi's opera *Giustino*.

L'apothéose de Corelli, François Couperin's chamber music.

WORLD EVENTS

Kingdom of Dahomey founded.

Russia and Turkey divided northwestern Persia.

1725

LITERATURE

William Bradford began publishing *The New-York Gazette*, the first newspaper in the colony (1725–1744).

Alexander Pope's edition of *Shakespeare*.

VISUAL ARTS

d. José de Churriguera, Madrid architect and sculptor (b. 1665).

d. Melchor Pére Holguín, Spanish-American painter (b. ca. 1660).

THEATER & VARIETY

d. Chikamatsu Monzaemon, Japanese playwright (b. 1652).

d. Florent Carton Dancourt, French playwright and actor (b. 1661).

d. William Penkethman, English comedian (b. 1725).

MUSIC & DANCE

Four Seasons, Antonio Vivaldi's four linked violin concertos, part of his *Il cimento dell'armonia e dell'inventione* (ca. 1725).

Rodelinda, George Frideric Handel's opera, libretto by Antonio Salvi and Nicola Haym; opened at the King's Theater, London, February 13.

L'apothéose de Lully, François Couperin's chamber music.

Use of thumb positions in cello playing developed (early 18th c.) by cellist Francesco Alborea (1691–1739).

WORLD EVENTS

d. Peter the Great (b. 1672), czar of Russia; succeeded by his wife, Catherine I.

Maroon War: Jamaican rebellion of escaped slaves against British rule (1725–1739).

Turks took Tabriz.

1726

LITERATURE

Jonathan Swift's *Gulliver's Travels*, a satirical tale of humans and their institutions, told through his hero's travels and experiences with peoples such as the Lilliputians (under six inches tall), the Brobdingnagian giants, the Laputan wise men, and the Houyhnhnms and loutish Yahoos.

James Thomson's descriptive poem in blank verse,

Winter, the first of the quartet known as *The Seasons*.

VISUAL ARTS

Georg Baehr began his Frauenkirche in Dresden (1726–1743).

Giovanni Battista Tiepolo's frescoes for the Palazzo Arcivescovile, Udine, Italy (ca. 1726).

THEATER & VARIETY

d. John Vanbrugh, English playwright and architect; his unfinished play was produced by Colley Cibber in 1728 (b. 1664).

MUSIC & DANCE

Alessandro, George Frideric Handel's opera, libretto by Paolo Rolli, premiered in London, May 5; also Handel's *Scipione*.

WORLD EVENTS

Persian general Nader Shah began the reconquest of Persia, with Shah Tasmasp.

Russia and Austria entered a new alliance against Turkey.

1727

LITERATURE

Edinburgh printer William Ged developed a method of duplicating a form of type by making a unified copy, later called a *stereotype*, which (when adopted after 1794) greatly eased both printing preparation and reprinting (ca. 1727).

James Thomson's poem *Summer*, the second of the quartet known as *The Seasons*.

Samuel Richardson's novel *Clarissa Harlowe*.

VISUAL ARTS

Jean-Baptiste-Siméon Chardin's painting *The Skate* (1727–1728).

William Kent edited the *Designs of Inigo Jones*, published by Richard Burlington.

THEATER & VARIETY

Pierre Carlet de Chamblain de Marivaux's *La Seconde Surprise de l'amour*.

Destouches's *Le Philosophe marié*.

MUSIC & DANCE

Johann Sebastian Bach's choral works *St. Matthew Passion* (1727) and *Singet dem Herrn* (ca. 1727); also his *7 motets* (ca. 1727).

George Frideric Handel's opera *Admeto*; also his four *Coronation Anthems for George II*.

Orlando, Antonio Vivaldi's opera; also his 12 concertos *La Cetra* (*The Lyre*).

WORLD EVENTS

Failed Spanish siege of Gibraltar.

Failed Tibetan revolt against the Manchus (1727–1728).

Nader Shah defeated the Afghans at Herat.

d. Catherine I (b. 1684), empress of Russia; succeeded by Peter II.

1728

LITERATURE

Alexander Pope's *The Dunciad*, a satirical "dunce-epic" in heroic couplets, published in three books.

Ephraim Chambers began publishing his *Cyclopaedia*.

James Thomson's poem *Spring*, the third of the quartet known as *The Seasons*.

Voltaire's poem *La Henriade*.

d. Cotton Mather, New England cleric and writer (b. 1663).

VISUAL ARTS

William Hogarth's painting *The Beggar's Opera*.

Jean-Baptiste-Siméon Chardin's painting *Le Buffet*.

James Gibbs published his *Book of Architecture*, influential in both Britain and America.

THEATER & VARIETY

The Beggar's Opera, John Gay's play, was produced by John Rich at Lincoln's Inn Fields in January with

Lavinia Fenton; it was the basis for Bertolt Brecht and Kurt Weill's 1928 musical *The Threepenny Opera.*

Henry Fielding's *Love in Several Masques.*

MUSIC & DANCE

The Beggar's Opera, the first ballad opera, libretto by John Gay, music by Christopher Pepusch; opened at Lincoln's Inn Fields, London, February 9; basis for Bertolt Brecht–Kurt Weill 1928 *The Threepenny Opera.*

d. Marin Marais, celebrated solo viol player (b. 1656), a pupil of Jean-Baptiste Lully.

WORLD EVENTS

Long guerrilla war began between escaped slaves and the Dutch colonial government in Surinam (1728–1761).

Long series of slave insurrections began in Haiti (1728–1781).

1729

LITERATURE

Benjamin Franklin began publishing the *Pennsylvania Gazette* (1729–1766), in which first appeared material for his *Poor Richard's Almanack.*

Jonathan Swift's satirical pamphlet *A Modest Proposal for Preventing Children of the Poor People in Ireland from Being a Burden to their Parents . . .* ; also his poetic work *The Grand Question Debated.*

Allan Ramsay's poem *Sang* (*My Peggy is a young thing*).

The Dunciad Variorum, a revised version of Alexander Pope's poetic satire.

VISUAL ARTS

William Hogarth's paintings included *Captain Woodes Rogers and His Family* and *The Wedding of Stephen Beckingham and Mary Cox* (1729–1730).

d. Colen Campbell, English architect (1676–1729), a key figure in the development of English Palladianism, especially through his folio *Vitruvius Brittanicus.*

THEATER & VARIETY

d. William Congreve, English playwright (b. 1670).

d. Michel Baron, French actor (b. 1653).

MUSIC & DANCE

The Contrivances, Henry Carey's work in ballad-opera style.

d. Elisabeth-Claude Jacquet de la Guerre, French composer and harpsichordist, a protégée of Louis XIV; among the first in France to write in the sonata and cantata forms (b. 1666).

WORLD EVENTS

Nader Shah defeated the Afghans in several battles.

Natchez Indian uprising against French rule.

1730

LITERATURE

James Thomson's poem *Autumn*, the last of the quartet known as *The Seasons.*

VISUAL ARTS

James Gibbs began St. Bartholomew's Hospital.

William Hogarth's paintings included *A Fishing Party*, *A Musical Party*, and *The Fountaine Family* (all ca. 1730).

The Stone Mason's Yard, Canaletto's painting.

THEATER & VARIETY

Henry Fielding's *Tom Thumb: A Tragedy* opened at London's Haymarket Theater on April 25; the year also saw his *The Temple Beau.*

Pierre Carlet de Chamblain de Marivaux's *Le Jeu de l'amour et du hasard.*

d. Adrienne Lecouvreur, French actress (b. 1692).

MUSIC & DANCE

Partenope, George Frideric Handel's opera.

The Flowers of the Forest, poignant Scottish song, by Alison Rutherford (ca. 1730).

Johann Adolf Hasse's dramatic musical work *Artaserse*.

Flûte d'amour, a one-keyed flute, popular in Europe (ca. 1730–1800).

WORLD EVENTS

Nader Shah completed the expulsion of the Afghans from Persia.

1731

LITERATURE

Manon Lescaut (*L'Histoire du Chevalier des Grieux et de Manon Lescaut*), Abbé Prévost's novel of love and degradation; basis for the 1884 Massenet and 1893 Puccini operas.

Alexander Pope's poetic work *Moral Essays* (1731–1735).

Charleston, South Carolina, got its first newspaper.

Use of "Law French" finally abolished in England.

Gentleman's Magazine, the first English publication called a magazine.

d. Daniel Defoe, English novelist (b. 1660).

VISUAL ARTS

Giovanni Battista Tiepolo's ceiling frescoes for Milan's Palazzo Archinto.

Jean-Baptiste-Siméon Chardin's paintings included *Attributes of the Arts* and *Attributes of the Sciences*.

John Michael Rysbrack's tomb of Sir Isaac Newton.

William Hogarth's work included the painting *The Conquest of Mexico* (*The Indian Emperor*) and the engraving *A Harlot's Progress*.

d. Francis Bird, English sculptor (b. 1667).

THEATER & VARIETY

George Lillo's *The London Merchant* opened at Drury Lane on June 22.

Rasmus Montanus, Ludwig Holberg's play.

MUSIC & DANCE

St. Mark Passion, Johann Sebastian Bach's choral work; also his keyboard works 6 *Partitas* and choral work *Wachet auf*.

George Frideric Handel's opera *Poro* (1731) and *Six Sonatas for Two Violins, Oboes or German Flutes and Continuo* (ca. 1731).

Traveling Italian singers brought the first opera to Moscow.

d. Bartolomeo Cristofori, Italian harpsichord maker (b. 1655), credited with developing the piano; three of his grand pianos survived (dated 1720–1726).

Johann Adolf Hasse's dramatic musical work *Cleofide*.

WORLD EVENTS

French built fort at Crown Point, New York.

Turkey and Persia were at war.

1732

VISUAL ARTS

William Hogarth's work included the beginning of his eight-painting series *A Rake's Progress*, and his painting of *The Cholmondeley Family*.

Giovanni Battista Tiepolo's work included the painting *The Adoration of the Christ Child* and the frescoes for the Cappella Colleoni, Bergamo.

John Michael Rysbrack's tomb of the Duke of Marlborough.

THEATER & VARIETY

First theater opened at London's Covent Garden site, on December 7, with a production of William Congreve's play *The Way of the World*.

Henry Fielding's *The Modern Husband* and *The Mock Doctor*.

Voltaire's *Zaïre* opened.

d. John Gay, English poet and satirist, author of *The Beggar's Opera* (b. 1685).

MUSIC & DANCE

George Frideric Handel's opera *Sosarme*, choral work *Esther* (both 1732), and *12 Fugues; Fantasia in C Major* for harpsichord (ca. 1732).

Giovanni Battista Pergolesi's dramatic musical works *Lo frate 'nnamorato* and *Salustia*.

Antonio Vivaldi's opera *La fida ninfa*.

Earliest known works written expressly for piano,

described as "sonatas for *cimbalo di piano e forte*," by L. Giustini of Pistoia.

WORLD EVENTS

Persian ruler Tahmasp lost much of western Persia to the Turks, and was then deposed by Nader Shah, who went to war against the Turks again.

Georgia colony charter granted to James Oglethorpe.

Spain retook Oran from the Algerians.

1733

LITERATURE

Poor Richard's Almanack, collective name for a series of almanacs issued by Benjamin Franklin writing as Richard Saunders, introducing adages such as "God helps those that help themselves" and "Early to bed and early to rise . . ." (1733–1758).

Jonathan Swift's verse work *On Poetry: A Rapsody*.

VISUAL ARTS

Jean-Baptiste-Siméon Chardin's paintings included *Lady Sealing a Letter* and *The Copper Fountain*.

William Hogarth's paintings included *Southwark Fair*.

THEATER & VARIETY

Henry Fielding's *The Miser*.

Jean-Philippe Rameau's *Hippolyte et Aricie*.

Pierre La Chaussée's *La Fausse Antipathie*.

d. Barton Booth, English actor (b. 1681).

MUSIC & DANCE

George Frideric Handel's opera *Orlando*, oratorio *Deborah*, and *Suites de pièces* for harpsichord (ca. 1733).

Giovanni Battista Pergolesi's opera *Il prigionier superbo* and intermezzo *La serva padrona*.

Hippolyte et Aricie, Jean-Philippe Rameau's opera.

Johann Adolf Hasse's opera *Siroe rè di Persia*.

John Christopher Smith's opera *Ulysses*.

d. François Couperin, French composer (b. 1668), nephew of Louis Couperin.

WORLD EVENTS

Americans protested passage of the British Molasses Act, as discriminating against American trade with the Caribbean; beginning of the long prelude to the American Revolution.

English settlers led by James Oglethorpe founded Savannah, Georgia.

Nader Shah defeated by Turks at Karkuk, in Mesopotamia.

War of the Polish Succession (1733–1735).

1734

LITERATURE

John Arbuthnot's poem *Know Thyself*.

VISUAL ARTS

Holkham Hall, Norfolk, built for the Earl of Leicester (from 1734), designed by William Kent.

THEATER & VARIETY

Carlo Goldoni's *Belisario*.

d. John Dennis, English critic and playwright (b. 1657).

MUSIC & DANCE

Johann Sebastian Bach's *Christmas Oratorio*.

Arianna, George Frideric Handel's opera on story of Ariadne in Crete.

Giovanni Battista Pergolesi's operas *Adriano in Siria* and *L'Olimpiade*, and his intermezzo *Livietta e Tracollo*.

Dido and Aeneas, Thomas Arne's masque.

WORLD EVENTS

France and Austria were at war.

War of the Polish Succession: Russians besieged and took Danzig.

1735

LITERATURE

John Peter Zenger was tried and acquitted for "sedi-

tious libels" in his New York *Weekly Journal*, a victory for freedom of the press in North America.

VISUAL ARTS

William Hogarth's work included the engraving *A Rake's Progress*; and the paintings *The Distressed Poet* (ca. 1735) and *The Good Samaritan*.
John Michael Rysbrack's statue of *William III*.

THEATER & VARIETY

Henry Fielding's *An Old Man Taught Wisdom; or, the Virgin Unmasked*.
Jean-Philippe Rameau's *Les Indes galantes*.
Robert Dodsley's *The Toy Shop*.
Pierre La Chaussée's *Le Préjuge à la mode*.

MUSIC & DANCE

George Frideric Handel presented two new operas at London's Covent Garden: *Ariodante*, libretto by Antonio Salvi based on Ludivico Ariosto's 1516 poem *Orlando Furioso*, opened January 8; and *Alcina*, libretto by A. Marchi, premiered April 27, with Anna Strada creating the title role.
George Frideric Handel's *Alexander's Feast*, setting of Dryden's *Ode for St Cecilia's Day*, with additions from Newburgh Hamilton's *The Power of Music*.
Johann Sebastian Bach's keyboard works *French Overture* and *Italian Concerto* for harpsichord; also his "*Coffee Cantata*" (ca. 1735).
Antonio Vivaldi's opera *Griselda*.
Les Indes galantes, Jean-Philippe Rameau's opera–ballet.
Flaminio, Giovanni Battista Pergolesi's dramatic musical work.
Johann Adolf Hasse's dramatic musical work *Tito Vespasiano*.

WORLD EVENTS

Russia and Turkey were at war (1735–1739).
Spain and Portugal were at war in South America (1735–1737).

1736

LITERATURE

Williamsburg, Virginia, got its first newspaper.

VISUAL ARTS

William Hogarth's painting *The Four Times of the Day* (ca. 1736).
d. Nicholas Hawksmoor, British architect (b. 1661).

THEATER & VARIETY

George Farquhar's *The Recruiting Officer* was the first play presented by Charleston's Dock Street Theater, South Carolina.
Henry Fielding's play *Pasquin: A Dramatick Satire on the Times*.
Pierre Marivaux's *Le Legs*.
Voltaire's *Alzire*.

MUSIC & DANCE

David's Lamentation over Saul and Jonathan, William Boyce's oratorio, his first major work.
d. Giovanni Battista Pergolesi, Italian composer (b. 1710).

WORLD EVENTS

Peruvian Indian miners revolted at Oruro, Peru, now Bolivia (1736–1737).
Russo-Turkish war: Russians invaded the Crimea and took Azov, then withdrew; Turks invaded the Ukraine (1736–1737).

1737

LITERATURE

Alexander Pope's *The Works of Mr. Alexander Pope, in Prose*.
French type founder Pierre Fournier developed the point system used in measuring type sizes in printing.

VISUAL ARTS

Giovanni Battista Tiepolo's frescoes for the Chapel of S. Vittore, S. Ambrogio, Milan.

James Gibbs began Oxford's Radcliffe Library (1737–1749).

Jean-Baptiste-Siméon Chardin's paintings included *Sketching Youth Sharpening Pencil* and *Woman Drinking Tea*.

THEATER & VARIETY

Pierre Marivaux's *False Secrets* opened with the Italian Comedians in Paris on March 16.

Pierre Marivaux's *Les Fausses Confidences*.

Poética, Ignacio Luzan y Claramont's work on dramatic theory.

Robert Dodsley's *The King and the Miller of Mansfield*.

Robert Dodsley's *Sir John Cockle at Court*.

MUSIC & DANCE

Castor et Pollux, Jean-Philippe Rameau's opera.

Antonio Salvi's opera *Berenice*.

Les Élémens, Jean-Féry Rebel's dance symphony.

Teatro di San Carlo opened in Naples, with a production of Domenico Sarro's *Achille in Sciro*.

d. Antonio Stradivari, Italian violin maker, active in Cremona (b. 1644?); trained by Nicolò Amati, he is regarded as one of history's finest violin makers. Nearly 600 violins, along with some violas and cellos, survive.

WORLD EVENTS

Austria entered the Russo-Turkish war on the side of Russia, attacking the Turks in Bosnia and Serbia.

Nader Shah of Persia took Afghanistan.

1738

LITERATURE

Samuel Johnson's *London: A Poem*.

VISUAL ARTS

Jean-Baptiste-Siméon Chardin's painting *Scouring Maid*.

Naples National Museum was founded.

William Hogarth's engraving *The Strolling Actresses Dressing in a Barn*.

d. Georg Baehr, German architect (b. 1666).

MUSIC & DANCE

Serse (*Xerxes*), George Frideric Handel's opera, libretto by Nocola Minato and Silvio Stampiglia, premiered in London, April 26.

Comus, Thomas Arne's dialogue opera.

WORLD EVENTS

Nader Shah of Persia invaded northern India, sacked Delhi and other northern cities, then returned to Persia.

1739

LITERATURE

Verses on the Death of Dr. Swift, Jonathan Swift's satirical response to premature reports of his death.

Samuel Johnson's satirical prose works *A Compleat Vindication of the Licensers of the Stage* and *Marmor Norfolciense*.

Voltaire's story *Les Voyages du Baron de Gangan*.

VISUAL ARTS

Giovanni Battista Tiepolo's vault frescoes for the Church of the Gesuati, Venice (ca. 1739).

Jean-Baptiste-Siméon Chardin's painting *The Provider*.

THEATER & VARIETY

Jean-Philippe Rameau's *Dardanus*.

MUSIC & DANCE

George Frideric Handel's choral works *Ode for St. Cecilia's Day*, *Israel in Egypt*, and *Saul*; also his *Seven Sonatas or Trios for Two Violins or German Flutes* (ca. 1739).

Jean-Philippe Rameau's opera–ballet *Les Fêtes d'Hébé*, and his dramatic musical work *Dardanus*.

Francisco António de Almeida's opera *La Spinalba*.

Hark! the Herald Angels Sing, Christmas hymn by

Charles Wesley to music by Felix Mendelssohn.

Oldest known American-made spinet, produced by Clemm of Philadelphia.

d. Reinhard Keiser, German composer (b. 1674).

WORLD EVENTS

Slave rebellions flared in South Carolina.

British took Portobello.

Turks took Belgrade, by terms of peace treaty ending war with Austria.

1740

LITERATURE

Samuel Richardson's *Pamela, or Virtue Rewarded*, the prototype of the epistolary novel, told in first person primarily through letters, journals, and diaries; often considered the first modern English novel (1740–1742).

Rule, Britannia!, James Thomson's poem.

VISUAL ARTS

William Hogarth's paintings included *Captain Thomas Coran* and *Miss Mary Edwards* (ca. 1740).

François Boucher's painting *Triumph of Venus*.

Giovanni Battista Tiepolo's frescoes for the Palazzo Clerici, Milan.

Jean-Baptiste-Siméon Chardin's painting *Le Bénédicité*.

Peter Scheemakers's *Shakespeare* monument at Westminster Abbey.

Japanese *ukiyo-e* artists introduced color printing of their woodcut illustrations (ca. 1740).

Development of master molds for use with plaster of paris allowed mass production of pottery figures (ca. 1740).

THEATER & VARIETY

Pierre Marivaux's *L'Épreuve*.

The Joy of Mary, Flemish mystery play, on biblical themes (ca. 1715).

The Servant of Two Masters, Carlo Goldoni's play.

MUSIC & DANCE

Alfred, Thomas Arne's masque to a libretto by David

Mallett and James Thomso, which includes the song *Rule, Britannia*.

George Frideric Handel's choral work *L'allegro, il penseroso ed il moderato*.

Peleus and Thetis, William Boyce's masque (by 1740).

WORLD EVENTS

War of the Austrian Succession began, involving much of Europe (1740–1748).

British colonial forces invaded Florida during the War of Jenkins' Ear.

Failed Chinese Rebellion against Dutch on Java (1740–1743).

Nader Shah took Bokhara, Khiva, and much of southern Turkestan.

University of Pennsylvania founded.

1741

LITERATURE

North America's first two magazines, both short-lived: *The American Magazine* and Benjamin Franklin's *The General Magazine*.

John Arbuthnot's attack on pedantry, *The Memoirs of Martinus Scriblerus*.

VISUAL ARTS

Robert Feke's painting of *Isaac Royall and His Family*.

THEATER & VARIETY

David Garrick made his formal debut as Shakespeare's Richard III.

Gotthold Ephraim Lessing's *Damon* (1741–1746).

Pierre La Chaussée's *Mélanide*.

Luise Gottsched's *Misalliance*.

MUSIC & DANCE

Johann Sebastian Bach's *Goldberg Variations* (1741–1742).

Deidamia, George Frideric Handel's opera.

Artaserse, Christoph Gluck's first opera, performed in Milan.

d. Antonio Vivaldi, Italian composer (b. 1678).

WORLD EVENTS

Anti-Black hysteria in New York City, around the "Negro Conspiracy"; more than twenty Blacks were legally murdered.

Elizabeth of Russia mounted a coup against Czar Ivan VI; he went into exile.

Frederick the Great of Prussia pursued a successful attack on Silesia, defeating the Austrians at Mollwitz.

1742

LITERATURE

The New Dunciad, the fourth and final book of Alexander Pope's satirical epic poem *The Dunciad*.

Pierre Simon Fournier published *Modèles des Caractères de l'imprimerie et des Autres Choses Nécessaires au Dit Art*.

William Shenstone's poem *The Schoolmistress*.

VISUAL ARTS

Hubert-François Bourguignon Gravelot illustrated Richardson's *Pamela*.

William Hogarth's painting *The Graham Children*.

Batty Langley's controversial book *Ancient Architecture, Restored and Improved . . . in the Gothick Mode*.

MUSIC & DANCE

Messiah, George Frideric Handel's landmark oratorio, with its *Hallelujah Chorus*, text by Jennens from the Bible, opened in Dublin in 1742; he performed it regularly for the rest of his life, usually in the Christmas season.

Hofoper (Court Opera) established in Berlin, later called the Berlin Staatsoper; its first production, of Karl Heinreich Graun's *Cleopatra e Cesare*, opened December 7.

Earliest known square piano, with lighter action than later pianos, made by Johann Sacher of Bavaria; popular for home use until replaced by uprights (ca. 1820–1850).

WORLD EVENTS

Prussia left the War of the Austrian Succession,

by the terms of the Treaty of Berlin, taking Silesia.

1743

LITERATURE

The Dunciad in Four Books, the final version of Alexander Pope's satirical epic poem.

Henry Fielding's *Miscellanies*, in prose.

VISUAL ARTS

Giovanni Battista Tiepolo's work included the frescoes for the Villa Cordellina, Montecchio Maggiore, Vicenza, and the vault frescoes for the Church of the Scalzi, Venice (1743–1744).

William Hogarth's work included six paintings as scenes for his *Marriage à la Mode*.

d. Thomas Archer, English architect (b. 1668).

d. Ogata Shinsho, called Kenzan, Japanese pottery painter (b. 1660).

THEATER & VARIETY

Voltaire's *Mérope* opened, with Mlle. Dumesnil in the title role.

Carlo Goldoni's *The Servant of Two Masters*.

Pierre La Chaussée's *La Gouvernante*.

MUSIC & DANCE

George Frideric Handel's choral work *Samson*.

d. Henry Carey, British musician and songwriter (b. 1687?).

WORLD EVENTS

Persia and Turkey were at war (1743–1745).

Russo-Swedish war ended with Russia taking part of Finland and other territories.

1744

LITERATURE

Samuel Johnson's *An Account of the Life of Mr. Richard Savage*.

Poems on Several Occasions, by Welsh poet Jane

Hughes Brereton (1685–1744), posthumously published.

d. Alexander Pope, English poet (b. 1688).

VISUAL ARTS

Giovanni Battista Tiepolo's work include his *Allegory of Fortitude and Wisdom*, the frescoes for the Ca'Rezzonico, Venice; and his *Time Revealing Truth*, the frescoes for the Palazzo Barbarigo, Venice (both 1744–1745).

William Hogarth's painting *Mrs. Elizabeth Salter*.

MUSIC & DANCE

George Frideric Handel's opera *Semele*, libretto by William Congreve, opened at Covent Garden, London, February 10; also his oratorio *Joseph*.

Ein feste Burg, Johann Sebastian Bach's choral music (ca. 1744).

Christoph Gluck's operas *Ipermestra* and *Sofonisba* (*Siface*).

Thomas Arne's vocal work *The Death of Abel*.

London Bridge (Is Falling Down), traditional children's song (ca. 1744).

WORLD EVENTS

France was at war with Britain and Austria, their war becoming part of the War of the Austrian Succession, in the Americas known as King George's War (1744–1748).

1745

LITERATURE

Samuel Johnson's *Miscellaneous Observations on the Tragedy of Macbeth*.

d. Jonathan Swift, English satirist (b. 1667).

VISUAL ARTS

William Hogarth's paintings included *Garrick in the Character of Richard III*, *Lord George Graham in His Cabin*, and a *Self-Portrait*.

Giovanni Battista Piranesi began publishing the etchings in *Vedute*.

THEATER & VARIETY

Jean-Philippe Rameau's *Platée*.

MUSIC & DANCE

The Art of Fugue, Johann Sebastian Bach's collection of keyboard works (1745–1750).

George Frideric Handel's oratorio *Belshazzar* and dramatic choral work *Hercules*.

Jean-Philippe Rameau's operas *La princesse de Navarre*, *Le temple de la gloire*, *Les fêtes de Polymnie*, and *Platée*.

God Save Our King, patriotic hymn by Henry Carey, the melody later used for *America*.

First official employment of a piper by a Highland company.

d. Giuseppe Guarneri "Del Gesu," Italian violin maker (1687–ca. 1745); nephew of Andrea Guarneri, he was regarded as one of the finest of Cremona's instrument makers.

WORLD EVENTS

British forces captured the French fortress of Louisburg, on southern Cape Breton Island, Nova Scotia.

Failed Scots revolt against English rule, with French allies—the "Forty-Five."

Nader Shah of Persia took Armenia from the Turks.

Saratoga, New York, was destroyed by French and Indian forces.

1746

LITERATURE

William Collins's *Odes on Several Descriptive and Allegorical Subjects*.

VISUAL ARTS

Thomas Gainsborough's paintings included *Lady and Gentleman in Landscape* and *Moses Brought Before Pharoah's Daughter*.

Joshua Reynolds's painting *Captain the Honourable John Hamilton*.

THEATER & VARIETY

The House of Sugawara (*Sugawara Denju Tenarai Kogami*), Takeda Izuma's play, originally presented as a puppet theater piece, and later a staple of the *kabuki* theater.

Gotthold Ephraim Lessing's *Der Misogyn* and *Die alte Jungfer.*

d. Thomas Southerne, English playwright (b. 1660).

MUSIC & DANCE

La Caduta de' giganti (*The Fall of the Giants*) and *Artemene*, Christoph Gluck's operas written in London and opened at the Theater Royal, Haymarket.

Lyric Harmony, Thomas Arne's songs.

WORLD EVENTS

Scots forces led by Charles Stuart (Bonnie Prince Charlie, the Young Pretender) were defeated at Culloden; followed by English reign of terror in Scotland.

War of the Austrian Succession: French victory at Roucoux.

1747

LITERATURE

Samuel Johnson's *The Plan of a Dictionary of the English Language.*

Voltaire's story *Zadig.*

VISUAL ARTS

William Hogarth's engraving *Industry and Idleness.*

THEATER & VARIETY

David Garrick played Fribble in his own *The Medley of Lovers*; he also wrote *Miss in Her Teens.*

Edward Moore's *The Foundling.*

d. Alain René Lesage, French novelist and playwright (b. 1668).

MUSIC & DANCE

Judas Maccabaeus, George Frideric Handel's oratorio.

Christoph Gluck's opera *Le Nozze d'Ercole e d'Ebe.*

Les fêtes de l'Hymen et de l'Amour, Jean-Philippe Rameau's opera.

d. Jean-Féry Rebel, French violinist and composer (b. 1666).

WORLD EVENTS

War of the Austrian Succession: French defeated Allied forces at Lauffeld.

d. Nader Shah (b. 1688), king of Persia, assassinated; his empire then quickly dissolved.

1748

LITERATURE

Tobias Smollett's *The Adventures of Roderick Random*, a notable early picaresque novel, modeled on Alain René Lesage's *Gil Blas.*

Voltaire's story *Vision de Babouc.*

James Thomson's poem *Castle of Indolence.*

First complete Bible in Portuguese printed in Batavia, Holland.

d. Isaac Watts, British cleric and poet (b. 1674).

VISUAL ARTS

Jean-Honoré Fragonard's paintings included *Blind-Man's Buff, Girl with a Marmot*, and *The Education of the Virgin* (all ca. 1748–1752).

Thomas Gainsborough's paintings included *Cornard Wood* ("Gainsborough's Forest") and *The Charterhouse.*

Robert Feke's painting of *Isaac Winslow.*

d. William Kent, English painter, architect, and landscape gardener (b. 1685), sometimes called the father of modern landscape gardening; long associated with architect and patron Richard Boyle Burlington, both contributing to the introduction of Palladianism to English architecture .

THEATER & VARIETY

Carlo Goldoni's *The Wily Widow.*

Gotthold Ephraim Lessing's *Der junge Gelehrte*.
Takeda Izumo's *Kanadehon Chushingura*.

MUSIC & DANCE

Jean-Philippe Rameau's operas *Zaïs, Les Surprises de l'Amour*, and *Pygmalion*.,
Alexander Balus, George Frideric Handel's oratorio to a text by Thomas Morell.
Christoph Gluck's opera *Semiramide riconosciuta*.

WORLD EVENTS

War of Austrian Succession ended with the Treaty of Aix-la-Chapelle. Louisburg, taken by the British, was returned to the French as part of the peace settlement.
Princeton University was founded.

1749

LITERATURE

Henry Fielding's *The History of Tom Jones, a Foundling*, one of the finest comic novels in English, focusing on the experiences of its spirited and none-too-heroic hero; basis for the 1963 Tony Richardson film.
The Governess, the first English novel written expressly for children, by Sarah Fielding (sister of Henry).
Samuel Johnson's poetic works *Irene: A Tragedy* and *The Vanity of Human Wishes*.

VISUAL ARTS

Peter Harrison began Boston's King's Chapel (1749–1758) and Newport's Redwood Library (1749–1758).

THEATER & VARIETY

Carlo Goldoni's *The Good Wife*.
Gotthold Ephraim Lessing's *Der Freigeist* and *Die Juden*.
Jean-Philippe Rameau's *Zoroastre*.
d. Johann Elias von Schlegel, German playwright, essayist, and diplomat, an influential figure in the development of the German theater (b. 1719).

MUSIC & DANCE

George Frideric Handel's *Fireworks Music* (*Music for the Royal Fireworks*) premiered at the London celebrations of the Aix-la-Chapelle peace treaty; premiering the same year were Handel's oratorios *Susanna* and *Solomon*.
Johann Sebastian Bach's *Mass*.
Jean-Philippe Rameau's operas *Naïs* and *Zoroastre*.
Magnificat, Carl Philipp Emanuel Bach's vocal work.
Charles Wesley's hymn *In Temptation*, opening "Jesu, Lover of my soul."
Thomas Arne's *Vocal Melody* (1749–1764).

WORLD EVENTS

France and England were at war in India, with Indian allies, over the Carnatic in southern India (1749–1754).
Halifax, Nova Scotia, was founded.

1750

LITERATURE

The Rambler, a series of essays, published semiweekly, by Samuel Johnson (1750–1752).
John Baskerville established a print shop, foundry, and paper mill, and began developing his highly influential printing techniques and typography.
In his *Aesthetica*, German philosopher Alexander Baumgarten introduced the term "aesthetics" to denote poetic feeling.
Wu Ching-tzu's satirical novel *Informal History of the Literati* (*Mu-lin wai-shih*).

VISUAL ARTS

Giovanni Battista Tiepolo's work included the frescoes *Story of Anthony and Cleopatra*, for the Palazzo Labia, Venice; the frescoes *Gifts Offered to Cleopatra, The Glorification of Francesco Barbaro*, and *Timocleia and the Thracian Commander* (all ca. 1750); and those for the Kaisersaal (1750–1752).
Hubert-François Bourguignon Gravelot illustrated Henry Fielding's *Tom Jones*.
Jean-Honoré Fragonard's painting *The See-Saw*.
Lancelot "Capability" Brown created the Warwick Castle Park (ca. 1750).

Thomas Gainsborough's paintings included *Heneage Lloyd and His Sister* and *Mr. and Mrs. Andrews* (both ca. 1750).

THEATER & VARIETY

Carlo Goldoni's *The Coffee House* and *The Liar*.
Gotthold Ephraim Lessing's *Der Schatz*.
d. Aaron Hill, English playwright (b. 1685).

MUSIC & DANCE

Theodora, George Frideric Handel's oratorio.
Christoph Gluck's opera *Ezio*.
English guitar was popular in drawing rooms, regarded as a ladies' instrument (mid-18th c.).
d. Johann Sebastian Bach, German composer and organist, key figure in the musically active Bach family (b. 1685).

WORLD EVENTS

Karim Khan took power in Persia, winning the succession battle that had followed the death of Nader Shah (1750–1779).
Treaty of Madrid: Portugal took much of Brazil, Spain, the Philippines, and seven Guarani villages on the Uruguay, over Guarani objections, leading to insurrection.

1751

LITERATURE

Encyclopédie (*Encyclopédie, ou Dictionnaire raisonné des sciences, des arts et des métiers*, or *Methodical Dictionary of the Sciences, Arts, and Trades*), by Denis Diderot and his staff, began publication (1751–1772).
Elegy Written in a Country Churchyard, Thomas Gray's poetic meditation on pastoral life and death, one of the most popular poems of the century.
The Adventures of Peregrine Pickle, Tobias Smollett's novel inspired by a journey to Paris.
Gotthold Ephraim Lessing's poetic work *Kleinigkeiten*.
Henry Fielding's novel *Amelia*.
First newspaper started in North Carolina, at New Bern.

Revised standard Slavonic edition of the Bible, called the *Bible of Elizabeth*, was printed in St. Petersburg.

VISUAL ARTS

Jean-Honoré Fragonard's painting *Winter* (ca. 1751–1761).
Lancelot "Capability" Brown designed Croome Court Park.
William Hogarth's engravings included *The Four Stages of Cruelty*, *Beer Street*, and *Gin Lane*.
d. Batty Langley, English architect (b. 1696), author of a wide range of books on architecturally related matters.
d. Ralph Earl, New England painter (d. 1801).

THEATER & VARIETY

Carlo Goldoni's *La Locandiera* opened in Venice on December 26.

MUSIC & DANCE

George Frideric Handel's *Hallelujah Concerto*.
The Shepherd's Lottery, William Boyce's dramatic music.
Jean-Philippe Rameau's operas *Acante et Céphise* and *La guirlande*.
d. Tomaso Giovanni Albinoni, Italian composer (b. 1671).

WORLD EVENTS

Benjamin Franklin's *Experiments and Observations on Electricity*.
Chinese forces invaded and took Tibet.
Robert Clive took and then successfuly defended Arcot, in India's Carnatic.

1752

LITERATURE

Diderot's *Encyclopédie* temporarily suppressed by the French government, largely because of Jesuit opposition to its philosophical discussions.
Charlotte Ramsay Lennox's novel *The Female Quixote; or, The Adventures of Arabella*.
Printing began in French Canada, in Quebec City.

VISUAL ARTS

Jacques-François Blondel began his *Architecture françoise*, a folio of engravings (1752–1756).
Joshua Reynolds's painting *Lady Chambers*.
d. Jacopo Amigoni, Italian painter (b. 1682).

MUSIC & DANCE

Jephtha, George Frideric Handel's final choral work, written as he was going blind.
La Clemenze di Tito, Christoph Gluck's opera.

WORLD EVENTS

Alaungpaya of Burma led a successful independence movement against the French-backed Mons (1752–1759).
Great Britain and British North America adopted the Gregorian calendar.

1753

LITERATURE

Samuel Richardson's novel *Sir Charles Grandison*.
British Library founded.

VISUAL ARTS

Giovanni Battista Tiepolo's painting *Olympus*.
Joshua Reynolds's painting *Honourable Augustus Keppel* (1753–1754).
Thomas Gainsborough's painting *The Woodcutter Courting a Milkmaid*.
d. Balthasar Neumann, German architect (b. 1687).
d. Richard Boyle, Earl of Burlington, English architect (b. 1694).

THEATER & VARIETY

Edward Moore's *The Gamester*.
Samuel Foote's *The Englishman in Paris*.

MUSIC & DANCE

Jean-Philippe Rameau's operas *Daphnis et Eglé* and *Les Sybarites*.
Carl Philipp Emanuel Bach's *Essay on the True Art of Playing Keyboard Instruments*.
d. Gottfried Silberman, German builder of organs and later pianos (ca. 1709).

WORLD EVENTS

Carolus Linnaeus's *Species of Plants*.
French troops occupied portions of Ohio Valley; George Washington defeated by French at Fort Le Boeuf.

1754

LITERATURE

Daphnis, Salomon Gessner's pastoral romance.
Gotthold Ephraim Lessing's prose work *Rettungen*.
Wu Ching-tzu's *Ju-lin wai-shih* (translated as *The Scholars*) (before 1754).
d. Henry Fielding, English novelist (b. 1707).
d. Wu Ching-tzu, Chinese novelist (b. 1701).
d. William Hamilton of Bangour, Scottish poet (b. 1704).

VISUAL ARTS

Giovanni Battista Tiepolo's vault frescoes for the Church of the Pietà, Venice (1754–1755).
William Hogarth began his four-scene set of paintings, *An Election* (1754–1758).
Winter Palace built for Czar Peter in St. Petersburg (1754–1762).
d. James Gibbs, Scottish architect (b. 1682).
d. Gabriel-Germain Boffrand, French architect and engineer (b. 1667).

THEATER & VARIETY

d. Destouches, French playwright (b. 1680).
d. Ignacio Luzan y Claramont, Spanish man of letters (b. 1702).
d. Ludvig Holberg, Norwegian-Danish playwright (b. 1684).
d. Pierre Claude Nivelle La Chaussée, French playwright (b. 1692).

MUSIC & DANCE

Jean-Philippe Rameau's operas *Anacréon* and *La*

Naissance d'Osiris.

First mention of the banjo in North America, in Maryland.

WORLD EVENTS

French and Indian War began (1754–1763); in 1756, it became part of the worldwide Seven Years' War.

Columbia University was founded.

1755

LITERATURE

A *Dictionary of the English Language*, Samuel Johnson's great work in two volumes, which became a standard reference tool.

Henry Fielding's *The Journal of a Voyage to Lisbon.*

THEATER & VARIETY

Mlle. Clairon opened in Voltaire's *The Orphan of China.*

Gotthold Ephraim Lessing's *Miss Sara Sampson.*

d. Francesco Scipione Maffei, Italian playwright (b. 1675).

MUSIC & DANCE

Yankee-Doodle was written (ca. 1755) by an unknown writer and composer, based on an old Dutch folk melody.

John Christopher Smith's opera *The Fairies.*

d. Francisco António de Almeida, Portuguese composer (1702–ca. 1755).

WORLD EVENTS

Edward Braddock's army was defeated by French and Indian forces in western Pennsylvania; Braddock was killed in battle; George Washington commanded the retreating British and Colonial army.

Massive earthquake destroyed most of Lisbon.

1756

LITERATURE

Salomon Gessner's *Idyllen.*

VISUAL ARTS

William Hogarth's work included the two-plate engravings *The Invasion* and the painting *The Ascension.*

Giovanni Battista Tiepolo's frescoes for the Villa Contarini, Mira (ca. 1756).

Giovanni Battista Piranesi's etching *Antichità romane.*

THEATER & VARIETY

d. Takeda Izumo, Japanese playwright of the *Noh* and *kabuki* theaters (b. ca. 1690).

John Home's *Douglas* opened in Edinburgh.

MUSIC & DANCE

Flügelhorn developed from older hunting horns by Hanoverian soldiers in the Seven Years' War (1756–1763); adapted by the British, it became the bugle.

Ave Regina, Franz Joseph Haydn's church work (ca. 1756).

Come, Thou Almighty King, words by Charles Wesley, music by Felice de Giardini.

The Tempest, John Christopher Smith's opera.

WORLD EVENTS

Seven Years' War began, a world war involving most of the major countries of Europe, India, and the Americas; in North America called the French and Indian War (1754–1763).

Calcutta taken after Bengali siege; 123 British soldiers taken after the siege, died in prison in the "Black Hole of Calcutta."

Failed Mongolian Revolt against Manchus (1756–1757).

1757

LITERATURE

England's George II added his library to the British Library, along with rights to receive a copy of every book published in Britain.

VISUAL ARTS

Giovanni Battista Tiepolo's frescoes for the Villa Valmarana, Vincenza.

Joshua Reynolds's painting *Anne Countess of Albemarle* (1757–1759).

William Chambers's book *Designs of Chinese Buildings*.

THEATER & VARIETY

d. Colley Cibber, English actor, theater manager, and playwright (b. 1671).

d. Edward Moore, English playwright (b. 1712).

MUSIC & DANCE

First known horn band, in which each player's horn played a single note, organized for the Empress at St. Petersburg; others were organized up to the 1830s.

d. Domenico Scarlatti, Italian composer and keyboard player (b. 1685).

d. Johann Stamitz, Bohemian composer (b. 1717).

WORLD EVENTS

Seven Years' War: major European battles at Prague, Kolin, Hasteneck, Gross-Jägersdorf, Rossback, Breslau, and Leuthen.

French and Indian War: Fort William Henry on Lake George, New York, taken by French.

Robert Clive retook Calcutta and went on to defeat the Bengalis and French at Plassey.

1758

LITERATURE

Samuel Johnson's philosophical romance *Rasselas* (*The History of Rasselas, Prince of Abyssinia*; 1758), attacking 18th-century optimism about simple solutions to life problems; also periodic essays under the title *The Idler* (1758–1760).

Charlotte Ramsay Lennox's novel *Angelica; or, Quixote in Petticoats*.

Salomon Gessner's prose epic *Der Tod Abels*.

d. Allan Ramsay, Scottish poet (1685?–1758).

VISUAL ARTS

John Singleton Copley's painting *Mary and Elizabeth Royall* (ca. 1758).

Thomas Gainsborough's work included the paintings *Painter's Daughters Chasing a Butterfly* (ca. 1758), *Hogarth's Servants* (ca. 1758), and *Picquet, or Virtue in Danger* (1758–1759); and the engraving *The Bench*.

d. Rosalba Giovanna Carriera, Italian painter (b. 1675).

THEATER & VARIETY

Robert Dodsley's tragedy *Cleone*.

MUSIC & DANCE

L'île de Merlin, Christoph Gluck's comic opera.

Florian Leopold Gassmann's opera *Issipile*.

WORLD EVENTS

British and American forces took Fort Duquesne (Pittsburgh).

Louisburg was again taken by British, and this time destroyed.

Seven Years' War: major battles at Krefeld, Zorndorf, and Hichkirch.

1759

LITERATURE

Candide (*Candide, ou L'Optisme*), Voltaire's philosophical novel, featuring Candide and his tutor, Dr. Pangloss, satirizing Leibnitz's notion that "All is for the best in this best of all possible worlds."

Tristram Shandy (*The Life and Opinions of Tristram Shandy, Gentleman*), Laurence Sterne's innovative novel, its chaotic organization—much criticized at the time—influenced by John Locke's theories of the association of ideas (1759–1767).

Oliver Goldsmith's essays *An Enquiry into the Present State of Polite Learning in Europe* and *The Bees*.

Gotthold Ephraim Lessing's *Fabeln*.

Diderot's *Encyclopédie* temporarily suppressed by the French government and condemned by the pope.

VISUAL ARTS

British Museum was founded.

William Hogarth's paintings included *The Shrimp Girl* (ca. 1759) and *Mr. William Woollaston* (late 1750s).

Peter Harrison began the Newport (Rhode Island) Synagogue (1759–1763).

Robert Adam began his work at Harewood House, Yorkshire (1759–1781), and Shardeloes, Buckinghamshire (1759–1761).

William Chambers's book *Civil Architecture*.

Josiah Wedgwood began producing earthenware for the general public, as well as fine wares for the aristocracy.

THEATER & VARIETY

Gotthold Ephraim Lessing's *Philotas*.

MUSIC & DANCE

Christoph Gluck's comic operas *L'arbre enchanté* and *La Cythère assiégée*.

d. George Frideric Handel (Georg Friederich Händel), German composer working largely in England (b. 1685).

WORLD EVENTS

Long British–French struggle for North America ended when British defeated French forces on the Plains of Abraham, at Quebec City; generals Wolfe and Montcalm died in battle.

Seven Years' War: major battles at Zullichau, Minden, Kuneersdorf, and Maxen.

1760

LITERATURE

The Connecticut Courant founded in Hartford by Thomas Green, surviving as the Hartford *Courant*.

Tobias Smollett's novel *The Adventures of Launcelot Greaves*.

Laurence Sterne's *Sermons of Mr. Yorick* (1760–1769).

VISUAL ARTS

George Stubbs's painting *Mares and Foals in a Landscape* (ca. 1760).

Jean-Baptiste-Siméon Chardin's paintings included *A Vase of Flowers*, *Pipe and Drinking Glasses*, and *The Jar of Olives*.

Jean-Honoré Fragonard's paintings included *Head of an Old Man* (1760–1767), *Landscape and Greensward* (ca. 1760–1765), and *Landscape with Cowherd* (1760–1765).

Joshua Reynolds's paintings *Garrick Between Comedy and Tragedy* (1760–1761), *Lord Ligonier*, and *Nelly O'Brien* (1760–1762).

THEATER & VARIETY

George Colman the elder's *Polly Honeycombe*.

Isaac Bickerstaffe's *Thomas and Sally; or, the Sailor's Return*.

Samuel Foote's *The Minor*.

d. Peg Woffington, Irish-born English actress (b. 1718).

d. Lavinia Fenton, English actress (b. 1708).

d. Carolina Neuber, German actress and manager (b. 1697).

MUSIC & DANCE

Franz Joseph Haydn's *Maria Theresa* symphony (ca. 1760).

Les Paladins, Jean-Philippe Rameau's opera.

Niccolò Piccinni's opera *La Cecchina*.

Thomas and Sally, Thomas Arne's opera buffa.

Jean Georges Noverre's *Letters on Ballet and Dancing*.

Clarinets came into general use and were added to oboes, bassoons, and horns in European military bands, soon replacing oboes altogether (1760s); added shortly afterward were often a trumpet and a serpent, a deep-toned wind instrument shaped like its name.

Basset horn developed in Germany or Austria (ca. 1760).

Pianos were generally built with five octaves (ca. 1760–1790).

WORLD EVENTS

Seven Years' War: major battles at Landshut, Liegnitz, Warburg, Kloster-Kamp, and Torgau.

RETA E. KING LIBRARY
CHADRON STATE COLLEGE
CHADRON, NE 69337

1761

LITERATURE

Julie ou la Nouvelle Héloïse, Jean-Jacques Rousseau's popular epistolary novel, a moralistic tale of a young wife, her husband, and her lover.

Savannah, Georgia, got its first newspaper.

d. Samuel Richardson, English novelist (b. 1689).

VISUAL ARTS

Jean-Honoré Fragonard's paintings included *The Dream of Love*, *The Gardens of the Villa d'Este*, *The Stolen Kiss*, *The Stable*, *The Storm*, and *The Washerwoman* (all ca. 1761–1765).

Thomas Gainsborough's painting *Maria, Duchess of Glouscester* (early 1760s).

Hubert-François Bourguignon Gravelot illustrated Rousseau's *Nouvelle Héloïse*.

Lancelot "Capability" Brown's Bowood park.

Peter Harrison's Brick Market at Newport, Rhode Island (1761–1772).

THEATER & VARIETY

Carlo Gozzi's *The Love of Three Oranges* and *The Raven*.

MUSIC & DANCE

Franz Joseph Haydn's *Symphony No. 6–8—Le Matin, Le Midi,* and *Le Soir*).

Christoph Gluck's ballet *Don Juan ou le festin de pierre* and comic opera *Le Cadi dupé*.

Benjamin Franklin invented a *glass harmonica*, a set of small glass bowls tuned to different notes, set on a wheel, and played by the fingers.

Jean-Georges Noverre's ballet *Admète et Alceste*.

Judith, Thomas Arne's oratorio.

WORLD EVENTS

Seven Years' War: Battle of Vellinghausen.

Tokugawa Iyeharu became Japanese shogun (1761–1786).

1762

LITERATURE

Émile, ou l'Education, Jean-Jacques Rousseau's novel of the raising of young Émile, which much influenced 19th-century educators.

First university chair in English literature established, at University of Edinburgh.

James MacPherson's *Fingal, an Ancient Epic Poem, in Six Books*, supposedly based on work by the Gaelic poet Ossian.

John Wilkes began publishing the *North Briton* in England, but lost it and his Parliament seat for reporting too freely on the government.

English typographer John Baskerville produced his edition of *Virgil*, a prime example of his influential Baskerville typefaces.

Oliver Goldsmith essays *The Citizen of the World; or, Letters from a Chinese Philosopher, Residing in London, to his Friends in the East*, in two volumes.

Salomon Gessner's *Gedichte*.

VISUAL ARTS

Giovanni Battista Tiepolo's frescoes *Apotheosis of the Pisani Family*, for the Villa Pisani, Strà, Italy.

Robert Adam began Lansdowne House, Berkeley Square, London (1762–1768), Mersham-le-Hatch, Kent (1762–1772), and Syon House, Middlesex (1762–1769).

William Hogarth's engraving *The Times, I*.

THEATER & VARIETY

Carlo Gozzi's *Turandot* and *King Stag*.

Isaac Bickerstaffe's *Love in a Village*.

Philipp Hafner's *Der geplagte Odoardo*.

d. Prosper Jolyot de Crébillon, French playwright (b. 1674).

d. Luise Adelgunde Viktoria Gottsched, German playwright (b. 1713).

MUSIC & DANCE

Orfeo ed Euridice (*Orpheus and Eurydice*), Christoph Gluck's opera, libretto by Ranieri da Calzabigi, premiered in Vienna October 5; a French version, *Orphée*, was produced in 1774.

The Lass with the Delicate Air, Michael Arne's song.

Franz Joseph Haydn began his employment by Hungarian Prince Nikolaus Esterházy, whose family he would serve for decades.

Georg Philipp Telemann's oratorio *Der Tag des Gerichts*.

The Death of Hercules, Jean-Georges Noverre's ballet.

Thomas Arne's opera *Artaxerxes* and pasticcio *Love in a Village*.

WORLD EVENTS

British seaborne forces took the remainder of the French Caribbean islands, Havana, and Manila.

Seven Years' War: Battle of Wilhelmsthal.

Spain and Portugal were at war in South America.

1763

LITERATURE

d. William Shenstone, English poet (b. 1714).

VISUAL ARTS

Jean-Baptiste-Siméon Chardin's painting *Dessert*.

Jean-Honoré Fragonard's painting *Portrait of a Man* (ca. 1763–1765).

THEATER & VARIETY

Charles Collé's comedy *Dupuis et Desronais*.

Jean-François de la Harpe's *Le Comte de Warwick*.

d. Pierre Carlet de Chamblain de Marivaux, French playwright (b. 1688).

d. Thomas Godfrey, American playwright (b. 1736).

MUSIC & DANCE

Jean-Georges Noverre's ballets *Medea* and *Orpheus and Eurydice*.

Orione, Johann Christian Bach's dramatic musical work.

WORLD EVENTS

Peace of Paris between Britain, France, and Spain ended the Seven Years' War with major French territorial losses.

Pontiac's Rebellion: war in Great Lakes region, with the Ottawas and their allies fighting British colonial forces (1763–1766).

British forces took Bengal (1763–1764).

1764

LITERATURE

d. Ts-ao Chan, Chinese novelist (b. ca. 1716), best known for his *Dream of the Red Chamber* (*Hung-lou meng*), an autobiographical novel of the decline of an aristocratic Chinese family, controversially completed by Kao Eh (1764).

Horace Walpole's *The Castle of Otranto*, considered the first Gothic novel in English.

Oliver Goldsmith's *An History of England in a Series of Letters from a Nobleman to His Son* (2 vols.); also his poetic work *The Traveller, or a Prospect of Society*.

Pierre Simon Fournier published his *Manual Typographique*, on type and type founding.

Voltaire's stories *Jeannot et Colin* and *Le Blanc et le noir*.

VISUAL ARTS

The Hermitage was founded in St. Petersburg.

Giovanni Battista Tiepolo's painting *Apotheosis of the Spanish Monarchy*, for the ceiling of the throne room of the Spanish royal palace in Madrid.

Jean-Baptiste-Siméon Chardin's painting *The Wild Duck*.

Joshua Reynolds's painting *Mrs. Abingdon as "The Comic Muse"* (1764–1765).

Lancelot "Capability" Brown's Dodington Park; he also became gardener to George II at Hampton Court.

d. William Hogarth, English artist (b. 1697).

THEATER & VARIETY

Philipp Hafner's *Der Furchtsame*.

d. Philipp Hafner, Austrian playwright and director (b. 1736).

d. Robert Dodsley, English playwright and publisher (b. 1703).

MUSIC & DANCE

Christoph Gluck's comic opera *La rencontre imprévue* or *Die Pilgrime von Mekka*.

Jean-Georges Noverre's ballet *Hypermestra*.

Les Boréades, Jean-Philippe Rameau's dramatic musical work.

The Arcadian Nuptials, Thomas Arne's masque.

d. Jean-Philippe Rameau, French composer and music theorist (b. 1683).

WORLD EVENTS

Catherine II confiscated Russian church lands.

Louis-Antoine de Bougainville independently discovered the Falkland Islands, and claimed them for France.

St. Louis, Missouri, founded.

Brown University founded.

1765

LITERATURE

Reliques of Ancient English Poetry, ballads collected by Thomas Percy.

Samuel Johnson's edition of *The Plays of William Shakespeare*, in eight volumes.

VISUAL ARTS

Jean-Honoré Fragonard's paintings included *Rinaldo in the Gardens of Armida*, *The Stolen Shift* (ca. 1765), *Abbé de Saint-Non in Spanish Costume* (ca. 1765–1772), and *The Useless Resistance* (ca. 1765–1772).

Jean-Baptiste-Siméon Chardin's paintings *The Attributes of Music* and *The Attributes of the Arts*.

Japanese *ukiyo-e* illustrators developed true color prints (*benizuri-e*), using as many as 20–30 woodcut blocks (from ca. 1765).

François Boucher's painting *Chinese Tapestries*.

George Stubbs's painting *Lion Attacking a Horse*.

John Singleton Copley's *Boy with Squirrel*.

Thomas Gainsborough's painting *Gertrude, Lady Alston* (mid-1760s).

Robert Adam began Kedleston Hall, Derbyshire (1765–1770).

Isoda Koryusai, Japanese color-print master (active 1765–1784).

THEATER & VARIETY

Carlo Gozzi's *The Beautiful Green Bird*.

MUSIC & DANCE

Wolfgang Amadeus Mozart's *Symphony No. 1*, written at age nine, and three piano concertos based on sonatas by Johann Christian Bach.

Franz Joseph Haydn's *Alleluia Symphony*.

Christoph Gluck's ballets *Iphigenie* and *Semiramide*.

Tom Jones, François-André Danican Philidor's Opéra-Comique.

Jean-Georges Noverre's *Cleopatra*, ballet (1765).

WORLD EVENTS

British Stamp Act drew massive opposition in 13 Colonies; although repealed in 1766, the struggle against it was a precursor to the American Revolution.

Steam engine model was built by James Watt.

1766

LITERATURE

Jean-Jacques Rousseau began writing his *Confessions* (1776–1770), published posthumously (1781–1788).

Laocoön, or On the Limits of Painting and Poetry, Gotthold Ephraim Lessing's notable essay suggesting a common critical approach to both art and literature.

The Vicar of Wakefield: A Tale, Oliver Goldsmith's popular pastoral novel.

Miscellanies in Prose and Verse, by Welsh poet Anna Williams.

VISUAL ARTS

George Stubbs's engravings and book *Anatomy of the Horse*.

Jean-Honoré Fragonard's paintings included *Inspiration* (ca. 1766) and *The Swing* (ca. 1766).

Joseph Wright of Derby's *The Orrery*.

John Singleton Copley's painting *Mrs. Sylvanus Bourne.*

Joshua Reynolds's painting *The Honourable Henry Fane with His Guardians, Inigo Jones and Charles Blair.*

Robert Adam began Luton Hoo, Bedfordshire (1766–1775), and the redecoration of Nostell Priory, Yorkshire (1766–1785).

THEATER & VARIETY

George Colman the elder's *The Clandestine Marriage.*

MUSIC & DANCE

Wolfgang Amadeus Mozart's concerto for three pianos.

Jean-Georges Noverre's ballet *The Rape of Prosperine.*

WORLD EVENTS

British defeated Mysore in the First Mysore War (1766–1769).

John Byron claimed the Falklands Islands for Britain.

Louis-Antoine de Bougainville explored in the Pacific (1766–1769).

1767

LITERATURE

Johann Wolfgang von Goethe's poetic work *Das Buch Annette.*

d. Michael Bruce, Scottish poet (b. 1746)

VISUAL ARTS

Benjamin West's painting *Agrippina with the Ashes of Germanicus.*

Joshua Reynolds's painting *Mrs. Richard Hoare with Her Son* (1767–1768).

Lancelot "Capability" Brown's Ashburnham Park.

Robert Adam began his work at Kenwood House, Hampstead, London, and Newby Hall, Yorkshire (ca. 1767–1785).

Thomas Gainsborough's paintings included *John, 4th Duke of Argyll* and *Peasants Returning from Market* (ca. 1767).

THEATER & VARIETY

Gotthold Ephraim Lessing's *Minna von Barnhelm* was produced at Hamburg's National Theater; and his critical and theoretical work *Hamburgische Dramaturgie* (*Hamburg Dramaturgy*) (1767–1769).

Johann Wolfgang von Goethe's *Die Laune des Verliebten.*

Pierre-Augustin Caron de Beaumarchais's *Eugénie.*

d. Dufresne, French actor (b. 1693).

MUSIC & DANCE

Alceste, Christoph Gluck's opera, libretto by Ranieri da Calzabigi, based on Euripides; choreographed by Jean-Georges Noverre, premiered in Vienna, December 26.

Franz Joseph Haydn's oratorio *Stabat Mater* and opera *La Canterina.*

Wolfgang Amadeus Mozart wrote four piano concertos, based on sonatas by other composers.

François-André Danican Philidor's opera *Ernelinde.*

d. Georg Philipp Telemann, German composer (b. 1681).

WORLD EVENTS

British Townshend Act: massive resistance in 13 Colonies, as "taxation without representation" issue took hold.

Jesuits expelled from Spain and all Spanish possessions in the Americas.

Joseph Priestley's *The History and Present State of Electricity.*

1768

LITERATURE

First volume of the *Encyclopaedia Britannica* appeared (1768–1771).

Fanny Burney's *Early Diary, 1768–1778,* published posthumously (1889).

Giambattista Bodoni headed the Duke of Parma's Stamperia Reale, where he developed an influential set of typefaces.

James Boswell's *An Account of Corsica, the Journal of a Tour to That Island; and Memoirs of Pascal Paoli.*

Voltaire's story *La Princesse de Babylone*.

d. Laurence Sterne, English novelist (b. 1713), leaving unfinished *A Sentimental Journey*, a work caricaturing sentimentalism.

VISUAL ARTS

British Royal Academy was founded.

Thomas Gainsborough's paintings included *Augustus John, Third Earl of Bristol, Hon. Thomas Needham*, and *John, 10th Viscount Kilmorey* (ca. 1768).

Robert Adam began the Town House at 20 St. James Square, London (1772–1774).

Joseph Wright of Derby's *The Experiment with the Air Pump*.

d. Canaletto (Giovanni Antonio Canal), Venetian painter (b. 1697).

THEATER & VARIETY

Oliver Goldsmith's comedy *The Good Natur'd Man*.

Johann Wolfgang von Goethe's *Die Mitschuldigen*.

Isaac Bickerstaffe's *Lionel and Clarissa*.

Trick rider Philip Astley created the first circus ring, beginning the creation of the modern circus.

d. Hannah Pritchard, English actress (b. 1711).

MUSIC & DANCE

Piramo e Tisbe, Johann Adolf Hasse's dramatic musical work.

Franz Joseph Haydn's *Symphony No. 49* (*La Passione*) and his opera *Lo Speziale*.

Wolfgang Amadeus Mozart's *Missa solemnis*, the *Waisenhausmesse*; also the opera *Bastien und Bastienne*.

Jean-Jacques Rousseau's *A Dictionary of Music*.

WORLD EVENTS

Unrest continued in the 13 Colonies; Boston riots and meetings drew increased British armed presence.

Confederation of the Bar; Polish uprising crushed by Russians (1768–1774).

Turkey and Russia were at war.

Failed Corsican rebellion against French rule (1768–1769).

James Cook made his first voyage of exploration into the Pacific.

Joseph Priestley's *Essay on the First Principles of Government*.

1769

LITERATURE

Morning Chronicle began publication in England; its contributors would include Samuel Taylor Coleridge, William Hazlitt, and Charles Lamb.

Two early Canadian novels in English: Frances Brooke's *The History of Emily Montague* and John Richardson's *Wacousta*.

VISUAL ARTS

Benjamin West's painting *Regulus Returning to Carthage*.

Thomas Gainsborough's painting *Isabella, Countess of Sefton*.

George Romney's painting *Sir George and Lady Warren and Their Daughter*.

Jean-Honoré Fragonard's painting *Music* (ca. 1769).

Robert Adam began Gunton Church, Norfolk, and Pulteney Bridge, Bath (1769–1774).

THEATER & VARIETY

Richard Cumberland's *The Brothers*.

Johannes Ewald's *Adam and Eve*.

MUSIC & DANCE

Franz Joseph Haydn's *Fire Symphony*, symphony No. 59 (by 1769).

Wolfgang Amadeus Mozart's *Dominicus Missa* and opera *La finta semplice* (*The Pretend Simpleton*).

Thomas Arne's *Shakespeare Ode*.

Carl Philipp Emanuel Bach's oratorio *Die Israeliten in der Wüste*.

WORLD EVENTS

Catholic priest Junipero Serra established the first of the California Missions, San Diego de Alcala.

Madame du Barry (Jeanne Bécu) openly became mistress of Louis XV, presented at court.

1770

LITERATURE

The Deserted Village, Oliver Goldsmith's evocative poem about rural depopulation.

Johann Wolfgang von Goethe's poems *Neue Lieder*.

Michael Bruce's *Ode to the Cuckoo*, published posthumously.

The Massachusetts Spy first published.

d. Thomas Chatterton, English poet and literary fabricator, who commited suicide (b. 1752).

VISUAL ARTS

Thomas Gainsborough's paintings included *The Blue Boy* and *The Harvest Wagon* (both ca. 1770).

Joshua Reynolds's painting of *Dr. Samuel Johnson* (1770–1780).

Jean-Honoré Fragonard's paintings included *Portrait of a Lady with a Dog*, *The Music Lesson*, *The New Model*, *The Sleeping Bacchante*, and *The Three Graces* (all ca. 1770).

Robert Adam's Chandos House, Portland Place, London (1770–1771).

George Dance began Newgate Prison (1770–1778).

d. François Boucher, French painter (b. 1703).

d. Giovanni Battista Tiepolo, Italian painter (b. 1696).

d. John Michael Rysbrack, Belgian sculptor, later lived in England (b. 1694).

THEATER & VARIETY

Pierre-Augustin Caron de Beaumarchais's *Les deux amis*.

Johannes Ewald's *Rolf Krage*.

MUSIC & DANCE

d. Marie Camargo (Marie-Anne de Cupis de Camargo), French dancer of Spanish-Italian ancestry (b. 1710); she was the first female dancer to do previously male-only steps such as entrachets and cabrioles, and shortened the skirt of the dancing costume.

Christoph Gluck's ballet *Achille* and opera *Paride ed Elena*.

Franz Joseph Haydn's opera *Le Pescatrici*.

Wolfgang Amadeus Mozart's first opera, *Mitridate, re di Ponto*.

Marcha Real, by an unknown German composer, became Spain's national anthem.

La contessina, Florian Leopold Gassmann's comic opera.

Lyre-guitar (imitative of the Greek lyre) common among amateur musicians, especially "ladies" (ca. 1770–1840).

d. Giuseppe Tartini, Italian composer and violinist (b. 1692).

WORLD EVENTS

British troops fired on rioters in Boston, killing five, in the Boston Massacre.

James Cook discovered Australia's Botany Bay.

Dauphin of France (later Louis XVI) married Marie Antoinette, daughter of Maria Theresa of Austria.

Edmund Burke's *Thoughts on the Cause of the Present Discontents*.

1771

LITERATURE

The Autobiography of Benjamin Franklin, the classic and widely read memoirs of Franklin's life; updating segments were added to 1790, but the entire work was not published until 1868.

Tobias Smollett's epistolary novel *The Expedition of Humphrey Clinker*.

Richard Brinsley Sheridan's poem *The Ridotto of Bath*.

Welsh poet Anne Penny's *Poems with a Dramatic Entertainment*.

d. Tobias Smollett, Scottish-born English novelist and surgeon (b. 1721).

VISUAL ARTS

Joseph Wright of Derby's painting *A Blacksmith's Shop*.

Benjamin West's painting *The Death of Wolfe*.

Thomas Gainsborough's paintings included *Dr. Ralph Schomberg* (1771–1772) and *Penelope, Viscountess Ligonier*.

Jean-Baptiste-Siméon Chardin's works included the paintings *Love as Conqueror* (ca. 1771), *Love as*

Folly, *The Loves of Shepherds* (four paintings), and a *Portrait of Chardin* in pastels.

Charles Wilson Peale's portrait of *George Washington* and *Portrait of Mrs. Thomas Harwood.*

George Romney's painting *Mrs. Gates as the Tragic Muse.*

Jacques-Louis David's painting *Combat de Minerve contre Mars.*

Jean-Antoine Houdon's portrait sculpture of *Diderot.*

Schönbrunn, Hapsburg palace in Vienna, completed.

THEATER & VARIETY

d. Konrad Ernst Ackermann, German actor (b. 1712).

Richard Cumberland's *The West Indian.*

MUSIC & DANCE

Franz Joseph Haydn's six string quartets.

Zémire et Azor, André-Ernest-Modeste Grétry's dramatic musical work.

Il Ruggiero, Johann Adolf Hasse's dramatic musical work.

Thomas Arne's masque *The Fairy Prince.*

WORLD EVENTS

Americans in North Carolina revolted against British rule; the Regulator Revolt.

Britain took the Falkland Islands from Spain.

Russia took the Crimea.

1772

LITERATURE

Diderot's *Encyclopédie* completed publication, in 17 volumes plus 11 volumes of plates; others later added a 5-volume supplement (1776–1777) and a 2-volume analytical index (1780).

Bristowe Tragedie: or, the Dethe of Syr Charles Bawdin, a literary fabrication by Thomas Chatterton, purportedly by 15th-century poet Thomas Rowley.

Richard Brinsley Sheridan's *The Rival Beauties. A Poetical Contest.*

Morning Post began publication in England; its contributors included William Wordsworth and Robert Southey.

Wilhelm Haas of Basel built the first printing press in which the stressed parts were made of iron, the first major change in the press since Gutenberg.

VISUAL ARTS

Joseph Wright of Derby's painting *The Iron Forge.*

Francisco de Goya's painting *The Adoration of the Name of God.*

Benjamin West's painting *William Penn's Treaty with the Indians.*

Thomas Gainsborough's painting *The Linley Sisters— Mrs. Sheridan and Mrs. Tickell* (ca. 1772).

Joshua Reynolds's painting *William Robertson.*

Robert Adam began the Royal Society of Arts, London (1772–1774).

Thomas Bank's relief *Thetis and her Nymphs Rising from the Sea* (ca. 1772–1779).

d. Tsou I-Kuei, Chinese painter (b. 1686).

THEATER & VARIETY

Gotthold Ephraim Lessing's *Emilia Galotti.*

MUSIC & DANCE

Franz Joseph Haydn's *Symphony No. 45* (*Farewell*); also six string quartets.

Lucio Silla, Wolfgang Amadeus Mozart's second opera.

Temistocle, Johann Christian Bach's dramatic musical work.

Florian Leopold Gassmann's oratorio *La Betulia liberata.*

Vienna piano maker J. A. Stein invented a free-reed instrument called a *Melodika*, designed to be laid on a grand piano to provide an organ accompaniment.

WORLD EVENTS

Massachusetts Committees of Correspondence were formed, as the American Revolution was organized.

First Partition of Poland, between Prussia, Russia, and Austria.

Daniel Rutherford discovered nitrogen.

Failed Carib rebellion on St. Vincent (1772–1773).

Slave revolt against the Dutch in Surinam (1772–1799).

1773

LITERATURE

Benjamin Franklin's satires *Edict by the King of Prussia* and *Rules by Which a Great Empire May Be Reduced to a Small One*.

Johann Wolfgang von Goethe's critical work *Von deutscher Baukunst*.

VISUAL ARTS

Gilbert Stuart's painting *Francis Malbone and His Brothers Saunders* (1773–1775).

Jacques-Louis David's painting *The Death of Seneca*.

Jean-Honoré Fragonard's paintings *The Happy Family* (ca. 1773–1776) and *View of an Italian Villa* (ca. 1773).

John Singleton Copley's painting *Mr. and Mrs. Thomas Mifflin*.

Joshua Reynolds's paintings *Three Ladies Adorning a Term of Hymen* (1773–1774) and a *Self-Portrait*.

Robert Adam's Derby House, Grosvenor Square, London (1773–1774).

d. Hubert-François Bourguignon Gravelot, French book illustrator, engraver, and designer (b. 1699).

THEATER & VARIETY

She Stoops to Conquer, Oliver Goldsmith's play, opened at Covent Garden on May 15.

Johann Wolfgang von Goethe's landmark play *Götz von Berlichingen mit der eiserman Hand* was produced in Berlin, its highly emotive style soon to become a prototype for the emerging *Sturm und Drang* (Storm and Stress) movement.

d. Alexis Piron, French playwright (b. 1689).

MUSIC & DANCE

Jean-Georges Noverre's ballet *Venus and Adonis*.

Franz Joseph Haydn's opera *L'infedelité delusa*.

Wolfgang Amadeus Mozart's *Concertone* for two violins and a piano concerto.

Etienne Joseph Floquet's opera–ballet *L'union de l'Amour et des arts*.

"Viennese action" design for pianos developed (ca. 1773), in use by Bösendorfer up to 1909.

WORLD EVENTS

British Tea Act generated still further opposition in the 13 Colonies, culminating in the Boston Tea Party.

Yemelyan Pugachoff led a failed Cossack insurrection in Russia (1773–1774).

1774

LITERATURE

The Sorrows of Young Werther (*Die Leiden des jungen Werthers*) Johann Wolfgang von Goethe's semiautobiographical epistolary novel, influenced by Samuel Richardson, and his first major success.

Oliver Goldsmith's *Retaliation: A Poem*, including caricatures of his and Samuel Johnson's literary circle; also his eight-volume *An History of the Earth, and Animated Nature*.

Letters to My Son, advice from Lord Chesterfield (Philip Dormer Stanhope, Earl of Chesterfield; written 1737–1768), published.

Voltaire's story *Le Taureau blanc*, a satirical view of the Old Testament.

d. Oliver Goldsmith, English writer (b. 1730).

VISUAL ARTS

Jacques-Louis David's painting *Antiochus and Stratonice*.

Jean-Honoré Fragonard's paintings included *Study Portrait of a Girl* (ca. 1774) and *The Washerwomen* (ca. 1774).

Robert Adam began Home House, 20 Portman Square, London (1775–1777).

d. Jacques-François Blondel, French architect (b. 1705).

THEATER & VARIETY

Johann Wolfgang von Goethe's *Clavigo* and *Götter, Helden und Wieland*; in this period, he was also beginning to write *Faust* and *Egmont*.

Jakob Michael Reinhold Lenz's *Der Hofmeister*.

MUSIC & DANCE

Iphigénie en Aulide (*Iphigenia in Aulis*), Gluck's opera,

libretto by Lebland du Roullet, based on the 1674 Racine play, in turn based on Euripides, opened in Paris, April 19.

Wolfgang Amadeus Mozart's *Dixit Dominus*, *Magnificat* and his concerto for bassoon.

Lucio Silla, Johann Christian Bach's dramatic musical work.

L'espiègle du village, Franz Asplmayr's ballet written for Gaspero Angiolini.

The Waterman, Charles Dibdin's ballad opera.

d. Florian Leopold Gassmann, Bohemian composer (b. 1729).

d. Johann Friedrich Agricola, German composer and writer (b. 1774).

WORLD EVENTS

Port of Boston was closed by the British, along with other repressive measures; massive British armed presence in Boston; American armed militias formed; First Continental Congress convened.

British and Americans defeated the Shawnees and their allies in Lord Dunmore's War, in Virgina.

Rebellion in Shantung organized by the White Lotus Society.

Russo-Turkish peace treaty gave the Crimea and other Turkish territories to Russia.

1775

LITERATURE

A Journey to the Western Islands of Scotland, Samuel Johnson's version of his 1773 walking tour of the Hebrides with James Boswell, whose own version appeared 10 years later.

Ho Xuan Huong, Vietnamese woman poet (active end of 18th c.).

VISUAL ARTS

Jean-Honoré Fragonard's paintings included *A Young Girl Reading Blind-Man's-Buff* (ca. 1775), *Marie-Catherine Colombe as Victorious Venus* (ca. 1775–1776), *The Fete at Saint-Cloud* (ca. 1775), and *The Swing* (ca. 1775).

George Romney's painting *Mrs. Carwardine and Son*.

Jean-Antoine Houdon's portrait sculpture of *Gluck*.

Katsukawa Shunsho's *The Hundred Poets and Their Poems in Brocade*.

Thomas Gainsborough's painting *William Henry, Duke of Gloucester* (ca. 1775).

Jean-Baptiste-Siméon Chardin's pastels included *Portrait of Chardin with Eye Shades* and *Portrait of Mme. Chardin*.

d. Peter Harrison, American architect (b. 1716).

THEATER & VARIETY

Richard Brinsley Sheridan's *The Rivals* opened at Covent Garden January 17, introducing Mrs. Malaprop and contributing a new word to the language; also *St. Patrick's Day* and *The Duenna*.

Beaumarchais's *The Barber of Seville* opened at the Comédie Française.

Vittorio Amedeo Alfieri's tragedy *Cleopatra*.

David Garrick's *High Life Above Stairs*.

d. Pierre Laurent Buirette de Belloy, French playwright (b. 1727).

MUSIC & DANCE

The Duenna, comic opera by Thomas Linley and his son Thomas, based on Richard Brinsley Sheridan's libretto; basis for Sergei Prokofiev's 1946 opera.

Franz Joseph Haydn's opera *L'incontro improvviso*.

May-day, Thomas Arne's afterpiece.

Wolfgang Amadeus Mozart's operas *La finta giardinera* and *Il re pastore*; and his five violin concertos.

Johann Wolfgang von Goethe's operetta *Erwin und Elmire*.

Six strings (each paired) became standard on guitars, rather than the earlier five, or the still earlier four on smaller "folk" guitars (late 18th c.).

Musical boxes developed in French-speaking Switzerland, originally for watches and snuffboxes (late 18th c.).

Barrel pianos began to be produced in Italy (late 18th c.).

Orchestrion, or mechanical orchestras, essentially large barrel organs, developed in Germany (late 18th c.).

WORLD EVENTS

American Revolution (1775–1783) began with battles of Lexington and Concord on April 19, sig-

naled by Paul Revere; Second Continental Congress; George Washington commanded Continental Army; Battle of Bunker Hill; sea war began.

Daniel Boone party created the Wilderness Road, a path west through Kentucky's Cumberland Gap.

1776

LITERATURE

Thomas Paine's *Common Sense* (1776), urging the American Colonies to break away from England, and *The American Crisis*, a series of 16 pamphlets (1776–1783), speaking to key issues of the American Revolution, the first opening "These are the times that try men's souls."

The History of the Decline and Fall of the Roman Empire, Edward Gibbon's classic and ever-popular work (1776–1788).

The Flowers of the Forest, Jane Elliot's poem, based on an old song.

Ueda Akinari's *Ugetsu monogatari* (*Tales of Moonlight and Rain*).

VISUAL ARTS

George Romney's paintings included *Richard Cumberland* and *The Gower Children*.

Joshua Reynolds's paintings included *Lady Bamfylde*, *St. John in the Wilderness*, and *The Infant Samuel*.

Francisco de Goya began painting his series of tapestry cartoons (1776–1791).

Robert Adam began Portland Place, London (1776–ca. 1780), and Mistley Church, Essex.

William Chambers began Somerset House.

THEATER & VARIETY

Beaumarchais wrote *The Marriage of Figaro*; it was produced in 1784.

Johann Wolfgang von Goethe's *Stella*.

Hannah Cowley's *The Runaway*.

MUSIC & DANCE

Wolfgang Amadeus Mozart's four Missas, the *Credo*, *Organ Solo*, *Spatzenmesse*, and *Spaur Missa*

Brevises; also his *Haffner Serenade* and two piano concertos.

Pygmalion, Franz Asplmayr's melodramatic work.

The Bolshoi Ballet was founded.

WORLD EVENTS

American Declaration of Independence signed in Philadelphia July 4; war continued as British fled Boston, took New York City.

Adam Smith's *The Wealth of Nations*.

1777

LITERATURE

An *Excelente Balade of Charitie*, a literary fabrication by Thomas Chatterton, purportedly by 15th-century poet Thomas Rowley.

James Boswell's prose work *The Hypochondriack* (1777–1783).

VISUAL ARTS

Benjamin West's painting *Saul and the Witch of Endor*.

Joseph Wright of Derby's painting *Vesuvius in Eruption* (1777–1780).

Joshua Reynolds's paintings included *John Musters* (1777–1780), *Lady Elizabeth Delmé and Children*, and *The Society of Dilettanti I & II* (1777–1779).

Thomas Gainsborough's paintings included *The Watering Place*, *C. F. Abel*, and *Mrs. Graham* (ca. 1777).

Jean-Antoine Houdon's sculpture *Morpheus*.

Jean-Honoré Fragonard's painting *The Schoolmistress* (ca. 1777–1778).

Robert Adam began Culzean Castle, Ayrshire (1777–1790).

Coalbrookdale Bridge built of iron, in England.

THEATER & VARIETY

The School of Scandal, Richard Brinsley Sheridan's play opened at the Drury Lane on May 8, with Frances Abington as Lady Teazle, Jane Pope as Mrs. Candour, and Robert Baddeley as Moses; also Sheridan's *A Trip to Scarborough*.

Johann Wolfgang von Goethe's play *Der Triumph der Empfindsamkeit* (1777–1778).

Vittorio Amedeo Alfieri's tragedy *Saul*.

d. Barry Spranger, Irish actor (b. 1719).

d. Samuel Foote, English actor and playwright (b. 1720).

MUSIC & DANCE

Armide, Christoph Gluck's opera; libretto by Philippe Quinault, based on Torquato Tasso's 1581 poem *Gerusalleme liberata*.

Franz Joseph Haydn's opera *Il Mondo della luna*; also six string quartets (1777–1781).

Wolfgang Amadeus Mozart's *Missa brevis* and a piano concerto.

Grand pianoforte first described in a patent by Robert Stodart for a harpischord–piano.

WORLD EVENTS

American Revolution: British took Philadelphia, but suffered decisive defeat as General John Burgoyne's army surrendered at Saratoga; battles of Trenton, Brandywine, Princeton, Germantown, and Bennington; Continental Army greatly threatened by winter at Valley Forge; Articles of Confederation adopted.

Joseph Priestley's *Disquisition Relating to Matter and Spirit*.

1778

VISUAL ARTS

John Singleton Copley's painting *Brook Watson and the Shark*.

Jean-Antoine Houdon's portrait bust of *Benjamin Franklin*.

Lancelot "Capability" Brown's Nuneham Courtenay park.

Gilbert Stuart's *Self-Portrait*.

d. Giovanni Battista Piranesi, Italian etcher, archaeologist, and architect (b. 1720).

THEATER & VARIETY

John O'Keeffe's *Tony Lumpkin in Town*.

Vicente García de la Huerta's *La Raquel*.

d. Konrad Ekhof, German actor (b. 1720).

MUSIC & DANCE

Teatro alla Scala—known worldwide as La Scala—opened in Milan, with a production of Antonio Salieri's *Europa Riconosciuta*.

Wolfgang Amadeus Mozart's *Symphony No. 31*, the *Paris*; his two flute concertos; and his sinfonie concertante for oboe, clarinet, horn, and bassoon.

La Clemenza di Scipione, Johann Christian Bach's dramatic musical work.

L'amant jaloux, André-Ernest-Modeste Grétry's dramatic musical work.

Niccolò Piccinni's opera *Roland*.

d. Thomas Augustine Arne, English composer (b. 1710).

WORLD EVENTS

American Revolution: French–American alliance negotiated by Benjamin Franklin; British fled Philadelphia, but war of attrition difficult for Americans; battles of Monmouth, Savannah, and Cherry Valley Massacre.

France and Britain were at war.

British defeated French in India, taking Pondichery.

War of the Bavarian Succession began (1778–1779).

1779

LITERATURE

Fanny Burney's novel *Evelina, or The History of a Young Lady's Entrance into the World*; also her *Diaries and Letters, 1778–1840*, published later (1842–1848).

Samuel Johnson's four-volume *The Lives of the Most Eminent English Poets*, a series of 52 critical essays noted especially for exploring the relationship between the artist's life and art (1779–1781).

Mrs. E. Johnson's Sunday Monitor and British Gazette became the first Sunday paper, sparking many imitators.

Richard Brinsley Sheridan's *Verses to the Memory of Garrick Spoken as a Monody*.

d. Jean-Jacques Rousseau, French writer and philosopher (b. 1712).

VISUAL ARTS

John Bacon's monument to the Earl of Chatham (1779–1783), and his monument to Thomas Guy.

John of York Carr began the Crescent at Buxton, Derbyshire (1779–1784).

John Singleton Copley's painting *The Death of the Earl of Chatham* (1779–1780).

d. Jean-Baptiste-Siméon Chardin, French painter (b. 1699).

THEATER & VARIETY

Gotthold Ephraim Lessing's dramatic work *Nathan der Weise*.

Johann Wolfgang von Goethe's play *Iphigenie auf Tauris* (1779; final version, 1787).

Nathan the Wise, Gotthold Ephraim Lessing's finest play.

Richard Brinsley Sheridan's *The Critic* opened in London on October 30.

d. David Garrick, English actor (b. 1717).

MUSIC & DANCE

Amazing Grace, American hymn that became a popular song during the folk-song revival of the 1970s.

Iphigénie en Tauride, Christoph Gluck's opera, book by Francois Guillard, premiered at the Académie de Musique, Paris, May 18; also his opera *Écho et Narcisse*.

Wolfgang Amadeus Mozart's *Coronation Mass*, *Posthorn Serenade*, concerto for two pianos, and sinfonie concertante for violin, viola, and orchestra.

Polly, John Gay's ballad opera, produced in London; banned when first written (between 1729 and 1732).

Johann Christian Bach's dramatic musical work *Amadis de Gaule* and oratorio *Gioas, rè di Giuda*.

D. L. Rogart wrote music to Johannes Ewald's poem, *Kong Kristian stod ved Højen mast*, popular Danish anthem.

François-André Danican Philidor's oratorio *Carmen saeculare*.

Franz Joseph Haydn's opera *L'isola disabitata*.

d. William Boyce, English composer (b. 1711).

WORLD EVENTS

American Revolution: war of attrition continued; John Paul Jones's naval victory; Battle of Vincennnes.

British and the Marathas were at war in India (1779–1782).

David Hume's *Dialogues of Natural Religion* published.

Peace of Teschen ended the War of the Bavarian Succession.

1780

LITERATURE

First translation of the Bible into High German (as opposed to Judeo-German, or Yiddish), though using Hebrew characters, by Moses Mendelssohn.

Bengal Gazette or *Calcutta General Advertiser*, the first English newspaper in India, begun by Englishman James Augustus Hicky.

VISUAL ARTS

Gilbert Stuart's painting of *Benjamin West* (1780–1781).

Jean-Honoré Fragonard's painting *The Fountain of Love* (ca. 1780–1781).

Thomas Gainsborough's paintings included *Johann Christian Fischer* and *The Cottage Door* (ca. 1780).

Francisco de Goya's paintings included *Christ on the Cross* and *The Queen of Martyrs* (1780–1781).

Jacques-Louis David's painting *Belisarius Asking Alms*.

Jean-Antoine Houdon's sculpture *Diana*.

Federal style ascendant in the new United States (ca. 1780–1820).

d. Jaques-Germain Soufflot, French architect (b. 1713), a key figure in mid-18th-century reconstruction of Paris.

THEATER & VARIETY

Hannah Cowley's *The Belle's Stratagem*.

Johannes Ewald's *The Fishermen*.

MUSIC & DANCE

Die Auferstehung und Himmelfahrt Jesu, Carl Philipp Emanuel Bach's oratorio.

Franz Joseph Haydn's opera *La Fedeltà premiata*.

Wolfgang Amadeus Mozart's unfinished opera *Zaide*.

Cajo Mario, Domenico Cimarosa's opera.

Etienne Joseph Floquet's comic opera *Le Seigneur bienfaisant*.

Modern violin bow developed by François Tourte in Paris; neck and fittings also redesigned (1780s).

Six strings (each paired) became standard on guitars, first in Spain (ca. 1780).

"England grand action" design for pianos developed by English, Scottish, and German piano makers; later superseded (ca. 1780).

First description of a type of *harmonium*, a "free-reed" keyboard instrument (built ca. 1780).

Bass drum developed in England (ca. 1780).

WORLD EVENTS

American Revolution: American forces reinforced by French army and fleet began to turn tide of war; General Charles Cornwallis occupied Yorktown, waited for promised British fleet and reinforcements; battles of Kings Mountain and Camden.

British at war with French and Mysore in India (1780–1783).

Failed Peruvian Indian revolt against Spanish rule—Tupac Amaré's Rebellion (1780–1783).

1781

LITERATURE

Jean-Jacques Rousseau's extraordinary 12-volume exploration of his life and development *The Confessions of J. J. Rousseau* published posthumously (written 1766–1770).

Kritik der reinen Vernunft (*Critique of Pure Reason*), Immanuel Kant's exploration of the possibility of rational knowledge based on sense experience.

VISUAL ARTS

Thomas Gainsborough's paintings included *Mrs. Robinson* (*Perdita*) and *Queen Charlotte*.

Charles Cameron began Pavlovsk Palace (1781–1796).

John of York Carr began Grimston Garth, Yorkshire (1781–1786).

Abate Filippo Baldinucci's book *Notizie de' Professori del disegno*.

d. Peter Scheemakers, Belgian-English sculptor (b. 1691).

THEATER & VARIETY

Friedrich von Schiller's *Die Räuber* (*The Robbers*), a major work of the *Sturm und Drang* movement.

d. Gotthold Ephraim Lessing, German playwright (b. 1729).

d. Johannes Ewald, Danish lyric poet and playwright (b. 1743).

MUSIC & DANCE

Idomeneo, Wolfgang Amadeus Mozart's opera, libretto by Abbé Varesco, opened in Munich, January 29.

Stabat mater, Luigi Boccherini's sacred vocal music.

Franz Joseph Haydn's *Symphony No. 73, La Chasse*.

Niccolò Piccinni's opera *Iphigénie en Tauride*.

d. Faustina Bordoni, Italian mezzo-soprano (b. 1700).

WORLD EVENTS

American Revolution effectively ended with defeat of British fleet by French in Chesapeake Bay and subsequent encirclement and surrender of General Charles Cornwallis's army at Yorktown. Loyalists began to flee, largely to Canada and England.

Colombian Comunero insurrection against Spanish rule began (1781–1782).

Immanuel Kant's *Critique of Pure Reason*.

1782

LITERATURE

J. Hector St. John de Crèvecoeur's *Letters from an American Farmer*, describing rural life in 18th-century America, seen as a refuge for people from troubled lands.

Fanny Burney's novel *Cecilia, or Memoires of an Heiress*.

Friedrich Schiller's poetic work *Anthologie auf das Jahr.*

William Cowper's ballad *John Gilpin.*

VISUAL ARTS

Francisco de Goya's painting *St. Bernardino of Siena* (1782–1783).

Jacques-Louis David's painting *Portrait of Pierre Desmaisons.*

Joseph Wright of Derby's painting *John Whitehurst* (1782–1783).

Gilbert Stuart's painting *The Skater.*

Joshua Reynolds's painting *Colonel George Coussmaker.*

Antonio Canova's sculpture *Theseus and the Minotaur.*

THEATER & VARIETY

Charles Hughes left the Philip Astley Company to form England's Royal Circus.

Hannah Cowley's *Which Is the Man?*

The Minor, Denis I. Fonvizin's play.

MUSIC & DANCE

Die Entführung aus dem Serail (*The Abduction from the Seraglio*), Wolfgang Amadeus Mozart's opera, libretto by Gottlieb Stephanie, premiered at Munich's Burgtheater, July 16; its elaborate songs led to Emperor Joseph II's famous comment, "Too many notes, my dear Mozart."

Wolfgang Amadeus Mozart's *Symphony No. 35,* the *Haffner;* his *Haydn Quartets,* six string quartets dedicated to Haydn (1782–1785); his four horn concertos (1782–1786); and for piano, two concert rondos and a concerto.

Il Barbiere di Siviglia, Giovanni Paisiello's opera based on Beaumarchais's 1775 play *Le Barbier de Séville,* premiered in St. Petersburg; popular until supplanted by Gioacchino Rossini's 1816 version.

Franz Joseph Haydn's *Missa Celensis;* also his opera *Orlando paladino.*

Jean-Georges Noverre's ballet *Apollo et les Muses.*

Johann Gottlieb Naumann's opera *Cora och Alonzo.*

Stockholm's Royal Opera House was opened by Gustave III.

d. Johann Christian Bach, German composer, youngest (sixth) son of Johann Sebastian Bach (b. 1735).

WORLD EVENTS

British fleet in the Caribbean defeated French at the Saints.

Unification of Hawaii by Kamehameha began (1782–1810).

Peace talks began between the United States and Britain.

Spanish forces took Minorca from the British.

1783

LITERATURE

William Blake's *Poetical Sketches,* illustrated with his own engravings.

Noah Webster's *The American Spelling Book,* the "Blue-Back."

VISUAL ARTS

John Singleton Copley's paintings included *The Children of George III, The Death of Major Pierson,* and *Lord Rodney.*

Thomas Gainsborough's paintings included *Mrs. Siddons* (ca. 1783) and *The Mall in St. James' Park.*

Charles Cameron began his additions, a sculpture gallery and the Agate Pavilion, to the Great Palace of Tsarskoe Selo (1783–1785).

Francisco de Goya's painting *The Count of Floridablanca and Goya.*

Giacomo Quarenghi began Leningrad's Academy of Sciences (1783–1787).

Jacques-Louis David's painting *Andromache Mourning Hector.*

Jean-Antoine Houdon's sculpture *La Frileuse.*

d. Lancelot "Capability" Brown, English architect and landscape gardener (b. 1716).

d. Richard Wilson, British painter (b. 1714).

THEATER & VARIETY

Friedrich von Schiller's *Fiesco; or The Genoese Conspiracy.*

Hannah Cowley's *A Bold Stroke for a Husband.*

Jean-François de la Harpe's *Philoctète.*

John O'Keeffe's *The Poor Soldier.*

d. Charles Collé, French playwright and librettist (b. 1709).

MUSIC & DANCE

Wolfgang Amadeus Mozart's *Symphony No. 36*, the *Linz*, and two piano concertos.

Carl Philipp Emanuel Bach's ode *Morgengesang am Schöpfungsfeste*.

La Caravane du Caire, André-Ernest-Modeste Grétry's dramatic musical work.

Antonio Bianchi's opera *La Villanella rapita*.

Domenico Cimarosa's opera *I due baroni*.

Niccolò Piccinni's opera *Didon*.

The sustaining pedal was added to the piano by Broadwood of England, allowing more harmonic resonance among the strings, a characteristic often used by later composers, such as Claude Debussy.

d. Johann Adolf Hasse, German composer (b. 1699).

d. Lucrezia Aguiari, Italian soprano nicknamed "La Bastardina" or "La Bastardella" (b. 1743).

WORLD EVENTS

Peace of Versailles: U.S., Britain, France, and Spain formally ended the American Revolution and related hostilities.

Spanish siege of Gibraltar ended.

1784

LITERATURE

Robert Burns's poem *Green Grow the Rashes*.

First Roman Catholic Bible in Slovenian, based on the Latin Vulgate, published in Laibach (1784–1802).

d. Samuel Johnson, English writer (b. 1709).

d. Denis Diderot, French encyclopedist and philosopher (b. 1713).

VISUAL ARTS

Thomas Gainsborough's painting *Three Eldest Princesses* (*Princess Charlotte and Her Two Sisters*).

Jacques-Louis David's paintings included *Portrait de Charles-Pierre Pécoul*, *Oath of the Horatii*, and *Portrait of Mme. Pécoul*.

Joshua Reynolds's painting *Sarah Siddons as the Tragic Muse*.

John Opie's painting *The Schoolmistress*.

Thomas Bewick's illustrations for *The Select Fables*.

d. Allan Ramsay, Scottish portrait painter (b. 1713), whose work was done largely in England.

THEATER & VARIETY

Beaumarchais's *The Marriage of Figaro* opened, overcoming difficulties caused by censorship.

Friedrich von Schiller's *Kabale und Liebe*.

Jean-François de la Harpe's *Coriolan*.

Mirra, Vittorio Amedeo Alfieri's tragedy.

MUSIC & DANCE

André-Ernest-Modeste Grétry's *Richard Coeur-de-lion*, dramatic musical work (1784).

Franz Joseph Haydn's opera *Armida*.

Six piano concertos by Wolfgang Amadeus Mozart.

Il re Teodoro in Venezia, Giovanni Paisiello's opera.

Antonio Bianchi's opera *Il disertore francese*.

d. Wilhelm Friedemann Bach, German composer, eldest son of Johann Sebastian Bach (b. 1710).

WORLD EVENTS

Russo-Turkish war ended with the Treaty of Constantinople, ceding the Crimea and Kuban to Russia.

Immanuel Kant's *Notion of a Universal History in a Cosmopolitan Sense*.

1785

LITERATURE

The Journal of a Tour to the Hebrides, with Samuel Johnson, LL.D., James Boswell's account of the pair's 1773 walking tour, appearing 10 years after Johnson's own version.

The Daily Universal Register began publication, under John Walter; renamed *The Times* of London (1788), it became one of Britain's premier papers.

Prayers and Meditations, composed by Samuel Johnson, LL.D., published posthumously.

William Cowper's poem *The Task*.

VISUAL ARTS

Thomas Gainsborough's paintings included *Mrs.*

Sheridan (ca. 1785), *The Cottage with Dog and Pitcher*, and *The Morning Walk*.

Francisco de Goya's painting *The Annunciation*.

Jean-Honoré Fragonard's painting *Portrait of Mme. Bergeret de Norinval* (ca. 1785).

John Singleton Copley's painting *The Three Princesses*.

THEATER & VARIETY

August Wilhelm Iffland's *Die Jäger*.

Elizabeth Inchbald's *I'll Tell You What*.

d. Kitty Clive, English actress (b. 1711).

MUSIC & DANCE

Ludwig van Beethoven's three piano quartets.

Wolfgang Amadeus Mozart's oratorio *Davide penitente*, opera *Der Schauspieldirektor*, and three piano concertos, including the one used as a score for the 1967 Swedish film *Elvira Madigan*.

Joseph Haydn's *Symphony No. 83, La Poule*; also his string quartet.

De profundis, Christoph Gluck's church music (after 1785?).

Panurge dans l'île des lanternes, André-Ernest-Modeste Grétry's dramatic musical work.

d. Etienne Joseph Floquet, French composer (b. 1748).

WORLD EVENTS

Russian expansion reached the Americas, with Russian settlements in the Aleutian Islands.

Thomas Jefferson organized the new United States monetary system.

Frederick the Great formed the League of German Princes (*Die Fürstenbund*).

Immanuel Kant's *Groundwork of the Metaphysic of Ethics*.

William Herschel's *On the Construction of the Heavens*.

1786

LITERATURE

Robert Burns's long poems *The Cotter's Saturday Night*, on Scottish peasant life, and *The Holy Fair*,

ridiculing immorality at the supposedly sacred gathering.

Friedrich Schiller's novel *Der Verbrecher aus Infamie*.

VISUAL ARTS

Francisco de Goya's paintings included *The Marquesa de Pontejos* (ca. 1786) and *Sir Christopher and Lady Sykes*.

Jacques-Louis David's painting *The Death of the Ugolino*.

James Gillray's caricatures *A New Way to Pay the National Debt*.

John of York Carr began Farnley Hall, Yorkshire (1786–1790).

Thomas Gainsborough's paintings included *The Cottage Girl with a Bowl of Milk* and *The Market Cart*.

THEATER & VARIETY

Elizabeth Inchbald's *The Widow's Vow*.

d. Sophia Snow, English actress (b. 1745).

MUSIC & DANCE

Le nozze di Figaro (*The Marriage of Figaro*), Wolfgang Amadeus Mozart's opera, book by Lorenzo da Ponte, premiered at Munich's Burgtheater, May 1.

Wolfgang Amadeus Mozart's *Symphony No. 38*, the *Prague*, and three piano concertos.

Franz Joseph Haydn's *Symphony No. 84*.

Domenico Cimarosa's opera *L'impresario in angustie*.

Le gare generose, Giovanni Paisiello's opera.

Johann Gottlieb Naumann's operas *Orpheus og Eurydike* and *Gustaf Wasa*.

Nina, Nicolas-Marie Dalayrac's comic opera.

d. Michael Arne, English composer (b. 1740), son of Thomas Arne.

d. Franz Asplmayr, Austrian composer and violinist (b. 1786).

WORLD EVENTS

Massachusetts farmers mounted Shays's Rebellion, quickly suppressed by the new federal government (1786–1787).

Annapolis convention organized by James Madison and Alexander Hamilton.

British expanded further in India, taking Penang.
William Herschel's *Catalogue of Nebulae*.

1787

LITERATURE

Mary Wollstonecraft's *Thoughts on the Education of Daughters*, an early call for education for women.
Robert Burns's poem *Auld Lang Syne*.

VISUAL ARTS

Joshua Reynolds's paintings included *Heads of Angels, Lady Gertrude Fitzpatrick as "Sylvia,"* and *Selina, Lady Skipwith*.
Thomas Gainsborough's paintings included *Boy with a Cat-Morning, Lady Bate Dudley,* and *The Wood Gatherers (Cottage Children)*.
Henry Raeburn's painting *The Archers* (ca. 1787).
Jacques-Louis David's painting *The Death of Socrates*.
John Opie's painting *The Death of Rizzio*.

THEATER & VARIETY

Friedrich von Schiller's *Don Carlos*.
Royall Tyler's comedy *The Contrast* opened at New York's John Street Theater on April 16.
George Colman the younger's *Inkle and Yarico*.
d. Vicente García de la Huerta, Spanish playwright (b. 1734).

MUSIC & DANCE

Don Giovanni, Wolfgang Amadeus Mozart's opera, libretto by Lorenzo da Ponte, premiered at the National Theater, Prague, October 29.
Eine Kleine Nachtmusik (A Little Night Music), Wolfgang Amadeus Mozart's serenade for strings; also two of his six string quintets.
Franz Joseph Haydn's six string quartets dedicated to Frederick William II of Prussia, including the *Frog Quartet* and *Die Sieben Worte Letzten des Erlösers am Kreuze (The Last Seven Words of Our Saviour on the Cross* [vocal version, 1796]); also his *Symphony No. 88*.
Antonio Salieri's opera *Tarare*.
d. Christoph Gluck, German composer (b. 1714).

d. Carl Friedrich Abel, German composer and bass-viol player (b. 1723).

WORLD EVENTS

U.S. Constitution was adopted by the Constitutional Convention on September 15.
U.S. Northwest Ordinance prohibited slavery in Northwest Territory, as the long prelude to the American Civil War began.
First whaling ship (British) rounded Cape Horn to hunt Pacific whales.
Publication of *The Federalist* began (1787–1788).

1788

LITERATURE

Critique of Practical Reason (Kritik der praktischen Vernunft), Immanuel Kant's attempt to shape a philosophy of ethics based on the ideas of reason and free will.
Mary Wollstonecraft's novel *Mary*.
d. Salomon Gessner, Swiss poet (b. 1730).

VISUAL ARTS

Francisco de Goya's paintings included *Family of the Duke of Osuna* and *Manuel Osorio de Zúñiga*.
Joshua Reynolds's paintings included *The Age of Innocence, Mrs. Abbingdon as "Roxalana,"* and *Lord Heathfield, Governor of Gibraltar*.
Jacques-Louis David's paintings included *Les Amours de Paris et d'Hélene* and *Portrait of Lavoisier and His Wife*.
Benjamin West's painting *King Lear*.
Jean-Honoré Fragonard's painting *The Stolen Kiss* (ca. 1788).
d. Thomas Gainsborough, English painter (b. 1727).

THEATER & VARIETY

Johann Wolfgang von Goethe's *Egmont*.
Collin d'Harleville's *L'Optimiste*.
d. George Anne Bellamy, English actress (b. 1727)

MUSIC & DANCE

Wolfgang Amadeus Mozart's symphonies *No. 40* and

No. 41, the *Jupiter*; also his *Coronation Concerto* for piano.

Franz Joseph Haydn's six string quartets, including *The Razor* (by 1788).

d. Carl Philipp Emanuel Bach, German composer, second son of Johann Sebastian Bach (b. 1714).

d. Charles Wesley, Methodist missionary and writer of hymns (b. 1707).

WORLD EVENTS

Constitution of the United States was ratified by the original 13 states.

Austria and Turkey were at war.

Botany Bay penal settlement founded by the British.

Sweden was at war with Russia.

Tibet was at war with Nepal (1788–1855).

1789

LITERATURE

Songs of Innocence, William Blake's book of poems, including most notably *The Lamb*, with his own illustrations; also *The Book of Thel*, the first of Blake's mystical or prophetic writings.

Robert Burns's poems *Afton Water* (*Flow Gently, Sweet Afton*) and *John Anderson My Jo*.

The Interesting Narrative of the Life of Olaudah Equiano or Gustavus Vassa the African, later published as *Equaino's Travels* (1967), a notable early African work in English.

VISUAL ARTS

Charles Bulfinch's Beacon Monument, Boston.

Jacques-Louis David's painting *The Lictors Bringing to Brutus the Bodies of His Sons*; he also began the ultimately unfinished painting *The Tennis Court Oath*.

Jean-Honoré Fragonard's painting *Evariste Fragonard as Pierrot* (ca. 1789–1780).

Thomas Bewick's illustrations for *The Chillingham Bull*.

THEATER & VARIETY

Misanthropy and Repentance (*The Stranger*), A. F. F. von Kotzebue's play.

Collin d'Harleville's *Les Châteaux en Espagne*.

The Father; or, American Shandyism, William Dunlap's comedy opened at New York's John Street Theater on September 7.

John O'Keeffe's *The Little Hunch-Back; or, a Frolic in Bagdad*.

Marie-Joseph Chénier's *Charles IX*.

MUSIC & DANCE

Franz Joseph Haydn's *Symphony No. 92*.

Wolfgang Amadeus Mozart's three string quartets dedicated to the King of Prussia (1789–1790) and his clarinet quintet.

Jean Dauberval's ballet *La Fille mal gardée* (originally *Le Ballet de la Paille*).

Jean-Baptiste Lemoyne's opera *Nephté* and opera comique *Les prétendus*.

Giovanni Paisiello's operas *Nina* and *La molinara*.

Earliest American-made square piano, from Charles Albrecht, Philadelphia.

WORLD EVENTS

French Revolution: Third Estate became National Assembly; Bastille stormed; march of women moved Louis XVI from Versailles to Paris; National Assembly adopted Declaration of the Rights of Man; church property seized.

First 10 amendments to the U.S. Constitution—the Bill of Rights—were sent by Congress to the states.

Inauguration of George Washington as first president of the United States; cabinet included Secretary of State Thomas Jefferson and Treasury Secretary Alexander Hamilton; John Jay was U.S. Supreme Court chief justice.

1790

LITERATURE

William Blake's main mystical or prophetic book, *The Marriage of Heaven and Hell*, dealing with profund themes of human self-destruction and redemption.

Declaration of the Rights of Women and Citizens, a call for women's equality, by French revolutionary Olympe de Gouges.

Mary Wollstonecraft's *A Vindication of the Rights of Man*.

Carl Michael Bellman's poetry *Fredmans epistlar*.

Charlotte Ramsay Lennox's novel *Euphemia*.

Johann Wolfgang von Goethe's *Versuch die Metamorphose der Pflanzen zu erklären*.

d. Benjamin Franklin, American writer and public official (b. 1706).

VISUAL ARTS

Hokusai's prints *Festivals for the Twelve Months* and *Festivals of the Green Houses* (both ca. 1790).

Jacques-Louis David's *Self-Portrait*.

Thomas Banks's portrait bust of *Warren Hastings*.

Thomas Bewick's illustrations for *A General History of Quadrupeds*.

THEATER & VARIETY

Johann Wolfgang von Goethe's *Torquato Tasso* and *Faust, Ein Fragment*.

MUSIC & DANCE

Cosi fan tutte, Wolfgang Amadeus Mozart's opera, libretto by Lorenzo da Ponte, opened at Vienna's Burgtheater, January 26.

Ludwig van Beethoven's *Cantata on the death of Joseph II* and *Cantata on the accession of Leopold II*; also he began his *8 songs* (1790–1796).

Franz Joseph Haydn's six string quartets, including *The Lark*.

Antonio Bianchi's opera *La vendetta di Nino*.

Domenico Cimarosa's intermezzo *Il maestro di cappella* (ca. 1790).

Euphrosine, Etienne-Nicolas Méhul's dramatic musical work.

Six single strings, not the former six pairs, became standard on guitars, first in Spain (ca. 1790).

Pianos were generally built with five and a half octaves (ca. 1790–1820).

WORLD EVENTS

Belgian revolutionary movement was crushed by Austrian intervention.

George Vancouver explored the Pacific coast of North America.

Edmund Burke's *Reflections on the Revolution in France*.

Russo-Swedish War ended with Treaty of Verela, ceding portions of Finland to Russia.

1791

LITERATURE

The Rights of Man, Thomas Paine's defense of the French Revolution, against attack by leaders such as Edmund Burke (1791–1792).

James Boswell's *The Life of Samuel Johnson, LL.D.*, one of the best known and most widely read of all biographies.

Marquis de Sade's novel *Justine ou les malheurs de la vertu*.

Observer began publication in London, Britain's oldest surviving national Sunday newspaper.

Robert Burns's narrative poem *Tam o'Shanter*.

Carl Michael Bellman's drinking songs and biblical parodies *Fredmans sånger*.

VISUAL ARTS

Beiträge zur Optik, Johann Wolfgang von Goethe's work on optics and light theory, which much influenced painters such as J. M. W. Turner and the Impressionists (1791–1792).

James Northcote's painting *The Murder of the Princes in the Tower*.

John Singleton Copley's painting *Relief of Gibraltar*.

THEATER & VARIETY

John O'Keeffe's *Wild Oats; or, the Strolling Gentleman*.

MUSIC & DANCE

The Magic Flute (*Die Zauberflöte*), Wolfgang Amadeus Mozart's opera, libretto by Emanuel Schikaneder, premiered at Vienna's Theater auf der Wieden, Vienna, September 30. Nannetta Gottlieb created the Pamina role, and Josefa Hofer the Queen of Night.

d. Wolfgang Amadeus Mozart, Austrian composer (b. 1756); also written in the year of his death were the opera *La clemenza di Tito*, his clarinet concerto, his final piano concerto, and his unfinished

Requiem, completed after his death by Franz Xaver Süssmayr.

Joseph Haydn's symphonies *No. 94*, the *Surprise*, and *No. 96*, the *Miracle*; also his opera *L'anima del filosofo*.

Luigi Cherubini's opera *Lodoïska* premiered in Paris.

Camille, Nicolas-Marie Dalayrac's opera.

Lodoïska, Rodolphe Kreutzer's Opéra-Comique.

WORLD EVENTS

First 10 amendments to the Constitution, the Bill of Rights, were ratified by the United States.

Canada Constitution Act divided Canada into provinces of Ontario and Quebec (Upper and Lower Canada).

Haitian revolution against French rule was led by Toussaint Louverture (1791–1803).

French Constitution is passed by National Assembly, making France a constitutional monarchy.

Wolfe Tone, Thomas Russell, and Napper Tandy founded the Society of United Irishmen.

Mysore forces defeated by British at Seringapatam.

Vermont became a state.

1792

LITERATURE

Mary Wollstonecraft's *A Vindication of the Rights of Women*, her landmark argument for women's equality, one of the earliest documents of what would half a century later emerge as the women's rights movement.

Robert Burns's poem *Ye Banks and Braes* (*o bonie Doon*), third version.

VISUAL ARTS

White House, Washington, D.C., was designed by James Hoban, who supervised its building (1793–1801) and rebuilding after it was burned by the British during the War of 1812 (1814–1829).

Antonio Canova's Tomb of Pope Clement XIII, at St. Peter's, Rome.

Joseph Wright of Derby's painting *Erasmus Darwin* (1792–1793).

Anne-Louis Girodet de Roucy's painting *The Sleep of Endymion*.

Jacques-Louis David's paintings *Portrait de Mme. Trudaine* (*Portrait de Mme. Chalgrin*) and *Portrait of Devienne*.

The Beloved Child, Jean-Honoré Fragonard's painting (ca. 1792).

Giacomo Quarenghi began the Alexander Palace, at Tsarskoe Selo (1792–1796).

d. Joshua Reynolds, English painter (b. 1723).

d. Robert Adam, British architect (b. 1728), a major figure in British architecture for his theoretical work and his country-house designs, prefiguring later town planners.

d. Katsukawa Shunsho, Japanese color-print master and painter (b. 1726).

THEATER & VARIETY

Johann Wolfgang von Goethe's *Der Gross-Cophta*.

Leandro Fernández de Moratín's *La comedia nueva o el café*.

Marie-Joseph Chénier's *Caius Gracchus*.

Thomas Holcroft's *The Road to Ruin*.

Thomas Morton's *Columbus; or, a World Discovered*.

Collin d'Harleville's *Le Vieux Célibataire*.

d. Denis Ivanovich Fonzivin, Russian playwright (b. 1744).

d. Jakob Michael Reinhold Lenz, German playwright (b. 1751).

MUSIC & DANCE

La Marseillaise, Claude Rouget de Lisle's song, composed April 24–25 at Strasbourg as a marching song for the soldiers (originally titled *Chant de guerre pour l'armée du Rhin*), and performed publicly for the first time there on Sunday, April 29, by a band of the National Guard, later becoming the French anthem.

Il matrimonio segreto (*The Secret Marriage*), Domenico Cimarosa's opera, libretto by Giovanni Bertati, opened in Vienna, February 7.

Etienne-Nicolas Méhul's opera *Stratonice*.

The Pirates, Stephen Storace's opera.

Venice's Teatro La Fenice (Phoenix) opened on May 16 with a production of Giovanni Paisiello's *I Giuochi d'Agrigento*.

Last of the previously regular great gatherings of Irish harpers, in Belfast.

WORLD EVENTS

French Revolution: Tuileries sacked; Paris Revolutionary Commune established in Paris; Republic established; Jacobins led by Georges-Jacques Danton took power from Girondins; royal family held by new government.

War of the First Coalition began, pitting new French Republic against European alliance led by Austria and Britain: allied advance stopped at Valmy (1792–1797).

1793

LITERATURE

Robert Burns's patriotic poem *Scots, Wha Hae*, commemorating the Scots' victory over the English at the 1314 Battle of Bannockburn. Set to the 1512 melody *Hey, Tutti Tattie*, the poem would become the unofficial Scottish anthem.

William Wordsworth's earliest poetic works, *An Evening Walk* and *Descriptive Sketches*.

William Blake's prophetic books *The Gates of Paradise* and *The Visions of the Daughters of Albion*.

Johann Wolfgang von Goethe's poetic work *Römische Elegien*.

VISUAL ARTS

The Louvre was opened to the public as a museum.

William Thornton won a competition to design the U.S. Capitol, and George Washington laid the foundation stone.

Jacques-Louis David's painting *The Death of Marat*.

William Blake's engravings for his principal prose work, *The Marriage of Heaven and Hell*.

John Flaxman's illustrations for the *Iliad* and *Odyssey*.

Charles Bulfinch's State House (1793–1800) and the residences at Franklin Crescent, all in Boston.

Thomas Banks's monument for Penelope Boothby.

THEATER & VARIETY

Johann Wolfgang von Goethe's play *Des Bürgergeneral*.

Frederick Reynolds's *How to Grow Rich*.

Thomas Morton's *The Children in the Wood*.

d. Carlo Goldoni, Italian playwright (b. 1709).

d. Karl Theophil Döbbelin, German actor–manager (b. 1727).

MUSIC & DANCE

Franz Joseph Haydn's six *Apponyi* string quartets dedicated to Count Franz Apponyi, including *The Rider*; also his *Variations in F Minor* for piano.

Ludwig van Beethoven's *Octet and Rondino* (ca. 1793).

Jean-Georges Noverre's ballet *Iphigenia in Aulis* (1793).

Auld Lang Syne, one of the best-known of the Scottish songs shaped by Robert Burns (ca. 1793).

First known use of chimes, a tune played by church bells, at Great St. Mary's, Cambridge, England.

WORLD EVENTS

Explorer Alexander Mackenzie reached the Pacific by land, north of Vancouver.

French Committee of Public Safety, led by Danton, took absolute power.

Louis XVI (b. 1754) and Marie Antoinette (b. 1755) were executed by the new French government; there were many other executions, as well, including those of revolutionaries.

Royalist revolt in southern France against the new government—the Vendée Revolt (1793–1796).

War of the First Coalition: battles of Neerwinden, Hondschoote, and Wattignies.

Eli Whitney invented the cotton gin.

1794

LITERATURE

William Blake's major self-illustrated poetic work, *Songs of Experience*, including *The Sick Rose* and *The Tiger*.

Robert Burns's poem (*My Luv's Like*) *A Red, Red Rose*.

Thomas Paine's pamphlet on religion, *The Age of Reason* (1794–1795).

William Godwin's melodramatic novel *The Adventures of Caleb Williams, or Things as They Are*.

Johann Wolfgang von Goethe's novel *Reineke Fuchs*.

The process of stereotype printing (developed ca. 1727) was adopted, named, and spread by printer Firmin Didot.

d. Edward Gibbon, English historian (b. 1737).

VISUAL ARTS

Jacques-Louis David's paintings *Self-Portrait, Joseph Bara, View of the Luxembourg Gardens*, and *Les Sabines* (*The Intervention of the Sabine Women*) (1794–1799).

Francisco de Goya's paintings *The Madhouse* and *The Marquesa de la Solana* (ca. 1794–1795).

Utagawa Toyokun's prints *Yakusha Butai Sugatae* (1794–1796).

Henry Raeburn's painting *Sir Jacob Sinclair* (ca. 1794).

THEATER & VARIETY

Hannah Cowley's *The Town Before You.*

Tammany, libretto by Mrs. (Anne Kemble) Hatton and music by James Hewitt, opened at New York's John Street Theater on March 3.

Richard Cumberland's *The Jew.*

d. George Colman the elder, English playwright and theater manager (b. 1723).

d. Robert Baddeley, English actor (b. 1732).

MUSIC & DANCE

Franz Haydn's symphonies *No. 100, The Military*, and *No. 101, The Clock.*

Ludwig van Beethoven's first string trio (by 1794).

Dancer–choreographer Filippo Taglioni made his debut in Pisa, dancing female roles.

d. Jean-Jacques Beauvarlet-Charpentier, French composer and organist, from 1783 at Notre Dame Cathedral (b. 1734).

WORLD EVENTS

Massive executions in revolutionary France, including those of Georges-Jacques Danton, Camille Desmoulins, Maximilien de Robespierre, and Louis-Antoine-Léon de St. Just, as the "revolution ate its own children."

War of the First Coalition: battles of Tourcoing, Tournai, Charleroi, Fleurus, and Montagne Noir; sea battle of Ushant.

Alliance of St. Petersburg, of Britain, Russia, and Austria against France.

Erasmus Darwin's *Zoonomia, or the Laws of Organic Life.*

Failed Polish rising against Russian rule, led by Tadeusz Kosciuszko; suppressed by Russians.

Slavery was abolished in all French colonies.

U.S. antitax Whiskey Rebellion suppressed.

1795

LITERATURE

Johann Wolfgang von Goethe's *Wilhelm Meister's Apprenticeship* (*Wilhelm Meisters Lehrjahre*) (1795–1796), regarded as the prototype of the *Bildungsroman*, a novel of development from youth to maturity (completed in 1829); also his novel *Unterhaltungen deutscher Ausgewanderten* (1795) and verses *Venezianische Epigramme* (1795).

Marquis de Sade's novels *Aline et Valcour* and *La Philosophie dans le Boudoir.*

Robert Burns's poem *For A' That and A' That* (1795–1796).

Nikolay Karamzin's *Letters of a Russian Traveller.*

William Blake's prophetic books *The Book of Los* and *The Song of Los.*

d. James Boswell, English writer (b. 1740).

d. Carl Michael Bellman, Swedish poet and songwriter (b. 1740).

VISUAL ARTS

Gilbert Stuart's "Vaughan" portrait of George Washington.

Humphry Repton's *Sketches and Hints on Landscape Gardening.*

Portrait de Mme. Sériziat, Jacques-Louis David's painting.

John Flaxman's monument to Lord Mansfield (1795–1801).

THEATER & VARIETY

Beaumarchais's *La Mère coupable.*

William Dunlap's Fontainville Abbey.

John Murdock's *The Triumphs of Love.*

MUSIC & DANCE

Ludwig van Beethoven's *Piano Concerto No. 1*, the song *Adelaide*, seven piano sonatas in three sets (1795–1798), two sonatinas (1795–1797), and

various chamber music works, including his first string quintet, his first three piano trios, the *Trio for 2 oboes and English horn*, and his *Sextet* (ca. 1795). In 1795 Beethoven also made his public debut as a virtuoso pianist.

Franz Joseph Haydn's symphonies *No. 102, No. 103*, the *Drum Roll*, and *No. 104*, the *London*.

Poland's popular anthem *Jeszkeze Polska nie zginela* was first performed, the words written by Józef Wybicki to a tune of unknown authorship.

Upright grand pianos "in the form of a bookcase" were being made by Stodart of Londonn.

Paris Conservatoire founded by Bernard Sarrette.

d. Johann Christoph Friedrich Bach, German composer, fifth son of Johann Sebastian Bach (b. 1732).

d. François-André Danican Philidor, French composer (b. 1726).

d. John Christopher Smith, English composer (b. 1712).

WORLD EVENTS

Prussia, Russia, and Austria agreed on the third partition of Poland.

The Directory took power in France.

War of the First Coalition: Siege of Loano; several sea battles; Napoleon commanded French forces in Italy.

British forces took the Cape of Good Hope and Ceylon from the Dutch.

British Northwest Company was organized.

Dutch Batavian Republic formed; French took Holland.

1796

LITERATURE

Jane Austen's *First Impressions* was rejected even for subsidized publication; much revised, it would become *Pride and Prejudice* (1813).

Hasty Pudding, Joel Barlow's mock-heroic poem on the preparing and eating of the New England dish.

Xenien, a work in verse written jointly by Johann Wolfgang von Goethe and Friedrich Schiller.

Fanny Burney's novel *Camilla*.

Printing began in Australia.

Friedrich Arnold Brockhaus's *Konversations–Lexikon* (1796–1811).

d. Robert Burns, Scottish poet (b. 1759).

VISUAL ARTS

Thomas Jefferson began to rebuild his home at Monticello, Virginia.

J. M. W. Turner's painting *Fishermen at Sea*.

Gilbert Stuart's "Athenaeum" portrait of George Washington, and his full-length "Lansdowne" painting of Washington.

Hokusai's prints *Foreigners Observing Japanese Customs*.

Charles Bulfinch built his first of three houses for Harrison Grey Otis.

John Bacon's statue of *Dr. Johnson*.

d. William Chambers, architect (b. 1723).

THEATER & VARIETY

The Borderers, a Tragedy, William Wordsworth's history play.

George Colman the younger's *The Iron Chest*.

d. Richard Yates, English comedian (b. 1706).

MUSIC & DANCE

Ludwig van Beethoven's quintet for piano, oboe, clarinet, bassoon, and horn; his first two cello sonatas; and the song *Ah! perfido*.

Franz Joseph Haydn's oratorio *Die Sieben Letzen Worte (The Seven Last Words)*; his *Missa in tempore belli*, the *Paukenmesse*, and the *Missa St. Bernardi de Offida*, the *Heiligmesse*.

First public performance of the German anthem *Heil dir im Siegerkranz*. Heinrich Harries's 1790 poem, modified by B.G. Schumacher, sung to the music of Britain's *God Save the King*, which was used by many countries simultaneously.

Domenico Cimarosa's opera *Gli Orazi ed i Curiazi*.

d. Jean-Baptiste Lemoyne, French composer (b. 1751).

d. Stephen Storace, English composer (b. 1762).

WORLD EVENTS

George Washington's farewell address.

John Adams was elected second president of the

United States, defeating Thomas Jefferson, who became vice-president.

War of the First Coalition: Napoleon Bonaparte's Italian campaign resulted in a massive victory for France over the Allies.

Aga Mohammed of Persia seized Khorasan in Khuzistan.

Edward Jenner performed vaccination against smallpox.

1797

LITERATURE

Kubla Khan, Samuel Taylor Coleridge's unfinished poem, inspired by his dream about the Mongol emperor's palace.

d. Mary Wollstonecraft, English writer and women's rights advocate (b. 1759), best known for her *A Vindication of the Rights of Women*, died from complications after giving birth to her only child, Mary Wollstonecraft Shelley, English novelist (d. 1851), who would later write *Frankenstein*.

Johann Wolfgang von Goethe's narrative pastoral poem *Hermann und Dorothea*, on the love of a young German farmer for a refugee from the French Revolution; also his verses *Balladenjahr*.

Jane Austen began writing *Elinor*, which became *Sense and Sensibility* (1811).

Marquis de Sade's novel *Juliette*.

d. Horace Walpole, English author and historian (b. 1717).

VISUAL ARTS

Francisco de Goya's painting *The Duchess of Alba*; also his etching *Los Caprichos* (1797–1798).

J. M. W. Turner's painting *Limekiln at Coalbrookdale* (ca. 1797).

Thomas Bewick's illustrations in his *A History of British Birds* (*Land Birds*).

d. Joseph Wright of Derby, English painter (b. 1734).

THEATER & VARIETY

Elizabeth Inchbald's *Wives as They Were and Maids as They Are*.

George Colman the younger's *The Heir at Law*.

Guilbert Pixérécourt's *Les Petits Auvergnats*.

John Daly Burk's *Bunker-Hill; or, the Death of General Warren*.

Matthew Gregory Lewis's *The Castle Spectre*.

d. Charles Macklin, Irish actor (b. 1700).

MUSIC & DANCE

Médée (*Medea*), Luigi Cherubini's opera, libretto by Francois Benoit Hoffman, based on the 1635 Corneille tragedy, opened in Paris, March 13.

Franz Joseph Haydn's six string quartets dedicated to Count Joseph Erdödy, including the *Emperor*, *Fifths*, and *Sunrise*. Haydn also wrote the *Emperor's Hymn*, "Gott erhalte unsern Kaiser," to text by Lorenz Leopold Haschka, Austria's first national anthem, inspired by hearing Britain's *God Save the King*; Haydn's melody was later used for Germany's *Deutschland, Deutschland über alles*, to the 1841 poem by H. A. Hoffman von Fallersleben.

Le Jeune Henri, Etienne-Nicolas Méhul's dramatic musical work.

Ludwig van Beethoven's chamber music works, including his second string trio, the *Serenade*; his fourth piano trio; his fourth piano sonata; and a duet piano sonata.

WORLD EVENTS

British fleet defeated Spanish off Cape Vincent; Horatio Nelson emerged as major figure.

Charles Talleyrand became French foreign minister.

France occupied the Ionian Islands.

Immanuel Kant's *Metaphysical Foundations of the Theory of Right*.

1798

LITERATURE

Lyrical Ballads, by William Wordsworth and Samuel Taylor Coleridge, the first major work of the English Romantic period; included were Coleridge's *The Rime of the Ancient Mariner* and Wordsworth's *Lines Composed a Few Miles Above Tintern Abbey* and *Simon Lee*.

Aloys Senefelder developed the lithographic printing process (1796–1804).

Nicolas Louis Robert developed the first paper-

making machine to produce a continuous roll of paper, rather than single sheets (1798–1806).

Charles Brockden Brown's gothic novel *Wieland*.

Johann Wolfgang von Goethe edited the journal *Die Propyläen* (1798–1800).

Allgemeine Zeitung began publication under Johann Cotta in Leipzig.

Robert Southey's ballad *The Battle of Blenheim*.

VISUAL ARTS

Benjamin Henry Latrobe built the Bank of Pennsylvania, Philadelphia, one of the first examples of the Greek Revival style in America.

Francisco de Goya's paintings *Ferdinand Guillemardet* and *The Taking of Christ*; also his *A Miracle of St. Anthony of Padua* and other scenes.

J. M. W. Turner's paintings *Self-Portrait* (ca. 1798) and *Buttermere Lake, with Part of Cromack Water, Cumberland, a Shower.*

Comforts of Bath, Thomas Rowlandson's caricature.

THEATER & VARIETY

Park Theater, New York, opened with a production of *As You Like It*.

André, William Dunlap's tragedy, opened at the Park Theater March 30.

Thomas John Dibdin's *The Mouth of the Nile*.

MUSIC & DANCE

Franz Joseph Haydn's oratorio *The Creation* (*Die Schöpfung*) and *Missa in angustiis* (*Nelson Mass*).

Ludwig van Beethoven's *Piano Concerto No. 2*; the *Pathétique* and two other piano sonatas (1798–1799); his last three string trios; and his first three violin sonatas.

Blue Beard, Michael Kelly's dramatic work.

Simon Mayr's opera *Che originali*.

Griselda, Ferdinando Paer's opera.

Slide trumpet developed in England by John Hyde (ca. 1798).

WORLD EVENTS

France and Turkey were at war.

Horatio Nelson destroyed French fleet in Egypt at Aboukir Bay, at the Battle of the Nile.

Napoleon Bonaparte took Egypt for France, after French victory at the Battle of the Pyramids.

U.S. Alien and Sedition Acts unsuccessfully attacked dissenters in the new democracy.

Wolfe Tone, with French allies, led an unsuccessful Irish insurrection against British rule; Irish forces were decisively defeated at Vinegar Hill.

Thomas R. Malthus's *Essay on the Principle of Population*.

1799

LITERATURE

Charles Brockden Brown's gothic novels *Edgar Huntley, Or Memoirs of a Sleepwalker* (1799), *Ormond, Or the Secret Witness* (1799), and *Arthur Mervyn, or Memoirs of the Year 1793* (1799–1780).

VISUAL ARTS

J. M. W. Turner's paintings included *Harlech Castle* and *Kilgarran Castle*.

Francisco de Goya's paintings *La Tirana* and *Queen Maria Luisa on Horseback*.

Benjamin Henry Latrobe's Sedgeley House, one of the earliest examples of the Gothic Revival style in America.

d. John Bacon, English sculptor (b. 1740).

THEATER & VARIETY

Friedrich von Schiller's *Wallenstein*.

Richard Brinsley Sheridan's *Pizarro*.

Louis-Benoît Picard's *Le Collatéral, or la Diligence à Joigny*.

d. Beaumarchais (Pierre-Augustin Caron de Beaumarchais), French playwright (b. 1732).

d. Johann Christian Brandes, German actor and playwright (b. 1735).

MUSIC & DANCE

Franz Joseph Haydn's two string quartets dedicated to Prince Lobkowitz; also his *Mass*, the *Theriesienmesse*.

Ariodant, Étienne-Nicolas Méhul's dramatic musical work.

Camilla, Ferdinando Paer's opera.

WORLD EVENTS

Napoleon Bonaparte seized power in France, dissolving the Directory and ruling as first consul of the Consulate.

Austria, Britain, Russia, Turkey, Portugal, and Naples formed the Second Coalition against France; War of the Second Coalition began (1799–1801).

Alessandro Volta invented the electrical battery.

British in India took Mysore and the Carnatic.

1800

LITERATURE

Library of Congress founded at Washington, D.C.; originally intended for use by the U.S. Congress, it became one of the world's greatest public libraries.

Castle Rackrent, Maria Edgeworth's novel of absentee landlords in Ireland.

Thomas Campbell's ballad *Ye Mariners of England*.

Charles, Earl of Stanhope, built the first all-iron printing press.

Chentini, Javanese poem (18th c.).

First newspaper in South Africa, the English–Dutch *Cape Times Gazette and African Advertiser*.

Friedrich Schiller's verse work *Gedichte* (1800– 1803).

d. William Cowper, English poet (b. 1731).

VISUAL ARTS

Francisco de Goyas paintings included *The Naked Maja* (ca. 1800–1805), *The Clothed Maja* (ca. 1800–1805), and *The Family of Charles IV*.

J. M. W. Turner's painting *The Fifth Plague of Egypt*.

Hokusai's *Chushingura* series (I) (ca. 1800).

Jacques-Louis David's paintings included *Bonaparte Crossing Mount St. Bernard* and *Portrait de Mme. Récamier*.

Charles Bulfinch built his second of three houses for Harrison Grey Otis.

Thomas Girtin's painting *White House at Chelsea*.

António Francisco Lisboa's statues *Twelve Prophets* (1800–1805).

THEATRE & VARIETY

Thomas Morton's *Speed the Plough*.

Giacinto Gallina's *So Wags the World, My Child*.

Guilbert Pixérécourt's *A Tale of Mystery*.

MUSIC & DANCE

Ludwig van Beethoven's first symphony and first six string quartets; also his *Piano Concerto No. 3* (ca. 1800) and his *Septet*, as well as his fourth violin sonata, his horn sonata, and a piano sonata.

Luigi Cherubini's opera *Les Deux journées* (*The Water Carrier*).

Le Calife de Bagdad, Adrien Boieldieu's opera.

Hail Columbia!, by P. Fyls to the 1798 poem of Joseph Hopkinson, was first performed.

First true upright piano developed, in Vienna by Matthias Müller and in Philadelphia by Isaac Hawkins (ca. 1800).

Orchestras began to be led by nonplaying conductors, rather than from the violin or piano (ca. 1800).

Harpsichord manufacture virtually ceased, as interest in the instrument declined (ca. 1800).

The Italian word "oboe" with an English pronunciation replaced the older French term for the instrument, *hautbois* or *hautboy* (by early 19th c.).

Snare drums came to have brass shells instead of wood (ca. 1800).

Handbell ringing—the organized ringing of large sets of bells laid out on tables—was developed in Yorkshire and Lancashire (early 1800s).

d. Niccolò Piccinni, Italian composer (b. 1728).

WORLD EVENTS

Thomas Jefferson and Aaron Burr tied in U.S. presidential election.

U.S. capital was moved from Philadelphia to Washington, D.C..

War of the Second Coalition: battles of Magnano, Cassano, Trebbia River, Novi, Stockach, Zurich, Bergen, Alkmaar, Kastrikum, and Montebello

British forces took Malta.

France regained Louisiana from Spain.

William Herschel discovered infrared radiation .

1801

LITERATURE

Charles Brockden Brown's gothic novels *Clara Howard* and *Jane Talbot*.
Maria Edgeworth's novel *Belinda*.
The New York Evening Post founded.
François René de Chateaubriand's story *Atala*.

VISUAL ARTS

Lord Elgin removed statues by Phidias from the Athens Parthenon and placed them in the British Museum, later called the Elgin Marbles.
J. M. W. Turner's painting *Dutch Boats in a Gale* (*Bridgewater Seapiece*).
Hokusai's *Brocade Prints of the Thirty-six Poetesses*.
Jean-Auguste-Dominique Ingres's painting *The Envoys from Agamemnon*.

THEATER & VARIETY

Friedrich von Schiller's *Maria Stuart* and *The Maid of Orleans*.
Louis-Benoît Picard's *La Petite Ville*.

MUSIC & DANCE

Ludwig van Beethoven's overture and ballet *The Creatures of Prometheus*; his second string quintet; three piano sonatas, the *Moonlight*, *Pastoral*, and *quasi una fantasia*; his *Serenade* for flute, violin, and viola; and his fifth violin sonata, the *Spring*.
Franz Joseph Haydn's *Creation Mass* (mass No. 13); *Mass in B Flat Major*, the *Schöpfungmesse*; and oratorio *The Seasons*.
Ginevra di Scozia, Simon Mayr's opera.
Theater auf der Wieden opened in Vienna; it would see the first staging of Ludwig van Beethoven's *Fidelio* and many 19th-century operettas.
d. Domenico Cimarosa, Italian composer (b. 1749).
d. Johann Gottlieb Naumann, German composer (b. 1741).

WORLD EVENTS

British fleet commanded by Horatio Nelson defeated a Danish fleet off Copenhagen.

Thomas Jefferson was elected president by the U.S. House of Representatives, breaking an 1800 presidential election tie.
U.S. ships attacked North African Barbary pirates operating out of Tripoli (1801–1803).
Spain ceded Louisiana to France.
d. Paul I (b. 1754), czar of Russia, assassinated; succeeded by Alexander I.

1802

LITERATURE

Minstrelsy of the Scottish Border, Sir Walter Scott's first important published work, a three-volume collection of ballads (1802–1803).
New South Wales General Standing Orders, Australia's first printed book, produced by George Howe, a convict working as a government printer.
Friedrich Schiller's novel *Der Verbrecher aus verlorener Ehre*.
Jippensha Ikku's novel *Hizakurige*.
Samuel Taylor Coleridge's *Dejection: An Ode*.
Thomas Campbell's ballad *Hohenlinden*.
François René de Chateaubriand's *Le Génie du Christianisme* (*The Genius of Christianity*).
Edinburgh Review was founded in Scotland (1802–1929).

VISUAL ARTS

J. M. W. Turner's paintings included *Ships Bearing Up for Anchorage* ("Egremont Seapiece") and *The Tenth Plague of Egypt*.
Hokusai's *Fifty Fanciful Poets, Each with One Poem*.
Benjamin West's painting *Death on a Pale Horse*.
Thomas Girtin's painting *Panorama* of London.
Bertel Thorwaldsen's statue *Jason*.
d. George Romney, English painter (b. 1734).
d. Thomas Girtin, English landscape painter (b. 1775).

THEATER & VARIETY

Adam Gottlob Oehlenschläger's *Sanct-Hans Aften Spil*.
Thomas Holcroft's *A Tale of Mystery*.
d. Jean-François de la Harpe, French playwright (b. 1739).

MUSIC & DANCE

Ludwig van Beethoven's *Symphony No. 2*; six *Gellert Songs*; three violin sonatas; and various keyboard works, including three piano sonatas, *7 Bagatelles*, the *Eroica Variations*, and a set of other variations, among them six on an original theme. It was in this year that Beethoven realized his progressive deafness was incurable.

Franz Joseph Haydn's *Mass in B Flat Major*, the *Harmoniemesse*.

Carl Maria von Weber's *Mass in E Flat Major*, *Grosse Jugendmesse*.

First performance of the song that would later be known as *The Blue Bells of Scotland*, music by a Mrs. Jordan, words by Annie McVicar Grant.

I fuorusciti di Firenze, Ferdinando Paer's opera.

Johnann Nepomuk Hummel's *Piano Quintet*.

WORLD EVENTS

Napoleon Bonaparte was named lifetime first consul and became president of the Italian Republic; France annexed Piedmont, Parma, and Piacenza.

Britain and France were formally at peace, with the Peace of Amiens.

Jeremy Bentham's *Civil and Penal Legislation* propounded utilitarianism.

1803

LITERATURE

d. Johann Gottfried Herder, German writer (b. 1744).

VISUAL ARTS

J. M. W. Turner's paintings included *Calais Pier* and *Venus and Adonis* (1803–1805).

Henry Raeburn's painting *The McNab* (ca. 1803).

Hokusai's *A Picture Book of Kyoka* (1803–1804) and *Fuji in Spring*.

Humphry Repton's book *Observations on the Theory and Practice of Landscape Gardening*.

John Flaxman's statue of *Sir Joshua Reynolds* (1803–1813).

Benjamin Henry Latrobe oversaw the completion of the U.S. Capitol's south wing (1803–1807).

THEATER & VARIETY

Johann Wolfgang von Goethe's *Faust*.

Friedrich von Schiller's *The Bride of Messina*.

August von Kotzebue's *Die deutschen Kleinstadten*.

Frederick Reynolds's *The Caravan; or, the Driver and His Dog*.

d. Mlle. Clairon, French actress (b. 1723).

d. Vittorio Amedeo Alfieri, Italian playwright (b. 1749).

MUSIC & DANCE

Ludwig van Beethoven's oratorio *Christus am Ölberge* (*Christ on the Mount of Olives*); also his ninth violin sonata, the *Kreutzer*.

Adeste Fideles (*Oh, Come, All Ye Faithful*), the "Portuguese Hymn on the Nativity," first published in America.

Luigi Cherubini's opera–ballet *Anacréon*.

Proserpine, Giovanni Paisiello's opera.

Ferdinando Paer's opera *Sargino*.

d. (Domenico Maria) Gaspero Angiolini, Italian choreographer (b. 1731).

WORLD EVENTS

Britain and France were once again at war, beginning the worldwide Napoleonic Wars; earliest actions were in the Caribbean and South America (1803–1815).

Failed Irish rebellion against British rule, led by Robert Emmet, with French support.

Louisiana Purchase: France sold the United States huge territory from the Mississippi to the Rockies.

In the landmark *Marbury v. Madison*, the U.S. Supreme Court declared its power to hold a legislative act unconstitutional.

Ohio became a state.

1804

LITERATURE

Charles, Earl of Stanhope, developed a plaster method of the sterotype printing (ca. 1727) developed by William Ged.

William Blake's long mystical poem *Jerusalem*, his

symbolic poem *Milton*, and *The Emanation of the Giant Albion*.

d. Charlotte Ramsay Lennox, American writer (b. 1720).

VISUAL ARTS

J. M. W. Turner's paintings included *Boats Carrying Out Anchors and Cables to Dutch Men-of-War, in 1665* and *Narcissus and Echo*.

Thomas Bewick's illustrations for *A History of British Birds (Water Birds)*.

Benjamin Henry Latrobe began Baltimore Cathedral (1804–1818).

David Wilkie's painting *Pitlessie Fair*.

Hokusai's *Fifty-three Stations on the Tokaido*.

Jean-Auguste-Dominique Ingres's painting *Bonaparte as First Consul*.

Washington Allston's painting *The Rising of a Thunderstorm at Sea*.

d. George Morland, English painter (b. 1763).

THEATER & VARIETY

Friedrich von Schiller's *Wilhelm Tell*.

Johann Wolfgang von Goethe's *Die Natürliche Tochter*.

Heinrich von Kleist's *Die Familie Schroffenstein*.

d. Françoise Vestris, French actress (b. 1743).

MUSIC & DANCE

Beginning of Ludwig van Beethoven's "middle period," following recognition of progressive deafness; he completed two piano sonatas, including the *Waldstein*, and began several other major works, including his third symphony, the *Eroica*.

Ferdinando Paer's opera *Leonora*.

WORLD EVENTS

Lewis and Clark explored from St. Louis to the Pacific, with Shoshoni woman Sacagawea as guide and interpreter in the West (1804–1806).

Thomas Jefferson won a second presidential term.

Haitian revolutionary government of Jean-Jacques Dessalines massacred the remaining French on the island.

Napoleon Bonaparte became Emperor Napoleon I.

Napoleonic law code adopted in France; model for many later European codes.

Unsuccessful Serbian insurrection against Turks (1804–1813).

1805

LITERATURE

Sir Walter Scott's narrative poem, *The Lay of the Last Minstrel*, about the love between Lady Margaret and Baron Henry, whose families were deadly enemies.

Johann Wolfgang von Goethe's verse work, *Epilog zu Schillers Glocke*, and the critical work *Winkelmann und sein Jahrhundert*.

d. Friedrich Schiller, German writer (b. 1759).

d. Jane Elliot, Scottish poet (b. 1727).

VISUAL ARTS

Franklin Drawing Electricity from the Sky, Benjamin West's painting.

J. M. W. Turner's painting *The Shipwreck*.

Charles Bulfinch built his third house for Harrison Grey Otis (1805–1806).

Jacques-Louis David's paintings included *Napoleon Crowning the Empress Josephine* (1805–1807) and his *Portrait du Pape Pie VII*.

Henry Raeburn's painting *Mrs. James Campbell* (ca. 1805).

Jean-Auguste-Dominique Ingres's painting *Mme Philibert Rivière*.

John Crome's painting *Slate Quarries*.

THEATER & VARIETY

Elizabeth Inchbald's *To Marry, or Not to Marry*.

Thomas Dibdin's *Nelson's Glory*.

Thomas Morton's *The School of Reform; or, How to Rule a Husband*.

d. (Johann Christoph) Friedrich von Schiller, German playwright and poet (b. 1759), a leading figure in the *Sturm und Drang* movement, many of whose stage works were produced by Goethe at Weimar.

d. Arthur Murphy, English actor and playwright (b. 1727).

MUSIC & DANCE

Eroica Symphony, Ludwig van Beethoven's third, received its first public performance at the Theater an der Wien, Sunday evening, April 7; the dedication was originally intended for Napoleon, but had been changed as his truer nature became more obvious.

Fidelio, Ludwig van Beethoven's opera, including *Leonore* overture No. 2, book by Joseph Sonnleithner and Georg Sonnleithner, premiered at the Theater auf der Wien, Vienna, November 20; Beethoven conducted (rev. 1806; 1814, with *Fidelio Overture*).

Appassionata, one of Ludwig van Beethoven's finest piano sonatas; also his song *An die Hoffnung*.

Jean Aumer's ballet *Rosina et Lorenzo*.

Filippo Taglioni made his debut as a choreographer with *Atalante und Hippomenes*, in Vienna.

Keys were added to the small Northumbrian bagpipes (ca. 1805).

d. Luigi Boccherini, Italian composer and cellist (b. 1743).

WORLD EVENTS

British fleet commanded by Horatio Nelson destroyed the combined French and Spanish fleets at Trafalgar; Nelson died in battle.

War of the Third Coalition: battles of Ulm, Caldiero, Dürrenstein, and Hollabrunn; Napoleon's decisive victory at the massive battle of Austerlitz, which took Austria out of the war.

Haitian Civil Wars began (1805–1820).

Mungo Park explored on the Niger.

Napoleon became king of Italy.

1806

LITERATURE

First university chair of English literature in the United States, at Harvard University, occupied by later-President John Quincy Adams.

Sir Walter Scott's *Ballads and Lyrical Pieces*.

VISUAL ARTS

Arch of Triumph (*Arc de Triomphe de l'Étoile*), Paris arch honoring troops of Napoleon Bonaparte and Unknown Soldier, built by Jean-François Chalgrin (1806–1836).

J. M. W. Turner's painting *The Victory Returning from Trafalgar*.

Francisco de Goya's painting *Doña Isabel de Porcel* (ca. 1806).

Henry Raeburn's painting *Lord Newton* (ca. 1806).

Hokusai's prints *Chushingura* series (II).

Anne-Louis Girodet de Roucy's painting *Déluge*.

Jean-Auguste-Dominique Ingres's paintings included *Napoleon I on the Imperial Throne* and *François-Marcus Granet* (ca. 1806).

Antoine-Jean Gros's painting *The Battle of Aboukir*.

Charles Wilson Peale's painting *The Exhumation of the First American Mastodon*.

d. Jean-Honoré Fragonard, French painter (b. 1732).

d. George Stubbs, English animal painter and etcher (b. 1724).

d. Claude-Nicolas Ledoux, French architect (b. 1736).

d. James Barry, Irish history painter (b. 1741).

THEATER & VARIETY

Leandro Fernández de Moratín's *When a Girl Says Yes*.

d. Carlo Gozzi, Italian playwright (b. 1720).

d. Collin d'Harleville, French playwright (b. 1755).

MUSIC & DANCE

Ludwig van Beethoven's *Symphony No. 4*; *Piano Concerto No. 4*; *Violin Concerto*; *Leonore Overture No. 3*; the keyboard work *32 variations in C*; and the three *Razumovsky* string quartets, the final movement of the first including a Russian folk theme requested by Count Razumovsky, to whom they were dedicated.

Faniska, Luigi Cherubini's opera.

Rodolphe Kreutzer's ballet *Paul et Virginie*.

Uthal, Etienne-Nicolas Méhul's dramatic musical work.

Jean-Louis Duport's *Essai sur le doigter*, the classic work on cello fingering.

WORLD EVENTS

Formal end of the Holy Roman Empire, which became Austria.

Napoleon's "Continental System" declared a

blockade of Britain and closed European ports to British ships; Britain blockaded French ports.

War of the Third Coalition: battles of Saalfeld, Auerstädt, Jena, Halle, Tscharnovo, Pultusk, and Golymin.

Russia and Turkey were at war.

1807

LITERATURE

William Wordsworth's collection *Poems in Two Volumes*, including most notably *The Daffodils*, *Composed upon Westminster Bridge*, *I Wandered Lonely as a Cloud*, and *The Solitary Reaper*; also his *Ode: Intimations of Immortality from Recollections of Early Childhood*.

Byron's *Hours of Idleness: A Series of Poems, Original and Translated*, his first published work, savaged by critics in the *Edinburgh Review*.

Tales from Shakespeare, Charles and Mary Lamb's adaptations for children.

Washington Irving's satirical writings *Salmagundi; or, The Whim-Whams and Opinions of Launcelot Langstaff, Esq., and Others* (1807–1808).

Thomas Moore's *Irish Melodies*, lyrics set to traditional folk tunes (1807–1835).

George Crabbe's long poem *The Village*.

Joel Barlow's epic *The Columbiad*.

VISUAL ARTS

J. M. W. Turner's paintings *Sun Rising Through Vapour: Fishermen Cleaning and Selling Fish* and *Thames Sketches* (ca. 1807).

Hokusai's painting *Suikoden*.

d. Angelica Kauffmann, Swiss painter (b. 1740).

d. John of York Carr, English architect (b. 1723).

d. John Opie, English painter (b. 1761).

THEATER & VARIETY

Adam Gottlob Oehlenschläger's *Baldur hin Gode* and *Hakon Jarl hin Rige*.

MUSIC & DANCE

Ludwig van Beethoven's *Mass*, *Coriolan Overture*, and *Leonore Overture No. 1*.

La vestale (*The Vestal Virgin*), Gaspare Spontini's opera, libretto by Etienne de Jouy, opened at Paris's Popera Theatre, December 15.

Milan Conservatory founded, an important training ground for La Scala artists; in 1901 it would be renamed Conservatorio di Musica "Giuseppe Verdi."

Joseph, Etienne-Nicolas Méhul's dramatic musical work.

WORLD EVENTS

War of the Third Coalition: battles of Möhrungen, Ionkovo, Hoff, Eylau, Danzig, Heilsberg, and Friedland.

Boston Athenaeum founded.

Deposing Selim III of Turkey, Mustapha IV became Ottoman Sultan.

France took Portugal; the Portuguese royal family fled to Brazil.

Georg Hegel's *Phenomenology of Spirit*.

1808

LITERATURE

Marmion: A Tale of Flodden Field, Sir Walter Scott's romantic narrative poem about Lord Marmion, slain at the Battle of Flodden Field, who had rejected his love in hopes of a wealthy wife.

The Examiner began publication, edited by Leigh Hunt.

VISUAL ARTS

Amsterdam's Rijksmuseum was founded.

J. M. W. Turner's paintings included *The Confluence of the Thames and the Medway*, *The Forest of Bere*, and *Spithead: Boat's Crew Recovering an Anchor*.

Anne-Louis Girodet de Roucy's painting *The Entombment of Atala*.

Jean-Auguste-Dominique Ingres's paintings included *Oedipus and the Sphinx* and *Valpinçon Bather*.

Antoine-Jean Gros's painting *The Battle of Eylau*.

Pierre-Paul Prudhon's painting *Justice and Divine Vengeance Pursuing Crime*.

Thomas Rowlandson's caricature *The Miseries of Life*.

d. Joseph Bonomi, Italian-English architect (b. 1739).

THEATER & VARIETY

Johann Wolfgang von Goethe's *Faust I* and *Pandoras Wiederkunft*.

James Nelson Barker's *The Indian Princess*.

The Broken Jug, Heinrich Kleist's play.

d. John Daly Burke, Irish-born playwright who settled in America (b. 1775).

MUSIC & DANCE

Ludwig van Beethoven's *Symphony No. 5*, with its "Victory" theme made famous during World War II; *Symphony No. 6*, the *Pastoral*; the fifth and sixth piano trios, including the *Ghost Trio*; the third cello sonata; and the *Choral Fantasy*. By now, Beethoven's career as a pianist had effectively ended, due to his deafness.

Thomas Moore's *Selection of Irish Melodies* (1808–1834), which sparked interest in Irish folk music.

Les Amours d'Antoine et Cléopatre, Jean Aumer's ballet.

Rodolphe Kreutzer's comedy *Aristippe*.

WORLD EVENTS

France took Spain, beginning the Peninsular War; massive rising against French occupation began in Madrid, spread throughout Spain; British force under Arthur Wellesley (duke of Wellington) joined Spanish forces.

David Thompson explored and mapped the Columbia River (1808–1812).

James Madison was elected U.S. president.

Slave trade was prohibited by law in the United States.

1809

LITERATURE

Washington Irving's satire *A History of New York from the Beginning of the World to the End of the Dutch Dynasty*, introducing Diedrich Knickerbocker; Irving and other early 19th-century New York-based writers were called the Knickerbocker Group.

English Bards and Scotch Reviewers: A Satire, Byron's response to the critical savaging of his *Hours of Idleness*.

Johann Wolfgang von Goethe's symbolic novel *Die Wahlverwandtschaften*.

Thomas Campbell's ballads *Lord Ullin's Daughter* and *The Battle of the Baltic*.

d. Thomas Paine, American writer (b. 1737).

VISUAL ARTS

J. M. W. Turner's paintings included *Fishing Upon the Blyth-Sand*, *Tide Setting In*, *Guardship at the Great Nore*, *Sheerness*, and *Trout Fishing in the Dee*.

Jacques-Louis David's painting *Sappho and Phaon*.

John Constable's painting *Malvern Hall, Warwickshire*.

John Flaxman's monument to Lord Nelson.

THEATER & VARIETY

New Covent Garden Theatre, rebuilt after an 1808 fire, opened in London.

d. Thomas Holcroft, English playwright (b. 1722), whose melodramas played a major role in establishing the form on the English-speaking stage.

d. Hannah Parkhouse Cowley, English playwright (b. 1743).

MUSIC & DANCE

Ludwig van Beethoven's *Emperor Concerto*, his fifth piano concerto; the *Harp* string quartet; two piano sonatas; *6 Songs*; and *4 Ariettas and Duet* (ca. 1809).

Fernand Cortez, Gaspare Spontini's dramatic musical work (rev. 1817).

Carl Maria von Weber's chamber music *Grand Quatuor*.

Ferdinando Paer's opera *Agnese*.

d. Franz Joseph Haydn, Austrian composer (b. 1732).

d. Nicolas-Marie Dalayrac, French composer (b. 1753).

WORLD EVENTS

Austrian–French War: battles of Sacile, Abensberg, Landshut, Eggmühl, Ebersberg, Aspern-Essling, Raab, and Wagram; defeated Austria ended the war with major territorial losses.

Peninsular War: battles of Uclés, Corunna,

Saragossa, Medellín, Oporto, Gerona, Talavera, Almonacid, Ocaña, and Alba de Tormes.
Napoleon took the Papal States.

1810

LITERATURE

The Lady of the Lake, Sir Walter Scott's long narrative poem about Ellen Douglas and her suitors, against the backdrop of border wars.

George Crabbe's poetic work *The Borough*, which included the tale of Peter Grimes, basis for Benjamin Britten's 1945 opera.

Esaias Tegnér's poem *Det eviga*.

Johann Wolfgang von Goethe's prose work *Zur Farbenlehre*.

d. Charles Brockden Brown, American author (b. 1771).

VISUAL ARTS

J. M. W. Turner's paintings included *Dorchester Mead, Oxfordshire*, and *Cockermouth Castle*.

Francisco de Goya's paintings included *Allegory of the City of Madrid*, *General Manuel Romero* (ca. 1810), *The Colossus*, and *Time and the Old Women* (ca. 1810–1812); and his etching *Los desastres de la guerra*.

Jean-Auguste-Dominique Ingres's painting *Monsieur Marcotte*.

Hokusai's *Portraits of Six Poets* (ca. 1810).

Jacques-Louis David's painting *Napoleon Distributing the Eagles*.

John Cotman's painting *Landscape with River and Cattle* (ca. 1810).

Charles Bulfinch's Boston Court House.

THEATER & VARIETY

Heinrich Kleist's *Käthchen von Heilbronn* and *Prinz Friedrich von Homburg*.

Adam Gottlob Oehlenschläger's *Axel og Valborg*.

James Sheridan Knowles's *Leo; or, the Gypsy*.

MUSIC & DANCE

Les Adieux, Ludwig van Beethoven's 26th piano sonata; his preferred title was *Das Lebewohl*, refer-

ring to the farewell, absence, and return to Vienna of Archduke Rudolph.

Ludwig van Beethoven's *Serioso* string quartet; *3 Goethe songs*; and *Egmont*, incidental music, including an overture.

Cendrillon, Nicolas Isouard's fairy-tale opera.

Nicolò Paganini toured Italy (1810–1828), giving virtuoso violin performances.

Surbahar, a large form of sitar, developed in India, especially popular in Bengal (early 19th c.).

d. Jean-Georges Noverre, French choreographer and dancer (b. 1727).

WORLD EVENTS

Peninsular War: battles of Ciudad Rodrigo, Almeida, and Busaco.

Mexican War of Independence began (1810–1821).

South American Wars of Independence from Spain began (1810–1825).

Spain lost Gulf Coast territories to the United States.

University of Berlin founded.

1811

LITERATURE

Sense and Sensibility, Jane Austen's first published (though not her first written) novel, about the Dashwood sisters, sensible Elinor and unrestrained Marianne, and their search for love and marriage.

Johann Wolfgang von Goethe's autobiography *Aus meinem Leben, Dichtung und Wahrheit* (1811–1822).

Sir Walter Scott's poem *The Vision of Don Roderick*.

VISUAL ARTS

J. M. W. Turner's paintings *Somer Hill, Tunbridge* and *Mercury and Horse*.

David Wilkie's painting *The Village Festival*.

Washington Allston's painting *Dead Man Revived* (1811–1813).

John Nash designed Regent's Park and Regent's Street, London.

THEATER & VARIETY

Matthew Gregory Lewis's *Timour the Tartar*.

Louis-Benoît Picard's *La Vielle Tante*.
d. Heinrich von Kleist, German playwright (b. 1777).
d. Marie-Joseph Chénier, French playwright (b. 1764).
d. Richard Cumberland, English playwright (b. 1732).

MUSIC & DANCE

Archduke Trio, Ludwig van Beethoven's final piano trio, named for its dedication to Archduke Rudolph of Austria; also Beethoven's dramatic musical works *The Ruins of Athens* and *King Stephen*.
Carl Maria von Weber's Singspiel (musical play) *Abu Hassan*, libretto by F. C. Heimer based on *The 1001 Nights* (*Arabian Nights*); also von Weber's *Bassoon Concerto* and clarinet concertos *No. 1* and *No. 2*.
Les amazones, Etienne-Nicolas Méhul's opera.
Londoner Robert Wornum developed a "cottage piano," an upright designed for use in the home.
Harp-lute for use by "ladies" developed by Edward Light in England.

WORLD EVENTS

Peninsular War: battles of Gebora, Barrosa, Sabugal, Fuentes de Oñoro, La Albuera, Tarragona, Saguntum, Arroyo dos Molinos, and Murviedro.
Battle of Tippecanoe (Indiana): Native American forces led by Tecumseh were defeated by U.S. forces led by William Henry Harrison; American settlers continued to push west.
Paraguayan War of Independence began.
Venezuela won independence from Spain.
North English "Luddites" protest working conditions by destroying machines.
Great earthquake at New Madrid, Missouri.

1812

LITERATURE

Childe Harold's Pilgrimage, Byron's widely popular narrative poem in Spenserian stanzas, began publication with cantos 1 and 2, telling of its melancholy hero's solitary wanderings through historical Europe (1812–1818).
Esaias Tegnér's *Skaldens morgonpsalm*.
Jacob and Wilhelm Grimm's first folktale collection *Kinder-und Hausmärchen* (*Children's and Household Tales*), later world famous as *Grimm's Fairy Tales* (1812–1813).
Maria Edgeworth's novels *The Absentee* and *Vivian*.
Per Daniel Amadeus Atterbom's poems *Blommorna*.
d. Joel Barlow, American writer (b. 1754).

VISUAL ARTS

Francisco de Goya's paintings included *The Duke of Wellington, Mariano Goya* (ca. 1812–1814), and *The Majas on the Balcony* (ca. 1812).
J. M. W. Turner's paintings included *Snowstorm: Hannibal and His Army Crossing the Alps* and *Bridge Mill, Devonshire*.
Jean-Auguste-Dominique Ingres's paintings *Romulas Victorious over Acron* and *Virgil Reading the Aeneid* (ca. 1812).
Jacques-Louis David's painting *Napoleon in His Study*.
Thomas Rowlandson's caricatures in *The Tours of Dr. Syntax*, (1812–1820).
Jean Louis Géricault's painting *Light Cavalry Officer*.
John Flaxman's statue of William Pitt.
d. Charles Cameron, Scottish architect (b. 1740).

THEATER & VARIETY

d. Isaac Bickerstaffe, English playwright (b. 1735), a leading writer of ballad operas and a major figure on the London stage from the early 1760s until he was forced to leave England to avoid criminal charges (1772).
Joseph Jefferson opened in Philadelphia in the title role of *Wilhelm Tell*.

MUSIC & DANCE

Ludwig van Beethoven's symphonies *No. 7* and *No. 8*; also his last violin sonata.
Gioacchino Rossini's operas *The Silken Ladder* and *The Touchstone*.
Tancredi, Gioacchino Rossini's opera, libretto by Gaetano Rossi, based on Voltaire's *Tancrède*, premiered in Venice, February 6.

WORLD EVENTS

Franco-Russian War: Napoleon invaded Russia with massive Grand Army, winning battle after battle,

climaxing at Borodino, and took Moscow in September. The long French retreat from Moscow began on October 9; it cost the French most of their fighting force.

Peninsula War: battles of Ciudad Rodrigo, Badajoz, Salamanca, Bornos, Castalla, and Burgos.

James Madison was elected U.S. president.

U.S.–British War of 1812 began (1812–1814).

Louisiana became a state.

1813

LITERATURE

Jane Austen published her deftly comic novel *Pride and Prejudice* (written 1796–1797 as *First Impressions* and rejected for publication), introducing not only the willfully crossed lovers, Elizabeth Bennet and Fitzwilliam Darcy, but notable minor portraits, as of the self-important Mr. Collins and Lady Catherine de Bourgh.

The Swiss Family Robinson, Swiss writer J. R. Wyss's widely translated children's novel about a clergyman, his wife, and their four sons shipwrecked on a desert island.

Queen Mab, a Philosophical Poem, Percy Bysshe Shelley's attack on the restrictions of orthodox Christianity.

Thomas Moore's poem *'Tis the Last Rose of Summer*.

Sir Walter Scott's poems *Rokeby* and *The Bridal of Triermain*.

Byron's poems *The Bride of Abydos* and *The Giaour*.

d. J. Hector St. John de Crèvecoeur (Michel-Guillaume Jean de Crèvecoeur), French-born American writer (b. 1735).

VISUAL ARTS

J. M. W. Turner's paintings included *Falmourth Harbor*, *Frosty Morning*, and *A River Valley*.

Washington Allston's *The Dead Man Restored to Life by Touching the Bones of the Prophet Elisha*.

Samuel Morse's painting *Dying Hercules*.

William Collins's painting *Disposal of a Favourite Lamb*.

d. James Wyatt, English architect (b. 1746).

THEATER & VARIETY

Adolf Bäuerle's *Die Bürger in Wien*.

d. Yakov Emelyanovich Shusherin, Russian actor (b. 1753).

MUSIC & DANCE

The Italian Girl in Algiers, Gioacchino Rossini's opera, libretto by Angelo Annelli, opened at Venice's Teatro San Benedetto, May 22.

Gioacchino Rossini's opera *Il Signor Bruschino*.

Franz Schubert's first symphony and the dramatic musical work *Des Teufels Lustschloss* (1813–1814), not publicly performed until 1879.

Wellington's Victory, Ludwig van Beethoven's battle symphony, originally written for the orchestrion, or mechanical orchestra.

Nicolò Paganini's bravura violin piece, variations on *Le streghe*.

Johannes Cotta wrote the music for the German anthem *Was ist des Desutschen Vaterland?*, text by E. N. Arndt; G. Reichardt later wrote alternative music (1826).

Argentina's national anthem, "Oid, mortales, el grito sagrado Libertad," was written by José Blas Parera, to a poem by Vicente López y Planes.

Simon Mayr's operas *La rosa bianca e la rosa rossa* and *Medea in Corinto*.

Faust, Louis Spohr's opera.

d. André-Ernest-Modeste Grétry, French composer (b. 1741).

d. Giuseppe Aprile, Italian castrato singer and singing teacher (b. 1732).

WORLD EVENTS

European alliance led by Prussia, Russia, Britain, and Sweden defeated Napoleon's forces in a series of major battles in Germany, including Lützen, Bautzen, Dresden, Dennewitz, and the massive Battle of the Nations at Leipzig.

Peninsular War: battles of Castalla, Vitoria, Ordal, Pyrénées, San Sebastian, San Marceil, Bidassoa River, Nivelle River, Nive River, Bayonne, Orthez, and Toulouse.

War of 1812: Battle of Lake Erie; U.S. invasion of Canada.

U.S. Creek War began in the American South (1813–1814).

1814

LITERATURE

Sir Walter Scott's *Waverley*, the first of his popular series of 32 historical novels, this one set against Bonnie Prince Charlie's reach for the English throne.

Library of Congress partly burned during British attack on Washington, but reestablished from Thomas Jefferson's personal library.

(Lord) George Gordon Byron's poetic works *The Corsair* and *Lara: A Tale*.

First use of a power printing press, by the *Times* of London; developed by German printer Friedrich Koenig.

Mansfield Park, Jane Austen's novel.

Fanny Burney's *The Wanderer, or Female Difficulties*.

Kyokutei Bakin's novel *Nanso Satomi Hakkenden* (1814–1841).

Stendhal's prose work *Vies de Haydn, de Mozart et de Métastase*.

William Wordsworth's poem *The Excursion*.

d. Marquis de Sade (Donatien Alphonse François Sade), French novelist (b. 1740).

VISUAL ARTS

Francisco de Goya's paintings included *The 2nd of May 1808 in Madrid: The Charge of the Mamelukes, The 3rd of May 1808: The Execution of the Defenders of Madrid, Ferdinand VII in an Encampment* (ca. 1814), and *Young Women with a Letter* (ca. 1814–1818).

J. M. W. Turner's paintings included *Lake Avernus: Aeneas and the Cumacan Sybil* (1814–1815).

Hokusai's *Hokusai manga*, volume 1.

Jacques-Louis David's painting *Léonidas aux Thermopyles*.

Samuel Morse's painting *Judgment of Jupiter*.

Washington Allston's painting *Saint Peter in Prison*.

d. António Francisco Lisboa, Brazilian sculptor and architect (b. ca. 1738).

THEATER & VARIETY

d. Philip Astley, trick rider and circus impresario (b. 1742), who built Astley's Amphitheatre on the south bank of the Thames in 1784, after having worked in the circus on the Continent and in England; the creator of the modern circus.

d. August Wilhelm Iffland, German actor and playwright (b. 1759), long associated wth Mannheim's National Theatre, and also with Goethe at Weimar.

d. Charles Dibdin, English actor, playwright, and composer of many ballads and ballad operas; also a notable solo performer (b. 1745).

MUSIC & DANCE

The Star-Spangled Banner, poem written by Francis Scott Key on board H.M. Frigate *Surprise* in Baltimore Harbor, September 14; set to music by John Stafford Smith (based on his *To Anacreon in Heaven*), it became the United States' national anthem.

The Turk in Italy, Gioacchino Rossini's opera, libretto by Felice Romani, premiered at La Scala, Milan, August 14.

Ludwig van Beethoven's choral work *Der glorreiche Augenblick*.

Franz Schubert's song *Gretchen am Spinnrade*.

Nicolas Isouard's operas *Jeannot et Colin* and *Joconde*.

Stalybridge Old Band founded; regarded as the first of the working-men's bands that became so popular in Britain.

WORLD EVENTS

Allied forces attacked France, and in a series of battles defeated Napoleon's remaining armies and took Paris. Napoleon abdicated on April 6, and went into exile on Elba.

Peninsular War: battles of Bayonne, Orthez, and Toulose.

Congress of Vienna convened.

War of 1812: Washington, D.C., taken and partially burned by British; Battle of Champlain; Treaty of Ghent ended war December 24.

U.S.–Creek Indian War: U.S. forces led by Andrew Jackson defeated Creek forces at the Battle of Horseshoe Bend, effectively ending war.

British took Nepal from Gurkhas (1814–1816).

1815

LITERATURE

Emma, Jane Austen's novel centered on Miss Wood-

house of Highbury and the misconceptions and misguided plans she entertains on the way to maturity.

Adolphe, the novel by Swiss-born French politician and writer Benjamin Constant, based partly on his relationship with Madame de Staël; regarded as an early psychological novel.

Guy Mannering, Sir Walter Scott's novel of coincidences, introducing characters such as Dandie Dinmont and Meg Merrilies; Scott also published the poem *The Lord of the Isles*.

Byron's poem *The Destruction of Sennacherib*.

Aleksandr Pushkin's ballad *The Cossack*.

Alessandro Manzoni's poems *Inni sacri* (1815–1822).

William Wordsworth's poem *The White Doe of Rylstone*.

The North American Review began publication.

VISUAL ARTS

J. M. W. Turner's paintings included *Dido Building Carthage* and *Crossing the Brook*.

John Constable's painting *Boatbuilding near Flatford Mill*.

Francisco de Goya's work included the etching *La tauromaquia* (1815–1816) and a *Self-Portrait*.

Jacques-Louis David's painting *Three Women of Ghent* (ca. 1815).

John Nash rebuilt Brighton Pavilion (1815–1823).

Jean-Auguste-Dominique Ingres's drawing *The Family of Lucien Bonaparte*.

d. John Singleton Copley, American painter (b. 1738).

d. James Gillray, English caricaturist (b. 1757).

d. Kiyonaga Torii, Japanese color-print artist (b. 1752).

THEATER & VARIETY

Johann Wolfgang von Goethe's *Des Epimenides Erwachen*.

Eugène Scribe's *Une Nuit de la Garde Nationale*.

Giambattista Niccolini's *Nabucco*.

d. Frances Abington, English actress (b. 1737).

MUSIC & DANCE

Elisabetta, regina d'Inghilterra (*Elizabeth, Queen of England*), Gioacchino Rossini's opera, libretto by Giovanni Schmidt, opened at the San Carlos Theatre, Naples, October 4, with Isabella Colbran creating the title role.

Carl Maria von Weber's chamber music *Grosses Quintett*.

Franz Schubert's opera *Claudine von Villa Bella*; his choral works *God in the Storms* (ca. 1815) and *Hymn to Infinity*; his second and third symphonies; and the songs *Heidenröslein* and *Erlkönig*.

Ludwig van Beethoven's final two cello sonatas; the choral work *Calm Sea and Prosperous Voyage*; and *Nameday* overture.

J. N. Maelzel invented a clockwork type of metronome for keeping time in music, the notation M.M. meaning Maelzel's metronome.

Valves for brass musical instruments first patented by horn players Heinrich Stoelzel and Friedrich Blühmel.

d. Sergei Ivanovich Taneyev, Russian composer (b. 1856).

WORLD EVENTS

Congress of Vienna reordered the post-Napoleonic map of Europe, with victors dividing up the French empire and setting a series of major power balances that would last essentially unchanged until World War I.

Napoleon escaped from Elba, reentered France, and in the "Hundred Days" raised a new army. He was defeated by Allied forces led by the Duke of Wellington at Waterloo on June 18, abdicated, and was exiled permanently to St. Helena.

U.S. forces led by Andrew Jackson decisively defeated British forces at Battle of New Orleans on January 8, after War of 1812 had ended.

U.S.–Algeria war: U.S. naval operations against Algeria, Tunis, and Tripoli ended with capitulation of all three.

1816

LITERATURE

On First Looking into Chapman's Homer, John Keats's first published poem; also his *On Solitude*.

Byron's poetic works, including canto 3 of *Childe Harold's Pilgrimage*, *The Siege of Corinth*, *Parisina*, and *The Prisoner of Chillon*, about a 16th-century

victim of religious persecution, imprisoned so long that his "very chains and I grew friends."

Italienische Reise (*Italian Journey*), Johann Wolfgang von Goethe's description of 1786–1788 travels in Italy; Goethe also began editing the periodical *Über Kunst und Altertum* (1816–1832).

William Nicholson improved printing by developing the first curved stereotypes, which could be fitted to press cylinders.

Sir Walter Scott's novels *Old Mortality*, *The Black Dwarf*, *Tales of My Landlord* (first series), and his personal favorite *The Antiquary*.

Jacob and Wilhelm Grimm's *Deutsche Sagen* (*German Legends*).

Bengal Gazette, the first Indian-owned newspaper, begun by Gangadhar Bhattacharjee.

Airs of Palestine, John Pierpont's poem.

José Fernández de Lizardi's satirical novel *The Itching Parrot*.

Rommohan Roy's notable English translation of four *Upanishads* (1816–1820).

William Wordsworth's *Thanksgiving Ode*.

VISUAL ARTS

French Académie, dissolved in 1793, was refounded as the Académie des Beaux Arts.

Fitzwilliam Museum, Cambridge University, was founded.

J. M. W. Turner's painting *View of the Temple of Jupiter Panellenius, with the Greek National Dance of the Romaika*.

John Wesley Jarvis's painting *Commodore Oliver Hazard Perry at the Battle of Lake Erie*.

Benjamin West's painting *Christ Healing the Sick*.

John Constable's painting *Wivenhoe Park, Essex*.

Charles Bulfinch's Congregational Church at Lancaster, Massachusetts.

John Martin's painting *Joshua Commanding the Sun to Stand Still*.

THEATER & VARIETY

Louis-Benoît Picard's *Les Deux Philibert*.

d. Richard Brinsley Sheridan, English playwright (b. 1751), most notably by far as author of the *The Rivals* and *The School for Scandal*; also an owner and manager of the Drury Lane Theatre.

d. Dorothy Jordan, English actress, long associated

with comedy and London's Drury Lane Theatre (b. 1761).

d. Friedrich Ludwig Schröder, German actor (b. 1744).

MUSIC & DANCE

Gioacchino Rossini's *The Barber of Seville* (*Il Barbiere di Siviglia*), opera, libretto by Cesare Sterbini, based on the 1775 Beaumarchais play, premiered at the Teatro Argentina, Rome, February 20; considered by some the finest Italian comic opera, though at first a failure.

Franz Schubert's symphonies *No. 4*, the *Tragic*, and *No. 5*.

Ludwig van Beethoven's song cycle *An die ferne Geliebte* (*To the Distant Beloved*), settings of six poems by Alois Jeitteles.

La Journée avec aventures, Etienne-Nicolas Méhul's dramatic musical work.

Johnann Nepomuk Hummel's *Septet* (ca. 1816).

Luigi Cherubini's *Requiem*.

Thomas Moore's *Sacred Songs*.

José Maurício Nunes Garcia's *Requiem*.

d. Anna Lucia De Amicis, Italian soprano (b. 1733).

d. Giovanni Paisiello, Italian composer (b. 1740).

WORLD EVENTS

James Monroe was elected U.S. president.

Argentina declared its independence from Spain.

Simon Bolivar led New Grenada forces invading Venezuela.

Ghent University was founded.

Indiana became a state.

1817

LITERATURE

d. Jane Austen, English novelist (b. 1775); her final complete novels, published in the year of her death, were: *Northanger Abbey*, a gentle mockery of gothic novels, and *Persuasion*, a study of country life and the waste attendant on obeying society's sanctions.

Thanatopsis, William Cullen Bryant's poem, a meditation on death, drawing comfort from nature and the thought that all eventually join the "innumer-

able caravan" and "lie down to pleasant dreams" in the grave.

The Poems of John Keats, his first published collection.

Lalla Rookh, Thomas Moore's four romantic verse tales, told within a prose story, the title character and narrator being the daughter of the emperor of Delhi.

Byron's poems *Manfred: A Dramatic Poem* and *The Lament of Tasso*.

Aleksandr Pushkin's *Ode to Freedom*.

Blackwood's Magazine began publication as a Tory journal in Scotland; it lasted until 1988.

Johann Wolfgang von Goethe's journal *Zur Naturwissenschaft überhaupt, besonders zur Morphologie* (1817–1823).

Ormond, Maria Edgeworth's novel.

Sir Walter Scott's poem *Harold the Dauntless*.

Stendhal's prose works *Histoire de la peinture en Italie* and *Rome, Naples et Florence en 1817*.

William Hazlitt's essay collections *The Characters of Shakespeare's Plays* and *The Round Table*, the latter with Leigh Hunt.

Visual Arts

J. M. W. Turner's painting *The Decline of the Carthaginian Empire*.

Flatford Mill on the River Stour, John Constable's painting.

Jean Géricault's painting *The Raft of Medusa*.

Bertel Thorwaldsen's portrait bust of Byron.

Francisco de Goya's painting *SS. Justa and Rufina*.

Washington Allston's painting *Jacob's Dream*.

Jacques-Louis David's painting *Cupid and Psyche*.

d. Giacomo Quarenghi, Italian architect (b. 1744).

Theater & Variety

The Ancestress, Franz Grillparzer's first play; he went on to become one of the leading figures of the Austrian theater.

Giambattista Niccolini's *Giovanni da Procida*.

Music & Dance

La Cenerentola (*Cinderella*), Gioacchino Rossini's comic opera based on the old folktale, libretto by Jacopo Ferretti, opened at the Teatro Valle, Rome, January 25.

Gioacchino Rossini's operas *Armida* and *La Gazza Ladra* (*The Thieving Magpie*).

Franz Schubert's song *Death and the Maiden* and his choral work *Stabat mater*.

Ludwig van Beethoven's third and last *String Quintet*.

Lalla Rookh, Thomas Moore's story-poem, with exotic imagery that much influenced later Romantic composers.

Parisian instrument maker Halary introduced a bass brass instrument with keys, called an *ophicleide*; it would be widely used in military bands up to and even during World War I.

The new Teatro di San Carlo opened in Naples on January 12, rebuilt after an 1816 fire.

d. Antonio Bianchi, Italian singer and composer (b. 1752).

d. Etienne-Nicolas Méhul, French composer (b. 1763).

World Events

First Seminole Indian War began, with invasion of Spanish Florida by U.S. forces to attack the Seminoles (1817–1818).

Matabele Zulus led by Mzilikazi fled Shaka's forces into the High Veld of South Africa.

Mississippi became a state.

Georg Hegel's *Encyclopedia of Philosophy*.

David Ricardo's *Principles of Political Economy and Taxation*.

1818

Literature

Frankenstein, or the Modern Prometheus, Mary Wollstonecraft Shelley's classic tale of a young scientist, Frankenstein, whose newly created being destroys them both; basis of numerous dramatizations, most notably the 1931 film.

Sir Walter Scott's novels *Rob Roy*, its title character being a Scottish Robin Hood–type figure, and *The Heart of Midlothian* (*Tales of My Landlord*, second series), based on events during the Porteous riots in Edinburgh in 1736.

Endymion: A Poetic Romance: A Poetic Romance, John Keats's critically attacked allegorical poem on the search for ideal beauty.

Byron's poems *Beppo: A Venetian Story* and canto 4 of *Childe Harold's Pilgrimage*, completing the work.

Nightmare Abbey, Thomas Love Peacock's novel.

William Hazlitt's essay collections, *A View of the English Stage* and *Lectures on the English Poets*.

Jacob Grimm's influential study of German language, *Geschichte der deutschen Sprache*.

Danish philologist Rasmus Rask noted the changes later described in Grimm's Law.

The Red Book, John Pendleton Kennedy's sketches (1818–1819).

José Fernández de Lizardi's novel *Noches tristes y día alegre*.

VISUAL ARTS

The Prado was founded in Madrid.

Charles Bulfinch became chief architect of the Capitol, in Washington, D.C. (1818–1828).

Francis Howard Greenway's painting of *Macquarie Lighthouse*, in Sydney Harbor.

J. M. W. Turner's paintings included *Dort or Dordrecht* and *The Field of Waterloo*.

Edwin Landseer's painting *Fighting Dogs Getting Wind*.

John Crome's painting *The Poringland Oak* (ca. 1818).

d. Humphry Repton, English landscape gardener (b. 1752), credited with introducing the phrase "landscape gardening."

THEATER & VARIETY

Franz Grillparzer's *Sappho*.

d. Jane Pope, English actress (b. 1742); she originated the role of Mrs. Candour in Richard Brinsley Sheridan's *The Scandal*.

d. Matthew Gregory Lewis, English novelist and playwright (b. 1775).

MUSIC & DANCE

Ludwig van Beethoven's *Piano Sonata No. 29*, the *Hammerklavier*, that being the name given to the new larger pianos of the time.

Silent Night (*Stille Nacht*), the popular Christmas carol, music by Franz Gruber, organist and cantor of St. Nicholas's, Oberndorf, Austria, to words by assistant pastor Josef Mohr.

Franz Schubert's *Sixth Symphony*.

Giacchino Rossini's opera *Moses in Egypt* (*Mosé in Egitto*).

Thomas Moore's *Popular National Airs* (1818–1828).

d. Elizabeth Billington, English soprano (b. 1765?–1768).

d. Nicolas Isouard, French composer of Maltese birth (b. 1775).

WORLD EVENTS

U.S.–Seminole War: U.S. forces led by General Andrew Jackson took East Florida.

Allied occupation forces left France.

Chile won independence from Spain.

Zulu general Shaka took in full power in Natal, developing the Mfecane (the Crushing), a period of mass murders and forced migrations in the region.

Illinois became a state.

Bonn University was founded.

1819

LITERATURE

Ivanhoe, Sir Walter Scott's romantic tale of Saxon knight Wilfred of Ivanhoe and his two loves in Norman England; also Scott's novels *A Legend of Montrose*, *Tales of My Landlord* (third series), and *The Bride of Lammermoor*.

Washington Irving's *Sketch Book of Geoffrey Crayon, Gent.*, essays and short stories, introducing the popular tales *The Legend of Sleepy Hollow* and *Rip Van Winkle*, later adapted for the stage.

John Keats's *Ode on a Grecian Urn* and *Ode to a Nightingale*.

Deutsche Grammatik, Jacob Grimm's work outlining the pattern of language changes now called Grimm's Law (1819–1837).

Don Juan, cantos 1 and 2, Byron's unfinished satirical epic poem (1819–1824); also *Mazeppa: A Poem*.

Johann Wolfgang von Goethe's poem cycle *West-östlicher Divan*, inspired by the Persian poet Hafiz.

Memoirs of James Hardy Vaux, an early work by a transported convict in Australia.

William Wordsworth's poems *The Waggoner* and *Peter Bell*.

Percy Bysshe Shelley's essay *A Philosophical View of Reform*.

Aleksandr Pushkin's poem *The Village*.

William Hazlitt's *Lectures on the English Comic Writers*.

Esaias Tegnér's poem *Sången*.

José Fernández de Lizardi's satirical novel *La quijnotita y su prima*.

Visual Arts

Francisco de Goya's paintings included *Agony in the Garden, Portrait of Don Juan Antonio Cuervo, The Forge,* and *The Last Communion of St. Joseph of Calasanz*.

J. M. W. Turner's paintings included *England; Richmond Hill, on the Prince Regent's Birthday* and *Entrance of the Meuse: Orange-Merchant on the Bar, Going to Pieces*.

Jean-Auguste-Dominique Ingres's paintings included *Paolo and Francesca* and *Roger Delivering Angélique*.

John Constable's painting *The White Horse*.

Hokusai's *Hokusai gashiki*.

Destruction of Sodom and Gomorrah, John Martin's painting.

Washington Allston's paintings included *The Flight of Florimell* and *The Moonlight Landscape*.

Francis Greenway's painting *Convict Barracks*.

Menai Straits Bridge built by Thomas Telford, an early iron suspension bridge (1819–1826).

Theater & Variety

Percy Bysshe Shelley's verse-play *The Cenci*.

John Howard Payne's *Brutus; or, the Fall of Tarquin* opened New York's Park Theatre on March 15, with James Pritchard in the title role that had earlier been created by Edmund Kean.

João Batista de Almeida Garrett's *Lucrécia*.

d. August Friedrich Ferdinand von Kotzebue, greatly prolific German playwright (b. 1761); his more than 200 melodramas did not survive in the repertory into the 20th century.

Music & Dance

Franz Schubert's *Piano Quintet in A Major*, the *Trout*, one of his finest pieces of chamber music; and his *Mass in A Flat Major* (1819–1822).

Olimpie, Gaspare Spontini's dramatic musical work, revised as *Olympia* (1821).

Gioacchino Rossini's *The Lady of the Lake* (*La donna del lago*).

H. E. Krøyer wrote the Danish national song, *Der er et yndigt Land*, to words by Adam Oehlenschläeger (ca. 1819).

Louis Spohr's opera *Zemire und Azor*.

Portable Irish harp for home use produced in Dublin by John Egan (ca. 1819).

World Events

Peterloo Massacre: British troops killed 11 people attending a peaceful reform meeting in Manchester.

In *McCulloch v. Maryland*, the U.S. Supreme Court established a measure of federal government primacy over the states in U.S. system.

Simon Bolivar became president of Colombia.

Singapore was founded by the British East India Company.

Spain formally ceded Florida to the U.S.

British took Oman (1819–1821).

1820

Literature

Lamia, Isabella, The Eve of St. Agnes and Other Poems, John Keats's third and final collection, including some of his finest work, including the ballad *La Belle Dame Sans Merci,* the lyric poem *To Autumn,* and his great odes, *On a Grecian Urn, To a Nightingale, To Psyche, To the West Wind, To Autumn, On Indolence,* and *On Melancholy,* some previously published.

Ruslan and Lyudmila, the long poem on folk themes that established Aleksandr Pushkin's reputation as a distinguished poet.

The Cloud, Percy Bysshe Shelley's poem about nature's eternal cycle as exemplified by the cloud's journey to earth and return to the sky.

Essays of Elia, Charles Lamb's pseudonymous essays, began appearing in *London Magazine* (1820–1823; 1824–1825), the most famous being *A Dissertation on Roast Pig*.

Poems Descriptive of Rural Life and Scenery, the first published work of English farmer–poet John Clare.

Alphonse de Lamartine's *Méditations poétiques*.

James Fenimore Cooper's novel *Precaution*.

José María de Heredia's poem *En el teocalli de Cholula*.

Sir Walter Scott's novels *The Abbot* and *The Monastery*.

William Hazlitt's *Lectures on the Dramatic Literature of the Age of Elizabeth*.

William Wordsworth's poem *The River Duddon*.

VISUAL ARTS

Francisco de Goya's works included the paintings *Self-Portrait with Doctor Arrieta* and *The Black Paintings from the Quinta del Sordo* (1820–1830), and the etching *Los disparates* (ca. 1820–1824).

John Constable's paintings included *Dedham Lock and Mill* and *Stratford Mill*.

Hokusai's *Hokusai soga*.

J. M. W. Turner's paintings included *The Rialto, Venice* and *Rome, from the Vatican*.

Jean-Auguste-Dominique Ingres's painting *The Sistine Chapel*.

Edward Hicks began to paint his more than 100 versions of *The Peaceable Kingdom* (1820–1849).

William Collins's painting *The Young Anglers*.

Francis Greenway's painting *St. Matthew's Church*, Windsor.

d. Benjamin Henry Latrobe, English-American architect (b. 1764).

d. Benjamin West, American painter (b. 1738).

THEATER & VARIETY

Percy Bysshe Shelley's *Prometheus Unbound*.

Fritz Grillparzer's trilogy *The Golden Fleece*, including *The Guest-Friend*, *The Argonauts*, and *Medea*.

James Sheridan Knowles's *Virginius; or, the Liberation of Rome*.

MUSIC & DANCE

Franz Schubert's Easter oratorio *Lazarus*; *Song of the Spirits over the Water* (1820–1821); and his dramatic musical work *Die Zwillingsbrüder*.

Henry Bishop's song *Tell me, my heart*.

Valves came into use on trumpets, first in Germany (1820s), enabling them to play the full range of notes, as older "natural trumpets" could not, and

giving them the versatility that made them so popular, first in bands, later in jazz.

Brass bands, containing only brass instruments and possibly percussion, first developed (1820s).

Pianos were generally built with six and a half octaves (ca. 1820–1850).

Organettos, a type of accordion, first made in Italy by Paolo Soprani of Castelfidardo.

Psalmodikon, a one-stringed bowed zither, used in Swedish churches as an aid to psalm singing (ca. 1820–1870s).

WORLD EVENTS

James Monroe was reelected U.S. president.

Missouri Compromise provided that Missouri was to enter the Union as a slave state, balanced by Maine as a free state, and that slavery was to be abolished in the remainder of the Louisiana Purchase.

Democratic uprising in Naples was defeated by Austrian intervention (1820–1821).

Spanish republican rebellion crushed by French intervention (1820–1823).

Antarctica was discovered by a sealing ship.

Thomas R. Malthus's *Principles of Political Economy*.

1821

LITERATURE

Promessi sposi, I, (The Betrothed), Alessandro Manzoni's romantic historical novel (1821–1827), thought by some to be Italy's finest; also Manzoni's poetic work *Il cinque maggio*.

Don Juan, cantos 3 and 4 of Byron's unfinished epic poem; also his poems *Marino Faliero: Doge of Venice*, *Sardanapalus*, *The Prophecy of Dante: A Poem*, *Cain*, and *The Two Foscari*.

Adonais, Percy Bysshe Shelley's elegy composed for his friend, John Keats.

Kenilworth, Sir Walter Scott's novel of Elizabeth I's court, including her courtier Robert Dudley, Earl of Leicester, and his unhappy wife, Amy Robsart.

William Cullen Bryant's *Poems*, including *The Ages*.

William Hazlitt's essays *Table Talk* (1821–1822).

Aleksandr Pushkin's poem *The Robber Brothers* (1821–1822).

Heinrich Heine's *Poems*.

James Fenimore Cooper's second novel *The Spy* and first success.

John Clare's poem *The Village Minstrel*.

Sequoyah's list of Cherokee syllables; the first known written form of a North American Indian language.

The first Russian-language version of the New Testament appeared.

The Saturday Evening Post began publication in the United States.

d. John Keats, English poet (b. 1795).

VISUAL ARTS

The Hay-Wain, John Constable's painting.

Edwin Landseer's painting *Rat Catchers*.

Jean-Auguste-Dominique Ingres's painting *Count Gouriev*.

d. John Crome, English landscape painter (b. 1768), a Norwich painter known as "Old Crome."

THEATER & VARIETY

Aleksander Fredro's *Mr. Moneybags*.

Francisco Martínez de la Rosa's *The Daughter at Home and the Mother at the Masquerade*.

London's rebuilt Haymarket Theatre opened with a production of Richard Brinsley Sheridan's *The Rivals*.

d. Elizabeth Inchbald, English actress (b. 1753), from the mid-1780s one of the earliest of women playwrights.

MUSIC & DANCE

Franz Schubert's song *The Trout* and opera *Alfonso und Estrella* (1821–1822), not publicly performed until 1854.

Der Freischütz, Carl Maria von Weber's opera, book by Johann Friedrich Kind, premiered at the Schaupielhaus, Berlin, June 18.

Carl Maria von Weber's orchestral work *Konzertstück in F minor*.

Érard of France patented their design for the "action" of the grand piano, the basis of most modern piano actions.

Harmonica developed by Christian Friedrich L. Buschmann (1805–1864), originally as an organ-tuning instrument, in Berlin (ca. 1821).

The Paris Opéra, housed previously in several theaters, moved to a permanent site in the rue Le Peletier.

WORLD EVENTS

Greece declared its independence from Turkey; war began (1821–1829).

Guatemala, Peru, Panama, and San Domingo all won independence from Spain.

Simon Bolivar defeated Spanish forces at Carabobo, Venezuela.

British West Africa founded, joining the British colonies of Sierra Leone, Gambia, and the Gold Coast.

Intervening Austrian forces crushed Neapolitan democrats at Rieti.

James Mill's *Elements of Political Economy*.

1822

LITERATURE

French scholar Jean François Champollion deciphered the inscription on the Rosetta Stone, opening the way to reading Egyptian hieroglyphics.

German philologist Jacob Grimm outlined Grimm's Law, a pattern of changes in sounds associated from the earlier Indo-European to the modern Germanic (including English), e.g., "p" as in *pedal* became "f" in *foot*.

Confessions of an English Opium Eater, Thomas De Quincey's largely autobiographical work on his experience with addiction.

Johann Wolfgang von Goethe's autobiographical works *Campagne in Frankreich, 1792* and *Die Belagerung von Mainz 1793*.

Sir Walter Scott's novels *Peveril of the Peak*, *The Fortunes of Nigel*, and *The Pirate*.

The Vision of Judgment, Byron's response to attack on his work by Robert Southey, among others.

Adam Mickiewicz's poems *Poezje Tom pierwszy*.

The Prisoner of the Caucasus, Aleksandr Pushkin's poem.

Alfred de Vigny's *Poèmes*.

Britain's *The Sunday Times* began publication.

Carl Jonas Love Almquist's poetic fugue *Amorina*.

Charles Lamb's essay *Dream Children: A Reverie*.

Stendhal's essay *De l'amour* (*On Love*).

Victor Hugo's *Odes et poésies diverses*.

Bracebridge Hall, Washington Irving's romantic sketches.

William Wordsworth's poetic works *Ecclesiastical Sketches* and *Memorials of a Tour on the Continent, 1820*.

Charles Nodier's *Trilby, ou le Lutin d'Argail*; basis of various ballets called *La Sylphide*, notably 1832 and 1836.

d. Percy Bysshe Shelley, English writer (b. 1792).

VISUAL ARTS

J. M. W. Turner's paintings included *What You Will* and *An Avenue of Trees*.

David Wilkie's painting *Chelsea Pensioners Reading the Gazette of the Battle of Waterloo*.

View on the Stour near Dedham, John Constable's painting.

Eugène Delacroix's painting *Dante and Virgil in Hell*.

John Flaxman's statue of *Robert Burns*.

John Nash designed All Souls' Church, London.

Pierre-Paul Prudhon's painting *Christ on the Cross*.

Charles Wilson Peale's *The Artist in His Museum*.

Samuel Morse's painting *The Old House of Representatives*.

d. Antonio Canova, Italian sculptor (b. 1757).

THEATER & VARIETY

Percy Bysshe Shelley's *Hellas, a Lyrical Drama*.

Sir Walter Scott's *Halidon Hill*.

Charles Powell Clinch's play *The Spy, A Tale of the Neutral Ground*, opened at New York's Park Theatre on March 1.

Woe from Wit, Alexander S. Griboyedov's play.

Christian Dietrich Grabbe's *Scherz, Satire, Ironie und tiefere Bedeutung*.

MUSIC & DANCE

Franz Schubert's great *Symphony in B Minor*, the *Unfinished*, of which only two movements were completed; also his virtuoso piano piece *Fantasy in C Major*, the *Wanderer*; his choral work *God in Nature*; and his opera *Alfonso und Estrella*, libretto by F. von

Schober, not publicly performed until 1854.

Marie Taglioni made her debut in Vienna in *La Réception d'une jeune nymphe à la cour de Terpsichore*, the ballet by her father, Filippo Taglioni.

Felix Mendelssohn's *Piano Quartet No. 1*.

Ludwig van Beethoven's *11 Bagatelles* and his overture *Consecration of the House*.

Nurmahal, Gaspare Spontini's dramatic musical work.

Dom Pedro I of Brazil (previously King Pedro IV of Portugal) composed his country's anthem, *O Patria, O rei, O povo*.

WORLD EVENTS

Brazil won independence from Portugal (1822–1823).

Denmark Vesey led a failed Charleston, South Carolina, slave uprising.

Liberia was founded as an African homeland for former U.S. slaves.

Portuguese democrats won a constitution and establishment of a constitutional monarchy.

1823

LITERATURE

James Fenimore Cooper's *The Pioneers*, the first of the *Leatherstocking Tales*, five novels centering on Natty Bumppo, also called Hawkeye, Pathfinder, or the Deerslayer; also Cooper's *The Pilot*, the first American sea novel.

Quentin Durward, Sir Walter Scott's historical romance novel set in 15th-century France, where the hero of the title is a member of Louis XI's Scottish Guards.

Don Juan, cantos 6–14 of Byron's unfinished epic poem.

Victor Hugo's novel *Han d'Islande* (*Hans of Iceland*).

Alphonse de Lamartine's poem *La Mort de Socrates* (*The Death of Socrates*); also his *Nouvelles méditations poétiques*.

Dionysios Solomos's poetic work *Ymnos Eis Tin Eleftherian*.

James Kirke Paulding's novel *Koningsmarke, the Long Finne*.

Johann Wolfgang von Goethe's poetic work *Trilogie der Leidenschaft*.

Mary Wollstonecraft Shelley's novel *Valperga*.

Stendhal's *Vie de Rossini*.

Liber Amoris, William Hazlitt's account of a failed love affair.

VISUAL ARTS

John Constable's painting *Salisbury Cathedral from the Bishop's Grounds*.

J. M. W. Turner's paintings included *The Battle of Trafalgar* (1823–1824) and *The Bay of Baiae, with Apollo and the Sibyl*.

Jean-Auguste-Dominique Ingres's paintings included *Mme Leblanc*, *Monsieur Leblanc*, and *Landscape's painting Le Petit Chaville, near Ville-d'Avray* (1823–1825).

Hokusai's prints *Paintings with One Stroke of the Brush*.

George Cruikshank's drawings for Grimm's *German Popular Stories*.

First museum in Berlin opened by King Frederick William III of Prussia, opened to the public in 1830; it was much damaged during World War II.

d. Henry Raeburn, Scottish portrait painter (b. 1756).

d. Pierre-Paul Prudhon, French painter (b. 1758).

THEATER & VARIETY

Franz Grillparzer's *König Ottokars Glück und Ende*.

Giambattista Niccolini's *Antonio Foscarini*.

Mazeppa, a dramatization of Byron's poem, opened at London's Coburg Theatre.

Walter Scott's *Macduff's Cross*.

Ferdinand Raimund's *The Barometer-Maker on the Magic Island*.

d. John Philip Kemble, English actor (b. 1757), eldest son of Roger Kemble and Sarah Ward.

MUSIC & DANCE

Euryanthe, Carl Maria von Weber's opera, libretto by Helmine von Chezy, opened at the Kärnthnerthor Theatre, Vienna, October 25; Henriette Sontag created the title role.

Franz Schubert's 20-song cycle *Die schöne Müllerin* (*The Miller's Beautiful Daughter*); and his opera *Fierrabras*, not publicly performed until 1897.

Diabelli Variations, Ludwig van Beethoven's piano work, 33 variations on a waltz by Anton Diabelli; also Beethoven's *Missa Solemnis*.

Home, Sweet Home, song introduced in Henry Bishop's opera *Clari, the Maid of Milan*, lyrics by John Howard Payne; it was later popularized by Jenny Lind.

Semiramide, Gioacchino Rossini's opera, book by Gaetano Rossi, premiered in Venice.

Felix Mendelssohn's *Piano Quartet No. 2* and *String Quartet in E Flat Major*.

Arpeggione or *guitar d'amour*, a guitar played cello-like with a bow, developed by Viennese guitar maker J. G. Staufer.

Gaetano Donizetti's opera *Alfredo il Grande*.

Jessonda, Louis Spohr's opera.

WORLD EVENTS

U.S. Monroe Doctrine declared prinicple of noninterference of European powers in the affairs of Western Hemisphere countries, to be enforced by the United States.

Mexican Republic established.

Catholic Association established in Ireland by Daniel O'Connell.

John VI of Portugal annulled the newly granted 1822 Constitution.

1824

LITERATURE

William Cullen Bryant's poems *An Indian at the Burial Place of His Fathers*, *Monument Mountain*, and *Rizpah* (all 1824–1825).

Washington Irving's *Tales of a Traveller*, a collection of 32 stories and sketches.

Don Juan, cantos 15–17 of Byron's unfinished epic poem.

Percy Bysshe Shelley's *Posthumous Poems*, edited by Mary Wollstonecraft Shelley.

Aleksandr Pushkin's poem *The Fountain of Bakhchisarai*.

Westminster Review began publication under Jeremy Bentham.

James Fenimore Cooper's novel *Lionel Lincoln*.

Victor Hugo's *Nouvelles Odes*.

Le Globe began publication in Paris.

José María de Heredia's poem *Niagara*.

Sir Walter Scott's novels *Redgauntlet* and *St. Ronan's Well*.

d. Byron (George Gordon, Lord Byron), English poet (b. 1788).

VISUAL ARTS

Francisco de Goya's work included the painting *Leandro Fernández de Moratín* and the lithograph *The Bulls of Bordeaux* (1824–1825).

John Constable's painting *The Lock*.

The Massacre at Chios, Eugène Delacroix's painting.

Jacques-Louis David's painting *Mars and Venus*.

Jean-Auguste-Dominique Ingres's painting *Vow of Louis XIII*.

Richard Parkes Bonington's painting *A Fishmarket Near Boulogne*.

Decimus Burton designed Clarence Terrace and Cornwall Terrace, both in Regent's Park, London.

Francis Howard Greenway's painting of *St. James's Church*, Sydney.

d. Jean Louis André Théodore Géricault, French painter (b. 1791).

d. Anne-Louis Girodet de Roucy, French painter (b. 1767).

THEATER & VARIETY

Aleksandr Pushkin wrote *Boris Godunov* (1824–1825); banned by the Russian censors, it was first produced in 1870; basis of the Moussourgsky opera.

Superstition, James Nelson Barker's tragedy, opened at the Chestnut Street Theatre, Philadelphia, March 12.

MUSIC & DANCE

Ludvig van Beethoven's *Ninth Symphony*, the *Choral*; the final movement, including soloists and chorus, was built around Friedrich Schiller's *Ode to Joy*; also Beethoven's *6 Bagatelles* for piano.

Franz Schubert's string quartet *Death and the Maiden*; *Octet in F Major*; *Sonata in A Minor* for piano; *Grand Duo* for two pianos; and choral works *The Gondolier* and *Prayer*.

Felix Mendelssohn's *Symphony No. 1* and *String Sextet*.

Emilia di Liverpool, Gaetano Donizetti's opera (1824).

Giacomo Meyerbeer's opera *Il crociato in Egitto*.

Alessandro nelle Indie, Giovanni Pacini's opera.

d. Jean-Baptiste Viotti, Italian-born violin teacher (b. 1752), credited with revolutionizing violin playing and teaching, in Paris from 1782. The chain of teachers runs from Viotti through Joseph Joachim to Jascha Heifetz and Yehudi Menuhin.

WORLD EVENTS

None of the four candidates had a majority in the U.S. presidental election; election went into the House of Representatives.

U.S.–Russian treaty established 54'40" as southern limit of Russian North American territory.

Erie Canal was completed (1817–1824).

British and Ashantis were at war in West Africa (1824–1826).

British Indian army invaded and defeated Burma in First Burma War, taking much territory (1824–1826).

1825

LITERATURE

Samuel Pepys's *Diary*, his private view of life and politics in late 17th-century England, first deciphered and parts published.

Sir Walter Scott's novels *Tales of the Crusaders*, *The Betrothed*, and *The Talisman*.

William Hazlitt's essay *The Spirit of the Age*.

Alphonse de Lamartine's poetic work *Le Dernier Chant du pélerinage d'Harold* (*The Last Canto of Childe Harold's Pilgrimage*).

Aleksandr Pushkin's ballad *The Bridegroom*.

Esaias Tegnér's poetic works *Frithiofs saga* and *Mjältsjukan*.

Mihály Vörösmarty's epic poem *Zalán Futása*.

New York Advertiser began publication; the first American newspaper to use a steam-driven press.

Pierre-Jean de Béranger's poems *Chansons nouvelles*.

Thomas Hood's *Odes and Addresses to Great People*.

William Leggett's poems *Leisure Hours at Sea*.

VISUAL ARTS

J. M. W. Turner's paintings included *Valley with a Distant Bridge and Tower* and *Harbor of Dieppe*.

Jean-Baptiste-Camille Corot's *Self-Portrait at the Age of 29*.

John Constable's painting *The Leaping Horse*.

Thomas Cole's painting *Lake with Dead Trees*.

Richard Parkes Bonington's painting *Picardy Coast with Children*.

Francis Danby's painting *The Delivery of Israel Out of Egypt*.

Francisco de Goya's painting *The Milkmaid of Bordeaux* (1825–1827).

National Academy of Design was founded in 1825 in New York City as the Society for the Improvement of Drawing.

d. Jacques-Louis David, French painter (b. 1748).

d. Utagawa Toyokuni, Japanese color-print master and book illustrator (b. 1769).

d. George Dance, English architect (b. 1741).

THEATER & VARIETY

Aleksander Fredro's Polish farce *Ladies and Hussars*.

Samuel Woodworth's *The Forest Rose* opened at New York's Chatham Garden Theater on October 7; the play featured the music of John Davies.

MUSIC & DANCE

La Dame blanche, Adrien Boieldieu's opera, libretto by Eugène Scribe, opened at the Opéra-Comique, Paris, December 10.

Ludwig van Beethoven's two string quartets, *Opus 127* and *132*.

Die Hochzeit des Camacho, Felix Mendelssohn's opera; also his *Piano Quartet No. 3*, *Sonata for Violin and Piano*, and *String Octet*.

Franz Schubert's song *Die junge Nonne*.

Le Maçon, Daniel-François-Esprit Auber's opera.

Gioacchino Rossini's choral work *Il viaggio a Reims*.

L'ultimo giorno di Pompei, Giovanni Pacini's opera.

Cast-iron frame first developed for the piano, originally for the square piano, by Alphaeus Babcock (1785–1842) of Boston; it made far more tension and power possible than the older metal-braced wooden frames, giving the piano its distinctive modern sound.

Modern-style bassoon developed in Germany by Carl Almenraeder and J. A. Heckel (1825–1831).

Modern form of xylophone developed by soloists in central and eastern Europe (early 19th c.).

Hof und National Theater opera house in Munich (1825–1943).

d. Antonio Salieri, Italian composer (b. 1750), best known today as Mozart's jealous antagonist in Peter Shaffer's 1980 play *Amadeus*.

d. Armand Vestris, French ballet dancer (b. 1788), the leading male star of his day.

WORLD EVENTS

John Quincy Adams was chosen U.S. president by the House of Representatives after a four-way contest in the election of 1824 had not yielded an electoral college winner.

Failed Decembrist liberal insurrection in Russia (1825–1826).

Robert Owen founded the Utopian Socialist colony at New Harmony, Indiana.

Russo-Persian War began; Persia lost its territories north of the Caucasus (1825–1828).

1826

LITERATURE

The Last of the Mohicans, the second of James Fenimore Cooper's five novels in the *Leatherstocking Tales* centered on Hawkeye (Natty Bumppo); the last Mohican of the title, Uncas, dies trying to save a British girl from death.

Vivian Grey, the first novel of Benjamin Disraeli, later prime minister of Britain.

Über deutsche Runen, Wilhelm Grimm's pioneering study of the early Scandinavian script called *runes*.

Victor Hugo's novel *Bug-Jargal* and *Odes et ballades*, later enlarged to include earlier poems and collections (1828).

A type-casting machine was developed to produce finished letters for compositors.

Elizabeth Barrett Browning's *Essay on Mind, with Other Poems*.

Sonety, Adam Mickiewicz's sonnets.

Woodstock, Sir Walter Scott's novel.

Alfred de Vigny's *Poèmes antiques et modernes*; also his novel *Cinq-Mars*.

Reisebilder (*Pictures of Travel*), Heinrich Heine's first literary success.

Johann Wolfgang von Goethe's *Novelle* (*Novel*).

Mary Wollstonecraft Shelley's novel *The Last Man*.

Oliver Wendell Holmes's *Songs in Many Keys*.

François René de Chateaubriand's poem *Les Natchez*.

VISUAL ARTS

Jean-Baptiste-Camille Corot's paintings included *View of the Forum from the Farnese Gardens*, *Old Man Sitting in Corot's Studio*, *Rome*, *The Roman Campagna, with the Claudian Aqueduct* (1826–1828), and *The Bridge at Narni* (1826–1827).

J. M. W. Turner's paintings included *Cologne: the Arrival of a Packet Boat*, *Evening* and *Forum Romanum*.

John Constable's painting *The Cornfield*.

Eugène Delacroix's paintings included *Baron Schwiter* and *The Execution of the Doge Marino Faliero* (both ca. 1826–1827).

Ando Hiroshige's *Views of the Eastern Capital*, a set of color prints.

Francis Danby's painting *The Opening of the Sixth Seal*.

Hokusai's *Thirty-six Views of Mt. Fuji* (1826–1833).

John Martin's painting *Belshazzar's Feast*.

Conway Suspension Bridge built of iron by Thomas Telford.

d. John Flaxman, English sculptor (b. 1755).

THEATER & VARIETY

Ira Aldridge opened in the title role of *Othello* at London's Royalty Theatre, making his London debut, beginning the major career that had been denied him in the United States because of his color, and including many of the major classic and contemporary roles, being by no means limited to "Black" roles.

Ferdinand Raimund's *The Girl from Fairyland*.

Franz Grillparzer's *His Master's Faithful Servant*.

d. François-Joseph Talma, French actor (b. 1763).

MUSIC & DANCE

Ludwig van Beethoven's final four string quartets, including the *Grosse Fuge*.

Felix Mendelssohn's overture *A Midsummer Night's Dream*, and his *String Quintet No. 5*.

Marie Taglioni created the title role in *Danina, oder Jocko dre brasilianische Affe*, the ballet by her father, Filippo Taglioni, at Stuttgart; music by Peter von Lindpaintner.

Oberon, Carl Maria von Weber's opera, libretto by James Robertson Planché, premiered at Covent Garden, London, April 12.

Franz Schubert's choral work *Night's Brightness* and his songs *An Sylvia* and *Gesänge aus Wilhelm Meister*.

The Siege of Corinth (*Le Siège de Corinthe*), Gioacchino Rossini's opera.

Fiorella, Daniel-François-Esprit Auber's opera.

Hector Berlioz's choral work *La révolution grecque* and orchestral work *Les francs-juges*.

Die letzten Dinge, Louis Spohr's oratorio.

d. Carl Maria von Weber, German composer (b. 1786).

d. Michael Kelly, Irish tenor and composer (b. 1762).

WORLD EVENTS

Pan-American Congress met in Panama.

Russia and Turkey were at war.

Siam and Laos were at war (1826–1829).

University College, London, was founded.

André Ampère's *Electrodynamics* was published.

1827

LITERATURE

The Prairie, the third published of the five novels in James Fenimore Cooper's *Leatherstocking Tales*, but the last in terms of the story, focusing on the death of his hero, Natty Bumppo (Hawkeye); also Cooper's novel *The Red Rover*.

Sir Walter Scott's novels *Chronicles of the Canongate* (first series), *The Highland Widow*, *The Surgeon's Daughter*, and *The Two Drovers*.

Stendhal's novel *Armance, ou quelques scènes d'un salon de Paris en 1827*.

Tamerlane and Other Poems, Edgar Allan Poe's first published work, released anonymously.

Poems by Two Brothers, verses published jointly by Alfred, Lord Tennyson, and his brother Charles Tennyson Turner.

Aleksandr Pushkin's poems *Count Nulin* and *The Gypsies*.

Heinrich Heine's *Buch der Lieder* (*The Book of Songs*).

John Clare's poem *The Shepherd's Calendar*.

The Midsummer Fairies, Thomas Hood's poetry.

d. José Joaquín Fernández de Lizardi, Mexican satirist (b. 1776).

VISUAL ARTS

John James Audubon published *The Birds of America, from Original Drawings, with 435 Plates Showing, 1,065 Figures* (1827–1838).

Eugène Delacroix's paintings included *Combat Between the Giaour and the Pasha, Greece expiring on the Ruins of Missolonghi*, and *The Death of Sardanapalus*.

Thomas Cole's paintings *Expulsion from the Garden of Eden* and *John the Baptist Preaching in the Wilderness* (both 1827–1828).

Francisco de Goya's paintings included *Don José Pío de Molina* (1827–1828) and *Don Juan Bautista de Muguiro*.

Hokusai's *Flowers and Birds, Snow, Moon, and Flowers*, and *Views of Famous Bridges* (all ca. 1827–1830).

Jean-Auguste-Dominique Ingres's work included the painting *The Apotheosis of Homer* and the drawing *Study of Horseman for St. Symphorien*.

John Constable's painting *Chain Pier, Brighton*.

William Blake's engravings for *The Book of Job*.

Jean-Baptiste-Camille Corot's painting *Italian Monk Reading*.

John Martin's painting *The Fall of Nineveh* (1827–1828).

John Nash began the Carlton House Terrace (1827–1832).

d. Charles Willson Peale, American painter (b. 1741).

d. Thomas Rowlandson, English caricaturist (b. 1756).

d. William Blake, English artist, philosopher, and poet (b. 1757); his designs for the *The Divine Comedy* were unfinished.

THEATER & VARIETY

Victor Hugo's highly political melodrama *Cromwell*, a long play that was a considerable departure in the French theater of the day.

Douglas William Jerrold had his first substantial success with the farce *Paul Pry*, produced at London's Coburg Theatre, beginning a three-decade-long career as a well-received playwright and manager.

MUSIC & DANCE

Franz Schubert's highly Romantic 24-song cycle *Winterreise* (*Winter Journey*) and two piano trios.

Felix Mendelssohn's *String Quartet No. 2* and *Four Pieces for String Quartet* (1827–1847).

Marie Taglioni made her Paris debut in the ballet *Le Sicilien*, in a variation written especially for the occasion by her father, Filippo Taglioni.

Il pirata (*The Pirate*), Vincenzo Bellini's opera; libretto by Felice Romani, premiered at La Scala, Milan, October 27.

Gaetano Donizetti's operas *Il borgomastro di Sardaam* and *Le convenienze ed inconvenienze teatrali*.

Frédéric Chopin's *C Minor Sonata* for piano.

Moses, Gioacchino Rossini's opera.

Giovanni Pacini's opera *Gli arabi nelle Gallie*.

Jean Aumer's ballet *La Somnambule*.

d. Ludwig van Beethoven, German composer (b. 1770).

d. James Hewitt, English-American conductor, composer, and publisher (b. ca 1770).

WORLD EVENTS

Brazil at war against Uruguay and Argentina; battle of Ituzaingó.

Peru became independent of Colombia.

Greek War of Independence: Turks took Athens, capturing and damaging the Acropolis.

Russia took Erivan from the Turks.

1828

LITERATURE

Noah Webster's American *Dictionary of the English Language*, which began to codify the distinctions between the American and British versions of English, as in *honor* and *honour*.

Fanshawe, a Tale, Nathaniel Hawthorne's first novel, published anonymously, based on his college life at Bowdoin College, Maine; he later retrieved and destroyed most copies.

First publication of Li Ju-chen's *Ching hua yuan* (*Flowers in the Mirror*).

Sir Walter Scott's novel *St. Valentine's Day; or, The Fair Maid of Perth* (*Chronicles of the Canongate*, second series).

Washington Irving's *History of the Life and Voyages of Christopher Columbus.*

Adam Mickiewicz's story *Konrad Wallenrod.*

Aleksandr Pushkin's *Message to Siberia* and *To My Friends.*

First chair of modern English literature in England, at University of London's University College.

Jacob Grimm's *Deutsche Rechtpsaltertümer.*

VISUAL ARTS

John Constable's paintings included *Dedham Vale* and *Hampstead Heath: Branch Hill Pond.*

J. M. W. Turner's paintings included *The Regatta at Cowes* and *Boccaccio Relating the Tale of the Birdcage.*

Pierre-Jean David's sculpture of *Jeremy Bentham.*

Hokusai's *The Poems of China and Japan Mirrored to Life* (ca. 1828–1833).

Ichabod Crane Pursued by the Headless Horseman, John Quidor's painting.

d. Francisco de Goya, Spanish artist (b. 1746).

d. Richard Parkes Bonington, English painter (b. 1828).

d. Jean-Antoine Houdon, French sculptor (b. 1741).

d. Thomas Bewick, English animal artist and wood engraver (b. 1755).

THEATER & VARIETY

Ferdinand Raimund's *The King of the Alps and the Misanthrope.*

Johan Ludvig Heiberg's *Elfin Hill.*

Victor Hugo's *Amy Robsart*; based on Sir Walter Scott's novel *Kenilworth.*

Douglas William Jerrold's melodrama *Fifteen Years of a Drunkard's Life.*

d. Leandro Fernández de Moratín, Spanish poet and playwright (b. 1760).

d. Louis-Benoît Picard, French actor–manager and playwright (b. 1769).

MUSIC & DANCE

Frédéric Chopin gave numerous concerts as pianist in Warsaw, Vienna, and Paris, often of his own new works (1828–1832), such as his *Piano Trio in G Minor* (1828–1829).

Le Comte Ory, Gioacchino Rossini's opera, libretto by Eugène Scribe and Delestre-Poirson, opened at the Académie Royale, Paris, August 20.

La muette de Portici (*The Dumb Girl of Portici*), Daniel-François-Esprit Auber's opera, libretto by Eugène Scribe and Germaine Delavigne, opened at the Opéra, Paris, February 29.

Felix Mendelssohn's overture *Calm Sea and Prosperous Voyage* (*Meeresstille und glückliche Fahrt*).

Gaetano Donizetti's operas *Il giovedì grasso* and *La regina di Golconda.*

Hector Berlioz's overture *Waverly.*

James Hewitt's song *The Minstrel's Return'd from the War* (ca. 1828).

Nicolò Paganini gave notable violin performances in Vienna.

Pape of Paris developed a new method of stringing a piano, with the strings for the bottom two octaves being strung diagonally above the other strings, slanting oppositely; at first used in uprights, but in grand pianos by the 1860s.

Bösendorfer piano-manufacturing firm established in Vienna.

Cornet invented, probably in France (ca. 1828).

d. Franz Schubert, Austrian composer (b. 1797). Among his final works were the 14-song *Schwanengesang* (*Swan Song*), including *Der Doppelgänger*; *Mirian's Victory Song*; *Symphony in C Major,* the *Great*; *Mass in E Flat Major*; and *String Quintet in C Major.*

WORLD EVENTS

Andrew Jackson was elected U.S. president.

France, Britain, and Russia recognized the independence of Greece, ultimately forcing Turkey to withdraw.

Miguelite civil war began in Portugal (1828–1834).

Russia and Turkey were at war (1828–1829).

Russia won Erivan and other Armenian territory from Persia, as provided by the Treaty of Turkmanchai, ending the Russo-Persian war.

Uruguay won independence from Brazil.

1829

LITERATURE

Les Chouans, Honoré de Balzac's historical novel, the heroine Marie de Verneuil being a spy for the peasant royalists (Chouans) and the hero a Roy-

alist leader, the Marquis de Montauran; Balzac's first great success.

Wilhelm Meister's Travels, or the Renunciants (*Wilhelm Meisters Wanderjahre, oder Die Entsagenden*), the second and concluding volume of Johann Wolfgang von Goethe's tale.

Aleksandr Pushkin's poems *Poltava* (1829) and *Rusalka* (1829–1832).

James Fenimore Cooper's novel *The Wept of Wish-ton-Wish.*

Sir Walter Scott's novel *Anne of Geierstein.*

Stendhal's *Promenades dans Rome.*

Le Dernier Jour d'un condamné, Victor Hugo's novel; also his *Les Orientales.*

Edgar Allan Poe's poem *Al Aaraaf.*

Washington Irving's *A Chronicle of the Conquest of Granada.*

Wilhelm Grimm's *Die deutsche Heldensage.*

William Leggett's *Tales and Sketches, By a Country Schoolmaster.*

VISUAL ARTS

J. M. W. Turner's paintings included *Chichester Canal, Ulysses Deriding Polyphemus, Brighton from the Sea,* and *The Lake, Petworth: Sunset, a Stag Drinking.*

Eugène Delacroix's painting *The Assassination of the Bishop of Liège.*

Hadleigh Castle, John Constable's painting.

Thomas Birch's painting *Shipwreck.*

THEATER & VARIETY

Franz Grillparzer's *Des Meeres und der Liebe Wellen.*

Victor Hugo's play *Marion de Lorme.*

Henri III et sa cour, play by Alexandre Dumas (*père*).

Edward Fitzball's *The Red Rover; or, the Mutiny of the Dolphin.*

d. Wojciech Boguslawski, Polish actor, director, and playwright (b. 1757).

MUSIC & DANCE

William Tell (*Guillaume Tell*), Gioacchino Rossini's opera; libretto by Etienne de Jouy and Hippolyte Bis, based on the Schiller play, opened at the Opéra, Paris, August 3; Marie Taglioni had great success dancing in the production, choreographed by Jean Aumer.

Felix Mendelssohn's *Symphony No. 5*, the *Reformation* (1829–1830); *String Quartet No. 1*; and opera *Die Heimkehr aus der Fremde.*

Frédéric Chopin's *Piano Concerto No. 2 in F Minor* (1829–1830) and *Twelve Grand Études* for piano (1829–1832).

Vincenzo Bellini's *La straniera* (*The Stranger*), opera, libretto by Felice Romani, opened at La Scala, Milan, February 14.

Il castello di Kenilworth, Gaetano Donizetti's opera based on Sir Water Scott's 1821 novel.

Fromental Halévy's opera *Le dilettante d'Avignon.*

Hector Berlioz's choral works *Chant sacré* and *Huits Scènes de Faust*; song *Irlande*; vocal work *Elégie en prose*; and *La Mort de Cléopatre*, for voice and orchestra.

La Belle au bois dormant, Jean Aumer's ballet version of the tale of Sleeping Beauty.

Johann Nepomuk Hummel's *Septett militaire.*

Accordion granted a patent in Vienna.

Mouth-blown symphonium developed (ca. 1829).

WORLD EVENTS

Greek independence was achieved by the terms of the Treaty of Adrianople, ending the Russo-Turkish War; Turkey also lost much territory in the Balkans.

Jackson administration in U.S. brought American populism for the first time into the White House; also instituted spoils system.

Spanish attack on Mexico failed.

1830

LITERATURE

The Red and the Black (*Le rouge et le noir*), Stendhal's most acclaimed novel, a psychological study of the romantic Julien Sorel, set during France's Bourbon restoration.

Old Ironsides, Oliver Wendell Holmes's poem about the frigate *Constitution*, much used in the War of 1812.

Honoré de Balzac's novels *Étude de femme, La Vendetta, Sarrasine, Un Épisode sous la Terreur, Une Double Famille, Une Passion dans le désert, La Maison du chat-qui-pelote, La Paix du ménage* (all 1830), and *Gobseck* (1830–1835); also his philo-

sophical studies *Adieu*, *El Verdugo*, and *L'Élixir de longue vie* (all 1830).

Sarah Josepha Hale's *Poems for Our Children*, including *Mary Had a Little Lamb*.

Aleksandr Pushkin's poem *A Small House in Kolomna*.

Alfred, Lord Tennyson's *Poems, Chiefly Lyrical*.

Alphonse de Lamartine's *Harmonies poétiques et religieuses*.

Fraser's Magazine began publication in Britain.

Godey's Lady's Book began publication in the United States.

James Fenimore Cooper's novel *The Water Witch; or, The Skimmer of the Seas*.

Kashiprasad Ghosh's *The Shair and Other Poems*, an early work by a Bengali writing in English.

d. Li Ju-chen, Chinese novelist (b. 1763).

d. William Hazlitt, English essayist and literary critic (b. 1778).

VISUAL ARTS

Eugène Delacroix's paintings included *La Liberté guidant le peuple (Le 28 juillet 1830)* [*Liberty Leading the People*] and *Bataille de Poitiers*.

J. M. W. Turner's paintings included *Jessica* and *Pilate Washing His Hands*.

Jean-Auguste-Dominique Ingres's works included the painting *Façade ouest de la Cathédrale de Chartres* and the drawing *Mme Désiré Raoul-Rochette*.

John Constable's painting *Stoke-by-Nayland*.

William Sidney Mount's paintng *Rustic Dance After a Sleighride*.

Charles Barry designed the Travellers' Club, Pall Mall, London.

THEATER & VARIETY

Victor Hugo's *Hernani* opened on February 25 at the Comédie Française; presentation of the play, highly controversial in form and content, generated a riot at the theater, and also ushered a new period in the French theater; basis for the 1844 Giuseppe Verdi opera.

Francisco Martínez de la Rosa's *The Venetian Conspiracy of 1310*.

Sir Walter Scott's plays *Auchindrane; or, The Ayrshire Tragedy* and *The Doom of Devorgoil, a Melodrama*.

MUSIC & DANCE

Anna Bolena (Anne Boleyn), Gaetano Donizetti's opera, libretto by Felice Romani, opened at the Teatro Carcano, Milan, December 20.

Felix Mendelssohn's *Symphony No. 3*, the *Scottish* (1830–1842); overture *The Hebrides (Fingal's Cave)* (1830–1832); and sacred music *Three motets*.

Frédéric Chopin's *Piano Concerto No. 1 in E Minor*.

Hector Berlioz's *Symphonie fantastique (Épisode de la vie d'un artiste)*.

Abegg Variations for piano, Robert Schumann's first work, so-called because the main theme is built on the notes A-B flat-E-G-G.

I Capuleti e i Montecchi (The Capulets and the Montagues), Vincenzo Bellini's opera, libretto by Felice Romani, opened in Venice March 11.

Jean Aumer's ballet *Manon Lescaut*, music by Fromental Halévy, opened at the Opéra, Paris, April 30.

Fra Diavolo, Daniel-François-Esprit Auber's opera, libretto by Eugène Scribe, premiered at the Opéra-Comique, Paris, January 28.

Nicolò Paganini's *Violin Sonata*.

Earliest known book of dances for the *nyckelharpa*, a Swedish folk instrument, a fiddle with keys.

Zither developed in modern form from folk instruments in Austria and Bavaria (during 19th c.).

Hand-turned children's musical boxes made (ca. 1830s).

d. José Maurício Nunes Garcia, Brazilian composer (b. 1767).

WORLD EVENTS

Republican insurrection in France; Charles X deposed, new constitutional mcnarchy formed under King Louis-Phillippe.

France began its conquest of Algeria (1830–1847).

Belgium began its war of independence from the Netherlands (1830–1833).

Ecuador won its independence.

Polish revolt against Russian rule began.

Venezuela won its independence from Colombia.

Joseph Smith's *Book of Mormon*.

Mary Fairfax Somerville's *The Mechanism of the Heavens*.

1831

LITERATURE

The Hunchback of Notre Dame (*Nôtre-Dame de Paris*), Victor Hugo's famous romantic novel of the hunchbacked bellringer, Quasimodo, and his devotion to the beautiful Esmeralda; also Hugo's poetic work *Les Feuilles d'automne*.

America (*My Country 'Tis of Thee*), Samuel Francis Smith's patriotic hymn set to the tune of Britain's *God Save the King*; reportedly first sung in Boston at a Fourth of July celebration; first published in 1832.

The Domestic Manners of the Americans, the widely read light but critical account of a United States tour by Frances Trollope, mother of novelist Anthony Trollope.

Edgar Allan Poe's *Poems*, including *To Helen, Israfel, The Sleeper, The City in the Sea*, and *Valley of Unrest*.

Honoré de Balzac's novel *La Femme de trente ans* (1831–1834); also his philosophical studies *L'Auberge rouge, Jésus-Christ en Flandre, La Peau de chagrin, Le Chef-d'oeuvre inconnu, Les Proscrits, Le Réquisitionnaire, Maître Cornélius* (all 1831), and *L'Enfant Maudit* (1831–1836).

Legends of New-England in Prose and Verse, John Greenleaf Whittier's first published work.

Nikolay Gogol's story *Evenings on a Farm near Dikanka* (1831–1832).

Benjamin Disraeli's novel *The Young Duke*.

The Sydney Morning Herald began publication in Australia.

James Fenimore Cooper's novel *The Bravo*.

The Dutchman's Fireside, James Kirke Paulding's novel.

Thomas Love Peacock's novel *Crotchet Castle*.

d. Jippensha Ikku, Japanese novelist (b. 1765).

VISUAL ARTS

J. M. W. Turner's paintings included *Caligula's Palace and Bridge* and *Admiral Van Tromp's Barge at the Entrance to the Texel, 1645*.

John Constable's painting *Salisbury Cathedral from the Meadows*.

Eugène Delacroix's paintings included *Boissy d'Anglas at the Convention* and *The Battle of Nancy*.

Washington Allston's paintings *The Spanish Girl* and *Roman Lady Reading*.

d. James Hoban, Irish-American architect (b. ca. 1762).

d. James Northcote, English painter (b. 1746).

THEATER & VARIETY

Aleksandr Pushkin's *Mozart and Salieri*.

Antony, play by Alexandre Dumas (*père*).

Alfred de Vigny's *La Maréchale d'Ancre*.

Edwin Forrest produced Robert Bird's *The Gladiator*.

Manuel Bretón de los Herredos's *Marcela, o ¿cual de los tres?* (*Marcela, or Which One of the Three?*).

d. Sarah Siddons, a leading English tragedian (b. 1755), who began her career as a child in her father's theater company, and played in many major roles, perhaps most notably as Lady Macbeth.

MUSIC & DANCE

Robert le diable (*Robert the Devil*), Giacomo Meyerbeer's opera, book by Eugène Scribe and Germaine Delavigne, opened in Paris; Marie Taglioni danced to choreography by her father, Filippo Taglioni.

Norma, Vincenzo Bellini opera, libretto by Felice Romani, premiered at La Scala, Milan, December 26.

La Sonnambula (*The Sleepwalker*), Vincenzo Bellini's opera, libretto by Felice Romani, premiered at the Teatro Carcano, Milan, March 6.

Frédéric Chopin left troubled Poland for Paris, where he quickly became a major musical figure; he also began work on his *B Minor Scherzo* (1831–1832) and *G Minor Ballade* (1831–1835), both for piano.

Felix Mendelssohn's *Piano Concerto No. 1*.

Hector Berlioz's overtures *Rob Roy, Le Roi Lear* (*King Lear*), and *Le Corsaire* (1831–1852); and his choral works *Lélio ou Le Retour à la vie* and *Méditation religieuse*.

Luigi Ricci's opera *Chiara di Rosembergh*.

d. Rodolphe Kreutzer, French violinist, composer, and teacher (b. 1766), to whom Ludwig van Beethoven dedicated his ninth violin sonata, now called the *Kreutzer*.

WORLD EVENTS

Nat Turner led a failed slave revolt in Virginia.

William Lloyd Garrison began publishing the abolitionist journal *The Liberator*, in Boston.

Insurrections in several Italian cities were crushed by Austrian intervention.

Polish insurrection against Russian rule failed as Russian forces defeated the Polish army and took Warsaw.

Egypt and Turkey were at war; Egyptian forces took Syria from the Turks (1831–1833).

1832

LITERATURE

Indiana, the semiautobiographical romantic novel that made George Sand's literary reputation; also her novel *Valentine*.

The Alhambra, Washington Irving's collection of tales and sketches.

Alfred, Lord Tennyson's *Poems*, including *The Lady of Shalott*, *The Lotos-Eaters*, and *The Dream of Fair Women*.

Honoré de Balzac's novels *La Femme abandonnée*, *Madame Firmiani*, *La Grenadière*, *La Bourse*, *Le Colonel Chabert*, *Le Curé de Tours*, and *Le Message*; also his philosophical studies *Louis Lambert* and *Les Marana* (1832–1833).

Chambers's Journal was founded by the brothers Chambers in Scotland.

William Cullen Bryant's *Poems*, including *To the Fringed Gentian*, *Mutation*, *The Death of the Flowers*, and *The Song of Marion's Men*; also his *A Forest Hymn*.

Benjamin Disraeli's psychological romance *Contarini Fleming*.

Carl Jonas Love Almquist's short novel *Jaktslottet* and *The Book of the Wild Rose*, including stories and plays.

Edward Bulwer-Lytton's novel *Eugene Aram*.

James Kirke Paulding's novel *Westward Ho!*

José Fernández de Lizardi's novel *Don Catrín de la Fachenda*.

Aleksandr Pushkin's novel *Dubrovsky* (1832–1833).

Alfred de Vigny's novel *Stello*.

d. Johann Wolfgang von Goethe, German writer (b. 1749).

d. George Crabbe, English poet (b. 1754).

d. Sir Walter Scott, Scottish writer (b. 1771); his last works included *Castle Dangerous*, *Count Robert of Paris*, and *Tales of My Landlord* (fourth series).

VISUAL ARTS

John Constable's paintings included *Waterloo Bridge from Whitehall Stairs* and *The Grove at Hampstead*.

J. M. W. Turner's paintings included *Childe Harold's Pilgrimage: Italy* and *Shadrack, Mesach, and Abednego in the Burning Fiery Furnace*.

George Washington, Horatio Greenough's sculpture for the Rotunda of the U.S. Capitol.

Jean-Auguste-Dominique Ingres's painting *Monsieur Louis-François Bertin*.

John Quidor's painting *The Money Diggers*.

THEATER & VARIETY

Johann Wolfgang von Goethe's *Faust II*.

Aleksandr Pushkin's *Feast in Time of the Plague*.

Sheridan Knowles's *The Hunchback* opened at Covent Garden on April 5 with Knowles and Fanny Kemble in the leads.

Victor Hugo's play *Le Roi s'amuse*; basis of Giuseppe Verdi's 1851 opera *Rigoletto*.

Robert Montgomery Bird's *Oralloossa*.

The Tower of Nesle, play by Alexandre Dumas (*père*), with Mlle. Georges.

d. William Warren, the elder, British-born American actor (b. 1767).

d. Ludwig Devrient, German actor (b. 1784).

MUSIC & DANCE

La Sylphide, Filippo Taglioni's ballet based on Charles Nodier's *Trilby, ou le Lutin d'Argail* (1822), music by Jean Schneitzhoeffer, first danced March 12 in Paris; Marie Taglioni, his daughter, in the title role, became the first to dance on her toes (*en pointe*), emerging as the first great ballerina in the history of the dance.

L'elisir d'amore (*The Elixir of Love*), Gaetano Donizetti's opera, libretto by Felice Romani, premiered at the Teatro della Canobbiana, Milan, May 12.

Stabat Mater, Gioacchino Rossini's choral work.

Ivanhoe, Giovanni Pacini's opera, based on the 1819 Sir Walter Scott novel.

Robert Schumann's *Papillons*, for piano.

Frédéric Chopin's *Twelve Études* for piano (1832–1836).

Hector Berlioz's choral work *Lélio*.

Nightingale; Alexander Alexandrovich Alyab'yev's song.

Louis Spohr's *Symphony No. 4*.

Rock of Ages, popular hymn (ca. 1832).

WORLD EVENTS

U.S.–Sauk Indian War (Black Hawk War); massacre of Sauks by U.S. troops in Wisconsin; capitulation of Black Hawk.

French intervened against Holland in the Belgian war of independence.

Giuseppe Mazzini founded "Young Italy."

Passage of Reform Bill in Britain climaxed long campaign for enactment.

Zurich University was founded.

1833

LITERATURE

Eugene Onegin, Aleksandr Pushkin's masterwork, a novel in verse focusing on the experiences of his eponymous Byronic hero, basis for Tchaikovsky's 1879 opera; also Pushkin's ballads *The Tale of the Dead Princess*, *The Tale of the Fisherman and the Fish*, and *The Tale of Tsar Saltan*.

Sartor Resartus (*The Tailor Retailored*; 1833–1834), Thomas Carlyle's philosophical satire, inspired by Jonathan Swift's 1704 publications.

Lélia, George Sand's frankly erotic and thus highly controversial novel.

Honoré de Balzac's novel *Eugénie Grandet*, which explored the stifling of the eponymous heroine by her tyrannical father; also Balzac's other novels *Le Médecin de campagne*, *Les Parisiens en province: L'Illustre Gaudissart*, *Histoire des Treize-Ferragus* (all 1833), *La Duchesse de Langeais* (1833–1834), and *La Fille aux yeux d'or* (1834–1835).

Ms. Found in a Bottle won Edgar Allan Poe $50 in a Baltimore *Sunday Visitor* short-story contest.

Robert Browning's first poem, *Pauline: A Fragment of a Confession*.

Benjamin Disraeli's historical novel *The Wondrous Tale of Alroy*.

Dionysios Solomos's poetic work *O Kritikos*.

Heinrich Heine's prose study *Die Romantische Schule* (*The Romantic School*; 1833–1835).

Pierre-Jean de Béranger's poems *Chansons nouvelles et dernières*.

Mosaïque, Prosper Mérimée's collection of tales.

The Knickerbocker began publication in New York.

The New Testament was published in the Ojibwa language.

The *New York Sun* began publication under Benjamin Day.

VISUAL ARTS

J. M. W. Turner's paintings included *Rotterdam Ferry Boat* and *Mouth of the Seine, Quille-Boeuf*.

Jean-Baptiste-Camille Corot's painting *View of Soissons*.

Pierre-Jean David's sculpture of *Goethe*.

Eugène Delacroix's painting *Arab Fantasy*.

Hokusai's *Toshi-sen* (1833–1836).

Samuel Morse's painting *The Exhibition Gallery of the Louvre*.

Horatio Greenough's relief sculpture *Saint John and the Angel*.

THEATER & VARIETY

Aleksander Fredro's *Maidens' Vows*.

Alfred de Vigny's *Quitte pour la peur*.

Johann Nepomuk Nestroy's *Des vöse Geist Lumpazivagabundus*.

The Caprices of Marianne, Alfred de Musset's play.

Victor Hugo's *Lucrèce Borgia* and *Marie Tudor*.

d. Edmund Kean, leading English tragedian (b. 1789), who began a child actor emerging as a major figure in 1814 with his Shylock in *The Merchant of Venice*, and then becoming one of the leading theatrical personalities of his day.

d. John O'Keeffe, Irish-born playwright (b. 1747).

d. Thomas John Dibdin, English actor and playwright (b. 1771).

MUSIC & DANCE

Lucrezia Borgia, Gaetano Donizetti's opera, libretto

by Felice Romani, opened at La Scala, Milan, December 26.

Gaetano Donizetti's operas *Torquato Tasso* and *Il furioso all'isola di San Domingo.*

Beatrice di Tenda, Vincenzo Bellini's opera, libretto by Felice Romani, premiered in Venice.

Felix Mendelssohn's *Symphony No. 4*, the *Italian*, and his overture *The Lovely Melusine* (*Die Schöne Melusine*).

Gustave III, Daniel-François-Esprit Auber's opera, basis for Giuseppe Verdi's *Un Ballo in maschera* (*A Masked Ball*); choreography by Filippo Taglioni. Both portray the 1792 assassination of Sweden's Gustav III in Stockholm's Royal Opera House.

Richard Wagner's first two operas, *Die Feen* (not publicly performed until 1888) and *Das Liebesverbot* (first staged in 1836).

Bozhe Tsarya khrani, Russian anthem, was composed by Alexis Lvov for Czar Nicholas I, replacing the instrumental anthem *God Save the King.*

d. Jean Aumer, French choreographer and dancer (b. 1774).

WORLD EVENTS

American Anti-Slavery Society founded by leading abolitionists.

British Factory Act enacted, regulating some abuses of industrial workers.

Civil war in Spain began, the first "Carlist" War, named after throne claimant Don Carlos (1833–1840).

British took the disputed Falkland Islands.

Egyptian–Turkish war ended with Egypt taking Syria and Aden from Turkey.

d. Ferdinand VII (b. 1784), king of Spain; succeeded by Isabella II.

1834

LITERATURE

Le Père Goriot (1834–1835), Honoré de Balzac's tale of old Goriot's devotion to his unworthy daughters; also Balzac's novel *Histoire de la grandeur et de la décadence de César Birotteau* (1834–1837) and philosophical studies *La Recherche d'absolu* (1834) and *Séraphîta* (1834–1835).

Edward Bulwer-Lytton's enormously popular novel *The Last Days of Pompeii*, relating the thwarted romance of Glaucus and Ione, who become free to love each other after Mt. Vesuvius erupts.

The Queen of Spades, Aleksandr Pushkin's gothic tale of the downfall of a gambler; basis of the Tchaikovsky opera.

Victor Hugo's novel *Claude Gueux.*

Edgar Allan Poe's short story *The Assignation.*

Alphonse de Lamartine's *La France parlementaire* (1834–1851).

d. Samuel Taylor Coleridge, English poet and essayist (b. 1772).

d. Charles Lamb (pen name Elia), English essayist (b. 1775).

VISUAL ARTS

Jean-Baptiste-Camille Corot's paintings included *Hagar in the Wilderness* (1834–1835) and *View of Genoa.*

J. M. W. Turner's paintings included *The Fountain of Indolence*, *The Burning of the House of Lords and Commons, 16th October, 1834*, and *Wreckers—Coast of Northumberland.*

Honoré Daumier's lithographs included *Rue Transnomain, April 15, 1834*, and *The Legislative Belly.*

Women of Algiers in Their Apartment, Eugène Delacroix's painting.

Hokusai's *Hundred Views of Mt. Fuji* (1834–1835).

The Martyrdom of St. Symphorien, Jean-Auguste-Dominique Ingres's painting.

Asher Durand's painting *The Capture of Major André.*

John Martin's painting *The Deluge.*

Pierre-Jean David's sculpture of *Paganini.*

d. Thomas Telford, Scottish architect (b. 1757).

THEATER & VARIETY

Alfred de Musset's *Lorenzaccio.*

John Baldwin Buckstone's *Married Life.*

Aleksander Fredro's *Vengeance.*

Josef Kajetán Tyl's *The Fair.*

Robert Montgomery Bird's *The Broker of Bogota.*

MUSIC & DANCE

Mary Stuart (*Maria Stuarda*), Gaetano Donizetti's opera, libretto by Giuseppe Bardari, premiered at the Teatro San Carlo, Naples, October 18.

Hector Berlioz's symphony *Harold en Italie*, inspired by Lord Byron's *Childe Harold's Pilgrimage* (1812–1818); also Berlioz's choral work *Sara la baigneuse* (1834–1841), *La Captive* for voice and orchestra, and five songs *Les Nuits d'été*.

Hector Berlioz's *Grande traité d'instrumentation*, a treatise designed to inform composers about the new musical instruments available to them; revised 1855.

Robert Schumann's piano works *Études symphoniques* and *Carnaval* (1834–1835), a series of pieces with literary or personal associations.

Adolphe Adam's opera *Le Chalet*.

Daniel-François-Esprit Auber's opera *Lestocq*.

Franz Liszt's piano work *Apparitions*.

Gaetano Donizetti's opera *Gemma di Vergy*.

Luigi Ricci's opera *Un avventura di Scaramuccia*.

A *Capriccio on Russian Themes*, Mikhail Glinka's piano duet.

Giuseppe Gabetti's instrumental march became an Italian anthem.

F. Skroup wrote *Kde domov muj*, to words by Josef Kajetán Tyl; the song would, combined with a Slovak folk song, later become part of the Czechoslovakian anthem.

d. Adrien Boieldieu, French composer (b. 1775).

WORLD EVENTS

Slavery was abolished throughout the British Empire; in South Africa, strong Boer objections began to build into a separatist movement.

British Houses of Parliament were largely destroyed by a massive fire.

Failed insurrection in Savoy by Mazzini's "Young Italy."

Failed Republican insurrection in Paris.

Sikhs took Peshawar.

Cyrus McCormick invented his reaper.

1835

LITERATURE

Aleksandr Pushkin's ballad *The Tale of the Golden Cockerel*.

Democracy in America, Alexis de Tocqueville's landmark study of American democratic institutions (1835–1840).

Kalevala, Finnish folk epic poem, compiled from oral traditions and popular songs by philologist Elias Lönnrot (revised and expanded 1849).

Hans Christian Andersen's stories, including *The Princess and the Pea*, *The Emperor's Clothes*, *The Ugly Duckling*, and *The Red Shoes* (all 1835–1872).

Honoré de Balzac's novels *Le Contrat de mariage* and *Le Lys dans la vallée* (1835–1836); also his philosophical studies *Melmoth réconcilié* and *Un Drame au bord de la mer*.

Outre-Mer: A Pilgrimage Beyond the Sea, Henry Wadsworth Longfellow's first book, travel sketches.

Edgar Allan Poe's short stories *Berenice*, *Morella*, and *The Unparalleled Adventures of One Hans Pfaal* (1835–1837).

Alfred de Vigny's short stories *Servitude et grandeur militaires* (*The Military Necessity*).

Alphonse de Lamartine's *Souvenirs, impressions, pensées et paysages, pendant un voyage en Orient, 1832–1833*.

New York Herald began publication, under James Gordon Bennett.

Edward Bulwer-Lytton's novel *Rienzi*; basis for Richard Wagner's 1842 opera.

Robert Browning's poem *Paracelsus*.

Victor Hugo's poems *Les Chants du crépuscule*.

Washington Irving's *A Tour on the Prairies* and *The Crayon Miscellany*.

William Wordsworth's *Yarrow Revisited, and Other Poems*.

Nathaniel Hawthorne's story *Young Goodman Brown*.

Jacob Grimm's *Deutsche Mythologie*.

James Fenimore Cooper's novel *The Monikins*.

John Clare's poem *The Rural Muse*.

Mary Wollstonecraft Shelley's novel *Lodore*.

Mirgorod, Nikolay Gogol's story collection.

Printing began in New Zealand.

VISUAL ARTS

J. M. W. Turner's paintings included *Norham Castle, Sunrise* (ca. 1835–1845), *Keelmen Heaving in Coals by Moonlight*, and the *Burning of the Houses of Parliament*.

John Constable's painting *A Cottage at East Bergholt* (ca. 1835).

Washington Allston's painting *The Evening Hymn*.

Bargaining for a Horse, William Sidney Mount's painting.

d. Antoine-Jean Gros, French painter (b. 1771).

d. John Nash, English architect (b. 1752).

THEATER & VARIETY

Chatterton, Alfred Vigny's play premiered at the Theatre Français, Paris, in February.

Georg Büchner's *Danton's Death*.

Masquerade, Mikhail Y. Lermontov's play.

Aleksander Fredro's *The Life Annuity*.

Christian Dietrich Grabbe's *Napoleon*.

Johann Nepomuk Nestroy's *On the Ground Floor and on the First Floor*.

Angelo, tyran de Padoue, Victor Hugo's play.

d. Charles Mathews, English actor (b. 1776), a popular comedian and singer in the series of solo shows with which he became identified.

MUSIC & DANCE

Lucia di Lammermoor, Gaetano Donizetti's opera, libretto by Salvatore Cammarano, based on the 1819 Sir Walter Scott novel, *The Bride of Lammermoor*, opened at the Teatro San Carlo, Naples, September 26. Fanny Tacchinardi-Persiani created the title role.

I puritani (*The Puritans*), Vincenzo Bellini's opera, libretto by Count Pepoli, premiered at the Théâtre des Italiens, Paris, January 25.

Franz Liszt's piano works *Album d'un voyageur* (1835–1836) and *Années de pèlerinage* (1835–1877).

Fromental Halévy's opera *La Juive*, libretto by Eugène Scribe, opened at the Opéra, Paris, February 23; also his opera *L'éclair*.

Gaetano Donizetti's opera *Marino Faliero*, after Byron.

The Siege of Rochelle, Michael William Balfe's opera.

Die beiden Schützen, Albert Lortzing's dramatic musical work.

Bass tuba introduced by Wilhelm Wieprecht, made by Moritz of Berlin.

Modern flügelhorn introduced in Germany; it would largely replace the keyed bugle (late 1830s).

Boston Brass Band founded.

d. Vincenzo Bellini, Italian composer (b. 1801).

WORLD EVENTS

Argentine dictatorship established by Juan de Rosas (1835–1852).

French "September Laws" were aimed at stifling dissent.

Philadelphia's Liberty Bell cracked.

Second Seminole Indian War, a long guerrilla war against U.S. rule, led by Osceola (1835–1842).

Texans, led by Sam Houston, began preparing for an insurrection against Mexican rule (1835–1836).

1836

LITERATURE

Sketches by "Boz", Illustrative of Everyday Life and Everyday People, Charles Dickens's first writings published in book form, with illustrations by George Cruikshank; the sketches originally appeared serially in periodicals such as the *Old Monthly Magazine* (from 1833).

Nature, Ralph Waldo Emerson's essay exploring the meaning of nature and its relationship with and value to humans; a prime exploration of the Transcendentalist philosophy.

Honoré de Balzac's novels *La Messe de l'athée, Facino Cane, L'Interdiction* (all 1836), and *La Cabinet des antiques* (1836–1839).

Aleksandr Pushkin's novel *The Captain's Daughter*, and travel writings *A Journey to Erzurum*.

Benjamin Disraeli's novel *Henrietta Temple*.

Washington Irving's history *Astoria*.

Caroline Elizabeth Sarah Norton's verses *A Voice from the Factories*.

Mihály Vörösmarty's poem *Szózat*.

The Clockmaker, an early Canadian novel by Thomas Halliburton.

d. William Godwin, English novelist and political theorist (b. 1756).

VISUAL ARTS

Thomas Cole's painting *The Course of Empire*; also his *Essay on American Scenery*, in *American Monthly Magazine*.

J. M. W. Turner's painting included *Juliet and Her Nurse* and *Rome, from Mount Aventine*.

John Constable's painting *The Cenotaph at Coleorton*.

Étienne-Pierre-Théodore Rousseau's painting *Descente des Vaches*.

Jean-Baptiste-Camille Corot's painting *Diana Surprised by Actaeon*.

Samuel Morse's painting *The Muse*.

Joseph Paxton began the Great Conservatory at Chatsworth (1836–1840/41).

Arc de Triomphe, Paris, completed.

Robert Mills began the Washington Monument and the Treasury Building, both in Washington, D.C. (1836–1842).

THEATER & VARIETY

The Inspector-General, Nikolai Gogol's play opened in Moscow and St. Petersburg; and in the same year, his play *Revizor*.

Aleksandr Pushkin's play *The Covetous Knight*.

Kean, ou Désordre et génie, play by Alexandre Dumas (*père*).

Antonio García Gutiérrez's *El Trovador*.

Charlotte Mary Sanford Barnes's *Octavia Bragaldi*.

Frederick Reynolds's *Harlequin and Old Gammer Gurton; or, the Lost Needle*.

Henrik Hertz's *The Savings Bank*.

d. George Colman the younger, English playwright and theater manager (b. 1762).

d. Christian Dietrich Grabbe, German poet and playwright (b. 1801).

d. Ferdinand Raimund, Austrian playwright and actor (b. 1790).

MUSIC & DANCE

Les Huguenots, Giacomo Meyerbeer's opera, book by Eugène Scribe and Emile Deschamps, choreography by Filippo Taglioni, premiered at the Opéra, Paris, February 29.

August Bournonville's ballet *La Sylphide*, music by Herman Løvenskjold, opened in Copenhagen, November 38, with Bournonville and Lucile Grahn dancing; based on Charles Nodier's 1822 novel *Trilby, ou le Lutin d'Argail*.

A *Life for the Tsar*, Mikhail Glinka opera, libretto by Georgy Rozen, opened in St. Petersburg.

Adolphe Adam's opera *Le Postillon de Longjumeau* (*The Coachman of Longjumeau*).

Felix Mendelssohn's oratorio *St. Paul*.

Frédéric Chopin's *F Major Ballade* (1836–1839) and *Twenty-four Preludes* (1836–1839), all for piano.

Gaetano Donizetti's operas *Il campanello di notte*, *Belisario*, and *Betly*.

Luigi Cherubini's *Requiem*.

The Maid of Artois, Michael William Balfe's opera.

Robert Schumann's *Fantasy in C Major*, for piano.

Richard Wagner's second opera *Das Liebesverbot* (1833) first staged.

WORLD EVENTS

Texas War of Independence: Mexican army besieged and took the Alamo, but was decisively defeated at San Jacinto. Texas won its independence; Sam Houston was first president of the new country.

Boer Trek in South Africa: migration of 10,000–14,000 Boers and their slaves ("apprentices") out of Cape Colony north into Zulu lands. Boers defeated Matabele Zulus at Vegkop in the Transvaal.

Martin Van Buren was elected U.S. president.

Arkansas became a state.

Chile was at war with Peru and Bolivia.

Persia and Afghanistan were at war (1836–1838).

1837

LITERATURE

The Pickwick Papers, Charles Dickens's first novel, which began life as serial sketches (from 1836) under the pseudonym Boz as *The Posthumous Papers of the Pickwick Club*, becoming instantly popular and making Dickens's name, with characters such as Serjeant Buzfiz, Alfred Jingle, Samuel Weller, and Mrs. Bardell. Another serial, *Oliver Twist*, began appearing in *Bentley's Miscellany*, a periodical Dickens edited, with illustrations by George Cruikshank.

History of the French Revolution, Thomas Carlyle's massive three-part work, which made his reputation.

Twice-Told Tales, Nathaniel Hawthorne's collection of stories, including *The Grey Champion, The Great Carbuncle, The Minister's Black Veil, Howe's Masquerade*, and *Endicott and the Red Cross*, basis for one of the three plays in Robert Lowell's trilogy *Old Glory* (1965).

Honoré de Balzac's novels *Les Employés, Les Rivalités—La Vielle Fille* (both 1837); *Illusions perdues: Les Deux Poètes* (1837); *Un Grand Homme de province à Paris* (1839); and *Les Souffrances de l'inventeur* (1842).

Aleksandr Pushkin's novel *Egyptian Nights* and poem *The Bronze Horseman*.

Electrotyping was developed, an improvement on the earlier stereotyping used in printing.

Fredrika Bremer's novel *Grannarne*.

Washington Irving's *The Adventures of Captain Bonneville, U.S.A.*, a sequel to his *Astoria*.

Ralph Waldo Emerson's essay *The American Scholar*.

Robert Browning's poem *Strafford*.

Victor Hugo's poems *Les Voix intérieures*.

William Makepeace Thackeray's *The Yellowplush Correspondence*.

d. Aleksandr Pushkin, Russian poet (b. 1799).

VISUAL ARTS

J. M. W. Turner's paintings included *The Grand Canal, Venice*, and *The Parting of Hero and Leander*.

Eugène Delacroix's paintings *La Bataille de Taillebourg* (*The Battle of Taillebourg*) and *Portrait de l'artiste* (ca. 1837).

Avenue of Chestnut Trees, Étienne-Pierre-Théodore Rousseau's painting.

Gavarni's drawings *Fourberies de Femmes en Matière de Sentiment* (1837–1841).

Charles Barry designed the Reform Club, London.

Horatio Greenough began his sculpture *Venus Victrix* (1837–1841).

d. John Constable, English painter (b. 1776).

d. Francis Howard Greenway, English-Australian architect (b. 1777).

THEATER & VARIETY

Robert Browning's *Strafford*.

Henrik Hertz's *The House of Sven Dyring*.

Manuel Bretón de los Herredos's *Die and You Will See*.

d. Georg Büchner, German playwright and doctor (b. 1813); unknown in his lifetime, he later became highly respected as a forerunner of German expressionism.

d. Joseph Grimaldi, English actor and very early English clown (b. 1778).

MUSIC & DANCE

Robert Devereux, Gaetano Donizetti's opera, libretto by Salvatore Cammarano, premiered in Naples October 29.

Robert Schumann's piano works *Phantasiestücke*, a collection of mood pieces, and *Davidsbündlertänze* (*Dances of the league of David*), musical portraits of those who, with David, fought the Philistines.

Tsar and Carpenter (*Zar und Zimmermann*), Albert Lortzing's opera, to his own libretto.

Traité général d'instrumentation, an influential work on the playing of various musical instruments, by French music theorist and composer Jean-Georges Kastner.

Hector Berlioz's requiem *Grande messe des morts*.

Felix Mendelssohn's *Piano Concerto No. 2* and *String Quartet Nos. 4–6* (1837–1838).

Frédéric Chopin's *B Flat Minor Scherzo* for piano.

Gaetano Donizetti's opera *Pia de' Tolomei*.

Agnes von Hohenstaufen, Gaspare Spontini's dramatic musical work.

Franz Liszt's *Dante Sonata*, for piano (1837–1849).

Mélophone invented in Paris, a free-reed, guitar-shaped instrument, with buttons for one hand and bellows for the other.

Marie Taglioni danced her *La Sylphide* in St. Petersburg to great acclaim.

Venice's new Teatro La Fenice (Phoenix) opened, rebuilt after an 1837 fire.

d. Johann Nepomuk Hummel, Austrial pianist and composer (b. 1778).

WORLD EVENTS

Trekboers founded the Natal Republic.

Seminole leader Osceola was captured, but Seminole armed resistance continued into the 1840s.

Michigan became a state.

Victoria became queen of England, succeeding William IV.

Small-scale failed insurrections against British rule in Quebec and Ontario (1837–1838).

Druze insurrection against Egyptian rule failed (1837–1838).

Thomas Carlyle's *French Revolution*.

1838

LITERATURE

Oliver Twist; or, The Parish Boy's Progress, Charles Dickens's previously serialized story appeared in book form, relating the experiences of the

orphaned Oliver in the workhouse and on the street, with notable characters such as Fagin, the Artful Dodger, Bill Sikes, and Dickens's favorite, Nancy; basis for numerous dramatizations, including the musical *Oliver*. Also appearing were Dickens's *Sketches of Young Gentlemen* and the first serialized parts of *Nicholas Nickleby*.

The Mabinogion, collection of medieval Welsh tales, first translated into English by Lady Charlotte Guest (1838–1849).

The Narrative of A. Gordon Pym, Edgar Allan Poe's previously serialized novella (from 1837) of a boy's adventures after stowing away on a whaler, appeared in book form.

Letters on the Equality of the Sexes and the Condition of Women, sisters Angelina and Sarah Grimké's argument for women's full equality, including the right to participate in political action, in this case to be active in the abolition movement.

Edward Bulwer-Lytton's novel *Leila*.

Elizabeth Barrett Browning's *The Seraphim and Other Poems*.

William Wordsworth's *Sonnets*.

Honoré de Balzac's novel *La Maison Nucingen*.

James Fenimore Cooper's novels *Homeward Bound* and *Home As Found*.

Alphonse de Lamartine's poems *La Chute d'un ange*.

Ralph Waldo Emerson's essay *Divinity School Address*.

William Makepeace Thackeray's *Some Passages in the Life of Major Gahagan*.

Times of India founded.

VISUAL ARTS

J. M. W. Turner's paintings included *The "Fighting Téméraire" Tugged to Her Last Berth to be Broken Up 1838* and *Ancient Italy—Ovid Banished from Rome*.

Jean-Baptiste-Camille Corot's painting *A View near Volterra*.

Thomas Cole's paintings included *Schroon Mountain, Adirondacks* and *The Past and The Present*.

Eugène Delacroix's paintings included his *Portrait of Frédéric Chopin*, *Portrait of George Sand*, and *Furious Medea*.

John Quidor's painting *A Battle Scene from Knickerbocker's History*.

Alexander Jackson Davis designed Lyndhurst, on the Hudson River.

Horatio Greenough's sculpture *Angel Abdiel*.

Asher Durand's paintings *Dance on the Battery in the Presence of Peter Stuyvesant.* and *Sunset*.

THEATER & VARIETY

Edward George Bulwer-Lytton's *The Lady of Lyons; or, Love and Pride*.

Franz Grillparzer's *Thou Shalt Not Lie*.

Johan Ludvig Heiberg's *Fata Morgana*.

Ruy Blas, Victor Hugo's play.

d. Thomas Morton, English playwright (b. ca. 1838).

MUSIC & DANCE

Benvenuto Cellini, Hector Berlioz's opera, libretto by León de Wailly and Auguste Barbier, based on Cellini's autobiography, premiered in Paris.

Robert Schumann's piano works *Kinderszenen* (*Scenes from Childhood*) and *Kreisleriana*, pieces exploring the character of a mad Kapellmeister.

Federico Ricci's opera *La prigione di Edimburgo*.

Franz Liszt's piano work *Études d'exécution transcendante d'après Paganini*, transcriptions of six Paganini violin caprices; revised as *Grandes études de Paganini* (1851).

Adolphe Sax patented his design for the bass clarinet.

WORLD EVENTS

Cherokee Nation was pushed west into Oklahoma by U.S. armed forces; final genocidal forced march was called the Trail of Tears.

Decisive Blood River battle in South Africa; large Zulu army was defeated by small Boer force equipped with guns and horses.

France occupied Vera Cruz; Mexico and France were at war.

Britain and Afghanistan were at war.

London Working Men's Association created the People's Charter, basic document of the Chartist movement.

1839

LITERATURE

The Charterhouse of Parma (*La Chartreuse de Parme*),

Stendhal's great historical novel following its hero, Fabrizio del Dongo, through a series of adventures in post-Napoleonic Italy.

Nicholas Nickleby, Charles Dickens's initially serialized novel published in book form, following his penniless eponymous hero through contacts with characters such as Wackford Squeers, Smike, and the Cheeryble brothers.

Honoré de Balzac's novels *Beatrix*, *Le Curé de village*, *Une Fille d'Ève*, *Les Secrets de la Princesse de Cadignan* (all 1839), and *Splendeurs et misères des courtisanes* (in four parts; 1839–1847); also his philosophical study *Massimilla Doni* (1839).

Henry Wadsworth Longfellow's *Voices of the Night*, his first published poems; also the semiautobiographical romance *Hyperion*.

The Haunted Palace, Edgar Allen Poe's poem, later attributed to his Roderick Usher in *The Fall of the House of Usher* (1939).

Fredrika Bremer's novel *Hemmet* (translated as *The Home*).

Alphonse de Lamartine's *Recueillements poétiques*.

William Makepeace Thackeray's novel *Catherine* (1839–1840).

d. José María de Heredia, Cuban poet (b. 1803).

d. William Leggett, American newspaper editor (b. 1802).

VISUAL ARTS

Louis Daguerre invented the daguerrotype, the first practical photograph.

J. M. W. Turner's paintings included *Modern Rome— Campo Vaccino* and *Cicero at His Villa*.

Odalisque with Slave, Jean-Auguste-Dominique Ingres's painting.

Charles Barry began the new Houses of Parliament, London.

Decimus Burton designed the London Athenaeum.

Eugène Delacroix's painting *The Return of Columbus*.

Thomas Crawford's sculpture *Orpheus* (1839–1843).

THEATER & VARIETY

Richelieu, Edward Bulwer-Lytton's play, opened in London on March 7, with William Charles Macready and Helen Faucit in the leads.

Aleksandr Pushkin's play *The Stone Guest*.

John Baldwin Buckstone's play *Single Life*.

d. William Dunlap, American playwright, theater manager, and theater historian (b. 1766).

MUSIC

La Fille mal Gardée, Jean Dauberval's ballet, music by Johann Hentel, first danced in New York, July 6.

Obert, Conte di San Bonifacio, Giuseppe Verdi's first opera, staged at La Scala.

Modern form of the clarinet developed (patented 1844) by Louis-Auguste Buffet.

August Bournonville's ballet *Festival in Albano*.

Congregazione dei Musici di Roma (ca. 1566) renamed Accademia di S Cecilia (ca. 1839).

Romeo and Juliet, Hector Berlioz's dramatic symphony.

Felix Mendelssohn's *Piano Trio No. 1*.

Frédéric Chopin's piano works *B Flat Minor Sonata* and *C Sharp Minor Scherzo*.

First valves used on bass brass instruments, in Germany and Austria (late 1830s).

d. Ferdinando Paer, Italian composer (b. 1771).

WORLD EVENTS

Chinese–British Opium War began when Chinese government tried to stop the British-sponsored opium trade at Canton; British forces with modern weapons easily defeated the Manchus.

First Afghan War: British Indian forces invaded Afghanistan, took Ghazni, and occupied Kabul until their disastrous retreat in 1841 (1839–1842).

Demonstrations flared throughout Britain, as Chartist demonstrations grew.

Charles Darwin published his journal of the 1832–1836 voyage of the *Beagle*.

Independence of Belgium and Luxembourg was recognized by the Treaty of London.

"Rebecca Riots" began; attacks on tollgates and roads by Welsh farmers protesting high toll-road fees (1839–1844).

Russian forces expanding into south-central Asia were defeated in Khiva and Kazakhstan.

1840

LITERATURE

A Hero of Our Time (*Geroy nashego vremeni*), Mikhail

Lermontov's character study of a young aristocrat, Grigory Pechorin, a "superfluous man" in 1830s Czarist Russia.

The Pathfinder, or The Inland Sea, the fourth published of the five novels in James Fenimore Cooper's *Leatherstocking Tales*, here following Natty Bumppo (Hawkeye, or the Pathfinder) during the French and Indian Wars.

Two Years Before the Mast, Richard Henry Dana, Jr.'s journal of his sailing experiences, especially the unchecked power of the captain over the sailors, helping to spur legal reform.

Tales of the Grotesque and Arabesque, Edgar Allan Poe's first collection of short stories, many previously published in magazines.

Honoré de Balzac's novels *Pierre Grassou*, *Les Célibataires: Pierrette*, *Un Prince de la Bohème*, and *Z. Marcas*.

Adalbert Stifter's story *Der Kondor*.

Charles Dickens's *Sketches of Young Couples*.

Robert Browning's poem *Sordello*.

Matthew Arnold's poem *Alaric at Rome*.

Taras Shevchenko's poems *Kobzar*.

Victor Hugo's poems *Les Rayons et les ombres*.

William Makepeace Thackeray's *The Paris Sketch Book*.

d. Fanny Burney (Madame d'Arblay), English author (b. 1752).

VISUAL ARTS

J. M. W. Turner's paintings included *The Slave Ship*, *Venice, the Bridge of Sighs*, and *Rockets and Blue Lights*.

Jean-Baptiste-Camille Corot's paintings included *Les Bords du Cousin* (ca. 1840–1845) and *The Little Shepherd*.

Thomas Cole's painting *The Voyage of Life*.

Eugène Delacroix's paintings included *The Taking of Constantinople by the Crusaders on April 12, 1204*, and *The Justice of Trajan*.

Gavarni's drawings *Les Débardeurs*.

Honoré Daumier's drawing *Two Men Looking Toward the Left* (ca. 1840).

Francis Danby's painting *Temple of Flora*.

Adolf Menzel's work included the painting *The Berlin-Potsdam Railway*, and the engraving *Life of Frederick the Great* (1840–1842).

THEATER & VARIETY

A Glass of Water, Eugène Scribe's play.

Edward George Bulwer-Lytton's *Money*.

Friedrich Hebbel's *Judith*.

Vautrin, Honoré de Balzac's play.

Johan Ludvig Heiberg's *Day of the Seven Sleepers*.

Manuel Bretón de los Herredos's *As Green as Grass*.

MUSIC & DANCE

La Fille du régiment (*The Daughter of the Regiment*), Gaetano Donizetti's opera, libretto by Jules-Henry Vernoy and Jean Bayard, opened in Paris February 11.

La favorite, Gaetano Donizetti's opera, libretto by Alphonse Royer and Gustav Vaez.

Un Giorno Di Regno (*King for a Day*), Giuseppe Verdi's second opera, libretto by Felice Romani, opened at La Scala, Milan, September 5; it was an utter failure.

Robert Schumann's song cycles *Frauenliebe und leben* (*Woman's Love and Life*), *Liederkreis* (*Song Circle*), and *Dichterliebe* (*A Poet's Love*), to verses by Heinrich Heine. Also in 1840, he married virtuoso pianist and composer Clara Wieck.

Franz Liszt's *Hungarian Rhapsodies*, 20 piano pieces (1840s–1885); themes from *No. 14* were used in his *Hungarian Fantasy* (ca. 1852).

Felix Mendelssohn's cantata *Lobgesang* (*Hymn of Praise*).

Rocked in the Cradle of the Deep, popular song, words by Emma Willard (written 1832), music by J. P. Knight.

Bátori Mária, Ferenc Erkel's opera.

Richard Wagner's *Eine Faust Ouvertüre*.

Ballet star Fanny Elssler toured North America.

Gaetano Donizetti's opera *Poliuto*.

Symphonie funèbre et triomphale, Hector Berlioz's choral work.

Saffo, Giovanni Pacini's opera.

Efterklange af Ossian, Niels Gade's concert overture.

Hans Sachs, Albert Lortzing's dramatic musical work.

Aristide Cavaillé-Coll built the organ for St. Denis Abbey, France; the first major example of the more "orchestral" sound of the instrument.

Cornet became the dominant instrument in brass bands (before 1840), remaining so in Britain and France.

Harmonium patented by François Debain in Paris; later called an *orgue melodium*.

Grand square piano developed in America, by Jonas Chickering (1840s).

d. Nicolò Paganini, Italian violinist and composer (b. 1782), the first outstanding violin virtuoso.

WORLD EVENTS

William Henry Harrison was elected U.S. president.

Texas and the Comanches were at war, after the murders of Comanche chiefs while negotiating a peace treaty.

Britain defeated Maori insurrection in New Zealand.

British forces took Acre.

Surrender of remaining Carlist forces ended civil war in Spain.

1841

LITERATURE

The Deerslayer, the last published of the five novels in James Fenimore Cooper's *Leatherstocking Tales*, focusing on the youth of his hero Natty Bumppo (the Deerslayer) and his friendship with Delaware Chief Chingachgook.

Honoré de Balzac gave the name *La Comédie humaine* (*The Human Comedy*) to the series of interlocking novels that were his main work, approximately 90 of which were completed in less than 20 years. Novels published in 1841 were *Ursule Mirouët*, *La Fausse Maîtresse*, *Un Ténébreuse Affaire*, and *La Rabouilleuse* (1841–1842); also his philosophical study *Sur Catherine de Médicis*.

The Murders in the Rue Morgue, Edgar Allen Poe's "ratiocinative tale" featuring amateur sleuth C. Auguste Dupin, appeared in *Graham's Magazine*, setting the pattern for the English-language detective story.

Punch, or the London Charivari began publication as a radical political journal with cartoons and humorous articles, under wood engraver and draftsman Ebenezer Landells.

Henry Wadsworth Longfellow's *Ballads and Other Poems*, including *Excelsior*, *The Village Blacksmith*, and *The Wreck of the Hesperus*.

New York Tribune was founded by Horace Greeley, the crusading editor.

Charles Dickens's novels *Barnaby Rudge* and *The Old Curiosity Shop*.

Robert Browning's poem *Pippa Passes*.

Thomas Carlyle's *On Heroes, Hero-worship, and the Heroic in History*.

Grandfather's Clock, Nathaniel Hawthorne's story for children.

Colomba, Prosper Mérimée's collection of tales.

Ralph Waldo Emerson's *Essays: First Series*.

William Makepeace Thackeray's *The History of Samuel Titmarsh and the Great Hoggarty Diamond*.

Taras Shevchenko's poems *Haydamaky*.

d. Mikhail Lermontov, Russian poet and novelist (b. 1814).

VISUAL ARTS

J. M. W. Turner's paintings included *Peace: Burial at Sea* (1841–1842), honoring David Wilkie, who died at sea, and *Ducal Palace, Dagano, with Part of San Georgio, Venice*.

William Sidney Mount's painting *Cider Making*.

Eugène Delacroix's painting *The Shipwreck of Don Juan*.

Ford Madox Brown's painting *The Execution of Mary, Queen of Scots*.

Jean-Auguste-Dominique Ingres's painting *Charles Gounod*.

Noah Webster, sculpture by Chauncey Bradley Ives.

The Fisher Boy, sculpture by Hiram Powers.

d. David Wilkie, Scottish painter (b. 1785).

THEATER & VARIETY

London Assurance, Dion Boucicault's comedy, opened at New York's Park Theatre.

Johan Ludvig Heiberg's *A Soul After Death*.

Johannes Carsten Hauch's *Svend Grathe*.

d. Tyrone Power, Irish actor (b. 1797); lost at sea when the S.S. *President* sank during a trans-Atlantic voyage; father of the American actor Tyrone Power and grandfather of stage and screen star Tyrone Power.

d. Frederick Reynolds, English playwright (b. 1764).

d. Joseph Alois Gleich, Austrian playwright, author of some 220 plays (b. 1772).

MUSIC & DANCE

Giselle, Jean Coralli and Jules Perrot's ballet, music

by Adolphe Adam, first danced June 28 at the Opéra, Paris; Carlotta Grisi created the role of Giselle, Lucien Petipa that of Albrecht.

Robert Schumann's *Symphony No. 1*, the *Spring*, and his *Symphony No. 4* (revised 1851).

Invitation to the Dance (*Aufforderung zum Tanze*), Carl Maria von Weber's rondo brilliant for piano; orchestrated by Hector Berlioz.

Hector Berlioz's *Rêverie et caprice* for violin and orchestra and *Les Nuits d'été*, for voice and orchestra.

F. Oakeley and George Keith made their English translation of the centuries-old hymn *O Come, All Ye Faithful*.

Frédéric Chopin's *Fantasie in F Minor* for piano.

Casanova, Albert Lortzing's dramatic musical work.

Federico Ricci's opera *Corrado d'Altamura*.

La reine de Chypre, Fromental Halévy's opera.

WORLD EVENTS

U.S. President William Henry Harrison died one month after his inauguration, and was succeeded by John Tyler.

First Afghan War: British forces were destroyed by the Afghans during the retreat from Kabul; the British later retook and then once again evacuated Kabul, this time without significant losses.

Bolivia and Peru were at war.

British missionary David Livingstone began his work in South Africa.

British took New Zealand, though Maori resistance continued.

1842

LITERATURE

Robert Browning's *Dramatic Lyrics*, including *Porphyria's Lover*, *Soliloquy in a Spanish Cloister*, *The Pied Piper of Hamelin*, *Waring*, *King Victor and King Charles*, and the haunting dramatic monologue *My Last Duchess*.

Lays of Ancient Rome, Thomas Babington Macaulay's collection of ballads, including *Horatius*, *The Battle of Lake Regillus*, and *Virginia*.

The Mystery of Marie Rogêt, *Masque of the Red Death*, and *The Pit and the Pendulum*, Edgar Allan Poe's short stories.

Nikolay Gogol's short story *The Overcoat* and novel *Dead Souls*, acclaimed as one of Russia's finest.

Alfred, Lord Tennyson's *Poems*, including *Locksley Hall* and *Break, Break, Break*.

Consuelo, George Sand's novel.

Honoré de Balzac's novels *Albert Savarus*, *Autre Étude de femme*, *L'Envers de l'histoire contemporaine: Madame de la Chanterie*, and *Un Début dans la vie*.

Adalbert Stifter's story *Der Hochwald*.

James Fenimore Cooper's novels *The Two Admirals* and *The Wing-and-Wing*; or *Le Feu-follet*.

Nathaniel Hawthorne's *Biographical Stories for Children*.

d. Stendhal (Marie Henri Beyle), French novelist (b. 1783).

VISUAL ARTS

J. M. W. Turner's painting *Snow Storm—Steam-Boat Off a Harbour's Mouth Making Signals in Shallow Water, and Going by the Lead* and *Campo Santo, Venice*.

Eugène Delacroix's painting *George Sand's Garden at Nohant* (ca. 1842–1843).

Gustave Courbet's painting *Courbet with a Black Dog*.

Jean-Auguste-Dominique Ingres's painting *Duc d'Orléans*.

Honoré Daumier's lithograph *Pygmalion*.

John James Audubon's *Quadrupeds of America*.

d. John Sell Cotman, English landscape and watercolor painter (b. 1782).

d. Francis Leggatt Chantrey, English sculptor (b. 1781).

d. Marie-Louise Elisabeth Vigée-Lebrun, French painter (b. 1755).

THEATER & VARIETY

Honoré de Balzac's play *Les Ressources de Quinola*.

Nikolai Vasilievich Gogol's *Gamblers* and *Marriage*.

MUSIC & DANCE

Ruslan and Lyudmila, Mikhail Glinka's opera, libretto by Valeryan Shirkov, opened in St. Petersburg.

Rienzi, Richard Wagner's opera, libretto by Wagner based on the 1835 Bulwer-Lytton novel, opened at Hofoper, Dresden, October 20.

Napoli, August Bournonville's ballet, music by Neils

Gade and others, first danced March 29, by the Royal Danish Ballet, Copenhagen.

Nabucco, Giuseppe Verdi's opera, libretto by Temistocle Solera, premiered at La Scala, Milan.

Der Wildschütz (*The Poacher*), Albert Lortzing's opera, libretto by Lortzing, premiered in Leipzig, December 31.

Frédéric Chopin's *E Major Scherzo* and *F Minor Ballade*, both for piano.

Linda di Chamounix, Gaetano Donizetti's opera.

Anton Bruckner's *Short Chorale Mass in C Major* (ca. 1842).

Niels Gade's *First Symphony*.

August Bournonville's ballet *Napoli*.

Giovanni Pacini's opera *La fidanzata corsa*.

Robert Schumann's *Piano Quartet*.

Vienna Philharmonic Orchestra established.

New York Philharmonic Orchestra founded.

d. Luigi Cherubini, Italian composer and teacher (b. 1760).

WORLD EVENTS

Opium War ended with the Treaty of Nanking, which greatly expanded European penetration into China by opening several "treaty ports," including Shanghai, and provided for large indemnities from China to Britain.

British forces occupied Natal, forcing dissolution of the short-lived Boer Natal Republic.

Consolidation of Hawaii completed; U.S. recognized Hawaiian nation.

William Prescott's *The Conquest of Mexico*.

1843

LITERATURE

A Christmas Carol, Charles Dickens's now literally perennial tale of the miser Scrooge, his views of Christmases past, present, and future; and the clerk Bob Cratchit and his son, Tiny Tim.

Modern Painters, John Ruskin's five-volume treatise on painting; the first volume, stressing the superiority of contemporary painters, especially J. M. W. Turner, played a major role in public acceptance of new artists (1843–1860).

The Tell-Tale Heart, *The Black Cat*, and *The Gold Bug*, Edgar Allan Poe's short stories.

Robert Browning's poems *A Blot in the 'Scutcheon* and *The Return of the Druses*.

Ivan Turgenev's poem *Parasha*.

Adalbert Stifter's story *Abdias*.

Britain's sensational *The News of the World* began publication.

Edward Bulwer-Lytton's novel *The Last of the Barons*.

Elizabeth Barrett Browning's poem *The Cry of the Children*.

Atta Troll, a Midsummer Night's Dream, Heinrich Heine's narrative poem about the death of a trained bear.

Honoré de Balzac's novels *Honorine* and *La Muse du département*.

James Fenimore Cooper's novels *Ned Myers* and *Wyandotté; or, The Hutted Knoll*.

John Greenleaf Whittier's *Lays of My Home and Other Poems*.

John Pierpont's *The Anti-Slavery Poems of John Pierpont* (1832).

Cromwell, Matthew Arnold's poem.

Mihály Vörösmarty's poem *To a Dreamer*.

Thomas Babington Macaulay's *Critical and Historical Essays*.

The Song of the Shirt, Thomas Hood's poem.

William Ellery Channing's *Poems*.

William Makepeace Thackeray's *The Irish Sketch-Book*.

d. Noah Webster, American lexicographer (b. 1758).

d. Robert Southey, English poet (b. 1774).

VISUAL ARTS

J. M. W. Turner's paintings included *Light and Colour* (*Goethe's Theory*) and *Shade and Darkness: The Evening of the Deluge*.

Jean-Baptiste-Camille Corot's painting *Marietta "L'Odalisque Romaine."*

Honoré Daumier's paintings included *Les Noctambules* (ca. 1843–1848) and *Three Lawyers in Conversation* (ca. 1843–1846).

James Renwick began New York's Grace Church.

The Genius of Mirth, sculpture by Thomas Crawford.

The Greek Slave, sculpture by Hiram Powers.

John Ruskins's book *Modern Painters* (1843–1860), his famous defense of J. M. W. Turner's painting.

d. John Trumbull, American painter (b. 1756).

d. Washington Allston, American painter (b. 1779).

THEATER & VARIETY

Helen Faucit starred in Robert Browning's *A Blot in the 'Scutcheon*, in London.

Honoré de Balzac's *Paméla Giraud*.

Ivan Turgenev's *Neostorozhnost*.

François Ponsard's *Lucrèce*.

Giambattista Niccolini's *Arnaldo da Brescia*.

Henrik Hertz's *Kong Renes Datter*.

Joáo Batista de Almeida Garrett's *Frei Luís de Sousa*.

Victor Hugo's play *Les Burgraves*.

d. Casimir Delavigne, French playwright (b. 1793).

MUSIC & DANCE

Der Fliegende Holländer (*The Flying Dutchman*), Richard Wagner opera, book by Wagner, based on an old legend, related in Heinrich Heine's *Aus den Memoiren des Herren von Schnabelewopski* (1831), premiered at Hofoper, Dresden. Wilhelmine Schröder-Devrient created the role of Senta.

I Lombardi (*The Lombards*), Giuseppe Verdi's opera, libretto by Temistocle Solera; premiered at La Scala, Milan, February 11.

The Bohemian Girl, Michael Balfe's opera, libretto by Alfred Bunn, opened at the Drury Lane, London, November 17; among its enormously popular songs were *Then You'll Remember Me* and *I Dreamt That I Dwelt in Marble Halls*.

Don Pasquale, Gaetano Donizetti's opera, libretto by Donizetti and Giovanni Ruffini.

Gaetano Donizetti's operas *Dom Sébastien, roi de Portugal*, and *Maria di Rohan*.

Felix Mendelssohn's incidental music *A Midsummer Night's Dream*.

Robert Schumann's cantata *Das Paradies und die Peri*.

Old Dan Tucker, Daniel Decatur Emmett's popular song.

Giovanni Pacini's opera *Medea*.

Daniel-François-Esprit Auber's opera *La Part du diable*.

Benjamin Egressy wrote the Hungarian popular anthem *Szózat* (*The Appeal*), to the 1836 text by Mihály Vörösmarty.

Fromental Halévy's opera *Charles VI*.

d. Francis Scott Key, American lawyer and author (b. 1779) who wrote the words to *The Star-Spangled Banner*, adopted as the American national anthem.

WORLD EVENTS

British in India took Sind and Gwalior.

British took Basutoland in South Africa.

United Free Church of Scotland founded.

James Stuart Mill's *Logic*.

1844

LITERATURE

The Three Musketeers (*Les Trois Mousquetaires*; 1844), the historical romance by Alexandre Dumas (*père*), introducing the dashing D'Artagnan (based on a real person) and his three friends; also his *The Count of Monte Cristo* (1844–1845).

The Memoirs of Barry Lyndon, Esq. Written by Himself, William Makepeace Thackeray's novel of the adventures of scoundrel Irish hero, Redmond Barry, who marries the widow Countess Lyndon.

Coningsby, or the New Generation, Benjamin Disraeli's political *roman à clef*.

Charles Dickens's novel *Martin Chuzzlewit*.

The Premature Burial, Edgar Allan Poe's short story.

Elizabeth Barrett Browning's *Poems*, including *Lady Geraldine's Courtship*.

Heinrich Heine's *New Poems*, including *Germany, a Winter's Tale*.

Honoré de Balzac's novels *Modeste Mignon*, *Gaudissart II*, and *Les Paysans*.

James Fenimore Cooper's novel *Afloat and Ashore*.

Ralph Waldo Emerson's *Essays: Second Series*.

Robert Browning's poem *Colombe's Birthday*.

Sándor Petöfi's poems *A Helység Kalapácsa* and *Az Alföld*.

Adalbert Stifter's stories *Brigitta* and *Das alte Siegel*.

d. Thomas Campbell, Scottish poet (b. 1777).

VISUAL ARTS

Gustave Courbet's painting *Juliette Courbet*.

J. M. W. Turner's painting *Rain, Steam, and Speed—the Great Western Railway* and *Fishing Boats Bringing a Disabled Ship into Port Ruysdael*.

View in the Catskills, Asher Durand's painting.

Honoré Daumier's lithograph *Pardon Me, Sir, If I Bother You a Bit*.

Joseph Paxton began Palm House, Kew Gardens, London.

Narcisse-Virgile Diaz de la Peña's painting *Gypsies Going to a Fête*.

Pierre-Jean David's sculpture *Balzac*.

View of Gloucester from Dolliver's Neck, Fitz Hugh Lane's painting.

Alexander Jackson Davis designed the Waddell House, New York City.

Washington Allston, Edward Augustus Brackett's sculpture.

d. Charles Bulfinch, American architect (b. 1763).

THEATER & VARIETY

b. Sarah Bernhardt, French actress (d. 1923).

Honoré de Balzac's play *Le Faiseur* (1844; produced 1851).

Mary Magdalen, Christian Friedrich Hebbel's tragedy.

The Forest Princess, Charlotte Barnes's play, based on the story of Pocahontas.

d. Guilbert Pixérécourt, French playwright (b. 1773).

MUSIC & DANCE

Ernani, Giuseppe Verdi's opera; libretto by Francesco Piave, based on Victor Hugo's 1830 play *Hernani*, premiered at the Fenice Theatre, Venice.

The Sacred Harp, the best-known songbook for rural American shape singing, singing by distinctively shaped notes, without knowing how to read music.

Hector Berlioz's overtures *Le Corsaire* and *Le Carnaval romain*; and his choral work *Hymne à la France*.

Felix Mendelssohn's *Violin Concerto* and church music *Hear My Prayer*.

Anton Bruckner's *Chorale Mass in F Major*.

Daniel-François-Esprit Auber's opera *La sirène*.

Hunyadi László, Ferenc Erkel's opera.

Frédéric Chopin's *B Minor Sonata* for piano.

Alessandro Stradella, Friedrich Flotow's opera.

Giuseppe Verdi's opera *I Due Foscari* (*The Two Foscari*).

Oboe was redesigned and patented in France (1844).

Berlin Staatsoper (founded 1742) reopened, rebuilt after an 1843 fire.

English concertina (originally *melophone*) developed by Charles Wheatstone (by 1844).

WORLD EVENTS

James K. Polk was elected U.S. president.

Anti-Catholic "nativist" riots erupted in Philadelphia and several other U.S. cities.

Telegraph was introduced by Samuel Morse.

John Stuart Mill's *Unsettled Questions of Political Economy*.

1845

LITERATURE

The Raven and Other Poems, including the title poem that made Edgar Allan Poe famous; also his stories *The Purloined Letter*, *The Imp of the Perverse*, and *Thou Art the Man*.

Narrative of the Life of Frederick Douglass, the classic autobiography of the man who was a slave, escaped, worked to buy his freedom, and became a popular orator and abolitionist.

Robert Browning's *Dramatic Romances and Lyrics*, including *How They Brought the Good News from Ghent to Aix*, *The Bishop Orders His Tomb at St. Praxed's Church*, and *Home Thoughts, from Abroad*.

Margaret Fuller published *Woman in the Nineteenth Century*, a full-scale call for women's equality, which helped inspire the first American women's movement.

Charles Dickens started a weekly called *Household Words*, which included his own work and that of others such as Wilkie Collins, Edward Bulwer-Lytton, and Elizabeth Cleghorn Gaskell; also his novel *The Chimes*.

The Biglow Papers (first series), poems and sketches that brought James Russell Lowell's his first literary success.

La Reine Margot and *Vingt ans après*, novels by Alexandre Dumas (*père*).

George Sand's novel *Le Meunier d'Angibault*.

Henry Wadsworth Longfellow's *The Belfry of Bruges and Other Poems*.

Honoré de Balzac's novels *Un Homme d'affaires* (1845) and *Les Petits Bourgeois* (1845–1856).

Ivan Turgenev's verse work *Razgovor* (*A Conversation*).

Adalbert Stifter's story *Der Hagestolz*.

Benjamin Disraeli's *Sybil, or The Two Nations*.

James Fenimore Cooper's novels *Satanstoe; or, The Littlepage Manuscripts* and *The Chain-Bearer*.

Sándor Petöfi's poetry *János Vitéz*.

d. Thomas Hood, English poet and humorist (b. 1799).

VISUAL ARTS

J. M. W. Turner's paintings included *Whalers* and *Venice, Evening, Going to the Ball.*

View Across Frenchman's Bay: From Mount Desert Island, Maine, After a Squall, Thomas Cole's painting.

Jean-Baptiste-Camille Corot's painting *Homer and the Shepherds.*

The Fur Traders Descending the Missouri, George Caleb Bingham's painting.

Eugène Delacroix's painting *Muley-Abd-er-Rahmann, Sultan of Morocco.*

Hokusai's *Hundred Poems Explained by the Nurse* (ca. 1845).

Jean-Auguste-Dominique Ingres's painting *Mme d'Haussonville.*

The Death Struggle, Charles Deas's painting.

Adolf Menzel's painting *The French Window.*

d. Louis-Léopold Boilly, French painter and engraver (b. 1761).

THEATER & VARIETY

Fashion; or, Life in New York, Anna Cora Mowatt's comedy, contrasting nouveau riche upward climbing with avowed Yankee honesty and other virtues, opened at New York's Park Theatre.

John Baldwin Buckstone's *The Green Bushes; or, A Hundred Years Ago.*

d. Pavel Stepanovich Mochalov, Russian tragedian (b. 1800), most notably in Shakespeare.

MUSIC & DANCE

Tannhäuser (und der Sängerkrieg auf Warburg), Richard Wagner opera, libretto by Wagner, premiered in Dresden October 19; Wagner conducted.

Giovanni d'Arco (Joan of Arc), Giuseppe Verdi's opera; libretto by Temistocle Solera, based on Friedrich Schiller's *The Maid of Orleans*, opened at La Scala, Milan, February 15.

Pas de Quatre, Jules Perrot ballet, music by Cesare Pugni, first danced in London, with Marie Taglioni, Carlotta Grisi, Lucile Grahn, and Fanny Cerito.

Frédéric Chopin's *Polonaise-Fantaisie* (1845–1846) for piano and *Sonata for Piano and Cello* (1845–1846).

Undine, Albert Lortzing's dramatic musical work.

Felix Mendelssohn's *String Quintet No. 2.*

Robert Schumann's *Piano Concerto.*

Franz Liszt's piano pieces *Harmonies poétiques et religieuses* (1845–1852).

Maritana, Vincent Wallace's opera.

Adolphe Sax developed a series of valved brass instruments called the *saxhorns*; they were the basis of instruments such as the baritone, euphonium, soprano cornet, tenor (horn), and bass.

Ferencz Erkel composed the music for the Hungarian anthem *Himnusz*, to the 1823 text by Ferencz Kölcsey.

d. Simon Mayr (Johannes Simon Mayer; in Italy, Giovanni Simone), German composer working largely in Italy (b. 1763).

WORLD EVENTS

Potato famine came to Ireland; more than one million died, most of starvation-induced disease.

Texas was annexed by the U.S., which moved closer to war with Mexico as U.S. troops moved to the Mexican border.

British defeated Sikhs in the Punjab, in the First Sikh War (1845–1846).

Dominican Republic won independence from Haiti.

Friedrich Engels's *The Condition of the Working Classes in England.*

1846

LITERATURE

The Double (Dvoinik), Fyodor Dostoyevsky's novel detailing its hero's degeneration into madness, faced with his own double; also his epistolary novel *Poor Folk.*

Typee: A Peep at Polynesian Life, Herman Melville's novel based on his own experiences sailing the South Seas; his first published work, a distinct literary success.

Edgar Allan Poe's short story *The Cask of Amontillado*; also his notable critical work, *The Philosophy of Composition.*

Charles Dickens's novels *The Battle of Life* and *The Cricket on the Hearth.*

Honoré de Balzac's novels *Les Comédiens sans le savoir* and *La Cousine Bette.*

George Sand's novel *La Mare au diable.*

Ivan Turgenev's verse works *Andrey* and *Pomeshchik* (*The Landowner*).

La Dame de Monsoreau, the novel by Alexandre Dumas (*père*).

Antônio Gonçalves Dias's poem *Song of Exile*.

James Fenimore Cooper's novel *The Redskins: Or, Indian and Injin*.

John Greenleaf Whittier's poems *Voices of Freedom*.

Mosses from an Old Manse, Nathaniel Hawthorne's stories.

Ralph Waldo Emerson's *Poems*.

Rotary-sheet printing press patented by Richard Hoe, of New York.

Robert Browning's poems *A Soul's Tragedy* and *Luria*.

Sándor Petőfi's poetry *Egy Gondolat Bánt Engemet*.

William Makepeace Thackeray's *Notes of a Journey from Cornhill to Grand Cairo* (1846) and *The Snobs of England* (1846–1847).

VISUAL ARTS

J. M. W. Turner's paintings included *The Angel Standing in the Sun* and *Undine Giving the Ring to Massaniello, Fisherman of Naples*.

The Cross and the World, Thomas Cole's painting (1846–1847).

Jean-Baptiste-Camille Corot's painting *The Forest of Fontainebleau*.

Charles Barry designed the Treasury Buildings, Whitehall.

The Jolly Flatboatman, George Caleb Bingham's painting.

Edward Lear illustrated *The Book of Nonsense*.

Jean-Auguste-Dominique Ingres's painting *Mme Reiset*.

Eugène Delacroix's painting *The Abduction of Rebecca*.

Gustave Courbet's painting *L'Homme à la pipe* (*Man with a Pipe*) (ca. 1846).

James Renwick began the Smithsonian Institution, Washington, D.C.

The Voyageurs, Charles Deas's painting.

Wellington Arch in London built, originally topped by an equestrian statue of the Duke of Wellington.

THEATER & VARIETY

Ivan Turgenev's satirical play *Penniless: or, Scenes from the Life of a Young Nobleman*.

d. Jean-Gaspard Deburau, French pantomimist (b. 1796), whose new concept of the commedia dell'arte Pierrot became the modern standard.

MUSIC & DANCE

La Damnation de Faust, Hector Berlioz's opera, first performed as a choral work in Paris in 1846 and as an opera in London in 1848.

Poet and Peasant, Franz Suppé's comedy with songs; the overture remained a perennial favorite.

Attila, Giuseppe Verdi's opera; libretto by Temistocle Solera, opened in Venice March 17.

Paquita, Joseph Mazilier ballet, music by Ernest Deldeve, the title role danced by Carlotta Grisi, premiered at the Opéra, Paris, April 1.

Der Waffenschmied, Albert Lortzing's dramatic musical work.

Ave Maria, Anton Bruckner's work for chorus and organ.

Ruth, César Franck's choral work.

Felix Mendelssohn's oratorio *Elijah* and accompanied choral music *Lauda Sion*.

Johan Peter Emilius Hartmann's opera *Liden Kirsten*.

Robert Schumann's *Symphony No. 2*.

Adolphe Sax invented the saxophone, a brass instrument with a clarinetlike mouthpiece but capable of producing more volume; actually a family of instruments, including alto, tenor, baritone, bass, and the rare contrabass.

Jeremiah Carhart of Buffalo took out a patent (later voided) for a free-reed organ called a *Melodeon*, made until the 1920s.

WORLD EVENTS

U.S.–Mexican War (1846–1847): Mexican forces defeated at the Battle of Palo Alto, retreating south of Rio Grande; California annexed by U.S.

Brigham Young led the Mormon trek west from Nauvoo, Illinois, to Council Bluffs, Iowa.

British–U.S. Oregon treaty established the Canada–U.S. northwestern border at the 49th parallel.

Irish potato crop again failed, with further deaths due to famine and disease; Irish emigration to North America soared.

Polish insurrection against foreign rule was crushed by Austria and Russia.

Civil war again broke out in Spain—the Second
Carlist War (1846–1849).

Washington's Smithsonian Institution was founded.

W. H. Prescott's *The Conquest of Peru.*

1847

LITERATURE

Brontë sisters made their extraordinary literary
debuts, initially under male pseudonyms: Emily
(as Ellis Bell) introduced the haunting tale of
Heathcliff and Cathy in *Wuthering Heights*; Char-
lotte (as Currer Bell) presented the orphaned gov-
erness *Jane Eyre* and her tormented lover,
Rochester; and Anne (Acton Bell) told of a qui-
eter governess in *Agnes Grey.* The first two have
been much dramatized.

Vanity Fair, a Novel without a Hero, William Make-
peace Thackeray's novel detailing the career of
the scheming Becky Sharp, whose progress is
made possible by the blindness of her friend
Amelia Sedley and the vanity and self-satisfaction
of others (1847–1848).

Evangeline, Henry Wadsworth Longfellow's long nar-
rative poem about the tragic expulsion of the
Acadians from Nova Scotia.

Omoo: A Narrative of Adventures in the South Seas,
second of Herman Melville's travel-based novels.

Benjamin Disraeli's novel *Tancred, or the New Crusade.*

Edgar Allan Poe's poem *Ulalume* and short story *The
Domain of Arnheim.*

Honoré de Balzac's novel *Le Député d'Arcis* and *Le
Cousin Pons.*

The Princess, Alfred, Lord Tennyson's poem.

James Fenimore Cooper's novel *The Crater; Or,
Vulcan's Peak.*

Charles Baudelaire's *La Fanfarlo.*

Adalbert Stifter's story *Der Waldgänger.*

Alphonse de Lamartine's *Histoire des Girondins (His-
tory of the Girondins).*

Sándor Petőfi's poetry *A Tisza.*

*Settlers and Convicts; Or, Recollections of Sixteen Years'
Labour in the Australian Backwoods*, Alexander
Harris's early Australian work.

VISUAL ARTS

Castor and Pollux, Horatio Greenough's sculpture

(1847–1851).

Gustave Courbet's painting *St. Nicolas ressuscitant les
petits enfants.*

View of the Falls of Munda, Thomas Cole's painting.

Dead Pearl Diver, Benjamin Paul Akers's sculpture.

The Prairie Fire, Charles Deas's painting.

d. William Collins, English painter (b. 1788).

THEATER & VARIETY

New York's Broadway Theatre opened, with Henry
Wallack starring in a production of Richard
Brinsley Sheridan's *The School for Scandal.*

Giambattista Niccolini's *Filippo Strozzi.*

John Buckstone's *The Flowers of the Forest.*

Josef Kajetán Tyl's *The Bagpiper of Strakonice.*

Witchcraft, Cornelius Mathews's play.

New York's Astor Place Opera House opened.

MUSIC & DANCE

Martha, Friedrich Flotow's opera, libretto by W.
Friedrich, opened in Vienna, with Anna Zerr in
the title role.

Macbeth, Giuseppe Verdi's opera, libretto by Francesco
Piave based on Shakespeare's 1605–1606 play, pre-
miered in Florence.

Frédéric Chopin's piano piece *Minute Waltz*, so-called
because it can be played within 60 seconds, if
played extremely fast.

Marie Taglioni gave her farewell performance in the
ballet *Le Judgment de Pâris* in London.

Albert Lortzing's opera *Zum Grossadmiral.*

Haydée, Daniel-François-Esprit Auber's opera.

Felix Mendelssohn's *Piano Trio No. 2* and *String
Quartet No. 6.*

Robert Schumann's began writing his opera *Gen-
oveva* (1847–1850).

Niels Gade's *Third Symphony.*

Vincent Wallace's opera *Lurline.*

Barcelona's opera house, Teatro Liceo, opened.

d. Felix Mendelssohn, German composer (b. 1809).

WORLD EVENTS

U.S.–Mexican War: Mexican forces defeated at
Battle of Buena Vista; Americans took Vera Cruz,
and moved inland to take Mexico City, effectively
ending war.

Pueblo Revolt: U.S. troops shelled and took Taos Pueblo, ending Pueblo Indian resistance.

Catholic cantons formed Sonderbund, and seceded from Switzerland; Protestant cantons defeated them in a small-scale civil war, and reunited the country.

Liberia was proclaimed an independent republic.

United Presbyterian Church of Scotland was formed.

George Boole's *Mathematical Logic*.

Karl Marx's *The Poverty of Philosophy*.

1848

LITERATURE

Declaration of Sentiments and Resolutions, Elizabeth Cady Stanton's call for women's equality, presented and signed at the Seneca Falls (New York) Women's Rights Convention.

Dante Gabriel Rossetti began the semiautobiographical sonnet sequence that would become *The House of Life* (1848–1881), the title being an astrological phrase.

French feminist Jeanne Deroin's *Cours de droit social pour les femmes*.

Memories from beyond the Tomb (*Mémoires d'outre-tombe*), François René de Chateaubriand's autobiographical musings (written 1811–1841; published 1848–1850).

Dombey and Son, Charles Dickens's novel in which the elder Dombey sacrifices his family for the sake of his ambition; also Dickens's novel *The Haunted Man*.

La Dame aux camélias, the novel by Alexandre Dumas (*fils*); basis for his 1852 play and the 1927 and 1936 films *Camille*.

The History of Pendennis, William Makepeace Thackeray's novel (1848–1850).

Edward Bulwer-Lytton's novel *Harold*.

George Sand's novel *La Petite Fadette*.

Louisa May Alcott's first published book, *Flower Fables*.

The Anti-Slavery Harp, William Wells Brown's poems.

Honoré de Balzac's novel *L'Initié*.

The Vision of Sir Launfal, James Russell Lowell's long poem; also his verse satire *A Fable for Critics*.

Sándor Petőfi's poetry *Nemzeti Dal*.

Thomas Babington Macaulay's *History of England from the Accession of James the Second* (1848, 1855, 1861).

Alphonse de Lamartine's *Histoire de la Restauration* (*History of the Restoration of Monarchy in France*).

d. Emily Brontë, English novelist and poet (b. 1818).

d. François René de Chateaubriand, French writer (b. 1768).

d. Kyokutei Bakin, Japanese novelist (b. 1767).

d. Steen Steensen Blicher, Danish poet and writer (b. 1782).

VISUAL ARTS

Eugène Delacroix's painting *The Entombment*.

Honoré Daumier's sculpture *The Refugees* (1848–1849) and his painting *The Republic* (ca. 1848).

d. Thomas Cole, American painter (b. 1801).

THEATER & VARIETY

Ivan Turgenev's *One May Spin a Thread Too Finely* (*Zavtrak u predvoditelya*).

The Toodles, William E. Burton's play, opened at London's Burton's Chambers Street Theatre on October 2.

Josef Kajetán Tyl's *Jan Hus* and *The Bloody Trial*.

Alfred de Musset's *The Decoy*.

Honoré de Balzac's *La Marâtre*.

Johann Nepomuk Nestroy's *Freiheit in Krähwinkel*.

MUSIC & DANCE

Manual générale de musique militaire, Jean-Georges Kastner's book, containing a collection of bugle calls used by various European armies, some dating back to the 16th century or earlier.

Robert Schumann's *Manfred Overture* (1848–1849), inspired by Lord Byron's 1817 poem.

Oh! Susanna, Stephen Foster's popular song.

Giuseppe Verdi's opera *Il Corsaro*.

Regina, Albert Lortzing's opera (1848; perf. 1899).

Anton Bruckner's *Requiem in D Minor* (1848–1849).

Franz Liszt's *Concert Studies*, for piano (1848, 1862–1863).

La Mort d'Ophélie, Hector Berlioz's work for voice and orchestra.

Ben Bolt, popular song, words by Thomas Dunn English, music probably by Nelson K. Kneass.

Kamarinskaya, Mikhail Glinka's orchestral variations.

Niels Gade's *String Octet*.

Frederick Pacius composed the melody for both the

Finnish national anthem, *Maamme Laulu* (*Song of our Country*; in Swedish, *Vårtland*), to the 1846 text of Finnish poet Johan Ludvig Runeberg; and the Estonian, *Mu isamaa, mu önn ja röön*, text written later by J. Jannsen (1965).

Franz Lachner composed *Bayern, o Heimatland*, to words by F. Beck, the Bavarian national anthem.

Modern flute redesigned by Munich flautist Theobald Boehm (1794–1881).

d. Gaetano Donizetti, Italian composer (b. 1797).

WORLD EVENTS

Elizabeth Cady Stanton and Lucretia Coffin Mott organized the landmark Seneca Falls Women's Rights Convention, at Seneca Falls, New York.

Karl Marx and Friedrich Engels's *The Communist Manifesto*.

Wave of democratic revolutions swept Europe; revolutions in France, Austria-Hungary, Poland, and Italy. Louis Napoleon emerged as president of the Second Republic in France; Lajos Kossuth led the Hungarian revolution; Czech revolt was crushed by Austrians; Metternich resigned and Ferdinand I was replaced by Franz Joseph I in Austria; Polish rebellion failed; republic in Venice; and Romanian revolt failed.

Major gold strike at Sutter's Mill, Sacramento, California; it would open up massive U.S. western migration.

U.S.–Mexican War ended with Treaty of Guadalupe Hidalgo; U.S. took a huge territory that included California, the Southwest, and part of the Rocky Mountains.

Mexican War general Zachary Taylor was elected U.S. president.

1849

LITERATURE

Civil Disobedience, Henry David Thoreau's enormously influential essay calling for citizens to passively resist laws they regard as unjust, laying the basis for modern nonviolent protest movements such as Gandhi's in India and Martin Luther King, Jr.'s in the United States; also his first published book, *A Week on the Concord and Merrimack Rivers*.

d. Edgar Allan Poe, American writer (b. 1809). Works from the year of his death include the poems *Annabel Lee*, *The Bells*, *To My Mother*, and *Eldorado* and the stories *Hop-Frog* and *Landor's Cottage*.

The Oregon Trail, Francis Parkman's description of his journey to Wyoming and experiences with the Sioux.

Alphonse de Lamartine's *Les Confidences* (*Confidential Disclosures*) and *Memoirs of My Youth*; also his story *Raphael; or, Pages of the Book of Life at Twenty*.

Shirley, Charlotte Brontë's novel set in the Yorkshire woolen industry, the heroine modeled after Emily Brontë.

Leaves from Margaret Smith's Journal in the Province of Massachusetts Bay, 1678–79, John Greenleaf Whittier's novel; also his *Poems*, largely on abolitionist themes.

Fyodor Dostoyevsky's unfinished novel *Netochka Nezvanova*.

Herman Melville's novels *Redburn, His First Voyage* and *Mardi and a Voyage Thither*.

John Ruskin's *The Seven Lamps of Architecture*.

Representative Men: Seven Lectures, Ralph Waldo Emerson's capsule biographies of great men; also his *Addresses and Lectures*.

James Fenimore Cooper's novel *The Sea Lions*.

The Strayed Reveller, and Other Poems, Matthew Arnold's first published poems.

Washington Irving's sketches, *A Book of the Hudson*.

d. Maria Edgeworth, Irish novelist (b. 1767).

VISUAL ARTS

Dante Gabriel Rossetti's painting *The Girlhood of Mary*.

Gustave Courbet's painting *L'Après-dinée à Ornans* (*After Dinner at Ornans*) and *Un Enterrement à Ornans* (*Burial at Ornans*).

Honoré Daumier's paintings *Nymphs Pursued by Satyrs* (ca. 1849–1850) and *The Miller, His Son, and the Ass* (ca. 1849).

Kindred Spirits, Asher Durand's painting.

Charles Barry designed Bridgewater House, St. James.

Gavarni in London, drawings by the caricaturist.

John Ruskins's book *Seven Lamps of Architecture*.

d. Hokusai (Katsushika Hokusai), Japanese artist (b. 1760).

THEATER & VARIETY

Astor Place Riots: Supporters of American actor Edwin Forrest attacked British actor William Charles Macready, then playing *Macbeth* at New York's Astor Place Theatre, on May 10, climaxing years of bitterness between the two actors; the militia guarding the theater opened fire, killing 22 people and injuring at least 36 more; the incident was the basis of Richard Nelson's play *Two Shakespearean Actors*.

Adrienne Lecouvreur, Eugène Scribe's play.

Josef Kajetán Tyl's *A Stubborn Woman* and *The Bloody Christening*.

Alexander Nikolayevich Ostrovsky's *The Bankrupt*.

The Bachelor, Ivan Turgenev's play.

Alfred de Musset's *It's Impossible to Think of Everything*.

La Vie de Bohème, Théodore Barrière's play.

Johann Nepomuk Nestroy's *Judith und Holofernes*.

Friedrich Hebbel's *Herodes und Marianne*.

George Henry Boker's *Calaynos*.

Johannes Carsten Hauch's *The Sisters of Kinnekullen*.

d. Marie-Thomase-Amélie Dorval, French actress (b. 1798).

MUSIC & DANCE

The Battle at Legnano, Giuseppe Verdi's opera, libretto by Salvatore Sammarano, opened at the Teatro Argentina, Rome, January 27.

Luisa Miller, Giuseppe Verdi's opera, libretto by Salvatore Sammarano, premiered at Naples.

Konservatoriet (*The Dancing School*), August Bournonville's ballet, music by Holger Simon Paulli, first danced May 6, by the Royal Danish Ballet, Copenhagen.

Le Prophète, Giacomo Meyerbeer opera, libretto by Eugène Scribe, opened at Grand Opéra, Paris, April 16.

Albert Lortzing's opera *Rolands Knappen*.

Ambroise Thomas's opera *Le Caïd*.

Jubel-Ouvertüre, Bedřich Smetana's orchestral work (1849, rev. 1883).

Franz Liszt's *Concerto No. 1* and *Totentanz*, for piano and orchestra.

Giacomo Meyerbeer's opera *Le prophète*.

Hector Berlioz's choral work *Te Deum*.

d. Frédéric (Fryderyk Franciszek) Chopin, Polish composer working largely in France (b. 1810).

WORLD EVENTS

Massive California Gold Rush migration of "49ers" began, by land and sea.

Giuseppe Mazzini headed a new Roman Republic, but it was crushed by French and other foreign troops, who restored Pope Pius IX in Rome.

Austrian forces crushed the Hungarian and Austrian revolutions.

Britain defeated the Sikhs in the second Sikh War.

Elizabeth Blackwell graduated from Geneva College, becoming the first woman graduate of an American medical college.

French women's rights advocate Jeanne Deroin was the first woman candidate for the French National Assembly.

Haitian invasion of the Dominican Republic failed.

1850

LITERATURE

David Copperfield, Charles Dickens's semiautobiographical novel exposing mistreatment of children and introducing characters such as the improvident, ever-optimistic Mr. Micawber, the villainous Uriah Heep, and the Peggotty family.

Sonnets from the Portuguese, Elizabeth Barrett Browning's series of love sonnets written as a gift for her husband, Robert Browning, including the famous "How do I love thee? Let me count the ways."

The Prelude, or Growth of a Poet's Mind, William Wordsworth's long autobiographical poem exploring the growth of his mind and poetic sensibility, originally written in 1805 and much revised.

The Scarlet Letter, Nathaniel Hawthorne's novel of Hester Prynne, condemned to wear the red letter "A" on her clothing as a sign of her adulterous relationship with the minister, Arthur Dimmesdale.

In Memoriam, Alfred, Lord Tennyson's elegy for his friend Arthur Hallam (written 1833–1850).

Harper's New Monthly Magazine began publication in the United States under Henry Jarvis Raymond, at first primarily featuring British writers.

Dante Gabriel Rossetti's poems *The Blessed Damozel*; also his periodical *The Germ*.

Christmas-Eve and Easter-Day, Robert Browning's long poem.

George Sand's novel *François le Champi*.

Herman Melville's novel *White-Jacket; or, The World in a Man-of-War*.

James Fenimore Cooper's novels *The Ways of the Hour*.

Songs of Labor, John Greenleaf Whittier's poems.

Charles Kingsley's novel *Alton Locke*.

Times of India began publication in Bombay.

d. William Wordsworth, British poet (b. 1779).

d. Honoré de Balzac, French novelist (b. 1799).

VISUAL ARTS

J. M. W. Turner's paintings included *Mercury Sent to Admonish Aeneas*, *The Visit to the Tomb*, and *The Departure of the Fleet*.

Jean-Baptiste-Camille Corot's paintings included *Bretonnes à la fontaine* (early 1850s) and *La Danse des nymphes*.

Ships in Ice off Ten Pound Island, Gloucester, Fitz Hugh Lane's painting (ca. 1850).

John Millais's painting *Christ in the House of His Parents*.

Dante Gabriel Rossetti's paintings *The Annunciation* and *Ecce Ancilla Domini*.

Étienne-Pierre-Théodore Rousseau's painting *Edge of a Forest—Sunset* (1850–1851).

Gustave Courbet's painting *The Peasants of Flagey Returning from the Fair*.

Morning and *Evening*, sculptures by Erastus Dow Palmer (1850–1851).

Adolf Menzel's painting *Frederick at Dinner with His Friends*.

John C. Calhoun, Hiram Powers's sculpture.

Honoré Daumier's sculpture *Ratapoil*.

Jean François Millet's painting *Sower*.

Morning and *Evening*, sculptures by Erastus Dow Palmer (1850–1851).

Shipwrecked Mother and Child, Edward Augustus Brackett's sculpture (1850–1851).

The Gallery of Illustrious Americans, book of portrait photographs by Mathew B. Brady.

Thomas Crawford's equestrian statue of George Washington.

William Butterfield began All Saints, Margaret Street, London.

Navajos learned silversmithing from Spaniards in the American Southwest (ca. 1850) and began developing their distinctive style.

THEATER & VARIETY

A Month in the Country, Ivan Turgenev's play, first produced in 1872; his most notable stage work.

Henrik Ibsen's plays *The Burial Mound* and *Catiline*.

Eduard von Bauernfeld's *Der kategorische Imperative*.

Eugène Scribe's *Un Verre d'eau*.

François Ponsard's *Charlotte Corday*.

Georg Büchner's *Leonce und Lena*.

Johannes Carsten Hauch's *Marsk Stig*.

d. Adam Gottlob Oehlenschläger, Danish actor, playwright, and poet (b. 1779).

d. Josef Kajetán Tyl, Czech playwright and actor (b. 1808), a central figure in the development of the Czech theater.

MUSIC & DANCE

Franz Liszt's *Liebesträume*, three piano nocturnes, transcriptions of his own songs (ca. 1850).

Lohengrin, Richard Wagner's opera, libretto by Wagner, about the knight Lohengrin, son of Parsifal, keeper of the Holy Grail, premiered in Weimar August 28; Franz Liszt conducted.

Jenny Lind began an extended, and triumphant, tour of the United States.

Robert Schumann's *Symphony No. 3*, the *Rhenish Symphony*; his *Genoveva*; and his *Cello Concerto*.

Camptown Races, Stephen Foster's song.

Ambroise Thomas's opera *Le Songe d'une nuit d'été*.

Camille Saint-Saëns's *Symphony in A* (ca. 1850).

Giuseppe Verdi's opera *Stiffelio*; later revised as *Aroldo* (1857).

First opera performed in Chicago, Illinois, was a production of Vincenzo Bellini's *La Sonnambula*.

Pianos were generally built with seven octaves or more (from ca. 1850).

The *sarrusophone*, a double-reed metal wind instrument, was developed, to replace oboes and bassoons in outdoor bands (ca. 1850); made in France until ca. 1930, but now seldom seen.

Czechoslovakia's National Theatre (Národni Divadlo) was founded; composer Bedrich Smetana would be closely associated with it.

Septimus Winner (writing as Alice Hawthorne) published the first of his popular songs, *What is Home*

Without a Mother and *How Sweet Are the Roses*.

A type of flute that can be played in different keys and in harmony replaced the traditional fife in British military "fife and drum" bands (ca. 1850); the "true" fife remained in military use on the Continent up to World War I.

Tympani developed in Germany with handles that could quickly be used to change the tuning (ca. 1850).

Pedal harp largely replaced triple harp in Wales (mid-19th c.).

WORLD EVENTS

Taiping rebellion led by Hung Hsiu-ch'uan began in China, with Taiping attacks on Manchus in Kwangsi; it would ultimately result in the death of an estimated 20–40 million people.

California became a free (nonslavery) state.

Persecution of Baha'is grew in Persia (1850–1852).

1851

LITERATURE

Moby-Dick; or, The Whale, Herman Melville's epic novel, narrated by Ishmael, telling of Captain Ahab's obsessive pursuit of the great white whale, Moby-Dick, but more widely a profound study of good and evil; one of the finest American novels ever written, but ill received during Melville's lifetime.

The House of the Seven Gables, Nathaniel Hawthorne's novel about past wrongs cursing the family that obtained the house by falsely condemning its owner to death for witchcraft; also his *The Snow-Image, and Other [Twice-Told] Tales* and *A Wonder Book for Girls and Boys*.

John Ruskin's fantasy novel *The King of the Golden River*.

Alphonse de Lamartine's stories *Geneviève; or, the History of a Servant Girl* and *The Stonecutter of St. Point*; also his prose works *Nouvelles Confidences* and *The Wanderer and His Home*.

Elizabeth Barrett Browning's poem *Casa Guidi Windows*.

George Meredith's *Poems*, including *Love in the Valley*.

George Sigl, of Vienna, developed a mechanical press for lithographic printing.

Heinrich Heine's poems *Romanzero*.

Charles Kingsley's novel *Yeast*.

The New York Times was founded by Henry Jarvis Raymond, with two financial partners.

d. James Fenimore Cooper, American novelist (b. 1789).

d. Mary Wollstonecraft Shelley, English novelist (b. 1797).

VISUAL ARTS

Ford Madox Brown's painting of *Chaucer at the Court of Edward III*.

Washington Crossing the Delaware, Emmanuel Gottlieb Leutze's painting.

Gustave Courbet's painting *Young Ladies from the Village* (1851–1852).

The Trappers' Return, George Caleb Bingham's painting.

Jean-Baptiste-Camille Corot's painting *The Harbor of La Rochelle*.

The Return of the Dove to the Ark, John Millais's painting.

Charles Barry designed Cliveden House.

Joseph Paxton designed the Great Exhibition Building, Hyde Park.

Storm in the Wilderness, Jasper F. Cropsey's painting.

Blue Hole, Flood Waters, Little Miami River, Robert S. Duncanson's painting.

John Ruskin's *The Stones of Venice*, in three volumes (1851–1853).

d. J. M. W. Turner, English painter (b. 1775).

d. John James Audubon, American writer, painter, and naturalist (b. 1785).

d. Louis Jacques Mandé Daguerre, French inventor (b. 1789), who developed the first practical photograph, the daguerrotype.

d. Thomas Birch, American painter (b. 1779).

THEATER & VARIETY

Ivan Turgenev's *A Provincial Lady*.

Mercadet the Promoter, Honoré de Balzac's play, produced posthumously.

The Italian Straw Hat, Eugene M. Labiche's play, one of his few plays remaining in the repertory.

Henrik Ibsen's play *Norma, or a Politician's Love*.

Adelardo López de Ayala's *The Statesman*.

Alfred de Musset's *Les Caprices de Marianne*.

MUSIC & DANCE

Rigoletto, Giuseppe Verdi's opera; libretto by Francesco Piave, based on Victor Hugo's 1832 play *Le Roi s'amuse*, opened at La Fenice, Venice.

Franz Liszt's *Grandes Études de Paganini* and *Études d'exécution transcendante* (*Transcendental Etudes*), some of the most difficult piano pieces ever written.

Kermesse in Bruges, August Bournonville's ballet, music by Holger Simon Paulli, first danced April 4 by the Royal Danish Ballet, in Copenhagen.

Old Folks at Home, Stephen Foster's song.

Albert Lortzing's opera *Die Opernprobe*.

Ambroise Thomas's opera *Raymond*.

b. Vincent d'Indy, French composer (d. 1931).

d. Albert Lortzing, German composer (b. 1801).

d. Alexander Alexandrovich Alyab'yev, Russian composer (b. 1787).

d. Gaspare Spontini, Italian composer and conductor (b. 1774).

WORLD EVENTS

Taiping rebellion extended throughout China, as millions became involved.

Fugitive Slave Law took the U.S. another long step toward civil war.

Louis Napoleon carried out a successful coup in France.

On the Enfranchisement of Women, an anonymous call for women's suffrage, probably by Harriet Taylor.

Substantial gold strike in Australia began a gold rush.

1852

LITERATURE

Uncle Tom's Cabin, Harriet Beecher Stowe's powerful antislavery novel, serialized in the magazine *National Era*; its tale of the old slave Uncle Tom, his cruel master Simon Legree, the death of the white girl Little Eva, and the pursuit of Eliza and her baby across the icy river strongly fanned abolitionist sentiment.

Pierre; or The Ambiguities, Herman Melville's pessimistic novel of a young writer's experiences, echoing some of Melville's own artistic problems; the theme of incest disturbed many critics.

The Blithedale Romance, Nathaniel Hawthorne's novel set in a utopian New England community.

The History of Henry Esmond, Esq., William Makepeace Thackeray's novel; also his *A Shabby Genteel Story, and Other Tales*.

Ain't I a Woman? Sojourner Truth's speech at Akron women's rights convention.

Alfred, Lord Tennyson's *Ode on the Death of the Duke of Wellington*.

Clovernook; or Recollections of Our Neighborhood in the West, Alice Cary's quasi-autobiographical stories.

Alphonse de Lamartine's story *Graziella; or, My First Sorrow*.

Matthew Arnold's *Empedocles on Etna, and Other Poems*.

Roget's Thesaurus published.

d. Nikolay Gogol, Russian writer (d. 1852).

d. Thomas Moore, Irish poet (b. 1779).

VISUAL ARTS

Leo von Klenze completed the Hermitage, St. Petersburg.

Honoré Daumier's lithograph *The Orchestra During the Performance of a Tragedy*.

John Martin's painting *Destruction of Sodom and Gomorrah*.

The County Election, George Caleb Bingham's painting.

Adolf Menzel's painting *The Flute Concert*.

d. Horatio Greenough, American sculptor (b. 1805).

THEATER & VARIETY

La Dame aux camélias, dramatization by Alexandre Dumas (*fils*) of his own 1848 novel, opened February 2; basis for several works, including the opera *La Traviata* and the 1936 film *Camille*.

The Silver Spoon, Joseph Stevens Jones's comedy, opened at the Boston Museum on February 16.

Gustav Freytag's *The Journalists* opened in Breslau.

Charles Reade's *Masks and Faces*.

Johannes Carsten Hauch's *The Youth of Tycho Brahe*.

Friedrich Hebbel's *Agnes Bernauer*.

d. Nikolai Vasilievich Gogol, Russian writer and playwright (b. 1809).

d. Junius Brutus Booth, Sr., English-born American actor (b. 1796) who played leads in London before emigrating to the United States, becoming

a leading figure on the American stage. He was the father of actors Edwin Booth, Junius Brutus Booth, Jr., and John Wilkes Booth.

d. John Howard Payne, American actor and playwright (b. 1791).

MUSIC & DANCE

Hungarian Dances, Johannes Brahms's 21 piano duets in four volumes (1852–1860); many were later orchestrated and some arranged for solo piano.

Fantasia on Hungarian Folk Tunes (Hungarian Fantasy) (ca. 1852), Franz Liszt's work for piano and orchestra based on the 14th of his Hungarian Rhapsodies (1840s–1885).

Franz Liszt's *Sonata in B Minor*, for piano (1852–1853).

Massa's in the Cold, Cold Ground, one of Stephen Foster's "Plantation Melodies."

Anton Bruckner's choral work *Psalm CXIV*.

Charles Gounod's opera *Sapho*.

Federico Ricci's musical comedy *Il marito e l'amante*.

Si j'étais roi, Adolphe Adam's opera.

d. Thomas Moore, Irish poet and musician (b. 1779).

WORLD EVENTS

Franklin Pierce was elected U.S. president.

Louis Napoleon became Napoleon III, emperor of the French Second Empire.

Antoinette-Louisa Brown Blackwell became the first ordained American woman minister.

British invasion of Basutoland was defeated by Basutos, led by King Moshoeshoe (1852–1883).

Burma was at war with Britain, which took Pegu.

Montenegro and Turkey were at war (1852–1877).

South African Republic (Transvaal) was founded.

1853

LITERATURE

Bleak House, Charles Dickens's novel centered on the illegitimate Esther Summerson and the all-squandering Jarndyce vs. Jarndyce lawsuit, and introducing Mrs. Jellyby, who had charity only at a distance, not at home.

Villette, Charlotte Brontë's intense novel about a penniless, plain teacher, Lucy Snowe, her secret love and finally her true mate; based partly on Brontë's own experiences at a Brussels school (1842–1844).

Bartleby the Scrivener, Herman Melville's enigmatic short story about the clerk who "prefers not to" work or in the end to do anything; published in *Putnam's Monthly Magazine*.

The Times (of London) hired the world's first war correspondent, William Howard Russell, who covered the Crimean War (1853–1856).

Matthew Arnold's *Poems: A New Edition*, including *Sohrab and Rustum*, *The Forsaken Merman*, and *The Scholar Gipsy*; the volume that made his literary reputation.

Victor Hugo's poems *Les Châtiments*.

The Newcomes, William Makepeace Thackeray's novel.

Gérard de Nerval's *Les Illuminés ou les précurseurs de socialisme* and *Petits châteaux de Bohème*.

John Greenleaf Whittier's poems *The Chapel of the Hermits*.

Charles Reade's novel *Peg Woffington*.

Nathaniel Hawthorne's *Tanglewood Tales for Girls and Boys*.

William Wells Brown's novel *Clotelle, or, The President's Daughter*.

VISUAL ARTS

John Millais's painting *The Order of Release*.

The Progress of American Civilization, Thomas Crawford's sculpture in the Senate wing of the U.S. Capitol (1853–1863).

Adam and Eve, *Beethoven*, and *Flora* (ca. 1853), sculptures by Thomas Crawford.

Eugène Delacroix's painting *Alfred Bruyas*.

Summer Afternoon, Sanford Robinson Gifford's painting.

Gustave Courbet's painting *Les Baigneuses*.

Uncle Tom and Little Eva, Robert S. Duncanson's painting.

James Renwick began St. Patrick's Cathedral, New York (1853–1887).

Narcisse-Virgile Diaz de la Peña's painting *The Battle of Medina*.

The Days of Elizabeth, Jasper F. Cropsey's painting.

Indian Girl; or, The Dawn of Christianity, Erastus Dow Palmer's sculpture (1853–1856).

THEATER & VARIETY

Uncle Tom's Cabin, George L. Aiken's play, based on Harriet Beecher Stowe's novel, opened at New York's Purdy's National Theatre on July 18.

Henrik Ibsen's play *St. John's Night*.

François Ponsard's *L'Honneur et l'argent*.

George Henry Boker's *Leonor di Guzman*.

Paolo Giacometti's *Elisabetta regina d'Inghilterra*.

MUSIC & DANCE

Il Trovatore (*The Troubador*), Giuseppe Verdi's opera; libretto by Salvatore Cammarano, opened at the Teatro Apollo, Rome.

La Traviata (*The Fallen Woman*), Giuseppe Verdi's opera; libretto by Francesco Piave, based on Alexandre Dumas's 1852 play from his 1848 novel *La Dame aux camélias*, itself basis for the 1927 and 1936 films *Camille*, opened at La Fenice, Venice.

My Old Kentucky Home, Stephen Foster's song.

Camille Saint-Saëns's *Symphony No. 1*.

Petite Messe solennelle, Gioacchino Rossini's choral work.

First British Open Brass Band Championship held, in Manchester.

WORLD EVENTS

Crimean War began, pitting Britain, France, Turkey, and Sardinia against Russia. Sea battle of Sinope and land battle of Akhaltikhe were earliest substantial actions of the war (1853–1856).

Commodore Matthew Perry's Tokyo visit began the reopening of Japan to the West.

France took New Caledonia.

Second war against Burma by British ended with more Burmese territory taken by the British.

1854

LITERATURE

Walden, or, Life in the Woods, Henry David Thoreau's account of his time living in isolation at Walden Pond, near Concord, Massachusetts (1845–1847), attempting to come closer to nature and to simplify existence, noting that "the mass of men lead lives of quiet desperation."

Hard Times, Charles Dickens's novel set in industrial England, focusing on the ultrapractical Thomas Gradgrind and his children, Tom and Louisa, who marries repellant banker Josiah Bounderby.

Deutsches Wörterbuch, the great German dictionary begun by Jacob and Wilhelm Grimm, continuing into the late 20th century.

A Brief Summary in Plain Language of the Most Important Laws Concerning Women, Barbara Leigh-Smith Bodichon's call for women's property rights, especially in marriage.

Heinrich Heine's *Poems 1853 and 1854*.

Mihály Vörösmarty's poem *The Old Gypsy*.

John Esten Cooke's novels *Leather Stocking and Silk* and *The Virginia Comedians*.

Angel in the House, Coventry Patmore's poem (1854–1863).

Maria Susanna Cummins's novel *The Lamplighter*.

French feminist Jeanne Deroin's *Almanach des femmes*.

Alphonse de Lamartine's *Histoire des Constituants* (*History of the Constituant Assembly*).

Nikolay Nekrasov's poem *Vlas*.

Le Figaro began publication in Paris.

VISUAL ARTS

Eugène Delacroix's paintings included *Christ on the Sea of Galilee* and *Turkish Women Bathing*.

Gustave Courbet's paintings included *La Rencontre ou bonjour, Portrait de Bruyas, Monsieur Courbet, La Roche de dix-heures* (ca. 1854), and *Les Cribleuses de blé*.

William Holman Hunt's painting *The Light of the World*.

Coming to the Point, William Sidney Mount's painting.

Dante Gabriel Rossetti's painting *Found*.

The Millenial Age, Jasper F. Cropsey's painting.

Pandora, Chauncey Bradley Ives's sculpture.

The Little Gleaner, William Morris Hunt's painting.

d. John Martin, English painter (b. 1789).

THEATER & VARIETY

Mr. Poirier's Son-in-Law (*Le Gendre de M. Poirier*), Émile Augier's play.

Robert Browning's *Colombe's Birthday*.

Charles Reade's *The Courier of Lyons*.

d. Harriet Smithson, English actress (b. 1800).

d. Joáo Batista de Almeida Garrett, Portuguese playwright (b. 1799).

MUSIC & DANCE

(I Dream of) Jeanie with the Light Brown Hair, Stephen Foster's song.

Academy of Music opened in New York; the theater had the largest stage in the world at that time, seating 4,600.

A Folk Tale, August Bournonville's ballet, music by Niels Gade and J. Hartmann, first danced March 20 by the Royal Danish Ballet, Copenhagen.

La Ventana, August Bournonville's ballet, music by Hans Lumbye and Wilhelm Holm, first danced June 19, in Copenhagen.

Franz Schubert's opera *Alfonso und Estrella* first performed (written 1822).

Johannes Brahms's first *Piano Trio* (1854, rev. 1859).

L'Etoile du Nord, Giacomo Meyerbeer's opera, premiered in Paris.

Anton Bruckner's *Missa Solemnis in B flat Minor*.

Bedrich Smetana's *Triumph-Symphonie* (revised 1881).

L'Enfance du Christ (*The Childhood of Christ*), Hector Berlioz's oratorio.

Charles Gounod's opera *La Nonne sanglante*.

A Faust Symphony, Franz Liszt's tone poem.

Giacomo Meyerbeer's opera *L'Étoile du nord*.

Orpheus, Franz Liszt's symphonic poem.

Carl Wilhelm wrote the music under which Max Schneckenburger's 1840 poem became effectively a German anthem, *Die Wacht am Rhein* (*Watch on the Rhine*), especially after 1870.

Mexico's national anthem—*Mexicano's, al grito de guerra*—was first performed; Francisco González Bocanegra's poem was set to music by Jaime Nunó, orchestrated by Bernardino Beltrán.

WORLD EVENTS

Kansas–Nebraska Act repealed Missouri Compromise of 1820; war began between antislavery and proslavery forces in "Bleeding Kansas."

Crimean War: battles of Chetate, Alma River, Balaclava, Inkerman, Batum, and Kurudere; charges of British Heavy and Light Brigades at Balaclava.

New York's Crystal Palace Exhibition.

Orange Free State founded by Boers.

Republican party founded in the United States.

Dublin's University College was founded.

George Boole's *The Laws of Thought on Which Are Founded the Mathematical Theories of Logic and Probabilities*.

1855

LITERATURE

The Warden, the first of six novels in Anthony Trollope's *Chronicles of Barsetshire* (*Cathedral Stories*), featuring clerical characters (1855–1867); basis for the television series.

Leaves of Grass, the first edition of Walt Whitman's poetry collection, starting with the long *Song of Myself*, and also including *I Sing the Body Electric* and *There Was a Child Went Forth*; the original self-published work of only 12 poems was expanded, revised, and reordered until Whitman's death (1855–1892).

Robert Browning's poetry collection *Men and Women*, including *Andrea del Sarto*, *Fra Lippo Lippi*, *Two in the Campagna*, *A Grammarian's Funeral*, *Bishop Blougram's Apology*, and *Love Among the Ruins*.

Westward Ho! Charles Kingsley's historical romance.

Henry Wadsworth Longfellow's long narrative poem *Hiawatha*, later much parodied.

Alfred, Lord Tennyson's *Maud and Other Poems*, including *The Charge of the Light Brigade*.

Britain's *The Daily Telegraph* became the first popular daily newspaper.

The Rose and the Ring, William Makepeace Thackeray's fantasy novel.

Age of Fable, Thomas Bulfinch's introduction to mythology.

Washington Irving's *Life of Washington* (1855–1859) and the sketches *Wolfert's Roost* (1855).

North and South, Elizabeth Cleghorn Gaskell's novel.

George Meredith's novel *The Shaving of Shagpat: An Arabian Entertainment*.

Herman Melville's novel *Israel Potter: His Fifty Years of Exile*.

Ivan Turgenev's story *Russian Life in the Interior*.

Nikolay Nekrasov's poem *Be Silent, Muse*

Saturday Review began publication in Britain.

d. Charlotte Brontë, English novelist and poet (b. 1816).

d. Anne Brontë, English poet and novelist (b. 1820).

d. Sunthon Phu, Thai poet (b. ca. 1786), whose main work was the epic romance *Phra Aphaimani* (undated).

d. Adam Mickiewicz, Polish poet (b. 1798).

d. Gérard de Nerval, French poet (b. 1808).

d. Mihály Vörösmarty, Hungarian poet (b. 1800).

d. Per Daniel Amadeus Atterbom, Swedish poet (b. 1790).

VISUAL ARTS

Gustave Courbet's paintings *The Artist's Studio, a Real Allegory of a Seven-Year Long Phase of My Artistic Life*, and *Mère Grégoire*.

Armed Liberty, bronze statue atop the dome of the U.S. Capitol, designed by Thomas Crawford (1855–1862); also his bronze doors for the U.S. Senate.

Bronze full-length statue of *Benjamin Franklin*, Boston City Hall.

George Inness's painting *The Lackawanna Valley*.

Dante Gabriel Rossetti's painting *Paolo et Francesca*.

The Andes of Ecuador, Frederic Edwin Church's painting.

Edgar Degas's painting *Portrait of the Duchess of Morbilli* (1855–1856).

Ford Madox Brown's painting *The Last of England*.

Jean-Baptiste-Camille Corot's painting *Entrée de village* (*environs de Beauvais du côte de Voinsinlieu*) (ca. 1855–1860).

Undine Receiving Her Soul, Chauncey Bradley Ives's sculpture.

William Holman Hunt's painting *The Scapegoat*.

Frederic Leighton painting *Cimabue's Madonna Carried in Procession*.

d. Robert Mills, American architect (b. 1781).

THEATER & VARIETY

Henrik Ibsen's play *Lady Inger*.

Le Demi-Monde, play by Alexandre Dumas (*fils*).

Francesca da Rimini, George H. Boker's tragedy, opened at the Broadway Theatre, New York.

The Game of Love, John Brougham's play, opened at New York's Wallack's Theatre, September 12.

Émile Augier's *Le Mariage d'Olympe*.

MUSIC & DANCE

The Sicilian Vespers, Giuseppe Verdi's opera; libretto by Eugène Scribe and Charles Duveyrier, premiered at the Opéra, Paris, June 13.

Hector Berlioz's epic opera *Les Troyens* (*The Trojans*) written, but not performed until 1863 (Part I) and 1890 (Part II).

Franz Liszt's *A Symphony to Dante's Divina Commedia* (1855–1856); his oratorio *Christus* (1855–1866); and his *Missa solemnis* (*Grand Mass*).

George Frederick Bristow's opera *Rip Van Winkle*, based on Washington Irving's 1819 tale.

Listen to the Mocking Bird, popular song by Septimus Winner and (probably) Richard Milburn.

Frédéric Chopin's *Seventeen Polish Songs*, published posthumously.

Georges Bizet's *Symphony in C* and *Overture* (ca. 1855).

Alexander Dargomïzhsky's opera *Rusalka*.

Bedrich Smetana's *Piano Trio* (1855, rev. 1857).

Charles Gounod's *Messe de Sainte-Cécile*.

d. Henry Bishop, English composer (b. 1786).

WORLD EVENTS

Violence flared between proslavery and antislavery forces in Kansas, the latter led by John Brown.

Failed risings of Panthay southern Chinese Muslims against Manchus (1855–1871) and of southwest Chinese Miao people against Manchu rule (1855–1872).

Second Haitian invasion of Dominican Republic failed (1855–1856).

Herbert Spencer's *Principles of Psychology*.

1856

LITERATURE

The Piazza Tales, Herman Melville's collection of short stories, some previously serialized, including *Bartleby the Scrivener*, *The Piazza*, *The Lightning-Rod Man*, *The Encantadas, or, Enchanted Isles*, and *Benito Cereno*, basis for one of the three plays in Robert Lowell's 1965 *Old Glory* trilogy.

Leaves of Grass, the second edition of Walt Whitman's poetry collection, still self-published, introducing *Crossing Brooklyn Ferry*, *Song of the Open Road*, By

Blue Ontario's Shore, Miracles, Salut au Monde! Song of the Broad-Axe, and *Spontaneous Me.*

First Footsteps in Eastern Africa, Richard Francis Burton's acount of his travels with John Speke searching for the source of the Nile.

Aurora Leigh, Elizabeth Barrett Browning's poem.

John Greenleaf Whittier's *The Panorama and Other Poems,* including perhaps his best known, *The Barefoot Boy.*

Sergei Aksakov's autobiographical works *Reminiscences* and *The Family Chronicle;* also his novel *A Russian Gentleman.*

Victor Hugo's *Les Contemplations.*

Charles Sangster's *The St. Lawrence and the Saguenay and Other Poems.*

Hertha, Frederica Bremer's feminist novel.

French feminist Jeanne Deroin's *Lettre aux travailleurs.*

James Anthony Froude's *History of England from the Fall of Wolsey to the Defeat of the Spanish Armada* (1856–1870).

Harriet Beecher Stowe's novel *Dred: A Tale of the Great Dismal Swamp.*

Ralph Waldo Emerson's essay *English Traits.*

Ivan Turgenev's first novel, *Rudin* (*Dmitri Roudine*).

Nikolay Nekrasov's poems *Stikhotvoreniya.*

d. Heinrich Heine, German poet (b. 1797).

VISUAL ARTS

Edgar Degas's painting *Achille de Gas in the Uniform of a Cadet* (1856–1857).

John Millais's painting *The Blind Girl.*

Gustave Courbet's painting *Young Women on the Banks of the Seine.*

Honoré Daumier's paintings *The Drinkers* (ca. 1856) and *The Melodrama* (ca. 1856–1860).

Jean-Auguste-Dominique Ingres's paintings included *La Source, Mme Moitessier Seated,* and *Portrait of Monsieur Étienne-Jean Delécluze.*

Saint Elizabeth of Hungary, Benjamin Paul Akers's sculpture.

The Banjo Player, William Sidney Mount's painting.

William Frederick Cumberland began University College, University of Toronto.

d. Pierre-Jean David, French sculptor (b. 1788).

THEATER & VARIETY

Self, Mrs. Sidney F. Bateman's comedy, opened at

New York's Burton's Chambers Street Theatre on October 27.

Henrik Ibsen's play *The Feast at Solhoug.*

Paolo Ferrari's *La satira e Parini.*

d. Mme. Vestris (Lucy Elizabeth Bartolozzi), English actress (b. 1788).

MUSIC & DANCE

d. Robert Schumann, German composer (b. 1810); his wife, Clara Wieck Schumann, prepared a complete edition of his work over the next 40 years.

Manon Lescaut, Daniel-François-Esprit Auber's opera based on Abbé Prévot's 1731 novel *L'Histoire du Chevalier des Grieux et de Manon Lescaut,* first performed at Turin, February 1.

Camille Saint-Saëns's *Symphony, Urbs Roma.*

Darling Nelly Gray, Benjamin Russell Hanby's popular song.

Bolshoi Theatre opened in Moscow, rebuilt after an 1853 fire.

Steinway piano-manufacturing firm established in New York.

d. Adolphe Adam, French composer (b. 1803), best known for his music for the ballet *Giselle.*

WORLD EVENTS

French and British attacked China, taking Tientsin and Peking, where they looted and burned the Summer Palace; Britain took Kowloon and Hongkong from China (1856–1860).

James Buchanan was elected U.S. president.

Britain and Persia were at war.

Richard Burton and John Speke discovered lakes Tanganyika and Victoria (1856–1858).

1857

LITERATURE

Marian (or Mary Ann) Evans published her first works of fiction, under the male pseudonym George Eliot, in *Blackwoods* magazine: *Mr. Gilfil's Love-Story, Jane's Repentance,* and *The Sad Fortunes of the Reverend Amos Barton;* published in book form as *Scenes of Clerical Life.*

The Confidence-Man; His Masquerade, Herman

Melville's novel; ill received, it was his last prose writing for three decades.

Madame Bovary, Gustave Flaubert's novel focusing on the provincial Emma, stifled and finally desperate in her bourgeois surroundings.

Cuneiform script deciphered through the efforts of numerous scholars, most notably Henry Rawlinson, opening the way to learning about Sumerians and early Mesopotamian peoples.

The Virginians, William Makepeace Thackeray's sequel to *The History of Henry Esmond*, following two brothers to America, where they fight on different sides in the Revolution (1857–1859).

Atlantic Monthly magazine began publication in the United States, edited by James Russell Lowell; among its noted contributors were Ralph Waldo Emerson, Henry Wadsworth Longfellow, James Greenleaf Whittier, and Oliver Wendell Holmes.

Harper's Weekly began publication, a spin-off from *Harper's Monthly*, including from the start cartoons by Thomas Nast, who created the Republican elephant and Democratic donkey.

Les Fleurs du mal (*The Flowers of Evil*), Charles Baudelaire's poems exploring good and evil in the morbid, distorted, or grotesque.

Barchester Towers, second of six novels in Anthony Trollope's *Chronicles of Barsetshire* (1855–1867).

Francis J. Child published the first edition of *English and Scottish Popular Ballads*, in eight volumes (1857–1858).

Little Dorrit, Charles Dickens's novel.

George Meredith's novel *Farina: A Legend of Cologne*.

José Martiniano de Alencar's novel *O Guarani*.

Nikolay Nekrasov's poem *Silence*.

Adalbert Stifter's novel *Der Nachsommer*.

Viktor Rydberg's novel *Singoalla*.

d. Dionysios Solomos, Greek poet (b. 1798).

d. Pierre-Jean de Béranger, French poet (b. 1780).

VISUAL ARTS

Niagara, Frederic Edwin Church's painting.

Honoré Daumier's painting *The Print Collector* (ca. 1857–1860).

James McNeill Whistler's *Self-Portrait* (ca. 1857–1858).

Dante Gabriel Rossetti's paintings *The Tune of the Seven Towers* and *The Wedding of St. George and Princess Sabra*.

Jean François Millet's painting *The Gleaners*.

William Henry Rinehart's sculpture group *Indian and Pioneer*.

Jean-Baptiste-Camille Corot's painting *Portrait de Maurice Robert Enfant*.

The Belated Kid, William Morris Hunt's painting.

William Henry Rinehart's sculpture group *Indian and Pioneer*.

d. Thomas Crawford, American sculptor (b. 1813).

THEATER & VARIETY

Henrik Ibsen's play *Olaf Liljekrans*.

E. A. Sothern opened in Dion Boucicault's *The Poor of New York*, at New York's Wallack's Theatre.

d. Alfred de Musset, French poet and playwright (b. 1810).

d. Douglas William Jerrold, English actor, playwright, and journalist (b. 1803).

d. Mrs. Duff (Mary Ann Dyke), English-American actress (b. 1794).

MUSIC & DANCE

Simon Boccanegra, Giuseppe Verdi's opera; libretto by Francesco Piave, opened at La Fenice, Venice.

Franz Liszt's *Dante Symphony* and *Faust Symphony*; symphonic poem *Hunnenschlacht*; *Concerto No. 2* for piano; and oratorio *Die Legende von der heiligen Elisabeth* (1857–1862).

Georges Bizet's operetta in one act *Le Docteur Miracle*.

Paul Karrer's opera *Marcos Botsaris*.

Giuseppe Verdi's *Aroldo*, opera, libretto by Francesco Piave; a revision of Verdi's 1850 opera *Stiffelio*.

Teatro Colón opened in Buenos Aires, with a production of Giuseppe Verdi's *La Traviata*.

Matthias Hohner founded his harmonica-making firm in Germany.

d. Mikhail Glinka, Russian composer (b. 1804).

WORLD EVENTS

U.S. Supreme Court's Dred Scott decision forced return of escaped slaves, greatly increasing antislavery feeling in the North.

Indian forces in the British Indian colonial army rose against British rule, and were joined in the ultimately failed rebellion by substantial Indian armed forces; the Sepoy Mutiny.

Afghan independence was recognized by Britain and Persia in the Treaty of Paris, which ended the Persian–British war.

First Married Women's Property Bill was passed by the British Parliament; a landmark move toward equal status for women in the law.

First transatlantic cable was laid.

Irish Republican Brotherhood (Fenians) founded in New York.

Italian National Association founded by Giuseppe Garibaldi.

1858

LITERATURE

The Courtship of Miles Standish, Henry Wadsworth Longfellow's narrative in which John Alden, stand-in for Standish, is told "Speak for yourself."

The Autocrat of the Breakfast Table, Oliver Wendell Holmes's essays, witty, wide-ranging monologues ostensibly delivered to a group of boarders; originally published in the *Atlantic Monthly* magazine; also his famous poems *The Chambered Nautilus* and *The Deacon's Masterpiece, or, The Wonderful "One-Hoss" Shay*.

Doctor Thorne, third of six novels in Anthony Trollope's Chronicles of Barsetshire (1855–1867); also his *The Three Clerks*.

Merope, Matthew Arnold's dramatic poem on classical themes.

Alphonse Daudet's verses *Les Amoureuses*.

Annouchka, Ivan Turgenev's story.

Years of Childhood of Bagrov's Grandson, Sergei Timofeyevich Aksakov's autobiographical novel.

Age of Chivalry, Thomas Bulfinch's work on mythology.

William Morris's *The Defense of Guenevere and Other Poems*.

Adelaide Proctor's two-volume poetry collection, *Legends and Lyrics*.

Phantastes, George Macdonald's fantasy novel.

English Woman's Journal, founded by Barbara Leigh-Smith Bodichon.

Frankfurter Zeitung began publication.

The Advertiser began publication in Adelaide, Australia.

VISUAL ARTS

James McNeill Whistler's work included the painting *At the Piano* and *Twelve Etchings from Nature*.

Rhode Island Landscape, Martin Johnson Heade's painting.

Eugène Delacroix's paintings included *A Lion Hunt*, *The Abduction of Rebecca*, and *View of Tangiers from the Seashore*.

Honoré Daumier's painting *Crispin and Scapin* (ca. 1858–1860) and his drawing *Connoisseurs* (ca. 1858).

Eugène Viollet-le-Duc published his *Dictionnaire raisonné de l'architecture française* (1858–1875), on medieval architecture and the Gothic style.

Head of a Woman, William Rimmer's granite sculpture.

Ruins on the Nile, Thomas Moran's painting.

Henry Clay and *Daniel Webster*, Thomas Ball's statues.

d. Ando Hiroshige, Japanese color-print artist (b. 1797).

THEATER & VARIETY

Joseph Jefferson appeared as Asa Trenchard in the New York premiere of Tom Taylor's comedy *Our American Cousin*; this was the play being performed at Ford's Theatre at the time of President Lincoln's assassination in 1865.

Henrik Ibsen's play *The Vikings at Helgeland*.

Jessie Brown, Dion Boucicault's play opened at New York's Wallack's Theatre on February 22.

William W. Pratt's *Ten Nights in a Barroom* opened at New York's National Theatre on August 23.

Le Fils naturel, play by Alexandre Dumas (fils).

Bjørnstjerne Bjørnson's plays *Between the Battles* and *Lame Hulda*.

Émile Augier's *Les Lionnes pauvres*.

d. James Nelson Barker, American playwright (b. 1784).

d. Rachel, French actress (b. 1820), one of the most notable tragedians of her time, as Camille, as Phèdre, and in many other classical roles; a great star in France, she also toured in England and America.

MUSIC & DANCE

Orpheus in the Underworld (*Orphée aux Enfers*),

Jacques Offenbach's two-act opera, libretto by Hector Crémieux and Fromental Halevy, premiered at Bouffes-Parisiens, Paris, October 21; expanded to four acts in 1874.

Halka, Stanislaw Moniuszko's opera, libretto by Wlodzimierz Wolski, opened in Warsaw.

The new Royal Opera House, Covent Garden, London, reopened with a production of Giacomo Meyerbeer's *Les Huguenots*; it had been rebuilt after an 1856 fire.

Georges Bizet's opera *Don Procopio*; also his piano pieces *Trois esquisses musicales*.

Johannes Brahms's *Serenade No. 1*.

August Bournonville's ballet *Flower Festival in Genzano*.

Camille Saint-Saëns's *Piano Concerto No. 1*.

César Franck's choral work *Trois Motets*.

Charles Gounod's opera *Le Médecin malgré lui*.

A. Olivieri wrote the music for the popular Italian anthem known as *Garibaldi's Hymn*.

d. Luigi Lablache, Italian bass (b. 1794).

WORLD EVENTS

Britain and France won massive new concessions from China in the Treaty of Tientsin, concluding the Chinese–British war.

Legal discrimination against Jews was relaxed in Britain; Lionel de Rothschild became the first Jewish member of Parliament.

Civil war in Mexico won by forces of Benito Juárez (1858–1861).

French began their conquest of Vietnam (1858–1862).

Minnesota became a state.

Ottawa became the capital of Canada.

Bernadette Soubirous had a religious vision at Lourdes, France.

1859

LITERATURE

A Tale of Two Cities, Charles Dickens's stirring novel of London and Paris during the French Revolution.

Adam Bede, the first full-length novel by George Eliot (Marian or Mary Ann Evans).

The Rubáiyát of Omar Khayyám, Edward Fitzgerald's English-language translation–adaptation from the Persian of Khayyam's poetry.

He and She (*Elle et lui*), George Sand's novel based loosely on her love affair with French writer Alfred de Musset.

Idylls of the King, Alfred, Lord Tennyson's series of poems in 10 books, on Arthurian themes.

Fyodor Dostoyevsky's novels *The Village of Stepanchikovo and Its Inhabitants* (*The Friend of the Family*) and *Uncle's Dream*.

The Ordeal of Richard Feverel: A History of Father and Son, George Meredith's novel.

Diario de un testigo de la guerra de África, Pedro Antonio de Alarcón's journal of campaigns in Morocco.

Victor Hugo's poems, *La Légende des siècles*, first of three series.

Gustavo Adolfo Bécquer's poetry *Rimas* (1859–1861).

Henrik Ibsen's poems *Paa vidderne* (*On the Heights*).

John Ruskin's *The Two Paths* (from lectures given 1856–1859).

The Irish Times founded.

d. Alexis, Comte de Tocqueville, French liberal politician and writer (b. 1805).

d. Thomas Babington Macaulay, English writer and statesman (b. 1859).

d. Washington Irving, American writer (b. 1783).

d. Wilhelm Karl Grimm, German philologist and literary scholar (b. 1786).

d. Sergei Timofeyevich Aksakov, Russian writer (b. 1791).

d. Thomas De Quincey, English essayist and critic (b. 1785).

VISUAL ARTS

National Gallery of Scotland, Edinburgh, opened.

The Angelus, Jean François Millet's painting.

Hackensack Meadows, Sunset, George Inness's painting.

Étienne-Pierre-Théodore Rousseau's painting *Farm in the Landes*.

Heart of the Andes, Frederic Edwin Church's painting.

Claude Monet's painting *Still Life* (ca. 1859).

Jean-Auguste-Dominique Ingres's paintings included *Macbeth and the Witches* and his *Self-Portrait, Aged 79*.

Édouard Manet's painting *The Absinthe Drinker*.

Gustave Courbet's painting *La Toilette de la mariée* (*The Bride at Her Toilet*).

Thomas Fuller began the Dominion Parliament Buildings, Ottawa (1859–1866).

Lewis Carroll's photo of *Alice, Lorina, and Edith Liddell*.

Old Kentucky Home: Life in the South, Eastman Johnson's painting.

Thomas Jefferson, Hiram Powers's sculpture for the U.S. Senate and House of Representatives (1859–1863).

The White Captive, Erastus Dow Palmer's sculpture.

THEATER & VARIETY

Aerialist Charles Blondin twice crossed Niagara Falls on a tightrope.

La Femme de Claude, play by Alexandre Dumas (*fils*).

French acrobat Jules Léotard invented the flying trapeze.

Joseph Jefferson played Caleb Plummer in *Dot*, Dion Boucicault's version of Dickens's *The Cricket on the Hearth*.

Joseph Jefferson played Salem Scudder in Dion Boucicault's *The Octoroon; or, Life in Louisiana*, which opened in New York.

d. Adolf Bäuerle, Austrian playwright (b. 1786).

d. (James Henry) Leigh Hunt, English poet and essayist, pioneer of modern dramatic criticism (b. 1784).

MUSIC & DANCE

Un Ballo in maschera (*A Masked Ball*), Giuseppe Verdi's opera, libretto by Antonio Somma, based on the libretto for the 1833 opera *Gustave III*, opened at the Apollo Theatre, Rome.

Faust, Charles Gounod's opera, libretto by Jules Barbier and Michel Carré, based on Johann Wolfgang von Goethe's 1790 play, opened at the Opéra, Paris, March 3.

Johannes Brahms's *Serenade No. 2*.

Camille Saint-Saëns's *Symphony No. 2*.

When I Saw Sweet Nelly Home, John Fletcher's popular song.

Giacomo Meyerbeer's opera *Le Pardon de Ploërmel*.

Jingle Bells (*The One Horse Open Sleigh*), popular song, first published in America.

d. Louis Spohr, German composer, violinist, and conductor (b. 1784).

d. Luigi Ricci, Italian composer (b. 1805).

WORLD EVENTS

Antislavery forces led by John Brown seized the federal arsenal at Harpers Ferry; Brown was hanged after being taken by Union forces under Robert E. Lee.

Charles Darwin's *The Origin of Species*.

Austria was at war with and was defeated by France and Sardinia.

Comstock Lode (silver) was discovered in Nevada.

Kansas voted to join the Union as a free state.

Oregon became a state.

Queensland, Australia, became a separate political entity.

Spain and Morocco were at war (1859–1860).

John Stuart Mill's *On Liberty*.

Karl Marx's *Criticism of Political Economy*.

1860

LITERATURE

Leaves of Grass, third edition of Walt Whitman's poetry collection, the first from a regular publisher, introducing *Out of the Cradle Endlessly Rocking, Facing West from California's Shores, I Hear It Was Charged Against Me, Once I Pass'd Through a Populous City, Calamus, Children of Adam*, and *Starting from Paumanok*.

The Mill on the Floss, George Eliot's novel of provincial life, focusing on Maggie Tulliver and her brother Tom at Dorlcote Mill on the river Floss.

Cornhill Magazine began publication in Britain, edited by William Makepeace Thackeray, who also published the novel *Lovel the Widower*.

Ivan Turgenev's autobiographical story *First Love* (*Pervaya lyubov*) and his novel *On the Eve*.

The Woman in White, Wilkie Collins's mystery novel.

The Marble Faun: Or, the Romance of Monte Beni (*Transformation*), Nathaniel Hawthorne's novel.

Elizabeth Barrett Browning's *Poems before Congress*.

Jakob Christoph Burckhardt's *The Civilization of the Renaissance in Italy*.

George Meredith's novel *Evan Harrington; or, He Would Be a Gentleman*.

Charles Sangster's *Hesperus and Other Poems*.

John Greenleaf Whittier's *Home Ballads, Poems and Lyrics*.

Ralph Waldo Emerson's essay *The Conduct of Life*.

d. James Kirke Paulding, American writer (b. 1778).

VISUAL ARTS

Edgar Degas's paintings included *At the Races* (1860–1862), *Portrait of Mme Brunet* (1860), *The Bellelli Family* (1860–1862), and *Young Spartans Exercising*.

Jean-Baptiste-Camille Corot's painting *Jeune fille à sa toilette* (ca. 1860–1865).

Autumn on the Hudson, Jasper Cropsey's painting.

Édouard Manet's painting *Spanish Singer*.

Twilight in the Wilderness, Frederic Edwin Church's painting.

Gustave Courbet's painting *La Diligence dans la neige*.

Ship "Starlight" in the Fog, Fitz Hugh Lane's painting.

Honoré Daumier's drawing *Soup* (ca. 1860–1862); and his paintings *The Horsemen* and *The Washer-woman* (both ca. 1860–1862).

Dante Gabriel Rossetti's painting *Arthur's Tomb*.

Jean-Baptiste Carpeaux's sculpture *Ugolino*.

Saint Stephen, William Rimmer's sculpture.

d. Charles Barry, English architect (b. 1795).

THEATER & VARIETY

The Colleen Bawn, Dion Boucicault's play, opened at New York's Laura Keene's Theatre on March 29.

A Scrap of Paper (*Les Pattes de mouche*), Victorien Sardou's play.

Alexander Nikolayevich Ostrovsky's *The Storm*.

Eugène Labiche's *Le Voyage de M. Perrichon*.

d. Johan Ludvig Heiberg, Danish poet, playwright, and critic (b. 1791).

d. Robert Brough, English playwright (b. 1828).

d. William Evans Burton, English-born actor–manager (b. 1804).

MUSIC & DANCE

Far from Denmark, August Bournonville's ballet, music by Joseph Glaeser and others, first danced April 20 by the Royal Danish Ballet, Copenhagen.

Daniel Decatur Emmett published his song *Dixie* (originally *I Wish I Was in Dixie's Land*), later taken up as a Confederate anthem.

Trois Odes Funèbres, Franz Liszt's tone poem (1860–1866).

Roma, Georges Bizet's symphony (1860–1868; rev. 1871).

Johannes Brahms's *String Sextet*.

Nearer, My God, to Thee, popular hymn, words by Sarah F. Adams, music by Lowell Mason.

César Franck's *Messe à troix voix*.

Charles Gounod's operas *La Colombe* and *Philémon et Baucis*.

Alexander Dargomïzhsky's opera *The Stone Guest* (1860s).

WORLD EVENTS

Abraham Lincoln defeated Stephen Douglas to win election as U.S. president.

South Carolina seceded from the U.S., beginning the train of events that began the Civil War.

Pony Express began, from St. Joseph, Missouri, to Sacramento, California.

Italian Risorgimento (Unification): Giuseppe Garibaldi led a series of battles that resulted in the establishment of the kingdom of Italy, its first king Victor Emmanuel II.

Muslims massacred Maronite Christians in Lebanon.

1861

LITERATURE

Great Expectations, Charles Dickens's ever-popular novel of the maturation of the hero Pip and his relations with blacksmith Joe Gargery, the eccentric Miss Havisham and her ward Estella, lawyer Jaggers, and the convict Abel Magwitch.

Walt Whitman's Civil War recruiting poem *Beat! Beat! Drums!*

The House of the Dead (1861–1862), Fyodor Dostoyevsky's semiautobiographical novel about life in a Siberian prison; also his novel *The Insulted and Injured*.

Silas Marner: The Weaver of Ravenloe, George Eliot's novel.

Framley Parsonage, fourth of six novels in Anthony Trollope's Chronicles of Barsetshire (1855–1867).

The Cloister and the Hearth, Charles Reade's historical novel.

Rebecca Harding Davis's story *Life in the Iron Mills*.

William Makepeace Thackeray's novel *The Adventures of Philip on His Way Through the World* (1861–1862).

Mother Right, Johann Bachofen's work positing early matriarchies.

The Early Italian Poets, Dante Gabriel Rossetti's translations.

Nikolay Nekrasov's poem *Freedom*.

Oliver Wendell Holmes's novel *Elsie Venner*.

Matthew Arnold's essays *On Translating Homer* and *The Popular Education of France with Notices of that of Holland and Switzerland*.

George Newnes's *Tit-Bits from all the Most Interesting Books, Periodicals and Newspapers of the World*, one of the first popular magazines, began publication in Britain.

d. Elizabeth Barrett Browning, English poet, wife of Robert Browning (b. 1806).

d. Taras Shevchenko, Ukrainian poet (b. 1814).

VISUAL ARTS

Delaware Water Gap, George Inness's painting.

James McNeill Whistler's paintings included *Alone with the Tide*, *Coast of Brittany*, and *Wapping*.

Gustave Courbet's painting *Combat de cerfs. Le Rut du printemps* (*Battle Between Two Stags*).

Westward the Course of Empire Takes Its Way, Emmanuel Gottlieb Leutze's painting.

Edgar Degas's painting *Semiramis Founding Babylon*.

Falling Gladiator, William Rimmer's sculpture.

Gustave Doré's illustrations for Dante's *Inferno*.

Land of the Lotus Eaters, Robert S. Duncanson's painting.

Thomas Rowlandson's caricatures in *World in Miniature*.

William Henry Rinehart completed his doors for the U.S. Senate and House of Representatives, Washington, D.C.

d. Francis Danby, Irish painter (b. 1793).

THEATER & VARIETY

Adah Isaacs Menken opened in Albany in the title role of *Mazeppa*, the role with which she was to become identified.

Alfred de Musset's *There's No Trifling with Love*.

Eugène Labiche's *La Poudre aux yeux*.

John Davis's *The Roll of the Drum*.

Émile Augier's *Les Effrontés* (*Bold as Brass*).

Paolo Giacometti's *The Outlaw*.

Bjørnstjerne Bjørnson's *King Sverre*.

d. (Augustin) Eugène Scribe, French playwright (b. 1791).

d. Giambattista Niccolini, Italian playwright (b. 1782).

d. Gustavo Modena, Italian actor (b. 1803).

MUSIC & DANCE

Johannes Brahms's *Piano Concerto No. 1*, *Piano Quartet*, and *Handel Variations* for piano.

Aura Lea, popular song, words by William Whiteman Fosdick, music by George R. Poulton.

Nikolay Rimsky-Korsakov's *Symphony No. 1* (1861–1865).

Modest Mussorgsky's *Intermezzo in modo classico*, for piano.

Afferentur, Anton Bruckner's choral work.

Maryland, My Maryland! James Ryder Randall's popular song.

Carlos Gomes's opera *A noite do castelo*.

E.A. Hübsch's musical setting for a poem by Basile Alexandri, *Traeas a Regele in pace si onor*, won a competition for Rumania's national song.

Bánk bán, Ferenc Erkel's opera.

George Frederick Bristow's overture *Columbus*.

The Bonnie Blue Flag, Confederate Civil War song, by Harry McCarthy.

d. Eugène Scribe, French dramatist and librettist (b. 1791).

WORLD EVENTS

U.S. Civil War: Mississippi, Alabama, Georgia, Louisiana, and Florida seceded, with South Carolina forming the Confederacy, with Jefferson Davis as president; later joined by Texas, Virginia, Arkansas, North Carolina, and Tennessee. War began April 12, with Confederate attack on Fort Sumter, South Carolina. Earliest major action was the First Battle of Bull Run.

Apache Wars began in the American Southwest (1861–1886).

Following the death of Emperor Hs'en Feng, his chief concubine, Tzu-hsi, became the real ruler of China, beginning her long reign as Dowager Empress (1861–1908).

Kansas became a state.

Russian serfs were emancipated.

1862

LITERATURE

Les Misérables (*The Miserable Ones*), Victor Hugo's massive novel centering on Jean Valjean, arrested for stealing a single piece of bread, and pursued even after his redemption by the obsessive detective Javert.

Fathers and Sons (or *Fathers and Children*; *Ottsy i deti*), Ivan Turgenev's novel exploring the conflicts between the aristocracy and the newer democratic intelligentsia in contemporary Russia.

Salammbô, Gustave Flaubert's historical novel set in ancient Carthage.

Aleksey Tolstoy's poem *Don Juan*.

Alphonse Daudet's novel *Le Roman du Chaperon-Rouge*.

Anthony Trollope's novel *Orley Farm*.

Christina Rossetti's *Goblin Market and Other Poems*.

Elizabeth Barrett Browning's *Last Poems*.

George Meredith's *Modern Love, and Poems of the English Roadside, with Poems and Ballads*.

Henrik Ibsen's poems *Terje Vigen*.

Matthew Arnold's *On Translating Homer: Last Words*.

Rebecca Harding Davis's novel *Margaret Howth*.

A translation of the Bible into the Cree language was completed by Wesleyan missionary W. Mason.

d. Henry David Thoreau, American writer (b. 1817).

VISUAL ARTS

Alexander Gardner's photo *President Lincoln on the Battlefield of Antietam*.

James McNeill Whistler's painting *Symphony in White No. 1: The White Girl*.

Honoré Daumier's painting *The Third-Class Carriage* (ca. 1862).

Édouard Manet's paintings included *Ballet Espagnol*, *The Street Singer*, *La Musique aux Tuileries*, and *Mademoiselle Victorine in the Costume of an Espada*.

Gustave Doré's illustrations for *Don Quixote*.

Edgar Degas painted a *Self-Portrait* (ca. 1862).

Jean-Auguste-Dominique Ingres's painting *The Turkish Bath*.

Benjamin Franklin, Hiram Powers's statue for the U.S. Senate and House of Representatives.

Charles Barry designed the Halifax, Nova Scotia, Town Hall.

Flowers on a Window Ledge, John La Farge's painting.

George Gilbert Scott began the Albert Memorial, London.

d. Benjamin Paul Akers, American neoclassical sculptor (b. 1825).

THEATER & VARIETY

Henrik Ibsen's play *Love's Comedy*.

Ivan Turgenev's *Nakhlebnik*.

Benten the Thief, Japanese *kabuki* play by Kawatake Mokuami.

La Dernière Idole, Alphonse Daudet's play, written with E. L'Épine.

Maggie Mitchell opened on June 9 in *Fanchon, the Cricket* at New York's Laura Keene's Theatre.

Bjørnstjerne Bjørnson's trilogy *Sigurd Slembe*.

Augustin Daly's *Leah the Forsaken*.

Émile Augier's *Le Fils de Giboyer*.

d. Francisco Martínez de la Rosa, Spanish playwright (b. 1787).

d. James Sheridan Knowles, Irish-born playwright (b. 1784).

d. Johann Nepomuk Nestroy, Austrian actor and playwright (b. 1801).

MUSIC & DANCE

Béatrice et Bénédict, Hector Berlioz's opera, libretto by Berlioz, based on Shakespeare's *Much Ado About Nothing* (1598–1599), opened in Baden-Baden.

Battle Hymn of the Republic, Julia Ward Howe's verses to the tune of *John Brown's Body*, first published in the *Atlantic Monthly*; written at the request of the Union Army, for whom it became an anthem.

La forza del destino, Giuseppe Verdi's opera, libretto by Francesco Piave, opened in St. Petersburg.

Giuseppe Verdi's *Inno delli nazioni* (*Hymn of the Nations*).

La Fille du Pharaon, Marius Petipa's ballet, premiered at the Bolshoi Theatre, St. Petersburg, January 30, with a cast of almost 400; Carolina Rosati created the title role, in her final appearance.

Johannes Brahms's *Piano Quartet* and *Paganini Variations* for piano (1862–1863).

Alexander Borodin's *Piano Quintet*.

Baba-Yaga, Alexander Sergeievich Dargomïzhsky's orchestral work.

Anton Bruckner's cantata *Preiset den Herrn*.

César Franck's *Six Pièces* for organ.

Charles Gounod's opera *La Reine de Saba*.

We Are Coming, Father Abraham, James Sloane Gibbons's popular Civil War song.

Barcelona's opera house, Teatro Liceo, reopened, rebuilt after an 1861 fire.

d. Fromental Halévy, French composer, teacher, and writer (b. 1799).

WORLD EVENTS

U.S. Civil War: battles of Shiloh, second Bull Run, Harpers Ferry, Antietam, and Fredericksburg; sea war between first ironclad ships.

Sioux–U.S. war in Minnesota.

French forces invaded Mexico.

France took Cochin-China.

Otto von Bismarck became premier of Prussia.

Herbert Spencer's *First Principles*.

John Stuart Mill's *Utilitarianism*.

1863

LITERATURE

Gettysburg Address, Abraham Lincoln's stirring speech at the dedication of the national cemetery at the Gettysburg battlefield on November 19; an enduring statement of American ideals, inspiring aspirants to freedom around the world.

Henry Wadsworth Longfellow's *Tales of a Wayside Inn*, a collection of narrative poems on historical subjects told at a New England tavern, including *Paul Revere's Ride*; modeled after Chaucer's *Canterbury Tales* and Boccaccio's *Decameron*.

The Water-Babies, a Fairy Tale for a Land-Baby, Charles Kingsley's fantasy novel of Tom, the young chimney sweep who became a "merman" after falling into a river.

George Eliot's only historical novel, *Romola*, set in Renaissance Italy at the time of Savanorola.

Winter Notes on Summer Impressions, Fyodor Dostoyevsky's account of his first European trip, to Paris, London, and Geneva, in 1862.

Hospital Sketches, Louisa May Alcott's first literary success.

Alphonse de Lamartine's *Mémoires politiques*.

Elizabeth Cleghorn Gaskell's novel *Sylvia's Lovers*.

Nathaniel Hawthorne's *Our Old Home: A Series of English Sketches*.

The Canadians of Old, Philippe Aubert de Gaspé's historical romance.

d. Alfred de Vigny, French writer (b. 1863).

d. Jacob Ludwig Grimm, German philologist and literary scholar (b. 1785).

d. William Makepeace Thackeray, English novelist (b. 1811).

VISUAL ARTS

Jean François Millet's painting *The Man with the Hoe*.

Édouard Manet's paintings included *Le Déjeuner sur l'herbe*, *Olympia*, and *The Trellis* (ca. 1863).

The Rocky Mountains, Albert Bierstadt's painting.

James McNeill Whistler's painting *Battersea Reach* (ca. 1863–1865).

Timothy O'Sullivan's photo *A Harvest of Death* (Gettysburg).

Cotopaxi, Frederic Edwin Church's painting.

Two Hummingbirds, Martin Johnson Heade's painting (ca. 1863–1865).

Dante Gabriel Rossetti's painting *Beata Beatrix* (ca. 1863).

View Near West Point on the Hudson, John Frederick Kensett's painting.

Peace in Bondage, Erastus Dow Palmer's sculpture.

The Carthaginian Girl, Richard Saltonstall's neoclassical statue.

d. Eugène Delacroix, French painter (b. 1798).

d. Charles Robert Cockerell, English architect (b. 1788).

d. James Renwick, American architect (b. 1792).

THEATER & VARIETY

Henrik Ibsen's play *The Pretenders*.

Kate Bateman opened in Augustin Daly's *Leah, the Forsaken* at New York's Niblo's Garden on January 19.

Les Absents, Alphonse Daudet's play, written with E. L'Épine.

East Lynne, Clifton W. Tayleure's play, opened at New York's Winter Garden Theatre on March 23.

Rosedale, Lester Wallack's play, opened at New York's Wallack's Theatre on September 30.

The Ticket-of-Leave Man, Tom Taylor's play, opened in London on May 27.

d. Bocage, French actor (b. 1797).

d. Charlotte Barnes, American actress and playwright (b. 1818) who took up the question of women's oppression and sexual equality.

d. Friedrich Hebbel, German playwright (b. 1813) who took up questions of women's oppression and sexual equality.

d. Mikhail Semenovich Shchepkin, Russian actor (b. 1788).

MUSIC & DANCE

Les Troyens (The Trojans), Hector Berlioz's opera, libretto by Berlioz, based on Virgil (written 1855); Part I, La Prise de Troie (The Capture of Troy), opened at the Théâtre-Lyrique, Paris, November 4, 1863; Part II, Les Troyens à Carthage (The Trojans at Carthage), at Carlsruhe, Germany, in December 1890.

The Pearl Fishers (Les pêcheurs de perles), Georges Bizet's opera, libretto by Eugène Carré and Michel Cormon, opened in Paris.

When Johnny Comes Marching Home, Patrick S. Gilmore's song.

Finnish Fantasy, Alexander Sergeievich Dargomïzhsky's orchestral work (1863–1867).

Anton Bruckner's cantata Germanenzug.

Carlos Gomes's opera Joana de Flandres.

Franz Liszt's Légendes, for piano (ca. 1863).

Hector Berlioz's songs Trente-trois Melodies.

Jules Massenet's Requiem (ca. 1863).

All Quiet Along the Potomac To-night, popular Civil War song, words by Ethel Lynn Beers, music by John Hill Hewitt.

WORLD EVENTS

U.S. Civil War: Lincoln's Emancipation Proclamation; African-American troops joined Union forces in large numbers; decisive battles of Gettysburg and Vicksburg sealed fate of Confederacy; Lincoln's Gettysburg Address; battles of Chancellorsville, Chickamauga, and Chattanooga.

Ecuador and Colombia were at war.

Failed Polish insurrection against Russian rule (1863–1864).

French forces took Mexico City.

1864

LITERATURE

The Small House at Allington, fifth of six novels in Anthony Trollope's Chronicles of Barsetshire (1855–1867); minor characters Plantagenet Palliser and Lady Glencora became central characters in his six Palliser (Parliamentary) novels, begun that same year with Can You Forgive Her?; basis for the television series.

Notes from Underground, Fyodor Dostoyevsky's novel in two parts, the first a monologue by and about the narrator, and the second tales of his adventures, both stressing humanity's essential irrationality.

Apologia pro Vita Sua (Defence of his Life), John Henry Newman's history of his intellectual and spiritual life, leading to his conversion to Catholicism.

Robert Browning's poetry collection Dramatis Personae, including Prospice, Abt Vogler, Caliban upon Setebos, Mr. Sludge, "The Medium," and Rabbi Ben Ezra.

Alfred, Lord Tennyson's poems Enoch Arden and Sea Dreams.

A Voyage to the Center of the Earth, Jules Verne's science fantasy novel.

John Greenleaf Whittier's In War Time and Other Poems, including Barbara Frietchie.

J. S. Le Fanu's novel Uncle Silas.

Henry James's first published story, A Tragedy of Error.

Elizabeth Cleghorn Gaskell's novel Wives and Daughters (1864–1866).

James Russell Lowell's sketches Fireside Travels.

George Meredith's novel Emilia in England.

Henrik Ibsen's poetry Episke Brand (Epic Brand) (written 1864–1865).

Joachim María Machado de Assis's poetry Chrysalidas.

Neue Freie Presse began publication in Vienna.

Matthew Arnold's A French Eton; or, Middle Class Education and the State.

d. Nathaniel Hawthorne, American writer (b. 1804).

d. John Clare, English poet (b. 1793).

d. Antônio Gonçalves Dias, Brazilian poet and ethnologist (b. 1823).

VISUAL ARTS

James McNeill Whistler's paintings included Caprice in Purple and Gold, No. 2: The Golden Screen, Lady of the Lang Lijsen, and Rose and Silver: La

Princesse du Pays de la Porcelaine (*Portrait of Miss Christine Spartali*).

Alexander Hamilton, William Rimmer's sculpture.

Auguste Rodin's sculpture *The Man with the Broken Nose*.

George Inness's painting *Harvest Time*.

Claude Monet's painting *Farm in Normandy* (ca. 1864).

Jean-Baptiste-Camille Corot's painting *Souvenir de Mortefontaine*.

Édouard Manet's painting *The Races at Longchamp, Paris*.

Joseph Paxton began the Thames Embankment (1864–1870).

Twilight in the Adirondacks, Sanford Robinson Gifford's painting.

Julia Margaret Cameron's portrait photo of *Ellen Terry*.

Daniel Maclise's painting of *The Death of Nelson*, at the Houses of Parliament.

Honoré Daumier's lithograph *The Muse of the Beer Parlour*.

Ignace Henri Jean Théodore Fantin-Latour's painting *Hommage à Delacroix*.

Indian Hunter, John Quincy Adams Ward's bronze statue.

Twilight in the Adirondacks, Sanford Robinson Gifford's painting.

d. John Leech, English caricaturist and illustrator (b. 1817).

d. Kunisada, Japanese color-print artist (b. 1785).

d. Leo von Klenze, German architect (b. 1784).

THEATER & VARIETY

Aleksis Kivi's tragedy *Kullervo* and his rural comedy *The Village Cobblers*.

Dion Boucicault's *The Wicklow Wedding*.

Charles Reade's *It's Never Too Late to Mend*.

Eugène Labiche's *La Cagnotte*.

Bjørnstjerne Bjørnson's *Maria Stuart i Skotland*.

T. W. Robertson's *David Garrick*.

Antonio García Gutiérrez's *Venganza catalana*.

MUSIC & DANCE

La belle Hélène, Jacques Offenbach operetta, libretto by Henri Meilhac and Ludovic Halevy, opened at the Théâtre des Variétés, Paris, December 17, with Hortense Schneider in the title role.

Mireille, Charles Gounod's opera, libretto by Michel Carré, opened at Théâtre-Lyrique, Paris, March 19.

Just Before the Battle, Mother and *Tramp! Tramp! Tramp!* (*The Prisoner's Hope*), George F. Root's Civil War songs (ca. 1864).

Kazochok, Alexander Sergeievich Dargomïzhsky's orchestral work.

Anton Bruckner's *Symphony No. 0* and *Mass No. 1 in D Minor*.

Johannes Brahms's *Piano Quintet*.

Tenting To-night, Walter Kittredge's Civil War song.

Edvard Grieg's *Symphony*.

Oh Where O Where Has My Little Dog Gone (*Der Deitcher's Dog*), Septimus Winner's popular song.

Peter Ilich Tchaikovsky's *Overture* to Ostrovsky's play *The Storm*.

The Blue Tail Fly (*Jim Crack Corn*), popular song, first published in America.

Song of Norway, Norway's popular anthem, Bjørnstjerne Bjørnson's 1859 poem set to music of Rikard Nordraak.

d. Giacomo Meyerbeer, German composer (b. 1791).

d. Stephen (Collins) Foster, American songwriter (1826).

WORLD EVENTS

U.S. Civil War: battles of the Wilderness, Spotsylvania, Cold Harbor, and siege of Petersburg, as Ulysses S. Grant's army systematically destroyed Robert E. Lee's remaining forces, and William Tecumseh Sherman's army marched through Georgia to the sea. Lincoln reelected U.S. president.

France installed Maximilian as the puppet ruler of Mexico.

Meiji Restoration wars began in Japan (1864–1869).

Massacre of Cheyenne and Arapahoe Indians by U.S. forces at Sand Creek, Colorado.

First Geneva Convention covered the medical and general treatment of prisoners of war.

Nevada became a state.

1865

LITERATURE

War and Peace, Leo Tolstoy's massive novel with hun-

dreds of characters, most notably Pierre Bezhukov, Andrey Bolkonsky, and Natasha Rostova, in Russian during the Napoleonic years, especially his 1812 invasion (1865–1869).

Alice's Adventures in Wonderland, Lewis Carroll's fantastical story of Alice's encounters with all its delightfully eccentric characters, such as the White Rabbit, Cheshire Cat, and Queen of Hearts, illustrated by John Tenniel; originally written for young Alice Liddell.

Walt Whitman's *Drum-Taps* (1865) and *Sequel to Drum-Taps* (1865–1866), containing *Vigil Strange I Kept on the Field One Night*, *One's Self I Sing*, *Pioneers! O Pioneers! Come Up from the Fields, Father*, *Chanting the Square Deific*, and most importantly the two great dirges for Lincoln, *O Captain! My Captain!* and *When Lilacs Last in the Door Yard Bloom'd*.

Matthew Arnold's *Essays in Criticism*, including *The Function of Criticism at the Present Time*, *The Literary Influence of Academies*, *Heinrich Heine*, *Spinoza*, and *Marcus Aurelius*.

Mark Twain's story *The Celebrated Jumping Frog of Calaveras County*.

Hans Brinker; or, The Silver Skates, Mary Mapes Dodge's story.

Our Mutual Friend, Charles Dickens's novel.

Victor Hugo's *Les Chansons des rues et des bois*.

La Confession de Claude, Émile Zola's first novel.

Algernon Charles Swinburne's poetic tragedy *Atalanta in Calydon*.

Anthony Trollope's novel *The Belton Estate*.

Bankim Chandra Chatterjee's novel *Durgesanandini* (*Daughter of the Lord of the Fort*).

James Russell Lowell's poem *Commemoration Ode*.

John Ruskin's lecture *Sesame and Lilies*.

Iracema, José Martiniano de Alencar's novel.

Louisa May Alcott's novel *Moods*.

Mocher Seforim Mendele's *Dos Vinschfingerl* (*The Wishing Ring*).

Rhoda Fleming, George Meredith's novel.

Charles Kingsley's novel *Hereward the Wake*.

Fortnightly Review began publication in Britain.

William Bullock developed a rotary press that took advantage of continuous rolls of paper.

d. Elizabeth Cleghorn Gaskell, English novelist (b. 1810).

d. Fredrika Bremer, Swedish novelist and travel writer (b. 1801).

d. George Arnold, American poet and humorist (b. 1834).

VISUAL ARTS

Alexander Gardner's portrait photo of *Abraham Lincoln*; his photos of John Wilkes Booth and his associates; and his *Photographic Sketch Book of the War* (1865–1866).

Delaware Valley and *Peace and Plenty*, George Inness's paintings.

Auguste Rodin's sculptures *Young Girl with Flowers in Her Hair* and *Young Mother and Child*.

Claude Monet's painting *View of the Coast at Le Havre*.

Winslow Homer's painting *Pitching Quoits*.

Jean-Baptiste-Camille Corot's paintings *L'atelier* (1865–1858) and *The Gust of Wind* (ca. 1865–1870).

Approaching Storm: Beach near Newport, Martin Johnson Heade's painting (1865–1870).

James McNeill Whistler's painting *Harmony in Blue and Silver: Trouville*.

Gustave Courbet's painting *Proudhon et ses enfants* (*Proudhon and His Family*).

Starrucca Viaduct, Jasper F. Cropsey's painting.

James Renwick began Vassar College.

George Sand, portrait photo by Nadar.

Susannah and the Elders, William Holbrook Beard's painting.

William Burges began to rebuild Cardiff Castle and Castle Coch (1865–1875).

d. Fitz Hugh Lane, American lithographer and painter (b. 1804).

d. Joseph Paxton, English architect (b. 1803).

THEATER & VARIETY

Algernon Charles Swinburne's *Chastelard*.

L'Oeillet blanc, Alphonse Daudet's play, written with E. L'Épine.

Antonio García Gutiérrez's *Juan Lorenzo*.

Bjørnstjerne Bjørnson's *The Newly-Marrieds*.

T. W. Robertson's *Society*.

d. John Wilkes Booth, American actor (b. 1839), after assassinating Abraham Lincoln for unknown reasons. He was the son of Junius Brutus Booth, Sr., and the brother of Junius Brutus Booth, Jr., and Edwin Booth, all also actors.

MUSIC & DANCE

Tristan and Isolde, Richard Wagner's opera, libretto by Wagner, based on an old legend, opened in Munich June 10, Hans von Bülow conducting. Ludwig Schnorr von Carolsfeld and Malvina Schnorr von Carolsfeld created the title roles.

L'Africaine, Giacomo Meyerbeer's opera, libretto by Eugène Scribe, premiered after Meyerbeer's death at the Grand Opéra, Paris, April 28.

Johannes Brahms's first cello conata, second piano trio, and second string sextet.

Anton Bruckner's *Symphony No. 1*, the "Linz" version (1865–1866).

Antonín Dvořák's first symphony, *The Bells of Zlonice*.

Edvard Grieg's *Violin Sonata* and *Humoresker* for piano.

Marching Through Georgia, Henry Clay Work's Civil War song.

Gabriel Fauré's *Cantique de Jean Racine*.

Ignacio Marti Calderón wrote *Himno de Capotillo*, an anti-Spanish anthem of the Dominican Republic (ca. 1865).

Georges Bizet's opera *Ivan IV*.

d. Vincent Wallace, Irish composer (b. 1812).

WORLD EVENTS

Robert E. Lee surrendered to Ulysses S. Grant at Appommatox, effectively ending the U.S. Civil War.

d. Abraham Lincoln, 16th U.S. president (b. 1809), assassinated by John Wilkes Booth at Ford's Theater, Washington, D.C., shot April 14, died April 15; succeeded by Vice-President Andrew Johnson.

U.S. 13th Amendment prohibited slavery.

Ku Klux Klan was founded.

Russian forces took Tashkent.

Santo Domingo won independence from Spain.

William Booth founded the Salvation Army.

1866

LITERATURE

Crime and Punishment, Fyodor Dostoyevsky's masterly psychological novel about the murders committed by the penniless student Raskolnikov, and his eventual redemption; also the short novel *The Gambler*.

Émile Gaboriau established the form of the modern detective novel, or *roman policier*, with his novel *L'Affaire Lerouge*; his sleuth, Monsieur Lecoq, was based on actual Parisian chief detective François Vidocq.

The Good Gray Poet, William D. O'Connor's defense of Walt Whitman, dismissed from his government post because his superiors regarded *Leaves of Grass*, which had become popular, as an immoral book.

Matthew Arnold's poem *Thyrsis*, written in memory of a friend, Arthur Hugh Clough.

Felix Holt, the Radical, George Eliot's novel.

Battle-Pieces and Aspects of the War, Herman Melville's verses.

Paul Verlaine's *Poèmes saturniens*.

Snow-Bound, A Winter Idyll, John Greenleaf Whittier's long poem.

Aleksey Tolstoy's poem *Death of Ivan the Terrible* (1866–1870).

Toilers of the Sea (*Les Travailleurs de la mer*), Victor Hugo's novel.

Charles Baudelaire's poem *Les Epaves*.

Algernon Charles Swinburne's *Poems and Ballads: First Series*.

Christina Rossetti's *The Prince's Progress and Other Poems*.

George Arnold's *Drift: A Sea-Shore Idyll and Other Poems*.

John Henry Newman's poem *A Dream of Gerontius*.

John Ruskin's lecture *The Crown of Wild Olive*.

The *New York World* began publication.

d. Carl Jonas Love Almquist, Swedish writer (b. 1793).

d. Thomas Love Peacock, English novelist and poet (b. 1785).

d. François-Xavier Garneau, Quebec historian and poet (b. 1809).

d. John Pierpont, American poet (b. 1785).

d. Maria Susanna Cummins, American author (b. 1827).

VISUAL ARTS

Metropolitan Museum of Art, New York, was founded.

Claude Monet's paintings included *Camille* (*The*

Green Dress), *Garden of the Princess, Paris*, *The Terrace at Sainte-Adresse*, and *Women in the Garden* (1866–1867).

James McNeill Whistler's paintings included *Symphony in Grey and Green: The Ocean* (1866–1867) and *Valparaiso: Crepuscule in Flesh Colour and Green*.

Winslow Homer's paintings included *Prisoners from the Front* and *Croquet Scene*.

Gustave Courbet's paintings included *Roe-Deer in Cover by the Plaisir-Fontaine Stream*, *Sleeping Women*, and *The Woman with a Parrot*.

Paul Cézanne's painting *Uncle Dominic as a Monk* (ca. 1866).

Édouard Manet's paintings *Bullfight* and *The Fifer*.

Storm in the Rocky Mountains, Albert Bierstadt's painting.

Pierre-Auguste Renoir's painting *Le Carabet de la mère Anthony*.

Dante Gabriel Rossetti's painting *Monna Vanna*.

Edgar Degas's pastel *Woman Drying Her Foot* (ca. 1866).

Storm King on the Hudson, Samuel Colman's painting.

Gustave Doré's illustrations for the Bible.

Storm King on the Hudson, Samuel Colman's painting.

Honoré Daumier's *The Painter at His Easel* (ca. 1866).

The Wolf Charmer, John La Farge's painting (1866–1867).

d. Gavarni (Sulpice Guillaume Chevalier), French caricaturist (b. 1804).

d. Henry Kirke Brown, American sculptor (b. 1814).

THEATER & VARIETY

Joseph Jefferson opened in the title role of Dion Boucicault's adaptation of Washington Irving's *Rip Van Winkle*, at New York's Olympic Theatre; Jefferson would be identified with the role for four decades.

Brand, Henrik Ibsen's play.

The Power of Darkness, Leo Nikolayevich Tolstoi's play.

Dion Boucicault's *Hunted Down* and *The Flying Scud*.

François Ponsard's *Le Lion amoureux*.

T. W. Robertson's *Ours*.

MUSIC & DANCE

The Bartered Bride, Bedrich Smetana's highly suc-

cessful second opera (revised 1870), libretto by Karel Sabina, which became virtually the Czech national opera, premiered in Prague.

The Brandenburgers in Bohemia, Bedrich Smetana's first opera.

Mignon, Ambroise Thomas's opera, libretto by Thomas based on Johann Wolfgang von Goethe's 1795 novel *Wilhem Meister*, premiered at the Opéra-Comique, Paris, November 17.

Arthur Sullivan's *Cello Concerto*; "Irish" Symphony; dramatic musical work *Cox and Box*; and overture *In Memoriam*.

Nikolay Rimsky-Korsakov's *Overture on Russian Themes*.

Alexander Sergeievich Dargomïzhsky's opera *The Stone Guest* (1866–1869).

Jacques Offenbach's dramatic musical work *Barbebleue* and operetta *La vie parisienne*.

When You and I Were Young (Maggie), popular song, words by George W. Johnson, music by J. A. Butterfield.

Anton Bruckner's *Mass No. 2 in E Minor*.

Moscow Conservatory founded by the Russian Musical Society.

WORLD EVENTS

Reconstruction period began in the defeated U.S. South.

Sioux and Northern Cheyenne led by Red Cloud were at war with U.S. in Wyoming (1866–1868).

Alfred Nobel invented dynamite.

Irish Fenian revolutionaries raided across U.S.–Canada border.

Prussia and Italy were at war with Austria and several German states.

The *Great Eastern* completed the laying of the first permanent transatlantic cable.

The Marquess of Queensberry codified the rules of boxing.

1867

LITERATURE

Dover Beach, Matthew Arnold's poem, with its haunting call for love and truth in the face of the ebbing of the "sea of faith"; also his *On the Study of Celtic Literature*.

Thérèse Raquin, Émile Zola's controversial natural-istic novel, in which Thérèse and her lover kill her husband.

The Last Chronicle of Barset, last of six novels in Anthony Trollope's Chronicles of Barsetshire (1855–1867); also his *The Claverings* (1867).

Leaves of Grass, the fourth edition of Walt Whitman's collected poetry.

Le Dossier no. 113, Émile Gaboriau's novel featuring his detective, Monsieur Lecoq.

Ivan Turgenev's novel *Smoke*.

Alfred, Lord Tennyson's poem *The Window, or the Song of the Wrens*.

Algernon Charles Swinburne's poetry *A Song of Italy*.

Camilo Castelo Branco's novel *O Judeu*.

William Morris's poetic work *The Life and Death of Jason*.

George Meredith's novel *Vittoria*.

Ralph Waldo Emerson's poems *May-Day, and Other Pieces*.

Alfred de Vigny's *Le Journal d'un poète*.

John Greenleaf Whittier's verse cycle *The Tent on the Beach*.

Nikolay Nekrasov's poem *Hey Ivan!*

Tiger-Lilies, Sidney Lanier's novel.

d. Charles Baudelaire, French poet (b. 1821).

d. Thomas Bulfinch, American teacher and writer (b. 1796).

VISUAL ARTS

Camille Pissarro's paintings included *Jallais Hill, Pontoise*, *Still Life*, and *The Hermitage at Pontoise* (ca. 1867).

Edgar Degas's paintings included *Mlle. Fiocre in the Ballet "La Source*," *Portrait of a Young Woman*, and *Duke and Duchess of Morbilli*.

Édouard Manet's paintings included *The Execution of the Emperor Maximilian of Mexico* and *Mme Édouard Manet au piano* (ca. 1867–1868).

James McNeill Whistler's paintings included *Symphony in White No. 3* and *The Artist in His Studio* (ca. 1867–1868).

August Saint-Gaudens's bust of his father *Bernard Saint-Gaudens*.

John Herschel, Julia Margaret Cameron's portrait photo.

Pierre-Auguste Renoir's paintings included *Diana*, *Lise*, and *Portrait du peintre Bazille*.

Adolf Menzel's painting *Afternoon in the Tuileries*.

d. Jean-Auguste-Dominique Ingres, French painter (b. 1780).

d. Étienne-Pierre-Théodore Rousseau, French painter (b. 1812).

d. Charles Deas, American painter (b. 1818).

THEATER & VARIETY

Henrik Ibsen's *Peer Gynt*.

Caste, T. W. Robertson's play, was produced in London in April.

Under the Gaslight, Augustin Daly's play, opened at the New York Theatre on August 13.

Wilkie Collins and Charles Dickens wrote the play *No Thoroughfare*.

Lotta Crabtree opened in John Brougham's *Little Nell and the Marchioness* in New York.

Achille Torelli's *I mariti*.

Les Idées de Madame Aubray, play by Alexandre Dumas (*fils*).

Aleksis Kivi's *The Betrothal*.

Le Frère aîné, Alphonse Daudet's play.

Eduard von Bauernfeld's *Aus der Gesellschaft*.

d. François Ponsard, French playwright (b. 1814).

d. Ira Frederick Aldridge, African-American actor (b. 1804), working mainly in Britain.

MUSIC & DANCE

Romeo and Juliet, Charles Gounod's opera, libretto by Jules Barbier and Michel Carré, based on Shakespeare's 1594 play, opened at the Théâtre-Lyrique, Paris, April 27.

By the Beautiful Blue Danube, Johann Strauss's waltz.

The Fair Maid of Perth (*La Jolie Fille de Perth*), Georges Bizet's opera, libretto by Jules-Henri Vernoey Saint Georges and Henri Adenis, opened at the Théâtre-Lyrique, Paris, December 26.

Don Carlos, Giuseppe Verdi's opera, libretto by Joseph Méry and Camille du Locle, based on Friedrich Schiller's 1878 play, premiered at the Opéra, Paris, March 11.

Alexander Borodin's *Symphony No. 1* and farcical opera *The Bogatïrs*.

St. John's Night on the Bar Mountain (*Ivanova noch na Lysoy gore*), Modest Mussorgsky's orchestral work.

Anton Bruckner's *Mass No. 3 in F Minor* (1867–1868).

Edvard Grieg's *violin sonata*.

Franz Liszt's oratorio *Christus* and *Requiem* (1867–1868).

Nikolay Rimsky-Korsakov's *Fantasy on Serbian Themes*.

Jacques Offenbach's opera *La Grande-Duchesse de Gérolstein*.

The Maple-leaf for Ever, popular Canadian anthem, was written by Alexander Muir.

John Knowles Paine's *Mass in D*.

d. Fanny Tacchinardi-Persiani, Italian soprano (b. 1812).

d. Giovanni Pacini, Italian composer (b. 1796).

WORLD EVENTS

After U.S. insistence, French forces in Mexico were withdrawn; Emperor Maximilian was executed.

Dominion of Canada founded by the British North America Act.

Nebraska became a state.

U.S. purchased Alaska from Russia.

Karl Marx's *Das Kapital* (volume 1).

1868

LITERATURE

The Ring and the Book, Robert Browning's book-length poem, actually 12 dramatic monologues, in which different characters give their views of a 1698 Italian murder case; the work that finally brought Browning a wide audience (1868–1869).

The Idiot, Fyodor Dostoyevsky's novel of the saintly Prince Myshkin enmeshed in corrupt Russian society (1868–1869).

Little Women, or Meg, Jo, Beth, and Amy, Louisa May Alcott's first best-selling novel; basis for several dramatizations.

Charles Baudelaire's critical essays *Curiosités esthétiques* and *L'Art romantique*.

Earthly Paradise, William Morris's collection of narrative poems (1868–1871).

Mocher Seforim Mendele's *Ha'avot ve'ha-Banim*, his last novel in Hebrew, after which he wrote in Yiddish.

Émile Zola's novel *Madeleine Férat*.

Ivan Turgenev's story *The Story of Lieutenant Ergúnoff*.

Joaquin Miller's poetry *Specimens*.

Passages from the American Note-Books of Nathaniel Hawthorne.

Rebecca Harding Davis's novel *Waiting for the Verdict*.

Alphonse Daudet's novel *Le Petit Chose*.

The Overland Monthly began publication in San Francisco, edited by Bret Harte.

d. Adalbert Stifter, Austrian writer (b. 1805).

VISUAL ARTS

Claude Monet's painting *The River*.

Eadweard Muybridge's Yosemite photos.

Edgar Degas's paintings included *Jacques-James Tissot* and *Les Musiciens à l'orchestre* (1868–1869).

Winslow Homer's painting *The Bridle Path, White Mountains*.

Édouard Manet's paintings included his *Portrait d'Émile Zola* and *The Luncheon*.

James McNeill Whistler's painting *Three Figures Pink and Grey* (ca. 1868).

Gustave Courbet's painting *La Source ou baigneuse à la source*.

Jean-Baptiste-Camille Corot's painting *La Femme à la perle* (ca. 1868–1870).

Pierre-Auguste Renoir's painting *The Painter Sisley and His Wife*.

Honoré Daumier's painting *Don Quixote* (ca. 1868), and his drawing *Clown*.

Thunderstorm over Narragansett Bay, Martin Johnson Heade's painting.

d. Emmanuel Gottlieb Leutze, German-American historical painter (b. 1816).

d. William Sidney Mount, American painter (1807).

THEATER & VARIETY

Alexander Nikolayevich Ostrovsky's *Even a Wise Man Stumbles*.

Flash of Lightning, Augustin Daly's play.

T. W. Robertson's *Play*.

Paolo Ferrari's *Il duello*.

Achille Torelli's *La moglie*.

d. Adah Isaacs Menken, American actress (b. 1835), most remembered for her seminude role in *Mazeppa*.

d. Charles John Kean, English actor–manager (b. 1811).

d. Sophie Schröder, Austrian actress (b. 1781).

MUSIC & DANCE

Die Meistersinger von Nürnberg (*The Mastersinger of Nuremberg*), Richard Wagner's opera, libretto by Wagner, involving the singing shoemaker Hans Sachs (1494–1576), premiered at the Royal Court Theatre, Munich, June 21.

La Périchole, Jacques Offenbach's operetta, libretto by Henri Meilhac and Ludovic Halévy, based on Prosper Merimée's 1829 play *Le Carrosse du Saint-Sacrement*, opened in Paris. Hortense Schneider created the title role.

Tales from the Vienna Woods, Johann Strauss's waltz.

Dalibor, Bedrich Smetana's opera on a heroic nationalist theme, text by Josef Wenzig, opened in Prague, May 16.

Mefistofele, Arrigo Boito's opera, libretto by Boito, based on Johann Wolfgang von Goethe's 1790 play, opened at La Scala, Milan, March 5.

The Flying Trapeze, popular song by George Leybourne and/or Alfred Lee.

Ambroise Thomas's opera *Hamlet*.

Johannes Brahms's *21 Hungarian Dances* for two pianos (1868–1880).

Camille Saint-Saëns's *Piano Concerto No. 2*.

Edvard Grieg's *Piano Concerto*.

Le Premier Jour de bonheur, Daniel-François-Esprit Auber's opera.

Sweet By and By, Sanford Fillmore Bennett's popular song.

Nikolay Rimsky-Korsakov's *Symphony No. 2*, the *Antar*.

Fate, Peter Ilich Tchaikovsky's orchestral work.

Arshak II, Tigran Chukhadjian's historical–heroic stage work.

Brankovics György, Ferenc Erkel's opera (1868–1872).

Georges Bizet's *Variations chromatiques*, for piano.

Chilpéric, Hervé's opera.

Anton Bruckner's *Pange Lingua*, choral work.

Whispering Hope, popular song by Septimus Winner (as Alice Hawthorne).

d. Gioacchino Rossini, Italian composer (b. 1792).

d. Franz Berwald, Swedish composer and violinist (b. 1796).

WORLD EVENTS

Shogunate was abolished in Japan as Meiji dynasty was restored.

Impeachment of U.S. President Andrew Johnson; survived by slim Senate vote.

Ulysses S. Grant was elected U.S. president.

Benjamin Disraeli became British prime minister.

Women's rights periodical *The Revolution* was founded by Elizabeth Cady Stanton and Susan B. Anthony (1868–1870).

1869

LITERATURE

Phineas Finn, second of Anthony Trollope's six Palliser or Parliamentary novels, introducing the young Irish MP with his way to make in British politics (1869).

Lorna Doone, a Romance of Exmoor, R. D. Blackmore's tale of young Lorna, brought up by the outlaw Doones, and John Ridd, whose life she saves, against the backdrop of the 17th-century Duke of Monmouth's rebellion.

The Innocents Abroad; or, The New Pilgrim's Progress, Mark Twain's notes on European travel, based on letters written as correspondent to American newspapers.

Culture and Anarchy, Matthew Arnold's wide-ranging essays, several exploring the importance of literature in spiritual life.

Ivan Turgenev's novel *A Nest of Gentlefolk* and story *An Unfortunate Woman*.

Émile Gaboriau's detective novel *Monsieur Lecoq*.

Alfred, Lord Tennyson's *The Holy Grail and Other Poems*.

Paul Verlaine's poetry *Fêtes galantes*.

Victor Hugo's novel *L'Homme qui rit*.

Charles Baudelaire's *Petits Poèmes en prose*.

Ignacio Manuel Altamirano's fictional work *Clemencia*.

Isaac Joel Linetzky's *The Polish Boy* (*Dos poilische Yingel*).

Among the Hills, John Greenleaf Whittier's poetry.

Lewis Carroll's *Phantasmagoria and Other Poems*.

Mocher Seforim Mendele's novel *Fishke der Krumer*.

d. Alphonse de Lamartine, French poet (b. 1790).

d. Asadullah Khan Ghalib, Urdu and Persian poet (b. 1797).

VISUAL ARTS

Edgar Degas's paintings included *Madame Camus au*

piano, *Mlle Hortense Valpinçon*, *The False Start* (1868–1872), and *The Balcony*.

Paul Cézanne's paintings *Paul Alexis Reading to Zola* (ca. 1869) and *The Black Clock* (1869–1871).

Winslow Homer's painting *Long Branch, New Jersey*.

Pierre-Auguste Renoir's paintings *Barges on the Seine* (ca. 1869) and *La Grenouillère*.

Rocky Coast at Newport, John Frederick Kensett's painting.

Eadweard Muybridge's photos *A Study of Clouds* (ca. 1869).

George Browne Post began the Equitable Building, New York.

George Washington, Thomas Ball's equestrian statue in Boston's Public Gardens.

Jean-Baptiste Carpeaux's sculpture group *La Danse*.

Spirit of the Indian, Thomas Moran's painting.

William Henry Rinehart's sculpture of *Chief Justice Taney*.

THEATER & VARIETY

Henrik Ibsen's play *The League of Youth*.

Folies-Bergère opened in Paris.

Alphonse Daudet's play *Le Sacrifice*.

T. W. Robertson's *School*, another of his works introducing a new realism into the English-speaking theater.

MUSIC & DANCE

Das Rheingold (*The Rhine Gold*), Richard Wagner's opera, libretto by Wagner; the first of the four operas in *Der Ring Des Nibelungen* (*The Ring of the Nibelung*), opened in Munich September 22.

Don Quixote, Marius Petipa's ballet, music by Ludwig Minkus, libretto by Petipa, based on Miguel de Cervantes's 1605 novel, premiered December 26, at the Bolshoi Theatre, Moscow.

Johannes Brahms's *Liebesliederwalzer*, 18 "love song" waltzes for two pianos, with soprano, alto, tenor, and bass soloists; text from G. F. Daumer's 1869 *Polydora*, but often omitted.

Johannes Brahms's *Alto Rhapsody* (*Rhapsody for alto, male chorus, and orchestra*); text from Goethe's poem *Harzreise im Winter*; also Brahms's vocal work *15 Romances from Tieck's "Magelone."*

None But the Lonely Heart, Peter Ilich Tchaikovsky's songs; also his orchestral work *Romeo and Juliet*,

and operas *Undine* and *Voyevoda*.

Sweet Genevieve, popular song, words by George Cooper, music by Henry Tucker.

Camille Saint-Saëns's *Piano Concerto No. 3*.

Shew! Fly, Don't Bother Me, popular song, probably by T. Brigham Bishop.

Une folie à Rome, Federico Ricci's musical comedy.

Le petit Faust, Hervé's opera.

Little Brown Jug, Joseph Eastburn Winner's popular song.

Vienna's Imperial and Royal Opera House, designed by Eduard van der Null and August Siccard, opened with a production of Wolfgang Amadeus Mozart's *Don Giovanni*.

d. Hector Berlioz, French composer (b. 1803).

d. Alexander Dargomïzhsky, Russian composer (b. 1813).

WORLD EVENTS

Fifteenth Amendment to the U.S. Constitution established universal male suffrage, but excluded women.

John Stuart Mill's *The Subjection of Women*, a call for complete legal, economic, and social equality.

Louis Riel led the Canadian Red River Rebellion.

Ferdinand de Lesseps completed the Suez Canal.

Uriah Stephens founded the Knights of Labor.

Women won the right to vote and hold office in Wyoming.

Girton College, Cambridge, was founded.

Women's Christian Temperance Union founded.

1870

LITERATURE

Jules Verne published his remarkably prescient novel, *Twenty Thousand Leagues under the Sea*, presaging development of submarines in an underwater tale dominated by the powerful Captain Nemo; another novel, *The Mysterious Island*, appeared the same year.

Bret Harte published *The Luck of Roaring Camp and Other Stories*, the title story focusing on heart-of-gold figures in a tough gold-mining camp.

The Mystery of Edwin Drood, Charles Dickens's unfinished last novel, which has tempted many to hazard endings.

The Eternal Husband, Fyodor Dostoyevsky's short novel focusing on the relationship between a husband and his wife's lover.

Internationale, the poem that set to music would later become a communist anthem, was written by Parisian Eugène Pottier (ca. 1871).

Joaquin Miller self-published *Pacific Poems*, bringing him fame as a "frontier poet."

First novel in Finnish, *Seitsemän veljestä*, by playwright and novelist Aleksis Kivi.

Dante Gabriel Rossetti's *Poems*, for a time buried in the coffin of his late wife, Elizabeth Siddal.

Ralph Waldo Emerson's essay *Society and Solitude*.

An Old-Fashioned Girl, Louisa May Alcott's novel.

Paul Verlaine's poem *La Bonne Chanson*.

Brewer's Dictionary of Phrase and Fable first published.

Dante Gabriel Rossetti's *Poems*, including *Sister Helen*.

Thomas Bailey Aldrich's novel *The Story of a Bad Boy*.

Gustave Flaubert's novel *Sentimental Education* (*L'Education sentimentale: Histoire d'un jeune homme*).

Ignacio Manuel Altamirano's novella *La navidad en las montañas*.

James Russell Lowell's critical work *Among My Books*.

Joachim María Machado de Assis's poetry *Phalenas*.

Matthew Arnold's *St. Paul and Protestantism*.

Passages from the English Note-Books of Nathaniel Hawthorne.

Charles Scribner began *Scribner's Monthly*.

d. Charles Dickens, English novelist (b. 1812).

d. Alexandre Dumas (*père*), French novelist and playwright (b. 1802), father of Alexandre Dumas (*fils*).

d. Prosper Mérimée, French novelist (b. 1803).

d. Gustavo Adolfo Bécquer, Spanish poet (b. 1836).

d. John Pendleton Kennedy, American writer (b. 1795).

VISUAL ARTS

Boston Museum of Fine Arts was founded.

Camille Pissarro's paintings *Louveciennes, the Road to Versailles* and *Lower Norwood, London, Snow*.

Paul Cézanne's painting *The Man with a Straw Hat* (*Portrait of Boyer*) (1870–1871).

Gustave Courbet's paintings *The Cliffs at Étretat* and *Mer orageuse* (*La Vague*).

Claude Monet's painting *The Beach at Trouville*.

Thomas Eakins's painting *A Street Scene in Seville*.

Pierre-Auguste Renoir's painting *Odalisque*.

Winslow Homer's painting *High Tide*.

Edgar Degas's painting *Carriage at the Races* (1870–1873).

John Millais's painting *Chill October*.

Édouard Manet's painting *La Brioche*.

Jean François Millet's painting *The Death of the Pig*.

John Millais's painting *Chill October*.

William Butterfield began Keble College, Oxford.

John Ruskin became the first Slade Professor of Fine Arts at Oxford (1870–1879; 1883–1884).

d. Daniel Maclise, Irish painter (b. 1806).

THEATER & VARIETY

Alexander Nikolayevich Ostrovsky's *Easy Money*.

James Albery's comedy *Two Roses* opened at London's Vaudeville Theatre.

Saratoga, Bronson Howard's comedy, opened at New York's Fifth Avenue Theatre on December 21.

Gerolamo Rovetta's *In Dreams*.

Henry François Becque's *Michel Pauper*.

Ludwig Anzengruber's *Der Pfarrer von Kirchfeld*.

Pietro Cossa's *Pushkin*.

William Gilbert's *The Palace of Truth*.

d. Henrik Hertz, Danish poet and playwright (b. 1798).

d. Jules Léotard, French acrobat (d. 1830), who invented the flying trapeze.

MUSIC & DANCE

Die Walküre, Richard Wagner's opera, libretto by Wagner; the second of the four operas in *Der Ring Des Nibelungen* (*The Ring of the Nibelung*), opened in Munich June 26.

Richard Wagner's *Siegfried Idyll*.

Coppelia, Arthur Saint-Léon's ballet; music by Léo Delibes, libretto by Saint-Léon and Charles Nuitter, premiered May 25 at the Opéra, Paris.

Musical Million began publication (1870–1914), focusing on shape singing—singing music written in distinctively shaped symbols, without knowing how to read music—common in rural America.

Arthur Sullivan's *Overture di ballo*.

Carlos Gomes's opera *Il Guarany*.

RETA E. KING LIBRARY
CHADRON STATE COLLEGE
CHADRON 69337

Modest Mussorgsky's song cycle *The Nursery*.

Dresden Philharmonic Orchestra founded (ca. 1870).

Autoharp or *Akkordzither*, a kind of zither, invented in Germany (ca. 1870s).

d. Michael William Balfe, Irish composer and singer (b. 1800).

d. William Henry Hill, British builder of organs (b. 1789), many exported.

WORLD EVENTS

Franco-Prussian War: German armies pushed French frontier forces back, and ultimately trapped and defeated the French at Sedan, Napoleon III then surrendering his entire army. France did not surrender, forming Third Republic. Germans then besieged and took Paris, which fell in January, effectively ending the war (1870–1871).

Failed Fenian attack from U.S. on Quebec.

Heinrich Schliemann began his excavations at Troy.

1871

LITERATURE

The Possessed (also translated as *The Devils and the Demons*), Fyodor Dostoyevsky's novel of the nihilistic aristocrat Nikolay Stavrogin against the backdrop of Russia's revolutionary movement (1871–1872).

Middlemarch: A Study of Provincial Life, George Eliot's novel of shattered ideals, focusing on heroine Dorothea Brooke, her brief marriage to the scholar Reverend Casaubon, and her attempt to live with the restrictions placed upon her at his death (1871–1872).

Émile Zola's novel *La Fortune des Rougons*, first of his series *Les Rougon-Macquart*, 20 naturalistic novels centered on the affairs of the Rougon-Bacquart family under France's Second Empire, ultimately including some of his best-known works (1871–1893).

Walt Whitman's poem *Passage to India*, celebrating the linking of the world, as by the Suez Canal and the Atlantic cable; also *Democratic Vistas*, his pamphlet on democracy and individualism.

Desperate Remedies, Thomas Hardy's first published novel, after several rejections, released anonymously.

Joaquin Miller's self-published *Songs of the Sierras*.

Algernon Charles Swinburne's *Songs before Sunrise*.

Le Bateau ivre (*The Drunken Boat*), Arthur Rimbaud's poem.

John Burroughs's essay *Wake Robin*.

Little Men, Louisa May Alcott's novel.

George Meredith's novel *The Adventures of Harry Richmond*.

Henrik Ibsen's poetry *Digte*.

John Greenleaf Whittier's *Miriam and Other Poems*.

Mark Twain's (Burlesque) Autobiography.

Robert Browning's poems *Balaustion's Adventure* and *Prince Hohenstiel-Schwangau, Saviour of Society*.

William Ellery Channing's poetry *The Wanderer*.

Matthew Arnold's prose work *Friendship's Garland*.

Emma Lazarus's *Admetus and Other Poems*.

Passages from the French and Italian Note-Books of Nathaniel Hawthorne.

d. Alexandr Nikolayevich Afanasyev, Russian folklorist (b. 1823).

d. Alice Cary, American author (b. 1820).

d. Philippe Aubert de Gaspé, Canadian novelist (b. 1786).

VISUAL ARTS

Whistler's Mother: James McNeill Whistler's painting, *Arrangement in Grey and Black, No. 1: The Artist's Mother* (1871–1872).

Claude Monet's paintings included *Hyde Park, London* and *The Thames and the Houses of Parliament*.

Thomas Eakins's paintings *Home Scene* and *Max Schmitt in a Single Scull*.

Winslow Homer's painting *The Country School*.

Dante Gabriel Rossetti's paintings included *Dante's Dream* and *The Blessed Damozel* (1871–1879).

The Hatch Family, Eastman Johnson's painting.

Pierre-Auguste Renoir's painting *Captain Darras*.

Dying Centaur and *Fighting Lions*, William Rimmer's sculptures.

Camille Pissarro's painting *Crystal Palace, London*.

The Old Professor, Frank Duveneck's painting.

THEATER & VARIETY

Uemara Bunrakuken founded Osaka's Bunraken puppet theater, for which the entire Japanese puppet theater was later renamed the Bunraken theater.

Henry Irving opened on November 25 in London in *The Polish Jew* (*The Bells*).

August Strindberg's *The Outlaw*.

William Gilbert's plays *Pygmalion and Galatea* and *Thespis; or, the Gods Grown Old*.

Kit, the Arkansas Traveller, T. B. De Walden and Edward Spencer's play, opened in New York.

Augustin Daly's plays *Horizon* and *Divorce*.

Phineas T. Barnum and James A. Bailey founded their circus.

Wilkie Collins's *The Woman in White*.

Alexander Nikolayevich Ostrovsky's *The Forest*.

Ludwig Anzengruber's *Der Meineidbauer*.

d. T. W. Robertson, English playwright (b. 1829).

d. James Henry Hackett, American actor (b. 1800).

MUSIC & DANCE

Aïda, Giuseppe Verdi's opera, commissioned to celebrate the opening of the Suez Canal; libretto by Antonio Ghislanzone, premiered in Cairo December 24.

Lifeguards of Amager, August Bournonville's ballet, music by Wilhelm Holm, first danced February 19 by the Royal Danish Ballet, in Copenhagen.

Onward Christian Soldiers (*St. Gertrude*), popular hymn with words by Sabine Baring, music by Arthur Sullivan.

Georges Bizet's orchestral work *Petite suite* and piano duet *Jeux d'enfants*.

Song of Destiny, Johannes Brahms's song cycle.

Trois Offertoires, César Franck's choral work.

Anton Bruckner's *Symphony No. 2* (1871–1872).

d. Filippo Taglioni, Italian dancer and choreographer (b. 1777); father of Marie and Paul Taglioni, all key figures in the development of modern ballet.

d. Daniel-François-Esprit Auber, French composer (b. 1782).

WORLD EVENTS

Paris Commune was besieged and fell to the forces of the Third Republic.

Germany took Alsace-Lorraine from France under the Treaty of Frankfurt, ending the Franco-Prussian war.

Anti-Chinese riots in Los Angeles.

Britain took the Kimberley diamond fields in South Africa.

British Columbia became a Canadian province.

Great Chicago Fire destroyed much of the city.

1872

LITERATURE

Through the Looking-Glass and What Alice Found There, Lewis Carroll's sequel to *Alice's Adventures in Wonderland*, on the reversed world Alice encounters on the far side of the mirror; it included the popular poem *Jabberwocky*.

Erewhon, Samuel Butler's utopian novel satirizing English life, institutions, and attitudes; the title is an anagram for "Nowhere."

Roughing It, Mark Twain's spirited, tall-tale travel narrative, based loosely on his journey from St. Louis to San Francisco and the South Pacific in the 1860s.

Aventures prodigieuses de Tartarin de Tarascon, Alphonse Daudet's novel, centering on the comic country character, Tartarin; part of his Provençal series.

Thomas Hardy's novel *Under the Greenwood Tree*, published anonymously.

Septimus Felton, Nathaniel Hawthorne's unfinished novel, published.

Émile Zola's novel *La Curée*.

Victor Hugo's *L'Année terrible*.

Christina Rossetti's *Sing-Song: A Nursery Rhyme Book* (enlarged 1893).

Alfred, Lord Tennyson's poems *Gareth and Lynette* and *The Last Tournament*.

Ivan Turgenev's story *Spring Floods*.

Robert Browning's poem *Fifine at the Fair*.

Walt Whitman's poem *The Mystic Trumpeter*.

William Dean Howells's first novel, *Their Wedding Journey*.

VISUAL ARTS

Edgar Degas's paintings *Mme René de Gas* (1872–1873) and *The Dancing Class*.

James McNeill Whistler's painting *Old Battersea Bridge: Nocturne—Blue and Gold* (ca. 1872–1875).

Jean-Baptiste-Camille Corot's painting *Mademoiselle de Foudras*.

Snap the Whip, Winslow Homer's painting.

On the Balcony, Mary Cassatt's painting.

Paul Cézanne's painting *The Suicide's House* (1872–1873).

Thomas Eakins's paintings *Katherine* and *The Pair-Oared Shell*.

Pierre-Auguste Renoir's painting *The Breakfast*.

Claude Monet's paintings *Impression: Fog* and *Impression: Sunrise*.

Jungle Orchids and Hummingbirds, Martin Johnson Heade's painting.

Ships of the Plains, Samuel Colman's painting.

Dante Gabriel Rossetti's painting *The Bower Meadow*.

d. John Frederick Kensett, American painter (b. 1816).

d. Samuel Finley Breese Morse, American painter (b. 1791), who also invented the telegraph.

d. Robert S. Duncanson, American painter (b. 1821).

THEATER & VARIETY

Ivan Turgenev's *A Month in the Country*, written in 1850, was finally produced.

Girish Chandra Ghosh founded the Bengali National Theatre.

Alphonse Daudet's plays *L'Arlésienne* and *Lise Tavernier*.

Dion Boucicault's *Mimi*.

Giacinto Gallina's *Family Quarrels*.

Ludwig Anzengruber's *Der Kreuzlschreiber*.

Pietro Cossa's *Nerone*.

The Midnight Revel, Henri Meilhac's play.

d. Aleksis Kivi (Aleksis Stenvall), Finnish playwright and novelist (b. 1834).

d. Edwin Forrest, American tragedian (b. 1806).

d. Franz Grillparzer, Austrian playwright (b. 1791).

d. Johannes Carsten Hauch, Danish playwright, poet, and novelist (b. 1790).

MUSIC & DANCE

Má vlást (*My Fatherland*), Bedřich Smetana's cycle of six symphonic poems celebrating his country (ca. 1872–1875).

Bedřich Smetana's nationalistic opera *Libuse* written; not publicly performed until 1881.

Georges Bizet's opera *Djamileh*; also his incidental music *L'Arlésienne* for Alphonse Daudet's play, parts of which were later used in *Carmen*.

La Camargo, Marius Petipa's ballet in honor of dancer Marie Camargo (1710–1770).

Peter Ilich Tchaikovsky's *Symphony No. 2*, the *Little Russian*.

Antonín Dvořák's choral work *The Heirs of the White Mountain*.

Panis Angelicus, César Franck's choral work.

Davorin Jenko composed the music for the *Serbian Hymn* (*Srpska Himna*), words by J. Djordjewic.

St. Peter, John Knowles Paine's oratorio.

System of pedals for tympani developed by Pittrich of Dresden.

d. Stanislaw Moniuszko, Polish composer (b. 1819).

WORLD EVENTS

Ulysses S. Grant was reelected U.S. president.

Montana's Yellowstone National Park was established; the world's first national park.

Brooklyn Bridge opened.

Carlist forces were defeated in the Spanish Civil War.

Philippine insurrection against Spanish rule failed.

1873

LITERATURE

Anna Karenina, Leo Tolstoy's second major novel, centering on Anna's love for Aleksei Vronski and her eventual suicide (1873–1877).

Around the World in Eighty Days, Jules Verne's novel following Phileas Fogg and his valet, Passepartout, on their global journey to win a bet.

The Eustace Diamonds, third of Anthony Trollope's six Palliser or Parliamentary novels, introducing the spirited but unwise Lady Lizzie Eustace.

Un Saison en enfer (*A Season in Hell*), Arthur Rimbaud's spiritual or psychological autobiography written in the form of a prose poem.

The Gilded Age, a tale of financial speculation, written by Mark Twain with Charles Dudley Warner.

Ambrose Bierce's essay collections *Nuggets and Dust Panned Out in California* and *The Fiend's Delight*.

A Pair of Blue Eyes, Thomas Hardy's first successful novel.

Anatole France's *Poèmes dorés*.

Émile Zola's novel *Le Ventre de Paris*.

Louisa May Alcott's novel *Work*.

A Chance Acquaintance, William Dean Howells's novel.

Benito Pérez Galdós's novel *Trafalgar*.

Alphonse Daudet's *Contes de lundi* (*Monday Tales*).

Die Klatsche (*The Mare*), Mocher Seforim Mendele's novel written in Yiddish.

Matthew Arnold's *Literature and Dogma*.

Walter Pater's *Studies in the History of the Renais-sance*.

First degree in English literature offered at Oxford University.

Thoreau, the Poet-Naturalist, William Ellery Channing's biography.

d. Alessandro Manzoni, Italian novelist (b. 1785).

d. Edward George Earle Lytton Bulwer-Lytton, English novelist and dramatist (b. 1803).

d. J. S. (Joseph Sheridan) Le Fanu, Irish novelist and short-story writer (b. 1814).

d. Émile Gaboriau, French detective novelist (b. 1832).

VISUAL ARTS

Edgar Degas's paintings included *Foyer de Danse* (ca. 1873), *New Orleans Cotton Office*, and *Sulking* (ca. 1873–1875).

Claude Monet's painting *Wild Poppies*.

Pierre-Auguste Renoir's paintings *Monet Painting in His Garden* and *Horsewoman in the Bois de Boulogne*.

Gare Saint-Lazare, Édouard Manet's painting.

James McNeill Whistler's paintings included *Miss Cicely Alexander: Harmony in Grey and Green* and *Arrangement in Grey and Black, No. 2: Thomas Carlyle*.

Richard Morris Hunt began the Tribune Building, New York City.

The Monk, George Inness's painting.

Thomas Eakins's paintings included *John Biglin in a Single Scull* and *The Biglin Brothers Turning the Stake*.

d. Edwin Landseer, English painter (b. 1802).

d. Hiram Powers, American sculptor (b. 1805).

THEATER & VARIETY

Émile Zola's *Thérèse Raquin*, adapted by Zola from his own 1867 novel, opened in Paris on July 11.

Henrik Ibsen's play *Emperor and Galilean*; also his play *The Comedy of Love* was presented in Christiania.

Led Astray, Dion Boucicault's play, opened at New York's Union Square Theatre on December 6.

Alexander Nikolayevich Ostrovsky's *The Snow Maiden*.

L'Étrangère, play by Alexandre Dumas (*fils*).

Pietro Cossa's *Plauto e il suo secolo*.

d. Laura Keene, English actress and (in America) theater manager (b. ca. 1820). She was playing the lead in *Our American Cousin* at Washington's Ford Theatre when Abraham Lincoln was assassinated.

d. William Charles Macready, English actor (b. 1793).

d. Manuel Bretón de los Herredos, Spanish playwright (b. 1796).

d. Edward Fitzball, English playwright (b. 1792).

MUSIC & DANCE

The Maid of Pskov (*Pskovityanka*), Nikolay Rimsky-Korsakov's opera, libretto by Rimsky-Korsakov, based on Lev Mey's 1860 play, first performed January 13 in St. Petersburg.

Johannes Brahms's first two string quartets and his orchestral work *Variations on the St. Antony Chorale*.

Anton Bruckner's *Symphony No. 3*, the *Wagner Symphony*.

Rédemption, César Franck's choral work.

Patrie, Georges Bizet's overture.

Giuseppe Verdi's *String Quartet in E Minor*.

Silver Threads Among the Gold, popular song, words by Eben Eugene Rexford, music by Hart Pease Danks.

WORLD EVENTS

U.S. financial panic triggered by failure of Jay Cooke and Company.

Oil strike in Baku, Russia.

Prince Edward Island became a Canadian province.

Russian forces took Khiva.

Walter Pater's *Studies in the History of the Renaissance*.

Herbert Spencer's *The Study of Sociology*.

1874

LITERATURE

Far from the Madding Crowd, Thomas Hardy's novel focusing on the beautiful Bathsheba Everdene and the three men who love her.

Phineas Redux, fourth of Anthony Trollope's six Palliser or Parliamentary novels, in which impoverished Irish MP Phineas Finn returns to political life.

Alphonse Daudet's novels *Robert Helmont*, *Les Femmes d'artistes* (Artists' Wives), and *Fromont jeune et Risler aîné* (*Fromont the Younger and Risler the Elder*) (all 1874); he also began his collection of literary criticism *Pages inédites de critique dramatique, 1874–1889* (pub. 1923).

Pedro Antonio de Alarcón's story *The Three-Cornered Hat*, inspired by a ballad and basis of the Manuel de Falla ballet.

The City of Dreadful Night, James Thomson's poem about lives of despair in London.

Victor Hugo's novel *Quatrevingt-treize* (*Ninety-Three*).

Ambrose Bierce's essays *Cobwebs from an Empty Skull*.

Paul Verlaine's poems *Romances sans paroles*.

Walt Whitman's poem *Song of the Redwood-Tree*.

Émile Zola's novel *La Conquête de Plassans*.

Govinda Samanta: Bengali Peasant Life, Lal Behari Day's novel, in English.

Gustave Flaubert's novel *La Tentation de St. Antoine* (*The First Temptation of St. Anthony*).

For the Term of his Natural Life, Marcus Clarke's early Australian tale of convict settlements.

Thomas Bailey Aldrich's novel *Prudence Palfrey*.

Nikolay Nekrasov's *Elegiya*.

VISUAL ARTS

First exhibit of Impressionist art, held at the studios of French photographer Nadar, after the French Salon in 1873 had rejected paintings of Claude Monet, Pierre-Auguste Renoir, Camille Pisarro, Paul Cézanne, Alfred Sisley, and others; it would be followed by seven others (1876, 1877, 1879, 1880, 1881, 1882, 1886).

Jean-Baptiste-Camille Corot's paintings included *La Charrette—Souvenir de Saintry* and *La Dame en bleu*.

Paul Cézanne's painting *View of Auvers*.

Édouard Manet's paintings included *Monet Working on His Boat in Argenteuil* and *Boating*.

Pierre-Auguste Renoir's paintings included *The Theatre Box* and *Dancer*.

James McNeill Whistler's painting *Nocturne in Black and Gold: The Falling Rocket* (ca. 1874).

Thomas Eakins's paintings *Pushing for Rail* and *Sailing*.

Alfred Sisley's painting *Effet de neige*.

Camille Pissarro's painting *Quarry Near Pontoise*.

Dante Gabriel Rossetti's painting *Proserpine*.

Gustave Courbet's painting *Portrait de Regis Courbet*.

William M. Evarts, August Saint-Gaudens's portrait sculpture.

d. William Henry Rinehart, American sculptor (b. 1835).

THEATER & VARIETY

Bjørnstjerne Bjørnson's *The Editor*.

The Shaughraun, Dion Boucicault's play, opened in New York; also his *Belle Lamar*.

The Two Orphans, Adolphe D'Ennery's play.

Charlotte "Lotta" Crabtree opened in Frederick Marsden's *Zip* in New York.

London's Criterion Theatre opened.

Gustave Flaubert's play *Le Candidat*.

Pietro Cossa's *Cola di Rienzox*.

MUSIC & DANCE

Die Fledermaus (*The Bat*), Johann Strauss's operetta, libretto by Carl Haffner and Richard Genée, based on Henri Meilhac and Ludovic Halévy's *Le Réveillon* (1872), itself based on Roderich Bendix's 1851 comedy *Das Gefängnis*, premiered at Theater an der Wien, Vienna, April 5.

Boris Godunov, Modest Mussorgsky's opera; libretto by Mussorgsky based on the 1826 Pushkin play *The Comedy of the Distress of the Muscovite State, of Tsar Boris, and of Grishka Otrepiev*; full opera premiered in St. Petersburg February 8. Nikolay Rimsky-Korsakov revised it after Mussorgsky's death (1896).

The Two Widows, Bedřich Smetana's opera, libretto by Emmanuel Züngel, opened in Prague.

Vltava, Bedřich Smetana's symphonic poem celebrating the river running through Prague, part of his *Má vlast*.

Peter Ilich Tchaikovsky's *Piano Concerto No. 1* (1874–1875) and his opera *Oprichnik*.

Danse macabre, Camille Saint-Saëns's symphonic poem, after a poem by Henri Cazalis; Franz Liszt transcribed it for piano (1877).

Modest Mussorgsky's *Pictures from an Exhibition* and song cycle *Sunless*.

Antonín Dvořák's *Rhapsody*, and his opera *King and Collier* (*Král a uhlíř*).

Jacques Offenbach's 1858 *Orpheus in the Underworld*, expanded into a four-act opera, premiered in Paris.

Anton Bruckner's *Symphony No. 4*, the *Romantic*.

Nikolay Rimsky-Korsakov's *Symphony No. 3*.

Franz Liszt's *Die heilige Cäcilia* (ca. 1874).

Iceland's anthem *O Gud vors land* was written by Sven Sveinbjørnsson, to Mathias Jochumsen's poem.

Sostenuto pedal for the piano was perfected by Steinway.

WORLD EVENTS

Red River War: Comanches, Southern Cheyennes, and Kiowas were at war with the U.S. in Kansas, Texas, and New Mexico (1874–1875).

France took Annam, holding it as a protectorate.

Britain took the Fiji Islands.

U.S. Greenback party founded.

1875

LITERATURE

The Way We Live Now, Anthony Trollope's satirical novel centering on speculative financier Augustus Melmotte and his role in contemporary society.

The Wreck of the Deutschland, Gerard Manley Hopkins's first great poem, on the death of five nuns drowned en route to the United States, seeking refuge from religious persecution in Germany.

A Passionate Pilgrim and Other Tales, the first published collection of Henry James's stories, focusing on the experiences of Americans in Europe; also his *Transatlantic Sketches*.

Alphonse Daudet's novel *The New Don Quixote or the Wonderful Adventures of Tarascon*; part of his Provençal series.

Oliver Wendell Holmes's *Songs of Many Seasons*.

William Dean Howells's novel *A Foregone Conclusion*.

Pedro Antonio de Alarcón's novel *El escándalo*.

Émile Zola's novel *La Faute de l'abbé Mouret*.

A Raw Youth, Fyodor Dostoyevsky's novel.

Robert Browning's poems *Aristophanes's Apology* and *The Inn Album*.

George Meredith's novel *Beauchamp's Career*.

John Greenleaf Whittier's poems *Hazel-Blossoms*.

Louisa May Alcott's novel *Eight Cousins*.

Camilo Castelo Branco's novel *Novelas dó Minho* (1875–1876).

Mark Twain's Sketches, New and Old.

Walt Whitman's autobiographical narrative *Memoranda During the War*.

J. G. A. Eickhoff developed the four-cylinder printing press, allowing simultaneous printing on both sides of the paper.

Danish philologist Karl Verner posited Verner's Law, describing changes in certain consonants in the Germanic languages, such as "s" becoming "z."

Die Eerste Afrikaanse Taalbewerging (First Afrikaans Language Movement) established, the first recorded use of "Afrikaans" (mid-1870s).

VISUAL ARTS

Claude Monet's painting *The Railroad Bridge at Argenteuil*.

The Gross Clinic, Thomas Eakins's painting.

Daniel Chester French's sculpture, *The Minute Man*, was unveiled at Concord's Old North Bridge by Ralph Waldo Emerson.

Edgar Degas's paintings *Place de la Concorde* (*Vicomte Lepic and His Daughters*) (ca. 1875) and *Women Combing Their Hair* (1875–1876).

Pierre-Auguste Renoir's paintings include *La Première Sortie* (1875–1876) and *Mme Chocquet*.

Édouard Manet's painting *The Laundress*.

Autumn Oaks, George Inness's painting.

James McNeill Whistler's painting *Cremorne Gardens, No. 2* (ca. 1875).

Paul Gauguin's painting *La Seine au Pont d'Iéna*.

Adolf Menzel's painting *The Steel Mill*.

A Brittany Interior, Julian Alden Weir.

Camille Pissarro's painting *The Little Bridge*.

Art Students League founded in New York City.

d. Jean-Baptiste-Camille Corot, French painter (b. 1796).

d. Jean François Millet, French painter (b. 1814).

d. Jean-Baptiste Carpeaux, French sculptor and painter (b. 1827).

THEATER & VARIETY

Trial by Jury, William Gilbert and Arthur Sullivan's musical play, the first Gilbert-and-Sullivan success, was presented in London on March 3.

Alexander Nikolayevich Ostrovsky's *Wolves and Sheep*.

Alfred, Lord Tennyson's play *Queen Mary*.

The Big Bonanza, Augustin Daly's comedy, opened at New York's Fifth Avenue Theatre on February 17.

The Mighty Dollar, Benjamin E. Woolf's play.

Bjørnstjerne Bjørnson's *The Bankrupt*.

Henry James Byron's *Our Boys*.

Paolo Ferrari's *Il suicido*.

d. John Davis, British-American actor, manager, and playwright (b. 1822), who during the Civil War devoted himself to the Southern cause, operating the New Orleans Confederate Theatre and writing pro-Rebellion theater pieces.

MUSIC & DANCE

Carmen, Georges Bizet's opera, libretto by Henri Meilhac and Ludovic Halévy based on the 1845 Prosper Mérimée novel, premiered at the Opéra-Comique, Paris, March 3.

Peer Gynt, Edvard Grieg's incidental music for Henrik Ibsen's 1867 play, arranged into two orchestral suites.

Antonín Dvořák's *Symphony No. 5*.

Bedřich Smetana's symphonic poem *From Bohemia's Woods and Fields*, part of his *Má vlást*; also his orchestral work *Sarka*.

Peter Ilich Tchaikovsky's *Symphony No. 3* and his song *Why Did I Dream of You?*

Johannes Brahms's third and last piano quartet.

The new Paris Opéra theater, designed by Charles Garnier, opened on January 5.

Camille Saint-Saëns's *Piano Concerto No. 4*.

La Petite Mariée, Charles Lecocq's opera.

Nikolay Rimsky-Korsakov's *String Quartet*.

Anton Bruckner's *Symphony No. 5* (1875–1876).

John Knowles Paine's *First Symphony*.

Hawaiian musicians developed a distinctive method of playing guitar, using a comb or other movable bridge to produce a sliding sound (late 19th c.).

Ukelele developed in Hawaiian Islands, from a small Portuguese guitar, the *cavaquinho* (late 19th c.).

d. Georges Bizet, French composer (b. 1838).

WORLD EVENTS

Egyptian–Abyssinian War: Abyssinia defeated two Egyptian invasion forces (1875–1879).

Failed risings against Turkish rule in Bosnia and Herzegovina.

Mary Baker Eddy published *Science and Health*, the cornerstone, with the Bible, of the new Christian Science faith.

1876

LITERATURE

The Adventures of Tom Sawyer, Mark Twain's enormously popular novel introducing young Tom, his Aunt Polly, and his friends Huckleberry Finn and Becky Thatcher.

Daniel Deronda, George Eliot's final novel, her eponymous hero being a Jew raised in England as a Christian, who becomes inspired by Jewish nationalism and goes to Palestine.

The Prime Minister, fifth in Anthony Trollope's six Palliser or Parliamentary novels, in which Plantagenet Palliser becomes an initially unwilling prime minister, with the Lady Glencora at his side.

Henry James's first novel, *Roderick Hudson*, about a young expatriate American's artistic failure.

Prélude à l'Après-midi d'un faune, Stéphane Mallarmé's poem, basis of Claude Debussy's 1894 orchestral work and Vaslav Nijinsky's 1912 ballet.

Fyodor Dostoyevsky's *Diary of a Writer*, part 1, including essays and stories such as *A Gentle Spirit* (new editions: 1877, 1880–1881).

Louisa May Alcott's novel *Rose in Bloom*; also her prose work *Silver Pitchers and Independence*.

The Dolliver Romance, and Other Pieces, Nathaniel Hawthorne's unfinished novel published.

Walt Whitman's *Two Rivulets*, a volume of prose and poetry, new and old.

Lewis Carroll's poem *The Hunting of the Snark*.

Thomas Hardy's novel *The Hand of Ethelberta*.

Émile Zola's novel *Son Excellence Eugène Rougon*.

Benito Pérez Galdóss's novel *Doña Perfecta*.

Herman Melville's *Clarel: A Poem and Pilgrimage in the Holy Land*.

Ralph Waldo Emerson's *Letters and Social Aims*.

Robert Browning's *Pacchiarotto and How He Worked in Distemper*.

William Morris's poem *Sigurd the Volsung*.

d. George Sand (Amandine Lucile Aurore Dupin, Baronne Dudevant), French writer (b. 1804).

d. Harriet Martineau, English author (b. 1892).

VISUAL ARTS

The Age of Bronze, Auguste Rodin's sculpture.

Winslow Homer's painting *Breezing Up*.

Claude Monet's painting *La Japonaise*.

Pierre-Auguste Renoir's painting *La Moulin de la galette*.

Edgar Degas's painting *L'Absinthe*.

Thomas Eakins's paintings *Chess Players* and *Will Schuster and Blackman Going Shooting*.

Gustave Eiffel began the Eiffel Tower (1876–1877), 944-foot-high tower built for the 1889 Paris Exhibition.

Emancipation Group; or, Lincoln Freeing the Slaves, Thomas Ball's sculpture in Lincoln Park, Washington, D.C.

Turkish Page, William Merritt Chase's painting.

Etienne Cariat's portrait photo of *Victor Hugo*.

James McNeill Whistler decorated *The Peacock Room* (1876–1877).

The Old Red Mill, Jasper Cropsey's painting.

Paul Cézanne's painting *Portrait of Chocquet* (1876–1877).

William Burges began the Cathedral of St. Finbar, Cork, Ireland.

d. Narcisse-Virgile Diaz de la Peña, French painter (b. 1807).

THEATER & VARIETY

Harold, play by Alfred, Lord Tennyson.

Émile Augier's *Mme. Caverlet*.

Ludwig Anzengruber's *Der Doppelselbstmord*.

Pietro Cossa's *Messalina*.

d. George L. Aiken, American actor and playwright (b. 1830), author of the play *Uncle Tom's Cabin* (1852), his stage adaptation of the classic Harriet Beecher Stowe antislavery novel.

d. Aleksander Fredro, Polish poet and playwright (b. 1793).

d. Charlotte Saunders Cushman, American actress (b. 1816).

d. Frédérick, French actor (b. 1800).

MUSIC & DANCE

Bayreuth Festival founded by Richard Wagner with the first complete performance of his opera tetralogy from his own librettos, *Der Ring Des Nibelungen* (*The Ring of the Nibelung*); *Das Rheingold* (*The Rhine Gold*) (1869); *Die Walküre* (1870); and *Siegfried* and *Götterdämmerung* (*The Twilight of the Gods*), the third and fourth operas premiering on August 16 and 17.

Bedřich Smetana's *String Quartet No. 1, From My Life*, the high tone of the last movement being the sound of his own approaching deafness; also his opera *The Kiss*, libretto by Eliska Krasnohorska.

La Gioconda (*The Ballad Singer*), Amilcare Ponchielli's opera, libretto by Arrigo Boito, opened at La Scala, Milan, April 8.

Francesca da Rimini, Peter Ilich Tchaikovsky's symphonic fantasia; also his opera *Vakula the Smith* and *Variations on a Rococo Theme*, for cello and orchestra.

Sylvia, Louis Mérante's ballet, music by Léo Delibes.

Antonín Dvořák's songs *Moravian Duets* (*Moravské dvojzpevy*) and choral work *Stabat Mater* (1876–1877).

Johannes Brahms's *Symphony No. 1* (ca. 1876).

Nikolay Rimsky-Korsakov's *Quintet for Piano and Winds* and *String Sextet*.

I'll Take You Home Again, Kathleen, Thomas P. Westendorf's poignant song.

Alexander Borodin's *Symphony No. 2*.

Les Éolides, César Franck's symphonic poem.

Grand-father's Clock, Henry Clay Work's song.

WORLD EVENTS

Custer's Last Stand: Sioux and Northern Cheyenne cavalry led by Crazy Horse destroyed the U.S. Seventh Cavalry, led by George Armstrong Custer, at the Little Big Horn, Montana.

Porforio Díaz took power in Mexico, ruling until his overthrow in the Mexican Revolution of 1911.

Alexander Graham Bell invented the telephone.

Colorado became a state.

Felix Adler founded the Society for Ethical Culture.

1877

LITERATURE

The American, Henry James's novel of wealthy American Christopher Newman, who seeks unsuccessfully to marry a member of an aristocratic French family.

Harriet Martineau's *Autobiography*, the story of her life as a leading women's rights advocate, journalist, and author; published posthumously (d. 1876).

L'Assommoir (*The Dram Shop*), Émile Zola's novel on the deleterious effects of alcohol on working-class people; part of his *Les Rougon-Macquart* series (1871–1893).

Black Beauty, The Autobiography of a Horse, Anna Sewell's popular novel.

Le Nabab (*The Nabob*), Alphonse Daudet's novel of Parisian manners.

Anthony Trollope's novel *The American Senator*.

The Dream of a Ridiculous Man, Fyodor Dostoyevsky's story.

Gustave Flaubert's stories *Hérodias, La Légende de St. Julien l'Hospitalier, Trois Contes* (*Three Tales*), and *Un Coeur simple*.

Coventry Patmore's poems *The Unknown Eros*.

Frances Hodgson Burnett's novel *That Lass o'Lowrie's*.

Ivan Turgenev's novel *Virgin Soil*.

Sidney Lanier's *Poems*.

Thomas Bailey Aldrich's novel *The Queen of Sheba*; also his poems *Flower and Thorn*.

Victor Hugo's poems *L'Art d'être grand-père* and *La Légende des siècles*, second of three series.

John Burroughs's essay *Birds and Poets*.

Robert Browning's translation of *The Agamemnon of Aeschylus*.

d. Nikolay Alekseyevich Nekrasov, Russian poet (b. 1821).

d. Caroline Elizabeth Sarah Norton, English writer (b. 1808).

d. José Martiniano de Alencar, Brazilian novelist (b. 1829).

d. Toru Dutt, Indian poet writing in English (b. 1859).

VISUAL ARTS

Camille Pissarro's paintings included *Orchard with Flowering Fruit Trees, Springtime, Pontoise* and *The Red Roofs, View of a Village in Winter*.

Thomas Eakins's painting *William Rush Carving His Allegorial Figure of the Schuylkill River*.

Claude Monet's painting *Gare Saint-Lazare, Paris*.

Paul Cézanne's painting *Chocquet Seated* (ca. 1877).

Edgar Degas's painting *The Rehearsal*.

Gloucester Harbor, William Morris Hunt's painting.

Édouard Manet's paintings included *Nana, Skating*, and *The Plum*.

Dante Gabriel Rossetti's painting *Astarte Syriaca*.

Petrus Josephus Hubertus Cuypers began the *Rijksmuseum* (1877–1885).

d. Gustave Courbet, French painter (b. 1819).

THEATER & VARIETY

Henrik Ibsen's play *Pillars of Society* opened at Copenhagen on November 18.

The Sorcerer, libretto by William Gilbert and music by Arthur Sullivan, was presented at the Opera-Comique on November 17; first of many Gilbert-and-Sullivan operettas produced under the management of D'Oyly Carte.

Ah Sin, play by Bret Harte and Mark Twain, opened at New York's Fifth Avenue Theatre on July 31.

The Moonstone, Wilkie Collins's dramatization of his 1868 novel opened at London's Olympic Theatre.

The Danites, Joaquin Miller's play.

Our Boarding House, Leonard Grover's comedy.

Bjørnstjerne Bjørnson's *The King*.

Dora, Victorien Sardou's play.

Abraham Goldfaden's *The Recruits*.

José Echegaray's *Madman or Saint*.

d. Edward Loomis Davenport, American actor and manager (b. 1815), who headed his own acting company, which included his wife and costar Fanny Elizabeth Vining.

d. George Washington Lafayette Fox, American pantomimist, manager, and actor (b. 1825), best known for his *Humpty Dumpty*.

MUSIC & DANCE

Swan Lake (*Lebedinoe ozero* or *le Lac des cygnes*), Peter

Ilich Tchaikovsky's ballet in four acts, libretto by V. P. Begitchev and V. Geltser; choreography by Wenzel Reisinger, premiered at the Bolshoi Theatre, Moscow, March 4.

La Bayadère, Marius Petipa's ballet, libretto by Petipa and Sergei Khudekov, music by Ludwig Minkus, opened at the Bolshoi Theatre, St. Petersburg.

Thomas Edison invented the phonograph, the first recording—on a tinfoil cylinder—being a reading of *Mary Had a Little Lamb*.

Samson et Dalila, Camille Saint-Saëns opera, libretto by Ferdinand Lemaire, premiered at Weimar.

Accademia di S. Cecilia became Italy's principal conservatory (Conservatorio di Musica "Santa Cecilia").

The Lost Chord, Arthur Sullivan's song.

Le Roi de Lahore, Jules Massenet's first successful opera.

Gabriel Fauré's *Requiem*.

Johannes Brahms's *Symphony No. 2*.

Mozart festivals held in Salzburg (1877–1910).

d. Federico Ricci, Italian composer (b. 1809).

WORLD EVENTS

Rutherford B. Hayes was elected U.S. president by an electoral commission, after an 1876 election deadlock; to gain Southern support, Hayes withdrew federal troops from the South, ending Reconstruction. A reign of terror against African-Americans grew in the South.

Failed revolt of Satsuma clan on Kyushu was the final armed conflict of the Japanese civil war.

Nez Percé Indians fled from Washington State to Canada.

1878

LITERATURE

The Return of the Native, Thomas Hardy's novel about Clym Yeobright, who returns to Egdon Heath, there to become disastrously entangled in a web of relationships, most notably with Eustacia Vye.

Henry James's novel *The Europeans*, about the visit by the worldly Baroness Münster and her brother Felix Young to their worthy New England relatives; also his novel *Watch and Ward* and his prose work *French Poets and Novelists*.

Algernon Charles Swinburne's *Poems and Ballads: Second Series*, controversial for their focus on sensual love.

An Inland Voyage, Robert Louis Stevenson's writings on a European tour.

Émile Zola's novel *Un Page d'amour* (*A Love Affair*).

Robert Browning's poem *La Saisiaz: The Two Poets of Croisic*.

George Moore's poems *Flowers of Passion*.

John Greenleaf Whittier's poems *The Vision of Echard*.

Anthony Trollope's novel *Is He Popenjoy?*

Edward Bellamy's novel *Six to One: A Nantucket Idyl*.

Svatopluk Cech's poem *Evropa*.

Theodor Fontane's novel *Vor dem Sturm*.

Joseph Pulitzer established the *St. Louis Post-Dispatch*.

d. William Cullen Bryant, American poet (b. 1794).

VISUAL ARTS

Auguste Rodin's sculpture *St. John the Baptist Preaching*.

Claude Monet's painting *Rue Montorquiel Bedecked with Flags*.

Edgar Degas's pastels included *Ballet at the Opera* (1878–1880), *L'Étoile* (ca. 1878), and *The Rehearsal on the Stage* (1878–1879).

Mary Cassatt's painting *Little Girl in a Blue Armchair*.

Édouard Manet's paintings included *The Blonde with Bare Breasts* and *Rue Mosnier, Paris, Decorated with Flags*.

Pierre-Auguste Renoir's painting *Mme. Charpentier and Her Children* (1878).

Winslow Homer's painting *Fresh Air*.

The Oyster Gatherers of Cancale, John Singer Sargent's painting.

Christopher Columbus: The Discoverer and *The Flight of Night*, William Morris Hunt's murals at the New York State Capitol, Albany.

Richard Morris Hunt began the William Vanderbilt house, New York City.

d. George Cruikshank, English artist and caricaturist (b. 1792).

d. George Gilbert Scott, English architect (b. 1811).

THEATER & VARIETY

H.M.S. Pinafore, William Gilbert and Arthur Sul-

livan's musical play was produced by D'Oyly Carte on May 25.

Banker's Daughter, Bronson Howard's play, opened at New York's Union Square Theatre on November 30.

Adelardo López de Ayala's *Consuelo*.

Émile Augier's *Les Fourchambeault*.

d. George Henry Lewes, philosopher, playwright, and dramatic critic (b. 1817), the longtime companion of novelist George Eliot (Marian Evans). His work in the theater included several plays, but he was much more notable as a critic and essayist.

d. Samuel Phelps, English actor and manager (b. 1804).

MUSIC & DANCE

The Secret (*Tajemstvi*), Bedrich Smetana's opera, libretto by Eliska Krasnohorska, opened in Prague September 18.

Antonín Dvořák's *Serenade* for instrumental ensemble; three *Slavonic Rhapsodies*; and two sets of *Slavonic Dances* (1878, 1886).

Johannes Brahms's *Violin Concerto*, written for Joseph Joachim.

Carry Me Back to Old Virginny, James A. Bland's song.

Edvard Grieg's vocal work *The Mountain Thrall* and his string quartet.

Anton Bruckner's *String Quintet in F Major* (1878–1879) and his choral work *Tota Pulchra es*.

Peter Ilich Tchaikovsky's *Violin Concerto* and his songs *Don Juan's Serenade* and *Mid the Din of the Ball*.

Tábor, Bedřich Smetana's orchestral work.

César Franck's *Trois Pièces* for organ.

Le Petit Duc, Charles Lecocq's opera.

Hugo Wolf's *String Quartet* (1878–1884).

Blodwen, Joseph Parry's opera.

WORLD EVENTS

Thomas A. Edison invented the phonograph.

First Woman Suffrage Amendment was introduced before the U.S. Congress.

Treaty of San Stefano ended the Russo-Turkish war, establishing the independence of Serbia, Montenegro, and Romania.

Austria occupied Bosnia and Herzegovina.

U.S. physicist Albert Abraham Michelson measured the speed of light.

1879

LITERATURE

The Brothers Karamazov, Fyodor Dostoyevsky's final great novel, focusing on the brothers' tangled conflicts; includes the parable *Legend of the Grand Inquisitor* (1879–1880).

Henry James's novella *Daisy Miller*, about a young American woman who runs afoul of strict European social conventions; also his novel *Confidence*, critical study *Hawthorne*, and collection of stories *The Madonna of the Future and Other Tales*, including *An International Episode*.

J. A. H. Murray began editing the Philological Society's *New English Dictionary on Historical Principles*, which would become the *Oxford English Dictionary*.

The Egoist: A Comedy in Narrative, George Meredith's novel.

Les Rois en exil (*Kings in Exile*), Alphonse Daudet's novel of Parisian manners.

William Dean Howells's novel *The Lady of the Aroostook*.

Robert Browning's poems *Dramatic Idylls* (1879–1880).

August Strindberg's novel *The Red Room*.

Robert Louis Stevenson's *Travels with a Donkey in the Cévennes*.

Matthew Arnold's *Mixed Essays*.

John Burroughs's essay *Locusts and Wild Honey*.

George Washington Cable's stories *Old Creole Days*.

W. W. Skeat's *Etymological English Dictionary*.

d. Sarah Josepha Hale, American author (b. 1788).

VISUAL ARTS

Ice Age Magdalenian cave paintings discovered by Maria Sautuola while exploring the Altamira caves, in Spain.

Edgar Degas's paintings included *Éventail* and *Miss Lala at the Cirque Fernando*.

Pierre-Auguste Renoir's paintings included *Little Blue Nude* (1879–1880) and *Oarsmen at Chatou*.

Édouard Manet's paintings included *Chez le Père Lathuille*, *The Conservatory*, and *The Waitress*.

John Twachtman's painting *Coast Scene*.

Paul Cézanne's *Self-Portrait* (1879–1882).

Thomas Eakins's painting *The Fairman Rogers Four-in-Hand*.

d. Honoré Daumier, French caricaturist and painter (b. 1808).

d. George Caleb Bingham, American painter (b. 1811).

d. Julia Margaret Cameron, British portrait photographer (b. 1815).

d. William Morris Hunt, American painter (b. 1824).

d. Eugène Emmanuel Viollet-le-Duc, French architect and archaeologist (b. 1814), noted for his studies of medieval architecture.

d. William Rimmer, American painter and sculptor (b. 1816).

THEATER & VARIETY

Henrik Ibsen's play *A Doll's House*, starring Fru Hennings, was produced in Copenhagen.

Mulligan Guards' Ball, music by David Braham, book and lyrics by Edward Harrigan, opened at New York's Theatre Comique on January 13.

Louis Aldrich and Henry Crisp opened in Bartley Campbell's *My Partner* in New York.

Alfred, Lord Tennyson's verse play *The Falcon*.

Bjørnstjerne Bjørnson's *The New System*.

Abraham Goldfaden's *The Witch*.

d. Adelardo López de Ayala, Spanish playwright (b. 1829).

d. John Baldwin Buckstone, English actor and playwright (b. 1802), long-time manager of London's Haymarket Theatre.

MUSIC & DANCE

Eugene Onegin, Peter Ilich Tchaikovsky's opera, libretto by Tchaikovsky based on the 1833 Aleksandr Pushkin novel in verse, as adapted by Modeste Tchaikovsky, the composer's brother, opened in Moscow March 29.

Peter Ilich Tchaikovsky's *Piano Concerto No. 2* (1879–1880).

Oh, Dem Golden Slippers! James A. Bland's song.

César Franck's oratorio *Les Béatitudes* and his *Quintet in F Minor*.

Johannes Brahms's first violin sonata.

Anton Bruckner's *Symphony No. 6* (1879–1881).

Blánik, Bedřich Smetana's orchestral work.

Alexander Borodin's first string quartet.

Étienne Marcel, Camille Saint-Saëns's dramatic musical work.

d. August Bournonville, Danish choreographer and dancer (b. 1805).

WORLD EVENTS

Belva Lockwood became the first woman to be admitted to practice before the United States Supreme Court.

Britain and Zulu nation were at war in South Africa; British defeated at Isandhlwana.

Chile was at war with Peru and Bolivia in the War of the Pacific (1879–1884).

Russian forces attacked but failed to take the fortress of Geok Tepe in Turkestan.

Thomas A. Edison invented the electric light.

1880

LITERATURE

Washington Square, Henry James's novel about the shy heiress Catherine Sloper, her unsympathetic father, and her gold-hungry suitor, Morris Townsend; basis for the 1947 play *The Heiress* and the 1949 film; also James's story *The Diary of a Man of Fifty*.

Nana, Émile Zola's novel about a young prostitute, a naturalistic work stressing the double influence of heredity and environment in shaping people's lives; part of his *Les Rougon-Macquart* series (1871–1893).

The Duke's Children, last of Anthony Trollope's six Palliser or Parliamentary novels, in which Plantagenet Palliser must help his children face their lives after Glencora's death.

Ben-Hur, Lew Wallace's historical novel about Judah Ben-Hur, a Jew in Roman Palestine; basis for the 1899 dramatization and the 1926 Fred Niblo and 1959 William Wyler screen epics.

Uncle Remus: His Songs and His Sayings, Joel Chandler Harris's folktales, including *Tar Baby*.

Les Soirées de Médan, Guy de Maupassant's first collection of short stories.

Mark Twain's travel notes *A Tramp Abroad*.

Thomas Hardy's novel *The Trumpet-Major*.

Paul Verlaine's poems *Sagesse*.

Alfred, Lord Tennyson's *Ballads and Other Poems*.

George Meredith's novel *The Tragic Comedians*.

Pedro Antonio de Alarcón's novel *El niño de la bola* (*The Infant with the Globe*).

George Washington Cable's novel *The Grandissimes*.

Ignacio Manuel Altamirano's poems *Rimas*.

Louis Frechette's poems *Les Oiseaux de neige*.

John Ruskin's *A Joy for Ever*, based on lectures given in 1856–1859.

Century Illustrated Monthly Magazine began publication in the United States.

d. George Eliot (Marian or Mary Ann Evans), English novelist (b. 1819).

VISUAL ARTS

Auguste Rodin's sculptures *The Thinker*, *The Gates of Hell*, and *Adam*.

National Gallery of Canada and the Royal Canadian Academy of Arts were founded.

Claude Monet's painting *Vétheuil in Summer*.

Edgar Degas's sculpture *A Dancer at the Age of Fourteen*; and his painting *The Dancing Class*.

George Inness's painting *The Coming Storm*.

James McNeill Whistler's painting *The Lagoon, Venice: Nocturne in Blue and Silver*; and his twelve Venetian etchings.

Springtime, John Henry Twachtman (1880–1885).

Berthe Morisot's painting *Jeune Femme au bal*.

Georges Seurat's painting *Casseurs de pierre, Le Raincy* (ca. 1880–1881).

Mending the Harness, Albert Pinkham Ryder's painting (ca. 1880).

Gustave Eiffel began the Garabit Viaduct (1880–1884).

Tenth Street Studio, William Merritt Chase's painting.

Louis Sullivan began Chicago's Rothschild Store (1880–1881).

Amy Folsom, Frank Duveneck's painting.

Paul Gauguin's painting *Seamstress*.

Thomas Eakins's painting *The Crucifixion*.

The Bulls and Bears of Wall Street, William Holbrook Beard's painting (ca. 1880).

Winslow Homer's painting *Gloucester Harbor and Dory*.

The Flying Dutchman, Albert Pinkham Ryder's painting (ca. 1880).

d. Sanford Robinson Gifford, American painter (b. 1823).

THEATER & VARIETY

The Pirates of Penzance, William Gilbert and Arthur Sullivan's musical play, opened in London.

Hazel Kirke, Steele MacKaye's play, opened at New York's Madison Square Theatre on February 4.

Abraham Goldfaden's plays *Shulamit* and *The Two Kune Lemels*.

Victorien Sardou's *Divorçons*.

d. John Brougham, American actor and playwright, born in Ireland (b. 1810).

MUSIC & DANCE

Peter Ilich Tchaikovsky's orchestral works *1812 Overture* and *Capriccio italien*; also his *Serenade for Strings*.

Maiskaya Noch (*A May Night*), Nikolay Rimsky-Korsakov's opera; libretto by Rimsky-Korsakov, opened in Moscow January 21.

Teatro Costanzi opened in Rome, with a production of Gioacchino Rossini's *Semiramide*; it is now the Teatro dell' Opera.

Johannes Brahms's *Academic Festival Overture*, composed for Breslau University, incorporating student songs.

Gustav Mahler's cantata *Das klagende Lied* and songs *Lieder und Gesänge aus der Jugendzeit* (1880–1888).

O Canada! popular Canadian anthem, was written by Calixa Lavallée to French text by Adolphe Basile Routhier (ca. 1880); the English translation was by Robert Stanley Weir (1908).

Modest Mussorgsky's orchestral work *The Capture of Kars* (*Vzatiye Karsa*) and his opera *Khovanshchina*.

Alexander Borodin's *In the Steppes of Central Asia*.

In the Evening by the Moonlight, James A. Bland's song.

Antonín Dvořák's *Symphony No. 6*.

From the Homeland, Bedřich Smetana's work for violin and piano.

Suite algérienne, Camille Saint-Saëns's orchestral work.

Scenes from Prometheus Unbound, Hubert Parry's cantata.

Léo Delibes's opera *Jean de Nivelle*.

Kaiserbass (*Emperor bass*) or *Bierbass* developed by Cervený in Bohemia (1802).

Redesigned modern trumpet developed by Besson in Paris (1880s).

Paul Leipzig invented the disk-type musical box, in Leipzig (1880s), called *Symphonium* or *Polyphon*.

Large barrel pianos, on two-wheeled carts, manufactured in Italy (from ca. 1880s).

Harpsichord manufacture resumed, first in Paris, as the interest in the instrument revived (ca. 1880).

d. Jacques Offenbach, French composer of German origin (b. 1819).

WORLD EVENTS

James A. Garfield was elected U.S. president.

Boers successfully rebelled against British rule, establishing Transvaal Republic (1880–1881).

Cecil Rhodes founded the De Beers Mining Corporation in South Africa.

Alaska gold strike began a gold rush.

Civil war in Argentina.

France and Sudanese forces led by Samory Touré were at war (1880–1898).

France took Tahiti.

Louis Pasteur introduced the germ theory of disease.

1881

LITERATURE

The Portrait of a Lady, Henry James's novel about heiress Isabel Archer and her ultimately unsatisfactory selection of a husband.

The Prince and the Pauper, Mark Twain's popular novel of lookalike Prince Edward VI and pauper Tom Canty, who change places for a few days before Henry VIII's death makes Edward king.

English Revised Version of the New Testament first published.

William Dean Howells's novel *A Fearful Responsibility*.

Anthony Trollope's novels *Ayala's Angel* and *Dr. Wortle's School*.

Benito Pérez Galdós's novel *La desheredada*.

Christina Rossetti's *A Pageant and Other Poems*.

Dante Gabriel Rossetti's *Ballads and Sonnets*.

George Moore's *Pagan Poems*.

Numa Roumestan, Alphonse Daudet's novel of Parisian manners.

George Washington Cable's *Madame Delphine*, novelette.

Gustave Flaubert's novel *Bouvard et Pécuchet*.

Guy de Maupassant's *La Maison Tellier* (*The Tellier House*).

James Thomson's *Vane's Story and Other Poems*.

Robert Gissing's novel *The Nether World*.

Robert Louis Stevenson's *Virginibus puerisque*, prose.

Thomas Bailey Aldrich's poems *Friar Jerome's Beautiful Book*.

Thomas Hardy's novel *A Laodicean*.

Victor Hugo's poems *Les Quatre Vents de l'esprit*.

Charles Scribner, Jr., founded *Scribner's Magazine*.

d. Fyodor Dostoyevsky, Russian writer (b. 1821).

d. Benjamin Disraeli, English statesman and novelist (b. 1804).

d. Sidney Lanier, American writer (b. 1842).

d. Thomas Carlyle, Scottish-born English prose writer (b. 1795).

VISUAL ARTS

Pierre-Auguste Renoir's paintings *Bather* and *The Luncheon of the Boating Party*.

Auguste Rodin's sculpture *Eve*.

Camille Pissarro's paintings included *Peasant Girl with a Stick* and *The Cafe au Lait*.

Edgar Degas's painting *Jockeys* (ca. 1881–1885).

Georges Seurat's drawings *Le Labourage* and *Le Marchand d'oranges*; and his painting *Maison dans les arbres*.

Édouard Manet's painting *The Artist's Garden in Versailles*.

Henri de Toulouse-Lautrec's painting *Mme. la Comtesse A. de Toulouse-Lautrec* (ca. 1881–1882).

Sunday Morning, Thomas Hovenden's painting.

Thomas Eakins's painting *The Pathetic Song*.

Petrus Josephus Hubertus Cuypers began Amsterdam's Central Station (1881–1897).

d. Decimus Burton, English architect (b. 1800).

d. John Quidor, American painter (b. 1801).

d. Samuel Palmer, English painter (b. 1805).

d. William Burges, English architect (b. 1827).

THEATER & VARIETY

Ada Rehan and John Drew opened in Augustin Daly's *The Passing Regiment* in New York.

Esmeralda, Francis Hodgson Burnett and William Gillette's play, opened in New York.

José Echegaray's *El gran Galeoto*.

Patience, William Gilbert and Arthur Sullivan's musical play, opened at London's Opera-Comique.

The Professor, William Gillette's play.

d. Edward Askew Sothern, English actor (b. 1826).

d. Pietro Cossa, Italian playwright (b. 1830).

MUSIC & DANCE

The Tales of Hoffmann (*Les Contes d'Hoffmann*), Jacques Offenbach's opera, libretto by Jules Barbier and Michel Carré, based on their 1851 play, opened in Paris. In piano score only at Offenbach's death, it was orchestrated by Ernest Guiraud.

The Maid of Orleans (*Orleanskaya Deva*), Peter Ilich Tchaikovsky's opera, libretto by Tchaikovsky based on Schiller's 1801 play about Joan of Arc, opened in St. Petersburg, February 25.

The new National Theatre in Prague opened with two Bedřich Smetana nationalistic operas, *Dalibor* (1867) and *Libuse* (1881); the theater was destroyed by fire only two months later, but was reopened with *Libuse* again in 1883.

A la Voreta del Mar (*On the Seashore*), Juan Goula's one-act opera, the first in Catalan, opened at the Teatro Liceo, Barcelona in July.

Kol nidrei, Max Bruch's best-known work, for cello and orchestra.

Alexander Borodin's second string quartet.

Anton Bruckner's *Symphony No. 7* (1881–1883) and *Te Deum*.

Antonín Dvořák's overture *My Home* (*Domov muj*) and his opera *Tvrdé palice* (*The Pig-headed Peasants*).

Augusta Holmès's choral work *Les Argonautes*.

Edward MacDowell's *First Modern Suite*, for piano.

Gabriel Fauré's *Messe basse*.

d. Modest Mussorgsky, Russian composer (b. 1839).

WORLD EVENTS

d. James A. Garfield, 20th U.S. President (b. 1831), assassinated by Charles J. Guiteau, shot July 2, died two months later; succeeded by Vice-President Chester A. Arthur.

First Mahdist War began, pitting Britain and Egypt against Sudanese forces led by the Mahdi (1881–1885).

France took Tunis.

Helen Hunt Jackson published *A Century of Dishonour*, on injustices suffered by Native Americans.

U.S. nurse Clara Barton established the American branch of the International Red Cross.

Tuskegee Institute was founded.

d. Alexander II (b. 1818), czar of Russia, assassinated; succeeded by Alexander III.

1882

LITERATURE

The English and Scottish Popular Ballads, the definitive annotated critical collection by Francis J. Child, published in 10 volumes, and a prime source ever since (1882–1898).

José Martí's poem collection *Ismaelillo*; he also wrote *Versos libres* (not published until the 20th c.), and began keeping his journal *Diario de Cabo Haitiano a Dos Ríos* (published 1941).

William Dean Howells's *A Modern Instance*, one of the earliest American novels of social realism, focusing on the marriage, its degeneration and its then-controversial dissolution.

Robert Louis Stevenson's *Familiar Studies of Men and Books*; also his *New Arabian Nights*, in two volumes.

Emma Lazarus's poems *Songs of a Semite*, including *Dance to Death*.

Guy de Maupassant's *Mademoiselle Fifi*.

Algernon Charles Swinburne's poem *Tristram of Lyonesse*.

Émile Zola's novel *Pot-Bouille*.

Mark Twain's *The Stolen White Elephant and Other Stories*.

Matthew Arnold's *Irish Essays*.

Theodor Fontane's novel *L'Adultera*.

d. Anthony Trollope, English novelist (b. 1815).

d. Ralph Waldo Emerson, American essayist and poet (b. 1803).

d. Henry Wadsworth Longfellow, American poet (b. 1807).

d. James Thomson, English poet (b. 1834).

d. Dante Gabriel Rossetti, English poet and painter (b. 1828).

d. Richard Henry Dana, Jr., American writer (b. 1815).

VISUAL ARTS

Auguste Rodin's sculpture *The Little Man with the Broken Nose*.

John Singer Sargent's paintings included *El Jaleo* and *The Daughters of Edward Darley Boit*.

Édouard Manet's painting *A Bar at the Folies-Bergère*.

Georges Seurat's drawings *La Mère de l'artiste*, and *Paysans* (both 1882–1883).

Mary Cassatt's painting *La Loge* (ca. 1882).

Spinning and *Knitting*, relief sculptures by Thomas Eakins.

Camille Pissarro's painting *Towpath at Pontoise*.

Edgar Degas's pastel *At the Milliner's* (ca. 1882).

Circe, Richard Saltonstall's statue.

Charles Follen McKim began the Villard Houses, Madison Avenue, New York.

d. Dante Gabriel Rossetti, English painter and poet (b. 1828).

d. Alexander Gardner, American photographer (b. 1821).

THEATER & VARIETY

Henrik Ibsen's play *Ghosts* had its world premiere in Chicago; his *An Enemy of the People* also was performed.

Iolanthe, William Gilbert and Arthur Sullivan's musical, opened on November 25.

Alfred, Lord Tennyson's play *The Promise of May* opened at London's Globe Theatre.

Oscar Wilde's *Vera; or, the Nihilists*.

Henry Arthur Jones's *The Silver King*.

Abraham Goldfaden's *Dr. Almosado*.

Henry François Becque's *Les Corbeaux*.

Victorien Sardou's *Fédora*.

Howard Bronson's *Young Mrs. Winthrop*.

d. Ben Nottingham Webster, English actor, manager, and playwright (b. 1797).

d. Céline Céleste, French actress, dancer, and pantomimist (b. 1814).

d. Paolo Giacometti, Italian playwright (b. 1816).

MUSIC & DANCE

Parsifal, Richard Wagner's opera, libretto by Wagner, based on Wolfram von Eschenbach's early 13th-century poem about the Keeper of the Holy Grail, premiered at the Bayreuth Festival July 26.

The Snow Maiden (*Snegurochka*), Nikolay Rimsky-Korsakov's opera, libretto by Rimsky-Korsakov, based on the 1873 Aleksandr Nikolayevich Ostrovsky play, opened in St. Petersburg.

The Devil's Wall, Bedřich Smetana's last opera.

Johannes Brahms's *Piano Concerto No. 2*, his first string quintet, and his third piano trio.

Antonín Dvořák's choral *Amid Nature* and opera *Dimitrij*.

César Franck's symphonic poem *Le Chasseur maudit* (*The Accursed Hunter*).

Edward MacDowell's *Piano Concerto No. 1* and his *Second Modern Suite*, for piano.

Ernest Chausson's orchestral works *Poème de l'amour et de la mer* (1882–1893) and *Viviane*.

Nikolay Rimsky-Korsakov's *Piano Concerto* (1882–1883).

La Rédemption, Charles Gounod's choral work.

WORLD EVENTS

U.S. Chinese Exclusion Act.

Edmond de Rothschild, head of the House of Rothschild in France, provided large financial support to the Lovers of Zion and other Zionist organizations.

Egyptian Revolt against European domination failed; Britain more openly took control of Egypt.

Italy founded a colony in Eritrea.

1883

LITERATURE

Treasure Island, Robert Louis Stevenson's novel about young Jim Hawkins and his search for treasure, helped by marooned sailor Ben Gunn to outwit the villanous Long John Silver; also Stevenson's tale *The Silverado Squatters*.

Life on the Mississippi, Mark Twain's reminiscences of his apprenticeship as a river pilot on the Mississippi, and the changes that he saw in the river.

Emma Lazarus's sonnet *The New Colossus*, with its

famous phrase "Give me your tired, your poor, / Your huddled masses yearning to breathe free," was written on the base of the Statue of Liberty.

Story of an African Farm, Olive Schreiner's novel of South Africa, published under the male pseudonym Ralph Iron.

Anton Chekhov's short stories *Doch Albiona* (*A Daughter of Albion*), *Radost* (*Joy*), and *Tragik* (*A Tragic Actor*).

Lewis Carroll's poetry *Rhyme? and Reason?*

Alphonse Daudet's novel *L'Evangéliste*.

Émile Zola's novel *Au bonheur des dames*.

George Meredith's *Poems and Lyrics of the Joy of Earth*.

Une Vie (*A Woman's Life*), Guy de Maupassant's novel; also his *Contes de la bécasse*.

Henry James's story *The Siege of London*; also his essays *Portraits of Places*.

Doctor Grimshawe's Secret and *The Ancestral Footsteps*, Nathaniel Hawthorne's unfinished novels published.

Robert Browning's poem *Jocoseria*.

Victor Hugo's poems *La Légende des siècles*, third of three series.

James Whitcomb Riley's *The Old Swimmin'-Hole and 'Leven More Poems*, including *When the Frost Is on the Punkin*.

Mary Hallock Foote's novel *The Led-Horse Claim*.

Ladies' Home Journal began publication.

d. Ivan Turgenev, Russian writer (b. 1818).

d. Edward FitzGerald, English translator and writer (b. 1809).

VISUAL ARTS

Vincent van Gogh's painting *In the Field*.

Antonio Gaudí began his church of the Sagrada Familia in Barcelona, his masterpiece, incomplete at his death (1883–1926).

Winslow Homer's paintings included *Inside the Bar, Tynemouth*, *The Gale*, and *Tynemouth*.

The Breakfast Table, John Singer Sargent's painting (1883–1884).

Pierre-Auguste Renoir's paintings included *The Dance at Bougival* and *Les Parapluies* (ca. 1883).

Thomas Eakins's painting *The Swimming Hole*.

Georges Seurat's paintings included *Les Pêcheurs à la ligne* and *Une Baignade, Asnières* (1883–1884).

James McNeill Whistler's painting *Portrait of Théodore Duret*.

Paul Cézanne's painting *The Blue Vase* (1883–1887).

Edgar Degas's pastel *Blue Dancer* (ca. 1883).

William Merritt Chase's *Portrait of Miss Dora Wheeler*.

The Beach at Dunkirk, Childe Hassam's painting.

Ernst Josephson's painting *Jeanette Rubenson*.

Washington, John Quincy Adams Ward's statue, at the Federal Hall National Memorial, New York City.

d. Édouard Manet, French artist (b. 1825).

d. Gustave Doré, French book illustrator (b. 1832).

THEATER & VARIETY

August Strindberg's *Lucky Peter's Travels*.

Daisy Miller, Henry James's play based on his 1879 novel.

"Buffalo Bill" Cody organized the first Wild West show.

Bjørnstjerne Bjørnson's plays *A Gauntlet* and *Pastor Sang*.

The Rajah, William Young's comedy.

Siberia, Bartley Campbell's play.

Giuseppe Giacosa's *The Cat's Paw*.

Abraham Goldfaden's *Bar Kochba*.

Gostav von Moser's *The Private Secretary*.

d. Junius Brutus Booth, Jr., American actor (b. 1821). He was the son of Junius Brutus Booth, Sr., and the brother of Edwin and John Wilkes Booth, all also actors.

MUSIC & DANCE

Lakmé, Léo Delibes's opera, libretto by Edmond Gondinet and Philippe Gille, from Pierre Loti's 1880 novel *Le Mariage de Loti*, opened at the Opéra-Comique, Paris, April 14.

Metropolitan Opera House—the Met—opened in New York on October 22 with a production of Charles Gounod's *Faust*.

Johannes Brahms's *Symphony No. 3*.

Bedřich Smetana's *String Quartet No. 2*.

Henry VIII, Camille Saint-Saëns's dramatic musical work.

Edvard Grieg's *Cello Sonata*.

Richard Strauss's first horn concerto.

Gustav Mahler's songs *Lieder eines fahrenden Gesellen* (1883–1885).

Hervé's opera *Mam'zelle Nitouche*.

Eine Nacht in Venedig, Johann Strauss's operetta.

Vincent d'Indy's opera *Le Chant de la cloche*.

José Reyes wrote the music for Emilio Prud'homme's

Quisqueyanos valientes alcemos, anthem of the Dominican Republic.

d. Richard Wagner, German composer (b. 1883).

d. Friedrich Flotow, German composer (b. 1812).

d. Hedwig Reicher-Kindermann, German soprano (b. 1853).

WORLD EVENTS

Massive volcanic eruption at Krakatoa.

British fled Sudan after defeat by forces of the Madhi.

French took Tonkin, completing their conquest of Vietnam, and also generating a French–Chinese border war (1883–1885).

Germany founded Southwest Africa colony.

Orient Express introduced.

1884

LITERATURE

The Adventures of Huckleberry Finn, Mark Twain's enormously popular sequel to his 1876 book, with Huck and runaway slave Jim rafting on the Mississippi.

Ottmar Mergenthaler, a German-American immigrant working in Baltimore, invented the Linotype machine, a typecasting compositor that cast a solid one-piece line, or slug.

Esther, Henry Adams's novel about a painter who breaks her engagement with a clergyman on finding their view on religion and "proper" behavior incompatible.

Henry James's story collection *Tales of Three Cities*; also his prose writings *The Art of Fiction* and *A Little Tour in France*.

The Lady or the Tiger? Frank R. Stockton's famous short story that leaves the ending to the reader.

Anton Chekhov's short stories *Khameleon* (*A Chameleon*) and *Drama na okhote* (*The Shooting Party*).

First volume of the *Oxford English Dictionary* published, edited by James Murray (completed 1928).

Lafcadio Hearn's stories *Stray Leaves from Strange Literature*.

August Strindberg's short stories *Married* (1884–1885).

Sapho, Alphonse Daudet's novel of Parisian manners.

Benito Pérez Galdós's novels *Tormento* and *La de Bringas*.

Émile Zola's novel *La Joie de vivre*.

Edward Bellamy's novel *Miss Ludington's Sister*.

Ernst Ahlgren's novel *Från Skåne*.

Guy de Maupassant's short story *Miss Harriet*.

Sarah Orne Jewett's novel *A Country Doctor*.

Joris Karl Huysmans's novel *Against the Grain*.

Paul Verlaine's poems *Jadis et naguère*.

Ralph Waldo Emerson's *Lectures and Biographical Sketches*.

Svatopluk Cech's poem *Slavie*.

d. Elias Lönnrot, Finnish folklorist and philologist (b. 1802).

d. William Wells Brown, Black American leader and author (b. 1816?).

VISUAL ARTS

Georges Seurat's painting *Sunday Afternoon on the Island of La Grande Jatte* (1884–1886), his prototypical *pointillist* work; inspiration for the 1984 musical *Sunday in the Park with George*.

Augustus Saint-Gaudens's memorial to *Colonel Robert Gould Shaw of the 54th Massachusetts*, in Boston Commons.

James McNeill Whistler's paintings included *The Angry Sea* (ca. 1884), *Arrangement in Black: Pablo de Sarasate*, *Arrangement in Black: The Lady in the Yellow Buskin—Lady Archibald Campbell* (ca. 1884), *Grey and Silver: The Life Boat* (ca. 1884).

Auguste Rodin's sculptures included *The Earth* and *The Burghers of Calais* (1884–1886).

Madame X, John Singer Sargent's painting.

Pierre-Auguste Renoir's painting *Bathers* (1884–1887).

Vincent van Gogh's painting *The Loom*.

Edgar Degas's painting *Two Laundresses*.

Winslow Homer's painting *The Life Line*.

Brush Burning, George Inness's painting.

Claude Monet's painting *Haystacks at Giverny*.

Edward Coley Burne-Jones's painting *King Cophetua and the Beggar Maid*.

Kate Lewis, Susan Eakins's painting.

Louis Sullivan began Chicago's Troescher Building.

d. Bertel Thorwaldsen, Danish sculptor (b. 1768).

THEATER & VARIETY

Cavalleria rusticana, Giovanni Verga's play, basis of the libretto of Pietro Macagni's 1890 opera.

Henrik Ibsen's *The Wild Duck*.

Princess Ida, William Gilbert and Arthur Sullivan's musical, opened on January 5.

May Blossom, David Belasco's play, opened at New York's Madison Square Theatre on April 12.

Peck's Bad Boy, Charles Pidgin's play.

Ivan Turgenev's play *Vecher v Sorrente*.

Henry Arthur Jones's *Saints and Sinners*.

Giuseppe Giacosa's *L'Onorevole Ercole Malladri*.

d. Antonio García Gutiérrez, Spanish playwright (b. 1813).

d. Charles Reade, English novelist and playwright (b. 1814).

d. Denis Johnston, Irish playwright (b. 1901).

d. George Leybourne, English music-hall star (b. 1842).

d. Henry James Byron, English actor and playwright (b. 1834).

MUSIC & DANCE

d. Marie Taglioni, Italian-Swedish dancer (b. 1804), and dancer and ballet master Paul Taglioni (b. 1808), children of dancer–choreographer Filippo Taglioni; all key figures in the development of ballet.

Manon, Jules Massenet opera, libretto by Henri Meilhac and Philippe Gille, premiered at the Opéra-Comique, Paris, January 19.

Mazeppa, Peter Ilich Tchaikovsky's opera, libretto by Tchaikovsky, based on Aleksandr Pushkin's 1829 poem *Poltava*, opened in Moscow, February 19.

Nellie Melba made her opera debut as Gilda in a production of *Rigoletto* in Brussels.

Hungarian State Opera House (Magyar Állami Operah'ź) opened on September 27.

Holberg Suite, Edvard Grieg's orchestral work.

Love's Old Sweet Song, popular song, words by G. Clifton Bingham, music by James L. Molloy.

Antonín Dvořák's choral work *Svatební kosile* (*The Spectre's Bride*).

César Franck's symphonic poem *Les Djinns* and his *Prélude, choral et fugue* for piano.

The Fountain in the Park (*While Strolling in the Park*), Ed Haley's popular song.

Claude Debussy's cantata *L'Enfant prodigue*.

Edward MacDowell's symphonic poems *Hamlet* and *Ophelia* (both 1884–1885), and his *Piano Concerto No. 2* (1884–1886).

Oh My Darling Clementine, popular song, probably by Percy Montrose.

Giacomo Puccini's first opera, *Le villi*.

Tamboo bamboo bands formed in Trinidad and Tobago after the Peace Preservation Act barred African drums; basis for the later steel bands.

Duet concertina, with two keyboards, patented by John H. MacCann.

d. Bedřich Smetana, Czech composer (b. 1824).

d. Fanny (Franziska) Elssler, Austrian dancer (b. 1810).

d. Henry Clay Work, American composer (b. 1832).

WORLD EVENTS

Grover Cleveland was elected U.S. president.

Beatrice Webb, Sidney Webb, and Bernard Shaw led in the formation of Britain's Socialist Fabian Society.

National Equal Rights Party nominated Bella A. Lockwood first U.S. woman presidential candidate.

Germany extended its African holdings, taking Southwest Africa (Namibia), Togoland, and Cameroons.

1885

LITERATURE

Germinal, Émile Zola's naturalistic novel about the terrible conditions of workers in French mines, a powerful call for social reform; part of his *Les Rougon-Macquart* series (1871–1893).

The Rise of Silas Lapham, William Dean Howells's novel about the social education of self-made Silas, coincident with his financial ruin.

A Child's Garden of Verses, Robert Louis Stevenson's popular collection of poems for children, including *My Shadow* and *The Lamplighter*; also his novel *Prince Otto*.

Marius the Epicurean, Walter Pater's historical novel set in 2nd-century Rome, against a backdrop of the still-forbidden early Christian worship.

Bel-Ami, Guy de Maupassant's novel of an unprincipled journalist; also his short stories *Toine* and *Yvette*.

Alfred, Lord Tennyson's *Tiresias and Other Poems*.

H. Rider Haggard's novel *King Solomon's Mines*; basis for the film.

Little Orphant Annie, James Whitcomb Riley's poem in dialect.

Alphonse Daudet's novel *Tartarin sur les Alpes*; part of his Provençal series.

Anton Chekhov's short stories *Gore* (*Sorrow*), *Prishibeyev* (*Sergeant Prishibeyev*), and *Yeger* (*The Huntsman*).

Diana of the Crossways, George Meredith's novel.

George Moore's then-shockingly realistic novel *A Mummer's Wife.*

Henry James's short stories *Stories Revived,* including his *The Author of Beltraffio.*

Matthew Arnold's *Discourses in America.*

George Washington Cable's novel *Dr. Sevier.*

Sarah Orne Jewett's novel *A Marsh Island.*

Oxford University established its first chair in modern English literature.

English Revised Version of the Old Testament first published.

d. Victor (Victor-Marie) Hugo, French writer (b. 1802).

VISUAL ARTS

Vincent van Gogh's paintings included *The Potato Eaters, Autumn Landscape with Four Trees,* and *Peasant Woman in a Red Bonnet.*

Winslow Homer's paintings included *Conch Divers, Fog Warning, Shark Fishing, Street Scene, Santiago, Cuba,* and *The Herring Net.*

Paul Cézanne's paintings included *Mont Sainte-Victoire* (1885–1887) and *The Bather* (1885–1887).

Washington Monument was completed.

Arques-la-Bataille, John Henry Twachtman's painting.

Childe Hassam's painting *Rainy Day, Columbus Avenue, Boston.*

Auguste Rodin's sculpture *The Martyr.*

Edgar Degas's painting *The Millinery Shop* (ca. 1885).

Henri de Toulouse-Lautrec's painting *Portrait of Mrs. Suzanne V.*

Frederic Leighton's illustrations for *The Captive Andromache.*

Georges Seurat's painting *Le Bec du Hoc, Grandcamp.*

James A. McNeill Whistler, William Merritt Chase's painting.

Mary Cassatt's painting *Lady at the Tea Table.*

Thomas Eakins's painting *Lady with a Setter Dog* (*Mrs. Eakins*).

Moonlight, Albert Pinkham Ryder's painting.

Paul Gauguin's painting *Still Life in an Interior.*

William Holman Hunt's painting *The Triumph of the Innocents.*

Henry Hobson Richardson began Chicago's Marshall Field store.

d. William Page, American painter (b. 1811).

THEATER & VARIETY

The Mikado, William Gilbert and Arthur Sullivan's musical play, opened in London March 14.

La Parisienne, Henri Becque's play, opened in Paris.

One of Our Girls, Bronson Howard's comedy.

Arthur Wing Pinero's *The Magistrate.*

Henry François Becque's *La Parisienne.*

Bjørnstjerne Bjørnson's *Love and Geography.*

Gustave Flaubert's play *Le Château des coeurs.*

Holger Henrik Herholdt Drachmann's *Once Upon a Time.*

MUSIC & DANCE

The Gypsy Baron (*Der Zigeunerbaron*), Johann Strauss's operetta, libretto by Ignaz Schnitzer, opened at Theater an der Wien, Vienna.

Le Cid, Jules Massenet's opera, libretto by Adolphe D'Ennery, Louis Gallet, and Edouard Blau, based on Corneille's 1637 play, opened in Paris November 30.

Antonín Dvořák's *Symphony No. 7* and his choral work *Hymn of the Czech Peasants* (*Hymna ceskoslovensk'y rolnictva*).

Anton Bruckner's *Symphony No. 8* (1884–1885).

César Franck's *Variations symphoniques.*

Mors et Vita, Charles Gounod's choral work.

Franz Liszt's *Historische ungarische Bildnisse,* for piano.

Gustav Mahler's *Songs of a Wayfarer* (*Lieder eines fahrenden Gesellen*).

Johannes Brahms's *Symphony No. 4.*

Manfred, Peter Ilich Tchaikovsky's symphony.

Ecce Sacerdos, Anton Bruckner's choral work.

Richard Strauss's *Burleske* for piano and orchestra.

WORLD EVENTS

Sudanese forces led by the Mahdi took Khartoum; British General Gordon died in battle.

Indian National Congress (Congress party) founded.

Louis Riel led a second failed French and Indian

rebellion against British rule in western Canada.

Belgium took the Congo.

Britain completed the conquest of Burma in the Third Burma War and took Mandalay.

British took southern New Guinea; Germans took northern New Guinea.

Germany took Tanganyika and Zanzibar.

Gold strike in Transvaal.

1886

LITERATURE

The Strange Case of Dr. Jekyll and Mr. Hyde, Robert Louis Stevenson's novel about a drug-induced dual personality, with evil predominating; basis of several theatrical and television films; also his novel *Kidnapped*, a historical novel set in Jacobite times.

Henry James's novel *The Bostonians*, focusing on the influence of feminist Olive Chancellor on an impressionable girl; also his novel *The Princess Casamassima*.

The Mayor of Casterbridge, Thomas Hardy's novel about a farmer who sells his wife while drunk, and his attempts to redeem himself.

Little Lord Fauntleroy, Frances Hodgson Burnett's classic children's tale about a poor American boy who becomes an English earl.

Departmental Ditties and Other Verses, Rudyard Kipling's first book of poems.

Anton Chekhov's short stories *Anyuta*, *Grisha*, *Khoroshiye lyudi* (*Excellent People*), *Kto vinovat?* (*Who Was to Blame?*), *Panikhida* (*The Requiem*), *Sobytiye* (*An Incident*), *Toska* (*Misery*), and *Uchitel* (*The Schoolmaster*).

The History of Woman Suffrage (first three volumes) published, by Susan B. Anthony, Elizabeth Cady Stanton, and Matilda Joslyn Gage.

William Dean Howells's novel *Indian Summer*.

Arthur Rimbaud's poem *Illuminations*.

Émile Zola's novel *L'Oeuvre*.

Alphonse Daudet's novel *La Belle-Nivernaise*.

Alfred, Lord Tennyson's poem *Locksley Hall Sixty Years After*.

Victor Hugo's poems *La Fin de Satan* (pub. 1886).

Benito Pérez Galdós's novel *Fortunata y Jacinta* (1886–1887).

John Greenleaf Whittier's *St. Gregory's Guest*.

Marie Corelli's *A Romance of Two Worlds*.

Linotype machine first used commercially, by the *New York Tribune*.

d. John Esten Cooke, American author (b. 1830).

VISUAL ARTS

Statue of Liberty, a gift from the French people, designed by Frederic Auguste Bartholdi, installed overlooking New York harbor.

Auguste Rodin's sculpture *The Kiss*.

Georges Seurat's work included the paintings *The Bridge at Courbevoie* and *The Asylum and the Lighthouse, Honfleur*; and the drawing *Au concert européen* (1886–1887).

Paul Cézanne's paintings included *Mountains in Provence* (1886–1890) and *The Bay from l'Estaque* (ca. 1886).

Gustav Klimt painted the Vienna City Theatre murals.

James McNeill Whistler's 26 Venetian etchings.

Paul Gauguin's painting *Dance of Four Breton Women*.

Edvard Munch's painting *The Sick Child*.

Vincent van Gogh's painting *Skull with a Cigarette*.

George Watts's painting *Hope*.

Winslow Homer's painting *Eight Bells*.

Louis Sullivan began Chicago's Auditorium Building (1886–1889).

d. Asher Durand, American painter (b. 1796).

d. Henry Hobson Richardson, American architect (b. 1838).

THEATER & VARIETY

Henrik Ibsen's play *Rosmersholm*.

Arthur Wing Pinero's *The Schoolmistress*.

Richard Mansfield opened in the title role of A. C. Gunter's *Prince Carl*, in New York.

Held by the Enemy, William Gillette's play, opened at New York's Madison Square Theatre August 16.

d. Alexander Nikolayevich Ostrovsky, Russian playwright (b. 1823), whose satirical antibureaucratic plays were far more popular in the 20th century than with the czarist censors of his own time.

MUSIC & DANCE

The Carnival of Animals (*Le carnival des animaux*),

Camille Saint-Saëns's "grand zoological fantasy," with 14 movements, each representing a different animal.

Camille Saint-Saëns's *Symphony No. 3*, the *Organ*.

Khovanshchina (*The Khovansky Affair*), Modest Mussorgsky's opera, completed and orchestrated by Nikolay Rimsky-Korsakov; libretto by Mussorgsky and Vladimir Stasov, opened in St. Petersburg.

Johannes Brahms's *Tragic Overture*, and his second cello sonata, fourth piano trio, and second violin sonata.

César Franck's *Sonata for Violin and Piano*.

Antonín Dvořák's choral work *St. Ludmilla* (*Svatá Ludmila*).

Rock-a-Bye Baby, Effie I. Canning's popular lullaby.

The Golden Legend, Arthur Sullivan's cantata.

Lancelot und Elaine, Edward MacDowell's symphonic poem.

Nikolay Rimsky-Korsakov's *Fantasy on Russian Themes*.

Vincent d'Indy's *Symphonie sur un chant montagnard français* for piano and orchestra.

Le roi Arthus, Ernest Chausson's opera (1886–1895).

Intermezzo, Hugo Wolf's string quartet.

WORLD EVENTS

Bombing of police in Chicago's Haymarket Square; anarchist leaders tried and convicted on little evidence and four executed; three pardoned in 1893.

Samuel Gompers founded and became first president of the American Federation of Labor (AFL).

Trans-Canada Canadian Pacific Railway was completed.

Home Rule bill for Ireland was introduced in the British Parliament.

Peace of Bucharest between Serbia and Bulgaria.

Heinrich Hertz discovered and produced radio waves (ca. 1886).

1887

LITERATURE

Arthur Conan Doyle created the first great fictional British detective, Sherlock Holmes, who was aided by his friend and chronicler, Dr. Watson, in *A Study in Scarlet*.

La Terre (*The Soil*), Émile Zola's naturalistic novel about greed for land among French peasants; part of his *Les Rougon-Macquart* series (1871–1893).

Polish oculist Ludwig Lazarus Zamenhof published a guide to the new international language he had invented, later named for his pseudonym: Doktor Esperanto.

Anton Chekhov's short stories *Kashtanka*, *Potseluy* (*The Kiss*), *Tyf* (*Typhus*), *Verochka*, *Volodya*, and *Vragi* (*Enemies*).

Robert Louis Stevenson's *The Merry Men and Other Tales and Fables*, poems *Underwoods*, and prose work *Memories and Portraits*.

Stéphane Mallarmé's *Album de vers et de prose* and *Poésies*.

Robert Browning's poem *Parleyings with Certain People of Importance in Their Day*.

H. Rider Haggard's adventure novel *Allan Quartermain*.

Thomas Hardy's novel *The Woodlanders*.

William Dean Howells's story *The Minister's Charge*.

Guy de Maupassant's novel *Mont-Oriol* and story *Le Horla*.

Dead Man's Rock, a novel by "Q" (Arthur Quiller-Couch).

August Strindberg's novel *The People of Hemsö*.

Emma Lazarus's poem *By the Waters of Babylon*.

Ernst Ahlgren's novels *Folkliv och småberättelser* and *Fru Marianne*.

Futabatei Shimei's novel *Ukigumo* (*The Drifting Cloud*) (1887–1889).

George Meredith's *Ballads and Poems of Tragic Life*.

James Whitcomb Riley's poems *Afterwhiles*.

Louis Frechette's epic poems *La Légende d'un peuple*.

Thomas Nelson Page's *In Ole Virginia*, stories.

William Michael Rossetti's *Life of Keats*.

d. Emma Lazarus, American poet (b. 1849).

VISUAL ARTS

Augustus Saint-Gaudens's work included the Lincoln Memorial and the statue *The Puritan*.

Charles McKim began the Boston Public Library.

Henri Rousseau's painting *Landscape with Tree Trunks*.

Childe Hassam's painting *Grand Prix Day*.

Eadweard Muybridge's photos of *Animal Locomotion*.

Paul Gauguin's painting *Martinique Landscape*.

Thomas Eakins's painting *Walt Whitman*.

Georges Seurat's paintings included *Invitation to the*

Side-Show and *The Models* (both 1887–1888).

Henri de Toulouse-Lautrec's painting *Mme la Comtesse A. de Toulouse-Lautrec, mère de l'artiste*.

Robert Frederick Blum's paintings *Italian Bead Stringers* (1887–1888) and *Venetian Lace Makers*.

d. Nathaniel Currier, American lithographer (b. 1803).

THEATER & VARIETY

Ruddigore, William Gilbert and Arthur Sullivan's musical play, opened in London on January 22.

La Tosca, Victorien Sardou's play, written for Sarah Bernhardt.

The Father, August Strindberg's play.

Ivanov, Anton Chekhov's play.

The Henrietta, Bronson Howard's play, opened at New York's Union Square Theatre.

The Old Homestead, Denman Thompson and George W. Ryer play, opened in New York.

The Railroad of Love, Augustin Daly's comedy.

The Wife, David Belasco and Henry C. de Mille's play, opened at New York's Lyceum Theatre.

Arthur Wing Pinero's *Dandy Dick*.

Georges-Léon-Jules-Marie Feydeau's *Tailleur pour dames*.

Théâtre libre was founded by André Antoine.

Francillon, play by Alexandre Dumas (*fils*).

d. John T. Raymond, American actor (b. 1836).

MUSIC & DANCE

Otello, Giuseppe Verdi's opera, libretto by Arrigo Boito, based on Shakespeare's play (1604–1605), opened at La Scala, Milan, February 5.

Peter Ilich Tchaikovsky's opera *The Sorceress* and orchestral work *Pezzo capricioso*.

Edward MacDowell's symphonic poem *Romanze*, for cello and orchestra.

Johannes Brahms's *Double Concerto* for violin and cello.

Nikolay Rimsky-Korsakov's *Capriccio espagnol*.

Erik Satie's songs *3 mélodies* and piano pieces *3 Sarabandes*.

Antonín Dvořák's *Mass in D Major* and the chamber work *Terzetto*.

Anton Bruckner's *Symphony No. 8*.

Charles Gounod's *Messe à la mémoire de Jeanne d'Arc*.

Edvard Grieg's third and final violin sonata.

César Franck's *Prélude, area et final* for piano.

Hubert Parry's cantata *Blest Pair of Sirens*.

The Oresteia, Sergei Ivanovich Taneyev's opera (1887–1894).

d. Alexander Borodin, Russian composer (b. 1833). Among his final works was his *Symphony No. 3*.

d. Jenny (Johanna Maria) Lind, Swedish soprano (b. 1820), known as the "Swedish nightingale."

WORLD EVENTS

Italy and Abyssinia were at war.

Portugal took Macao from China.

Britain celebrated Queen Victoria's Golden Jubilee.

France formally organized its Southeast Asian holdings as Indo-China.

1888

LITERATURE

The Aspern Papers, Henry James's novel about a literary scholar on the track of some unpublished documents; also his novel *The Reverberator* and prose work *Partial Portraits*.

Rudyard Kipling's collections of short stories *Plain Tales from the Hills* and *Soldiers Three*, introducing the trio Otheris, Learoyd, and Mulvaney; also his *Wee Willie Winkie*.

Alphonse Daudet's novel *L'Immortel*, and his memoirs *Souvenirs d'un homme de lettres* (*Recollections of a Literary Man*) and *Trente ans de Paris* (*Thirty Years of Paris and of My Literary Life*), memoirs.

Matthew Arnold's *Essays in Criticism. Second Series*, including *The Study of Poetry* and essays on Milton, Thomas Gray, Keats, Wordsworth, Byron, Shelley, Tolstoy, and Amiel.

Anton Chekhov's short stories *Pari* (*The Bet*), *Pripadok* (*A Nervous Breakdown*), and *Step* (*The Steppe*).

Émile Zola's novel *La Rève* (*The Dream*).

Thomas Hardy's *Wessex Tales: Strange, Lively and Commonplace*.

The Black Arrow: A Tale of the Two Roses, Robert Louis Stevenson's novel.

Guy de Maupassant's novel *Pierre et Jean*; also his *Le Rosier de Madame Husson*.

Troy Town, the novel by "Q" (Arthur Quiller-Couch).

George Moore's novel *Confessions of a Young Man*.

Herman Melville's poems *John Marr, and Other Sailors; With Some Sea-Pieces* (1888).

Benito Pérez Galdós's novel *Miau*.

George Meredith's poems *A Reading of Earth*.

Edward Bellamy's novel *Looking Backward: 2000–1887*.

George Washington Cable's novel *Bonaventure*.

Gerhart Hauptmann's story *Bahnwärter Thiel*.

James Whitcomb Riley's poems *Pipes o' Pan at Zekesbury*.

Paul Verlaine's poems *Amour*.

Rubén Darío's *Azul*, his poetry and short-story collection.

Theodor Fontane's novel *Irrungen*.

Toute la lyre, Victor Hugo's poems published.

William Dean Howells's story *April Hopes*.

Collier's began publication in the United States (1888–1957).

d. Matthew Arnold, English poet (b. 1822).

d. Louisa May Alcott, American writer (b. 1832).

d. Ernst Ahlgren, Swedish novelist and story writer (b. 1850).

VISUAL ARTS

Vincent van Gogh's paintings included *The Chair and the Pipe (Van Gogh's Chair)* (1888–1889), *The Postman Roulin*, *The Night Café*, *View of Arles with Irises*, and his *Self-Portrait in Front of an Easel*.

Paul Gauguin's paintings included *Old Women of Arles*, *The Vision After the Sermon*, and *The Swineherd*.

Georges Seurat's painting *Sunday at Port-en-Bessin*.

Camille Pissarro's painting *Île Lacroix, Rouen—Effect of Fog*.

The Flower Garden, Childe Hassam's painting.

Claude Monet's painting *Antibes*.

Edvard Munch's painting *The Evening Hour*.

Henri de Toulouse-Lautrec's paintings included *Girl in the Artist's Studio* and *In the Circus Fernando: The Ringmaster*.

The Last of the Buffalo, Albert Bierstadt's painting.

James Ensor painting *Entry of Christ into Brussels*.

Siegfried and the Rhine Maidens, Albert Pinkham Ryder's painting (1888–1891).

George Grey Barnard's book *The Nature of Man* (1888–1894).

Their Pride, Thomas Hovenden's painting.

Thomas Eakins's painting *Letitia Wilson Jordan Bacon*.

d. Edward Lear, English artist and author (b. 1812).

d. John Gully, New Zealand painter (b. 1819).

THEATER & VARIETY

William Gilbert and Arthur Sullivan's *The Yeomen of the Guard* opened in London on October 31.

Arthur Wing Pinero's *Sweet Lavender* opened in London on March 21.

Henrik Ibsen's *The Lady from the Sea*.

August Strindberg's *Miss Julie*.

Anton Chekhov's *Medved* (*The Bear*).

William Gillette's *Legal Wreck*.

Augustin Daly's *The Lottery of Love*.

London's Shaftesbury Theatre opened with Johnston Forbes-Robertson in a production of Shakespeare's *As You Like It*.

d. Eugène Labiche, French playwright (b. 1815), best known for his *The Italian Straw Hat*.

MUSIC & DANCE

Emile Berliner first demonstrated the Gramophone, which made sound recordings on flat disks, which would by the late 1910s replace cylinders.

César Franck's *Symphony in D Minor*, and the symphonic poem *Psyché*.

Claude Debussy's *Ariettes oubliées*, songs set to poems by Verlaine; his piano solo *Deux Arabesques*; and the cantata *The Blessed Damozel* (*La Damoiselle élue*), text by Dante Gabriel Rosetti.

Gustav Mahler's songs *Des Knaben Wunderhorn* and his *Symphony No. 1*.

Johannes Brahms's song *Zigeunerlieder*; also his second and final violin sonata.

Peter Ilich Tchaikovsky's *Symphony No. 5* and orchestral work *Hamlet*.

Nikolay Rimsky-Korsakov's *Russian Easter Festival Overture*.

Richard Wagner's first opera *Die Feen* (*The Fairies*) had its public premiere (written 1833).

Carl Nielsen's orchestral work *Little Suite*, and first two string quartets.

Sheherazade, Nikolay Rimsky-Korsakov's symphonic suite.

Lamia, Edward MacDowell's symphonic poem.

Erik Satie's *3 Gymnopédies*, for piano.

Jan Paderewski's *Piano Concerto*.

Where Did You Get That Hat? Joseph J. Sullivan's comic song.

Édouard Lalo's opera *Le Roi d'Ys.*

Judith, Hubert Parry's oratorio.

Macbeth, Richard Strauss's tone poem.

d. Charles-Valentin Alkan, French pianist and composer (b. 1813), a virtuoso in concerts, best known today for his harmonic studies and *Grande sonate* for piano.

WORLD EVENTS

Benjamin Harrison was elected U.S. president.

British established land of Matabele Zulus as protectorate, with mining rights to Cecil Rhodes (Rhodesia, now Zimbabwe). They also took North Borneo and Brunei, Sarawak, and Sikkim.

Mathematician Sonya Kovalesksy produced *On the Rotation of a Solid Body Around a Fixed Point.*

1889

LITERATURE

A Connecticut Yankee in King Arthur's Court, Mark Twain's novel about a young American who shows off his ingenuity when transported in time.

The Phantom Rickshaw, Rudyard Kipling's collection of stories, including *The Man Who Would Be King*, basis for the 1975 John Huston film.

William Butler Yeats's *The Wanderings of Oisin and Other Poems*, the long title work being based on Irish legend.

Alfred, Lord Tennyson's *Demeter and Other Poems*, including the famous *Crossing the Bar.*

Fanny Burney's *Early Diary, 1768–1778* first published.

The Master of Ballantrae, Robert Louis Stevenson's adventure novel.

Anton Chekhov's short stories *Skuchnaya istoriya* (*A Dreary Story*; 1889) and *Tragik po nevole* (*An Unwilling Martyr*; 1889–1890).

Guy de Maupassant's novel *Fort comme la mort* (*The Master Passion*).

Henry James's story *A London Life.*

Parallèlement, Paul Verlaine's poems.

Robert Browning's poem *Asolando: Fancies and Facts.*

William Dean Howells's story *Annie Kilburn.*

d. Robert Browning, English poet (b. 1812).

d. Gerard Manley Hopkins, English poet and Jesuit priest (b. 1844).

d. Wilkie Collins, novelist and playwright (b. 1824).

VISUAL ARTS

Vincent van Gogh's paintings included *The Starry Night, Self-Portrait with Pipe and Bandaged Ear, Pietà, Hospital Corridor at Saint-Rémy*, and *Green Corn.*

Pierre-Auguste Renoir's painting *Mount Sainte-Victoire.*

Paul Gauguin's paintings included *La Belle Angèle, Bonjour Monsieur Gauguin! The Yellow Christ*, and a *Self-Portrait.*

Georges Seurat's paintings included *A Young Woman Holding a Powder-puff* and *Le Chahut* (both 1889–1890).

Henri de Toulouse-Lautrec's painting *Monsieur Samary, de la Comédie-Française.*

Portrait of Thomas Eakins, Susan Eakins's painting (ca. 1889).

Thomas Eakins's paintings included *Miss Van Buren* (ca. 1889) and *The Agnew Clinic.*

George Browne Post began the New York Times Building and the Pulitzer Building.

Henri Rousseau's painting *The Present and the Past* (ca. 1889).

THEATER & VARIETY

Anton Chekhov's *The Wood-Demon* (*Leshy*), *The Proposal* (*Predlozheniye*), and *The Wedding* (*Svadba*).

William Gilbert and Arthur Sullivan's *The Gondoliers* opened in London on December 7.

Bronson Howard's *Shenandoah.*

Arthur Wing Pinero's *The Profligate.*

Frank Wedekind's *Die junge Welt.*

Georges Ancey's *L'École des veufs* and *Les Inséparables.*

Before Dawn (*Vor Sonnenaufgang*), Gerhart Hauptmann's first play.

Gerolamo Rovetta's *La trilogia di Dorina.*

d. Émile Augier, French playwright (b. 1820).

d. James Albery, English playwright (b. 1838).

d. Ludwig Anzengruber, Austrian playwright (b. 1839).

d. Paolo Ferrari, Italian playwright (b. 1822).

MUSIC & DANCE

John Philip Sousa's *The Washington Post*, one of the best known and most popular of all marches.

Edgar, Giacomo Puccini's opera, libretto by Ferdinando Fontana, based on Alfred de Musset's 1832 play *La Coupe et les Lèvres*, premiered in Milan.

Jakobín (The Jacobin), Antonín Dvořák's opera, libretto by Marie Cervinková-Riegrová, premiered in Prague on February 12.

Antonín Dvořák's *Symphony No. 8*.

The Talisman, Marius Petipa's ballet to music by Riccardo Drigo.

César Franck's *String Quartet*.

Oh Promise Me, perennial wedding song, words by Clement Scott, music by Reginald de Koven.

Don Juan, Richard Strauss's symphonic poem.

Giuseppe Verdi's choral work *Ave Maria*.

Jules Massenet's opera *Esclarmonde*.

Natalka-Poltavka, Mykola Vytal'yevych Lysenko's opera.

Down Went McGinty, Joseph Flynn's popular song.

Tuned sets of gongs, called *gamelan*, popular in Southeast Asia, played at the 1889 Paris World Exhibition, influencing Claude Debussy, among others.

The Auditorium, Chicago's second opera house, opened with a production of Charles Gounod's *Roméo et Juliette*.

WORLD EVENTS

Jane Addams and Ellen Gates founded Chicago's Hull House, generating the American settlement house movement.

Crown Prince Archduke Rudolf of Austria committed suicide at Mayerling.

Johnstown, Pennsylvania, flood.

Oklahoma Land Rush.

Washington became a state.

France took the Ivory Coast.

Socialist Second International was founded.

1890

LITERATURE

The Golden Bough, James George Frazer's seminal work on religion, magic, and folklore; originally two volumes, in 1915 expanded to 13, it was enormously influential, especially in the work of psychoanalyst C. G. Jung.

Thaïs, Anatole France's novel of the ascetic Paphnu-tius, a reformed débauché who converts the courtesan Thaïs to a religious life, but finds himself still powerfully attracted to her.

A Hazard of New Fortunes, William Dean Howells's novel about a nouveau riche family beginning a social climb.

Hunger (Sult), Knut Hamsun's first novel, which brought him wide literary success.

Alphonse Daudet's novel *Port-Tarascon*, one of his Provençal stories.

Guy de Maupassant's novel *Notre Coeur* and story *L'Inutile Beauté*.

Rudyard Kipling's novel *The Light That Failed*.

Henry James's novel *The Tragic Muse*.

La Bête humaine, Émile Zola's novel.

Anton Chekhov's short stories *Duel* and *Gusev*.

August Strindberg's novel *By the Open Sea*.

Robert Louis Stevenson's *Ballads*.

James Whitcomb Riley's *Rhymes of Childhood*.

John Greenleaf Whittier's poems *At Sundown*.

Leopoldo Alas y Ureña's novel *Su único hijo*.

Ogai Mori's novel *The Girl Who Danced*.

Thomas Bailey Aldrich's poems *Wyndham Towers*.

d. Richard Francis Burton, English explorer and writer (b. 1821).

VISUAL ARTS

Vincent van Gogh's paintings included *L'Arlésienne*, *Mademoiselle Gachet at the Piano*, *Old Man in Sorrow*, *Stairway at Auvers*, *The Church at Auvers*, and a *Self-Portrait*.

Paul Cézanne's paintings included *Bathers*, *Still Life with Basket of Apples*, *Still Life with Peppermint Bottle*, *Tulips and Apples* (all 1890–1894), and *The Card Players* (1890–1892).

Childe Hassam's painting *Washington Arch in Spring*.

Paul Gauguin's paintings included *La Perte du pucelage* (1890–1891) and *Marie Derrien*.

Georges Seurat's paintings included *The Circus* (1890–1891) and *The Channel at Gravelines, Evening*.

How the Other Half Lives, photos and text by Jacob A. Riis.

John Singer Sargent began the Boston Public Library murals (1890–1910).

Henri Rousseau's paintings included *L'Octroi* (ca. 1890) and *Myself: Portrait-Landscape*.

John Twachtman's paintings *Snowbound* (ca.

1890–1900) and *Meadow Flowers* (ca. 1890–1892).

Louis Sullivan began the Wainwright Building, St. Louis (1890–1891).

Park Bench, William Merritt Chase's painting.

A Cavalryman's Breakfast on the Plains, Frederic Remington's painting.

Breaking Home Ties, Thomas Hovenden's painting.

Ferdinand Hodler's painting *Night*.

Signal of Peace, Cyrus Edwin Dallin's sculpture.

Richard Morris Hunt began the George Vanderbilt house, Biltmore, North Carolina.

d. Vincent van Gogh, Dutch painter (b. 1853).

THEATER & VARIETY

August Strindberg's plays *Master Olof* and *Creditörer*.

Richard Mansfield opened in the title role of Clyde Fitch's *Beau Brummell*, at New York's Madison Square Theatre on May 19.

Arthur Wing Pinero's *The Cabinet Minister*.

Joseph Arthur's *Blue Jeans* opened in New York.

The Coming of Peace, Gerhart Hauptmann's play.

Augustin Daly's *The Last Word*.

Men and Women, David Belasco and Henry C. de Mille's play, opened in New York.

d. Dion Boucicault (born Dionysius Lardner Boursiquot), Irish playwright and actor–manager (b. 1820).

d. George Henry Boker, American playwright (b. 1823), best remembered for his play *Francesca da Rimini*.

d. Eduard von Bauernfeld, Austrian playwright (b. 1802).

MUSIC & DANCE

The Sleeping Beauty, Marius Petipa's ballet, music by Peter Ilich Tchaikovsky, first danced January 13 at the Maryinsky Theatre, St. Petersburg.

Cavalleria rusticana, Pietro Mascagni's opera, libretto by Guido Menasci and Giovanni Targioni-Tozzeatti, based on Giovanni Verga's 1884 play from his own story, opened in Rome.

Prince Igor, Alexander Borodin's opera, libretto by Borodin from an outline by Vladimir Stasov, opened in St. Petersburg. The work was finished by Nicolai Rimsky-Korsakov and Alexander Glazunov after the composer's death (1887).

The Queen of Spades (*Pikovaya Dama*), Peter Ilich Tchaikovsky's opera, libretto by the composer and his brother, Modest Tchaikovsky, based on Pushkin's 1834 story, opened in St. Petersburg.

Anton Bruckner's revision of his *Symphony No. 1*, the "Vienna" version (1890–1891).

Claude Debussy's piano work *Clair de lune*, in the *Suite bergamasque* (1890–1905).

Taras Bul'ba, Mykola Lysenko's epic opera.

Johannes Brahms's second string quintet.

Souvenir de Florence, Peter Ilich Tchaikovsky's chamber music.

Little Annie Rooney, Michael Nolan's popular song.

Robin Hood, Reginald De Koven's opera.

Camille Saint-Saëns's *Ascanio*, dramatic musical work.

Carl Nielsen's third string quartet.

Antonín Dvořák's *Requiem Mass*.

Edward MacDowell's *Six Love Songs*.

Erik Satie's *3 Gnossiennes*, for piano.

L'allegro ed il penseroso, Hubert Parry's cantata.

Appalachian dulcimer at height of popularity in America (ca. 1890s).

d. César Franck, Belgian-French composer (b. 1822).

d. Niels Gade, Danish composer (b. 1817).

WORLD EVENTS

Sioux villagers were massacred by U.S. forces at Wounded Knee, during the Ghost Dance War.

First U.S. antitrust law, the Sherman Act.

Daughters of the American Revolution founded.

Wyoming became a state.

William James's *The Principles of Psychology*.

1891

LITERATURE

d. Herman Melville, American writer (b. 1891). Left at his death was one of his finest short novels, *Billy Budd, Foretopman* (written ca. 1887–1891 but not published until 1924); also his poem *Timoleon*.

Tess of the D'Urbervilles; A Pure Woman, Thomas Hardy's novel of an innocent entangled in the sexual hypocrisies of the men around her.

Ambrose Bierce's *Tales of Soldiers and Civilians*, later known as *In the Midst of Life* (1892; 1898), including some of his best-known tales, *An Occurrence at Owl Creek Bridge*, *The Eyes of the Panther*, and *A Horseman in the Sky*.

The Picture of Dorian Gray, Oscar Wilde's novel about a youth whose portrait shows the degeneracy into which he has been led.

New Grub Street, George Gissing's novel on the new urban poverty.

Main-Travelled Roads, Hamlin Garland's first collection of short stories and sketches, including *Under the Lion's Paw*.

José Martí's essay *Nuestra América* and his collection of poems *Versos sencillos*.

Gösta Berling's Saga: the Selma Lagerlöf novel; basis of the 1921 Mauritz Stiller film.

Joachim María Machado de Assis's poem *Epitaph for a Small Winner*; also his *Quincas borba*.

Paul Verlaine's poems *Bonheur* and *Chansons pour elle*.

Émile Zola's novel *L'Argent*.

Peter Ibbetson, George du Maurier's novel.

Walt Whitman's final collection of poems and prose, *Good-Bye My Fancy*.

Victor Hugo's poems *Dieu*.

George Meredith's novel *One of Our Conquerors*.

Rudyard Kipling's *Life's Handicap*.

Pages, Stéphane Mallarmé's verse and prose.

An Comunn Gaidhealach (The Highland Association) founded to foster the Gaelic language and culture, and the Scottish lifestyle in general.

d. Arthur Rimbaud, French poet (b. 1854).

d. James Russell Lowell, American writer (b. 1819).

d. Pedro Antonio de Alarcón, Spanish novelist (b. 1833).

VISUAL ARTS

Henri de Toulouse-Lautrec's paintings included *At the Moulin de la Galette*, *La Goulue at the Moulin Rouge*, *At the Nouveau Cirque*, *Five Stuffed Shirts*, and *À la mie*; and the poster *Moulin Rouge—La Goulue*.

Paul Gauguin's paintings included *Street in Tahiti*, *Femmes de Tahiti ou sur la plage*, *Ia Orana Maria*, *Reverie*, and *Suzanne Bambridge*.

Aubrey Beardsley's illustrations for the *Morte d'Arthur* (1891–1892).

Claude Monet's painting *Two Haystacks*.

Winslow Homer's painting *Huntsman and Dogs*.

Georges Rouault's painting *The Road to Calvary*.

Maua, Our Boatman, John La Farge's painting.

Daniel Chester French's sculpture *The Angel of Death and the Sculptor*.

Thomas Eakins's painting *Professor Henry A. Rowland*.

Henry Ward Beecher, John Quincy Adams Ward's statue, at Borough Hall, Brooklyn.

Louis Sullivan began Chicago's Schiller Building (1891–1892).

d. Georges Seurat, French painter (b. 1859).

THEATER & VARIETY

Anton Chekhov's play *The Anniversary* (*Yubiley*).

Frank Wedekind's *Frühlings Erwachen*.

Gerhart Hauptmann's play *Lonely Lives* (*Einsame Menschen*).

Frau Conrad-Ramlo opened in the title role of Henrik Ibsen's *Hedda Gabler* in Munich.

The Americans, Henry James's play, an adaptation of his own 1877 novel.

The Lost Paradise, Henry C. de Mille's play, opened at Proctor's 23rd Street Theatre, New York.

James A. Herne's *Margaret Fleming* opened at New York's Palmer's Theatre on December 9.

Mavourneen, George H. Jessop and Horace Townsend's play, opened in New York.

Oscar Wilde's *The Duchess of Padua*.

Robin Hood, music by Reginald De Koven and libretto by Harry B. Smith, opened in New York.

Sickness of Youth, Ferdinand Bruckner's play.

The Awakening of Spring, Frank Wedekind's play.

A *Trip to Chinatown*, music by Percy Gaunt, book and lyrics by Charles H. Hoyt, opened in New York.

De Wolf Hopper opened at New York's Broadway Theatre in the Woolson Morse–J. Cheever Goodwin musical *Wang*.

d. P(hineas) T(aylor) Barnum, American showman (b. 1810).

MUSIC & DANCE

Kalkabrino, Marius Petipa's ballet to music by Ludwig Minkus, libretto by Modest Tchaikovsky, premiered at the Maryinsky Theatre, St. Petersburg.

L'amico Fritz, Pietro Mascagni's opera, libretto by P. Suardon (Nicolo Daspuro), opened in Rome.

Antonín Dvořák's overtures *Carnival* and *In Nature's Realm* (*V přérode*); also his second piano trio, the *Dumky*.

Edward MacDowell's *Orchestral Suite No. 1* and

Sonata tragica for piano (1891–1892).

Johannes Brahms's *Clarinet Quintet* and his fifth and final piano trio.

Sergei Rachmaninoff's *Piano Concerto No. 1*.

Condor, Carlos Gomes's final opera, staged in Milan.

Ta-Ra-Ra-Boom-De-Ay, Henry J. Sayers's popular song.

David Popper's *Requiem* for three cellos and orchestra.

Salut drapeau! Erik Satie's song.

New York's Carnegie Hall was built.

Chicago Symphony Orchestra formed.

Central Council of Bell Ringers founded.

d. Léo Delibes, French composer (b. 1836).

WORLD EVENTS

Building of Trans-Siberian Railway began.

Chilean President José Manuel Balmaceda was overthrown by an army-led insurrection.

U.S. Populist party was founded.

Britain took Nyasaland.

University of Chicago founded.

1892

LITERATURE

Barrack-Room Ballads, Rudyard Kipling's second volume of poems, including popular favorites *Fuzzy Wuzzy*, *The Road to Mandalay*, *If*, *Tommy*, and especially *Gunga Din*.

Maxim Gorky's first published story, *Makar Chudra*.

Anton Chekhov's short stories *Palata No. 6 (Ward No. 6)*, *Poprygunya (The Grasshopper)*, *Sosedi (Neighbors)*, and *Strakh (Terror)*.

George Meredith's *Poems. The Empty Purse. With Odes to the Comic Spirit, to Youth in Memory, and Verses*.

Mysteries, Knut Hamsun's novel examining unconscious motivation.

Henry James's story *The Lesson of the Master*.

Mark Twain's novel *The American Claimant*.

Émile Zola's novel *La Débâcle*.

Robert Louis Stevenson's *Across the Plains*.

Alfred, Lord Tennyson's *The Death of Oenone, Akbar's Dream, and Other Poems*.

Stendhal's *Souvenirs d'égotisme (Memoirs of an Egotist)*, prose.

Ambrose Bierce's poems *Black Beetles in Amber*.

Benito Pérez Galdós's novel *Realidad (Reality)*.

Paul Verlaine's poems *Liturgies intimes*.

Alphonse Daudet's novel *Rose et Ninette*.

d. Walt Whitman, American writer (b. 1819).

d. Alfred, Lord Tennyson, English poet (b. 1809).

d. John Greenleaf Whittier, American poet (b. 1807).

VISUAL ARTS

Henri de Toulouse-Lautrec's works included the paintings *At the Moulin Rouge, Jane Avril dansant, Jane Avril Leaving the Moulin Rouge*, and *Quadrille at the Moulin Rouge*; and the posters *Le Divan Japonais* and *Reine de Joie*.

Paul Gauguin's paintings included *Manao Tupapau, When Shall We Be Married?* and *The Market*.

Edvard Munch's paintings included *Evening on Karl Johan Street* and *Inger Munch*.

Winslow Homer's paintings included *Adirondacks* and *After the Hunt*.

Pierre-Auguste Renoir's paintings included *Bather* and *Young Girl Reading*.

Mary Cassatt's painting *The Bath*.

Thomas Eakins's painting *The Concert Singer*.

Alfred Gilbert began his tomb of the Duke of Clarence (1892–1926).

Diana, Augustus Saint-Gaudens's sculpture.

Pierre Bonnard's painting *The Croquet Game*.

Topkapi Saray, the 15th-century Byzantine-Turkish Palace in Istanbul, opened as a museum.

d. Alexander Jackson Davis, American architect (b. 1803).

THEATER & VARIETY

Lady Windermere's Fan, Oscar Wilde's play, opened in London February 20 at the St. James Theatre.

George Bernard Shaw's first play, *Widowers' Houses*.

Pelléas and Melisand, Maurice Maeterlinck's play; basis of the 1902 Claude Debussy opera.

The Countess Cathleen, William Butler Yeats's play.

James M. Barrie's first play *Walker*.

Alfred, Lord Tennyson's play *The Foresters*.

Charley's Aunt, Brandon Thomas's play, opened in London on December 21.

Jacob Gordin's *The Jewish King Lear*.

Georges-Léon-Jules-Marie Feydeau's *Le Système Ribadier*.

Gerhart Hauptmann's plays *College Crampton* and *The Weavers* (*Die Weber*).

MUSIC & DANCE

The Nutcracker, perennially favored children's holiday season ballet, choreographed by Lev Ivanov, music by Peter Ilich Tchaikovsky opera, libretto by Marius Petipa, first danced December 17 at the Maryinsky Theater, St. Petersburg.

Pagliacci (*Clowns*), Ruggiero Leoncavallo's opera, libretto by Leoncavallo, premiered in Milan.

Werther, Jules Massenet's opera, libretto by Edouard Blau, Paul Milliet, and Georges Harmann, based on Johann Wolfgang von Goethe's 1774 novel, opened at the Vienna Opera, February 16.

Iolanta, Peter Ilich Tchaikovsky's final opera, libretto by Modest Tchaikovsky, opened in St. Petersburg.

Sergei Rachmaninoff's *Prelude in C Sharp Minor* and *Five Pieces for Piano*.

En Saga, Jean Sibelius's symphonic tone poem; also his *Kullervo Symphony*.

Claude Debussy's songs *Proses lyriques* (1892–1893) and *Fêtes galantes*, with texts by Verlaine (1892; 1904).

John Philip Sousa formed Sousa's Band, which performed under his direction until 1931.

After the Ball, Charles K. Harris's popular song.

Anton Bruckner's cantata *Das deutsche Lied* and *Psalm CL*.

Antonín Dvořák's overture *Othello* and choral work *Te Deum*.

Daisy Bell (*A Bicycle Made for Two*), Harry Dacre's popular song.

Carl Nielsen's *Symphony No. 1*.

Frederick Delius's opera *Irmelin*.

The Man Who Broke the Bank at Monte Carlo, Fred Gilbert's comic song.

Ignacy Jan Paderewski's opera *Manru* (1892–1901).

The Sweetest Story Ever Told (*Tell Me, Do You Love Me*), R. M. Stults's popular song.

Josef Suk's *Serenade for strings*.

The Bowery, popular song with words by Charles H. Hoyt and music by Percy Gaunt.

Saul of Tarsus, Joseph Parry's oratorio.

d. Hervé (Florimond Hervé Ronger), French composer, singer and conductor (b. 1825).

d. Patrick S. Gilmore, Irish-American bandmaster and impresario (b. 1829).

d. Antonio de Torres Jurado, Spanish guitar designer and maker (b. 1817), who developed the form of the modern guitar.

WORLD EVENTS

Grover Cleveland was elected U.S. president.

Anarchist Alexander Berkman tried but failed to assassinate Carnegie Steel Corporation head Henry Clay Frick.

Ellis Island immigration station was opened; it was consumed by fire the next day.

Failed Homestead Steel Strike.

Standard Oil of Ohio was adjudged an illegal trust, and was ordered to dissolve by the U.S. courts.

France completed its conquest of Dahomey.

1893

LITERATURE

Maggie: A Girl of the Streets, Stephen Crane's dark tale of a girl doomed by her slum environment, regarded as the first realistic American novel; printed privately, it was only widely published in 1896.

Francis Thompson's *Poems*, including *The Hound of Heaven*, his most famous work, the "autobiography" of a person feeling the love of God.

McClure's began publication in the United States; it would become a major reform publication, noted for its muckraking articles (1893–1929).

Tolbert Lanston developed the *Monotype* machine to set and cast individual letters in a line; it was first exhibited at the Chicago World Fair.

Woman, Church, and State, Matilda Gage's feminist analysis of their interrelationships.

Henry James's *The Real Thing and Other Tales*; also his story *The Private Life* and *Picture and Text*.

The Lake Isle of Innisfree, William Butler Yeats's poem.

Mark Twain's *The £1,000,000 Bank-Note and Other New Stories*.

Robert Louis Stevenson's novel *Catriona*, a sequel to *Kidnapped*.

Benito Pérez Galdós's novel *The Madwoman of the House* (*La loca de la casa*).

Rabindranath Tagore's poems *Morning Songs*.

Paul Verlaine's *Odes en son honneur*.

Anton Chekhov's short story *Zhena (The Wife)*.

B. R. Rajam Ayyar's novel *Kamalambal, or the Fatal Rumour* (1893–1895).

Bliss Carman's *Low Tide on Grand Pré: A Book of Lyrics*.

Stéphane Mallarmé's *Vers et prose*.

Christina Rossetti's *Verses*.

Émile Zola's novel *Le Docteur Pascal*.

James Whitcomb Riley's *Poems Here at Home*.

Rudyard Kipling's *Many Inventions*.

Theodor Fontane's novel *Frau Jenny Treibel*.

Juhani Aho's novel *Papin rouva*.

Gaelic League founded, fighting for use of Irish language in Ireland.

d. Guy de Maupassant, French writer (b. 1850).

d. Ignacio Manuel Altamirano, Mexican novelist and poet (b. 1834).

d. Charles Sangster, Canadian poet (b. 1822).

d. Francis Parkman, American writer (b. 1823).

VISUAL ARTS

Frank Lloyd Wright started the Winslow House, River Forest, Illinois.

Richard Morris Hunt began the John Jacob Astor house, New York City, and the Breakers, the Cornelius Vanderbilt house in Newport, Rhode Island (1893–1895).

Edvard Munch's paintings included *The Cry* and *Vampire* (1893–1894).

Henri de Toulouse-Lautrec's work included the painting *Portrait of L. Delaporte* and the poster *Aristide Bruant dans son cabaret*.

Robert Henri's painting *Girl Seated by the Sea*.

Georges Rouault's painting *The Ordeal of Samson*.

Frederick Macmonnies's sculpture *The Ship of the Republic*.

Henri Rousseau's painting *The Artillerymen* (ca. 1893).

Daniel Chester French's statue of the *Republic* at Chicago's Columbian Exposition.

Auguste Rodin's sculpture *Balzac, Nude*.

Paul Gauguin's painting *Hina Tefatou*.

Primavera, Herbert Adams's sculpture.

Louis Sullivan designed the Transportation Building for Chicago's Columbian Exposition.

Thomas Hovenden's painting *Breaking Home Ties*.

d. Ford Madox Brown, English painter (b. 1821).

THEATER & VARIETY

Emanuel Reicher opened in Berlin on January 19 in the title role of Henrik Ibsen's *The Master Builder*.

Mrs. Warren's Profession, George Bernard Shaw's play.

A Woman of No Importance, Oscar Wilde's play, opened in London on April 19.

The Second Mrs. Tanqueray, Arthur Wing Pinero's play, opened in London with Mrs. Patrick Campbell in the title role; also opening that year was his play *The Amazons*.

Henry Irving opened at the Lyceum in the title role and produced *Becket*, by Alfred, Lord Tennyson.

The Girl I Left Behind Me, David Belasco's play opened at New York's Empire Theatre.

Madame Sans-Gène, Victorien Sardou's play, with Gabrielle Réjane starring in her first major role.

William Gilbert and Arthur Sullivan's musical *Utopia Limited*.

d. Edwin Thomas Booth, outstanding tragedian (b. 1833), and founder of the Players Club in New York (1888), to which he donated his Gramercy Park home; son of Junius Brutus Booth, Sr., and brother of John Wilkes Booth and Junius Brutus Booth, Jr, all also actors.

d. Georgiana Drew, American actress (b. 1856), on stage from 1872 in her mother's company; she was married to actor Maurice Barrymore, and was the mother of actors John, Ethel, and Lionel Barrymore.

d. Fanny (Francis Anne) Kemble, English actress (b. 1809), daughter of actor–manager Charles Kemble and actress Maria De Camp; she entered the theater in 1829 to save her father's Covent Garden management from bankruptcy, later starring in Britain and the United States.

d. Kawatake Mokuami, Japanese playwright (b. 1816), who wrote more than 50 plays for the *kabuki* theater, helping to move kabuki toward the more melodramatic modern forms and away from its classical roots.

MUSIC & DANCE

Manon Lescaut, Giacomo Puccini's opera, libretto by Marco Praga, Domenico Oliva, and Luigi Illica, based on Abbé Prévost's 1731 novel *L'Histoire du Chevalier des Grieux et de Manon Lescaut*, premiered in Turin February 1.

Falstaff, Giuseppe Verdi's opera, libretto by Arrigo Boito, based on Shakespeare's character from *Henry IV* (1597–1598) and *The Merry Wives of Windsor* (1600), premiered in Milan.

Hänsel und Gretel, Engelbert Humperdinck's opera; libretto by Adelheid Wette, based on a story from the Grimm brothers' folktale collection (1812–1814), opened at the Hoftheater, Vienna, December 23.

Antonín Dvořák's *Symphony No. 9* (*From the New World*); his string quartet, the *American*; a string quintet, and his choral work *The American Flag*, all written during his American stay.

Jean Sibelius's symphonic tone poems *Four Legends* and *The Swan of Tuonela*; his *Karelia Suite*; and his *Sonata in F Major*.

Sergei Rachmaninoff's *Aleko*, opera, libretto by Vladimir Nemirovich-Danchenko, based on Aleksandr Pushkin 1831 poem *The Gypsies*.

Sergei Rachmaninoff's *Suite No. 1* for two pianos; *Trio Elegiaque*; his orchestral work *The Rock*; and some of his over 70 songs (1893–1916).

Katherine Lee Bates's patriotic hymn *America the Beautiful*; informally, a second national anthem.

Peter Ilich Tchaikovsky's *Piano Concerto No. 3* and *Symphony No. 6*, the *Pathétique*.

Helgoland, Anton Bruckner's cantata.

Claude Debussy's *String Quartet*.

Say "Au Revoir," But Not "Good-Bye," Harry Kennedy's popular song.

Edward MacDowell's *Eight Songs*.

Erik Satie's *Vexations* for piano (ca. 1893).

The Cat Came Back, Harry S. Miller's popular novelty song.

Sidney Jones's operetta *A Gaiety Girl*.

d. Peter Ilich Tchaikovsky, Russian composer (b. 1840).

d. Charles Gounod, French composer (b. 1818).

d. Ferenc Erkel, Hungarian composer, conductor, and pianist (b. 1810).

WORLD EVENTS

Eugene V. Debs organized the American Railway Union, the first major U.S. industrial union.

Britain's Independent Labour party was founded; a forerunner of the Labour party.

Elizabeth Cabot Agassiz cofounded and became first president of Radcliffe College.

Women won the vote in New Zealand.

Italian forces in Eritrea defeated invading Sudanese forces.

Failed insurrection against British rule by Matabeles in Rhodesia (now Zimbabwe).

Italian forces in Eritrea defeated invading Sudanese forces.

Columbian Exposition (World's Fair) in Chicago.

1894

LITERATURE

First of Sholem Aleichem's *Tevye the Dairyman* stories, set in an Eastern European Jewish farming village (1894–1899); basis for the 1964 Broadway musical *Fiddler on the Roof*.

The Prisoner of Zenda, Anthony Hope Hawkins's adventure novel in which Englishman Rudolf Rassendyl saves the crown of Ruritania by impersonating its look-alike king.

Rudyard Kipling's *The Jungle Book*, introducing the Indian boy Mowgli, raised by wolves.

Trilby, George du Maurier's novel of a young singer who comes under the power of a sinister musician, Svengali.

A Traveler from Altruria, William Dean Howells's novel consisting of conversations in which Aristides Homos compares American society with that of the utopian Altruria.

Yellow Book, a short-lived illustrated quarterly, began publication; it would include work from Aubrey Beardsley, Henry James, Max Beerbohm, and Edmund Gosse.

Rainer Maria Rilke's poems *Leben und Lieder*, *Bilder und Tagebuchblätter*.

Mark Twain's novels *The Tragedy of Pudd'nhead Wilson* and *Tom Sawyer Abroad*.

Anatole France's novels *Le lys rouge* and *The Garden of Epicurus*.

Homeward: Songs by the Way, poems by George William Russell (A.E.).

George Santayana's *Sonnets and Other Verses*.

Lafcadio Hearn's *Glimpses of Unfamiliar Japan*.

George Meredith's novel *Lord Ormont and His Aminta*.

Maxim Gorky's short story *Goremkya Pavel* (*Orphan Paul*).

Pan, Knut Hamsun's novel.

Algernon Charles Swinburne's poems *Astrophel*.

Émile Zola's novel *Lourdes*.

George Moore's novel *Esther Waters*.

Gertrude Atherton's novel *Before the Gringo Came*.

Kate Chopin's *Bayou Folk*.

Mary Hallock Foote's novel *Coeur d'Alene*.

d. Robert Louis Stevenson, Scottish writer (b. 1850).

d. Bankimchandra Chatterji, Bengali novelist (b. 1838).

d. Oliver Wendell Holmes, American writer (b. 1809).

d. Christina Georgina Rossetti, English poet (b. 1830).

d. Walter Pater, English essayist and critic (b. 1839).

VISUAL ARTS

Aubrey Beardsley's illustrations for Oscar Wilde's *Salome*, including *Toilette of Salome*; and his illustrations for the first volume of *The Yellow Book*.

Autumn Landscape, George Inness's painting.

Claude Monet's painting *Rouen Cathedral, Sunset*.

Henri de Toulouse-Lautrec's works included the paintings *Au Salon de la Rue des Moulins, Femme tirant son bas, ou femme de maison* (ca. 1894), and *Le Docteur Tapié de Céleyran dans un couloir de théâtre*; and the poster *Confetti*.

Bernard Berenson's book *Venetian Painters of the Renaissance*.

Paul Cézanne's painting *Rocks at Fontainebleau* (1894–1898).

Berthe Morisot and Her Daughter, Pierre-Auguste Renoir's painting.

Edvard Munch's paintings included *Ashes* and *Puberty*.

Thomas Eakins's painting *Frank Hamilton Cushing* (1894–1895).

William Merritt Chase's paintings *Idle Hours* and *Portrait of Virginia Gerson*.

Singing Boys, Herbert Adams's relief sculpture.

Ferdinand Hodler's paintings *Eurhythmics* (1894–1895) and *The Disappointed*.

Gustav Klimt began his ultimately unfinished Art Nouveau murals at the University of Vienna.

Struggle of the Two Natures in Man, George Grey Barnard's sculpture.

Henri Rousseau's painting *War*.

Louis Sullivan began Buffalo's Guaranty Building (1894–1895).

d. George Inness, American painter (b. 1825).

d. Chauncey Bradley Ives, American sculptor (b. 1810).

THEATER & VARIETY

George Bernard Shaw's play *Arms and the Man*; he also wrote *The Devil's Disciple*.

The Land of Heart's Desire, William Butler Yeats's play.

Too Much Johnson, William Gillette's comedy, opened at New York's Standard Theatre.

Henry James's *Theatricals*, consisting of two comedies *Tenants* and *Disengaged*, and *Theatricals: Second Series*, including *The Album* and *The Reprobate*.

Holger Henrik Herholdt Drachmann's plays *Renaessance* and *Wayland the Smith*.

James M. Barrie's *The Professor's Love Story*.

Angel Guimerà's *Maria Rosa*.

The Passing Show, George Lederer's revue, opened at New York's Casino Theatre on May 12.

Edmond Rostand's *Les Romanesques*.

Gerhart Hauptmann's *Hannele* (*The Assumption of Hannele*).

Enrico Butti's *L'Utopia*.

Giuseppe Giacosa's *The Rights of the Soul*.

Gunnar Edvard Rode Heiberg's *The Balcony*.

d. (James Morrison) Steele MacKay, American actor, playwright, and theater designer (b. 1842), one of the most important innovators in the 19th-century American theater; founder of the American Academy of Dramatic Art.

MUSIC & DANCE

Thaïs, Jules Massenet's opera, libretto by Louis Gallet, based on Anatole France's 1890 novel, opened at the Opéra, Paris, March 16; Sybil Sanderson created the title role.

Prélude à l'après-midi d'un faune, Claude Debussy's orchestral work, based on Stéphane Mallarmé's 1876 poem; itself the basis for Vasav Nijinsky's 1912 ballet *L'après-midi d'un faune*.

Marie Dressler sang *Heaven Will Protect the Working Girl* in *Tilly's Nightmare*.

Antonín Dvorák's piano duet *From the Bohemian Woods* (*Ze ˘Sumavy*) and *Eight Humoresques* for piano.

I Don't Want to Play in Your Yard, popular song, words by Philip Wingate, music by H. W. Petrie.

Johannes Brahms's two sonatas for clarinet and viola.

Gustav Mahler's *Symphony No. 2*, the *Resurrection*.

The Sidewalks of New York (East Side, West Side), Charles B. Lawlor and James W. Blake's song.

Richard Strauss's opera *Guntram*.

The Beginning of a Romance, Leoš Janáček's opera.

La Bonne Chansone, Gabriel Fauré's song cycle.

Sergei Rachmaninoff's *Capriccio on Gypsy Themes*, for orchestra.

Vasily Sergeievich Kalinnikov's *First Symphony* (1894–1895).

d. Anton Rubinstein, Russian pianist, composer and teacher (b. 1829).

d. Adolphe (Antoine Joseph) Sax, inventor of saxophones and saxhorns (b. 1814).

WORLD EVENTS

Chinese Republican leader Sun Yat-sen founded the Revive China Society in Hawaii, a step on the road to the Chinese Revolution of 1911.

Eugene V. Debs led the failed Pullman Strike; the union was destroyed, and he was jailed after the strike, becoming a Socialist while in prison.

Japan attacked China, and took Korea, Taiwan, and other Chinese territories (1894–1895).

Massacres of Armenians began in Turkey (1894–1896).

"Mahatma" Gandhi organized the Natal Indian Congress.

1895

LITERATURE

The Red Badge of Courage: An Episode of the American Civil War, Stephen Crane's classic antiwar novel; also his *The Black Riders and Other Lines*.

The Time Machine, H. G. Wells's science fiction novel, with a time traveler witnessing society's future degradation; also Wells's novel *The Wonderful Visit* and *The Stolen Bacillus and Other Stories*.

Quo Vadis, Henryk Sinkiewicz's novels of early Christians in Rome; basis of the films.

The Women's Bible, women's rights leader Elizabeth Cady Stanton's feminist interpretation of the Bible (1895–1898).

Anton Chekhov's short stories *Ariadna (Ariadne)*, *Tri goda (Three Years)*, and *Ubiystvo (The Murder)*.

Maxim Gorky's short stories *Chelkash* and *Starukha Izergil (The Old Woman Izergil)*.

Robert Louis Stevenson's travel writings *The Amateur Emigrant*.

Almayer's Folly, Joseph Conrad's first novel.

Lafcadio Hearn's stories *Out of the East*.

Theodor Fontane's best-known realistic novel *Effi Briest*.

Jude the Obscure, Thomas Hardy's novel.

Alphonse Daudet's novel *La Petite Paroisse*.

Benito Pérez Galdós's novel *Nazarín*.

George Meredith's novel *The Amazing Marriage*.

The Mayflower, Vicente Blasco Ibañez's novel.

Mark Twain's novel *Personal Recollections of Joan of Arc*.

Rudyard Kipling's short stories *The Second Jungle Book*.

Svatopluk Cech's poems *Pisen otroka*.

d. Frederick Douglass, American lecturer, former slave (b. 1817).

d. José Martí, Cuban poet and essayist (b. 1853).

d. Camilo Castelo Branco, Portuguese novelist (b. 1825).

d. Viktor Rydberg, Swedish poet and novelist (b. 1828).

VISUAL ARTS

Paul Cézanne's paintings included *Still Life with Apples and Oranges* (1895–1900), *Still Life with Cupid*, *Still Life with Onions and Bottle* (1895–1900), *The Clockmaker* (ca. 1895–1900), and *Women Bathers* (1895–1900).

The Red Bridge, Julian Alden Weir's painting.

Winslow Homer's painting *Northeaster*.

Shinnecock Hill, William Merritt Chase's painting.

Cinematograph invented by Auguste and Louis Lumière, basis for the movies.

Edvard Munch's paintings included *In Hell*, *Self-Portrait* (ca. 1895), *Jealousy*, and *Self-Portrait with a Cigarette*.

Henri de Toulouse-Lautrec's paintings included *Chilpéric* (1895–1896), *La Clownesse Cha-U-Kao*, *La Danse de la Goulue, ou les Almées*, *May Belfort*, and *Women in a Brothel*.

Pierre-Auguste Renoir's painting *After the Bath* (ca. 1895).

Pablo Picasso's *Girl with Bare Feet*.

Frederic Remington's work included the sculpture *The Bronco-Buster* and the painting *The Fight for the Waterhole* (ca. 1895–1900).

Henri Rousseau's painting *The Child Among Rocks* (ca. 1895).

Pierre Bonnard's work included the painting *Street Scene with Two Dogs* and the lithograph *Quelques aspects de la vie de Paris*.

d. Berthe Morisot, French painter (b. 1841).

d. Richard Morris Hunt, American architect (b. 1827).

d. James M. Ives, American lithographer (b. 1824).

d. James Renwick, English-American architect and engineer (b. 1818).

d. Thomas Hovenden, American painter (b. 1840).

THEATER & VARIETY

Oscar Wilde's *An Ideal Husband* opened in London on January 3; his *The Importance of Being Earnest* opened in London on February 14. His *Salome* was privately shown but publicly banned in Britain, and publicly shown in France in 1896.

Henrik Ibsen's play *Little Eyolf* opened in Berlin.

Maurice Barrymore and Mrs. Leslie Carter starred in David Belasco's *The Heart of Maryland*, opening at New York's Herald Square Theatre.

Trilby, Paul M. Potter's play based on George du Maurier's 1894 novel, opened in New York.

George Alexander opened at New York's Lyceum Theatre on September 4, in the double starring roles in Edward E. Rose's *The Prisoner of Zenda*; based on Anthony Hope Hawkins's 1894 novel.

Arthur Wing Pinero's *The Notorious Mrs. Ebbsmith*.

d. Alexandre Dumas (*fils*), French playwright and novelist (b. 1824), son of Alexandre Dumas (*père*). His first and by far his best-known play, *La Dame aux camèlias* (*Camille*) was based on his own novel.

MUSIC & DANCE

Swan Lake, ballet to Peter Ilich Tchaikovsky's music from the 1877 Wenzel Reisinger ballet, with new choreography by Marius Petipa (acts 1 and 3) and Lev Ivanov (acts 2 and 4), first danced January 27, at the Maryinsky Theatre, St. Petersburg.

Richard Strauss's *Til Eulenspiegel's Merry Pranks* (*Till Eulenspiegels lustige Streiche*).

Inauguration of the Promenade Concerts, or Proms, informal summer concerts held annually in London; conducted until 1944 by Henry Wood, and then named after him.

Edward MacDowell's *Orchestral Suite No. 2*, the *Indian*, and his *Sonata eroica* for piano.

El Capitan, John Philip Sousa's operetta, including the popular march of the same name.

The Magic Fountain, Frederick Delius's dramatic work, later performed on radio, but not staged.

The Band Played On, popular song, music by Charles B. Ward, words by John F. Palmer.

Sergei Rachmaninoff's *Symphony No. 1*.

Carl Nielsen's first violin sonata.

Haugtussa, Edvard Grieg's song cycle.

Messe des pauvres, Erik Satie's choral work.

WORLD EVENTS

Cuban War of Independence from Spain began (1895–1898).

French closed court martial unjustly convicted and imprisoned Alfred Dreyfus for Treason.

Sun Yat-sen made a first, failed attempt to organize a Chinese revolution, in Canton.

Lenin became an active member of the Russian Social-Democratic party, and was exiled to Siberia (1895–1900).

Oscar Wilde brought an unsuccessful libel action against the Marquess of Queensberry and in a sensational trial was found guilty of homosexuality charges.

London School of Economics and Political Science was founded.

Anti-Saloon League of America founded.

1896

LITERATURE

A Shropshire Lad, A. E. Housman's main poetic volume, primarily lyrics of youth and love in the English countryside.

An Outcast of the Islands, Joseph Conrad's novel of a European "gone native," involving previous lives of characters introduced in *Almayer's Folly* (1895); basis of the 1951 Carol Reed film.

Edwin Arlington Robinson's *The Torrent and the Night Before*; his first poetry collection.

Stephen Crane's short stories *The Little Regiment, and Other Episodes of the American Civil War*, short stories.

Anton Chekhov's short stories *Dom s mezoninom (An Artist's Story)* and *Moya zhizn (My Life)*.

H. G. Wells's novel *The Island of Doctor Moreau*.

Harold Frederic's novel *The Damnation of Theron Ware*.

Henry James's novel *The Other House* and story *Embarrassments*.

Thomas Bailey Aldrich's poems *Judith and Holofernes*.

Stephen Crane's novel *George's Mother*.

Paul Laurence Dunbar's *Lyrics of Lowly Life*.

Algernon Charles Swinburne's poems *A Tale of Balen*.

Mark Twain's novel *Tom Sawyer, Detective*.

Paul Valéry's essays *The Evening with Mr. Teste*.

Émile Zola's novel *Rome*.

Alphonse Daudet's novels *L'Enterrement d'une étoile* and *La Fédor*.

Christina Rossetti's *New Poems*.

Benito Pérez Galdós's novel *Doña Perfecta*.

George Santayana's *The Sense of Beauty*.

Robert Louis Stevenson's *Songs of Travel and Other Verses*.

James Lane Allen's novel *A Summer in Arcady*.

Paul Verlaine's poetry *Chair, dernières poésies* and *Invectives*.

Rainer Maria Rilke's poems *Larenopfer*; also *Wegwarten*.

Rudyard Kipling's poems *The Seven Seas*.

Sarah Orne Jewett's *The Country of the Pointed Firs*, sketches.

The Comedienne, Wladyslaw Reymont's novel.

d. Harriet Beecher Stowe, American writer (b. 1811).

d. Paul Verlaine, French poet (b. 1844).

d. William Morris, English writer, visual artist, and reformer (b. 1834).

d. George du Maurier, English novelist and illustrator (b. 1834).

d. Higuchi Ichiyo, Japanese novelist (b. 1872).

d. Coventry Patmore, English poet (b. 1823).

VISUAL ARTS

Winslow Homer's painting *The Lookout—"All's Well."*

Union Square in the Spring, Childe Hassam's painting.

Hall of Annual Prayers, in the Temple of Heaven, Peking, China (completed ca. 1896).

Paul Cézanne's paintings included *The Lake of Annecy*, *Nave Nave Mahana (Holiday)*, *Poèmes Barbares*, *The King's Wife*, and *The Moulin David*.

Pierre Bonnard's work included the painting *The Bridge at Chatou* (ca. 1896) and the lithographs *Child with Lamp* and *The Laundry Girl*.

Pierre-Auguste Renoir's painting *The Artist's Family*.

Henri de Toulouse-Lautrec's painting *La Toilette*.

Maurice Prendergast's painting *Revere Beach*.

Pan, statue by George Grey Barnard, at Columbia University (1896–1902); also his statue *The Hewer*.

Ferdinand Hodler's painting *The Return from Marignano* (1896–1900).

d. John Everett Millais, English painter (b. 1829).

d. Matthew Brady, American photographer (b. 1823?), most notably of the Civil War.

d. Frederic Leighton, English painter and sculptor (b. 1830).

THEATER & VARIETY

Oscar Wilde's *Salome*, banned in Britain, was produced by Sarah Bernhardt in Paris.

Anton Chekhov's *The Seagull (Chayka)* was a failure in its initial production.

De Wolf Hopper starred in John Philip Sousa's musical *El Capitan* in New York.

Under the Red Robe, Edward E. Rose's play, opened at New York's Empire Theatre on December 28.

Henry Arthur Jones's *Michael and His Lost Angel* opened in London and New York.

William Gilbert and Arthur Sullivan's *The Grand Duke*.

Liebelei, Arthur Schnitzler's play.

Alfred Jarry's *Ubu-roi*.

Gerhart Hauptmann's *Florian Geyer*.

Angel Guimerà's *Terra baixa*.

Georges-Léon-Jules-Marie Feydeau's *Le Dindon*.

Jacinto Benavente y Martínez's *Important People*.

Giovanni Verga's *The She-Wolf*.

MUSIC & DANCE

La Bohème (The Bohemian Life), Giacomo Puccini's opera, libretto by Giuseppe Giacosa and Luigi Illica, based on Henry Murger's novel *Scènes de la Vie de Bohème*, opened in Turin February 1, con-

ducted by the young Arturo Toscanini.

Andrea Chenier, Umberto Giordano's opera, libretto by Luigi Illica, opened at La Scala, Milan.

Antonín Dvořák's symphonic poems *The Noonday Witch* (*Polednice*); *The Wood Dove* (*Holoubek*), *The Water-Goblin* (*Vodnik*); and *The Golden Spinning-Wheel* (*Zlatý kolovrat*).

Richard Strauss's *Also sprach Zarathustra* (*Thus Spoke Zarathustra*), symphonic poem based on Friedrich Nietszche's work.

Johannes Brahms's *Vier ernste Gesänge* (*Four Serious Songs*) and 11 chorale preludes.

A Hot Time in the Old Town, popular song, words by Joe Hayden, music by Theodore A. Metz.

Camille Saint-Saëns's *Piano Concerto No. 5*, the *Egyptian*.

Mother Was a Lady (*If Jack Were Only Here*), popular ballad, words by Edward B. Marks, music by Joseph W. Stern.

Charles Ives's first string quartet.

Those Wedding Bells Shall Not Ring Out! popular vaudeville song by Monroe H. Rosenfeld.

Shamus O'Brien, Charles Villiers Stanford's opera.

The Light of Life, Edward Elgar's choral oratorio.

Edward MacDowell's *Woodland Sketches* for piano.

Giuseppe Verdi's choral work *Te Deum*.

Gustav Mahler's *Symphony No. 3*.

In the Baggage Coach Ahead, Gussie L. Davis's melodramatic popular song.

Sergei Rachmaninoff's *Six Moments Musicaux*.

Alexander Scriabin's *Piano Concerto*.

Sweet Rosie O'Grady, Maude Nugent's popular song.

Pepita Jiménez, Isaac Albéniz's opera.

Paul Dukas's *Symphony in C Major*.

The Geisha, Sidney Jones's operetta.

Czech Philharmonic Orchestra founded in Prague.

d. Ambroise Thomas, French opera composer (b. 1811).

d. Anton Bruckner, Austrian composer (b. 1824); his *Symphony No. 9* was left unfinished.

d. Clara Schumann (born Clara Wieck), German pianist and composer (d. 1896); wife of Robert Schumann.

d. Carlos Gomes, Brazilian composer (b. 1836).

d. Paul Karrer, Greek composer (b. 1829).

WORLD EVENTS

William Jennings Bryan made his populist Cross of Gold speech at the Democratic Convention.

William McKinley defeated Democrat William Jennings Bryan, becoming the 25th president of the United States.

Emilio Aguinaldo led the successful rebellion against Spanish rule that grew into the Philippine War of Independence and the Philippine–American War.

British-Egyptian forces commanded by Horatio Kitchener defeated Sudanese forces at Omdurman.

Olympic Games were reestablished; Athens hosted the first modern Olympics.

Radioactivity was discovered by Antoine-Henri Becquerel.

Utah became a state.

d. Alfred Nobel, Swedish inventor and industrialist (b. 1833), whose bequest established the Nobel Prizes.

1897

LITERATURE

Dracula, Bram Stoker's classic vampire story; basis of several films, most notably Tod Browning's 1932 film with Bela Lugosi and Francis Ford Coppola's 1992 version.

The Nigger of the "Narcissus," Joseph Conrad's novel exploring the effect of a dying black man on the sailors of the *Narcissus*.

The Invisible Man, H. G. Wells's science fiction novel; basis of the 1933 James Whale film; also Wells's short story *The Plattner Story*.

Recessional, Rudyard Kipling's poem for Queen Victoria's Diamond Jubilee, honoring the 60th anniversary of her accession to the British throne, and cautioning the British people to remember their imperial obligations.

Henry James's novels *The Spoils of Poynton* and *What Maisie Knew*.

Fruits of the Earth, André Gide's prose poem.

Maxim Gorky's short stories *Byvshye lyudi* (*Creatures That Once Were Men*), *Malva*, and *Suprugi Orlovy* (*The Orloff Couple*).

Mark Twain's *Following the Equator* and *How to Tell a Story and Other Essays*.

Anton Chekhov's short stories *Muzhiki* (*Peasants*) and *V rodnom uglu* (*At Home*).

Stéphane Mallarmé's prose poem *Un Coup de dés jamais n'abolira le hasard* and essays *Divagations*.

Liza of Lambeth, Somerset Maugham's first novel.

The Descendant, Ellen Glasgow's novel.

Thomas Hardy's novel *The Well-Beloved*.

William Dean Howells's novel *The Landlord at Lion's Head*.

William James's philosophcal work *The Will to Believe*.

Rainer Maria Rilke's poems *Im Frühfrost*; also *Traumgekrönt*.

Alphonse Daudet's novel *Le Tresor d'Arlatan*.

Anatole France's novels *L'orme du mail* and *Le mannequin d'osier*.

Inferno, August Strindberg's autobiography.

Benito Pérez Galdós's novel *Misericordia*.

Bliss Carman's *Ballads of Lost Haven: A Book of the Sea*.

The Earth Breath, poems of George William Russell (A.E.).

James Lane Allen's novel *The Choir Invisible*.

Kate Chopin's short stories *A Night in Acadie*.

Juhani Aho's novel *Panu*.

Edward Bellamy's novel *Equality*.

d. Alphonse Daudet, French writer (b. 1840).

d. Jakob Christoph Burckhardt, Swiss historian of art and culture (b. 1818).

VISUAL ARTS

Auguste Rodin's sculptures included *Balzac*, *Victor Hugo*, and *Fugit Amor*.

Tate Gallery, London, was opened.

Käthe Kollwitz began her series of etchings *The Weavers' Revolt* (1897–1888).

James McNeill Whistler's painting *George W. Vanderbilt* (ca. 1897).

Pierre-Auguste Renoir's painting *Sleeping Bather*.

Henri Matisse's painting *The Dinner Table*.

Paul Gauguin's paintings included *Te Rerioa*, *Nevermore*, and *Where Do We Come From? What Are We? Where Are We Going?* (1897–1898).

Camille Pissarro's paintings included *Boulevard des Italiens*, *Morning*, *Sunlight* and *Paris, the Boulevard Montmartre at Night*.

Henri Rousseau's painting *The Sleeping Gypsy*.

Isabella; or, The Pot of Basil, John White Alexander's painting.

Louis Sullivan began the New York's Condict Building (1897–1899).

Pierre Bonnard's lithograph *Boating* (ca. 1897).

THEATER & VARIETY

Cyrano de Bergerac, Edmond Rostand's play, opened in Paris on December 28; he also wrote *The Woman of Samaria*.

John Gabriel Borkman, Henrik Ibsen's play, opened at Helsingfors on January 10.

George Bernard Shaw's *The Man of Destiny* and *You Can Never Tell*.

Maude Adams opened at New York's Empire Theatre in James M. Barrie's *The Little Minister*.

Sweet Inniscarra, Augustus Pitou's play, opened New York's 14th Street Theatre on January 24.

Gerhart Hauptmann's play *The Sunken Bell* (*Die versunkene Glocke*).

The Liars, Henry Arthur Jones's play.

Tor Hedberg's *Gerhard Grim*.

d. Mrs. John Drew (Louisa Lane), American actress and theater manager (b. 1820).

d. Giacinto Gallina, Italian playwright (b. 1852).

MUSIC & DANCE

The Sorcerer's Apprentice (*L'apprenti sorcier*), Paul Dukas's symphonic scherzo, based on a poem by Johann Wolfgang von Goethe.

Don Quixote, Richard Strauss's tone poem with cello and viola solos, inspired by Miguel de Cervantes's novel (1605; 1615).

The Stars and Stripes Forever, John Philip Sousa's march.

Antonín Dvořák's symphonic poem *Hero's Song* (*Písen bohat'yrská*).

On the Banks of the Wabash, Far Away, popular song by Paul Dresser, brother of novelist Theodore Dreiser; Indiana's state song.

Sapho, Jules Massenet's dramatic musical work.

Frederick Delius's *Piano Concerto*.

Asleep in the Deep, popular song; words by Arthur Lamb, music by H. W. Petrie.

Arnold Schoenberg's *String Quartet in D Major*.

Take Back Your Gold, popular ballad; words by Louis W. Pritzkow, music by Monroe H. Rosenfeld.

Hymnus amoris, Carl Nielsen's choral work.

Erik Satie's *Pièces froides* for piano.

Stabat mater, Giuseppe Verdi's choral work.

Nikolay Rimsky-Korsakov's string quartet.

Fervaal, Vincent d'Indy's opera.

Edwin S. Votey was granted a patent for a *Pianola*, or

player piano, where keys are "played" by holes and slots in a paper roll (ca. 1901–1951).

d. Johannes Brahms, German composer (b. 1833).

d. Karel Bendl, Czech composer and conductor (b. 1838).

WORLD EVENTS

Theodor Herzl founded and became first president of the Congress of Zionist Organizations.

Joseph Thomson discovered the electron.

British took Benin and joined it to Nigeria.

France took Chad (1897–1901).

Gold strike in the Klondike triggered a gold rush.

Greece and Turkey were at war.

Henry Havelock Ellis began publication of his seven-volume *Studies in the Psychology of Sex* (1897–1928).

1898

LITERATURE

Henry James's book *The Two Magics*, including the novellas *The Turn of the Screw* and *Covering End*; also his novel *In the Cage*.

The War of the Worlds, H. G. Wells's novel of a Martian invasion of Earth; basis of Orson Welles's 1938 radio dramatizations.

The Ballad of Reading Gaol, Oscar Wilde's poem of a man condemned to death, based on his own experiences at the prison.

Stephen Crane's *The Open Boat, and Other Tales of Adventure*, the title story based on his 1897 experience in a shipwreck.

Anton Chekhov's short stories *Chelovek v futlyare* (*The Man in a Case*), *Ionych*, *Kryzhovnik* (*Gooseberries*), *O lyubvi* (*About Love*), and *Sluchay iz praktiki* (*A Doctor's Visit*).

Victoria, Knut Hamsun's novel.

Émile Zola's novel *Paris*.

Joseph Conrad's *Tales of Unrest*.

Thomas Hardy's *Wessex Poems and Other Verses*.

George Bernard Shaw's study *The Perfect Wagnerite*.

Rainer Maria Rilke's poetic work *Advent*.

Victor Hugo's poems *Les Années funestes, 1852–1870*.

Alphonse Daudet's novel *Soutien de famille* (*The Hope of the Family*).

George Meredith's *Odes in Contribution to the Song of French History*.

Rudyard Kipling's short stories *The Day's Work*.

The Cabin, Vicente Blasco Ibañez's novel.

The Californians, Gertrude Atherton's novel.

A *Dictionary of Austral English*, edited by Edward Ellis Morris, published in London.

d. Lewis Carroll (Charles Lutwidge Dodgson), English writer (b. 1832).

d. Stéphane Mallarmé, French writer (b. 1842).

d. B. R. Rajam Ayyar, Tamil novelist (b. 1872).

d. Edward Bellamy, American writer (b. 1850).

d. Harold Frederic, American author and newspaper editor (b. 1856).

d. Theodor Fontane, German novelist (b. 1819).

VISUAL ARTS

Winslow Homer's paintings included *The Turtle Pound* and *The Adirondack Guide*.

Frank Lloyd Wright began the River Forest Golf Club, River Forest, Illinois.

Thomas Eakins's paintings included *Taking the Count* and *Salutat*.

Paul Cézanne's painting *Montagne le Victoire from the Bibémus Quarry* (1898–1900).

Camille Pissarro's paintings included *Place du Théâtre Français Rue de l'Épicerie, Rouen—Morning, Gray Weather*.

Paul Gauguin's painting *The White Horse*.

Henri Rousseau's painting *Banks of the Seine* (ca. 1898).

Asher Wertheimer, John Singer Sargent's painting.

Henri de Toulouse-Lautrec's painting *At the Bar*.

Pierre Bonnard's painting *Interior*.

Louis Sullivan began Chicago's Gage Building (1898–1899).

Frederick Macmonnies's statue of *Shakespeare*, U.S. Library of Congress.

Piazza di San Marco, Maurice Prendergast's painting (1898–1899).

William Holman Hunt's painting *The Miracle of the Sacred Fire*.

d. Aubrey Vincent Beardsley, English artist and illustrator (b. 1872).

d. Eugene Boudin, French painter (b. 1824).

d. Gustave Moreau, French painter (b. 1826).

d. Edward Coley Burne-Jones, English painter (b. 1833).

d. Pierre Puvis de Chavannes, French painter (b. 1824).

THEATER & VARIETY

Moscow Art Theatre was founded by Constantin Stanislavsky and Vladimir Nemirovich-Danchenko.

Second production of Anton Chekhov's *The Seagull*, staged by Constantin Stanislavsky at the Moscow Art Theatre on December 17, was a success.

Arthur Wing Pinero's *Trelawny of the "Wells."*

The Fortune Teller, comic opera with book and lyrics by Harry B. Smith and music by Victor Herbert, opened at New York's Wallack's Theatre.

Way Down East, Lottie Blair Parker's play opened at New York's Manhattan Theatre on February 7.

The Wolves, Romain Rolland's play, on the Dreyfus case.

George Bernard Shaw's *The Philanderer*.

Gerhart Hauptmann's *Drayman Henschel* (*Fuhrmann Henschel*).

MUSIC & DANCE

Raymonda, Marius Petipa's ballet, music by Alexander Glazunov, first danced January 19, at the Maryinsky Theatre, St. Petersburg; Pierini Legnani created the role of Raymonda.

Mozart and Salieri, Nikolay Rimsky-Korsakov's opera from his own libretto, based on Pushkin's 1830 dramatic poem, premiered in Moscow.

Sadko, Nikolay Rimsky-Korsakov's opera, libretto by Rimsky-Korsakov and Vladimiris Ivanovich Belsku, opened in Moscow, January 7.

Fedora, Umberto Giordano's opera, libretto by Arturo Colautti based on Victorien Sardou's 1882 play, opened at the Teatro Lirico, Milan.

Valdemar Poulsen, in Denmark, invented the first magnetic recorder, using wire, but the technology would not be developed until World War II.

The Cedar and the Palm, Vasily Sergeievich Kalinnikov's symphonic work.

Aloha Oe, song by Hawaii's Queen Liliuokalani.

Pelléas et Mélisande, Gabriel Fauré's incidental music.

Chansons de Bilitis, Claude Debussy's songs with text by Pierre Louÿs.

Edward MacDowell's *Four Songs* and *Sea Pieces* for piano.

The Rosary, popular song, words by Robert Cameron Rogers, music by Ethelbert Nevin.

Shéhérazade, Maurice Ravel's overture for orchestra.

A Hero's Life (*Ein Heldenleben*), Richard Strauss's symphonic poem.

Hiawatha's Wedding Feast, Samuel Coleridge-Taylor's cantata.

Arnold Schoenberg's *Six Songs* (1898–1900).

She Is More to Be Pitied, Than Censured, William B. Gray's popular song.

Carl Nielsen's fourth string quartet.

When You Were Sweet Sixteen, James Thornton's popular song.

Charles Ives's first symphony.

She Was Bred in Old Kentucky, popular song, words by Harry Braisted, music by Stanley Carter.

Laudi alla Vergine Maris, Giuseppe Verdi's choral work.

Pietro Mascagni's opera *Iris*.

Who Threw the Overalls in Mistress Murphy's Chowder, George L. Geifer's comic song.

Sergei Ivanovich Taneyev's *Symphony in C Minor*.

The Fortune Teller, Victor Herbert's operetta.

Julian Felipe composed the music to the Phillipine national hymn *Tierra adorada* (originally called *Marcha nacional filipina*), to words by José Palma.

Sousaphone, a deep brass instrument, developed, probably by J. W. Pepper of Philadelphia.

Stockholm's new Royal Opera House, home of the Royal Swedish Opera, opened; the old opera house had been demolished in 1890.

d. George Frederick Bristow, American composer (b. 1825).

d. Nikolay Yakovlevich Afanasyev, Russian violinist and composer (b. 1821).

d. Aristide Cavaillé-Coll, French organ builder (b. 1811), noted for bringing a more "orchestral" sound to the organ.

d. Tigran Chukhadjian, Armenian composer and conductor (b. 1837).

WORLD EVENTS

U.S.S. *Maine* was sunk in Havana harbor.

Spanish–American War: Spanish forces were defeated in Cuba, the Philippines, and Puerto Rico; U.S. took Puerto Rico, Guam, and established Cuba and the Philippines as protectorates.

Antiforeign Boxers founded in China.

Marie Curie and Pierre Curie discovered polonium and radium, and learned that thorium emits "uranium rays," which she named *radioactivity*.

Émile Zola's open letter *J'Accuse*, on the unjust conviction and imprisonment of Alfred Dreyfus.

U.S. took Hawaii.

Dutch botanist Martinus Willem Beijerinck discovered the virus (Latin for "poison").

1899

LITERATURE

White Man's Burden, Rudyard Kipling's famous poem about the "superior" imperial countries' obligations to the peoples in their colonies; also *From Sea to Sea*, letters from his 1889 return trip to England via Japan and America; and *Stalky and Co.*, his novel of late 19th-century boarding-school life.

The Awakening, Kate Chopin's then-controversial novel about a woman's open though ultimately disastrous exploration of sexual passion, involving both adultery and miscegenation.

Stephen Crane's *The Monster and Other Stories*; his poetry collection *War Is Kind*, with its ironic title poem *Do Not Weep, Maiden, War Is Kind*; also his novel *Active Service*.

The House Behind the Cedars, Charles W. Chesnutt's first book; also his *The Wife of His Youth and Other Stories of the Color Line*, including *The Conjure Woman*.

The Promised Land, Wladyslaw Reymont's novel about the effects of European industrialization.

Maksim Gorky's short story *Twenty-Six Men and a Girl* (*Dvadtsat shest i odna*) and his first novel *Foma Gordeyev*.

Anton Chekhov's short stories *Dama s sobachkoy* (*The Lady with the Lapdog*) and *Dushechka* (*The Darling*).

When the Sleeper Awakes, H. G. Wells's novel; also his *Tales of Space and Time*.

Jerome K. Jerome's novel *Three Men in a Boat, Not to Mention the Dog*.

Henry James's novel *The Awkward Age*.

Leo Tolstoy's novel *Resurrection*.

William Butler Yeats's poetry collection *The Wind Among the Reeds*.

McTeague, Frank Norris's naturalistic novel.

André Gide's *Prometheus Misbound* (*Prométhée mal enchaîné*).

A Boy's Life on the Prairie, Hamlin Garland's short-story collection.

Notes sur la Vie, Alphonse Daudet's memoirs.

Anatole France's novel *L'anneau d'améthyste*.

Edwin Markham's *The Man with the Hoe and Other Poems*.

Paul Laurence Dunbar's *Lyrics of the Hearthside*.

Rainer Maria Rilke's poems *Mir zur Feier*.

Richard Carvel, Winston Churchill's popular novel.

d. Horatio Alger, Jr., American writer of books for boys (b. 1832).

VISUAL ARTS

Claude Monet's painting *Water-Lily Pool* (1899–1906).

Winslow Homer's paintings included *The Gulf Stream* and *After the Hurricane, Bahamas*.

Edgar Degas's pastel *The Dancers*.

James Ensor's painting *Portrait of the Artist Surrounded By Masks*.

Henri Matisse's painting *Compote and Glass Pitcher*; and his sculpture *Jaguar Devouring a Hare*.

Edvard Munch's painting *The Dance of Life* (1899–1900).

Henri de Toulouse-Lautrec's paintings included *The Tête-à-Tête Supper* and *Aux courses*.

Maurice Prendergast's paintings included *Square of San Marco, Venice* and *Ponte della Paglia*.

Paul Gauguin's painting *Two Tahitian Women*.

Thomas Eakins's paintings included *Between Rounds* and *Benjamin Eakins*.

Pierre-Auguste Renoir's painting *Le Lever*.

Alfred Gilbert's Shaftesbury Memorial Fountain with the statue of Eros, Piccadilly, London.

Lafayette, equestrian statue by Paul Wayland Bartlett.

Louis Sullivan began Chicago's Carson Pirie Scott Store (1899–1904).

d. Alfred Sisley, French painter (b. 1839).

THEATER & VARIETY

Anton Chekhov's *Uncle Vanya* opened at the Moscow Art Theatre.

George Bernard Shaw's *Caesar and Cleopatra*.

Arthur Wing Pinero's *The Gay Lord Quex*.

August Strindberg's plays *Gustav Vasa* and *Erik XIV*.

William Gillette starred in his own play, *Sherlock Holmes*, which opened at New York's Garrick Theatre on November 6; he would be identified with the role for the rest of his career.

Julia Marlowe opened at New York's Criterion Theatre in Clyde Fitch's *Barbara Frietchie*.

Mrs. Fiske and Tyrone Power opened at New York's Fifth Avenue Theatre in Langdon Mitchell's *Becky Sharpe*, based on William Makepeace Thackeracy's 1847 novel *Vanity Fair*.

Ben Hur, William Young's melodrama based on Lew Wallace's 1880 novel, opened in New York.

Henrik Ibsen's play *When We Dead Awaken*.

Owen Hall's *Floradora* opened in London.

Georges-Léon-Jules-Marie Feydeau's *The Girl from Maxim's* and *Hotel Paradiso*.

David Belasco's *Zaza*.

Gabriele D'Annunzio's *La Gioconda*.

Roberto Bracco's *Tragedy of a Soul*.

d. Augustin Daly, American manager and playwright (b. 1839).

d. Henry François Becque, French playwright (b. 1837).

MUSIC & DANCE

Enigma Variations, Edward Elgar's 14 variations on an original theme, each portraying one of his friends, but the last portraying himself; basis for Frederick Ashton's 1968 ballet.

Sea Pictures, Edward Elgar's song cycle.

Finlandia, Jean Sibelius's orchestral work on Finnish folk themes, adopted as a national work; also his *Symphony No. 1* and the song *Black Roses*.

Scott Joplin's *Original Rags*, including *The Maple Leaf Rag*, which brought him fame.

Lift Every Voice and Sing, the song by brothers John Rosamond Johnson and James Weldon Johnson, which became known as the "Negro national anthem."

Cendrillon (*Cinderella*), Jules Massenet's opera.

Nikolay Rimsky-Korsakov's opera *The Tsar's Bride* and choral work *Song of Oleg the Wise*.

Hello Ma Baby, popular song by Joseph E. Howard and Ida Emerson, who introduced it in vaudeville.

Anton von Webern's *Two Pieces for Cello and Piano* and *Three Poems*, voice with piano (1899–1903).

Hearts and Flowers, popular song; words by Mary D. Brine, music by Theodore Moses-Tobani.

Gustav Mahler's songs *Der Tamboursg'sell* and *Revelge* (both 1899–1901).

Edward MacDowell's *Three Songs* and his *Sonata No. 3, the Norse*, for piano.

My Wild Irish Rose, Chauncey Olcott's popular song.

Pavane pour une infante défunte, Maurice Ravel's orchestral work.

Antonín Dvořák's opera *The Devil and Kate* (*Cert a Káca*).

The Story of the Rose (*Heart of My Heart*), popular song, words by "Alice," music by Andrew Mack.

Paris: The Song of a Great City, Frederick Delius's orchestral work.

You Tell Me Your Dream, I'll Tell You Mine, popular song, words by Seymour Rice and Albert H. Brown, music by Charles N. Daniels.

Verklärte Nacht, Arnold Schoenberg's string sextet.

Nocturnes, Claude Debussy's orchestral works.

Feodor Chaliapin made his first appearance at Moscow's Bolshoi Theatre.

d. Johann Strauss, Austrian composer–conductor (b. 1825).

d. Ernest Chausson, French composer (b. 1855).

WORLD EVENTS

Second British–Boer War began with the invasion of British South African territory by South African Republic and Orange Free State forces on October 12. Advancing Boers won battles at Stormberg, Magersfontein, and Colenso; besieged Ladysmith, Mafeking, and Kimberley.

U.S. announced an "open door" policy regarding China, warning others against taking China's treaty ports, which were to be left multinational.

Alfred Dreyfus was pardoned by the president of France.

Antiforeign, anti-Manchu riots spread in China.

Emilio Aguinaldo became first president of the Philippine Republic; the U.S.–Philippine war began.

Aspirin was invented.

John Dewey's *School and Society*.

Thorstein Veblen's *The Theory of the Leisure Class*.

1900

LITERATURE

Sister Carrie, Theodore Dreiser's controversial novel, not available until 1912, even though heavily expurgated; basis of the 1952 William Wyler film.

The Wonderful Wizard of Oz, L. Frank Baum's novel,

the first of the 14 Oz books, together the basis of the 1903 stage musical and the 1939 film.

d. Stephen Crane, American writer (b. 1871); published that year were *Whilomville Stories* and *Wounds in the Rain: A Collection of Stories Relating to the Spanish-American War of 1898.*

The Tale of Peter Rabbit, first of Beatrix Potter's many children's books, originally self-published.

Lord Jim, Joseph Conrad's novel of cowardice and redemption.

Claudine at School, first of five novels in Colette's Claudine series.

The Three of Them, Maxim Gorky's novel.

Mark Twain's *The Man That Corrupted Hadleyburg and Other Stories and Sketches.*

Alphonse Daudet's memoirs *Premier voyage, premier mensonge (My First Voyage, My First Lie).*

Anton Chekhov's short story *V ovrage (In the Ravine).*

Henry James's story *The Soft Side.*

Eben Holden, Irving Bacheller's novel.

Monsieur Beaucaire, Booth Tarkington's novel.

Frank Norris's novel *A Man's Woman.*

John Burroughs's essay *Squirrels and Other Fur-Bearers.*

Love and Mr. Lewisham, H. G. Wells's novel.

Rainer Maria Rilke's *Stories of God.*

The Son of the Wolf, Jack London's short stories.

Joachim María Machado de Assis's poem *Occidentaes* and novel *Dom Casmurro.*

d. John Ruskin, English writer (b. 1819).

VISUAL ARTS

Bernard Berenson established his home and studios at I Tatti, near Florence, becoming a leading authenticator of Italian Renaissance art.

Maurice Prendergast's painting *Carnival.*

Richard Morris Hunt began the facade of the Metropolitan Museum of Art, New York City (1900–1902).

Edvard Munch's paintings *The Dance of Life* and *The Red Vine.*

Frank Lloyd Wright's work included the Bradley House and the Hickox House, both at Kankakee, Illinois.

Frederick Macmonnies sculpted the army and navy groups at Prospect Park, Brooklyn.

d. Paul Cézanne, French painter (b. 1839).

d. Frederic Edwin Church, American landscape painter (b. 1826).

d. Jasper F. Cropsey, American painter (b. 1823).

d. William Butterfield, English architect (b. 1814).

d. William Holbrook Beard, American painter (b. 1824).

THEATER & VARIETY

Sarah Bernhardt opened in Paris on March 15 in Edmond Rostand's *L'Aiglon.*

George Bernard Shaw's *Captain Brassbound's Conversion* was produced in London.

Madame Butterfly, David Belasco and John Luther Long's play, opened at New York's Herald Square Theatre on March 5; basis of the 1904 Giacomo Puccini opera.

Mrs. Patrick Campbell appeared at London's Royalty Theatre in Max Beerbohm's *The Happy Hypocrite.*

August Strindberg's *Till Damascus.*

Danton, Romain Rolland's play.

Gerhart Hauptmann's plays *Michael Kramer* and *Schluck und Jau.*

Augustus Thomas's *Arizona* opened in New York.

Sag Harbor, James A. Herne's play, opened at New York's Republic Theatre on September 27.

Enrico Annibale Butti's plays *La tempesta, Lucifero*, and *The Pursuit of Pleasure.*

Fred Terry and Julia Neilson (husband and wife) starred in Paul Kester's *Sweet Nell of Old Drury.*

Réjane starred in Paris in Eugène Brieux's *La Robe Rouge.*

The Living Corpse, Leo Tolstoi's play.

Georges Méliès's *One Man Band.*

Jacob Gordin's *God, Man and Devil.*

Giuseppe Giacosa's *Like the Leaves.*

Per Hallström's tragedy *Bianco Capello.*

The Cloister, Emile Verhaeren's play.

Holger Henrik Herholdt Drachmann's *Hallfred Vandraadeskjald.*

José Echegaray's *The Divine Madman.*

Roberto Bracco's *One of the Honest Men.*

The Good Hope, Hermann Heijerman's play.

d. Oscar (Fingal O'Flahertie Wills) Wilde, Irish playwright (b. 1854), in the early 1890s author of the distinguished comedies *Lady Windemere's Fan, A Woman of No Importance, An Ideal Husband,* and

his classic *The Importance of Being Earnest*. He died in Paris the victim of homophobia, broken after his two-year British prison sentence for homosexuality.

MUSIC & DANCE

Tosca, Giacomo Puccini's opera, libretto by Guiseppe Giacosa and Luigi Illica, based on the 1887 Victorien Sardou melodrama, opened in Rome.

The Flight of the Bumble Bee, orchestral interlude from Nikolay Rimsky-Korsakov's opera *Tsar Saltan*.

Louise, Gustave Charpentier's opera from his own libretto, its controversial theme being women's liberation, opened at the Opéra-Comique, Paris, February 2. Marthe Rioton created the title role.

American electrical engineer Reginald Fessenden transmitted the human voice for the first time, to a receiver a mile away.

Gustav Mahler's *Symphony No. 4, Ode to Heavenly Joy*.

A Bird in a Gilded Cage, popular song introduced by Jerry Mahoney; words by Arthur J. Lamb, music by Harry Von Tilzer.

Prométhée, Gabriel Fauré's lyric tragedy.

Alexander Nikolayevich Scriabin's *Symphony No. 1*.

Tell Me Pretty Maiden (Are There Anymore at Home Like You?), Leslie Stuart's popular song.

Charles Ives's second symphony (1900–1902).

The Dream of Gerontius, Edward Elgar's oratorio.

Edward MacDowell's *Sonata No. 4*, the *Keltic*, for piano.

Josef Suk's *Fairy Tale Suite*.

Philadelphia Orchestra founded.

First National Championship for brass bands held at the Crystal Palace, London.

d. Arthur Sullivan, English composer (b. 1842) who teamed with William Gilbert in the Gilbert-and-Sullivan comic operettas.

d. Johan Peter Emilius Hartmann, Danish composer and organist (b. 1805).

WORLD EVENTS

William McKinley again defeated Democrat William Jennings Bryan for the American presidency.

Philippine–American war spread throughout the country; 50,000–60,000 American troops fought

the Philippine army and guerrillas.

Boxer Rebellion: International forces relieved the siege of Peking, then sacked the city.

Boer War: British forces took Paardeberg, relieved Ladysmith, took Bloemfontein, capital of the Orange Free State, relieved Mafeking, and invaded the South African Republic, taking Johannesburg and then Pretoria on June 5.

Ellis Island immigration station reopened, rebuilt eight years after the 1892 fire.

Britain's Independent Labour party became the Labour Representation Committee, direct forerunner of the Labour party.

First Pan-African Congress, organized by W. E. B. Du Bois and other U.S. and West Indian Black leaders in London.

Galveston hurricane (Sept. 8) destroyed much of the city; an estimated 6,000 people died.

German Count Ferdinand von Zeppelin built the first rigid dirigible, thereafter called the zeppelin.

U.S. physician and bacteriologist Walter Reed discovered that mosquitoes carry yellow fever.

Sigmund Freud's *The Interpretation of Dreams*.

1901

LITERATURE

Buddenbrooks, Thomas Mann's novel about the decline of a prosperous German family, an extraordinary work more astonishing for being his first.

Kim, Rudyard Kipling's novel about India-raised Irish orphan Kimball O'Hara's travels through India with a Tibetan mystic.

The Octopus, first novel in Frank Norris's projected trilogy about American wheat, here focusing on the conflict between California wheat farmers and the railroad, seen as a strangling octopus.

The First Men on the Moon, H. G. Wells's novel; also his *Anticipations of the Reaction of Mechanical and Scientific Progress upon Human Life and Thought*.

Joseph Pulitzer's *New York World* was published in a single half-size edition, the first tabloid.

The Inheritors, a novel written in collaboration by Joseph Conrad and Ford Madox Hueffer (Ford).

Alice Hegan Rice's children's story *Mrs. Wiggs of the Cabbage Patch*.

Thomas Hardy's *Poems of the Past and the Present*.

Henry James's novel *The Sacred Fount*.

Jerusalem, Selma Lagerlöf's novel (1901–1902).

Anatole France's novel *Monsieur Bergeret à Paris*.

Charles W. Chesnutt's novel *The Marrow of Tradition*.

George Meredith's *A Reading of Life, with other Poems*.

Ignacio Manuel Altamirano's novel *El Zarco*.

Maurice Maeterlinck's *The Life of the Bee*.

Winston Churchill's novel *The Crisis*.

d. William Ellery Channing, American poet (b. 1818).

d. Leopoldo Alas y Ureña, Spanish writer (b. 1852).

VISUAL ARTS

Pablo Picasso's paintings included *The Dwarf Dancer*, *The Mourners*, and *Golden Bodies*; Picasso began his "blue period" (1901–1904).

Henri Matisse's painting *La Coiffure*; and his sculpture *Madelaine I*.

Paul Gauguin's painting *Sunflowers and Pears*.

Wassily Kandinsky's painting *The Sluice*.

Waterfront Scene–Gloucester, John Henry Twachtman's painting.

Winslow Homer's painting *Searchlight Harbor Entrance, Santiago de Cuba*.

Camille Pissarro's painting *The Church of Saint-Jacques, Dieppe—Morning, Rainy Day*.

Maurice Prendergast's paintings *Stony Beach, Ogunquit* and *The Mall, Central Park*.

East Entrance, City Hall, John Sloan's painting.

An Arrangement, Alfred Henry Maurer's painting.

Edvard Munch's painting *White Night*.

The Human Figure in Motion, photos by Eadweard Muybridge.

George Luks's painting *The Butcher Cart*.

Man Cub, Alexander Stirling Calder's sculpture.

The Mirror, portrait of the artist's daughter, William Merritt Chase's painting.

d. Henri de Toulouse-Lautrec, French artist (b. 1864).

d. Arnold Boecklin, Swiss painter (b. 1827).

THEATER & VARIETY

Anton Chekhov's *The Three Sisters* (*Tri sestry*) opened at the Moscow Art Theatre on January 31; produced by Constantin Stanislavsky, with Masha created by Olga Knipper (Chekhov's wife).

George Bernard Shaw's *Captain Brassbound's Conversion*.

Jacob Adler starred in New York as Shylock in a Yiddish-language version of *The Merchant of Venice*.

David Belasco's *The Auctioneer* opened in New York.

Richard Mansfield opened at New York's Herald Square Theatre in *Beaucaire*, by Booth Tarkington and Evelyn Greenleaf Sutherland's; based on Tarkington's 1900 novel *Monsieur Beaucaire*.

August Strindberg's plays *The Dance of Death* and *The Saga of the Folkungs*.

Ethel Barrymore played in her first starring role, in Clyde Fitch's *Captain Jinks of the Horse Marines*.

Gerhart Hauptmann's play *The Conflagration* (*Der rote Hahn*).

Hermann Sudermann's *The Joy of Living* opened in Berlin.

Mrs. Patrick Campbell appeared in London in Bjørnstjerne Bjørnson's *Beyond Human Power*.

If I Were King, Justin McCarthy's play.

When Knighthood Was in Flower, Paul Kester's play.

d. George Augustus Conquest, British playwright and actor (b. 1837).

d. James A. Herne, American actor and playwright (b. 1901).

d. Louis Aldrich, American actor (b. 1843).

MUSIC & DANCE

Edward Elgar's *Pomp and Circumstance* (1901–1930), his five marches, the first providing the melody for the song *The Land of Hope and Glory*; also his concert overture *Cockaigne* (*In London Town*).

Rusalka (*The Water Nymph*), Antonín Dvořák's opera, libretto by Jaroslav Kvapil, opened at the National Theatre, Prague, March 31.

Gustav Mahler's songs *Kindertotenlieder* and *Fünf Lieber nach Rückert* (both 1901–1904).

Rumanian Rhapsodies, George Enescu's best-known work, based on folk themes.

Sergei Rachmaninoff's second piano concerto, *Sonata for Cello and Piano*, and *Suite No. 2*, for two pianos.

Jean Sibelius's *Symphony No. 2*; also his song *The Maid Came from Her Lover's Tryst*.

Feuersnot (*Fire-Famine*), Richard Strauss's opera on a Flemish legend, opened in Dresden November 21.

Alexander Nikolayevich Scriabin's *Symphony No. 2*.

Might Lak' a Rose, popular song, words by Frank L. Stanton, music by Ethelbert Nevin.

Much Ado About Nothing, Charles Villiers Stanford's opera.

Edward MacDowell's *Three Songs*.

Manru, Jan Paderewski's opera.

Yale Boola!, A. M. Hirsch's march and two step.

Anton von Webern's *Eight Early Songs* (1901–1904).

Paul Dukas's *Sonata*.

Sergei Ivanovich Taneyev's first string quintet.

Prinzeregententheater opened in Munich, with a production of Richard Wagner's *Die Meistesinger*.

d. Giuseppe Verdi, Italian composer (b. 1813).

d. Vasily Sergeievich Kalinnikov, Russian composer (b. 1866).

d. Henry Willis, British organ builder (b. 1821) who built many late 19th-century British organs.

WORLD EVENTS

U.S. President William McKinley (b. 1843) was assassinated by anarchist William Czolgosz on September 6 at the Buffalo Pan-American Exposition; he was succeeded by Vice-President Theodore Roosevelt. Czolgosz was executed on October 29.

Philippine leader Emilio Aguinaldo was captured on March 23, effectively ending the Philippine–American War.

Socialist Party of the United States founded; led by Eugene V. Debs.

Boxer Protocol, with harsh anti-Chinese terms, formally ended the Boxer Rebellion.

Gugliemo Marconi transmitted the first transatlantic telegraph message.

J. Pierpont Morgan organized the United States Steel Corporation.

Sigmund Freud's *The Psychopathology of Everyday Life*.

d. Victoria (b. 1819), queen of England.

1902

LITERATURE

The Four Feathers, A. E. W. Mason's novel about charges of cowardice, set largely in the British-Sudan wars of the 1890s; basis of several dramatizations, notably the 1939 film.

The Nobel Prize for Literature was awarded to Theodor Mommsen.

Rudyard Kipling's *Just So Stories for Little Children*, explaining such things as how the camel got his hump and the leopard his spots.

Anna of the Five Towns, Arnold Bennett's novel of a young woman in an oppressive life in England's pottery towns.

The Wings of the Dove, Henry James's novel of an elaborate charade by a couple to gain the fortune of a young woman about to die.

Joseph Conrad's short novels *Heart of Darkness* and *Typhoon*; and short stories *The End of the Tether* and *Youth: A Narrative*.

John Masefield's *Salt Water Ballads*, including *Cargoes* and *Sea-Fever*, with its classic opening, "I must go down to the sea again."

J. M. Barrie's novel *The White Bird*, basis for his 1904 play *Peter Pan*.

The Times (of London) began publication of its weekly *The Times Literary Supplement* (*TLS*).

The Valley of Decision, Edith Wharton's novel of 18th-century Italy, her first success.

The Love Sonnets of a Hoodlum, Wallace Irwin's Petrarchan verses in American slang.

André Gide's novel *The Immoralist*.

William James's *The Varieties of Religious Experience*.

Anton Chekhov's short story *Arkhierey* (*The Bishop*).

William Dean Howells's novel *The Kentons*.

Rainer Maria Rilke's poems *Das Buch der Bilder*.

Stephen Crane's short stories *Last Words*.

August Strindberg's novel *Fair Haven and Foul Strand*.

Euclides da Cunha's *Os Sertoes* (*Rebellion in the Backlands*).

d. Émile Zola, French novelist (b. 1840).

d. Frank Norris, American writer (b. 1870).

d. Frank R. Stockton, American novelist and short-story writer (b. 1834).

d. Bret Harte, American writer (b. 1836).

d. Edward Eggleston, American writer (b. 1837).

d. Mary Catherwood, American author of fiction (b. 1847).

VISUAL ARTS

Photo-Secession photography group was founded in New York by Alfred Stieglitz; it included Edward Steichen, Clarence H. White, and Gertrude Käsebier.

Winslow Homer's painting *Early Morning After a Storm at Sea*.

Camille Pissarro's painting *Louvre from Pont Neuf*.

Frank Lloyd Wright's work included the Heurtley

House, Oak Park; and the Willits House, Highland Park, both in Illinois.

West 57th Street, New York, Robert Henri's painting.

Gustav Klimt's painting *Portrait of Emilie Flöge*.

Paul Gauguin's paintings included *Contes barbares* and *L'Appel*.

Thomas Eakins painted a *Self-Portrait*.

Pierre Bonnard's painting *Place Blanche* (ca. 1902).

d. Albert Bierstadt, American painter (b1 1830).

d. John Henry Twachtman, American painter (b. 1853).

THEATER & VARIETY

The Lower Depths, Maxim Gorky's play, set in the underside of czarist Russian society, opened at the Moscow Art Theatre October 25.

Henry Irving starred in London in the title role in James M. Barrie's *The Admirable Crichton*; Barrie also wrote *Quality Street*.

A Trip to the Moon (*Le Voyage Dans la Lune*), the first silent feature film, by Georges Méliès.

Clyde Fitch's *Girl with the Green Eyes* opened at New York's Savoy Theatre on December 25.

The Darling of the Gods, David Belasco and John Luther Long's play, opened in New York.

Le Page, Sacha Guitry's first play.

Wilhelm Meyer-Förster's *Old Heidelberg*.

Eugène Brieux's *Les Avariés*.

Gerhart Hauptmann's play *Henry of Auë* (*Der arme Heinrich*).

William Butler Yeats and Lady Gregory's *Cathleen ni Houlihan*.

Monna Vanna, Maurice Maeterlinck's play.

Nils Kjaer's *Day of Reckoning*.

The Dream Play, August Strindberg's play.

The Fourteenth of July, Romain Rolland's play.

Gabriele D'Annunzio's *Francesca da Rimini*.

MUSIC & DANCE

Scott Joplin's piano rag *The Entertainer*; also his ballet *The Ragtime Dance*.

Pelléas et Mélisande, Claude Debussy's opera, based on the 1892 Maurice Maeterlinck play, premiered in Paris. Mary Garden created the role of Melisande.

Saul and David, Carl Nielsen's opera, libretto by Einar Christiansen, based on the Bible's *Samuel I*, opened at the Royal Theatre, Copenhagen.

Edward MacDowell's piano works *Fireside Tales* and *New England Idyls*.

Under the Bamboo Tree, popular song by Robert Cole, J. Rosamond Johnson, and James Weldon Johnson.

Frederick Delius's dramatic musical work *Margot la Rouge*.

Because, popular song at weddings, English verses by Edward Teschemacher, to the French song by Guy d'Hardelot.

Gustav Mahler's *Symphony No. 5*, the *Giant*.

Come Down Ma Evenin' Star, John Stromberg's song, popularized by Lillian Russell.

Le Jongleur de Notre-Dame, Jules Massenet's opera.

Kashchey the Immortal, Nikolay Rimsky-Korsakov's opera.

In the Good Old Summer Time, popular song, words by Ren Shields, music by George Evans.

Carl Nielsen's *Symphony No. 2, The Four Temperaments*.

Bill Bailey, Won't You Please Come Home?, Hughie Cannon's popular song.

Charles Villiers Stanford's *Clarinet Concerto*.

Jean Sibelius's song *Was It a Dream?*

WORLD EVENTS

Ibn Saud's forces began to take control of southern Arabia's Nejd district, beginning the long struggle for power (1902–1925).

Boer forces surrendered on May 31, ending the Boer War.

Mount Pelée volcanic eruption killed an estimated 30,000 and destroyed Saint-Pierre, Martinique.

American troops evacuated Cuba.

J. A. Hobson's *Imperialism*.

1903

LITERATURE

The Ambassadors, Henry James's novel of Americans in Paris; also his short stories *The Better Sort*, *The Birthplace*, and *The Beast in the Jungle*.

The Nobel Prize for Literature was awarded to Bjørnstjerne Bjørnson.

The Call of the Wild, Jack London's novel about sheepdog Buck in Klondike; London's first big success, basis of several dramatizations, notably the 1935 film.

The Way of All Flesh, Samuel Butler's partly autobiographical novel bitterly satirizing middle-class English life and religion, published posthumously.

The Home: Its Work and Influence, Charlotte Perkins Gilman's classic study of women's roles.

Joseph Conrad's *Typhoon and other Stories* and his novel *Romance*.

The Souls of Black Folk, W. E. B. Du Bois's influential essays and sketches.

First regularly published tabloid (half-size) newspaper, the *London Daily Mirror*, founded by Alfred Harmsworth, later Lord Northcliffe.

City of Slaughter, Hayim Nachman Bialik's poem protesting the 1903 Kishinev massacres.

The Pit, second novel in Frank Norris's projected trilogy about American wheat.

Stéphane Mallarmé's *Vers et prose*, including *Poésies*.

Tonio Kröger, Thomas Mann's novel.

William Butler Yeats's poetry collection *In the Seven Woods*.

Beatrix Potter's *The Tailor of Gloucester*.

Kate Douglas Wiggin's novel *Rebecca of Sunnybrook Farm*.

Anton Chekhov's short story *Nevesta* (*The Betrothed*).

Ambrose Bierce's poems *Shapes of Clay*.

The Shadow of the Cathedral, Vicente Blasco Ibañez's novel.

Paul Laurence Dunbar's *Lyrics of Love and Laughter*.

August Strindberg's autobiographical work *Ensam*.

Andrei Bely's poems *Gold in Ashes*.

Romain Rolland's six-volume biography *Beethoven*.

Stephen Crane's novel *The O'Ruddy*.

George Ade's *People You Know*.

H. G. Wells's *Mankind in the Making*.

Andy Adams's novel *The Log of a Cowboy*.

Rainer Maria Rilke's prose works *Auguste Rodin* and *Worpswede*.

Mary Austin's *The Land of Little Rain*.

d. Robert Gissing, English novelist, critic, and essayist (b. 1857).

VISUAL ARTS

Pablo Picasso's paintings included *The Tragedy*, *La Vie*, and *The Blind Man's Meal*.

Edward Steichen's work included his landmark portrait photos of *J. Pierpont Morgan* and *Eleanora Duse*.

Wassily Kandinsky's painting *The Blue Rider*.

Henri Matisse's painting *Carmelina*.

Alfred Stieglitz founded the magazine *Camera Work* (1903–1917).

Daniel Chester French's *Alma Mater*, statue at Columbia University.

Augustus Saint-Gaudens's Sherman monument.

Camille Pissarro's painting *Bridge at Bruges*.

Pierre Bonnard's painting *Girl in a Straw Hat* (ca. 1903).

Charles McKim began the Morgan Library, New York City.

Robert Henri's painting *Storm Tide*.

Constantin Brancusi's sculpture *General Dr. Carol Davila*.

Josef Hoffmann's painting *Pukersdorff Sanatorium*.

d. Paul Gauguin, French painter (b. 1848).

d. James McNeill Whistler, American artist (b. 1834).

d. Camille Pissarro, Danish West Indies painter (b. 1830).

d. Robert Frederick Blum, American painter (b. 1857).

THEATER & VARIETY

Man and Superman, George Bernard Shaw's play.

The Wizard of Oz opened at New York's Majestic Theatre; L. Frank Baum's musical adaptation of his 1900 book *The Wonderful Wizard of Oz*.

The Great Train Robbery, Edwin M. Porter's silent film, almost 12 minutes long, the first Western and the first American feature film.

Babes in Toyland, Victor Herbert's musical, book and lyrics by Glen MacDonough; opened October 13 at New York's Majestic Theatre.

The Round Dance, Arthur Schnitzler's play; basis of the 1950 Max Ophüls film *La Ronde*.

The Prince of Pilsen, musical with book and lyrics by Frank Pixley, and music by Gustav Luders, opened at the Broadway Theatre, New York, March 17.

Raffles, the Amateur Cracksman, E. W. Hornung and Eugene Presbrey's play, based on several Hornung stories about the gentleman burglar, opened at New York's Princess Theatre on October 27.

New York's Lyric Theatre opened, with Richard Mansfield starring in *Old Heidelberg*.

David Belasco's *Sweet Kitty Bellairs* opened at New York's Belasco Theatre on December 9.

The County Chairman, George Ade's comedy, opened at New York's Wallack's Theatre.

New York's New Amsterdam Theatre opened, with Nat Goodwin in a production of William Shakespeare's *A Midsummer Night's Dream*.

New York's Hudson Theatre opened, with Hubert Henry Davies's *Cousin Kate*, starring Ethel Barrymore.

In Dahomey opened at the New York Theatre on February 18; lyrics by Paul Laurence Dunbar, music by Will Marion Cook, book by J. A. Shipp.

Bertha Kalich opened in New York on December 10 in Jacob Gordin's *God, Man, and Devil*.

Maxine Elliott opened at New York's Garrick Theatre on in Clyde Fitch's *Her Own Way*.

In the Shadow of the Glen, John Millington Synge's play.

Arthur Wing Pinero's *Letty*.

Thomas Hardy's play *The Dynasts: A Drama of the Napoleonic Wars*, parts 1–3.

The Other Girl, Augustus Thomas's play, opened at the Criterion Theatre, New York, December 29.

Gerhart Hauptmann's *Rose Bernd*.

The Other Girl, Augustus Thomas's play.

d. Alexander Vasilievich Sukhovo-Kobylin, Russian playwright (b. 1817) whose work was largely banned in Russia; later exiled to France.

d. Louis-Arsène Delaunay, French actor (b. 1826).

MUSIC & DANCE

Babes in Toyland, Victor Herbert's operetta, with the song *Toyland*; there were three film versions, including the classic 1934 Laurel and Hardy movie.

Waltzing Matilda, Australia's unofficial national song; music by Marie Cowan, lyrics by A. B. Patterson.

Appalachia, Frederick Delius's work for choir and orchestra; also his *Variations on an Old Slave Song from North America*.

Tiefland (*The Lowlands*), Eugen D'Albert's opera, libretto by Rudolph Lothar based on Angel Guimerá's 1896 Catalan play *Terra Biaxa*, opened in Prague November 15.

Ida, Sweet as Apple Cider, words and music by Eddie Leonard and Eddie Munson; Eddie Cantor (whose wife was Ida Tobias) later adopted it as the signature for his 1930s radio show.

Maurice Ravel's *Pavane for a Dead Princess*; *String Quartet*; song cycle *Shéhérazade*, song cycle.

Jean Sibelius's *Violin Concerto* and song *Autumn Evening*.

Edward Elgar's oratorio *The Apostles*; sequel is *The Kingdom* (1906).

Pelleas und Melisande, Arnold Schoenberg's orchestral work.

Scott Joplin's *A Guest of Honor*, the first ragtime opera.

You're the Flower of My Heart, Sweet Adeline, perennial barbershop quartet favorite, words by Richard H. Gerard, music by Harry Armstrong.

Leos Janácek's opera *Osud* (1903–1907), not publicly performed until 1958.

Résurrection, Albert Roussel's orchestral work.

Anton von Webern's *Three Avenarius Songs* (1903–1904).

Kossuth, Béla Bartók's symphonic poems.

Dear Old Girl, popular hit, words by Richard Henry Buck, music by Theodore F. Morse.

Erik Satie's piano duets *3 morceaux en forme de poire*.

Helios, Carl Nielsen's orchestral work.

Sergei Rachmaninoff's *Variations on a Theme of Chopin*.

Ildebrando Pizzetti's *Per l'Edipo re di Sofocle*, three orchestral preludes.

Richard Strauss's *Sinfonia Domestica* (*Domestic Symphony*).

Vincent d'Indy's opera *L'étranger*.

d. Augusta Holmès, French composer of Irish parentage (b. 1847).

d. Hugo Wolf, Austrian composer (b. 1860).

d. Joseph Parry, Welsh composer (b. 1841).

WORLD EVENTS

Orville and Wilbur Wright made their historic powered flight near Kitty Hawk, North Carolina.

Vladimir Illich Lenin founded the Bolshevik wing of the Russian Social-Democratic Workers' party.

Emmeline and Christabel Pankhurst founded the militant Women's Social and Political Union.

Kishinev, Bessarabia, pogroms began a series of attacks that killed an estimated 50,000 Jews,

spurring migration to America and revolutionary and Zionist movements.

Cuban–American Treaty of 1903 made Cuba an American protectorate; the U.S. occupied Guantánamo base.

Panamanian revolution won independence from Colombia.

Chicago Iroquois Theater fire killed 602 people.

1904

LITERATURE

The Golden Bowl, Henry James's novel about Americans in Europe and the subtle differences between related cultures.

The Nobel Prize for Literature was awarded to Frédéric Mistral and José Echegaray.

Jean Christophe, Romain Rolland's 10-volume series of novels about a musician's place in society (1904–1912).

The Peasants, Wladyslaw Reymont's multivolume masterwork on life in rural Poland (1904–1909).

The Sea-Wolf, Jack London's novel of shipwreck; basis of the 1941 Michael Curtiz film.

Aristide Briand and Jean Jaurès founded *L'Humanité*.

Benito Pérez Galdós's novel *El abuelo (The Grandfather)*.

Rudyard Kipling's *Traffics and Discoveries*, stories linked by poems.

O. Henry's short stories *Cabbages and Kings*.

Beatrix Potter's *The Tale of Benjamin Bunny*.

Nostromo, Joseph Conrad's novel.

Dreamers, Knut Hamsun's novel.

Saki's short stories *Reginald*.

The Late Mattia Pascal, Luigi Pirandello's novel.

The Red Laugh, Leonid Andreyev's novel.

Algernon Charles Swinburne's poems *A Channel Passage*.

Christina Rossetti's *Poetical Works*.

Songs of the Beautiful Lady, Alexander Blok's poems.

Jeppe Aakjaer's novel *The Children of Wrath*.

Liu E's novel *The Travels of Lao Ts'an* (1904–1907).

Winston Churchill's novel *The Crossing*.

H. G. Wells's *The Food of the Gods and How It Came to Earth*.

Offset lithography developed by New York lithographer Ira Rubel, improving printing.

d. (Patricio) Lafcadio (Tessima Carlos) Hearn, Irish-American author (b. 1850).

d. Kate Chopin, American author (b. 1851).

VISUAL ARTS

Pablo Picasso's painting *Woman Ironing*.

Frank Lloyd Wright's work included the Cheney House, Oak Park, Illinois, and the Larkin Building, Buffalo, New York (1904–1905).

Thomas Eakins's painting *Mrs. Edith Mahon*.

George Watts's sculpture *Physical Energy*.

Paul Klee's etching *Comedian II*.

Georges Rouault's painting *Duet*.

Henri Matisse's painting *Luxe, calme, et volupté* (1904–1905).

Mrs. Edith Mahon, Thomas Eakins's painting.

Henri Rousseau's painting *Spring in the Valley of the Bièvre* (ca. 1904).

Charles McKim began Pennsylvania Railway Station, New York.

The Drive–Central Park, William Glackens's painting.

Wassily Kandinsky's painting *Beach Baskets in Holland*.

d. Eadweard Muybridge, British-American photographer, a pioneer in motion studies (b. 1830).

d. Frédéric-Auguste Bartholdi, sculptor of the Statue of Liberty (b. 1834).

d. Ignace Henri Jean Théodore Fantin-Latour, French painter and lithographer (b. 1836).

d. Martin Johnson Heade, American painter (b. 1819).

d. Erastus Dow Palmer, American sculptor (b. 1817).

d. George Frederick Watts, English painter and sculptor (b. 1817).

d. Richard Saltonstall, American sculptor (b. 1819).

THEATER & VARIETY

Dublin's Abbey Theatre opened on December 27; chief founders were William Butler Yeats, Lady Gregory, and John Millington Synge.

Constantin Stanislavsky produced Anton Chekhov's *The Cherry Orchard* at the Moscow Art Theatre.

Maude Adams starred in James M. Barrie's *Peter Pan*, based on his 1902 novel *The White Bird*; basis for the 1954 musical version.

George Bernard Shaw's *John Bull's Other Island* opened in London on November 1.

Riders to the Sea, John Millington Synge's one-act play.

George M. Cohan's *Little Johnny Jones* opened at New York's Liberty Theatre on November 7.

The Virginian, Owen Wister and Kirke La Shelle's play, opened in New York.

Charles Klein's *The Music Master* opened at New York's Belasco Theatre on September 26.

Lawrence Housman's *Prunella* opened in London.

Abraham Goldfaden's *David at War*.

Gunnar Edvard Rode Heiberg's *The Tragedy of Love*.

Bjørnstjerne Bjørnson's *Daglannet*.

George Ade's *College Widow*.

The Lonely Way, Arthur Schnitzler's play.

Giuseppe Giacosa's *The Stronger*.

d. Anton Chekhov, Russian playwright and short-story writer (b. 1860).

d. Dan Leno, star of the English music hall and pantomime (b. 1860).

MUSIC & DANCE

Madame Butterfly, Giacomo Puccini's opera, libretto by Guiseppe Giacosa and Luigi Illica, based on the 1900 David Belasco play, the story of the betrayal of Cho-Cho-san by her American lover, opened at La Scala, Milan, February 17.

Meet Me in St. Louis, Louis, popular song sparked by the city's 1904 Louisiana Purchase Exposition; words by Andrew B. Sterling, music by Kerry Mills; inspiration for the 1944 Judy Garland film.

Jenufa, Leo Janáček's opera, libretto by Janáček, opened at Brno January 21.

Give My Regards to Broadway and *The Yankee Doodle Boy*, songs from the musical *Little Johnny Jones*; words and music by George M. Cohan.

Koanga, Frederic's Delius opera, libretto by Charles Keary, opened March 30, Elberfield, Germany.

Frederick Delius's *Sea Drift*, for voices and orchestra.

In the South, Edward Elgar's concert overture.

Max Reger's *Variations and Fugue on a Theme of Bach*, for piano; and *Variations and Fugue on a Theme of Beethoven*, for two pianos.

Good Bye, My Lady Love, Joseph E. Howard's song, introduced in vaudeville by his wife, Ida Emerson.

Alexander Scriabin's *Symphony No. 3*, the *Divine Poem*.

Sergei Rachmaninoff's operas *Francesca da Rimini* and *The Miser Knight*.

The Mystic Trumpeter, Frederick Shepherd Converse's symphonic poem.

Gustav Mahler's *Songs of the Deaths of Children*.

Le Promenoir des deux amants, Claude Debussy's songs (1904–1910).

Anton von Webern's *Im Sommerwind*, for orchestra.

Charles Ives's third symphony.

Arnold Schoenberg's *String Quartet No. 1*.

Ferruccio Busoni's *Piano Concerto*.

Karol Szymanowski's first piano sonata.

Player-piano companies began to "record" live performances on paper rolls, first by Welte and Sons in Germany. Among those recorded were Sergei Rachmaninoff, Artur Rubinstein, Claude Debussy, and George Gershwin.

London Symphony Orchestra founded.

d. Antonín Dvořák, Bohemian composer (b. 1841). Among his last works was his opera *Armida*.

d. Dan Emmett, American composer and minstrel performer (b. 1815).

WORLD EVENTS

Theodore Roosevelt won a full term as American president, defeating Democrat Alton B. Parker.

Russo-Japanese War began, with surprise Japanese attack upon the Russian far eastern fleet at anchor in Port Arthur harbor. Japanese besieged and took Port Arthur, Korea, and most of Manchuria; and decisively defeated Russians at Mukden.

France and Britain formed the Entente Cordiale, settling some differences in several colonial areas; part of the prelude to World War I.

General Slocum excursion steamer fire in the East River off Manhattan cost more than 1,000 lives.

Panama's Canal Zone was ceded to America, for building of the Panama Canal.

Ida Tarbell published *History of the Standard Oil Company*, her classic muckraking exposé.

Lincoln Steffens's *The Shame of the Cities*.

d. Theodor Herzl, Hungarian lawyer and writer (b. 1860), the founder of the Zionist movement.

1905

LITERATURE

The House of Mirth, Edith Wharton's satirical novel, on orphaned Lily Bart's attempts to enter New York society.

The Nobel Prize for Literature was awarded to Henryk Sienkiewicz.

Rainer Maria Rilke's *Das Stunden-Buch*, translated as *Poems from the Book of Hours*, written from the stance of a Russian monk.

Oscar Wilde's *De Profundis*, inspired by his prison experiences and published posthumously.

Where Angels Fear to Tread, E. M. Forster's first published novel, its title from Alexander Pope's *Essay on Criticism*, "For fools rush in where angels fear to tread."

H. G. Wells's novel *Kipps: The Story of a Simple Soul*; also his *A Modern Utopia*.

Henry James's *English Hours*; also his lectures *The Lesson of Balzac* and *The Question of Our Speech*.

The Mob, Vicente Blasco Ibañez's novel.

Paul Laurence Dunbar's *Lyrics of Sunshine and Shadow*.

Romain Rolland's biography *Michelangelo*.

Charles W. Chesnutt's novel *The Colonel's Dream*.

Mary Austin's novel *Isidro*.

Maclean's Magazine founded in Toronto.

d. Jules Verne, French writer (b. 1828).

d. Lew Wallace, American writer (b. 1827).

d. Mary Mapes Dodge, American author (b. 1831).

VISUAL ARTS

Pablo Picasso began his "rose period" (1905–1906); his work included the paintings *Family of Saltimbanques*, *Woman in a Chemise* (ca. 1905), and *Woman with a Fan*; the drawing *Salomé*; and the sculpture *The Jester*.

Lewis Hine's American immigration photos included *Ellis Island Madonna* and *Albanian Woman with Headcloth*.

Alfred Stieglitz and others opened the Little Galleries of the Photo-Secession (1905–1917).

Die Brücke (The Bridge), a group of artists, most of them German expressionists—including Fritz Bleyl, Eric Heckel, Ludwig Kirchner, Max Pechstein, Emil Nolde, and Karl Schmidt-Rottluff—exhibited together (1905–1913).

Aristide Maillol's sculpture *The Mediterranean*.

Henri Matisse's paintings included *Joy of Life* (1905–1906), *Open Window*, and *Woman with the Hat*.

Auguste Rodin's sculptures included *The Walking Man* and *The Bather*.

Henri Rousseau's painting *The Hungry Lion*.

Edward Steichen's photo of New York's *Flatiron Building*.

Mary Cassatt's pastel *Mère et enfant*.

Summer in the Park, Maurice Prendergast's painting (1905–1907).

Thomas Eakins's painting *Monsignor Diomede Falconio*.

George Luks's paintings included *Hester Street*, *Allen Street*, *The Old Duchess*, and *The Spielers*.

Edvard Munch's painting *Village Street* (1905).

Georges Rouault's painting *Head of Christ*.

Josef Hoffman designed the Stoclet family house, Brussels.

d. Adolf Menzel, German painter and illustrator (b. 1815).

THEATER & VARIETY

Man and Superman, George Bernard Shaw's play, opened in London on May 25; he also wrote *Major Barbara*, basis for the 1941 film.

David Belasco's *The Girl of the Golden West*, opened at New York's Belasco Theatre on November 14; basis of the 1910 Giacomo Puccini opera.

Victor Herbert's *Mlle. Modiste* opened at New York's Knickerbocker Theatre on December 25.

The Squaw Man, Edwin Milton Royle's play, opened at New York's Wallack's Theatre on October 23.

David Belasco and John Luther Long's *Adrea*.

August Strindberg's *Comrades*.

In the Well of the Saints, John Millington Synge's play.

Maxim Gorky's plays *Dachniki* and *Deti solntsa*.

Gerhart Hauptmann's *Elga*.

Padraic Colum's *The Land*.

José Echegaray was awarded the Nobel Prize for Literature, shared with poet Frédéric Mistral.

d. Henry Irving, English actor–manager (b. 1838), from his 1871 appearance in *The Bells* a leading figure in the English theater, and from 1878 a leading actor–manager, most notably in the classics.

d. Maurice Barrymore, English actor, husband of Georgiana Drew and father of John, Ethel, and Lionel Barrymore (b. 1847).

d. Joseph Jefferson, American actor (b. 1829), the grandson and son of two actors of the same name; making his debut as a child actor, he was by midcentury playing leads, and in 1865 first played Rip

Van Winkle, the part with which he was associated for the rest of his life.

MUSIC & DANCE

The Merry Widow (*Die lustige Witwe*), Franz Lehár's opera, libretto by Viktor Léon and Leo Stein, based on Henri Meilhac's comedy *L'Attache*, premiered in Vienna December 30.

Salomé, Richard Strauss's opera, libretto by Hedwig Lachmann, based on Oscar Wilde's 1893 play, opened in Dresden December 9.

Mary's a Grand Old Name, George M. Cohan introduced his song in his own *Forty-five Minutes from Broadway*.

I Don't Care, Eva Tanguey's signature song; words and music by Jean Lenox and Harry Sutton.

La Mer, Claude Debussy's orchestral work; also his piano solos *Images* (1905, 1907).

Wait 'Til the Sun Shines, Nellie, popular song introduced by Byron Harlan; words by Andrew B. Sterling, music by Harry Von Tilzer.

Gustav Mahler's *Symphony No. 7, Song of the Night*.

My Gal Sal, introduced by Byron G. Harlan; words and music by Paul Dresser.

Pelléas et Mélisande, Jean Sibelius's incidental music.

Will You Love Me in December As You Do in May?, Ernest Ball's popular song, words by James J. Walker.

Mlle. Modiste, Victor Herbert's operetta.

Forty-five Minutes from Broadway, George M. Cohan's hit song.

Anton von Webern's chamber work *Langsamer Satz*, his first string quartet, and *Eight Songs*.

Where the River Shannon Flows, James I. Russell's popular song.

Henry Wood's *Fantasia on British Sea Songs*.

(*Come Away with Me, Lucile*) *In My Merry Oldsmobile*, popular waltz, words by Vincent Bryan, music by Gus Edwards.

Re Enzo, Ottorino Respighi's opera.

The Whistler and His Dog, Arthur Pryor's popular caprice.

Charles Ives's *Three-Page Sonata* for piano.

In the Shade of the Old Apple Tree, popular song, words by Harry H. Williams, music by Egbert Van Alstyne.

Pablo Casals, Alfred Cortot, and Jacques Thibaud formed their famous trio.

Mother, Pin a Rose on Me, popular song by Dave Lewis, Paul Schindler, and Bob Adams.

Béla Bartók and Zoltán Kodály began collecting and transcribing folk songs.

The Pipe of Desire, Frederick Shepherd Converse's opera.

Karol Szymanowski's *Concert Overture*.

Leoš Janáček's *Sonata* for piano.

Introduction et allegro, Maurice Ravel's chamber music.

Max Reger's *Sinfonietta*.

Sergei Koussevitsky's *Double Bass Concerto*.

First selective coin-operated phonograph player, the Multiphone (manufactured 1905–1908).

d. Carolina Rosati (Carolina Galletti), Italian-born dancer (b. 1826).

WORLD EVENTS

Albert Einstein put forward the historic theory of relativity, leading to his equation of $E = mc^2$ and recognition of a space–time continuum.

On Bloody Sunday, January 17, Russian troops killed more than 100 unarmed protesters at the Winter Palace, St. Petersburg, setting off the first Russian revolution of the 20th century.

Sailor's mutiny on the Russian battleship *Potemkin*; subject of the classic 1925 Sergei Eisenstein film, *Potemkin*.

Battle of Tsushima: the Russian Black Sea fleet, having steamed around the world to fight, was destroyed by the Japanese navy. Treaty of Portsmouth, New Hampshire, ended the war with major Japanese gains.

Industrial Workers of the World (IWW) founded.

Irish Republican political organization Sinn Fein became a political party.

Norway peacefully won its independence from Sweden.

Theodore Roosevelt initiated the U.S. Forest Service.

1906

LITERATURE

Man of Property, John Galsworthy's first novel and beginning of his trilogy *The Forsyte Saga* (1906–1921); with succeeding volumes, the basis of the 1967 26-part BBC series.

Pelle the Conqueror (1906–1910), Martin Anderson

Nexo's four-part novel on the underside of Danish life; basis of Bille August's 1988 film.

The Nobel Prize for Literature was awarded to Giosuè Carducci.

The Jungle, Upton Sinclair's landmark muckraking novel on the meat industry, sparking reform movements.

O. Henry's short stories *The Four Million*, including *The Gift of the Magi*.

Mark Twain's *The $30,000 Bequest, and Other Stories*, *Eve's Diary*, and *What Is Man?*

Rainer Maria Rilke's *The Tale of the Love and Death of Cornet Christopher Rilke*.

Jack London's novels *Martin Eden* and *White Fang*.

Rudyard Kipling's stories *Puck of Pook's Hil*.

Joseph Conrad's *The Mirror of the Sea, Memories and Impressions*.

Alfred Noyes's narrative poem *Drake: An English Epic* (1906–1908).

Break of Noon, Paul Claudel's novel.

Futabatei Shimei's novel *Sono Omokage*.

George Moore's novel *Memories of My Dead Life*.

Jeppe Aakjaer's poems *Fri felt* and *Rugens sange*.

Endre Ady's poem *Uj Versek*.

Margaret Deland's novel *The Awakening of Helena Richie*.

Rex Beach's novel *The Spoilers*.

Gertrude Atherton's novel *Rezánov*.

Andy Adams's *Cattle Brands*.

Mary Austin's *The Flock*.

Emma Goldman founded the magazine *Mother Earth*.

d. Paul Laurence Dunbar, a seminal Black American writer (b. 1872).

VISUAL ARTS

Pablo Picasso's work included his landmark cubist painting *Les Demoiselles d'Avignon* and the paintings *Gertrude Stein*, *La Toilette*, and *Self-Portrait with a Palette*.

Aristide Maillol's sculpture *Action in Chains*.

George Bernard Shaw, Auguste Rodin's sculpture.

Childe Hassam's painting *Church at Old Lyme*.

Paul Cézanne's painting *The Gardener* (ca. 1906).

Georges Braque's paintings included *L'Estaque*, *l'embarcadière* and *Le Port d'Anvers*.

Claude Monet began his series of paintings *Les Nymphéas* (1906–1926).

Edvard Munch's painting *Marat's Death*.

Frank Lloyd Wright began Unity Temple, Oak Park, Illinois.

Henri Matisse's painting *Joy of Life* and his sculpture *Small Head* (1906–1907).

Unicorns, Arthur Davies's painting.

Henri Rousseau's painting *L'Herbage* (ca. 1906).

Pierre Bonnard's painting *Repas des bêtes* (ca. 1906).

d. Eastman Johnson, American painter (b. 1824).

d. Ernst Josephson, Swedish painter (b. 1851).

THEATER & VARIETY

First known radio program in the United States was broadcast on Christmas Eve by Reginald Fessenden from Brant Rock, Massachusetts.

George Bernard Shaw's *Caesar and Cleopatra* opened in New York; basis for the 1946 film.

Fay Templeton and Victor Moore starred in George M. Cohan's *Forty-five Minutes from Broadway*; opened at New York's New Amsterdam Theatre.

Victor Herbert's *The Red Mill*, music by Herbert and book and lyrics by Henry Blossom, opened at New York's Knickerbocker Theatre on September 24.

The Three of Us, Rachel Crothers's play, opened at New York's Madison Square Theatre.

Bertha, the Sewing Machine Girl, Theodore Kremer's melodrama, opened in New York.

Brewster's Millions, Winchell Smith's play, opened at New York's New Amsterdam Theatre on December 31.

George Bernard Shaw's play *The Doctor's Dilemma*.

Margaret Anglin opened in New York in William Vaughan Moody's *The Great Divide*.

Alla Nazimova starred in New York in a new production of Henrik Ibsen's *Hedda Gabler*.

Gerhart Hauptmann's play *And Pippa Dances*.

Arthur Wing Pinero's *His House in Order*.

The Silver Box, John Galsworthy's first play.

Alexander Blok's *The Puppet Show* and *The Rose and the Cross*.

d. Henrik Ibsen, Norwegian playwright and poet (b. 1828) whose work had enormous influence on European and American social and cultural thinking and on the development of the modern theater.

d. Adelaide Ristori, Italian actress (b. 1822).

MUSIC & DANCE

I Quattro Rusteghi (*The Four Boors* or *The School for*

Fathers), Ermanno Wolf-Ferrari's opera, libretto by Giuseppe Pizzolato, based on the 1790 Carlo Goldoni play *I Rusteghi*, opened in Munich.

Suite Iberia (Iberian Suite), 12 piano pieces, Isaac Albéniz's most famous work (1906–1909).

Naughty Marietta, Victor Herbert's operetta; basis of the 1935 Nelson Eddy–Jeanette MacDonald musical.

You're a Grand Old Flag, George M. Cohan's song, from *George Washington, Jr.*

The Red Mill, Victor Herbert's operetta.

Waltz Me Around Again, Willie, popular song introduced by Blanche Ring; words by Will D. Cobb, music by Ren Shields.

Anna Pavlova became premier ballerina at St. Petersburg's Maryinsky Theatre.

The Kingdom, Edward Elgar's oratorio; sequel to his *The Apostles* (1902).

The Bird on Nellie's Hat, popular hit, words by Arthur J. Lamb, music by Alfred Solman.

Masquerade, Carl Nielsen's opera, libretto by Vilhelm Andersen, premiered in Copenhagen November 11.

I Love You Truly, Carrie Jacobs-Bond's song.

Charles Ives's works for chamber orchestra *Central Park in the Dark* and *The Unanswered Question*.

Anton von Webern's *Five Songs after Poems by Richard Dehmel* (1906–1908) and his *Rondo for string quartet* (ca. 1906).

Gustav Mahler's *Symphony No. 6*, the *Tragic*.

Arnold Schoenberg's *Chamber Symphony No. 1*.

Sergei Prokofiev's *Ten Pieces for Piano* (1906–1913).

Edgard Varèse's *Un Grand Sommeil noir*, IV, for piano.

Pohjola's Daughter, Jean Sibelius's symphonic tone poem.

Josef Suk's symphony *Asrael*.

Summer Evening, Zoltán Kodály's orchestral work.

Albert Roussel's first symphony.

Histoires naturelles, Maurice Ravel's song cycle.

Max Reger's *Serenade*, orchestral work.

Artur Rubinstein made his first American tour.

John McCormack (under the pseudonym Giovanni Foli) made his debut in the title role of Pietro Mascagni's *L'Amico Fritz* in Savona, Italy.

Thomas Beecham founded Britain's New Symphony Orchestra.

d. John Knowles Paine, American composer (b. 1839).

WORLD EVENTS

San Francisco earthquake destroyed most of city on April 18; 700–800 people died.

"Mahatma" Gandhi began the first nonviolent civil disobedience *satyagraha* ("firmness in truth") campaign, in South Africa (1906–1913).

India's Congress party demanded home rule.

Muslim League (All-India Muslim League) founded in British India.

American troops reoccupied Cuba (1906–1909).

Britain's Labour Representation Committee became the Labour party; with Keir Hardie as its first leader.

Czar Nicholas II named Pyotr Stolypin Premier; Stolypin then instituted a reign of terror against the revolutionaries of 1905 and other dissenters.

William James's *Pragmatism*.

d. Pierre Curie, French physicist (b. 1859).

d. Susan B. Anthony, for almost six decades a militant leader of the American and worldwide campaigns for women's suffrage (b. 1820).

1907

LITERATURE

The Secret Agent, Joseph Conrad's novel of anarchists in London; basis for the film *Sabotage*.

Mother (Mat), Maxim Gorky's novel, set among Russian revolutionaries; basis of the 1926 Vsevolod Pudovkin film and the 1931 Bertolt Brecht play.

The Education of Henry Adams: A Study of 20th Century Multiplicity, Henry Adams's autobiographical work, only privately printed until 1918.

Robert Service's *Songs of a Sourdough* (in 1915 retitled *The Spell of the Yukon*), including his best-known poem *The Shooting of Dan McGrew*.

The Nobel Prize for Literature was awarded to Rudyard Kipling.

Sholem Aleichem began his *Mottel, the Cantor's Son* stories (1907–1916).

The Wonderful Adventures of Nils, Selma Lagerlöf's children's stories.

James Joyce's poems *Chamber Music*.

William James's *Pragmatism*.

King Hunger, Leonid Andreyev's novel.

The Longest Journey, E. M. Forster's novel.

William Dean Howells's novel *Through the Eye of the Needle*.

O. Henry's *Heart of the West* and *The Trimmed Lamp*.

Henry James's essays *The American Scene*.

Rainer Maria Rilke's *New Poems* (1907–1908).

Sara Teasdale's *Sonnets to Duse and Other Poems*.

Tayama Katai's *Futon*.

Futabatei Shimei's novel *Heibon*.

George Bernard Shaw's *Dramatic Opinions and Essays*.

Dorothy Canfield's novel *Gunhild*.

d. Francis Thompson, English poet (b. 1859).

d. Thomas Bailey Aldrich, American writer (b. 1836).

VISUAL ARTS

Georges Braque's paintings included *The Port of La Ciotat* and *View from the Hôtel Mistral, L'Estaque*.

Henri Rousseau's paintings included *La Bougie Rose*, *The Repast of the Lion*, and *The Snake-Charmer*.

John Sloan's paintings included *Haymarket, Wake of the Ferry, No. 2*, and *South Street Bathers* (1907–1908).

Edvard Munch's painting *The Bathers' Triptych* (1907–1913).

Constantin Brancusi's sculpture *The Prayer*.

Edgar Degas's painting *Ballet Scene*.

George Bellows's painting *Stag at Sharkey's*, one of many on sports themes.

Henri Matisse's paintings included *The Blue Nude* and *Le Luxe*.

Rube Goldberg created the *Boob McNutt* comic strip.

Piet Mondrian's painting *The Red Cloud*.

Robert Henri's portrait of *Eva Green*.

Wassily Kandinsky's painting *The Night*.

Georges Rouault's painting *Aunt Sallys*.

French Landscape, Alfred Henry Maurer's painting (ca. 1907).

Louis Sullivan began the National Farmers' Bank, Owatonna, Minnesota (1907–1908).

d. Augustus Saint-Gaudens, American sculptor (b. 1848).

THEATER & VARIETY

The Playboy of the Western World, John Millington Synge's classic Irish play, was produced by the Irish National Dramatic Society at Dublin's Abbey Theatre, and for its honesty was met by riots in the streets of Dublin and later on tour.

Florenz Ziegfeld presented the first of his 24 *Ziegfeld Follies* (1907–1931).

The Devil's Disciple, George Bernard Shaw's satire,

set during the American Revolution, opened in London; it had premiered privately in the 1890s.

The God of Vengeance, Sholem Asch's play, written in Yiddish and first produced in German by Max Reinhardt in Berlin.

Franz Lehar's operetta *The Merry Widow* opened at New York's New Amsterdam Theatre.

The Warrens of Virginia, William C. de Mille's play, opened at New York's Belasco Theatre.

Georges Méliès's film *20,000 Leagues Under the Sea*, based on the Jules Verne novel.

August Strindberg's *The Spook Sonata*.

Deirdre, William Butler Yeats's play.

The Rising of the Moon, Lady Augusta Gregory's play.

Lady Frederick, Somerset Maugham's play.

George Fitzmaurice's *The Country Dressmaker*.

The Devil, Ferenc Molnar's play.

Georges-Léon-Jules-Marie Feydeau's farce *A Flea in Her Ear*.

Padraic Colum's *The Desert*.

d. Alfred Jarry, French poet and playwright (b. 1873).

d. Richard Mansfield, American actor (b. 1854).

MUSIC & DANCE

Anna Pavlova introduced *The Dying Swan* (*La Mort du cygne*), the solo choreographed for her by Michel Fokine to music from Camille Saint-Saëns's *Carnival of Animals* (1886), her most famous role, and the epitome of classical Russian ballet, premiered in St. Petersburg.

Les Sylphides, ballet choreographed by Mikahil Fokine to music by Frédéric Chopin; originally called *Chopiniana*, premiered at the Maryinsky Theatre, St. Peterburg, February 23.

A Village Romeo and Juliet, Frederick Delius's opera to his own libretto, based on Gottfried Keller's 1856 story *Romeo und Juliet aus dem Dorfe*, opened in German in Berlin, February 21; the English version premiered in London February 22, 1910.

Ariane et Barbe-bleue (*Ariadne and Bluebeard*), Paul Dukas's opera, based on Maurice Maeterlinck's play, opened May 10 in Paris.

The Legend of the Invisible City of Kitezh and the Maiden Fevronia, Nikolay Rimsky-Korsakov's opera, libretto by Vladimir Ivanovich Belsky, premiered at St. Petersburg, February 20.

Frederick Delius's *Brigg Fair, an English Rhapsody*.

Gustav Mahler's *Symphony of a Thousand* (*Eighth Symphony*).

Maurice Ravel's *Rapsodie espagnole*.

Igor Stravinsky's *Symphony in E Flat Major*.

Variations and Fugue on a Theme of Hiller, Max Reger's orchestral work.

Sergei Rachmaninoff's *Symphony No. 2*.

Jean Sibelius's *Symphony No. 3*.

Irving Berlin's *Marie from Sunny Italy*, his first published song.

Anton von Webern's *Quintet* for string quartet and piano.

Thérèse, Jules Massenet's dramatic musical work.

Ferruccio Busoni's *Sketch of a New Aesthetic of Music*.

John McCormack made his English debut at Covent Garden as Turiddu in Pietro Mascagni's *Cavalleria Rusticana*.

Zionist movement adopted as its national anthem *Hatikvah* (*Hope*), music based on traditional Hebrew melodies, the text an 1886 poem by Baftali Herz Imber; later the Israeli anthem (1948).

d. Edvard Grieg, Norwegian composer (b. 1843).

d. Joseph Joachim, Hungarian violinist and composer (b. 1831), for whom Johannes Brahms wrote his *Violin Concerto*.

WORLD EVENTS

American financial Panic of 1907; the onset of major depression was narrowly averted by the private action of a group of financiers led by J. Pierpont Morgan.

Gentlemen's Agreement, an informal American–Japanese agreement, providing for Japanese curbs on American emigration and American curbs on Western anti-Japanese propaganda.

August von Wasserman developed the first blood test for syphilis.

Belgian-American chemist Hendrik Baekeland developed Bakelite, the first wholly synthetic plastic.

Hermann Minkowski theorized that time was a kind of fourth dimension.

1908

LITERATURE

A Room With a View, E. M. Forster's novel of the conflict between the conventional world and true passion; basis of the 1985 James Ivory film.

The Nobel Prize for Literature was awarded to Rudolf Eucken.

Anne of Green Gables, L. M. Montgomery's popular novel about the carrot-topped orphan on Prince Edward Island; later televised.

Blood and Sand, Vicente Blasco Ibañez novel, its protagonist a bullfighter; basis of the 1922 Rudolph Valentino silent film.

The War in the Air, H. G. Wells's prescient novel; also his *First and Last Things* and *New Worlds for Old*.

The Trail of the Lonesome Pine, John Fox, Jr.'s novel; basis for the 1936 film.

Tayama Katai's novel *One Soldier*, and novel trilogy *Sei*, *Tsuma*, and *Enishi*.

Anatole France's novel *Penguin Island*.

Buried Alive, Arnold Bennett's novel.

Gerhart Hauptmann's travel diary *Griechischer Frühling*.

The Circular Staircase, Mary Roberts Rinehart's first mystery novel.

The Old Wives Tale, Arnold Bennett's novel.

Henry James's *Views and Reviews*.

The Inferno, Henri Barbusse's early novel.

Joseph Conrad's *A Set of Six*.

Maxim Gorky's novels *The Spy* and *A Confession*.

The Iron Heel, Jack London's novel.

O. Henry's *The Gentle Grafter* and *The Voice of the City*.

Winston Churchill's novel *Mr. Crewe's Career*.

Ludwig Lewisohn's novel *The Broken Snare*.

Mary Austin's *Santa Lucia: A Common Story*.

English Review founded and edited by Ford Madox (Hueffer) Ford.

d. Joel Chandler Harris, American writer (b. 1848).

d. Joachim María Machado de Assis, Brazilian novelist and poet (b. 1839).

d. Louis Fréchette, Canadian poet and journalist (b. 1839).

d. Svatopluk Cech, Czech poet, novelist and dramatist (b. 1846).

VISUAL ARTS

First (and only) exhibit of The Eight—Robert Henri, John Sloan, William Glackens, George Luks, Everett Shinn, Arthur Davies, Ernest Lawson, and Maurice Prendergast—at the Macbeth

Gallery, New York, after the National Academy of Design rejected works by Henri's students (Sloan, Luks, and Glackens); later (along with George Bellows) derided as the Ashcan School.

Constantin Brancusi's sculptures included *The Kiss, Sleeping Muse,* and *Portrait of Nicolae Darascu.*

Wassily Kandinsky's paintings included *Blue Mountain* and *Street in Murnau with Women.*

Henri Matisse's work included the paintings *Red Madras Headdress* and *The Dessert, a Harmony in Red*; and the sculpture *Two Negresses.*

Piet Mondrian's paintings included *The Red Tree, Windmill in Sunlight,* and *Woods near Oele.*

Jacob Epstein created his 18 monumental and controversial nude statues on the British Medical Association building.

Amedeo Modigliani's paintings *Head of a Young Woman* and *La Juive.*

Pablo Picasso's painting *Fruit Dish* (1908–1909).

Käthe Kollwitz's series of etchings *The Peasants' War* (1908–1910).

Henri Rousseau's paintings included *Football Players* and *The Rabbit's Feeding.*

Marc Chagall's painting *The Dead Man.*

Augustus John's *The Smiling Woman.*

Frank Lloyd Wright designed the Coonley House, Riverside, Illinois.

Georges Braque's painting *Houses at L'Estaque.*

Robert Henri's painting *Laughing Child.*

Georges Rouault's painting *Judges.*

Steaming Streets, George Bellows's painting.

Gustav Klimt's painting *The Kiss.*

Pierre Bonnard's painting *Regatta* (1908–1912).

Fontaine Fox created the *Toonerville Trolley* comic strip; it ran until 1955.

The Mountains, Marsden Hartley's landscape.

Bud Fisher created the *Mutt and Jeff* comic strip.

d. Edward Augustus Brackett, American sculptor (b. 1818).

THEATER & VARIETY

James M. Barrie's *What Every Woman Knows* opened in London in September, with Hilda Trevelyan, Gerald du Maurier, Lillah McCarthy, Edmund Gwenn, and Mrs. Beerbohm Tree.

The Tinker's Wedding, John Millington Synge's play.

John Masefield's *The Tragedy of Nan* opened in London on May 24.

Maxine Elliott opened Maxine Elliott's Theatre.

George Bernard Shaw's *Getting Married.*

Per Hallström's legend-plays *Ahasverus* and *Alkestis,* and his comedy *Erotikon.*

Georges-Léon-Jules-Marie Feydeau's farces *A Cad Among the Pigeons* and *Look after Lulu.*

The Unicorn from the Stars, William Butler Yeats's play.

Israel Zangwill's *The Melting Pot.*

Henry James's *The High Bid.*

Abraham Goldfaden's *Son of My People.*

Gerhart Hauptmann's *Charlemagne's Hostage* (*Kaiser Karls Geisel*).

Jerome K. Jerome's *The Passing of the Third Floor Back.*

d. John Millington Synge (Edmund John Millington Synge), leading Irish playwright (b. 1871).

d. Tony Pastor, American vaudeville performer and producer (b. 1837), who from 1881 owned and operated New York's Tony Pastors Theatre.

d. Victorien Sardou, French playwright (b. 1831).

d. Abraham Goldfaden, Yiddish playwright (b. 1840).

MUSIC & DANCE

The Gay Hussars (*Tatárjárás*), Imre Kálmán's operetta, was an instant success on its opening in Budapest.

Savitra, Gustav Holst's opera to his own libretto, based on part of India's epic poem, the *Mahabharata*; not staged until 1916, in London.

Cléopâtre (originally *Une Nuit d'Égypte* or *Egiptskie notchi*), Mikhail Fokine's ballet to music by Anton Arensky, opened at the Maryinsky Theatre, with Anna Pavlova and Vaslav Nijinsky.

Maurice Ravel's *Spanish Rhapsody* and *Gaspard de la nuit,* for piano.

Max Reger's *Symphonic Prologue to a Tragedy* and *Violin Concerto.*

Poem of Ecstasy, Alexander Scriabin's orchestral work.

Fireworks, Igor Stravinsky's orchestral work.

Das Lied von der Erde, Gustav Mahler's symphony.

Anton von Webern's *Passacaglia* for orchestra and vocal work *Entflieht auf leichten Kähnen.*

Claude Debussy's *Trois Chansons de Charles d'Orléans,* for unaccompanied choir, and his piano solos *Children's Corner.*

Arnold Schoenberg's *Das Buch der hängenden Gärten,*

for voice and piano, on poems by S. George (1908–1909).

Béla Bartók's first violin concerto and first string quartet.

Saga-drum, Carl Nielsen's orchestral work.

Charles Ives's first violin sonata.

In a Summer Garden, Frederick Delius's rhapsody for orchestra.

Edward Elgar's Symphony No. 1.

Franz Schreker's ballet *Der Geburtstag der Infantim*.

The Dance in Place Congo, Henry F. Gilbert's orchestral work (ca. 1908).

Alban Berg's piano sonata.

Arturo Toscanini became artistic director of the Metropolitan Opera (1908–1915).

Buenos Aires's new Teatro Colón, rebuilt after being destroyed in 1889, opened on May 25 with a production of Giuseppe Verdi's *Aïda*.

d. Nikolay Rimsky-Korsakov, Russian composer (b. 1908).

d. Edward MacDowell, American composer (b. 1860).

WORLD EVENTS

Republican William Howard Taft defeated Democrat William Jennings Bryan, becoming 27th president of the United States (1909–1913).

Abdication of Ts'u Hsi, the Dowager Empress of China, regent but actual ruler of China during the catastrophic decades of the later 19th century. She was succeeded by child Emperor Hsüan T'ung (Henry P'u Yi).

Messina earthquakes took an estimated 100,000–150,000 lives.

First U.S. Pure Food, Drug, and Cosmetic Act.

U.S. Supreme Court in the Danbury Hatters' case (*Loewe v. Lawlor*) outlawed the union-organized boycott as a tool of industrial action.

U.S. Federal Bureau of Investigation (FBI) established, as the Bureau of Investigation.

1909

LITERATURE

H. G. Wells's novels *Ann Veronica*, on the fight for women's rights, and *Tono-Bungay*, a semiautobiographical novel about quack medicine.

Three Lives, Gertrude Stein's first published work, containing three stories: *The Good Woman, Melanctha*, and *The Gentle Lena*.

Selma Lagerlöf won the Nobel Prize for Literature, the first woman so honored.

Wallace Irwin's *Letter of a Japanese Schoolboy*, creating the character of Hashimura Togo, who appeared in other letters over two decades.

Strait Is the Gate, André Gide's novel about faith and sacrifice.

William Carlos Williams's *Poems*.

Thomas Hardy's poems *Time's Laughingstocks and Other Verses*.

Henry James's *Julia Bride* and *Italian Hours*.

Rabindranath Tagore's poems *Gitanjali*.

François Mauriac's poems *Clasped Hands*.

Frank Norris's *The Third Circle*.

Maxim Gorky's novels *Gorodok Okurov* and *Leto*.

Rudyard Kipling's stories *Actions and Reactions*.

Robert Service's poems *Ballads of a Cheechako*.

George Meredith's *Last Poems*.

O. Henry's *Options* and *Roads of Destiny*.

Mori Ogai's novel *Vita sexualis*.

Rainer Maria Rilke's poetic work *Requiem*.

Kafu Nagai's novel *The River Sumida*.

Mark Twain's *Is Shakespeare Dead?*

The Man in Lower Ten, Mary Roberts Rinehart's mystery novel.

Andrei Bely's *Ashes*.

d. Algernon Charles Swinburne, English poet (b. 1837).

d. George Meredith, English novelist (b. 1828).

d. Liu E, Chinese novelist (b. 1857).

d. Augusta Jane Evans, American author (b. 1835).

d. Euclides da Cunha, Brazilian writer (b. 1866).

d. Futabatei Shimei, Japanese novelist (b. 1864).

d. Richard Watson Gilder, American writer (b. 1844).

d. Sarah Orne Jewett, American writer (b. 1849).

VISUAL ARTS

Pablo Picasso's works included the paintings *Bust of a Woman* and *Seated Nude* (1909–1910) and the sculpture *Woman's Head* (ca. 1909).

Henri Matisse's painting *Dance* and his sculpture *The Back I–IV* (1909–1930).

Oskar Kokoschka's paintings included *Adolf Loos, Dent du Midi, Portrait of Dr. Tietze and His Wife*,

and *Still Life with Tortoise and Hyacinth*.

Henri Rousseau's paintings included *Promenade au Luxembourg*, *The Muse Inspiring the Poet*, *Vase of Flowers*, and *View of the Île Saint-Louis*.

Amedeo Modigliani's paintings *Paul Alexandre* and *The Cellist*.

Constantin Brancusi's sculpture *The Wisdom of the Earth*.

Marc Chagall's painting *My Fiancée with Black Gloves*.

Umberto Boccioni's painting *Riot in the Gallery*.

Fernand Léger's painting *Nude Figures in a Wood* (1909–1910).

Marcel Duchamp's painting *Nude on Nude*.

Filippo Marinetti published the futurist *Manifesto*.

Rockwell Kent's painting *Road Roller*.

d. Charles Follen McKim, American architect (b. 1847).

d. Frederic Remington, American painter (b. 1861), most notably of the American West.

THEATER & VARIETY

Glasgow Repertory Theatre opened with a production of George Bernard Shaw's *You Never Can Tell*.

George Bernard Shaw's *The Shewing-Up of Blanco Posnet*.

John Galsworthy's *Strife* was produced both in London and New York.

Liliom, Ferenc Molnar's play, basis of the 1945 film *Carousel*.

Elsie Janis starred in George Ade's *The Fair Co-Ed*.

Mary Roberts Rinehart and Avery Hopwood's comedy *Seven Days* opened in New York.

Sphinx and Strawman and *Murderer, Hope of Women*, two plays by painter Oskar Kokoschka.

John Barrymore starred in Winchell Smith's *The Fortune Hunter*; opened in New York.

Clyde Fitch's *The City* opened at New York's Lyric Theatre on December 21; he also wrote *The Woman in the Case*.

New York's Comedy Theatre opened with a production of Israel Zangwill's *The Melting Pot*.

Arthur Wing Pinero's *Mid-Channel*.

Bjørnstjerne Bjørnson's *When the New Wine Blooms*.

Gerhart Hauptmann's *Griselda*.

The Blue Bird, Maurice Maeterlinck's play.

d. Clyde Fitch, American playwright (b. 1865).

d. Coquelin Aîné (Benoît-Constant Coquelin), French actor (b. 1841), brother of Coquelin Cadet.

d. Ernest-Alexandre-Honoré Coquelin (Coquelin Cadet), French actor (b. 1848), brother of Coquelin Aîné.

d. Fred William Evans, acrobat and clown (b. 1840).

d. Helena Modjeska, Polish actress (b. 1840), a leading player in Warsaw from 1868 until her emigration to the United States in 1876, and thereafter a leading tragedian on the English-speaking stage, most notably in Shakespeare.

d. Jacob Gordin, Jewish playwright, born in Ukraine (b. 1853).

MUSIC & DANCE

Ballets Russes ballet company (1909–1929) was founded by Sergei Diaghilev, and made its debut at the Théâtre du Châtelet, Paris on May 18, initiating the modern ballet theater. The first program included *Le Pavillon d'Armide*, *Le Festin*, and the Polotvetsian dances from *Prince Igor*, Mikhail Fokine's choreography to music from Alexander Borodin's 1890 opera, with Adolphe Bolm dancing the lead.

Sergei Diaghilev's Ballets Russes presented the first Paris productions of Mikhail Fokine's ballets *Les Sylphides* (1907) and *Cléopâtre* (1908), opened June 2, with Anna Pavlova, Vaslav Nijinsky, Tamara Karsavina, and Fokine.

Le Coq d'or (*The Golden Cockerel*), Nikolay Rimsky-Korsakov's opera; libretto by Vladimir Ivanovich Bielsky, based on an 1834 Pushkin story, premiered Moscow, October 7.

Electra (*Elektra*), Richard Strauss's opera, based on Sophocles via Hugo von Hofmannstal's 1903 play, opened in Dresden January 25.

Der Graf von Luxemburg (*The Count of Luxemburg*), Franz Lehár's operetta, libretto by Alfred Maria Willner and Robert Bodansky, opened in Vienna.

Susanna's Secret (*Il Segreto di Susanna*), Ermanno Wolf-Ferrari's opera, libretto by Enrico Golisciani.

Ralph Vaughan Williams's song *On Wenlock Edge*, overture *The Wasps*, and *Symphony No. 1, A Sea Symphony*.

Sergei Rachmaninoff's *Piano Concerto No. 3* and symphonic poem *The Island of Death*.

Gustav Mahler's *The Song of the Earth*.

Jean Sibelius's *String Quartet in D Minor, Voces intimae*.

I've Got Rings on My Fingers, Maurice Scott's song, trademark of Blanche Ring.

Arnold Schoenberg's *Five Orchestral Pieces* and *Three Piano Pieces*.

In the Faery Hills, Arnold Bax's symphonic poem.

Anton von Webern's *Five Movements for String Quartet, Six Pieces for Orchestra*, and 10 *George* songs in 3 sets.

Charles Ives's first piano sonata.

Jan Paderewski's *Symphony in C Major*.

A Summer's Tale, Josef Suk's symphonic poem.

Karol Szymanowski's *Symphony*.

John McCormack made his Metropolitan Opera debut in *La Traviata*, thereafter making his career largely in the United States.

d. Isaac Albéniz, Spanish composer and pianist (b. 1860).

d. Francisco Tárrega, Spanish guitar soloist and transcriber (b. 1852), who transcribed for guitar many classical works.

WORLD EVENTS

Robert E. Peary, Matthew Henson, and four Eskimos reached the North Pole.

National Association for the Advancement of Colored People (NAACP) was founded.

Halley's comet again sighted.

French aviator Louis Blériot became the first to fly over the English Channel, on July 25.

Henry Ford introduced the Model T.

Revolution in Iran; Ahmed Shah took power; British exploration and extraction of Iranian oil began.

Young Turks took power in Turkey; figurehead ruler was Muhammad V.

1910

LITERATURE

Howards End, E. M. Forster's novel focusing on the Wilcox and Schlegel families and their lives interconnected with the house, Howards End; basis of James Ivory's 1992 film.

The Nobel Prize for Literature was awarded to Paul von Heyse.

Clayhanger, first in Arnold Bennett's series of novels about Edwin Clayhanger and Hilda Lessways in England's pottery towns (1910–1918).

The Love Song of J. Alfred Prufrock, T. S. Eliot's poem on the sterility and paralysis of social custom, written while a Harvard undergraduate (1910–1911); not published until 1915.

William Butler Yeats's poems *The Green Helmet*.

Chaka the Zulu, Thomas Mofolo's novel.

Gerhart Hauptmann's novel *Der Narr in Christo, Emanuel Quint* (*The Fool in Christ, Emanuel Quint*).

H. G. Wells's novel *The History of Mr. Polly*.

Henry James's *The Finer Grain*.

The Journal of Malte Laurids Brigge, Rainer Maria Rilke's novel.

John Masefield's *Ballads and Poems*.

Maxim Gorky's novel *Zhizn Matveya Kozhemyakina* (1910–1911).

Rudyard Kipling's stories *Rewards and Fairies*.

Saki's *Reginald in Russia*.

Jeppe Aakjaer's poems *Den Sommer og den Eng*.

The Village, Ivan Bunin's novel.

Auguste Rodin's *À la Vénus de Milo* (*To the Venus de Milo*).

Ishikawa Takuboku's poems *Ichiaku no suna* (*A Handful of Sand*).

Romain Rolland's biography *Handel*.

d. Leo Tolstoy, Russian author (b. 1828).

d. Mark Twain, American writer (b. 1835).

d. William Sydney Porter (O. Henry), American writer (b. 1862); his final works included *Strictly Business* and *Whirligigs*.

d. William James, American author (b. 1842).

d. Julia Ward Howe, American poet and reformer (b. 1819).

d. Rebecca Harding Davis, American writer (b. 1831).

VISUAL ARTS

First Abstract Watercolor, Wassily Kandinsky's painting, a gouache thought by some to have been the first fully nonobjective work.

Exhibition of Independent Artists was organized by Robert Henri, with Walt Kuhn and John Sloan.

Pablo Picasso's *Girl with a Mandolin*.

Umberto Boccioni, Giacomo Balla, Gino Severini, Luigi Rossolo, and Carlo Carra published *Technical Manifesto of the Futurist Painters*.

Henri Rousseau's paintings included *The Cascade, Tropical Forest with Monkeys, Yadivgha's Dream*, and *Landscape* (ca. 1910).

John Marin's painting *Brooklyn Bridge*.

Marcel Duchamp's painting *The Chess Players*.

John Sloan's painting *Pigeons*.

Marc Chagall's painting *Sabbath*.

Alexander Young Jackson's painting *April Snow*.

Composition with Three Figures, Max Weber's sculpture.

Georges Braque's paintings included *Piano and Lute* and *Violin and Jug*.

Crescendo, Arthur Davies's painting.

Edvard Munch began his murals for the Aula of Oslo University (1910–1916).

Fernand Léger's painting *Nude Figures in a Wood*.

French Tea Garden, Childe Hassam's painting.

Henri Matisse's sculpture *Jeanette I–V*.

Paul Klee's drawing *Furniture Caricature*.

Rockwell Kent painting *Down to the Sea*.

Krazy Cat comic strip was created by cartoonist George Herriman.

Giacomo Balla's painting *Dynamism of a Dog on a Leash*.

Augustus John's *Provençal Sketches*.

d. Winslow Homer, American artist (b. 1836).

d. Henri Rousseau, French painter (b. 1844).

d. Nadar (Gaspard Félix Tournachon), French caricaturist, writer, and leading early portrait photographer (b. 1820).

d. Franz Marc, German expressionist painter, a founder of the Blue Rider group.

d. John La Farge, American painter and author (b. 1835).

d. John Quincy Adams Ward, American sculptor (b. 1830).

THEATRE & VARIETY

John Millington Synge's *Deirdre of the Sorrows*, unfinished at his death (1908), premiered at the Abbey Theatre and was also produced in London.

John Galsworthy's *Justice* and *The Skin Game*.

The Guardsmen, Ferenc Molnar's play.

Victor Herbert's *Naughty Marietta* opened at the New York Theatre on November 7.

Nobody's Widow, Avery Hopwood's comedy, opened at New York's Hudson Theatre on November 15.

Rebecca of Sunnybrook Farm opened at New York's Republic Theatre; adapted by Kate Douglas Wiggin and Charlotte Thompson from the Wiggin book.

H. B. Warner and Laurette Taylor starred in Paul Armstrong's *Alias Jimmy Valentine*; opened at New York's Wallack's Theatre on January 21.

Anatol, Arthur Schnitzler's play, was produced in 1910 in Vienna and Berlin.

Comedian Eddie Foy introduced his new act: *Eddie Foy and the Seven Little Foys*.

George Bernard Shaw's *Misalliance*.

August Strindberg's *The Great Highway*.

Edmond Rostand's *Chantecler*.

Maxim Gorky's plays *Vassa Zhelznova* and *Deti*.

Per Hallström's saga-plays *A Thousand and One Nights* and *The Wishes*.

d. Bjørnstjerne Bjørnson, Norwegian poet, playwright, and novelist (b. 1832).

d. Vera Fedorovna Komisarjevskaya, Russian actress and theater manager (b. 1864), sister of Theodore Komisarjevsky.

d. William Vaughn Moody, American playwright (b. 1869).

MUSIC & DANCE

Sergei Diaghilev's Ballets Russes company premiered two new Mikhail Fokine ballets at the Opéra, Paris: *Shéhérazade* (*Schéhérazade*), music by Nikolay Rimsky-Korsakov on June 4, with Vaslav Nijinsky and Ida Rubinstein in the leads; and *The Firebird* (*L'Oiseau de feu* or *Shar Ptiza*), music by Igor Stravinsky, on June 25, with Tamara Karsavina and Fokine dancing the leads.

La Fanciulla del West (*The Girl of the Golden West*), Giacomo Puccini's opera, libretto by Guelfo Civinnini and Carlo Zangarini, based on the 1905 David Belasco play, premiered in New York December 10, with Jenny Destinn and Enrico Caruso creating the leading roles and Arturo Toscanini conducting.

Anna Pavlova founded her dance company and soon began the tours that brought ballet to new audiences worldwide.

Don Quichotte, Jules Massenet opera, libretto by Henri Cain, based on the Miguel de Cervantes novel (1605; 1615), opened in Monte Carlo, with Fyodor Chaliapin creating the title role.

Königskinder (*Royal Children*), Engelbert Humperdinck's opera, libretto by Ernest Rosmer (Elsa Bernstein), premiered in New York.

Ralph Vaughan Williams's *Fantasia on a Theme of Thomas Tallis* for orchestra.

Prometheus, the Poem of Fire, Alexander Scriabin's symphonic poem.

Some of These Days, Shelton Brooks's song, which would become Sophie Tucker's signature song.

Claude Debussy's songs *Trois Ballades de François Villon* and piano solos *Douze Préludes* (1910; 1913).

John Philip Sousa took his band on a world tour (1910–1911).

Edward Elgar's *Violin Concerto* was introduced by Fritz Kreisler.

Macbeth, Ernest Bloch's opera.

Erik Satie's *Nouvelles pièces froides*, for piano.

Fenimore and Gerda, Frederick Delius's opera.

Zigeunerliebe (*Gypsy Love*), Franz Lehár's operetta.

Gustav Mahler's *Symphony No. 9.*

Anton von Webern's *Four Pieces for Violin and Piano* and *Two Songs.*

Charles Ives's second violin sonata.

Sergei Rachmaninoff's *Liturgy of St. John Chrysostomus.*

Karol Szymanowski's *Symphony.*

Max Reger's *Piano Concerto.*

Alban Berg's *String Quartet* and *4 songs.*

Herois do mar became the official anthem of the Republic of Portugal; music by Alfredo Keil, to Lopex de Mondonça's 1890 poem.

Chicago Grand Opera Company (later the Chicago Civic Opera) was formed.

Marimba developed in the United States, from African-derived Central American folk instruments (ca. 1910).

d. Marius Petipa, French choreographer and dancer (b. 1818).

WORLD EVENTS

Los Angeles Times bombing killed 21 people; union leaders John J. and James B. McNamara were sentenced to long prison terms after Clarence Darrow pleaded them guilty to save their lives.

Mexican Revolution and civil war began as a revolt against the Porfirio Díaz dictatorship after Díaz arrested opposing presidential candidate Francisco Madero; the civil war ultimately cost an estimated one million lives (1910–1920).

Union of South Africa was formed, consisting of the British Cape Colony and Natal, and the former Boer republics of the Transvaal and Orange Free State.

Thomas Hunt Morgan discovered a link between genes and heredity.

1911

LITERATURE

The Egoist began publication in England; the literary magazine introduced the work of poets such as H.D. (Hilda Doolittle), T. S. Eliot, and Ezra Pound (1911–1919).

Ethan Frome, Edith Wharton's novel; basis for the 1993 film.

Ambrose Bierce's wonderully acerbic *The Devil's Dictionary* (originally *The Cynic's Word Book*).

The Innocence of Father Brown, G. K. Chesterton's novel, the first of the "Father Brown" series.

Jennie Gerhardt, Theodore Dreiser's novel.

Maurice Maeterlinck was awarded the Nobel Prize for Literature.

Zuleika Dobson, Max Beerbohm's novel.

D. H. Lawrence's novel *The White Peacock.*

The Death of a Nobody, Jule Romains's novel.

Hilda Lessways, second novel in Arnold Bennett's *Clayhanger* series (1910–1918).

André Gide's *Isabelle.*

Dry Valley, Ivan Bunin's novel.

George Moore's novel *Farewell* (1911–1914).

The New Macchiavelli, H. G. Wells's novel.

Joseph Conrad's novel *Under Western Eyes.*

Henry James's *The Outcry.*

O. Henry's *Sixes and Sevens.*

Rupert Brooke's *Poems.*

Sara Teasdale's *Helen of Troy.*

Jenny, Sigrid Undset's novel.

John Masefield's long narrative poem *The Everlasting Mercy.*

Juhani Aho's novel *Juha.*

Mary Johnston's novel *The Long Roll.*

Saki's *The Chronicles of Clovis.*

Maxim Gorky's *Tales of Italy* (1911–1912).

Auguste Rodin's *L'Art* (1911 and 1946).

Romain Rolland's biography *Tolstoy.*

The Daily Mirror began publication in Britain, the first to circulate over one million copies a day.

VISUAL ARTS

Der Blaue Reiter (*The Blue Rider*), essays edited by

Franz Marc and Wassily Kandinsky, which became the manifesto of an experimentally minded group of that name, most of them expressionists, who exhibited together (1911–1914); among those exhibiting with the *Blaue Reiter* group were Paul Klee, August Macke, Jean Arp, and Maurice de Vlaminck.

Frank Lloyd Wright built Taliesin, his Wisconsin home; destroyed by fire (1915), then rebuilt and altered (1925), it became his architecture school and workshop.

Marcel Duchamp's paintings included *Nude Descending a Staircase, No. 1* and *Sad Young Man in a Train.*

Georges Braque's paintings included *Man with a Guitar, The Portuguese,* and *Portrait of Mr. X.*

Pablo Picasso's paintings included *Accordionist (Pierrot)* and *Still Life with Chair Caning* (1911–1912).

Henri Matisse's paintings included *Goldfish and Sculpture, The Blue Window,* and *The Red Studio.*

Marc Chagall's paintings included *Half-Past Three, Hommage à Apollinaire* (1911–1912), *I and My Village,* and *The Artist's Father.*

Constantin Brancusi's sculpture *Prometheus.*

Franz Marc's painting *Blue Horses.*

Raymond Duchamp-Villon's sculpture *Baudelaire.*

Wassily Kandinsky's paintings included *All Saints Picture II* and *Encircled.*

Lewis Hine's photo *Breaker Boys in Coal Mine.*

Piet Mondrian's painting *Still Life with Gingerpot* (1911–1912).

Wilhelm Lehmbruck's sculpture *Kneeling Woman.*

Max Weber's painting *Interior with Still Life.*

Childe Hassam's painting *Sunset at Sea.*

Gustav Klimt painted the Palais Stoclet murals, in Brussels.

Ludwig Mies van der Rohe designed the Perls house, Berlin.

Portrait of the Artist's Niece Rose Marie Ormond ("Nonchaloire"), John Singer Sargent's painting.

The Geraniums, Max Weber's painting.

James MacDonald's painting *By the River, Early Spring.*

Lorado Taft's sculpture *Black Hawk.*

Umberto Boccioni's painting *The City Rises.*

Walter Gropius designed the Fagus Works, Alfeld-an-der-Leine, Germany.

THEATER & VARIETY

Eyvind of the Hills, Jóhann Sigurjónsson's play, was produced in Iceland.

George M. Cohan's *The Little Millionaire* opened at New York's George M. Cohan Theatre.

Justice, John Galsworthy's play, was first performed in the United States by the Hull House Players in Chicago.

Kismet, Edward Knoblauch's play, opened at the Knickerbocker Theatre, New York, December 25.

Liverpool Playhouse opened (originally Liverpool Repertory Theatre).

The Return of Peter Grimm, David Belasco's play, opened at New York's Belasco Theatre.

The Scarecrow, Percy MacKaye's play.

Fanny's First Play, George Bernard Shaw's play.

Cradle Song, Gregorio Martinez Sierra's play; opened in Madrid in March.

Louis Parker's *Disraeli* opened in New York.

Lord Dunsany's *King Argimenes* and *The Gods of the Mountain.*

Gerhart Hauptmann's *The Rats (Die Ratten).*

Rachel Crothers's *He and She.*

d. Rose Ettinge, American actress (b. 1835).

d. William Schwenck Gilbert, English playwright (b. 1836), partner of Arthur Sullivan.

MUSIC & DANCE

Sergei Diaghilev's Ballets Russes company presented two new Mikhail Fokine ballets: *La Spectre de la Rose,* music by Carl Maria von Weber, first danced April 19 in Monte Carlo, with Vaslav Nijinsky and Tamara Karsavina; and *Petrushka,* music by Igor Stravinsky, first danced June 13 at the Théâtre du Châtelet, Paris, with Vaslav Nijinsky in the title role, opposite Tamara Karsavina and Alexander Orlov.

Der Rosenkavalier (The Knight of the Rose), Richard Strauss's opera, libretto by Hugo von Hofmannstal, opened in Dresden, January 26.

Treemonisha, Scott Joplin's folk opera, not publicly heard until 1915, and not fully staged until 1975, when it won a posthumous Pulitzer Prize.

Alexander's Ragtime Band, the landmark Irving Berlin song, infusing ragtime rhythms into American popular music.

L'Heure espagnole (The Spanish Hour), Maurice

Ravel's opera, libretto by Franc-Nohain (Maurice Legrand) from his own 1904 play, opened at the Opéra-Comique, Paris, May 19.

Frederick Delius's *A Song of the High Hills* and orchestral work *Summer Night on the River*.

Valses nobles et sentimentales, Maurice Ravel's eight short waltzes for piano.

A Tale of Old Japan, Samuel Coleridge-Taylor's choral work.

Sergei Prokofiev's *First Piano Concerto*.

Arnold Schoenberg's choral cantata *Gurrelieder* and *Herzegewächse*, for voice and instruments.

My Melancholy Baby, popular song, words by George A. Norton, music by Ernie Burnett.

Bluebeard's Castle, Béla Bartók's opera.

Edward Elgar's *Symphony No. 2*.

Gustav Mahler's *Symphony No. 10* (before 1911).

The King of the Stars, Igor Stravinsky's choral work.

Jean Sibelius's *Symphony No. 4*.

En habit de cheval, Erik Satie's piano duet.

Carl Nielsen's *Violin Concerto* and *Symphony No. 3, Sinfonia espansiva*.

Le Martyre de Saint Sébastien, Claude Debussy's incidental music for a mystery play.

Charles Ives's *Tone Roads No. 1*, for chamber orchestra.

The Sea, Frank Bridge's orchestral suite.

Evocations, Albert Roussel's orchestral work.

The Sacrifice, Frederick Shepherd Converse's opera.

Enrique Granados's *Goyescas*, suite of seven piano pieces.

Karol Szymanowski's second piano sonata.

Max Reger's *Overture to a Comedy*.

d. Gustav Mahler, Austrian composer and conductor (b. 1860).

d. Carl Nielsen, Danish composer (b. 1865).

d. James A. Bland, American songwriter (b. 1854).

WORLD EVENTS

Chinese Revolution began, with armed uprisings against the Manchus at Wuchang, in central China. Sun Yat-sen returned home from America and was elected provisional president, but general Yüan Shih-k'ai ultimately emerged in 1912 as first president of the new Republic of China.

Francisco Madero took power in Mexico. The revolutionary movement soon split; Emiliano Zapata and others warred with the new government. Madero decisively defeated government forces at Ciudad Juárez.

General European war threatened when Germany again provoked a crisis over Morocco, withdrawing its gunboat *Panther* when Britain and France seemed ready to go to war.

New York Triangle Shirtwaist Company fire killed 146 workers, most of them young immigrant women, trapped by barred factory exit doors.

Italy declared war on Turkey, and invaded and took Libya, Rhodes, and the Dodecanese Islands.

Japan annexed Korea.

U.S. Supreme Court forced breakup of the massive Standard Oil trust in *Standard Oil Company of New Jersey v. United States*.

Russian Premier Pyotr Stolypin was assassinated in Kiev.

American explorer Hiram Bingham rediscovered the lost Inca city Machu Picchu, in the high Peruvian Andes.

1912

LITERATURE

Death in Venice, Thomas Mann's short novella, basis of the 1971 Luchino Visconti film and the 1973 Benjamin Britten opera.

Rabindranath Tagore's *Song Offerings*, an English-language translation of the poetry collection *Gitanjali*.

Arthur Quiller-Couch (pen name "Q") became the first professor of English Literature at Cambridge University, his inaugural lectures being published as *On the Art of Writing* (1916).

Zane Grey's *The Riders of the Purple Sage*, his most popular Western novel; basis of several films.

The Bird of Time, the early poetry of the Indian poet, feminist, and political leader Sarojini Naidu.

Gerhart Hauptmann was awarded the Nobel Prize for Literature; also his novel *Atlantis*.

A Dome of Many-Coloured Glass, Amy Lowell's first poetry collection.

Anatole France's novel *Les Dieux ont soif*.

Anna Akhmatova's *Evening*.

August Strindberg's *The Confessions of a Fool*.

Autobiography of an Ex-Colored Man, James Weldon Johnson's novel.

Gertrude Atherton's novel *Julia France and Her Times*.

H. G. Wells's novel *The Marriage*.

John Masefield's long narrative poem *The Widow in the Bye Street*.

Joseph Conrad's *Some Reminiscences* and *Twixt Land and Sea*.

Mary Austin's novel *A Woman of Genius*.

Robert Service's *Rhymes of a Rolling Stone*.

Subramania Bharati's *Kuyil's Song* and *Panchali's Vow* (1912–1924).

The Financier, Theodore Dreiser's novel.

The Tidings Brought to Mary, Paul Claudel's novel.

Dorothy Canfield's novel *The Squirrel-Cage*.

d. Ishikawa Takuboku, Japanese poet (b. 1886); his last year saw the poetry collections *Sad Toys* and *The Flute*.

d. Bram (Abraham) Stoker, English writer (b. 1847), creator of Dracula.

VISUAL ARTS

Nude Descending a Staircase, No. 2, Marcel Duchamp's emblematic and in its time highly controversial abstract painting, the great hit of the 1913 New York Armory Show; also his painting *The King and Queen Surrounded by Swift Nudes*.

Constantin Brancusi's sculpture *Maiastra*, a very recognizable mythical bird that by 1940, 28 versions later, would become the highly abstracted *Bird in Flight*; also his sculpture *Muse*.

Gaston Lachaise's sculpture *Standing Woman* (1912–1927); the beginning of his long series of "goddess" nudes, apparently inspired by Magdalenian cave figures.

Alexander Archipenko's innovative sculpture *Walking*, introducing the concept of inner space by boring holes in what earlier would have been solid figures.

Georges Braque's paintings included *Composition à l'as de trèfle* (ca. 1912–1913) and *Fruit Dish and Glass*.

Auguste Rodin's sculpture *Nijinsky*.

Georges Rouault's painting *Christ Mocked*.

José Clemente Orozco's painting *House of Tears*.

Pablo Picasso's painting *The Aficionado*.

Marc Chagall's paintings included *Calvary*, *Homage to Apollinaire*, *Self-Portrait with Seven Fingers* (ca. 1912), *The Fiddler*, and *The Soldier Drinks*.

Raymond Duchamp-Villon's paintings included *Horse*, *Maggy*, and *The Seated Woman*.

Amedeo Modigliani's paintings included *Cariatide in Piedi* (ca. 1912) and *Seated Nude* (ca. 1912–1913).

Giacomo Balla's painting *Speeding Automobile*.

Movement, Fifth Avenue, John Marin's painting.

Henri Matisse's painting *Goldfish*.

Jacob Epstein built the tomb of Oscar Wilde, Paris.

Oskar Kokoschka's painting *Double Portrait* (*Oskar Kokoschka and Alma Mahler*).

James MacDonald's painting *Tracks and Traffic*.

Frank Kupka's painting *Fugue in Two Colors*.

Piet Mondrian's painting *The Gray Tree*.

Daniel Chester French's statue of *Abraham Lincoln*.

Umberto Boccioni published the *Manifesto of Futurist Sculpture*.

d. Thomas Ball, American sculptor (b. 1819).

THEATER & VARIETY

George Bernard Shaw's *Androcles and the Lion* opened in Berlin; he also wrote *Overruled*.

Laurette Taylor starred in J. Hartley Manners's *Peg o' My Heart*, at New York's Cort Theatre.

Mack Sennett began the Keystone Kops comedy series.

Frank Reicher starred in John Galsworthy's *The Pigeon*, opening in London on January 30.

Paul Claudel's *The Tidings Brought to Mary* was produced in Paris.

Edward Knoblock's *Milestones* was produced in London on March 5.

Fritz Kortner opened in Berlin in Arthur Schnitzler's *Professor Bernhardi*.

Quo Vadis, Enrico Guazzoni's epic silent film version of the 1895 Henryk Sinkiewicz early-Christians-in-Rome novel.

Eyvind of the Hills, Jóhann Sigurjónsson's play, was produced in Copenhagen May 20.

The Firefly opened at New York's Lyric Theatre.

The Dead Day (*Der tote Tag*), Ernst Barlach's play.

Georges Méliès's *The Conquest of the Pole*.

Gerhart Hauptmann's *Gabriel Schillings Flucht*.

The Man Who Married a Dumb Wife, Anatole France's play.

The Rose and the Cross, Alexander Blok's verse play.

d. August Strindberg, Swedish playwright (b. 1849).

d. Enrico Annibale Butti, Italian playwright (b. 1868).

MUSIC & DANCE

The Afternoon of the Faun (*L'après-midi d'un faune*), ballet to Claude Debussy's 1894 work, choreographed by and starring Vaslav Nijinsky, with Sergei Diaghilev's Ballets Russes company; the controversial premiere was in Paris, May 29.

Daphnis and Chloe, Michel Fokine's ballet, music by Maurice Ravel, first danced June 8, in Paris, by Sergei Diaghilev's Ballets Russes with Tamara Karsavina, Vaslave Nijinsky, and Adolphe Bolm.

Ariadne auf Naxos, Richard Strauss opera, libretto by Hugo von Hofmannsthal, opened in Stuttgart.

Frederick Delius's orchestral works *On Hearing the First Cuckoo in Spring* and *Summer Night on the River*.

Memphis Blues, W. C. Handy's first hit.

A Shropshire Lad, George Butterworth's orchestral rhapsody, based on A. E. Housman's 1896 poems.

Valses nobles et sentimentales, Maurice Ravel's orchestral work.

Rose of Tralee, Charles Glover and C. Mordaunt Spencer's song, poularized by John McCormack.

Decoration Day, Charles Ives's orchestra work.

Gustav Holst's *Choral Hymns from the Rig Veda*.

In the Mists, Leoš Janáček's piano work (by 1912).

When Irish Eyes Are Smiling, Ernest R. Ball's popular song, lyrics by Chauncey Olcott and George Graff, Jr.

Arnold Schoenberg's *Pierrot Lunaire*, for voice and orchestra.

Claude Debussy's orchestral work *Images* and chamber work *Syrinx*.

Erik Satie's piano duet *Aperçus désagréables*.

Franz Schreker's opera *Der ferne Klang*.

Romantic Suite, Max Reger's orchestral work.

Paul Dukas's opera *La Peri*.

The Firefly, Rudolf Friml's operetta.

Carl Nielsen's second violin sonata.

Alban Berg's *5 Altenberg Songs*.

Chinese anthem *Tsung-kuoh hiung li jüh dschou tiän* (*The Middle Kingdom stands like a hero in the universe*) (ca. 1912), by authors unknown.

Deutsche Oper opened with a production of Ludwig van Beethoven's *Fidelio* in Berlin.

d. Jules Massenet, French composer (b. 1842).

d. Samuel Coleridge-Taylor, English composer (b. 1875).

d. Mykola Vytalýevych Lysenko, Ukrainian composer (b. 1842).

WORLD EVENTS

Democrat Woodrow Wilson won the American presidency, defeating Republican William Howard Taft and Progressive (Bull Moose) third party candidate Theodore Roosevelt.

Balkan League armies attacked Turkish forces in Macedonia and Thrace, beginning the First Balkan War; they took Salonika, Adrianople, and Yannina, and besieged Constantinople.

Bolsheviks split away from Mensheviks to form their own Russian revolutionary party.

The "unsinkable" British liner *Titanic* sank off Newfoundland, on April 15, after striking an iceberg on its first trans-Atlantic voyage; 1,500 lives were lost.

African National Congress (ANC) founded in South Africa.

Industrial Workers of the World (IWW) organized the successful Lawrence textile strike.

Abdication of Hsüan T'ung (Henry P'u Yi), the last Manchu (Ch'ing) emperor of China.

Alfred Wegener introduced the continental drift theory.

1913

LITERATURE

Remembrance of Things Past (*À la recherche du temps perdu*), Marcel Proust's seven-part work (1913–1927), a centerpiece of 20th-century literature, began with *Swann's Way*.

Sons and Lovers, D. H. Lawrence's autobiographical novel; basis of the 1960 Jack Cardiff film; also his novel *The Trespasser*.

My Childhood, first volume of Maxim Gorky's autobiographical trilogy (1913–1914); and his novel *Khozyain*.

Willa Cather published *O Pioneers!*, her first major novel, set in Nebraska.

Rabindranath Tagore was awarded the Nobel Prize for Literature.

The Society for Pure English was founded in England by Robert Bridges and others.

Alcohols, Guillaume Apollinaire's poetry collection.

Andrei Bely's novel *Petersburg*.

Anna Akhmatova's *The Rosary*.

Henry James's autobiography *A Small Boy and Others*.

In Virginia, Ellen Glasgow's novel.

John Masefield's long narrative poem *Dauber*; also his *The Daffodil Fields*.

Joseph Conrad's novel *Chance*.

The Soul of Melicent, first of James Branch Cabell's "Poictesme" novels.

William Rose Benét's poetic work *Merchants from Cathay*.

Young Man in Chains, François Mauriac's novel.

Max Eastman's *Enjoyment of Poetry*.

Miguel de Unamuno's *The Tragic Sense of Life*.

Mori Ogai's novel *The Wild Geese*.

Osip Mandelstam's poetry collection *Stone*.

Pär Lagerkvist's *Verbal Art and Pictorial Art*.

Rainer Maria Rilke's *The Life of the Virgin Mary*.

The Judgment, Franz Kafka's story.

Rex Beach's novel *The Iron Trail*.

The first crossword puzzle was published, in the *New York World*.

d. Joaquin Miller (Cincinnatus Hiner Miller), American writer (b. 1841?).

VISUAL ARTS

The Armory Show—formally The International Exhibition of Modern Art—the landmark first major American 20th-century international art exhibition, held at New York's 69th Regiment Armory from February 17–March 15; of the 1,600 works shown, 400 were modern European works, among them Marcel Duchamp's then-shocking cubist *Nude Descending a Staircase, No. 2*.

Marcel Duchamp's *Bicycle Wheel*, thought to be the first 20th-century kinetic sculpture.

Wassily Kandinsky's paintings included *Black Lines*, *With the Black Arch*, *Composition VII*, *Improvisation No. 30*, and *Reminiscences*; and he published *On the Question of Form*.

Pablo Picasso's painting *Harlequin*.

Tom Thomson's painting *A Northern Lake*.

Vladimir Tatlin's constructivist design for the proposed but never built *Monument to the Third International*.

Battle of Lights, Mardi Gras, Coney Island, Joseph Stella's painting.

Himself and *Herself*, paintings by Robert Henri.

Constantin Brancusi's sculpture *Mlle. Pogany*.

Bringing Up Father, the George McManus comic strip (1913–1945), featuring Maggie and Jiggs.

Georges Braque's paintings *Jeune Fille à la Guitare* and *The Musician's Table*.

Piet Mondrian's painting *Oval Composition* (*Trees*).

Cass Gilbert designed New York City's Woolworth Building.

Paul Manship's sculpture *Centaur and Dryad*.

E. J. Bellocq's photo collection *Storyville Portraits* (ca. 1913).

Franz Marc's paintings *The Tiger* and *Animal Destinies*.

Giacomo Balla's painting *Swifts: Paths of Movement*.

James MacDonald's painting *The Lonely North*.

Marc Chagall's painting *Paris Through the Window*.

Pierre Bonnard's painting *The Dining Room*.

The Promenade, Maurice Prendergast's painting.

Daniel Chester French began the sculpture *The Spirit of Life*, at Saratoga Springs (1913–1915).

Wilhelm Lehmbruck's sculpture *Standing Youth*.

d. J(ohn) Pierpont Morgan, American collector; his bequests included New York's Morgan Library and a massive gift of art to the Metropolitan Museum of Art.

d. George Browne Post, American civil engineer and architect (b. 1837).

d. Juan Guadalupe Posada, Mexican graphic artist (b. 1852).

THEATER & VARIETY

American Actors' Equity Association founded.

George Bernard Shaw's *Androcles and the Lion* opened in London on September 1.

St. John Irvine's *Jane Clegg* opened in London on May 19, with Sybil Thorndike in the title role.

George M. Cohan's *Seven Keys to Baldpate* opened at New York's Astor Theatre on September 22.

New York's Shubert Theatre opened, with Johnston Forbes-Robertson in *Hamlet*.

Victor Herbert's operetta *Sweethearts* opened at New York's New Amsterdam Theatre on September 8.

The Count of Monte Cristo, Edwin S. Porter directed the screen version of Alexandre Dumas's 1844 novel, with James O'Neill in the title role.

The Student of Prague, pioneering horror silent film starring Paul Wegener and directed by Stellan Rye.

The Great Adventure, Arnold Bennett's play, based on his 1908 novel *Buried Alive*.

Romance, Edward Sheldon's play, opened at New York's Maxine Elliott's Theatre on February 10.

August Strindberg's plays *After the Fire* and *Pariah* were staged posthumously.

Birmingham Repertory Theatre founded.

Chitra, Rabindranath Tagore's play.

Edward Gordon Craig's influential book *Toward a New Theatre*.

Georg Kaiser's *Die Bürger von Calais*.

Maxim Gorky's *Zykovy*.

Gerhart Hauptmann's *Commemoration Masque* (*Festspiel in deutschen Reimen*).

Harold Marsh Harwood's *The Mask*.

d. Stanley Houghton, English playwright (b. 1881).

MUSIC & DANCE

The Rite of Spring (*Le Sacre du printemps*), Vaslav Nijinsky's ballet, music by Igor Stravinsky, presented by Sergei Diaghilev's Ballets Russes company, with Marie Piltz dancing the lead; from its May 29 opening at Paris's Théâtre des Champs-Elysées, early audiences were scandalized by the ballet's fertility rite including a ritual sacrifice.

Jeux, Vaslav Nijinsky's ballet, music by Claude Debussy, first danced May 15 by Sergei Diaghilev's Ballets Russes in Paris, with Nijinsky, Tamara Karsavina, and Ludmila Shollar.

The Love of Three Kings (*L'amore dei tre re*), Italo Montemezzi's opera, libretto by Sem Benelli, opened at La Scala, Milan, April 10.

Le festin de l'araignée (*The Kiss of the Spider*), Albert Roussel ballet-pantomime, libretto Gilbert de Voisins, premiered April 3 at Paris's Théâtre des Arts, starring Sarah Djeli.

Anton von Webern's *Four Pieces for Clarinet and Piano*, *Five Pieces for Orchestra*, and *Six Bagatelles for String Quartet*.

Charles Ives's *Holidays Symphony*, his orchestral work *The Fourth of July*, and second and last string quartet.

Erik Satie's dramatic musical work *Le Piège de Méduse*, and his piano works *Embryons desséchés*, *Croquis et agaceries d'un gros bonhomme en bois*, and *Vieux sequins et vieilles cuirasses*, for piano.

La Vida Breve (*The Brief Life*), Manuel de Falla's opera, libretto by Carlos Fernandez Shaw, opened in Nice April 1.

Pénelope, Gabriel Fauré opera, libretto by René Fauchois, opened Monte Carlo, March 4.

Jean Sibelius's symphonic tone poem *The Bard* and vocal work *Luonnotar*.

Julien, Gustave Charpentier's opera, an unsuccessful sequel to his 1900 *Louise*.

Goyescas, Enrique Granados's piano suite, developed into his 1916 opera.

Max Reger's *Ballet Suite* and his orchestal work *4 Portraits after Arnold Böcklin*.

Ralph Vaughn Williams's *Symphony No. 2*, the *London Symphony*.

Sweethearts, Victor Herbert's operetta.

The Bells, Sergei Rachmaninoff's choral symphony.

Claude Debussy's songs *Trois Poèmes de Stéphane Mallarmé*.

Sergei Prokofiev's second piano concerto.

Falstaff, Edward Elgar's symphonic poem.

Do They Think of Me at Home?, popular song, words by J. E. Carpenter, music by Charles W. Glover.

When You and I Were Young (*Maggie*), popular song, words by George W. Johnson, music by J. A. Butterfield.

d. David Popper, Austrian cellist (b. 1843).

WORLD EVENTS

Sun Yat-sen led an unsuccessful revolution against the Chinese Republic government of President Yüan Shih-k'ai, then fleeing to Japan.

Treaty of London ended the First Balkan War, creating Albania and ceding much of European Turkey to the victorious Balkan League.

The Second Balkan War began with Bulgarian surprise attacks on Serbia and Greece. Romania and Turkey came into the war against Bulgaria; defeated, Bulgaria lost its First Balkan War gains.

Victoriano Huerta, commander of the Mexico City garrison, deposed and assassinated President Francisco Madero, ruled as a dictator (February 1913–July 1914), and then fled Mexico, unsuccessfully trying to organize a revolt from exile in Texas.

James Connolly and James Larkin organized the small Irish Citizen Army, and began to prepare for the insurrection that would become the 1916 Easter Rising.

Ulster Volunteers, Protestant Northern Ireland armed militia, founded.

Leo Frank was lynched by an anti-Jewish mob in Marietta, Georgia, on August 17, after his highly questionable conviction and death sentence for

rape and murder was commuted to life imprisonment, based on new evidence.

Sixteenth Amendment to the U.S. Constitution authorized Congress to levy income taxes.

U.S. Federal Reserve System was established, becoming operative in 1914.

John B. Watson founded the psychological school of behaviorism.

Niels Bohr developed his model of atomic structure.

American biochemist Elmer McCollum and others discovered vitamin A.

Johannes Geiger invented the radiation measurement tool called the Geiger counter.

1914

LITERATURE

Dubliners, James Joyce's short-story collection, a seminal 20th-century work.

Robert Frost's *North of Boston*, including the poems *Mending Wall* and *The Death of the Hired Man*.

Maurice, E. M. Forster's novel, on homosexual themes; published posthumously, in 1972.

Henry James's autobiographical work *Notes of a Son and Brother*; also his prose work *Notes on Novelists*.

Andre Gidé's sharply anticlerical *The Vatican Swindle* caused immense controversy in France.

The Little Review, an American literary journal, began publication (1914–1929), introducing work from writers such as Ezra Pound, T. S. Eliot, Ernest Hemingway, and James Joyce.

Edgar Rice Burroughs's novel *Tarzan of the Apes*, first of the many "Tarzan" books.

The Titan, Theodore Dreiser's novel.

Saki's short stories *Beasts and Superbeasts*.

Amy Lowell's poems *Sword Blades and Poppy Seed*.

Young Woman of 1914, Arnold Zweig's antiwar novel.

Selma Lagerlöf became the first woman member of the Swedish Academy.

Thomas Hardy's *Satires of Circumstances: Lyrics and Reveries with Miscellaneous Pieces*.

Vachel Lindsay's *General William Booth Enters into Heaven and Other Poems*.

Penrod, Booth Tarkington novel; there were two sequels, in 1916 and 1920.

Joyce Kilmer's *Trees and Other Poems*.

Anatole France's novel *La Révolte des anges*.

Auguste Rodin's *Les Cathédrales de France* (*Cathedrals of France*).

Boris Pasternak's poetic work *The Twin in the Clouds*.

Conrad Aiken's poetic work *Earth Triumphant*.

D. H. Lawrence's *The Prussian Officer and Other Stories*.

Gabriela Mistral's *Sonnets of Death*.

Gertrude Stein's poetic work *Tender Buttons*.

H. G. Wells's novel *The Wife of Sir Isaac Harman*.

Manuel Gálvez's novel *The Schoolmistress*.

Mist, Miguel de Unamuno's novel.

Pär Lagerkvist's poetic work *Anguish*.

William Rose Benét's poetic work *The Falconer of God*.

Wladyslaw Reymont's trilogy *Rok 1794* (1914–1919).

Yakub Kadri Karaosmanoglu's short stories *Bir Serencam*.

The Nobel Prize for Literature was not awarded.

d. Ambrose Bierce, American writer (b. 1842).

VISUAL ARTS

Pablo Picasso's work included the sculpture *Glass of Absinthe* and the painting *Still Life*.

Marc Chagall's paintings included *Over Vitebsk*, *The Rabbi of Vitebsk*, and *Jew in Green*.

Jacques Lipchitz's sculpture *Sailor on Horseback*.

Marcel Duchamp's paintings included *Bottle Dryer* and *Network of Stoppages*.

Wassily Kandinsky's paintings included *Autumn* and *Picture with Three Spots*.

Amedeo Modigliani's painting *Diego Rivera*.

Constantin Brancusi's sculpture *The Prodigal Son*.

At the Beach, William Glackens's painting.

Eliel Saarinen began the Helsinki railroad terminal.

John Sloan's painting *Backyards, Greenwich Village*.

Tom Thomson's painting *Red Leaves*.

Maurice Prendergast's painting *Neponset Bay*.

Oskar Kokoschka's painting *The Tempest*.

Portrait of a German Officer, Marsden Hartley's painting (1914–1915).

Frank Lloyd Wright began Midway Gardens, Chicago.

Georges Braque's painting *Music*.

Paul Klee's drawing *War Destroying the Country*.

Jack Sullivan created the cartoon *Felix the Cat*.

Ludwig Mies van der Rohe designed the Urbig house, Neubabelsberg.

Piet Mondrian's painting *Blue Facade*.

d. August Macke, German expressionist painter (b. 1887), a founder of the Blue Rider group.

d. Jacob A. Riis, American documentary photographer and social reformer (b. 1849).

d. Vinnie Ream, American sculptor (b. 1847), the first woman to receive a U.S. government commission for sculpture.

THEATER & VARIETY

Pygmalion, Mrs. Patrick Campbell as Eliza Doolittle and Herbert Beerbohm Tree as Henry Higgins starred in the classic George Bernard Shaw play; basis of the 1938 film and the 1956 musical My Fair Lady.

The Perils of Pauline, Pearl White starred in the greatly popular silent film serial.

The Squaw Man, Dustin Farnum starred in the Cecil B. DeMille silent film classic, the first release of the Jesse Lasky company; De Mille coproduced and codirected.

D. W. Griffith wrote and directed the silent film Judith of Bethulia; the cast included Blanche Sweet, Mae Marsh, Lillian Gish, Dorothy Gish, and Henry B. Walthall.

Cabiria, Italian epic silent film, set in ancient Rome; written, directed, and produced by Giovanni Pastrone, it starred Lidia Quaranta, Umberto Mozzato, and Bartolomeo Pagano.

Mary Pickford starred in the silent film Tess of the Storm Country, directed and shot by Edwin S. Porter.

Marie Dressler, Charles Chaplin, and Mabel Normand starred in Mack Sennett's silent film Tillie's Punctured Romance, adapted from the play Tillie's Nightmare (1910), which had starred Dressler.

The Dynasts, Thomas Hardy's play, opened in London on November 25.

On Trial, Elmer Rice's play, opened at New York's Candler Theatre on August 19.

The Show Shop, James Forbes's play, opened at New York's Hudson Theatre on December 31.

Too Many Cooks, Frank Craven's comedy, opened at New York's 39th Street Theatre on February 24.

Watch Your Step opened in New York; book by Harry Smith, music and lyrics by Irving Berlin.

Ferenc Molnar's The Swan.

Leonid Andreyev's He Who Gets Slapped and The Waltz of the Dogs.

The Hour-Glass, William Butler Yeats's play.

D. H. Lawrence's The Widowing of Mrs. Holroyd.

Gerhart Hauptmann's play The Bow of Odysseus (Der Bogen des Odysseus).

d. Charles Klein, British-born American playwright (b. 1867); drowned in the 1915 sinking of the Lusitania.

d. Fanny Whiteside Brough, English actress (b. 1854).

d. Hjalmar Bergstrøm, Danish playwright (b. 1868).

d. Laurence Sidney Brodribb Irving, English actor and playwright (b. 1871), son of actor Henry Irving.

d. Sydney Grundy, English playwright (b. 1848).

MUSIC & DANCE

They Didn't Believe Me, Jerome Kern's first hit song, lyrics by Herbert Reynolds; introduced by Julia Sanderson and Donald Brian in The Girl from Utah.

St. Louis Blues and Yellow Dog Blues, W. C. Handy's popular songs.

Till the Boys Come Home, Ivor Novello's song.

The Lark Ascending, Ralph Vaughan Williams's romance for violin and orchestra; also his opera Hugh the Drover, or Love in the Stocks, libretto by Harold Child, not publicly performed until 1924.

The Nightingale (Le Rossignol), Igor Stravinsky's opera, based on the Hans Christian Andersen story, opened at the Opéra, Paris, May 26.

Igor Stravinsky's Three Pieces for String Quartet.

Francesca da Rimini, Riccardo Zandonai's opera, libretto by Tito Ricordi based on the Gabriele D'Annunzio 1902 play, itself drawn from Dante's Divine Comedy, opened in Turin, February 19.

Legend of Joseph (Josephslegende), Mikhail Fokine's ballet, music by Richard Strauss, libretto by Herry Graf Kessler and Hugo von Hofmannsthal, premiered by Sergei Diaghilev's Ballets Russes company in the Paris Opéra on April 15.

Summer, Frank Bridge's symphonic poem.

North Country Sketches, Frederick Delius's orchestral work.

Charles Ives's orchestral work Three Places in New England; his second piano sonata, the Concord; and his third violin sonata.

Mikhail Fokine's 1909 ballet Le Coq d'or, to Nikolay Rimsky-Korsakov's music, introduced in Paris by Sergei Diaghilev's Ballets Russes company.

Carl Nielsen's chamber music Serenata in vano and 40 Danish songs (1914; 1917).

Anton von Webern's Sonata for Cello and Piano and Three Orchestral Songs.

I Love a Piano, Irving Berlin's popular song, from the show *Stop! Look! Listen!*

Sergei Prokofiev's *Sarcasms*, for piano.

Erik Satie's songs *3 poèmes d'amour* and his *Sports et divertissements* for piano.

Karol Szymanowski's *Love-songs of Hafiz*.

Maurice Ravel's *Trio for Violin, Cello and Piano*.

Max Reger's *Variations and Fugue on a Theme of Mozart*, orchestral work.

Alban Berg's *Three Pieces for Orchestra*.

Baltimore Symphony Orchestra founded.

Ted Shawn founded the Modern Dance company.

Modern Dance, the book by Vernon and Irene Castle.

WORLD EVENTS

At Sarajevo, on June 28, Bosnian nationalists armed by the Serbian nationalist Black Hand society assassinated Austro-Hungarian Archduke Francis Ferdinand, heir to the Austrian throne, igniting World War I.

World War I (The Great War) began (1914–1918), with Austro-Hungarian attack on Serbia. France, the British Empire, Russia, Serbia, Italy, Belgium, Greece, Romania, Montenegro, Japan, Portugal, and (from 1917) the United States were allied against the Central Powers: Germany, Austria-Hungary, Turkey, and Bulgaria. At least 8 million of the 65 million soldiers ultimately mobilized died, plus at least 6–7 million civilians, though far more counting the 1918 influenza pandemic.

Battles of the Frontiers (August 14–23), a series of major battles, in Alsace-Lorraine, the Ardennes, Belgium's Sambre River and Mons, at Le Cateau and Guise, as German armies following the long-established Schlieffen plan raced to bypass Paris and fold up the Allied armies.

First Battle of the Marne (September 5–10): The French army stopped the German advance on Paris and then the German offensive, changing the entire course of the war.

First Battle of Ypres (October 20–November 24): German forces failed to take the North Sea ports, dooming both armies to four years of trench warfare.

Battles of Tannenberg and Masurian Lakes (August–September), massive German defeats of Russian armies in East Prussia.

Battle of Jadar (August 12–21): Serbs defeated Austrians in their first major World War I battle.

Battle of Rava Ruska (September 3–11): Russians defeated Austrians, taking most of Galicia.

Battle of Lódz (November 11–25): German armies defeated Russians, forcing withdrawal from Silesia back into Poland.

Emiliano Zapata and Francisco Villa took Mexico City.

American forces occupied Vera Cruz, Mexico, after the arrest of several sailors in the Tampico Incident.

Sun Yat-sen founded the Kuomintang in China.

Margaret Sanger coined the term "birth control".

1915

LITERATURE

Herland, Charlotte Perkins Gilman's feminist utopian novel.

Romain Rolland was awarded the Nobel Prize for Literature; he published the essay collection *Above the Battlefield*.

The Metamorphosis, Franz Kafka's story.

D. H. Lawrence's novel *The Rainbow*.

The Voyage Out, Virginia Woolf's novel, her first.

Of Human Bondage, Somerset Maugham novel, about a medical student ultimately defeated in work and marriage; basis of the 1934 John Cromwell, 1946 Edmund Goulding, and 1964 Henry Hathaway films.

The Thirty-Nine Steps, John Buchan's World War I spy thriller; basis of Alfred Hitchcock's 1935 film.

1914 and Other Poems, Rupert Brooke's war poems, published posthumously.

Bedrich Hrozny deciphered the cuneiform script of the Hittites (1915–1916).

Joseph Conrad's novel *Victory*; and his short story *Within the Tides*.

The Genius, Theodore Dreiser's novel.

In the World, second volume of Maxim Gorky's autobiographical trilogy (1915–1916).

The Songs of a Sentimental Bloke, a popular narrative poem by Australian writer C. J. Dennis.

The Good Soldier, Ford Madox Ford's novel.

Muhammad Iqbal's poetic work *The Secrets of the Self*.

Dorothy Canfield's novel *The Bent Twig*.

Edgar Lee Masters's *Spoon River Anthology*.

Eduardo Barrios's novel *The Boy Who Went Mad for Love*.

Ernest Poole's novel *The Harbor*.

H. G. Wells's novel *Bealby: A Holiday*.

The Three Leaps of Wang-Lun, Alfred Doblin's novel.

d. J. A. H. (James Augustus Henry) Murray, Scottish lexicographer who initiated the *Oxford English Dictionary* (b. 1837).

d. Rupert Brooke, British poet (b. 1887).

VISUAL ARTS

Frank Lloyd Wright began Tokyo's Imperial Hotel (1915–1922).

The Bathers, Alexander Archipenko's early collage.

Kasimir Malevich's painting *Black Square*.

Pablo Picasso's painting *Harlequin* and his drawing *Max Jacob*.

Max Weber's paintings *Chinese Restaurant* and *Rush Hour, New York*, his futurist view of New York City.

Tom Thomson's painting *Northern River*.

Amedeo Modigliani's painting *Bride and Groom*.

Constantin Brancusi's sculpture *The New-Born*.

Edwin Landseer Lutyens began the British Indian government buildings in New Delhi (1915–1930).

Oskar Kokoschka's painting *Knight Errant* (*Der Irrende Ritter*).

Marcel Duchamp's painting *Large Glass* (1915–1923).

Henri Matisse's painting *Goldfish*.

Jacob Epstein's sculpture *Rock Drill*.

Marc Chagall's painting *Birthday* (1915–1923).

Pierre Bonnard's painting *Woman with Basket of Fruit* (1915–1918).

Depew Fountain, Indianapolis, Alexander Stirling Calder's sculpture.

d. Umberto Boccioni, Italian Futurist painter and sculptor (b. 1882).

d. John White Alexander, American artist, an Art Nouveau theorist (b. 1856).

THEATER & VARIETY

The Birth of a Nation, landmark, technically innovative, wholly racist D. W. Griffith silent film epic, starring Lillian Gish, Mae Marsh, Henry B. Walthall, Ralph Lewis, and Miriam Cooper; based on two Thomas E. Dixon, Jr., novels, *The Clansman* and *The Leopard's Spots*.

Provincetown Players (1915–1929), the Provincetown, Massachusetts–based theater group that became the main vehicle for introducing Eugene O'Neill's early plays; there and (from 1916) at the New York's Players Theater, it presented plays by Paul Green, Edna St. Vincent Millay, John Reed, and others.

Jerome Kern's musical *Very Good Eddie* opened at New York's Princess Theatre on December 23; music by Kern, book by Philip Bartholomae and Guy Bolton, lyrics mainly by Schuyler Greene.

Cecil B. DeMille produced and directed the silent film *The Warrens of Virginia*, starring Blanche Sweet, James O'Neill, and House Peters.

The Boomerang, Winchell Smith and Victor Mapes's comedy, opened at New York's Belasco Theatre.

Avery Hopwood's *Fair and Warmer* opened at New York's Eltinge Theatre on November 6.

The Great Lover, Leo Ditrichstein and Frederic and Fanny Hatton's play, opened in New York.

Hit-the-Trail Holliday, George M. Cohan's comedy, opened at New York's Astor Theatre.

The House of Glass, Max Marcin's play, opened at the Chandler Theatre, New York, September 1.

Rudolf Friml's operetta *Katinka*, book and lyrics by Otto Harbach and music by Friml, opened at New York's 44th Street Theatre on December 23.

Mary Pickford starred in Allen Dwan's silent film *A Girl of Yesterday*.

Theda Bara starred in the silent film *A Fool There Was*, her first major role.

Jerome Kern's musical *Nobody Home* opened at New York's Princess Theatre on April 20.

Owen Davis's *Sinners* opened in New York.

Susan Glaspell's play *Bernice*.

d. Charles Klein, British-born American playwright (b. 1867).

d. Paul Armstrong, American playwright (b. 1869).

MUSIC & DANCE

Love the Magician (*El Amor brujo*), ballet choreographed by and starring Pastora Imperio, music by Manuel de Falla, including the *Ritual Fire Dance*, premiered at Madrid's Teatro Lara April 15.

Nights in the Gardens of Spain (*Noches en los jardines de España*), Manuel de Falla's piano concerto.

The Buffoon (*Le Chout*), ballet choreographed by Tadeusz Slavinsky and Mikhail Larionov, music

by Sergei Prokofiev; presented by Sergei Diaghilev's Ballets Russes company at the Théâtre Gaité-Lyrique, Paris, May 17.

Scott Joplin's folk opera *Treemonisha* (1911) presented with no sets, and only Joplin on piano, the only presentation during his lifetime.

Charles Ives's *Piano Sonata No. 2*, the *Concord*, and his *Second Orchestral Set*.

Claude Debussy's *Sonata for Cello and Piano*; *Sonata for Flute, Viola and Harp*; and *Douze Études*, piano solos.

Jean Sibelius's *Symphony No. 5*.

Richard Strauss's tone poem *Eine Alpensinfonie* (*Alpine Symphony*).

I Ain't Got Nobody, popular song, words by Roger Graham and Dave Peyton, music by Spencer Williams.

Scythian Suite, Sergei Prokofiev's orchestral work.

Sergei Rachmaninoff's *Vesper Mass*.

Charles T. Griffes's *Roman Sketches*.

Erik Satie's *Avant-dernières Pensées* for piano.

Fedra, Ildebrando Pizzetti's opera.

Karol Szymanowski's piano work *Metopes*.

Sergei Ivanovich Taneyev's cantata *At the Reading of a Psalm*.

Ruth St. Denis and Ted Shawn founded the Denishawn school and dance company.

Thomas Beecham founded Britain's Beecham Opera Company (National Opera Company).

d. Alexander Nikolayevich Scriabin, Russian composer (b. 1872).

WORLD EVENTS

British liner *Lusitania* was torpedoed and sunk by a German submarine off Ireland; 1,198 people died, 128 of them Americans; the event strongly pushed American public opinion toward the Allies.

Germans used chlorine gas against British at the Second Battle of Ypres (April 22–May 25); it was the first large-scale use of poison gas, had little effect on the outcome of the battle or war, but began the use of potentially humanity-destroying chemical and biological weapons.

Gallipoli expedition (February 1915–January 1916), failed Allied attack on Turks in the Dardanelles and the Gallipoli Peninsula; estimated more than 500,000 casualties, half each side.

Second Battle of Masurian Lakes (February 7–21),

massive German victory over Russians on eastern front forced Russian retreat.

Gorlice-Tarnow Breakthrough, a massive German-Austrian advance against the Russians on Polish front.

German, Austrian, and Bulgarian forces attacked Serbia and took it and Montenegro.

Battle of Ctesiphon (November 22–26): Turks defeated British advancing in Mesopotamia.

Battle of Sarikamish (January 1–3): Turkish army destroyed by Russians in the Caucasus, with an estimated 30,000 of 80,000 Turks dead.

Italy entered World War I on the Allied side.

Machine guns synchronized to fire through propellors were installed on German Fokker warplanes.

d. Edith Louisa Cavell, British nurse (b. 1865), executed by the Germans on October 7.

Battle of Celaya (April): Mexican government forces defeated forces of Francisco (Pancho) Villa, who then retreated north.

French inventor Paul Langevin developed sonar (Sound Navigation and Ranging), an underwater scanning device.

1916

LITERATURE

Carl Sandburg's *Chicago Poems*.

D. H. Lawrence's work included the poetic work *Amores* and *Travel in Italy*.

Henri Barbusse's powerful antiwar novel *Under Fire*, based on his own World War I experiences.

The Four Horsemen of the Apocalypse, Vicente Blasco Ibañez's World War I family drama; basis of the 1921 and 1961 films.

Easter, 1916, William Butler Yeats's poem, on the Easter Rising in Dublin.

The Nobel Prize for Literature was awarded to Verner von Heidenstam.

The Home and the World, Rabindranath Tagore's novel.

Portrait of the Artist as a Young Man, James Joyce's autobiographical novel.

Amy Lowell's poetry collection *Men, Women, and Ghosts*.

Mark Twain's novel *The Mysterious Stranger* (posthumously published 1916).

Saratchandra Chatterji's novel *Queen's Gambit*.

Robert Graves's first poetry collection, *Over the Brazier*.

Conrad Aiken's poetry *The Jig of Forslin: A Symphony* and *Turns and Movies*.

Edgar Lee Masters's poetic work *Songs and Satires*.

Endre Ady's poem *Man among Inhumanity*.

H. G. Wells's novel *Mr. Britling Sees It Through*.

These Twain, third novel in Arnold Bennett's Clay-hanger series.

Hilda Doolittle (H.D.)'s poetic work *Sea Garden*.

Kan Kikuchi's *The Madman on the Roof*.

Manuel Gálvez's novel *Metaphysical Anguish*.

Margaret Deland's novel *The Rising Tide*.

Bliss Carman's *April Airs: A Book of New England Lyrics*.

William Rose Benét's poetic work *The Great White Wall*.

Mariano Azuela's novel *The Underdogs*.

Ring Lardner's short stories *You Know Me, Al; A Busher's Letters*.

Seventeen and *Mr. Antonio*, Booth Tarkington's novels.

The Gentleman from San Francisco, Ivan Bunin's short story.

Hispano-American New Testament was published in Madrid, the first in the Spanish language, after long Catholic church prohibition.

Mister Antonio, Booth Tarkington novel.

d. Henry James, American writer, in Britain from 1876 (b. 1843).

d. Jack (John Griffith) London, American writer (b. 1876).

d. James Whitcomb Riley, American poet (b. 1849).

d. Saki (Hector Hugh Munro) British writer (b. 1870).

d. Sholem Aleichem (Solomon Rabinovich), Jewish-Russian Yiddish-language writer (b. 1859).

VISUAL ARTS

Dada movement was founded in Zurich as an antiart, antiliterature protest against the enormities of the Great War; some leading Dadaists in the arts were Jean Arp, Marcel Duchamp, Francis Picabia, and Max Ernst.

Marcel Duchamp's painting *Nude Descending a Staircase, No. 3*.

Amedeo Modigliani's paintings included *Beatrice Hastings con Cappello*, *Jacques Lipchitz and His Wife* (1916–1917), and *Paul Guillaume*.

Henri Matisse's painting *Piano Lesson*.

Blue Lines, Georgia O'Keeffe's painting.

Georges Rouault's painting *The Old King* (1916–1936).

Aristide Maillol's sculpture *Monument to Cezanne*.

Constantin Brancusi's sculptures included *The Sorceress* and *Princess X*.

Abstraction, Provincetown, Marsden Hartley's painting.

Paul Klee's lithograph *Destruction and Hope*.

Arthur B. Davies's *Day of Good Fortune*.

Piet Mondrian's painting *Composition*.

James MacDonald's *Tangled Garden*.

Dancer and Gazelles, Paul Manship's sculpture.

Max Weber's *Essays on Art*.

John Gutzon Borglum began the Confederate memorial at Stone Mountain, Georgia (unfinished at his death in 1941).

Maurice Prendergast's painting *Along the Shore*.

Wilhelm Lehmbruck's sculpture *Dying Warrior*.

d. Thomas Eakins, American painter (b. 1844).

d. William Merritt Chase, American painter and teacher (b. 1849).

THEATER & VARIETY

Intolerance, D. W. Griffith's silent film epic, consisting of four thematically linked stories about inhumanity; generally regarded as an attempt to atone for his racist *Birth of a Nation* (1915), but also a classic early film.

August Strindberg's play *Ghost Sonata*.

Bound East for Cardiff, Eugene O'Neill's first produced play, a one-acter, was staged by the Provincetown Players at Provincetown, Massachusetts, on July 28.

Charles Sidney Gilpin became manager of the first all-Black stock company in New York, at the Lafayette Theatre, Harlem.

Oscar Asche's *Chu Chin Chow* opened in London.

Harold Brighouse's play *Hobson's Choice*; basis for the 1931 and 1954 films.

Ballerina Anna Pavlova starred in her only feature film, *The Dumb Girl of Portici*, written and codirected by Lois Weber.

Gregorio Martínez Sierra's *El Reino de Dios*.

A Kiss for Cinderella, James M. Barrie's play.

Luigi Chiarelli's *La maschera e il volto*.

Nothing But the Truth, James Montgomery's play, opened at New York's Longacre Theatre.

The White-Headed Boy, Lennox Robinson's comedy.

Radio carried its first news report.

d. Ada Rehan, Irish-born American actress (b. 1860).

d. José Echegaray, Spanish playwright (b. 1832).

d. Mounet-Sully, French actor (b. 1841).

MUSIC & DANCE

Roses of Picardy, a World War I song, introduced by John McCormack; music by Haydn Wood and words by F. E. Weatherly.

Beale St. Blues, W. C. Handy's song.

Ottorino Respighi's *The Fountains of Rome* (*Fontane di Roma*), orchestral work.

The Gambler, Sergei Prokofiev's opera to his own libretto, based on Fyodor Dostoevsky's 1866 novel; its 1917 opening canceled during the Russian Revolution, it premiered only in 1929.

Gustav Holst's *Savitri*, opera set in India, based on *The Mahabharata*; libretto by Holst, opened in London December 5.

The Planets, Gustav Holst's orchestral work.

Le Renard, Igor Stravinsky's stage work with action mimed by dancers, while singers (all male) performed from the orchestra.

Frederick Delius's *Requiem*; *Violin and Cello Concerto*; and *Violin Concerto*.

Karol Szymanowski's first violin concerto, third symphony, and piano work *Masques*.

Carl Nielsen's *Symphony No. 4, The Inextinguishable*, and *Chaconne*, for piano.

Till Eulenspiegel, Vaslav Nijinsky's ballet.

Ethel Smyth's opera *The Boatswain's Mate*.

Charles Ives's fourth violin sonata.

Hubert Parry's *Songs of Farewell*.

The Garden of Fand, Arnold Bax's tone poem.

Vibraphone designed by Leedy Drum Co., United States, improved in 1921.

d. Enrique Granados, Spanish composer and pianist (b. 1867); he died en route to Europe after the Metropolitan Opera opening of his opera *Goyescas* (developed from his 1913 piano suite), when his ship was torpedoed by a German submarine.

d. George Butterworth, English composer (b. 1885), in World War I.

d. Max Reger, German composer (b. 1873).

WORLD EVENTS

Running on a "peace" platform, Woodrow Wilson won a second term as American president.

In the Armenian Holocaust, 1–1.5 million Arme-nians died, most of them in Turkish concentration camps in the Syrian desert.

Battle of the Somme (July 1–November 13), a massive, failed British–French offensive in the Somme Valley; it cost an estimated more than 1.2 million casualties, two-thirds Allied, one-third German. Tanks were introduced into warfare by the British at the Somme.

Battle of Verdun (February 21–December 18), a massive German assault against the French fortress of Verdun, which ultimately failed; it cost an estimated one million casualties, 550,000 French, 450,000 German. Phosgene gas was introduced by the Germans at Verdun.

British and German fleets fought to a draw at the Battle of Jutland (May 31–June 1); the Germans then fled, not to emerge for the remainder of the war.

Brusilov Offensive, the ultimately failed Russian summer offensive in Poland; it cost an estimated two million casualties, half each side, and brought the Russian Revolution a step nearer.

Hussein Ibn Ali, Sharif of Mecca, led the Arab Revolt against Turkish rule in Arabia, taking Mecca, attacking Medina, and becoming part of the Allied war effort in the Middle East.

Patrick Pearse of the Irish Volunteers and James Connolly of the Irish Citizen Army led the failed Easter Rising (April 24–29) in Dublin; they and 13 other leaders of the uprising were subsequently executed, becoming martyrs of the developing Irish war of independence.

Irish Republican leader Roger Casement was executed for treason on August 3; he had sought German support for the Irish Republican cause.

Sun Yat-sen returned to China, after the death of President Yüan Shih-k'ai.

d. Rasputin (Gregory Yefimovich Novykh), Russian monk and faith healer (b. 1872), advisor to Czarina Alexandra and generator of much scandal in high Russian circles; he was assassinated.

San Francisco Preparedness Day parade bombing on killed 10 people; labor leaders Thomas J. Mooney and Warren K. Billings were convicted of the bombing. Mooney's death sentence was commuted to life imprisonment after a worldwide campaign.

Mexican guerrilla forces led by Pancho Villa attacked Columbus, New Mexico. An American force led by John J. Pershing responded by invading

northern Mexico, but could not find Villa, instead skirmishing with Mexican army forces.

Montana Republican feminist and pacifist Jeanette Pickering Rankin became the first woman to be elected to the U.S. House of Representatives.

American forces occupied the Dominican Republic (1916–1924).

Liberal party leader David Lloyd George became British wartime coalition prime minister.

Romania joined the Allies.

First news report was carried on radio.

1917

LITERATURE

T. S. Eliot's poetry *Prufrock and Other Observations*.

Vladimir Mayakovsky's poem *War and Peace*.

William Butler Yeats's poetry *The Wild Swans at Coole*.

A *Son of the Middle Border*, the first of Hamlin Garland's eight autobiographical works.

Henry James's autobiographical work *The Middle Years* and two unfinished fictional works *The Ivory Tower* and *The Sense of the Past*.

The Nobel Prize for Literature was awarded to Karl A. Gjellerup and Hendrik Pontoppidan.

Ditte, Daughter of Man, Martin Andersen Nexö's five-volume novel (1917–1921).

Saratchandra Chatterji's novels *The Deliverance* (1917), *Srikanta* (1917-33), and *The Krishna Songs*.

Edna St. Vincent Millay, *Renascence and Other Poems*.

Growth of the Soil, Knut Hamsun's novel.

Abel Sanchez, Miguel de Unamuno's novel.

Boris Pasternak's poetic work *Over the Barriers*.

D. H. Lawrence's poetic work *Look! We Have Come Through*.

Christopher Morley's novel *Parnassus on Wheels*.

H. G. Wells's novel *The Soul of a Bishop*; also his *God the Invisible King*.

Conrad Aiken's poetic work *Nocturne of Remembered Spring*.

Eduardo Barrios's novel *A Failure*.

Muhammad Iqbal's poems *The Mysteries of Selflessness*.

Ernest Poole's Pulitzer Prize–winning novel *His Family*.

The New Book of Martyrs, Georges Duhamel's war novel.

Joseph Conrad's novel *The Shadow-Line: A Confession*.

Rudyard Kipling's short stories *A Diversity of Creatures*.

Joseph Hergesheimer's novel *The Three Black Pennys*.

Ring Lardner's short stories *Gullible's Travels*.

Mariano Azuela's novel *The Bosses*.

Sara Teasdale's poetry collection *Love Songs*.

Mary Austin's novel *The Ford*.

O. Henry's short stories *Waifs and Strays*.

Paul Valéry's poems *The Young Fate*.

Sakutaro Hagiwara's poems *Howling at the Moon*.

d. Mocher Seforim Mendele (Shalom Jacov Abramovitch), Hebrew and Yiddish author whose pen name means "Mendele the Itinerant Bookseller" (b. 1835).

VISUAL ARTS

De Stijl was founded, the magazine of the Dutch *De Stijl* group of artists; edited by Theo van Doesburg (1917–1932).

Amedeo Modigliani's paintings included *Nude with Necklace, Chaim Soutine, Girl with Braids, Hanka Zborowska seduta su un divano*, and *Léon Bakst*.

Evening Star III, Georgia O'Keeffe's painting.

Piet Mondrian's paintings included *Composition in Colour A, Composition in Black and White*, and *Composition III with Colour Planes*.

Marc Chagall's painting *Double Portrait with a Glass of Wine*.

Childe Hassam's painting *Allies Day*.

Tom Thomson's paintings included *The Jack Pine* and *The West Wind*.

Church Bells Ringing, Rainy Winter Night, Charles Burchfield's painting.

Fernand Léger's painting *Soldiers Playing at Cards*.

Georges Braque's painting *The Woman Musician* (1917–1918).

Seated Woman, Max Weber's synthetic Cubist painting.

Max Beckmann's painting *The Descent from the Cross*.

Georges Rouault's painting *Three Clowns*.

Henri Matisse's painting *Interior with a Violin Case* (1917–1918).

Auguste Rodin, French sculptor (b. 1840).

d. Edgar Degas, French artist (b. 1834).

d. Tom Thomson (Thomas John Thompson), Cana-

dian painter (b. 1877), an inspirational figure in the Group of Seven.

d. Albert Pinkham Ryder, American painter (b. 1847).

THEATER & VARIETY

George Bernard Shaw's *Misalliance* premiered as the first production of New York's Broadhurst Theatre.

Nahum Zemach founded Moscow's Hebrew-language Hamimah Theatre.

Gerald du Maurier opened in London on October 17 in James M. Barrie's *Dear Brutus*.

Eugene O'Neill's one-act play *The Long Voyage Home* was produced by the Provincetown Players in New York on November 2; partial basis for John Ford's 1940 film.

Sigmund Romberg's operetta *Maytime* opened at New York's Shubert Theatre on August 16.

Mary Pickford starred in the silent films *Rebecca of Sunnybrook Farm* and *Poor Little Rich Girl*.

Jerome Kern's musical *Oh, Boy!* opened in New York; music by Kern, lyrics by P. G. Wodehouse, book and Guy Bolton and Wodehouse.

John Barrymore appeared in the title role of *Peter Ibbetson*.

Helen Hayes starred as *Pollyanna*.

Our Betters, Somerset Maugham's play, opened in New York on March 12.

Ina Claire starred in *Polly with a Past*, the George Middleton and Guy Bolton comedy; opened at New York's Belasco Theatre on September 6.

Luigi Pirandello's plays *Right You Are (If You Think You Are)* and *The Pleasure of Honesty*.

Theda Bara, Fritz Lieber, and Thurston Hall starred in the silent film *Cleopatra*, directed by J. Gordon Edwards.

William Farnum starred in the silent film *A Tale of Two Cities*, directed by Frank Lloyd.

From Morn to Midnight, Georg Kaiser's play.

Jane Cowl's play *Lilac Time*.

Abel Sánchez, Miguel de Unamuno y Jugo's novel and play.

Mottke the Vagabond, Sholem Asch's play.

Allen Dwan's silent film *A Modern Musketeer*.

Tor Hedberg's play *Perseus and the Monster*.

Antigone, Walter Hasenclever's antiwar play.

Gerhart Hauptmann's play *Winterballade*.

d. Florence Farr, English actress and director (b. 1860).

d. Herbert Beerbohm Tree (b. 1853), a leading British actor and manager from the late 1880s and a founder of the Royal Academy of Dramatic Art. He was the first English-language Henry Higgins, opposite Mrs. Patrick Campbell as Eliza Doolittle in his own 1914 London production of George Bernard Shaw's *Pygmalion*.

d. Hubert Henry Davies, English playwright (b. 1869).

d. Kate Josephine Bateman, American actress (b. 1842).

d. William Frederick ("Buffalo Bill") Cody, American Western scout and showman (b. 1846), who became an actor and a worldwide figure at the head of his touring Wild West show.

MUSIC & DANCE

Over There, George M. Cohan's World War I song.

Parade, Leonid Massine's ballet, music by Erik Satie, libretto by Jean Cocteau, set and costumes by Pablo Picasso, first presented by the Sergei Diaghilev's Ballets Russes company May 18 in Paris, with Massine and Maria Chabelska in the leads.

Sergei Prokofiev's *Symphony No. 1 (Classical Symphony)*, first *Violin Concerto*; and piano work *Visions Fugitive*.

Béla Bartók's ballet *The Wooden Prince*, and his second string quartet.

La Rondine (The Swallow), Giacomo Puccini's opera, libretto by Giuseppi Adami, opened at Monte Carlo March 27.

Harlequin (Arlecchino), Ferruccio Busoni's opera to his own libretto, premiered in Zurich, May 11.

First known jazz recordings made, by a group of white jazz enthusiasts known as the Original Dixieland Jazz Band, their first hit being *Darktown Strutter's Ball*.

Five Poems of Ancient China and Japan, Charles T. Griffes's piano music; also his ballet *Sho-jo*.

Arnold Bax's tone poem *November Woods*.

Frederick Delius's *2 Songs to be Sung of a Summer Night on the Water*.

Karol Szymanowski's third piano sonata and first string quartet.

Erik Satie's *Sonatine bureaucratique* for piano.

Gustav Holst's *The Hymn of Jesus*.

Claude Debussy's *Sonata for Violin and Piano*.

The Ripening, Josef Suk's orchestral work.

Le Tombeau de Couperin, Maurice Ravel's piano piece.

Carl Nielsen's *Theme and Variations*, for piano.

The Soldier's Song, anthem of Eire (Republic of Ireland), was written by Patrick Heaney, to words by Patrick Kearney (ca. 1917).

d. Scott Joplin, American composer and pianist (b. 1868), a central figure in the development of ragtime.

WORLD EVENTS

Russian Revolution: Insurrection began in January; Nicholas II of Russia abdicated on March 15; provisional government took control of the country, with Aleksandr Kerensky as prime minister.

Kerensky Offensive (July 1): Russian armies attacked Austro-German forces in Galicia, and were destroyed after German counterattacks.

Lenin returned to Russia from Swiss exile, arriving at Leningrad's Finland railway station on April 6, after journeying across Europe with a German safe conduct.

October (Bolshevik) Revolution: On November 7, Bolshevik forces in Petrograd (St. Petersburg) commanded by Leon Trotsky took key government centers, stormed and took the Winter Palace, headquarters of the Kerensky government, and began the 1917–1922 Russian Civil War.

Nivelle Offensive (April 16–20), a massive failed French offensive in Champagne, which triggered French army mutinies.

Third Battle of Ypres (Passchendaele, July 31–November 10), a failed British attack that cost an estimated 320,000 casualties.

Battle of Cambrai (November 20–December 3), a British attack on the Hindenburg Line, led by 200 tanks; although failed, it was the first use of massed tanks, prefiguring World War II tank tactics.

Battle of Caporetto (October 24–November 12): German–Austrian forces decisively defeated Italian forces on the Isonzo.

American General John "Blackjack" Pershing's forces withdrew from Mexico in February.

U.S. Congress declared war on Germany on April 2.

Pershing became commander of the American Expeditionary Force; American troops began moving into Europe.

Whole leadership of IWW arrested by U.S. government on sedition charges.

American troops intervened in Cuba, defeating rebellion.

Baghdad fell to British forces on March 11.

British forces in the Middle East took Beersheba, Gaza, and Jerusalem.

A burning munitions ship in Halifax harbor exploded on December 6, igniting massive onshore munitions dumps; 1,600 people died.

d. Mata Hari (Margaretha Geertruida Zelle), Dutch dancer (b. 1876), executed by the French as a German spy on October 15.

Major French army mutinies in April and May; tens of thousands of arrests and 55 executed.

Defeated by the Central Powers, Romania left the war in December.

Carl Gustav Jung's *Psychology of the Unconscious*.

1918

LITERATURE

Within a Budding Grove, second part of Marcel Proust's *Remembrance of Things Past*.

The Twelve, Alexander Blok's celebration of the Bolshevik Revolution.

Calligrammes, Guillaume Apollinaire poetry collection.

Carl Sandburg's poems *Cornhuskers*.

First American publication of James Joyce's *Ulysses* in installments of *The Little Review*, four issues of which were confiscated and destroyed by the U.S. government (1918–1921).

The Magnificent Ambersons, Booth Tarkington's Pulitzer Prize–winning novel; basis of the 1942 Orson Welles film classic.

Conrad Aiken's *The Charnel Rose, Senlin: A Biography, and Other Poems*.

Crusts, Paul Claudel's novel.

The Roll Call, fourth in Arnold Bennett's series of novels about Edwin Clayhanger and Hilda Lessways, here focusing on Hilda's son.

Gerhart Hauptmann's novel *Der Ketzer von Soana* (*The Heretic of Soana*).

Lytton Strachey's biographical essays *Eminent Victorians*.

My Ántonia, Willa Cather's novel.

D. H. Lawrence's *New Poems*.

William Rose Benét's poetic work *The Burglar of the Zodiac*.

Mariano Azuela's novels *The Flies* and *Trials of a*

Respectable Family.
Maxwell Bodenheim's poems *Minna and Myself.*
H. G. Wells's novel *Joan and Peter.*
Ring Lardner's short stories *Treat 'Em Rough.*
Siegfried Sassoon's poems *Counterattack.*
Tarr, Wyndham Lewis's novel.
The Hostage, Paul Claudel's novel.
The Outcast, Selma Lagerlöf novel.
The Return of the Soldier, Rebecca West's novel.
d. Guillaume Apollinaire (Wilhelm Albert Kostrowitzky) French writer and critic (b. 1880), credited with originating the term *surrealism.*
d. Rubén Darío (Félix Rubén García Sarmiento), Nicaraguan writer (b. 1867).
d. Henry Adams, American writer (b. 1838), grandson of President John Quincy Adams.
d. Joyce Kilmer, American poet (b. 1886).
d. Wilfred Owen, British war poet (b. 1893).

VISUAL ARTS

Amedeo Modigliani's paintings included *Anna, Little Girl in Blue, Jeanne Hebuterne in camicia, La giovane Lattaia, Leopold Zborowski, Madame Amédée,* and *Elvira Ritratto di Baranowski.*
Childe Hassam's painting *The Union Jack, New York, April Morn.*
Pablo Picasso's painting *The Bathers.*
Kasimir Malevich's painting *Suprematist Composition: White on White.*
Henri Matisse's paintings included *Interior with a Violin Case* and *Montalban, Large Landscape.*
Georgia O'Keeffe's painting *Red Flower.*
Joseph Stella's painting *Brooklyn Bridge.*
Georges Braque's painting *Musical Forms.*
Marcel Duchamp's painting *Nude Descending a Staircase, No. 4.*
Leonard Wooley began his archaeological work at Ur.
Marc Chagall's painting *Green Violinist.*
Piet Mondrian's painting *Composition: Colour Planes with Gray Contours.*
Fernand Léger's painting *Acrobats in the Circus.*
Georges Rouault's painting *Crucifixion.*
Paul Klee's painting *Zoological Garden.*
The Murder of Edith Cavell, George Bellows's painting.
Paul Nash's painting *We Are Making a New World.*
Frank O. King created the *Gasoline Alley* comic strip.

George Washington, Alexander Stirling Calder's statue at Washington Square Arch, New York.
d. Gustav Klimt, Austrian artist.
d. Raymond Duchamp-Villon, French sculptor (b. 1918), brother of Marcel Duchamp and half-brother of Gaston Duchamp (Jacques Villon).
d. Ferdinand Hodler, Swiss painter (b. 1853).

THEATER & VARIETY

Exiles, James Joyce's only play.
Baal, Bertolt Brecht's first major play.
The Rules of the Game, Luigi Pirandello's play.
The Moon of the Caribbees, Eugene O'Neill's one-act play, opened at New York's Provincetown Theatre on December 20.
Jerome Kern's musical *Oh, Lady! Lady!!* opened in New York; music by Kern, lyrics by P. G. Wodehouse, book by Guy Bolton and Wodehouse.
Vladimir Mayakovsky's *Mystery-Bouffe* opened on November 7, its theme the Bolshevik Revolution.
D. W. Griffith directed and produced the silent film *Hearts of the World,* starring Lillian Gish and Robert Harron.
Sacha Guitry's *Deburau* opened in Paris on February 9, with Guitry in the cast.
Lionel Barrymore starred as Milt Shanks in Augustus Thomas's *The Copperhead.*
Rachel Crothers's *A Little Journey* opened at New York's Little Theatre on December 26.
Elmo Lincoln starred as the first film *Tarzan.*
Al Jolson starred on Broadway in *Sinbad.*
Michel de Ghelderode's play *La Mort regarde à la fenêtre.*
Per Hallström's history plays *Gustaf III* and *Karl XI.*
Pola Negri starred as *Carmen* in the silent film.
Theda Bara starred in the silent film *Salomé.*
d. Edmond Eugène Alexis Rostand, French playwright (b. 1868).
d. Frank Wedekind, German playwright and actor (b. 1864).
d. George Alexander, English actor–manager (b. 1858).
d. Seumas O'Kelly, Irish playwright, poet, novelist, short-story writer, and journalist (b. ca. 1878).

MUSIC & DANCE

Oh, How I Hate to Get Up in the Morning, Irving

Berlin's song, which he sang in *Yip Yip Yaphank*. *God Bless America*; also written for *Yip Yip Yaphank*, but not used; it became very popular in 1939.

Al Jolson introduced two notable songs in the musical *Sinbad*: *Swanee*, George Gershwin's first hit song, and *Avalon*, words and music by Jolson and Vincent Rose.

Igor Stravinsky's narrative ballet *L'Histoire du Soldat* (*The Soldier's Tale*), directed and choreographed by Georges Pitoëff, premiered in Lausanne.

Three Giacomo Puccini one-act operas opened at the Metropolitan Opera, New York: *The Cloak* (*Il Tabarro*), libretto by Guiseppe Adami; *Sister Angelica* (*Suor Angelica*), libretto by Giovacchino Forzano; and *Gianni Schicchi*, libretto by Forzano.

Duke Bluebeard's Castle, Béla Bartók's opera, libretto by Béla Bélazs, premiered in Budapest May 24.

Tiger Rag became a hit for the Original Dixieland Jazz Band.

L'homme et son désir (*Man and His Desire*), ballet to music by Darius Milhaud, choreographed by Jean Börlin, premiered June 6 in Paris.

Sergei Prokofiev's cantata *Seven, They Are Seven*.

Pan and Syrinx, Carl Nielsen's orchestral work.

After You've Gone, popular song, words by Henry Creamer, music by Turner Layton.

Socrate, Erik Satie's choral work.

Die Gezeichneten, Franz Schreker's opera.

Arnold Bax's *First Quartet*.

Taras Bulba, Leoš Janáček's orchestral work.

Cleveland Orchesta founded.

d. Charles Lecocq, French composer (b. 1832).

d. Claude Debussy, French composer (b. 1862).

d. Vernon Castle (Vernon Castle Blythe), British-born dancer, partnered with his wife, Irene Castle (b. 1887).

d. Hubert Parry, English composer and teacher (b. 1848).

WORLD EVENTS

Influenza pandemic ("Spanish flu"), a mainly untreatable pandemic, killed an estimated 25–50 million people worldwide (1918–1919).

Treaty of Brest-Litovsk (March 3), between the Soviets and the Central Powers, taking the Soviets out of the war, with large territorial losses; repudiated by the Soviet government after German defeat.

After Brest-Litovsk, civil war began in Russia. Red Army and Cheka (secret police) organized; abolition of private property and other Bolshevik programs began. Czech Legion (former Czech and Slovak war prisoners) tried to fight their way out to Siberia and home, allied with White armies of Admiral Alexandr Kolchak. Carl Gustaf Mannerheim's forces took Finland. Simon Petlyura's army set up an independent Ukraine. American, British, French, and Japanese armed forces intervened against Bolsheviks.

Battle of Cantigny (May 28–29), U.S. First Division's action, the first American action of the war.

Battle of Belleau Wood (May 30–June 17), U.S. Second Division's counterattack during German Aisne offensive.

Battle of Chateau-Thierry (May 30–June 17), U.S. Second and Third Division action on the Marne during the German Aisne offensive.

Second Battle of the Marne (July 15–August 5), the failed German offensive; Allied forces then went over to the offensive until the war ended.

Amiens offensive (August 8–September 4): Allied offensive forced German withdrawal to the Hindenburg Line.

Hindenburg Line offensive (September 27–November 11): Allied attacks breached the Hindenburg Line, in progress when the war ended.

Battle of Vittorio Veneto (October 24–November 4): Austrian army was destroyed; followed by an Allied–Austrian armistice, taking Austria-Hungary out of the war.

German Revolution of 1918 forced abdication of Emperor Wilhelm II November 9, bringing the November 11 Armstice that ended World War I.

Czechoslovak Republic won its independence from the Austro-Hungarian Empire.

Yugoslavia founded, by the union of Serbia, Montenegro, Croatia, Dalmatia, and Bosnia-Herzegovina.

Woodrow Wilson put forward his postwar Fourteen Points, including formation of a League of Nations.

Irish Republican Sinn Fein party won an electoral majority.

Equal voting rights were won for all British women over 30.

1919

LITERATURE

Jurgen, second of James Branch Cabell's "Poictesme" novels, and the center of a celebrated "obscenity" case that greatly enhanced Cabell's popular appeal.

The Nobel Prize for Literature was awarded to Carl Spitteler.

The magazine *Littérature* was founded by André Breton and others.

Ten Days That Shook the World, John Reed's account of Russia's 1917 Bolshevik Revolution; basis of the 1928 Sergei Eisenstein classic film.

The Moon and Sixpence, Somerset Maugham's novel; basis of Albert Lewin's 1942 film.

The Trial, Franz Kafka's novel.

Winesburg, Ohio, Sherwood Anderson's celebrated midwestern short stories.

The American Language, H. L. Mencken's seminal work on American usage, treating American English as an original, rather than as derivative matter.

Illustrated Daily News, the first regularly published American tabloid newspaper, was founded in New York City.

Andre Gidé's *The Pastoral Symphony*.

Babette Deutsch's poetry *Banners*.

Christopher Morley's novel *The Haunted Bookshop*.

D. H. Lawrence's *Bay: A Book of Poems*.

Demian, Hermann Hesse's novel.

Fannie Hurst's short stories *Humoresque*.

Civilization 1914–1917, Georges Duhamel's war novel.

Joseph Conrad's novel *The Arrow of Gold*.

The Undying Fire, H. G. Wells's religious work.

Light, Henri Barbusse's novel.

In the Penal Colony, Franz Kafka's story.

John Masefield's narrative poem *Reynard the Fox*.

Night and Day, Virginia Woolf's novel.

Joseph Hergesheimer's novels *Java Head* and *Linda Condon*.

Manuel Gálvez's novel *Nacha Regules*.

Richard Aldington's poems *Images of War*.

Rudyard Kipling's poems *The Years Between*.

T. S. Eliot's *Poems*.

d. Endre Ady, Hungarian poet (b. 1877).

d. John Fox, Jr., American fiction writer (b. 1862).

d. L. Frank Baum, American writer (b. 1856), creator of the "Wizard of Oz."

d. Leonid Andreyev, Russian writer (b. 1871).

d. Ricardo Palma, Peruvian writer (b. 1833).

d. William Michael Rossetti, English art critic and author (b. 1829).

VISUAL ARTS

Walter Gropius became director of the Weimar Bauhaus (1919–1928).

Pablo Picasso's painting *Guitar*.

Georgia O'Keeffe's paintings included *From the Plains I*, *Orange and Red Streak*, *Music—Pink and Blue I*, *Red Canna*, and *Orange and Red Streak*.

Piet Mondrian's paintings included *Composition Checkerboard* and *Composition in Diamond Shape*.

Amedeo Modigliani's paintings included *Gypsy Woman with Baby*, *Reclining Nude* (ca. 1919), *The Servant Girl*, *Yellow Sweater* (ca. 1919), and a *Self-Portrait*.

Georges Braque's paintings included *Café Bar* and *Still Life with Playing Cards*.

Constantin Brancusi's sculpture *Golden Bird*.

Fernand Léger's painting *The City*.

Jacob Epstein's sculpture of *Christ*.

Flag Day, Childe Hassam's painting.

Joan Miró's painting *Self-Portrait*.

Backdrop of East Lynne, Charles Demuth's painting.

Edvard Munch's painting *Self-Portrait—Spanish Influenza*.

Max Beckmann's painting *The Night*.

Tree of My Life, Joseph Stella's painting.

Paul Klee's painting *Villa R.*

Abstract Still Life, Alfred Henry Maurer's painting (ca. 1919).

Oskar Kokoschka's painting *The Power of Music*.

Paul Nash's painting *The Menin Road*.

Marc Chagall painted murals, and did the sets and costumes at the Kamerny Theatre, Moscow.

d. Pierre-Auguste Renoir, French painter (b. 1841).

d. Julian Alden Weir, American painter (b. 1852).

d. Frank Duveneck, American painter (b. 1848).

d. Henry Clay Frick, American art collector, whose bequest funded New York's Frick Museum, set up at his home (b. 1849).

d. Kenyon Cox, American painter (b. 1856).

d. Wilhelm Lehmbruck, German sculptor (b. 1881).

THEATER & VARIETY

The Theatre Guild was founded in New York, its first production being *The Bonds of Interest*, Jacinto Benavente's play, with Helen Westley, Dudley Digges, and Augustin Duncan.

The successful Actors Equity strike brought new wages and working conditions to the New York theater.

D. W. Griffith wrote, directed, and produced the silent film *Broken Blossoms*, starring Lillian Gish, Richard Barthelmess, and Donald Crisp.

J'Accuse, Abel Gance's classic antiwar silent film, extraordinarily well received in post–World War I Europe.

United Artists was founded by Charles Chaplin, Mary Pickford, Douglas Fairbanks, and D. W. Griffith.

Elmer Rice's *Street Scene* opened in New York.

Pola Negri and Emil Jannings starred in the silent film *Madame Dubarry* (*Passion*), directed and produced in Germany by Ernst Lubitsch.

George White's Scandals, first of a series of revues produced by White (1919–1926).

The Gold Diggers, Avery Hopwood's backstage comedy, opened at New York's Lyceum Theatre on September 30; basis of the five "Gold Diggers" movie musicals (1929; 1933; 1935; 1937; 1938).

Edith Day starred in the title role of Harry Tierney's musical *Irene* in New York.

Abraham Lincoln, John Drinkwater's play, premiered at the Birmingham Repertory Theatre and then opened at London's Lyric Theatre.

Ethel Barrymore starred in *Déclassé*; Zoë Akins's play opened at the Empire Theatre, New York.

The Famous Mrs. Fair, James Forbes's play, opened at New York's Henry Miller's Theatre.

Transfiguration, Ernst Toller's play, based on his World War I experiences.

Up in Mabel's Room, Wilson Collison and Otto Harbach's farce, opened in New York.

Carl Sternheim's plays *Tabula Rasa* and *Die Marquise von Arcis*.

George Bernard Shaw's *The Apple Cart*.

Hans Henny Jahnn's *Pastor Ephraim Magnus*.

Lady Gregory's *The Dragon*.

Henri-René Lenormand's *Le Temps est un songe*.

The Poor Cousin, sculptor Ernst Barlach's play.

Home and Beauty, Somerset Maugham's play.

Jacinto Benavente y Martínez's *The Bonds of Interest*.

Jane Cowl's *Smilin' Through*.

Michel de Ghelderode's *Le Repas des fauves*.

Der Retter, Walter Hasenclever's antiwar play.

Moses Nadir's *The Last Jew*.

d. Nat Carl Goodwin, American actor (b. 1857).

MUSIC & DANCE

Happy Days Are Here Again, song with music by Milton Agar, words by Jack Yellen; used in the film *Chasing Rainbows* (1930), it became Franklin Delano Roosevelt's 1932 campaign song.

A Pretty Girl Is Like a Melody, Irving Berlin's song, from the *Ziegfeld Follies of 1919*.

The Three-Cornered Hat, Leonid Massine's ballet, music by Manuel de Falla (*El sombrero de tres picos*), set and costumes by Pablo Picasso, first presented by Sergei Diaghilev's Ballets Russes company July 22 in London, with Tamara Karsavina and Leonid Massine dancing the leads.

La Boutique fantasque, Leonid Massine's ballet, music by Gioacchino Rossini arranged by Ottorini Respighi, first danced in London June 5 by Sergei Diaghilev's Ballet Russes.

Die Frau ohne Schatten (*The Woman without a Shadow*), Richard Strauss's opera, libretto by Hugo von Hofmannsthal, opened in Vienna.

Edward Elgar's *Cello Concerto*.

Arnold Bax's tone poem *Tintagel* and *Second Piano Sonata*.

Igor Stravinsky's *Piano Rag-Music* and *Three Pieces for Clarinet Solo*.

Carl Nielsen's *string quartet*.

Fennimore and Gerda, Frederick Delius's opera.

Masques et Bergamasques, Gabriel Fauré's lyrical comedy.

Gustav Holst's *Ode to Death*.

Kurt Weill's first string quartet.

Diary of One Who Disappeared, Leoš Janáček's song cycle.

Mörder, Hoffnung der Frauen, Paul Hindemith's opera.

Alfred Cortot founded the Paris-based École Normale de Musique.

Los Angeles Philharmonic Orchestra founded.

Arnold Dolmetsch helped sparked a revival of interest in recorders, a type of "duct" flute popular in the Renaissance, but with roots in antiquity.

d. Ruggero Leoncavallo, Italian composer and librettist (b. 1857).

d. Adelina Patti, Italian soprano (b. 1843).

WORLD EVENTS

Paris Peace Conference concluded with the Treaty of Versailles (January 18–June 28); victorious Allies organized the League of Nations; recarved the European colonial system; remade the map of Europe, establishing several new nations and sharply cutting the territories of the losers; and called for reparations.

Covenant of the League of Nations was signed by many attendees at the Paris Peace Conference, establishing the League of Nations.

World Court (International Court of Justice) founded, originally as the Permanent Court of International Justice.

International Labor Organization (ILO) was founded; part of the League of Nations.

Austro-Hungary was dismembered, and the Hapsburg monarch was replaced by a republic.

Russian Civil War: White armies of Aleksandr Kolchak, Anton Ivanovich Denikin, and Nikolay Yudenich failed to defeat Red Army.

Communist International (Comintern, or Third International) founded; an instrument of Soviet policy until its dissolution in 1943.

German general staff, allied with the Social-Democratic Friedrich Ebert government, used the Freikorps militia to defeat the Spartacist revolt in Berlin and left forces throughout Germany, establishing the Weimar Republic. German Socialist leaders Rosa Luxemburg and Karl Liebnicht were murdered by right-wing forces.

German Workers' party founded; forerunner of the Nazi party.

Sinn Fein declared Ireland an independent republic on January 21; Eamon de Valera was its first president. The Irish War of Independence followed.

Afghan-British War (May): *jihad* (holy war) against British India pursued by Afghan King Amanullah Khan, who was soon defeated.

U.S. Attorney General A. Mitchell Palmer became a prime mover in developing the Red Scare (1919–1920); its extralegal roundups of radicals and aliens were known as the Palmer Raids.

Amritsar massacre (April 13): British troops in the Punjab fired on unarmed demonstrators, killing at least 379 and wounding 1,200; a landmark in the development of India's independence movement.

Arabian Civil War (1919–1925), a civil war fought in western Arabia (the Hejaz) between the forces of Ibn Saud and those of the Hashemite king of Arabia, Hussein Ibn Ali.

Béla Kun led the Hungarian Socialist Republic (March–August), which ended when the Romanian army occupied Budapest.

Chinese students protesting pro-Japanese aspects of the Treaty of Versailles demonstrated in Peking on May 4, igniting a nationwide series of demonstrations—the May 4th Movement—from which came many of the leaders of the Kuomintang and the Chinese Communist party.

An estimated 300,000–350,000 American steelworkers, led by William Z. Foster, struck for union recognition and the eight-hour day, but extraordinarily violent steel company tactics broke the strike, delaying organization for two decades.

Eighteenth Amendment to the U.S. Constitution began the Prohibition era.

Benito Mussolini founded the first Italian Fascist organization.

Daily scheduled airplane flights were begun in Europe.

Nancy Langhorne Astor became the first woman member of the British Parliament.

Robert Hutchings Goddard's A *Method of Reaching Extreme Altitudes* predicted space flight.

1920

LITERATURE

The Age of Innocence, Edith Wharton's Pulitzer Prize–winning novel; basis of the 1993 Martin Scorsese film.

The Good Soldier Schweik, Jaroslav Hašek's four-volume antibureaucratic satire (1920–1923).

The Guermantes Way, third part of Marcel Proust's *Remembrance of Things Past*.

Knut Hamsun was awarded the 1920 Nobel Prize for Literature.

Carl Sandburg's poems *Smoke and Steel*.

Kristin Lavransdatter (1920–1922), Sigrid Undset's trilogy, set in medieval Norway.

Main Street, Sinclair Lewis's novel, satirizing small-town midwestern America.

The Mysterious Affair at Styles, Agatha Christie's first novel, introducing Hercule Poirot.

In Chancery, second volume of John Galsworthy's trilogy *The Forsyte Saga* (1906–1921).

Women in Love, largely autobiographical D. H. Lawrence novel; basis of the 1970 Ken Russell film; also Lawrence's novel *The Lost Girl*.

This Side of Paradise, F. Scott Fitzgerald's first novel.

Paul Valéry's poetic works *The Album of Early Verse* and *The Graveyard by the Sea*.

Cheri, first novel in Colette's Cheri series.

Edna St. Vincent Millay's poems *A Few Figs from Thistles*.

William Rose Benét's poetic work *Moons of Grandeur*.

The Story of a New Zealand River, by Jane Mander.

Edgar Lee Masters's poems *The Domesday Book*.

George Ade's *Hand-Made Fables*.

Salavin Cycle, Georges Duhamel's five-volume work (1920–1922).

H. G. Wells's *The Outline of History*.

Joseph Conrad's novel *The Rescue*.

Katherine Mansfield's *Bliss and Other Stories*.

Sherwood Anderson's novel *Poor White*.

Darkwater, W. E. B. Du Bois's essays and sketches.

Potterism, Rose Macaulay's novel.

Conrad Aiken's poetic work *The House of Dust: A Symphony*.

Romain Rolland, Stefan Zweig's biography.

Rudyard Kipling's *Letters of Travel*.

Saratchandra Chatterji's novel *The Fire*.

The Humiliation of the Father, Paul Claudel's novel.

Wallenstein, Alfred Doblin's novel.

d. Benito Pérez Galdós, Spanish novelist (b. 1843).

d. John Reed, American writer (b. 1887).

d. Olive Schreiner, South African writer (b. 1855).

d. William Dean Howells, American author (b. 1837).

d. Mori Ogai (Mori Rintaro), Japanese writer (b. 1862).

FILM & BROADCASTING

Cabinet of Dr. Caligari, Conrad Veidt and Werner Krauss starred in Robert Wiene's silent film, a landmark in German Expressionism and world cinema.

Dr. Jekyll and Mr. Hyde, John Barrymore starred in the dual doctor–monster role in John S. Robertson's silent film, based on the 1886 Robert Louis Stevenson story.

The Mark of Zorro, Douglas Fairbanks starred as the Spanish California outlaw in Fred Niblo's silent film, an often-remade film classic.

Buster Keaton cowrote, codirected, and starred in the silent film comedy *One Week*, with Sybil Sealy.

D. W. Griffith directed and produced the silent film *Way Down East*, starring Lillian Gish.

Manahatta, Charles Sheeler and Paul Strand's celebration of Manhattan.

Paul Wegener cowrote, codirected, and played the title role in the silent film *The Golem*, a landmark German expressionist film based on the Jewish legend.

Pauline Frederick starred in the title role of the silent film *Madame X*, based on Alexandre Bisson's play. Frank Lloyd directed; Wiliam Courtleigh and Casson Ferguson costarred.

Mary Pickford starred in the silent film *Pollyanna*.

VISUAL ARTS

Alexander Young Jackson's painting *March Storm, Georgian Bay*.

Canada's Group of Seven began to exhibit together (1920–1931), including Lawren Harris, James MacDonald, Alexander Jackson, Arthur Lismer, Frederick Varley, Franklin Carmichael, and Frank Johnston; an earlier associate and inspiration was Tom Thomson (d. 1917).

Pablo Picasso's works included his paintings *Two Seated Women* and *The Rape*; and the drawing *Portrait of Stravinsky*.

Lower Manhattan, John Marin's painting.

Naum Gabo and his brother, Antoine Pevsner, issued the *Realistic Manifesto*, with their view of constructivism.

Frank Lloyd Wright began the Barnsdall House, Hollywood.

Vladimir Tatlin's proposal for a *Monument to the Third International*.

Georgia O'Keeffe's paintings included *Zinnias* and *Red Cannas*.

Charles Burchfield's painting *February Thaw, The Interurban Line, Railroad*.

Wassily Kandinsky's painting *White Line*.

Charles Demuth's painting *Stairs, Providence, Machinery, End of the Parade, Box of Tricks, The Tower.*

Edwin Landseer Lutyens began Britannic House, Finsbury (1920–1928).

Fernand Léger's painting *The Mechanic.*

Piet Mondrian's painting *Composition with Red, Blue and Yellow Green.*

Jo Davidson's bronze portrait bust of *Gertrude Stein.*

Georges Rouault's painting *Pierrot.*

New York Interpreted, a series of paintings by Joseph Stella (1920–1922).

Pierre Bonnard's paintings included *Interior with Woman in Wicker Chair* and *The Brothers Jean and Gaston Bernheim.*

Gunnar Asplund began the Stockholm City Library (1920–1928).

Fountain of Time, Lorado Taft's sculpture.

Rockwell Kent's *Wilderness! A Journal of Quiet Adventure in Alaska.*

Roger Fry's essays in his *Vision and Design.*

d. Amedeo Modigliani, Italian painter and sculptor (b. 1884).

d. Samuel Colman, American painter (b. 1832).

THEATER & VARIETY

Beyond the Horizon, Eugene O'Neill's early play, opened at New York's Morosco Theatre on February 2; Edward Arnold, Richard Bennett, and Helen MacKellar starred. It helped set a new course for the American theater.

Lynn Fontanne starred in Eugene O'Neill's *Chris Christopherson*, the failed original version of his *Anna Christie.*

The Emperor Jones, Eugene O'Neill's play, opened with Charles S. Gilpin in the title role at New York's Neighborhood Playhouse on November 1; Paul Robeson played the role on stage in 1925 and in the 1933 film.

Heartbreak House, George Bernard Shaw's play, was given its world premiere by the Theatre Guild, New York, November 12.

Marilyn Miller starred in the title role in Jerome Kern's *Sally*; opened at New York's New Amsterdam Theatre on December 21, with Miller singing *Look for the Silver Lining*; book by Guy Bolton, lyrics mostly by Clifford Grey, and music by Kern.

John Barrymore appeared in New York in the title role of Shakespeare's *Richard III.*

Fanny Brice introduced the songs *My Man* and *Second Hand Rose* in the *Ziegfeld Follies of 1920.*

Ladies' Night (in a Turkish Bath), Avery Hopwood and Charlton Andrews's comedy, opened at New York's Eltinge Theatre on August 9.

Calvary, William Butler Yeats's play.

Janet Velie starred in the title role of the musical *Mary*; opened at New York's Knickerbocker Theatre; book and lyrics by Otto Harbach and Frank Mandel, music by Louis A. Hirsch.

The First Year, Frank Craven's comedy, opened at New York's Little Theatre on October 20.

The Bat, Mary Roberts Rinehart and Avery Hopwood's play, opened in New York.

The Failures, Henri René Lenormand's play, was produced by Firmin Gemier in Paris and by Max Reinhardt in Vienna.

The Green Goddess, William Archer's play, opened in Philadelphia on December 16.

Welcome Stranger, Aaron Hoffman's comedy, opened at New York's Cohan and Harris Theatre.

Zona Gale's *Miss Lulu Bett* opened at New York's Belmont Theatre on December 27.

Mr. Pim Passes By, A. A. Milne's play, opened in London.

Roland Young starred in Clare Kummer's comedy *Rollo's Wild Oat*; opened in New York.

D. H. Lawrence's *Touch and Go.*

Édouard Bourdet's *La Cage ouverte.*

Fernand Crommelynck's *Le Cocu magnifique.*

Gerhart Hauptmann's *The White Saviour (Der weisse Heiland).*

Mary Rose, James M. Barrie's play.

Goat Song, Franz Werfel's play.

Harold Marsh Harwood's *The Grain of Mustard Seed.*

Henri-René Lenormand's plays *Les Ratés* and *Simoun.*

MUSIC & DANCE

My Man, Fanny Brice's signature song, from the *Ziegfeld Follies of 1920*; in France, identified with Mistinguett.

Look for the Silver Lining, Jerome Kern and Buddy DeSylva's song, introduced by Marilyn Miller in *Sally.*

Pulcinella, Leonid Massine's ballet, music by Igor

Stravinsky, first danced May 15 by Sergei Diaghilev's Ballets Russes in Paris, with Massine and Tamara Karsavina.

Rose of Washington Square, popularized by Fanny Brice; words and music by Ballard MacDonald and James Hanley.

Le Boeuf sur le toît, Darius Milhaud's pantomime spectacle, later a ballet.

Igor Stravinsky's *Concertino for String Quartet* and *Symphonies of Wind Instruments*.

Song of the Nightingale, Leonide Massine's ballet, music by Igor Stravinsky, first danced February 2, 1920, by Sergei Diaghilev's Ballets Russes in Paris.

Anton von Webern's *Trio Movement for Clarinet, Trumpet, and Violin*.

Pastorale d'été, Arthur Honegger's orchestral work.

First million-selling records in America, both instrumentals: Paul Whiteman's *Whispering* backed by *The Japanese Sandman*, and Ben Selvin's *Dardanella* and *My Isle of Golden Dreams*.

Carl Nielsen's *Suite* for piano.

La belle excentrique, Erik Satie's ballet (ca. 1920).

Der Schatzgräber, Franz Schreker's opera.

The Adventures of Mr. Broucek, Leos Janácek's opera.

Sidney Bechet adopted the saxophone as an alternative to the clarinet, speeding its acceptance in jazz circles.

Cleveland Institute was founded.

Tom-tom used in jazz, later in rock (1920s).

d. Max Bruch, German composer (b. 1838).

d. Charles T. Griffes, American composer (b. 1884).

d. Reginald De Koven, American composer (b. 1859).

WORLD EVENTS

Nineteenth Amendment (women's suffrage) to the U.S. Constitution was ratified, granting women citizens the right to vote. League of Women Voters was founded, succeeding the National American Woman Suffrage Association, which dissolved.

Republican Warren Gamaliel Harding defeated Democrat James M. Cox, to become 29th American president. Socialist Eugene V. Debs won more than 900,000 votes, although in jail for opposing World War I.

Russian Civil War: Alexandr Kolchak was taken and executed by Red Army; Pyotr Wrangel's White Army was defeated in the Crimea.

Soviet–Polish War (April–August) pitted Red Army and Polish and Ukrainian armies; Russian army was smashed in the August Battle of Warsaw. Treaty of Riga set large Polish territorial gains and recognized Latvian independence. Treaty of Moscow recognized Lithuanian independence and Treaty of Dorpat recognized Estonian and Finnish independence.

Anti-Jewish pogroms in the Ukraine were carried out by the forces of Ukrainian nationalist Simon Petlyura.

Communist Party of China (CCP) was founded by Ch'en Tu-hsiu and Li ta-chao.

Mexican Civil War ended, with the accession to power of General Alvaro Obregón.

Turkish forces led by Mustapha Kemal (Atatürk) defeated Greek forces in western Turkey; Kemal then led in the formation of the Turkish Republic, becoming its first president.

German Freikorps, led by Wolfgang Kapp, failed to take control of the Weimar Republic in the Kapp Putsch.

Palestinian Jews formed the paramilitary Haganah, which ultimately became the Israeli army.

American Civil Liberties Union (ACLU) founded..

H. G. Wells's *Outline of History*.

Carl Gustav Jung's *Psychological Types*.

1921

LITERATURE

Cities of the Plain (1921–1922), fourth part of Marcel Proust's *Remembrance of Things Past*.

The Nobel Prize for Literature was awarded to Anatole France.

Crome Yellow, Aldous Huxley's novel.

Rain, Somerset Maugham's South Seas short story, about a prostitute and a preacher; basis of the 1922 play and the 1928 and 1932 films.

To Let, third volume of John Galsworthy's trilogy *The Forsyte Saga* (1906–1921).

Alice Adams, Booth Tarkington's Pulitzer Prize–winning novel; basis of the 1935 George Stevens film; and his novel *Intimate Strangers*.

A Daughter of the Middle Border, the Pulitzer Prize–winning second of Hamlin Garland's eight autobiographical volumes.

Edwin Arlington Robinson's Pulitzer Prize–winning *Collected Poems*.

Conrad Aiken's poetic work *Punch: The Immortal Liar*.

Amy Lowell's poetry *Legends*.

Marianne Moore's *Poems*.

D. H. Lawrence's poetry *Tortoises*; also his travel writings *Sea and Sardinia*.

George Moore's novel *Héloise and Abélard*.

Dorothy Canfield's novel *The Brimming Cup*.

Edna St. Vincent Millay's poems *Second April*.

Gerhart Hauptmann's poetic work *Anna*.

Joseph Conrad's *Notes on My Books*.

Gertrude Atherton's novel *The Sisters-in-Law*.

Wallace Irwin's *Seed of the Sun*.

Robert Benchley's essays *Of All Things*.

Samuel Hopkins Adams's novel *Success*.

Suzanne and the Pacific, Jean Giraudoux's novel.

d. Alexander Blok, Russian poet (b. 1880).

d. C. Subrahamanya Bharati, Tamil poet (b. 1882).

d. John Burroughs, American writer (b. 1837).

d. Juhani Aho, Finnish writer (b. 1861).

d. Subramania Bharati, Indian writer (b. 1882).

FILM & BROADCASTING

The Sheik, Rudolph Valentino as the desert chief and Agnes Ayres starred in the George Melford confection, an enormously popular silent film.

Charles Chaplin and Jackie Coogan starred in *The Kid*.

Nosferatu, the Vampire, Max Shreck starred in F. W. Murnau's silent film, based on the 1897 Bram Stoker vampire story.

Gösta Berling's Saga, Greta Garbo and Lars Hanson starred in Mauritz Stiller's silent film, based on the 1921 Selma Lagerlöf novel.

Cecil B. DeMille directed and produced the silent film *The Affairs of Anatol*, starring Gloria Swanson, Wallace Reid, Bebe Daniels, Monte Blue, and Elliott Dexter; loosely based on the Arthur Schnitzler play.

Douglas Fairbanks starred as D'Artagnan in the silent film *The Three Musketeers*, directed by Raoul Walsh and based on the 1844 Alexandre Dumas novel.

Constance Talmadge starred as the feminist candidate in the silent film *Woman's Place*, directed by Victor Fleming, screenplay by Anita Loos and John Emerson.

Jackie Cooper starred in the title role of the silent film *Peck's Bad Boy*, directed by Sam Wood.

Richard Barthelmess starred in the title role of the silent film *Tol-able David*, directed by Henry King; the Edmund Goulding screenplay was based on a Joseph Hergeseimer story.

Rudolph Valentino starred in the silent film *The Four Horsemen of the Apocalypse*, based on Vicente Blasco Ibañez's 1916 novel; Rex Ingram directed.

Actress Virginia Rappe died at a Fatty Arbuckle party in San Francisco; he was later acquitted on a charge of manslaughter, but his career was ruined.

VISUAL ARTS

Pablo Picasso's paintings included *The Dancers* and *Three Musicians*.

Georgia O'Keeffe's painting *Lake George with Crows*.

George Grosz's caricature collection *The Face of the Ruling Class*.

James MacDonald's paintings included *Autumn in Algoma* and *The Solemn Land*.

Light Space Modulator, László Moholy-Nagy's kinetic sculpture (1921–1930).

Fernand Léger's work included the painting *Three Women* and designs for the Swedish Ballet.

Paul Klee's painting *Graduated Shades of Red-Green*.

Constantin Brancusi's sculpture *Adam and Eve*.

Sun, Sea, Land, Maine, John Marin's painting.

Max Ernst's painting *The Elephant of the Celebes*.

Stuart Davis's painting *Lucky Strike, Bull Durham*.

Lyonel Feininger's painting *Gelmeroda, VIII*.

Piet Mondrian's painting *Composition with Red, Yellow, and Blue*.

Wassily Kandinsky's painting *Blue Segment*.

William Zorach's sculpture *Figure of a Child*.

Alberto Giacometti's painting *Self-Portrait*.

Alexander Archipenko's sculpture *Turning Torso*.

Arthur Dove's painting *Thunderstorm*.

Elie Nadelman's sculpture *Dancer*.

Incense of a New Church, Charles Demuth's painting.

Joan Miró's painting *The Farm* (1921–1922).

Joseph Stella's *Collage #11*.

Max Weber's painting *Still Life*.

The Phillips Gallery in Washington, D.C., opened.

d. Petrus Josephus Hubertus Cuypers, Dutch architect (b. 1827).

THEATER & VARIETY

Anna Christie, Eugene O'Neill's play, set in a water-

front saloon, starred Pauline Lord, George Marion, and Frank Shannon; basis for the 1923 silent film, the 1930 talking film (Greta Garbo's first), and the 1957 musical *New Girl in Town*.

Shuffle Along, Eubie Blake and Noble Sissle's musical, the first Broadway musical acted, directed, and written by Blacks, which introduced the songs *I'm Just Wild About Harry* and *Love Will Find a Way*; lyrics by Sissle, music by Blake; opened in New York.

R.U.R., Karel Capek's Rossum's Universal Robots, and the genesis of the word "robot," in Capek's early science fiction satire; opened in Prague.

Katharine Cornell starred in Clemence Dane's *A Bill of Divorcement*.

Six Characters in Search of an Author, Luigi Pirandello's play.

Liliom, Ferenc Molnar's play, was first produced in America with Joseph Schildkraut and Eva Le Gallienne at the Garrick Theatre, New York.

Man and the Masses, Ernst Toller's play, was produced in Berlin.

Nice People, Rachel Crothers's play, opened at New York's Klaw Theatre on March 2.

Diff'rent, Eugene O'Neill's play, opened in New York.

Lynn Fontanne opened in the George S. Kaufman and Marc Connelly comedy *Dulcy*, in New York.

Getting Gertie's Garter, Wilson Collison and Avery Hopwood's farce, opened in New York.

The Chief Thing, Nikolai Nikolayevitch Evreinov's play, was first performed at Petrograd.

Al Jolson starred on Broadway in *Bombo*.

Sigmund Romberg's operetta *Blossom Time* opened at New York's Ambassador Theater.

Clemence Dane's play *Will Shakespeare*.

Lady Gregory's *Aristotle's Bellows*.

The Circle, Somerset Maugham's play.

The Secret Heaven, Par Lagerkvist's play.

d. Georges-Léon-Jules-Marie Feydeau, French playwright (b. 1862).

MUSIC & DANCE

April Showers, Al Jolson's hit, from the Broadway musical *Bombo*; music by Louis Silvers and words by Buddy DeSylva.

Sergei Prokofiev's *Le Chout* (*The Buffoon*), libretto and music for the ballet, introduced by the Ballets Russes of Sergei Diaghilev in Paris.

The Love for Three Oranges, Sergei Prokofiev conducted the December 30 premiere of his opera, in French, in Chicago; based on the 1761 Carlo Gozzi play *L'Amore delle Tre Melarance*.

Sergei Prokofiev's *Piano Concerto No. 3* premiered in Chicago, with the composer at the keyboard.

California, Here I Come, Al Jolson's song, words and music by Jolson, Buddy DeSylva, and Joseph Meyer.

Second Hand Rose, Fannie Brice's song, from the *Ziegfeld Follies of 1921*; words by Grant Clarke; music by James F. Hanley.

I'm Just Wild About Harry, song by Eubie Blake and Noble Sissle, introduced by Lottie Gee in *Shuffle Along*; later Harry Truman's political signature song.

Ralph Vaughan Williams's *Symphony No. 3*, the *Pastoral*; *Mass*; and opera *The Shepherds of the Delectable Mountains*.

Katya Kabanova, Leoš Janáček's opera, libretto by Janáček, opened in Brno October 23.

Le Roi David (*King David*), Arthur Honegger's opera, libretto by René Morax, based on *I Samuel* from the Bible, premiered in Mézière June 11.

Edgard Varèse's orchestral works *Offrandes* and *Amériques*, which includes parts for fire siren, cyclone whistle, etc.

El fuego nuevo, Carlos Chávez's Aztec ballet.

Charles Ives, *Thirty-four Songs for Voice and Piano*.

Frederick Delius's *Cello Concerto*.

Howard Hanson's *Concerto for Organ, Strings, and Harp*.

La bella dormente nel bosco, Ottorino Respighi's opera.

Sancta Susanna, Paul Hindemith's opera.

Anton von Webern's *Six Songs*.

Albert Roussel's second symphony.

La Giovinezza, Italian fascist anthem, was composed by G. Castaldi, drawing on earlier work by Giuseppe Blanc, words by Marcello Manni.

Leningrad Philharmonic Orchestra founded.

Mary Garden's realistic performance of *Salomé* created a scandal in Chicago.

Nadia Boulanger became a composition teacher at the American Conservatory at Fontainebleau.

d. Camille Saint-Saëns, French composer, pianist, and organist (b. 1835).

d. Engelbert Humperdinck, German composer and teacher (b. 1854).

d. Enrico Caruso, Italian tenor (b. 1873).

WORLD EVENTS

Irish Civil War (1921–1922) between the new Irish Free State government and those Irish Republican Army activists who refused to accept the terms of the Irish Civil War peace agreement, especially as to Northern Ireland; the government won, but IRA guerrilla warfare would continue.

Kronstadt Rebellion: Bolshevik sailors at Leningrad's Kronstadt naval base briefly rose against the Soviet government; put down by Red Army units.

Italian-American anarchists Nicola Sacco and Bartolomeo Vanzetti were convicted of the murder of two people during a 1920 payroll robbery in Braintree, Massachusetts, on very slim evidence after a highly prejudiced trial; despite worldwide protests, they would be executed in 1927.

Benito Mussolini became a Fascist member of the Italian parliament. Italian Fascist Blackshirts begin to take control of streets, their terrorism paving the way for Mussolini's coming takeover.

Moderate Japanese Prime Minister Takashi Hara was assassinated by a right-wing zealot; one of the wave of assassinations that were an integral part of the move to military control.

Archaeologist Leonard Woolley began his historic excavations at Ur (1922–1934).

Iranian general Shah Reza Pahlevi (Reza Khan) seized power, deposing Ahmad Shah, then taking full control of Iran.

Rif War (1921–1926): Abd el-Krim's Moroccan army defeated Spanish forces at the Battle of Annoual.

With British sponsorship, Faisal, son of Hussein Ibn Ali, became the first king of Iraq.

Pacifist and antiwar War Resisters' International (WRI) founded.

Margaret Sanger founded the American Birth Control League, forerunner of the Planned Parenthood Federation. Marie Stopes founded Britain's first birth control clinic.

1922

LITERATURE

Ulysses, James Joyce's landmark novel, in which he explored the inner journeys of Leopold Bloom and Stephen Dedalus on a single day (June 16, 1904); called obscene and therefore made unusually popular. Though an obscurely written work, it was banned in the United States until 1933, and even longer in several other countries.

The Waste Land, T. S. Eliot's long poem, a seminal modernist work.

The Nobel Prize for Literature was awarded to Jacinto Benavente y Martínez.

Indian Summer of a Forsyte and *Awakening*, John Galsworthy's novels continuing his initial trilogy, *The Forsyte Saga* (1906–1921).

The Thibaults (1922–1940), eight-novel Roger Martin du Gard series.

Aldous Huxley's short stories *Mortal Coils*.

Babbitt, Sinclair Lewis's novel satirizing urban life in his fictional midwestern Zenith.

Carl Sandburg's poems *Slabs of the Sunburnt West*; also his *Rootabaga Stories* (1922–1930).

Boris Pasternak's poems *My Sister Life*.

Siddharta, Hermann Hesse's novel; basis of the 1973 Conrad Rooks film.

The Enormous Room, e e cummings's World War I story.

Boris Pilnyak's *The Naked Year*.

The Soul Enchanted, Romain Rolland's seven-volume series of novels (1922–1933).

D. H. Lawrence's novel *Aaron's Rod* and his *England, My England and Other Stories*.

One of Ours, Willa Cather's Pulitzer Prize–winning novel.

Katherine Mansfield's short stories *The Garden Party*.

Gabriela Mistral's poetic work *Desolation*.

Christopher Morley's novel *Where the Blue Begins*.

Gerhart Hauptmann's novel *Phantom*.

Conrad Aiken's poetic work *Priapus and the Pool*.

Janet Lewis's poetic work *The Indians in the Woods*.

Mário de Andrade's poetic work *Hallucinated City*.

Julio Jurenito, Ilya Ehrenburg's novel.

Ludwig Lewisohn's autobiographical work *Upstream*.

Yakub Kadri Karaosmanoglu's stories *Kiralik Konak* and *Nur Baba*.

Maxwell Bodenheim's poetic work *Introducing Irony*.

Osip Mandelstam's poems *Tristia*.

Paul Valéry's poetic work *Charms*.

Robert Benchley's essays *Love Conquers All*.

The Judge, Rebecca West's novel.

Thomas Hardy's *Late Lyrics and Earlier*.

Reader's Digest founded in United States.

d. Marcel Proust, French writer (b. 1871), author of

the seven-part *Remembrance of Things Past* (1913–1927).

d. Mori Ogai, Japanese novelist (b. 1862).

d. Ogai Mori, Japanese novelist and poet (b. 1862).

d. Thomas Nelson Page, American author (b. 1853).

FILM & BROADCASTING

Orphans of the Storm, Lillian Gish, Dorothy Gish, and Joseph Schildkraut starred in D. W. Griffith's silent film epic story of the French Revolution.

Nanook of the North, Robert Flaherty's silent film study of Eskimo life, a landmark documentary that Flaherty wrote, directed, shot, and edited.

Blood and Sand, Rudolph Valentino starred as the bullfighter in Fred Niblo's silent film, based on the 1922 Vicente Blasco Ibañez novel.

John Barrymore starred in the title role of the silent film *Sherlock Holmes*, directed by Albert Parker; the cast included Carol Dempster and Hedda Hopper.

Douglas Fairbanks starred in the title role of the silent film *Robin Hood* in a cast that included Wallace Beery, Enid Bennett, William Lowery, and Alan Hale; Allan Dwan directed. The screenplay was written by Fairbanks, as Elton Thomas.

Jackie Coogan starred in the title role of the silent film *Oliver Twist*, based on Charles Dickens's novel; Frank Lloyd directed; Lon Chaney as Fagin and Gladys Brockwell costarred.

Alla Nazimova starred as Nora in a silent film version of Henrik Ibsen's 1879 *A Doll's House*, directed by Charles Bryant.

Mary Pickford starred in the silent film *Tess of the Storm Country*.

Asta Nielsen starred in the silent film *Miss Julie*.

Beginning of the long "Our Gang" comedy series, developed by Hal Roach.

Buster Keaton starred in *The Playhouse*.

Lewis Stone starred in the title role of the silent film *A Prisoner of Zenda*, directed by Rex Ingram.

VISUAL ARTS

Daniel Chester French's sculpture *Abraham Lincoln* was unveiled at the Lincoln Memorial, Washington, D.C.; the memorial itself was designed by Henry Bacon.

Gaston Lachaise's sculpture *Walking Woman*.

John Sloan's painting *The City from Greenwich Village*.

Joseph Stella's paintings included *New York Interpreted* and *Skyscrapers*.

Paul Klee's paintings included *A Young Lady's Adventure* and *Dance, Monster, to My Soft Song!*

Georges Braque's painting *The Mantelpiece*.

William Zorach's sculpture *Floating Figure* and his painting *Sailing by Moonlight*.

Piet Mondrian's painting *Composition 2*.

Constantin Brancusi's sculpture *Poisson*.

John Marin's painting *Maine Islands*.

Arthur Dove's painting, *Gear*.

Charles Demuth's painting *Still Life, No. 1*.

Since Cezanne, Clive Bell's book of essays.

Edwin Landseer Lutyens began the Cenotaph, Whitehall.

Detroit's Institute of Fine Arts was founded.

Maurice Prendergast's painting *Acadia*.

Paul Nash's painting *The Wall Against the Sea*.

The Baltimore Museum of Art opened.

d. James Edward Hervey MacDonald, Canadian painter (b. 1873), a member of the Group of Seven.

THEATER & VARIETY

George Bernard Shaw's *Back to Methusaleh* was produced in New York by the Theatre Guild.

The Dybbuk, by Ansky (Solomon Rappoport), was produced by Moscow's Hebrew-language Habimah Theatre, opening on January 31.

John Barrymore's New York *Hamlet* established him as a major Shakespearean actor; Rosalinde Fuller was Ophelia.

Anne Nichols's *Abie's Irish Rose* opened at New York's Fulton Theatre on May 23.

Merton of the Movies, George S. Kaufman and Marc Connelly's comedy, based on short stories by Harry Wilson, opened at New York's Cort Theatre on November 13; there were three film versions (1924; 1932; 1947).

Seventh Heaven, Austin Strong's play, starring Helen Menken, opened at New York's Booth Theatre.

The God of Vengeance, Sholem Asche's play; a production in English, starring Joseph Schildkraut, opened at New York's Provincetown Playhouse.

The Hairy Ape, Eugene O'Neill's play.

Karel Capek and Joseph Capek's *The Insect Play*.

Little Nellie Kelly, George M. Cohan's musical; basis of the 1940 film.

Loyalties, John Galsworthy's play, opened in London.

Kempy, J. C. and Elliott Nugent's comedy, opened at New York's Belmont Theatre on May 15.

The Old Soak, Don Marquis's comedy, opened at New York's Plymouth Theatre on August 22.

The Texas Nightingale, Zoë Akins's play, opened at New York's Empire Theatre on November 20.

To the Ladies, George S. Kaufman and Marc Connelly's comedy, opened in New York.

The Torch-Bearers, George Kelly's comedy, opened at New York's 48th Street Theatre on August 30.

The Fool, Channing Pollock's melodrama, opened at New York's Times Square Theatre on October 23.

Drums in the Night, Bertolt Brecht's play.

Henry IV, Luigi Pirandello's play.

The Machine Wreckers, Ernst Toller's play.

d. Bert Williams, African-American entertainer and song writer (ca. 1876–1922), long partnered in vaudeville with George Walker and a featured performer in the Ziegfeld Follies.

d. Lillian Russell, American singer (b. 1861), a star in vaudeville and in musicals on the New York stage from the early 1880s.

d. Achille Torelli, Italian playwright (b. 1841).

d. Eugene V. Vakhtangov, Soviet actor and director (b. 1883).

d. Giovanni Verga, Italian playwright (b. 1840).

d. Marie Lloyd, British music-hall star (b. 1870).

MUSIC & DANCE

Way Down Yonder in New Orleans, song with words and music by Henry Creamer and Turner Layton.

Water Boy, song strongly associated with Paul Robeson; words and music by Avery Robinson, based on the folk song *Jack o' Diamonds*.

Louis Armstrong joined King Oliver's Chicago-based band, quickly emerging as a major figure in jazz.

Le Renard, Bronislava Nijinska's choreography for Igor Stravinsky's 1916 stage work; produced by Diaghilev's Ballets Russes, Paris.

Duke Ellington formed his influential band, with four saxophones, three trumpets, three trombones, four rhythm, and one piano, setting the pattern for many other jazz orchestras.

Igor Stravinsky's *Mavra*, opera, libretto by Boris Kochno, opened in Paris, June 2.

Runnin' Wild, words by Joe Grey and Leo Wood, music by A. Harrington Gibbs; sung by Marilyn Monroe in the 1959 film *Some Like It Hot*.

Aaron Copland, *Passacaglia for Piano*.

Carl Nielsen's *Symphony No. 5* and *Wind Quintet*.

Maurice Ravel's *Sonata for Violin and Cello*.

Paul Hindemith's music for ballet *Der Dämon*.

Howard Hanson, *Symphony No. 1*, the *Nordic*.

Hagith, Karol Szymanowski's opera.

Kurt Weill's *Divertimento* and *Sinfonia sacra*.

Escales, Jacques Ibert's orchestral piece.

Giulietta e Romeo, Riccardo Zandonai's opera.

Sir Arthur Bliss's *A Colour Symphony*.

George Antheil, *Symphony No. 1*.

Anton von Webern's *Five Sacred Songs* (1917–1922).

British National Opera Company established.

WORLD EVENTS

Benito Mussolini's Fascist Blackshirts marched on Rome; he became premier on October 31.

Teapot Dome scandal: U.S. Secretary of the Interior Albert M. Fall took $400,000 in bribes in return for leases on Teapot Dome, Wyoming, and Elk Hills, California, federal oil reserves.

With the Soviet–German Treaty of Rapallo, Germany became the first world power to recognize the Soviet Union and normalize relations.

d. Walter Rathenau, German-Jewish industrialist (b. 1838), assassinated by right-wing terrorists (June 24).

China's Kuomintang party reorganized on the Bolshevik model, on the advice of Sun Yat-sen's Soviet advisors.

Howard Carter excavated the tomb of "King Tut" (Tutankhamen), Egyptian pharaoh (ca. 1350 BC).

Oswald Spengler's *The Decline of the West*.

Ludwig Wittgenstein's *Tractatus Logico-Philosophicus*.

d. Michael Collins (b. 1890), commander of the Irish Free State forces during the Irish Civil War, assassinated.

1923

LITERATURE

New Hampshire, Robert Frost's Pulitzer Prize–winning

poetry collection, including *Stopping by Woods on a Snowy Evening*.

The Nobel Prize for Literature was awarded to William Butler Yeats.

D. H. Lawrence's *Studies in Classic American Literature*; also his novel *Kangaroo*, short story *The Ladybird*, and poetic work *Birds, Beasts and Flowers*.

Edna St. Vincent Millay's Pulitzer Prize–winning *The Harp-Weaver and Other Poems*.

Dorothy L. Sayers's mystery, *Whose Body?*, introducing her detective Lord Peter Wimsey.

Antic Hay, Aldous Huxley's novel.

Joseph Conrad's novel *The Rover*.

Katherine Mansfield's short stories *The Dove's Nest*.

The Prophet, Khalil Gibran's self-illustrated mystical work.

Rainer Maria Rilke's poetry *Duino Elegies* and *Sonnets to Orpheus*.

Boris Pasternak's poetry *Themes and Variations*.

e e cummings's poems *Tulips and Chimneys*.

Pablo Neruda's poetry *Crepusculario*.

Gertrude Atherton's novel *Black Oxen*.

Jorge Luis Borges's poems *Fervor de Buenos Aires*.

Conrad Aiken's poetic work *The Pilgrimage of Festus*.

Lion Feuchtwanger's *The Ugly Duchess*.

Louise Bogan's poems *Body of This Death*.

Maxwell Bodenheim's poetry *Against This Age* and *The Sardonic Arm*.

Muhammad Iqbal's poems *The Message of the East*.

My Life and Loves, Frank Harris's autobiography (1923–1927).

My Universities, third volume of Maxim Gorky's autobiography.

O. Henry's short stories *Postscripts*.

Sakutaro Hagiwara's poetic work *Blue Cat*.

Romain Rolland's *Mahatma Gandhi*.

Told by an Idiot, Rose Macaulay's novel.

Wallace Stevens's poetry *Harmonium*.

d. Jaroslav Hašek, Czech writer (b. 1883).

d. Kate Douglas Wiggin, American writer (b. 1856).

d. Katherine Mansfield (Kathleen Beauchamp-Murry), New Zealander–British short-story writer, associated with the Bloomsbury group (b. 1888).

FILM & BROADCASTING

Anna Christie, Blanche Sweet, George F. Marion, and William Russell starred in the first film of Eugene O'Neill's 1921 play; directed by John G. Wray.

Dr. Mabuse, the Gambler, Fritz Lang's silent film, set in Weimar Germany; Rudolf Klein-Rogge starred.

Abel Gance directed his spectacular silent film *La Roué*.

Cecil B. DeMille directed and produced his silent film version of the Bible epic *The Ten Commandments*; his sound-film version came in 1956.

Douglas Fairbanks starred in the title role of the silent film *The Thief of Bagdad*, directed by Raoul Walsh and based on a story by Fairbanks, as Elton Thomas.

Laurette Taylor starred in the title role of the silent film *Peg O' My Heart*, directed by King Vidor.

Lon Chaney and Patsy Ruth Miller starred in the title role of the silent film *The Hunchback of Notre Dame*, based on the 1831 Victor Hugo novel; Wallace Warsley directed.

Lillian Gish and Ronald Colman starred in *The White Sister*, directed by Henry King and based on the Francis Marion Crawford novel.

Mary Pickford starred in the title role of the silent film *Rosita*, directed by Ernst Lubitsch; Holbrook Blinn costarred.

George Arliss and Alice Joyce starred in the silent film *The Green Goddess*, directed by Sidney Olcott.

Gloria Swanson starred in the title role of the silent film *Zaza*, directed by Allan Dwan; it was the first of the eight Swanson–Dwan films.

James Cruze directed and produced the silent film Western epic *The Covered Wagon*, based on the Emerson Hough novel; the cast included Lois Wilson, Ernest Torrence, Charles Ogle, J. Warren Kerrigan, and Alan Hale.

Pola Negri starred in the silent film comedy *A Woman of the World*, based on the Carl Van Vechten novel *The Tattooed Countess*; Malcolm St. Clair directed.

Ramon Navarro and Alice Terry starred in the silent film *Scaramouche*, directed by Rex Ingram.

VISUAL ARTS

Pablo Picasso's paintings included *Pipes of Pan* and *Seated Women*.

Wassily Kandinsky's painting *In the Black Circle*.

Paul Klee's painting *Magic Theatre*.

Marc Chagall's painting *Over Vitebsk*.

Georgia O'Keeffe's painting *Calla Lily*.

Charles Sheeler's painting *Bucks County Barn, Self-Portrait*.

Fernand Léger's paintings included *The Great Tug* and *Woman with Book*.

Child, Yasuo Kuniyoshi's painting.

Marsden Hartley's painting, *New Mexico Recollections, Color Analogy*.

Oskar Kokoschka's painting *Dresden, Augustus Bridge with Steamer*.

Composition with Nude Figures, Max Weber's painting.

Frank Lloyd Wright designed the Millard House, Pasadena, California.

George Bellows's painting *Between Rounds*.

Rockwell Kent's paintings included *Shadows of Evening* (1921–1923) and *The Kathleen*.

Gertrude Whitney's sculpture *Chinoise*.

John Marin's painting, *Ship, Sea and Sky Forms, Impression*.

Pierre Bonnard's lithograph *Place Clichy* (ca. 1923).

d. Gustave Eiffel, French engineer (b. 1832).

THEATER & VARIETY

Winifred Lenihan starred in the title role of George Bernard Shaw's *Saint Joan*; the New York Theatre Guild production was its world premiere.

Edna May Oliver and Willard Robertson starred in *Icebound*, Owen Davis's play, which opened at New York's Sam H. Harris Theatre.

The Adding Machine, Elmer Rice's play, opened at the Garrick Theatre (Theatre Guild), New York, with Dudley Digges and Helen Westley.

The Nervous Wreck, Owen Davis's comedy, opened at New York's Sam H. Harris Theatre on October 9.

The Potters, J. P. McEvoy's comedy, opened at New York's Plymouth Theatre on December 8.

The Shame Woman, Lula Vollmer's play, opened at New York's Greenwich Village Theatre.

The Shadow of a Gunman, Sean O'Casey's first Irish civil war play.

Eva Le Gallienne and Basil Rathbone starred in Ferenc Molnár's *The Swan*.

Leon Gordon's *White Cargo* opened at New York's Greenwich Village Theatre on November 5.

Eddie Cantor starred on Broadway in the Harry Tierney and Joseph McArthur musical *Kid Boots*.

You and I, Philip Barry's comedy, opened at New York's Belmont Theatre on February 19.

The Makrapoulos Affair, Karel Capek's play; basis for the 1926 Janacek opera.

In the Swamp, Bertolt Brecht's play.

Frantisek Langer's *The Camel Through the Needle's Eye*.

Dr. Knock, Jules Romains's play.

d. Sarah Bernhardt, French actress (b. 1844), from the early 1870s recognized as one of the leading players of her time, in a very wide range of roles, though most notably by far as a tragedian in French and English classics. She was also a writer and visual artist, though on an entirely different level.

d. Albert Chevalier, British music-hall star (b. 1861).

d. Charles Henry Hawtrey, English actor–manager (b. 1858).

MUSIC & DANCE

Master Peter's Puppet Show (*El Retablo de Maese Pedro*), Manuel de Falla's opera, his libretto based on Miguel de Cervantes's *Don Quixote* (1605, 1615); a concert version premiered in Seville.

Les Noces, Bronislava Nijinska's ballet, music by Igor Stravinsky, first danced June 13, by Sergei Diaghilev's Ballet Russes, in Paris. An early version of the score had been written for player piano, using many more keys than could be played by humans, with their limit of 10 fingers.

Downhearted Blues, Bessie Smith's first number-one best-seller, accompanied by Clarence Williams.

Ralph Vaughan Williams's *English Folk Song Suite*.

Charleston, Cecil Mack and James P. Johnson's song that started a dance craze; from the musical *Runnin' Wild*.

Igor Stravinsky's ballet *The Wedding*, and his *Octet for Wind Instruments*.

Wolverine Blues, popular song by John Spikes, Benjamin Spikes, and Jelly Roll Morton, popularized by Morton with King Oliver's Creole Jazz Band.

Padmăvati, Albert Roussel's opera–ballet, libretto by Louis Laloy, opened at the Opéra, Paris.

Arthur Honegger's orchestral works *Chant de joie* and *Pacific 231*.

Arnold Schoenberg's *Serenade* for voice and instruments, *Five Piano Pieces*, and *Piano Suite*.

Edgard Varèse's *Hyperprism* for wind and percussion and *Octandre*, for wind and double bass.

The Creation of the World (*La Création du monde*), Darius Milhaud's ballet.

Leoš Janáček's *String Quartet No. 1*, the *Kreutzer Sonata*.

Psalmus hungaricus, Zoltan Kodály's choral work.

What'll I Do?, Irving Berlin's song.

Béla Bartók's *Dance Suite*.

Ernest Bloch's *Piano Quintet No. 1*.

The Perfect Fool, Gustav Holst's opera.

Jean Sibelius's *Symphony No. 6*.

You've Got to See Mama Every Night or You Can't See Mama at All, Sophie Tucker's hit song, by Billy Rose and Con Conrad.

Belfagor, Ottorino Respighi's opera.

Kurt Weill's second string quartet.

Roger Sessions's incidental music *The Black Maskers*.

Boston banned a production of Richard Strauss's 1905 opera *Salomé*.

San Francisco Opera founded.

Modern Mozart festivals began in Salzburg, which opened a new Festspielhaus for the purpose.

Cello-style guitar, with an arched top, developed by the Gibson Company in the United States.

d. Sayed Darwish, Egyptian composer (b. 1892).

WORLD EVENTS

Hitler's Nazi party mounted the failed Beer Hall Putsch, an attempted coup in Bavaria; while in prison, Hitler wrote the first volume of *Mein Kampf*, emerging from jail a German national figure.

d. Warren Gamaliel Harding, 29th American president (b. 1865), while in office; succeeded by Vice-President Calvin Coolidge.

Tokyo–Yokohama earthquake and fire (September 1); both cities were largely destroyed, with an estimated 140,000 people dead.

French and Belgian forces occupied the Ruhr, because of German nonpayment of World War I reparations set by the Treaty of Versailles.

National Woman's party leader Alice Paul wrote the first version of the Equal Rights Amendment.

1924

LITERATURE

A Passage to India, E. M. Forster's novel, a sensitive, small-scale study in Indian–British cultural abra-

sion; basis of the epic 1984 film.

The Magic Mountain, Thomas Mann's novel, his tuberculosis-sanitarium look back at a prewar Europe about to destroy itself.

The Captive, fifth part of Marcel Proust's *Remembrance of Things Past*; published posthumously.

Andre Gidé's *Corydon*, an open defense of homosexuality that was bitterly and widely attacked.

Billy Budd, Foretopman, Herman Melville's last novel, first published 33 years after completion.

André Breton's *Manifesto of Surrealism*.

So Big, Edna Ferber's Pulitzer Prize–winning novel.

William Faulkner's poetic work *The Marble Faun*.

Wladyslaw Reymont was awarded the Nobel Prize for Literature.

Cement, Fyodor Gladkov's post–Russian Civil War novel.

St.-John Perse's epic poem *Anabasis*.

André Maurois's fictionalized biography *Ariel: The Life of Shelley*.

D. H. Lawrence's novel *The Boy in the Bush* (with M. L. Skinner).

DuBose Heyward's poems *Skylines and Horizons*.

Edwin Arlington Robinson's Pulitzer Prize–winning poetry collection *The Man Who Died Twice*.

Robinson Jeffers's *Tamar and Other Poems*.

Odessa Tales, Isaak Babel's short stories.

Pablo Neruda's *Twenty Love Songs and a Song of Despair*.

Escape and *The Green Bay Tree*, Louis Bromfield's novels.

Ford Madox Ford's *Some Do Not*, first novel in his post–World War I quartet *Parade's End*.

Gerhart Hauptmann's novel *Die Insel der grossen Mutter* (*The Island of the Great Mother*).

Giganten, Alfred Doblin's novel.

John Crowe Ransom's poems *Chills and Fever*.

Joseph Conrad's novel *The Nature of a Crime* (with E. M. Ford).

Cities and Years, Konstantin Fedin's first novel.

Mark Twain's *Autobiography*.

Thomas Beer's novel *Sandoval*.

Vladimir Mayakovsky's poem *Vladimir Ilich Lenin*.

Mirage, Edgar Lee Masters's novel.

Muhammad Iqbal's *The Call of the Road*.

P. G. Wodehouse's *The Inimitable Jeeves*.

Rafael Alberti's poetic work *Marinero en tierra*.

I. A. Richards's influential work *Principles of Literary Criticism*.

The American Mercury began publication; notable as the home of the iconoclastic H. L. Mencken and George Jean Nathan.

Saturday Review (of Literature), American weekly founded by Henry Seidel Canby, Christopher Morley, William Rose Benét, and Amy Loveman.

d. Joseph Conrad (Jósef Teodor Konrad Korzeniowski), Polish-British writer (b. 1857).

d. Franz Kafka, Austrian-Czech writer (b. 1883).

d. Anatole France (Jacques Anatole François Thibault), French man of letters (b. 1844).

d. Frances Hodgson Burnett, American author (b. 1849).

d. Marie Corelli, English romantic novelist (b. 1855).

d. Monmohan Ghosh, Indian poet writing in English (b. 1869).

FILM & BROADCASTING

John Ford directed the classic silent film epic *The Iron Horse*, about the building of the first continent-spanning American railroad; the cast included George O'Brien, Madge Bellamy, Fred Kohler, and Cyril Chadwick.

John Barrymore and Mary Astor starred in the silent film *Beau Brummel*, directed by Harry Beaumont, also beginning their long off-screen liaison.

Greed, the Erich von Stroheim silent film, starring Gibson Gowland, Zasu Pitts, and Jean Hersholt; based on *McTeague*, the 1899 Frank Norris novel.

Glenn Hunter starred in the title role of the silent film *Merton of the Movies*, directed by James Cruze; adapted from the 1922 play.

Swedish director Victor Sjöstrom directed the silent film *He Who Gets Slapped*, an adaptation of the 1914 Leonid Andreyev play; Lon Chaney, John Gilbert, and Norma Shearer starred.

Harold Lloyd produced and starred in the silent film *The Freshman*.

Lillian Gish starred in the silent film *Romola*.

Alfred Lunt and Lynn Fontanne starred in the film adaptation of *The Guardsmen*.

Asta Nielsen starred in the silent film *Hedda Gabler*.

Buster Keaton starred in the silent film *The Navigator*.

D. W. Griffith directed and produced *America*, set in the American Revolution; the cast included Neil Hamilton, Carol Dempster, and Lionel Barrymore.

Rudolph Valentino and Bebe Daniels starred in *Monsieur Beaucaire*, directed by Sidney Olcott.

d. Thomas Harper Ince, American writer, director and producer, a leading creator of early Westerns (b. 1882).

VISUAL ARTS

André Breton published the first *Surrealist Manifesto*.

Constantin Brancusi's sculptures included *Miracle* (*The White Seal*), *The Beginning of the World*, and *The Cock*.

Georgia O'Keeffe's paintings included *Corn*, *Dark*, *Dark Abstraction*, *Flower Abstraction*, and *Petunia and Coleus*.

Gaston Lachaise's *Dolphin Fountain*.

Henry Moore's sculpture *Mother and Child* (1924–1925).

George Bellows's painting *Dempsey and Firpo*.

Joan Miró's painting *Carnival of Harlequin* (1924–1925).

Georges Rouault's painting *Circus Trio*.

Henri Matisse's painting *Odalisque with Magnolias*.

Wassily Kandinsky's painting *One Center*.

Alexander Stirling Calder's sculpture *The Horse*.

Malvina Hoffman's sculpture *Mask of Anna Pavlova*.

André Masson's painting *The Four Elements*.

Max Weber's painting *Still Life with Chinese Teapot*.

Alexander Archipenko's sculpture *Archipenturo*.

Wassily Kandinsky's painting *One Center*.

Pierre Bonnard's painting *Still Life* (ca. 1924).

Arthur G. Dove's painting *Portrait of Ralph Dusenberry*.

Fisherman, Yasuo Kuniyoshi's painting.

Harold Gray created the *Little Orphan Annie* comic strip, basis of the 1977 musical *Annie* and the 1982 film.

Bertram C. Goodhue designed the National Academy of Science and Research Council, Washington, D.C.

Rockwell Kent's book *Voyaging: Southward from the Straits of Magellan*.

Swann Memorial Fountain, Philadelphia, Alexander Stirling Calder's sculpture.

d. Louis Sullivan, American architect (b. 1856).

d. Maurice Prendergast, American painter (b. 1859).

d. Henry Bacon, American architect (b. 1866), who designed the Lincoln Memorial.

d. Léon Bakst, Russian stage designer and painter (b.

1866), who worked with Sergei Diaghilev's Ballet Russes company.

THEATER & VARIETY

Desire Under the Elms, Eugene O'Neill's Pulitzer Prize–winning play, starred Walter Huston, Mary Morris, and Charles Ellis as the three Cabots; opened at New York's Greenwich Village Theatre; basis of the 1958 film.

All God's Chillun Got Wings, Eugene O'Neill's play, controversial in its time for its interracial marriage theme, opened at New York's Province-town Playhouse; Paul Robeson and Mary Blair starred.

Juno and the Paycock, Sara Allgood and Barry Fitzgerald starred at Dublin's Abbey Theatre in the Sean O'Casey Irish Civil War play; basis of the 1930 Alfred Hitchcock film.

Fred Astaire, Jayne Auburn, and Adele Astaire starred in the musical *Lady, Be Good!*, lyrics by Ira Gershwin, music by George Gershwin; opened at New York's Liberty Theatre on December 1.

Orpheus, Jean Cocteau's contemporary version of the Orpheus and Eurydice story; he also adapted and directed the 1949 screen version.

They Knew What They Wanted, Pauline Lord and Richard Bennett starred in Sidney Howard's play; opened at New York's Garrick Theatre. There were three film versions, including the 1940 Garson Kanin film from Howard's screenplay, and a musical version, *The Most Happy Fella*.

What Price Glory?, Louis Wollheim and William Boyd starred in the Maxwell Anderson–Lawrence Stallings antiwar play; opened in New York; basis for the 1926 and 1953 films.

The Little Clay Cart (*Mrcchakatika*), Indian play, originally in Sanskrit, was presented in translation at New York's Neighborhood Playhouse.

Rudolph Friml's musical *Rose-Marie*, book and lyrics by Otto Harbach and Oscar Hammerstein II and music by Friml, opened in New York.

Beatrice Lillie and Gertrude Lawrence starred in *Charlot's Revue*.

Leslie Howard starred in Sutton Vane's *Outward Bound*, which in 1930 would become his first film.

George Kelly's *The Show-Off* opened at New York's Playhouse on February 5.

Jean-Jacques Bernard's *Invitation to the Voyage* opened in Paris on February 15.

George S. Kaufman and Marc Connelly's *Beggar on Horseback* opened in New York.

Rachel Crothers's *Expressing Willie* opened at New York's 48th Street Theatre on April 16.

Edwin Justus Mayer's *The Firebrand* opened at New York's Morosco Theatre on October 15.

Lewis Beach's *The Goose Hangs High* opened at New York's Bijou Theatre on January 29.

New York's Cherry Lane Theatre opened with Robert H. Presnell's *Saturday Night*.

The Man with a Load of Mischief, Ashley Dukes's play, opened in London on December 7.

Constantin Stanislavsky's book *My Life in Art*.

Each in His Own Way, Luigi Pirandello's play.

Close Harmony, Dorothy Parker and Elmer Rice's play.

I'll Say She Is, Marx Brothers's comedy.

Rachel Crothers's *Expressing Willie*.

d. Eleonora Duse, Italian actress (b. 1858).

d. Charlotte "Lotta" Crabtree, American actress (b. 1847).

d. Herman Heijermans, Dutch playwright (b. 1864).

d. Lew Dockstader, American vaudeville artist and "blackface" performer (b. 1856).

d. Angel Guimerà, Catalan poet and playwright (b. 1849).

d. Nils Kjaer, Norwegian playwright and essayist (b. 1870).

MUSIC & DANCE

Someone to Watch over Me, George and Ira Gershwin's song, introduced by Gertrude Lawrence in *Oh, Kay!*

Fascinatin' Rhythm George and Ira Gershwin's songs, from *Lady Be Good*, introduced by Fred and Adele Astaire; *The Man I Love*, written for the show, but cut, became a standard only later.

George Gershwin's *Rhapsody in Blue* premiered in New York; Paul Whiteman conducted.

The Cunning Little Vixen, Leoš Janáček opera, libretto by Janáček, premiered in Brno November 6.

Hugh the Drover, or Love in the Stocks, Ralph Vaughan Williams's ballad 1914 opera first publicly performed July 4, Royal College of Music, London.

Limehouse Blues, song introduced by Gertrude Lawrence in *Charlot's Revue*; music by Philip Braham, words by Douglas Furber.

Les Biches, Bronislava Nijinska's ballet, music by Francis Poulenc; danced first on January 6 by Sergei Diaghilev's Ballets Russes in Monte Carlo.

Nerone (*Nero*), Arrigo Boito's opera, libretto by Boito, opened at La Scala, Milan, May 1.

Ottorino Respighi's *Pini di Roma* (*The Pines of Rome*), orchestral work.

Richard Strauss's opera *Intermezzo* and ballet *Schlagobers*.

Rosemarie, Rudolf Friml's operetta.

Igor Stravinsky's *Concerto for Piano and Wind Instruments* and *Sonata for Piano*.

Gustav Holst's *First Choral Symphony* and choral work *The Evening-Watch*.

Erik Satie's ballets *Mercure* and *Relâche*.

Arnold Schoenberg's *Quintet for Winds*; stage work *Die glückliche Hand*; and monodrama *Erwartung*.

Anton von Webern's *Three Folktexts* and *Five Canons on Latin Texts*.

Charles Ives's *114 Songs*.

Aaron Copland's *Symphony for Organ and Orchestra*.

Irrelohe, Franz Schreker's opera.

Jean Sibelius's *Symphony No. 7*.

Kurt Weill's *Concerto for Violin and Wind Instruments*.

Mladi (*Youth*), Leoš Janáček's instrumental work.

Tzigane, Maurice Ravel's orchestral work.

Ralph Vaughan Williams's *Toccata marziale* for band.

Sergei Prokofiev's *Symphony No. 2*.

The Blue Danube, Leonide Massine's ballet.

Curtis Institute of Music founded in Philadelphia.

d. Giacomo Puccini, Italian opera composer (b. 1858).

d. Gabriel Fauré, French composer and teacher (b. 1845).

d. Victor Herbert, American composer (b. 1859).

d. Charles Villiers Stanford, British composer (b. 1852).

d. Ferruccio Benvenuto Busoni, Italian-German composer, pianist, and conductor (b. 1866).

WORLD EVENTS

Calvin Coolidge defeated Democrat John W. Davis and Progressive party candidate Robert M. La Follette for the American presidency.

Chicago "thrill killers" Nathan Leopold and Richard Loeb murdered 14-year-old Robert Franks; Clarence Darrow's pioneering insanity pleas saved them both from execution.

d. Vladimir Illich Lenin (Vladimir Illich Ulyanov),

Bolshevik party leader (b. 1870), organizer of the October Revolution, and first head of the Soviet Union and of the world Communist movement.

American Vice-President Charles Dawes developed the Dawes Plan, which loaned Germany money to pay World War I reparations, and also temporarily stabilized the German economy.

Ramsey MacDonald became the first British Labour prime minister (for 10 months).

J. Edgar Hoover became director of the U.S. Federal Bureau of Investigation (1924–1972).

A. S. Neill founded Summerhill School, his classic experiment in progressive education.

Otto Rank's *The Trauma of Birth*.

1925

LITERATURE

An American Tragedy, Theodore Dreiser's novel based upon the Gillette–Brown murder case; basis for the 1931 film and the 1951 film *A Place in the Sun*.

Arrowsmith, Sinclair Lewis's novel, about a young doctor torn between money and his higher aspirations; basis of the 1931 John Ford film. Lewis refused the Pulitzer Prize.

The Nobel Prize for Literature was awarded to George Bernard Shaw.

The Ring of the Lowenskölds, Selma Lagerlöf trilogy of novels (1925–1928).

The Sweet Cheat Gone, sixth part of Marcel Proust's *Remembrance of Things Past*; published posthumously.

The Informer, Liam O'Flaherty novel, set during the Irish revolution and civil war; basis of several films, including the 1935 John Ford classic.

Martin Buber and Franz Rosenzweig began publication of their 15-volume translation of and commentary on the Hebrew Bible into German in Berlin (1925–1937).

The White Guard, Michael Bulgakov's autobiographical novel.

The Great Gatsby, F. Scott Fitzgerald's novel, set in newly rich Long Island circles in the 1920s; basis of several films and plays.

T. S. Eliot's poetic work *The Hollow Men*.

The Heart of a Dog, Michael Bulgakov's long-suppressed satirical novel.

Olaf Audunsson (*The Master of Hestvikken*), Sigrid Undset's four-part novel, set in medieval Norway (1925–1927).

Mrs. Dalloway, Virginia Woolf's stream-of-consciousness novel.

Amy Lowell's poems *What O'Clock*.

Phantom of the Opera, Gaston Leroux's horror novel, basis of several theater and film versions.

D. H. Lawrence's novel *St. Mawr*; and his *Reflections on the Death of a Porcupine and Other Essays*.

The Cantos, Ezra Pound's long, unfinished work (1925–1972).

No More Parades, second novel in Ford Madox Ford's tetralogy *Parade's End*.

Barren Ground, Ellen Glasgow's novel.

Chains, Henri Barbusse's novel.

Dark Laughter, Sherwood Anderson's novel.

Color, Countee Cullen's poetry collection.

e e cummings's poetry *&* and *XLI Poems*.

Ernest Hemingway's short stories *In Our Time*.

Babette Deutsch's poetry *Honey Out of the Rock*.

DuBose Heyward's novel *Porgy and Bess*.

Eugenio Montale's poetic work *Cuttlefish Bones*.

Gabriela Mistral's poems *Tenderness*.

Thomas Hardy's poetry *Human Shows, Far Phantasies: Songs and Trifles*.

William Carlos Williams's essays *In the American Grain*.

Giants in the Earth, Ole Rolvaag's novel.

Manhattan Transfer, John Dos Passos's novel.

Lion Feuchtwanger's novel *Jew Suss*.

Joseph Conrad's short stories *Tales of Hearsay*.

Mikhail Sholokov's short stories *The Tales of the Don*.

Mitya's Love, Ivan Bunin's novel.

Possession, Louis Bromfield's novel.

Rafael Alberti's poetic work *La amante canciones*.

The Desert of Love, François Mauriac's novel.

Harold Ross founded *The New Yorker* magazine.

d. Amy Lowell, American poet (b. 1874).

d. George Washington Cable, American writer (b. 1844).

d. H(enry) Rider Haggard, English novelist (b. 1856).

d. James Lane Allen, American writer (b. 1849).

d. Wladyslaw Reymont, Polish writer (b. 1867).

FILM & BROADCASTING

Potemkin, Alexander Antonov and Vladimir Barsky starred in Sergei Eisenstein's silent film classic, camera by Eduard Tisse, about the sailor's revolt on the Russian battleship *Potemkin* during the 1905 Russian revolution, which included the classic scene of the massacre on the Odessa Steps.

The Gold Rush, Charles Chaplin's film, set in Alaska; Chaplin produced, directed, wrote, and starred as the Little Tramp.

The Last Laugh, F. W. Murnau's German silent film classic, screenplay by Carl Mayer, camera by Karl Freund; Emil Jannings starred.

Phantom of the Opera, Lon Chaney starred as the mad composer in the silent film version of the Gaston Leroux novel, directed by Rupert Julian.

John Gilbert, Karl Dane, Tom O'Brien, and Renée Adorée starred in the silent film *The Big Parade*, set in World War I; King Vidor directed.

Ronald Colman and Vilma Banky starred in the silent film *The Dark Angel*, directed by George Fitzmaurice.

Rudolph Valentino and Vilma Banky starred in the silent film *The Eagle*, based on Pushkin's novel *Dubrovsky*; Clarence Brown directed.

Belle Bennett starred in the title role of the silent film *Stella Dallas*, opposite Ronald Colman; the film, based on the 1923 Olive Higgins Prouty novel, was directed by Henry King.

D. W. Griffith directed and produced the silent film *Sally of the Sawdust*, starring Carol Dempster in the title role, W. C. Fields, and Alfred Lunt.

Erich Von Stroheim cowrote and directed the silent film *The Merry Widow*, based on the 1905 operetta; John Gilbert and Mae Murray starred.

Gloria Swanson starred in the title role of the French-made silent film *Madame Sans-Gêne*, an adaptation of the 1893 Victorien Sardou and Emile Moreau play; Léonce Perret directed.

John Gilbert, Karl Dane, Tom O'Brien, and Renée Adorée starred in the silent film *The Big Parade*, set in World War I; King Vidor directed.

Mary Pickford starred in the silent film *Little Annie Rooney*.

Sidney Chaplin starred in the title role of the silent film *Charley's Aunt*, directed by Scott Sidney.

VISUAL ARTS

The Paris Exposition (Exposition Internationale des Arts Décoratifs et Industriels Modernes) introduced the Art Deco style.

Marcel Breuer, then teaching at the Bauhaus, invented the tubular steel chair.

Pedagogical Sketchbook, Paul Klee's essays.

Edward Hopper's painting *House by the Railroad*.

Fernand Léger's paintings included *Composition* and *Three Musicians* (1925–1944).

Georgia O'Keeffe's paintings included *New York with Moon*, *Petunia*, *Lake George*, and *Purple Petunias*.

Henri Matisse's sculpture *Seated Nude*.

Arthur Dove's paintings *Portrait of Alfred Stieglitz* and *Waterfall*.

Georges Rouault's painting *The Workman's Apprentice* (*Self-Portrait*).

Little Church, Ben Shahn's painting.

Lyonel Feininger's painting *Tower*.

Malvina Hoffman's sculpture *England*.

Alberto Giacometti's sculpture *Torso*.

Piet Mondrian's painting *Composition 1 with Blue and Yellow*.

Stuart Davis's painting *Italian Landscape*.

Chaim Soutine's painting *Side of Beef*.

Walter Gropius moved the Bauhaus to Dessau, Germany (1925–1926).

Yasuo Kuniyoshi's painting *Waitresses from Sparhawk*.

Wassily Kandinsky's painting *Yellow-Red-Blue*.

Charles Demuth's painting *Apples and Bananas*.

Paul Manship's sculpture *Flight of Europa*.

Pierre Bonnard's painting *The Table*.

Young Girl, Bradley Walker Tomlin's painting.

d. John Singer Sargent, American painter (b. 1856), a leading portraitist, working largely in Britain.

d. George Bellows, American painter (b. 1882), a leading member of the Ashcan School.

d. Paul Wayland Bartlett, American sculptor (b. 1865).

THEATER & VARIETY

Marilyn Miller starred in Jerome Kern's *Sunny*, book and lyrics by Otto Harbach and Oscar Hammerstein II; opened at New York's New Amsterdam Theatre on September 22.

Elisabeth Bergner starred in Max Reinhardt's German production of *The Circle of Chalk*, adapted from a Chinese play (ca. 1300).

Hay Fever, Noël Coward's play.

La Revue Negro, Parisian cabaret review that established Josephine Baker as a major European star.

Craig's Wife, George Kelly's Pulitzer Prize–winning

drama opened at New York's Morosco Theatre on October 12.

Jack Barker sang *Tea for Two* in the Vincent Youmans musical *No, No, Nanette*; opened at New York's Globe Theater on September 16.

Rudolf Friml's operetta *The Vagabond King* opened at New York's Casino Theatre on September 21.

Processional, John Howard Lawson's play, opened in New York on January 12.

The Jazz Singer, Samson Raphaelson's comedy–drama, starred George Jessel; opened at New York's Fulton Theatre on September 14.

The Butter and Egg Man, George S. Kaufman's play, opened at New York's Longacre Theatre.

The Garrick Gaieties, series of revues produced by the Theatre Guild, New York (1925, 1926, 1930).

The Fall Guy, James Gleason and George Abbott's comedy, opened at New York's Eltinge Theatre.

A Man's a Man, Bertolt Brecht's play.

The Cocoanuts, Marx Brothers's comedy.

Man, Beast, and Virtue, Luigi Pirandello's play.

The Dove, Djuna Barnes's play, starred Judith Anderson.

Alexei Mikhailovich Faiko's *Bubus the Teacher*.

Hjalmar Frederik Bergman's *Swedenhjelms*.

Ben Travers's *A Cuckoo in the Nest*.

Henry Bernstein's *La Galérie des glaces*.

Henri Ghéon's *L'Histoire du jeune Bernard de Menthon*.

Halper Leivick's *The Golem*.

MUSIC & DANCE

The Hot Five—Louis Armstrong, Lillian Hardin Armstrong, Kid Ory, Johnny Dodds, and Johnny St. Cyr—began their series of classic jazz recordings in Chicago (1925–1927).

If You Knew Susie, the Al Jolson and Eddie Cantor song, from the musical *Big Boy*; words by Buddy De Sylva, music by Joseph Meyer.

Wozzeck, Alban Berg's opera, libretto by Berg, based on the 1875 Georg Buchner play *Woyzeck*, opened at the Berlin Staatsoper, December 14.

Arnold Schoenberg's *Four Pieces* and *Three Satires* for mixed chorus; also his *Suite for Seven Instruments*.

Maurice Ravel's *L'Enfant et les sortilèges* (*The Child and the Magic*), opera, libretto by Colette, premiered at Monte Carlo March 21.

Doktor Faust, Ferruccio Busoni opera, libretto by Busoni, opened in Dresden May 21.

RETA E. KING LIBRARY
CHADRON STATE COLLEGE
CHADRON, NE 69337

Carl Orff's dramatic musical works *Orpheus*, *Klage der Ariadne*, and *Tanz der Sproden*.

Ralph Vaughan Williams's choral/orchestral works *Flos Campi* (*Flower of the Field*) and *Sancta civitas*; also his *Concerto accademico* for violin.

The Vagabond King, Rudolph Friml's operatta.

Sweet Georgia Brown, Ben Bernie, Maceo Pinkard, and Kenneth Casey's popular song introduced by Bernie, but popularized by Ethel Waters and Her Ebony Four.

The Child and the Enchantments, Maurice Ravel's opera.

Portsmouth Point, William Walton's concert overture.

Alban Berg's *Chamber Concerto* and *Lyric Suite* string quartet.

Arthur Honegger's *Piano Concertino*.

Béla Bartók's *Dance Suite* arranged for piano.

Carl Nielsen's *Symphony No. 6*, *Sinfonia semplice*.

Dmitri Shostakovich's *Symphony No. 1*.

George Gershwin's *Concerto in F*.

Anton von Webern's *Three Songs*.

Los cuatro soles, Carlos Chávez's Aztec ballet.

Les malheurs d'Orphée, Darius Milhaud's opera.

Ernest Bloch's *Concerto grosso No. 1 for strings and piano*.

Paganini, Franz Lehár's operetta.

L'orfeide, Gian Francesco Malipiero's opera.

At the Boar's Head, Gustav Holst's opera.

Igor Stravinsky's *Serenade*, for piano.

Sárka, Leoš Janáček's opera.

Paul Hindemith's *Concerto for Orchestra*.

Iosif the Beautiful, Sergei Nikiforovich Vasilenko's ballet.

Le Pas d'acier, Sergei Prokofiev's ballet.

Grand Ole Opry, Nashville radio country music show began its long run, which continues.

George Balanchine became chief choreographer of the Ballets Russes company.

d. Erik Satie, French composer (b. 1866).

WORLD EVENTS

Trial of Tennessee biology teacher John T. Scopes for teaching evolution rather than the fundamentalist Bible version of Creation prescribed by the state constitution, with Clarence Darrow for the defense and William Jennings Bryan for the prosecution. The trial was fictionalized in the 1955 play and 1960 film *Inherit the Wind*.

American military aviator William "Billy" Mitchell, an advocate of air power, was court-martialed and convicted for his sharp public criticism of the military after the loss of the dirigible *Shenandoah*.

Australian-South African anthropologist Raymond A. Dart discovered the human skull he named *Australopithecus Africanus*.

Ibn Saud's forces won control of western Arabia (the Hejaz) and ended the Arabian Civil War (1919–1925).

Rif War (1921–1926): Abd el-Krim and his Moroccan guerrilla forces destroyed a string of French forts and almost took Fez.

Hitler published the second volume of *Mein Kampf*.

Locarno Treaties guaranteed French and German borders, and the continuing demilitarization of the Rhineland.

Prussian general and World War I German hero Paul von Hindenburg became president of the Weimar Republic.

The Ruhr was evacuated by French and Belgian forces after large German World War I reparations payments were made.

Mid-Atlantic Ridge was discovered by use of sonar.

Vere Gordon Childe's *The Dawn of European Civilization*.

Alfred North Whitehead's *Science and the Modern World*.

1926

LITERATURE

The Sun Also Rises, Ernest Hemingway novel, a prototypical post–World War I "lost generation" story; Henry King directed the 1957 screen version.

The Nobel Prize for Literature was awarded to Grazia Deledda.

The Plumed Serpent, D. H. Lawrence's novel; and his short stories *Glad Ghosts* and *Sun*.

Soldier's Pay, William Faulkner's novel.

The Castle, Franz Kafka's novel.

The Death Ship, B. Traven's novel, set in Germany.

Red Cavalry, Isaak Babel's stories of the Russian Revolution and civil war, based largely on his own experiences.

Early Autumn, the Pulitzer Prize–winning Louis Bromfield novel.

Boris Pilnyak's *The Tale of the Unextinguished Moon*.

Carl Sandburg's two-volume biography *Abraham Lincoln: The Prairie Years*.

Show Boat, Edna Ferber's novel, basis of the 1927 Oscar Hammerstein II–Jerome Kern operetta and the 1936 James Whale film.

A Man Could Stand Up, third novel in Ford Madox Ford's tetralogy *Parade's End*.

Hugh MacDiarmid's poem-sequence *A Drunk Man Looks at the Thistle*.

Archibald MacLeish's poetry *Streets of the Moon*.

Lolly Willowes, Sylvia Townsend Warner's novel.

Bella, Jean Giraudoux's novel.

Dorothy Canfield's novel *Her Son's Wife*.

Under the Sun of Satan, Georges Bernanos's novel.

e e cummings's poetry *is 5*.

Ring Lardner's short stories *The Love Nest*.

H. G. Wells's novel *The World of William Clissold*.

The Murder of Roger Ackroyd, Agatha Christie's novel.

Hart Crane's poetry *White Buildings*.

Israfel, Hervey Allen's biography of Poe.

Mary, Vladimir Nabokov's novel.

Joseph Conrad's *Last Essays*.

Liam O'Flaherty's short stories *Spring Sowing*.

Manuel Altolaguirre's poetry *Las islas invitades*.

Rudyard Kipling's short stories *Debits and Credits*.

Samuel Hopkins Adams's novel *Revelry*.

The Cabala, Thornton Wilder's novel.

Thomas Beer's novel *The Mauve Decade*.

A Dictionary of Modern English Usage, Henry W. Fowler's standard reference.

Book-of-the-Month Club founded in the United States.

d. Charles Montagu Doughty, English traveler and writer (b. 1843).

d. Rainer Maria Rilke, Austro-German poet (b. 1875).

FILM & BROADCASTING

d. Rudolph Valentino (Rodolfo Alfonzo Guglielmi), Italian-American dancer and actor; the most popular of all male silent film stars and a worldwide sex symbol, he became "The Sheik" after starring in the 1921 film of that name (b. 1895).

Rudolph Valentino and Vilma Banky starred in the silent film *The Son of the Sheik*, directed by George Fitzmaurice; it was Valentino's final film, released shortly before his death.

Metropolis, Fritz Lang's landmark of the German cinema, a highly innovative science fiction silent film.

Mother, Vsevolod Pudovkin's silent film classic, set among Russian revolutionaries; based on the 1911 Maxim Gorky novel.

What Price Glory?, Victor McLaglen as Captain Flagg, Edmund Lowe, and Dolores Del Rio starred in Raoul Walsh's silent film of the 1924 Maxwell Anderson–Lawrence Stallings antiwar play.

Ben-Hur, Fred Niblo's silent film, based on the 1880 Lew Wallace novel, starred Ramon Navarro and Francis X. Bushman.

Buster Keaton cowrote, codirected, and starred in the silent film *The General*, based on William Pittenger's story *The Great Locomotive Chase*.

Warner Baxter starred in the title role of the silent film *The Great Gatsby*, directed by Herbert Brenon; based on the F. Scott Fitzgerald novel.

Jean Renoir directed the French silent film *Nana*, based on Émile Zola's novel; Catherine Hessling starred in the title role, opposite Werner Krauss, Jean Angelo, and Raymond Guerin-Catelain.

John Barrymore and Mary Astor starred in the silent film *Don Juan*, based loosely on Byron's poem; Alan Crosland directed a cast that included Myrna Loy.

Greta Garbo emerged as a silent film star with her role in *The Torrent*.

Conrad Veidt starred in the silent film *The Student of Prague*.

Douglas Fairbanks starred in the title role of the silent film *The Black Pirate*; Albert Parker directed a cast that included Billie Dove, Donald Crisp, and Anders Randolf.

G. W. Pabst directed the silent film *Secrets of a Soul*.

Lillian Gish starred in the silent film *The Scarlet Letter*, directed by Victor Seastrom.

Ronald Colman starred in the title role of the first film version of *Beau Geste*, based on the Christopher Wren novel; Herbert Brenon directed.

The Desert Song, the silent film version of the Sigmund Romberg operetta.

National Broadcasting Company (NBC) organized the first lasting radio station network.

John Baird made the first public demonstration of television in London.

VISUAL ARTS

American customs officials had to be forced by court order to admit a version of Constantin Brancusi's *Bird in Space* as a work of art for an American

show of Brancusi's work; they wanted to tax it as a piece of metal.

Georgia O'Keeffe's paintings included *Black Iris*, *City Night*, *Pink Tulip*, the *Shell on Old Shingle* series, *White Sweet Peas*, and *The Shelton with Sunspots*.

Ludwig Mies van der Rohe designed the Liebknecht-Luxemburg Monument, Berlin; the Wolf house, Guben, and a cantilevered tubular steel chair.

Oskar Kokoschka's paintings included *Adele Astaire*, *London Bridge View of the Thames*, and *Tigon*.

Edward Hopper's painting *Mrs. Acorn's Parlor*.

Pablo Picasso's painting *Guitar*.

Alberto Giacometti's sculptures included *Cubist Composition*, *The Spoon-Woman*, and *The Couple*.

John Marin's painting *Fir Tree, Deer Isle, Maine*.

Charles Demuth's painting *Eggplant and Tomatoes*.

Paul Klee's painting *Around the Fish* and drawing *Before Birth*.

Alexander Calder's sculpture *Josephine Baker*.

Georges Braque's painting *Nude Woman with Basket of Fruit*.

Alexander Young Jackson's painting *North Shore, Lake Superior*.

Pierre Bonnard's painting *The Palm*.

Barbara Hepworth's sculpture *Doves*.

Sulphurous Evening, Charles Burchfield's painting.

Chaim Soutine's painting *Flayed Ox*.

The Artist and His Mother, three versions of the same painting by Arshile Gorky (1926–1929).

Edwin Landseer Lutyens designed the British Embassy, Washington, D.C.

Walt Kuhn's painting *Dressing Room*.

Fernand Léger's painting *Three Faces*.

Joan Miró's painting *Dog Barking at the Moon*.

Paul Manship's sculpture *Indian Hunter*.

Thomas Hart Benton's painting *The Lord Is My Shepherd*, *The Path Finder*.

Walter Gropius designed the Toerten Housing Development, Dessau, Germany (1926–1928).

d. Claude Monet, French artist (b. 1840).

d. Antonio Gaudí, Spanish architect (b. 1852).

d. Thomas Moran, American painter (b. 1837).

d. Mary Cassatt, American painter and graphic artist (b. 1845).

THEATER & VARIETY

The Plough and the Stars, Sean O'Casey's work about the Irish Easter Rising of 1916, was produced by the Abbey Theatre; its less-than-adulatory look at the revolutionaries caused riots in Dublin.

Brooks Atkinson became *New York Times* dramatic critic (1926–1960).

Gentlemen Prefer Blondes, Anita Loos and John Emerson's comedy, opened in New York.

The Great God Brown, Eugene O'Neill's play, opened at New York's Greenwich Village Theatre.

Earle Larrimore, Margalo Gilbert, and Laura Hope Crewes starred in Sidney Howard's *The Silver Cord*, produced by the Theatre Guild at New York's John Golden Theatre; Howard wrote the screenplay for John Cromwell's 1933 film version.

Clare Eames, Alfred Lunt, and Albert Perry starred in Sidney Howard's *Ned McCobb's Daughter*; opened at New York's John Golden Theatre.

Gertrude Lawrence starred in the George and Ira Gershwin musical *Oh, Kay!*; opened at New York's Imperial Theatre on November 8.

Eva Le Gallienne founded New York City's Civic Repertory Theater (1926–1933), bringing theater to mass audiences at popular prices.

Saturday Night, Jacinto Benavente's play, opened in New York October 25, at Eva Le Gallienne's Civic Repertory Theater, with Le Gallienne, Egon Brecher, and Beatrice Terry.

Mae West wrote, produced, and starred in *Sex*; opened at New York's Daly's Theatre on April 26.

Sigmund Romberg and Oscar Hammerstein II's operetta *The Desert Song* opened in New York.

Peggy Ann, the Richard Rodgers–Lorenz Hart musical, opened at New York's Vanderbilt Theatre.

The Constant Wife, Somerset Maugham's play, opened in New York November 29.

In Abraham's Bosom, Paul Green's drama, opened at New York's Provincetown Playhouse.

Berkeley Square, John Lloyd Balderston's play, opened in London on October 6.

Broadway, Philip Dunning and George Abbott's drama opened at New York's Broadhurst Theatre.

The Ladder, J. Frank Davis's play, opened at New York's Mansfield Theatre on October 22.

The Shanghai Gesture, John Colton's melodrama, opened at New York's Martin Beck Theatre.

White Wings, Philip Barry's comedy, opened at New York's Booth Theatre on October 15.

The Wisdom Tooth, Marc Connelly's comedy, opened at New York's Little Theatre on February 15.

The Garrick Gaieties, second of a series of revues produced by the Theatre Guild.

Gerhart Hauptmann's *Dorothea Angermann*.

Ben Travers's *Rookery Nook*.

Clemence Dane's plays *Granite* and *Naboth's Vineyard*.

Miguel de Unamuno y Jugo's *The Other*.

D. H. Lawrence's play *David*.

Maurice Schwartz opened New York's Yiddish Art Theatre.

The Big House, Lennox Robinson's play.

Walter Hasenclever's *A Man of Distinction*.

Zoë Akins's *First Love*.

d. Jacob Adler, Russian-American actor, star of Yiddish-language theater, very notably in Yiddish-language translations of Shakespeare (b. 1855).

d. Georges Ancey, French playwright (b. 1860).

d. Henry Miller, British-born American actor and manager (b. 1860).

d. Israel Zangwill, Jewish author (b. 1864).

d. Squire Bancroft, English actor–manager (b. 1841).

MUSIC & DANCE

Turandot, Giacomo Puccini's opera, based on the 1765 Carlo Gozzi play, libretto by Giuseppe Adami and Renato Simoni; the work, which premiered at La Scala, had been completed by Franco Alfano.

Martha Graham debuted in New York as a choreographer and dancer in *Three Gopi Maidens* and *A Study in Lacquer*.

Dipper Mouth Blues (*Sugar Foot Stomp*) was introduced by Louis Armstrong soloing with the Fletcher Henderson Orchestra; words by Walter Melrose, music by King Oliver.

Muskrat Ramble recorded by Louis Armstrong and his Hot Five; words by Ray Gilbert, music by Edwards "Kid" Ory; a 1954 hit by the McGuire Sisters.

(I Want a) Big Butter and Egg Man, Louis Armstrong's song, written with Percy Venable.

Jelly Roll Morton and his Red Hot Peppers were organized.

The Makropoulos Affair, the Leos Janácek opera, libretto by Janácek based on the Karel Capek play, opened in Brno December 18.

Cardillac, Paul Hindemuth opera; libretto by Ferdinand Lion, opened in Dresden, November 9.

The Traveling Companion, Charles Villiers Stanford's opera, performed posthumously.

Erik Satie's ballet *Jack-in-the-box*, choreographed by George Balanchine.

Béla Bartók's first piano concerto and ballet *The Miraculous Mandarin*.

Karol Szymanowski's opera *King Roger* and choral work *Stabat mater*.

Leos Janácek's orchestral work *Sinfonietta* and *Glagolithic Mass*.

A Tragedy of Fashion, Frederick Ashton's first ballet.

Aaron Copland's *Piano Concerto*.

Judith, Arthur Honegger's biblical opera.

Sergei Rachmaninoff's *Fourth Piano Concerto*.

Arthur Bliss's orchestral work *Introduction and Allegro*.

Sonata da chiesa, Virgil Thomson's chamber music.

Siesta, William Walton's orchestral work.

Anton von Webern's *Two Songs*.

Carl Nielsen's *Flute Concerto*.

Darius Milhaud's *Le carnaval d'Aix*, for piano and orchestra.

Jonny spielt auf, Ernst Krenek's dramatic musical work.

Tre commedie goldoniane, Gian Francesco Malipiero's opera.

Háry János, Zoltán Kodály's opera.

The Tempest, Jean Sibelius's incidental music.

Der Protagonist, Kurt Weill's dramatic musical work.

Josephine Baker's first recordings, including *Sleepy Time Gal* and *Dinah*.

Chansons madécasses, Maurice Ravel's song cycle.

Ruth Crawford Seeger's *Suite for Small Orchestra*.

Ninette de Valois founded Britain's Academy of Choreographic Art (later the Royal Ballet).

WORLD EVENTS

British miners' union strike mushroomed into Trades Union Congress general strike, which was broken in only nine days (May 4–12) by the Conservative government, using troops and mobilized private citizens; the miners' strike ended in August.

Kuomintang's Northern Expedition offensive against the Chinese warlords began; Chiang Kai-shek's forces captured Hankow, Nanking, and Shanghai.

American physicist and rocketry pioneer Robert Hutchings Goddard launched the first liquid-propellant rocket (March 16).

Eamon De Valera founded the Fianna Fail party, beginning his long dominance over Irish politics.

Hirohito became emperor of Japan.

Rif War (1921–1926): Large French and Spanish forces defeated Moroccan guerrilla forces led by Abd el-Krim, ending the war.

R. H. Tawney's *Religion and the Rise of Capitalism*.

The Seven Pillars of Wisdom, by T. E. Lawrence ("Lawrence of Arabia").

1927

LITERATURE

Elmer Gantry, Sinclair Lewis's novel about a Bible-thumping evangelical faker; basis of the 1960 Richard Brooks film.

Edwin Arlington Robinson's Pulitzer Prize–winning poetry collection *Tristam*.

The Nobel Prize for Literature was awarded to Henri Bergson.

Federico Garcia Lorca's poetry *Canciones*.

The Nineteen, Alexander Fadeyev's Russian Civil War novel.

Time Regained, seventh part of Marcel Proust's *Remembrance of Things Past*; published posthumously.

To the Lighthouse, Virginia Woolf's novel.

Steppenwolf, Hermann Hesse's novel, basis of the 1974 Fred Haines film.

The Bridge of San Luis Rey, Thornton Wilder's Pulitzer Prize–winning novel.

James Weldon Johnson's *God's Trombones: Seven Negro Sermons in Verse*.

Countee Cullen's poetry collections *Copper Sun* and *The Ballad of the Brown Girl*.

Vagabonds, Knut Hamsun's novel.

Amerika, Franz Kafka's novel.

Andre Gidé's novel *The Counterfeiters*.

The Life of Klim Samghin, Maxim Gorky's four-volume novel (1927–1936).

Thérèse Desqueyroux, François Mauriac's novel.

Don Marquis's humorous fiction *archy and mehitabel*.

André Maurois's fictionalized biography *Disraeli: A Picture of the Victorian Age*.

Death Comes for the Archbishop, Willa Cather's novel.

Armijn Pané's poetry *Flowers and Clouds*.

Aspects of the Novel, E. M. Forster's exploration of fiction.

Janet Lewis's poetry *The Wheel in Midsummer*.

A Good Woman, Louis Bromfield's novel.

D. H. Lawrence's travel writings *Mornings in Mexico*.

Dusty Answer, Rosamond Lehmann's novel.

The Case of Sergeant Grischa, Arnold Zweig's antiwar novel.

Eglantine, Jean Giraudoux's novel.

James Boyd's novel *Marching On*.

The Hotel, Elizabeth Bowen's novel.

Jean Rhys's *The Left Bank and Other Stories*.

Maxwell Bodenheim's poetry *Returning to Emotion*.

John Crowe Ransom's poems *Two Gentlemen in Bonds*.

Manuel Altolaquirre's poetry *Ejemplo*.

Mário de Andrade's novel *Fräulein*.

Rafael Alberti's poetry *Cal y canto* and *El alba del alhelí*.

Muhammad Iqbal's poetry *Psalms of the East*.

Robert Benchley's essays *The Early Worm*.

Vernon L. Parrington's *Main Currents in American Thought*, (1927–1930).

William Rose Benét's poetry *Man Possessed*.

FILM & BROADCASTING

The Jazz Singer, Al Jolson starred in the breakthrough sound film musical, signaling the beginning of the era of the "talkies," and the emergence of the screen forms as central carriers of world culture.

Napoléon, Albert Dieudonné starred as Napoleon in Emil Gance's epic, a landmark in film history that was essentially lost until reconstructed by Kevin Brownlow in 1981.

Seventh Heaven, Janet Gaynor and Charles Farrell starred as the young lovers parted by war in Frank Borzage's silent film classic, based on the Austin Strong play.

Sunrise, Janet Gaynor and George O'Brien starred in F. W. Murnau's silent film melodrama.

Wings, Clara Bow, Buddy (Charles) Rogers, and Richard Arlen starred in William Wellman's World War I silent film airplane story, which was the first film to win a Best Picture Oscar.

Greta Garbo and John Gilbert starred in the silent film *Flesh and the Devil*, adapted by Benjamin Glazer from the Herman Sudermann novel *The Undying Past*; Clarence Brown directed. Garbo emerged as a Hollywood star in this first of the four Garbo–Gilbert films. The pair also starred in the silent film *Love*, directed by Edmund Goulding.

It, the Clara Bow silent film vehicle; thereafter she was to be the "It girl."

Fred Niblo directed Norma Talmadge in the title role of *Camille*, opposite Gilbert Roland; the film was adapted from Alexandre Dumas's 1848 novel and 1852 play *La Dame aux camélias*.

Emil Jannings starred in the silent film *The Way of All Flesh*, directed by Victor Fleming.

G. W. Pabst directed the silent film *The Love of Jeanne Ney*.

Josef von Sternberg directed the silent film *Underworld*, starring Evelyn Brent and George Bancroft.

Lon Chaney and Joan Crawford starred in the silent film *The Unknown*, directed by Tod Browning.

Stan Laurel and Oliver Hardy began their long series of Laurel and Hardy film comedies.

Vsevolod Pudovkin directed the silent film *The End of St. Petersburg*.

VISUAL ARTS

Georgia O'Keeffe's paintings included *East River from the Shelton* (1927–1928), *Abstraction—White Rose No. 2*, *Black Abstraction*, *Red Poppy*, and *Radiator Building—Night, New York*.

Edward Hopper's painting *Manhattan Bridge, Lighthouse Hill*.

Georges Braque's painting *Black Rose*.

Ecce Homo, George Grosz's caricature collection.

Richard Neutra designed the Heath House, Los Angeles.

Henri Matisse's painting *Decorative Figure on an Ornamental Background*.

Ludwig Mies van der Rohe designed the Weissenhof flats, Stuttgart.

Oskar Kokoschka's paintings *Courmayeur* and *Venice. Santa Maria Della Salute II*.

Arthur Dove's paintings *Hand Sewing Machine* and *George Gershwin, Rhapsody in Blue, Part I*.

Stuart Davis began his "Egg Beater" series of paintings (1927–1930).

Lyonel Feininger's painting *The Steamer Odin, Village*.

Marc Chagall's painting *The Dream*.

Paul Klee's painting *Pastorale*.

Alberto Giacometti's sculpture *Observing Head* (1927–1928).

Fernand Léger's painting *The Vase*.

Charles Demuth's painting *My Egypt, Eggplant and Squash*.

Piet Mondrian's painting *A Fox Trot*.

Elie Nadelman's sculpture *Man in a Top Hat*.

Gaston Lachaise's sculpture *Elevation*.

Walter Gropius designed the Municipal Employment Office, Dessau, Germany (1927–1928).

d. Eugène Atget (Jean Eugène August Atget), French photographer (b. 1856), a seminal figure for his thousands of photos of Paris life.

d. Juan Gris (José Victoriano González), Spanish artist, an early cubist (b. 1887).

THEATER & VARIETY

Show Boat, the Oscar Hammerstein II–Jerome Kern musical, based on Edna Ferber's 1926 novel, starring Howard Marsh, Norma Terriss, Jules Bledsoe, and Helen Morgan; opened at New York's Ziegfeld Theatre; basis for the 1936 film.

Edna Ferber and George S. Kaufman's *The Royal Family*, their comedy–satire of the Barrymores, opened at New York's Selwyn Theatre; basis of the 1930 George Cukor film.

Barbara Stanwyck and Hal Skelly starred in *Burlesque*, George Manker Watters and Arthur Hopkins's play; opened at New York's Plymouth Theatre on September 1.

Rose McClendan and Frank Wilson starred in *Porgy*, Dorothy and Dubose Heyward's play, basis of *Porgy and Bess*; opened at New York's Guild Theatre on October 10.

Saturday's Children, Maxwell Anderson's play, opened at New York's Booth Theatre on January 26.

Vsevolod Vyacheslavich Ivanov's *Armored Train 14-69* was produced in Moscow and Leningrad, on the 10th anniversary of the Russian Revolution.

The Second Man, S. N. Behrman's comedy, his first play, opened at New York's Guild Theatre.

A Connecticut Yankee, the Richard Rodgers–Lorentz Hart musical, based on the Mark Twain novel, opened at New York's Vanderbilt Theatre.

Miriam Hopkins and Eric Dressler starred in John McGowan's *Excess Baggage*; opened at New York's Ritz Theatre on December 26.

The Road to Rome, Robert Sherwood's play, opened at New York's Playhouse, New York, January 31.

Shadow and Substance, Paul Vincent Carroll's play, opened in Dublin on January 25.

Paris Bound, Philip Barry's comedy opened at New York's Music Box Theatre on December 27.

The Racket, Bartlett Cormack's play, opened with John Cromwell and Edward G. Robinson at New York's Ambassador Theatre, on November 22.

Helen Hayes starred in *Coquette*, the George Abbott and Ann Preston Bridgers play; opened at Maxine Elliot's Theatre, New York, November 8.

Bertolt Brecht's *The Rise and Fall of the City of Mahoganny*.

Adam the Creator, Karel Capek and Joseph Capek's play.

Cock Robin, Elmer Rice's play.

d. Jerome K(lapka) Jerome, English humorist, novelist, playwright, and actor (b. 1859).

d. John Drew, American actor (b. 1853).

MUSIC & DANCE

Among the notable new songs from *Show Boat*, music by Jerome Kern, words by Oscar Hammerstein II, were: *Ol' Man River*, introduced by Jules Bledsoe, later Paul Robeson's signature song; *Bill*, Helen Morgan's song; and *Why Do I Love You?* and *Make Believe*, first sung by Norma Terris and Howard Marsh.

Blue Skies, Irving Berlin's song, from his musical *Betsy*; introduced by Belle Baker, it became identified with Al Jolson after he sang it in the pioneering sound film *The Jazz Singer* (also 1927).

Oedipus Rex, Igor Stravinsky's opera–oratorio, libretto by Jean Cocteau; Stravinsky conducted the concert version opening at the Sarah Bernhardt Theatre, Paris, May 30.

Le Pauvre Matelot (*The Poor Sailor*), Darius Milhaud's opera, libretto by Jean Cocteau, premiered December 16 at the Opéra-Comique, Paris.

The Red Poppy, ballet choreographed by Lev Alexandrovich Lashchilin and Vassili Dimitrievich Tikhmirov, music by Reinhold Moritzovich Glière, premiered at the Bolshoi Theatre, Moscow.

Jelly Roll Morton, with Kid Ory on trombone, had three big hits: *Black Bottom Stomp*, *Original Jelly Roll Blues*, and *Grandpa's Spells*.

The Carter Family (1927–1943), American country singing group originated by A. P. (Alvin Pleasant) Carter, Sara Dougherty Carter, and Maybelle Addington Carter.

'S Wonderful, George and Ira Gershwin song, introduced in the musical *Funny Face* by Adele Astaire and Allen Kearns; in the 1957 film, sung by Audrey Hepburn and Fred Astaire. *How Long Has This Been Going On?* was cut from the play, but used in the film.

Strike Up the Band, title song of the George and Ira Gershwin musical.

The Flaming Angel, Sergei Prokofiev's opera.

Four Saints in Three Acts, Gertrude Stein and Virgil Thomson's opera.

Martha Graham founded her School of Contemporary Dance.

Dmitri Shostakovich's *Second Symphony*, the *October*.

Angelique, Jacques Ibert's opera.

William Walton's *Sinfonia concertante*.

Egdon Heath, Gustav Holst's orchestral work.

Ottorino Respighi's orchestral works *The Birds* (*Gli Uccelli*) and *Trittico botticelliano*.

Royal Palace, Kurt Weill's dramatic musical work.

Enter Spring, Frank Bridge's rhapsody.

The Age of Steel, Sergei Prokofiev's ballet in two scenes.

The King's Henchmen, Deems Taylor's opera.

Der Zarewitsch, Franz Lehár's operetta.

Maurice Ravel's *Sonata for Violin and Piano*.

Anton von Webern's *String Trio*.

Arnold Schoenberg's *String Quartet No. 3*.

Antigone, Arthur Honegger's opera.

Béla Bartók's third string quartet.

Edgard Varèse's orchestral work *Arcana*.

Karol Szymanowski's second string quartet.

Hin und zurück, Paul Hindemith's opera.

d. Isadora Duncan, American dancer and teacher, a key figure in the development of the modern dance (b. 1878).

WORLD EVENTS

Charles A. Lindbergh made the first solo transAtlantic flight, from New York to Paris, in *The Spirit of St. Louis* (May 20–21).

Sacco and Vanzetti were executed in Massachusetts on August 23, in spite of a six-year-long worldwide protest movement; both were "posthumously rehabilitated" half a century later.

Chiang Kai-shek broke with his Chinese Communist allies in the Kuomintang in April, beginning with the Shanghai Massacre of 5,000–6,000 Communists and other Left allies (as related in André Malraux's *Man's Fate*, whose main character was modeled on Communist Zhou En-lai). The

ensuing Chinese Civil War lasted 22 years, ending with Communist victory in 1949.

Nicaraguan Liberal forces led by Augusto César Sandino retreated into the mountains, mounting a guerrilla war against dictator Anastasio Somoza and the American Marine occupation force.

Fossil remains of Peking Man were found near Peking (Beijing).

American geneticist Hermann J. Muller discovered that X-rays could cause mutations on genes.

Ivan Pavlov's *Conditioned Reflexes*.

Sigmund Freud's *The Future of an Illusion*.

1928

LITERATURE

The Conquerors, André Malraux's novel, set during the Chinese revolution and civil war.

The Quiet Don, Mikhail Sholokov's four-novel Russian Civil War work, set among the Don Cossacks.

Sigrid Undset was awarded the Nobel Prize for Literature.

Lady Chatterley's Lover, D. H. Lawrence's romantic novel, thought obscene and widely banned in its time, and therefore very popular, Constance and Mellors becoming household names; also Lawrence's *Collected Poems*, in two volumes, and *The Woman Who Rode Away and Other Stories*, including *Rawdon's Roof*.

John Brown's Body, Stephen Vincent Benét's Pulitzer Prize–winning long poem.

Radclyffe Hall published *The Well of Loneliness*, her pioneering novel about lesbians openly living their lives.

Orlando, Virginia Woolf's novel.

Bibhuti Bhusan Banerji's novel *Pather Panchali*; with his novel *Aparajito* (1932) the basis of Satyajit Ray's "Apu" film trilogy (1955–1959).

William Butler Yeats's poetry *The Tower*.

Robinson Jeffers's *Cawdor, and Other Poems*.

Ashenden, Or the British Agent, Somerset Maugham's novel; basis of the 1936 Alfred Hitchcock film.

Point Counter Point, Aldous Huxley's novel.

Carl Sandburg's poetry *Good Morning, America*.

A. A. Milne's *The House at Pooh Corner*.

Thomas Hardy's poetry *Winter Words in Various Moods and Metres*.

Decline and Fall, Evelyn Waugh's novel.

Old New York, four Edith Wharton novelettes.

The Assassin, Liam O'Flaherty's novel.

Djuna Barnes's novel *Ryder*.

Edna St. Vincent Millay's poetry *The Buck in the Snow*.

Federico García Lorca's poetry *Gypsy Ballads*.

The Last Post, fourth and last novel in Ford Madox Ford tetralogy *Parade's End*.

Gerhart Hauptmann's poetry *Till Eulenspiegel*; also his novel *Wanda*.

Home to Harlem, Claude McKay's novel.

Justice Denied in Massachusetts, Edna St. Vincent Millay's poem on the Sacco–Vanzetti case.

King, Queen, Knave, Vladimir Nabokov's novel.

Ludwig Lewisohn's novel *The Island Within*.

Maxwell Bodenheim's *The King of Spain and Other Poems*.

Mário de Andrade's novel *Macunaíma*.

Bess Streeter Aldrich's novel *A Lantern in Her Hand*.

Morley Callaghan's novel *Strange Fugitive*.

Peter Victorious, Ole Rolvaag's novel.

Little Caesar, William Riley Burnett's novel, basis of the 1930 Mervyn LeRoy film.

The Eclipse, Shen Yen-ping's novel trilogy.

The Brothers, Konstantin Fedin's novel.

The Childermaas, Wyndham Lewis's novel.

W. E. B. Du Bois's novel *The Dark Princess*.

Vicente Aleixandre's poem *Ámbito*.

Publication of the *Oxford English Dictionary* completed.

d. Hugo von Hofmannstal, Austrian writer (b. 1874).

d. Thomas Hardy, English novelist (b. 1840).

d. Vicente Blasco Ibañez, Spanish writer (b. 1867).

FILM & BROADCASTING

Ten Days That Shook the World (October), Sergei Eisenstein's silent film classic, based on John Reed's account of the 1917 Bolshevik Revolution. Censored by Joseph Stalin, it was shown in full only in 1967.

Steamboat Willie, the first Mickey Mouse cartoon with a sound track, and therefore a worldwide hit.

An Andalusian Dog (*Un Chien Andalou*), the classic Luis Buñuel–Salvador Dali short surrealist silent film, so innovative as to become a landmark in cinema history.

Charles Chaplin wrote, directed, produced, and starred again as the Little Tramp in the silent film *The Circus*.

Storm Over Asia (*The Heir of Genghis Khan*), Valery Inkishinov starred in Vsevolod I. Pudovkin's Russian Civil War epic silent film, set in Mongolia.

Dolores Del Rio starred in the silent film *Ramona*.

Journey's End, Colin Clive starred in James Whale's film, set in the trenches of the western front during World War I; based on the 1928 R. C. Sherriff play.

Pandora's Box, Louise Brooks starred as Lulu in G. W. Pabst's silent classic, based on the Franz Wedekind plays *Earth Spirit* and *Pandora's Box*.

Gloria Swanson starred as the prostitute in the title role of the silent film *Sadie Thompson*, based largely on Somerset Maugham's short story *Rain*. Lionel Barrymore costarred as the preacher; Raoul Walsh directed and appeared in the film.

Fanny Brice starred in *My Man*.

Janet Gaynor and Charles Farrell starred in the silent film *Street Angel*, directed by Frank Borzage.

Jacques Feyder directed the silent film *Thérèse Raquin*.

Alexander Dovzhenko directed the silent film *Zvenigora*.

Joan Crawford and Johnny Mack Brown starred in the silent film *Our Dancing Daughters*, directed by Harry Beaumont.

Josef von Sternberg directed the silent film *The Last Command*, starring Emil Jannings, Evelyn Brent, and William Powell.

Carl Dreyer wrote, produced, and directed the classic French silent film *The Passion of Joan of Arc*, starring Maria Falconetti in the title role.

John Baird made the first trans-Atlantic television transmission.

Academy Awards for 1927–1928 (awarded the following year): Best Picture: *Wings*; Best Director (tie): Frank Borzage, *Seventh Heaven*, Lewis Milestone, *Two Arabian Knights*; Best Actor: Emil Jannings, *The Way of All Flesh*; Best Actress: Janet Gaynor, *Seventh Heaven*.

d. Mauritz Stiller (Moshe Stille) Polish-Jewish director, a leading Swedish director of the silent era, and the discoverer of Greta Garbo (b. 1883).

VISUAL ARTS

Georgia O'Keeffe's paintings included *Black Night*, *Black Petunia*, *White Calla Lilies with Red Anemone*, *Shell I*, *East River from the Shelton*, and *Hickory Leaves with Daisy*.

Alexander Calder's sculptures included *Romulus and Remus*, *The Horse*, *Helen Wills*, and *Soda Fountain*.

Edward Hopper's painting *From Williamsburg Bridge*.

Alexander Young Jackson's *The Far North: A Book of Drawings*.

Ansel Adams's *Parmelian Prints of the High Sierras*, an early soft-focus collection.

Georges Braque's paintings included *Lemons and Napkin Ring* and *Still Life: The Table*.

Henry Moore's sculpture *North Wind* (1928–1929).

Jacques Lipchitz's sculpture *Harpist*.

Arshile Gorky's painting *Composition, Horse and Figures*.

Charles Demuth's *I Saw the Figure 5 in Gold*, his "poster" painting.

René Magritte's painting *The False Mirror*.

Thomas Hart Benton's painting *Louisiana Rice Fields*.

John Sloan's painting *Sixth Avenue Elevated at Third Street*.

Marc Chagall's painting *Bride and Groom with Eiffel Tower*.

Wassily Kandinsky's painting *On the Points*.

Marsden Hartley's painting *The Window*.

Charles Sheeler's painting *River Rouge Industrial Plant*.

Fernand Léger's painting *Still Life with Lamps*.

Albert Kahn began the Fisher Building, Detroit.

Gaston Lachaise's sculpture *Dancer*.

Paul Klee's drawing *Wandering Animals*.

Joan Miró's painting *Dutch Interior*.

Max Weber's painting *Tranquility*.

Cass Gilbert began the New York Life Insurance Company, New York.

Walt Disney and Ib Iwerks created Mickey Mouse.

d. Arthur B. Davies, American painter and printmaker (b. 1862).

d. Edward Hicks, American painter (b. 1780).

THEATER & VARIETY

The Threepenny Opera (*Die Dreigroschenoper*), Bertolt Brecht and Kurt Weill's musical, based on John Gay's 1728 *The Beggar's Opera*; the 1931 screen version was by G. W. Pabst.

The Front Page, Lee Tracy and Osgood Perkins starred in the Ben Hecht–Charles MacArthur play; basis of several films, including the 1931 Lewis Milestone, 1940 Howard Hawks (*His Girl Friday*), and 1974 Billy Wilder versions.

Holiday, Philip Barry's comedy–love story opened at

New York's Plymouth Theatre on November 26; basis of the 1938 George Cukor film.

Mae West wrote, produced, and starred in *Diamond Lil*; opened at New York's Royale Theatre.

Paul Robeson as Joe sang *Ol' Man River* and Alberta Hunter costarred in the London production of *Show Boat*.

Alfred Lunt and Margalo Gillmore starred in Eugene O'Neill's *Marco Millions*; opened at New York's Guild Theatre on January 9.

Squaring the Circle, Valentine Petrovich Katayev's play, ran for some 800 performances at the Moscow Art Theatre.

Strange Interlude, Lynn Fontanne starred in Eugene O'Neill's play; opened at New York's John Golden Theatre January 30.

The Bedbug, Vladimir Mayakovsky's play, critical of the new Soviet bureaucracy.

Topaze, Marcel Pagnol's play, opened in Paris.

Sigmund Romberg's operetta *The New Moon*, lyrics by Oscar Hammerstein II and music by Romberg, opened at New York's Imperial Theatre.

Animal Crackers, Marx Brothers' comedy.

Ethel Barrymore Theatre, New York, opened with Ethel Barrymore in Martinez Sierra's *The Kingdom of God*.

The Flight and *The Red Island*, both long-suppressed Michael Bulgakov plays, were first produced.

The Captain of Képenick, Karl Zuckmayer's play, opened in Berlin with Werner Krauss.

The Criminals, Ferdinand Bruckner's play, opened in Berlin.

Gods of the Lightning, Maxwell Anderson's play, opened in New York on October 24.

Journey's End, Laurence Olivier starred in R. C. Sherriff's war play; basis of the 1930 James Whale film.

him, e e cummings's play, was produced at the Provincetown Playhouse in New York's Greenwich Village.

Machinal, Sophie Treadwell's play, opened at New York's Plymouth Theatre on September 7.

The Bed Bug, Vladimir Mayakovsky's play.

Michel de Ghelderode's *Les Femmes au tombeau*.

d. Ellen Terry, leading British actress (b. 1847); mother of stage designer Gordon Craig and aunt of actor John Gielgud, she was from 1878 the leading woman player in Henry Irving's company.

d. Eddie Foy (Edwin Fitzgerald), American comedian (b. 1854).

d. John Hartley Manners, Irish-born American playwright (b. 1870).

d. Little Tich, English music-hall comedian (b. 1868).

d. May Irwin, American vaudeville comedienne and singer (b. 1862).

d. Richard Claude Carton, English playwright (b. 1856).

MUSIC & DANCE

Among the notable new songs introduced in *The Threepenny Opera* (*Die Dreigroschenoper*), music by Kurt Weill's operetta, libretto by Bertolt Brecht, were *Pirate Jenny*, introduced by Lotte Lenya as Jenny, and *Mack the Knife*.

Bolero, ballet to Maurice Ravel's music, choreographed by Bronislava Nijinska and danced first by the Ida Rubinstein company at the Paris Opéra; the music was put to comic use in the film *10*.

Makin' Whoopee, the Eddie Cantor song, from the musical *Whoopee*, words by Gus Kahn, music by Walter Donaldson.

An American in Paris, George Gershwin's tone poem for orchestra; basis and inspiration for the 1951 Vincente Minnelli film.

Apollo, Igor Stravinsky's ballet was produced in the American in April and definitively by the Ballets Russes in Paris in June, choreographed by George Balanchine. Serge Lifar danced the title role.

Carl Nielsen's *Clarinet concerto*, *3 Pieces* for piano, and orchestral work *Bohmiskdansk folketone*.

Die Ägyptische Helena (*The Egyptian Helen*), Richard Strauss's opera.

The Three Musketeers, Rudolf Friml's operetta.

Sergei Prokofiev's *Symphony No. 3* and his ballet *The Prodigal*.

Chôros, Heitor Villa-Lobos's series of orchestral impressions.

The Fairy's Kiss (*Le Baiser de la fée*) and *Apollo Musagetes*, Igor Stravinsky's ballets.

Ildebrando Pizzetti's opera *Fra Gherardo* and orchestral work *Concerto dell'estate*.

Kurt Weill's dramatic musical work *Der Zar lässt sich photographieren* and vocal work *Das Berliner Requiem*.

Fats Waller's song *Honeysuckle Rose* (ca. 1928).

Olivier Messiaen's *Le Banquet céleste*, for organ.

Feste romane, Ottorino Respighi's orchestral work.

I Can't Give You Anything but Love, popular song, words by Dorothy Fields, music by Jimmy McHugh.

Leoš Janáček's *String Quartet No. 2, Intimate Letters*.

Virgil Thomson's *Symphony on a Hymn Tune*.

Aaron Copland's *Two Pieces for String Quartet*.

Anton von Webern's *Symphonie*.

Rugby, Arthur Honegger's orchestral work.

Béla Bartók's fourth string quartet.

Der singende Teufel, Franz Schreker's opera.

Frederick Jacobi's *Indian Dances*.

Helen Tamiris's *Negro Spirituals* (1928–1942).

Arnold Schoenberg's *Orchestral Variations*.

Alban Berg's *3 Pieces from the Lyric Suite* and *7 Early Songs*.

Mexican Symphony Orchestra was founded by Carlos Chávez; he directed the orchestra until 1948.

Doris Humphrey and Charles Weidman founded the Humphrey-Weidman dance school and company.

d. Leoš Janáček, Czech composer (b. 1854).

d. Henry F. Gilbert, American composer (b. 1868).

WORLD EVENTS

Republican Herbert Clark Hoover defeated Democrat Alfred E. Smith, to become the 31st president of the United States (1929–1933).

First Soviet five-year plan included a massive attack on the *kulaks* (family farmers) (1928–1932), beginning the Stalinist reign of terror.

Kuomintang armies decisively defeated China's northern warlords, took Peking, and brought the Northern Expedition to a successful close.

Fully equal voting was finally won by British women.

Kellogg–Briand Pact, an international effort to end war; although ultimately signed by 62 countries, it had no real impact on the course of events.

Lake Okeechobee, Florida, flood killed an estimated 2,000–2,500 people (September 16–17).

Scottish bacteriologist Alexander Fleming discovered penicillin.

British physicist Paul Dirac postulated the existence of antimatter.

Margaret Mead issued *The Coming of Age in Samoa*, her landmark study of comparative sex practices.

1929

LITERATURE

All Quiet on the Western Front, Erich Maria Remarque's first novel, about the horror and futility of World War I trench warfare as seen by a frontline German soldier; basis of Lewis Milestone's classic 1930 film.

The Nobel Prize for Literature was awarded to Thomas Mann.

Virginia Woolf's essay *A Room of One's Own*, expressing a strongly feminist point of view.

The Sound and the Fury, William Faulkner's novel about a decaying family from his fictional Yoknapatawpha County, Mississippi; basis of the 1972 Martin Ritt film; also Faulkner's novel *Sartoris*.

Dodsworth, Sinclair Lewis's novel; basis for the 1934 Sidney Howard play and 1936 William Wyler film.

A Farewell to Arms, Ernest Hemingway's novel, set in Italy during World War I; basis of the 1930 Lawrence Stallings play and of the 1932 Frank Borzage and 1957 Charles Vidor films.

Banjo, Claude McKay's novel.

Oliver La Farge's Pulitzer Prize–winning novel *Laughing Boy*.

Paul Éluard's poetry *L'Amour la poésie*.

Berlin Alexanderplatz, Alfred Doblin's novel set in Berlin; basis of the 1931 film and of Rainer Werner Fassbinder's television miniseries and 1980 film.

D. H. Lawrence's *Pornography and Obscenity*; also his novel *The Escaped Cock* and poems *Pansies*.

Red Harvest and *The Dain Curse*, Dashiell Hammett's mystery novels.

A Modern Comedy, series of John Galsworthy novels, including *The White Monkey*, *The Silver Spoon*, and *Swan Song*, further developing the characters of the *The Forsyte Saga*.

William Butler Yeats's poetry *The Winding Stair*.

The Last of the Udegs, Alexander Fadeyev's tetralogy (1929–1940).

The Satin Slipper, Paul Claudel's novel, basis of the 1945 Jean-Louis Barrault play.

The Roman Hat Mystery, first of the Ellery Queen mystery novels, written by the team of Frederic Dannay and Manfred Lee.

Look Homeward, Angel, Thomas Wolfe's first novel.

DuBose Heyward's novel *Mamba's Daughters*.

James Thurber and E. B. White's *Is Sex Necessary?*; also E. B. White's short fiction, verse, and essays *The Lady Is Cold*.

William Plomer's *Turbott Wolfe*, a pioneering South African novel on racial issues.

Edgar Lee Masters's poems *The Fate of the Jury*.

Conrad Aiken's *Selected Poems*.

The Time of Indifference, Alberto Moravia's novel.

Hamilton Basso's novel *Relics and Angels*.

The Good Companions, J. B. Priestley's novel.

Louis MacNiece's poems *Blind Fireworks*.

The Last September, Elizabeth Bowen's novel.

Louise Bogan's poems *Dark Summer*.

Masuji Ibuse's satirical work *The Salamander*.

Southern Mail, Antoine St.-Exupéry's novel.

Robinson Jeffers's *Dear Judas, and Other Poems*.

Morley Callaghan's short stories *A Native Argosy*.

Quartet, Jean Rhys's novel.

Richard Aldington's novel *Death of a Hero*.

S. J. Perelman's *Dawn Ginsbergh's Revenge*.

Samuel Edward Krune Mohayi's novel *U-Don Jadu* (1929–1935).

Shen Yen-ping's novels *Rainbow* and *Wild Roses*.

Some Prefer Nettles, Junichiro Tanizaki's novel.

The Pure in Heart, Franz Werfel's novel.

Ring Lardner's short stories *Round Up*.

Clare Drummer, V. S. Pritchett's novel.

I. A. Richard's *Practical Criticism*.

Joseph Wood Krutch's essays *The Modern Temper*.

d. Bliss Carman, Canadian-born American poet (b. 1861).

d. Vernon L. Parrington, scholar of American literature (b. 1871).

FILM & BROADCASTING

G. W. Pabst directed the classic silent film *Diary of a Lost Girl*, starring Louise Brooks.

Columbia Broadcasting System (CBS) was founded by William S. Paley, then only 27.

Greta Garbo and Lew Ayres starred in *The Kiss*, directed by Jacques Feyder.

Mary Pickford starred in *Coquette*, directed by Sam Taylor.

Sergei Eisenstein directed the film *The General Line*.

Hallelujah!, King Vidor's film, the first with an all-black cast.

Broadway Melody, Bessie Love and Anita Page starred in the show-business story; Harry Beaumont directed.

Alexander Dovzhenko directed the silent film *Arsenal*.

William Powell starred in the first of his Philo Vance series, *The Canary Murder Case*.

The Goldbergs (1929–1945), Gertrude Berg's radio comedy series; she starred as Molly Goldberg, opposite James R. Waters as Jake Goldberg.

The Rudy Vallee Show (1929–1943), his radio variety show.

Amos 'n Andy (1929–1954), Freeman J. Gosden and Charles J. Correll, both White performers working in dialect, starred in the long-running radio show (television version 1951–1953).

Gold Diggers of Broadway, Roy Del Ruth's musical, based on the 1919 Avery Hopwood play; it was the first of the five "Gold Diggers" movie musicals (1929; 1933; 1935; 1937; 1938).

The Cocoanuts, the Marx Brothers comedy.

Ronald Colman and Joan Bennett starred in the adventure film *Bulldog Drummond*.

Frank Lloyd starred in *The Divine Lady*.

Maurice Chevalier and Jeanette MacDonald starred in *The Love Parade*, directed by Ernst Lubitsch.

Academy Awards for 1928–1929 (awarded the following year): Best Picture: *Broadway Melody*; Best Director: Frank Lloyd, *The Divine Lady*; Best Actor: Warner Baxter, *In Old Arizona*; Best Actress: Mary Pickford, *Coquette*.

VISUAL ARTS

(Albert) Hirschfeld's drawings of theater notables began appearing in the *New York Times*; the name of his daughter, Nina, appears at least once somewhere in each drawing.

Richard Neutra designed the Lovell House, Los Angeles, an International Style centerpiece.

Edward Hopper's painting *The Lighthouse at Two Lights*.

Alberto Giacometti's sculptures included *Man, Reclining Woman Who Dreams*, and *Three Figures Outdoors*.

Georgia O'Keeffe's paintings included *Black Cross with Red Sky*; *Black Cross, New Mexico*; *Black Hollyhock, Blue Larkspur*; *Iris*; *New York Night*; *Ranchos Church, Taos*; and *Yellow Cactus Flowers*.

Georges Braque's paintings included *Boats on the Beach, Dieppe*, *Still Life: Le Jour*, and *The Round Table*.

Grant Wood's paintings included *Pioneering, Woman with Plants*, and *John B. Turner*.

Ludwig Mies van der Rohe designed the German pavilion at the Barcelona Exposition and invented the Barcelona chair.

Isamu Noguchi's sculpture *Head of Martha Graham*.

Alexander Calder's sculpture *Spring*.

Piet Mondrian's painting *Composition with Yellow and Blue*.

Second Avenue El, Reginald Marsh's painting.

Jacques Lipchitz's sculpture *The Couple*.

Arshile Gorky's painting *The Artist and His Mother*.

Paul Nash's painting *Wood on the Downs*.

Charles Sheeler's painting *Upper Deck*.

Edvard Munch's painting *Model by the Armchair*.

Joan Miró's painting *Imaginary Portraits*.

Henry Moore's sculpture *Reclining Figure*.

Paul Klee's painting *Monument at the Edge of an Orchard*.

Thomas Hart Benton's painting *Georgia Cotton Pickers*.

Walter Gropius designed the Siemensstadt Housing Estate, Berlin (1929–1930).

Elzie Segar created the *Popeye the Sailor* comic strip.

Paul Cret designed the Folger Shakespeare Library, Washington, D.C.

Gertrude Vanderbilt founded the Whitney Museum of American Art.

Philip Nowlan and Richard Calkins created the *Buck Rogers* comic strip.

Museum of Modern Art (MOMA) was founded.

d. Robert Henri, American painter and teacher (b. 1865), key figure in The Eight, or Ashcan School.

d. Émile-Antoine Bourdelle, French sculptor (b. 1861).

THEATER & VARIETY

Street Scene, Sylvia Sidney starred as the tragic heroine in Elmer Rice's Depression-era play; Rice adapted it for the 1931 King Vidor film.

Bitter Sweet, Noël Coward's musical, starring Peggy Wood and Georges Metaxa; it was adapted twice for film (1933; 1940).

Marius, Marcel Pagnol's play, set in Marseilles; basis of the 1931 Alexander Korda film.

Dynamo, Eugene O'Neill's play, opened at New York's Martin Beck Theatre on February 11.

Cole Porter's *Fifty Million Frenchmen*, book by Herbert Fields, lyrics and music by Porter, opened at New York's Lyric Theatre on November 27.

June Moon, the Ring Lardner and George S. Kaufman comedy, opened in New York.

Strictly Dishonorable, Preston Sturges's comedy, opened at New York's Avon Theatre.

Sweet Adeline, musical with book and lyrics by Oscar Hammerstein II and music by Jerome Kern, opened with Helen Morgan at New York's Hammerstein Theatre, September 3.

The Apple Cart, George Bernard Shaw's play, the first of his works to be performed at the Malvern Festival; opened on August 19.

The Silver Tassie, Sean O'Casey's play, opened in London on October 11.

The Bathhouse, Vladimir Mayakovsky's play, critical of the new Soviet bureaucracy.

Let Us Be Gay, Rachel Crothers's comedy, opened at New York's Little Theatre on February 21.

Lovers' Breakfast, André Birabeau's play, opened at the Comédie Française.

Follow Thru, Ray Henderson's musical, opened at New York's 46th Street Theatre on January 9.

It's a Wise Child, Laurence E. Johnson's comedy, opened at New York's Belasco Theatre.

British Actors' Equity Association was founded.

Tonight We Improvise, Luigi Pirandello's play.

Amphitryon 38, Jean Giraudoux's play.

Ben Travers's *A Cup of Kindness*.

Ernst Barlach's *Der blaue Boll* (*The Blue Bulb*).

Miguel de Unamuno y Jugo's *Brother Juan*.

Franz Theodor Csokor's *Gesellschaft der Menschenrechte*.

d. Darley George "Dot" Boucicault, English actor and playwright (b. 1859), the son of Dion Boucicault and Agnes Robertson.

d. Lillie Charlotte Langtry, English actress (b. 1853).

d. Jeanne Eagels, American actress, who in 1922 created the Sadie Thompson role in *Rain* (b. 1894).

d. Gunnar Edvard Rode Heiberg, Norwegian playwright (b. 1857).

d. Henry Arthur Jones, English playwright (b. 1851).

MUSIC & DANCE

Star Dust, Hoagy Carmichael's popular song, theme song for an era.

Nobody Knows You When You're Down and Out, Jimmie Cox's 1923 song, made into a major hit by Bessie Smith.

La Valse, ballet choreographed by Bronislava Nijinska, music by Maurice Ravel (written 1920), premiered in Monte Carlo January 12 with Ida Rubenstein.

The Gambler, Sergei Prokofiev's 1916 opera, first staged publicly, in a French version as *Le Joueur*, in Brussels on April 29.

The Prodigal Son, George Balanchine's ballet, music by Sergei Prokofiev, book by Boris Kochno, decor by Georges Roualt, first danced May 21, by Sergei Diaghilev's Ballets Russes in Paris, with Serge Lifar and Felia Dubrovska in the leads.

I'll See You Again, Noël Coward's song, introduced by Peggy Wood and Coward in his operetta *Bitter Sweet*.

Louise, Maurice Chevalier's signature song from his starring role in the film *Innocents of Paris*.

Ralph Vaughan Williams's operas *Sir John in Love* and *The Poisoned Kiss*, the latter not publicly performed until 1936.

Igor Stravinsky's *Capriccio* for piano and orchestra.

Ottorino Respighi's *Roman Festival*.

Der Wein, Alban Berg's concert aria.

Ain't Misbehavin', Fats Waller's song.

Samuel Barber, *Serenade for String Quartet*.

Why Was I Born, Oscar Hammerstein II and Jerome Kern's song, popularized by Helen Morgan, from the musical *Sweet Adeline*.

William Walton's *Viola Concerto*.

Carl Nielsen's *29 Little Preludes* for organ and *3 motets*.

What Is This Thing Called Love?, Cole Porter's song.

Dmitri Shostakovich's *Third Symphony*, the *First of May*.

Aubade, Francis Poulenc's dramatic musical work for piano and 18 instruments.

More Than You Know, popular song, words by Billy Rose and Edward Eliscu, music by Vincent Youmans.

The Land of Smiles, Franz Lehár's operetta.

Epilog, Josef Suk's choral–orchestral work.

Roy Harris, *Piano Sonata, American Portraits*.

Happy End, Kurt Weill's opera.

Walter Piston, *Viola Concerto*.

Ivor Novello's *Symphony in Two Flats*.

d. Sergei Diaghilev, Russian ballet producer, founder of the Ballets Russes company, and a central figure in modern ballet (b. 1872).

WORLD EVENTS

The Crash: American stock market panic led to the Great Depression; October 29 became Black Tuesday.

Earthquake in China's south central Kansu province cost an estimated 150,000–200,00 lives (December 16).

Lateran Treaty, between Benito Mussolini's government and the Vatican, provided much-needed Catholic church recognition of Mussolini, in return for his recognition of Vatican sovereignty and of Catholicism as the Italian state religion.

Led by Jawaharlal Nehru, the Indian Congress party changed its main demand, from home rule to full independence.

St. Valentine's Day Massacre, the killing of seven people in Chicago by order of Al Capone.

Sunni Islamic fundamentalist Muslim Brotherhood founded, mainly in Egypt.

Geneva Convention on the treatment of prisoners of war.

German dirigible *Graf Zeppelin* made an around-the-world voyage.

American sociologists Robert Staughton Lynd and Helen Merrell Lynd published their classic study *Middletown*.

1930

LITERATURE

Robert Frost's Pulitzer Prize–winning *Collected Poems*.

The Nobel Prize for Literature was awarded to Sinclair Lewis.

Vladimir Mayakovsky's poem *At the Top of My Voice*.

T. S. Eliot's poem *Ash-Wednesday*.

The 42nd Parallel, first in John Dos Passos's *U.S.A.* trilogy.

Poems, W. H. Auden's early poetry collection.

The Maltese Falcon, Dashiell Hammett's classic mystery novel, set in San Francisco; basis of the 1941 John Huston film.

D. H. Lawrence's novel *The Virgin and the Gipsy*; also his short stories *Love Among the Haystacks, and Other Pieces*; and the poems *Nettles*, *The Triumph of the Machine*, and *Love Poems and Others*.

The Royal Way, second of André Malraux's Chinese revolution and civil war novels.

Murder at the Vicarage, Agatha Christie's novel in which she created Jane Marple.

Cakes and Ale, Somerset Maugham's novel; basis of the 1946 Edmund Goulding film.

Strong Poison, Dorothy Sayers's novel introducing mystery novelist and amateur sleuth Harriet Vane, along with Lord Peter Wimsey.

Cimarron, Edna Ferber's pioneer novel; basis for the 1931 Wesley Ruggles film and the 1960 Anthony Mann remake.

1066 and All That, W. B. Sellar and R. Yeatman's humorous version of English history.

Not Without Laughter, Langston Hughes's novel.

Opium, Jean Cocteau's autobiographical work, on his addiction and recovery.

Mario and the Magician, Thomas Mann's novel.

East Wind, West Wind, Pearl Buck's first novel.

Mao Dun's novel *The Eclipse*.

After Leaving Mr. Mackenzie, Jean Rhys's novel.

Vile Bodies and *Scoop*, Evelyn Waugh's novels.

Andre Gidé's *Travels in the Congo*.

Samuel Beckett's poetry *Whoroscope*.

The Woman of Andros, Thornton Wilder's novel.

Angel Pavement, J. B. Priestley's novel.

Maxwell Bodenheim's poems *Bringing Jazz*.

Armijn Pané's *Verses of a Wanderer*.

August, Knut Hamsun's novel.

Manuel Gálvez's novel *Holy Wednesday*.

Babette Deutsch's poetry *Fire for the Night*.

Katherine Anne Porter's short stories *Flowering Judas*.

Conrad Aiken's poetry *John Deth*.

Dorothy Canfield's novel *The Deepening Stream*.

Kay Boyle's story *Wedding Day*.

Gabriela Mistral's poems *Questions*.

H. G. Wells's novel *The Autocracy of Mr. Parham*.

Lion Feuchtwanger's *Success*.

Ludwig Lewisohn's novel *Stephen Escott*.

Margaret Ayer Barnes's Pulitzer Prize–winning novel *Years of Grace*.

Meyer Levin's novel *Frankie and Johnny*.

Morley Callaghan's novel *It's Never Over*.

S. J. Perelman's *Parlor, Bedroom, and Bath*.

The Apes of God, Wyndham Lewis's novel.

The Bridge, Hart Crane's long poem.

The Well of Days, Ivan Bunin's novel.

Seven Types of Ambiguity, William Empson's exploration of the verbal nuances of and reader's response to literary language.

John Masefield became Britain's poet laureate (1930–1967).

d. Arthur Conan Doyle, British writer, the creator of Sherlock Holmes (b. 1859).

d. D. H. Lawrence (David Herbert Lawrence), British writer (b. 1885).

d. Vladimir Mayakovsky, Soviet poet and playwright (b. 1893).

d. Jeppe Aakjaer, Danish poet and novelist (b. 1866).

d. Tayama Katai, Japanese novelist (b. 1871).

FILM & BROADCASTING

All Quiet on the Western Front, Lewis Milestone's classic antiwar film starred Lew Ayres as a doomed World War I frontline German soldier; it was based on Erich Maria Remarque's 1929 novel. Delbert Mann's 1979 remake starred Richard Thomas.

The Blue Angel, Marlene Dietrich became an international film star as Lola, opposite Emil Jannings, in Josef von Sternberg's film, which was based on Heinrich Mann's 1905 novel *The Small Town Tyrant*.

Walter Huston starred in D. W. Griffith's *Abraham Lincoln*; the film costarred Una Merkel.

Anna Christie, Greta Garbo starred as the waterfront prostitute in her first talking movie, in Clarence Brown's screen version of the 1921 Eugene O'Neill play.

Earth, Alexander Dovzhenko's film, set in the Ukraine during the forced collectivizations of the time.

George Arliss appeared as *Disraeli* on screen; he had played the role on stage in 1911 and in the 1921 silent film.

Little Caesar, Edward G. Robinson as the gangster and Douglas Fairbanks starred in Mervyn Leroy's classic, based on the W. R. Burnett novel.

James Cagney starred opposite Jean Harlow in the gangster film *Public Enemy*, directed by William Wellman.

Marlene Dietrich and Adolphe Menjou starred in *Morocco*, directed by Josef von Sternberg.

The Royal Family of Broadway, George Cukor's film, based on the 1926 Edna Ferber–George S. Kaufman play, their comedy-satire of the Barrymores.

Alfred Hitchcock directed *Juno and the Paycock*, the film version of the Sean O'Casey play, starring Sara Allgood as Juno.

Animal Crackers, the classic Marx Brothers comedy, directed by Victor Heerman.

Richard Barthelmess and Douglas Fairbanks, Jr., starred in *Dawn Patrol*, directed by Howard Hawks.

Jean Cocteau wrote and directed *The Blood of a Poet*.

John Barrymore starred as Ahab in *Moby Dick*, directed by Lloyd Bacon; based on the Herman Melville novel.

Charles Farrell and Rose Hobart starred in *Liliom*, directed by Frank Borzage.

Roman Scandals starred Eddie Cantor.

The Easy Aces (radio 1930–1946; television 1948–1949), the comedy series starred Goodman Ace and Jane Sherwood Ace.

Don Ameche starred in *The First Nighter Program* (1930–1936), a radio drama series.

Robert L. Ripley's *Believe It or Not* began its radio career.

Chester Lauck and Norris Goff starred as radio's *Lum and Abner*.

Academy Awards for 1929–1930 (awarded the following year): Best Picture: *All Quiet on the Western Front*; Best Director: Lewis Milestone, *All Quiet on the Western Front*; Best Actor: George Arliss, *Disraeli*; Best Actress: Norma Shearer, *The Divorcee*.

d. Lon Chaney (Alonso Chaney), American actor, the cinema's "man of a thousand faces" (b. 1883).

VISUAL ARTS

American Gothic, Grant Wood's bitterly realistic painting of a mid-American farm couple.

Ansel Adams's book *Taos Pueblo*; photos by Adams, text by Mary Austin.

Georgia O'Keeffe's paintings included *Apple Blossoms Black and White*, *Clam Shell*, the *Jack-in-the-Pulpit* series, *Light Iris*, and *Red Rust Hills*.

George Washington, John Gutzon Borglum's monumental presidential sculpture at Mount Rushmore, South Dakota.

Blondie, Chic Young's comic strip, featuring Blondie, Dagwood, their dog Daisy, Mr. Dithers, Baby Dumpling, Cookie, and the "Dagwood sandwich."

Edward Hopper's painting *Early Sunday Morning*.

José Clemente Orozco's the *Prometheus* mural, Pomona College, California.

Bernard Berenson's book *The Italian Painters of the Renaissance*.

Pablo Picasso's painting *Seated Bather*.

Jacob Epstein's sculpture *Genesis*.

Alexander Calder's sculptures included *Little Ball with Counterweight* and *Portrait of Shepard Vogelgesang*.

Marc Chagall's painting *Time Is a River Without Banks* (*Le Temps n'a point de rive*) (1930–1939).

Pierre Bonnard's paintings included *The Breakfast Room* (ca. 1930–1931) and *The Road to Nantes* (ca. 1930).

Reginald Marsh's paintings *Why Not Use the "L"?* and *The Bowery*.

Wassily Kandinsky's painting *Scarcely* (*Kaum*).

Gaston Lachaise's sculpture *Torso*.

Alberto Giacometti's sculpture *Suspended Ball* (1930–1931).

Piet Mondrian's painting *Composition with Red, Blue and Yellow*.

Rockwell Kent's painting *Adirondacks*.

Sixth Avenue, Raphael Soyer's painting (ca. 1930–1935).

Paul Klee's painting *The Mocker Mocked*.

Jacques Lipchitz's sculpture *Mother and Child*.

America Today, mural by George Hart Benton.

John Marin's painting *Storm over Taos*.

Ludwig Mies van der Rohe became director of the Bauhaus (1930–1933); in that year, he designed the Tugendhat house and chair, Brno, Czechoslovakia.

Pier Luigi Nervi began Berta Stadium, Florence (1930–1932).

Two Heads with White Hair, Alfred Henry Maurer's painting (ca. 1930).

William Van Alen began the Chrysler Building, New York.

John Russell Pope began Constitution Hall, Philadelphia.

THEATER & VARIETY

Private Lives, Noël Coward and Gertrude Lawrence starred in Coward's classic comedy; Sidney Franklin directed the 1931 film version.

The Green Pastures, Marc Connelly's Pulitzer

Prize–winning play on Bible themes, opened at New York's Mansfield Theatre on February 26, with Richard Berry Harrison as "De Lawd" leading an all-Black cast; basis of the 1936 film.

George and Ira Gershwin's *Strike Up the Band* opened at New York's Times Square Theatre on January 14; a failure in 1927, but a hit in this revised version.

Elizabeth the Queen, Lynn Fontanne and Alfred Lunt starred in Maxwell Anderson's first blank-verse play, the tragedy of Elizabeth and Essex; opened at New York's Guild Theatre on November 3.

Hotel Universe, Philip Barry's play, opened at New York's Martin Beck Theatre, April 14.

Waterloo Bridge, Robert Sherwood's wartime love story, set during World War I; basis of Mervyn Leroy's 1940 World War II film.

Once in a Lifetime, Moss Hart and George S. Kaufman's comedy, opened in New York.

Paul Robeson starred in London as *Othello*, opposite Peggy Ashcroft as Desdemona.

Ethel Merman emerged as a star in *Girl Crazy*; the George and Ira Gershwin musical opened at New York's Alvin Theatre on October 14.

Alison's House, Susan Glaspell's drama opened at Eva LeGalliene's Civic Repertory Theatre, New York.

London's Cambridge Theatre opened with *Charlot's Masquerade*, starring Beatrice Lillie.

Five Star Final, Louis Weitzenkorn's melodrama, opened at New York's Cort Theatre.

The Garrick Gaieties, third of a series of revues produced by the Theatre Guild, New York.

The Last Mile, John Wexley's tragedy, opened at New York's Sam H. Harris Theatre on February 13.

Green Grow the Lilacs, Lynn Riggs's play, basis for *Oklahoma*.

As You Desire Me, Luigi Pirandello's play.

The Human Voice, Jean Cocteau's play.

Badger's Green, R. C. Sherriff's play.

Édouard Bourdet's *Le Sexe faible*.

Stanley Lupino's *The Love Race*.

Franz Theodor Csokor's *Besetztes Gebiet*.

Miguel de Unamuno y Jugo's *Dream Shadows*.

Harold Marsh Harwood's *The Man in Possession*.

James Bridie's *Tobias and the Angel*.

W. A. Darlington's *Carpet Slippers*.

Teresa Deevy's *The Reapers*.

Zoë Akins's *The Greeks Had a Word for It*.

d. Charles Sidney Gilpin, African-American actor (b. 1878), who would originate the Brutus Jones role in Eugene O'Neill's *The Emperor Jones* (1921); he directed New York's first African-American theater company, at Harlem's Lafayette Theatre.

d. Raul Brandão, Portuguese novelist and playwright (b. 1867).

MUSIC & DANCE

Hoagy Carmichael published two of his most enduring songs: *Georgia on My Mind*, music by Carmichael, words by Stuart Gorrell; and *Rockin' Chair*, words and music by Carmichael.

Some Day I'll Find You, song introduced by Noël Coward and Gertrude Lawrence in Coward's play *Private Lives*.

New George and Ira Gershwin songs from *Girl Crazy*, including *I Got Rhythm*, sung by Ethel Merman, and *Embraceable You*, sung by Ginger Rogers and Allan Kearns on stage and by Judy Garland in the 1943 film.

Rise and Fall of the City of Mahagonny (*Aufstieg und Fall der Stadt Mahagonny*), Kurt Weill's opera, libretto by Bertolt Brecht, opened in Leipzig.

The Nose, Dmitri Shostakovich's opera, libretto by Shostakovich and others, based on an 1835 Nikolay Gogol short story, opened June 18 at the Mikhailovsky Theatre, Leningrad.

From the House of the Dead, Leoš Janáček opera, libretto by Janáček, premiered in Brno, April 12.

Christopher Columbus, Darius Milhaud's opera, libretto by Paul Claudel, opened in Berlin, May 5.

William Grant Still's *Afro-American Symphony*.

Gustav Holst's *A Choral Fantasia* and orchestral work *Hammersmith*.

Puttin' on the Ritz, Irving Berlin's song, popularized by Fred Astaire.

Ildebrando Pizzetti's opera *Lo straniero*, and his *Canti della stagione alta*, for piano and orchestra.

Howard Hanson's *Fourth Symphony*, the *Romantic*.

Olivier Messiaen's orchestral work *Les offrandes oubliés* and *Diptyque*, for organ.

Sergei Prokofiev's *Symphony No. 4*.

Dances of Marosszék, Zoltán Kodály's orchestral work.

Something to Remember You By, Howard Ditez and Arthur Schwart's song.

Virgil Thomson's *Violin Sonata*.

But Not for Me, George and Ira Gershwin's song.

LITERATURE · 1931 **419**

Anton von Webern's *Quartet for Violin, Clarinet, Tenor Saxophone and Piano*.

Arnold Schoenberg's opera *Von Heute auf Morgen* and *Six Pieces for Male Chorus*.

Body and Soul, popular song by Edward Heyman, Robert Sour, Frank Eyton, and Johnny Green.

Arthur Honegger's first symphony.

Béla Bartók's *Cantata Profundo*.

You're Driving Me Crazy, Walter Donaldson's popular song.

The Age of Gold, Dmitri Shostakovich's ballet.

Oration, Frank Bridge's orchestral work with solo cello.

On the Sunny Side of the Street, words by Dorothy Fields, music by Jimmy McHugh.

Symphony of Psalms, Igor Stravinsky's choral work.

Divertimento, Jacques Ibert's orchestral piece.

Horst Wessel Song (*Lied*) was written by young Nazi Wessel, who became a martyr and his song the Nazi anthem, its tune based on a comic music-hall song (ca. 1930).

Veni Creator, Karol Szymanowski's choral work.

Der Jasager, Kurt Weill's opera.

Morning Heroes, Arthur Bliss's choral symphony.

The Footballer, Igor Moiseyev's ballet.

Arthur Fiedler began his over 40-year-long association with the Boston Pops Orchestra.

Chicago Civic Opera opened its Civic Opera House with a production of Giuseppe Verdi's *Aïda*.

Electric guitar introduced and popularized in the United States by Les Paul (1930s).

Steel bands of tuned pans and oil drums formed in Trinidad (ca. 1930s), originally used in carnivals.

Montreal Symphony Orchestra founded.

d. Blind Lemon Jefferson, American singer, composer, and guitarist (b. 1897).

d. Leopold Auer, Hungarian violinist (b. 1845).

d. Emmy Destinn, Czech soprano (b. 1878).

WORLD EVENTS

U.S. Smoot–Hawley Tariff law triggered a worldwide protectionist trade war, sharply cut international trade, and greatly deepened the Great Depression.

Kuomintang forces defeated the Chinese Communists at the Battle of Ch'angsha; the Communists then fled and developed a Soviet Republic (1930–1934) in the mountains of western Kiangsi.

Mahatma Gandhi led the all-India salt tax satyagraha campaign.

Japanese Prime Minister Hamaguchi Osachi was fatally wounded by a right-wing assassin.

W. D. Farah Muhammad founded the Nation of Islam (Black Muslims).

Clyde Tombaugh discovered Pluto.

John Maynard Keynes's *Treatise on Money*.

José Ortega y Gasset's *The Revolt of the Masses*.

Sigmund Freud's *Civilization and Its Discontents*.

1931

LITERATURE

Sanctuary, William Faulkner's story of Southern life in his time, a series of horrors culminating in the lynching of an innocent; Steven Roberts directed the 1933 and Tony Richardson the 1960 screen versions.

The Nobel Prize for Literature was awarded to Erik Axel Karlfeldt.

Residence on Earth, Pablo Neruda's poems, in three volumes (1931–1937).

Night Flight, Antoine St.-Exupéry's novel.

The Good Earth, Pearl Buck's Pulitzer Prize–winning novel, set in China; basis for the 1937 film.

Haldor Laxness's two-volume novel *Salka Valka* (1931–1932).

Shmuel Yoseph Agnon's novel *A Bridal Canopy*.

Afternoon Men, Anthony Powell's novel.

The Road Back, Erich Maria Remarque's novel.

The Waves, Virginia Woolf's stream-of-consciousness novel.

Their Fathers' God, Ole Rolvaag's novel.

Boris Pasternak's poetry *Spektorsky*.

Shadows on the Rock, Willa Cather's novel.

Boris Pilnyak's *The Volga Falls to the Caspian Sea*.

Marquis de Sade's *Les 120 Journées de Sodome* first published (1931–1935).

Cecil Day Lewis's *From Feathers to Iron*.

The Glass Key, Dashiell Hammett's mystery novel.

La Doulou, Alphonse Daudet's notebooks.

Arna Bontemps's novel *God Sends Sunday*.

Back Street, Fannie Hurst's melodramatic novel about a mistress and her married lover; basis for the 1932, 1941, and 1961 screen adaptations.

Conrad Aiken's poetry *Preludes for Memnon* and *The Coming Forth by Day of Osiris Jones*.

Frank O'Connor's short stories *Guests of the Nation*.

George Moore's novel *Aphrodite in Aulis*.

George Seferis's *Turning Point*.

Kay Boyle's novel *Plagued by the Nightingale*.

Manuel Altolaquirre's poetry *Amor* and *Un día*.

Meyer Levin's novel *Yehuda*.

Oliver La Farge's novel *Sparks Fly Upward*.

St. Manuel Bueno, Martyr, Miguel de Unamuno's novel.

John Crowe Ransom's essays *God Without Thunder: An Unorthodox Defense of Orthodoxy*.

Edmund Wilson's critical work *Axel's Castle*.

d. Arnold Bennett, British writer (b. 1867).

d. Vachel Lindsay, American poet (b. 1879).

d. Ole Edvart Rolvaag, Norwegian-American writer (b. 1876).

d. Khalil Gibran, Lebanese writer and artist (b. 1883).

d. Frank Harris (James Thomas Harris), Irish-American writer and editor (b. 1856).

FILM & BROADCASTING

City Lights, Charles Chaplin's silent film; he wrote, directed, scored, and starred, opposite Virginia Cherill as the blind flower girl.

Peter Lorre starred as the mass murderer in Fritz Lang's classic Weimar Germany film M, with Otto Wernicke and Gustaf Grundgrens.

Frankenstein, Boris Karloff and Colin Clive starred in James Whale's classic horror film, based on the Mary Wollstonecraft Shelley novel.

Arrowsmith, Ronald Colman and Helen Hayes starred in John Ford's film, adapted by Sidney Howard from the 1925 Sinclair Lewis novel.

Scarface, Paul Muni starred as the Al Capone–style gangster in the Howard Hawks classic. Al Pacino starred in Brian De Palma's 1983 remake.

Street Scene, Sylvia Sidney and William Collier, Jr., starred in King Vidor's screen version of the 1929 Elmer Rice play.

An American Tragedy, Josef Von Sternberg's film starred Sylvia Sidney and Philips Holmes; adapted from the 1925 Theodore Dreiser novel, based upon the Gillette–Brown murder case.

Cimarron, Richard Dix and Irene Dunne starred in the Wesley Ruggles film, based on the 1930 Edna Ferber novel.

Marlene Dietrich and Victor McLaglen starred in Josef von Sternberg's *Dishonored*.

The Front Page, Pat O'Brien and Adolf Menjou starred in Lewis Milestone's film, based on the 1928 Ben Hecht–Charles MacArthur play about Chicago newspaper people.

Alfred Lunt and Lynn Fontanne starred in *The Guardsman*, directed by Sidney Franklin.

Marius, Raimu, Pierre Fresney, Orane Demazis, and Charpin starred in Alexander Korda's film, based on the 1929 Marcel Pagnol play.

Fanny, Raimu, Pierre Fresney, Orane Demazis, and Charpin starred in the Marc Allégret film, based on the 1931 Marcel Pagnol play.

Greta Garbo starred in *Mata Hari*, directed by George Fitzmaurice.

Jean Renoir directed *La Chienne*, starring Michel Simon and Janie Marèze; based on the Georges de la Fouchardière novel.

Monkey Business, the Marx Brothers comedy, directed by Norman Z. McLeod.

Gracie Fields sang her signature song, *Sally*, in the film *Sally in Our Alley*.

Wallace Beery and Jackie Cooper starred in *The Champ*, directed by King Vidor.

Eddie Cantor introduced his very popular radio show (1931–1939); its signature song was *Ida, Sweet as Apple Cider*.

The March of Time (1931–1945); beginning of *Time* magazine's radio documentary series.

Academy Awards for 1930–1931 (awarded the following year): Best Picture: *Cimarron*; Best Director: Norman Taurog, *Skippy*; Best Actor: Lionel Barrymore, *Free Soul*; Best Actress: Marie Dressler, *Min and Bill*.

d. F. W. Murnau (Friedrich William Plumpe), German director (b. 1888).

VISUAL ARTS

José Clemente Orozco's painting *Zapatistas*, and the murals at New School for Social Research, New York City, both seminal works.

Thomas Hart Benton's mural *City Scenes* at New York's New School for Social Research.

Salvador Dali's paintings *La Persistance de la Mémoire* and *The Origin of the Fleeting Wish*.

Whitney Museum opened in New York.

Georgia O'Keeffe's paintings included *Cow's Skull— Red, White and Blue*, *Horse's Skull with White Rose*, and *Shell on Red*.

Grant Wood's paintings included *Fall Plowing* and *Midnight Ride of Paul Revere*.

Chester Gould created the *Dick Tracy* comic strip; it became the basis of the 1935–1948 radio series, several 1940s films, and the 1990.

Alberto Giacometti's sculptures included *Disagreeable Object* and *Kiki's Nose*.

Barbara Hepworth's *Pierced Hemisphere Form*, her pioneering abstract sculpture.

Edward Hopper's painting *Route 6, Eastham*.

Ben Shahn's series of 23 *Sacco and Vanzetti* paintings (1931–1932).

Georges Braque's painting *The Bathers*.

Henri Matisse's painting *The Dance I* (1931–1932).

Isamu Noguchi sculpture *The Queen*.

Marc Chagall's paintings included *Synagogue at Safed* and *The Circus*.

Walt Kuhn's painting *The Blue Clown*.

Paul Klee's drawing *Abstract Script*.

Erich Salomon's collection of photos of *Celebrated Contemporaries in Unguarded Moments*.

Othmar Ammann began the George Washington Bridge, New York and New Jersey.

Empire State Building, built by Shreve, Lamb, and Harmon, was completed; at 102 stories and 1,250 feet high, the world's tallest building at the time.

d. Daniel Chester French, American sculptor (b. 1850).

THEATER & VARIETY

Harold Clurman, Lee Strasberg, and Cheryl Crawford organized the Group Theater (1931–1941); their first production was of Paul Green's play *The House of Connelly*.

Mourning Becomes Electra, Eugene O'Neill's trilogy, a free adaptation of the Oresteia, set in late 19th-century New England, consisting of *Homecoming*, *The Hunted*, and *The Haunted*; opened at the Guild Theatre, New York, October 26. Dudley Nichols directed the 1947 screen version.

The Circle of Chalk, English version of the Chinese play (ca. 1300), opened in London January 22, with Anna May Wong and Laurence Olivier.

Katharine Cornell starred as Elizabeth Barrett Browning in Rudolf Besier's *The Barretts of Wimpole Street*, opened at New York's Empire Theatre on February 9; basis of the 1934 and 1957 films.

Lynn Fontanne and Alfred Lunt opened in Robert Sherwood's *Reunion in Vienna*, at New York's Martin Beck Theatre on November 16.

Of Thee I Sing, musical with book by George S. Kaufman and Morrie Ryskind, lyrics by Ira Gershwin, and music by George Gershwin, opened at New York's Music Box Theatre.

Tomorrow and Tomorrow, Philip Barry's play, opened at New York's Henry Miller Theatre, January 13.

Fred Astaire and Adele Astaire starred in *The Band Wagon*, opened at New York's New Amsterdam Theater on June 3; featured were the songs *Dancing in the Dark* and *I Love Louisa*.

Fanny, Marcel Pagnol's play, set in Marseilles, the second of the *Marius* trilogy; basis of the 1931 Marc Allégret film.

Fear, Alexander Afinogenov's play; originally banned, it later opened at the State Dramatical Theatre, Leningrad, and the Moscow Art Theatre.

Jerome Kern's *The Cat and the Fiddle*, music by Kern, book and lyrics by Otto Harbach opened at New York's Globe Theatre on October 15.

Cavalcade, Noël Coward's multigenerational patriotic set piece; Frank Lloyd directed the 1933 film.

Counsellor-at-Law, Paul Muni starred in the Elmer Rice play; opened at New York's Plymouth Theatre, November 6.

The Ermine, Jean Anouilh's first play.

The Good Fairy, Ferenc Molnar's play; basis of the 1935 William Wyler film.

The Left Bank, Elmer Rice's play, opened at New York's Little Theatre, on October 5.

Oedipus, André Gide's play.

Rachel Crothers's *As Husbands Go*.

Stanley Lupino's *Hold My Hand*.

d. Arthur Schnitzler, Austrian playwright (b. 1862).

d. David Belasco, American playwright, producer, and actor (b. 1859).

d. Hjalmar Frederik Bergman, Swedish playwright and novelist (b. 1883).

d. Tor Hedberg, Swedish playwright (b. 1862).

d. Will Evans, star of British music hall and pantomime (b. 1840).

MUSIC & DANCE

As Time Goes By, words and music by Herman Hupfield; the song that became identified with the 1942 film *Casablanca*, as played by Dooley Wilson

and requested and demanded by Ingrid Bergman and Humphrey Bogart ("Play it, Sam").

Façade, Frederick Ashton's ballet, music by William Walton, first danced April 26 by the Camargo Society, London, with Lydia Lopokova, Alicia Markova, and Ashton in the leads.

Life Is Just a Bowl of Cherries, song introduced by Ethel Merman in *George White's Scandals*; music by Ray Henderson, words by Lew Brown.

Job, Ninette de Valois's ballet, music by Ralph Vaughan Williams; Anton Dolin and Stanley Judson danced the leads.

Duke Ellington's *Mood Indigo*.

Where the Blue of the Night (Meets the Gold of the Day), Bing Crosby's hit song, theme of his radio show (from 1931).

Minnie the Moocher, Cab Calloway's signature song, words and music by Calloway, Irving Mills, and Clarence Gaskill.

Of Thee I Sing, title song of the George and Ira Gershwin stage musical.

Doris Humphrey's *The Shakers* (originally *The Dance of the Chosen*), to traditional American music.

Alan D. Blumlein patented a system of stereophonic recording, not practical until 1958.

The BBC Symphony Orchestra was founded in Britain, notably including 19 women (playing strings or harp), when many other orchestras of the time had few or none.

Lazy River, Hoagy Carmichael and Sidney Arodin's song.

Lily Pons made her Metropolitan Opera debut in the title role of *Lucia de Lammermoor*.

Ionisation, Edgard Varèse's pioneer work for 13 percussion instruments only.

I'm Through with Love, Bing Crosby's hit song.

Le Tombeau resplendissant, Olivier Messiaen's orchestral work.

Virgil Thomson's *Symphony No. 2* and his first string quartet.

Belshazzar's Feast, William Walton's cantata.

Sergei Rachmaninoff's *Corelli Variations*.

Igor Stravinsky's *Violin Concerto*.

George Gershwin's *Second Rhapsody*.

Bacchus and Ariadne, Albert Roussel's ballet.

Béla Bartók's second piano concerto.

Samuel Barber's *Violin Sonata* and vocal work *Dover Beach*.

Bolt, Dmitri Shostakovich's ballet.

Ralph Vaughan Williams's *Piano Concerto*.

Das Unaufhörliche, Paul Hindemith's oratorio.

Peter Ibbetson, Deems Taylor's opera.

Phantasm, Frank Bridge's orchestral work with solo piano.

Martha Graham's *Primitive Mysteries*.

Maurice Ravel's *Piano Concerto*.

National Symphony Orchestra founded in Washington, D.C.

Ninette de Valois founded the Vic-Wells Ballet Company.

d. Anna Pavlova, Russian ballerina (b. 1882).

d. Carl Nielsen, Danish composer (b. 1865).

d. Nellie Melba (Helen Porter Armstrong), Australian soprano (b. 1861).

d. Bix Biederbecke, (Leon Bismarck Biederbecke), jazz cornettist, pianist, and composer (b. 1903).

d. Vincent d'Indy, French composer (b. 1851).

WORLD EVENTS

Japan's Kwangtung Army seized Mukden, China, and then all of Manchuria, which they renamed Manchukuo and held until their defeat in World War II.

Scottsboro case, an American civil-rights cause célèbre involving the rape convictions of nine young African-Americans in Alabama on false evidence and in a wholly prejudiced courtroom and community. Five of nine convictions were ultimately upheld; none of eight death sentences were carried out; all but one were ultimately paroled.

Walter Francis White became executive secretary of the National Association for the Advancement of Colored People (NAACP) (1931–1955).

Irgun Zvai Leumi (National Military Organization) founded in Jerusalem, led by Avraham Tehomi.

American radio engineer Karl Guthe Jansky discovered that radio waves are emitted from astronomical objects, laying the basis for radio astronomy.

1932

LITERATURE

Brave New World, Aldous Huxley's novel, an attack on the bureaucratic state, eugenics theories, and Fascism.

Light in August, William Faulkner's novel.

The Nobel Prize for Literature was awarded to John Galsworthy.

Tobacco Road, Erskine Caldwell's portrayal of a demoralized Depression-era Georgia farm family; basis of the 1933 Jack Kirkland play and the 1941 John Ford film.

1919, John Dos Passos's novel, second in the *U.S.A.* trilogy.

The Thin Man, Dashiell Hammett's mystery novel, which introduced Nick and Nora Charles; W. S. Van Dyke directed the 1934 screen version.

Satan in Goray, Isaac Bashevis Singer's novel.

Young Lonigan, first of James Farrell's three Studs Lonigan novels.

Jules Romains began his 27-novel series *Men of Good Will* (1932–1946).

Conquistador, Archibald MacLeish's Pulitzer Prize–winning poem.

Mutiny on the Bounty, Charles Nordhoff–Norman Hall story of an 18th-century British naval mutiny; basis of the 1935 and 1962 films.

Journey to the End of the Night (*Voyage au bout de la nuit*), Louis-Ferdinand Céline's misanthropic novel.

D. H. Lawrence's *Last Poems*.

George Seferis's poetry *The Cistern*.

Gerhart Hauptmann's story *Die Hochzeit auf Buchenhorst*.

H. G. Wells's *The Work, Wealth and Happiness of Mankind*.

In This Our Life, Ellen Glasgow's Pulitzer Prize–winning novel.

Invitation to the Waltz, Rosamond Lehmann's novel.

Kay Boyle's novel *Year Before Last*.

Lewis Grassic Gibbon's novel quartet *A Scots Quair* (1932–1934).

Black Mischief, Evelyn Waugh's novel.

Marie Antoinette, Stefan Zweig's novel.

Seeds of Tomorrow, Mikhail Sholokov's novel.

Mary Austin's autobiography *Earth Horizon*.

Yakub Kadri Karaosmanoglu's story *Yaban*.

Muhammad Iqbal's poems *The Pilgrimage of Eternity*.

Richard Aldington's satirical writings *Soft Answers*.

Limits and Renewals, Rudyard Kipling's stories and poems.

Sean O'Faolain's *Midsummer Night Madness and Other Stories*.

Sherwood Anderson's novel *Beyond Desire*.

Sons, Pearl Buck's novel.

Vicente Aleixandre's poetry *Espadas como labios*.

William Rose Benét's novel *Rip Tide*.

Aissa Saved, Joyce Cary's novel, set in Africa.

André Maurois's fictionalized biography *Voltaire*.

Helen Diner's *Mothers and Amazons*.

Scrutiny, highly influential journal edited by F. R. Leavis (1932–1953).

d. Charles W. Chesnutt, Black American author (b. 1899), often regarded as the first African-American novelist.

d. Hart Crane (Harold Hart Crane), American poet (b. 1899).

d. Giles Lytton Strachey, British writer (b. 1880), a member of the Bloomsbury group, best known for his biographies.

FILM & BROADCASTING

I Am a Fugitive from a Chain Gang, Paul Muni starred in this indictment of the Southern penal system; Mervyn Leroy directed.

Grand Hotel, Edmund Goulding's film, based on the Vicki Baum novel; a set of star vignettes featuring Greta Garbo, John Barrymore, Lionel Barrymore, Joan Crawford, Wallace Beery, Lewis Stone, and Jean Hersholt.

Shanghai Express, Marlene Dietrich as Shanghai Lily, Clive Brook, and Anna May Wong starred in Josef von Sternberg's story of wartorn China.

Dr. Jekyll and Mr. Hyde, Fredric March starred in the dual doctor–monster role opposite Miriam Hopkins in Rouben Mamoulian's film, based on the 1886 Robert Louis Stevenson story.

Dracula, Bela Lugosi starred in the classic Tod Browning horror film, based on the 1897 Bram Stoker vampire story.

Sergei Eisenstein directed his unfinished *Que Viva Mexico!*

Rain, Joan Crawford as prostitute Sadie Thompson and Walter Huston as the preacher starred in Lewis Milestone's screen version of the 1921 Somerset Maugham South Seas short story.

A Farewell to Arms, Gary Cooper and Helen Hayes starred in the Frank Borzage film, based on the 1920 Ernest Hemingway novel, set in Italy during World War I.

Back Street, Irene Dunne and John Boles starred as the mistress and her married lover in John M.

Stahl's film version of the 1931 Fannie Hurst melodrama.

Clark Gable and Jean Harlow starred in *Red Dust*.

Horse Feathers, the Marx Brothers comedy.

Katharine Hepburn starred opposite John Barrymore in *A Bill of Divorcement*, directed by George Cukor.

Luis Buñuel directed *Land Without Bread*.

Johnny Weissmuller starred as Tarzan and Maureen O'Sullivan as Jane in *Tarzan, the Ape Man*, the most successful version of the Tarzan stories; W. S. Van Dyke directed.

The Kid from Spain starred Eddie Cantor.

Cecil B. DeMille directed the epic *The Sign of the Cross*, starring Claudette Colbert and Fredric March.

Walter Huston starred as Wyatt Earp in *Law and Order*.

The Jack Benny Show (1932–1955), the radio show starred Jack Benny and Mary Livingstone (Sadie Marks; his wife).

George Burns and Gracie Allen began their long-running radio comedy show (1932–1950), then continued into the early days of television (1950–1958).

One Man's Family, Anthony Smythe starred as Henry Barbour for 27 years in the popular daytime radio series (1932–1959).

Academy Awards for 1932–1933 (awarded the following year): Best Picture: *Grand Hotel*; Best Director: Frank Borzage, *Bad Girl*; Best Actor (tie): Fredric March, *Dr. Jekyll and Mr. Hyde*, Wallace Beery, *The Champ*; Special: Walt Disney, *Mickey Mouse*.

VISUAL ARTS

Philip Johnson and Henry-Russell Hitchcock published their seminal book *The International Style*.

Philip Johnson became director of the architecture and design department of the Museum of Modern Art.

Georgia O'Keeffe's paintings included *Bleeding Heart*, *Cross By the Sea*, *Canada*, *Grey Hills II*, *Nature Forms*, *Gaspé*, and *The White Trumpet Flower*.

Spirit of the Dance, William Zorach's sculpture, at Radio City Music Hall, New York City.

Alberto Giacometti's sculptures included *Hand Caught by a Finger*, *The Palace at 4 A.M.*

(1932–1933), and *Woman with Her Throat Cut*.

Grant Wood's painting *Daughters of the American Revolution*.

Alexander Calder's sculptures included *Calderberry Bush* and *Dancing Torpedo Shape*.

Reginald Marsh's paintings *Tattoo and Haircut* and *Locomotive Watering*.

The Arts of Life in America, mural by George Hart Benton.

Paul Klee's painting *Arab Song*; and his drawing *Please!*

Diego Rivera's Detroit Museum murals.

Henri Matisse's painting *The Dance II* (1932–1933).

Jacques Lipchitz's sculpture *Song of the Vowels*.

Raphael Soyer's painting *Mina*.

Arshile Gorky's painting *Organization*.

Georges Rouault's painting *Christ Mocked by Soldiers*.

Clyfford Still's painting *Spring Landscape*.

David Smith's sculpture *Head, Construction*.

John Marin's painting *Region of Brooklyn Bridge Fantasy*.

Oskar Kokoschka's painting *Self-Portrait with Cap*.

Wassily Kandinsky's painting *Affirmed Pink*.

Leif Ericsson Memorial, Alexander Stirling Calder's sculpture.

d. Alfred Henry Maurer, American painter (b. 1868).

THEATER & VARIETY

Dinner at Eight, the George S. Kaufman–Edna Ferber play, set in New York society; opened at New York's Music Box Theatre on October 22; basis of the 1933 George Cukor film.

Twentieth Century, Ben Hecht and Charles MacArthur's play, opened at New York's Broadhurst Theatre on December 29.

Cole Porter's *Gay Divorce* opened at New York's Ethel Barrymore Theatre on November 29; the 1934 film version was titled *The Gay Divorcée*.

The Animal Kingdom, Philip Barry's comedy, opened at New York's Broadhurst Theatre January 12.

Ina Claire starred in S. N. Behrman's *Biography*, opened at New York's Guild Theatre.

Music in the Air, the Jerome Kern–Oscar Hammerstein II musical, opened in New York.

Goodbye Again, Allan Scott and George Haight's comedy, opened at New York's Masque Theatre.

Clemence Dane's *Wild Decembers*.

Dangerous Corner, J. B. Priestley's play.

The Late Christopher Bean, Sidney Howard's play.

Édouard Bourdet's *La Fleur des pois*.

To Find Oneself, Luigi Pirandello's play.

Gerhart Hauptmann's *Vor Sonnenuntergang*.

Maxim Gorky's *Yegor Bulichoff and Others*.

Nikolai Fedorovich Pogodin's *My Friend*.

Paul Vincent Carroll's *Things That Are Caesar's*.

Rachel Crothers's *When Ladies Meet*.

Ben Travers's *Dirty Work*.

d. Augusta, Lady Gregory, Irish playwright (b. 1852).

d. Florenz Ziegfeld, leading American musical theater manager–producer (b. 1967).

d. Jessie Bonstelle, American actress and theater manager, nicknamed "the Maker of Stars" (b. 1872).

d. Minnie Maddern Fiske, American actress (b. 1865).

d. Eugène Brieux, French playwright (b. 1858).

d. André Antoine, French actor, director, and theater manager (b. 1858).

d. Henri Ghéon, French playwright (b. 1875).

d. Rose Coghlan, American actress (b. 1850).

MUSIC & DANCE

Brother, Can You Spare a Dime?, the Depression-era song, popularized by Bing Crosby and Rudy Vallee; words by Yip Harburg, lyrics by Jay Gorney.

Night and Day, Cole Porter's song, introduced by Fred Astaire and Clare Booth (later Luce) in *The Gay Divorcée*.

Let's Have Another Cup of Coffee, Irving Berlin's Depression song, from the stage musical *Face the Music*.

Mad Dogs and Englishmen, Noël Coward's song, introduced by Beatrice Lillie in *The Third Little Show*.

The Green Table, Kurt Jooss's ballet, music by Fritz Cohen, first danced in Paris, by the Ballets Jooss.

Olivier Messiaen's orchestral work *Hymne au Saint Sacrement* and *Apparition de l'église éternelle*, for organ.

Karol Szymanowski's fourth symphony, the *Symphonie Concertante*, with piano.

I Gotta Right to Sing the Blues, theme song of Jack Teagarden and his Orchestra; words by Ted Koehler, music by Harold Arlen; from the revue *Earl Carroll's Vanities*.

Die Bürgschaft, Kurt Weill's dramatic musical work.

Samuel Barber's *Violincello Sonata*.

Sinfonietta, Benjamin Britten's orchestral work.

Isn't It Romantic?, Richard Rodgers and Lorenz Hart's song.

Maximilien, Darius Milhaud's opera.

Le Bal masqué, Francis Poulenc's vocal work.

Pantea, Gian Francesco Malipiero's ballet.

Gustav Holst's choral work *8 Canons*.

Igor Stravinsky's *Duo Concertant*.

Don Quichotte à Dulcinée, Maurice Ravel's song cycle.

Ruth Crawford Seeger's *Three Songs*.

Sergei Rachmaninoff's *Variations on a Theme of Corelli*.

Dichotomy, Wallingford Riegger's orchestral work.

The Transylvanian Spinning-Room, Zoltán Kodály's opera.

Ted Shawn founded the All-Male Dancers Company.

Roy Acuff founded the country music band that eventually became the Smokey Mountain Boys.

London Philharmonic Orchestra founded by Thomas Beecham.

San Francisco's War Memorial Opera House opened with a production of Giacomo Puccini's *Tosca*.

"Minipianos," small upright pianos, were developed in Britain (from 1932).

d. John Philip Sousa, American composer and bandmaster (b. 1854).

d. Eugen Albert, German composer and pianist (b. 1864).

WORLD EVENTS

Antonio de Oliviera Salazar became prime minister of Portugal; he was to rule as a Fascist dictator until 1968.

Famine in the Soviet Union took 2–6 million lives; caused largely by Stalin's collectivization program and attack on the *kulaks* (family farmers).

"I pledge you, I pledge myself, a new deal for the American people," from Franklin Delano Roosevelt's acceptance speech to the 1932 Democratic nominating convention. He went on to defeat incumbent Republican President Herbert Hoover.

General Douglas MacArthur, under orders issued by President Hoover, used tanks and regular army units in divisional strength to violently disperse

5,000 World War I veteran Bonus Marchers in Washington, D.C., burning their squatters' camps.

Norris–La Guardia Anti-Injunction Act encouraged American union organization.

Charles A. Lindbergh, Jr., 20-month-old son of the famous aviator, was kidnapped (March 1) and murdered; Bruno Richard Hauptmann was convincted of the crime, and later executed (1936).

China-wide boycotts of Japanese goods followed Japanese seizure of Manchuria. Japan responded by sending troops to attack Shanghai; although initially held off by Chinese forces, a Japanese breakthrough forced rescission of the boycotts as the price of Japanese withdrawal from Shanghai.

Japanese Prime Minister Inukai Tsuyohi, who had opposed the seizure of Manchuria and growing control of the military, was assassinated by naval officers, directly ushering in military rule.

Japanese zaibatsu leader Takuma Dan was assassinated by right-wing Japanese nationalists.

Hsüan T'ung (Henry P'u Yi), who as a child had been the last Manchu (Ch'ing) emperor of China (1908–1912), became the Japanese puppet ruler of Manchuria. He was the subject of the 1987 film, *The Last Emperor*.

While in a British Indian prison, Mahatma Gandhi began his lifelong campaign on behalf of the *Harijans* (Children of God), the Untouchables.

Eamon De Valera became prime minister of Ireland.

Ibn Saud became king of the new Saudi Arabia.

Samuel Insull's midwestern utilities companies failed, with great damage to small investors; he fled, was forced to return to stand trial, and was acquitted, making the cast for securities regulation even stronger.

1933

LITERATURE

Man's Fate (La Condition humaine), André Malraux's seminal third Chinese Civil War novel; its central character, Kyo, was modeled on Communist leader Zhou Enlai.

The Nobel Prize for Literature was awarded to Ivan Gasse Bunin.

Hordubal, Karel Capek's novel.

The Shape of Things to Come, H. G. Wells's science fiction novel; William Cameron Menzies directed the 1936 screen version.

Lost Horizon, James Hilton's novel, set in Shangri-La; basis of the 1937 Frank Capra film.

Murder Must Advertise, Dorothy Sayers's Lord Peter Wimsey detective novel, set in an advertising agency.

Earle Stanley Gardner's *The Case of the Velvet Claws*, first of his long series featuring lawyer–detective Perry Mason; basis of the radio and television series, 1943–1966, and subsequent films.

Octavio Paz's poems *Forest Moon*.

Gertrude Stein's *The Autobiography of Alice B. Toklas*.

Mao Dun's novel *Midnight*.

Tanizaki Jun-ichiro's novel *Shunkinsho*.

God's Little Acre, Erskine Caldwell novel, basis of the 1958 Anthony Mann film.

George Orwell's essays *Down and Out in Paris and London*.

A Nest of Simple Folk, Sean O'Faolain's novel.

Hervey Allen's novel *Anthony Adverse*.

Miss Lonelyhearts, Nathanael West's novel.

Archibald MacLeish's poems *Frescoes for Mr. Rockefeller's City*.

Lion Feuchtwanger's novel *The Oppermans*.

Banana Bottom, Claude McKay's novel.

Robinson Jeffers's *Give Your Heart to the Hawks, and Other Poems*.

Conrad Aiken's novel *Great Circle*.

Stephen Spender's *Poems*.

The Forty Days of Musa Dagh, Franz Werfel's novel.

Dorothy Parker's short stories *After Such Pleasures*.

Edith Sitwell's *English Eccentrics*.

The Road Leads On, Knut Hamsun's novel.

Three Cities, Sholem Asch novel trilogy.

Pasquier Chronicles, Georges Duhamel's 10-volume work (1933–1945).

Kay Boyle's story *First Lover*.

The Rape of Europe, Konstantin Fedin's two-volume novel (1933, 1935).

Li Fei-kan's novel *Family*.

Richard Aldington's novel *All Men Are Enemies*.

Shen Yen-ping's novel *Midnight*.

South Moon Under, Marjorie Kinnan Rawlings's novel.

d. John Galsworthy, British writer (b. 1867).

d. Constantine Peter Cavafy, Greek poet (b. 1863).

d. George Moore, Irish novelist, playwright, poet, and critic (b. 1852).

d. Ring (Ringgold Wilmer) Lardner, American writer (b. 1885).

d. Anthony Hope Hawkins, English writer (b. 1863).

d. Sara Teasdale, American poet (b. 1884).

FILM & BROADCASTING

The Private Life of Henry VIII, Charles Laughton, Elsa Lanchester, Binnie Barnes, Merle Oberon, Wendy Barrie, and Everley Gregg starred in Alexander Korda's story of Henry and his wives.

Franklin Delano Roosevelt began his "fireside chats," speaking to huge Depression radio audiences.

42nd Street, Lloyd Bacon's musical, choreographed by Busby Berkeley; Warner Baxter, Ruby Keeler, Bebe Daniels, George Brent, Ginger Rogers, and Dick Powell starred.

Gold Diggers of 1933, Mervyn Leroy's musical, choreography by Busby Berkeley, based on the 1919 Avery Hopwood play; Joan Blondell, Ruby Keeler, Dick Powell, and Ginger Rogers starred.

King Kong, Fay Wray as the screaming object of the huge gorilla's love was highly visible in Merian D. Cooper's classic monster movie.

Design for Living, Fredric March, Miriam Hopkins, and Gary Cooper starred as a ménage à trois, although slightly obscured for Hays Office "morality" purposes, in Ernst Lubitsch's film, based on the 1933 Noël Coward stage comedy.

Dinner at Eight, George Cukor's film, set in New York society; John Barrymore, Lionel Barrymore, Marie Dressler, Jean Harlow, Wallace Beery, Billie Burke, and Jean Hersholt starred.

The Last Will of Dr. Mabuse, Fritz Lang's second "Dr. Mabuse" film, set in Nazi Germany; Rudolf Klein-Rogge starred.

The Invisible Man, Claude Rains starred as the rogue scientist in James Whale's film, based on the 1897 H. G. Wells science fiction novel.

Bitter Sweet, Anna Neagle and Fernand Gravet starred in Herbert Wilcox film's version of the 1929 Noël Coward stage musical.

Cavalcade, Clive Brook, Diana Wynward, and Ursula Jeans starred in Frank Lloyd's screen version of Noël Coward's 1931 patriotic play.

Counsellor-at-Law, John Barrymore starred in William Wyler's screen version of the 1931 Elmer Rice play.

Duck Soup, Groucho, Harpo, Chico, and Zeppo Marx starred in the antiwar satire, directed by Leo McCarey.

Fred Astaire and Ginger Rogers starred in *Flying Down to Rio*, directed by Thornton Freeland; their first pairing.

G. W. Pabst directed *Don Quixote*, with Feodor Chaliapin in the title role.

Katharine Hepburn and Douglas Fairbanks starred in *Morning Glory*, directed by Lowell Sherman.

Greta Garbo and John Gilbert starred in *Queen Christina*, directed by Rouben Mamoulian.

Mae West, Cary Grant, and Gilbert Roland starred in *She Done Him Wrong*, directed by Lowell Sherman.

The Story of Temple Drake, Miriam Hopkins starred in Steven Roberts's screen version of the 1931 William Faulkner novel, a story of Southern life that culminated in the lynching of an innocent.

Hedy Lamarr made a highly publicized appearance nude in *Ecstasy*.

George Seaton as the masked man and John Todd as Tonto starred in radio's *The Lone Ranger*.

d. Fatty Arbuckle (Roscoe Conkling Arbuckle), American film actor, writer, and director (b. 1887), whose career was ruined in 1921 by the death of actress Virginia Rappe at his party.

VISUAL ARTS

Diego Maria Rivera painted the mural *Man at the Crossroads* at Rockefeller Center, destroyed before completion because he had included a portrait of Lenin; he later recreated it at Mexico City's Palace of Belles Artes.

Pablo Picasso's *The Sculptor's Studio*, a group of 46 etchings (1933–1934).

Giacomo Manzù's sculpture *Girl on a Chair*; the first of his long series.

Gaston Lachaise's sculptures included *The Conquest of Time and Space*, *Knees*, and *Knowledge Combating Ignorance*.

Pierre Bonnard's paintings included *Bowl of Fruit* (ca. 1933), *Dining Room on the Garden* (ca. 1933), and *Nude Before a Mirror*.

The Bauhaus was forced to close by the Nazis.

Edward Hopper's painting *Cottages at Wellfleet*.

Alberto Giacometti's sculptures included *No More Play* and *Nude* (1933–1934).

William Gropper's painting *Farmers' Revolt*.

Alexander Young Jackson's painting *Grey Day, Laurentians*.

Wassily Kandinsky's painting *Development in Brown*.

Ben Shahn, *Tom Mooney* paintings.

David Smith's sculpture *Chain Head*.

Georges Rouault's painting *The Holy Face*.

Marc Chagall's painting *Solitude*.

Paris by Night, the Brassaï photography collection.

Straphanger, Seymour Lipton's sculpture.

Piet Mondrian's painting *Composition with Yellow Lines*.

Reginald Marsh's painting *The Park Bench*.

d. Georges Braque, French painter (b. 1882), cofounder of cubism.

d. George Luks, American painter (b. 1867), a member of the Ashcan School.

d. Louis Comfort Tiffany, American artist (b. 1848), leading stained-glass producer.

THEATER & VARIETY

Design for Living, Alfred Lunt, Lynn Fontanne, and Noël Coward starred in Coward's comedy; Ernst Lubitsch directed the screen version.

Roberta, the Jerome Kern–Otto Harback musical, which introduced *Smoke Gets in Your Eyes* and several other Kern classics; opened in New York.

Elisha Cook, Jr., and George M. Cohan starred in Eugene O'Neill's comedy *Ah, Wilderness!*, opened at New York's Guild Theatre on October 2.

Tobacco Road, Jack Kirkland's play, based on the Erskine Caldwell novel, opened at New York's Masque Theatre on December 4; Henry Hull, Dean Jagger, and Ruth Hunter starred.

Katharine Cornell opened in Sidney Howard's *Alien Corn* at New York's Belasco Theatre.

Irving Berlin's *As Thousands Cheer*, starring Ethel Waters, Marilyn Miller, and Clifton Webb, opened in New York; featured songs included *Heat Wave* and *Supper Time*.

Helen Hayes and Helen Menken starred in Maxwell Anderson's *Mary of Scotland*; opened at New York's Alvin Theatre on November 27.

Sailor, Beware!, Kenyon Nicholson and Charles Robinson's comedy, opened in New York.

She Loves Me Not, Howard Lindsay's comedy, opened at New York's 46th Street Theatre.

Men in White, Sidney Kingsley's play, opened in a Group Theater production in New York.

Both Your Houses, Sheppard Strudwick starred in Maxwell Anderson's play; opened in New York.

The Pursuit of Happiness, comedy by Alan Child and Isabelle Louden (pen names of Lawrence Langner and Armina Marshall), opened in New York.

Blood Wedding, Federico García Lorca's play.

The Dance of Death, W. H. Auden's drama.

Ferdinand Bruckner's plays *Races* and *Timon, the Tragedy of the Superfluous Man*.

Maxim Gorky's *Dostigaeff and the Others*.

One Doesn't Know How, Luigi Pirandello's play.

Paul Vincent Carroll's *The Wise Have Not Spoken*.

Bernard Binlin Dadié's *Les Villes*.

Intermezzo, Jean Giraudoux's play.

Laburnum Grove, J. B. Priestley's play.

d. George Moore, Irish novelist and playwright (b. 1852).

d. Langdon Elwyn Mitchell, American poet and playwright (b. 1862).

d. Paul Kester, American playwright (b. 1870).

MUSIC & DANCE

Stormy Weather, Harold Arlen and Ted Koehler's song, a powerful Depression-era artifact, an initial hit for Ethel Waters in *The Cotton Club Parade*, later identified with Lena Horne, who sang it in the 1943 film.

42nd Street, *Lullaby of Broadway*, and *About a Quarter to Nine*, all songs from the film *42nd Street*.

Richard Strauss's *Arabella*, opera; libretto by Hugo von Hofmannsthal, opened in Dresden July 1.

Smoke Gets in Your Eyes, Jerome Kern and Otto Harbach's song, from *Roberta*; a number-one hit for the Platters in 1959.

Les Rendezvous, Frederick Ashton's ballet, music by Daniel Auber, first danced December 5, by the Vic-Wells Ballet, in London.

Four Saints in Three Acts, Virgil Thomson's opera, libretto by Gertrude Stein; a concert version premiered in Ann Arbor, Michigan, May 20.

Inka Dinka Doo, Jimmy Durante's signature song; by Durante and Ben Ryan.

Duke Ellington's *Sophisticated Lady*, words by Mitchell Parish and Irving Mills.

Karol Szymanowski's second violin concerto, *Songs of a Fairy-tale Princess*, and choral work *Litany to the Virgin Mary*.

Kurt Weill's *Symphony No. 2*; dramatic musical work

Der Silbersee; and sung ballet *Die sieben Todsünden*.
Uuno Klami's *Kalevala Suite*.
Dmitri Shostakovich's *Piano Concerto No. 1*.
Aaron Copland's second symphony.
Dances of Galánta, Zoltán Kodály's orchestral suite.
Aram Il'yich Khachaturian's *Dance Suite*.
A Boy Was Born, Benjamin Britten's choral work.
Arthur Honegger's *Mouvement symphonique No. 3*.
Brook Green Suite, Gustav Holst's orchestral work.
L'ascension, Olivier Messiaen's orchestral work.
d. Jimmy Rodgers, American country music singer, songwriter, and guitarist (b. 1897), the first major country music star, known for his yodeling blues.

WORLD EVENTS

Adolf Hitler took dictatorial power in Germany (February 28), after the Nazis had burned the Reichstag and successfully blamed the Communists for it. The Nazis then began their long reign of terror and mass murder that eventuated in World War II, at the cost of at least 65 million lives, 6 million of them the Jews of the Holocaust.

Germans established Buchenwald, one of their earliest concentration camps, and later the site of highly publicized antihuman medical "experiments."

Britain's Oxford Union enunciated the pacifist Oxford Pledge, that "this House will not fight for King and Country," a sentiment soon overtaken by events.

President Franklin Delano Roosevelt took office on March 4, and immediately moved to counter the effects of the Great Depression and rebuild the American economy. His first moves included a bank holiday (March 5–13); the beginning of his long series of radio broadcast "fireside chats" to the nation; a series of major New Deal reforms and agencies, including establishment of the Federal Emergency Relief Administration, Agricultural Adjustment Administration, National Industrial Recovery Administration, Civilian Conservation Corps, Federal Deposit Insurance Corporation, and Public Works Administration; and the end of Prohibition (21st Amendment).

President Franklin D. Roosevelt introduced the Good Neighbor Policy, rejecting American imperial ambitions in Latin America.

Anastasio Somoza Garcia became dictator of Nicaragua, ruling until his 1956 assassination.

Reformer Lazaro Cardenas Del Rio became president of Mexico (1933–1940).

Ibn Saud made the first Arabian oil concession, with John D. Rockefeller's Standard Oil.

Mohammad Zahir Shah succeeded to the Afghan throne after the assassination of his father, Nader Shah.

Second Soviet five-year plan began (1933–1937).

George Papanicolaou developed the Pap smear, a test for cervical cancer.

1934

LITERATURE

Seven Gothic Tales, Isak Dinesen's short stories.
Tender Is the Night, F. Scott Fitzgerald's novel.
Luigi Pirandello was awarded the Nobel Prize for Literature.
The Postman Always Rings Twice, James M. Cain's first novel, a Depression-era tale about a woman and her lover who murder her husband for money; basis of several films, including Luchino Visconti's 1942 neorealist *Obsession*, the 1945 Tay Garnett film, and the 1981 Bob Rafelson film.
Burmese Days, George Orwell's novel.
I, Claudius, Robert Graves's novel.
Uhuru wa Watumwa (*Freedom for the Slaves*), James Mbotela's historical novel, written in Swahili.
Isak Dinesen's *Seven Gothic Tales*.
Dylan Thomas's *Eighteen Poems*.
Eyvind Johnson's four autobiographical novels *The Novel of Olof* (1934–1937).
Murder on the Orient Express, Agatha Christie's Hercule Poirot mystery novel; basis of the 1974 Sidney Lumet film.
Goodbye, Mr. Chips, James Hilton's novel, the story of a dedicated British teacher; basis of the 1939 Sam Wood film.
Dorothy Sayers's Lord Peter Wimsey mystery novel *The Nine Tailors*, set in the Fen country.
Charles Nordhoff and Norman Hall's novels *Men Against the Sea* and *Pitcairn's Island*.
Fer-de-Lance, Rex Stout's first mystery novel, introducing the rotund, orchid-loving, food-loving, stay-at-home detective Nero Wolfe.
The Young Manhood of Studs Lonigan, second of James Farrell's three *Studs Lonigan* novels.

Tropic of Cancer, Henry Miller's novel.

A Handful of Dust, Evelyn Waugh's novel.

Appointment in Samarra, John O'Hara's novel.

Malcolm Cowley's essays *An Exile's Return*.

Conrad Aiken's poetry *Landscape West of Eden*.

Nicolás Guillén's poems *West Indies Ltd.*

E. B. White's stories and poems in *Every Day Is Saturday*.

House of the Titans, poetry of George William Russell (A.E.).

Edna St. Vincent Millay's poems *Wine from These Grapes*.

Lust for Life, Irving Stone's fictional biography of painter Vincent Van Gogh; basis of the 1956 Vincente Minnelli film.

H. G. Wells's *Experiment in Autobiography*.

Going Abroad, Rose Macaulay's novel.

Erasmus of Rotterdam, Stefan Zweig's novel.

Independent People (1934–1935), two-volume Haldor Laxness's novel.

Jonah's Gourd Vine, Zora Neale Hurston's novel.

Joseph and His Brothers, Thomas Mann's four-part novel (1934–1942).

Road to the Ocean, Leonid Leonov's novel.

Samuel Beckett's *More Pricks Than Kicks*.

A Coin in Nine Hands, Marguerite Yourcenar's novel.

An Ordinary Life, Karel Capek's novel.

Voyage in the Dark, Jean Rhys's novel.

William Saroyan's short stories *The Daring Young Man on the Flying Trapeze*.

Yakub Kadri Karaosmanoglu's *Ankara*.

The Meteor, Karel Capek's novel.

d. Andrei Bely, Russian writer, a leading Symbolist (b. 1880).

d. Hayim Nachman Bialik, Russian-Jewish poet (b. 1873).

d. Mary Austin, American writer (b. 1868).

FILM & BROADCASTING

It Happened One Night, Claudette Colbert and Clark Gable starred in Frank Capra's romantic comedy, a classic of Hollywood's Golden Age.

The Thin Man, William Powell and Myrna Loy as Nick and Nora Charles starred in W. S. Van Dyke's screen version of the 1932 Dashiell Hammett mystery novel; the first of five Thin Man films.

Man of Aran, Robert Flaherty's classic documentary, shot on the Irish coastal island of Aran.

Babes in Toyland, the classic Laurel and Hardy children's film, based on Victor Herbert's 1903 operetta.

Of Human Bondage, Leslie Howard and Bette Davis starred in John Cromwell's screen version of the 1915 Somerset Maugham novel, about a medical student ultimately defeated in work and marriage.

The Barretts of Wimpole Street, Norma Shearer, Fredric March, and Charles Laughton starred in the Sidney Franklin film, adapted from the 1931 Rudolf Besier play.

Chapayev, the Sergei and Georgy Vasiliev film; Boris Bobochkin starred as the Russian Civil War Red Army leader.

Claudette Colbert starred in the title role opposite Henry Wilcoxon in Cecil B. DeMille's epic *Cleopatra*.

Evergreen, Jessie Matthews starred in the Victor Saville musical, screenplay by Emlyn Williams.

Harry Baur starred as Jean Valjean in *Les Misérables*, and in *Rothschild*.

Leslie Howard in the title role and Merle Oberon starred in *The Scarlet Pimpernel*, directed by Harold Young.

Marlene Dietrich starred in *The Scarlet Empress*, directed by Josef von Sternberg.

Shirley Temple starred in *Little Miss Marker*.

Ginger Rogers and Fred Astaire starred in *The Gay Divorcée*, directed by Mark Sandrich.

John Barrymore and Carole Lombard starred in *Twentieth Century*, directed by Howard Hawks.

Wallace Beery starred as Long John Silver in *Treasure Island*, with Freddie Bartholemew; Victor Fleming directed.

Town Hall Tonight (1934–1940), Fred Allen's tremendously popular weekly radio show, costarring Portland Hoffa (his wife).

Academy Awards for 1934 (awarded the following year): Best Picture: *It Happened One Night*; Best Director: Frank Capra, *It Happened One Night*; Best Actor: Clark Gable, *It Happened One Night*; Best Actress: Claudette Colbert, *It Happened One Night*.

VISUAL ARTS

An Epic of American Civilization, José Clemente Orozco's Dartmouth college murals.

Alberto Giacometti's sculptures included *1 + 1 = 3*, *Cubist Head*, and *The Invisible Object*.

Alexander Calder's sculptures included *A Universe*, *Steel Fish*, *The Circle*, and *White Frame*.

Walker Evans mounted a one-man show at the Metropolitan Museum of Art, the first there devoted to a photographer.

Charles Burchfield's paintings *November Evening* and *The Parade*.

Georgia O'Keeffe's painting *Barn with Snow*.

Negroes on Rockaway Beach, Reginald Marsh's painting.

Gaston Lachaise's sculpture *Torso*.

George Grosz's painting *Couple*.

Marcel Duchamp's painting *The Green Box*.

Georges Braque's painting *Still Life*.

Henry Moore's sculpture *Two Forms*.

In the City Park, Raphael Soyer's painting (ca. 1934).

Isabel Bishop's painting *Nude*.

Jack Levine's painting *String Quartet*.

Wassily Kandinsky's painting *Violet Dominant*.

René Magritte's painting *Perpetual Motion*.

Thomas Hart Benton's painting *Homestead*.

Eero Saarinen's Yale University School of Architecture plan, New Haven, Connecticut.

Prometheus, statue by Paul Manship, in Rockefeller Center, New York.

Lewis Mumford's book *Technics and Civilization*.

Life Goes On, Arthur G. Dove's painting.

Milton Caniff created his *Terry and the Pirates* comic strip.

Al Capp created the *L'il Abner* comic strip, later the basis of a play and two films.

Alex Raymond created the *Flash Gordon* science fiction comic strip.

Cartoonist Milt Caniff created *Terry and the Pirates*.

d. Roger Fry, British art critic and painter (b. 1866).

d. Cass Gilbert, American architect (b. 1859).

d. Alfred Gilbert, English sculptor and metalworker (b. 1854).

THEATER & VARIETY

Walter Huston in the title role and Fay Bainter starred in Sidney Howard's *Dodsworth*, based on the 1929 Sinclair Lewis novel; opened at New York's Shubert Theatre on February 24; Huston also starred in William Wyler's 1936 film version.

The Children's Hour, Lillian Hellman's first play, about a career-destroying false charge of lesbian attachment, opened in New York; basis of *These Three*, the 1936 Billy Wilder film.

Cole Porter's *Anything Goes* opened at New York's Alvin Theatre, with Ethel Merman singing the title song, as she would in the 1936 film; songs included *I Get a Kick Out of You* and *You're the Top*.

Katharine Cornell, Basil Rathbone, Brian Aherne, and Edith Evans played on Broadway in *Romeo and Juliet*.

Henry Fonda and June Walker starred in *The Farmer Takes a Wife*; Frank B. Elser and Marc Connelly's comedy opened in New York.

Tallulah Bankhead starred as incurably ill Judith Traherne in *Dark Victory*.

Eugene O'Neill's *Days Without End* opened in New York, with Earle Larrimore and Stanley Ridges.

Merrily We Roll Along, George S. Kaufman and Moss Hart's play, opened in New York.

Personal Appearance, Lawrence Riley's comedy, opened in New York.

Jane Cowl starred in S. N. Behrman's *Rain from Heaven*; opened in Boston on December 10.

Sidney Howard's *Yellow Jack* opened on Broadway.

Valley Forge, Maxwell Anderson's play, opened at New York's Guild Theatre on December 10.

The Infernal Machine, Jean Cocteau's play.

Armand Salacrou's *Une Femme libre*.

Carl Zuckmayer's *Der Schelm von Bergen*.

Yerma, Federico Garcia Lorca's play.

Denis Johnston's *Storm Song*.

Leonid Maximovich Leonov's *Skutarevski*.

Paul Vincent Carroll's *Shadow and Substance*.

Wan Chia-pao's *Thunderstorm*.

Within the Gates, Sean O'Casey's play.

d. Arthur Wing Pinero, English playwright and actor (b. 1855), popular from the 1885 London staging of his *The Magistrate*, and whose 1895 *Trelawney of the Wells* is a staple in the repertory.

d. Marie Dressler, vaudeville singer and film actress (b. 1871).

d. Gerald Hubert Edward du Maurier, English actor–manager (b. 1871); father of novelist Daphne du Maurier.

d. Augustus Thomas, American playwright (b. 1857).

d. Charles Bancroft Dillingham, American theater manager (b. 1868).

d. Nigel Playfair, English actor–manager and director (b. 1874).

Music & Dance

I Get a Kick Out of You, Cole Porter's song, introduced by Ethel Merman in *Anything Goes*.

The Haunted Ballroom, Ninette de Valois's ballet, music by Geoffrey Toye, first danced April 3 by the Vic-Wells Ballet, London.

Benny Goodman began his radio show, *Let's Dance*, which established him as the "King of Swing."

Lady Macbeth of the Mtsensk District, Dmitri Shostakovich's opera, libretto by Shostakovich and A. Pries, opened in Leningrad January 22.

Ink Spots were founded, by Orville "Hoppy" Jones, Jerry Daniels, Ivory Watson, and Charles Fuqua.

Sergei Prokofiev's orchestral works *Egyptian Nights* and *Lieutenant Kijé*.

Deep Purple, popular song, words by Mitchell Paris, music by Peter De Rose, introduced by Paul Whiteman and his Orchestra.

John Christie began a summer Mozart festival in a theater attached to his family's country house in Sussex, England; it would become the Glyndebourne festival.

On the Good Ship Lollipop, Shirley Temple's theme song, from *Bright Eyes*.

Ralph Vaughan Williams's *Symphony No. 4* and *Suite* for viola and small orchestra.

Django Reinhardt and Stéphane Grappelli formed their Quintet de Hot Club de France.

Sergei Rachmaninoff's *Rhapsody on a Theme of Paganini*, for piano and orchestra.

Hear Ye, Hear Ye, Aaron Copland's ballet.

I Only Have Eyes for You, Al Dubin and Harry Warren's song.

Albert Roussel's fourth symphony.

Sergei Prokofiev's *Lieutenant Kijé* suite for orchestra.

Anton von Webern's *Concerto for Nine Instruments*, *Suite for String Orchestra*, and *Three Songs*.

Arthur Honegger's *Cello Concerto*.

Béla Bartók's fifth string quartet.

Benjamin Britten's *Simple Symphony*.

Darius Milhaud's *Concertino de printemps*, for violin and chamber orchestra.

Diane de Poitiers, Jacques Ibert's ballet.

Ecuatorial, Edgard Varèse's ensemble work.

Giuditta, Franz Lehár's operetta.

The Wandering Scholar, Gustav Holst's opera.

Helen Tamiris's *Walt Whitman Suite*.

Persephone, Igor Stravinsky's ballet.

Ildebrando Pizzetti's *Cello Concerto*.

Riccardo Zandonai's *Concerto andaluso*, for cello.

Le Jazz Hot, an early study by Belgian Hugues Panassié.

Lincoln Kirstein and George Balanchine founded the School of American Ballet.

Sydney Symphony Orchestra formed by the Australian Broadcasting Commission.

First use of the Iranian anthem *Shahanshah-i ma Zandah bada*, by Najmi Moghaddam to words by S. Afsar.

Prague Symphony Orchestra founded.

d. Edward Elgar, English composer (b. 1857).

d. Frederick Delius, English composer (b. 1862).

d. Gustav Theodore Holst, British composer (b. 1894).

d. Franz Schreker, Austrian composer (b. 1878).

World Events

Leningrad Communist party leader Sergei Kirov was assassinated, probably on orders from Joseph Stalin, who used the murder to trigger his Great Purge (1934–1939).

Blood Purge (Night of the Long Knives; June 29–30): Nazi SS forces committed the mass murders of Ernst Roehm and thousands of other Nazi storm troopers (SA), on orders from Adolf Hitler.

Chinese Communist forces undertook a fighting retreat (the Long March) after their defeat by Kuomintang forces in Kiangsi, moving west and north 2,500–3,000 miles to Shensi. They suffered massive casualties; approximately 30,000–50,000 of the original 200,000 arrived in Shensi.

d. Augusto César Sandino, Nicaraguan guerrilla general (b. 1893), assassinated by order of dictator Anastasio Somoza while negotiating peace terms. Later Nicaraguan revolutionaries called themselves "Sandinistas" in his honor.

FBI agents killed American murderers and bank robbers: John Herbert Dillinger, publicized by the FBI as "Public Enemy Number One"; Charles Arthur "Pretty Boy" Floyd; and Bonnie Parker and Clyde Barrow, folk heroes who would be the subject of *Bonnie and Clyde*, the 1967 Faye Dunaway–Warren Beatty film.

d. Alexander I (b. 1888), king of Yugoslavia; assassi-

nated in Marseilles by Croatian nationalists (October 9).

Fire razed the city of Hakodate, Japan, killing an estimated 1,500 people (March 22).

Excursion liner *Morro Castle* sank on fire off New Jersey; 134 died (September 7–8).

French financier Serge Stavisky, a Russian Jew, was accused of bond fraud and committed suicide; the "Stavisky Affair" was used by French Fascists to generate anti-Jewish riots and bring down the French government.

French physicists Irène Joliot-Curie and Jean Frédéric Joliot-Curie were the first to induce artificial radioactivity.

Arnold Toynbee's 12-volume *The Study of History* (1934–1961).

Patterns of Culture was anthropologist Ruth Benedict's landmark work in cultural relativity.

1935

Literature

André Malraux's novel *Le Temps du mépris* (*Days of Wrath*).

Vincent Sheean's contemporary memoirs *Personal History*.

Butterfield 8, John O'Hara's novel, set in the underside of New York cafe life; basis of the 1960 Daniel Mann film; and O'Hara's *The Doctor's Son and Other Stories*.

The Stars Look Down, A. J. Cronin's novel, set among Welsh miners; basis of the 1939 Carol Reed film.

The Tower of Babel, Elias Canetti's novel.

Tortilla Flat, John Steinbeck's novel, set in a California coastal town hard-hit by the Great Depression; Victor Fleming directed the 1942 screen version.

The African Queen, C. S. Forester's novel, set in World War I East Africa; basis for the classic 1951 John Huston film.

Little House on the Prairie, autobiographical Laura Ingalls Wilder children's story, set on an 1870s Minnesota farm; basis of the 1974–1983 television series.

George Santayana's novel *The Last Puritan: A Memoir in the Form of a Novel*.

Of Time and the River, Thomas Wolfe's novel; and short stories *From Death to Morning*.

Come and Get It, Edna Ferber's novel, basis of the 1936 Howard Hawks–William Wyler film.

The Last of Mr. Norris, Christopher Isherwood's novel, based on his Berlin experiences.

Conrad Aiken's novel *King Coffin*.

Gaudy Night, Dorothy Sayers's novel Oxford-setting mystery involving Lord Peter Wimsey and Harriet Vane.

John Galsworthy's *End of a Chapter*, a trilogy of novels, further developing the characters of his *The Forsyte Saga*.

Vicente Aleixandre's poetry *La destrucción o el amor* and *Pasión de la tierra*.

It Can't Happen Here, Sinclair Lewis's novel.

Robert P. T. Coffin's Pulitzer Prize–winning poetry collection *Strange Holiness*.

Old Jules, Mari Sandoz's biography.

Education Before Verdun, Arnold Zweig's antiwar novel.

George Seferis's *Mythical Story*.

Muhammad Iqbal's poems *Gabriel's Wing*.

Golden Apples, Marjorie Kinnan Rawlings's novel.

Heaven's My Destination, Thornton Wilder's novel.

James Thurber's *The Middle-Aged Man on the Flying Trapeze*.

S. J. Perelman's *Strictly from Hunger*.

Judgment Day, third of James Farrell's three *Studs Lonigan* novels.

Louis MacNiece's *Poems*.

Margaret Ayer Barnes's novel *Edna, His Wife*.

Hamilton Basso's novel *In Their Own Image*.

Mistaken Ambitions, Alberto Moravia's novel.

Samuel Beckett's poetry *Echo's Bones*.

Morley Callaghan's novel *They Shall Inherit the Earth*.

Mulk Raj Anand's novel *Untouchable*.

Robinson Jeffers's *Solstice, and Other Poems*.

The House in Paris, Elizabeth Bowen's novel.

Swami and His Friends, Rasipuram Narayan's novel.

Ciro Alegría's novel *La serpente de oro* (*The Golden Serpent*).

The Making of Americans, Gertrude Stein's novel.

A House Divided, Pearl Buck's novel.

Penguin paperbacks introduced in Britain by publisher Allen Lane.

d. Andy Adams, American fiction writer (b. 1859).

d. Edwin Arlington Robinson, American poet (b. 1869).

d. George William Russell (pen name A.E.), Irish poet, painter, and journalist (b. 1867).

d. Henri Barbusse, French journalist, novelist, and poet, whose *Under Fire* became an emblematic antiwar work of the interwar period (b. 1873).

FILM & BROADCASTING

The Informer, Victor McLaglen starred as informer Gyppo Nolan in the John Ford classic, set in Ireland during the revolution and civil war; based on the 1925 Liam O'Flaherty novel.

Mutiny on the Bounty, Charles Laughton as Captain Bligh and Clark Gable as Fletcher Christian starred in Frank Lloyd's film version of the 1932 Charles Nordhoff–Norman Hall novel.

The Thirty-Nine Steps, Robert Donat and Madeleine Carroll starred in Alfred Hitchcock's classic spy thriller, based on the 1915 John Buchan novel.

Roberta, Fred Astaire, Ginger Rogers, Irene Dunne, and Randolph Scott starred in William A. Seitzer's screen version of the 1933 Jerome Kern–Otto Harback musical.

Top Hat, Fred Astaire and Ginger Rogers starred in the Irving Berlin screen musical; Mark Sandrich directed.

Les Misérables, Fredric March and Charles Laughton starred in Richard Boleslawski's classic screen version of the Victor Hugo novel.

A Night at the Opera, the Marx Brothers comedy, directed by Sam Wood.

A Tale of Two Cities, Ronald Colman starred as Sidney Carton in Jack Conway's epic screen version of the Dickens classic.

Ah, Wilderness!, Clarence Brown's film version of the 1933 Eugene O'Neill comedy; Mickey Rooney, Wallace Beery, and Lionel Barrymore starred.

Bride of Frankenstein, James Whale's sequel to *Frankenstein* starred Elsa Lanchester and Boris Karloff.

Errol Flynn emerged as an action film star in the title role and Olivia de Havilland costarred in the pirate film *Captain Blood*, directed by Michael Curtiz.

Alice Adams, Katharine Hepburn starred in George Stevens's screen version of the 1921 Booth Tarkington novel.

Anna Karenina starred Greta Garbo, Fredric March, Freddie Bartholomew, and Maureen O'Sullivan; Clarence Brown directed.

Madeleine Renaud and Jean Gabin starred in *Maria Chapdelaine*, directed by Julien Duvivier.

Françoise Rosay starred *Carnival in Flanders*; Jacques Feyder (her husband) directed.

Marlene Dietrich starred in *The Devil Is a Woman*, directed by Josef von Sternberg.

Irene Dunne and Robert Taylor starred in *Magnificent Obsession*, directed by John M. Stahl.

Night Must Fall, Robert Montgomery as the killer and Rosalind Russell starred in Richard Thorpe's film version of the 1935 Emlyn Williams play.

A Night at the Opera, Groucho, Chico, and Harpo Marx starred in Sam Woods's classic comedy.

Paul Robeson starred in *Sanders of the River*.

Charles Laughton starred in *Ruggles of Red Gap*, directed by Leo McCarey.

Shirley Temple starred in *Curly Top*.

The Song of Ceylon, the John Grierson documentary.

Jim and Marian Jordan began the *Fibber McGee and Molly* radio show (1935–1957).

Frequency modulation radio (FM) was developed by Edwin Armstrong.

Academy Awards for 1935 (awarded the following year): Best Picture: *Mutiny on the Bounty*; Best Director: John Ford, *The Informer*; Best Actor: Victor McLaglen, *The Informer*; Best Actress: Bette Davis, *Dangerous*.

VISUAL ARTS

Pablo Picasso's painting *Minotaur*; and his drawing *Minotauromachia*.

Georgia O'Keeffe's paintings included *Blue River*, *Ram's Head with Hollyhock*, *Rib and Jawbone*, and *Sunflower for Maggie*.

Georges Braque's paintings included *Still Life with a Mandolin* and *The Yellow Tablecloth*.

Cass Gilbert designed the National Archives, Washington, D.C.; also the U.S. Supreme Court building, which he had previously designed, was completed.

Marc Chagall's painting *Apparition of the Artist's Family* (1935–1947).

Paul Klee's paintings included *Child Consecrated to Suffering* and *Symptom to Be Recognized in Time*.

Salvador Dali's *Suburbs of the Paranoiac-critical Town*.

Reginald Marsh's murals for the American Post Office Building, Washington, D.C.

Oskar Kokoschka's painting *Tomas G. Masaryk* (1935–1936).

Henri Matisse's painting *The Pink Nude*.

Richard Neutra designed the Corona Elementary School, Los Angeles.

Suspended Figure, David Smith's sculpture.

Jackson Pollock's painting *Going West*.

The Senate, William Gropper's painting.

Wassily Kandinsky's painting *Succession*.

Jacob Epstein's sculpture *Ecce Homo*.

Alvar Aalto designed the Viipuri municipal library.

Ansel Adams's book *Making a Photograph*.

Broadway Norm, Mark Tobey's painting.

Cow I, Arthur G. Dove's painting.

Exhibition of African Negro Art at the Museum of Modern Art.

Gunnar Asplund began the Stockholm Crematorium (1935–1940).

Jo Davidson's sculpture *Dr. Albert Einstein*.

Sunrise I, Arthur G. Dove's painting.

William Glackens's painting *The Soda Fountain*.

d. (Frederick) Childe Hassam (b. 1859).

d. Gaston Lachaise, French-American sculptor (b. 1882).

d. Kasimir Malevich, Russian painter (b. 1878), the founder of suprematism (1915).

d. Charles Demuth, American painter (b. 1883).

THEATER & VARIETY

Inauguration of the American Federal Arts, Theatre, and Writers Projects (1935–1943), American Works Progress Administration (WPA) programs.

Porgy and Bess, folk opera with book and lyrics by Dubose Heyward and Ira Gershwin and music by George Gershwin, opened in New York.

Leslie Howard, Peggy Conklin, and Humphrey Bogart as gangster Duke Mantee starred in Robert Sherwood's *The Petrified Forest*, opened at New York's Broadhurst Theatre on January 7.

Burgess Meredith, Richard Bennett, and Margo starred in *Winterset*, Maxwell Anderson's verse play inspired by the Sacco–Vanzetti case; opened at New York's Martin Beck Theatre.

Awake and Sing, Clifford Odets's first play and the first produced by the Group Theater, opened in New York; Harold Clurman directed.

Dead End, Sidney Kingsley's quintessential Depression-era play, set in a New York slum neighborhood, opened at New York's Belasco Theatre on October 28.

John Gielgud and Laurence Olivier alternated as Mercutio and Romeo in Gielgud's 1935 production of *Romeo and Juliet*, both opposite Peggy Ashcroft's Juliet; Gielgud directed.

Jubilee, Cole Porter's musical, book by Moss Hart, opened at New York's Imperial Theatre.

Jumbo, the Richard Rodgers–Lorenz Hart musical, book by Charles MacArthur and Ben Hecht, opened at New York's Hippodrome on.

Mulatto, Langston Hughes's play, opened at New York's Vanderbilt Theatre on October 24.

T. S. Eliot's *Murder in the Cathedral* opened in London on November 1.

Helen Hayes starred as *Victoria Regina* in the Laurence Housman play.

Emlyn Williams starred as the driven murderer in his own *Night Must Fall*.

The Old Maid, Judith Anderson and Helen Mencken starred in the Zoë Akins play; opened at New York's Empire Theatre on January 7.

Boy Meets Girl, Bella and Sam Spewack's comedy, opened at New York's Cort Theatre.

Three Men on a Horse, John Cecil Holm's farce, opened at New York's Playhouse on January 30.

Night of January 16, Ayn Rand's play, opened at New York's Ambassador Theatre on September 16.

A Tiger at the Gates, Jean Giraudoux's play.

Armand Salacrou's *The Unknown Woman of Arras*.

Panic, Archibald MacLeish's verse play.

Dodie Gladys Smith's *Call It a Day*.

Doña Rosita la Soltera, Federico Garcia Lorca's play.

Gerhart Hauptmann's *Hamlet in Wittenberg*.

Mottke the Thief, Sholem Asch's play.

Henri Ghéon's *Le Noël sur la place*.

Our Honour and Our Power, Nordahl Grieg's antiwar play.

Ivor Novello's *Full House*.

American National Theatre and Academy (ANTA) founded.

d. Agha Hashr (b. 1876), Indian playwright and poet, whose works include *Bilwa Mangal* and *Sita Banbas*, the latter derived from the *Ramayana*.

d. Richard Berry Harrison, African-American actor (b. 1864).

d. Will (William Penn Adair) Rogers, American humorist (b. 1879).

MUSIC & DANCE

Porgy and Bess, the folk opera of African-American

life, opened in Boston, with Todd Duncan as Porgy, Anne Brown as Bess, and John W. Bubbles as Sportin' Life; music by George Gershwin, libretto by Du Bose Heyward and Ira Gershwin, based on Heyward's 1925 novel *Porgy* and 1927 play (with Dorothy Heyward). Songs (by G. Gershwin and D. Heyward) included *Summertime*; *Bess, You Is My Woman Now*; and *It Ain't Necessarily So*.

In the film *Top Hat*, Fred Astaire introduced the Irving Berlin songs *Top Hat, White Tie, and Tails*; *Isn't This a Lovely Day?*; and *Cheek to Cheek*, to which he and Ginger Rogers danced, which became a number-one hit.

The Rake's Progress, Ninette de Valois's ballet, music by Gavin Gordon, first danced May 20, by the Vic-Wells Ballet, in London.

Animal Crackers in My Soup, song introduced by Shirley Temple in the film *Curly Top*; music by Ray Henderson, words by Irving Caesar and Ted Koehler.

Frederick Ashton choreographed a new verion of the 1928 ballet *Le Baiser de las Fée*, with Margot Fonteyn and the Sadler's Wells Ballet.

St. Petersburg's Maryinsky Theatre company, the original home of such artists as Pavlova, Nijinsky, Karsavina, Fokine, Nureyev, and Baryshnikov, changed its name to the Kirov Ballet.

Arturo Toscanini began a notable series of concerts with the BBC Symphony Orchestra, London.

George Balanchine founded the American Ballet company, succeeding the School of American Ballet; it would evolve into the New York City Ballet.

Alicia Markova and Anton Dolin founded the Markova-Dolin Company, which later became the London Festival Ballet.

William Walton's *First Symphony*.

Igor Stravinsky's *Concerto for Two Solo Pianos*.

Aenéas, Albert Roussel's ballet.

Just One of Those Things, Cole Porter's song.

Alban Berg's *Violin Concerto*.

tom, e e cummings's ballet.

Das Augenlicht, Anton von Webern's choral work.

Aram Il'yich Khachaturian's first symphony.

Dmitri Shostakovich's *Bright Rivulet*, ballet.

La Passione, Gian Francesco Malipiero's choral work.

I Feel a Song Comin' On, Frances Langford's hit.

Orsélo, Ildebrando Pizzetti's opera.

Glamorous Night, Ivor Novello's musical.

Love's Victory, Janis Medins's ballet.

Harnasie, Karol Szymanowski's ballet.

Michael Tippett's first string quartet.

Olivier Messiaen's *La Nativité du Seigneur*, for organ.

Five Tudor Portraits, Ralph Vaughan Williams's vocal/orchestral work.

Die schweigsame Frau (*The Silent Woman*), Richard Strauss's opera.

Arthur Bliss's *Music for Strings*.

An electric (later electronic) organ was introduced by Laurend Hammond.

d. Alban Berg, Austrian composer (b. 1885).

d. Josef Suk, Czech composer and violinist (b. 1874).

d. Paul Dukas, French composer and critic (b. 1865).

d. Mikhayl Ippolitov-Ivanov, Russian composer (b. 1859), teacher at the Moscow Conservatory, and opera conductor of the Bolshoi from 1925.

WORLD EVENTS

Italy invaded Ethopia; Mussolini's forces advanced quickly against the lightly armed Ethiopians; heavy Italian terror bombing of defenseless civilian targets, while the League of Nations failed to effectively oppose aggression.

Nazi anti-Jewish Nuremberg Laws (decrees), another step on the path to the Holocaust.

Plebescite in the Saar produced a landslide vote for return to Germany.

Franklin D. Roosevelt's New Deal created millions of jobs with the stimulative Works Progress Administration (WPA), which built a huge and diverse set of public works.

U.S. Social Security system established by the Social Security Act.

Wagner Act established the National Labor Relations Board, and encouraged American union organization.

John L. Lewis led in founding the Committee for Industrial Organizations, which then organized the body of industrial unions that became the Congress of Industrial Organization (CIO).

Yenan was established as the Chinese Communist center after the Long March.

Bulgarian Communist Georgi Dimitrov, head of the Comintern, introduced the new worldwide "United Front against Fascism" policy, which lasted until the 1939 Soviet–German pact, and

was reinstated after the German attack on the Soviet Union.

Eduard Benes became president of Czechoslovakia (1935–1938); he resigned after the Munich agreement.

George Gallup founded the American Institute of Public Opinion, instituting the Gallup polls.

Bill Wilson and Bob Smith founded Alcoholics Anonymous (AA) in the United States.

Mary McLeod Bethune founded the National Council of Negro Women.

American seismologist Charles F. Richter developed his scale to measure the severity of earthquakes.

John Maynard Keynes's *The General Theory of Employment, Interest, and Money*.

1936

LITERATURE

The People, Yes, Carl Sandburg's long narrative poem.

Man's Hope (*L'Espoir*), André Malraux's Spanish Civil War novel, about the Loyalist air force, in which he served; Malraux wrote the screenplay and directed the 1945 film version.

The Nobel Prize for Literature was awarded to Eugene O'Neill.

Absalom, Absalom!, William Faulkner's novel.

E. M. Forster's essays *Abinger Harvest*.

Eyeless in Gaza, Aldous Huxley's novel.

The Four Quartets, T. S. Eliot's four-part poetic work, which began with *Burnt Norton* (1936–1943).

Gone with the Wind, Margaret Mitchell's Pulitzer Prize–winning only novel, about the Civil War South from the Confederate point of view, focusing on Scarlett O'Hara, Rhett Butler, and her plantation, Tara; basis of the 1939 Victor Fleming film.

In Dubious Battle, John Steinbeck's novel.

A World I Never Made, first of James Farrell's five *Danny O'Neill* novels.

The Flowering of New England, Van Wyck Brooks's Pulitzer Prize–winning literary history.

Double Indemnity, James M. Cain's novel; basis of the 1944 Billy Wilder film.

Kay Boyle's novel *Death of a Man*; and her story *The White Horses of Vienna*.

The Big Money, the third novel in John Dos Passos's *U.S.A.* trilogy.

Death on the Installment Plan (*Mort à Crédit*), Louis-Ferdinand Céline's misanthropic novel.

The House of Incest, Anaïs Nin's novel.

Kenneth Patchen's poetry *Before the Brave*.

Jamaica Inn, Daphne du Maurier's novel.

Arna Bontemps's novel *Black Thunder*.

The Thinking Reed, Rebecca West's novel.

Dorothy Parker's poems *Not So Deep a Well*.

Conrad Aiken's poetry *Time in the Rock*.

The Hangman, Pär Lagerkvist's anti-Nazi novel.

Djuna Barnes's novel *Nightwood*.

Dylan Thomas's *Twenty-Five Poems*.

Frank O'Connor's short stories *Bones of Contention*.

H. G. Wells's novel *The Croquet Player*.

Ciro Alegría's novel *Los perros hambrientos*.

Hamilton Basso's novel *Courthouse Square*.

Muhammad Iqbal's poems *The Rod of Moses*.

Mulk Raj Anand's novel *Coolie*.

Stevie Smith's *Novel on Yellow Paper*.

François Mauriac's *The Life of Jesus*.

Revaluation, F. R. Leavis's look at English poetry.

Robert Benchley's essays *My Ten Years in a Quandary*.

They Walk in the City, J. B. Priestley's novel.

We, the Living, Ayn Rand's novel.

Life began publication in the United States.

d. (Joseph) Rudyard Kipling, English writer (b. 1865).

d. Federico García Lorca, Spanish poet and playwright (b. 1899); murdered by Spanish fascists at Granada.

d. Maxim Gorky (Aleksei Maximovich Peshkov), Russian writer (b. 1868).

d. A. E. Housman, English poet and classical scholar (b. 1859).

d. Miguel de Unamuno, Spanish writer and philosopher (b. 1864).

d. G. K. Chesterton (Gilbert Keith Chesterton), British writer (b. 1874).

d. Mary Johnston, American author (b. 1870).

FILM & BROADCASTING

Dodsworth, Walter Huston, Ruth Chatterton, and Mary Astor starred in the classic William Wyler film, based on the 1929 Sinclair Lewis novel and the 1934 Sidney Howard play.

Modern Times, Charles Chaplin wrote, directed, produced, and starred with Paulette Goddard in his Tramp role, in his classic satire of an industrialized world.

Mr. Deeds Goes to Town, Gary Cooper as a triumphant Everyman and Jean Arthur starred in Frank Capra's populist comedy classic.

The Petrified Forest, Leslie Howard, Bette Davis, and Humphrey Bogart as gangster Duke Mantee starred in Archie Mayo's film version of the 1935 Robert Sherwood play.

Winterset, Burgess Meredith, Eduardo Ciannelli, Margo, and John Carradine starred in Alfred Santell's screen version of Maxwell Anderson's verse play on Sacco–Vanzetti case themes.

These Three, Miriam Hopkins, Merle Oberon, and Joel McCrea starred in Billy Wilder's screen version of the Lillian Hellman 1934 play *The Children's Hour*.

The Triumph of the Will, a German propaganda film, glorifying Adolf Hitler and the Nazi party; shot by Leni Riefenstahl at the Nuremberg Nazi Party Congress of 1934.

Show Boat, Paul Robeson, Irene Dunne, Allan Jones, and Helen Morgan starred in James Whale's film version of the 1927 Oscar Hammerstein II–Jerome Kern stage musical.

The Great Ziegfeld, William Powell, Louise Rainier, and Myrna Loy starred in the Robert Z. Leonard film, loosely based on the life of producer Florenz Ziegfeld.

Fury, Spencer Tracy and Sylvia Sidney starred in the Fritz Lang film, an indictment of lynching.

Anything Goes, Ethel Merman and Bing Crosby starred in Lewis Milestone's film version of the 1934 Cole Porter musical.

Camille, Greta Garbo starred as Camille and Robert Taylor as Armand in the the George Cukor film, based on Alexandre Dumas's 1848 novel and 1852 play *La Dame aux camélias*.

César, Raimu, Pierre Fresney, Orane Demazis, and Charpin starred in the Marcel Pagnol film, based on on his own 1936 play.

Gary Cooper and Madeleine Carroll starred in *The General Died at Dawn*, directed by Lewis Milestone.

Henry Fonda and Sylvia Sidney starred in *The Trail of the Lonesome Pine*, directed by Henry Hathaway.

William Powell and Carole Lombard starred in *My Man Godfrey*, directed by Gregory La Cava.

The Green Pastures, Marc Connelly's film, based on his 1930 play on Bible themes; Rex Ingram, Oscar Polk, George Reed, and Eddie Anderson starred in an all-Black cast.

Rembrandt, Charles Laughton as the painter, and Elsa Lanchester, Gertrude Lawrence, and Roger Livesey starred in Alexander Korda's biofilm.

Night Mail, the John Grierson documentary.

Pare Lorentz and Paul Strand, *The Plow That Broke the Plains*.

The Waves, Paul Strand's documentary, shot on the Mexican coast.

Ginger Rogers and Fred Astaire starred in *Swingtime*, directed by George Stevens.

Things to Come, Raymond Massey, Ralph Richardson, Cedric Hardwicke, and Ann Todd starred in William Cameron Menzies's screen version of the 1933 H. G. Wells science fiction novel *The Shape of Things to Come*.

The Ghost Goes West, René Clair's film, starring Robert Donat and Jean Parker.

The Secret Agent, the Alfred Hitchcock espionage thriller, starring John Gielgud and Madeleine Carroll.

San Francisco, W. S. Van Dyke's film, starring Clark Gable, Spencer Tracy, and Jeannette MacDonald singing *San Francisco*.

Fanny Brice created Baby Snooks on radio in *The Ziegfeld Follies of the Air*.

Mel Blanc created the voice of cartoon character Bugs Bunny.

Gangbusters (1936–1957), the radio series, blending fact and fiction in a quasi-documentary form.

Academy Awards for 1936 (awarded the following year): Best Picture: *The Great Ziegfeld*; Best Director: Frank Capra, *Mr. Deeds Goes to Town*; Best Actor: Paul Muni, *Story of Louis Pasteur*; Best Actress: Louise Rainer, *The Great Ziegfeld*.

d. John Gilbert (John Pringle), American actor (b. 1895).

d. Irving Thalberg, U.S. producer and husband of actress Norma Shearer (b. 1899).

VISUAL ARTS

Migrant Mother, Nipomo, California, Dorothea Lange's classic Depression-era photo.

José Clemente Orozco's University of Guadalajara murals.

Georgia O'Keeffe's paintings included *Grey Hill Forms*, *Perdernal*, and *Summer Days*.

Thomas Jefferson, John Gutzon Borglum's monumental presidential sculpture at Mount Rushmore, South Dakota.

Wassily Kandinsky's painting *Dominant Curve*.

Grant Wood's painting *The Breaking of Iowa's Virgin Soil*.

Death of a Loyalist Soldier, Robert Capa's celebrated Spanish Civil War photograph.

Alexander Calder's sculptures included *Dancers and Sphere* and *Hanging Mobile*, sculpture.

Frank Lloyd Wright designed the S. C. Johnson & Son, Inc. building, Racine, Wisconsin.

Arshile Gorky's paintings included *Enigmatic Combat* (ca. 1936), *Aviation*, and a *Self-Portrait*.

Marsden Hartley's paintings included *The Old Bars* and *Northern Seascape* (1936–1937).

Reginald Marsh's painting *Twenty-Cent Movie, End of the Fourteenth Street Crosstown Line*.

Artists on WPA, Moses Soyer's painting.

Raphael Soyer's paintings *Office Girls*, *Artists on WPA* and *Transients*.

Ben Shahn's painting *East Side Soap Box*.

Aerial Construction, David Smith's sculpture.

Jack Levine's painting *Brain Trust*.

Margaret Bourke-White did the first cover of *Life* magazine.

Julio González's sculpture *Women Combing Her Hair*.

To Fight Again, Herbert Ferber's sculpture.

The English at Home, Bill Brandt's photography collection.

Lyonel Feininger's painting *Church at Gelmeroda*.

Piet Mondrian's painting *Vertical Composition with Blue and White*.

William Gropper's painting *Suburban Post in Winter*.

Political Parade, a collection of David Low political cartoons.

d. Lorado Taft, American sculptor (b. 1860).

THEATER & VARIETY

You Can't Take It with You, Henry Travers, Josephine Hull, and Frank Wilcox starred in the Moss Hart–George S. Kaufman comedy; opened at New York's Booth Theatre on December 14.

Stage Door, Margaret Sullavan starred in the Edna Ferber–George S. Kaufman play, about a group of young actresses trying to make careers on the New York stage; opened at New York's Music Box Theatre on October 22.

Eugene O'Neill was awarded the Nobel Prize for Literature.

César, Marcel Pagnol's play, set in Marseilles, the third of the *Marius* trilogy; basis of the 1936 film, which Pagnol directed.

Constantin Stanislavsky's book *An Actor Prepares*.

Idiot's Delight, Alfred Lunt and Lynn Fontanne starred in Robert Sherwood's Pulitzer Prize–winning antiwar comedy, prophetically set at the beginning of a new world war; opened at New York's Shubert Theatre on March 24.

Elisabeth Bergner played David in James M. Barrie's *The Boy David*.

Orson Welles directed an all-Black *Macbeth* for the Federal Theatre Project.

W. H. Auden and Christopher Isherwood's *The Ascent of F-6* and *The Dog Beneath the Skin*.

The House of Bernardo Alba, Federico Garcia Lorca's play.

Katharine Cornell starred in Maxwell Anderson's *Wingless Victory*; opened in New York.

The Women, the comedy by Clare Boothe (Luce), opened at New York's Ethel Barrymore Theatre.

Brother Rat, John Monks, Jr., and Fred Finklehoffe's comedy opened with Eddie Albert in New York.

End of Summer, S. N. Behrman's comedy, opened at New York's Guild Theatre on February 17.

French Without Tears, Terrence Rattigan's play.

Johnny Johnson, Paul Green's antiwar play with music by Kurt Weill, opened in New York.

On Your Toes, Richard Rodgers and Lorenz Hart's musical, opened at New York's Imperial Theatre.

d. Luigi Pirandello, Italian playwright (b. 1867).

d. Marilyn Miller (Mary Ellen Reynolds), American singer, dancer, and actress (b. 1898).

d. Ben Greet, English actor–manager (b. 1857).

MUSIC & DANCE

Peter and the Wolf, Sergei Prokofiev's symphonic fairy tale, for narrator and orchestra; a perennial favorite, especially with children; also Prokofiev's *Russian Overture*.

Pennies from Heaven, Johnny Burke–Arthur Johnston song introduced by Bing Crosby in the 1936 Norman Z. McLeod film; it was both theme and title for Dennis Potter's television miniseries and the 1981 film.

Slaughter on Tenth Avenue, George Balanchine's ballet, from the Broadway musical *On Your Toes*, music by Richard Rodgers.

Samuel Barber's *Adagio for Strings*, part of his *String Quartet*; theme music for the film *Platoon* (1986).

Apparitions, Frederick Ashton's ballet, music by Franz Liszt, set and costumes by Cecil Beaton, first danced by the Sadler's Wells Ballet, London, with Margot Fonteyn and Robert Helpmann.

Jardin aux Lilas (*Lilac Garden*), Antony Tudor's ballet, to music by Ernest Chausson, first danced January 26 by the Ballet Rambert, London.

The Poisoned Kiss, Ralph Vaughan Williams's 1929 opera first performed, in Cambridge May 12.

Benjamin Britten and W. H. Auden's symphonic song cycle *Our Hunting Fathers*.

Doris Humphrey's trilogy *New Dance*, *Theatre Piece*, and *With My Red Fires*, to music by W. Rieger.

Dona nobis pacem (*Grant Us Peace*), Ralph Vaughan Williams's vocal/orchestral work.

A Fine Romance, Fred Astaire's number-one hit, from the film *Swing Time*; words by Dorothy Fields, music by Jerome Kern.

George Enescu's opera *Oedipe*, presented posthumously.

Zoltán Kodály's *Budavári Te Deum*.

Sergei Rachmaninoff's *Symphony No. 3.*

Dmitri Shostakovich's *Fourth Symphony*.

I've Got You Under My Skin, Cole Porter's song, from the film *Born to Dance*.

Béla Bartók's *Music for Strings, Percussion and Celesta*.

Prometheus, Ninette de Valois's ballet.

El Sálon Mexico, Aaron Copland's orchestral work.

Darius Milhaud's *Suite provençale*.

Aram Khachaturian's *Piano Concerto*.

Edgard Varèse's *Density 21.5*, for flute.

Giulio Cesare, Gian Francesco Malipiero's opera.

Johnny Johnson, Kurt Weill's fable.

Luigi Dallapiccola's choral work *6 cori di Michelangelo*.

Poèmes pour Mi, Olivier Messiaen's solo vocal.

Kyor-ogli̇̈, Uzeir Hajibeyov's opera.

Arnold Schoenberg's *Violin Concerto* and *String Quartet No. 4.*

Woody Herman organized his big band.

Eugene Ormandy began his long association with the Philadelphia Orchestra (1936–1980).

d. Ernestine Schumann-Heink, Austrian-American contralto (b. 1861), who became widely popular through her 20th-century concert tours.

d. La Argentina (Antonia Mercé), Spanish dancer (b. 1890), considered by many the finest exponent of Spanish dance, who toured the world to enthusiastic audiences from age 18.

d. Alexander Glazunov, Russian composer (b. 1865).

d. Ottorino Respighi, Italian composer (b. 1879).

World Events

Democratic incumbent American President Franklin D. Roosevelt won a second presidential term, defeating Alfred M. Landon in a landslide.

Spanish Civil War began July 18 (1936–1939), with military revolts in Morocco and Spain. Fascists were led by Francisco Franco, whose forces were by November besieging Madrid. Also a rehearsal for World War II, with German and Italian armed help for the Fascists, Soviet aid for the Republican government, an arms embargo by Western nations, Communist-organized International Brigades, and anarchist-organized volunteers.

Germany reoccupied the Rhineland, without French and British armed opposition; a major victory for Hitler and another step toward World War II.

Chiang Kai-shek was held by elements of his own army at Sian (Xian), until he agreed to negotiate a united Communist-Kuomintang against the Japanese. He negotiated a truce with Zhou Enlai, and was released.

February Coup (February 26–28), failed right-wing Japanese Army officers' coup in Tokyo, including elements of the First Division; many assassinations of government leaders.

African-American runner Jesse Owens starred in the Berlin Olympics, in spite of German racism directed at him.

d. George V (b. 1865), king of England (1910–1936); succeeded by Edward VIII, who on November 30 announced his decision to marry Wallis Simpson, an American divorcée. Edward abdicated on December 10, and was named duke of Windsor by his successor George VI.

Italians took Addis Abbaba (May) and occupied Ethiopia.

Moscow show trials began, as part of Stalin's Great Purge.

Greek officer Ioannis Metaxas became premier in April and took power as a dictator in August.

New Deal established the Rural Electrification Administration (REA).

Palestinian Arab insurrection began with a six-month general strike against British occupation and growing Jewish settlement, and grew into a failed armed conflict (1936–1939).

Léon Blum became premier of the French Popular Front coalition government.

The Shah of Iran abolished the veil for women.

Edgar Snow's *Red Star over China*.

1937

LITERATURE

Of Mice and Men, John Steinbeck's story of two migrant workers in 1930s California; basis of Steinbeck's 1937 play and the 1939 Lewis Milestone film.

Roger Martin du Gard was awarded the Nobel Prize for Literature.

Their Eyes Were Watching God, Zora Neale Hurston's novel.

Three Comrades, Erich Maria Remarque's anti-Fascist novel, set in interwar Germany; Frank Borzage directed the 1938 screen version.

The Years, Virginia Woolf's novel.

Isak Dinesen's autobiographical work *Out of Africa*; basis of the 1985 Sidney Pollack film.

The Citadel, A. J. Cronin's novel, about a young doctor in conflict about money and medical ethics; basis of the 1938 King Vidor film.

The Hobbit, J. R. R. Tolkien's fantasy novel.

Federico García Lorca's poetry *Lament for the Death a Bullfighter*.

And to Think That I Saw It on Mulberry Street, the first children's book written by Dr. Seuss (Theodore Geisel).

Stephen Vincent Benét's short story *The Devil and Daniel Webster*; basis of the 1941 William Dieterle film.

George Orwell's essays *The Road to Wigan Pier*.

The Sea of Grass, Conrad Richter's first novel; basis of the 1947 Elia Kazan film.

Diary of a Country Priest, George Bernanos's novel, basis of the 1950 Robert Bresson film.

Death at the President's Lodging, J. I. M. Stewart's mystery novel, introducing Inspector John Appleby.

The Late George Apley, J. P. Marquand's Pulitzer Prize–winning novel.

The Rains Came, Louis Bromfield's novel; basis of the 1939 Clarence Brown film.

Northwest Passage, Kenneth Roberts historical novel; basis of the 1940 King Vidor film.

Bread and Wine, Ignazio Silone's novel.

Stevie Smith's poetry *A Good Time Was Had by All*.

España, Nicolás Guillén's Spanish Civil War poems.

August Derleth's novel *Still Is the Night*.

Dorothy Sayers's novel *Busman's Honeymoon*.

Famine, Liam O'Flaherty's novel.

The Living Torch, essays by A.E. (George William Russell).

Gerhart Hauptmann's autobiographical work *Das Abenteuer meiner Jugend*

H. G. Wells's novel *The Brothers*.

Kafu Nagai's novel *A Strange Tale from East of the River*.

Léon Gontran Damas's poetry *Pigments*.

Kawabata Yasunari's story *The Snow Country*.

Louis MacNiece's poems *Out of the Picture*.

Masuji Ibuse's novel *John Manjiro, the Castaway*.

Louise Bogan's poems *The Sleeping Fury*.

Oliver La Farge's novel *The Enemy Gods*.

Serenade, James M. Cain's novel.

The Bachelor of Arts, Rasipuram Narayan's novel.

World Light (1937–1940), Haldor Laxness's four-volume novel.

Eric Partridge's *Dictionary of Slang and Unconventional English*.

Look began publication in the United States.

d. Don Marquis, American journalist and humorist (b. 1878).

d. Edith Wharton, American writer (b. 1862).

FILM & BROADCASTING

Dead End, William Wyler's film, set in a poor New York City neighborhood; screenplay by Lillian Hellman from the 1935 Sidney Kingsley play. Sylvia Sidney, Joel McCrea, and Humphrey Bogart starred, with the Dead End Kids.

The Grand Illusion, Jean Renoir's antiwar classic, set during World War I; Jean Gabin, Erich von Stroheim, Pierre Fresnay, Marcel Dalio, and Dito Parlo starred.

Snow White and the Seven Dwarfs, the first feature-length cartoon film, starring Snow White, Bashful, Doc, Dopey, Sleepy, Happy, Grumpy, and Sneezy.

Stage Door, Katharine Hepburn starred in Gregory La Cava's screen version of the Edna Ferber–George S. Kaufman play.

The Good Earth, Paul Muni and Louise Rainier starred in the Sidney Franklin film, set in China; based on the 1931 Pearl Buck novel.

The Life of Emile Zola, Paul Muni as Zola starred in William Dieterle's biofilm, with Joseph Schildkraut as Dreyfus, Donald Crisp, Louis Calhern, Gale Sondergaard, and Morris Carnovsky.

A Star Is Born, Fredric March and Janet Gaynor starred in William Wellman's classic story of a fading movie star and his protegée/wife.

Fred Astaire and Ginger Rogers starred in *Shall We Dance*.

Captains Courageous, Victor Fleming's film, starred Freddie Bartholomew, Spencer Tracy, and Lionel Barrymore.

Fire over England, Laurence Olivier, Vivien Leigh, Flora Robson, and Raymond Massey starred in William K. Howard's romance about the defeat of the Spanish Armada.

Gold Diggers of 1937, Lloyd Bacon's musical, choreography by Busby Berkeley, based on the 1919 Avery Hopwood play.

Julien Duvivier directed *Pepe Le Moko*, starring Jean Gabin.

Knight Without Armour, Robert Donat, Marlene Dietrich, and John Clements starred in Jacques Feyder's film, set during the Russian Civil War; based on James Hilton's novel.

Last Train from Madrid, James Hogan's Spanish Civil War film; Lew Ayres, Dorothy Lamour, Gilbert Roland, and Anthony Quinn starred.

Lost Horizon, Ronald Colman starred in Frank Capra's ultimate escapist film, set in Shangri-La; based on the 1933 James Hilton novel.

Seventh Heaven, Simone Simon and James Stewart starred as the young lovers parted by war in Henry King's remake of the 1927 Frank Borzage silent classic.

Shirley Temple starred in *Wee Willie Winkie*.

The Spanish Earth, Ernest Hemingway read the commentary accompanying Joris Ivens's pro-Loyalist Spanish Civil War film.

Coronation procession of George VI was broadcast on television by the British Broadcasting Corporation.

Academy Awards for 1937 (awarded the following year): Best Picture: *Life of Emile Zola*; Best Director: Leo McCarey, *The Awful Truth*; Best Actor: Spencer Tracy, *Captains Courageous*; Best Actress: Louise Rainer, *The Good Earth*.

d. Jean Harlow (Harlean Carpenter), American actress, having become ill while working on the film *Saratoga* (b. 1911).

VISUAL ARTS

Guernica, Pablo Picasso's homage to the Basque city, destroyed by Nazi bombers during the Spanish Civil War; exhibited at the Paris Exposition; basis of the 1950 Alain Resnais Picasso biofilm.

Frank Lloyd Wright's work included his celebrated Fallingwater, Bear Run, Pennsylvania, a home set in rock and concrete at a waterfall. He also began Taliesin West, his Scottsdale, Arizona, home and architecture school, and designed the Hanna House, Palo Alto, California, and the Jacobs House, Westmorland, Wisconsin.

Georgia O'Keeffe's paintings included *From the Faraway Nearby*, *Gerald's Tree I*, *Horse and Feather*, and *Red Amaryllis*.

Abraham Lincoln, John Gutzon Borglum's monumental presidential sculpture at Mount Rushmore, South Dakota.

After two decades of controversy, Jacob Epstein's 18 nude statues on the British Medical Association building were removed and destroyed.

You Have Seen Their Faces, Margaret Bourke-White's landmark photo-essay on the Depression-ravaged American South; text by her husband, Erskine Caldwell.

Joan Miró's mural at the Paris Exposition, in homage to the Spanish Republic; and his *Aidez l'Espagne* poster.

Wassily Kandinsky's paintings included *Sweet Trifles* and *Tensions Relaxed*.

Julio González's sculpture *Montserrat*, his homage to the people of the Spanish Republic.

Constantin Brancusi's sculpture *Endless Column*.

Alexander Calder's sculptures included *Tight Rope* and *Whale*.

Jacques Lipchitz's sculpture *Prometheus Strangling the Vulture*.

László Moholy-Nagy founded Chicago's New Bauhaus.

Georges Rouault's paintings included *Christ and Fishermen*, *Christ and the High Priest*, and *The Three Judges* (1937–1938).

Henri Cartier-Bresson's *Return to Life*, his Spanish Civil War film.

José Clemente Orozco's Guadalajara government center murals.

Henry Moore's sculpture *Figure*.

Walter Gropius designed his own Gropius House, Lincoln, Massachusetts.

Arthur Rothstein's painting *Dust Storm, Cimarron County*.

Ben Shahn's fresco for the Roosevelt, New Jersey, community center.

Philip Evergood's painting *American Tragedy*, a portrait of Chicago's Memorial Day, 1937, Little Steel Massacre.

Medals for Dishonor, sculpture series by David Smith (1937–1940).

Georges Braque's paintings included *Le Duo* and *Woman with Hat*.

Henri Matisse's painting *Lady in Blue*.

Jack Levine's painting *The Feast of Pure Reason*.

Miguel Covarrubias's book *Island of Bali*, on Balinese art and society.

Reginald Marsh's murals for the Customs House, New York City.

Jackson Pollock's painting *The Flame*.

Toussaint L'Ouverture, Jacob Lawrence's painting.

Paul Nash's painting *The Three Rooms*.

Scotts Run, West Virginia, Ben Shahn's painting.

Piet Mondrian's painting *Composition with Blue*.

Walt Kuhn's painting *Trio*.

d. Andrew Mellon, American financier and art collector (b. 1855), who funded and gave his collection to the National Gallery of Art, Washington, D.C.

d. Frederick Macmonnies, American sculptor (b. 1863).

d. Henry Ossawa Tanner, American painter (b. 1859).

THEATER & VARIETY

The Playwrights' Company was founded by Maxwell Anderson, S. N. Behrman, Sidney Howard, Elmer Rice, and Robert E. Sherwood.

Of Mice and Men, Broderick Crawford as Lennie and Wallace Ford as George starred in John Steinbeck's dramatization of his 1937 novel; opened at New York's Music Box Theatre on November 23.

Me and My Girl, Lupino Lane introduced the Lambeth Walk in the Noel Gay musical, notably revived in 1984, starring Robert Lindsay and Maryann Plunkett.

Burgess Meredith starred in Maxwell Anderson's *High Tor*; opened at New York's Martin Beck Theatre on January 9.

I'd Rather Be Right, the Richard Rodgers–Lorenz Hart musical, opened at New York's Alvin Theatre.

Luther Adler, Francis Farmer, and Morris Carnovsky starred in Clifford Odets's *Golden Boy*, about a musician turned boxer; opened at New York's Belasco Theatre on November 4.

Babes in Arms, the Richard Rodgers–Lorenz Hart musical, opened at New York's Shubert Theatre.

Gertrude Lawrence starred in Rachel Crothers's *Susan and God*; opened at New York's Plymouth Theatre on October 7.

Maxwell Anderson's *The Star Wagon* opened at New York's Empire Theatre on September 29.

Harold Rome's *Pins and Needles*, a musical on trade union themes, was produced by the International Ladies Garment Workers Union; opened at New York's Labor Stage on November 27.

Room Service, John Murray and Allen Boretz's farce, opened at New York's Cort Theatre on May 19.

Having Wonderful Time, Arthur Kober's comedy, opened at New York's Lyceum Theatre.

Yes, My Darling Daughter, Mark Reed's comedy, opened at New York's Playhouse on February 9.

The Fall of the City, Archibald MacLeish's verse play.

The White Scourge, Karel Capek's anti-Fascist play.

Time and the Conways, J. B. Priestley's play.

Tyrone Guthrie directed Laurence Olivier's *Hamlet*.

Wan Chia-pao's *Wilderness*.

Amphitryon 38, S. N. Behrman's play.

Julius Caesar, with Orson Welles, Joseph Cotten, and Martin Gabel.

Stanley Lupino's *Crazy Days*.

d. James M(atthew) Barrie, Scottish playwright and novelist (b. 1860).

d. Johnston Forbes-Robertson, English actor–manager (b. 1853).

d. William Gillette, American actor and playwright (b. 1855), long identified with his starring role in his own adaptation of *Sherlock Holmes*.

d. John Drinkwater, English poet and playwright (b. 1882).

d. Lilian Mary Baylis, English theater manager (b. 1874).

d. Osgood Perkins, American actor (b. 1892).

MUSIC & DANCE

The Cradle Will Rock, Marc Blitzstein's musical, produced by Orson Welles, John Houston and their Mercury Theater in New York City; its then-radical message generated a political storm.

Carmina Burana (*Songs of Beuren*), Carl Orff's cantata based on poems from a early 13th-century manuscript from Benediktbeuren; by far his best-known work, first of his *Trionfi* trilogy.

Amelia Goes to the Ball (*Amelia al ballo*), Gian Carlo Menotti's opera, libretto by Menotti, opened in Philadelphia, April 1.

Bei Mire Bist Du Schoen, the Andrews Sisters's signature song, music by Sholom Secunda, words by Secunda and Sammy Cahn.

Lulu, Alban Berg's unfinished opera, libretto by Berg based on two Wedekind plays; staged June 2 in Zurich; opera later completed by Friedrich Cerha, and premiered in 1979.

Les Patineurs, Frederick Ashton's ballet, to music by Giacomo Meyerbeer, first danced February 16 by the Vic-Wells Ballet, London.

The Lambeth Walk, song and dance introduced by Lupino Lane in *Me and My Girl*; words and music by Noel Gay and Douglas Furber.

Riders to the Sea, Ralph Vaughan Williams's opera, based on the J. M. Synge play, opened December 1 at the Royal College of Music, London.

A Wedding Bouquet, Frederick Ashton's ballet; music by Lord Berners, text by Gertrude Stein, first danced April 27 by the Vic-Wells Ballet, London.

Arturo Toscanini became conductor of the newly formed NBC Symphony Orchestra, with whom he made most of his recordings (1937–1954).

Benjamin Britten's song cycle *On This Island*, and *Variations on a Theme of Frank Bridge*, for strings.

In Honour of the City of London, William Walton's choral/orchestral work.

My Funny Valentine, Richard Rodgers and Lorenz Hart's song.

Sergei Prokofiev's *Cantata for the 20th Anniversary of the October Revolution*.

Checkmate, Ninette de Valois's ballet to Arthur Bliss's music and libretto.

Nice Work If You Can Get It, George and Ira Gershwin's song.

Ernest Bloch's *Violin Concerto*.

The Card Party, Igor Stravinsky's ballet.

Dmitri Shostakovich's *Fifth Symphony*.

The Second Hurricane, Aaron Copland's opera.

Roy Harris's *Third Symphony*.

Komei Abe's *Cello Concerto*.

Dark Elegies, Antony Tudor's ballet.

Francis Poulenc's *Mass*.

Julio Fonseca's *Gran fantasia sinfónica*.

L'Aiglon, Jacques Ibert's opera.

Tanglewood Music Festival (formerly Berkshire Music Festival) established.

d. George Gershwin, American composer (b. 1898).

d. Bessie Smith, celebrated blues singer (b. 1894).

d. Karol Szymanowski, Polish composer (b. 1882).

d. Maurice-Joseph Ravel, French composer (b. 1875).

d. Albert Roussel, French composer (b. 1869).

WORLD EVENTS

"I see one third of a nation ill-housed, ill-clad, ill-nourished," from Franklin Delano Roosevelt's second inaugural address.

Sino-Japanese War began on July 7, with armed hostilities between Chinese and Japanese troops at the Marco Polo Bridge, near Peking (1937–1945). During 1937, invading Japanese forces took most of north China, including Peking (Beijing), Shanghai, and Nanking, taking it so brutally that the attack was widely called the Rape of Nanking.

Panay Incident, Japanese warplanes bombed and sank the gunboat U.S.S. *Panay* in the Yangtse River; part of the prelude to Pearl Harbor.

Spanish Civil War: Bilbao fell to Fascist forces; Republican offensive took Teruel but could not hold it; International Brigade units saw their first action at the siege of Madrid; America's Abraham Lincoln Battalion saw its first action, at Jarama; armed clashes between Communist and anarchist Republican forces in Barcelona cost an estimated 400–1,000 lives.

Heavy German bombing of defenseless, nonmilitary Spanish town of Guernica, prefiguring bombings

of World War II; inspiration for Pablo Picasso's landmark painting *Guernica*.

d. Amelia Mary Earhart, leading woman aviator (b. 1897), lost in the central Pacific during an around-the-world flight.

d. Mikhail Nikolayevich Tukhachevsky, Soviet general (b. 1893), the key figure in the Red Army. His execution paved the way for the purge of the entire Soviet officers' corp, with consequent enormous early losses during World War II.

At least 73 people died in America after taking the drug Elixir Sulfanilamide, stimulating passage of the 1938 Pure Food and Drug Law.

Hydrogen-filled German zeppelin *Hindenburg* caught fire while landing at Lakehurst, New Jersey, on May 6, killing 36 people.

In *National Labor Relations Board v. Jones & Laughlin Steel Corporation*, the U.S. Supreme Court upheld the legality of the 1935 Wagner Act, opening the way to massive union organization.

Sit-down strikes became a major union tactic, most notably during the United Automobile Workers–General Motors organizing strike (January–February).

Late winter (January–February) Mississippi River flood killed 200–300 people and forced evacuation of 600,000–700,000.

Little Steel Massacre: Chicago police killed 10 unarmed striking steelworkers on Memorial Day.

American chemist Wallace A. Carothers invented nylon.

1938

LITERATURE

The Odyssey: A Modern Sequel, Nikos Kazantzakis's epic poem.

Homage to Catalonia, George Orwell's Spanish Civil War essays.

Pearl Buck was awarded the Nobel Prize for Literature.

The Fifth Column and the First Forty-Nine Stories, Ernest Hemingway's short-story collection, including *The Short Happy Life of Francis Macomber*, *The Snows of Kilimanjaro*, and *The Killers*, the latter two later the bases of films.

A Diary of My Times, George Bernanos's rejection of his former Fascism, a major event in pre–World War II France.

Uncle Tom's Children, four Richard Wright novellas.

Graham Greene's novel *Brighton Rock*.

The Yearling, Marjorie Kinnan Rawlings's Pulitzer Prize–winning novel; basis of the classic Clarence Brown children's film.

Energy, Fyodor Gladkov's novel.

Rebecca, Daphne du Maurier's novel, basis of the 1940 Alfred Hitchcock film.

Nausea, Jean-Paul Sartre's first novel.

Virginia Woolf's essays *Three Guineas*.

The Black Book, Lawrence Durrell's novel.

Stevie Smith's poetry *Tender Only to One*; and her novel *Over the Frontier*.

The Death of the Heart, Elizabeth Bowen's novel.

Tropisms, Nathalie Sarraute's novel.

Paul Éluard's poetry *Cours Naturel*.

Raja Rao's novel *Kanthapura*.

Epitaph for a Spy, Eric Ambler's espionage novel.

William Carlos Williams's *Complete Collected Poems 1906–1938*.

Gabriela Mistral's poems *Tala*.

Samuel Beckett's novel *Murphy*.

Hervey Allen's novel *Action at Aquila*.

Invitation to a Beheading, Vladimir Nabokov's novel.

Lao She's novel *Camel Xiangzi*.

A Guest for the Night, Shmuel Yoseph Agnon's novel.

Cyril Connolly's essays *Enemies of Promise*.

Delmore Schwartz's poems *In Dreams Begin Responsibilities*.

Ludwig Bemelmans's short story *Life Class*.

Muhammad Iqbal's poems *The Gift of Hejaz*.

Sailor on Horseback, Irving Stone's fictionalized biography of Jack London.

Taylor Caldwell's novel *Dynasty of Death*.

William Saroyan's short stories *The Trouble with Tigers*.

d. Boris Pilnyak (Boris Andreyevich Vogau), a leading pro-Soviet Russian writer (b. 1894); he died in a Soviet prison.

d. James Weldon Johnson, American writer and lyricist (b. 1871), who with his brother, John Rosamond Johnson, wrote *Lift Every Voice and Sing* (1899), called the "Negro national anthem."

d. Mary Hallock Foote, American novelist (b. 1847).

d. Muhammad Iqbal, Urdu and Persian poet (b. 1873).

d. Osip Mandelstam, Russian poet (b. 1891), in a Soviet prison.

d. Saratchandra Chatterji, Indian writer (b. 1876).

d. Thomas Wolfe, American writer (b. 1900).

FILM & BROADCASTING

Orson Welles's radio broadcast of *War of the Worlds* set off a national panic; based on the H. G. Wells novel, it described a fictional Martian landing.

Pygmalion, Wendy Hiller as Eliza Doolittle and Leslie Howard as Henry Higgins starred in Anthony Asquith's screen version of the classic George Bernard Shaw play.

Three Comrades, Robert Taylor, Margaret Sullavan, Franchot Tone, and Robert Young starred in Frank Borzage's screen version of Erich Remarque's 1937 anti-Fascist novel, set in interwar Germany; screenplay by F. Scott Fitzgerald and Edward Patmore.

You Can't Take It with You, Jean Arthur, Lionel Barrymore, James Stewart, and Edward Arnold led a large cast in Frank Capra's screen version of the Moss Hart–George S. Kaufman comedy.

Alexander Nevsky, Sergei Eisenstein's patriotic film, with music by Sergei Prokofiev, was about a 13th-century defense of Russia against a German invasion, featuring the climactic Battle on the Ice; Nikolai Cherkassov starred.

The Lady Vanishes, May Whitty, Margaret Lockwood, and Michael Redgrave starred in Alfred Hitchcock's espionage thriller, set in pre–World War II central Europe.

Fred Astaire and Ginger Rogers starred in *Carefree*.

The 400 Million, the Joris Ivens documentary, about China, then being attacked by the Japanese.

Alexander's Ragtime Band, Henry King's musical film, starred Tyrone Power and Alice Faye.

Blondie began the 28-film series (1938–1950) starring Penny Singleton as Blondie and Arthur Lake as Dagwood; based on the Chic Young comic strip.

Bob Hope made his film debut in *The Big Broadcast of 1938*, and introduced his signature song *Thanks for the Memory*.

Spencer Tracy and Mickey Rooney starred in *Boys' Town*, directed by Norman Taurog.

Gold Diggers in Paris, Ray Enright's musical film, choreography by Busby Berkeley, based on the 1919 Avery Hopwood play.

Marcel Carné directed *Port of Shadows*, starring Jean Gabin and Michèlle Morgan.

Room Service, the Marx Brothers comedy, directed by William A. Seiter.

Sergei Gerasimov directed *City of Youth*.

Shirley Temple starred in *Rebecca of Sunnybrook Farm*.

Sweethearts, the Nelson Eddy–Jeanette MacDonald musical, based on the 1913 Victor Herbert operetta; W. S. Van Dyke directed.

Errol Flynn and Olivia de Havilland starred in *The Adventures of Robin Hood*, directed by Michael Curtiz.

The Citadel, King Vidor's film, based on the 1937 A. J. Cronin novel; Robert Donat starred.

Vivien Leigh and Charles Laughton starred in *St. Martin's Lane*; Tim Whelan directed.

Academy Awards for 1938 (awarded the following year): Best Picture: *You Can't Take It with You*; Best Director: Frank Capra, *You Can't Take It with You*; Best Actor: Spencer Tracy, *Boys' Town*; Best Actress: Bette Davis, *Jezebel*.

d. Georges Méliès, early French filmmaker (b. 1861), whose pioneering films, such as *One Man Band* and *A Trip to the Moon*, were to take the theater into a whole new world.

d. Pearl White, American actress; she was the heroine of the serial *The Perils of Pauline* (b. 1889).

VISUAL ARTS

Walker Evans's Farm Security Administration photographs (1935–1938).

Georgia O'Keeffe's paintings included *Red and Orange Hills*, *Red Hill and White Shell*, *Two Jimson Weeds*, and *White Camellia*.

Walter Gropius designed a housing development at New Kensington, Pennsylvania (1938–1941).

Henry Moore's sculptures included *Mother and Child* and *Recumbent Figure*.

Jackson Pollock's painting *Composition with Figures and Banners*.

Frederick Douglass, Jacob Lawrence's painting (1938–1939).

Georges Rouault's paintings included *Diplomat* and *Head of Christ*.

Isamu Noguchi's bronze reliefs for New York's Associated Press building.

Joseph Stella's painting *Song of Barbados, Machina Naturale No. 13*.

Wassily Kandinsky's painting *Fifteen*.

Cotton from Field to Mill, Philip Evergood's mural.

London at Night, Bill Brandt's photography collection.

Marc Chagall's painting *White Crucifixion*.

Ben Shahn's mural for the Bronx, New York, Central Annex Post Office (1938–1939).

Thomas Hart Benton's paintings *Cradling Wheat, I Got a Gal on Sourwood Mountain, Rainy Day*.

David Smith's sculpture *Amusement Park*.

Edouard Vuillard's League of Nations murals, Geneva, Switzerland.

End of Day, Charles Burchfield's painting.

Jerry Siegel and Joe Schuster created the *Superman* comic strip.

Eliel and Eero Saarinen designed Kleinhan's Music Hall, Buffalo.

Paul Klee's painting *Rich Harbour*.

Willem de Kooning's painting *Pink Landscape*.

Pavel Tchelitchew's painting *Phenomena*.

Reginald Marsh's painting *Human Pool Tables*.

Walt Kuhn's painting *Musical Clown*.

d. Elzie Segar, American cartoonist (b. 1894), creator of Popeye the Sailor (1929).

d. William Glackens, American painter and illustrator (b. 1870).

d. Ernest Kirchner, German artist (b. 1880), a founder of *Die Brücke* group (1905).

d. Ernst Barlach, German sculptor and dramatist (b. 1870).

d. Susan Hannah Macdowell Eakins, American painter, accomplished pianist, and amateur photographer (b. 1851); wife of Thomas Eakins.

d. George Grey Barnard, American sculptor (b. 1863).

THEATER & VARIETY

Abe Lincoln in Illinois, Robert Sherwood's play, about the Illinois years of Abraham Lincoln; Raymond Massey starred as Lincoln, also in the 1940 John Cromwell film.

Orson Welles and John Houseman's Mercury Theater presented Marc Blitzstein's *The Cradle Will Rock* on June 16, playing on a bare stage after a court injunction had stopped the then-controversial play's scheduled premiere; it later played at New York's Windsor Theatre.

Thornton Wilder's *Our Town* opened at New York's Henry Miller's Theatre on February 4.

Walter Huston starred in the Maxwell Anderson–Kurt Weill musical *Knickerbocker Holiday*, which introduced *September Song*; opened at New York's Ethel Barrymore Theatre.

The Corn Is Green, Emlyn Williams's play, set in a Welsh mining valley, starred Dame Sybil Thorndike and the author.

I Married an Angel, the Richard Rodgers–Lorenz Hart musical, opened at New York's Shubert Theatre.

Sophie Tucker and Victor Moore starred in Cole Porter's musical *Leave It to Me!*, book by Bella and Sam Spewack; opened at New York's Imperial Theatre on November 9.

On Borrowed Time, Paul Osborne's play, opened at New York's Longacre Theatre on February 3.

Clifford Odets's *Rocket to the Moon* opened at New York's Belasco Theatre on November 24.

The Boys from Syracuse, the Richard Rodgers–Lorenz Hart musical with book by George Abbott, opened at New York's Alvin Theatre.

Ole Olsen and Chic Johnson opened on September 22 in their musical review *Hellzapoppin*, at New York's 46th Street Theatre.

Intimate Relations, Jean Cocteau's play; basis of his 1954 film.

The Fifth Column, Ernest Hemingway's Spanish Civil War play.

Asmodee, François Mauriac's play.

Caligula, Albert Camus's play.

The Mother, Karel Capek's anti-Fascist play.

The School for Dictators, Ignazio Silone's anti-Fascist play.

When We Are Married, J. B. Priestley's play.

After the Dance, Terrence Rattigan's play.

d. Constantin Stanislavsky (Constantin Sergeivich Alexeyev), celebrated Russian director, actor, and teacher (b. 1863).

d. Gabriele D'Annunzio, Italian poet, novelist, and playwright (b. 1863).

d. Gösta Ekman, Swedish actor, director, and manager (b. 1890).

d. Capek, Czech writer (b. 1890).

MUSIC & DANCE

Romeo and Juliet, Sergei Prokofiev's ballet, libretto by Prokofiev and others, based on Shakespeare's tragedy, premiered December 30 in Brno.

Billy the Kid, American folk ballet, choreographed by

Eugene Loring, music by Aaron Copland, danced by Ballet Caravan at the Chicago Civic Theater, with Loring in the title role.

A Tisket a Tasket, Ella Fitzgerald's first hit and signature song; words and music by Fitzgerald and Al Feldman.

Frankie and Johnny, Ruth Page and Bentley Stone's ballet, music by Jerome Moross, first danced June 19 by the Page-Stone Ballet, Chicago.

Gaieté Parisienne, Leonid Massine's ballet, music by Jacques Offenbach, first danced April 5 by the Ballets Russes de Monte Carlo, in Monte Carlo.

My Heart Belongs to Daddy, Mary Martin's signature song, from Cole Porter's Leave It to Me.

September Song, Walter Huston's song, from the Kurt Weill–Maxwell Anderson musical Knickerbocker Holiday.

Filling Station, Lew Christensen's ballet, music by Virgil Thomson, first danced January 6, by Ballet Caravan at Hartford, Connecticut.

Arthur Honegger's stage oratorio Jeanne d'Arc au bûcher and vocal orchestral work La Danse des morts.

John Hammond's first "From Spirituals to Swing" Carnegie Hall concert.

Mathis der Maler (Mathis the Painter), Paul Hindemith's opera to his own libretto, opened at the Stadttheater in Zurich May 28.

Jeepers Creepers, Louis Armstrong's hit song; words by Johnny Mercer, music by Harry Warren.

Passcaglia in C Minor, Doris Humphrey's dance to Johann Sebastian Bach's music.

You Go to My Head, popular song, words by Haven Gillespie, words by Fred Coots.

Serenade to Music, Ralph Vaughan Williams's vocal/orchestral work.

American Document, Martha Graham's dance to music of Ray Green.

Richard Strauss's operas Daphne and Friedenstag (Day of Peace).

Dumbarton Oaks, Igor Stravinsky's orchestral work.

This Can't Be Love, Richard Rodgers and Lorenz Hart's song.

Aaron Copland's An Outdoor Overture.

Nobilissima visione, Paul Hindemith's ballet.

Arnold Schoenberg's Kol Nidre, for voices and orchestra.

Benjamin Britten's Piano Concerto.

The Snowstorm, Sergei Nikiforovich Vasilenko's opera.

The Incredible Flutist, Walter Piston's ballet.

Anton von Webern's String Quartet.

Béla Bartók's second violin concerto.

Karl V, Ernst Krenek's dramatic musical work.

Antonio e Cleopatra, Gian Francesco Malipiero's opera.

Glenn Miller formed his popular swing orchestra.

Michael Tippett's first piano sonata.

Olivier Messiaen's solo vocal work Chants de terre et de ciel.

Nylon strings began to replace uneven gut strings in musical instruments (from 1938).

Bruno Hoffman developed a "glass harp," a set of 47 glasses that are stroked to produce sound.

d. Feodor Ivanovich Chaliapin, Russian bass (b. 1873), best known for his portrayals of Boris Godunov and Charles Gounod's Méphistophélès.

d. King Oliver (Joseph Oliver), New Orleans jazz trumpeter, cornettist, bandleader, and composer (b. 1885), a highly influential figure in early jazz.

WORLD EVENTS

Anschluss: On March 12, Germany annexed Austria, without resistance of any kind from any source, encouraging further German aggression and bringing much closer the onset of World War II.

Munich Agreement (September 29–30): France and Great Britain entirely gave way to German demands for the Sudetenland, paving the way for German dismemberment of Czechoslovakia (March 1939) and making World War II inevitable. British Prime Minister Neville Chamberlain told his people that the agreement had brought "peace for our time."

Nazi anti-Jewish terror campaign throughout Germany began with Crystal Night (Kristallnacht, November 9–10), so named for the broken glass littering the streets when Germans destroyed Jewish homes, businesses, and places of worship.

Sino-Japanese War: Japanese continued to advance, taking Süchow, Kaifeng, Canton, the temporary Chinese capital of Hankow, and much of central China and more of North China. A Japanese spring offensive was stopped in June, when the Chinese flooded the plain of the Yellow River by breaking the river dikes.

Spanish Civil War: Republican forces stopped a Fascist drive on Barcelona on the Ebro, and were

decisively defeated when they went over to the offensive; in December, the next Fascist offensive would take Barcelona, effectively ending the war.

Food, Drug, and Cosmetic Act passed by U.S. Congress, setting up the Food and Drug Administration (FDA).

American Chester Carlson invented xerography.

1939

LITERATURE

Finnegan's Wake, James Joyce's final and landmark novel; a 1965 film adaptation was directed by Mary Ellen Bute.

The Grapes of Wrath, John Steinbeck's Pulitzer Prize–winning story of the "Okies" of the Great Depression; it was adapted into the 1940 John Ford film and the 1990 Frank Gelati play.

Celebrated Soviet Jewish writer Isaac Babel was arrested; he died in prison in 1940, and was "posthumously rehabilitated" in the mid-1950s.

Franz E. Sillanpää was awarded the Nobel Prize for Literature.

W. H. Auden's poem *September 1, 1939*, written after his 1939 emigration to the United States, at the end of an era.

Goodbye to Berlin, Christopher Isherwood's novel, set in Germany during the rise of Fascism; basis for John Van Druten's play *I Am a Camera*, itself basis for the play and then musical *Cabaret*.

W. H. Auden and Christopher Isherwood's *Journey to a War*; prose and poetry written after a 1938 trip to wartime China.

Raymond Chandler's first novel *The Big Sleep*, a mystery classic, introducing Philip Marlowe; basis for the Howard Hawks and Michael Winner films.

Carl Sandburg's four-volume Pulitzer Prize–winning *Abraham Lincoln: The War Years*.

Coming Up for Air, George Orwell's novel.

The Wild Palms, William Faulkner's novel.

Horizon, literary magazine founded by Cyril Connolly.

Old Possum's Book of Practical Cats, T. S. Eliot's poetry collection; basis of the 1982 Andrew Lloyd-Webber–Trevor Nunn musical *Cats*.

Tropic of Capricorn, Henry Miller's autobiographical novel, controversial in its time for its sexual language and themes.

Pale Horse, Pale Rider, three short Katherine Anne Porter novels published in one volume.

Day of the Locust, Nathanael West's surreal, anti-Hollywood novel; basis for the 1975 John Schlesinger film.

Dylan Thomas's poetry collection *The Map of Love*.

Mark Van Doren's Pulitzer Prize–winning *Collected Poems*.

Jean Rhys's novel *Good Morning, Midnight*.

After Many a Summer Dies the Swan, Aldous Huxley's novel.

Muriel Rukeyser's poetry collection *A Turning Wind*.

Wind, Sand, and Stars, Antoine de Saint-Exupéry's stories and essays.

The Seventh Cross, Anna Seghers's anti-Nazi novel; basis for the 1944 Fred Zinneman film.

Eric Ambler's novel *The Mask of Dimitrios*, set in the Balkans; basis for the 1944 Peter Lorre–Sidney Greenstreet film.

The Nazarene, first novel of Sholem Asch's trilogy that included *The Apostle* (1943) and *Mary* (1949).

Adventures of a Young Man, the first novel of the John Dos Passos trilogy that would include *Number One* (1943) and *The Grand Design* (1949).

Captain Horatio Hornblower, first of C. S. Forester's Napoleonic Wars sea-novel series; basis for the 1951 Raoul Walsh film.

Christopher Morley's novel *Kitty Foyle*, basis for the 1940 Sam Wood film.

Mrs. Miniver, Jan Struther's novel, set in early World War II Britain; basis for the 1942 William Wyler film.

Rumer Godden novel *Black Narcissus*, set in India; basis for the 1947 Michael Powell–Emeric Pressburger film.

How Green Was My Valley, Richard Llewellyn's novel, set in a turn-of-the-century Welsh mining valley; basis for the 1941 John Ford film.

Eugenio Montale's poetry collection *Opportunities*.

Robert Penn Warren's novel *Night Rider*.

Thomas Wolfe's posthumously published autobiographical novel *The Web and the Rock*.

Marguerite Yourcenar's novel *Coup de Grace*.

Modern paperback publishing began in America with the establishment of Pocket Books.

d. Ethel M. Dell, British novelist (b. 1881).

d. Ford Madox Ford (Ford Madox Hueffer), British writer, editor, and critic; his major work was the post–World War I tetrology *Parade's End*.

d. Zane Grey, author of over 50 Western novels (b. 1872).

d. William Butler Yeats, celebrated Irish poet and dramatist (b. 1865).

FILM & BROADCASTING

RCA demonstrated television at the New York City's World's Fair; the first TV sets went on sale to the public; and the first major league baseball game, college football game, and American president (Franklin Roosevelt) were transmitted.

Gone with the Wind, Vivien Leigh as Scarlett O'Hara and Clark Gable as Rhett Butler starred in Victor Fleming's classic film, adapted by Sidney Howard from the 1936 Margaret Mitchell book, a story set in the American South during the Civil War and Reconstruction and told from the Confederate point of view. The film's "opening night" was televised, a landmark event.

Wuthering Heights, Laurence Olivier as Heathcliff and Merle Oberon as Kathy starred in William Wyler's screen version of the Emily Brontë novel.

The Wizard of Oz, Judy Garland as Dorothy, Ray Bolger, Bert Lahr, Jack Haley, Frank Morgan, Billie Burke, and Margaret Hamilton starred in Victor Fleming's classic musical; based on the 1900 L. Frank Baum novel.

The Rules of the Game, Jean Renoir's film, a drama of destructive intrigue, told as a comedy; set in a French country house on the eve of World War II, the work was a metaphor for France then.

The Stars Look Down, Michael Redgrave as the young Welsh miner, Margaret Lockwood, Emlyn Williams, and Cecil Parker starred in Carol Reed's screen version of the 1935 A. J. Cronin novel.

Stagecoach, John Wayne starred in the classic John Ford Western, about a group of travelers and an Apache attack.

Of Mice and Men, Lon Chaney, Jr., as Lennie and Burgess Meredith as George starred in the Lewis Milestone film version of John Steinbeck's story and play.

Basil Rathbone starred as Sherlock Holmes in *The Hound of the Baskervilles*, the first of his 14 Holmes films (1939–1946); Nigel Bruce costarred as Dr. Watson.

Mr. Smith Goes to Washington, James Stewart as the naive, heroic American senator, Jean Arthur,

Claude Rains, and Edward Arnold starred in Frank Capra's populist fantasy classic.

Ninotchka, Greta Garbo as the ultimately seduced Russian and Melvyn Douglas starred Ernst Lubitsch's comedy, set in Paris; basis of Cole Porter's 1955 *Silk Stockings*.

Goodbye, Mr. Chips, Robert Donat and Greer Garson starred in the Sam Wood film, the story of a dedicated British teacher; based on the 1934 James Hilton novel.

The Hunchback of Notre Dame, Charles Laughton as Quasimodo, Maureen O'Hara, and Cedric Hardwicke starred in the Hugo Dieterle film version of the 1831 Victor Hugo novel.

Holiday, Katharine Hepburn and Cary Grant starred in the George Cukor comedy–love story, based on the 1928 Philip Barry play.

Dark Victory, Bette Davis and George Brent starred as the dying woman and her doctor–lover in the Edmund Goulding melodrama.

Daybreak, Jean Gabin starred as the trapped murderer in Marcel Carné's film; screenplay by Jacques Viot and Jacques Prévert.

James Stewart as the young marshal and Marlene Dietrich as the entertainer starred in *Destry Rides Again*, directed by George Marshall; Dietrich sang *See What the Boys in the Back Room Will Have*.

Angel Street, Thorold Dickinson's film, a period thriller based on the 1938 Patrick Hamilton play, an early version of *Gaslight*; Diana Wynyard and Anton Walbrook starred.

Golden Boy, William Holden starred as the boxer, opposite Barbara Stanwyck and Lee J. Cobb, in the Rouben Mamoulian film, based on the 1937 Clifford Odets play.

Idiot's Delight, Clark Gable and Norma Shearer starred in Clarence Brown's screen version of the 1936 Robert Sherwood comedy, set at the beginning of a world war.

The Four Feathers, John Clements, Ralph Richardson, June Duprez, and C. Aubrey Smith starred in the Zoltan Korda film, based on the 1902 A. E. W. Mason novel.

Fred Astaire and Ginger Rogers starred in *The Story of Vernon and Irene Castle*.

Henry Fonda starred in John Ford's *Young Mr. Lincoln*, and costarred with Tyrone Power as the James brothers in Henry King's *Jesse James*.

Academy Awards for 1939 (awarded the following

year): Best Picture: *Gone with the Wind*; Best Director: Victor Fleming, *Gone with the Wind*; Best Actor: Robert Donat, *Goodbye, Mr. Chips*; Best Actress: Vivien Leigh, *Gone with the Wind*.

d. Douglas Fairbanks (Douglas Elton Ulman), American actor, producer, and screenwriter (b. 1883).

d. Carl Laemmle, early American film producer (b. 1867).

VISUAL ARTS

New Museum of Modern Art, on 53rd Street, New York, was designed by Philip Goodwin and Edward Durell Stone.

Solomon Guggenheim founded the Museum of Non-Objective Painting, later renamed the Guggenheim Museum.

Frank Lloyd Wright's work included the Hert Jacobs House, Middleton, Wisconsin; the Winckler-Goetsch House, Okemos, Michigan; and the Johnson Wax Administration Building, Racine, Wisconsin.

Georges Braque's paintings included *The Painter and His Model* and *The Studio*.

Alexander Calder's sculptures included *Lobster Trap and Fish Tail* and *Spherical Triangle*.

Theodore Roosevelt, John Gutzon Borglum's monumental presidential sculpture at Mount Rushmore, South Dakota.

Alvar Aalto designed the Finnish Pavilion at the New York World's Fair.

Man on Fire, José Clemente Orozco's Hospicio Cabañas orphanage murals.

Portrait of the Bourgeoisie, David Alfaro Siqueiros's murals, Mexico City.

Walter Gropius and Marcel Breuer designed the Black Mountain College project, North Carolina.

Isamu Noguchi's sculpture *Capital*.

Ludwig Mies van der Rohe began the Illinois Institute of Technology, Chicago (1939–1941).

Lafayette Maynard Dixon's mural at the American Department of the Interior, Washington, D.C.

Ben Shahn's mural for the Jamaica, New York, Post Office (1939–1940).

Norman Bel Geddes designed the General Motors Futurama building at the New York World's Fair.

The First Mail Arrives at Bronxville, 1846; John Sloan's mural for the Bronxville Post Office.

Edward Hopper's painitng *Cape Cod Evening*.

Pablo Picasso's painting *Night Fishing at Antibes*.

Henry Moore's sculpture *The Bride* (1939–1940).

Rufino Tamayo's painting *Women of Tehuantepec*.

Georgia O'Keeffe's painting *Cup of Silver*.

Henri Matisse's painting *La Musique*.

Joseph Stella's painting *The Brooklyn Bridge*.

Elegy, Willem de Kooning's painting (ca. 1939).

Thomas Hart Benton's painting *Roasting Ears*.

Grant Wood's painting *Parson Weems' Fable*.

Jacob Epstein's sculpture *Adam*.

Alexander Archipenko's sculpture *Moses*.

Wassily Kandinsky's painting *Composition X*.

Ben Shahn's paintings included *Handball* and *Vacant Lot*.

Marc Chagall's painting *The Cellist*.

Harriet Tubman, Jacob Lawrence's painting (1939–1940).

Paul Klee's painting *Demonry*; and his drawing *Fear Erupting*.

Roger Fry's *Last Lectures*.

Ten Shots, Ten Cents, Reginald Marsh's painting.

Walt Kuhn's painting *Girl with Plume*.

Woodrow Wilson Memorial, Paul Manship's sculpture, for the League of Nations complex, Geneva, Switzerland.

Cartoon History of Our Times, a collection of David Low political cartoons.

Inward Preoccupation, painting by Bradley Walker Tomlin.

Batman was created as a cartoon character by Robert Kane.

d. Joseph Duveen, British art dealer (b. 1869), working in both England and America; specialized in supplying wealthy American collectors with classic artworks, especially "old masters," many of which ultimately became bequests to major American art museums; his own bequest went to Britain's National Gallery.

THEATER & VARIETY

The Little Foxes, Tallulah Bankhead starred as Regina Giddens in the Lillian Hellman play about a corrosive Southern family; opened in New York.

Katharine Hepburn, Van Heflin, Shirley Booth, and Joseph Cotten starred in *The Philadelphia Story*; Philip Barry's comedy opened in New York.

Key Largo, Paul Muni starred as the Spanish Civil War veteran in Maxwell Anderson's play, set in

the Florida Keys; opened at New York's Ethel Barrymore Theatre on November 27.

My Heart's in the Highlands, William Saroyan's play, opened at New York's Guild Theatre April 13.

The Time of Your Life, William Saroyan's play, opened at New York's Booth Theatre on October 25.

Ondine, Jean Giraudoux's play, opened in Paris with Jouvet as Hans and Madeleine Ozeray as Ondine.

Stephen Vincent Benét's *The Devil and Daniel Webster*, music by Douglas Moore, opened at New York's Martin Beck Theatre on May 18.

Monty Woolley starred as Sheridan Whiteside (reportedly modeled on drama critic Alexander Woollcott) in *The Man Who Came to Dinner*; the Moss Hart–George S. Kaufman comedy opened at New York's Music Box Theatre on October 16.

Gertrude Lawrence starred in *Skylark*; Samson Raphaelson's comedy opened in New York.

Cole Porter's *DuBarry Was a Lady*, book by Buddy De Sylva and Herbert Fields, opened in New York.

Life with Father, Howard Lindsay and Dorothy Stickney starred as the early 1900s New York couple in the Lindsay–Russell Crouse comedy; opened at New York's Empire Theatre.

Margin for Error, the play by Clare Booth (Luce), opened at New York's Plymouth Theatre.

Morning's at Seven, Paul Osborn's comedy, opened at New York's Longacre Theatre on November 30.

Margalo Gillmore, Laurence Olivier, and Katharine Cornell starred in *No Time for Comedy*; S. N. Behrman's play opened at New York's Ethel Barrymore Theatre on April 17.

The Gentle People, Irwin Shaw's play, opened at New York's Belasco Theatre on January 5.

Barry Fitzgerald and Jessica Tandy starred in *The White Steed*; Paul Vincent Carroll's play opened in New York on January 10.

Alexei Nikolayevich Arbuzov's *Tanya*.

Armand Salacrou's *Histoire de rire*.

Denis Johnston's *The Golden Cuckoo*.

In Good King Charles's Golden Days, George Bernard Shaw's play.

T. S. Eliot's *The Family Reunion*.

The Death of Cuchulain, William Butler Yeats's play.

Gerhart Hauptmann's *Die Tochter der Kathedrale*.

Kjeld Abell's *Anna Sophie Hedvig*.

Leonid Maximovich Leonov's *The Snowstorm*.

Robert Ardrey's *Thunder Rock*.

d. Mrs. Patrick Campbell (Beatrice Stella Tanner), British actress (b. 1865), in 1914 in London the first English-language Eliza Doolittle in George Bernard Shaw's *Pygmalion*, opposite Herbert Beerbohm Tree as Henry Higgins.

d. Sidney Coe Howard, American playwright (b. 1891).

d. Ernst Toller, German playwright (b. 1893).

d. Fay Templeton, vaudeville singer (b. 1865).

d. Frank Robert Benson, English actor–manager (b. 1858).

MUSIC & DANCE

Marian Anderson gave a celebrated Easter Sunday concert at the Lincoln Memorial, in Washington, D.C., attended by 75,000–100,000 people; the concert was sponsored by Eleanor Roosevelt, who had resigned from the Daughters of the American Revolution after they denied Anderson use of Constitution Hall because of her race.

God Bless America was introduced by Kate Smith on radio, becoming an emblematic American patriotic song on the eve of another world war; Irving Berlin's song had been written for but not used in *Yip Yip Yaphank* (1918).

Judy Garland introduced *Over the Rainbow* in *The Wizard of Oz*; music by Harold Arlen, words by Yip Harburg.

Myra Hess, the indomitable classical pianist, began her long series of lunchtime concerts at London's National Gallery during World War II; she would play on, right through the Blitz.

We'll Meet Again, British World War II song, by Ross Parker and Hughie Charles; the signature song of Vera Lynn, the "Forces Sweetheart."

Capriccio Español, Leonide Massine's ballet, music by Nikolay Rimsky-Korsakov, first danced May 4 by the Ballets Russes de Monte Carlo at Monte Carlo.

Sergei Prokofiev's cantata *Alexander Nevsky*, derived from film score written for Eisenstein's film of the same name; also Prokofiev's opera *Semyon Kotko* and cantata *Zdravitsa*.

Strange Fruit, the anti-lynching song that became identified with "Lady Day," Billie Holiday; words and music by Lewis Allan.

There'll Always Be an England, Ross Parker and Hughie Charles's World War II song.

The Old Maid and the Thief, Gian Carlo Menotti's opera, had its world premiere on radio.

Aaron Copland's film score *The City* and *Of Mice and Men*.

If I Didn't Care, words and music by Jack Lawrence; signature song of the Ink Spots.

Bacchanale, Salvador Dali's ballet, premiere by Ballets Russes de Monte Carlo.

Frank Sinatra began singing with Harry James's band, his first record being *All or Nothing at All* (a 1943 hit on rerelease).

William Walton's *Violin Concerto*.

Pocahontas, Elliott Cook Carter's ballet.

Every Soul Is a Circus, Martha Graham's dance to music by Paul Nordhoff.

Merce Cunningham joined the Martha Graham company.

Woody Guthrie's *So Long, It's Been Good to Know You*.

Alwin Nikolais's dance *Eight Column Line*; music by E. Klenek.

Woody Herman's band recorded *The Woodchopper's Ball*.

All the Things You Are, words by Oscar Hammerstein II, music by Jerome Kern, from *Very Warm for May*.

Howard Hanson's *Fantasy for String Orchestra*.

Henry Cowell's *A Celtic Symphony*.

I Didn't Know What Time It Was, words by Lorenz Hart, music by Richard Rodgers, from *Too Many Girls*.

William Schuman's *Prelude for Voices*.

Do I Love You?, words and music Cole Porter from *Du Barry Was a Lady*.

Roger Sessions's *Pages from a Diary*.

Leonard Warren debuted at the Metropolitan Opera in *Simon Boccanegra*.

I'll Never Smile Again, words and music by Ruth Lowe.

Benjamin Britten's choral work *Ballad of Heroes* and *Violin Concerto*.

Peacock Variations, Zoltán Kodály's orchestral work.

Béla Bartók's *Divertimento for Strings* and his sixth string quartet.

First Cantata, Anton von Webern's choral work.

Roy Harris's *Symphony No. 4*.

South of the Border, words and music by Jimmy Kennedy and Michael Carr.

Medea, Darius Milhaud's opera.

Coleman Hawkins's record of *Body and Soul*.

Arnold Bax's *Symphony No. 7*.

Imaginary Landscape No. 1, John Cage's percussion work.

Michael Tippett's *Concerto for Double String Orchestra*.

Olivier Messiaen's *Les Corps glorieux*, for organ.

Arnold Schoenberg's *Chamber Symphony No. 2*, begun as early as 1906.

d. Ma Rainey (Gertrude Pridgett), American blues singer (b. 1886), a major figure in the history of the blues.

WORLD EVENTS

Spanish Civil War: Barcelona fell in January; France and Britain recognized Franco's government in February; the war ended when Madrid and Valencia surrendered in March.

Hitler continued his march to World War II: Germany occupied Czechoslovakia in March, concluded a 10-year alliance with Italy in May, and concluded the key Nazi–Soviet Pact (August 23–24). This "nonaggression" pact provided for partition of Poland between Germany and the Soviet Union, after German attack, with spheres of influence in Baltic, and would open the way for the Nazi attack on Poland.

Italy invaded and occupied Albania in April.

Sino-Japanese War: Kuomintang and Communist forces fought the Japanese to a standstill; the Japanese prepared for the 1940 invasion of Indo-China.

Winston Churchill, long a "voice in the wilderness," became first lord of admiralty in Britain.

World War II began, with the September 1 German invasion of Poland, followed by the September 3 French and British declarations of war on Germany. The British Expeditionary Force began to arrive in France, as the "Phony War" period began on the western front, while at sea the long Battle of the Atlantic began with the torpedoing of the *Athenia* off Ireland (September 3).

Finnish–Soviet War began, with the November 30 Soviet invasion of Finland.

Physicists Lise Meitner and Otto Frisch theorized that uranium could be split into smaller atoms, calling the process *nuclear fission*.

Albert Einstein wrote to President Franklin D. Roo-

sevelt of fears about German research activities, beginning the chain of research and events that would lead to the development of the atom bomb.

Migration of European artists and intellectuals to United States accelerated, with the arrival of such world figures as W. H. Auden, Thomas Mann, Igor Stravinsky, Yves Tanguy, and Wyndham Lewis.

U.S. Neutrality Act of 1939 allowed arms shipments to Allies; Roosevelt asked Congress for $552 million for defense.

Battle of the River Plate, off Montevideo; German pocket battleship *Graf Spee* disabled and sunk.

H.M.S. *Royal Oak* was sunk at Scapa Flow.

Burma Road opened; from Lashio, Burma, to K'unming, China.

Major floods along the Yangtze and other Chinese rivers caused an estimated 500,000 deaths.

New York World's Fair and San Francisco International Exposition opened.

Swiss chemist Paul Müller discovered that DDT was a powerful insecticide.

1940

LITERATURE

Native Son, Richard Wright's landmark novel, about African-American life on Chicago's South Side; basis of the 1941 Wright–Paul Green play, and Pierre Chenal's 1950 and Jerrold Freedman's 1986 films.

The Hamlet, first of William Faulkner's Snopes family novels.

Federico García Lorca's poetry *Poet in New York*.

B. Traven's "Jungle-novels" series, written during the 1940s: *Government*, *The Carreta*, *March to the Monteria*, *The Troza*, *The Rebellion of the Hanged*, and *The General from the Jungle*.

The Master and Margarita, Michael Bulgakov's long-suppressed novel, not published until the late 1960s.

Dylan Thomas's autobiographical work *Portrait of the Artist as a Young Dog*.

Edmund Wilson's critical work *To the Finland Station*.

William Riley Burnett's novel *High Sierra*; basis of the 1941 Raoul Walsh film.

You Can't Go Home Again, Thomas Wolfe's posthumously published autobiographical novel.

For Whom the Bell Tolls, Ernest Hemingway's novel set in the Spanish Civil War; basis of the 1943 film.

C. P. Snow published *Strangers and Brothers*, first of his 11-volume series of novels exploring private conscience and public power.

Arthur Koestler's novel *Darkness at Noon*, an exposé of the show trials of Stalin's Great Purge.

And Then There Were None, Agatha Christie's novel, basis of the 1945 René Clair film and two sequels, both titled *Ten Little Indians* (1966, 1975).

The Heart Is a Lonely Hunter, Carson McCullers's novel.

Farewell, My Lovely, Raymond Chandler's Philip Marlowe mystery novel; basis of Edward Dmytryk's 1944 film *Murder, My Sweet* and Dick Richards's 1975 film *Farewell, My Lovely*.

Journey into Fear, Eric Ambler's espionage novel, set in the Middle East; basis for the 1940 Orson Welles film.

The Razor's Edge, Somerset Maugham's novel.

The Trees, first in Conrad Richter's *The Awakening Land* trilogy.

New England: Indian Summer, Van Wyck Brooks's literary history.

Come Back to Erin, Sean O'Faolain's novel.

Fame Is the Spur, Howard Spring's novel; basis of the 1946 film.

George Seferis's poetry *The Exercise Book*.

H. L. Mencken's autobiographical work *Happy Days*.

James Thurber's *Fables for Our Time*.

Sapphira and the Slave Girl, Willa Cather's novel.

Kay Boyle's story *The Crazy Hunter*.

The Power and the Glory, Graham Greene's novel.

Lion Feuchtwanger's *Paris Gazette*.

Kenneth Rexroth's poetry *In What Hour?*

Li Fei-kan's novel *Autumn*.

Mulk Raj Anand's novel *Across the Black Waters*.

The Earth Is Ours, Carl Moberg's novel.

Walter Van Tilburg Clark's novel *The Oxbow Incident*.

William Saroyan's *My Name Is Aram*.

d. DuBose Heyward, American author (b. 1885).

d. Edwin Markham, American poet (b. 1852).

d. F. Scott (Francis Scott Key) Fitzgerald, American writer (b. 1896).

d. Hamlin Garland, American writer (b. 1860).

d. Michael Bulgakov, Soviet writer (b. 1891).

d. Nathanael West (Nathan Weinstein), American writer (b. 1903).

d. Selma Lagerlöf, Swedish writer (b. 1859).

d. Thomas Beer, American writer (b. 1889).

FILM & BROADCASTING

American network television officially debuted with an NBC broadcast from the General Electric station, WRGB, at Schenectady, New York, on February 1; by midyear there were 22 other American television stations.

The Grapes of Wrath; John Ford directed the film version of the John Steinbeck novel, starring Henry Fonda, Jane Darwell, and John Carradine.

Pride and Prejudice, Greer Garson, Laurence Olivier, Edmund Gwenn, and Maureen O'Sullivan starred in Robert Z. Leonard's film loosely based on Jane Austen's novel; screenplay by Aldous Huxley and Jane Murfin.

Rebecca, Joan Fontaine, Laurence Olivier, Judith Anderson, and George Sanders starred in Alfred Hitchcock's period thriller; based on the 1938 Daphne du Maurier novel.

Ginger Rogers starred in *Kitty Foyle*, directed by Sam Wood.

Raymond Massey recreated his stage role as Lincoln in *Abe Lincoln in Illinois*, directed by John Cromwell and based on the 1938 Robert Sherwood play.

Fantasia, the trailblazing Walt Disney film, merging animation and classical music played by Leopold Stokowski and the Philadelphia Orchestra.

The Philadelphia Story, Katharine Hepburn as Tracy Lord, James Stewart, and Cary Grant starred in George Cukor's film version of the Philip Barry play about the Main Line in Philadelphia.

Edward R. Murrow reported to America directly from the Blitz, his "This is London" radio reports fanning American pro-Allied sentiments.

The Mortal Storm, Margaret Sullavan, James Stewart, Frank Morgan, and Robert Young starred in Frank Borzage's anti-Nazi film, set in Germany.

The Great Dictator, Charles Chaplin's satire; he wrote, directed, and starred as both the Jewish barber and Adenoid Hynkel (Adolf Hitler), with Jack Oakie as Mussolini, and Paulette Goddard.

The Long Voyage Home, Thomas Mitchell, John Wayne, and Barry Fitzgerald starred in John Ford's film, based on four one-act Eugene O'Neill plays.

Bitter Sweet, Jeannette MacDonald and Nelson Eddy starred in the W. S. Van Dyke film, a Hollywood adaptation of the 1929 Noël Coward stage musical.

Northwest Passage, Spencer Tracy starred in King Vidor's screen version of the 1937 Kenneth Roberts historical novel.

Bob Hope, Bing Crosby, and Dorothy Lamour starred in *The Road to Singapore*, the first of their seven "Road" films.

Gary Cooper and Walter Brennan starred in *The Westerner*, directed by William Wyler.

His Girl Friday, Cary Grant, Rosalind Russell, and Ralph Bellamy starred in the Howard Hawks film, based on the 1928 Ben Hecht–Charles MacArthur play *Front Page*, about Chicago newspaper people.

Katharine Hepburn and Spencer Tracy starred in *Woman of the Year*, the first of the nine classic films made by the longtime professional and personal partners.

Our Town, William Holden, Martha Scott, and Frank Craven starred in Sam Wood's screen version of the Thornton Wilder play, set in New England.

Paul Robeson starred in *Proud Valley*.

The Mark of Zorro, Tyrone Power and Basil Rathbone starred in Rouben Mamoulian's remake of the classic 1920 Fred Niblo film.

Charles Laughton and Carole Lombard starred in *They Knew What They Wanted*, directed by Garson Kanin.

Waterloo Bridge, Vivien Leigh and Robert Taylor starred in Mervyn LeRoy's screen version of Robert Sherwood's 1930 wartime love story, originally set in World War I.

Bud Abbott and Lou Costello starred in *Buck Privates*.

W. C. Fields starred in *The Bank Dick*.

Peter Goldmark developed a way to produce effective color television.

Academy Awards for 1940 (awarded the following year): Best Picture: *Rebecca*; Best Director: John Ford, *The Grapes of Wrath*; Best Actor: James Stewart, *The Philadelphia Story*; Best Actress: Ginger Rogers, *Kitty Foyle*.

d. Tom Mix, American cowboy star (b. 1880).

VISUAL ARTS

Constantin Brancusi's sculpture *Bird in Flight*, a cele-

brated, highly abstracted version of the long series that began in 1912 with the *Maiastra*.

Four boys looking for a dog found the cave at Lascaux, in France's Dordogne Valley, with its prehistoric cave paintings.

Alexander Calder's sculptures included *Black Beast* and *Thirteen Spines*.

Edward Weston's photo collection *California and the West*.

Eliel and Eero Saarinen designed the Tabernacle Church of Christ, Columbus, Indiana, and the Berkshire Music Center pavilion.

Museum of Modern Art photo collection opened, a landmark recognition of the art of photography.

Georgia O'Keeffe's paintings included *Datura and Perdenal*, *Red and Yellow Cliffs*, *Stump on Red Hills*, and *White Place in Shadow*.

Ansel Adams directed the Pageant of Photography Exhibition at the Golden Gate International Exposition.

Frank Lloyd Wright began *Florida Southern College*, Lakeland, Florida (1940–1949).

Ben Shahn's mural for the Social Security Building (now the Dept. of Health, Education, and Welfare), Washington, D.C. (1940–1942).

Walter Gropius and Marcel Breuer designed the Workers' Village, New Kensington, Pennsylvania.

Edward Hopper's painting *Gas*.

Piet Mondrian's painting *Composition London* (1940–1942).

William Zorach's sculpture *Head of Christ*.

Jacques Lipchitz's sculpture *Flight*.

Aristide Maillol's sculpture *Dina*.

Wassily Kandinsky's painting *Moderation*.

Report from Rockport, Stuart Davis's painting.

Oskar Kokoschka's painting *The Red Egg* (1940–1941).

Paul Klee's painting *Death and Fire*.

Edvard Munch's painting *Between Clock and Bed, Self-Portrait*.

Paul Nash's painting *Night Fighter*.

Fishermen's Last Summer, Marsden Hartley's painting (1940–1941).

Joan Miró's painting *Woman in the Night*.

Martial Memory, Philip Guston's painting (1940–1941).

Rockefeller Center was completed.

Students of the Torah, Max Weber's painting (ca. 1940).

d. Lewis Wickes Hine, American photo-essayist (b. 1874), most notably of Ellis Island and the immigrant experience.

d. Paul Klee, Swiss artist (b. 1879), a member of the Blue Rider (*Blaue Reiter*) group and a major, very prolific colorist and modernist.

d. Edouard Vuillard, French artist (b. 1868).

d. Gunnar Asplund, Swedish architect (b. 1885).

THEATER & VARIETY

d. Vsevolod Meyerhold, Soviet actor and director (b. 1874), a world figure in the theater, and an old Bolshevik who died a victim of Stalinism in a Soviet prison.

The American Negro Theatre was founded.

The Time of Your Life, Eddie Dowling as the San Francisco waterfront saloon bartender, Gene Kelly, Julie Haydon, and Edward Andrews starred in the William Saroyan play; opened at New York's Booth Theatre on October 25.

Battle of Angels, early Tennessee Williams play; in 1957, he would rework it into *Orpheus Descending*.

Cabin in the Sky, the Lynn Root–John La Touche musical; an all-black cast starred Ethel Waters, Rex Ingram, Todd Duncan, Katherine Dunham, Dooley Wilson, and J. Rosamond Johnson; opened at New York's Martin Beck Theatre.

Ernest Hemingway and Benjamin Glazer's play *The Fifth Column* opened at New York's Alvin Theatre.

There Shall Be No Night, Robert E. Sherwood's play, opened at New York's Alvin Theatre April 29.

Ethel Merman starred in Cole Porter's musical *Panama Hattie*; opened at New York's 46th Street Theatre October 30.

Shirley Booth and Jo Ann Sayers starred in *My Sister Eileen*; the Joseph A. Fields–Jerome Chodorov comedy opened at New York's Biltmore Theatre.

Pal Joey, Gene Kelly starred in the Richard Rodgers–Lorenz Hart musical, book by John O'Hara; opened at the Ethel Barrymore Theatre, New York, December 25.

George Washington Slept Here, the George S. Kaufman–Moss Hart comedy, opened at the Lyceum Theatre, New York, October 18.

Johnny Belinda, Helen Craig, Horace McNally, and Willard Parker starred in the Elmer Harris

tragedy, the story of a victimized deaf mute girl; opened at the Belasco Theatre, New York.

Judith Anderson starred in John Gassner's *The Tower Beyond Tragedy*.

Irving Berlin's *Louisiana Purchase* opened at the Imperial Theatre, New York, May 28; Victor Moore and William Gaxton starred.

Jessie Royce Landis and Walter Huston starred in *Love's Old Sweet Song*; William Saroyan's play opened in New York on May 2.

Gene Tierney and Elliott Nugent starred in *The Male Animal*; the James Thurber–Nugent comedy, opened at the Cort Theatre, New York, January 9.

The Star Turns Red, Sean O'Casey's play.

Alberti Rafael's *Clover in Flower*.

Flight to the West, Elmer Rice's play.

d. Mrs. Patrick Campbell (Beatrice Stella Tanner), English actress (b. 1865).

d. Maxine Elliott, American actress (b. 1868).

d. Walter Hasenclever, German playwright and novelist (b. 1890).

MUSIC & DANCE

Romeo and Juliet, Leonid Lavrovsky's ballet, music by Sergei Prokofiev, first danced January 11, by the Kirov Ballet in Leningrad (St. Petersburg), with Konstantin Sergueyev and Galina Ulanova in the leads.

Walt Disney's animated film *Fantasia* used stereophonic sound (not yet practical for individual use) to enhance the sound of the Philadelphia Orchestra providing the music.

Frank Sinatra began singing with Tommy Dorsey's band, their first hits being *Polka Dots and Moonbeams* and *I'll Never Smile Again*, which topped the charts.

La Fête Étrange, Andrée Howard's ballet, to music by Gabriel Fauré, first danced May 23 by the London Ballet.

Graduation Ball, David Lichine's ballet, to music by Johann Strauss arranged by Antal Dorati, first danced February 28 by the Original Ballet Russe company, in Sydney, Australia.

The Last Time I Saw Paris, Oscar Hammerstein II and Jerome Kern's song, introduced by Ann Sothern in the film *Lady, Be Good*, but popularized by Kate Smith.

Seven Sonnets of Michelangelo, song cycle created by

Benjamin Britten for Peter Pears; also Britten's *Sinfonia da requiem*.

Pete Seeger, Woody Guthrie, Lee Hays, and Millard Lampell formed the Almanac Singers.

Paul Hindemith's *Symphony in E Flat* and *The Four Temperaments* for piano and strings.

William Walton's orchestral works *Scapino* and *The Wise Virgins*.

Taking a Chance on Love, song popularized by Ethel Waters; words by John Latouch and Ted Fetter, music by Vernon Duke.

Evgeny Brusilovsky's *Gulyandom*, the first Uzbek national ballet.

The Nearness of You, Hoagy Carmichael's song, lyrics by Ned Washington, popularized by Connie Boswell.

Katherine Dunham's *Tropics and Le Jazz Hot—From Haiti to Harlem*.

It Never Entered My Mind, Richard Rodgers and Lorenz Hart's song.

Aram Khachaturian's *Violin Concerto*.

Dmitri Shostakovich's *Piano Quintet*.

You Are My Sunshine, Jimmie Davis and Charles Mitchell's song.

Igor Stravinsky's *Symphony in C Major*.

Our Town, Aaron Copland's film score.

Anton von Webern's *Variations for Orchestra*.

Béla Bartók's *Concerto for two pianos*.

Samuel Barber's *Violin Concerto*.

Zoltán Kodály's *Concerto for Orchestra*.

Dante Sonata, Frederick Ashton's ballet.

Moïse, Darius Milhaud's ballet.

John Cage's *Bacchanale* for prepared piano.

Night Flight (*Volo di Notte*), Luigi Dallapicolla's first opera.

Panambi, Alberto Ginastera's ballet.

Ildebrando Pizzetti's *Symphony*.

d. Johnny Dodds, New Orleans jazz clarinetist (b. 1892).

d. Frederick Shepherd Converse, American composer (b. 1871).

WORLD EVENTS

Franklin Delano Roosevelt defeated Republican Wendell Willkie to win an unprecedented third presidential term.

Winston Churchill became prime minister of Britain (1940–1945).

Soviet offensive breached Mannerheim Line; defeated Finns granted the Soviet Union bases it had demanded at start of Soviet–Finnish war.

Soviet troops murdered an estimated 10,000 Polish soldiers and officers at Katyn Forest.

German forces took Denmark and Norway in April, and on May 10 invaded France, Holland, and Belgium. On May 13, German armor broke through at Sedan and crossed the Meuse, splitting and within two days smashing the French army in the Battle of France. Holland surrendered on May 14, Belgium May 28, the Germans marched into Paris June 14, and France surrendered June 21. The British army of more than 200,000 soldiers was evacuated at Dunkirk June 4.

Battle of Britain: Contest for air supremacy over Britain between Royal Air Force (RAF) and Luftwaffe was won by RAF, stopping planned German invasion of Britain; Germans switched to the Blitz, unsuccessful terror bombing of London and other British cities, notably Coventry (November 14–15), which became a symbol of British will to defeat the Nazis.

German heavy battleship *Bismarck* was sunk by the British navy.

Henri Phillippe Pétain became premier of the Vichy government of unoccupied France, collaborating with the Germans for the balance of the war.

After the fall of France, a Free French government-in-exile operated out of London; from June, it was led by Charles de Gaulle.

In North Africa, small British forces defeated invading Italian forces at Sidi Barrani, Bardia, and Tobruk.

Destroyers-for-bases swap (September), really a gift of 50 destroyers from America to Britain for use in the Battle of the Atlantic.

Anti-Comintern Pact (November 25), a German–Japanese treaty pledging support against Soviet Union.

Israeli terrorist Stern Gang (Lehi; Fighters for the Freedom of Israel) founded by Abraham Stern.

Italian and German forces took Greece (October 1940–April 1941).

Japanese troops occupied French Indochina (September 22).

Mohammad Ali Jinnah, head of the Muslim League, demanded the establishment of an independent Islamic state of Pakistan.

Benjamin Oliver Davis became the first African-American general in the United States.

American chemists Glenn Seaborg and Edwin M. McMillan discovered plutonium, an essential element in nuclear weapons and reactors.

Howard Walter Florey and Ernst Boris Chain isolated penicillin and refined it for medical use.

d. Leon Trotsky (Lev Davidovich Bronstein), an old Bolshevik (b. 1879), who had lost a power struggle with Stalin and been in exile from 1929; assassinated by Comintern agents in Mexico (August 20).

d. Neville Chamberlain (b. 1869), British prime minister (1937–1940), who had attempted to appease Hitler, most notably at Munich.

1941

LITERATURE

William Rose Benét's Pulitzer Prize–winning novel *The Dust Which Is God.*

Let Us Now Praise Famous Men, the classic work on Depression-era Southern tenant farmers, with James Agee's text and Walker Evans's photos.

Mildred Pierce, James M. Cain's novel about a woman who destroys her family by singlemindedly pursuing her career; basis of the 1945 Michael Curtiz film.

Random Harvest, James Hilton's love story about an amnesiac war casualty and the woman who marries him twice; Mervyn Leroy directed the 1942 screen version.

The Keys of the Kingdom, A. J. Cronin's novel, the story of a missionary priest in China; basis of the 1944 John M. Stahl film.

The Song of Bernadette, Franz Werfel's novel; basis of the 1943 Henry King film.

Thomas Wolfe's short stories *The Hills Beyond.*

New Criticism, John Crowe Ransom's influential work stressing analysis of literary text itself, apart from the author's life and purposes.

The Woman of the Pharisees, François Mauriac's novel.

Budd Schulberg's novel *What Makes Sammy Run?*

Eudora Welty's short stories *A Curtain of Green.*

Reflections in a Golden Eye, Carson McCullers's novel.

Saratoga Trunk, Edna Ferber's novel, basis of the 1945 film.

Frenchman's Creek, Daphne du Maurier's novel.

Theodore Roethke's poetry *Open House*.

Flotsam, Erich Maria Remarque's novel.

Between the Acts, Virginia Woolf's novel.

Herself Surprised, Joyce Cary's novel.

Edgar Lee Masters's *Illinois Poems*.

H. M. Pulham, Esquire, J. P. Marquand's novel.

H. L. Mencken's autobiographical work *Newspaper Days*.

Hamilton Basso's novel *Wine of the Country*.

The Fall of Paris, Ilya Ehrenburg's war novel.

José Lezama Lima's poetry *Hostile Sounds*.

Juan Carlos Onetti's novel *No Man's Land*.

Ludwig Bemelmans's short stories *At Your Service* and *Hotel Splendide*.

Mark Van Doren's essays *Private Reader*.

Taylor Caldwell's novel *The Earth Is the Lord's*.

The Colossus of Maroussi, Henry Miller's novel.

The Living and the Dead, Patrick White's novel.

The Real Life of Sebastian Knight, Vladimir Nabokov's novel.

d. James Joyce, Irish writer (b. 1882), a seminal figure in world literature.

d. Virginia Woolf (Adeline Virginia Stephen), leading British writer, Bloomsbury group member, and feminist (b. 1882), a suicide.

d. Isaak Emanuilovich Babel, Soviet writer (b. 1894), who celebrated the Bolshevik Revolution and Russian Civil War in *Red Cavalry*; he died a political prisoner.

d. Rabindranath Tagore, Indian writer, composer, and painter (b. 1861).

d. Sherwood Anderson, American writer (b. 1876).

FILM & BROADCASTING

Citizen Kane, the classic Orson Welles film, his first; based on the life of William Randolph Hearst. Welles produced, directed, starred, and cowrote the screenplay with Herman J. Mankiewicz.

The Maltese Falcon, Humphrey Bogart, Mary Astor, Sidney Greenstreet, and Peter Lorre starred in John Huston's classic film, set in San Francisco; based on the 1930 Dashiell Hammett novel.

High Sierra, Humphrey Bogart as trapped killer "Mad Dog" Earle starred with Ida Lupino in the Raoul Walsh film; screenplay by W. R. Burnett and John Huston, based on Burnett's novel.

The Little Foxes, Bette Davis starred as Regina Giddens in William Wyler's screen version of the 1939 Lillian Hellman play, about a corrosive Southern family.

So Ends Our Night, Fredric March, Margaret Sullavan, Glenn Ford, and Erich von Stroheim starred in John Cromwell's film version of the Erich Maria Remarque's *Flotsam*, an anti-Nazi novel about European refugees.

Major Barbara, Wendy Hiller and Rex Harrison starred in Gabriel Pascal's screen version of the 1905 George Bernard Shaw play.

Meet John Doe, Gary Cooper as the down-and-outer who refuses to be used by sinister big-money politicians starred with Barbara Stanwyck in Frank Capra's Depression-era populist film.

How Green Was My Valley, Walter Pidgeon and Maureen O'Hara starred in the John Ford film, set in a Welsh mining valley; based on the Richard Llewellyn novel.

Back Street, Margaret Sullavan and Charles Boyer starred as the mistress and her married lover in Robert Stevenson's film version of the 1931 Fannie Hurst melodrama.

Cary Grant and Joan Fontaine starred in Alfred Hitchcock's *Suspicion*.

Barbara Stanwyck and Henry Fonda starred in *The Lady Eve*, written and directed by Preston Sturges.

Blood and Sand, Rouben Mamoulian's remake of the 1922 Rudolph Valentino vehicle; Tyrone Power starred as the bullfighter.

Dr. Jekyll and Mr. Hyde, Spencer Tracy starred in the dual doctor–monster role in the Victor Fleming film, based on the 1886 Robert Louis Stevenson story.

Hold Back the Dawn, Charles Boyer and Olivia de Havilland starred in the Mitchell Leisen film, set in a Mexican border town; screenplay by Billy Wilder and Leigh Brackett.

Gary Cooper, Walter Brennan, and Joan Leslie starred in *Sergeant York*, directed by Howard Hawks.

The Devil and Daniel Webster, the William Dieterle film, based on the 1939 Stephen Vincent Benét short story; Walter Huston starred as the Devil and Edward Arnold as Daniel Webster.

The Sea Wolf, Edward G. Robinson, John Garfield, and Ida Lupino starred in the Michael Curtiz screen version of the 1903 Jack London novel.

Tobacco Road, John Ford's screen version of the 1932 Erskine Caldwell novel, about a demoralized

Depression-era Georgia farm family; Marjorie Rambeau, Gene Tierney, Charley Grapewin, and Dana Andrews starred.

Vsevolod Pudovkin directed *Suvorov*.

Commercial television authorized by the Federal Communications Commission (FCC) formally began on July 1, with 15 hours of programming from New York City's WNBT.

Academy Awards for 1941 (awarded the following year): Best Picture: *How Green Was My Valley*; Best Director: John Ford, *How Green Was My Valley*; Best Actor: Gary Cooper, *Sergeant York*; Best Actress: Joan Fontaine, *Suspicion*.

d. Edwin Stanton Porter, American cinematographer and director (b. 1869), who directed *The Great Train Robbery*.

VISUAL ARTS

National Gallery in Washington, D.C., opened; at its core were the Mellon, Kress, and Widener collections.

Georgia O'Keeffe's paintings included *An Orchid* and *Red Hills and Bones*.

Andrew Wyeth's paintings included *Blueberry Rackers, Grasses, Farm at Broad Cove, Cushing, Maine*.

Eliel and Eero Saarinen designed the Cranbrook Academy of Art, Bloomfield Hills, Michigan.

Jackson Pollock's paintings included *Birth, Bird*, and *Naked Man with Knife*.

Alexander Calder's sculptures included *Cockatoo* and *Hour Glass*.

Edward Hopper's painting *Nighthawks*.

Pablo Picasso's painting *Head of D.M.*

Adolph Gottlieb began his *Pictograph* series (1941–1951).

Robert Motherwell's painting *The Little Spanish Prison*.

Arshile Gorky's painting *Garden in Sochi*.

Wassily Kandinsky's painting *Various Actions*.

Rufino Tamayo's painting *Animals*.

Pavel Tchelitchew's painting *Hide and Seek*.

Willem de Kooning's painting *The Wave*.

Max Weber's painting *The Night Class*.

"Indian Art of the United States" exhibition at the Museum of Modern Art.

Piet Mondrian's painting *New York City I* (1941–1942).

Fernand Léger's painting *Divers on a Yellow Background*.

Stuart Davis's painting *New York under Gaslight*.

Isamu Noguchi's painting *Contoured Playground*.

Paul Nash's painting *Totes Meer*.

d. John Gutzon Borglum, American sculptor, who created the Mount Rushmore presidential sculptures (b. 1867).

THEATER & VARIETY

Mady Christians and Paul Lukas starred in *Watch on the Rhine*; Lillian Hellman's anti-Fascist play opened at the Martin Beck Theatre, New York.

Canada Lee starred as Bigger Thomas in *Native Son*; the Richard Wright–Paul Green play, based on Wright's 1940 novel about African-American life on Chicago's South Side, opened at the St. James Theatre, New York, March 24.

Helen Hayes starred in Maxwell Anderson's *Candle in the Wind*.

Josephine Hull and Jean Adair starred as the murderous sisters and Boris Karloff costarred in *Arsenic and Old Lace*; Joseph Kesselring's comedy opened at the Fulton Theatre, New York.

Noël Coward's comedy *Blithe Spirit* starred Peggy Wood, Clifton Webb, and Mildred Natwick on Broadway, in a séance complete with medium and ghost.

Gertrude Lawrence starred in *Lady in the Dark*; Kurt Weill's musical, book by Moss Hart and lyrics by Ira Gershwin; opened at the Alvin Theatre, New York, January 23.

Dorothy Maguire starred in *Claudia*; Rose Franken's comedy opened at the Booth Theatre, New York.

Katharine Cornell and Raymond Massey starred in George Bernard Shaw's *The Doctor's Dilemma*.

Francesca Bruning starred in *Junior Miss*; Jerome Chodorov and Joseph Fields's comedy opened at the Lyceum Theatre, New York, November 18.

Tallulah Bankhead, Joseph Schildkraut, and Robert Ryan starred on Broadway in Clifford Odets's *Clash by Night*.

Maurice Evans and Judith Anderson starred in *Macbeth*.

Delmore Schwartz's verse play, *Shenandoah*.

Gerhart Hauptmann's *Atrides Tetralogy*.

d. Lew Fields (Lewis Maurice Shanfield), American vaudeville and musical theater star (b. 1867).

d. Julian Eltinge, American actor and female impersonator (b. 1883).

MUSIC & DANCE

Paul Bunyan, Benjamin Britten's opera, libretto by W. H. Auden and Chester Kallman, opened at Columbia University, New York, May 5.

Dmitri Shostakovich's *Symphony No. 7*, the *Leningrad*, written in St. Petersburg (Leningrad), then besieged by the Germans.

Bluebeard, Michel Fokine's last ballet, music by Jacques Offenbach; Anton Dolin danced the title role, opposite Alicia Markova, at Mexico City.

Blues in the Night, title song of the 1941 Anatole Litvak film; music by Harold Arlen, words by Johnny Mercer.

A *Child of Our Time*, Michael Tippett's oratorio on modern moral themes; also his *Fantasia on a Theme of Handel* for piano and orchestra.

William Grant Still's operas A *Bayou Legend*, not staged until 1974, and *Troubled Island*.

Arthur Honegger's second symphony and dramatic musical work *Nicolas de Flue*.

God Bless the Child, Billie Holiday's song, written with Arthur Herzog, Jr.

Sergei Rachmaninoff's *Symphonic Dances*.

Benjamin Britten's first string quartet.

I Got It Bad (And That Ain't Good), Duke Ellington's song, lyrics by Paul Francis Webster.

Harmonica virtuoso Larry Adler and dancer Paul Draper began their long partnership.

Estancia, Alberto Ginastera's ballet.

When the Sun Comes Out, popular song, words by Ted Koehler, music by Harold Arlen.

Luigi Dallapicolla's *Songs of Prison* (*Canti di prigionia*).

Deep in the Heart of Texas, popular song.

Quatuor pour la fin du temps, Olivier Messiaen's chamber music.

Chattanooga Choo Choo, Glenn Miller's hit.

d. Ignacy Jan Paderewski, Polish pianist, composer, and statesman (b. 1860), who had become prime minister of his country in 1919.

d. Jelly Roll Morton (Ferdinand Joseph La Menthe), American jazz composer, pianist, and bandleader (b. 1890), the first major jazz composer.

d. Helen Morgan (Helen Riggins), American singer (b. 1900), best known for introducing *Bill* in *Show Boat*.

d. Frank Bridge, English composer (b. 1879).

WORLD EVENTS

World War II: German forces took Yugoslavia and Greece in April, took Crete in May, and invaded the Soviet Union (Operation Barbarossa) on June 22, besieging Leningrad and quickly taking Minsk, Smolensk, and more than two million prisoners. They reached the suburbs of Moscow in October, where they were stopped in early December; Soviet forces counterattacked, and then the Russian winter came.

U.S. Lend-Lease Act enabled Franklin D. Roosevelt to send massive amounts of aid to the Allies.

Freedom of speech and expression, freedom of worship, freedom from want, and freedom from fear of war—the Four Freedoms put forward by Franklin Delano Roosevelt in his State of the Union speech (January 6).

Tojo Hidecki became prime minister of Japan in October, then leading Japan into World War II.

On December 7, the Japanese surprise air attack on the American fleet at anchor in Pearl Harbor sank three battleships, capsized another, and heavily damaged three more; 250 planes were lost on the ground. But the key carriers *Lexington*, *Saratoga*, and *Enterprise* were at sea. On December 10, the Japanese invaded the Philippines, took Manila on December 14, and pursued retreating American and Philippine forces south. They invaded Malaya, sank the British battleship *Prince of Wales* and the battlecruiser *Repulse*, and took Hong Kong and many Pacific islands, including Guam and Wake Island.

Ho Chi Minh organized the League for the Independence of Vietnam (Vietminh).

Israeli Palmach combat force formed, fighting with British forces in the Middle East.

Victor Paz Estenssoro founded Bolivia's Historical Nationalist Revolutionary movement.

Edmund Wilson's *To the Finland Station*.

1942

LITERATURE

The Myth of Sisyphus, Albert Camus's essay, central to the development of the concept of "the absurd," a theme pursued by many in the arts and literature

for the balance of the century, perhaps most notably in the "theater of the absurd."

The Stranger, Albert Camus's novel.

The Seed Beneath the Snow, Ignazio Silone's novel.

Winter's Tales, Isak Dinesen's short stories.

Exil (Exile), St.-John Perse's poetry.

Cross Creek, Marjorie Kinnan Rawlings's autobiographical novel; basis of the 1983 Martin Ritt film.

Our Lady of the Flowers, Jean Genet's novel.

Dragon's Teeth, Upton Sinclair's Pulitzer Prize–winning political novel, part of his 10-volume Lanny Budd series.

Alfred Kazin's essays *On Native Grounds*.

Randall Jarrell's poetry *Blood for a Stranger*.

Dragon Seed, Pearl Buck's novel, set in wartime China; basis of the 1944 Jack Conway film.

James Thurber's *My World and Welcome to It*, including the story *The Secret Life of Walter Mitty*, basis of the 1947 Danny Kaye film.

Person, Place, and Thing and *The Place of Love*, Karl Shapiro's first two poetry collections.

Conrad Aiken's poetry *Brownstone Eclogues*.

One Man's Meat, E. B. White's collection of short fiction, verse, and essays.

Edith Sitwell's poetry *Street Songs*.

Gerhart Hauptmann's poetic work *Der grosse Traum*; and the story *Der Schuss im Park*.

Edna St. Vincent Millay's poem *The Murder of Lidice*.

Flight to Arras, Antoine St.-Exupéry's novel.

George Seferis's poetry *Thrush*.

H. G. Wells's *The Outlook for Homo Sapiens*.

Stevie Smith's poetry *Mother, What Is Man?*

Hamilton Basso's novel *Sun in Capricorn*.

Ludwig Bemelmans's short story *I Love You, I Love You, I Love You.*

Mari Sandoz's biography of *Crazy Horse*.

To Be a Pilgrim, Joyce Cary's novel.

Mark Van Doren's essays *Liberal Education*.

Maxwell Bodenheim's poetry *Lights in the Valley*.

Mrs. Parkington, Louis Bromfield's novel, basis of the 1944 Tay Garnett film.

The Company She Keeps, Mary McCarthy's novel.

Never Come Morning, Nelson Algren's novel.

Robert Penn Warren's *Eleven Poems on the Same Theme*.

The Unvanquished, Howard Fast's novel.

d. Stefan Zweig, Austrian writer (b. 1881).

d. L. M. (Lucy Maud) Montgomery, Canadian writer (b. 1874), creator of Anne of Green Gables.

d. Alice Hegan Rice, American author (b. 1870).

d. Sakutaro Hagiwara, Japanese poet (b. 1886).

d. Violet Hunt, English biographer and novelist (b. 1866).

FILM & BROADCASTING

Casablanca, Humphrey Bogart and Ingrid Bergman starred in the classic Michael Curtiz film, set in the North African city during World War II; the cast included Paul Henreid, Claude Rains, Conrad Veidt, Sidney Greenstreet, Peter Lorre, and Dooley Wilson.

The Magnificent Ambersons, Orson Welles wrote and directed the classic film, starring Joseph Cotten, Dolores Costello, Anne Baxter, Tim Holt, Agnes Moorehead, and Richard Bennett; based on the 1918 Booth Tarkington novel.

Day of Wrath, Carl Dreyer's classic anti-Nazi film, shot in Denmark during the German occupation; after completing the film, Dreyer fled to Sweden.

In Which We Serve, Noël Coward wrote, codirected with David Lean, and starred in the Battle-of-the-Atlantic film, with Bernard Miles, John Mills, Celia Johnson, and Richard Attenborough.

Journey into Fear, the Orson Welles thriller set in the Middle East starred Joseph Cotten, Dolores del Rio, and Welles; based on the 1940 Eric Ambler novel.

Mrs. Miniver, Greer Garson and Walter Pidgeon starred in William Wyler's story of a World War II British family.

John Ford directed the documentary *The Battle of Midway*.

Random Harvest, Ronald Colman and Greer Garson starred in Mervyn Leroy's screen version of the James Hilton love story, about an amnesiac war casualty and the woman who marries him twice.

Gary Cooper starred as baseball star Lou Gehrig in *The Pride of the Yankees*, directed by Sam Wood.

The Rains Came, the 1939 Clarence Brown film, based on the 1937 Louis Bromfield novel; Myrna Loy and Tyrone Power starred.

Tortilla Flat, Spencer Tracy, John Garfield, and Hedy Lamarr starred in Victor Fleming's screen version of John Steinbeck's 1935 novel, set in a California coastal town hard-hit by the Great Depression.

Academy Awards for 1942 (awarded the following year): Best Picture: *Mrs. Miniver*; Best Director:

William Wyler, *Mrs. Miniver*; Best Actor: James Cagney, *Yankee Doodle Dandy*; Best Actress: Greer Garson, *Mrs. Miniver*.

d. Carole Lombard (Jane Alice Peters) American actress and comedian (b. 1908), a star of Hollywood's Golden Age; she died in a plane crash.

VISUAL ARTS

David Alfaro Siqueiros's mural *Death to the Invader*, Chillán, Chile.

Georgia O'Keeffe's paintings included *It Was a Man and a Pot*, *The Grey Hills*, and *The White Place in Shadow*.

Oskar Kokoschka's paintings included *Anschluss-Alice in Wonderland*, *Ambassador Maysky*, and *Loreley*.

Alexander Calder's sculptures included *Horizontal Spines*, *Little Tree*, and *Red Petals*.

Andrew Wyeth's painting *Winter Fields*.

Edward Hopper's painting *Cobb's House, South Truto*.

Tombstones, Jacob Lawrence's painting.

Eliel and Eero Saarinen desgned the Kramer Homes, Center Line, Michigan.

Alberto Giacometti's sculpture *Woman with the Chariot I* (1942–1943).

Georges Braque's painting *La Table de cuisine au gril*.

Henri Matisse's painting *Dancer and Armchair, Black Background*.

Piet Mondrian's painting *New York City*.

Georges Rouault's painting *Christ Mocked*.

Jackson Pollock's paintings included *Moon Woman* and *Male and Female*.

Graphic Tectonics, lithograph by Josef Albers.

Chaim Gross's sculpture *Acrobatic Dancers*.

Thomas Hart Benton's paintings *July Hay and Negro Soldier, Invasion*.

Drawn and Quartered, Charles Addams's cartoon collection.

Marsden Hartley's painting *Evening Storm, Schoodic, Maine*.

Stuart Davis's painting *Ursine Park*.

The Annunciation, Romare Bearden's painting.

Mark Rothko's paintings included *The Eagle* and *The Omen*.

David Low's cartoon collections *The World at War* and *The Years of Wrath*.

Yves Tanguy's painting *Slowly toward the North*.

d. Grant Wood, American painter (b. 1892).

d. William Henry Jackson, American photographer, most notably of the American West (b. 1843).

d. Walter Sickert, British painter (b. 1860).

d. Julio González, Spanish sculptor (b. 1876).

THEATER & VARIETY

Fredric March, Florence Eldridge, Tallulah Bankhead, and Montgomery Clift starred in *The Skin of Our Teeth*; Thornton Wilder's play opened at the Plymouth Theatre, New York.

By Jupiter, the Richard Rodgers–Lorenz Hart musical, opened at the Shubert Theatre, New York, with Ray Bolger, Constance Moore, and Benay Venuta.

Katharine Hepburn and Elliott Nugent starred in Philip Barry's *Without Love*.

Katharine Cornell, Burgess Meredith, Raymond Massey, and Mildred Natwick starred in George Bernard Shaw's *Candida*.

Eve of St. Mark, Maxwell Anderson's play, opened at the Cort Theatre, New York, October 7.

Alfred Lunt and Lynne Fontanne starred in *The Pirate*; S. N. Behrman's comedy opened at the Martin Beck Theatre, New York, November 25.

Gregory Peck and Gladys Cooper starred in Emlyn Williams's *The Morning Star*.

Katharine Cornell, Judith Anderson, Ruth Gordon, and Kirk Douglas starred in Anton Chekhov's *The Three Sisters*.

Irving Berlin wrote and appeared in *This Is the Army*.

Joseph Schildkraut starred in *Uncle Harry*; Thomas Job's play opened at the Broadhurst Theatre, New York, May 20.

Gypsy Rose Lee and Bobby Clark opened in *Star and Garter*.

Leonid Maximovich Leonov's *Invasion*.

Nikolai Fedorovich Pogodin's *Moscow Nights*.

Paul Vincent Carroll's *The Strings, My Lord, Are False*.

Ring Around the Moon, Jean Anouilh's play.

d. John Barrymore (John Sidney Blythe), celebrated American actor, brother of Ethel and Lionel Barrymore (b. 1882).

d. George M. Cohan, American actor–manager and writer (b. 1878).

d. Otis Skinner, American actor (b. 1858).

d. Stanley Lupino, English comedian (b. 1893).

d. Violet Augusta Mary Vanbrugh, English actress (b. 1867).

d. Carl Sternheim, German playwright (b. 1878).

d. Luigi Antonelli, Italian playwright (b. 1882).

d. Marie Tempest, English actress (b. 1864).

MUSIC & DANCE

White Christmas, Irving Berlin's song, introduced by Bing Crosby in the film *Holiday Inn*.

Rodeo, Agnes de Mille's ballet, music by Aaron Copland, opened at the Metropolitan Opera House, New York, October 16, in the Ballets Russes de Monte Carlo production, with de Mille, Frederic Franklin, and Casimir Kokitch dancing the leads.

Alexander Vassilevich Alexandrov composed the popular *Song of Stalin* (ca. 1942), in 1944 becoming the official Soviet anthem.

Pillar of Fire, Antony Tudor's ballet, music by Arnold Schoenberg, first performed April 8 by the American Ballet Theater in New York.

Aram Khachaturian's ballet *Gayané*, choreographed by Nina Anisimova, which included his noted *Sabre Dance*, first danced by the Kirov Ballet.

Robert Helpmann created the ballet *Hamlet*, to music by Peter Ilich Tchaikovsky, first danced May 19 by the Sadler's Wells Ballet, London, with Helpmann and Margot Fonteyn.

Helen of Troy, David Lichine's ballet, music by Jacques Offenbach, first danced November 20 by the Ballet Theater, in Detroit.

That Old Black Magic, Harold Arlen and Johnny Mercer's song, from *Star Spangled Rhythm*.

William Walton's film music *The First of the Few* and *Went the Day Well?*

Frank Sinatra and Tommy Dorsey's hit *There Are Such Things*.

Woody Herman's band recorded their version of *Blues in the Night* and introduced *There Will Never Be Another You*.

Aaron Copland's *Fanfare for the Common Man* and *Lincoln Portrait*.

Leonard Bernstein's *Symphony No. 1*, the *Jeremiah*, and his *Clarinet Sonata*.

Praise the Lord and Pass the Ammunition!, Frank Loesser's song, introduced by Kay Kyser and his Orchestra.

Igor Stravinsky's *Circus polka (for a young elephant) and* his orchestral work *Danses concertantes*.

This Is the Army, Mr. Jones, Irving Berlin's song.

Arnold Schoenberg's *Piano Concerto* and *Ode to Napoleon Buonaparte*, for voice and instruments.

I'm Old Fashioned, popular song, words by Johnny Mercer, music by Jerome Kern.

Benjamin Britten's *A Ceremony of Carols* and *Hymn to St. Cecilia*.

Don't Get Around Much Anymore, Duke Ellington's hit, words by Bob Russell.

Organist E. Power Biggs began his weekly radio show (1942–1958).

String of Pearls, Glenn Miller's hit.

Richard Strauss's second horn concerto and his opera *Capriccio*.

Lionel Hampton's hit *Flying Home*.

Elliott Carter's *Symphony No. 1*.

Rosie, the Riveter, popular song.

Lamentatio Jeremiae prophetae, Ernst Krenek's choral work.

When the Lights Go On Again (All Over the World), popular song.

Les Animaux modèles, Francis Poulenc's dramatic musical work.

The Island God, Gian Carlo Menotti's opera.

I capricci di Callot, Gian Francesco Malipiero's opera.

Komei Abe's *Clarinet Quintet*.

Michael Tippett's second string quartet.

Glenn Miller formed a service band, stationed in England.

d. Michel Fokine, Russian dancer and choreographer (b. 1880).

WORLD EVENTS

Roosevelt–Churchill conference at sea off Newfoundland (August 9–12) resulted in the Atlantic Charter, a statement of joint war aims.

German spring offensives took more of the southern Soviet Union; Sevastopol fell, but Leningrad and Moscow held, and the tide turned at Stalingrad.

Battle of Stalingrad: German Sixth Army forces reached the Volga on August 23, beginning the long, failed German attempt to take the city.

Battle of the Coral Sea, first aircraft carrier battle in the Pacific: Although both sides suffered losses, without a clear victor, the Japanese invasion of New Guinea was stopped.

Battle of Midway: American aircraft carriers defeated a large Japanese invasion fleet off Midway Island, in the most decisive battle of the Pacific war. The loss of all four Japanese carriers to only one Amer-

ican carrier cost the Japanese fleet all its air cover; the Americans then went over to the offensive.

Huge quantities of American war materials flowed to the Soviet Union along the Murmansk Run, the North Atlantic convoy route from assembly areas near Iceland to Murmansk, as the Allies won the Battle of the Atlantic.

German armies took Yugoslavia and Greece in April; British forces were evacuated from Greece by sea.

d. Reinhard Heydrich ("Heydrich the Hangman"), Nazi Gestapo chief (b. 1904); assassinated in Czechoslovakia. In reprisal, German troops destroyed the village of Lidice, murdered all of the men over 16, and sent to concentration camps the rest of the village's 1,200 people.

Libyan fortress of Tobruk, which had withstood a long 1941 siege, was taken by the Germans in June, with 33,000 Allied prisoners.

Battle of El Alamein (October 23–November 4): British North African troops led by General Bernard Montgomery decisively defeated attacking German and Italian troops led by General Erwin Rommel.

Allied forces successfully invaded North Africa (Operation Torch, November 8–11).

In the United States, more than 110,000 Pacific Coast Japanese-Americans were forced into concentration camps, many also driven into poverty.

Japanese siege of Corregidor, off Bataan peninsula, in the Philippines, ended in May with the surrender of the surviving American and Philippines defenders, who were forced to endure the Bataan death march to their prison camp.

Japanese forces invaded Burma, and took Mandalay; British-led forces retreated to Imphal, and prepared for a Japanese attack on India.

Japanese forces took the Malaya mainland.

Japanese invasion forces took the East Indies against weak Dutch resistance.

Singapore was taken by the Japanese on February 15, after a one-week battle; 70,000 surrendered after their water supply had been captured.

American Lieutenant Colonel James Doolittle led a group of American bombers against Tokyo and other Japanese cities; a morale-building exercise.

Cross-channel Canadian–British raid on Dieppe failed, with more than 3,000 casualties.

American atomic bomb program began, code-named Manhattan Project (1942–1946); Enrico Fermi's research group achieved a chain reaction, a self-sustaining process of nuclear fission.

American physicists John Atanasoff and Clifton Berry built the first fully electronic computer.

James Farmer founded the Congress of Racial Equality (CORE) in Chicago.

Boston Cocoanut Grove fire killed 491 people (November 28).

1943

LITERATURE

André Malraux's novel *The Walnut Trees of Altenburg*.

Western Star, Stephen Vincent Benét's Pulitzer Prize–winning long poem.

The Human Comedy, William Saroyan novel, based on his film script for Clarence Brown's film.

The Lady in the Lake, the Raymond Chandler mystery novel, basis of the 1946 Robert Montgomery film.

Antoine St.-Exupéry's novel *The Little Prince*.

The Fountainhead, Ayn Rand novel; basis of the 1949 King Vidor film.

The Golden Fleece, Robert Graves's novel.

The Real World, Louis Aragon's four-volume group of novels (1943–1944).

The Way Some People Live, John Cheever's short-story collection.

Pluies (Rains), poetry by St.-John Perse.

Betty Smith's novel *A Tree Grows in Brooklyn*, basis of the 1945 Elia Kazan film.

Copenhagen Burning, Haldor Laxness's novel (1943–1946).

Eudora Welty's short stories *The Wide Net*.

H. L. Mencken's autobiographical work *Heathen Days*.

Whitman, Henry Seidel Canby's literary study.

House of Liars, Elsa Morante's novel.

Jean-Paul Sartre's essays *Being and Nothingness*.

Lion Feuchtwanger's *Simone*.

Louis Adamic's *My Native Land*.

Magister Ludi, Hermann Hesse's novel.

Number One, John Dos Passos's novel.

Romain Gary's *A European Education*.

So Little Time, J. P. Marquand's novel.

Tanizaki Jun-ichiro's novel *Sasame-yuki* (1943–1948).

Taylor Caldwell's novel *The Arm and the Darkness*.

The Apostle, Sholem Asch's novel.

Wallace Stegner's novel *The Big Rock Candy Mountain*.

d. Beatrix Potter, British writer and illustrator (b. 1866), who created Peter Rabbit.

d. Radclyffe Hall, English novelist and short-story writer (b. 1886).

d. Stephen Vincent Benét, American writer (b. 1898).

FILM & BROADCASTING

Watch on the Rhine, Bette Davis and Paul Lukas in a reprise of his stage role starred in Herman Shumlin's screen version of Lillian Hellman's 1941 anti-Fascist play; screenplay by Dashiell Hammett.

Now, Voyager, Bette Davis, Paul Henreid, and Claude Rains starred in Irving Rapper's story of a Boston Brahmin's reclamation through love.

The Life and Death of Colonel Blimp, Roger Livesey as the progressively more outmoded British officer, Deborah Kerr in four roles, and Anton Walbrook starred in the Michael Powell–Emeric Pressburger classic.

Maria Candelaria, Dolores Del Rio and Pedro Armendariz starred in the Emilio Fernandez film, a central work of the Mexican cinema.

For Whom the Bell Tolls, the Sam Wood film, based on the Ernest Hemingway Spanish Civil War story; Gary Cooper, Ingrid Bergman, and Katina Paxinou starred.

Cabin in the Sky, Vincente Minnelli's film, based on the 1940 Lynn Root–John La Touche musical; an all-Black cast starred Ethel Waters, Lena Horne, Louis Armstrong, Rex Ingram, Eddie Anderson, Cab Calloway, and John W. Bubbles.

John Ford directed the documentary *December 7*.

Lassie, Roddy McDowall, and Donald Crisp starred in *Lassie Come Home*, directed by Fred M. Wilcox.

Lifeboat, Tallulah Bankhead, Walter Slezak, William Bendix, Hume Cronyn, and Canada Lee starred in Alfred Hitchcock's sea-war survivors film.

Greer Garson and Walter Pidgeon starred in *Madame Curie*, directed by Mervyn LeRoy.

Old Acquaintance, Bette Davis and Miriam Hopkins starred as the two lifelong, quite incompatible friends in the Vincent Sherman film.

Robert Bresson directed *Angels of the Streets*.

Joseph Cotten and Teresa Wright starred in *Shadow of a Doubt*, directed by Alfred Hitchcock.

Henry Fonda and Dana Andrews starred in *The Ox-Bow Incident*, directed by William Wellman.

Perry Mason, the radio and television series (1943–1966), based on the Erle Stanley Gardner novels; Raymond Burr starred as Mason; occasional television films followed into the 1990s.

Academy Awards for 1943 (awarded the following year): Best Picture: *Casablanca*; Best Director: Michael Curtiz, *Casablanca*; Best Actor: Paul Lukas, *Watch on the Rhine*; Best Actress: Jennifer Jones, *The Song of Bernadette*.

d. Leslie Howard (Leslie Stainer), British actor (b. 1893); German fighters shot down his plane en route to Lisbon.

d. Conrad Veidt, German actor (b. 1893).

d. W(illiam) S. Van Dyke, American director (b. 1889).

VISUAL ARTS

Frank Lloyd Wright began the Solomon R. Guggenheim Museum, New York (1943–1959).

Piet Mondrian's paintings included *Broadway Boogie Woogie* and *Victory Boogie Woogie* (1943–1944).

Pablo Picasso's work included the paintings *Bull's Head* and *First Steps*; the drawing *Portrait of D.M. as a Bird*, and a pen-and-ink *Self-Portrait*.

Georgia O'Keeffe's paintings included *Cliffs Beyond Aliquiu*, *Cottonwood Tree in Spring*, *Pelvis with Moon*, and *White Flower on Red Earth*.

Andrew Wyeth's paintings included *Public Sale*, *Spring Beauty*, and *The Hunter*.

Marc Chagall's paintings included *The Feathers and the Flowers*, *The Juggler*, and *Yellow Crucifixion*.

Oskar Kokoschka's paintings included *Marianne-Maquis* and *What We Are Fighting For*.

Robert Motherwell's paintings included *Surprise and Inspiration*, *Pancho Villa*, and *Dead and Alive*.

Jackson Pollock's paintings included *Guardians of the Secret*, *Pasiphaë*, and *The She-Wolf*.

Isamu Noguchi's sculptures included *This Tortured Earth*, and *Monument to Heroes*.

Jacques Lipchitz's sculpture *Prayer*.

Constantin Brancusi's sculpture *Flying Turtle*.

Richard Neutra designed the John B. Nesbitt House, Brentwood, California.

Alexander Calder's sculpture *Morning Star*.

Anna Mary ("Grandma") Moses's painting *The Thanksgiving Turkey*.

Ben Shahn's painting *Girl Jumping Rope*.

Fernand Léger's painting *The Black Trellis* (1943–1944).

Albert Kahn designed a Ford Motor Company factory in Ypsilanti, Michigan.

Formation I, Arthur G. Dove's painting.

Georges Braque's painting *Le Tapis vert*.

Henry Moore's sculpture *Madonna and Child*.

Thomas Hart Benton's painting *Picnic*.

Wassily Kandinsky's paintings included *Circle and Square, Division-Unity*, and *Seven*.

Eliel and Eero Saarinen designed the Willow Run Housing development, Willow Run, Michigan.

Pierre Bonnard's painting *Table Before Window*.

Ultramarine, Stuart Davis's painting.

Reginald Marsh's painting *Coney Island Beach, Number 1*.

William Dobell's painting *Joshua Smith*.

Reuben Nakian's sculpture *Head of Marcel Duchamp*.

d. Chaim Soutine, Russian-French artist (b. 1893).

d. Marsden Hartley, American painter (b. 1877).

THEATER & VARIETY

Oklahoma!, Alfred Drake, Joan Roberts, and Celeste Holm starred in the trendsetting Rodgers-and-Hammerstein musical, choreography by Agnes de Mille; based on *Green Grow the Lilacs*, the 1931 Lynn Riggs play, it opened at the St. James Theatre, New York, March 31.

Paul Robeson in the title role, José Ferrer, Uta Hagen, and Margaret Webster starred in Shakespeare's *Othello*.

Ralph Bellamy, Skippy Homeier, and Shirley Booth starred in the anti-Nazi *Tomorrow the World*; James Gow and Arnaud d'Usseau's play opened at the Ethel Barrymore Theatre, New York.

Jean Giraudoux's *Sodome et Gomorrhé* opened in Nazi-occupied Paris.

Margaret Sullavan and Elliott Nugent starred in *The Voice of the Turtle*; John Van Druten's play opened at the Morosco Theatre, New York, December 8.

Mary Martin and John Boles starred in *One Touch of Venus*; Kurt Weill's musical opened at the Imperial Theatre, New York, October 7.

Helen Hayes starred in *Harriet*; Florence Ryerson and Colin Clements's play opened in New York.

Three's a Family, Phoebe and Henry Ephron's comedy, opened at the Longacre Theatre, New York, May 5.

Winged Victory, Moss Hart's play, with a military cast, opened at the 44th Street Theatre, New York.

Purple Dust and *Red Roses for Me*, Sean O'Casey plays.

The Flies, Jean-Paul Sartre's play.

This Happy Breed, Noël Coward's wartime play; basis of the 1944 film.

d. Alexander (Humphreys) Woollcott, American dramatic critic (b. 1887), supposedly model for Sheridan Whiteside in *The Man Who Came to Dinner*.

d. Max Reinhardt (Maximilian Goldman), Austrian actor, director, and producer, a major figure in the German-speaking theater (b. 1983).

d. Lorenz Hart, American lyricist (b. 1895).

d. Harry Baur, French actor (b. 1880), a film star in the 1930s.

d. Moses Nadir, American Yiddish Theatre playwright (b. 1885).

d. Nordahl Grieg, Norwegian playwright, poet, and novelist (b. 1902).

MUSIC & DANCE

Oh, What a Beautiful Morning, People Will Say We're In Love, and *The Surrey with the Fringe on Top* were introduced by Alfred Drake and Joan Roberts in Richard Rodgers and Oscar Hammerstein II's musical *Oklahoma!*; choreography by Agnes de Mille.

Frank Sinatra's hits *You'll Never Know* and *In the Blue of the Evening*; he became a pop idol with sold-out concerts at New York's Paramount theater, then moved onto radio's *Your Hit Parade* (1943–1945).

Mademoiselle Angot, Leonide Massine's ballet, music by Charles Lecocq, first danced October 19 by the American Ballet Theater, at the Metropolitan Opera, New York.

Suite en Blanc, Serge Lifar's ballet, music by Edouard Lalo, first danced June 19 by the Paris Opéra Ballet, in Zurich.

Die Kluge (*The Clever Girl*), Carl Orff's opera, to his own libretto, opened in Frankfurt, February 20.

Howard Hanson's Pulitzer Prize–winning *Fourth Symphony*, the *Requiem*.

Maya Plisetskaya became a soloist at the Bolshoi Ballet.

Benjamin Britten's *Serenade*, choral work *Rejoice in the Lamb*, and song cycle *Serenade for Tenor, Horn and Strings*.

Black, Brown, and Beige, Duke Ellington's orchestral work.

Aram Khachaturian's second symphony.

I'll Be Home for Christmas, Bing Crosby's hit.

Béla Bartók's *Concerto for Orchestra*.

Speak Low, popular song, words by Ogden Nash, music by Kurt Weill.

Catulli carmina (*Songs of Catullus*), Carl Orff's cantata; second of his *Trionfi* trilogy.

While We're Young, popular song, words by William Engvick and Morty Palitz, music by Alec Wilder.

Paul Hindemith's *Symphonic Metamorphosis on Themes of Carl Maria von Weber*.

Elliott Carter's *Elegy*, for cello and piano.

Figure humaine, Francis Poulenc's choral work.

Karl-Birger Blomdahl's *Symphony*.

Boyhood's End, Michael Tippett's cantata.

Anton von Webern's *Second Cantata*.

I'll Be Around, Alec Wilder's popular song.

Ralph Vaughn Williams's *Fifth Symphony*.

The Quest, William Walton's ballet.

d. Sergei Rachmaninoff, Russian composer, conductor, and pianist (b. 1873).

d. Edward William Elgar, English composer (b. 1857).

d. Fats (Thomas Wright) Waller, American jazz composer and musician (b. 1904).

WORLD EVENTS

Encircled German Sixth Army surrendered to Soviet forces at Stalingrad, ending the decisive battle of the war on the eastern front; the series of Soviet offensives that followed would end in Berlin.

Allied shuttle bombing of Europe began, between Britain and North Africa.

Hamburg bombings in 1943–1944 killed an estimated 50,000, created firestorms.

Battle of Kursk, a huge tank battle in which Soviet armor defeated massive German armor concentrations and stopped the last German counteroffensive on Russian front.

Warsaw Ghetto uprising (April–May): With 400,000–450,000 Warsaw Jews dead or in German death camps, the remaining 60,000 chose to die fighting. Only a few Jews survived the German mass murders that followed.

Tunis fell to the Allies on May 7; with surrender of 250,000 German and Italian trooops, the war ended in North Africa.

On July 23, Allied forces invaded Sicily; Mussolini was deposed by his own Fascist Grand Council, and restored to office as a German puppet, while the Germans took over the war in Italy. Sicily was taken in August.

On September 3, Allied forces invaded Italy, with landings at Salerno and Taranto September 9. Overcoming strong German resistance at the beachheads, Allied armies moved north, facing the Gustav Line in mid-November.

Italy signed an armistice with Allies September 7.

Roosevelt–Churchill–Stalin summit meeting at Tehran (November 28–December 1) set the time of the Allied invasion of western Europe, set entry of the Soviet Union into the Pacific war after German defeat, agreed to establish the United Nations, and partially redrew the postwar map of Europe.

American troops attacked Guadalcanal Island; after heavy fighting, Japanese evacuated.

New Georgia Island, in the Solomons, was attacked by American troops, which took the major Japanese base in two months of heavy fighting.

J. Robert Oppenheimer's group began to design and build the atomic bomb, at Los Alamos, New Mexico.

Irgun Zvai Leumi, led by Menachem Begin, began a terror campaign against the British in Palestine.

Hallucinogenic properties of LSD discovered accidentally by a Swiss chemist.

1944

LITERATURE

Lillian Smith's novel *Strange Fruit*.

The Nobel Prize for Literature was awarded to Johannes V. Jensen.

Karl Shapiro's Pulitzer Prize–winning *V-Letter and Other Poems*.

Two Adolescents, Alberto Moravia's novel.

The Dwarf, Pär Lagerkvist's novel.

The Horse's Mouth, Joyce Cary's novel.

Robert Lowell's poems *Land of Unlikeness*.

Gigi, the Colette novel, basis of the 1959 Vincente Minnelli film.

Robert Penn Warren's *Selected Poems 1923–1943*.

Freedom Road, Howard Fast's novel.

Hilda Doolittle (H.D.)'s poetry *The Walls Do Not Fall*.

Conrad Aiken's poetry *The Soldier*.

William Rose Benét's poetry *Day of Deliverance*.

Edith Sitwell's poetry *Green Song*.

Fictions, Jorge Luis Borges's short-story collection.

Frank O'Connor's short stories *Crab-Apple Jelly*.

Jacobowsky and the Colonel, Franz Werfel's comic novel.

Jean Stafford's novel *Boston Adventure*.

Osamu Dazai's novel *Tsugaru*.

The Ballad and the Source, Rosamond Lehmann's novel.

The World of Washington Irving, Van Wyck Brooks's literary history.

Vicente Aleixandre's poetry *Sombra del paraíso*.

d. Anne Frank, German Jewish diarist (b. 1929), killed with her family at the Bergen-Belsen Nazi extermination camp.

d. Antoine St.-Exupéry, French writer and flyer (b. 1900).

d. George Ade, American humorist and playwright (b. 1866).

d. Arthur (Thomas) Quiller-Couch (pen name "Q"), English writer and teacher (b. 1863).

d. James Boyd, American author (b. 1888).

d. Romain Rolland, French writer (b. 1866), most notably of the 10-volume novel *Jean Christophe* (1904–1912).

FILM & BROADCASTING

Jane Eyre, Orson Welles and Joan Fontaine starred in the Robert Stevenson film, based on the 1847 Charlotte Brontë novel.

Ivan the Terrible, Parts 1 and 2 (1944, 1946), Nikolai Cherkassov starred in the Sergei Eisenstein films, scores by Sergei Prokofiev. Part 2 was suppressed by Joseph Stalin, who saw its unflattering portrayal of Ivan as hitting too close to home (released 1958).

To Have and Have Not, Humphrey Bogart and Lauren Bacall were first paired in Howard Hawks's World War II anti-Fascist film, set on a Vichy-ruled French Caribbean island; William Faulkner and Jules Furthman adapted the 1937 Ernest Hemingway novel.

The Keys of the Kingdom, Gregory Peck starred as the missionary priest in China in the John M. Stahl film, based on A. J. Cronin's 1941 novel.

The Mask of Dimitrios, Peter Lorre and Sidney Greenstreet starred in Jean Negelesco's film, based on the 1939 Eric Ambler thriller.

This Happy Breed, Robert Newton, Stanley Holloway, Celia Johnson, Kay Walsh, and John Mills starred in David Lean's wartime film, based on the 1943 Noël Coward play.

Arsenic and Old Lace, Frank Capra's film, adapted from Joseph Kesselring's 1941 play; Josephine Hull and Jean Adair recreated their murderous stage sisters; Cary Grant and Raymond Massey costarred.

Meet Me in St. Louis, Judy Garland starred in the Vincente Minnelli film musical, set at the 1903 St. Louis World's Fair.

Farewell, My Lovely, Dick Powell, Claire Trevor, and Mike Mazurski starred in the Edward Dmytryk thriller, based on the 1940 Raymond Chandler mystery novel.

Gaslight, Ingrid Bergman, Charles Boyer, and Joseph Cotten starred in the George Cukor film, a period thriller based on the 1938 Patrick Hamilton play; a remake of *Angel Street*.

Bette Davis and Claude Rains starred in *Mr. Skeffington*, directed by Vincent Sherman.

Cary Grant and John Garfield starred in *Destination Tokyo*, directed by Delmer Daves.

Double Indemnity, Barbara Stanwyck, Fred MacMurray, and Edward G. Robinson starred in the Billy Wilder conspiracy-to-murder film, based on the 1936 James M. Cain novel.

Dragon Seed, Katharine Hepburn and John Huston starred in the Jack Conway film, set in wartime China, based on the 1942 Pearl Buck novel.

Going My Way, Bing Crosby, Barry Fitzgerald, and Risë Stevens starred in the Leo McCarey film; screenplay by Frank Butler and Frank Cavett, based on a McCarey story.

Laura, Gene Tierney, Dana Andrews, and Clifton Webb starred in Otto Preminger's New York love story–thriller, based on Vera Caspary's novel.

None But the Lonely Heart, Clifford Odets's film, starred Cary Grant and Ethel Barrymore.

Academy Awards for 1944 (awarded the following year): Best Picture: *Going My Way*; Best Director: Leo McCarey, *Going My Way*; Best Actor: Bing

Crosby, *Going My Way*; Best Actress: Ingrid Bergman, *Gaslight*.

d. Billy (George William) Bitzer, American cinematographer and technical innovator (b. 1872), who shot *The Birth of a Nation* (1915) and *Intolerance* (1916).

VISUAL ARTS

Arshile Gorky's paintings included *The Water of the Flowery Hill*, *The Liver Is the Cock's Comb*, and the *Plow and the Son* series (1944–1947).

Born Free and Equal, Ansel Adams's photographic essay on interned Japanese-Americans at the Manzanar detention camp during World War II.

Three Studies for Figures at the Base of a Crucifixion, the celebrated Francis Bacon triptych.

Wassily Kandinsky's paintings included *Tempered Élan* and *White Balancing Act*.

Andrew Wyeth's paintings included *Christmas Morning* and *Springhouse*.

Georgia O'Keeffe's paintings included *Aliquiu Country*, *Flying Backbone*, *Pelvis III*, *The Black Place II*, and *The Black Place III*.

Edward Hopper's painting *Morning in a City*.

Pablo Picasso's painting *Man with a Sheep*.

Oskar Kokoschka's painting *Cathleen, Countess of Drogheda* (1944–1947).

Fernand Léger's painting *Leisure* (1944–1949).

William Zorach's sculpture *The Future Generation* (1942–1944).

Folk Song, Seymour Lipton's sculpture.

Isamu Noguchi's sculpture *Bird's Nest*.

Jackson Pollock's paintings included *Gothic* and *The Totem, Lesson I*.

Reginald Marsh's painting *Bowery and Mell Street—Looking North*.

Moon Maiden, Philip Evergood's painting.

David Smith began his sculpture series *Spectre*.

The Red Stairway, Ben Shahn's painting.

d. Piet Mondrian (Pieter Cornelis Mondriaan), Dutch artist (b. 1872).

d. Wassily Kandinsky, Russian painter and teacher, pioneering nonobjective artist (b. 1866).

d. Aristide Maillol, French artist (b. 1861).

d. Edvard Munch, Norwegian painter (b. 1863).

d. Edwin Landseer Lutyens, English architect (b. 1869).

d. Cyrus Edwin Dallin, American sculptor (b. 1861).

d. Erich Salomon, German photographer (b. 1886).

d. George Herriman, American cartoonist, the creator of Krazy Cat (b. 1881).

THEATER & VARIETY

Frank Fay, Josephine Hull, and Jane Van Duser starred in *Harvey*; the Mary Chase play, featuring an invisible six-feet-tall white rabbit, opened at the 48th Street Theatre, New York, November 1.

Mady Christians starred as the immigrant San Francisco Norwegian mother in John Van Druten's *I Remember Mama*; opened at the Music Box Theatre, New York, October 19.

Fredric March starred in *A Bell for Adano*; Paul Osborn's play opened in New York.

Jean Anouilh's *Antigone* opened in Nazi-occupied Paris.

Celeste Holm starred in *Bloomer Girl*; the Harold Arlen–E. Y. Harburg musical opened at the Shubert Theatre, New York, October 5.

On the Town opened at the Adelphi Theatre, New York, December 28; music by Leonard Bernstein, based on the ballet *Fancy Free*, with book and lyrics by Betty Comden and Adolph Green.

Hilda Simms and Earle Hyman starred *Anna Lucasta*; Philip Yordan's play was produced by the American Negro Theatre at the Mansfield Theatre.

Louis Calhern starred in S. N. Behrman's *Jacobowsky and the Colonel*.

June Havoc and Bobby Clark starred in Cole Porter's *Mexican Hayride*.

Elizabeth Bergner starred in Martin Vale's *The Two Mrs. Carrolls*.

Leo G. Carroll starred in *The Late George Apley*, John P. Marquand and George S. Kaufman's comedy; opened at the Lyceum Theatre, New York.

The Searching Wind, Lillian Hellman's play, about the rise of Fascism during the interwar period.

Burl Ives and Alfred Drake starred in the musical *Sing Out Sweet Land*.

Gerhart Hauptmann's *Iphigenie in Aulis*.

No Exit and *The Flies*, Jean-Paul Sartre's plays.

The Misunderstanding, Albert Camus's play.

d. Édouard Bourdet, French playwright (b. 1887).

d. George Ade, American journalist, humorist, and playwright (b. 1866).

d. Jean Giraudoux (Hippolyte Jean Giraudoux), French writer (b. 1882).

d. Richard Bennett, American actor (b. 1873); father of Constance and Joan Bennett.

d. Yvette Guilbert, French singer (b. 1865).

MUSIC & DANCE

Appalachian Spring, Aaron Copland's ballet on American folk themes, originally choreographed by Martha Graham, with sets by Isamu Noguchi, first produced at the Library of Congress October 30.

Frank Sinatra and Tommy Dorsey's hit *I'll Be Seeing You* (recorded 1940); at the opening of a second series of Paramount Theater concerts, his young audiences blocked the streets in what was called the "Columbus Day Riot" (October 12).

Jerome Robbins created the jazz ballet *Fancy Free* to music by Leonard Bernstein, first danced April 18 by the American Ballet Theater at New York's Metropolitan Opera.

Miracle in the Gorbals, Robert Helpmann's ballet to Arthur Bliss's music, premiered at London's Princes Theatre in the Sadler's Wells Ballet production, with Helpmann dancing the lead.

Der Kaiser Von Atlantis (*The Emperor of Atlantis*), Viktor Ullmann's opera written while a prisoner in a German concentration camp, before being killed at Auschwitz; the work premiered in Amsterdam on December 16, 1975.

Constantia, William Dollar's ballet, music by Frédéric Chopin, first danced October 31 by the Ballet International, New York.

Olivier Messiaen's choral work *Trois Petites Liturgies de la Présence Divine* and piano work *Vingt regards sur l'enfant Jésus*.

Igor Stravinsky's *Sonata for Two Pianos*; *Elegy*, for viola; choral work *Babel*; and orchestral work *Scènes de Ballet*.

Swingin' on a Star, Bing Crosby's hit song, by Johnny Burke and Jimmy Van Heusen, from the film *Going My Way*.

Renata Tebaldi made her debut as Elena in *Mefistofele* in Rovigo, Italy.

Blues in the Night, popular song, words by Johnny Mercer, music by Harold Arlen.

Ralph Vaughan Williams's *Oboe Concerto* and *String Quartet*.

I'm Beginning to See the Light, Duke Ellington's hit song.

Sergei Prokofiev's *Symphony No. 5*.

Ac-Cent-Tchu-Ate the Positive, Johnny Mercer and Harold Arlen's popular song.

Don't Fence Me In, Cole Porter's song, introduced by Roy Rogers and the Sons of the Pioneers in the film *Hollywood Canteen*, but a hit for Bing Crosby and the Andrews Sisters.

Henry V, William Walton's film music.

The Boy Next Door, Judy Garland's hit from the film *Meet Me in St. Louis*.

Ev'ry Time We Say Goodbye, Cole Porter's song, from the Broadway revue *The Seven Lively Arts*.

Baltimore Oriole, Hoagy Carmichael's popular torch song, words by Paul Francis Webster.

Masquerade, Aram Khachaturian's orchestral work.

Letter from Home, Aaron Copland's orchestral work.

Sentimental Journey, theme song of Les Brown and his Orchestra, sung by Doris Day.

On the Town, Leonard Bernstein's musical.

Benjamin Britten's *Festival Te Deum*.

Béla Bartók's *Sonata* for solo violin.

Elliott Carter's *Holiday Overture*.

Sebastian, Gian Carlo Menotti's ballet.

Long Ago and Far Away, Perry Como's hit song.

Zoltán Kodály's *Missa brevis*.

Hérodiade, Paul Hindemith's ballet.

The Perilous Night, John Cage's work for prepared piano.

d. Glenn Miller, American bandleader and trombonist (b. 1904), in a World War II plane crash into the English Channel.

d. Josef Lhévinne, Russian pianist (b. 1874).

d. Riccardo Zandonai, Italian composer (b. 1883).

d. Yvette Guilbert, French folksinger and actress (b. 1865), a leading café artist in Paris from the 1890s, also touring in England and the United States.

WORLD EVENTS

Franklin Delano Roosevelt defeated Republican Thomas E. Dewey to win an unprecedented fourth presidential term.

Allied forces broke through the Gustav Line in May, moving north in Italy; Monte Cassino was taken.

Rome, declared an open city, was taken by the Allies on June 4.

Allied shuttle bombing between Britain and the Soviet Union began.

German rocket-powered V-1 bomb terror attacks on

Britain began in June; V-2 attacks began in September.

First jet warplane, a Messerschmidt, flown in combat.

Normandy invasion (D day, June 6), successful cross-Channel invasion of Europe; breakthrough at St.-Lô in July; Paris taken in late August and Allies on the Seine; Allies at Siegfried Line in September; Aachen fell in October, as the Allies moved into Germany.

Battle of Arnhem: British troops established a failed bridgehead across the Meuse, retreating with very heavy losses.

Battle of the Bulge (December 1944–January 1945): German forces counterattacked in the Ardennes, creating a 50-mile-deep salient (bulge), and surrounded the U.S. 82nd Airborne and 101st Airborne divisions at Bastogne, until they were relieved by the U.S. Third Army.

Soviet offensives retook Minsk and destroyed major German forces, as Red armies moved into Poland; Odessa and Sevastopol retaken; Romania and Yugoslavia taken as Soviets moved into southeastern Europe; Soviet forces pursued the Germans into East Prussia and took the Baltic coast.

Failed July 20 German officers' attempt to assassinate Hitler.

Finnish forces were defeated after Soviet forces had breached the Mannherheim Line in June.

Allied forces took much of New Guinea (April–July).

Battle of Leyte Gulf and Philippine invasion (October 24–25), huge American naval forces destroyed much of the remaining Japanese navy and landed on Leyte, taken by December.

Japanese forces invaded India in March, besieging Imphal and Kohima; they retreated with heavy losses in June.

Burma Road, cut by Japanese in 1942, reopened.

Bretton Woods Conference set up much of postwar international financial structure, including the International Monetary Fund and the International Bank for Reconstruction and Development.

Potsdam Conference further developed Allied postwar plans, including the German occupation and the removal of Germans from occupied areas.

Dumbarton Oaks Conference (August–October) planned the United Nations.

Israeli Stern Gang terrorists assassinated British diplomat Lord Moyne.

Munitions ships exploded at Port Chicago, near San Francisco, killing 322 people.

Pan-African Federation founded.

Gunnar Myrdal's *An American Dilemma*.

Carl Gustav Jung's *Psychology and Religion*.

Freidrich August von Hayek's *The Road to Serfdom*.

1945

LITERATURE

Animal Farm, George Orwell's bitterly satirical novel attacking Stalinism and other forms of totalitarianism, with its quintessential slogan: "All Animals Are Equal, But Some Animals Are More Equal Than Others."

Gabriela Mistral was awarded the Nobel Prize for Literature.

The Treasure of the Sierra Madre, B. Traven's novel about a hunt for gold in 1920s Mexico; basis of John Huston's classic 1948 film.

Ivo Andric's *The Bridge on the Drina*, *Bosnian Chronicle*, and *The Woman from Sarajevo*, written during World War II, were all published in the same year.

The Naked and the Dead, Norman Mailer's World War II novel, set in the Pacific frontlines; basis of the 1958 Raoul Walsh flm.

Brideshead Revisited, Evelyn Waugh's novel, set in Anglo-Catholic English life in the 1930s; basis of the 1982 television series.

Cannery Row, John Steinbeck's novel, set in a Depression-era California town; basis of the 1982 David S. Ward film.

Days and Nights, Konstantin Simonov's World War II novel, set in the battle of Stalingrad.

The Friendly Persuasion, Jessamyn West's novel about a Quaker family in the Civll War; basis of the 1956 William Wyler film.

The Age of Reason, Jean-Paul Sartre's novel.

Richard Wright's autobiography *Black Boy*.

Prater Violet, Christopher Isherwood's novel.

Two Solitudes, Hugh MacLennan's novel.

Stuart Little, E. B. White's classic children's book.

Kingsblood Royal and *Cass Timberlane*, Sinclair Lewis's novels.

Edith Sitwell's poetry *Song of the Cold*.

James Thurber's *The Thurber Carnival*.

If He Hollers Let Him Go, Chester Himes's novel.

John Crowe Ransom's *Selected Poems*.

Gwendolyn Brooks's poetry *A Street in Bronzeville*.

H. G. Wells's *Mind at the End of Its Tether*.

Kenneth Patchen's essays *The Memoirs of a Shy Pornographer*.

Léopold Senghor's *Chants d'ombre*.

The Tin Flute, Gabrielle Roy's first novel.

Louis Adamic's *A Nation of Nations*.

The English Teacher, Rasipuram Narayan's novel.

Peter Abrahams's novel *Song of the City*.

Alexander Fadeyev's novel *The Young Guard*.

Shu Ch'ing-ch'un's novel *Rickshaw Boy*.

The Day Before Yesterday, Shmuel Yoseph Agnon's novel.

d. Theodore Dreiser, American writer (b. 1871).

d. Paul Valéry, French poet and essayist (b. 1871).

d. Ellen Glasgow, American writer (b. 1874).

d. Franz Werfel, Austrian writer (b. 1890).

d. Margaret Deland, American novelist (b. 1857).

d. Mário de Andrade, Brazilian writer and critic (b. 1892).

d. Robert Benchley, American drama critic, humorist, and actor (b. 1889).

d. Samuel Edward Krune Mohayi, South African novelist and poet (b. 1875).

FILM & BROADCASTING

Henry V, Laurence Olivier directed and starred in his film version of Shakespeare's play, with George Robey, Max Adrian, Renee Asherson, Felix Aylmer, and Robert Newton.

Open City, Aldo Fabrizi, Anna Magnani, and Marcello Paglieri starred in Roberto Rossellini's anti-Fascist and landmark neorealist film, set in Rome durng the closing days of World War II.

Brief Encounter, David Lean's film, adapted by Noël Coward from his 1936 one-act play *Still Life*; Celia Johnson and Trevor Howard starred.

Children of Paradise (*Les Enfants du Paradis*), Arletty and Jean-Louis Barrault starred as Garance and the mime Deburau in Marcel Carné's film set in 19th-century Paris; screenplay by Jacques Prévert.

The Lost Weekend, Ray Milland and Jane Wyman starred in Billy Wilder's trailblazing antialcoholism film; based on Charles R. Jackson's novel.

Blithe Spirit, David Lean's film, adapted from Noël Coward's 1941 stage comedy about a medium, a séance, and a ghost; Rex Harrison, Kay Hammond, Margaret Rutherford, Constance Cummings, and Jacqueline Clark starred.

I Know Where I'm Going, Wendy Hiller and Roger Livesey starred in the Michael Powell–Emeric Pressburger love story, in a Highlands coastal setting.

A Tree Grows in Brooklyn, Dorothy McGuire, Joan Blondell, Peggy Anne Garner, and James Dunn starred in Elia Kazan's turn-of-the-century story adapted from the 1943 Betty Smith novel.

The Postman Always Rings Twice, John Garfield and Lana Turner starred in Tay Garnett's screen version of the 1934 James M. Cain novel, about a woman and a man who kill her husband for money.

Murder, My Sweet, Dick Powell as Philip Marlowe, Claire Trevor, and Mike Mazurki starred in Edward Dmytryk's thriller, based on Raymond Chandler's 1940 novel *Farewell, My Lovely*.

Dead of Night, the multistory horror film, directed by Alberto Cavalcanti, Basil Dearden, Robert Hamer, and Charles Crichton; Michael Redgrave led the large cast.

Diary of a Chambermaid, Paulette Goddard starred in Jean Renoir's film, set in France in the 1930s.

Jean Renoir directed *The Southerner*, starring Zachary Scott.

Mildred Pierce, Joan Crawford starred as the family-destroying career woman in the Michael Curtiz film, based on the 1941 James M. Cain novel.

Robert Bresson directed *Ladies of the Bois de Boulogne*.

Ingrid Bergman and Gregory Peck starred in *Spellbound*, directed by Alfred Hitchcock.

The Bells of St. Mary's, Bing Crosby and Ingrid Bergman starred in Leo McCarey's sequel to his 1944 *Going My Way*.

The Corn Is Green, Bette Davis and John Dall starred in Irving Rapper's film version of the 1938 Emlyn Williams play.

The House I Live In, Mervyn Leroy directed the documentary, a plea for tolerance that won him a special Oscar in 1945.

George Sanders and Hurd Hatfield starred in *The Picture of Dorian Gray*, directed by Albert Lewin; based on Oscar Wilde's 1891 novel.

John Wayne and Robert Montgomery starred in *They Were Expendable*, directed by John Ford.

And Then There Were None, Rene Clair's film, based on Agatha Christie's 1940 novel.

Academy Awards for 1945 (awarded the following year): Best Picture: *The Lost Weekend*; Best Director: Billy Wilder, *The Lost Weekend*; Best Actor: Ray Milland, *The Lost Weekend*; Best Actress: Joan Crawford, *Mildred Pierce*.

VISUAL ARTS

Margaret Bourke-White's photographs of the Allied liberation of the German death camp at Buchenwald; a towering moment in 20th-century photojournalism.

"Action painting" introduced by American abstract impressionists, and developed by Jackson Pollock and others into the "drip and splash" and other "automatic painting" techniques.

Pablo Picasso's painting *The Charnel House*.

Georgia O'Keeffe's paintings included *Cliffs*, *My Backyard*, *Dead Tree with Pink Hill*, *Hills and Mesa to the West*, *Pelvis Series*, *Red with Yellow*, *Red Hills and Blue Sky*, and *Spring Tree No. II*.

Andrew Wyeth's paintings included *East Waldoboro*, *Kuerner's Hill*, *The Woodshed*, and *Young Buck*.

Wassily Kandinsky retrospective at the Museum of Non-Objective Painting (now the Guggenheim Museum), New York.

Alexander Calder's sculptures included *Bayonets Menacing a Flower* and *The Water Lily*.

Jackson Pollock's paintings included *Totem Lesson II* and *Moon Woman Cuts the Circle*.

Walter Gropius designed the Harvard University Graduate Center.

Henry Moore's sculpture *Memorial Figure*.

Jacques Lipchitz's sculpture *Joy of Orpheus*.

Arshile Gorky's painting *Diary of a Seducer*.

Baptismal Scene, paintng by Mark Rothko.

Charles Burchfield's painting *Autumnal Fantasy*.

Headless Horse Who Wants to Jump, Yasuo Kuniyoshi's painting.

Charles Sheeler's painting *Water*.

Fernand Léger's painting *The Great Julie*.

Mark Rothko's painting *Baptismal Scene*.

Georges Braque's painting *Le Billard*.

Herbert Ferber's sculpture *Three Legged Woman I*.

Isamu Noguchi's sculptue *Kouros*.

Paul Nash's painting *Solstice of the Sunflower*.

Philip Guston's painting *Sentimental Moment*.

Up Front, Bill Mauldin's World War II cartoon collection.

Saul Steinberg's cartoon collection *All in Line*.

The Song of Orpheus, Barnett Newman's painting.

d. Alexander Stirling Calder, American sculptor (b. 1870), son of Alexander Milne Calder (1846–1923) and father of Alexander Calder (1898–1976).

d. Käthe Kollwitz, German antiwar and anti-Nazi artist (b. 1867).

d. Emily Carr, Canadian painter (b. 1871).

d. Herbert Adams, American sculptor (b. 1858).

THEATER & VARIETY

Laurette Taylor as Amanda Wingfield, Eddie Dowling, and Julie Haydon starred in *The Glass Menagerie*; the Tennessee Williams play opened at the Playhouse, New York, March 31.

Bertolt Brecht's *The Private Life of the Master Race* opened in Berkeley, California, on June 7; in the same year, he wrote his modern version of the ca. 1300 Chinese work *The Caucasian Chalk Circle*.

Jean Giraudoux's *The Madwoman of Chaillot* was produced posthumously in Paris on December 23; directed by Louis Jouvet.

Ralph Bellamy as the presidential candidate, Ruth Hussey, and Kay Johnson starred in *State of the Union*; the Howard Lindsay–Russell Crouse play opened at the Hudson Theatre, New York.

John Raitt and Jan Clayton starred in *Carousel*; the Richard Rodgers and Oscar Hammerstein II musical, adapted from Ferenc Molnar's 1921 play, *Liliom*, opened in New York.

Gérard Philipe starred in *Caligula*, Albert Camus's play.

Gordon Heath and Barbara Bel Geddes starred in the postwar prointegration *Deep Are the Roots*; Arnaud d'Usseau and James Gow's play opened at the Fulton Theatre, New York, September 26.

Arthur Laurents's *Home of the Brave*, about anti-Jewish discrimination in the wartime American army; basis of the 1949 Mark Robson film.

Betty Field and Wendell Corey starred in *Dream Girl*; Elmer Rice's play opened in New York.

Walter Hendl's *Dark of the Moon*, book by Howard Richardson and William Berney, opened at the 46th Street Theatre, New York, March 14.

Gertrude Lawrence and Raymond Massey starred in George Bernard Shaw's *Pygmalion*.

Sigmund Romberg's musical *Up in Central Park*

opened at the Century Theatre, New York.

Fritz Hochwälder's *The Fugitive*.

Halper Leivick's *The Miracle of the Warsaw Ghetto*.

Max Rudolf Frisch's *Now They Sing Again*.

Robert Woodruff Anderson's *Come Marching Home*.

d. Alla Nazimova, Russian actress (b. 1879), in the American theater from 1905.

d. Georg Kaiser, German playwright (b. 1878).

MUSIC & DANCE

Peter Grimes, Benjamin Britten's opera, with Peter Pears singing the title role of the English fisherman accused of murder; libretto by Montagu Slater, opened June 7 at Sadler's Wells, London.

War and Peace (*Voyna i mir*), Sergei Prokofiev's opera, libretto by Prokofiev and Mira Mendelson, based on Leo Tolstoy's novel; a concert version opened in Moscow, first staged in Leningrad (1946); revised version staged posthumously in 1955.

If I Loved You, June Is Bustin' Out All Over, and *You'll Never Walk Alone*, songs from the musical *Carousel*, music by Richard Rodgers, words by Oscar Hammerstein II.

Songs and Proverbs of William Blake and *The Holy Sonnets of John Donne*, song cycles created by Benjamin Britten for Peter Pears.

La Vie en Rose, Edith Piaf's song, English lyrics by Mack David, to music by R. S. Lourgay.

At the Martyr's Grave, Zoltán Kodály's choral work.

Frank Sinatra's hit *Saturday Night Is the Loneliest Night of the Week*.

Heitor Villa-Lobos's *Bachianas Brasilieras*.

Alicia Markova and Anton Dolin founded the Markova-Dolin Company.

Spring Will Be a Little Late This Year, Frank Loesser's popular song.

Undertow, Antony Tudor's ballet.

Till the End of Time, Perry Como's hit song.

Benjamin Britten's second string quartet.

Béla Bartók's third piano concerto.

Samuel Barber's *Violoncello Concerto*.

Erick Hawkins's *God's Angry Man*.

Gian Carlo Menotti's *Piano Concerto*.

Igor Stravinsky's *Symphony in Three Movements*.

Michael Tippett's first symphony.

Memories of a Child's Sunday, Roy Harris's symphony.

Philharmonia Orchestra founded by Walter Legge in London.

Royal Opera established in London.

d. John McCormack, Irish tenor (b. 1884) who sang in opera and also became one of the most popular concert singers of his time.

d. Béla Bartók, Hungarian composer, pianist, and teacher (b. 1881).

d. Jerome Kern, American composer (b. 1885).

d. Anton Webern, Austrian composer, an early modernist (b. 1883).

d. Pietro Mascagni, Italian composer (b. 1863).

WORLD EVENTS

Roosevelt, Churchill, and Stalin definitively redrew the postwar map of Europe at the Yalta Conference.

d. Franklin Delano Roosevelt (b. 1882), 32nd president of the United States (1933–1945), who had seen his country through the Great Depression and World War II, at Warm Springs, Georgia, on April 12. He was succeeded by Vice-President Harry S. Truman.

United Nations was founded at the San Francisco Conference. Eleanor Roosevelt became a member of the American delegation to the United Nations (1945–1952).

First atom bomb exploded, at Alamogordo, New Mexico (July 16).

World War II, Europe: Allied forces continued to drive into Germany from east and west; firestorm destroyed much of Dresden after Allied bombing; Berlin fell to Soviet forces (April 22–May 2); Hitler and Eva Braun committed suicide in Berlin command bunker (April 30); Germans surrendered (May 7).

World War II, Pacific: Allied forces took Okinawa and the Philippines, began heavy bombing of Japan, including firebombing of Tokyo, from Okinawa bases, and prepared for invasion of Japan; Japanese retreated in Southeast Asia and China. America dropped atom bombs on Hiroshima (August 6) and Nagasaki (August 9); Japanese surrendered August 14. Brief Soviet–Japanese war (August 9–14).

First use of atom bomb, dropped on Hiroshima by America on August 6; bomb killed an estimated 70,000–80,000 quickly; 75,000–125,000 more within a few years, of radiation, cancer, and other bomb-related injuries; and is still killing survivors. Second use of atomic bomb was at

Nagasaki, on August 9; 40,000–70,000 died quickly; 50,000–100,000 more within a few years; survivors are still dying.

Chinese Civil War resumed, in spite of American Marine occupation of some areas in North China.

Massive Hindu–Muslim riots in India; British and Indians agreed to set up an independent Pakistan.

Republic of Indonesia proclaimed by independence leaders; War of Independence began.

Ho Chi Minh became the first president of the Democratic Republic of Vietnam (1946–1969).

Arab League (League of Arab States) founded in Cairo.

Guerrilla war for Kenyan independence began.

First microwave ovens patented.

d. Vidkun Quisling, head of the Norwegian Fascist puppet government during World War II (b. 1887); executed for treason.

1946

LITERATURE

Hiroshima, John Hersey's account of the atom bombing of the Japanese city; also his Pulitzer Prize–winning novel *A Bell for Adano*, set in the post–World War II Allied occupation of Italy; basis of the 1943 Henry King film.

All the King's Men, Robert Penn Warren's novel, based largely on the life of Louisiana politician Huey Long; basis of the 1949 Robert Rossen film.

Paterson, William Carlos Williams's five-volume work of poetry and prose, set in his own Paterson, New Jersey (1946–1958).

Arch of Triumph, Erich Maria Remarque's novel, about anti-Nazi refugees in Paris in the late 1930s; basis of the 1948 Lewis Milestone film.

The Member of the Wedding, Carson McCullers novel; basis of her 1950 play and the 1952 Fred Zinneman film.

Memoirs of Hecate County, Edmund Wilson's novel, attacked as obscene and therefore even more popular in its time.

Zorba the Greek, Nikos Kazantakis's novel; basis of the 1964 Michael Cacoyannis film.

Lord Weary's Castle, Robert Lowell's Pulitzer Prize–winning poems.

Mervyn Peake's *Titus Groan* trilogy of fantasy novels (1946–1949).

The Fields, second in Conrad Richter's *The Awakening Land* trilogy.

Nelly Sachs's poetry *In the Dwellings of Death*.

Hermann Hesse was awarded the Nobel Prize for Literature.

Jean-Paul Sartre's essays *Existentialism and Humanism*.

Delta Wedding, Eudora Welty's novel.

Winds, St.-John Perse's poetry.

Paul Éluard's poetry *Poésie ininterompue*.

Dylan Thomas's *Deaths and Entrances*.

Kay Boyle's *Thirty Stories*.

B. F.'s Daughter, J. P. Marquand's novel.

East River, Sholem Asch's novel.

Sagarana, João Guimaráes Rosa's story collection.

Denise Levertov's poems *The Double Image*.

King Jesus, Robert Graves's novel.

Pavilion of Women, Pearl Buck's novel.

Eyvind Johnson's *Return to Ithaca*.

Gerhart Hauptmann's poems *Neue Gedichte*.

Philip Larkin's poetry *The North Ship*.

Mr. President, Miguel Asturias's novel.

Peter Abrahams's novel *Mine Boy*.

The Inhabitants, Wright Morris's novel.

Romain Gary's *Tulip*.

Shu Ch'ing-ch'un's novel *Four Generations under One Roof*.

Taylor Caldwell's novel *This Side of Innocence*.

The King's General, Daphne du Maurier's novel.

d. H. G. Wells (Herbert George Wells), British writer (b. 1866).

d. (Newton) Booth Tarkington, American novelist and playwright (b. 1869).

d. Countee Cullen, American poet, a major figure of the Harlem Renaissance (b. 1903).

d. Damon Runyon (Alfred Damon Runyon), American writer (b. 1884).

d. Gertrude Stein, American writer, long resident in France (b. 1874).

d. Ray Stannard Baker, American writer (b. 1870).

FILM & BROADCASTING

The Best Years of Our Lives, William Wyler post–World War II film, screenplay by Robert Sherwood, based on the 1945 MacKinlay Kantor novel, and starring Fredric March, Myrna Loy, Dana Andrews, Teresa Wright, and Harold Russell.

The Big Sleep, Humphrey Bogart as Philip Marlowe and Lauren Bacall starred in the Howard Hawks

film of the 1939 Raymond Chandler novel.

Paisan, Roberto Rossellini's post–World War II homage to the Italian partisan movement; Rossellini and Federico Fellini cowrote the screenplay.

Shoeshine, the Vittorio De Sica World War II Italian classic, about two poor children whose lives are destroyed during the World War II German occupation of Italy.

Caesar and Cleopatra, Claude Rains and Vivien Leigh starred in the Gabriel Pascal film, based on the 1906 George Bernard Shaw play.

It's a Wonderful Life, James Stewart starred in Frank Capra's populist fantasy, a classic of Hollywood's Golden Age.

My Darling Clementine, Henry Fonda as Wyatt Earp and Victor Mature as Doc Holiday starred in John Ford's classic account of the Earp–Clanton O.K. Corral confrontation.

Anna and the King of Siam, Irene Dunne and Rex Harrison starred in the John Cromwell film, based on the Margaret Landon biography, about an English governess at the Siamese court in the 1860s; basis for the musical *The King and I*.

Blue Skies, Fred Astaire and Bing Crosby starred in the Irving Berlin musical, directed by Fred Heisler.

Duel in the Sun, the King Vidor film, based on the Niven Busch novel; Jennifer Jones, Gregory Peck, and Joseph Cotton starred, with Walter Huston, Lionel Barrymore, and Lillian Gish.

Great Expectations, John Mills, Finlay Currie, Valerie Hobson, Jean Simmons, and Alec Guinness starred in the David Lean film, based on the Dickens novel.

The Killers, Burt Lancaster as Swede and Ava Gardner starred in Robert Siodmak's film version of the Ernest Hemingway short story about thieves fallen out.

The Razor's Edge, Tyrone Power, Herbert Marshall, Gene Tierney, and Anne Baxter starred in Edmund Goulding's screen version of the 1940 Somerset Maugham novel.

The Stranger, Orson Welles, Edward G. Robinson, and Loretta Young starred in the Welles film, about a German war criminal unmasked by a Nazi hunter in a small American town.

The Yearling, Gregory Peck, Jane Wyman, and Claude Jarman starred in Clarence Brown's classic children's film, based on the 1938 Marjorie Kinnan Rawlings novel.

Vsevolod Pudovkin directed *Admiral Nakhimov*.

Academy Awards for 1946 (awarded the following year): Best Picture: *The Best Years of Our Lives*; Best Director: William Wyler, *The Best Years of Our Lives*; Best Actor: Fredric March, *The Best Years of Our Lives*; Best Actress: Olivia de Havilland, *To Each His Own*.

d. Léon Gaumont, French film inventor and producer (b. 1864).

d. William S. Hart, American actor and director (b. 1870).

VISUAL ARTS

Georgia O'Keeffe's painting *A Black Bird with Snow-covered Red Hills*.

Ansel Adams founded the first college photography department, at San Francisco's California School of Fine Arts.

Chaim Gross's sculpture *Sisters*; and his painting *Peace, II*.

Ludwig Mies van der Rohe designed the Farnsworth house, Plano, Illinois (1946–1950).

Jackson Pollock's paintings included *Eyes in the Heat*, *Sounds in the Grass: Shimmering Substance*, and *The Blue Unconscious*.

Willem de Kooning's painting included *Light in August*.

Andrew Wyeth's painting *Winter*.

Mark Rothko's painting *Prehistoric Memories*.

Pablo Picasso's lithograph *Françoise*.

Jack Levine's painting *Welcome Home*.

David Smith's sculpture *Spectre of Profit*.

Georges Rouault's painting *De Profundis*.

Adolph Gottlieb's painting *Forgotten Dream*.

Isamu Noguchi's sculpture *Euripides*.

José de Rivera's sculpture *Yellow Block*.

Louise Nevelson's sculpture *Lovers II*.

Pierre Bonnard's painting *Flowering Almond Tree*.

Spectre of Kitty Hawk, Theodore Roszak's sculpture (1946–1947).

William Zorach's sculpture *The Artist's Daughter*.

Yousuf Karsh's portrait photo collection *Faces of Destiny*.

d. Alfred Stieglitz, American photographer (b. 1864), founder of the Photo-Secession (1902) and of *Camera Work* magazine (1903); husband of Georgia O'Keeffe.

d. László Moholy-Nagy, Hungarian artist and photographer, in the 1920s a leading Bauhaus figure, and from 1937 of Chicago's New Bauhaus (b. 1895).

d. Arthur Garfield Dove, American painter (b. 1880).

d. Joseph Stella, American painter (b. 1877).

d. Lafayette Maynard Dixon, American painter (b. 1875).

d. Paul Nash, British painter (b. 1889).

THEATER & VARIETY

Eva Le Gallienne, Margaret Webster, and Cheryl Crawford founded the American Repertory Theatre.

Jean-Louis Barrault and Madeleine Reynaud founded the Reynaud-Barrault repertory company at the Theatre Marigny, Paris; their first production starred Barrault in André Gide's translation of Shakespeare's *Hamlet*.

James Barton starred as Hickey in *The Iceman Cometh*; the Eugene O'Neill play, set in a New York bar, opened at the Martin Beck Theatre, New York, October 9.

Ethel Merman starred as Annie Oakley in *Annie Get Your Gun*, singing *There's No Business Like Show Business* and *Doin' What Comes Naturally*; the Irving Berlin musical opened at the Imperial Theatre, New York, May 16.

Judy Holliday, Paul Douglas, and Gary Merrill starred in *Born Yesterday*; Garson Kanin's comedy, opened at the Lyceum Theatre, New York, February 4.

Ingrid Bergman starred in Maxwell Anderson's *Joan of Lorraine*.

Patricia Neal, Mildred Dunnock, and Leo Genn starred in *Another Part of the Forest*; Lillian Hellman's play opened at the Fulton Theatre, New York, November 20.

Ruby Hill, Rex Ingram, and Pearl Bailey led an all-black cast in the Harold Arlen–Johnny Mercer musical *St. Louis Woman*.

Katharine Cornell and Marlon Brando starred in George Bernard Shaw's *Candida*.

Katharine Cornell and Cedric Hardwicke played in Jean Anouilh's *Antigone*.

Happy Birthday, Anita Loos's comedy, opened at the Broadhurst Theatre, New York, October 31.

An Inspector Calls, J. B. Priestley's play; basis of the 1954 Guy Hamilton film.

Jean Louis Barrault opened in Paris in Armand Salacrou's *Nights of Wrath*.

Alfred Lunt and Lynn Fontanne starred in Terence Rattigan's *O Mistress Mine*.

Ruth Gordon's comedy *Years Ago* opened at the Mansfield Theatre, New York, December 3.

Witold Gombrowicz's *Marriage*.

The Eagle Has Two Heads, Jean Cocteau's play.

Austin Clarke's *The Second Kiss*.

Jose Ferrer starred in *Cyrano de Bergerac*.

Micheál MacLiammóir's *Ill Met by Moonlight*.

Carl Zuckmayer's *The Devil's General*.

Max Rudolf Frisch's *The Great Wall of China*.

Lajos Bíró's *Our Katie*.

Marcel Achard's *Auprès de ma blonde*.

d. W. C. Fields (William Claude Dukenfield), American actor and vaudeville comedian (b. 1879).

d. Laurette Taylor (Helen Laurette Cooney Taylor), American actress (b. 1884).

d. Gerhart Hauptmann, German playwright (b. 1862).

d. George Arliss (George Augustus Andrews), British actor (b. 1868).

d. Harley Granville-Barker, English theater scholar, actor, and director (b. 1877).

d. Edward Brewster Sheldon, American playwright (b. 1886).

MUSIC & DANCE

Betrothal in a Monastery (*The Duenna*), Sergei Prokofiev's opera to his own libretto (additional verses by Mira Mendelson), based on the 1775 comic opera *The Duenna*, first performed in Leningrad November 3.

The Four Temperaments, George Balanchine's ballet, music by Paul Hindemith, first danced November 20, in New York, by the Ballet Society.

Symphonic Variations, Frederick Ashton's ballet to music by César Franck, first danced by the Sadler's Wells Ballet, in London, with Margot Fonteyn.

The Medium, Gian Carlo Menotti's opera, libretto by Menotti, opened at Columbia University, New York, May 8.

Woody Herman's band premiered Igor Stravinsky's *Ebony Concerto* at Carnegie Hall.

There's No Business Like Show Business, *Doin' What Comes Naturally*, and *They Say It's Wonderful* (*Falling in Love*), Irving Berlin's songs, introduced

by Ethel Merman in *Annie Get Your Gun*.

The Rape of Lucretia, Benjamin Britten's opera, libretto by Ronald Duncan, premiered at the Glyndebourne Festival July 12.

Benjamin Britten's *The Young Person's Guide to the Orchestra*, variations on a theme by Henry Purcell, often narrated; originally written for a film; basis for the 1953 ballet *Fanfare*.

La Sonnambula, George Balanchine's ballet; music by Vittorio Rieti, first danced February 27, by the Ballets Russes de Monte Carlo, in New York.

Facsimile, Jerome Robbins's ballet, music by Leonard Bernstein, first danced October 24, by the Ballet Theater, New York.

Adam Zero, Robert Helpmann's ballet to Arthur Bliss's music; Helpmann danced the lead.

Prisoner of Love, Perry Como's hit.

When Lilacs Last in the Door-yard Bloom'd, Paul Hindemith's choral work.

Come Rain or Come Shine, popular song, words by Johnny Mercer, music by Harold Arlen.

Pierre Boulez's first piano sonata and vocal work *Le visage nuptial*.

Richard Strauss's *Oboe Concerto* and *Metamorphosen*, for strings.

Medea, Samuel Barber's ballet.

Aaron Copland's third symphony.

The Medium, Gian Carlo Menotti's opera.

Arthur Honegger's fourth and fifth symphonies.

Airborne, Marc Blitzstein's symphony.

Michael Tippett's *Little Music* for strings.

Aram Khachaturian's *Cello Concerto*.

Igor Stravinsky's *Concerto for Strings*.

Elliott Carter's *Piano Sonata*.

Avignon Festival established as an annual summer festival.

Benjamin Britten founded the English Opera Group.

Juilliard School of Music founded in New York.

Thomas Beecham founded Britain's Royal Philharmonic Orchestra.

Welsh National Opera founded in Cardiff.

Galpin Society, focusing on history of musical instruments, founded in London.

d. Manuel de Falla, Spanish composer (b. 1876).

d. Vincent Youmans, American composer and producer (b. 1898).

d. Sidney Jones, English composer (b. 1861).

WORLD EVENTS

Nuremberg war-crimes trial began (November 1945–October 1946); 11 leading Nazis were sentenced to death for crimes against humanity, seven imprisoned, and three acquitted.

Chinese Civil War continued; almost all American troops were withdrawn, while Kuomintang forces took much of North China and Manchuria.

American atom-bomb tests began on Bikini Atoll, in the Marshall Islands.

Civil war between Greek Communists and Greek government began.

Indochina War (Vietnamese War of Independence) began, pitting Democratic Republic of Vietnam against French colonial forces (1946–1954).

Irgun Zvai Leumi terrorists, commanded by Menachim Begin, bombed Jerusalem's King David Hotel, killing 91 people, 17 of them Jews.

Winston Churchill's "iron curtain" speech, at Westminster College, Fulton, Missouri (March 5).

Jordan (Hashemite Kingdom of Jordan) became a fully independent state (May 25).

Juan Domingo Perón was elected president of Argentina, becoming dictator (1946–1955).

President Harry S. Truman appointed Frederick Moore Vinson chief justice of the U.S. Supreme Court.

Republic of the Philippines became fully independent (July 4).

Syrian Arab Republic became a fully independent state (April 17).

Trygve Lie of Norway became the first secretary-general of the United Nations.

Mother (Francesca) Cabrini became the first American Catholic saint.

John William Mauchly and John Presper Eckert developed the ENIAC (Electronic Numerical Integrator and Calculator) computer.

1947

LITERATURE

Anne Frank's diary, the journal of a young German-Jewish girl hiding in Nazi-held Amsterdam, was first published, after her death and war's end, as *Het Achterhus*; basis of the 1955 play and 1959 film.

The Plague, Albert Camus's novel.

André Gide was awarded the Nobel Prize for Literature.

A Woman of Rome, Alberto Moravia's novel.

The Reprieve, Jean-Paul Sartre's novel.

The Wayward Bus, John Steinbeck's novel.

Tales of the South Pacific, James Michener's Pulitzer Prize–winning first novel; basis of the 1949 musical and 1958 film *South Pacific*.

The Big Sky, A. B. Guthrie's Western novel; basis of the 1952 Howard Hawks film.

Under the Volcano, Malcolm Lowry's novel about a self-destructive British alcoholic in 1930s Mexico; basis of the 1984 John Huston film.

Doctor Faustus, Thomas Mann's novel.

Jean Genet's novels *Thief's Journal* and *Querelle of Brest*.

Bend Sinister, Vladimir Nabokov's novel.

Budd Schulberg's novel *The Harder They Fall*.

Richard Wilbur's poetry *The Beautiful Changes*.

Cecil Day Lewis's *Poems* (1943–1947).

The Portrait of a Man Unknown, Nathalie Sarraute's novel.

Conrad Aiken's poetry *The Kid*.

Vance Bourjaily's novel *The End of My Life*.

Frank O'Connor's short stories *The Common Chord*.

The Storm, Ilya Ehrenburg's war novel.

Henry James's *Notebooks* were published.

Karl Shapiro's poetry *Trial of a Poet*.

Léon Gontran Damas's *African Songs of Love, War, Grief and Abuse*.

Snow Country, Yasunari Kawabata's novel.

Meyer Levin's novel *My Father's House*.

Osamu Dazai's novels *The Setting Sun* and *Villon's Wife*.

Raja Rao's short-story collection *Cow of the Barricades*.

Thakazhi Sivasankara Pillai's novel *The Scavenger's Son*.

Bhabani Bhattacharya's novel *So Many Hungers*.

The Times of Melville and Whitman, Van Wyck Brooks's literary history.

Stephen Potter's *The Theory and Practice of Gamesmanship; or, The Art of Winning Games without Actually Cheating*.

d. Willa Cather, American writer (b. 1873).

d. Charles Bernard Nordhoff, American writer (b. 1887).

d. Winston Churchill, American writer (b. 1871).

FILM & BROADCASTING

Gentleman's Agreement, Gregory Peck, John Garfield, Celeste Holm, Dorothy McGuire, and Anne Revere starred in Elia Kazan's attack on anti-Semitism; Moss Hart's screenplay was based on the Laura Z. Hobson novel.

Monsieur Verdoux, Charles Chaplin wrote, directed, produced, and starred as a serial murderer of his wives in the satire, based on the story of mass murderer Charles Landru.

Black Narcissus, Deborah Kerr, Flora Robson, Jean Simmons, and David Farrar starred in the Michael Powell–Emeric Pressburger film, set in a Himalayan nunnery; based on the 1939 Rumer Godden novel.

Odd Man Out, James Mason as the wounded Irish Republican Army leader starred in Carol Reed's Northern Ireland Civil War film.

Mourning Becomes Electra, Raymond Massey, Michael Redgrave, Rosalind Russell, and Katina Paxinou starred in Dudley Nichols's screen version of the 1931 Eugene O'Neill trilogy, a free adaptation of the Oresteia, set in late 19th-century New England.

John Garfield and Lilli Palmer starred in *Body and Soul*, directed by Richard Rossen.

Robert Ryan and Robert Mitchum starred in *Crossfire*, directed by Edward Dmytryk.

Devil in the Flesh, the Claude Autant–Lara postwar love story, controversial in its time; Gerard Philipe and Micheline Presle starred.

Life with Father, William Powell and Irene Dunne starred as the early 1900s New York couple in the Michael Curtiz film version of the 1939 Howard Lindsay–Russell Crouse stage comedy.

Dolores Del Rio starred in *The Fugitive*, directed by John Ford in Mexico.

Michael Redgrave starred in *Fame Is the Spur*, directed by Roy Boulting.

Miracle on 34th Street, Edmund Gwenn as Santa Claus, Maureen O'Hara, John Payne, and Natalie Wood starred in George Seaton's Christmas film.

The Ghost and Mrs. Muir, Gene Tierney as Mrs. Muir and Rex Harrison as the sea captain's ghost starred in the Joseph L. Mankiewicz film.

Sergei Gerasimov directed *The Young Guard*.

Claudette Colbert and Fred MacMurray starred in *The Egg and I*, directed by Chester Erskine.

The Sea of Grass, Katharine Hepburn and Spencer

Tracy starred in Elia Kazan's screen version of the 1937 Conrad Richter novel, set in the American Southwest.

Academy Awards for 1947 (awarded the following year): Best Picture: *Gentleman's Agreement*; Best Director: Elia Kazan, *Gentleman's Agreement*; Best Actor: Ronald Colman, *A Double Life*; Best Actress: Loretta Young, *The Farmer's Daughter*.

d. Ernst Lubitsch, German director (b. 1892), long in Hollywood, whose comedies were celebrated as having "the Lubitsch touch."

VISUAL ARTS

Alberto Giacometti's sculptures included *Head of a Man on a Rod*, *Tall Figure I*, and *Man Pointing*.

Andrew Wyeth's paintings included *Christina Olson*, *Hoffman's Slough*, and *Wind from the Sea*.

Jackson Pollock's paintings included *Cathedral*, *Full Fathom Five*, and *Lucifer*.

Georgia O'Keeffe's painting *White Primrose*.

Robert Motherwell's painting included *The Red Skirt* and *Western Air* (1946–1947).

André Malraux's *The Psychology of Art*, in three volumes (1947–1949), later appearing as *The Voices of Silence* (1951).

Arshile Gorky's paintings included *Agony* and *The Betrothal II*.

Marcel Breuer designed the Robinson House, Williamstown, Massachusetts.

Bill Mauldin's cartoon book *Coming Home*.

Isamu Noguchi's sculpture *Night Land*.

José de Rivera's sculpture *Yellow Black*.

William Zorach's sculpture *The Future Generation*.

Richard Neutra designed the Kauffmann desert house, Palm Springs, California.

Milton Caniff created the *Steve Canyon* comic strip.

Stuart Davis's painting *Iris*.

Vision in Motion, László Moholy-Nagy's book, published posthumously.

Willem de Kooning's painting *Noon*.

d. Pierre Bonnard, French painter, illustrator, and set designer (b. 1867).

THEATER & VARIETY

Jessica Tandy as Blanche DuBois, Marlon Brando as Stanley Kowalski, Kim Hunter, and Karl Malden starred in *A Streetcar Named Desire*, Tennessee Williams's Pulitzer Prize–winning classic; Elia Kazan directed the 1951 film version.

Ed Begley and Arthur Kennedy starred in *All My Sons*; Arthur Miller's story of generational conflict, set in World War II, opened in New York.

Medea, Judith Anderson in her classic Medea and John Gielgud as Jason starred in Robinson Jeffers's adaptation of the Euripides play; opened at the National Theatre, New York, October 20.

Cheryl Crawford, Robert Lewis, and Elia Kazan organized the seminal Stanislavsky-based Actors Studio in New York City.

Wendy Hiller and Basil Rathbone starred in *The Heiress*; the Ruth and Augustus Goetz play, based on the Henry James novel, opened at the Biltmore Theatre, New York, September 29; basis of the 1949 William Wyler film.

The Avignon Festival was founded by Jean Vilar; he starred in Shakespeare's *Richard II*, its opening production.

David Brooks and George Keane starred in *Brigadoon*; the Alan Jay Lerner–Frederick Loewe musical opened in New York, March 13.

Albert Sharpe, Ella Logan, and David Wayne starred in *Finian's Rainbow*; the Burton Lane–E. Y. Harburg musical opened in New York.

William Prince and Nina Foch starred in *John Loves Mary*; Norman Krasna's comedy, opened at the Booth Theatre, New York, February 4.

William Douglas Home's plays *The Chiltern Hundreds* and *Now Barabbas*

John Gielgud and Lillian Gish starred on Broadway in *Crime and Punishment*.

The Edinburgh Festival of Music and Drama was founded.

Charles Laughton starred in Bertolt Brecht's play *Galileo*.

Michael Redgrave starred as *Macbeth* in London.

The Maids, Jean Genet's play.

Armand Salacrou's *L'Archipel Lenoir*.

Fritz Hochwälder's *The Public Prosecutor*.

The Linden Tree, J. B. Priestley's play.

Jacques Audiberti's *Le Mal court*.

Oak Leaves and Lavender, Sean O'Casey's play.

Junui Kinoshita's *The Sound of the Loom*.

Kjeld Abell's *Days on a Cloud*.

Stig Dagerman's *The Condemned*.

d. Charlotte "Lotta" Crabtree, American actress (b. 1869).

d. Eva Tanguay, Quebec-born American vaudeville star (b. 1878), who sang I Don't Care.

d. Dudley Digges, Irish-American actor (b. 1879).

d. James Evershed Agate, English dramatic critic (b. 1877).

d. Luigi Chiarelli, Italian playwright (b. 1884).

MUSIC & DANCE

Sergei Prokofiev's Symphony No. 6 (1945–1947).

The Telephone, Gian Carlo Menotti's opera, libretto by Menotti, opened at the Heckscher Theater, New York, February 18.

The Mother of Us All, Virgil Thomson's opera, libretto by Gertrude Stein, opened May 7 at Columbia University, New York.

Danton's Death, Gottfried von Einem's opera, libretto by von Einem and Boris Blatcher, based on Georg Büchner's 1835 play, opened at the Salzburg Festival August 6.

Albert Herring, Benjamin Britten's opera, libretto by Eric Crozier, opened at Glyndebourne June 20.

Symphony in C, George Balanchine's ballet to music by Georges Bizet, first danced July 28, in Paris.

Die Bernauerin (The Bernauer Girl), Carl Orff's play with music, based on a 17th-century Bavarian legend, first performed June 15 in Stuttgart.

The Breasts of Tiresias (Les Mamelles de Tirésias), Francis Poulenc's opera, libretto by Guillaume Apollinaire, opened June 3 at the Opéra-Comique, Paris.

It's Almost Like Being in Love, Alan Jay Lerner and Frederick Loewe's song from Brigadoon.

José Limón founded the American Dance Company.

Arnold Schoenberg's A Survivor from Warsaw, for voice and orchestra.

Knoxville: Summer of 1915, Samuel Barber's vocal work; also his ballet Medea.

Bing Crosby's hit version of the Whiffenpoof Song (written ca. 1893).

Sarah Vaughan and Billy Eckstine's recording of It's Magic.

Night Journey, Martha Graham's dance to music by William Schuman.

Benjamin Britten's first canticle.

The Taras Family, Dmitry Kabalevsky's opera.

Day on Earth, Doris Humphrey's dance to music by Aaron Copland.

The Minotaur, Elliott Carter's ballet.

L'oro, Ildebrando Pizzetti's opera.

Errand into the Maze, Gian Carlo Menotti's ballet.

Walter Piston's Pulitzer Prize–winning Third Symphony.

The Ballad of Reading Gaol, Jacques Ibert's ballet.

Aram Khachaturian's third symphony.

William Walton's String Quartet.

Karl-Birger Blomdahl's Symphony.

Milton Babbitt's Three Compositions, for piano.

Ralph Vaughan Williams's Symphony No. 6.

Sergei Prokofiev's Symphony No. 4 (revision).

The Trial of Lucullus, Roger Sessions's opera.

Wallingford Riegger's Symphony No. 3.

WORLD EVENTS

President Harry S. Truman introduced the practice of the "loyalty oath," a major feature of the witch-hunting McCarthy period.

Ten American film directors and screenwriters (the Hollywood Ten) refused to testify before the House Un-American Activities Committee, and were jailed for contempt and blacklisted, signaling the beginning of the witchhunting period.

President Harry S. Truman announced the anti-Communist Truman Doctrine in calling for massive aid to Greece and Turkey.

U.S. Secretary of State George C. Marshall developed the Marshall Plan, a massive American aid program aimed at rebuilding postwar Europe.

George Frost Kennan authored the cold-war policy of containment of the Soviet Union.

U.S. Taft–Hartley Act greatly impeded further union organization and strike action.

India was partitioned, creating the independent states of India and Pakistan, accompanied by huge riots, mass murders, and internal migrations, in which an estimated 10–18 million people migrated and 500,000–1,000,000 died. India and Pakistan began an undeclared war over Kashmir (1947–1949).

Partition of Palestine into Arab and Jewish states was recommended by the United Nations, with British withdrawal scheduled for October 1, 1948.

American and British military supplies and advisors to Greek government began to turn the tide of the Greek Civil War.

Colombian Civil War (La Violencia) began (1947–1958); it would cost an estimated 200,000–300,000 lives.

Explosion of a nitrate-carrying freighter in the harbor of Texas City, Texas (April 16), triggered further explosions, costing 500–1,000 lives.

Bell X-1, piloted by American aviator Charles Yeager, broke the sound barrier.

First group of Dead Sea Scrolls found in Qumran Cave, Palestine.

Jackie (Jack Roosevelt) Robinson broke the color line in American professional sports, joining the Brooklyn Dodgers and becoming the first African-American major-league baseball player.

Thor Heyerdahl sailed across the Pacific on his balsa-wood raft, the *Kon-Tiki*.

American chemist Willard Frank Libby invented the carbon-14 dating technique.

1948

LITERATURE

The Fable, William Faulkner's Pulitzer Prize–winning novel, and his *Intruder in the Dust*, about Southern racism, directed by Clarence Brown in the 1949 screen adaptation.

The Nobel Prize for Literature was awarded to T. S. Eliot.

Cry, the Beloved Country, Alan Paton's novel, about South African racism; basis of the 1949 Maxwell Anderson–Kurt Weill musical, *Lost in the Stars*, and the 1951 film.

Ashes and Diamonds, Jerzy Andrzejewski's novel, about the Polish resistance movement during World War II; basis of the 1958 Andrzej Wajda film.

The Young Lions, Irwin Shaw World War II novel; basis of the 1958 Edward Dmytryk film.

Christ Stopped at Eboli, Carlo Levi's autobiography, based on his World War II experiences; basis of the 1979 Francesco Rosi film.

Aldous Huxley's novel *Ape and Essence*.

Other Voices, Other Rooms, Truman Capote's novel.

The Heart of the Matter, Graham Greene's novel.

Confessions of a Mask, Yukio Mishima's novel.

Seraph on the Sewanee, Zora Neale Hurston's novel.

Alfred Doblin's trilogy of novels *November, 1918*.

The Loved One, Evelyn Waugh's novel.

The Age of Anxiety, W. H. Auden's poem.

Paul Éluard's poetry *Poèmes Politiques*.

Wisdom of the Sands, Antoine St.-Exupéry's novel.

Remembrance Rock, Carl Sandburg's novel.

Léopold Senghor's *Hosties noires*.

No Ordinary Summer, Konstantin Fedin's novel.

The Ides of March, Thornton Wilder's novel.

Guard of Honor, James Gould Cozzens's Pulitzer Prize–winning novel.

Osamu Dazai's novel *No Longer Human*.

The Home Place, Wright Morris's novel.

The Makioka Sisters, Junichiro Tanizaki's novel.

Ross Lockridge's novel *Raintree County*, basis of the Edward Dmytryk film.

S. J. Perelman's *Westward Ha!*

The Corner That Held Them, Sylvia Townsend Warner's novel.

Derek Walcott's *25 Poems*.

The Precipice, Hugh MacLennan's novel.

Theodore Roethke's poetry *The Lost Son*.

G. V. Desani's novel *All About H. Hatterr*.

(Burrhus Frederic) Skinner's *Walden Two*.

Bollingen Prize in Poetry was established.

The Great Tradition, F. R. Leavis's reassessment of the English novel.

d. Georges Bernanos, French writer (b. 1888), author of *Diary of a Country Priest*.

d. Claude McKay, Jamaican-American writer, a leading figure in the Harlem Renaissance (b. 1890).

d. Gertrude Atherton, American author (b. 1857).

d. Kan Kikuchi, Japanese novelist and playwright (b. 1888).

d. Osamu Dazai, Japanese novelist (b. 1909).

d. Ross Lockridge, American novelist (b. 1914).

d. Thomas Mofolo, Lesotho writer (b. 1875).

FILM & BROADCASTING

The Hollywood Ten—Alvah Bessie, Herbert Biberman, Lester Cole, Edward Dmytryk, Ring Lardner, Jr., John Howard Lawson, Albert Maltz, Samuel Ornitz, Adrian Scott, and Dalton Trumbo—were jailed for contempt of Congress after defying a House Un-American Activities Committee Communist witchhunt, and were all blacklisted by the film industry.

The Treasure of Sierra Madre, Humphrey Bogart, Walter Huston, and Tim Holt starred as the gold-seeking partners in 1920s Mexico, in John Huston's film version of the 1945 B. Traven novel.

Key Largo, Humphrey Bogart, Edward G. Robinson,

Lauren Bacall, Lionel Barrymore, and Claire Trevor starred in the classic John Huston thriller, set in the Florida Keys.

The Snake Pit, Olivia de Havilland starred in the trailblazing Anatole Litvak film about a woman trapped in an insane asylum, by extension an attack on the system that produced the asylum.

Hamlet, Laurence Olivier's film version of Shakespeare's play; Olivier directed, cowrote the screenplay with Alan Dent, and starred, with Felix Aylmer, Basil Sydney, Eileen Herlie, and Jean Simmons.

All My Sons, the Irving Reis film of the 1947 Arthur Miller World War II generational conflict play; Edward G. Robinson and Burt Lancaster starred.

State of the Union, Spencer Tracy as the presidential candidate, Katharine Hepburn, and Angela Lansbury starred in Frank Capra's screen version of the Howard Lindsay–Russell Crouse play.

Arch of Triumph, Charles Boyer and Ingrid Bergman starred in the Lewis Milestone film, based on the 1946 Erich Maria Remarque novel, about anti-Nazi refugees in Paris in the late 1930s.

Oliver Twist, Alec Guinness, Robert Newton, and Anthony Newley starred in David Lean's version of the Dickens novel.

Fort Apache, the John Ford film, set during the western Indian wars, the first in his Cavalry trilogy; Henry Fonda, John Wayne, and Shirley Temple starred.

Red River, John Wayne and Montgomery Clift starred in Howard Hawks's classic Western, set during an early Chisholm Trail drive to Missouri.

Easter Parade, Fred Astaire and Judy Garland starred in the Irving Berlin musical, directed by Charles Walters.

I Remember Mama, Irene Dunne starred as the immigrant San Francisco Norwegian mother in George Stevens's screen version of the 1944 John Van Druten play.

Johnny Belinda, Jane Wyman, Lew Ayres, and Stephen McNally starred in Jean Negulesco's screen version of the 1940 Elmer Harris tragedy, the story of a victimized deaf mute girl who kills to save her illegitimate child.

Mr. Blandings Builds His Dream House, Cary Grant, Myrna Loy, and Melvyn Douglas starred in H. C. Potter's post–World War II suburban life comedy.

The Lady from Shanghai, Orson Welles wrote, directed, and starred as Michael O'Hara in the thriller, with Rita Hayworth and Everett Sloane.

Max Ophüls directed *La Ronde* and *Letter from an Unknown Woman*.

The Naked City, Barry Fitzgerald, Don Taylor, and Howard Duff starred in Jules Dassin's New York police procedural; basis of the 1959–1963 television series.

The Red Shoes, Moira Shearer, Anton Walbrook, and Marius Goring starred in the Michael Powell–Emeric Pressburger classic ballet theater fantasy.

Ed Sullivan Show debuted; the durable television variety show (1948–1971).

Milton Berle starred in the *Texaco Star Theater*, in that period when he was known as "Mr. Television" (1948–1953).

Kukla, Fran and Ollie, beginning of Burt Tillstrom's puppet show, the television children's series, with Fran Allison.

Academy Awards for 1948 (awarded the following year): Best Picture: *Hamlet*; Best Director: John Huston, *Treasure of Sierra Madre*; Best Actor: Laurence Olivier, *Hamlet*; Best Actress: Jane Wyman, *Johnny Belinda*.

d. D. W. (David Lewelyn Wark) Griffith, seminal American director and producer (b. 1875).

d. Sergei Eisenstein, Soviet director (b. 1898).

d. Gregg Toland, leading American cinematographer; among the films he shot were *Citizen Kane*, *The Best Years of Our Lives*, *Wuthering Heights*, and *The Grapes of Wrath* (b. 1904).

d. Jacques Feyder (Jacques Frederix), Belgian-French director (b. 1885).

VISUAL ARTS

Andrew Wyeth's paintings included *Christina's World*, his painting of his neighbor Anna Christina Olson; *Karl*; *Seed Corn*; and *Winter Corn*.

Eero Saarinen designed the General Motors Technical Center, Warren, Michigan (1948–1956), and the Jefferson National Expansion Memorial (the Arch), St. Louis, Missouri (1948–1964).

Rube Goldberg's *Peace Today*, his Pulitzer Prize–winning anti-nuclear arms editorial cartoon.

Alexander Calder's sculpture *Red and White on Post*.

Georges Rouault's painting *Head of a Clown*.

Alberto Giacometti's sculpture *City Square*.

Edward Hopper's painting *Seven A.M.*

Alvar Aalto designed Baker House, Massachusetts Institute of Technology.

Bernard Berenson's book *Aesthetics and History*.

Henri Matisse's painting *Large Interior in Red*.

Marc Chagall's illustrations for Gogol's *Dead Souls*.

Henry Moore's sculpture *Family Group* (1948–1949).

Frank Lloyd Wright designed the V. C. Morris Shop, San Francisco.

Jackson Pollock's painting *Summertime*.

Pablo Picasso's ceramic work *Woman Vase*.

Jacques Lipchitz's sculpture *Primordial Figure* (1947–1948).

Labors of Hercules, Herbert Ferber's sculpture.

Barnett Newman's paintings *Onement I* and *Onement II*.

Painting, Willem de Kooning's painting.

Richard Neutra designed the Tremaine house, Santa Barbara, California.

Willem de Kooning's painting *Woman*.

Sentinel, Seymour Lipton's sculpture.

Vigil, Adolph Gottlieb's painting.

Walt Kelly's *Pogo* comic strip began to appear in the *New York Star*.

d. Arshile Gorky (Vosdanig Adoian), Armenian-American painter (b. 1905).

THEATER & VARIETY

Margaret Phillips as Alma and Tod Andrews starred in *Summer and Smoke*; the Tennessee Williams play opened at the Music Box Theatre, New York.

Henry Fonda, William Harrigan, and David Wayne starred in *Mister Roberts*; the Thomas Heggen–Joshua Logan play, set on a World War II naval vessel, opened at the Alvin Theatre, New York, February 18.

Rex Harrison starred as Henry VIII and Joyce Redman as Anne Boleyn in *Anne of the Thousand Days*; Maxwell Anderson's blank-verse drama opened at the Shubert Theatre, New York.

Madeleine Carroll, Sam Wanamaker, and Conrad Nagel starred in *Goodbye, My Fancy*; Fay Kanin's comedy opened in New York.

Alfred Drake and Patricia Morison starred in *Kiss Me, Kate*; Cole Porter's musical, inspired by Shakespeare's *The Taming of the Shrew*, opened at the New Century Theatre, New York.

Ray Bolger starred in *Where's Charley?*; the Frank Loesser–George Abbott musical opened at the St. James Theatre, New York, October 11.

Light Up the Sky, Moss Hart's comedy, opened at the Royale Theatre, New York, November 18.

Nancy Walker and Harold Lang starred in Hugh Martin's *Look, Ma, I'm Dancin'*.

Soiled Hands, Jean-Paul Sartre's play, opened in Paris.

Estelle Winwood starred in Jean Giraudoux's *The Madwoman of Chaillot*.

Lee Strasberg became artistic director of the Actors Studio.

Marcel Achard's *Nous irons à Valparaiso*.

The Philosopher's Stone, Par Lagerkvist's play.

William Douglas Home's *Ambassador Extraordinary*.

Robert Morley starred in *Edward, My Son*.

Austin Clarke's *As the Cow Flies*.

Gerhart Hauptmann's *Elektra* and *Agamemnons Tod*.

Henri de Montherlant's *Le Maître de Santiago*.

Jacques Audiberti's plays *La Fête noire* and *Les Femmes du boeuf*.

Lion Feuchtwanger's *Madness, or the Devil in Boston*.

d. Antonin Artaud, French writer, actor, and producer (b. 1896), who developed the "theater of cruelty."

d. Lilian Braithwaite, English actress (b. 1873).

d. Gregorio Martínez Sierra, Spanish playwright (b. 1881).

d. Susan Glaspell, American novelist and playwright (b. 1882).

d. Lajos Bíró, Hungarian playwright (b. 1880).

d. Matheson Lang, Canadian-born Scotland-raised actor–manager and playwright (b. 1879).

d. Nellie Jane Wallace, English music-hall star (b. 1870).

MUSIC & DANCE

Long-playing records (33-1/3 rpm), invented by Peter Goldmark, were introduced, allowing recording of longer unbroken stretches of music, becoming standard by 1960, with smaller (45 rpm) disks for singles.

Cinderella, Frederick Ashton's ballet, to music by Sergei Prokofiev, first danced by the Sadler's Wells ballet in London December 23, with Moira Shearer in the title role.

Fall River Legend, Agnes de Mille's ballet treatment of the Lizzie Borden ax murders, music by Morton

Gould, first danced April 22 by the American Ballet Theater, New York, with Alicia Alonso dancing the lead.

Orpheus, George Balanchine's ballet, music by Igor Stravinsky, sets by Isamu Noguchi, first danced April 28 by the Ballet Society, New York.

Pete Seeger, Lee Hays, Ronnie Gilbert, and Fred Hellerman formed the Weavers, the protest-oriented American folksinging group; the group would be destroyed by being blacklisted during the McCarthy period.

Tape recording, developed during World War I, first used commercially when ABC recorded the *Bing Crosby Show*.

Aaron Copland's *Concerto for Clarinet and String Orchestra* and film score *The Red Pony*.

Milton Babbitt's *Composition for 4 Instruments*, *Composition for 12 Instruments*, and his first string quartet.

Olivier Messiaen's *Turangalila-symphonie* and *Cantéyodjayâ*, for piano.

Aldeburgh Festival founded in United Kingdom by Benjamin Britten, whose music was featured, with 26 premieres (1948-76).

Lester Flatt and Earl Scruggs organized the Foggy Mountain Boys.

Elliott Carter's *Woodwind Quintet* and *Sonata* for cello and piano.

Pierre Boulez's second piano sonata and vocal work *Le Soleil des eaux*.

Leonard Bernstein's *Brass Music* and piano work *Four Anniversaries*.

Once in Love with Amy, Frank Loesser's song from *Charley's Aunt*, sung by Ray Bolder.

Richard Strauss's *Four Last Songs*.

Bing Crosby's hit version of the 1946 song *Now Is the Hour*.

Czinka Panna, Zoltán Kodály's opera.

St. Nicolas, Benjamin Britten's choral work.

Boogie Chillen', John Lee Hooker's hit single.

Kentuckiana, Darius Milhaud's orchestral work.

Dmitri Shostakovich's *Violin Concerto No. 1*.

Igor Stravinsky's *Mass*.

John Cage's *Sonatas and Interludes* for prepared piano.

Marsia, Luigi Dallapiccola's ballet.

Michael Tippett's orchestral work *Suite*.

d. Franz Lehár, Hungarian composer (b. 1870).

d. Alan Lomax, American folklorist, with his son John a key figure in the mid-20th-century folk revival (b. 1875).

d. Richard Tauber, Austrian tenor (b. 1891).

d. Uzeir Hajibeyov, Azerbaijani composer (b. 1885).

WORLD EVENTS

d. Mohandas "Mahatma" (Great Soul) Gandhi, leader of the Indian independence movement (b. 1869), one of the most revered figures of the 20th century; assassinated by a Hindu extremist in New Delhi, on January 30.

Eleanor Roosevelt was the chief architect of the historic United Nations Declaration of Human Rights.

As the British prepared to leave Palestine, the Israeli War of Independence (First Arab–Israeli War) began (May 1948–January 1949), accompanied by massive Palestinian Arab evacuations. Israeli independence was proclaimed on May 14, the day British forces left Palestine; on May 15, Syrian, Lebanese, Iraqi, Jordanian, and Egyptian forces invaded Israel, but were defeated. De facto partition ended the war, which began decades of Arab–Israeli conflict in the region.

Harry S. Truman won a full presidential term, defeating Republican Thomas E. Dewey, Progressive Henry A. Wallace, and Dixiecrat Strom Thurmond.

Soviet forces blockaded West Berlin (June 22); the Allies responded with the Berlin Airlift (June 26, 1948–September 30, 1949).

American diplomat Alger Hiss was accused by Whittaker Chambers of being a Communist spy, in testimony before the House Committee on Un-American Activities.

Smith Act trials of American Communist leaders began.

Communist coup toppled the democratic government in Czechoslovakia. Foreign Minister Jan Masaryk, who did not resign, died in a highly questionable "fall" from an office window.

Yugoslavia and the Soviet Union broke off relations.

Greek government forces were ascendant in Greek Civil War; with Soviet–Yugoslav break, Greek Communist sources of supply dried up, and the war quickly ended.

Burma became independent nation (January 4), led by Prime Minister U Nu.

Racist National Party, led by Daniel Malan, came to power in South Africa, introducing the system of apartheid.

Korea, occupied in separate American and Soviet zones during World War II, was divided into two independent states: Democratic People's Republic of Korea (North Korea) and Republic of Korea (South Korea).

World Health Organization established.

Britain's National Health Service went into full operation.

Alfred Kinsey's *Sexual Behavior in the Human Male*, the first "Kinsey report."

Norbert Wiener's *Cybernetics; or Control and Communication in the Animal and the Machine*.

d. Folke Bernadotte, Swedish diplomat and United Nations Palestine mediator (b. 1895); assassinated by Israeli Stern Gang terrorists.

1949

LITERATURE

1984, George Orwell's bitterly satirical novel about the near-future bureaucratic state; basis of the 1956 Michael Anderson and 1984 Michael Radford films.

Shirley Jackson's story collection, *The Lottery*, with her chilling title story; and her novel *The Road Through the Wall*.

Heinrich Böll's novel *The Train Was On Time*.

The Nobel Prize for Literature was awarded to William Faulkner.

Gwendolyn Brooks's *Annie Allen*, her Pulitzer Prize–winning poetry collection, on African-American themes.

The Man with the Golden Arm, Nelson Algren's novel, about a drug addict; Otto Preminger directed the 1955 screen version.

The Way West, A. B. Guthrie's Pulitzer Prize–winning Western novel; basis of the 1967 Andrew McLaughlin film.

The Second Sex, Simone de Beauvoir's essays, central to the development of the modern feminist movement.

Troubled Sleep, Jean-Paul Sartre's novel.

William Riley Burnett's novel *The Asphalt Jungle*, basis of the 1950 John Huston film.

Britain lifted the ban on Radclyffe Hall's lesbian novel *The Well of Loneliness* (1928).

The Moving Target, Ross Macdonald's mystery novel introducing detective Lew Archer.

The Heat of the Day, Elizabeth Bowen's novel.

Angus Wilson's short stories *The Wrong Set*.

A Rage to Live, John O'Hara's novel.

Eudora Welty's short stories *The Golden Apples*.

The Communists, Louis Aragon's five-volume novel (1949–1951).

Walter Van Tilburg Clark's novel *The Track of the Cat*.

The Emigrants, Carl Moberg's novel; basis of the 1971 Jan Troell film.

Miguel Angel Asturias's novels *Men of Maize* and *Strong Wind*.

The Aleph, Jorge Luis Borges's short-story collection.

Conrad Aiken's poetry *Skylight One*.

Point of No Return, J. P. Marquand's novel.

Dannie Abse's poetry *After Every Green Thing*.

Sexus, Henry Miller's novel.

Hamilton Basso's novel *The Greenroom*.

The Holiday, Stevie Smith's novel.

Nadine Gordimer's short stories *Face to Face*.

Kenneth Rexroth's poetry *The Signature of All Things*.

Léopold Senghor's *Chants por Naëtt*.

Manuel Altolaquirre's peotry *Fin de amor*.

St.-John Perse's *Exile, and Other Poems*.

Mary, Sholem Asch's novel.

The Brave Bulls, Tom Lea's self-illustrated novel.

Masuji Ibuse's novel *No Consultation Today*.

New Day, Vic Reid's novel, in Jamaican English.

Mr. Sampath, Rasipuram Narayan's novel.

Story of Youth, Fyodor Gladkov's autobiography.

The Grand Design, John Dos Passos's novel.

d. Margaret Mitchell, author of *Gone with the Wind* (b. 1900).

d. Sigrid Undset, Norwegian writer (b. 1882).

d. Sarojini Naidu, Indian poet writing in English (b. 1879).

d. Hervey Allen, American historical novelist (b. 1889).

d. Rex Beach, American novelist (b. 1877).

FILM & BROADCASTING

Ingrid Bergman was blacklisted in America after leaving her husband and daughter for film director Roberto Rossellini; blacklisting for many reasons was endemic in that witch-hunting period.

The Third Man, Joseph Cotten, Orson Welles as Harry Lime, and Trevor Howard starred to the tune of Anton Karas's *Harry Lime Theme* in Carol

Reed's post–World War II story, screenplay by Graham Greene.

All the King's Men, Broderick Crawford starred as an almost undisguised Huey Long in Robert Rossen's biofilm, based on Robert Penn Warren's 1946 novel.

The Bicycle Thief, Vittorio de Sica's postwar Italian neorealist centerpiece, screenplay by Cesare Zavattini; Lamberto Maggiorani starred as a poverty-stricken Italian Everyman.

Orpheus, Jean Marais, Maria Casares, Francois Perier, and Juliette Greco starred in Jean Cocteau's screen version of his own 1924 play, a contemporary Orpheus and Eurydice story.

The Heiress, Olivia de Havilland, Ralph Richardson, and Montgomery Clift starred in William Wyler's screen version of the Ruth and Augustus Goetz play, based on the Henry James novel; score by Aaron Copland.

Fred Astaire and Ginger Rogers starred in *The Barkleys of Broadway*.

Home of the Brave, James Edwards starred as the black soldier in the Mark Robson antidiscrimination film; in the 1945 Arthur Laurents play, on which the film was based, the lead had been a Jewish soldier.

Intruder in the Dust, Clarence Brown's screen version of William Faulkner's 1948 novel, about racism in a Southern town; Juano Hernandez and Elizabeth Patterson starred.

Judy Garland starred in *In the Good Old Summertime*, directed by Robert Z. Leonard.

Kind Hearts and Coronets, Alec Guinness starred as all eight murderees, with Dennis Price, Joan Greenwood, and Valerie Hobson, in the Robert Hamer comedy.

On the Town, Gene Kelly, Frank Sinatra, Jules Munshin, Betty Garrett, Ann Miller, and Vera-Ellen starred in the Gene Kelly–Stanley Donen film, based on the 1944 Betty Comden–Adolph Green stage musical.

She Wore a Yellow Ribbon, the John Ford film, set toward the end of the western Indian wars, the second in his Cavalry trilogy; John Wayne starred.

The Fallen Idol, Ralph Richardson, Bobby Henrey, and Michele Morgan starred in the Carol Reed film, screenplay by Graham Greene.

Tight Little Island (*Whisky Galore*), Joan Greenwood and James Robertson led a large cast in the Alexander Mackendrick World War II comedy,

featuring a whiskey salvage from a sunken ship in the Outer Hebrides.

Arthur Godfrey and His Friends, his television variety show (1949–1959).

Dragnet, Jack Webb starred in the radio and television series (1949–1970).

Father Knows Best, the family situation comedy, starring Robert Young and Jane Wyatt (radio 1949–1954, television 1954–1963).

Mama, Peggy Wood starred as the immigrant San Francisco Norwegian mother in the television series, based on the 1944 John van Druten play (1949–1956).

Academy Awards for 1949 (awarded the following year): Best Picture: *All the King's Men*; Best Director: Joseph L. Mankiewicz, *Letter to Three Wives*; Best Actor: Broderick Crawford, *All the King's Men*; Best Actress: Olivia de Havilland, *The Heiress*.

d. Wallace Beery, American actor (b. 1885).

VISUAL ARTS

Philip Johnson designed The Glass Box, his New Canaan, Connecticut, home, an International-Style showplace.

Diego Rivera's painting *Dream of a Sunday Afternoon in the Central Alameda*; Del Prado Hotel, Mexico City.

Robert Motherwell's *Elegy to the Spanish Republic*, the first of his series of almost 150 paintings on the same theme.

Alberto Giacometti's sculptures included *Tall Figure*, *Three Men Walking*, and *Walking Quickly Under the Rain*.

Jacob Epstein's sculpture *Lazarus*.

Andrew Wyeth's painting *The Revenant*.

Georgia O'Keeffe's painting *Black Place Green*.

Jackson Pollock's painting *Number Ten, 1949*.

Alexander Calder's sculptures included *Blériot* and *Jacaranda*.

Frank Lloyd Wright began the Laboratory Tower for S. C. Johnson and Son, Racine, Wisconsin.

Louise Bourgeois's sculpture *The Blind Leading the Blind*.

The Four Seasons, Charles Burchfield's painting.

Richard Neutra designed the Warren Tremaine House, Montecito, California.

Andreas Feininger's book *Feininger on Photography*.

Isamu Noguchi sculpture *Unknown Bird*.

Ludwig Mies van der Rohe began the Promontory Apartments, Chicago (1949–1951).

Robert Gwathmey's painting *Sowing*.

Walter Gropius began the Harvard University Graduate Center, Cambridge, Massachusetts (1949–1950).

Portrait of Jackson Pollack, Herbert Ferber's sculpture.

Saul Steinberg's cartoon collection *The Art of Living*.

Willem de Kooning's painting *Ashville, Attic*.

Stuart Davis's painting *The Paris Bit*.

d. James Ensor, Belgian artist (b. 1860).

d. José Clemente Orozco, Mexican painter (b. 1883).

d. Helen Edna Hokinson, American cartoonist (b. 1893), whose satirical work often appeared in *The New Yorker*.

d. Solomon Guggenheim, American art collector, founder of the Guggenheim Museum (b. 1861).

d. Walt Kuhn, American painter, often of circus life (b. 1877).

d. Robert Ripley, American cartoonist (b. 1893).

THEATER & VARIETY

Bertolt Brecht and Helene Wiegel founded the Berliner Ensemble.

Lee J. Cobb created the Willy Loman role in *Death of a Salesman*, with Mildred Dunnock, Cameron Mitchell, and Arthur Kennedy; Arthur Miller's play opened at the Morosco Theatre, New York.

Mary Martin as Nellie Forbush and Ezio Pinza as Emile de Becque starred in *South Pacific*; the Rodgers and Hammerstein musical, based on James Michener's 1947 *Tales of the South Pacific*, opened at the Majestic Theatre, New York, April 7; Joshua Logan directed the 1958 film version.

Todd Duncan starred in *Lost in the Stars*; the Maxwell Anderson–Kurt Weill musical, based on Alan Paton's South African novel *Cry, the Beloved Country*, opened in New York.

Ralph Bellamy and Lee Grant starred in *Detective Story*; Sidney Kingsley's play opened at the Hudson Theatre, New York, March 23.

John Garfield starred in *The Big Knife*, Clifford Odets's bitterly effective attack on Hollywood.

The Browning Version, Terence Rattigan's play, starred Maurice Evans and Edna Best; Eric Portman had starred in the London production.

Richard Burton starred in the London production of

Christopher Fry's play *The Lady's Not for Burning*.

Carol Channing starred in the Jule Styne–Leo Robin play *Gentlemen Prefer Blondes*.

Alfred Lunt and Lynn Fontanne starred in S. N. Behrman's *I Know My Love*.

Cedric Hardwicke and Lilli Palmer starred in George Bernard Shaw's *Caesar and Cleopatra*.

Cock-a-Doodle-Dandy, Sean O'Casey's play.

Edith Evans starred in James Bridie's *Daphne Laureola*.

Friedrich Dürrenmatt's *Romulus der Grosse*.

Max Rudolf Frisch's *When the War Was Over*.

Hans Christian Branner's *The Riding Master*.

Stig Dagerman's *The Upstart*.

Henri de Montherlant's *Demain il fera jour*.

Junui Kinoshita's *Twilight Crane*.

Ray Lawler's play *Cradle of Thunder*.

d. Irene Vanbrugh, English actress (b. 1872).

d. Philip Barry, American writer, largely for the theater (b. 1896).

d. Jacques Copeau, French actor and director (b. 1879).

d. Sem Benelli, Italian playwright (b. 1875).

MUSIC & DANCE

I'm Gonna Wash That Man Right Outta My Hair, introduced by Mary Martin, and *Some Enchanted Evening*, by Ezio Pinza, both Richard Rodgers–Oscar Hammerstein II songs from *South Pacific*.

If I Had a Hammer, protest song made popular by the Weavers; words and music by Pete Seeger and Lee Hays.

The Moor's Pavane, José Limón's ballet version of *Othello* set to music by Henry Purcell, first danced by Limón (in the lead) and his company August 17, at Connecticut College.

Regina, Marc Blitzstein's opera to his own libretto based on Lillian Hellman's play *The Little Foxes*, opened in New Haven, October 6.

Tennessee Ernie Ford's *Mule Train*.

Til Eulenspiegel, Jean Babilee's ballet, music by Richard Strauss, first danced November 9 by Les Ballet des Champs-Elysées, Paris.

The Prisoner (*Il Prigioniero*), Luigi Dallapiccola's opera, libretto by Dallapiccola, opened in a radio concert version in Italy.

Leonard Bernstein's *Symphony No. 2, The Age of Anxiety*, after Auden; also his jazz ensemble *Prelude, Fugue and Riffs*.

Diamonds Are a Girl's Best Friend, Leo Robin and Jule Styne's song, introduced in the musical *Gentlemen Prefer Blondes* by Carol Channing, remaining her signature song.

Benjamin Britten's *Spring Symphony*, opera *The Little Sweep*, and *Lachrymae* for viola and piano.

Olivier Messiaen's choral work *Cinq rechants* and *Quatre études de rythme*, for piano.

Sergei Prokofiev's *Winter Bonfire*, for voice and orchestra.

Louis Armstrong's hit single *Blueberry Hill*.

Ralph Vaughan Williams's *An Oxford Elegy*, for speaker, chorus, and small orchestra.

I'm So Lonesome I Could Cry, Hank Williams's hit song.

Beauty and the Beast, John Cranko ballet.

The Heiress, Aaron Copland's film score.

Frankie Laine's hit recording of *That Lucky Old Sun*.

William Walton's *Violin Sonata*.

Kentucky Spring, Roy Harris's symphony.

Aram Khachaturian's *Funeral Ode in Memory of Lenin*.

Samuel Barber's *Piano Sonata*.

Anton Karas's theme from the film *The Third Man*.

Antigonae, Carl Orff's dramatic musical work.

Vanna Lupa, Ildebrando Pizzetti's opera.

La Malinche, José Limón's ballet.

Rudolph, the Red-Nosed Reindeer, popular song.

Wallingford Riegger's *Music for Brass Choir*.

Concertino, Luciano Berio's orchestral music.

Livre pour quatuor, Pierre Boulez's orchestral work.

d. Richard Strauss, German composer and conductor (b. 1864).

d. Bill "Bojangles" Robinson (Luther Robinson); American tap dancer (b. 1878).

d. Leadbelly (Huddie Ledbetter), American folksinger and composer (b. 1889), who wrote and collected many folk songs, often with John Lomax, including *Goodnight Irene*.

d. Wanda Landowska, Polish harpsichordist (b. 1897).

d. Harry Thacker Burleigh, American singer and composer (b. 1866), noted for his arrangements of African-American spirituals and minstrel melodies.

WORLD EVENTS

Peking (Beijing) fell to Communist forces January 22, and then the rest of China; the Kuomintang government fled to Formosa (Taiwan).

Soviet Union developed its own atomic bomb, beginning the period of the "balance of terror" between the superpowers.

Greek Civil War effectively ended when a Greek army summer offensive took Mount Grammos.

d. Laszlo Rajk, Hungarian Communist foreign minister (b. 1909), falsely accused of treason, who "confessed" during a show trial identical with those of the Soviet Great Purge of the 1930s, and was executed; he was later "posthumously rehabilitated."

Indonesian War of Independence ended with cease-fire, followed by Dutch withdrawal.

Kashmir was informally partitioned between India and Pakistan along the existing frontline.

Federal Republic of Germany (West Germany) became an independent state in May. The German Democratic Republic (East Germany) became an independent state in October, concluding the formal postwar partition of Germany.

Geneva Convention covered the treatment of civilians during civil wars.

Soviet bloc set up the Council for Mutual Economic Assistance (COMECON).

The Second Sex, Simone de Beauvoir's theoretical work on feminist themes, helping to spur the modern women's movement.

Eleanor Roosevelt's *This I Remember*.

1950

LITERATURE

The Martian Chronicles, Ray Bradbury's short science fiction story collection.

Bertrand Russell was awarded the Nobel Prize for Literature.

Simple Speaks His Mind, first of the five Langston Hughes "Simple" short-story collections.

The Town, Conrad Richter's Pulitzer Prize–winning novel, third in his *The Awakening Land* trilogy.

The Wall, John Hersey's novel, set in the World War II Warsaw Ghetto uprising; basis of the 1960 play and 1982 film.

A Town Like Alice (*The Legacy*), Nevil Shute's novel, set in Southeast Asia and the Australian Outback during and after World War II; basis of the 1956 Jack Lee film and a later television miniseries.

The Labyrinth of Solitude, essays by Octavio Paz, introducing the concept of Mexican machismo to the outside world.

Carl Sandburg's Pulitzer Prize–winning *Complete Poems*.

Across the River and into the Trees, Ernest Hemingway's novel.

The Sea Wall, Marguerite Duras's novel, basis of the 1958 René Clement film.

Giant, Edna Ferber's novel; basis of the 1950 George Stevens film.

Stevie Smith's poetry *Harold's Leap*.

The Strange Ones, Jean Cocteau's novel, basis of his 1950 film.

William Carlos Williams's *The Collected Later Poems*.

The Family Moscat, Isaac Bashevis Singer's novel.

Pablo Neruda's poems *General Song*.

The Four-Chambered Heart, Anaïs Nin's novel.

Thirst for Love, Yukio Mishima's novel.

Saratchandra Chatterji's *The Elder Sister and Other Stories*.

The Grass Was Singing, Doris Lessing's novel.

Peter Abrahams's novel *Wild Conquest*.

The Roman Spring of Mrs. Stone, Tennessee Williams's novel.

World Enough and Time, Robert Penn Warren's novel.

Budd Schulberg's novel *The Disenchanted*.

Edgar Mittelholzer's novel *Morning in Trinidad*.

Juan Carlos Onetti's novel *A Brief Life*.

Eduardo Barrios's novel *The Men in the Man*.

Frank O'Connor's short stories *Traveller's Samples*.

Lionel Trilling's essays *The Liberal Imagination*.

National Book Awards established.

D. H. Lawrence: Portrait of a Genius, But . . ., Richard Aldington's biography.

Strong Wind, Miguel Asturias's novel.

Wallace Stegner's novel *The Preacher and the Slave*.

d. George Orwell (Eric Arthur Blair), British writer (b. 1903).

d. Albert Camus, French writer (b, 1913); among his final works was *The Rebel*, an essay criticizing Stalinism.

d. Bibhuti Bhusan Banerji, Indian writer (b. 1894), who wrote *Pather Panchali* and *Aparajito*.

d. Edna St. Vincent Millay, American poet (b. 1892).

d. Edgar Lee Masters, American writer (b. 1868).

d. Carl Van Doren, American writer, editor, and critic (b. 1885), brother of Mark Van Doren.

d. Edgar Rice Burroughs, American writer (b. 1875).

d. Ernest Poole, American writer (b. 1880).

d. Irving Bacheller, American author (b. 1859).

d. William Rose Benét, American poet and critic (b. 1886).

d. Aurobindo Ghosh, Indian poet writing in English (b. 1872).

FILM & BROADCASTING

Sunset Boulevard, Gloria Swanson, William Holden, and Erich von Stroheim starred in Billy Wilder's classic film about Hollywood, age, and fame.

All About Eve, a film written and directed by Joseph Mankiewicz; set in the New York theater, it starred Bette Davis as Margot Channing, opposite Ann Baxter as Eve, George Sanders, Celeste Holm, and Hugh Marlowe, with Marilyn Monroe in a comic sex symbol bit part.

Katharine Hepburn and Spencer Tracy starred in *Adam's Rib*, directed by George Cukor.

The Glass Menagerie, Jane Wyman, Kirk Douglas, and Gertrude Lawrence starred in the Irving Rapper film version of the 1945 Tennessee Williams play.

Silvano Mangano and Vittorio Gassman starred in *Bitter Rice*, directed by Giuseppe de Santis.

Born Yesterday, Judy Holliday, Broderick Crawford, and William Holden starred in the George Cukor film, based on the 1946 Garson Kanin play.

Rio Grande, the John Ford film, set during the western Indian wars, the third film in his Cavalry trilogy; John Wayne and Maureen O'Hara starred.

The Man with the Golden Arm, Frank Sinatra starred as the drug addict in Otto Preminger's screen version of the 1945 Nelson Algren novel; with Eleanor Parker and Kim Novak.

Annie Get Your Gun, Betty Hutton starred as Annie Oakley in George Sidney's screen version of the 1946 Irving Berlin musical.

Diary of a Country Priest, Claude Laydu starred in the Robert Bresson film, based on the 1937 George Bernanos novel.

Spencer Tracy, Joan Bennett, and Elizabeth Taylor starred in *Father of the Bride*, directed by Vincente Minnelli.

Harvey, James Stewart, Josephine Hull, and Victoria Horne starred in the Henry Koster fantasy, featuring an invisible six-feet-tall white rabbit; based on the 1944 Mary Chase play.

La Ronde, Anton Walbrook and Simone Signoret led

a large cast in Max Ophüls's light exploration of the theme of love.

Marlon Brando starred in *The Men*, directed by Fred Zinneman.

Michelangelo Antonioni directed *L'Avventura*, starring Monica Vitti and Gabriele Ferzetti.

The Asphalt Jungle, John Huston's police procedural film, set in New York City and starring Sterling Hayden, Sam Jaffe, James Whitmore, and Marc Lawrence.

The Winslow Boy, Robert Donat starred in Anthony Asquith's screen version of the 1946 Terrence Rattigan play.

Your Show of Shows (1950–1954); and its successor, *Caesar's Hour* (1954–1957), the landmark early television comedy series, starring Sid Caesar, Imogene Coca, Carl Reiner, and Howard Morris.

Academy Awards for 1950 (awarded the following year): Best Picture: *All About Eve*; Best Director: Joseph L. Mankiewicz, *All About Eve*; Best Actor: Jose Ferrer, *Cyrano de Bergerac*; Best Actress: Judy Holliday, *Born Yesterday*.

d. Walter Huston (Walter Houghston), Canadian-American actor (b. 1884), father of director–actor John Huston, grandfather of actress Anjelica Huston.

d. Emil Jannings (Theodor Friedrich Emil Janenz), German actor (b. 1884); an enthusiastic Nazi, his career ended after World War II.

VISUAL ARTS

Eliel and Eero Saarinen designed the Christ Lutheran Church, Minneapolis.

Alberto Giacometti's sculptures included *Between Two Houses*, *Chariot*, *Four Women on a Base*, *The Artist's Mother*, *The Cage*, and *Composition with Seven Figures and a Head* (*The Forest*).

Charles Schultz created the *Peanuts* comic strip, with Charlie Brown, Snoopy, Lucy, and Linus.

Jackson Pollock's paintings included *Autumn Rhythm*, *Lavender Mist Mural*, *Number Thirty-two, 1950*, *Number Twenty-nine, 1950*, and *One* (*Number Thirty-One, 1950*).

Fernand Léger's war memorial at Bastogne, France; and his painting *The Builders*.

Eagle, Jaguar, and Serpent, Miguel Covarrubias's book work on indigenous American art.

Josef Albers began his *Homage to the Square* series of paintings.

Barnett Newman's painting *Vir Heroicus Sublimis* (1950–1951); and his shaped canvas *The Wild*.

Andrew Wyeth's paintings included *Northern Point* and *Soaring*.

Georgia O'Keeffe's paintings included *Poppies* and *White Rose*.

Pablo Picasso's painting *Goat*.

René Magritte's painting *The Empire of Light*.

Willem de Kooning began his *Woman* series (1950–1953).

Joan Miró's Harvard University mural.

David Smith's sculpture *Blackburn: Song of an Irish Blacksmith*.

Edward Weston's photo collection *My Camera on Point Lobos*.

Monster Rally, Charles Addams's cartoon collection.

Excavation, Willem de Kooning's painting.

Ludwig Mies van der Rohe designed the Farnsworth House, Polano, Illinois.

United Nations Headquarters, New York, designed by Harrison, Le Corbusier, Niemeyer, and Markelius.

Franz Kline's painting *Chief*.

Migrant, Theodore Roszak's sculpture.

Georges Braque's painting *The Studio, VI*.

Henry Moore's sculpture *Helmet Head No. 1*.

Number 9: In Praise of Gertrude Stein, Bradley Walker Tomlin's painting.

Herbert Ferber's sculpture *He Is Not a Man*.

Louise Bourgeois's sculpture *Sleeping Figure*.

Marc Chagall's painting *The Dance* (1950–1952).

Oskar Kokoschka's painting *Prometheus Saga*.

d. Eliel Saarinen, Finnish-American architect (b. 1873), the father and partner of architect Eero Saarinen.

d. Max Beckmann, German artist (b. 1884); his last work was the triptych *The Argonauts*.

d. Peter Behrens, German architect and industrial designer (b. 1868).

THEATER & VARIETY

Zelda Fichandler founded Washington, D.C.'s Arena Stage company.

Come Back Little Sheba, Sidney Blackmer and Shirley Booth starred in the William Inge play; opened at the Booth Theatre, New York, February 15.

Julie Harris and Ethel Waters starred in *Member of the Wedding*; Carson McCullers's play opened at the Empire Theatre, New York, January 5.

Lilli Palmer and Rex Harrison starred in *Bell, Book and Candle*; John van Druten's comedy opened at the Ethel Barrymore Theatre, New York.

Ethel Merman starred in *Call Me Madam*; Irving Berlin's musical opened in New York.

Paul Kelly, Uta Hagen, and Steven Hill starred in *The Country Girl*; the Clifford Odets play opened at the Lyceum Theatre, New York, November 10.

Sam Levene, Robert Alda, Isabel Bigley, and Vivian Blaine starred in *Guys and Dolls*; the Frank Loesser musical, based on the Damon Runyon stories, opened in New York.

Claude Dauphin and Eva Gabor starred in *The Happy Time*; Samuel Taylor's comedy, opened at the Plymouth Theatre, New York, January 24.

Judith Anderson starred in *The Tower Beyond Tragedy*; Robinson Jeffers's play opened at the ANTA Theatre, New York, November 26.

Season in the Sun, Wolcott Gibbs's comedy, opened at the Cort Theatre, New York, September 28.

Michael Redgrave starred as *Hamlet* in London.

Alec Guinness and Cathleen Nesbitt starred in T. S. Eliot's *The Cocktail Party*.

Helen Hayes starred in Joshua Logan's *The Wisteria Trees*.

Jean Arthur and Boris Karloff starred in *Peter Pan*.

Henri de Montherlant's *Malatesta*.

Home at Seven, R. C. Sherriff's play.

Jacques Audiberti's *Pucelle*.

James Bridie's *The Queen's Comedy*.

Marcel Dubé's *Le Bal triste*.

The Just Assassins, Albert Camus's play.

Venus Observed, Christopher Fry's play.

Austin Clarke's *The Plot Succeeds*.

d. George Bernard Shaw, British writer and critic, a major figure in world theater (b. 1856).

d. Sara Allgood, Irish actress (b. 1883).

d. Alexander Yakovlevich Taïrov, Soviet director (b. 1885).

d. Jane Cowl, American actress and playwright (b. 1884).

d. William Aloysius Brady, American actor and theater manager (b. 1863).

d. Julia Marlowe, British-born American actress (b. 1866).

MUSIC & DANCE

The Age of Anxiety, Jerome Robbins's ballet, music by Leonard Bernstein, first danced February 26, by the New York City Ballet.

The Consul, Gian Carlo Menotti's Pulitzer Prize–winning opera, libretto by Menotti, opened in Philadelphia March 1.

Illuminations, Frederick Ashton's ballet, music by Benjamin Britten, set and costumes by Cecil Beaton, first danced by the New York City Ballet.

Goodnight Irene became a number-one hit and a signature song for the Weavers; words and music by Leadbelly (with John Lomax).

Aaron Copland's *Old American Songs* (first set); *Quartet for Piano and Strings*; and song *Twelve Poems of Emily Dickinson*.

On Guard for Peace, Sergei Prokofiev's oratorio.

The Exiles, José Limón's ballet.

Virgil Thomson's *Cello Concerto*.

Bolivar, Darius Milhaud's opera.

Don Quijote, Ninette de Valois's ballet.

I'm Movin' On, Hank Snow's country hit.

Elliott Carter's *Eight Etudes and a Fantasy*.

Stabat mater, Francis Poulenc's choral work.

Ifigenia, Ildebrando Pizzetti's opera.

Karl-Birger Blomdahl's *Third Symphony*.

Variazioni canoniche, Luigi Nono's orchestral work.

The Jumping Frog of Calaveras County, Lukas Foss's opera.

The Widow's Lament in Springtime, Milton Babbitt's vocal work.

India's anthem *Jana Gana Mana* was offically adopted, though written by Rabindranath Tagore, based on an old melody, during World War II.

Olivier Messiaen's *Messe de la Pentecôte*, for organ.

Marlboro Music Festival founded.

Aspen Music Festival, USA, festival and training course, established.

Rudolf Bing became general manager of the Metropolitan Opera, New York (1950–1972).

d. Vaslav Nijinsky, Russian dancer and choreographer (b. 1890), the most notable male dancer of his time.

d. Al Jolson (Asa Yoelson), American singer and actor (b. 1886); he starred on screen in *The Jazz Singer* (1927).

d. Harry Lauder, British music-hall entertainer; his sig-

nature song was *Roamin' in the Gloamin* (b. 1870).

d. Kurt Weill, German composer, a Brecht collaborator in Weimar Germany and from the mid-1930s a leading composer for the theater in the United States (b. 1900).

d. Julio Fonseca, Costa Rican composer (b. 1885).

WORLD EVENTS

Korean War (1950–1953) began with a surprise North Korean attack on June 25; United Nations condemnation was followed by armed intervention, with American forces moving in; developing a defensive front, and in September landing 150 miles north at Inchon, then pursuing retreating North Korean forces north, taking Pyongyang and crossing the 38th Parallel to move up to the Yalu River Chinese boundary. Massive Chinese Red Army forces intervened on November 25, driving United Nations forces south with heavy losses.

Alger Hiss, accused by Whittaker Chambers of being a Communist spy, was convicted of perjury and was imprisoned for almost four years.

East and central Asian scholar Owen Lattimore was falsely accused of being a Soviet spy by Senator Joseph McCarthy, but was cleared by a Senate committee. Lattimore published *Ordeal by Slander*.

German-British atomic physicist Klaus Fuchs, head of the physics department at Britain's Harwell atomic energy installation, was exposed as a Soviet spy; he was imprisoned until 1959.

McCarthy-era anti-Communist McCarran Internal Security Act passed by U.S. Senate over veto of President Harry S. Truman.

Onset of the long Laotian Civil War (1950–1973), at the beginning an internal struggle between the Pathet Lao and the Laotian main independence forces fighting the French for independence.

Puerto Rican nationalists Oscar Collazo and Griselio Torresola attempted to assassinate President Harry S. Truman, who was unharmed; a guard and Torresola were killed.

American biologist Gregory Goodwin Pincus developed the birth control pill (1951-1955).

Erik Erikson's *Childhood and Society*.

L. Ron Hubbard's *Dianetics: The Modern Science of Mental Health*, foundation work of the Church of Scientology.

Immanuel Velikovsky's *Worlds in Collision*.

1951

LITERATURE

The Catcher in the Rye, J. D. Salinger's novel, prefiguring the culture of youthful alienation.

The Conformist, Alberto Moravia's novel.

Pär Lagerkvist was awarded the Nobel Prize for Literature.

Samuel Beckett's novels *Malone Dies* and *Molloy*.

Marianne Moore's Pulitzer Prize–winning *Collected Poems*.

E. M. Forster's essays *Two Cheers for Democracy*.

Dance to the Music of Time, Anthony Powell's 12-novel exploration of British life (1951–1976).

From Here to Eternity, James Jones's novel, set in Hawaii just before Pearl Harbor; basis of the 1953 Fred Zinneman film.

The Caine Mutiny, Herman Wouk's novel about a naval court martial; he adapted it for the 1953 play *The Caine Mutiny Court Martial* and the 1954 Edward Dmytryk film.

Requiem for a Nun, William Faulkner's novel.

Lie Down in Darkness, William Styron's novel.

Nadine Gordimer's short stories *The Soft Voice of the Serpent*.

The Grass Harp, Truman Capote's novel; basis of his 1952 play.

Foundation, Isaac Asimov's science fiction novels (1951–1953).

Barbary Shore, Norman Mailer's novel.

Robert Lowell's poems *The Mill of the Kavanaughs*.

The Masters, fifth volume of C. P. Snow's *Strangers and Brothers* series.

Memoirs of Hadrian, Marguerite Yourcenar's novel.

Theodore Roethke's poetry *Praise to the End!*

Adrienne Rich's poetry *A Change of World*.

The Greek Passion, Nikos Kazantakis's novel.

Thousand Cranes, Yasunari Kawabata's novel.

Clock Without Hands, Carson McCullers's novel.

Each Man's Son, Hugh MacLennan's novel.

Voss, Patrick White's novel.

Midcentury, John Dos Passos's novel.

Edgar Mittelholzer's novel *Shadows Move Among Them*.

Mr. Beluncle, V. S. Pritchett's novel.

Festival at Farbridge, J. B. Priestley's novel.

Hortense Calisher's short stories *In the Absence of Angels*.

Kay Boyle's story *The Smoking Mountain*.

Melville Goodwin, U.S.A., J. P. Marquand's novel.

Morley Callaghan's novel *The Loved and the Lost*.

The Oracle, Edwin O'Connor's novel.

Marshall McLuhan's *The Mechanical Bridge: Folklore of Industrial Man*.

d. (Harry) Sinclair Lewis, American writer (b. 1885).

d. Andre Gidé, French writer (b. 1869).

d. Harold Ross, founder and editor of *The New Yorker* (1925–1951).

d. Louis Adamic, Yugoslavian-American writer (b. 1899).

FILM & BROADCASTING

André Bazin cofounded and became chief editor of the French film magazine *Cahiers du Cinéma*, central to the development of "auteur" theory and the "new wave" by François Truffaut and other young directors.

The African Queen, Humphrey Bogart and Katharine Hepburn starred in the John Huston film, set in World War I East Africa; it was adapted by James Agee from the 1935 C. S. Forester novel.

A Streetcar Named Desire, Vivien Leigh as Blanche DuBois, Marlon Brando as Stanley Kowalski, Kim Hunter, and Karl Malden starred in Elia Kazan's screen version of the 1947 Tennessee Williams play.

Rashomon, Akiro Kurosawa's first internationally recognized film, set in medieval Japan, starred Toshiro Mifune, Michiko Kyo, Masiyuki Mori, and Takashi Shimura.

The Lavender Hill Mob, Alec Guinness starred as the bank clerk turned robber in Charles Crichton's comedy classic, with Stanley Holloway, Sidney James, Alfie Bass, and Marjorie Fielding.

Death of a Salesman, Fredric March starred as Willy Loman, with Mildred Dunnock, Cameron Mitchell, and Kevin McCarthy in the Laslo Benedek film version of the 1949 Arthur Miller play.

The River, Patrica Walters, Nora Swinburne, Esmond Knight, Radha, and Suprova Mukerjee starred in the Jean Renoir film, about a group of Britons on the Ganges; based on a Rumer Godden novel.

The Browning Version, the Anthony Asquith film, screenplay by Terence Rattigan, based on his own 1948 play; Michael Redgrave, Jean Kent, Nigel Patrick, and Wilfred Hyde-White starred.

A Place in the Sun, George Stevens's film starring Montgomery Clift, Shelley Winters, and Elizabeth Taylor, was adapted from the 1925 Theodore Dreiser novel, based upon the Gillette–Brown murder case.

An American in Paris, Gene Kelly and Leslie Caron starred in the Vincente Minnelli musical, with story, screenplay, and lyrics by Alan Jay Lerner, score by Johnny Green and Saul Chaplin.

An Outcast of the Islands, Ralph Richardson and Trevor Howard starred in Carol Reed's film version of the 1896 Joseph Conrad European-gone-native clash-of-cultures novel.

Canada Lee and Sidney Poitier starred in *Cry, the Beloved Country*, directed by Zoltan Korda.

Quo Vadis, Robert Taylor and Deborah Kerr starred in Mervyn LeRoy's epic screen version of the 1895 Henryk Sinkiewicz novel about early Christians in Rome.

Gregory Peck and Virginia Mayo starred in *Captain Horatio Hornblower*; Peck also starred as F. Scott Fitzgerald in *Beloved Infidel*.

Show Boat, William Warfield, Kathryn Grayson, Howard Keel, and Ava Gardner starred in George Sidney's remake of the 1936 James Whale film.

I Love Lucy, the television comedy series starring Lucille Ball, through which she became one of the world's leading comedians (1951–1957, and successor shows 1962–1973).

The Honeymooners, Jackie Gleason as Ralph Cramden, Art Carney, Audrey Meadows, and Joyce Randolph starred in the bitterly misogynistic, very popular television series (1951–1971).

Academy Awards for 1951 (awarded the following year): Best Picture: *An American in Paris*; Best Director: George Stevens, *A Place in the Sun*; Best Actor: Humphrey Bogart, *The African Queen*; Best Actress: Vivien Leigh, *A Streetcar Named Desire*.

d. Cecil B. DeMille, American director, screenwriter, and producer (b. 1881).

d. Robert J. Flaherty, American documentary filmmaker (b. 1884).

d. Warner Baxter, American actor (b. 1891); he was the Cisco Kid in *In Old Arizona* (1929).

d. Robert Walker, American actor (b. 1918).

VISUAL ARTS

Frank Lloyd Wright designed the First Unitarian Meeting House, Madison, Wisconsin.

Andrew Wyeth's paintings included *Man from Maine*, *The Trodden Weed*, and *Toll Rope*.

Georgia O'Keeffe's paintings included *Dry Waterfall* and *Patio Door—Green-Red*.

Edward Hopper's painting *Rooms by the Sea*.

The Destroyed City, Rotterdam, Ossip Zadkine's bronze monument to the city's World War II victims of the Nazis.

Mies van der Rohe designed 860 Lake Shore Drive Apartments, Chicago.

Pablo Picasso's painting *Baboon with Young*.

Jackson Pollock's paintings included *Echo* and *Number Twenty-three, 1951 (Frogman)*.

Robert Rauschenberg did his *White Painting* and began his series of black paintings (1951–1952).

David Smith's sculpture *Hudson River Landscape*; and he began his *Agricola* sculpture series.

Iberto Giacometti's sculpture *Dog*.

Adolph Gottlieb began his *Grids and Imaginary Landscapes* series (1951–1957).

Henri Matisse's Rosaire Chapel at Vence, France; and his *Large Interior in Red*.

Alexander Calder's sculpture *El Corcovado*.

David Douglas Duncan's Korean War photograph collection *This is War!*

Colors for a Large Wall, Ellsworth Kelly's painting.

Large Vertical, Ilya Bolotowsky's painting (1951–1959).

Fernand Léger's stained-glass works for Sacré-Coeur, Audincourt, France.

Oskar Kokoschka's painting *View of Hamburg Harbour*.

Eero Saarinen designed the General Motors Technical Research Center Auditorium, Detroit.

Satisfaction in New Jersey, Philip Evergood's painting.

Henry Moore's sculpture *Reclining Figure*.

Marino Marini's sculpture *Stravinsky*.

John Marin's painting *Sea Piece*.

Marc Chagall's painting *King David*.

The Village Clock, "Grandma" Moses's painting.

W. Eugene Smith's painting *Spanish Village*.

André Malraux's three-volume book *Museum Without Walls* (1952–1954).

d. John Sloan, American artist (b. 1871), a member of The Eight, or the Ashcan School.

d. Albert Barnes, American art collector (b. 1872), founder of the Barnes Museum.

THEATER & VARIETY

The Rose Tattoo, Maureen Stapleton and Eli Wallach starred in the Tennessee Williams play; opened at the Martin Beck Theatre, New York, February 3.

The Living Theatre was founded by Julian Beck and Judith Malina.

Stalag 17, John Ericson starred as the unjustly accused American World War II Nazi prisoner in the Donald Bevan–Edmund Trzcinski play; opened at the 48th Street Theatre, New York, May 8; basis of Billy Wilder's 1953 film.

Shirley Booth starred in *A Tree Grows in Brooklyn*; the Arthur Schwartz musical opened at the Alvin Theatre, New York, April 19.

Julie Harris starred as Sally Bowles in *I Am a Camera*; the John Van Druten play opened at the Empire Theatre, New York, November 28; based on Christopher Isherwood's 1939 *Goodbye to Berlin* and basis of the 1966 musical *Cabaret*.

Gertrude Lawrence and Yul Brynner starred in *The King and I*; the Richard Rodgers and Oscar Hammerstein II musical, based on the Margaret Landon novel *Anna and the King of Siam*, opened at the St. James Theatre, New York, March 29.

Gérard Philipe starred in the title role of *Le Cid*; Corneille's play opened at the Théâtre National Populaire, Paris.

Audrey Hepburn starred in Anita Loos's *Gigi*.

Barbara Bel Geddes, Donald Cook, and Barry Nelson starred in *The Moon Is Blue;* F. Hugh Herbert's comedy opened in New York.

Florence Eldridge and Fredric March starred in Lillian Hellman's *The Autumn Garden*.

Jessica Tandy and Hume Cronyn starred in Jan de Hartog's *The Fourposter*.

Paint Your Wagon, the Alan Jay Lerner–Frederick Loewe musical, starred James Barton and Olga San Juan.

Henry Fonda starred in *Point of No Return*; Paul Osborn's play opened in New York.

Charles Laughton, Charles Boyer, Cedric Hardwicke, and Agnes Moorhead toured in their reading of George Bernard Shaw's *Don Juan in Hell*.

New York's Circle-in-the-Square Theatre was founded.

Eli, Nelly Sachs's play.

Hans Christian Branner's *The Siblings*.

Max Rudolf Frisch's *Graf Öderland*.

Robert Kemp's *The Other Dear Charmer*.

The Love of Four Colonels, Peter Ustinov's play.

Henri de Montherlant's *La Ville dont le prince est un enfant*.

London's Mermaid Theatre was founded.

d. Fanny Brice (Fanny Borach), American singer and actress (b. 1891).

d. Ivor Novello, English actor–manager, playwright, and composer (b. 1893).

d. Canada Lee (Leonard Lionel Canegata), leading African-American actor of the 1930s and 1940s (b. 1907).

d. Charles Blake Cochran, English impresario (b. 1872).

d. Henri-René Lenormand, French playwright (b. 1882).

d. James Bridie, Scottish doctor and playwright (b. 1888).

d. Louis Jouvet, French actor, director, and manager (b. 1887).

MUSIC & DANCE

Amahl and the Night Visitors, Gian Carlo Menotti's opera, libretto by Menotti, a perennially popular children's Christmas story that premiered on television December 24.

Cakewalk, Ruthanna Boris's ballet, to music by Louis Gottschalk, first danced by the New York City Ballet at the City Center Theater June 12.

Billy Budd, Benjamin Britten's opera, libretto by E. M. Forster and Eric Crozier, adapted from Herman Melville's 1891 novel, an indictment of shipboard life and justice, opened at Covent Garden, London, December 1.

Pineapple Roll, John Cranko's ballet, to music by Arthur Sullivan, first danced March 13 by the Sadler's Wells Theatre Ballet, in London.

The Rake's Progress, Igor Stravinsky's opera, libretto by W. H. Auden and Chester Kallman, premiered September 11 at the Venice Festival.

In the Cool, Cool, Cool of the Evening, song from the film *Here Comes the Groom*; words by Johnny Mercer, music by Hoagy Carmichael.

The Cage, Jerome Robbins's ballet to Igor Stravinsky's *Concerto in D*, first danced June 14 by the New York City Ballet at the City Center Theater.

The Pilgrim's Progress, Ralph Vaughan Williams's oratorio–opera, based on the Bunyan work, opened at Covent Garden, London, April 26.

Nat "King" Cole had hits with *Mona Lisa* and *Unforgettable*, which his daughter, Natalie Cole, would later turn into an electronic duet (1992).

Virgil Thomson's *Five Songs from William Blake*.

Les Paul and Mary Ford's hit version of the 1940 song *How High the Moon*.

Doris Humphrey's dance to P. Rainier's music, *Night Spell (Quartet No. 1)*.

Luigi Nono's chamber music *Polifonica—Monodia—Ritmica* and *Composizione No. 1*, for orchestra.

Come On-A My House, Rosemary Clooney's hit song; words and music by William Saroyan and Ross Bagdasarian.

Olivier Messiaen's *Le Merle noir*, for flute and piano, and *Livre d'orgue*, for organ.

Hello, Young Lovers, Oscar Hammerstein II and Richard Rodgers's song, introduced by Gertrude Lawrence in *The King and I*.

Hans Werner Henze's ballets *Jack Pudding* and *Labyrinth*.

Wat Tyler, Alan Bush's opera; not staged until 1953.

Arthur Honegger's fifth symphony.

Dmitri Shostakovich's *24 Preludes and Fugues* for piano.

Frank Sinatra's hit *I'm a Fool to Want You*.

Elliott Carter's first string quartet.

I'm in the Mood, John Lee Hooker's hit song.

Music of Changes, John Cage's piano work.

Du, Milton Babbitt's vocal work.

Kreuzspiel, Karlheinz Stockhausen's chamber music.

The Heart's Assurance, Michael Tippett's vocal work.

Johnny Ray sang *Cry* and *The Little White Cloud That Cried*.

Die Harmonie der Welt, Paul Hindemith's symphony.

Witold Lutoslawski's *Little Suite* for orchestra.

Erick Hawkins began his dance company.

Dave Brubeck organized the Dave Brubeck Quartet.

Lawrence Welk and his band began broadcasting on television, in Los Angeles (1951–1982).

First electric bass guitar developed and marketed in California by Leo Fender.

d. Arnold Schoenberg, Austrian composer (b. 1874), a key modernist whose work with atonality and the 12-tone scale made him a world figure.

d. Sergei Koussevitsky, Russian-American conductor and teacher, a leading figure in classical music for more than four decades (b. 1874).

d. Artur Schnabel, Austrian pianist and composer, later naturalized American (b. 1882), best known for his interpretations of Beethoven and Schubert.

d. Sigmund Romberg, Hungarian-American composer (b. 1887).

d. Ivor Novello, Welsh composer (b. 1893).

WORLD EVENTS

Korean War: Chinese forces took Seoul January 4, then stalled. American General Douglas MacArthur was dismissed by President Truman when he demanded American bombing of Chinese Manchurian bases. Peace negotiations began July 1, the front then a line north of Seoul that became the truce line.

Nuclear weapons tests began at America's Nevada Test Site; resulting radioactive fallout contaminated hundreds of square miles, inhabited by more than 100,000 people (1951–1958).

Winston Churchill was once again British prime minister (1951–1953).

American Communists and accused Soviet atom spies Ethel Greenglass Rosenberg and Julius Rosenberg were convicted of espionage, and sentenced to death by Judge Irving R. Kaufman.

Bao Dai's Vietnamese government was recognized by the French, but Vietnamese independence forces grew stronger, joining with Pathet Lao and Khmer Rouge guerrilla armies.

Organization of American States (OAS) founded.

Senator Estes Kefauver of Tennessee led nationally televised anti-Mafia Kefauver Committee hearings.

Soviet spies Guy Burgess and Donald MacLean fled to the Soviet Union after their exposure in Britain.

Twenty-Second Amendment to the U.S. Constitution became law; the "two-term amendment" limited a president to two terms or one full term and more than two years of an expired term.

U.S. Supreme Court upheld the Smith Act convictions of 11 Communist leaders in *Dennis v. United States*.

Hannah Arendt's *The Origins of Totalitarianism*.

1952

LITERATURE

Diary of Anne Frank (*The Diary of a Young Girl*), the journal (1942–1944) of a young Dutch-Jewish girl in hiding in Nazi-occupied Amsterdam, was first published in English; basis of the 1955 Frances Goodrich–Albert Hackett play and the 1959 George Stevens film.

The Invisible Man, Ralph Ellison's National Book Award–winning novel on racial themes.

François Mauriac was awarded the Nobel Prize for Literature.

Edmund Wilson's *The Shores of Light*.

The Bridge on the River Kwai, Pierre Boulle's novel; basis of the 1957 David Lean film.

East of Eden, John Steinbeck's novel of generational conflict; basis of the 1955 Elia Kazan film.

Archibald MacLeish's Pulitzer Prize–winning *Collected Poems*.

The Natural, Bernard Malamud's novel; basis of the 1984 film, starring Robert Redford.

The Sailor from Gibraltar, Marguerite Duras's novel, basis of the 1967 Tony Richardson film.

Barabbas, Pär Lagerkvist's novel, basis of his 1953 play and the 1962 Richard Fleischer film.

Unto a Good Land, Carl Moberg's novel; basis of Jan Troell's 1972 film *The New Land*.

Jean Santeuil, Marcel Proust's unfinished novel, first published.

Charlotte's Web, E. B. White's classic children's book.

Joseph Wood Krutch's *The Desert Year*.

Duveen, S. N. Behrman's biography of the art dealer.

Men at Arms, Evelyn Waugh's novel.

Dylan Thomas's *Collected Poems*.

Spartacus, Howard Fast's novel.

Edgar Mittelholzer's novel *Children of Kaywana*.

Happy Warriors, Haldor Laxness's novel.

Hemlock and After, Angus Wilson's novel.

Jean Stafford's novel *The Catherine Wheel*.

Léon Gontran Damas's poetry *Graffiti*.

Martha Quest, Doris Lessing's novel, on feminist themes.

Prisoner of Grace, Joyce Cary's novel.

Shelby Foote's novel *Shiloh*.

Thomas Hardy's novel *Our Exploits at West Poley* first published.

The Groves of Academe, Mary McCarthy's novel.

The Second Sex, Simone de Beauvoir's essays, published in English.

Tom Lea's novel *The Wonderful Country*.

The Confident Years, Van Wyck Brooks's literary history.

Wise Blood, Flannery O'Connor's novel.

Amos Tutuola's allegorical novel *The Palm-Wine Drunkard and His Dead Palm-Wine Tapster in the Dead's Town*.

Lelia: The Life of George Sand, André Maurois's fictionalized biography.

Michael Ventris and John Chadwick deciphered the Mycenean script called Linear B.

Stephen Potter's *One-upmanship: Being some account of the activities and teaching of the Lifemanship Correspondence College and of one-upness and gameslife-mastery.*

d. Knut Hamsun (Knud Pedersen Hamsund), Norwegian writer (b. 1859).

d. George Santayana, Spanish-born American writer (b. 1863).

d. Mariano Azuela, Mexican novelist (b. 1873).

d. Paul Éluard, (Eugene Grindel), French poet (b. 1895).

FILM & BROADCASTING

Charles Chaplin, under attack during the McCarthy period for allegedly leftwing views, left the United States; he returned only in 1972 to accept a special Academy Award.

Limelight, Charles Chaplin wrote, directed, produced, and starred in this show-business story, with Claire Bloom, Sidney Chaplin, Nigel Bruce, and Buster Keaton.

High Noon, Gary Cooper starred as the lonely sheriff in Fred Zinneman's classic Western, with Grace Kelly, Katy Jurado, Lloyd Bridges, and Thomas Mitchell.

Singin' in the Rain, Gene Kelly, Donald O'Connor, and Debbie Reynolds starred in the classic musical, set in 1920s Hollywood; Kelly and Stanley Donen directed and choreographed, with screenplay by Betty Comden and Adolph Green.

Umberto D, Carlo Battisti, Maria Pia Casilio, and Lina Gennari starred in Vittorio De Sica's film about a destitute and desperate old man and his dog in post–World War II Italy.

Come Back Little Sheba, Shirley Booth and Burt Lancaster starred in the Daniel Mann film, based on the 1950 William Inge play.

The Quiet Man, John Wayne, Maureen O'Hara, and Victor McLaglen starred in John Ford's story of an Irish-American in Ireland.

The Man in the White Suit, Alec Guinness starred in Alexander Mackendrick's comedy classic as a scientist with a breakthrough commercial discovery who finds that it upsets every established interest.

Gregory Peck, Susan Hayward, and Ava Gardner starred in *The Snows of Kilimanjaro*, directed by Henry King.

Federico Fellini directed *The White Sheik*.

Greatest Show on Earth, Betty Hutton and Charlton Heston starred in Cecil B. DeMille's circus epic.

The Big Sky, Kirk Douglas starred in the Howard Hawks film, based on the 1947 A. B. Guthrie novel.

Michael Redgrave and Edith Evans starred in *The Importance of Being Earnest*, directed by Anthony Asquith.

The Member of the Wedding, Julie Harris, Ethel Waters, and Brandon de Wilde starred in the Fred Zinneman film, based on the 1946 Carson McCullers novel and her 1950 play.

Brigitte Fossey and Georges Poujouly starred in *Forbidden Games*, directed by René Clement.

What Price Glory?, James Cagney, Dan Dailey, Robert Wagner, and Corinne Calvet starred in John Ford's screen version of the 1924 Maxwell Anderson–Lawrence Stallings antiwar play.

Gunsmoke, Western series, starring William Conrad on radio (1952–1961) and James Arness on television (1955–1975) as Matt Dillon.

Hallmark Hall of Fame, the television anthology series (1952–1955); it continued with occasional offerings into the 1990s.

Academy Awards for 1952 (awarded the following year): Best Picture: *Greatest Show on Earth*; Best Director: John Ford, *The Quiet Man*; Best Actor: Gary Cooper, *High Noon*; Best Actress: Shirley Booth, *Come Back Little Sheba*.

d. John Garfield (Julius Garfinkle), American actor (b. 1933).

VISUAL ARTS

Gordon Bunshaft began Lever House; his seminal glass-walled International Style New York office building.

David Alfaro Siqueiros's murals at the Hospital de la Raza, Mexico City.

Fernand Léger's murals for the United Nations General Assembly auditorium, New York.

Le Corbusier began *Unité d'Habitation*, his concrete high-rise Marseilles apartment complex.

Andrew Wyeth's paintings included *Faraway* and *Miss Olson*.

Georgia O'Keeffe's painting *Wall with Green Door*.

Alberto Giacometti's sculpture *Head*.

Henry Moore's sculptures included *King and Queen* and *Time-Life Screen* (1952–1953).

Alvar Aalto designed the town hall group, Säynatsälo, Finland.

Jackson Pollock's paintings included *Convergence* (*Number Ten, 1952*) and *Number Seven, 1952*.

Georges Braque's painting *The Shower*.

Henri Matisse's painting *Sorrows of the King*.

Ad Reinhardt's *Red Painting, No. 15*.

Georges Rouault's painting *Christian Nocturne*.

Mark Rothko's painting *Black, Pink and Yellow over Orange*.

Rufino Tamayo's murals for the Palacio de Bellas Artes, Mexico City.

Amazing Juggler, Yasuo Kuniyoshi's painting.

Helen Frankenthaler's painting *Mountains and Sea*.

Spectrum Colors Arranged by Chance, Ellsworth Kelly's painting (1952–1953).

Adolph Gottlieb designed the stained-glass facade for the Milton Steinberg Memorial Center, New York City.

Richard Neutra designed the Hinds House, Los Angeles.

Number 7, Bradley Walker Tomlin's painting.

Jacques Lipchitz's sculpture *Sacrifice, II* (1948–1952).

Marc Chagall's book illustration *Fables*.

Alcoa Building, Pittsburgh, designed by Harrison and Abramovitz.

Henry Breuil's book *Four Hundred Centuries of Cave Art*.

d. Rollin Kirby, American editorial cartoonist (b. 1875), long with the *New York World*.

d. Boardman Robinson, American artist (b. 1876), a seminal editorial cartoonist.

d. Jo Davidson, American sculptor (b. 1883).

d. Robert Minor, American political cartoonist (b. 1884).

THEATER & VARIETY

Shirley Booth starred in *The Time of the Cuckoo;* the Arthur Laurents play opened at the Empire Theatre, New York, October 15.

Dial "M" for Murder, Frederic Knott's play, starred Maurice Evans and Gusti Huber.

The Seven Year Itch, George Axelrod's comedy, starred Tom Ewell and Vanessa Brown; opened at the Fulton Theatre, New York, November 20.

The Shrike, José Ferrer starred in Joseph Kramm's play; opened at the Cort Theatre, New York.

Patricia Neal and Kim Hunter starred in Lillian Hellman's *The Children's Hour*.

The Deep Blue Sea, Margaret Sullavan starred in Terence Rattigan's play.

Katharine Hepburn starred in George Bernard Shaw's *The Millionairess*.

An Evening with Beatrice Lillie, her solo show, on tour (1952–1956).

Anna Christie, Celeste Holm and Kevin McCarthy starred in the classic Eugene O'Neill play.

Olivia de Havilland starred in George Bernard Shaw's *Candida*.

The Mousetrap, Agatha Christie's who-dun-it, began its record-breaking run in London (1952–).

John Garfield starred in Clifford Odets's *Golden Boy*.

Time Out for Ginger, Ronald Alexander's comedy, opened at the Lyceum Theatre, New York.

Venus Observed, Christopher Fry's play, starred Rex Harrison and Lilli Palmer.

Sheila Bond and Jack Cassidy starred in Harold Rome's musical *Wish You Were Here*.

Mrs. McThing, Mary Chase's play, starred Helen Hayes and Brandon De Wilde.

Arthur Adamov's *La Parodie*.

Fernando Arrabal's *Pique-Nique en campagne*.

Fools Are Passing Through, Friedrich Dürrenmatt's play.

Franz Theodor Csokor's *Cäsars Witwe*.

Paul Vincent Carroll's *The Devil Came from Dublin*.

d. Gertrude Lawrence (Alexandra Lawrence-Klasen), British actress (b. 1898); she died while starring on Broadway in Richard Rodgers and Oscar Hammerstein's *The King and I*.

d. Ferenc Molnar, Hungarian playwright whose work became internationally performed (b. 1878).

d. Albert Bassermann, German actor (b. 1867), long associated with Max Reinhardt, one of Germany's leading classical actors in the 1920s. He fled Germany in 1934, returning after the war.

d. Vesta Tilley, leading British music-hall star (b. 1864), most noted for her male impersonations.

MUSIC & DANCE

Die Liebe der Danae (*The Loves of Danae*), Richard Strauss's opera first staged, posthumously, on August 14 in Salzburg; its original opening on

August 16, 1944, was canceled when Goebbels closed all the theaters in Salzburg.

Abraham and Isaac, Benjamin Britten's second cantiel, for alto, tenor, and piano on a text from the Chester miracle play.

Boulevard Solitude, Hans Werner Henze's opera, libretto by Grete Weil based on *Manon Lescaut*, opened in Hanover, February 17.

Caracole, George Balanchine ballet, music by Mozart, first danced February 19 by the New York City Ballet.

Ralph Vaughan Williams's *Symphony No. 7, Sinfonia antartica*, symphony with voices.

Ballade, Jerome Robbins's ballet, music by Claude Debussy, first danced February 14, by the New York City Ballet.

The Harvest According, Agnes de Mille's ballet, music by Virgil Thomson, first danced October 1, by the Ballet Theater, New York.

Sergei Prokofiev's *Symphony No. 7* and *Sinfonia Concerto for Cello and Orchestra*.

Gladys Knight and the Pips was founded by Knight, Merald Knight, Edward Patten, and William Guest.

Ildebrando Pizzetti's opera *Cagliostro* and orchestral work *Preludio a un altro giorno*.

John Cage's composition *4'33"*, and his piano work *Water Music*.

Vera Lynn sang her hit version of *Auf Wiedersehn, Sweetheart*.

Persephone, Robert Joffrey's ballet.

Aaron Copland's *Old American Songs* (second set).

Perry Como's hit *Don't Let the Stars Get in Your Eyes*.

The Battle for Stalingrad, Aram Khachaturian's orchestral work.

Elliott Carter's *Sonata* for flute, oboe, cello, and harpsichord.

Quatre Motets pour le temps de Moël, Francis Poulenc's choral work.

Gian Carlo Menotti's *Violin Concerto*.

Igor Stravinsky's *Septet*.

Kontra-Punkte, Karlheinz Stockhausen's chamber music.

Trouble in Tahiti, Leonard Bernstein's opera.

d. Fletcher Henderson (James Fletcher Henderson), American jazz pianist, arranger, composer, and bandleader (b. 1897).

d. Frederick Jacobi, American composer (b. 1891).

WORLD EVENTS

First successful hydrogen-bomb test, on the Pacific atoll of Eniwetok (November 1).

British nuclear weapons tests began, at Monte Bello Islands, off west coast of Australia.

Republican Dwight D. Eisenhower won the presidential election, defeating Adlai Stevenson.

U.S. Supreme Court ruled illegal President Harry Truman's steel plant seizure during a national steel strike, in *Youngstown Sheet and Tube Company v. Sawyer*.

Egyptian Revolution (June 23), an officers' coup, led by Gamal Abdel Nasser, that deposed Farouk I of Egypt and established a republic.

Camille Chamoun led a successful coup against the government of Bishara al-Khouri to become president of Lebanon.

European Coal and Steel Community established; it was the model for the later European Economic Community (EEC).

Jewish Czech Communist party leader Rudolph Slánsky and 13 others, 11 of them Jews, were falsely accused of treason, and convicted at show trials. Slánsky and 10 others were executed; all were later "posthumously rehabilitated."

KGB (Committee of State Security) formed; the main Soviet espionage and counterespionage organization.

Mau Mau Uprising (1952–1956), part of the long war for Kenyan independence; the mainly Kikuyu Mau Mau Society mounted an unsuccessful guerrilla insurrection against the British army and settlers. Independence leader Jomo Kenyatta was arrested in 1952 and held until 1961; he would ultimately be the first president of the Kenyan republic.

North Atlantic Treaty Organization (NATO) established.

Jonas Salk developed an effective polio vaccine; it was tested in 1953, and widely used from 1954.

British archaeologist Kathleen Kenyon began her excavations at Jericho (1952–1958).

Danish medical team performed a successful, controversial, sex-change operation on Christine Jorgenson (born George Jorgensen).

d. George V (Albert Frederick Arthur George) (b. 1895), king of England (1936–1952); succeeded by daughter Elizabeth II.

RETA E. KING LIBRARY
CHADRON STATE COLLEGE
CHADRON, NE 69337

1953

LITERATURE

Go Tell It on the Mountain, James Baldwin's Harlem-based autobiographical first novel.

The Nobel Prize for Literature was awarded to Winston Churchill.

Fahrenheit 451, Ray Bradbury's science fiction novel, about near-future authoritarian book burning; basis of the 1966 François Truffaut film; and Bradbury's science fiction short-story collection *The Golden Apples of the Sun*.

All the Young Strangers, Carl Sandburg's autobiographical novel.

Battle Cry, Leon Uris's first novel; Raoul Walsh directed the 1955 screen version.

Junkie; the Confessions of an Unredeemed Drug Addict, William Burroughs's first novel.

Theodore Roethke's Pulitzer Prize–winning poetry collection *The Waking*.

The Adventures of Augie March, Saul Bellow's National Book Award–winning novel.

The Bridges at Toko-Ri, James Michener's novel, basis of the 1954 Mark Robson film.

Too Late the Phalarope, Alan Paton's novel.

Except the Lord, Joyce Cary's novel.

The Long March, William Styron's novel.

i, e e cummings's six Harvard "nonlectures."

Love Among the Ruins, Evelyn Waugh's novel; George Cukor directed the 1975 telefilm version.

J. D. Salinger's *Nine Stories*.

Ira Levin's novel *A Kiss Before Dying*.

Edith Sitwell's poetry *Gardeners and Astronomers*.

The Lying Days, Nadine Gordimer's novel.

Hackenfeller's Ape, Brigid Brophy's novel.

Iris Murdoch's *Sartre: Romantic Rationalist*.

Joseph Wood Krutch's *The Great Chain of Life*.

Rose Macaulay's *The Pleasure of Ruins*.

The Light in the Forest, Conrad Richter's novel.

Karl Shapiro's *Poems* (1942–1953).

The Charioteer, Mary Renault's novel.

Mom Ratchawong Khu'krit Pramoj's novel *Si Phaen Din*.

Randall Jarrell's *Poetry and the Age*.

Samuel Beckett's essays in *The Unnamable* and *Watt*.

The Echoing Grove, Rosamond Lehmann's novel.

The Erasers, Alain Robbe-Grillet's novel.

Heinrich Böll's novel *Acquainted with the Night*.

The Outsider, Richard Wright's novel.

The Russian Forest, Leonid Leonov's novel.

The Schirmer Inheritance, Eric Ambler's novel.

Yakub Kadri Karaosmanoglu's *Panorama*.

Dark Child, Camara Laye's fictionalized autobiography.

Charles Olson's poetry *Cold Hell, in Thicket*.

Leon Edel published the first part of his five-volume biography of Henry James (1953–1971).

Architect and archaeologist Michael Ventris deciphered one of the three scripts from the island of Crete, called the Linear B script.

Alejo Carpentier's novel *The Lost Steps*.

d. Dylan Thomas, Welsh writer (b. 1914).

d. Ivan Bunin, Russian writer (b. 1870).

d. Marjorie Kinnan Rawlings, American writer (b. 1896).

FILM & BROADCASTING

From Here to Eternity, Burt Lancaster, Deborah Kerr, Montgomery Clift, Frank Sinatra, and Donna Reed starred in the Fred Zinneman film, based on James Jones's novel about Hawaiian army life just before Pearl Harbor.

The Cruel Sea, Jack Hawkins, Donald Sinden, and Denholm Elliott starred in Charles Frend's sea-war classic, set during the World War II Battle of the Atlantic.

The Caine Mutiny Court Martial, Humphrey Bogart, Van Johnson, and Fred MacMurray starred in Edward Dmytryk's film version of the Herman Wouk novel, adapted by Wouk for the screen.

Shane, Alan Ladd as the gunfighter, Van Heflin, Jean Arthur, and Brandon de Wilde starred in George Stevens's classic Western.

Stalag 17, William Holden starred as the ultimately vindicated American prisoner of war in Billy Wilder's screen version of the 1951 Donald Bevan–Edmund Trzcinski play.

William Holden, David Niven, and Maggie McNamara starred in *The Moon Is Blue*, directed by Otto Preminger.

Jose Ferrer starred as Toulouse-Lautrec in *Moulin Rouge*, directed by Sidney Lanfield.

Marlon Brando, James Mason, and Louis Calhern starred in *Julius Caesar*, directed by Joseph L. Mankiewicz.

Kenji Mizoguchi directed *Ugetsu*, starring Maciko

Kyo, Sakae Ozawa, Kinuyo Tanaka, and Masayuki Mori.

Kiss Me, Kate, Howard Keel and Kathryn Grayson starred in the screen version of the 1948 Cole Porter musical, directed by George Sidney.

Mr. Hulot's Holiday, the first of Jacques Tati's four "Mr. Hulot" films.

Lili, Leslie Caron, Jean-Pierre Aumont, and Mel Ferrer starred in Charles Walter's circus-world musical, based on a Paul Gallico short story.

Marilyn Monroe and Jane Russell starred in Howard Hawks's film *Gentlemen Prefer Blondes*.

Richard Burton and Jean Simmons starred in *The Robe*, directed by Henry Koster; the first Cinemascope film.

Tony Curtis starred in the title role of *Houdini*, directed by George Marshall.

Home at Seven, Ralph Richardson directed and starred in the screen adaptation of the 1950 R. C. Sherriff play.

Marty, Rod Steiger as Marty and Nancy Marchand starred in Paddy Chayevsky's television film; Delbert Mann directed the 1955 film version.

Omnibus, television cultural series hosted by Alistair Cooke (1953–1961).

The Danny Thomas Show, his family situation comedy (1953–1964).

The Life of Riley, William Bendix was Chester A. Riley in the television situation comedy series (1953–1958).

Academy Awards for 1953 (awarded the following year): Best Picture: *From Here to Eternity*; Best Director: Fred Zinnemann, *From Here to Eternity*; Best Actor: William Holden, *Stalag 17*; Best Actress: Audrey Hepburn, *Roman Holiday*.

d. Vsevolod Pudovkin, Soviet director, writer, and actor (b. 1893).

VISUAL ARTS

Henry Moore's sculptures included *Internal and External Forms* (1953–1954), *Mother and Child*, *Reclining Figure* (1953–1954), and *Warrior with Shield*.

Andrew Wyeth's paintings included *Cooling Shed*, *Flock of Crows*, and *Snow Flurries*.

Pablo Picasso's paintings included *Nude in the Studio* and *The Shadow*.

Jackson Pollock's paintings included *Blue Poles* (*Number Eleven, 1952*), *Easter and the Totem*, *Ocean Greyness*, *Portrait of a Dream*, *Sleeping Effort*, and *The Deep*.

Eero Saarinen began Concordia Senior College, Fort Wayne, Indiana (1953–1958), and the Milwaukee County War Memorial, Milwaukee, Wisconsin (1953–1957).

Eliel and Eero Saarinen designed a General Motors building at Warren, Michigan.

Pablo Picasso's *Three Doves*, his ceramic, which became a worldwide peace movement symbol.

Buckminster Fuller designed the Ford Rotunda, Dearborn, Michigan.

Alberto Giacometti's sculpture *Woman*.

Pier Luigi Nervi, Marcel Breuer, and Bernard Zehruss began the Paris UNESCO Headquarters (1953–1958).

Marc Chagall's paintings included *Portrait of Madame Chagall*, *Saint-Germain-des Pres*, and *The Roofs*.

Georges Braque's painting *Seascape*.

Larry Rivers's painting *Washington Crossing the Delaware*.

Georges Rouault's painting *Decorative Flowers*.

Henri Matisse's painting *Souvenir of Oceania*.

Marino Marini's sculpture *Dancer*.

Jack Levine's painting *Gangster Funeral*.

Louise Bourgeois's sculpture *Garden at Night*.

Joan Miró's painting *The Red Disc in Pursuit of the Lark*.

Big Red, Sam Francis's painting.

Collection 1953–54, Robert Rauschenberg's painting.

Oskar Kokoschka's painting *Galatea*.

Corning Glass Center, Corning, New York, designed by Harrison, Abramovitz, and Abbe.

Sanctuary, Seymour Lipton's sculpture.

Robert Rauschenberg's series of four red paintings.

David Smith began his *Tank Totem* sculpture series.

The Meeting, Richard Lindner's painting.

d. Everett Shinn, American painter (b. 1876), a member of The Eight, or Ashcan School.

d. Raoul Dufy, French painter, a leading colorist (b. 1877).

d. John Marin, American painter (b. 1870).

d. Bradley Walker Tomlin, American artist (b. 1899).

d. Francis Picabia, French painter, a leading dadaist and surrealist (b. 1879).

d. Yasuo Kuniyoshi, American painter (b. 1893).

d. Vladimir Tatlin, Russian artist and architect ((b. 1885).

THEATER & VARIETY

The Crucible, Beatrice Straight, Arthur Kennedy, Walter Hampden, and E. G. Marshall starred in Arthur Miller's play about the Salem witchhunts (and its McCarthy-era analogues); opened at the Martin Beck Theatre, New York, January 22.

Waiting for Godot, Samuel Beckett's landmark modernist work, on the theme of alienation, a centerpiece of the "theater of the absurd"; written in French, Beckett's English translation of his work came in 1955.

Tyrone Guthrie founded the Stratford (Ontario) Festival; his opening production starred Alec Guinness in *Richard III*.

New York's Phoenix Theatre was founded by T. Edward Hambleton and Norris Houghton; it opened with *Madam, Will You Walk?*, Sidney Howard's last play.

Camino Real, Tennessee Williams's play, starred Eli Wallach, Frank Silvera, Jo Van Fleet, and Martin Balsam.

Gwen Verdon starred in *Can-Can*; the Cole Porter musical opened in New York.

In the Summer House, the Jane Bowles play, starring Judith Anderson, opened in New York.

Raymond Massey, Tyrone Power, and Judith Anderson starred in Stephen Vincent Benét's *John Brown's Body*.

Picnic, the William Inge play, set in a small midwestern town, starred Ralph Meeker, Janice Rule, Kim Stanley, Eileen Heckart, and Peggy Conklin; opened at the Music Box, New York, February 19.

Joseph Cotten and Margaret Sullavan starred in Samuel Taylor's comedy *Sabrina Fair*; opened at the National Theatre, New York, November 11.

The Solid Gold Cadillac, Howard Teichmann and George S. Kaufman's comedy, opened at the Belasco Theatre, New York, November 5.

Deborah Kerr and John Kerr starred in *Tea and Sympathy*, Robert Anderson's play; opened at the Ethel Barrymore Theatre, New York.

The Teahouse of the August Moon, David Wayne and John Forsythe starred in the John Patrick comedy; opened at the Martin Beck Theatre.

The Sleeping Prince, Laurence Olivier and Vivien Leigh starred in the Terrence Rattigan play; Olivier directed the 1957 screen version, *The Prince and the Showgirl*, costarring Marilyn Monroe.

Witness for the Prosecution, Agatha Christie's play, based on her own story; basis of the 1957 Billy Wilder film.

Wonderful Town, Rosalind Russell and Edith Adams starred in Leonard Bernstein's musical version of the 1940 play *My Sister Eileen*, lyrics by Betty Comden and Adolph Green; opened at the Winter Garden Theatre, New York, February 25.

The Lark and *Médée*, Jean Anouilh's plays.

Arthur Adamov's plays *Le Professeur Taranne* and *Tous contre Tous*.

Friedrich Dürrenmatt's *Ein Engel kommt nach Babylon*.

T. S. Eliot's *The Confidential Clerk*.

William Douglas Home's *The Bad Samaritan*.

Ladies of the Corridor, Dorothy Parker and Armand d'Usseau's play.

Alexei Nikolayevich Arbuzov's *European Chronicle*.

d. Eugene O'Neill, American playwright (b. 1888).

d. Maude Adams (Maude Kiskadden), American actress (b. 1872); she was Peter Pan in the James M. Barrie play.

d. Godfrey Seymour Tearle, English actor (b. 1884).

d. Henry Bernstein, French playwright (b. 1876).

d. Ugo Betti, Italian playwright (b. 1892).

MUSIC & DANCE

Gloriana, Benjamin Britten's opera, libretto by William Plomer, opened Covent Garden, London, June 8, during the festival accompanying the coronation of Elizabeth II.

Coronation Te Deum, William Walton's choral/orchestral work.

Fanfare, Jerome Robbins's ballet based on Benjamin Britten's *The Young Person's Guide to the Orchestra*, with dancers depicting musical instruments through movement, first danced by the New York City Ballet, June 2.

Carl Orff's dramatic musical works *Astutuli* and *The Triumph of Aphrodite* (*Trionfo di Afrodite*), conclusion of his *Trionfi* trilogy, settings for medieval Latin lyrics.

Le Loup, Roland Petit's ballet, music by Henri Dutilleux, first danced by the Ballet de Paris.

Con Amore, Lew Christensen's ballet, to music by Gioacchino Rossini, first danced by the San Francisco Ballet.

I'm Walking Behind You, Eddie Fisher's hit.

Wonderful Town, Leonard Bernstein's musical.

Luigi Nono's chamber music *Epitaffio per Federico Garcia Lorca* and *Due espressioni*, for orchestra

Michael Tippett's *Fantasia concertante on a Theme of Corelli* for strings.

Ruins and Visions, Doris Humphrey's ballet to music of Benjamin Britten.

Your Cheatin' Heart, Hank Williams's hit song.

Souvenirs, Samuel Barber's ballet; also his *Hermit Songs*.

The Widow of Valencia, Aram Khachaturian's orchestral work.

Une Cantate de Noël, Arthur Honegger's vocal orchestral work.

Winter Words, Benjamin Britten's vocal work.

Dmitri Shostakovich's *Tenth Symphony*.

Here's That Rainy Day, popular song, words by Johnny Burke, music by James Van Heusen.

Réveil des oiseaux, Olivier Messiaen's orchestral work.

Chamber Music, Luciano Berio's vocal work.

Luigi Dallapiccola's *Goethe Lieder*, for solo voice and ensemble.

Alan Bush's opera *Wat Tyler* (1951) first staged, in Leipzig.

d. Sergei Prokofiev, Russian composer and pianist (b. 1891).

d. Arnold Bax, British composer (b. 1883).

d. Django Reinhardt, Belgian jazz guitarist, composer, and bandleader (b. 1910).

d. Hank Williams (Hiram Williams), American country singer (b. 1919).

d. Imre (Emmerich) Kálmán, Hungarian composer (b. 1882).

d. Ruth Crawford (Seeger), American composer (b. 1901).

WORLD EVENTS

Molecular biologists James Watson and Francis Crick discovered the "secret of life," the double-helix structure of DNA (deoxyribonucleic acid).

Soviet Union built its own hydrogen bomb.

President Dwight D. Eisenhower appointed moderate Republican California Governor Earl Warren chief justice of the U.S. Supreme Court, ushering in 16 years of landmark liberal Court decisions.

d. Joseph Stalin (Joseph Vissarionovich Dzhugashvili), Soviet leader (b. 1879). Following Stalin's death, a "thaw" began in the Soviet Union. Georgi Malenkov succeeded Stalin as Soviet leader; a power struggle with Nikita Khrushchev began.

Convicted as Soviet spies, Ethel Greenglass Rosenberg and Julius Rosenberg were executed, after a failed worldwide protest.

American atomic physicist J. Robert Oppenheimer, key developer of the atomic bomb, was accused of disloyalty and denied security clearance, in a McCarthy-era witchhunt. He was later "rehabilitated."

Renewed war in Korea was followed by final peace negotiations; the war ended with the June 27 Panmunjon armistice, which established the ceasefire line as the border.

British nuclear weapons tests began at Maralinga, Australia (1953–1963).

Dag Hammarskjöld became the second United Nations secretary-general.

Indian independence movement leader Vijaya Lakshmi Pandit became the first woman president of the United Nations General Assembly.

Anti-Japanese guerrilla leader Ramón Magsaysay became president of the Philippines (1953–1957).

Edmund Percival Hillary and Tenzing Norgay were the first to climb Mt. Everest (May 29).

On July 26, Fidel Castro led a failed Cuban guerrilla attack on the Moncada barracks; his movement became known as the July 26 movement.

I. F. Stone founded his muckraking political newsletter *I. F. Stone's Weekly* (1953–1972).

1954

LITERATURE

Ernest Hemingway was awarded the Nobel Prize for Literature.

The Lord of the Rings and *The Two Towers*, J. R. R. Tolkien's fantasy novels, the first two in the Rings trilogy.

Lord of the Flies, William Golding's novel; basis of the 1963 film.

Kamala Markandaya's novel *Nectar in a Sieve*, her first.

The Long Goodbye, Raymond Chandler's mystery novel, basis of the 1973 Robert Altman film.

The Confessions of Felix Krull, Thomas Mann's unfinished picaresque novel.

Bonjour Tristesse, Francoise Sagan's novel; basis of the 1958 Otto Preminger film.

My Left Foot, autobiographical work of Christy Brown, with cerebral palsy from birth, but able to paint and type with his left foot; basis of the 1989 film.

Aldous Huxley's *The Doors of Perception*.

Wallace Stevens's Pulitzer Prize–winning *Collected Poems*.

Amos Tutuola's *My Life in the Bush of Ghosts*.

Sayonara, James Michener's novel, basis of the 1957 Joshua Logan film.

Bhowani Junction, John Masters's novel of English in India, basis of the 1956 film.

James Thurber's *The Years with Ross*, about editor Harold Ross of *The New Yorker*.

Lucky Jim, Kingsley Amis's novel.

Camara Laye's novel *The Radiance of the King*.

Under the Net, Iris Murdoch's novel.

Bhabani Bhattacharya's novel *Who Rides a Tiger*.

The Green Pope, Miguel Asturias's novel.

Cyprian Ekwensi's novel *People of the City*.

The Flint Anchor, Sylvia Townsend Warner's novel.

Dannie Abse's novel *Ash on a Young Man's Sleeve*.

The Bird's Nest, Shirley Jackson's novel.

Edgar Mittelholzer's novel *Kaywana Stock*.

The Thaw, Ilya Ehrenburg's post-Stalinism novel.

Freedom or Death, Nikos Kazantzakis's novel.

The Ponder Heart, Eudora Welty's novel.

Hamilton Basso's novel *The View from Pompey's Head*.

Vance Bourjaily's novel *The Hound of Earth*.

Joseph Wood Krutch's essays *The Measure of Man*.

Louise Bogan's *Collected Poems*.

Love Is Eternal, Irving Stone's fictionalized biography of Mary Todd Lincoln.

Mari Sandoz's historical study *The Buffalo Hunters*.

Max Eastman's *Poems of Five Decades*.

Mongo Beti's novel *Cruel City*.

The Cashier, Gabrielle Roy's novel.

Peter De Vries's novel *Tunnel of Love*.

The Sound of the Mountain, Yasunari Kawabata's novel.

d. James Hilton, British writer, many of whose works became popular films, starting with *Lost Horizon* (b. 1954).

d. Colette (Sidonie Gabrielle Claudine Colette), French writer (b. 1873).

d. Bess Streeter Aldrich, American novelist (b. 1881).

d. Joseph Hergesheimer, American novelist (b. 1880).

d. Martin Andersen Nexö, Danish writer (b. 1869).

d. Maxwell Bodenheim, American writer (b. 1893).

FILM & BROADCASTING

The *auteur* theory, postulating that the director is the true author of each film, was put forward by François Truffaut in a *Cahiers du cinéma* article.

La Strada, Giulietta Masina as Gelsomina, Anthony Quinn as Zampano, and Richard Basehart as the Fool starred in the Federico Fellini classic.

On the Waterfront, Marlon Brando, Eva Marie Saint, Karl Malden, Lee J. Cobb, and Rod Steiger starred in Elia Kazan's labor union corruption film; based on the Budd Schulberg novel.

Hobson's Choice, Charles Laughton, John Mills, and Brenda De Banzie starred in the David Lean film, based on the Harold Brighouse play; Lean cowrote, directed, and produced.

A Star Is Born, James Mason as the fading movie star and Judy Garland as his much younger protégée and wife starred in George Cukor's remake of the 1937 William Wellman film.

Rear Window, James Stewart and Grace Kelly starred in the Alfred Hitchcock thriller, based on the Cornell Woolrich story.

The Seven Samurai, Akira Kurosawa's story of a group of samurai who for pay defend a threatened village from bandits; remade in English by John Sturges in 1960, as *The Magnificent Seven*.

The Country Girl, Bing Crosby, Grace Kelly, and William Holden starred in George Seaton's film version of the 1950 Clifford Odets play.

An Inspector Calls, Alastair Sim starred in Guy Hamilton's screen version of the 1946 J. B. Priestley play.

Gate of Hell, Teinosuke Kinugasa's film, set in medieval Japan, based on the Kan Kichuki novel; Michiko Kyo, Kazuo Hasegawa, and Isao Yamagata starred.

Andrzej Wajda directed *A Generation*.

Spencer Tracy and Robert Ryan starred in *Bad Day at Black Rock*, directed by John Sturges.

Humphrey Bogart, Jennifer Jones, and Gina Lollobrigida starred in *Beat the Devil*, directed by John Huston.

Simone Signoret and Veral Clouzot starred in *Diabolique*, directed by Henri-Georges Clouzot.

Ray Milland, Grace Kelly, Robert Cummings, and

John Williams starred in *Dial M for Murder*, the Alfred Hitchcock thriller.

Dorothy Dandridge, Harry Belafonte, Pearl Bailey, and Brock Peters starred in *Carmen Jones*, directed by Otto Preminger.

Kenji Mizoguchi directed *Sansho the Bailiff*.

Luchino Visconti directed *Senso*, starring Alida Valli and Farley Granger.

René Clément directed *Knave of Hearts*, starring Gérard Philipe.

Humphrey Bogart, Audrey Hepburn, and William Holden starred in *Sabrina*, directed by Billy Wilder.

Ava Gardner and Humphrey Bogart starred in *The Barefoot Contessa*, directed by Joseph L. Mankiewicz.

Marlon Brando starred in *The Wild One*, directed by Laslo Benedek.

Academy Awards for 1954 (awarded the following year): Best Picture: *On the Waterfront*; Best Director: Elia Kazan, *On the Waterfront*; Best Actor: Marlon Brando, *On the Waterfront*; Best Actress: Grace Kelly, *The Country Girl*.

d. Lionel Barrymore (Lionel Blythe), American actor, artist, and composer. (b. 1898), brother of Ethel and John Barrymore, who very late in his career created Dr. Gillespie in the *Dr. Kildare* films.

d. Sidney Greenstreet, British actor (b. 1879).

Visual Arts

Georgia O'Keeffe's paintings included *Antelope*, *From the Plains II*, and *Memory, Late Autumn*.

Buckminster Fuller introduced the geodesic dome.

Pablo Picasso's painting *Women of Algiers, After Delacroix*.

Louis Kahn designed the Yale Art Gallery, New Haven, Connecticut.

Edward Hopper's painting *Morning Sun*.

Andrew Wyeth's painting *Karl's Room*.

Pablo Picasso's drawing *Model and Monkey Painter*.

Man and Work, William Zorach's sculpture, at the Mayo Clinic, Rochester, Minnesota.

Fernand Léger's painting *The Great Parade*.

Franz Kline's painting *Third Avenue*.

Jackson Pollock's painting *White Light*.

Richard Neutra designed Oasis House, Ojai, California.

Jasper Johns's painting *Flag*.

Mark Rothko's painting *Earth and Green*.

Oskar Kokoschka's painting *Thermopylae*.

Andreas Feininger's book *Color Photography*.

Philip Evergood's painting *The New Lazarus*.

Charles Sheeler's painting *Architectural Cadences*.

Willem de Kooning's painting *Two Women in the Country*.

Edward Durell Stone designed the American embassy at New Delhi.

Manufacturer's Hanover Bank, New York, designed by Skidmore, Owings, and Merrill.

Saul Steinberg's cartoon collection *The Passport*.

d. Henri Matisse, French painter, sculptor, and graphic artist (b. 1869).

d. Robert Capa (Andrei Friedmann), American photographer (b. 1913).

d. Reginald Marsh, American painter and printmaker (b. 1898).

d. George McManus, American cartoonist (b. 1884), in 1913 the creator of Maggie and Jiggs.

d. André Derain, French painter and theater designer (b, 1889),

d. Bud (Harry Conway) Fisher, American cartoonist (b. 1884).

Theater & Variety

The Threepenny Opera, Lotte Lenya was once again Pirate Jenny in Marc Blitzstein's English-language version of the Bertolt Brecht–Kurt Weill musical; opened at the Theatre de Lys, New York.

Joseph Papp founded New York's Shakespeare Workshop, which became the New York Shakespeare Festival.

The Caine Mutiny Court Martial; Herman Wouk's play starred Henry Fonda, John Hodiak, and Lloyd Nolan.

The Pajama Game, John Raitt and Janis Paige starred in the Richard Adler–Jerry Ross musical; opened at the St. James Theatre, New York, May 13.

Under Milk Wood, Dylan Thomas's play; basis of the 1973 Anthony Sinclair film.

The Bad Seed, Patty McCormack and Nancy Kelly starred in Maxwell Anderson's study of a deeply disturbed child.

Julie Andrews starred in Sandy Wilson's *The Boy Friend*.

Mary Martin starred in *Peter Pan*, the musical version of the 1904 James M. Barrie play.

Ezio Pinza, Walter Slezak, and Florence Henderson
starred in *Fanny*; Harold Rome's musical opened
at the Majestic Theatre, New York, November 4.

House of Flowers, the Harold Arlen–Truman Capote
musical, opened at the Alvin Theatre, New York.

Audrey Hepburn and Mel Ferrer starred in Jean
Giraudoux's *Ondine*.

The Rainmaker, Geraldine Page and Darrin McGavin
starred in the Richard Nash play; opened at the
Cort Theatre, New York, October 28.

The Gold Diggers, the Jerome Moross musical, opened
at the Phoenix Theatre, New York, March 11.

The Quare Fellow, Brendan Behan's play.

William Douglas Home's *The Manor of Northstead*.

Henri de Montherlant's *Port Royal*.

Alexei Nikolayevich Arbuzov's *The Years of Wandering*.

d. Theodore Komisarjevsky, Russian director and
designer (b. 1882), brother of Vera Fedorovna
Komisarjevskaya.

d. Jacinto Benavente y Martínez, Spanish playwright
(b. 1866).

d. Stig Dagerman, Swedish novelist and playwright
(b. 1923).

MUSIC & DANCE

High-fidelity stereophonic sound recording and play-
back became available in two-channel form for
recordings and later broadcasting.

The Turn of the Screw, Benjamin Britten's opera,
libretto by Myfanwy Piper, based on Henry
James's 1898 story, opened September 14 at the
Venice Festival.

The Saint of Bleecker Street, Gian Carlo Menotti's
Pulitzer Prize–winning opera to his own libretto,
premiered December 27 at the Broadway Theater
in New York.

Robert Joffrey founded the Joffrey Ballet, originally
the Robert Joffrey Dance Concert. Among their
first productions was *Pas des Déesses*, choreo-
graphed by Joffrey to music by John Field, first
danced May 29 in New York.

Bill Haley and His Comets' single *Rock Around the
Clock*, which became a number-one hit in 1955
when used in the film *Blackboard Jungle*, and the
best-selling single up to then.

Arturo Toscanini gave his final concert, with his
NBC Symphony Orchestra.

Ralph Vaughan Williams's *Violin Sonata*, *Tuba Con-
certo*, and vocal/orchestral work *Hodie*.

The Fiery Angel, Sergei Prokofiev's opera, his libretto
based on the Valery Briusoff novel; a concert ver-
sion premiered in Paris November 25.

Darius Milhaud's opera *David* and his *Suite cisalpine*,
for cello and orchestra.

Leonard Bernstein's film score *On the Waterfront*,
piano work *Five Anniversaries*, and instrumental
work *Serenade*.

The Stone Flower, Sergei Prokofiev's ballet, choreo-
graphed by Mikahil Lavrosky, libretto by Mira
Mendelson and Lavrosky, premiered February 12
at the Bolshoi Theatre, Moscow.

Three Coins in the Fountain, Frank Sinatra's hit song
from the film of that name; music by Sammy
Cahn, words by Jule Styne.

Troilus and Cressida, William Walton's opera, libretto
by Christopher Hassall, opened December 3 at
Covent Garden, London.

The Man That Got Away, song introduced by Judy
Garland in *A Star Is Born*; words by Ira Gershwin,
music by Harold Arlen.

Luigi Nono's ballet *Il mantello rosso* and choral works
La victoire de Guernica and *Liebeslied*.

Witold Lutoslawski's *Concerto for orchestra* and *Dance
Preludes* for clarinet and piano.

Moses and Aron, Arnold Schoenberg's opera.

The Tender Land, Aaron Copland's opera.

Benjamin Britten's third canticle.

Jazz Goes to College, Dave Brubeck's album.

Edgard Varèse's *Déserts*, for wing piano, percussion,
and tape.

Miles Davis founded the Miles Davis Quintet.

I Need You Now, Eddie Fisher's hit.

Metastasis, Iannis Xenakis's orchestral work.

La figlia di Iorio, Ildebrando Pizzetti's opera.

Sisyphus, Karl-Birger Blomdahl's ballet.

Divertimento on Sellinger's Round, Michael Tippett's
orchestral work.

Milton Babbitt's second string quartet.

Tale of Shuzerji, Osamu Shimizu's opera.

Le marteau sans maître, Pierre Boulez's vocal work.

Lyric Opera of Chicago founded.

American Guild of English Handbell Ringers
founded, as part of a revival.

d. Charles Ives, American composer (b. 1874).

d. John Rosamond Johnson, American composer (b.
1873), who with his brother, James Weldon

Johnson, wrote *Lift Every Voice and Sing* (1899), called the "Negro national anthem."

d. Wilhelm Furtwängler, German conductor (b. 1886).

WORLD EVENTS

After a three-month siege, the North Vietnamese took the French Vietnamese stronghold of Dien Bien Phu, decisively ending the Indo-China War. The ceasefire agreement provided for withdrawal of French troops from Vietnam, and division of the country into North and South Vietnam. Following French withdrawal, civil war began.

Army–McCarthy hearings (April–May), 36 days of widely seen televised hearings, in which army counsel Joseph Welch exposed McCarthy's recklessness and inhumanity; Senate censure followed, ending McCarthy's witch-hunting career.

Chief Justice Earl Warren wrote the unanimous opinion in *Brown v. Board of Education of Topeka*, a landmark decision declaring school segregation unconstitutional.

America developed the Intercontinental Ballistic Missile (ICBM), a key instrument of nuclear war.

Algerian War of Independence began (1954–1962).

President Jacobo Arbenz and his elected left-of-center government of Guatemala were overthrown in an American-supported military coup led by Carlos Castillo Armas; a long guerrilla war began.

Gamal Abdel Nasser became premier of Egypt, having been the country's strongman since the 1952 revolution.

Paraguayan armed forces commander-in-chief Alfredo Stroessner seized power in a military coup (1954–1989).

Japanese *Toya Maru* sank in Tsugaru Strait during a typhoon, costing 1,172 lives.

Nautilus, the world's first nuclear submarine, was launched.

Joseph E. Murray led a Harvard medical team that did the first successful kidney transplant.

Mortimer Wheeler's *The Indus Civilization*.

1955

LITERATURE

Doctor Zhivago, Boris Pasternak's classic novel, set in the Russian Revolution and Civil War, written

but rejected for Russian publication; basis of the 1965 David Lean film.

Haldor Laxness was awarded the Nobel Prize for Literature.

Lolita, Vladimir Nabokov's widely banned best-selling novel of a love affair between a 12-year-old girl and a mature man; basis of the 1962 Stanley Kubrick film and the 1979 Edward Albee play.

North and South—A Cold Spring, Elizabeth Bishop's Pulitzer Prize–winning poetry collection, including her 1946 collection *North and South*.

Leaf Storm, Gabriel García Márquez's first novel, set in his imaginary Macondo.

The Return of the King, J. R. R. Tolkien's fantasy novel, third in the Rings trilogy.

Pictures of a Gone World, Lawrence Ferlinghetti's first poetry collection.

The Last Temptation of Christ, controversial Nikos Kazantzakis novel, attacked by some as anticlerical; basis of the equally controversial 1988 Martin Scorsese film.

Adventures in the Skin Trade, Dylan Thomas's novel.

Ten North Frederick, John O'Hara's novel; basis of the 1958 Philip Dunne film.

Andersonville, McKinley Kantor's Pulitzer Prize–winning novel, about the Confederate prison camp.

The Ginger Man, James Donleavy's novel.

A World of Love, Elizabeth Bowen's novel.

Flannery O'Connor's short stories *A Good Man Is Hard to Find*.

The Tree of Man, Patrick White's novel.

Officers and Gentlemen, Evelyn Waugh's novel.

The Deer Park, Norman Mailer's novel.

Adrienne Rich's poetry *Diamond Cutters*.

The Voyeur, Alain Robbe-Grillet's novel.

Samuel Beckett's *Stories and Texts for Nothing*.

William Carlos Williams's poetry *Journey to Love*.

Band of Angels, Robert Penn Warren's novel.

Conrad Aiken's poetry *A Letter from Li Po*.

Eudora Welty's short stories *The Bride of Innisfallen*.

The Usurpers, Czeslaw Milosz's novel.

Kay Boyle's novel *Seagull on the Step*.

Marjorie Morningstar, Herman Wouk's novel.

Khushwant Singh's novel *Train to Pakistan*.

Manuel Altolaquirre's *Poemas en América*.

Nor Honour More, Joyce Cary's novel.

Yehuda Amichai's poetry *Now and in Other Days*.

Philip Larkin's poetry *The Less Deceived*.

Lawrence of Arabia, Richard Aldington's biography.

The Prophet, Sholem Asch's novel.

Waiting for the Mahatma, Rasipuram Narayan's novel.

Yashar Kemel's novel *Memed, My Hawk*.

Alfred Kazin's essays *The Inmost Leaf*.

d. James Agee, American novelist, essayist, screenwriter, and film critic (b. 1909).

d. Wallace Stevens, American poet (b. 1879).

d. Paul Claudel, French writer (b. 1868).

d. Ludwig Lewisohn, German-born American novelist and critic (b. 1882).

d. Robert P. T. Coffin, American author (b. 1892).

FILM & BROADCASTING

Wild Strawberries, Victor Sjostrom, Ingrid Thulin, and Bibi Andersson led a large cast in the classic film, written and directed by Ingmar Bergman.

Smiles of a Summer Night, Gunnar Björnstrand, Ulla Jacobsson, Harriet Andersson, and Eva Dahlbeck starred in the Ingmar Bergman farce; basis of Stephen Sondheim's 1973 *A Little Night Music*.

Pather Panchali, the first film in Satyajit Ray's classic Apu Trilogy; based on the Bibhuti Bhusan Banerji novel, with music by Ravi Shankar.

Rebel Without a Cause, James Dean starred in the title role of Nicholas Ray's defiant-youth film, with Natalie Wood and Sal Mineo.

Mister Roberts, Henry Fonda, James Cagney, and Jack Lemmon starred in John Ford's screen version of the 1948 Thomas Heggen–Joshua Logan play.

The Rose Tattoo, Anna Magnani as the Southern widow and Burt Lancaster as the truck driver starred in Daniel Mann's film version of the Tennessee Williams play.

East of Eden, Raymond Massey and James Dean starred in the Elia Kazan film, based on the 1952 John Steinbeck novel.

The Deep Blue Sea, Vivien Leigh, Kenneth More, Eric Portman, and Emlyn Williams starred in Anatole Litvak's screen version of the 1952 Terrence Rattigan play.

The Desperate Hours, Humphrey Bogart, Fredric March, Arthur Kennedy, and Martha Scott starred in William Wyler's screen version of the 1955 Joseph Hayes play.

Guys and Dolls, Marlon Brando, Jean Simmons, Frank Sinatra, and Vivian Blaine starred in the Joseph Mankiewicz film, based on the 1950 stage musical, itself based on Damon Runyon's stories.

Lola Montès, Martine Carol starred as the elegant prostitute, with Anton Walbrook and Peter Ustinov, in the Max Ophüls film.

Marty, Ernest Borgnine (in the title role) and Betsy Blair starred in Delbert Mann's film version of Paddy Chayevsky's 1953 television film.

Night of the Hunter, Robert Mitchum as the psychopathic killer and Shelley Winters starred in Charles Laughton's only film as director; screenplay by James Agee.

Oklahoma!, Gordon MacRae, Shirley Jones, and Shirley Grahame starred in Fred Zinneman's screen version of the classic 1943 Rodgers and Hammerstein stage musical.

Picnic, William Holden as the outsider, Kim Novak, Rosalind Russell, and Betty Field starred in Joshua Logan's film version of the 1953 William Inge play.

The Blackboard Jungle, Glenn Ford and Sidney Poitier starred in the Richard Brooks film, based on the Evan Hunter novel, set in the New York City school system.

Frank Sinatra and Eleanor Parker starred in *The Man with the Golden Arm*, directed by Otto Preminger.

Love Me or Leave Me, Doris Day as singer Ruth Etting and James Cagney starred in the Charles Vidor biofilm.

Herr Puntila und sein Knecht Matti, Alberto Cavalcanti's film, an adaptation of the Bertolt Brecht play.

Carl Dreyer directed *The Word*.

Academy Awards for 1955 (awarded the following year): Best Picture: *Marty*; Best Director: Delbert Mann, *Marty*; Best Actor: Ernest Borgnine, *Marty*; Best Actress: Anna Magnani, *The Rose Tattoo*.

d. James Dean, American actor, the "rebel without a cause" of his generation (b. 1931).

d. Theda Bara (Theodosia Goodman), American silent film star; known briefly as "The Vamp" in her heyday (b. 1890).

VISUAL ARTS

The Family of Man photography exhibition at New York's Museum of Modern Art, organized by Edward Steichen.

Andrew Wyeth's paintings included *Cider and Pork*, *Alan*, *Alexander Chandler*, and *Nicholas*.

Georgia O'Keeffe's paintings included *From the Plains I* and *Patio with Black Door*.

Eero Saarinen's work included the Kresge auditorium and chapel at the Massachusetts Institute of Technology and the American Embassy, Oslo, Norway (1955–1959).

Frank Lloyd Wright designed the H. C. Price Tower, Bartlesville, Oklahoma.

Jackson Pollock's painting *Scent*.

Larry Rivers's painting *Portrait of Birdie*.

Pier Luigi Nervi began the Pirelli Building, Milan (1955–1959).

Henri Cartier-Bresson's photo collection *Cartier-Bresson's France*.

Louise Bourgeois's sculpture *One and Others*.

William Baziotes's painting *The Beach, Pompeii*.

Robert Motherwell's painting *Je l'aime, IIA*.

Socony-Mobil Building, New York, designed by Harrison and Abramovitz.

Helen Frankenthaler's painting *Blue Territory*.

Louise Nevelson's sculpture *Black Majesty*.

Monogram and *Bed*, combines by Robert Rauschenberg (1955–1959).

Hans Hofmann's painting *Exuberance*.

d. Fernand Léger, French painter (b. 1881).

d. Maurice Utrillo, French painter (b. 1883).

d. Yves Tanguy, French painter (b. 1900).

THEATER & VARIETY

American Shakespeare Theatre was founded at Stratford, Connecticut.

Burl Ives, Barbara Bel Geddes, and Ben Gazzara starred in *Cat on a Hot Tin Roof*; the Tennessee Williams play opened in New York.

A Hatful of Rain, Ben Gazzara, Shelley Winters, Anthony Franciosa, and Joey Silvera starred in the Michael V. Gazzo play, on drug-related themes.

A View from the Bridge, Van Heflin as Eddie Carbone, Gloria Marlowe, and Richard Davalos starred in Arthur Miller's one-act play; opened at the Coronet Theatre, New York, September 29; Sidney Lumet directed the 1962 screen version.

Bus Stop, William Inge's play starred Kim Stanley, Albert Salmi, and Elaine Stritch; opened at the Music Box Theatre, New York, March 2.

Gwen Verdon, Stephen Douglass, and Ray Walston starred in *Damn Yankees*; opened at the 46th Street Theatre, New York, May 5.

The Diary of Anne Frank, Susan Strasberg and Joseph Schildkraut starred in the Frances Goodrich–Albert Hackett play, the story of a young Dutch-Jewish girl caught in the Holocaust, based on her diary, published in 1952; opened at the Cort Theatre, New York, October 5.

Paul Muni, Ed Begley, and Tony Randall starred in *Inherit the Wind*, their characters based on Clarence Darrow, William Jennings Bryan, and H. L. Mencken; the Jerome Lawrence–Robert E. Lee play about the Scopes trial opened at the National Theatre, New York.

Janus, Margaret Sullavan, Claude Dauphin, and Robert Preston starred in the Carolyn Green comedy; opened at the Plymouth Theatre, New York, November 24.

No Time for Sergeants, Andy Griffith starred in the Ira Levin play; opened at the Alvin Theatre, New York, October 20.

Paul Scofield played *Hamlet* at the Moscow Art Theatre.

Plain and Fancy, the Albert Hague–Arnold Horwitt musical, opened at the Mark Hellinger Theatre, New York, January 27.

Cole Porter's musical *Silk Stockings* starred Hildegarde Neff and Don Ameche.

The Chalk Garden, Enid Bagnold's play, starred Gladys Cooper and Siobhan McKenna.

Tyrone Power, Katharine Cornell, and Christopher Plummer starred in Christopher Fry's *The Dark Is Light Enough*.

The Desperate Hours, Paul Newman, George Grizzard, George Mathews, Nancy Coleman, and Karl Malden starred in the Joseph Hayes play, based on his novel.

Julie Harris, Christopher Plummer, and Boris Karloff starred in Jean Anouilh's *The Lark*.

The Matchmaker, Ruth Gordon starred as Dolly Levi in Thornton Wilder's play, basis for the musical *Hello, Dolly!*; opened at the Royale Theatre, New York, December 5.

Hal Holbrook first performed his one-man show *Mark Twain Tonight!*, in which he toured for years.

The Bishop's Bonfire, Sean O'Casey's play.

Diego Fabbri's *The Trial of Jesus*.

Paul Vincent Carroll's *The Wayward Saint*.

The Long Sunset, R. C. Sherriff's play.

d. Robert Sherwood, American playwright (b. 1896).

d. Constance Collier (Laura Constance Hardie), British actress (b. 1878).

d. Walter Hampden, American actor (b. 1879).

d. Ford Lee Washington, Buck of the vaudeville team "Buck and Bubbles" (b. 1903).

d. Solomon Libin, playwright (b. 1872), who wrote 50 plays on the life of New York's immigrant Jewish workers.

MUSIC & DANCE

Marian Anderson became the first African-American artist to sing at the Metropolitan Opera, making her debut in *Un Ballo in Maschera*.

The Midsummer Marriage, Michael Tippett's opera, libretto by Tippett, opened January 27 at Covent Garden, London.

Michael Tippett's *Piano Concerto* and *Sonata* for four horns.

Vienna's new Staatsopera (State Opera) house, rebuilt after 1945 destruction of the old theater, opened with a production of Ludwig van Beethoven's *Fidelio*.

Igor Stravinsky's sacred cantata *Canticum Sacrum* (first performed 1956).

The Great Pretender, Buck Ram's song, was a top hit for the Platters.

Luigi Nono's chamber music *Canti per 13* and orchestral work *Incontri*.

Folsom Prison Blues and *Cry, Cry, Cry*, Johnny Cash's songs; words and music by Cash.

Richard III, William Walton's film music.

In the Wee Small Hours, Frank Sinatra's hit album; also hit title songs from two of his films, *Young at Heart* and *The Tender Trap*.

Ralph Vaughan Williams's *Symphony No. 8*.

Aaron Copland's *Canticle of Freedom* (revised 1965).

Ain't That a Shame, Fats Domino's number-one single.

Nikita Vershinin, Dmitry Kabalevsky's opera.

Sixteen Tons, Tennessee Ernie Ford's number-one hit version of Merle Travis's 1947 song.

La Procession de Vergès, Edgard Varèse's tape work.

Elliott Carter's *Variations* for orchestra.

I Got a Woman, Ray Charles's hit, written with Renald Richard.

Mimusique No. 2, Luciano Berio's dramatic musical work.

Songs of Liberation, Luigi Dallapicolla's choral work.

Bernard and François Baschet began exhibiting their "sound sculptures," which combined visual design and unusual sound.

d. Charlie "Bird" Parker (Charles Christopher Parker, Jr.), American jazz saxophonist, composer, and bandleader (b. 1920), a creator of bebop.

d. Arthur Honegger, Swiss-French composer (b. 1892).

d. George Enescu, Romanian composer and violinist (b. 1881).

WORLD EVENTS

Rosa Parks, an African-American, was arrested in Montgomery, Alabama, for refusing to give up her seat on a public bus; the resulting 381-day-long Montgomery bus boycott, organized by Martin Luther King, Jr., and Ralph D. Abernathy, began the modern civil-rights movement.

Nikita Khrushchev defeated Georgi Malenkov in an internal power struggle, and took full power in the Soviet Union.

American President Dwight D. Eisenhower and Soviet Premier Nikita Khrushchev met in Geneva, in the first atomic-age superpower summit.

Warsaw Pact created a Soviet-bloc military alliance, paralleling NATO.

American Federation of Labor (AFL) and the Congress of Industrial Organizations (CIO) merged.

Sudan gained full autonomy from Britain and Egypt; the long Sudanese Civil War began.

At Bandung, Indonesia, in April, President Sukarno hosted the Bandung Conference, the first major postwar conference of unaligned nations.

Juan Perón fled into exile after having been deposed by a military coup in Argentina.

Chicago schoolboy Emmett Till, an African-American, was lynched for whistling at a White woman, while visiting relatives in Mississippi; the case became a cause célèbre when two Whites were acquitted by an all-White jury.

Roy Wilkins succeeded Walter White as leader of the National Association for the Advancement of Colored People (NAACP) (1955–1977).

1956

LITERATURE

The Fall, Albert Camus's novel.

The Mandarins, Simone de Beauvoir's novel, about

the leaders of the existential movement.

The Nobel Prize for Literature was awarded to Juan Ramón Jiménez.

V. S. Naipaul's *Of Trees and the Sea*, on life in England and the Caribbean.

A *Walk on the Wild Side*, Nelson Algren's novel, from which the 1962 Edward Dmytryk film was loosely adapted.

Anglo-Saxon Attitudes, Angus Wilson's novel.

Some Came Running, James Jones's novel; basis of the 1958 Vincente Minnelli film.

The Roots of Heaven, Romain Gary's novel, basis of the 1958 John Ford film.

Things of This World, Richard Wilbur's Pulitzer Prize–winning poetry collection.

Bang the Drum Slowly, Mark Harris's baseball novel; basis of the 1973 John Hancock film.

Giovanni's Room, James Baldwin's novel.

Howl and Other Poems, Allen Ginsberg's first poetry collection.

The Secret of Luca, Ignazio Silone's novel.

John Berryman's poetry collection *Homage to Mistress Bradstreet*.

The Sibyl, Pär Lagerkvist's novel.

Yevgeny Yevtushenko's autobiographical work *Zima Junction*.

Comfort Me with Apples, Peter De Vries's novel.

Eugenio Montale's poetry *The Blizzard*.

These Thousand Hills, A. B. Guthrie's Western novel; basis of the 1959 Richard Fleischer film.

Ferdinand Léopold Oyono's novels *Houseboy* and *The Old Man and the Medal*.

Kenneth Rexroth's poetry *In Defense of the Earth*.

Léon Gontran Damas's poetry *Black-Label*.

The Temple of the Golden Pavilion, Yukio Mishima's novel.

Léopold Senghor's *Éthiopiques*.

The Towers of Trebizond, Rose Macaulay's novel.

Mao Dun's *Spring Silkworms and Other Stories*.

The Last of the Wine, Mary Renault's novel.

Mary McCarthy's *Venice Observed*.

The Key, Junichiro Tanizaki's novel.

Meyer Levin's novel *Compulsion*.

Naguib Mahfouz's novel *Bain-al-Qasrain*.

Peter Abrahams's novel *A Wreath for Udomo*.

Thakazhi Sivasankara Pillai's novel *Chemmeen*.

The Field of Vision, Wright Morris's novel.

Lionel Trilling's essays *Freud and the Crisis of Our Culture*.

Nancy Mitford's *Noblesse Oblige* popularized philologist A. S. C. Ross's distinction between "U" (upper class) and "Non-U" (non-upper class) English.

d. H. L. (Henry Louis) Mencken, American writer and editor (b. 1880).

d. A. A. Milne (Alan Alexander Milne), British writer (b. 1881), who created Winnie-the-Pooh.

d. Max Beerbohm, British writer and caricaturist (b. 1872), George Bernard Shaw's "the incomparable Max," drama critic of the *Saturday Review* from 1898 to 1910.

d. Alexander Fadeyev, Soviet writer (b. 1901).

d. Louis Bromfield, American writer (b. 1896).

FILM & BROADCASTING

The Seventh Seal, Max von Sydow, Bengt Ekerot, Gunnar Bjornstrand, Bibi Andersson, and Nils Poppe starred in the Ingmar Bergman classic, on the theme of death, with its ultimate Dance of Death.

Gregory Peck, Jennifer Jones, and Fredric March starred in *The Man in the Grey Flannel Suit*, written and directed by Nunnally Johnson; based on the Sloan Wilson novel.

Nights of Cabiria, Giulietta Masina as Roman prostitute Cabiria starred in Federico Fellini's classic; basis of the 1966 stage musical *Sweet Charity*.

Aparajito (*The Unvanquished*), a film written and directed by Satyajit Ray film, second in the "Apu" trilogy; music by Ravi Shankar.

The King and I, Yul Brynner as the king and Deborah Kerr as Anna starred in the Walter Lang film version of the 1949 Rodgers and Hammerstein musical.

Moby Dick, Gregory Peck as Ahab, Richard Basehart, and Orson Welles starred in John Huston's screen version of the Herman Melville novel.

Tea and Sympathy, John Kerr, Deborah Kerr, and Leif Erickson starred again in Vincente Minelli's film version of the 1953 Robert Anderson play, about a boy and an older woman.

1984, Edmond O'Brien and Michael Redgrave starred in Michael Anderson's film version of the 1949 George Orwell satirical novel, exposing the evils of the bureaucratic state.

Anastasia, Ingrid Bergman starred as possibly the only survivor of Nicholas II, the last Romanov Czar,

with Yul Brynner and Helen Hayes, in this Anatole Litvak film.

And God Created Woman, the Roger Vadim film that established Brigitte Bardot as a worldwide sex symbol film star.

Around the World in Eighty Days, David Niven and Cantinflas led a very large cast in Mike Todd's large-scale film, based on the Jules Verne novel.

Bus Stop, the Joshua Logan film, adapted from the 1955 William Inge play; Marilyn Monroe, Don Murray, Hope Lange, Eileen Heckart, Arthur O'Connell, and Betty Field starred.

Carousel, Gordon MacRae and Shirley Jones starred in Henry King's film version of the 1945 Rodgers and Hammerstein stage musical, itself adapted from Ferenc Molnar's 1921 play, *Liliom*.

Grace Kelly, Bing Crosby, Frank Sinatra, and Louis Armstrong starred in *High Society*, a musical film of Philip Barry's 1930 play *Philadelphia Story*.

John Wayne, Jeffrey Hunter, and Natalie Wood starred in *The Searchers*, directed by John Ford.

Marlon Brando and Glenn Ford starred in *The Teahouse of the August Moon*, directed by Daniel Mann.

The Bad Seed, Patty McCormack again played the deeply disturbed child in Mervyn Leroy's screen version of Maxwell Anderson's 1954 play.

The Friendly Persuasion, Gary Cooper, Anthony Perkins, and Phyllis Love starred in William Wyler's film, based on the 1945 Jessamyn West novel.

Giant, George Stevens's film based on the 1950 Edna Ferber novel, starring Elizabeth Taylor, Rock Hudson, and James Dean, in his last role.

Playhouse 90 (1956–1961), the television drama series, vehicle for several classic original telefilms.

Videotape recorders first developed, though not coming into widespread use until the 1980s.

Academy Awards for 1956 (awarded the following year): Best Picture: *Around the World in 80 Days*; Best Director: George Stevens, *Giant*; Best Actor: Yul Brynner, *The King and I*; Best Actress: Ingrid Bergman, *Anastasia*.

d. Alexander (Sándor Laszlo) Korda, Hungarian director and producer (b. 1893), a leading British film figure from the mid-1930s to the mid-1950s.

d. Bela Lugosi (Bela Blasco), Hungarian actor, long in Hollywood, who in 1931 created the definitive film *Dracula* (b. 1882).

d. Edward Arnold (Gunther Edward Arnold Schneider), American actor (b. 1890).

d. Alexander Dovzhenko, Soviet director (b. 1894).

d. Fred Allen (John Florence Sullivan), American comedian (b. 1894).

d. Kenji Mizoguchi, Japanese director (b. 1898).

VISUAL ARTS

Andrew Wyeth's painting included *Chambered Nautilus* and *Roasted Chestnuts*.

Pablo Picasso's paintings included *Nude in Rocking Chair* and *The Studio*.

Alberto Giacometti's sculpture *Nine Standing Figures*.

Ludwig Mies van der Rohe began the Seagram Building, New York (1956–1958), and designed Crown Hall, Illinois Institute of Technology.

Eero Saarinen's work included the Law School of the University of Chicago (1956–1960), the Trans World Airlines terminal, John F. Kennedy Airport, New York (1956–1962), and the General Motors Technical Center, Warren, Michigan.

Marc Chagall's work included illustrations for a new edition of the Bible; and the painting *The Circus*.

Henry Moore's sculptures included *Falling Warrior* (1956–1957), *Reclining Figure*, and *Seated Figure Against Curved Wall* (1956–1957).

Georgia O'Keeffe's painting *Patio with Cloud*.

Kenzo Tange designed the Hiroshima Peace Park.

Stuart Davis's painting *Colonial Cubism*.

Louise Nevelson's sculptures included *First Personage* and *Royal Voyage*.

Mark Rothko's painting *Orange and Yellow*.

Sundial, Herbert Ferber's "roofed sculpture."

Oscar Niemeyer began his work on the public structures of Brasilia (1956–1961).

Franz Kline's painting *Mahoning*.

Richard Neutra designed the Navy Chapel, Miramar, California.

Leonard Baskin's sculpture *Man with a Dead Bird*.

Edward Durell Stone designed the Graf House, Dallas.

Helen Frankenthaler's painting *Eden*.

Philip Johnson designed Kneses Tifeth Israel Synagogue, Port Chester, New York.

Theodore Roszak's sculpture *Sea Sentinel*.

Dial, Philip Guston's painting.

d. Jackson Pollock, American painter (b. 1912), in the 1940s and 1950s a leading abstract impres-

sionist, who pioneered in "drip and splash" and "action painting" techniques.

d. Lyonel Feininger, American painter (b. 1871).

d. Alex Raymond (Alexander Gillespie Raymond), American cartoonist (b. 1909).

d. Josef Hoffmann, Austrian architect (b. 1870).

THEATER & VARIETY

George Devine founded the English Stage Company, at London's Royal Court Theatre.

My Fair Lady, Julie Andrews and Rex Harrison starred in the Alan Jay Lerner–Frederick Loewe landmark musical; opened at the Mark Hellinger Theatre, New York, March 15.

Long Day's Journey into Night, Fredric March, Florence Eldridge, Jason Robards, Jr., and Dean Stockwell starred in the autobiographical Eugene O'Neill play; opened at the Helen Hayes Theatre, November 7.

Look Back in Anger, Richard Burton starred in John Osborne's play, establishing the "angry young man" as an archetypal figure in British culture; Tony Richardson directed the play and the 1958 film version, again starring Burton.

Edward G. Robinson and Gena Rowlands starred in *Middle of the Night*; the Paddy Chayevsky play opened at the ANTA Theatre, New York.

Rosalind Russell starred in *Auntie Mame*; the Jerome Lawrence–Robert E. Lee comedy, based on the Patrick Dennis novel, opened at the Broadhurst Theatre, New York, October 31.

The Bald Soprano, Eugène Ionesco's trailblazing one-act absurdist play.

Judy Holliday starred in *Bells Are Ringing*, the Jule Styne, Betty Comden, and Adolph Green musical.

Has Ivan Ivanovich Lived at All?, Nazim Hikmet's anti-Stalinist play.

Orson Welles directed, produced, and played the title role in *King Lear*.

The Most Happy Fella, Sammy Davis, Jr., starred in the Frank Loesser musical; opened at the Imperial Theatre, New York, May 3.

Romanoff and Juliet, the Peter Ustinov play; basis of the 1961 film, which he wrote, directed, and produced.

Siobhan McKenna starred in George Bernard Shaw's *Saint Joan*.

The Green Crow, Sean O'Casey's essays on the theater.

Separate Tables, Terence Rattigan's play, starred Margaret Leighton and Eric Portman.

Ferdinand Bruckner's plays *The Death of a Doll* and *The Fight with the Angel*.

James Ene Henshaw's *The Jewels of the Shrine* and *This Is Our Chance*.

The Balcony, Jean Genet's play.

Lion Feuchtwanger's *Die Witwe Capet*.

Henri de Montherlant's *Brocéliande*.

Wole Soyinka's *The House of Banegegi*.

Jacques Audiberti's *La Hobereaute*.

Marguerite Duras's *Le Square*.

Shu Ch'ing-ch'un's *Dragon Beard Ditch*.

d. Bertolt Brecht (Eugen Berthold Friedrich Brecht), German playwright (b. 1898), a central figure in the modern theater.

d. Charles MacArthur, American writer, director, and producer (b. 1895), husband of actress Helen Hayes.

d. Elsie Janis, vaudeville singer (b. 1889).

d. Owen Davis, American playwright (b. 1874).

d. Ruth Draper, American actress (b. 1884).

MUSIC & DANCE

Elvis Presley became an international rock-and-roll star with number-one songs *Love Me Tender*, *Heartbreak Hotel*, *Hound Dog*, and *I Want You, I Need You, I Love You*.

Frank Sinatra had a hit album, *Songs for Swingin' Lovers*, including *I've Got You Under My Skin*, *You Make Me Feel So Young*, and *You're Getting to Be a Habit with Me*.

The Concert, Jerome Robbins's ballet, to music by Frédéric Chopin, first danced March 6 by the New York City Ballet.

On the Street Where You Live, *The Rain in Spain*, and *With a Little Bit of Luck* were among Alan Jay Lerner and Frederick Loewe's hits from *My Fair Lady*.

Spartacus, Aram Khachaturian's ballet, libretto by Nicolai Volkov, premiered December 27 at Leningrad's Kirov Theatre.

König Hirsch (*The Stag*), Hans Werner Henze's opera, libretto by Heinz von Cramer, opened in Berlin .

True Love, duet by Bing Crosby and Grace Kelly, from the film *High Society*.

The Unicorn, the Gorgon and the Manticore, Gian Carlo Menotti's ballet.

The Party's Over, Judy Holliday's hit song from *Bells Are Ringing*; words by Betty Comden and Adolph Green, music by Jule Styne.

Bill Haley and His Comets' hit single *See You Later, Alligator*.

William Walton's *Cello Concerto* and *Johannesburg Festival Overture*.

Woody Guthrie's song *This Land Is Your Land*, a hit for the Weavers.

Louis Armstrong's hit singles *Mack the Knife* and *Blueberry Hill* (reissued from 1949).

Candide, Leonard Bernstein's comic operetta.

Whole Lotta Shakin's Goin' On, Jerry Lee Lewis's hit single.

Pithecanthropus Erectus, Charles Mingus's landmark jazz album.

Big Bill Broonzy's album *Big Bill's Blues*.

Aaron Copland's *Variations on a Shaker Melody*, for band.

Why Do Fools Fall in Love?, popular song, sung by Frankie Lymon.

Please, Please, Please, James Brown's first record.

Zeitmasse, Karlheinz Stockhausen's chamber music.

Luigi Dallapiccola's *5 canti*, for solo voice and ensemble.

Little Richard's hit *Long Tall Sally*.

Odetta Sings Ballads and Blues album.

Oiseaux exotiques, Olivier Messiaen's orchestral work.

Australian Opera national company founded in Sydney.

Britain's Royal Ballet was founded, succeeding the Sadler-Wells company.

d. Tommy Dorsey (Thomas Francis Dorsey), American bandleader and trombonist (b.1905).

d. Mistinguett (Jean-Marie Bourgeois), French singer and comedian (b. 1875).

d. Art (Arthur) Tatum, jazz pianist (b. 1910).

d. Walter Gieseking, German pianist (b. 1895).

d. Sergei Nikiforovich Vasilenko, Soviet composer (b. 1872).

WORLD EVENTS

Republican Dwight D. Eisenhower won a second presidential term, again defeating Democrat Adlai Stevenson.

Egyptian President Gamal Abdel Nasser nationalized the Suez Canal; Britain, France, and Israel then took concerted military action; Israeli troops began the Sinai–Suez War (Second Arab–Israeli War) by attacking in the Sinai in late October, while British and French forces attacked Port Said from the sea. America opposed the invasion, however, and forced all three countries to withdraw, the canal area then being occupied by United Nations peacekeeping forces.

Nikita Khrushchev exposed the crimes of Stalinism in a February speech to the 20th Congress of the Soviet Communist Party, bringing worldwide Communist splits and defections, and a greatly accelerated "thaw" in the Soviet Union.

Revolution broke out in Budapest on October 23, as unrest swept Eastern Europe following Khrushchev's speech exposing the crimes of Stalinism. A new government led by Imre Nagy began democratic reforms, as Soviet troops began to leave Hungary. Soviet troops crushed the revolution on November 4; Nagy was executed (1958) and a Soviet puppet government led by Janos Kádár was reinstalled.

Unrest also grew in Poland, bringing severe rioting and strikes in Poznan and other cities in June, met by Soviet troops. In October, the unrest brought down the hardline Stalinist government and brought the more moderate Communist Wladislaw Gomulka to power.

Cuban revolution began with landing of Fidel Castro–led guerrillas December 2.

"Let one hundred flowers bloom, and a hundred schools of thought contend": So Mao Zedong began his short-lived Hundred Flowers campaign, briefly seeming to encourage dissidency.

Popular Movement for the Liberation of Angola (MPLA) was founded, beginning the long anticolonial struggle that would become the Angolan War of Independence (1961–1974).

U.S. Federal Bureau of Investigation began Cointelpro, a domestic counterintelligence program that generated massive illegal activities directed against domestic dissidents.

Morocco became an independent nation (March 2).

Republic of Sudan became an independent state (January 1).

Republic of Tunisia became an independent state (March 20); its first president was Habib Bourgiba.

After a collision with the Swedish liner *Stockholm*,

the Italian liner *Andrea Doria* sank off Nantucket Island, costing 51 lives (June 25).

1957

LITERATURE

A Death in the Family, James Agee's posthumously published Pulitzer Prize–winning novel; basis of Tad Mosel's play *All the Way Home* (1960), adapted into the 1963 film.

Albert Camus was awarded the Nobel Prize for Literature.

Doctor Zhivago, Boris Pasternak's epic novel, was first published in an Italian translation in Italy.

Nelly Sachs's poetry *And No One Knows Where to Go*.

Sun Stone, Octavio Paz's 584-line poem, the number of lines in the Aztec calendar.

On the Road, Jack Kerouac's autobiographical novel, a classic of the "Beat Generation."

The Wapshot Chronicle, John Cheever's National Book Award–winning novel.

Two Women, Alberto Moravia's novel.

Last Tale, Isak Dinesen's short stories.

Justine, first novel of Lawrence Durrell's *Alexandria Quartet*, all set in Alexandria, Egypt; also his novel *Bitter Lemons*.

On the Beach, Nevil Shute's anti-nuclear war catastrophe novel, set in Australia; Stanley Kramer directed the 1959 screen version.

St.-John Perse's *Seamarks*.

The Town, second of William Faulkner's Snopes family novels.

Promises, Robert Penn Warren's Pulitzer Prize–winning poetry collection.

Room at the Top, John Braine's novel; Jack Clayton directed the 1958 film version.

Atlas Shrugged, Ayn Rand's novel.

Stevie Smith's poems *Not Waving But Drowning*.

Isaac Bashevis Singer's short stories *Gimpel the Fool*.

Dr. Seuss's *The Cat in the Hat*.

Love Among the Cannibals, Wright Morris's novel.

Naguib Mahfouz's novels *al-Sukkariyya* and *Qasr al-Shauq*.

Arturo's Island, Elsa Morante's novel.

Jealousy, Alain Robbe-Grillet's novel.

The Fish Can Sing, Haldor Laxness's novel.

The Sandcastle, Iris Murdoch's novel.

Ted Hughes's poems *The Hawk in the Rain*.

Owls Do Cry, Janet Frame's novel.

By Love Possessed, James Gould Cozzens's novel.

Mongo Beti's novel *Mission to Kala*.

Dandelion Wine, Ray Bradbury's science fiction novel.

Dwight Macdonald's essays *Memoirs of a Revolutionist*.

The Assistant, Bernard Malamud's novel.

Frank O'Connor's short stories *Domestic Relations*.

Noam Chomsky's *Syntactic Structures*.

The Mystic Masseur, V. S. Naipaul's novel.

Pnin, Vladimir Nabokov's novel.

S. J. Perelman's *The Road to Miltown; or, Under the Spreading Atrophy*.

The Fountain Overflows, Rebecca West's novel.

The Ordeal of Gilbert Pinfold, Evelyn Waugh's novel.

W. E. B. Du Bois's novels *The Black Flame: A Trilogy* (1957–1961).

d. (Arthur) Joyce (Lunel) Cary, British writer (b. 1999).

d. Nikos Kazantakis, Greek writer (b. 1883).

d. Christopher Morley, American author and journalist (b. 1890).

d. Dorothy Sayers, British mystery writer (b. 1893).

d. Gabriela Mistral (Lucila Godoy Alcayaga), Chilean poet (b. 1889).

d. Wyndham Lewis (Percy Wyndham Lewis), British writer and artist (b. 1881).

d. Kenneth Roberts, American historical novelist (b. 1885).

d. Sholem Asch, Jewish-American writer (b. 1887).

FILM & BROADCASTING

The Bridge on the River Kwai, the classic David Lean film, based on the 1952 Pierre Boulle novel; it was covertly adapted for the screen by Carl Foreman and Michael Wilson, both then blacklisted (Boulle, who did not speak English, was awarded the screenplay Oscar). Alec Guinness, William Holden, Jack Hawkins, and Sessue Hayakawa starred.

The Three Faces of Eve, Joanne Woodward starred as the woman with multiple personalities in the film, written, directed, and produced by Nunnally Johnson.

The Throne of Blood, Toshiro Mifune and Izuzu Yamada starred in Akiro Kurosawa's screen version of *Macbeth*, set in medieval Japan.

Twelve Angry Men, Henry Fonda as the recalcitrant

juror who ultimately wins, led a substantial cast in Sidney Lumet's jury-room film; adapted by Reginald Rose from his own 1954 telefilm.

Witness for the Prosecution, Charles Laughton and Marlene Dietrich starred in Billy Wilder's courtroom murder case thriller; based on the 1953 Agatha Christie play.

Desk Set, Spencer Tracy and Katharine Hepburn starred in the Walter Lang early computer-age film.

Paths of Glory, Kirk Douglas starred in Stanley Kubrick's World War I film.

A Face in the Crowd, Elia Kazan's film, starring Andy Griffith, Patricia Neal, Walter Matthau, and Lee Remick.

The Prince and the Showgirl, Laurence Olivier and Marilyn Monroe starred in Olivier's screen version of the 1953 Terrence Rattigan play, *The Sleeping Prince*.

The Sun Also Rises, Tyrone Power as Jake Barnes and Ava Gardner as Lady Brett Ashley starred in Henry King's screen version of Ernest Hemingway's 1926 "lost generation" novel.

A Hatful of Rain, Don Murray, Eva Marie Saint, and Anthony Franciosa starred in the Fred Zinneman film, based on Michael V. Gazzo's 1955 play.

Burt Lancaster and Katharine Hepburn starred in *The Rainmaker*, directed by Joseph Anthony.

Gunfight at the O.K. Corral, Burt Lancaster starred as Wyatt Earp and Kirk Douglas as Doc Holliday in the John Sturges Western.

The Cranes Are Flying, the Mikhail Kalatozov film, a seminal post-Stalinist work; Tatyana Samoilova, Alexei Batalov, and Vasili Merkuriev starred.

The Crucible, Yves Montand and Simone Signoret starred in the Raymond Rouleau film, adapted by Jean-Paul Sartre from the 1953 Arthur Miller play.

Lloyd Bridges starred in the television series *Sea Hunt* (1957–1960).

Maverick (1957–1961), the television Western series, starring James Garner.

You Bet Your Life, Groucho Marx's television quiz show (1956–1961).

Academy Awards for 1957 (awarded the following year): Best Picture: *The Bridge on the River Kwai*; Best Director: David Lean, *The Bridge on the River Kwai*; Best Actor: Alec Guinness, *The Bridge on the River Kwai*; Best Actress: Joanne Woodward, *The Three Faces of Eve*.

d. Humphrey (DeForest) Bogart, American actor (b. 1899).

d. Erich von Stroheim (Erich Oswald Stroheim), German-Austrian actor and director (b. 1885).

d. Max Ophüls (Max Oppenheimer) German director, father of Marcel Ophüls (b. 1902).

d. Louis B. Mayer, American producer (b. 1885).

d. Oliver Hardy, American actor and comedian, partnered with Stan Laurel in Laurel and Hardy (b. 1892).

d. Charles Pathé, early film producer (b. 1863).

d. James Whale, British director (b. 1896).

VISUAL ARTS

Pablo Picasso's work included the 58 paintings of *Las Meninas*; and his ceramic *Plate with Bullfight* (ca. 1957).

Andrew Wyeth's paintings included *Brown Swiss*, *Anna Christina*, and *Hay Ledge*.

Georgia O'Keeffe's painting *Red Hills with White Cloud*.

Henry Moore's sculptures included *Draped Seated Woman* (1957–1958) and *Reclining Figure* (1957–1958).

Kenzo Tange designed the Tokyo City Hall.

Eero Saarinen began the Deere & Company building at Moline, Illinois (1957–1963), and the Thomas J. Watson Research Centre, IBM, Yorktown, New York (1957–1961).

Ansel Adams began publishing his five-volume *Basic Photo Series* (1957–1969).

Graham Sutherland's Coventry Cathedral tapestry.

Night Crawlers, Charles Addams's cartoon collection.

Ellsworth Kelly's painting *New York, New York*.

Factum I and *Factum II*, combines by Robert Rauschenberg.

Georges Braque's painting *The Black Birds*.

Helen Frankenthaler's painting *Jacob's Ladder*.

The Struggle, Robert Goodnough's painting.

Adolph Gottlieb's painting series *Bursts* (1957–1974).

Connecticut General Life Insurance Company Building, Bloomfield, Connecticut, completed; designed by Skidmore, Owings, and Merrill (1953–1957).

Knight, Seymour Lipton's sculpture.

Pier Luigi Nervi began the Palazzetto dello Sport, Rome.

Mark Rothko's painting *Light Cloud, Dark Cloud*.

Pioneer, Seymour Lipton's sculpture.

Reuben Nakian's sculpture *The Burning Walls of Troy*.

David Smith began his sculpture series *Sentinel*.

Shortstop, John Chamberlain's sculpture.

The Whiteness of the Whale by Sam Francis.

d. Constantin Brancusi, Romanian sculptor (b. 1876).

d. Diego Rivera, Mexican painter, a leading muralist (b. 1886).

d. Christian Dior, French fashion designer (b. 1905).

d. Frank Kupka, early abstractionist Czech-French painter (b. 1871).

d. Pavel Tchelitchew, Russian artist and set designer (b. 1898).

d. Miguel Covarrubias, Mexican artist, writer, and teacher (b. 1904).

THEATER & VARIETY

West Side Story, Chita Rivera, Carol Lawrence, and Larry Kert starred in the Leonard Bernstein–Stephen Sondheim musical, a New York street gang version of *Romeo and Juliet*; opened at the Winter Garden Theatre, New York.

Eugene O'Neill's *A Moon for the Misbegotten* starred Wendy Hiller and Franchot Tone; opened at the Bijou Theatre, New York, May 2.

Robert Preston and Barbara Cook starred in *The Music Man*; the Meredith Willson musical opened at the Majestic Theatre, New York, December 19.

The Entertainer, Laurence Olivier in the title role of Archie Rice and Joan Plowright starred in John Osborne's play, as they did in the 1960 film, both directed by Tony Richardson.

William Inge's *The Dark at the Top of the Stairs* starred Pat Hingle, Teresa Wright, and Eileen Heckert; opened at the Music Box Theatre, New York.

Look Homeward, Angel, Anthony Perkins and Jo Van Fleet starred in the Ketti Frings play; opened at the Ethel Barrymore Theatre, New York.

Noël Coward starred in his own *Nude with Violin*.

Orpheus Descending, the Tennessee Williams play, starred Maureen Stapleton and Cliff Robertson.

Samuel Beckett's plays *Act Without Words* and *Endgame*; and his one-act radio play *All That Fall*.

The Chairs, Eugène Ionesco's one-act absurdist play.

Jean Anouilh's *The Waltz of the Toreadors* starred Ralph Richardson, Mildred Natwick, and Betty Field.

Susan Strasberg, Helen Hayes, and Richard Burton starred in Jean Anouilh's *Time Remembered*.

Visit to a Small Planet, Gore Vidal's play, opened at the Booth Theatre, New York, February 7.

Kim Stanley starred in Arthur Laurents's *A Clearing in the Woods*.

A Hole in the Head, Arnold Schulman's play, opened at the Plymouth Theatre, New York, February 28.

Wole Soyinka's plays *The Lion and the Jewel* and *The Swamp Dwellers*.

The Hostage, Brendan Behan's play.

Alexei Nikolayevich Arbuzov's *City at Dawn*.

Hugh Leonard's *A Leap in the Dark*.

Fernando Arrabal's *La Cimitière des voitures*.

Hans Christian Branner's *Thermopylae*.

Jacques Rabémananjara's *Ships of Dawn*.

Lion Feuchtwanger's *Die Gesichte der Simone Machard*.

d. Jack Buchanan, Scottish actor–manager, singer, dancer, and director (b. 1890).

d. Sacha Guitry (Alexander Pierre George Guitry), French writer (b. 1885).

d. John Van Druten, British-American writer (b. 1901).

d. Lord Dunsany (Edward John Morton Drax Plunkett), Irish man of letters (b. 1878).

d. Esmé Saville Percy, English actor (b. 1887).

MUSIC & DANCE

The Stone Flower, Yuri Grigorovich's new choreography to Sergei Prokofiev's music for the 1954 ballet, first danced April 27, by the Kirov Ballet in Leningrad (St. Petersburg).

Dialogues of the Carmelites, Francis Poulenc's opera, libretto by Emmet Lavery, based on the Georges Bernanos play of Gertrude von de Fort's 1931 novel *Die Letzte am Schafott*, opened at La Scala, Milan January 26.

Agon, George Balanchine's ballet, music by Igor Stravinsky, premiered at the New York City Ballet November 27; Diana Adams and Arthur Mitchell danced the leads.

All the Way, Frank Sinatra's song from the film *The Joker Is Wild*, music by Sammy Cahn, words by James Van Heusen.

Benjamin Britten's ballet *The Prince of the Pagodas* and *Songs from the Chinese*.

Elvis Presley's hit single *All Shook Up*.

Milton Babbitt's jazz ensemble *All Set* and piano work *Partitions*.

Great Balls of Fire, Jerry Lee Lewis's hit single.

Aaron Copland's *The Tender Land: Orchestral Suite*.

Blueberry Hill, Fats Domino's hit single.

Ralph Vaughan Williams's *Symphony No. 9* and *10 Blake Songs*.

The Kingston Trio was founded by Bob Shane, Nick Reynolds, and Dave Guard.

The Harmony of the World (*Die Harmonie der Welt*), Paul Hindemith's opera.

Chuck Berry's hits *School Day* and *Rock & Roll Music*.

The Willows Are New, Chou Wen-chung's piano work.

Dmitri Shostakovich's *Piano Concerto No. 2*.

That'll Be the Day, Buddy Holly's hit song.

Harrison Birtwistle's *Refrains and Choruses* for wind quintet.

Connie Francis's hit version of the 1923 song *Who's Sorry Now?*

Toru Takemitsu's *Requiem* for strings.

Partita, William Walton's orchestral work.

Spring Sings, Dmitry Kabalevsky's operetta.

Comoedia de Christi resurrectione, Carl Orff's dramatic musical work.

Odetta at the Gate of Horn album.

Achoripsis, Iannis Xenakis's orchestral work.

Winter Music, John Cage's piano work.

Minotauros, Karl-Birger Blomdahl's ballet.

Gruppen, Karlheinz Stockhausen's orchestral work.

Komei Abe's first symphony.

Luigi Nono's *Varianti*, for orchestra.

Michael Tippett's second symphony.

St. Michael, Peter Maxwell Davies's orchestral work.

Pierre Boulez's *Piano Sonata*.

d. Jean Sibelius, Finnish national composer.

d. Arturo Toscanini, leading Italian conductor (b. 1867).

d. Jimmy (James Francis) Dorsey, American bandleader, clarinetist, and saxophonist (b. 1904).

d. Beniamino Gigli, Italian tenor (b. 1890).

d. Ezio Pinza, Italian bass, who after a long operatic career created the Emil de Becque role opposite Mary Martin in *South Pacific*.

d. Dennis Brain, British musician (b. 1921).

WORLD EVENTS

Great Britain built its own hydrogen bomb.

Reactor fire at Britain's Sellafield (Windscale) caused a major nuclear accident, releasing a large radioactive cloud, contaminating large areas, and causing many deaths in later years; kept secret by British government for decades.

Soviet nuclear disaster at Chelyabinsk in the Urals, near Kyshtym, caused many deaths, thousands of casualties, and contaminated hundreds of square miles; kept secret by Soviet government for decades.

Soviet Union developed long-range ballistic missiles.

President Dwight D. Eisenhower stated the Eisenhower Doctrine, a pledge of American support, including direct military intervention, to Middle Eastern countries attacked by Communists.

Martin Luther King, Jr., Ralph Abernathy, and other civil-rights leaders founded the Southern Christian Leadership Conference (SCLC).

Newspaper publisher Daisy Gatson Bates, president of the Arkansas chapter of the NAACP, led the fight to desegregate Little Rock Central High School.

Conservative Harold Macmillan succeeded Anthony Eden as British prime minister (1957–1963).

François "Papa Doc" Duvalier won the Haitian presidential election, quickly emerging as a ruthless dictator, ruling until his death in 1971.

Independent Federation of Malaya became a nation, with Tunku Abdul Rahman its first prime minister.

Sputnik 1 became the first artificial satellite to orbit the earth (October 4).

Republic of Ghana became an independent nation, led by Kwame Nkrumah (1957–1966).

Canadian Conservative party leader John Diefenbaker became prime minister (1957–1963).

Thalidomide was widely prescribed for pregnant women in Great Britain and Germany, and experimentally in many countries; it would only later become clear that it caused serious birth defects.

Willy Brandt became mayor of West Berlin (1957–1966).

Worldwide "Asian flu" influenza pandemic (1957–1958).

Yugoslavian dissenter Milovan Djilas's *The New Class*.

d. Joseph Raymond McCarthy, witchhunting American senator (b. 1908), whose name supplied the new term "McCarthyism" to English.

1958

LITERATURE

Where the Air Is Clear, Carlos Fuentes's novel.

Doctor Zhivago, Boris Pasternak's novel, first appeared in English.

Boris Pasternak was awarded the Nobel Prize for Literature, but was forced by the Soviet government to reject the honor.

Balthazar and *Mountolive*, second and third novels of Lawrence Durrell's *Alexandria Quartet*.

The Leopard, Giuseppe Tomasi de Lampedusa's novel, set in 1860s Sicily; basis of the 1963 Luchino Visconti film.

Saturday Night and Sunday Morning, Alan Sillitoe's novel, about an "angry young man" in northern England; basis of the 1960 Karel Reisz film.

Things Fall Apart, Chinua Achebe's first novel, establishing him as a major African novelist and analyst of colonialism's impact on Africa.

Breakfast at Tiffany's, Truman Capote novella, basis of the 1961 Blake Edwards film.

Graham Greene's novel *Our Man in Havana*; basis for the 1960 film.

The Dharma Bums, Jack Kerouac's autobiographical novel.

The King Must Die, Mary Renault's novel.

A World of Strangers, Nadine Gordimer's novel.

Bernard Malamud's short stories *The Magic Barrel*.

A Mixture of Frailties, Robertson Davies's novel.

The Suffering of Elvira, V. S. Naipaul's novel.

Borstal Boy, Brendan Behan's autobiography.

Exodus, Leon Uris's novel about the founding of modern Israel.

Brave New World Revisited, Aldous Huxley's novel.

Theodore Roethke's poetry *Words for the Wind*.

From the Terrace, John O'Hara's novel, basis of the 1960 Mark Robson film.

Gasoline and *Bomb*, Gregory Corso's poetry collections.

Conrad Aiken's poetry *Sheepfold Hill*.

Dr. Seuss's *Yertle the Turtle*.

Jorge Amado's novel *Gabriela, Clove and Cinnamon*.

Memoirs of a Dutiful Daughter, Simone de Beauvoir's autobiography.

Edgar Mittelholzer's novel *Kaywana Blood*.

I Like It Here, Kingsley Amis's novel.

Robert Graves's essays *The White Goddess*.

Ice Palace, Edna Ferber's novel, basis of the 1960 Vincent Sherman film.

Salvatore Quasimodo's poems *The Incomparable Earth*.

Karl Shapiro's *Poems of a Jew*.

Mongo Beti's novel *King Lazarus*.

The Long Dream, Richard Wright's novel.

Rebecca West's essays *The Court and the Castle*.

Tambourines to Glory, Langston Hughes's novel.

Shirley Ann Grau's novel *The Hard Blue Sky*.

The Guide, Rasipuram Narayan's novel.

The Mackerel Plaza, Peter De Vries's novel.

Yehuda Amichai's poetry *Two Hopes Away*.

Eric Partridge's *Origins: An Etymological Dictionary of English*.

Agee on Film, James Agee's posthumously published collected film criticism.

Pinyin system of representing the Chinese language through English letters was introduced; officially adopted in 1979.

Good Boy, Ian Cross's novel.

d. Lion Feuchtwanger, German writer (b. 1884).

d. Roger Martin du Gard, French writer, author of *The Thibaults* (b. 1881).

d. Alfred Doblin, German writer (b. 1878).

d. Alfred Noyes, British poet (b. 1880).

d. Rose Macaulay, British writer (b. 1889).

d. Dorothy Canfield, American novelist (b. 1879).

d. Fyodor Gladkov, Soviet writer (b. 1882).

d. George Jean Nathan, American drama critic (b. 1882).

d. James Branch Cabell, American writer (b. 1879).

d. Mary Roberts Rinehart, American mystery writer (b. 1876).

d. Robert Service, Canadian writer, poet of the far north (b. 1874).

d. Samuel Hopkins Adams, journalist and author (b. 1871).

FILM & BROADCASTING

Black Orpheus, the Marcel Camus film, adapted from the Vinicius de Moraes play, set in Rio de Janeiro during carnival time; an all-black cast starred Breno Mello, Marpesa Dawn, and Adhemar Da Sylva.

The Old Man and the Sea, Spencer Tracy starred as the indomitable old fisherman in Preston Sturges's film of the 1952 Ernest Hemingway story.

The Last Hurrah, Spencer Tracy starred as the Boston politician (after James Michael Curley) in the John Ford film, based on the 1956 Edwin O'Connor novel.

Gigi, Leslie Caron, Maurice Chevalier, Louis

Jourdan, and Hermione Gingold starred in the Vincente Minnelli musical; screenplay by Alan Jay Lerner, based on the 1945 Colette novel, music by Lerner and Frederick Loewe.

Separate Tables, David Niven, Deborah Kerr, Burt Lancaster, Rita Hayworth, and Wendy Hiller starred in the Delbert Mann film, based on two short Terence Rattigan plays.

Cat on a Hot Tin Roof, Burl Ives, Elizabeth Taylor, and Paul Newman starred in the Richard Brooks film version of the 1955 Tennessee Williams play.

The Defiant Ones, Sidney Poitier and Tony Curtis starred in Stanley Kramer's Southern chain gang film.

The Long Hot Summer, Paul Newman, Joanne Woodward, and Orson Welles starred in the Martin Ritt film, based on William Faulkner's 1940 Snopes family novel *The Hamlet*.

Charlton Heston and Orson Welles starred in *Touch of Evil*, directed by Welles.

A Night to Remember, Kenneth More, Laurence Naismith, Alec McCowen, and Honor Blackman starred in Roy Baker's disaster film, about the 1912 sinking of the *Titanic*; screenplay by Eric Ambler.

Ashes and Diamonds, the Andrzej Wajda film, based on the 1948 Jerzy Andrzejewski novel, about the Polish resistance movement during World War II.

Auntie Mame, Morton DaCosta's film version of the Jerome Lawrence–Robert E. Lee play, based upon the Patrick Dennis novel, and again starring Rosalind Russell as Mame.

Bell, Book, and Candle, James Stewart and Kim Novak starred in Bill Quine's screen version of the 1950 John Van Druten play.

Desire Under the Elms, Burl Ives, Sophia Loren, and Anthony Perkins starred in the Delbert Mann film, based on the 1924 Eugene O'Neill play.

South Pacific, Mitzi Gaynor as Nellie Forbush and Rossano Brazzi as Emile de Becque starred in Joshua Logan's screen version of the 1949 Rodgers and Hammerstein stage musical.

Rawhide (1958–1965), Clint Eastwood's television Western series.

The Donna Reed Show (1958–1966), her situation comedy series.

The Garry Moore Show (1958–1964), his television variety series.

Academy Awards for 1958 (awarded the following year): Best Picture: *Gigi*; Best Director: Vincente Minnelli, *Gigi*; Best Actor: David Niven, *Separate Tables*; Best Actress: Susan Hayward, *I Want to Live*.

d. Tyrone Power (Tyrone Edmund Power, Jr.), American actor, son of actor Tyrone Frederick Power (1869–1931) and the great-grandson of Irish actor Tyrone Power (1797–1841).

d. Ronald Colman, British actor (b. 1891).

d. Robert Donat, British actor (b. 1905).

d. André Bazin, French film critic, author, and editor; he was the chief editor of *Cahiers du cinéma* (b. 1918).

VISUAL ARTS

Giacomo Manzù's Salzburg Cathedral doors.

Marc Chagall's stained-glass window for the cathedral at Metz (1958–1960).

Eero Saarinen began Dulles International Airport, Chantilly, Virginia (1958–1962), and designed the Ingalls Hockey Rink, Yale University.

Mies van der Rohe and Philip Johnson's Seagram Building, New York, was completed.

Mies van der Rohe designed the exterior of the Museum of Fine Arts, Houston.

Philip Johnson designed the Four Seasons Restaurant, New York.

Philip Johnson and Jacques Lipchitz designed the roofless church in New Harmony, Indiana.

Rufino Tamayo completed the Paris UNESCO headquarters murals.

Georgia O'Keeffe's painting *Ladder to the Moon*.

Edward Hopper's painting *Sunlight in a Cafeteria*.

Jasper Johns's painting *Three Flags*.

Painted Bronze, Jasper Johns's sculpture.

Joan Miró's Paris UNESCO tiles.

Kenzo Tange designed the Tagawa town hall.

Louise Nevelson's sculpture *Sky Cathedral*.

Alberto Giacometti's sculpture *Paris sansfin*.

Edward Durell Stone designed the Main Library, Palo Alto, California.

Willem de Kooning's painting *Woman and Bicycle*.

Naum Gabo's sculpture *Linear Construction in Space, Number 4*.

Pier Luigi Nervi began Flaminio Stadium, Rome (1958–1959).

Andrew Wyeth's paintings included *River Cove* and *Snow Flurries*.

Robert Motherwell's painting *Iberia No. 18*.

Sorcerer, Seymour Lipton's sculpture.

d. Edward Weston, American photographer (b. 1886).

d. Georges Rouault, French painter (b. 1871).

d. John Held, Jr., American cartoonist (b. 1889), most notably of Prohibition-era "flaming youth" life, who set the popular image of the "flapper."

d. Giacomo Balla, Italian painter, a leading Futurist (b. 1871).

d. Maurice de Vlaminck, French painter (b. 1876).

d. Norman Bel Geddes, American stage and industrial designer (b. 1893).

THEATER & VARIETY

A Taste of Honey, Shelagh Delaney's groundbreaking play, featuring a pregnant single white mother, a black sailor father, and a helpful gay friend; Tony Richardson directed the 1961 film version.

A Touch of the Poet, Kim Stanley, Eric Portman, Helen Hayes, and Betty Field starred in the Eugene O'Neill play; opened at the Helen Hayes Theatre, New York, October 2.

J.B., Pat Hingle, Raymond Massey, and Christopher Plummer starred in the highly allegorical Archibald MacLeish play; opened at the ANTA Theatre, December 11.

John Gielgud appeared in his Shakespearean recital *The Ages of Man*.

Pleasure of His Company, Samuel Taylor and Cornelia Otis Skinner's comedy, opened at the Longacre Theatre, New York, October 22.

Sunrise at Campobello, Ralph Bellamy as polio-ridden young Franklin D. Roosevelt and Mary Fickett as Eleanor Roosevelt starred in the Dore Schary play; opened at the Cort Theatre, New York.

Alfred Lunt, Lynn Fontanne, and Eric Porter starred in Friedrich Dürrenmatt's *The Visit*.

Henry Fonda and Anne Bancroft starred in *Two for the Seesaw*; the William Gibson play opened at the Booth Theatre, New York, January 16.

The World of Susie Wong, Paul Osborn's play, opened at the Broadhurst Theatre, New York.

Five Finger Exercise, Peter Shaffer's play; basis of the 1962 Daniel Mann film.

Flower Drum Song, the Richard Rodgers–Oscar Hammerstein musical starred Pat Suzuki, Juanita Hall, and Larry Blyden.

Harold Pinter's *The Birthday Party*, which he adapted for the 1968 film.

The Square Root of Wonderful, Carson McCullers's play.

Brass Butterfly, William Golding's play.

Eduardo de Filippo's *Pulcinella in Search of His Fortune in Naples*.

Chicken Soup with Barley, Arnold Wesker's play.

Clemence Dane's *Eighty in the Shade*.

Denis Johnston's *The Scythe and the Sunset*.

John Arden's *Live Like Pigs*.

Max Rudolf Frisch's *The Fire Raisers*.

Shu Ch'ing-ch'un's *Tea House*.

Fernando Arrabal's *La Communion solennelle*.

Fritz Hochwälder's *The Innocent Man*.

Henri de Montherlant's *Don Juan*.

d. Lion Feuchtwanger, German playwright and novelist (b. 1884).

d. Ferdinand Bruckner, Austrian playwright (b. 1891).

d. Harold Brighouse, English playwright (b. 1882).

d. Lennox Robinson, Irish playwright, actor, director, and critic (b. 1886).

d. Norman Bel Geddes, American scene designer (b. 1893).

d. Rachel Crothers, American playwright (b. 1878).

d. Zoë Akins, American playwright and poet (b. 1886).

MUSIC & DANCE

The Beatles were formed (1958–1970); four musicians from Liverpool would have an enormous worldwide impact on popular music: John Lennon, Paul McCartney, George Harrison, and Richard (Ringo) Starr (who replaced Pete Best as drummer in 1962); a fifth member, Stuart Sutcliffe, would also leave in 1962.

Where Have All the Flowers Gone?, Pete Seeger's song, which would become an anthem of the 1960s.

Stars and Stripes, George Balanchine's ballet, to music by John Philip Sousa, first danced January 17, by the New York City Ballet.

Maurice Chevalier introduced two classic Alan Jay Lerner–Frederick Loewe songs in *Gigi*: *Thank Heaven for Little Girls* and (with Hermoine Gingold) *I Remember It Well*.

Ondine, Frederick Ashton's ballet, music by Hans Werner Henze, first danced October 27 by the

Royal Ballet, London, with Margot Fonteyn dancing the lead.

Benjamin Britten's *Noye's Fludde*, musical adaptation of a Chester miracle play, premiered at the Aldeburgh Festival; he also composed the vocal works *Nocturne* and *Sechs Hölderlin-Fragmente*.

Clytemnestra, Martha Graham's ballet to music by Halim el-Dabh, set by Isamu Noguchi, premiered April 1 at New York's Adelphi Theatre.

Krzysztof Penderecki's orchestral work *Emanations* and choral music *From the Psalms of David*.

Alvin Ailey founded the American Dance Theater, with which he introduced his *Blues Suite*.

Frank Sinatra's albums *Come Fly with Me* and *Only the Lonely*.

Vanessa, Samuel Barber's Pulitzer Prize–winning opera.

RCA Electronic Music Synthesizer, Mark II, early programmable composition machine.

Luigi Nono's choral works *Cori di Didone* and *La terra e la compagne*.

Blues and Roots, Charles Mingus's album.

Gian Carlo Menotti founded the Spoleto Festival; his opera *Maria Golovin* premiered in Brussels.

Chuck Berry's hits *Sweet Little Sixteen* and *Johnny B. Goode*.

Missa Brevis, José Limón's ballet.

Poésie pour pouvoir, Pierre Boulez's orchestral work.

Peggy Sue, Buddy Holly's hit song.

Vergilii Aeneis, Gian Francesco Malipiero's opera.

Kammermusic, Hans Werner Henze's cantata.

Igor Stravinsky's choral work *Threni*.

Tom Dooley, the Kingston Trio's hit.

Assassinio nella cattedrale, Ildebrando Pizzetti's opera.

James Brown's hit song *Try Me*.

John Cage's *Concert* for piano and orchestra.

In the Path of Thunder, Kara Karayev's ballet.

Requiescant, Luigi Dallapiccola's choral work.

Oliver Messaien's *Catalogue d'oiseaux*, 13 pieces for piano.

Crown of the Year, Michael Tippett's choral work.

Minette Fontaine, William Grant Still's opera.

Poème électronique, Edgard Varèse's tape work.

Leonard Bernstein became musical director of the New York Philharmonic Orchestra (1958–1972).

d. Ralph Vaughn Williams, British composer (b. 1872).

d. Big Bill (William Lee Conley) Broonzy, American blues singer and guitarist (b. 1893).

d. W. C. (William Christopher) Handy, American musician and composer (b. 1873), best known for his *St. Louis Blues*.

d. Doris Humphrey, American dancer, choreographer, and teacher (b. 1895).

WORLD EVENTS

Mao Zedong initiated China's Great Leap Forward, a failed, extremely damaging nationwide industrialization campaign (1958–1960).

General Jacques Massu led a French officers' revolt in Algiers, bringing down the Fourth Republic and nearly causing a civil war in France; Charles de Gaulle's Fifth Republic would defeat the revolt.

Cuban guerrillas led by Fidel Castro came out of the Sierra Maestra as a guerrilla army.

Lebanese civil war; America intervened with 14,000 troops on the side of the Chamoun government.

European Economic Community (EEC) established.

Military dictator Ne Win took power in Burma.

Although he had been cleared by a Congressional committee, American presidential aide Sherman Adams resigned after having been accused of taking gifts as bribes.

Bertrand Russell became the first chairman of the British Campaign for Nuclear Disarmament (CND).

Republic of Guinea founded, led by Ahmed Sékou Touré, who was president of his one-party state (1958–1984).

Robert Welch founded the extremely conservative John Birch Society.

Syria and Egypt briefly joined in the largely unconsummated United Arab Republic (1958–1961).

Eleanor Roosevelt's *On My Own*.

John Kenneth Galbraith's *The Affluent Society*.

1959

LITERATURE

Advise and Consent, Allen Drury's Pulitzer Prize–winning first novel, an anti-McCarthy political story set in Washington, D.C.; basis for the 1962 film.

Alan Sillitoe's short-story collection *The Loneliness of the Long Distance Runner*; the lead story was the basis of the 1962 Tony Richardson film, screenplay by Sillitoe.

The Nobel Prize for Literature was awarded to Salvatore Quasimodo.

The Mansion, the third and last of William Faulkner's Snopes family novels.

Shirley Jackson's novel *The Haunting of Hill House*.

To Sir with Love, E. Braithwaite's novel, basis for the 1967 film.

Langston Hughes's *Selected Poems*.

Robert Penn Warren's novel *The Cave*.

Delmore Schwartz's Bollingen Prize–winning *Summer Knowledge: New and Selected Poems 1938–1958*.

Pamela Hansford Johnson's novels *The Unspeakable Skipton* and *The Humbler Creation*.

Henderson the Rain King, Saul Bellow's novel.

Nelly Sachs's poetry *Flight and Metamorphosis*.

Billiards At Half-Past Nine, Heinrich Böll's novel.

Hawaii, James Michener's novel, basis of the 1966 George Roy Hill film.

Hayden Carruth's poetry *The Crow and the Heart*.

John Hersey's novel *The War Lover*.

Momento Mori, Muriel Spark's novel.

Denise Levertov's poems *With Eyes in the Back of Our Heads*.

Hamilton Basso's novel *Light Infantry Ball*.

Robert Lowell's poetry collection *Life Studies*.

Marianne Moore's poetry *O to Be a Dragon*.

Françoise Sagan's novel *Aimez-vous Brahms?*

Nathalie Sarraute's novel *Le Planétarium*.

Louis Aragon's historical novel *La Semaine Sainte*.

Richard Wright's novel *The Long Dream*.

Louis Auchincloss's novel *Pursuit of the Prodigal*.

Howard Nemerov's *Mirrors and Windows: Poems*.

Robert Graves's *Collected Poems: 1959*.

John Updike's novel *Poorhouse Fair*.

Philip Roth's *Goodbye, Columbus, and Five Short Stories*.

Jules Romains's novel *Mémoires de Madame Chauverel*.

Maggie Cassidy, Jack Kerouac's novel.

Joseph Wood Krutch's *Human Nature and the Human Condition*.

Lady L, Romain Gary novel, basis of the 1966 Peter Ustinov film.

Khushwant Singh's novel *I Shall Not Hear the Nightingale*.

Miguel Street, V. S. Naipaul's novel.

Nexus, Henry Miller's novel.

Ezekiel Mphahlele's *Down Second Avenue*.

The Elements of Style, classic writer's guide expanded and revised by E. B. White from William Strunk, Jr.'s 1935 "little book."

d. Raymond Chandler, American writer (b. 1888).

d. Kafu Nagai, Japanese novelist (b. 1879).

d. Manuel Altolaguirre, Spanish poet (b. 1905).

d. Wallace Irwin, American writer (b. 1875).

FILM & BROADCASTING

Some Like It Hot, Marilyn Monroe as Honey, Tony Curtis, and Jack Lemmon starred in Billy Wilder's classic comedy, set in 1920s Chicago and Florida.

The Magician, Max von Sydow starred in the Ingmar Bergman film, set in 19th-century Sweden.

On the Beach, Gregory Peck, Ava Gardner, Fred Astaire, and Anthony Perkins starred in Stanley Kramer's anti-nuclear war film, set in postwar Australia; based on the 1957 Nevil Shute novel.

Laurence Harvey and Simone Signoret starred in *Room at the Top*, directed by Jack Clayton; based on the 1957 John Braine novel.

The 400 Blows, the autobiographical François Truffaut film; Jean-Pierre Leaud starred.

Suddenly Last Summer, Katharine Hepburn, Elizabeth Taylor, and Montgomery Clift starred in Joseph L. Mankiewicz's screen version of the 1958 Tennessee Williams play.

Hiroshima, Mon Amour, Emmanuele Riva and Eiji Okada starred as the lovers in the Alain Resnais "new wave" film, set in postwar Hiroshima; screenplay by Marguerite Duras.

Anatomy of a Murder, courtroom drama directed by Otto Preminger and starring James Stewart, Lee Remick, Ben Gazzara, Arthur O'Connell, and George C. Scott.

Ben-Hur, the William Wyler film, based on the 1880 Lew Wallace novel, starring Charlton Heston, Stephen Boyd, Hugh Griffith, and Jack Hawkins.

Breathless, Jean-Luc Godard's "new wave" film, starring Jean-Paul Belmondo and Jean Seberg; screenplay by François Truffaut.

The Devil's Disciple, Burt Lancaster, Kirk Douglas, and Laurence Olivier starred in the Guy Hamilton film version of the 1907 George Bernard Shaw satire, set during the American Revolution.

Damn Yankees, the George Abbott–Stanley Donen baseball film, based on the 1955 play; Gwen

Verdon, Tab Hunter, and Ray Walston starred.

John Wayne starred in *Rio Bravo*, directed by Howard Hawks.

Luis Buñuel directed *Nazarin*.

Middle of the Night, the Delbert Mann film, based on the 1958 Paddy Chayefsky play; Fredric March and Kim Novak starred.

North by Northwest, Cary Grant, Eva Marie Saint, and James Mason starred in Alfred Hitchcock's classic chase thriller, ending quite literally with a cliff-hanger at Mount Rushmore.

Porgy and Bess, Sidney Poitier, Dorothy Dandridge, and Sammy Davis, Jr., starred in Otto Preminger's screen version of George and Ira Gershwin's folk opera, set in African-American life.

Bonanza, the television Western series, starring Lorne Greene, Michael Landon, Dan Blocker, and Pernell Roberts as the Cartwright family (1959–1973).

Robert Stack starred as FBI agent Eliot Ness in the television series *The Untouchables* (1959–1963).

The Twilight Zone, Rod Serling's television science fiction series (1959–1965).

Academy Awards for 1959 (awarded the following year): Best Picture: *Ben Hur*; Best Director: William Wyler, *Ben-Hur*; Best Actor: Charlton Heston, *Ben-Hur*; Best Actress: Simone Signoret, *Room at the Top*.

d. Errol Flynn, Australian actor (b. 1909).

d. Preston Sturges (Edmond P. Biden), American writer and director (b. 1898).

d. Lou Costello (Louis Francis Cristello), American comedian (b. 1906).

d. Victor McLaglen, British actor (b. 1886).

d. Edmund Gwenn, British actor (b. 1875).

VISUAL ARTS

New York's Guggenheim Musem opened; designed by Frank Lloyd Wright.

Andrew Wyeth's paintings included *Blue Measure*, *Ground Hog Day*, *Morning Sun*, *The Mill*, and *Wolf Rivers*.

Georgia O'Keeffe's paintings included *Flagpole with White House* and *It Was Red and Pink*.

Eero Saarinen completed Concordia Senior College, Fort Wayne, and began North Christian Church, Columbus (1959–1963), both in Indiana.

Burning Building, a "happening" by Red Grooms.

The Marriage of Reason and Squalor, Frank Stella's painting.

Edward Durell Stone designed the Stanford University Medical Center, Palo Alto, California, and began the Gallery of Modern Art, New York City.

Pablo Picasso's painting *Nude Under a Pine Tree*.

Philip Johnson designed Asia House, New York.

Ellsworth Kelly's painting *Tate, Running White*.

Henry Moore's sculpture *Two-Piece Reclining Figure No. 1*.

Alexander Calder's sculpture *Big Red, Black Widow*.

Independence and the Opening of the West, George Hart Benton's painting.

Isamu Noguchi's sculpture *Integral*.

Jules Feiffer's cartoon collection *Sick, Sick, Sick*.

Oskar Kokoschka's painting *Sir Stanley Unwin*.

Marcel Duchamp's painting *With My Tongue in My Cheek*.

Larry Rivers's painting *The Last Civil War Veteran*.

Observations, Richard Avedon's photo collection, with text by Truman Capote.

Morris Louis's paintings included *Blue Veil* (1958–1959) and *Saraband*.

Numbers in Color, painting by Jasper Johns.

Louise Nevelson's sculpture *Dawn's Wedding Feast*.

Max Abramovitz began the Corning Glass Building, New York City.

Prophet, Seymour Lipton's sculpture.

Stuart Davis's painting *The Paris Bit*.

Time-Life Building, New York, designed by Harrison, Abramovitz, and Harris.

Willem de Kooning's painting *Merritt Parkway*.

d. Frank Lloyd Wright, American architect (b. 1867).

d. George Grosz, German artist (b. 1893).

d. Jacob Epstein, American-British sculptor (b. 1880).

THEATER & VARIETY

Sweet Bird of Youth, Geraldine Page and Paul Newman starred in the Tennessee Williams play; opened at the Martin Beck Theatre, New York.

Mary Martin and Theodore Bickel starred as Maria and George von Trapp in *The Sound of Music*; the Rodgers and Hammerstein musical opened at the Lunt-Fontanne Theatre, New York.

A Raisin in the Sun, Claudia McNeil and Sidney

Poitier starred in Lorraine Hansberry's story of Chicago black urban ghetto life; opened at the Ethel Barrymore Theatre, New York, March 11.

Anne Bancroft and Patty Duke starred in *The Miracle Worker*; the William Gibson play opened at the Playhouse, New York, October 19.

A Majority of One, Gertrude Berg and Cedric Hardwicke starred in the Leonard Spiegelgass comedy; opened at the Shubert Theatre, New York.

The Tenth Man, George Voskovec, Jack Gilford, and Lou Jacoby starred in the Paddy Chayefsky play; opened at the Booth Theatre, New York.

Ethel Merman starred in *Gypsy*; the Stephen Sondheim–Jule Styne musical, based on the Gypsy Rose Lee autobiography, opened at the Broadway Theatre, New York, May 21.

Tom Bosley starred as Fiorello La Guardia in *Fiorello!*; the Jerry Bock musical opened at the Broadhurst Theatre, New York, November 23.

The Connection, Jack Gelber's play, opened at the Living Theatre, New York, July 15.

Jessica Tandy, Michael Bryant, and Brian Bedford starred in Peter Shaffer's *Five Finger Exercise*.

Katharine Cornell starred as Mrs. Patrick Campbell in *Dear Liar*.

Little Mary Sunshine, Rick Besoyan's musical comedy, opened at the Orpheum Theatre, New York.

London's Hampstead Theatre Club opened.

Take Me Along, Walter Pidgeon, Una Merkel, and Jackie Gleason starred in the Robert Merrill musical adapted from Eugene O'Neill's *Ah, Wilderness!*

George C. Scott, Herbert Berghof, and Albert Dekker starred in Saul Levitt's *The Andersonville Trial*.

The Blacks, Jean Genet's play.

The Condemned of Altona, Jean-Paul Sartre's play.

John Arden's play *Serjeant Musgrave's Dance*.

Peter Kenna's *The Slaughter of St. Teresa's Day*.

d. Olga Knipper, Russian actress (b. 1870), star of the Moscow Art Theatre and the wife of playwright Anton Chekhov. She originated several classic roles, including Masha in *The Three Sisters* and Elena in *Uncle Vanya*.

d. Ethel Barrymore (Edith Blythe), American actress (b. 1879), sister of John and Lionel Barrymore.

d. Lupino Lane (Henry George Lupino), British actor (b. 1892), of the Lupino stage family; as a child actor, he was Nipper Lane.

d. Maxwell Anderson, American playwright (b. 1888).

d. Gérard Philipe, French actor (b. 1922).

d. Laurence Housman, English author and playwright (b. 1865).

MUSIC & DANCE

Mary Martin made a hit of Oscar Hammerstein II and Richard Rodgers's song *The Sound of Music*, from the Broadway musical, sung by Julie Andrews in the 1965 film.

Denise Duval created the single character in Francis Poulenc's final opera *La Voix Humaine*, libretto by Jean Cocteau; opened at the Opéra-Comique, Paris, February 6.

Episodes, George Balanchine's ballet; music by Anton von Webern, first danced May 14 by the New York City Ballet.

Everything's Coming Up Roses, the Jule Styne–Stephen Sondheim song, introduced by Ethel Merman in *Gypsy*.

High Hopes, Frank Sinatra's hit song, from the film *A Hole in the Head*, music by Sammy Cahn, words by James Van Heusen.

Kind of Blue, Miles Davis's enormously influential album.

Krzysztof Penderecki's choral works *Strophes* and *Dimensions of Time and Silence*.

Dance Panels, Aaron Copland's ballet music.

Igor Stravinsky's *Double Canon* and his symphonic work *Movements*.

Benjamin Britten's *Cantata academica* and *Missa brevis*.

Calypso, Harry Belafonte's top hit album, including *Jamaica Farewell* and *Banana Boat Song (Day-O)*.

Dmitri Shostakovich's *Cello Concerto No. 1*.

Oedipus de Tyrann, Carl Orff's dramatic musical work.

David Amram's *Shakespearean Concerto* for orchestra and chorus.

Gloria, Francis Poulenc's choral work.

Iannis Xenakis's orchestral works *Duel* and *Syrmos*.

Julian Bream founded the Bream Consort.

Aniara, Karl-Birger Blomdahl's opera.

Karlheinz Stockhausen's chamber music *Refrain*.

Allez-Hop! Luciano Berio's dramatic musical work.

Luigi Nono's *Composizione No. 2*, for orchestra.

Five Motets, Peter Maxwell Davies's choral work.

Harrison Birtwistle's vocal work *Monody for Corpus Christi*.

Academy of St. Martin-in-the-Fields, British chamber orchestra, founded in London by Neville Marriner.

d. Billie Holiday (Eleanora Fagan), American jazz singer (b. 1915).

d. Baby Dodds (Warren Dodds), New Orleans jazz drummer (b. 1898), who worked with jazz greats such as King Oliver, Louis Armstrong, and Jelly Roll Morton.

d. Wanda Landowska, Polish harpsichordist, chiefly responsible for the 20th-century renaissance of the instrument.

d. Buddy Holly (Charles Hardin Holley) American rock composer and singer (b. 1938); died in an airplane accident.

d. Sidney Bechet, American jazz saxophonist, clarinetist, and bandleader (b. 1897).

d. Ernest Bloch, American composer (b. 1880).

d. Heitor Villa-Lobos, Brazilian composer (b. 1887).

d. Lester Young, American tenor saxophonist and composer (n. 1909).

d. Curt Sachs, German-American scholar of musical instruments (b. 1881), who developed an ethnological classification of instruments.

WORLD EVENTS

Charles de Gaulle became president of France's Fifth Republic.

Fidel Castro's forces took Havana on January 8, as Cuba fell.

Yasir Arafat and others founded Fatah (al-Fatah), the Palestine Liberation movement.

The Dalai Lama, Tibetan religious and political ruler, fled Tibet to India following a failed Tibetan revolt against the Chinese, and was from then headquartered in northern India.

Makarios III (Michael Khristodoulou Mouskos) became first president of Cyprus, as guerrilla warfare between Greeks and Turks on the island continued to develop into full-scale civil war.

North Vietnamese opened the Ho Chi Minh Trail military supply route through Laos and Cambodia to southern Vietnam.

Southwest Africa People's Organization of Namibia (SWAPO) was founded as a peaceful independence organization; it would go over to armed conflict in 1966.

Antarctic Treaty (December) established Antarctica as a nuclear test-free zone, deferred conflicting territorial claims until 1989, and provided for multinational scientific research.

Mary and Louis Leakey discovered hominid remains as much as two million years old in central Africa, pushing human origins much farther back than had, until then, been thought possible.

Hawaii won statehood.

Hurricane Vera hit the Japanese island of Honshu, killing an estimated 4,500 (September).

St. Lawrence Seaway was opened, a Canadian–American waterway linking the Great Lakes and the Atlantic.

Xerox Corporation introduced the first commercial xerographic copier.

1960

LITERATURE

To Kill a Mockingbird, Harper Lee's Pulitzer Prize–winning novel, a modern Southern story about a white lawyer who successfully defends an African-American falsely accused of rape; basis of the 1962 Robert Mulligan film.

Alexis Léger, who wrote as St.-John Perse, won the Nobel Prize for Literature; he also published the poetic work *Chronique*.

Rabbit, Run, John Updike novel, first of the Rabbit quartet.

This Sporting Life, David Story novel, set in a rugby milieu; basis of his script for the 1963 Lindsay Anderson film.

The Inquisitors, Jerzy Andrzejewski's anti-witch-hunting novel, a key work of dissent in then-Communist Poland.

Andrei Voznesensky's poetry collections *Parabola* and *Mosaic*.

The Magician of Lublin, Isaac Bashevis Singer's novel.

The Woman at the Washington Zoo, Randall Jarrell's National Book Award–winning poetry collection.

Phyllis McGinley's Pulitzer Prize–winning *Times Three: Selected Verse from Three Decades*.

Clea, fourth novel in Lawrence Durrell's *The Alexandria Quartet*.

John Knowles's novel *A Separate Peace*.

C. P. Snow's *The Two Cultures and the Scientific Revolution*.

A Silence of Desire, Kamala Markandaya's novel.

Set This House on Fire, William Styron's novel.

The Child Buyer, John Hersey's novel.

André Malraux's *The Metamorphosis of the Gods*.

Homage to Clio, W. H. Auden's poetry collection.

Dr. Seuss's *Green Eggs and Ham*.

The Householder, Ruth Prawer Jhabvala's novel.

Gwendolyn Brooks's poetry *The Bean Eaters*.

The Violent Bear It Away, Flannery O'Connor's novel.

Dream Tigers, Jorge Luis Borges's short-story collection.

Her, Lawrence Ferlinghetti's novel.

Elias Canetti's essays in *Crowds and Masses*.

Ferdinand Léopold Oyono's novel *The Road from Europe*.

Harvest on the Don, Mikhail Sholokov's novel.

Kenneth Koch's poetry *Ko, or A Season on Earth*.

Into the Stone, James Dickey's poetry collection.

John Barth's novel *The Sot-Weed Factor*.

Mari Sandoz's novel *Son of the Gamblin' Man*.

Nadine Gordimer's short stories *Friday's Footprints*.

Miguel Angel Asturias's novel *The Eyes of the Interred*.

Plexus, Henry Miller's novel.

Morley Callaghan's novel *The Many-Colored Coat*.

Night, Elie Wiesel's novel.

Portrait of Max, S. N. Behrman's biography of Max Beerbohm.

Raja Rao's novel *The Serpent and the Rope*.

The General, Alan Sillitoe's novel.

The Trial Begins, Andrey Sinyavsky's novel.

Love and Death in the American Novel, Leslie A. Fiedler's critical study of male oriented novels.

Charles Olson's poetry *The Distances*.

New edition of Chrétien de Troyes's *Conte du graal*.

d. Boris Pasternak, Russian poet and novelist (b. 1980), the author of *Doctor Zhivago* (1955).

d. Richard Wright, African-American writer (b. 1908).

d. Nevil Shute (Nevil Shute Norway), British novelist (b. 1899).

d. J. P. (John Philips) Marquand, American writer (b. 1893).

d. Zora Neale Hurston, African-American writer and folklorist (b. 1901).

d. Franklin P. Adams, columnist, radio performer, and humorist (b. 1881).

FILM & BROADCASTING

Elmer Gantry, Burt Lancaster as the Bible-thumping evangelical faker, Jean Simmons, and Shirley Jones starred in the film directed and scripted by Richard Brooks, based on the 1927 Sinclair Lewis novel.

The Virgin Spring, Max von Sydow, Birgitta Pettersson, Birgitta Valberg, and Gunnel Lindblom starred in the Ingmar Bergman classic, set in medieval Sweden.

Tunes of Glory, Alec Guinness and John Mills as conflicting peacetime Scottish regimental officers starred in the Ronald Neame film.

The Entertainer, the Tony Richardson film, based on the 1957 John Osborne play also directed by Richardson; Laurence Olivier and Joan Plowright starred in both.

Butterfield 8, the Daniel Mann film, based on the 1935 John O'Hara novel; Elizabeth Taylor, Laurence Harvey, Mildred Dunnock, and Eddie Fisher starred.

Saturday Night and Sunday Morning, Albert Finney as the "angry young man," Rachel Roberts, and Shirley Anne Field starred in the Karel Reisz film, based on the 1958 Alan Sillitoe novel.

La Dolce Vita (*The Sweet Life*), Marcello Mastroianni starred in the Federico Fellini film, about decadent high life among "beautiful people" in contemporary Italy.

Sons and Lovers, Dean Stockwell, Trevor Howard, and Wendy Hiller starred in Jack Cardiff's story of an upwardly mobile miner's son; based on the autobiographical 1913 D. H. Lawrence novel.

Diary of Anne Frank, the George Stevens film, based on her diary, first published in 1947; Millie Perkins, Joseph Schildkraut, and Shelley Winters starred.

Spencer Tracy, Fredric March, and Gene Kelly starred in *Inherit the Wind*, directed by Stanley Kramer.

Jack Lemmon, Shirley MacLaine, and Fred MacMurray starred in *The Apartment*, directed and cowritten by Billy Wilder; basis of the 1968 Neil Simon stage musical *Promises, Promises*.

Melina Mercouri starred in *Never on Sunday*, directed by Jules Dassin.

Psycho, Anthony Perkins as the psychotic killer and Janet Leigh starred in Alfred Hitchcock's murder thriller.

Rocco and His Brothers, Alain Delon as Rocco, Katina Paxinou, Renato Salvatori, Claudia Cardinale,

and Annie Girardot starred in Luchino Visconti's film about five very poor brothers, set largely in Milan.

Sanctuary, Lee Remick and Yves Montand starred in Tony Richardson's screen version of the 1931 William Faulkner novel, a bitter lynching story that resonated strongly with the civil-rights movement events then emerging in the American South.

Kirk Douglas, Laurence Olivier, and Jean Simmons starred in *Spartacus*, directed by Stanley Kubrick.

Sunrise at Campobello, Ralph Bellamy as polio-ridden young Franklin D. Roosevelt and Greer Garson as Eleanor Roosevelt starred in Vincent J. Donehue's film, adapted by Dore Schary from his own play.

François Truffaut directed *Shoot the Piano Player*.

Fred MacMurray starred on television in *My Three Sons* (1960–1972).

Academy Awards for 1960 (awarded the following year): Best Picture: *The Apartment*; Best Director: Billy Wilder, *The Apartment*; Best Actor: Burt Lancaster, *Elmer Gantry*; Best Actress: Elizabeth Taylor, *Butterfield 8*.

d. Clark Gable (William Clark Gable), American actor (b. 1901); in 1939, he was Rhett Butler in *Gone with the Wind*.

d. Walt (Walter Elias) Disney, American film animator (b. 1901).

d. Mack Sennett (Michael Sinnott), early American comedy director and producer (b. 1880), creator of the Keystone Cops.

d. Margaret Sullavan (Margaret Brooke), American actress (b. 1911).

d. Frank Lloyd, British-American director (b. 1888).

d. Victor Sjostrom, Swedish director and actor (b. 1879).

VISUAL ARTS

Marc Chagall's stained-glass work *The Twelve Tribes of Israel*, at the Hadassah-Hebrew University Medical Center, Jerusalem (1960–1961).

Andrew Wyeth's paintings included *That Gentleman*, *The Finn*, and *Young Bull*.

Georgia O'Keeffe's paintings included *White Patio with Red Door*, *Blue, Black and Grey*, *It Was Blue and Green*, and *It Was Yellow and Pink III*.

Pablo Picasso's painting *Reclining Nude on a Blue Divan*.

Edward Hopper's painting *Second-Story Sunlight*.

Henry Moore's sculpture *Two-Piece Reclining Figure No. 2*.

Alberto Giacometti's sculptures included *Monumental Head*, *Tall Figures*, and *Walking Man I*.

Ludwig Mies van der Rohe designed the Colonnades Apartments, Newark, New Jersey.

Ansel Adams's book *This Is the American Earth*; text by Nancy Newhall.

Door to the River, Willem de Kooning's painting.

Frank Stella's painting *Marquis de Portago*.

Walter Gropius designed the American Embassy, Athens.

David Smith began his *Zig* sculpture series.

Gateway Center, Pittsburgh, designed by Harrison and Abramovitz.

House of Lords, Al Held's painting.

Jasper Johns's sculpture *Painted Bronzes*.

Philip Evergood's painting *Virginia in the Grotto*.

Saul Steinberg's cartoon collection *The Labyrinth*.

Louis Kahn designed the Richards Medical Center, University of Pennsylvania.

Louise Nevelson's sculpture *Sky Cathedral*.

Mark di Suvero's sculpture *Hankchampion*.

Robert Indiana's painting *Moon*.

Union Carbide Building, New York City, designed by Skidmore, Owings, and Merrill.

d. James Montgomery Flagg, American cartoonist and illustrator (b. 1877).

THEATER & VARIETY

A Man for All Seasons, Paul Scofield starred as Thomas More in the Robert Bolt play about the ultimately fatal dispute between Thomas More and Henry VIII; Fred Zinnemann directed the 1966 film version.

The Caretaker, Harold Pinter's play, a landmark in the development of the "theater of the absurd"; Clive Donner directed the 1964 film version.

Becket, Jean Anouilh's play, starred Laurence Olivier and Anthony Quinn.

The Fantasticks, musical with book and lyrics by Tom Jones and music by Harvey Schmidt, began its record-breaking run at the Sullivan Street Playhouse May 3, with songs such as *Try to Remember* and *Soon It's Gonna Rain*; Kenneth Nelson, Rita Gardner, and Jerry Ohrbach starred.

The Repertory Theatre of Lincoln Center was

founded, as part of the Lincoln Center for the Performing Arts.

The Best Man, Melvyn Douglas, Lee Tracy, and Frank Lovejoy starred in Gore Vidal's McCarthy-period play, attacking the witch-hunting political tactics of the day; opened at the Morosco Theatre, New York, March 31.

All the Way Home, Tad Mosel's play, based on James Agee's 1957 novel, *A Death in the Family*, starred Pat Hingle and Colleen Dewhurst.

Richard Burton, Julie Andrews, and Robert Goulet starred in *Camelot*; the Alan Jay Lerner–Frederick Loewe musical, set in Arthurian England; opened at the Majestic Theatre, New York, December 3.

Period of Adjustment, the Tennessee Williams play, starred James Daly, Barbara Baxley, and Robert Webber.

Toys in the Attic, Maureen Stapleton, Anne Revere, and Jason Robards starred in the Lillian Hellman play; opened at the Hudson Theatre, New York.

The Zoo Story, Edward Albee's play, opened at the Provincetown Playhouse, New York, January 14; his *The Death of Bessie Smith* opened in Berlin, and he also wrote *The Ballad of Sad Café*, based on the 1951 Carson McCullers story.

The Hostage, Brendan Behan's play, starred Alfred Lynch.

Tammy Grimes starred in the title role of Meredith Willson's *The Unsinkable Molly Brown*.

Samuel Beckett's play *Krapp's Last Tape and Other Dramatic Pieces*.

An Evening with Mike Nichols and Elaine May.

Bye Bye Birdie, Charles Strouse's rock musical, opened at the Martin Beck Theatre, New York.

Vivien Leigh and Mary Ure starred in Jean Giraudoux's *Duel of Angels*.

Krapp's Last Tape, Samuel Beckett's play, starred Donald Davis.

Laurence Olivier starred in Eugène Ionesco's *Rhinoceros*.

Robert Redford, Julie Harris, and John Justin starred in James Costigan's *Little Moon of Alban*.

Micheál MacLiammóir presented *The Importance of Being Oscar*, his first one-man show, on Oscar Wilde.

Peggy Ashcroft starred in *The Duchess of Malfi*, at London's Aldwych Theatre.

The Screens, Jean Genet's play.

John Arden's play *The Happy Haven*.

James Ene Henshaw's play *A Man of Character*.

I'm Talking About Jerusalem, Arnold Wesker's play.

Marcel Achard's play *L'Idiote*.

François Billetdoux's play *A la nuit la nuit*.

Henri de Montherlant's play *Le Cardinal d'Espagne*.

d. Oscar Hammerstein II, American lyricist and librettist (b. 1895).

d. Lillah McCarthy, English actress (b. 1875).

d. Massimo Bontempelli, Italian playwright (b. 1878).

d. Maurice Schwartz, Jewish actor and director (b. 1889).

d. Per Hallström, Swedish playwright, poet, novelist, essayist (b. 1866).

MUSIC & DANCE

Revelations, Alvin Ailey's ballet on African-American themes; it became the signature piece of his ballet company.

Liebeslieder Walzer, George Balanchine's ballet, to music by Johannes Brahms, first danced November 22, by the New York City Ballet.

Ray Charles had a number-one hit with the 1930 song *Georgia on My Mind*.

A Midsummer Night's Dream, Benjamin Britten's opera, libretto by Britten and Peter Pears, based on the Shakespeare play, opened June 11 at the Aldeburgh Festival; Britten also introduced the opera *The Prodigal Son*.

The Twist, Chubby Checker's hit song, which started a dance craze; words and music by Hank Ballard.

The Invitation, Kenneth MacMillan's ballet, music by Matyas Seiber, first danced by the Royal Ballet.

Diana Ross, Florence Ballard, and Mary Wilson formed the Supremes.

The Prince of Homburg (*Prinz von Homburg*), Hans Werner Henze's opera, libretto by Ingeborg Bachmann, based on Heinrich von Kleist's 1821 play, premiered at the Hamburg State Opera, May 22.

John Coltrane's albums *Coltrane Plays the Blues* and *My Favorite Things*.

Krzysztof Penderecki's orchestral work *Threnody to the Victims of Hiroshima* and *Anaklasis* for strings and percussion.

Alberto Ginastera's *Cantata para América mágica* for soprano and percussion.

Luigi Nono's vocal works *Ha venido* and *Sarà dolce tacere*; and his tape work *Omaggio a Emilio Vedova*.

Walter Piston's Pulitzer Prize–winning *Seventh Symphony*.

Edith Piaf's hit song *Milord*.

William Walton's *Second Symphony*.

Jim Reeves's country hit *He'll Have to Go*.

Music for Words Perhaps, Michael Tippett's vocal work.

Ludus de nato infante mirificus, Carl Orff's dramatic musical work.

Time Out, Dave Brubeck's album.

The Long Christmas, Paul Hindemith's opera.

Antigone, John Cranko's ballet.

O magnum mysterium, Peter Maxwell Davies's choral work.

Aaron Copland's *Nonet for Strings*.

Men of Blackmoor, Alan Bush's opera.

The Prayer to the Mountains, Osamu Shimizu's choral work.

Komei Abe's second symphony.

Missa pro defunctis, Virgil Thomson's choral work.

Iannis Xenakis's *Harp Concerto*.

Circles, Luciano Berio's vocal work.

Chronochromie, Olivier Messiaen's orchestral work.

Harrison Birtwistle's *Précis*, for piano.

Alcestis, Vivian Fine's ballet.

Cartridge Music, John Cage's electronic work.

Salzburg opened a second Festspielhaus for its Mozart festivals.

Carleen Hutchins, for the Catgut Society, began redesigning the violin family (from ca. 1960).

Composer Mihael Colgrass developed the *rototom*, a tunable drum (1960s).

d. Jussi Bjoerling (Johan Jonatan Bjoerling), Swedish tenor (b. 1911).

d. Lawrence Tibbett, American baritone (b. 1896).

d. Leonard Warren, American baritone (b. 1911).

WORLD EVENTS

John Fitzgerald Kennedy defeated Republican Richard M. Nixon, becoming the 35th president of the United States and the first Roman Catholic president (1961–1963).

U-2 incident, CIA reconnaissance plane piloted by Francis Gary Powers was shot down over the Soviet Union (May 1); Powers was imprisoned as a spy.

Sharpeville Massacre: On March 21, South African police fired on unarmed demonstrators at Sharpeville, killing 67, helping to push the African National Congress into armed insurgency.

Increasingly isolated because of its racist policies, South Africa withdrew from the British Commonwealth.

Congo (Zaire) Civil War (1960–1967): With Congolese independence came civil war; Moïse Tshombe, supported by Belgian troops and industrialists, announced the secession of Katanga; President Joseph Kasavubu asked for a United Nations peacekeeping force, which came and stayed until 1964.

France developed its own atomic bomb.

French settlers' revolt in Algeria was ended by French army action.

Sirimavo Bandaranaike of Ceylon (Sri Lanka) became the world's first woman prime minister.

Jomo Kenyatta, still imprisoned, became head of the Kenya African National Union (KANU).

Kong Le military coup in Laos triggered full-scale civil war between the government and the Pathet Lao.

Mohammed Ayub Khan took power in Pakistan.

Nazi war criminal Adolf Eichmann was found in Argentina by Nazi hunter Simon Wiesenthal.

Quebec separatist movement began, led by Quebec Premier Jean Lesage.

Helge Ingstad and George Decker discovered L'Anse aux Meadows, an 11th-century Viking settlement in northern Newfoundland.

British ethologist Jane Goodall began her work with chimpanzees at the Gombe Stream Game Reserve in Tanzania (then Tanganyika).

William Shirer's *The Rise and Fall of the Third Reich*.

Charles Snow's *Two Cultures and the Scientific Revolution*.

1961

LITERATURE

Babi Yar, Yevgeny Yevtushenko's landmark poem, about the German World War II massacres of Soviet Jews at Babi Yar, near Kiev; until his poem the Soviet government had not even bothered to mark the place.

Ivo Andric was awarded the Nobel Prize for Literature.

The Prime of Miss Jean Brodie, Muriel Spark's novel about a dedicated, idiosyncratic Edinburgh

teacher; basis of the 1966 Jay Presson Allen play and the 1969 Ronald Neame film.

Resistance, Rebellion, and Death, Albert Camus's essays, many from the World War II years of the French Resistance to German invaders.

Sanctuary, William Faulkner's novel.

Nobody Knows My Name, James Baldwin's essays.

Catch-22, Joseph Heller's anti–U.S. Army satirical novel, set during World War II, its title so apt as to become part of American English; basis of the 1970 Mike Nichols film.

Call for the Dead, John le Carré's spy novel, introducing George Smiley.

Stranger in a Strange Land, Robert Heinlein's science fiction novel.

J. D. Salinger's *Franny and Zooey*.

Isaac Bashevis Singer's short stories *The Spinoza of Market Street*.

A House for Mr. Biswas, V. S. Naipaul's novel.

Bernard Malamud's novel *A New Life* and short stories *Idiot's First*.

Gabriel García Márquez's *No One Writes to the Colonel and Other Stories*.

Allen Ginsberg's *Kaddish and Other Poems*.

The Agony and the Ecstasy, Irving Stone fictionalized biography of Michelangelo; basis of the 1965 Carol Reed film.

Denise Levertov's poems *The Jacob's Ladder*.

The Moviegoer, Walker Percy's National Book Award–winning first novel.

Shirley Ann Grau's novel *The House on Coliseum Street*.

The Winter of Our Discontent, John Steinbeck's novel.

A Severed Head, Iris Murdoch's novel; basis of the 1963 play.

The Man-Eater of Malgudi, Rasipuram Narayan's novel.

Andrey Sinyavsky's *The Icicle and Other Stories*.

Edmund Wilson's autobiographical work *Upstate*.

Cyprian Ekwensi's novel *Jagua Nana*.

The Edge of Sadness, Edwin O'Connor's Pulitzer Prize–winning novel.

The Old Men at the Zoo, Angus Wilson's novel.

Dawn, Elie Wiesel's novel.

Faces in the Water, Janet Frame's novel.

Hortense Calisher's novel *False Entry*.

Flight into Camden, David Story's novel.

Mila 18, Leon Uris's novel.

Fairy Tales of New York, James Donleavy's novel.

Wilderness, Robert Penn Warren's novel.

Cat and Mouse, Günter Grass's novel.

Morley Callaghan's novel *A Passion in Rome*.

James Thurber's *Lanterns and Lances*.

Leavetaking, Peter Weiss's novel.

S. J. Perelman's *The Rising Gorge*.

Mark Van Doren's essays *The Happy Critic*.

Richard Wright's short stories *Eight Men*.

Samuel Beckett's essays in *How It Is*.

Unconditional Surrender, Evelyn Waugh's novel.

The Soft Machine, William Burroughs's novel.

Through the Fields of Clover, Peter De Vries's novel.

Vasily Aksyonov's novel *A Ticket to the Stars*.

d. Ernest (Miller) Hemingway, American writer (b. 1899), a world figure from his "lost generation" novels of the 1920s to his novels of the 1950s; he committed suicide.

d. (Samuel) Dashiell Hammett, U.S. writer (b. 1894).

d. James Thurber, American writer and artist, a leading humorist and satirist (b. 1894).

d. Henry Seidel Canby, American writer (b. 1878).

d. Hilda Doolittle (H.D.), American poet (b. 1886).

d. Louis-Ferdinand Céline (Louis-Ferdinand Destouches), French novelist (b. 1894).

FILM & BROADCASTING

Judgment at Nuremberg, Spencer Tracy, Burt Lancaster, Maximilian Schell, Richard Widmark, Marlene Dietrich, Judy Garland, and Montgomery Clift starred in the Stanley Kramer postwar Nazi Nuremberg Trials film; adapted by Abby Mann from his television play.

A Raisin in the Sun, Sidney Poitier, Claudia McNeil, Ruby Dee, and Diana Sands starred in Daniel Petrie's screen version of the 1959 Lorraine Hansberry play, a tale of Chicago black urban ghetto life.

West Side Story, Natalie Wood, Russ Tamblyn, Rita Moreno, Richard Beymer, and George Chakiris starred in the Jerome Robbins–Robert Wise screen version of Leonard Bernstein's stage musical.

A Taste of Honey, Rita Tushingham starred as the pregnant single mother-to-be of a child fathered by a black sailor, who is helped by her homosexual friend, the film quite notable for these trailblazing qualities in its time.

Fanny, Leslie Caron, Maurice Chevalier, and Charles

Boyer starred in the Joshua Logan film, based on the 1954 stage musical and Marcel Pagnol's *Marius* stories.

The Misfits, Clark Gable, Marilyn Monroe, and Montgomery Clift starred in John Huston's modern Western, about wild-horse hunters, scripted by Arthur Miller from his own story; Gable and Monroe's last film.

Summer and Smoke, Geraldine Page as Alma and Laurence Harvey starred in Peter Glenville's screen version of the 1948 Tennessee Williams play.

Jules and Jim, Jeanne Moreau, Oskar Werner, and Henri Serre starred in François Truffaut's "new wave" film about a ménage à trois that ends in tragedy.

Alain Resnais directed *Last Year at Marienbad*, starring Delphine Seyrig.

Birdman of Alcatraz, Burt Lancaster starred as imprisoned murderer–ornithologist Robert Stroud in the John Frankenheimer film, based on the Thomas E. Gaddis book.

Breakfast at Tiffany's, Audrey Hepburn and George Peppard starred in the Blake Edwards film, based on the 1958 Truman Capote novella.

Accatone!, Pier Paolo Pasolini's film, his first.

Charlton Heston and Sophia Loren starred in *El Cid*, directed by Anthony Mann.

Marcello Mastroianni and Daniela Rocca starred in *Divorce—Italian Style*, directed by Pietro Germi.

Luis Buñuel directed *Viridiana*.

Marlon Brando and Karl Malden starred in *One-Eyed Jacks*, directed by Brando.

Sophia Loren, Raf Vallone, and Jean-Paul Belmondo starred in *Two Women*, directed by Vittorio De Sica.

Shirley Booth starred in the television series *Hazel* (1961–1965).

The Defenders, E. G. Marshall and Robert Reed starred in the television courtroom drama series (1961–1965).

The Dick Van Dyke Show starred Van Dyke and Mary Tyler Moore (1961–1966).

Academy Awards for 1961 (awarded the following year): Best Picture: *West Side Story*; Best Director: Jerome Robbins, Robert Wise, *West Side Story*; Best Actor: Maximilian Schell, *Judgment at Nuremberg*; Best Actress: Sophia Loren, *Two Women*.

d. Gary Cooper (Frank James Cooper), American actor (b. 1901).

d. Chico Marx (Leonard Marx), American actor and comedian (b. 1886).

VISUAL ARTS

Andrew Wyeth's paintings included *Distant Thunder*, *Tenant Farmer*, *Grain Bag*, *Milk Cans*, and *Above Archie's*.

Pablo Picasso's painting *Reclining Nude in an Interior*.

Henry Moore's sculpture *Standing Figure: Knife Edge*.

The Street, Claes Oldenburg's sculpture.

Frank Stella began his *Benjamin Moore* series of paintings.

Perspective of Nudes, Bill Brandt's photography collection.

Joan Miró's painting *Blue II*.

Mark Rothko's mural for the Harvard University Holyoke Center (1961–1963).

Robert Indiana's painting *Eat/Die, The American Dream I*.

Mies van der Rohe designed the Bacardi Building, Mexico City.

Marcel Breuer's work included the IBM Research Centre at La Gaude, France, and St. John's Abbey at Benedictine College, Collegeville, Minnesota.

Pier Luigi Nervi's work included the Palace of Labor, Turin, Italy; and the George Washington Bridge Bus Terminal, New York (1961–1962).

The Art of Assemblage, exhibition at Museum of Modern Art, New York.

Box with the Sound of Its Own Making, Robert Morris's sculpture.

Close-up III, Philip Guston's painting.

Roy Lichtenstein's comic-strip and comic-frame paintings (1961–1965).

Device, Jasper Johns's painting (1961–1962).

Alberto Giacometti's painting *Caroline*.

Louis I. Kahn designed the Alfred Newton Richards Medical Research Building, University of Pennsylvania.

Leonard Baskin's *Seater Birdman*.

Skinny's 21, Billy Al Bengston's painting.

Colossal Man, Leon Golub's painting.

Yousuf Karsh's photo collection *This Is the Holy Land*.

d. Eero Saarinen, Finnish-American architect (b. 1910), the son and partner of architect Eliel Saarinen; among his last works were the Dulles International Airport Terminal Building, Chantilly, Virginia; and Ezra Stiles and Morse College,

Yale University, New Haven, Connecticut.

d. Max Weber, American artist, an early cubist and fauvist (b. 1881).

d. Anna Mary Robertson Moses ("Grandma Moses"), American primitive painter (b. 1860).

d. Augustus John, British painter (b. 1876).

d. Vanessa Bell (Vanessa Stephen) British artist and with her husband Clive Bell a member of the Bloomsbury group (b. 1879); the sister of Virginia Stephen Woolf.

THEATER & VARIETY

Britain's Royal Shakespeare Company was founded; its first managing director was Peter Hall (1961–1968).

The American Dream, the Edward Albee play, opened at the York Playhouse, New York, January 24, on a double bill with his *The Death of Bessie Smith*.

Purlie Victorious, Ossie Davis starred as Purlie Victorious Judson in his own play, a satire set in modern Georgia, with Ruby Dee, Godfrey Cambridge, Sorrell Brooke, and Alan Alda; opened at the Cort Theatre, New York, September 28.

Robert Morse starred in *How to Succeed in Business Without Really Trying*; Frank Loesser's musical opened at the 46th Street Theatre, New York.

Come Blow Your Horn, Neil Simon's play, starred Hal March; opened at the Brooks Atkinson Theatre, New York, February 22.

Blood Knot, the first play in Athol Fugard's Port Elizabeth trilogy.

Ellen Stewart founded Café La Mama in New York.

Behind the Green Curtains, Sean O'Casey's play.

Gideon, Paddy Chayefsky's play, starred Fredric March and George Segal; opened at the Plymouth Theatre, New York, November 9.

Zero Mostel starred in the Broadway version of Eugène Ionesco's *Rhinoceros*.

Julie Harris, William Shatner, and Walter Matthau starred in Harry Kurnitz's *A Shot in the Dark*; adapted from Marcel Achard's *L'Idiote*.

Margaret Leighton, Alan Webb, and Patrick O'Neill starred in Tennessee Williams's *The Night of the Iguana*.

Barbara Bel Geddes and Barry Nelson starred in *Mary, Mary*; Jean Kerr's play opened at the Helen Hayes Theatre, March 8.

Stop the World—I Want to Get Off, Anthony Newley directed and starred in the Newley–Leslie Bricusse musical.

Take Her, She's Mine, Phoebe and Henry Ephron's play, opened at the Biltmore Theatre, New York.

The Blacks, Jean Genet's play, starred James Earl Jones.

Michael Redgrave and Googie Withers starred in Graham Greene's *The Complaisant Lover*.

Happy Days, Samuel Beckett's play.

Max Rudolf Frisch's *Andorra*.

Luther, John Osborne's play.

The Kitchen, Arnold Wesker's play.

Hans Henny Jahnn's *The Dusty Rainbow*.

John Pepper Clark's play *Song of a Goat*.

Marcel Dubé's play *Florence*.

d. Guthrie McClintic, American actor, director, and producer (b. 1893), often of plays starring his wife, Katharine Cornell.

d. Moss Hart, American playwright and director (b. 1904).

d. George S(imon) Kaufman, American playwright (b. 1889).

d. Barry Fitzgerald (William Joseph Shields), Irish actor (b. 1888).

d. Charles Douville Coburn, American actor and manager (b. 1877).

d. Alexei Dmitrevich Popov, Soviet director (b. 1892).

d. Kjeld Abell, Danish playwright and artist (b. 1901).

MUSIC & DANCE

Rudolf Nureyev, while performing in Paris in the Kirov Ballet's *Sleeping Beauty*, took political asylum in the West.

Elegy for Young Lovers, Hans Werner Henze's opera, libretto by W. H. Auden and Chester Kallman, opened at the Schwetzingen Festival on May 20.

Peter Yarrow, Paul Stookey, and Mary Travers formed the folksinging group Peter, Paul and Mary.

The Greek Passion, Bohuslav Martinu's opera based on Nikos Kazantzakis's novel *Christ Re-Crucified*, opened June 9 in Zurich.

The Two Pigeons, Frederick Ashton's ballet, music by André Messager, first danced February 14, by the Royal Ballet, London.

Luciano Pavarotti made his debut as Rodolfo in *La Bohème*, in Reggio Emilia, a role he repeated at his 1963 London debut.

The new Deutsche Oper (established 1912), rebuilt after war destruction (1942), opened in West Berlin with a production of Wolfgang Amadeus Mozart's *Don Giovanni*.

Moon River, song from the film *Breakfast at Tiffany's*, music by Henry Mancini, words by Johnny Mercer.

Patsy Cline's hits *I Fall to Pieces*, words by Hank Cochran, music by Harlan Howard; and *Crazy*, words and music by Willie Nelson.

Krzysztof Penderecki's orchestral works *Fluorescences*, *Fonogrammi*, and *Polymorphia*.

Michael Tippett's *Songs for Achilles* and choral work *Magnificat and nunc dimittis*.

Francis Poulenc's vocal work *La Dame de Monte Carlo* and choral work *Sept répons des ténèbres*.

Milton Babbitt's tape works *Composition for Synthesizer* and *Vision and Prayer*, with voice.

A Sermon, a Narrative and a Prayer, Igor Stravinsky's vocal work.

Il calzare d'argento, Ildebrando Pizzetti's opera.

Judy Collins's first album, *A Maid of Constant Sorrow*.

Something Wild, Aaron Copland's film score.

Surfin', the Beach Boys' first record.

Benjamin Britten's *War Requiem* and *Cello Sonata*.

Zoltán Kodály's *Symphony in C*.

Atlas eclipticalis, John Cage's orchestral work.

Epifanie, Luciano Berio's vocal work.

Intolleranza 1960, Luigi Nono's dramatic musical work.

Nocturnal, Edgard Varèse's vocal/orchestral work.

Elliott Carter's *Double Concerto* for harpsichord and piano.

d. Percy Grainger, Australian-American composer, pianist, and musicologist (b. 1882), best known for his collections and arrangements of folk songs.

d. Pastora Imperio (born Pastora Rojas), Spanish dancer and choreographer (ca. 1885/1894–1961), called La Emperaora; a key figure in 20th-century Andalusian dancing.

d. Thomas Beecham, English conductor (b. 1879).

d. Uuno Klami, Finnish composer (b. 1900).

d. Wallingford Riegger, American composer (b. 1885).

WORLD EVENTS

American direct military involvement in Vietnam began.

East German government erected the Berlin Wall overnight (August 12), closing the East German–West Berlin border.

CIA-organized Cuban exile force (1,200–1,500) landed at Cuba's Bay of Pigs, without air cover. No general Cuban insurrection occurred, and the invasion force was quickly defeated.

African-American James Howard Meredith won his fight to be admitted into the University of Mississippi, with a U.S. Supreme Court decision in his favor; President John F. Kennedy had to use federalized state national guard troops to end rioting which killed two people.

Nonviolent interracial Freedom Rides began, to integrate public facilities in the American South (May); they were often met by racist violence.

Following the Sharpeville massacre of 1960, the African National Congress (ANC) went over to guerrilla warfare and was outlawed.

Soviet astronaut Yuri Gagarin piloted *Vostok I* once around the earth, on April 12, in the first human space flight.

Alan Shepard piloted American Mercury spacecraft *Freedom 7* (May 5).

Algerian French terrorist Secret Army Organization (OAS), led by general Raoul Salan, began terrorist attacks in Algeria and France.

Congolese leader Patrice Lumumba set up a Soviet-backed government in Stanleyville, was captured, and was murdered while in a Katanga prison.

Burmese diplomat U Thant became third secretary-general of the United Nations.

America's Peace Corps was established.

Thalidomide, exposed as causing birth defects, withdrawn from sale; massive lawsuits followed.

Amnesty International was founded in London.

Angolan War of Independence began (1961–1974).

Dominican Republic dictator Rafael Leonidas Trujillo Molina was assassinated by a group of army officers, after 31 years in power.

Kuwait became an independent nation (June 19).

South Korean General Park Chung Hee took power in a military coup.

Franz Fanon's *The Wretched of the Earth*.

Michel Foucault's *Madness and Civilization*.

d. Dag Hammarskjöld, United Nations secretary-general (b. 1905), in an airplane crash while traveling to Congo peace negotiations.

1962

LITERATURE

One Day in the Life of Ivan Denisovich, Alexander Solzhenitzyn's landmark novel, an exposé of the Soviet prison system.

John Steinbeck was awarded the Nobel Prize for Literature; he also published *Travels with Charley in Search of America*.

One Flew Over the Cuckoo's Nest, Ken Kesey's novel, a revealing look at life inside an insane asylum; basis of the 1963 Dale Wasserman play and 1975 Milos Forman film.

Down There on a Visit, Christopher Isherwood's novel.

Another Country, James Baldwin's novel.

The Subterraneans and *Big Sur*, Jack Kerouac's novels.

The Thin Red Line, James Jones's novel; basis of the 1964 Andrew Marton film.

Gabriel García Márquez's novel *The Bad Hour* and his short-story collection *Grand Mama's Funeral*.

The Woman in the Dunes, highly allegorical Kobo Abe novel; he also adapted it into the 1964 Hiroshi Teshigahara film.

Doris Lessing published her novel *The Golden Notebook*, hailed by many as a feminist classic, though she disclaimed that intention.

The Rievers, William Faulkner's Pulitzer Prize–winning novel.

A Clockwork Orange, Anthony Burgess's satirical novel about violence in a near-future society; basis of the 1971 film.

Ship of Fools, Katherine Anne Porter's novel, about a German ship returning to newly Nazi Germany; basis of the 1965 Stanley Kramer film.

Ian Fleming's James Bond novels *Doctor No* and *From Russia with Love*.

Anne Sexton's poetry *All My Pretty Ones*.

Sylvia Plath's poetry *The Colossus*.

Anna Akhmatova's *Poem Without a Hero*.

The Bull from the Sea, Mary Renault's novel.

John Knowles's novel *Morning in Antibes*.

The Death of Artemio Cruz, Carlos Fuentes's novel.

Alejo Carpentier's novel *Explosion in a Cathedral*.

We Have Always Lived in the Castle, Shirley Jackson's novel.

Joseph Brodsky's *A Christmas Ballad*.

Cyprian Ekwensi's novel *Burning Grass*.

James Dickey's poetry collection *Drowning with Others*.

E. B. White's essays *The Points of My Compass*.

Marshall McLuhan's *The Gutenberg Galaxy*.

The Edge of the Alphabet, Janet Frame's novel.

Hortense Calisher's short stories *Tale for the Mirror*.

Edith Sitwell's novel *The Outcasts*.

King Rat, James Clavell's first novel.

Flesh, Brigid Brophy's novel.

Robert Bly's poetry *Silence in the Snowy Fields*.

Juan José Arreola's *Confabulario and Other Inventions*.

Letting Go, Philip Roth's novel.

Portrait in Brownstone, Louis Auchincloss's novel.

Robert Creeley's poetry *For Love*.

The Accident, Elie Wiesel's novel.

Alex La Guma's novel *A Walk in the Night*.

The Diary of a Mad Old Man, Junichiro Tanizaki's novel.

Vicente Aleixandre's poetry *En un vasto dominio*.

Derek Walcott's poetry *In a Green Night*.

Vanishing Point, Peter Weiss's novel.

Youngblood Hawke, Herman Wouk's novel.

d. William Faulkner (William Harrison Falkner), American writer (b. 1897).

d. Hermann Hesse, German novelist, a major figure in world literature (b. 1877).

d. Robinson Jeffers, American playwright and poet (b. 1887).

d. e e cummings (Edward Estlin Cummings), American writer (b. 1894).

d. Isak Dinesen (Karen Christence Dinesen Blixen), Danish writer (b. 1885).

d. Ludwig Bemelmans, Austrian-born American writer (b. 1898).

d. Manuel Gálvez, Argentine novelist (b. 1882).

d. Richard Aldington, English poet, novelist, biographer, and translator (b. 1892).

FILM & BROADCASTING

To Kill a Mockingbird, Gregory Peck starred as Southern small-town lawyer Atticus Finch, who successfully defends Brock Peters as Tom Robinson, the African-American falsely accused of rape; with Robert Duvall, Mary Badham, and Philip Alford; based on the 1960 Harper Lee novel.

Lawrence of Arabia, Peter O'Toole as Lawrence, Alec Guinness as Feisal, Omar Sharif, and Anthony Quinn starred in David Lean's epic biofilm, based

on T. E. Lawrence's autobiographical account of his role in the World War I Arab Revolt, in *Seven Pillars of Wisdom* (1926).

Through a Glass, Darkly, Harriet Andersson, Gunnar Björnstrand, Max von Sydow, and Lars Passgard starred in Ingmar Bergman's classic study of a schizophrenic and those around her.

The Playboy of the Western World, Siobhan McKenna and Gary Raymond starred in Brian Desmond Hurst's screen version of John Millington Synge's classic Irish play.

The Miracle Worker, Anne Bancroft and Patty Duke recreated their 1959 stage roles in the Helen Keller story; Arthur Penn again directed.

Days of Wine and Roses, Jack Lemmon and Lee Remick starred as alcoholics in the Blake Edwards film.

Sean Connery and Ursula Andress starred in *Dr. No*, the first James Bond film; Terence Young directed.

The Music Man, Robert Preston as the confidence man and Shirley Jones starred in Morton Da Costa's screen version of the 1957 Meredith Willson musical.

The Loneliness of the Long Distance Runner, Tom Courtenay, Michael Redgrave, and Alec McCowen starred in the Tony Richardson film, a story of youthful alienation set in a Borstal (reformatory).

Long Day's Journey into Night, Ralph Richardson, Katharine Hepburn, Jason Robards, Jr., and Dean Stockwell starred in Sidney Lumet's film version of the autobiographical Eugene O'Neill play.

These Three, William Wyler's remake of his own classic 1936 film, based on the Lillian Hellman play *The Children's Hour*; Audrey Hepburn, Shirley MacLaine, and James Garner starred.

Advise and Consent, the Otto Preminger film based on the Allen Drury novel about mudslinging and cabinet nomination intrigues; Henry Fonda, Walter Pidgeon, Charles Laughton, Don Murray, Franchot Tone, and Lew Ayres starred.

Billy Budd, the Peter Ustinov film, starring Terence Stamp in the title role, Robert Ryan, Melvyn Douglas, and Ustinov; based on a play from the 1891 Herman Melville novel.

Montgomery Clift starred in the title role of *Freud*, directed by John Huston.

Gypsy, Rosalind Russell and Natalie Wood starred in the Mervyn Leroy film, based on Gypsy Rose Lee's autobiography.

Lonely Are the Brave, Kirk Douglas starred as the alienated modern cowboy, with Walter Matthau and Gena Rowlands in the David Miller film.

Sweet Bird of Youth, Geraldine Page and Paul Newman starred in the Richard Brooks version of the 1959 Tennessee Williams play, as on stage.

Mutiny on the Bounty, Trevor Howard as Captain Bligh and Marlon Brando as Fletcher Christian starred in Lewis Milestone's film version of the 1932 Charles Nordhoff–Norman Hall fictionalized tale of real events.

Cape Fear, J. Lee Thompson's film of vengeance, starring Gregory Peck and Robert Mitchum, based on John D. MacDonald's novel *The Executioners*; remade in 1991.

Period of Adjustment, Jane Fonda, Tony Franciosa, Jim Hutton, and Lois Nettleton starred in George Roy Hill's screen version of the 1960 Tennessee Williams play.

The Longest Day, Robert Mitchum, John Wayne, Robert Ryan, Henry Fonda, and Richard Burton led a large multinational cast in a fictional recreation of the World War II Normandy invasion.

Lolita, Sue Lyon as Lolita, James Mason, and Shelley Winters starred in Stanley Kubrick's screen version of the 1955 Vladimir Nabokov novel.

Roman Polanski directed *Knife in the Water*.

Johnny Carson starred in NBC's *Tonight Show* (1962–1992).

Walter Cronkite became chief anchor of CBS's nightly news show (1962–1981).

Telstar was launched; the first communications satellite to relay television signals, the beginning of what would become Intelstat, a worldwide net.

Academy Awards for 1962 (awarded the following year): Best Picture: *Lawrence of Arabia*; Best Director: David Lean, *Lawrence of Arabia*; Best Actor: Gregory Peck, *To Kill a Mockingbird*; Best Actress: Anne Bancroft, *The Miracle Worker*.

d. Marilyn Monroe (Norma Jean Mortenson), American actress (b. 1926); she died of an overdose of barbiturates.

d. Charles Laughton, British-American actor (b. 1899).

d. Michael Curtiz (Mihaly Kertész), Hungarian director (b. 1888).

d. Frank Borzage, American director and actor (b. 1893).

VISUAL ARTS

Andrew Wyeth's paintings included *Chester County, Garret Room, Lime Banks,* and *Wood Stove.*

Georgia O'Keeffe's painting *Sky Above White Clouds I.*

Pablo Picasso's paintings included *Bust of a Woman, Still Life with Cat and Lobster,* and *The Rape of the Sabines.*

Alberto Giacometti's sculpture *Bust of Annette.*

Andy Warhol's *Baseball.*

Robert Indiana's paintings included *American Gas Works and Star.*

Sweet William, John Chamberlain's sculpture.

George Segal's sculptures *Bus Riders.*

Jim Dine's *Child's Blue Wall* and *The Toaster.*

Robert Indiana's *Love* and his pop poster.

Claes Oldenburg's sculptures, *Two Cheeseburgers with Everything* (*Dual Hamburgers*), and his painting *Giant Hamburger.*

Double Wall Piece, Sol Lewitt's relief.

Mark DiSuvero's sculpture *Blue Arch for Matisse.*

Edward Hopper, *New York Office.*

Vivian Beaumont Theater, Lincoln Center, New York, one of Eero Saarinen's last designs, completed.

Fine Arts Center, Howard University, Washington, D.C., designed by Le Corbusier.

Roy Lichtenstein's *Flatten . . . Sandfleas.*

Floor Burger and *The Store,* Claes Oldenburg's sculptures.

George Segal's *Dinner Table.*

Andy Warhol's *Green Coca-Cola Bottles* and *Marilyn Monroe's Lips.*

Henry Moore's sculpture *Knife-Edge Two-Piece.*

Isamu Noguchi's sculpture *Shrine of Aphrodite.*

Marisol's sculpture *The Family.*

Air Force Academy, Colorado Springs, Colorado, designed by Skidmore, Owings, and Merrill.

Max Abramovitz's works included Philharmonic Hall at the Lincoln Center for the Performing Arts and the Columbia University Law School and Library.

Pier Luigi Nervi designed Place Victoria, Montreal.

Times Square, Chryssa's sculpture.

Wallace Harrison designed New York's Metropolitan Opera House.

d. Antoine Pevsner, Russian sculptor (b. 1886), with his brother Naum Gabo, a founder of the constructivist movement.

d. Ding (Jay Norwood Darling), American cartoonist (b. 1876), long editorial cartoonist of the *New York Herald Tribune.*

d. Franz Kline, American painter (b. 1910), a leading abstract expressionist in the 1950s.

d. Ivan Mestrovic, Yugoslav sculptor (b. 1883).

THEATER & VARIETY

Who's Afraid of Virginia Woolf?, Uta Hagen and Arthur Hill starred as the warring couple in the Edward Albee play; opened at the Billy Rose Theatre, New York, October 13.

Zero Mostel starred in *A Funny Thing Happened on the Way to the Forum;* the Stephen Sondheim musical opened at the Alvin Theatre, May 8.

A Thousand Clowns, Jason Robards, Jr., and Sandy Dennis starred in the Herb Gardner play; opened at the Eugene O'Neill Theatre, New York.

The Deputy, Rolf Hochhuth's play, sharply criticizing Pope Pius XII of complicity through inaction in the Holocaust.

Beyond the Fringe, written and performed by Dudley Moore, Peter Cook, and Jonathan Miller.

Viveca Lindfors and George Voskovec starred in *Brecht on Brecht.*

Neil Simon's *Little Me* starred Sid Caesar and Virginia Martin.

Never Too Late, Paul Ford and Maureen O'Sullivan starred in the Sumner Arthur Long comedy; opened at the Playhouse, New York.

I Can Get It for You Wholesale, Harold Rome's play starred Elliott Gould and Barbra Streisand.

No Strings, Diahann Carroll and Richard Kiley starred in the Richard Rodgers musical; opened at the 54th Street Theatre, March 15.

Oh Dad, Poor Dad, Mamma's Hung You in the Closet and I'm Feelin' So Sad, Barbara Harris and Jo Van Fleet starred in Arthur Kopit's play; opened at the Phoenix Theatre, New York, February 26.

Paul Scofield directed and starred in *King Lear* at Britain's Royal Shakespeare Company.

Margaret Leighton and Anthony Quinn starred in Sidney Michaels's *Tchin-Tchin.*

Chips with Everything, Arnold Wesker's play.

James Saunders's play *Next Time I'll Sing to You.*

Edward Bond's *The Pope's Wedding.*

Jacques Rabémananjara's play *Feasts of the Gods.*

Hugh Leonard's *Stephen D.*

Jacques Audiberti's play *Fourmi dans le corps.*

John Pepper Clark's play *Song of a Goat*.

Jökull Jakobsson's *Hard Aport*.

d. Jean Forbes-Robertson, English actress (b. 1905), second daughter of Johnston Forbes-Robertson.

d. Halper Leivick, Jewish playwright (b. 1888).

d. Michel de Ghelderode, Belgian playwright (b. 1898).

d. Nikolai Fedorovich Pogodin, Soviet playwright (b. 1900).

MUSIC & DANCE

Where Have All the Flowers Gone, the Kingston Trio's hit version of the 1958 song.

Peter, Paul and Mary had hit singles with *Puff (the Magic Dragon)*, *Blowin' in the Wind*, and *If I Had a Hammer*, plus their album *Peter, Paul and Mary*.

Atlántida, Manuel de Falla's oratorio on a Catalan text by Jacinto Verdaguer, to which he had devoted the last years of his life (ca. 1929–1947); completed by Cristobal Halffter, it premiered in Milan.

A Midsummer Night's Dream, George Balanchine's ballet, to music by Felix Mendelssohn, first danced January 17 by the New York City Ballet.

Dmitri Shostakovich's *Babi Yar*, his *Thirteenth Symphony*, setting of five poems by Yevgeny Yevtushenko, including his 1962 *Babi Yar*.

Mick Jagger, Keith Richards, Bill Wyman, Charlie Watts, and Brian Jones organized the seminal British rock-and-roll band the Rolling Stones.

Rudolf Nureyev became permanent guest artist of the Royal Ballet, often partnered with Margot Fonteyn.

King Priam, Michael Tippett's opera, libretto by Tippett, opened at Coventry, England, May 29.

Michael Tippett's second sonata for piano, *Songs for Ariel*, and incidental music *The Tempest*.

Eddie Kendricks, Otis Williams, Paul Williams, Melvin Franklin, and Eldridge Bryant formed the Temptations.

The Tijuana Brass, led by Herb Alpert, invented the "Ameriachi" style, their first big hit being *Lonely Bull*.

Pierrot Lunaire, Glen Tetley's ballet, music by Arnold Schoenberg, first danced in New York May 5.

Iannis Xenakis's choral work *Polla ta dhina*; and orchestral works *ST/48* and *Stratégie*.

Tony Bennett's hit version of the 1954 song *I Left My Heart in San Francisco*.

The First Time Ever I Saw Your Face, Ewan MacColl's song, a 1972 hit for Roberta Flack.

Poème symphonique, 100 metronomes, György Ligeti's work for 100 metronomes.

Peter Maxwell Davies's orchestral works *In Nomine fantasia* and *Sinfonia*.

Phaedra, Martha Graham's ballet to music by Robert Starer.

Krzysztof Penderecki's choral work *Stabat mater* and *Kanon*, for strings and tape.

The Beatles' first hit single, *Love Me Do*.

Samuel Barber's Pulitzer Prize–winning *Piano Concerto*.

Benjamin Britten's *War Requiem*.

Tijuana Moods, Charles Mingus's album.

Odetta and the Blues album.

William Walton's *A Song for the Lord Mayor's Table*.

Duke Ellington and John Coltrane album.

The Flood, Igor Stravinsky's stage work.

Passaggio, Luciano Berio's dramatic musical work.

Canti di vita e d'amore, Luigi Nono's vocal work.

Sept haïkaï, Olivier Messiaen's orchestral work.

Pli selon pli, Pierre Boulez's vocal work.

Avery Fisher Hall (formerly Philharmonic Hall) opened at Lincoln Center for the Performing Arts, New York.

d. Bruno Walter (Bruno Walter Schlesinger), leading German conductor (b. 1876), a refugee from Nazism in the 1930s.

d. Fritz Kreisler, Austrian-American violinist (b. 1875).

d. Kirsten Flagstad, Norwegian soprano (b. 1895).

d. Alfred Cortot, French pianist, conductor, and teacher (b. 1877).

d. Jacques Ibert, French composer (b. 1890).

WORLD EVENTS

Nuclear war came very close during the Cuban Missile Crisis (October 22–November 2), as President John F. Kennedy prepared to go to war if Soviet missiles and bombers were not removed from Cuba. Ultimately, Kennedy and Nikita Khruschev negotiated unconditional Soviet withdrawal.

Silent Spring was Rachel Carson's influential work on the poisoning of the planet, which spurred development of the environmental movement.

South African freedom leader Nelson Mandela was

convicted of sabotage and imprisoned, then held (until 1990) under a life sentence.

Pope John XIII convened the historic Vatican II (Second Vatican Council; 1962–1965), to review the entire modern role of the Catholic church.

Chinese frontier troops mounted a successful border war against India, taking disputed Chinese–Indian border territory.

Republican revolt established the Free Yemen Republic, and began the Yemeni Civil War, pitting the Saudi Arabian–backed monarchy against the Egypt-backed republicans.

Algeria became an independent nation.

Burmese General Ne Win (Maung Shu Maung), who had relinquished power in 1960, again took control of Burma.

Eduardo Mondlane founded Frelimo, the Mozambique National Liberation Front.

Geneva peace agreement in July ended a phase of the Laotian Civil War; but war quickly resumed.

Julius Nyerere became president of Tanganyika (1962–1964).

Milton Obote became the first prime minister of the Republic of Uganda.

U-2 pilot Francis Gary Powers was swapped for Soviet spy Rudolph Abel.

American drug testing was tightened after the 1981 thalidomide disaster, by amendment of the Federal Food, Drug, and Cosmetic Act.

Virgil (Gus) Grissom, piloting America's Mercury spacecraft *Friendship 7*, became the first American to orbit around the earth (February 20).

Barbara Tuchman's *The Guns of August*.

Thomas Samuel Kuhn's *The Structure of Scientific Revolutions*.

d. Adolf Eichmann, Nazi SS war criminal (b. 1906); captured by Israeli agents in 1960 and tried and executed in Israel.

1963

LITERATURE

The Fire Next Time, James Baldwin's essays.

George Seferis was awarded the Nobel Prize for Literature.

William Carlos Williams's Pulitzer Prize–winning poetry *Pictures from Breughel*.

V, Thomas Pynchon's novel.

The Spy Who Came in from the Cold, John le Carré's Cold War spy novel; Martin Ritt directed the 1965 film version.

The Dog Years, third novel in Günter Grass's *Danzig* trilogy.

J. D. Salinger's *Raise High the Roof-Beam, Carpenters* and *Seymour: An Introduction*.

The Clown, Heinrich Böll's novel.

Sylvia Plath's autobiographical novel *The Bell Jar*.

The Group, Mary McCarthy's novel; Sidney Lumet directed the 1966 film version.

Planet of the Apes, Pierre Boulle's science fiction novel; basis of the 1968 Franklin J. Schaffner film.

The Silence of History, first of James Farrell's four *Eddie Ryan* novels.

Dorothy and Red, Vincent Sheean's biography of Dorothy Thompson and Sinclair Lewis.

Inside Mr. Enderby, first of Anthony Burgess's *Enderby* novels.

Kurt Vonnegut's novel *Cat's Cradle*.

A Singular Man, James Donleavy's novel.

The Centaur, John Updike's novel.

Joseph Brodsky's poems *Isaac and Abraham*.

Beauty and Sadness, Yasunari Kawabata's novel.

Ciro Alegría's *Duello de caballeros*.

The Golden Fruits, Nathalie Sarraute's novel.

Conrad Aiken's poetry *The Morning Song of Lord Zero*.

Scented Gardens for the Blind, Janet Frame's novel.

Cyprian Ekwensi's *Beautiful Feathers*.

Dwight Macdonald's essays *Against the American Grain*.

Mark Van Doren's *Collected and New Poems*.

Run River, Joan Didion's novel.

Miguel Angel Asturias's novel *Mulata*.

Yevgeny Yevtushenko's *A Precocious Autobiography*.

Anita Desai's novel *Cry, the Peacock*.

Wilfred Sheed's novel *The Hack*.

d. Aldous Leonard Huxley, British writer (b. 1894).

d. Robert Frost, American poet (b. 1874).

d. Jean Cocteau, French writer, filmmaker, and painter (b. 1889).

d. William Carlos Williams, American writer (b. 1883).

d. Sylvia Plath, American writer (b. 1932), a suicide.

d. Eduardo Barrios, Chilean novelist and dramatist (b. 1884).

d. Louis MacNiece, British poet (b. 1907).

d. Nazim Hikmet, Turkish writer (b. 1902).

d. Oliver La Farge, American ethnologist and author (b. 1901).

d. Theodore Roethke, American poet (b. 1908).

d. Van Wyck Brooks, American literary historian and critic (b. 1886).

d. W. E. B. Du Bois, Black American writer (b. 1868).

FILM & BROADCASTING

Tom Jones, Albert Finney as Tom Jones, Susannah York, Hugh Griffith, Edith Evans, Joyce Redman, and Joan Greenwood starred in Tony Richardson's full-of-life screen version of the 1749 Henry Fielding novel.

8½, the largely autobiographical Federico Fellini film; Marcello Mastroianni, Anouk Aimee, Claudia Cardinale, and Sandra Milo starred.

All the Way Home, Robert Preston and Jean Simmons starred in Alex Segal's film version of the 1960 Tad Mosel play.

The Leopard, Burt Lancaster, Alain Delon, and Claudia Cardinale starred in the Luchino Visconti film, set in 1860s Sicily; based on Giuseppe Tomasi de Lampedusa's novel.

America, America, Elia Kazan's film from his own screenplay, about turn-of-the-century emigration to the United States.

Billy Liar, the John Schlesinger film, set in small-town northern England; adapted by Keith Waterhouse and Willis Hall from a Waterhouse novel; Tom Courtenay, Julie Christie, and Mona Washbourne starred.

The Servant, Dirk Bogarde and James Fox starred in Joseph Losey's story of the dominance of a rich man by his servant; screenplay by Harold Pinter.

Marlon Brando and Eiji Okada starred in the *The Ugly American*, directed by George Englund.

Shirley MacLaine and Jack Lemmon starred in *Irma La Douce*, directed by Billy Wilder.

Lord of the Flies, Peter Brook's film, based on the 1954 William Golding novel.

Sidney Poitier and Lilia Skala starred in *Lilies of the Field*, directed by Ralph Nelson.

Sean Connery starred in *From Russia with Love*, directed by Terence Young.

Bye Bye Birdie, the George Sidney film, based on the 1960 Michael Stewart rock musical; Dick Van Dyke, Janet Leigh, Ann-Margret, and Maureen Stapleton starred.

Catherine Deneuve starred in *The Umbrellas of Cherbourg*, directed by Jacques Demy.

Cary Grant, Audrey Hepburn, and Walter Matthau starred in *Charade*, directed by Stanley Donen.

Gone Are the Days, Nicholas Webster's 1963 film version of Ossie Davis's 1961 play *Purlie Victorious*, again starring Davis, Ruby Dee, Godfrey Cambridge, Sorrell Brooke, and Alan Alda.

Hud, Paul Newman, Melvyn Douglas, Patricia Neal, and Brandon de Wilde starred in the Martin Ritt film, set in the modern West.

The Fugitive, David Jansen as the man on the run and Barry Morse as his pursuer starred in the television series (1963–1967).

Academy Awards for 1963 (awarded the following year): Best Picture: *Tom Jones*; Best Director: Tony Richardson, *Tom Jones*; Best Actor: Sidney Poitier, *Lilies of the Field*; Best Actress: Patricia Neal, *Hud*.

d. Dick (Richard E.) Powell, American actor, singer, director, and producer (b. 1904).

d. Pedro Armendariz, Mexican actor (b. 1912).

d. Yasujiro Ozu, Japanese director (b. 1903).

VISUAL ARTS

The March of Humanity in Latin America, David Alfaro Siqueiros's murals, Mexico City (1963–1969).

A *Rake's Progress*, David Hockney's series of 16 etchings.

Philip Johnson's work included the New York State Theater at Lincoln Center, New York City, a key postmodernist structure; and the Sheldon Memorial Art Gallery, University of Nebraska.

Andrew Wyeth's paintings included *Adam*, *Her Room*, and *Cider Apples*.

Georgia O'Keeffe's painting *The Winter Road*.

Pablo Picasso's painting *The Artist and His Model in the Studio*.

Giacomo Manzù's portrait bust of *Pope John XXIII*.

Claes Oldenburg's sculptures included *Bedroom Ensemble*, *The Bedroom*, and *Soft Typewriter*.

George Segal's sculpture *Cinema*; and his painting *Gas Station*.

Helen Frankenthaler's painting *Blue Atmosphere*.

Georgia O'Keeffe's painting *The Winter Road*.

Henry Moore's sculpture *Locking Piece* (1963–1964).

Andy Warhol's painting *Mona Lisa*.

Barbara Hepworth's sculpture *Square Stones with Circles*.

David Smith began his *Cubi* sculpture series.

Ellsworth Kelly's painting *Red, Blue, Green*.

Le Corbusier designed the Carpenter Center for the Visual Arts, Harvard University.

Three Brothers, Moses Soyer's painting.

Gordon Bunshaft designed the Beinecke Library at Yale University.

Toward a New Abstraction, Minimal Art exhibit at the Jewish Museum, New York City.

Broken Obelisk, Barnett Newman's sculpture (1963–1967).

Minoru Yamasaki designed the College of Education, Wayne State University, Detroit.

Oskar Kokoschka's painting *Double Portrait* (*Oskar Kokoschka and His Wife Olda*) (1963–1964).

Herbert Ferber's sculpture *Homage to Piranesi II*.

Jim Dine's painting *Walking Dream with a Four-Foot Clamp*.

Humphrey, Billy Al Bengston's painting.

Jasper Johns's painting *Map*, *Periscope*.

The Interaction of Color, Josef Albers's book.

d. Georges Braque, French painter (b. 1882).

d. David Low, leading British editorial cartoonist (b. 1891), the inventor of Colonel Blimp.

d. Jacques Villon (born Gaston Duchamp), French painter and printmaker (b. 1875), an early cubist; brother of Marcel Duchamp and Raymond Duchamp-Villon.

THEATER & VARIETY

Tyrone Guthrie founded the Guthrie Theatre in Minneapolis.

One Flew over the Cuckoo's Nest, Kirk Douglas starred in Dale Wasserman's version of the 1962 Ken Kesey novel, about life inside an insane asylum.

The Milk Train Doesn't Stop Here Anymore, the Tennessee Williams play, starred Mildred Dunnock.

Carol Channing starred as Dolly Levi in *Hello, Dolly!*, Michael Stewart's musical adaption of Thornton Wilder's *The Matchmaker*; basis of the 1969 Gene Kelly film.

Strange Interlude, Geraldine Page, Ben Gazzara, Pat Hingle, Franchot Tone, and Jane Fonda starred in Eugene O'Neill's play.

Oh! What a Lovely War, Joan Littlefield produced the antiwar play at her Theatre Workshop; basis of the Richard Attenborough film.

Oliver!, the Lionel Bart musical, based on *Oliver Twist*, starred Georgia Brown, Clive Revill, and Bruce Pochnik.

Elizabeth Ashley and Robert Redford starred in *Barefoot in the Park*; the Neil Simon comedy opened at the Biltmore Theatre, New York, October 23.

Enter Laughing, Joseph Stein's play, starred Vivian Blaine, Alan Arkin, and Sylvia Sidney.

110 in the Shade, the Harvey Schmidt–Tom Jones musical, starred Robert Horton and Inga Swenson.

Sidney Blackmer and Van Heflin starred in Henry Denker's *A Case of Libel*.

Ballad of the Sad Café, Edward Albee's play, starred Colleen Dewhurst and Michael Dunn.

Joseph Chaikin founded the Open Theater.

Albert Finney starred in John Osborne's *Luther*.

Morris Carnovsky starred as *King Lear* at the American Shakespeare Theatre; he repeated the role there in 1965 and 1975.

Anne Bancroft starred in the title role of Bertolt Brecht's *Mother Courage and Her Children*.

Ralph Richardson, John Gielgud, and Geraldine McEvan starred in *School for Scandal*.

She Loves Me, Jerry Bock's musical with book by Joe Masteroff, lyrics by Sheldon Harnick, and music by Bock, opened in New York.

The Garden Party, Václav Havel's play.

Fernando Arrabal's *Le Grand Cérémonial*.

Barry Foster starred in Peter Shaffer's *The Private Eye*.

Mildred Dunnock and Carrie Nye starred in Euripides's *The Trojan Women*.

Vivien Leigh and Jean Pierre Aumont starred in Lee Pockriss and Anne Crosswell's *Tovarich*.

Aimé Césaire's *La Tragédie du roi Christophe*.

d. Clifford Odets, American playwright (b. 1906), whose work was central to the Group Theater.

d. George Fitzmaurice, Irish playwright and short-story writer (b. 1877).

d. Gustav Gründgens, German actor and director (b. 1899).

d. Teresa Deevy, Irish playwright (b. 1894).

d. Vsevolod Vyacheslavovich Ivanov, Soviet playwright (b. 1895).

MUSIC & DANCE

The Beatles' hit songs *Please Please Me*, *She Loves You*, and *I Want to Hold Your Hand*; words and music by John Lennon and Paul McCartney.

Bob Dylan's album *Freewheelin' Bob Dylan*, including classic 1960s songs like *Blowin' in the Wind*, *A*

Hard Rain's A-Gonna Fall, and *Masters of War*, and the album *The Times They Are A-Changin'*, with its emblematic title song.

Las Hermanas, Kenneth MacMillan's ballet, libretto by MacMillan based on Federico García Lorca's *House of Bernardo Alba*; music by Frank Martin, first danced July 13, by the Stuttgart Ballet.

Flemming Flindt danced the lead in his ballet *The Lesson*, music by George Delerue, first danced September 16 on Danish television.

Echoing of Trumpets, Anthony Tudor's ballet, music by Bohuslav Martinu, first danced September 28 by the Royal Swedish Ballet, Stockholm.

Audiocassettes came into use for music recorded on tape, soon becoming widespread with the development of hand-size small recorder-players.

Don't Make Me Over, Dionne Warwick's hit song, music by Burt Bacharach, words by Hal David.

Gian Carlo Menotti's operas *Labyrinth* and *Le Dernier Sauvage*, and his cantata *The Death of Bishop Brindisi*.

Peter, Paul and Mary's albums *In the Wind* and *Moving*.

Call Me Irresponsible, song from the film *Papa's Delicate Condition*; music by Sammy Cahn, words by James Van Heusen.

Malcolm Williamson's opera *Our Man in Havana*, based on Graham Greene's novel.

Variations on a Theme by Hindemith, William Walton's orchestral work.

Krzysztof Penderecki's *Violin Concerto* and *Sonata* for cello and orchestra.

Leonard Bernstein's *Symphony No. 3*, the *Kaddish*.

Little Stevie Wonder, the 12-Year-Old Genius album.

The Barbra Streisand Album, with *Happy Days Are Here Again*.

Benjamin Britten's *Cantata misericordium* and *Cello Symphony*.

Odetta Sings Folk Songs album.

Erick Hawkins's dance work *Cantilever*.

George Crumb's *Night Music I* for voice and ensemble.

Roy Orbison's hit song *In Dreams*.

Hans Werner Henze's *Cantata della fiaba estrema*.

Abraham and Isaac, Igor Stravinsky's vocal work.

Canciones a Guiomar, Luigi Nono's vocal work.

Michael Tippett's *Concerto for Orchestra*.

Couleurs de la cité céleste, Olivier Messiaen's orchestral work.

Paul Hindemith's *Mass*.

Veni Sancte Spiritus, Peter Maxwell Davies's choral work.

Harrison Birtwistle's *Chorales*, for orchestra.

Staatsoper, rebuilt after war destruction, opened in Munich; home to the Bavarian State Opera.

d. Paul Hindemith, German composer (b. 1895).

d. Edith Piaf (Giovanna Gassion), French singer; her signature song was *La Vie en Rose*.

d. Francis Poulenc, French composer (b. 1899).

d. Amelita Galli-Curci, Italian soprano (b. 1882).

d. Dinah Washington (Ruth Lee Jones), American blues singer (b. 1924).

WORLD EVENTS

On November 22, President John F. Kennedy was assassinated in Dallas, Texas, by Lee Harvey Oswald, possibly with others. He was succeeded by Lyndon B. Johnson. On November 24, Oswald was assassinated by Jack Ruby. The subsequent Warren Commission report called Oswald the sole assassin, but controversy continued, as in the 1992 Oliver Stone film *JFK*.

Martin Luther King, Jr., led the civil-rights March on Washington (August 28), delivering his "I have a dream" speech to 250,000 civil-rights advocates at the Lincoln Memorial.

Four African-American Sunday school children were killed during the September 15 bombing of the Sixteenth Street Baptist Church, during the Birmingham, Alabama, civil-rights campaign.

Soviet–American–British Nuclear Test Ban Treaty banned all but underground testing.

American–Soviet Hot Line Agreement set up a direct line between the two superpower leaders.

Betty Friedan released *The Feminine Mystique*, urging women to move beyond their home and family roles to wider independence; it triggered a revival of the American women's movement.

British intelligence operative Kim Philby, a Soviet spy, fled to the Soviet Union.

British Profumo Affair, mixing politics, sex, and national security, forced resignation of War Minister John Profumo and weakened Harold Macmillan's government.

Greek–Turkish guerrilla conflict on Cyprus escalated into full-scale civil war (December).

Dominican Republic military coup deposed elected President Juan Bosch.

Republic of Kenya became an independent nation, with Jomo Kenyatta its first prime minister; in 1964, he became first president of Kenya.

Soviet astronaut Valentina Tereshkova became the first woman in space, orbiting the earth 48 times.

Terrorist bombings in Montreal by the Federation for the Liberation of Quebec.

American nuclear submarine *Thresher* sank off New Hampshire; crew of 129 all lost (April 10).

Thomas E. Starzl performed the first liver transplants.

Konrad Lorentz's *On Aggression*.

d. Medgar Wiley Evers, Mississippi African-American leader (b. 1925); assassinated at his home in Jackson, Mississippi.

d. Ngo Dinh Diem, South Vietnamese military dictator (b. 1902); deposed and assassinated by an American-backed group of generals.

1964

LITERATURE

Derek Walcott's *Selected Poems*.

Jean-Paul Sartre was awarded the Nobel Prize for Literature, which he refused.

The Wapshot Scandal, John Cheever's novel.

Marshall McLuhan's *Understanding Media: The Extensions of Man*.

77 Dream Songs, John Berryman's Pulitzer Prize–winning poetry collection.

Robert Lowell's poems *For the Union Dead*.

Shirley Ann Grau's Pulitzer Prize–winning novel *The Keepers of the House*.

Come Back, Dr. Caligari, a collection of Donald Barthelme's shorter fiction, many pieces previously published in *The New Yorker*.

Herzog, Saul Bellow's novel.

The Corridors of Power, ninth volume of C. P. Snow's *Strangers and Brothers* series.

Little Big Man, Thomas Berger's satirical revisionist Western novel; basis of the 1970 Arthur Penn film.

Ernest Hemingway's *A Moveable Feast*.

Galway Kinnell's poems *Flower Herding on Mount Monadnock*.

The Italian Girl, Iris Murdoch's novel; basis of the 1967 play.

Sometimes a Great Notion, Ken Kesey's novel; basis of the 1971 Paul Newman film.

The Goodbye Look, Ross Macdonald's Lew Archer novel.

Cold Ground Was My Bed Last Night, George Garrett's short stories.

Julian, Gore Vidal's novel.

Andrei Voznesensky's poetry *Anti-Worlds*.

The Garrick Year, Margaret Drabble's novel.

Anna Akhmatova's *Requiem*.

Arrow of God, Chinua Achebe's novel.

The Snow Ball, Brigid Brophy's novel.

I Was Dancing, Edwin O'Connor's novel.

Helmets, James Dickey's poetry collection.

Joseph Brodsky's *New Stanzas to Augusta*.

The Rector of Justin, Louis Auchincloss's novel.

With Shuddering Fall, Joyce Carol Oates's novel.

A. R. Ammons's poetry *Expressions of Sea Level*.

Kofi Awoonor's *Rediscovery and Other Poems*.

Weep Not, Child, a novel by Ngugi Wa Thiong'O.

Philip Larkin's poetry *Whitsun Weddings*.

Theodore Roethke's poetry *The Far Field*.

Reuben, Reuben, Peter De Vries's novel.

The Lion in the Gateway, Mary Renault's novel.

Roland Barthes's *Elements of Semiology*.

d. (Mary) Flannery O'Connor, American writer (b. 1925).

d. Edith Sitwell, British poet and critic (b. 1887), the sister of Sacheverell and Osbert Sitwell.

d. Hamilton Basso, American novelist (b. 1904).

FILM & BROADCASTING

Becket, Richard Burton and Peter O'Toole starred as Thomas à Becket and Henry II in the Peter Glenville film, adapted by Edward Anhalt from the 1959 Jean Anouilh play.

Dr. Strangelove, or How I Learned to Stop Worrying and Love the Bomb, Stanley Kubrick's classic antinuclear war black comedy; he produced, directed, and cowrote the screenplay; Peter Sellers starred in three roles, one of them Strangelove.

Fail-Safe, Henry Fonda, Walter Matthau, and Larry Hagman starred in Sidney Lumet's nuclear-war scenario, based on the Eugene Burdick–Harvey Wheeler novel.

A Hard Day's Night, the first Beatles film, directed by Richard Lester.

Cheyenne Autumn, the John Ford Western, a tribute to the Indian nations; Richard Widmark, Dolores Del Rio, Ricardo Montalban, Gilbert

Roland, Carroll Baker, and Karl Malden starred.

Anthony Quinn, Alan Bates, and Lila Kedrova starred in *Zorba the Greek*, directed by Michael Cacoyannis.

Yesterday, Today, and Tomorrow, Sophia Loren and Marcello Mastroianni starred in Vittorio De Sica's three-part sex comedy.

Diary of a Chambermaid, Jeanne Moreau starred in the Luis Buñuel film, set in France in the 1930s; based on the Octave Mirbeau novel.

King and Country, Tom Courtenay and Dirk Bogarde starred in Joseph Losey's antiwar film, about the courtmartial murder of a World War I British deserter.

Mary Poppins, Julie Andrews and Dick Van Dyke starred in Robert Stevenson's very popular musical.

Rex Harrison, Audrey Hepburn, and Stanley Holloway starred in the film version of *My Fair Lady*, directed by George Cukor.

Sean Connery starred in *Goldfinger*, directed by Guy Hamilton.

Seven Days in May, Burt Lancaster, Kirk Douglas, Fredric March, and Ava Gardner starred in John Frankenheimer's story about an attempted coup by the American military.

The Americanization of Emily, James Garner and Julie Andrews starred in Arthur Hiller's antiwar comedy, set in Britain during World War II; Paddy Chayevsky's screenplay was based on the William Bradford Huie novel.

The Best Man, Franklin J. Schaffner's film, adapted by Gore Vidal from his own anti-witch-hunting 1960 play; Henry Fonda, Cliff Robertson, Margaret Leighton, and Lee Tracy starred.

The Caretaker, Alan Bates, Robert Shaw, and Donald Pleasance starred in the Clive Donner film version of the 1960 Harold Pinter play, adapted by Pinter for the screen.

The Night of the Iguana, Richard Burton, Deborah Kerr, Ava Gardner, and Sue Lyon starred in John Huston's screen version of the 1962 Tennessee Williams play.

The Pink Panther, Blake Edwards's film, starring Peter Sellers, David Niven, and Capucine.

The Woman in the Dunes, the Hiroshi Teshigahara film, adapted by Kobo Abe from his own 1962 novel.

The Addams Family (1964–1966), television series based on the Charles Addams cartoons appearing from 1935 in *The New Yorker*; also a 1991 film.

Intelsat (International Telecommunications Satellite Organization) founded, first multinational satellite communications system.

Academy Awards for 1964 (awarded the following year): Best Picture: *My Fair Lady*; Best Director: George Cukor, *My Fair Lady*; Best Actor: Rex Harrison, *My Fair Lady*; Best Actress: Julie Andrews, *Mary Poppins*.

d. Alan Ladd, American actor (b. 1913).

d. Harpo Marx (Adolph Marx), American actor and comedian (b. 1888).

d. Peter Lorre (Laszlo Lowenstein), Hungarian actor, a star in Weimar Germany and then in Hollywood (b. 1904).

d. William Bendix, American actor (b. 1906), television's Chester A. Riley in *The Life of Riley*.

d. Gracie Allen, American comedian (b. 1905), often partnered with her husband, George Burns.

VISUAL ARTS

Portal of Death, Giacomo Manzù's doors of St. Peter's, in Rome.

David Alfaro Siqueiros's murals, Natural History Museum, Mexico City.

Le Corbusier's third capitol center building was completed at Chandrigar, in the Punjab.

Marc Chagall's Paris Opera murals.

Andrew Wyeth's paintings included *Open and Closed*, *The Drifter*, and *The Patriot*.

Georgia O'Keeffe's paintings included *Above Clouds Again* and *Road Past the View II*.

Pablo Picasso's paintings included *Reclining Nude Playing with a Cat*.

Kenzo Tange designed the National Gymnasiums for the 1964 Tokyo Olympics.

Philip Johnson designed the New York Pavilion at the New York World's Fair.

Robert Indiana's *EAT*, his massive pop-art poster at the New York World's Fair.

Alberto Giacometti's sculpture *Figure Standing*.

I. M. Pei designed the Green Center for the Earth Sciences, Massachusetts Institute of Technology.

Engineering Faculty Building at Leicester University, designed by James Stirling, was completed.

Henry Moore's sculpture *Atom Piece* (1964–1966).

Hans Scharoun's Berlin Philharmonic Hall was completed.

Andy Warhol's painting *Brillo Boxes*.

Compositions I, Roy Lichtenstein's notebook cover.

Ludwig Mies van der Rohe designed the Chicago Federal Center.

Homage to Thomas Eakins, Raphael Soyer's painting (1964–1965).

Jasper Johns's work included the sculpture *Painted Bronze II* (*Ale Cans*); and the paintings *Studio* and *According to What*.

Gallery of Modern Art, New York, opened; designed by Edward Durell Stone.

Louis Kahn's Unity Church at Rochester, New York, was completed.

Jim Dine's painting *Double Self-Portrait* (*The Green Line*).

Louise Nevelson's sculpture *Black Cord, Silent Music I*.

New York State Theater, Lincoln Center, New York, designed by Harrison and Johnson.

Standing Open Structure, Sol Lewitt's three-dimensional piece.

d. Alexander Archipenko, Russian sculptor, an early cubist (b. 1887).

d. Clive Bell, British art critic and with his wife Vanessa Bell associated with the Bloomsbury group (b. 1881).

d. Fontaine Fox, American cartoonist (b. 1884).

d. Stuart Davis, American painter (b. 1894).

THEATER & VARIETY

Marat/Sade, Patrick Magee, Ian Richardson, and Glenda Jackson starred in the Royal Shakespeare Company production of Peter Weiss's play, directed by Richard Brook, who directed the same cast in the 1966 film version.

Fiddler on the Roof, Zero Mostel starred in the Jerry Bock musical, based on Sholom Aleichem's *Tevye's Daughters*, set in a Jewish community in eastern Europe; opened at the Imperial Theatre, New York, September 22.

The Actors Theatre of Louisville was founded.

Blues for Mr. Charlie, James Baldwin's play, starred Al Freeman, Jr., Rip Torn, and Diana Sands.

Don Juan, Marcel Marceau's mime drama.

Alec Guinness and Kate Reid starred in Sidney Michaels's *Dylan*.

Imamu Amiri Baraka's three one-act plays, *The Dutchman*, *The Slave*, and *The Toilet*.

After the Fall, Barbara Loden and Jason Robards, Jr., alternating with Hal Holbrook starred in Arthur Miller's play; opened at ANTA Washington Square Theatre, New York, January 23.

Lorraine Hansberry's *The Sign in Sidney Brustein's Window* starred Rita Moreno and Gabriel Dell.

Tiny Alice, Irene Worth starred in Edward Albee's play; opened at the Billy Rose Theatre, New York.

James Earl Jones starred in Athol Fugard's *The Blood Knot*; in the same year he played *Othello*.

Paul Scofield played *King Lear* at the Royal Shakespeare Company.

Richard Burton played *Hamlet* on Broadway.

The Subject Was Roses, Martin Sheen and Jack Albertson starred in Frank D. Gilroy's play; opened at the Royale Theatre, New York.

Sandy Dennis, Gene Hackman, and Rosemary Murphy starred in *Any Wednesday*; Muriel Resnik's comedy opened at the Music Box Theatre, New York, February 18.

Funny Girl, Barbra Streisand and Sidney Chaplin starred in the Jule Styne musical, based on the life of Fanny Brice; opened at the Winter Garden Theatre, New York, March 26.

Inadmissible Evidence, Nicol Williamson starred in John Osborne's play.

Incident at Vichy, Arthur Miller's play, starred David Wayne and Hal Holbrook.

Eli Wallach, Anne Jackson, and Alan Arkin starred in *Luv*; Murray Schisgal's comedy opened at the Booth Theatre, November 11.

The Owl and the Pussycat, Bill Manhoff's play, opened at the ANTA Theatre, New York.

Philadelphia, Here I Come!, Brian Friel's play, opened in Dublin.

Sammy Davis, Jr., starred as boxer Joe Bonaparte in the musical version of Clifford Odets's *Golden Boy*.

Emlyn Williams and Jeremy Brett starred in Rolf Hochhuth's *The Deputy*.

The Owl and the Pussycat, Bill Manhoff's play, starring Diana Sands and Alan Alda, opened at New York's ANTA Theatre on Nov. 18.

Jessica Tandy, Hume Cronyn, and George Voskovec starred in Friedrich Dürrenmatt's *The Physicists*.

d. Sean O'Casey (John Casey), seminal Irish playwright (b. 1880).

d. Ben Hecht, American journalist, playwright, and legendary screenplay "fixer" of Hollywood's Golden Age (b. 1894).

d. Eddie Cantor (Edward Israel Iskowitz), American singer and comedian (d. 1964).

d. Brendan Behan, Irish playwright (b. 1923).

d. Cedric Webster Hardwicke, English actor (b. 1893).

MUSIC & DANCE

The Beatles' first American tour, beginning in February, and their film *A Hard Day's Night*, opening in August, made them worldwide popular music figures; their single *Can't Buy Me Love* topped the record charts.

The Dream, Frederick Ashton's ballet, based on Shakespeare's *A Midsummer Night's Dream*, to music by Felix Mendelssohn, first danced April 2 by the Royal Ballet, London.

Roger Daltrey, Pete Townshend, Keith Moon, and John Entwhistle formed the British rock band The Who.

Louis Armstrong's recording of *Hello, Dolly!* topped the charts.

Aaron Copland's choral work *The Promise of Living* and *Emblems*, for band.

Raindrops Keep Falling on My Head, Burt Bacharach's song, from *Butch Cassidy and the Sundance Kid*.

The Girl from Ipanema, song popularized by Astrud Gilberto, Joao Gilberto, and Stan Getz; music by Antonio Carlos Jobim; English lyrics by Norman Gimbel.

Walk on By, Dionne Warwick's hit song; music by Burt Bacharach, words by Hal David.

Krzysztof Penderecki's *Cantata on the 600th anniversary of the Jagellonian University* and *Funeral Song for Rutkowski*.

Rolling Stones, their first album.

Ferry Cross the Mersey, Gerry and the Pacemakers' hit song.

Entr'actes and Sappho Fragments, Harrison Birtwistle's vocal/instrumental work.

Roy Orbison's hit song *Oh, Pretty Woman*.

Curlew River, Benjamin Britten's church parable.

Bitter Tears: Ballads of the American Indian, Johnny Cash's album.

Mr. Tambourine Man, Bob Dylan's song, a hit for the Byrds.

The Execution of Stepan Razin, Dmitri Shostakovich's choral work.

Downtown, Petula Clark's hit version of Tony Hatch's song.

Martin's Lie, Gian Carlo Menotti's children's opera.

Hiketides, Iannis Xenakis's choral work.

Komei Abe's *Piano Sextet*.

Traces, Luciano Berio's dramatic musical work.

Don Rodrigo, Alberto Ginastera's opera.

The Music Makers, Zoltán Kodály's choral work.

Et exspecto resurrectionem mortuorum, Olivier Messiaen's orchestral work.

La fabbrica illuminata, Luigi Nono's vocal work.

Philomel, Milton Babbitt's work for tape with voice.

Montezuma, Roger Sessions's opera.

In Nomine fantasia, Peter Maxwell Davies's orchestral work.

Figures-Doubles-Prismes, Pierre Boulez's orchestral work.

First true electronic synthesizer, from Moog, Buchla, and Synket.

New York City Ballet succeeded the Ballet Society.

New York State Theater opened at Lincoln Center for the Performing Arts, New York.

d. Cole Porter, American composer and lyricist (b. 1893).

d. Jack (Weldon Leo) Teagarden, American jazz trombonist, bandleader, and singer (b. 1905).

d. Marc Blitzstein, American composer (b. 1905), whose left-leaning 1937 musical *The Cradle Will Rock* generated a political storm involving Orson Welles, John Houston, and their Mercury Theater.

d. Pierre Monteux, French composer (b. 1875).

WORLD EVENTS

President Lyndon B. Johnson defeated Republican Barry Goldwater, winning a full presidential term. Johnson put forth the slogan "Great Society" to characterize his domestic programs.

Reported North Vietnamese attacks on two American naval vessels in the Gulf of Tonkin led Congress to pass the Tonkin Gulf Resolution, used by President Lyndon B. Johnson to take the United States into the undeclared Vietnam War.

Chinese atom-bomb testing began, in the Lop Nor desert.

Civil Rights Act of 1964 was enacted, guaranteeing equal voting rights and outlawing discrimination in many other areas of American life.

Equal Employment Opportunity Commission (EEOC) created, as directed by the new Civil Rights Act.

Mississippi civil-rights workers James Chaney, Andrew Goodman, and Michael Schwerner were murdered by racists in Neshoba County, Mississippi; basis for the 1988 film *Mississippi Burning*.

U.S. Supreme Court in *Reynold v. Sims* applied the principle of "one man, one vote" to state electoral districts, forcing nationwide redrawing of electoral district lines.

Twenty-Fourth Amendment to the Constitution outlawed the poll tax.

Berkeley Free Speech Movement began at the Berkeley campus of the University of California, then spread nationwide (1964–1965).

British Labour party leader Harold Wilson became prime minister (1964–1970).

Palestine Liberation Organization (PLO) founded.

Mozambique War of Independence began, pitting Frelimo (National Liberation Front) forces against the Portuguese army (1964–1974).

United Nations mediation narrowly averted Greek–Turkish war, after Turkish air attacks on Greek Cypriots.

Zambia, formerly northern Rhodesia, became an independent nation (October 24).

1965

LITERATURE

The Autobiography of Malcolm X, by Alex Haley and Malcolm X; basis of the 1992 Spike Lee film.

Mikhail Sholokov was awarded the Nobel Prize for Literature.

The American Dream, Norman Mailer's Pulitzer Prize–winning "nonfiction novel."

Katherine Anne Porter's Pulitzer Prize and National Book Award–winning *Collected Stories*.

The Painted Bird, Jerzy Kosinski's autobiographical novel, set in Nazi-occupied Europe.

Muriel Spark's novel *The Mandelbaum Gate*.

The Millstone, Margaret Drabble's novel.

The Sailor Who Fell from Grace with the Sea, Yukio Mishima's novel; basis of the 1976 Lewis John Carlino film.

Cotton Comes to Harlem, Chester Himes's mystery novel, set in Harlem; basis of the 1970 Ossie Davis film.

The Source, James Michener's novel.

Flannery O'Connor's short stories *Everything That Rises Must Converge*.

The Kandy-Kolored Tangerine-Flake Streamline Baby, Tom Wolfe's essays and drawings.

A. R. Ammons's poetry collections *Corsons Inlet* and

Tape for the Turn of the Year.

God Bless You, Mr. Rosewater, Kurt Vonnegut's novel.

Dune, Frank Herbert's science fiction novel, the first of a series.

White Lotus, John Hersey's novel.

Derek Walcott's *The Castaway and Other Poems*.

The Green House, Mario Vargas Llosa's novel.

Edmund Wilson's *The Bit Between My Teeth*.

There Is Yet Time to Run Back Through Life and Expiate All That's Been Sadly Done, Gregory Corso's poetry collection.

Hayden Carruth's poetry *Nothing for Tigers*.

Buckdancer's Choice, James Dickey's National Book Award–winning poetry collection.

The Far Side of the Dollar, Ross Macdonald's Lew Archer detective novel.

Maxine Kumin's novel *Through Dooms of Love*.

Nadine Gordimer's short stories *Not for Publication*.

The Hot Gates, William Golding's novel.

Joseph Brodsky's *Verses on the Death of T. S. Eliot*.

Lost Empires, J. B. Priestley's novel.

George Garrett's novel *Do, Lord, Remember Me*.

Masuji Ibuse's novel *Black Rain*.

The River Between, a novel by Ngugi Wa Thiong'O.

Peter Abrahams's novel *A Night of Their Own*.

Samuel Beckett's novel *Imagination Dead Imagine*.

Taylor Caldwell's novel *A Pillar of Iron*.

The Vice Consul, Marguerite Duras's novel.

Wilfred Sheed's novel *Square's Progress*.

Anita Desai's novel *Voices in the City*.

Edgar Mittelholzer's novel *The Jilkington Drama*.

Wole Soyinka's novel *The Interpreters*.

The Adaptable Man, Janet Frame's novel.

Alfred Kazin's autobiographical work *Starting Out in the Thirties*.

d. T. S. (Thomas Stearns) Eliot, American-British writer and critic (b. 1888).

d. W(illiam) Somerset Maugham, British writer (b. 1874).

d. Randall Jarrell, American writer and critic (b. 1914).

d. Shirley Jackson, American writer (b. 1916).

d. Edgar Mittelholzer, British Guianan novelist (b. 1909).

d. Junichiro Tanizaki, Japanese writer (b. 1886).

d. Tanizaki Jun-ichiro, Japanese novelist (b. 1886).

FILM & BROADCASTING

Juliet of the Spirits, Giulietta Masina starred as the

woman in turmoil, in Federico Fellini's classic film.

Darling, Julie Christie, Dirk Bogarde, and Laurence Harvey starred in John Schlesinger's film, set in flashy 1960 London life; screenplay by Frederic Raphael.

Doctor Zhivago, David Lean's film, based on the 1955 Boris Pasternak novel as adapted by Robert Bolt, set in the Russian Revolution and Civil War; Omar Sharif, Julie Christie, Alec Guinness, Ralph Richardson, Tom Courtenay, Geraldine Chaplin, and Rod Steiger starred.

Shakespeare Wallah, Felicity Kendal, Shashi Kapoor, Geoffrey Kendal, Laura Liddell, Jennifer Kendal, and Madhur Jaffrey starred in James Ivory's story about a British Shakespearean troupe in modern India; screenplay by Ruth Prawer Jhabvala.

The Spy Who Came in from the Cold, Richard Burton and Claire Bloom starred in Martin Ritt's screen version of the 1963 John Le Carré spy thriller.

Woody Allen wrote and starred in *What's New, Pussycat?*, the first of his film comedies; Clive Donner directed.

Jason Robards and Barbara Harris starred in *A Thousand Clowns*, directed by Fred Coe.

The Sound of Music, Julie Andrews and Christopher Plummer starred as Maria and George von Trapp in George Wise's screen version of the 1965 Rodgers and Hammerstein musical.

The Pawnbroker, Rod Steiger starred as the East Harlem pawnbroker, a devastated Jewish concentration-camp survivor, in Sidney Lumet's film.

The Shop on Main Street, Ida Kaminska and Josef Kroner starred in the Jan Kadar–Elmar Klos story of German anti-Semitism and Czech compliance in German-occupied World War II Czechoslovakia.

Cat Ballou, Jane Fonda and Lee Marvin starred in the Elliot Silverstein Western comedy; Nat King Cole sang *The Story of Cat Ballou*.

Closely Watched Trains, the Jiri Menzel comedy, set in World War II Czechoslovakia; Vaclav Neckar, Vladimir Valenta, Jitka Bendova, Josef Somr, Libuse Havelkova, Jitka Zelenohorska, and Jiri Mendel starred.

Sean Connery starred in *Thunderball*, directed by Terence Young.

Ship of Fools, Vivien Leigh, Simone Signoret, Oskar Werner, Jose Ferrer, and Lee Marvin starred in Stanley Kramer's film version of the 1962

Katherine Anne Porter novel, about a German ship returning to newly Nazi Germany.

Jean-Luc Godard directed *Alphaville*, starring Eddie Constantine and Anna Karina.

Michael Caine starred in *The Ipcress File*, directed by Stanley T. Furie.

The Avengers (1965–1967), Diana Rigg as Emma Peel and Patrick Macnee as Steed starred in the television series.

Academy Awards for 1965 (awarded the following year): Best Picture: *The Sound of Music*; Best Director: Robert Wise, *The Sound of Music*; Best Actor: Lee Marvin, *Cat Ballou*; Best Actress: Julie Christie, *Darling*.

d. Jeannette MacDonald, American singer and actress (b. 1901), often costarred with Nelson Eddy in 1930s film musicals.

d. Clara Bow, American actress (b. 1905), in her heyday known as the "It girl."

d. David Selznick, American producer (b. 1902); husband of actress Jennifer Jones.

d. Dorothy Dandridge, American actress, singer, and dancer (b. 1923), a breakthrough black screen star.

d. Edward R(oscoe) Murrow, American broadcaster (b. 1908).

d. Stan Laurel (Arthur Stanley Jefferson), British actor and comedian (b. 1890).

d. Constance Bennett, American actress (b. 1904); sister of Joan Bennett and daughter of Richard Bennett.

VISUAL ARTS

Andrew Wyeth's paintings included *The Peavy*, *Up in the Studio*, and *Weather Side*.

Georgia O'Keeffe's paintings included *Sky Above Clouds III*, *Sky Above Clouds IV*, and *The Winter Road*.

Pablo Picasso's paintings included *Nude Man and Woman*, *Reclining Nude with a Green Background*, and *The Sleepers*.

Campbell's Soup Can, Andy Warhol's painting.

Henry Moore's sculpture *Reclining Figure*, at New York City's Lincoln Center.

Alexander Calder's sculpture *Stabile*, for New York's Lincoln Center.

Alberto Giacometti's sculptures included *Bust of Elie Lotar* and *Head of Diego*.

I. M. Pei designed the Place Ville-Marie, Montreal.

Larry Rivers's mural *The History of the Russian Revolution*, with associated sculptures.

The Responsive Eye, Minimal Art exhibit at the Museum of Modern Art, New York City.

Opening of the Vivian Beaumont Theater and the Library and Museum of the Performing Arts at New York's Lincoln Center.

Eero Saarinen's Gateway Arch (Jefferson National Expansion Memorial Arch) was installed in St. Louis; and his CBS Building opened in New York.

Four Mirrored Cubes, Robert Morris's sculpture.

Joan Miró's painting *Personage and Bird*.

Frank Stella's painting *Empress of India*.

Jim Dine's painting *Double Isometric Self-Portrait*.

Loft on 26th Street, Red Grooms's sculpture.

Louis Kahn designed the Salk Institute, La Jolla, California.

Marc Chagall's murals for the Metropolitan Opera House, New York.

Roy Lichtenstein's painting *Little Big Painting*.

Soft Dormeyer Mixer, Claes Oldenburg's sculpture.

Minoru Yamasaki designed the Woodrow Wilson School, Princeton University.

d. David Smith, American sculptor (b. 1906).

d. Dorothea Lange, American photographer (b. 1895).

d. Charles Sheeler, American painter and photographer (b. 1883).

THEATER & VARIETY

Laurence Olivier became the first director of Britain's National Theatre.

Man of La Mancha, Richard Kiley starred as Cervantes and Don Quixote in the Mitch Lee musical; opened at the ANTA Washington Square Playhouse, New York, November 22.

Robert Lowell's trilogy *Old Glory*, three one-act plays, based on Herman Melville's *Benito Cereno* and Nathaniel Hawthorne's *Endicott and the Red Cross* and *My Kinsman, Major Molyneux*.

A View from the Bridge, Arthur Miller's play, starred Robert Duvall and Jon Voight.

John Cullum and Barbara Harris starred in the Burton Lane–Alan Jay Lerner play *On a Clear Day You Can See Forever*.

William Ball founded the American Conservatory Theatre in Pittsburgh; later in San Francisco.

Hogan's Goat, William Alfred's play, starred Faye Dunaway and Cliff Gorman.

New Haven's Long Wharf Theater was founded.

The Amen Corner, James Baldwin's play, starred Bea Richards.

Anne Bancroft and Jason Robards starred in John Whiting's *The Devils*.

The Impossible Years, Bob Fisher and Arthur Marx's comedy, opened at the Playhouse, New York.

The Investigation, Peter Weiss's play about the 1964 Frankfurt war crimes trials.

Jerzy Grotowski founded the Theatre Laboratory.

The Memorandum, Václav Havel's play.

The Odd Couple, Neil Simon's play, starred Art Carney and Walter Matthau.

The Royal Hunt of the Sun, Peter Shaffer's play, starred Christopher Plummer and George Rose.

Happy Days, Samuel Beckett's play, starred Ruth White.

Lauren Bacall and Barry Nelson starred in Abe Burrows's *Cactus Flower*.

Henry Fonda starred in William Good Hart's *Generation*.

Athol Fugard's *Hello and Goodbye*, the second play in his Port Elizabeth trilogy.

Days in the Trees, Marguerite Duras's play, basis of her 1976 film.

A Patriot for Me, John Osborne's play.

Wole Soyinka's *Before the Blackout*.

Alexei Nikolayevich Arbuzov's *The Promise*.

Jacques Audiberti's *L'Opéra du monde*.

Jökull Jakobsson's *The Seaway to Baghdad*.

David Mercer's *Ride a Cock Horse*.

George Henry Boker's *Saved*.

d. Judy Holliday (Judith Tuvim), American actress (b. 1925).

d. Lorraine Hansberry, American writer (b. 1930).

d. Clemence Dane, English playwright and novelist (b. 1888).

d. Frantisek Langer, Czech playwright (b. 1888).

d. George Alexander Cassady Devine, English actor and theater director (b. 1910).

d. Jacques Audiberti, French poet, novelist, and playwright (b. 1899).

d. Richard Billinger, Austrian playwright and poet (b. 1890).

MUSIC & DANCE

Help!, Beatles' film and accompanying record, including *Yesterday*, by John Lennon and Paul

McCartney; also their album *Rubber Soul*, including *Nowhere Man*.

Simon and Garfunkel's first hit album, *Wednesday Morning, 3 A.M.*, with Simon's song *Sounds of Silence*.

Onegin, John Cranko's ballet, to music by Peter Ilich Tchaikovsky, based on Aleksandr Pushkin's 1833 poem *Eugene Onegin*, first danced April 13 by the Stuttgart Ballet.

The Doors was founded by Jim Morrison, Ray Manzarek, Robby Krieger, and John Densmore, their first album being *The Doors*.

Harlequinade, George Balanchine's ballet, music by Riccardo Drigo, first danced February 4 by the New York City Ballet.

John Phillips, Cass Elliott, Michelle Gilliam Phillips, and Dennis Doherty formed the Mamas and the Papas folk-rock group (1965–1968).

The Soldiers, Bernd Alois Zimmerman's opera, libretto by Zimmerman, opened in Cologne.

The Grateful Dead, the American rock band, was organized by Jerry Garcia, Bob Wier, Ron McKernan, Phil Lesh, and Bill Kreutzmann.

Song of the Earth, Kenneth MacMillan's ballet, music by Gustav Mahler, first danced November 7, by the Stuttgart Ballet.

Jackson Five formed (ca. 1965), including later-megastar Michael Jackson and his brothers Jackie (Sigmund Esco), Tito (Toriano Adryll), Marlon, and Jermaine.

Benjamin Britten's *Songs and Proverbs of William Blake* and *The Poet's Echo*, both song cycles written for Peter Pears; also his choral work *Voices for Today*.

Monotones I and II, Frederick Ashton's ballet, music by Eric Satie, first danced, by the Royal Ballet, London.

Frank Sinatra's album *September of My Years*.

Krzysztof Penderecki's orchestral work *Capriccio* and *St. Luke Passion* for narrator and orchestra.

Harrison Birtwistle's vocal work *Ring a Dumb Carillon*; *Tragoedia*, for orchestra; and *Verses*, for clarinet and piano.

Syd Barrett, Nick Mason, Roger Waters, and Richard Wright formed the British rock group Pink Floyd.

The Shadow of Your Smile, Tony Bennett's hit, from the film *The Sandpiper*.

The Young Lord, Hans Werner Henze's opera, libretto by Ingeborg Bachmann, opened in Berlin.

What's New, Pussycat?, Hal David and Burt Bacharach's song from the film, a hit for Tom Jones.

Dmitri Shostakovich's *Cello Concerto No. 2*.

B. B. King's album *Live at the Regal*.

(I Can't Get No) Satisfaction, the Rolling Stones' first big hit.

Ballads of the True West, Johnny Cash's album.

My Name Is Barbra, Streisand's album.

A Taste of Honey, popular hit for Herb Alpert and the Tijuana Brass.

Elliott Carter's *Piano Concerto*.

King of the Road, Roger Miller's country hit.

Ascension, John Coltrane's album.

Eddy Arnold's country hit *Make the World Go Away*.

The Jefferson Airplane folk-rock group was formed.

Erick Hawkins's dance work *Naked Leopard*.

Bob Dylan's hit song *Like a Rolling Stone*.

György Ligeti's *Requiem*.

Akrata, Iannis Xenakis's orchestral work.

Clitennestra, Ildebrando Pizzetti's opera.

Rozart Mix, John Cage's electronic work.

Chou Wen-chung's *Yü ko* for nine instruments.

Stop, Karlheinz Stockhausen's orchestral work.

Leonard Bernstein's *Chichester Psalms*, for orchestra and chorus.

Laborintus II, Luciano Berio's vocal work.

The Vision of St. Augustine, Michael Tippett's choral work.

The Twelve, William Walton's choral/organ work.

Electric sitars and tamburas developed for use in modern concert halls (from 1965).

d. Nat "King" Cole (Nathaniel Adams Coles), American jazz musician (b. 1917).

d. Clarence Williams, American jazz pianist, composer, and bandleader (b. 1898)

d. Myra Hess, British pianist (b. 1890), famed for her World War II National Gallery lunchtime concerts, some of them right through German bombing attacks.

d. Edgard Varèse, French-American composer (b. 1883).

d. Henry Dixon Cowell, American composer (b. 1897).

WORLD EVENTS

Full American commitment to the Vietnam War began, with heavy bombing of North Vietnam

beginning in February, American battalion-strength troop arrivals in March, and decision to commit hundreds of thousands of troops in July.

After a failed Indonesian Communist coup, the army and village militias committed the mass murders of an estimated 200,000–300,000 dissidents, and arrested tens of thousands more, many of them later murdered in prison.

At Selma, Alabama, civil-rights marchers led by Martin Luther King, Jr., were attacked, beaten, and gassed by Alabama state troopers (March 7). The response was a massive, historic Selma-to-Montgomery march (March 17–21) led by King and Ralph Bunche, which included many of the leading Black and White figures of the time.

Boston Unitarian minister and civil-rights activist James Reeb was murdered by racists in Selma, Alabama (March 9) as was Viola Gregg Liuzzo (March 25).

Massive summer race riots erupted in the Watts district of Los Angeles.

U.S. Voting Rights Act of 1965 prepared the way for mass African-American registration and voting in the South.

Farmworkers' organizer Cesar Chavez led a trailblazing grape growers' strike and boycott, calling it La Causa (The Cause; 1965–1970).

Pakistan initiated a divisional-strength armored attack in Kashmir, accompanied by bombing of Indian airfields; India responded with full-scale attacks in the Punjab; the United Nations mediated a ceasefire and withdrawal of both armies.

Dominican Republic Civil War began (1965–1966); American forces 21,000 strong intervened on the side of the government.

Fatah (al-Fatah), the Palestine Liberation Movement, began guerrilla warfare directed at Israel.

Low-level Eritrean guerrilla action escalated into the long Ethiopian–Eritrean War (1965–1991).

Mobutu Sese Seko (Joseph Désiré Mobuto) took full power in the Congo (November 25).

American cruise ship *Yarmouth Castle* sank off Nassau; 89 people died.

Ralph Nader's *Unsafe at Any Speed.*

d. Malcolm X (Malcolm Little), dissident Black Muslim leader (b. 1925); assassinated in New York City on February 21.

1966

LITERATURE

In Cold Blood, Truman Capote's "nonfiction novel" about a mass murder and courtroom case; basis of the 1967 Richard Brooks film.

The Jewel and the Crown, first volume of *The Raj Quartet*, Paul Scott's tetralogy of novels, set in India 1942–1947, on the eve of independence; basis of the 1984 television miniseries.

Index of Forbidden Books, published by the Sacred Congregation of the Roman Inquisition from 1559, discontinued.

Against Interpretation, Susan Sontag's essays.

Nelly Sachs and Shmuel Yoseph Agnon shared the 1966 Nobel Prize for Literature.

The Fixer, Bernard Malamud's Pulitzer Prize–winning novel.

Anne Sexton's Pulitzer Prize–winning poetry collection *Live or Die.*

The Magus, John Fowles's novel.

John Barth's novel *Giles Goat-Boy.*

Stevie Smith's *The Frog Prince and Other Poems.*

Anaïs Nin's *Diary* first published (1966–1976).

A Man of the People, Chinua Achebe's novel.

Sylvia Plath's poetry *Ariel.*

Kamala Markandaya's novel *A Handful of Rice.*

Wide Sargasso Sea, Jean Rhys's novel.

A. R. Ammons's *Northfield Poems.*

The Last Gentleman, Walker Percy's novel.

Cynthia Ozick's first novel, *Trust.*

Alice Adams's novel *Careless Love.*

Tai-Pan, James Clavell's novel.

Isaac Bashevis Singer's short stories *Zlatah the Goat.*

The Crying of Lot 49, Thomas Pynchon's novel.

Kay Boyle's story *Nothing Ever Breaks Except the Heart.*

The Mask of Apollo, Mary Renault's novel.

Nazim Hikmet's *Portraits from My Country* (1966–1967).

All in the Family, Edwin O'Connor's novel.

The Late Bourgeois World, Nadine Gordimer's novel.

Galway Kinnell's poetry *Body Rags.*

A Dream of Africa, Camara Laye's fictionalized autobiography.

Elsewhere, Perhaps, Amos Oz's novel.

John Gardner's novel *The Resurrection.*

Masuji Ibuse's novel *The Far-Worshipping Commander.*

José Lezama Lima's novel *Paradiso.*

Samuel Beckett's essays *Enough*.

The Birds Fall Down, Rebecca West's novel.

Margaret Atwood's poetry *The Circle Game*.

The Gates of the Forest, Elie Wiesel's novel.

The Saddest Summer of Samuel S., James Donleavy's novel.

d. Anna Akhmatova (Anna Andreyevna Gorenko), Soviet poet (b. 1889).

d. André Breton, French writer and editor, a founder of the Surrealist movement (b1896).

d. Evelyn Waugh, British writer (b. 1903).

d. Lao She, Chinese novelist (b. 1899).

d. Mari Sandoz, American author (b. 1896).

d. Delmore Schwartz, American poet (b. 1913).

d. Frank O'Connor (Michael John O'Donovan), Irish writer (b. 1903).

d. Ciro Alegría, Peruvian novelist (b. 1909).

d. Georges Duhamel, French writer (b. 1884).

d. Lillian Smith, American novelist (b. 1897).

FILM & BROADCASTING

A Man for All Seasons, Paul Scofield and Robert Shaw starred in Fred Zinnemann's celebrated screen version of the 1960 Robert Bolt play, in a cast that included Orson Welles, Wendy Hiller, and Vanessa Redgrave.

Who's Afraid of Virginia Woolf?, Richard Burton and Elizabeth Taylor starred as the warring couple in Mike Nichols's screen version of the 1962 Edward Albee play.

Ingmar Bergman directed *Persona*, starring Liv Ullmann and Bibi Andersson.

La Guerre Est Finie, Yves Montand, Ingrid Thulin, and Geneviève Bujold starred in the Alain Resnais film, a political work set in Spain and France; screenplay by Jorge Semprun.

Alfie, Michael Caine starred as Alfie, in Bill Naughton's adaptation of his own play; Lewis Gilbert directed.

Zero Mostel recreated his stage role in Richard Lester's film *A Funny Thing Happened on the Way to the Forum*.

A Man and a Woman, Anouk Aimée and Jean-Louis Trintignant starred in the Claude Lelouch love story.

A Fine Madness, Sean Connery, Joanne Woodward, Colleen Dewhurst, and Jean Seberg starred in the Irvin Kershner film, set in New York.

Vanessa Redgrave and David Hemmings starred in *Blow-up*, directed by Michelangelo Antonioni.

Charlton Heston and Laurence Olivier starred in *Khartoum*, directed by Basil Deardon.

Fahrenheit 451, the François Truffaut film, based on the Ray Bradbury science fiction novel; Oskar Werner and Julie Christie starred.

Georgy Girl, Lynn Redgrave, James Mason, Charlotte Rampling, and Alan Bates starred in the Silvio Narizzano film, based on the Margaret Forster novel, set in 1960s London.

Harper, Paul Newman, Lauren Bacall, Shelley Winters, Julie Harris, Janet Leigh, and Robert Wagner starred in the Jack Smight film; William Goldman's screenplay was based on Ross MacDonald's *The Moving Target*.

The Sand Pebbles, Steve McQueen, Candice Bergen, and Richard Attenborough starred in the Robert Wise film about an American gunboat and an armed clash with Chinese revolutionaries on the Yangtze.

Marat/Sade, the film version of the 1964 play; Peter Brook again directed.

Andrei Tarkovsky directed *Andrei Rublev*.

Robert Bresson directed *Balthazar*.

Star Trek (1966–1969), William Shatner, Leonard Nimoy, and James DeForest Kelley starred in Gene Roddenberry's television future space exploration science fiction series.

Batman, Adam West starred as Batman and Burt Ward as Robin in the television series (1966–1968).

Mission Impossible, the television adventure series (1966–1973).

Academy Awards for 1966 (awarded the following year): Best Picture: *A Man for All Seasons*; Best Director: Fred Zinnemann, *A Man for All Seasons*; Best Actor: Paul Scofield, *A Man for All Seasons*; Best Actress: Elizabeth Taylor, *Who's Afraid of Virginia Woolf?*

d. Nicolai Cherkassov, Soviet actor (b. 1903), star of *Alexander Nevsky* (1938), *Ivan the Terrible* (Part 1, 1944; Part 2, 1946), and *Don Quixote* (1957).

d. Buster Keaton (Joseph Francis Keaton), American actor, writer, and director (b. 1895).

d. Montgomery Clift (Edward Montgomery Clift), American actor (b. 1920).

d. Robert Rossen, American director and writer (b. 1908).

VISUAL ARTS

Atmosphere and Environment I, Louise Nevelson's "wall" sculpture in aluminum.

Marcel Breuer designed the Whitney Museum of American Art, New York.

Alfred Eisenstaedt's photo collection *Witness to Our Time*.

Mauve District, Helen Frankenthaler's painting.

Alexander Calder's sculpture *Totems*.

Mark di Suvero's sculpture *Elohim Adonai*.

Metropolitan Opera House, at New York's Lincoln Center, designed by Wallace K. Harrison, opened.

Andrew Wyeth's paintings included *Far from Needham*, *Grape Wine*, and *Maga's Daughter*.

Ampersand, Chryssa's neon work.

Barnett Newman's painting *Stations of the Cross*.

White Angle, Ellsworth Kelly's painting.

Roy Lichtenstein's painting *Yellow and Red Brushstrokes*.

Mies van der Rohe designed the School of Social Service Administration, University of Chicago.

Ad Reinhardt's *Black Painting* (1960–1966).

Joan Miró's painting *The Ski Lesson*.

Philip Johnson's Johnson Museum, New Canaan, Connecticut.

Metal Column B 1966, Ilya Bolotowsky's painting.

Rock—Rock, Richard Lindner's painting.

Minimal Art exhibit at New York's Guggenheim Museum.

I. M. Pei designed University Plaza, New York City.

Willem de Kooning's painting *Woman Acabonic*.

d. Le Corbusier (Charles Edouard Jenneret), Swiss-French architect and painter (b. 1887).

d. Alberto Giacometti, Swiss sculptor and painter (b. 1901).

d. Jean Arp (Hans Arp), German painter and sculptor (b. 1877).

d. Paul Manship, American sculptor (b. 1885).

THEATER & VARIETY

The Lion in Winter, Robert Preston as Henry II and Rosemary Harris as Eleanor of Aquitaine starred in James Goldman's play; opened at the Ambassador Theatre, March 3.

Vanessa Redgrave starred as the Edinburgh teacher in *The Prime of Miss Jean Brodie*, Jay Presson Allen's stage version of the 1961 Muriel Spark novel.

Cabaret, Jill Haworth, Bert Convy, and Joel Grey starred in the Fred Ebb–John Kander musical, set in Weimar Berlin, based on John Van Druten's 1951 play, *I Am a Camera*, itself based on Christopher Isherwood's 1939 *Goodbye to Berlin*; opened at the Broadhurst Theatre, New York.

A Delicate Balance, Jessica Tandy and Hume Cronyn starred in Edward Albee's play; opened at the Martin Beck Theatre, New York, September 22.

Sweet Charity, Gwen Verdon starred as the ever-resilient dance-hall hostess in the Cy Coleman–Dorothy Field–Neil Simon musical, based on Federico Fellini's film *The Nights of Cabiria*; opened at the Palace Theatre, New York.

Anthony Quayle starred in Bertolt Brecht's *Galileo*.

Don't Drink the Water, Woody Allen's play, starred Lou Jacobi; Allen adapted it into the 1969 film.

Auntie Mame, Angela Lansbury starred as Mame in the musical version of the 1956 play, with songs by Jerry Herman.

Mary Martin and Robert Preston starred in *I Do! I Do!*, the Harvey Schmidt–Tom Jones musical.

John Gielgud, Vivien Leigh, and Claire Bloom starred in Anton Chekhov's *Ivanov*.

Helen Hayes, Ellis Rabb, and Rosemary Harris starred in Sheridan's *School for Scandal*.

Dustin Hoffman starred in John Arden's *Serjeant Musgrave's Dance*.

The Killing of Sister George, Frank Marcus's play, starred Beryl Reid and Eileen Atkins.

The Star-Spangled Girl, Neil Simon's play, starred Anthony Perkins, Richard Benjamin, and Connie Stevens.

Lee Remick starred in Frederick Knott's *Wait Until Dark*.

Samuel Beckett's *Come and Go (Va et vient)* and *Eh Joe*.

Joe Orton's *Loot*.

Wole Soyinka's *Kongi's Harvest*.

John Pepper Clark's *Ozidi*.

Peter Handke's *Offending the Audience*.

David Mercer's *Belcher's Luck*.

d. Wilfrid Lawson, English actor (b. 1900).

d. Erwin Piscator, German director, proponent of the modern epic theater (b. 1893).

d. Hans Christian Branner, Danish novelist and playwright (b. 1903).

MUSIC & DANCE

The new Metropolitan Opera House opened in New

York's Lincoln Center with a specially commissioned opera, Samuel Barber's *Antony and Cleopatra*, libretto (after Shakespeare) and production by Franco Zeffirelli; Leontyne Price starred.

Rudolf Nureyev produced and starred in his first original ballet as choreographer, *Tancredi*, to music by Hans Werner Hanze, libretto by Peter Csobadi, opening at the Vienna State Opera Ballet.

Concerto, Kenneth MacMillan's ballet, music by Dmitri Shostakovich, first danced November 30 by the Berlin Opera Ballet.

The Beatles' album *Revolver*, including *Eleanor Rigby* and *Good Day Sunshine*.

Waist Deep in the Big Muddy, Pete Seeger's anti–Vietnam War protest song.

Alice's Restaurant, Arlo Guthrie's song and album; inspiration for the 1969 Arthur Penn film.

György Ligeti's dramatic musical works *Aventures* and *Nouvelles aventures*; choral work *Lux aeterna*; and *Cello Concerto*.

Hans Werner Henze's *The Bassarids*, opera, libretto by Henze based on Euripides's *The Bacchae*, opened in Salzburg, August 6.

Benjamin Britten's church parable *The Burning Fiery Furnace* and choral work *The Golden Vanity*.

Karlheinz Stockhausen's chamber music *Adieu* and tape work *Telemusik*.

Milton Babbitt's orchestral work *Relata I* and *Post-partitions*, for piano.

Strangers in the Night and *That's Life*, Frank Sinatra's hit singles.

Prometheus, Carl Orff's dramatic musical work.

When a Man Loves a Woman, Percy Sledge's hit.

Krzysztof Penderecki's oratorio *St. Luke Passion*.

The Rolling Stones' album *Aftermath*.

Twyla Tharp's dance work *Re-Moves*.

Pet Sounds, the Beach Boys' album.

Igor Stravinsky's *Requiem Canticles*.

It Serves You Right, John Lee Hooker's album.

Missa brevis, William Walton's choral/organ work.

Monday, Monday, hit for the Mamas and the Papas.

Jefferson Airplane Takes Off album.

Ricorda cose ti hanno fatto in Auschwitz, Luigi Nono's tape work.

Terretektorh, Iannis Xenakis's orchestral work.

Neil Diamond's hit song *Cherry, Cherry*.

Alan Bush's opera *The Sugar Reapers*.

d. Sophie Tucker (Sonia Kalish), American singer and actress (b. 1884).

d. Bud Powell (Earl Powell), American jazz pianist (b. 1924).

d. Deems Taylor, American composer and critic (b. 1885).

d. Janis Medins, Latvian composer (b. 1890).

WORLD EVENTS

Mao Zedong initiated China's Cultural Revolution, a massive set of purges of "bourgeois" tendencies; young Red Guards groups did enormous damage, especially by destroying irreplaceable art and other cultural treasures.

Indira Gandhi, daughter of Prime Minister Nehru, became prime minister of India.

French nuclear weapons testing began at Moruroa, in the South Pacific (1966–1974).

Barbara Jordan became the first African-American Texas state legislator since Reconstruction.

National Organization for Women (NOW) was founded in the United States, with Betty Friedan as its first president.

Huey Newton and Bobby Seale organized the Black Panther party (October).

New rules covering the rights of suspects were set by the U.S. Supreme Court in *Miranda v. Arizona*.

SWAPO (Southwest Africa People's Organization) began an armed war of independence in Namibia.

Jean Bédel Bokassa took dictatorial power in a Central African Republic military coup (1966–1977).

Jonas Savimbi organized the National Union for the Total Independence of Angola (UNITA).

Milton Obote seized dictatorial power in Uganda.

United Nations peacekeeping forces replaced American forces in the Dominican Republic, and supervised a presidential election.

Charles Whitman killed 16 people from the University of Texas observation tower before police killed him; he became known as the Texas Tower Sniper.

William H. Masters and Virgina Johnson published *Human Sexual Response*.

Carl Sagan's *Intelligent Life in the Universe*.

1967

LITERATURE

One Hundred Years of Solitude, Gabriel García

Márquez's novel, a multigenerational story set in his imaginary Macondo.

Miguel Asturias was awarded the Nobel Prize for Literature.

William Styron's Pulitzer Prize–winning fictionalized reconstruction of the slave rebellion led by Nat Turner, *The Confessions of Nat Turner.*

Rosemary's Baby, Ira Levin's novel, about a group of Manhattan devil worshippers; basis of the 1968 Roman Polanski film.

Robert Bly's National Book Award–winning poetry collection *The Light Around the Body.*

Samuel Beckett's *No's Knife: Collected Shorter Prose 1945–66*; also his *Ping* and *Têtesmortes.*

Marshall McLuhan and Quentin Fiore's *The Medium Is the Message.*

A Change of Skin, Carlos Fuentes's novel.

The Mimic Men, V. S. Naipaul's novel.

A Garden of Earthly Delights, Joyce Carol Oates's novel.

The Eighth Day, Thornton Wilder's novel.

A State of Siege, Janet Frame's novel.

Alex La Guma's novel *The Stone Country.*

No Laughing Matter, Angus Wilson's novel.

Amos Tutuola's fiction *Abaiyi and His Inherited Poverty.*

Snow White, Donald Barthelme's novel.

Mulk Raj Anand's novel *Lament on the Death of a Master of Arts.*

Wole Soyinka's *Idanre and Other Poems.*

The Voices of Marrakesh, Elias Canetti's travel essays.

The Joke, Milan Kundera's novel.

Thomas Berger's novel *Killing Time.*

Joseph Brodsky's *Elegy to John Donne and Other Poems.*

A Bride for the Sahib, Khushwant Singh's short-story collection.

Malcolm Cowley's essays *Think Back on Us.*

A Grain of Wheat, a novel by Ngugi Wa Thiong'O.

Robert Creeley's poems *Words.*

A Dictionary of Canadianisms on Historical Principles, edited by Walter S. Avis and others.

d. Carl Sandburg, American writer, a leading American poet and biographer (b. 1878).

d. (James) Langston Hughes, American writer, a leading African-American poet and storyteller (the "Simple" stories) (b. 1902).

d. Carson McCullers, American writer (b. 1917).

d. Siegfried Sassoon, British writer (b. 1886); a notable World War I poet.

d. Dorothy Parker, American writer and critic (b. 1893).

d. Ilya Ehrenburg, Soviet writer (b. 1891).

d. Malcolm Lowry, British writer (b. 1909).

d. John Masefield, British writer, best known for his poetry (b. 1878).

d. João Guimaráes Rosa, Brazilian novelist and short-story writer (b. 1908).

d. Margaret Ayer Barnes, American novelist and playwright (b. 1886).

FILM & BROADCASTING

The Graduate, Dustin Hoffman, Katharine Ross, and Anne Bancroft as Mrs. Robinson starred in the Mike Nichols coming-of-age comedy.

Bonnie and Clyde, Faye Dunaway and Warren Beatty starred as Depression-era midwestern outlaw folk heroes in the Arthur Penn film, with Estelle Parsons and Gene Hackman.

Guess Who's Coming to Dinner, Katharine Hepburn, Spencer Tracy, Sidney Poitier, and Katharine Houghton starred in the Stanley Kramer film, about an impending interracial marriage.

Catherine Deneuve starred in *Belle de Jour*, directed by Luis Buñuel.

The President's Analyst, James Coburn, Godfrey Cambridge, and Severn Darden starred in Theodore Flicker's cold war espionage satire.

In the Heat of the Night, Sidney Poitier as Mr. Tibbs and Rod Steiger as the sheriff starred in Norman Jewison's story of racism, murder, and detection, set in the small-town segregated South.

Cool Hand Luke, Paul Newman as Luke starred in Stuart Rosenburg's Southern chain gang film, with George Kennedy, Strother Martin, and Jo Van Fleet.

In Cold Blood, Richard Brooks's film version of the 1966 Truman Capote novel, about a mass murder and the trial and execution of the murderers.

Sean Connery starred in *You Only Live Twice*, directed by Lewis Gilbert.

Camelot, Richard Harris and Vanessa Redgrave starred in the Joshua Logan film, set in Arthurian England, adapted from the 1960 Alan Jay Lerner–Frederick Loewe stage musical.

The Producers, Zero Mostel and Gene Wilder starred in the Mel Brooks comedy, Mostel as the producer of *Springtime for Hitler.*

Milos Forman directed *The Fireman's Ball*, starring Jan Vostrcil, Josef Svet, and Josef Kolb.

Oedipus Rex, the Pier Paolo Pasolini film; Franco Citti, Silvana Mangano, and Carmelo Bene starred.

The Forsyte Saga, the 26-part BBC series, based on the John Galsworthy novels (1906–1921); Kenneth More, Eric Porter, Nyree Dawn Porter, and Susan Hampshire starred.

Raymond Burr starred in the television series *Ironside* (1967–1975).

The Carol Burnett Show began its long run (1967–1979).

Academy Awards for 1967 (awarded the following year): Best Picture: *In the Heat of the Night*; Best Director: Mike Nichols, *The Graduate*; Best Actor: Rod Steiger, *In the Heat of the Night*; Best Actress: Katharine Hepburn, *Guess Who's Coming to Dinner*.

d. Spencer Tracy, American actor (b. 1900), a star of Hollywood's Golden Age and for decades beyond; long the companion of Katharine Hepburn, his costar in many films.

d. Vivien Leigh (Vivian Mary Hartley), British actress (b. 1913); she was Blanche DuBois in *A Streetcar Named Desire* and Scarlett O'Hara in *Gone with the Wind*.

d. Basil Rathbone, British actor, long identified with Sherlock Holmes (b. 1892).

d. Claude Rains, British actor (b. 1889).

d. Jane Darwell (Patti Woodward), American character actress (b. 1979); in 1940, she was Ma Joad in *The Grapes of Wrath*.

d. Nelson Eddy, American singer and actor (b. 1901).

d. G. W. (Georg Wilhelm) Pabst, Austrian-German director (b. 1885).

d. Julien Duvivier, French director (b. 1896).

VISUAL ARTS

Moshe Safdie's Habitat complex was part of the Montreal Exposition.

Andrew Wyeth's paintings included *The Apron*, *Kitchen at Olsons*, *Pieberries*, *Spring Fed*, and *The Stanchions*.

Pablo Picasso's painting *Reclining Nude* and *Steel Sculpture*.

Claes Oldenburg's "earthwork," consisting of a hole dug in Central Park; and his sculpture *The Ghost Version of a Giant Soft Fan*.

Robert Motherwell began his "Open" series of paintings.

George Segal's sculpture *Portrait of Sidney Janis with Mondrian*.

I. M. Pei designed the National Center for Atmospheric Research, Boulder, Colorado.

Transparent Sculpture II, Louise Nevelson's "wall" sculpture in aluminum (1967–1968).

Clytemnestra, Chryssa's neon work.

Ellsworth Kelly's painting *Spectrum III*.

Louis I. Kahn designed the First Unitarian Church, Rochester, New York.

Ford Foundation, New York, designed by Roche and Dinkeloo.

Kenneth Noland's painting *Wild Indigo, Via Blues*.

Helen Frankenthaler's painting *Guiding Red*.

James Rosenquist's painting *U-Haul-It*.

Edward Durell Stone designed the Stuhr Museum, Grand Island, Nebraska.

d. Edward Hopper, American painter (b. 1882).

d. René Magritte, Belgian painter (b. 1898).

d. Charles Burchfield, American painter (b. 1893).

d. Ad Reinhardt (Adolf Frederick Reinhardt), American painter (b. 1912).

d. Ossip Zadkine, Russian-French sculptor, an early cubist (b. 1890).

THEATER & VARIETY

Hair, a trailblazing rock musical, opened at the New York Shakespeare Festival Public Theatre; music by Galt MacDermott, with book and lyrics by Gerome Ragni and James Rado.

Ingrid Bergman, Colleen Dewhurst, and Arthur Hill starred in Eugene O'Neill's *More Stately Mansions*.

Pearl Bailey starred in the title role of the all–African-American production of *Hello, Dolly!*

Rosencrantz and Guildenstern Are Dead, Tom Stoppard's play, starred Brian Murray and John Wood.

Harold Pinter's *The Birthday Party* starred Ruth White, Ed Flanders, and James Patterson.

Harold Pinter's *The Homecoming* starred Vivien Merchant, Ian Holm, and Paul Rogers.

Robert Hooks, Douglas Turner Ward, and Gerald Krone founded the Negro Ensemble Company.

The Dark at the Top of the Stairs, William Inge's play; Delbert Mann directed the 1960 screen version.

Soldiers, Rolf Hochhuth's play, sharply critical of

Winston Churchill for alleged World War II mass murders, as in the firebombing of German cities.

Black Comedy, Geraldine Page, Michael Crawford, and Lynn Redgrave starred in Peter Shaffer's play.

Irene Papas starred in Euripides's *Iphigenia in Aulia*.

Little Murders, the Jules Feiffer play, starred Elliott Gould and Barbara Cook; opened at the Broadhurst Theatre, New York, April 25.

Macbird, Barbara Garson's satire, starred Cleavon Little, Stacy Keach, and William Devane.

Scuba Duba, Jerry Orbach starred in Bruce Jay Friedman's comedy; opened at the New Theatre, New York, October 10.

The Little Foxes, Margaret Leighton, E. G. Marshall, Anne Bancroft, and George C. Scott starred in Lillian Hellman's play.

The Song of the Lusitanian Bogey, Peter Weiss's play, about the Angolan war of independence.

There's a Girl in My Soup, Terence Frisby's play, starred Gig Young and Barbara Ferris.

You Know I Can't Hear You When the Water's Running, four one-act plays by Robert Anderson; opened at the Ambassador Theatre, New York, March 13.

You're a Good Man, Charlie Brown, Gary Burghoff and Reva Rose starred in Clark Gesner's musical; opened at the Theatre 80 St. Marks, New York.

Peter Nichols's black comedy *A Day in the Death of Joe Egg*.

Anatomy of Revolution, Rolf Hochhuth's play.

The Architect and the Emperor of Assyria, Fernando Arrabal's play.

Aimé Césaire's *Une saison au Congo*.

James Ene Henshaw's *Dinner for Promotion*.

d. Elmer Rice (Elmer Reizenstein), American playwright (b. 1892).

d. Bert Lahr, American vaudeville and burlesque player (b. 1895).

d. Paul Muni (Muni Weisenfreund), leading American dramatic actor (b. 1895).

d. Joe Orton, English playwright (b. 1933).

d. Lee Simonson, American designer (b. 1888).

d. Robert Kemp, Scottish playwright (b. 1908).

MUSIC & DANCE

Sergeant Pepper's Lonely Hearts Club Band, the celebrated Beatles album, was released, including the title song, *Lucy in the Sky with Diamonds*, *With a*

Little Help from My Friends, *When I'm 64*, and the long finale *A Day in the Life*.

Strawberry Fields Forever, the Beatles song from their improvised film *Magical Mystery Tour*; words and music by John Lennon and Paul McCartney.

All You Need Is Love, the Beatles' hit single; words and music by John Lennon and Paul McCartney.

Aretha Franklin became the leading soul singer of her generation, with such hits as *A Natural Woman*, *Respect*, *I Never Loved a Man—the Way I Love You*, and *Baby I Love You*.

Simon and Garfunkel released their albums *Sounds of Silence* and *Parsley, Sage, Rosemary and Thyme*, and the song *Mrs. Robinson*, from the film *The Graduate*.

First major rock festival held at Monterey, California, January 16–18, where numerous folk and rock musicians performed; subject of D. A. Pennebaker's movie *Monterey Pop* and various songs and albums.

I Heard It Through the Grapevine, Norman Whitfield and Barrett Strong's song, was introduced by Gladys Knight and the Pips, but became a top 1968 hit for Marvin Gaye.

Both Sides Now (Clouds), Joni Mitchell's song (words and music), later the title song of a 1969 Mitchell album and a 1971 Judy Collins album; also Mitchell's song *Chelsea Morning*.

At Midnight, Eliot Feld's ballet, to music by Franz Joseph Haydn, sets by Leonard Baskin, first danced December 1 by the American Ballet Theater, in New York.

Glen Campbell had two hit songs: John Hartford's *Gentle on My Mind* and Jim Webb's *By the Time I Get to Phoenix*.

The Bear, William Walton's opera, libretto by Paul Dehn, opened June 3 at the Aldeburgh Festival.

Jaime "Robbie" Robertson, Rick Danko, Richard Manuel, Garth Hudson, and Levon Helm formed the rock band the Band (1967–1976).

Astarte, Robert Joffrey's designed-to-be-shocking mixed-media ballet, premiered at City Center.

Ain't Nothing Like the Real Thing, a hit for Marvin Gaye and Tammi Terrell.

Mick Fleetwood, John McVie, Peter Green, and Jeremy Spencer formed Fleetwood Mac, the British blues-rock band; later key figures included Christine Perfect McVie, Lindsay Buckingham, and Stevie (Stephanie) Nicks.

Jewels, George Balanchine's ballet, to music by Gabriel Fauré, first danced April 13 by the New York City Ballet.

Blood, Sweat, and Tears, the American rock band, was founded by Al Kooper; later key figures were Steve Katz, Al Colomby, and David Clayton-Thomas.

My Way, Paul Anka's song, to music by Jacques Revaux; became a major hit and signature song for Frank Sinatra (1969).

Luigi Nono's vocal work *A floresta è jovem e cheja de vida* and orchestral work *Per Bastiana Tai-Yang Cheng*.

Krzysztof Penderecki's *Pittsburgh Overture* and choral work *Dies irae*.

Up, Up and Away (*My Beautiful Balloon*) was a hit twice in 1967, once for composer Jim Webb and also for the Fifth Dimension.

Toru Takemitsu's *November Steps* for biwa, shakuhachi, and orchestra.

Bomarzo, Alberto Ginastera opera, libretto by Manuel Mujica Lainez, opened in Washington, D.C., May 19.

Their Satanic Majesties' Request, the Rolling Stones' album.

Light My Fire, the Doors' hit song.

The Who Sell Out album.

Big Brother and the Holding Company, Janis Joplin's album.

Wildflowers, Judy Collins's album.

Good Vibrations, the Beach Boys' album.

Dmitri Shostakovich's *Violin Concerto No. 2*.

George Crumb's *Echoes of Time and the River*, for orchestra.

Karlheinz Stockhausen's tape work *Hymnen*.

O King, Luciano Berio's vocal work.

Milton Babbitt's *Correspondences*, tape with instruments.

Twyla Tharp's dance work *Forevermore*.

Witold Lutoslawski's *Second Symphony*.

Orpheus in Hiroshima, Yasushi Akutagawa's opera.

d. Woody (Woodrow Wilson) Guthrie, American composer and folksinger (b. 1912); father of folksinger Arlo Guthrie (b. 1947).

d. Zoltán Kodály, Hungarian composer and teacher (b. 1882).

d. Mischa Elman, Russian-American violinist (b. 1891).

d. John Coltrane, American jazz saxophonist (b. 1926).

d. Paul Whiteman, American bandleader (b. 1890).

d. Mary Garden, Scottish-American soprano (b. 1874).

d. Geraldine Farrar, American singer and actress (b. 1882).

WORLD EVENTS

Biafra–Nigeria civil war began (1967–1970); an estimated 1.5–2 million people died, approximately 1 million as a result of famine and accompanying disease in Biafra, greatly worsened by Nigerian government refusal to admit food and other aid.

Thurgood Marshall was appointed to the U.S. Supreme Court; becoming its first African-American member.

American President Lyndon B. Johnson and Soviet Premier Aleksei N. Kosygin held a summit meeting at Glassboro, New Jersey (June).

Greek Army colonels George Papadapoulos and Stylianos Pattakos led a successful military coup, beginning the rule of "the colonels" (1967–1974).

Chinese hydrogen-bomb testing began, in the Lop Nor desert.

Cyprus was informally partitioned between Greeks and Turks.

American astronauts Virgil I. "Gus" Grissom, Edward H. White II, and Roger B. Chaffee died in an Apollo spacecraft fire during a rehearsal.

Svetlana Alliluyeva, daughter of Joseph Stalin, defected from the Soviet Union.

American oil tanker *Torrey Canyon* grounded off Cornwall, England; the resulting massive oil spill created an environmental disaster (March 18).

Dr. Christiaan Barnard made the first human heart transplant (December 3).

R. Buckminster Fuller exhibited his geodesic dome at the Montreal Exposition.

Marshall McLuhan's *The Medium Is the Message*.

d. Che Guevara (Ernesto Guevara de la Serna), Argentinian-Cuban revolutionary (b. 1928); killed while leading Bolivian rebels after having been captured by the Bolivian government.

1968

LITERATURE

Alexander Solzhenitsyn's novels *The First Circle* and *The Cancer Ward*.

Yasunari Kawabata was awarded the Nobel Prize for Literature, the first Japanese writer so honored.

Alice Walker's poetry *Once*.

The Algiers Motel Incident, John Hersey's account of the 1967 Detroit race riots.

The Day of the Scorpion, second volume of Paul Scott's *The Raj Quartet*, dramatized as *The Jewel in the Crown*.

Unspeakable Practices, Unnatural Acts, a collection of Donald Barthelme's shorter fiction, much previously published in *The New Yorker*.

The Beastly Beatitudes of Balthazar B., James Donleavy's novel.

Mr. Sammler's Planet, Saul Bellow's novel.

Yellow Flowers in the Antipodean Room, Janet Frame's novel.

2001: A Space Odyssey, Arthur C. Clarke novel, written at the same time as his cowritten screenplay for the Stanley Kubrick film.

Armies of the Night, Norman Mailer's Pulitzer Prize–winning essays.

Nikki Giovanni's poetry collections *Black Feeling, Black Talk*, and *Black Judgement*.

Salvatore Quasimodo's *To Give and to Have, and Other Poems*.

Delta of Venus, Anaïs Nin's short stories.

Couples, John Updike's novel.

André Malraux's *Anti-memoirs*.

John Berryman's *His Toy, His Dream, His Rest*.

Robert Penn Warren's poetry *Incarnations*.

Ayi Kwei Armah's novel *The Beautiful Ones Are Not Yet Born*.

Expensive People, Joyce Carol Oates's novel.

Marge Piercy's *Breaking Camp*.

Cocksure, Mordecai Richler's novel.

Gwendolyn Brooks's *In the Mecca*.

Maxine Kumin's novel *The Passions of Uxport*.

Louise Bogan's poems *The Blue Estuaries*.

Iris Murdoch's novel *A Time of the Angels*.

Myra Breckenridge, Gore Vidal's novel.

Cecil Day Lewis became British poet laureate (1968–1972).

d. John Steinbeck, American writer, notably of the Depression-era United States (b. 1902).

d. Gabriele D'Annunzio, Italian writer (b. 1863).

d. Salvatore Quasimodo, Italian poet and translator (b. 1901).

d. Upton Sinclair, American writer and social reformer (b. 1878).

d. Arnold Zweig, German writer (b. 1887).

d. Ian Fleming, British author, creator of James Bond (b. 1908).

d. Conrad Richter, American writer (b. 1890).

d. Edna Ferber, American writer (b. 1887).

d. Fannie Hurst, American writer (b. 1889).

FILM & BROADCASTING

The Lion in Winter, Peter O'Toole as Henry II and Katharine Hepburn as Eleanor of Aquitaine starred in Anthony Harvey's screen version of the 1966 James Goldman play.

Z, Yves Montand, Irene Papas, Jean-Louis Trintignant, and Charles Denner starred in the Constantin Costa-Gavras political thriller, set in Greece at the time of the colonels.

The Subject Was Roses, Martin Sheen, Jack Albertson, and Patricia Neal starred in Ulu Grosbard's screen version of Frank D. Gilroy's 1964 play.

The Swimmer, Burt Lancaster starred as the devastated suburbanite advertising man off the edge of madness in Frank Perry's film, based on a John Cheever short story.

The Yellow Submarine, the animated Beatles film; George Dunning directed.

Rosemary's Baby, Mia Farrow and John Cassavetes starred in Roman Polanski's film version of Ira Levin's novel, about a group of Manhattan devil worshippers.

2001: A Space Odyssey, Keir Dullea, Gary Lockwood, William Sylvester, and Daniel Richter starred in Stanley Kubrick's science fiction film; based on an Arthur C. Clarke story.

Rachel, Rachel, Joanne Woodward starred as the freedom-seeking small-town schoolteacher in Paul Newman's film, his first as director.

Albert Finney, Billie Whitelaw, Colin Blakely, and Liza Minnelli starred in *Charlie Bubbles*, set in northern England, screenplay by Shelagh Delaney; debuting were Finney as director and Minnelli on screen.

Charly, Cliff Robertson and Claire Bloom starred in the Ralph Nelson film, based on the Daniel Keyes story, *Flowers for Algernon*, about a retarded adult who gains and then again loses full acuity.

Funny Girl, Barbra Streisand and Omar Sharif starred in William Wyler's biofilm of Fannie Brice,

adapted by Isobel Lennart from her 1964 play, music by Jule Styne, words by Bob Merrill.

Ron Moody, Oliver Reed, Shani Wallis, and Mark Lester starred in the musical *Oliver!*, directed by Carol Reed.

Planet of the Apes, Charlton Heston starred in the Franklin J. Schaffner science fiction film, based on the 1963 Pierre Boulle novel.

Sergei Bondarchuk directed *War and Peace*.

Roger Vadim directed *Barbarella*, which featured his third wife, Jane Fonda.

Rowan and Martin's Laugh-In, Dan Rowan and Dick Martin starred in the television comedy series (1968–1973).

Academy Awards for 1968 (awarded the following year): Best Picture: *Oliver!*; Best Director: Sir Carol Reed, *Oliver!*; Best Actor: Cliff Robertson, *Charly*; Best Actress (tie): Katharine Hepburn, *The Lion in Winter*; Barbra Streisand, *Funny Girl*.

d. Dorothy Gish, American actress (b. 1898).

d. Anthony Asquith, British director (b. 1902).

d. Franchot Tone, American actor (b. 1905).

d. Finlay Currie, British actor (b. 1878).

d. Carl Dreyer, Danish director (b. 1899).

VISUAL ARTS

Giacomo Manzù's *Door of Peace and War* at St. Laurents Church, Rotterdam.

Andrew Wyeth's paintings included *Alvaro and Christina* and *Willard's Coat*.

Pablo Picasso's paintings included *Reclining Nude with Necklace*, *Reclining Woman with Bird*, and *Standing Nude and Seated Musketeer*.

Ludwig Mies van der Rohe designed the Gallery of the Twentieth Century, Berlin.

Joan Miró's painting *Red Accent in the Quiet*; and his mural for the "Labyrinthe" of the Fondation Maeght, Saint-Paul, France.

General Motors Building, New York, designed by Edward Durell Stone.

Horse Piece, Jim Dine's assemblage.

Frank Stella's painting *Hatra H. Sinjerli—Variation IV*.

Anghiari II, Robert Goodnough's painting.

Frank Stella began his "Protractor" series of paintings.

Richard Serra's sculpture *Splashing*.

Robert Morris's sculpture *Earthworks*.

Christo's construction the *Berne Kunsthalle*.

Romare Bearden's painting *Eastern Burn*.

Marisol's paintng *Portrait of Sidney Janis Selling Portrait of Sidney Janis by Marisol*.

Robert Rauschenberg's *Soundings*, interactive with its audience.

Walter De Maria's sculpture *Dirt Room, Mile Long Drawing*.

Marcel Breuer designed the Department of Housing and Urban Development, Washington, D.C.

Ellsworth Kelly's painting *Yellow Black, Green Blue*.

Juilliard School of Music, Lincoln Center, New York, designed by Harrison and Belluschi.

Laureate, Seymour Lipton's sculpture.

One Main Place, Dallas, designed by Skidmore, Owings, and Merrill.

Egyptian Temple of Dendur was installed at New York's Metropolitan Museum of Art.

d. Marcel Duchamp, French artist (b. 1887), who painted the landmark cubist *Nude Descending a Staircase, No. 2*, exhibited at the 1911 Armory Show.

d. Peter Arno (Curtis Arnoux Peters), American cartoonist (b. 1904), whose work often appeared in *The New Yorker*.

d. Erwin Panofsky, German art historian (b. 1892).

d. Harold Gray, American cartoonist (b. 1894).

d. William Zorach, American sculptor and painter (b. 1887).

THEATER & VARIETY

The Great White Hope, James Earl Jones and Jane Alexander starred in the Howard Sackler play, based on the life of African-American heavyweight champion Jack Johnson; opened at the Alvin Theatre, New York, October 3.

The Price, Arthur Miller's play, starred Arthur Kennedy, Pat Hingle, and Kate Reid.

Plaza Suite, Neil Simon's three one-act plays, starred Maureen Stapleton and George C. Scott, opened at the Plymouth Theatre, New York, February 14.

Promises, Promises, Burt Bacharach's musical, opened at the Shubert Theatre, New York, December 1.

Hal Holbrook, Lillian Gish, and Teresa Wright starred in Robert Anderson's *I Never Sang for My Father*.

In the Matter of J. Robert Oppenheimer, Heinar Kipphardt's play, starred Joseph Wiseman as witch-hunted atomic physicist Oppenhemier.

We Bombed in New Haven, Jason Robards and Diana Sands starred in Joseph Heller's play.

The Man in the Glass Booth, Robert Shaw's play, starred Donald Pleasence.

Alec Guinness starred in Eugène Ionesco's *Exit the King*.

The Boys in the Band, Mart Crowley's play on gay themes, opened at the Theatre Four, New York.

Julie Harris starred in Jay Allen's *Forty Carats*.

Joel Grey starred in *George M!*, about George M. Cohan.

Jacques Brel Is Alive and Well and Living in Paris, the New York cabaret show.

Lee J. Cobb starred in *King Lear*.

Marguerite Duras's *L'Amante anglaise*.

Peter Handke's *Kaspar*.

The Gingham Dog, Lanford Wilson's play.

The Increased Difficulty of Concentration, Václav Havel's play.

William Douglas Home's *The Secretary Bird*.

d. Tallulah Bankhead, U.S. actress (b. 1902), Regina Giddens in *The Little Foxes*.

d. Donald Wolfit, English actor–manager (b. 1902).

d. Howard Lindsay, American actor, writer, director, and producer (b. 1889).

d. Paul Vincent Carroll, Irish playwright (b. 1900).

Music & Dance

The Enigma Variations, Frederick Ashton's ballet, to music by Edward Elgar, first danced October 25 by the Royal Ballet, London.

Yellow Submarine, the Beatles' song; also *The Beatles*, called *The White Album*, including the enormous hit *Hey Jude*.

Spartacus, Yuri Grigorovich's new choreography to music by Aram Khachaturian's 1956 ballet music, first danced by the Bolshoi Ballet, in Moscow.

David Crosby, Stephen Stills, Graham Nash, and Neil Young formed the group Crosby, Stills, Nash, and Young (1968–1971).

Led Zeppelin was founded by Jimmy Page, John Bonham, Robert Plant, and John Paul Jones (John Baldwin).

The Story of My Life, hit song; music by Burt Bacharach, words by Hal David.

Benjamin Britten's choral work *Children's Crusade* and church parable *The Prodigal Son*.

Punch and Judy, Harrison Birtwistle's opera, libretto by Stephen Pruson, opened June 8 at the Aldeburgh Festival.

Iannis Xenakis's ballet music *Kraanerg*; orchestral work *Nomos gamma*; and choral work *Nuits*.

The Rolling Stones' album *Beggars Banquet*, including *Salt of the Earth* and *Sympathy for the Devil*.

Philip Glass formed the Philip Glass Ensemble, breaking down barriers between popular and classical music.

Hair, cast album from the musical, including the title song, *Aquarius*, and *Let the Sun Shine In*.

Wichita Lineman, Jim Webb's song, popularized by Glen Campbell.

Fleetwood Mac and *Mr. Wonderful*, Fleetwood Mac's albums.

Cheap Thrills, Janis Joplin's album.

Urban Blues, John Lee Hooker's album.

Help, Help, the Globolinks!, Gian Carlo Menotti's opera.

At Folsom Prison, Johnny Cash's album.

The Doors' albums *Strange Days* and *Waiting for the Sun*.

The Jefferson Airplane's album *Crown of Creation*.

Capriccio burlesco, William Walton's orchestral work.

Magic Bus, the Who's album.

Randy Newman album.

Simon and Garfunkel's album *Bookends*.

Domaines, Pierre Boulez's chamber music.

Miles in the Sky, Miles Davis's album.

Sail On, Muddy Waters's album.

Music from Big Pink, the Band's album.

Ulysses, Luigi Dallapicolla's opera.

The Promise of the Future, Hugh Masakela's album.

Stand By Your Man, Tammy Wynette's hit.

Harrison Birtwistle's *Nomos*, for orchestra.

d. Ruth St. Denis (Ruth Dennis), American dancer, choreographer (b. 1878).

d. Charles Münch, French conductor (b. 1891), longtime conductor of the Boston Symphony Orchestra (1949–1962).

d. Florence Austral, Australian soprano (b. 1894).

d. Karl-Birger Blomdahl, Swedish composer (b. 1916).

d. Ildebrando Pizzetti, Italian composer (b. 1880).

World Events

d. Martin Luther King, Jr., foremost African-American leader of the 20th century (b. 1929) and

worldwide symbol of nonviolence; assassinated by James Earl Ray in Memphis, Tennessee, on April 4.

Robert Francis Kennedy (b. 1925) was shot by Sirhan Sirhan in Los Angeles on June 5 while campaigning for the Democratic presidential nomination (d. June 6); brother of President John F. Kennedy and Senator Edward M. Kennedy.

North Vietnamese Tet Offensive (January–February) failed, but turned American public opinion decisively against continuation of the war, so often before then reported as "very nearly over." President Lyndon Johnson announced that he would not seek another term and declared a bombing pause; Paris peace negotiations soon began.

American platoon commanded by Lieutenant William L. Calley, Jr., committed mass murders of Vietnamese civilians and other atrocities at My Lai. Calley alone was later convicted.

Anti–Vietnam War activists, led by Catholic priests Daniel and Philip Berrigan, set fire to draft cards in a Catonsville, Maryland, draft board office; their trial was dramatized in *The Trial of the Catonsville Nine*.

Anti–Vietnam War protesters and police clashed violently at the Chicago Democratic National Convention, which ultimately nominated Hubert H. Humphrey.

Republican Richard M. Nixon defeated Democrat Hubert H. Humphrey, becoming the 37th president of the United States (1968–1974).

Prague Spring (January–December), a set of democratic reforms instituted by the Czech Communist reform government led by Alexander Dubček. Soviet troops took Czechoslovakia on August 20, forcing a return to hardline Communism.

Bikini Atoll, site of nuclear bomb tests, was declared safe and many returned to their homes, only to be evacuated again in 1978, when the earlier assessment proved overoptimistic.

North Korean forces seized the U.S.S. *Pueblo* and its crew in the Sea of Japan; ship and crew were released in 1969.

Protesting Columbia University students sat in at five campus buildings until removed by police, with hundreds of arrests.

U.S. Civil Rights Act of 1968 partially outlawed discrimination in housing.

French-Canadian politician René Lévesque founded the separatist Parti Québécois.

Pierre Elliot Trudeau became prime minister of Canada (1968–1979; 1980–1984).

Eldridge Cleaver's *Soul on Ice*.

René Dubos's *So Human an Animal*.

The Church and the Second Sex, Mary Daly's sharp feminist critique of Catholic practice.

1969

LITERATURE

Slaughterhouse-Five, or The Children's Crusade, Kurt Vonnegut's novel, set largely in bombed, firestormed Dresden during World War II.

The Nobel Prize for Literature was awarded to Samuel Beckett.

The French Lieutenant's Woman, John Fowles's novel, basis of the 1981 Karel Reisz film.

John Berryman's *Dream Songs*, consisting of his poetry collections *77 Dream Songs* (1964) and *His Toy, His Dream, His Rest* (1968).

them, Joyce Carol Oates's National Book Award–winning novel.

Portnoy's Complaint, Philip Roth's novel.

Susan Sontag's essays *Styles of Radical Will*.

The Bluest Eye, Toni Morrison's novel.

Conversation in a Cathedral, Mario Vargas Llosa's novel.

An Unfinished Woman, Lillian Hellman's autobiography.

The Book of Imaginary Beings, Jorge Luis Borges's short-story collection.

Joan Didion's essays *Slouching Towards Bethlehem*.

The Sea of Fertility (1969–1071), Yukio Mishima's four-volume novel.

Robert Lowell's *Notebooks 1967–68*.

The Edible Woman, Margaret Atwood's novel.

Elizabeth Bishop's National Book Award–winning *Complete Poems*.

Sakutaro Hagiwara's *Face at the Bottom of the World and Other Poems*.

Ada, Vladimir Nabokov's novel.

Adrienne Rich's poetry *Necessities of Life and Other Poems*.

Stevie Smith's poetry *The Best Beast*.

Yashar Kemel's *They Burn the Thistles*.

Anne Sexton's *Love Poems*.

The Waterfall, Margaret Drabble's novel.

Babette Deutsch's *Collected Poems*.

Randall Jarrell's *Complete Poems*.

Bernard Malamud's short stories *Pictures of Fidelman*.

Kenneth Patchen's *Collected Poems*.

Brian W. Aldiss's novel *Barefoot in the Head*.

In Transit, Brigid Brophy's novel.

Bullet Park, John Cheever's novel.

Joseph Brodsky's poetry *Song Without Music*.

Coffer Dams, Kamala Markandaya's novel.

Girls at Play, Paul Theroux's novel.

Kenneth Koch's poetry *The Pleasures of Peace*.

Going Down Fast, Marge Piercy's novel.

Jean Stafford's Pulitzer Prize–winning *Collected Stories*.

Robert Creeley's poetry *Pieces*.

d. B. Traven (perhaps Ret Marut or Hal Croves), reclusive German or American writer (b. 1890?), who never fully revealed his identity.

d. Jack Kerouac, American writer, oracle of the "Beat Generation" (b. 1926).

d. Max Eastman, American social critic (b. 1883).

d. Osbert Sitwell, British poet and essayist (b. 1892), the brother of Edith and Sacheverell Sitwell.

d. Stephen Potter, English humorist (b. 1900).

FILM & BROADCASTING

Midnight Cowboy, Jon Voight and Dustin Hoffman starred in the John Schlesinger film, set in the underside of 1960s American life.

The Damned, Dirk Bogarde, Ingrid Thulin, Helmut Griem, Helmut Berger, and Charlotte Rampling starred in the Luchino Visconti film, set in Nazi Germany.

The Prime of Miss Jean Brodie, Maggie Smith starred as the Edinburgh teacher in Ronald Neame's film version of the 1961 Muriel Spark novel.

Alice's Restaurant, Arthur Penn's film, inspired by the 1966 Arlo Guthrie song, and starring Guthrie, James Broderick, and Pat Quinn as Alice.

They Shoot Horses, Don't They?, Jane Fonda and Michael Sarrazin starred as 1930s dance marathon contest partners in the Sidney Pollack film.

Anne of the Thousand Days, Richard Burton starred as Henry VIII and Geneviève Bujold as Anne Boleyn in Charles Jarrott's screen version of the 1948 Maxwell Anderson play.

Bernardo Bertolucci wrote and directed *The Conformist*, starring Jean-Louis Trintignant.

Paul Newman, Robert Redford, and Katherine Ross starred in *Butch Cassidy and the Sundance Kid*, George Roy Hill's Western, screenplay by William Goldman.

Bob and Carol and Ted and Alice, Paul Mazursky's film about mate swapping in the sexually swinging America of the time; Natalie Wood, Robert Culp, Dyan Cannon, and Elliott Gould starred.

Easy Rider, Dennis Hopper's 1960s hippie motorcyclist film; starring were Hopper, Peter Fonda, and Jack Nicholson in the role that brought him fame.

Tell Them Willie Boy Is Here, Robert Blake as the young Native American on the run, Robert Redford as the sheriff, and Katharine Ross starred in the Abraham Polonsky film, his first since his 1951 blacklisting.

The Royal Hunt of the Sun, Robert Shaw and Christopher Plummer starred in Irving Lerner's screen version of the 1964 Peter Shaffer play.

Hello, Dolly!, Barbra Streisand starred as Dolly Levi in Gene Kelly's film version of the 1963 stage musical, with Walter Matthau and Louis Armstrong.

Isadora, Vanessa Redgrave starred as dancer Isadora Duncan in the Karel Reisz biofilm, with James Fox, Jason Robards, and Ivan Tchenko.

James Garner starred in *Marlowe*, directed by Paul Bogart.

John Wayne starred in *True Grit*, directed by Henry Hathaway.

Eric Rohmer directed *My Night at Maud's*.

Monty Python's Flying Circus (1969–1971), the British comedy television series, starring Graham Chapman, John Cleese, Eric Idle, Terry Jones, Michael Palin, and Terry Gilliam.

Oh! What a Lovely War, Laurence Olivier, John Mills, John Gielgud, Ralph Richardson, and Michael Redgrave led a multistar cast in Richard Attenborough's antiwar film, set during World War I; based on Joan Littlefield's 1963 play.

Sweet Charity, Shirley MacLaine starred as the dance-hall hostess in Bob Fosse's screen version of the stage musical.

Sesame Street, Joan Ganz Cooney's long-running children's television variety series (1969–).

Academy Awards for 1969 (awarded the following year): Best Picture: *Midnight Cowboy*; Best Director: John Schlesinger, *Midnight Cowboy*; Best Actor: John Wayne, *True Grit*; Best Actress: Maggie Smith, *The Prime of Miss Jean Brodie*.

d. Robert Taylor (Spangler Arlington Brugh), American actor (b. 1911).

d. Boris Karloff (William Henry Pratt), British actor (b. 1887); his was the definitive film *Frankenstein* (1931).

d. Josef von Sternberg, Vienna-born film director (b. 1894).

d. John Cassavetes, American director, actor, and screenwriter (b. 1929).

d. Leo McCarey, American director (b. 1898).

VISUAL ARTS

Andrew Wyeth's paintings included *End of Olson's*, *Sundown*, *The Bantrey*, and *Thin Ice*.

Pablo Picasso's paintings included *Couple with Bird*, *Seated Man with Sword*, and *The Smoker*.

Nelson Rockefeller donated his ethnic art ("primitive art") collection to New York's Metropolitan Museum of Art.

Robert Lehman's collection went to the Metropolitan Museum of Art.

Alfred Eisenstaedt's photo collection *The Eye of Eisenstaedt*.

Barnett Newman's painting *Jericho*.

Carl Andre's sculpture *144 Pieces of Lead*.

Double Negative, Michael Heizer's huge trench at Virgin River Mesa, Nevada.

Frank Stella's painting *Abra Variation I*.

Girl in a Doorway, George Segal's painting.

Helen Frankenthaler's paintings included *Commune* and *Stride*.

James Rosenquist's painting *Horse Blinders*.

I. M. Pei designed the John Hancock Center, Boston.

Laser Beam: Synthesizer, Michael J. Campbell and James Rockwell's kinetic sculpture.

Richard Serra's sculpture *House of Cards*.

Philip Pearlstein's painting *Nude Seated on Green Drape*.

Scarlet Diamond, Ilya Bolotowsky's painting.

The Painter's Mind, book by Romare Bearden, with Carl Holt.

d. Ludwig Mies van der Rohe, German architect, a leading modernist and International Style proponent (b. 1886).

d. Ben Shahn, American painter, printmaker, and photographer (b. 1898).

d. Bernard Berenson, American art critic and historian (b. 1865), an authority on the Italian painters of the Renaissance who was a leading authenticator of their works.

d. Daniel Fitzpatrick, American political cartoonist (b. 1891).

d. Frank O. King, American cartoonist, creator in 1918 of the *Gasoline Alley* comic strip (b. 1883).

d. Walter Gropius, German architect, designer, and teacher (b. 1883).

THEATER & VARIETY

Katharine Hepburn made her musical theater debut in Alan Jay Lerner's *Coco*.

Alec McCowen starred in Peter Luke's *Hadrian VII*.

In Celebration, Alan Bates starred in David Story's play, directed by Lindsay Anderson.

Maximilian Schell starred in John Osborne's *A Patriot for Me*.

Athol Fugard's *Boesman and Lena*, the third play in his Port Elizabeth trilogy.

Breath, the very, very brief Samuel Beckett play.

Blythe Danner, Keir Dullea, and Eileen Heckart starred in *Butterflies Are Free*; Leonard Gershe's play opened at the Booth Theatre, New York.

1776, Sherman Edwards's musical, starred Howard da Silva, William Daniels, and Ken Howard.

Ceremonies in Dark Old Men, Lonnie Elder's play, starred Billy Dee Williams.

Circle Repertory Company was founded.

Dear World, Jerry Herman's musical, starred Angela Lansbury and Milo O'Shea.

Delphine Seyrig appeared in Fernando Arrabal's *Le jardin des d'élices*.

Indians, Arthur Kopit's play, starred Stacy Keach and Sam Waterston.

The Last of the Red Hot Lovers, James Coco and Linda Lavin starred in the Neil Simon comedy; opened at the Eugene O'Neill Theatre, New York.

No Place to Be Somebody, Charles Gordone's play, opened at the New York Shakespeare Festival.

Oh, Calcutta!, Kenneth Tynan's nude musical, opened at the Eden Theatre, New York, June 17.

Henry Fonda starred in Thornton Wilder's *Our Town*.

Woody Allen starred in *Play It Again Sam*; opened at the Broadhurst Theatre, New York, February 12.

Tammy Grimes and Brian Bedford starred in Noël Coward's *Private Lives*.

Samuel Beckett was awarded the Nobel Prize for Literature.

Peter Nichols's *The National Health*.

Hanoch Levin's *The Adventures of Solomon Grip*.
Ola Rotimi's *Kurunmi*.
The Insurance, Peter Weiss's play.
d. Witold Gombrowicz, Polish novelist and playwright (b. 1904).
d. Franz Theodor Csokor, Austrian playwright (b. 1885).
d. Hallie Flanagan, American theater historian and organizer (b. 1890).
d. Lewis Thomas Casson, English actor and director (b. 1875).

MUSIC & DANCE

Woodstock, celebrated popular music festival, held on Max Yasgur's 600-acre farm at Bethel, New York (near Woodstock), on August 15–17, a high point of American counterculture, a peaceful and for some a quasi-religious experience; an estimated 400,000 people came to hear many of the leading folk and rock musicians of the day; the subject of a film, at least two albums, and various songs.
The Battle of Britain, William Walton's film score; also his orchestral work *Improvisations on an Impromptu of Benjamin Britten*.
Tommy, Peter Townshend's rock opera, performed by The Who in concert; Ken Russell directed the 1975 screen version; it was staged on Broadway in 1993.
The Beatles' albums *Yellow Submarine* and *Abbey Road*; also John Lennon's hit song *Give Peace a Chance*, by Lennon and the Plastic Ono Band.
The Taming of the Shrew, John Cranko's ballet, music by Kurt-Heinz Stolze, based on Shakespeare's play, first danced March 16 by the Stuttgart Ballet.
Ashley Hutchings, Maddy Prior, Gay Woods, Terry Woods, and Tim Hart founded the British folk band Steeleye Span; key later figures included Martin Carthy, Peter Knight, Rick Kemp, Bob Johnson, and Nigel Pegrum.
The Devils of Loudon, Krzysztof Penderecki's opera, libretto by Penderecki based on the John Whiting dramatization of the Aldous Huxley novel, opened in Hamburg, June 20.
Country Honk (Honky Tonk Woman) and *You Can't Always Get What You Want*, Rolling Stones hits.
Intermezzo, Eliot Feld's ballet, to music by Johannes Brahms, first danced June 29, by the American Ballet Company, at Spoleto.

Blood, Sweat, and Tears album, with the singles *Spinning Wheel*, *And When I Die*, and *You've Made Me So Happy*.
Dances at a Gathering, Jerome Robbins's ballet, to music by Frédéric Chopin, first danced May 8 by the New York City Ballet.
Allman Brothers founded (1969–1976), American blues heritage rock band, by Duane Allman, Gregg Allman, Butch Truchs, Dicky (Richard) Betts, Berry Oakley, and Jai Johanny Johanson (Jaimo or John Lee Johnson).
Olivier Messiaen's *The Transfiguration* (*La Tranfiguration de Notre Seigneur Jésus-Christ*), and his work for organ *Méditations sur le mystère de la Sainte Trinité*.
Quadrophonic (four-channel) sound-recording and playback systems were introduced.
Peter Maxwell Davies's orchestral works *Worldes blis* and *St. Thomas Wake*.
Karlheinz Stockhausen's orchestral work *Fresco* and chamber music *Für Dr. K.*
Earth, Wind, and Fire was formed by Maurice White and Verdine White.
Luigi Nono's vocal work *Un volto e del mare*, and his tape works *Musiche per Manzu* and *Non consumiamo Marx*.
Clouds, Joni Mitchell's album, including *Songs to Aging Children Come*, used in the 1969 film *Alice's Restaurant*.
John Denver's song *Leaving on a Jet Plane*, a hit for Peter, Paul and Mary.
Dmitri Shostakovich's *Symphony No. 14*.
Led Zeppelin I, their first album.
Harrison Birtwistle's *Down by the Greenwood Side* and *Cantata*.
Space Oddity, David Bowie's album.
John Cage's piano work *Cheap Imitation* and electronic work *HPSCHD*.
The Band's album *The Band*.
Vivian Fine's *Paean*.
The Doors' album *The Soft Parade*.
Synaphaï, Iannis Xenakis's orchestral work.
Recollections, Judy Collins's album.
B. B. King's album *Live and Well*.
Bayou Country, Creedence Clearwater Revival's album.
B. J. Thomas's hit single *Raindrops Keep Falling on My Head*.
Elliott Carter's *Concerto for orchestra*.
My Chérie Amour, Stevie Wonder's hit song.

Rod Stewart's album *An Old Raincoat Won't Ever Let You Down*.

György Ligeti's *Ramifications*, for strings.

Neil Diamond's song *Sweet Caroline*.

Luciano Berio's vocal works *Sinfonia* and *Questo vuol dire che*.

Alice Tully Hall opened at Lincoln Center for the Performing Arts, New York.

d. Ernest Ansermet, Swiss conductor (b. 1883).

d. Josh (Joshua Daniel) White, American singer and guitarist (b. 1908).

d. Frank Loesser, American songwriter (b. 1910).

d. Coleman Hawkins, American tenor saxophonist (b. 1904).

d. Irene Castle (Irene Foote), British ballroom dancer (b. 1893), partnered with her husband, Vernon Castle, until his 1918 death.

WORLD EVENTS

American forces began heavy, secret bombing of Cambodia (1969–1973).

Khmer Rouge forces began the Cambodian Civil War (1969–1975).

Neil Armstrong and Edwin Aldrin, Jr., left the *Apollo 11* lunar module and became the first people to walk on earth's moon (July 20).

Pentagon Papers, top-secret Southeast Asia Defense Department documents, were stolen by Daniel Ellsberg and published by the *New York Times*; the Supreme Court upheld the *Times*'s right to publish.

Muammar al-Qaddafi seized power in Libya, in a military coup.

Yasir Arafat became head of the Palestine Liberation Organization (PLO).

George Habash founded the terrorist Popular Front for the Liberation of Palestine.

Mohammed Siad Barre seized power in Somalia, in a military coup.

Massive Catholic demonstrations in Northern Ireland; Provisionals (Provisional Irish Republican Army) broke away from IRA; long guerrilla civil war began; British troops were sent to Northern Ireland in August.

Charles Manson and four others committed the cult murders of five people, including actress Sharon Tate and her unborn child, in Beverly Hills on August 9, and two more cult murders on August

11. Manson and his comurderers were sentenced to life terms.

Weathermen were founded; a splinter of the Students for a Democratic Society (SDS), its members going underground to mount a terror campaign against an American society they mistakenly thought was about to collapse.

Shirley Anita St. Hill Chisholm became the first African-American woman member of the House of Representatives (1969–1983).

Chappaquiddick incident: U.S. Senator Edward M. Kennedy failed for nine hours to inform police that Mary Jo Kopechne had drowned after he had driven the car in which they were riding off a bridge near Chappaquiddick Island.

Gay Liberation movement began, triggered by the June police raid on New York's Stonewall Inn.

Golda Meir became Israeli prime minister (1969–1973).

Quebec Liberation Front (Front de Libération du Québec) committed many terrorist bombings, kidnappings, and murders.

Elizabeth Kübler-Ross's *On Death and Dying*.

Michel Foucault's *The Archaeology of Knowledge*.

1970

LITERATURE

I Know Why the Caged Bird Sings, Maya Angelou's seminal African-American woman's autobiography; basis of the 1979 television film.

Alexander Solzhenitsyn was awarded the Nobel Prize for Literature.

Islands in the Stream, Ernest Hemingway's novel.

A Beggar in Jerusalem, Elie Wiesel's novel.

Andrei Voznesensky's poetry *Story Under Full Sail*.

Self Portrait in a Convex Mirror, John Ashbery's Pulitzer Prize–winning poetry collection.

Deliverance, James Dickey's novel, about a group of men on a whitewater river trip; basis of the 1972 John Boorman film.

The Exorcist, William Peter Blatty's demonic possession novel; basis of the 1973 William Friedkin film.

Fifth Business, Robertson Davies's novel.

Down All the Days, Christy Brown's novel.

Bech: A Book, John Updike's novel.

Fire from Heaven, Mary Renault's novel.

Nikki Giovanni's poetry *Poem of Angela Yvonne Davis* and *Re: Creation*.

Losing Battles, Eudora Welty's novel.

Ayi Kwei Armah's novel *Fragments*.

The Coming of Age, Simone de Beauvoir's study.

Local Anaesthetic, Günter Grass's novel.

Guest of Honor, Nadine Gordimer's novel.

Denise Levertov's essays *Relearning the Alphabet*.

Play It As It Lays, Joan Didion's novel.

Gwendolyn Brooks's *Family Pictures*.

John Gardner's novel *The Wreckage of Agathon*.

Vance Bourjaily's novel *Brill Among the Ruins*.

S. J. Perelman's *Baby, It's Cold Inside*.

Joseph Brodsky's *A Stop in the Desert: Verse and Poems*.

White Dog, Romain Gary's novel, basis of the 1982 Samuel Fuller film.

A. R. Ammons's poetry *Uplands*.

Louise Bogan's *Poet's Alphabet*.

John Berryman's autobiography *Love and Fame*.

Robert Creeley's poetry *The Finger*.

d. E. M. (Edward Morgan) Forster, British writer and critic (b. 1879).

d. Nelly Sachs, German Jewish writer, most notably of the Jewish Holocaust (b. 1891).

d. Erich Maria Remarque, German writer (b. 1898).

d. Yukio Mishima (Hiraoka Kimitake), Japanese writer; a right-wing ideologue, he publicly committed suicide as a form of protest against sociopolitical trends in modern Japan (b. 1925).

d. François Mauriac, French writer (b. 1885).

d. John Dos Passos, American writer (b. 1896).

d. Shmuel Yoseph Agnon (Samuel Yosef Czackzkes), Galician-Israeli writer (b. 1888).

d. John O'Hara, American writer (b. 1905).

d. Joseph Wood Krutch, American critic and nature writer (b. 1893).

d. Louise Bogan, American poet and critic (b. 1897).

d. Charles Olson, American poet (b. 1910).

d. Erle Stanley Gardner, American mystery writer (b. 1889).

FILM & BROADCASTING

The Sorrow and the Pity, the powerful Marcel Ophüls documentary, about Vichy France, the German occupation, the resistance of some and the complicity of others.

Women in Love, Glenda Jackson, Alan Bates, Oliver Reed, and Eleanor Bron starred in Ken Russell's screen version of the 1920 D. H. Lawrence novel, on sexual matters.

Patton, George C. Scott starred as World War II General George Patton in Franklin Schaffner's biofilm; screenplay by Francis Ford Coppola and Edmund North.

Five Easy Pieces, Jack Nicholson, Karen Black, and Susan Anspach starred in the Bob Rafelson film, about a young classical musician who ultimately finds himself.

Little Big Man, Dustin Hoffman, Faye Dunaway, and Chief Dan George starred in Arthur Penn's Western satire, based on the 1964 Thomas Berger novel.

*M*A*S*H*, Donald Sutherland and Elliott Gould starred as doctors in Robert Altman's Korean War black comedy; basis of the television series (1972–1983).

The Great White Hope, the Martin Ritt film version of the 1968 Howard Sackler play, based on the life of Black heavyweight champion Jack Johnson; James Earl Jones and Jane Alexander again starred.

Catch-22, the Mike Nichols film, based on Joseph Heller's 1961 anti-army satire; Alan Arkin, Richard Benjamin, Jack Gilford, and Art Garfunkel starred.

Cotton Comes to Harlem, Ossie Davis's film, based on the 1965 Chester Himes novel, set in Harlem; Godfrey Cambridge and Raymond St. Jacques starred.

Eric Rohmer directed *Claire's Knee*.

Gimme Shelter, the David and Albert Maysles Rolling Stones documentary, after their song.

I Never Sang for My Father, Gilbert Cates's film, adapted by Robert Anderson from his own play; Melvyn Douglas and Gene Hackman starred.

Investigation of a Citizen Above Suspicion, Gian Maria Volonte, Florinda Bolkan, Gianni Santuccio, and Salvo Randone starred in the Elio Petri murder mystery.

Robert Mitchum, Sarah Miles, and John Mills starred in *Ryan's Daughter*, directed by David Lean; so savaged by the critics that Lean would not make another film for 14 years.

Sidney Poitier starred in *They Call Me MISTER Tibbs*, a sequel to *In the Heat of the Night*.

Cliff Gorman and Laurence Luckinbill starred in *The Boys in the Band*, directed by William Friedkin.

The Mary Tyler Moore Show, her television situation comedy series (1970–1977); the cast included Edward Asner, Valerie Harper, and Cloris Leachman, all becoming television stars.

Upstairs, Downstairs, Gordon Jackson as Hudson and Jean Marsh led a large cast in the British television series (1970–1975), a period piece about a wealthy family and its servants.

Academy Awards for 1970 (awarded the following year): Best Picture: *Patton*; Best Director: Franklin Schaffner, *Patton*; Best Actor: George C. Scott, *Patton* (refused); Best Actress: Glenda Jackson, *Women in Love*.

d. Harry Stradling, American cinematographer (b. 1902), father of cinematographer Harry Stradling, Jr.; he shot both *Pygmalion* and *My Fair Lady*.

VISUAL ARTS

Philip Johnson designed the John F. Kennedy Memorial, Dallas.

Andrew Wyeth's paintings included *Evening at Kuerner's* and *Lynch*.

Georgia O'Keeffe's painting *Black Rock with Blue III*.

Pablo Picasso's paintings included *Reclining Nude with a Man Playing the Guitar* and *The Embrace*.

Romare Bearden's painting *Patchwork Quilt*.

Alice Neel's painting *Andy Warhol*.

Berkeley, Sam Francis's painting.

William L. Pereira designed the Central Library, University of California, San Diego.

Garry Trudeau created the comic strip *Doonesbury*.

Hyatt House, Chicago, designed by Portman, Grafton, and Spillis.

Jim Dine's painting *Twenty Hearts*.

Philip Guston's painting *Courtroom, Cellar*.

John Hancock Center, Chicago, designed by Skidmore, Owings, and Merrill.

Paolo Soleri designed the Outdoor Theatre at Santa Fe, New Mexico.

Philip Pearlstein's painting *Two Female Nudes with Red Drape*.

Red Grooms's painting *The Discount Store*.

Pier Luigi Nervi began the San Francisco Cathedral.

Robert Smithson's sculpture *Spiral Jetty*.

d. Mark Rothko (Marcus Rothkovich), American artist (b. 1903); among his final works was the mural for the Institute of Religion and Human Development of the Texas Medical Center, Houston.

d. Lawren Stewart Harris, Canadian artist (b. 1885), a member of the Group of Seven.

d. Naum Gabo (Naum Neemia Pevsner), Russian artist (b. 1890), with his brother of Antoine Pevsner a key figure in the constructivist movement.

d. Barnett Newman, American artist (b. 1905), a leading abstract expressionist.

d. Richard Neutra, Austrian architect (b. 1892).

d. Rube Goldberg (Reuben Lucius Goldberg), inventive American cartoonist (b. 1883).

d. William Dobell, Australian painter (b. 1899).

THEATER & VARIETY

Home, John Gielgud and Ralph Richardson starred as quite sane mental patients in David Storey's mental institution, his metaphor for contemporary Britain.

James Earl Jones and Ruby Dee starred in Athol Fugard's *Boesman and Lena*.

Company, Elaine Stritch and Dean Jones starred in Stephen Sondheim's musical; opened at the Alvin Theatre, New York, April 26.

The Effect of Gamma Rays on Man-in-the-Moon Marigolds, Sada Thompson starred in the Paul Zindel play; opened in New York.

Peter Brook mounted a highly experimental, controversial production of *A Midsummer Night's Dream*; in the same year, he founded the International Centre of Theatrical Research.

A Voyage Round My Father, John Mortimer's autobiographical play.

Lauren Bacall and Len Cariou starred in *Applause*, the Charles Strouse and Lee Adams musical.

Borstal Boy, Brendan Behan's play, starred Niall Tolbin and Frank Grimes.

Child's Play, Robert Marasco's play, starred Pat Hingle and Fritz Weaver.

Colette, Elinor Jones's play, starred Zoë Caldwell and Emlyn Williams.

Paul Jones and Jeremy Clyde starred in Barrie England's *Conduct Unbecoming*.

Purlie, Gary Geld and Peter Udell's musical version of *Purlie Victorious*, starred Melba Moore, Cleavon Little, and John Heffernan.

Happy Birthday, Wanda June, Kurt Vonnegut's play, starred Marsha Mason and Kevin McCarthy.

James Stewart and Helen Hayes starred in Mary Chase's *Harvey*.

Junji Kinoshita's *Between God and Man: A Judgment on War Crimes*.

Anthony Quayle and Keith Baxter starred in Anthony Shaffer's *Sleuth*.

Steambath, Bruce Jay Friedman's play, starred Anthony Perkins.

The Friends, Arnold Wesker's play.

Neil Simon's *The Gingerbread Lady* starred Maureen Stapleton.

Colleen Dewhurst starred in the title role in Bertolt Brecht's *The Good Woman of Setzuan*.

Lemon Sky, Lanford Wilson's play.

Vivat! Vivat Regina!, Robert Bolt's play.

Ray Lawler's *A Breach in the Wall*.

Slag, David Hare's play.

Ronald Millar's *Abelard and Heloise*.

The Guerrillas, Rolf Hochhuth's play.

Trotsky in Exile, Peter Weiss's play.

d. Gypsy Rose Lee (Rose Louise Hovick), American actress, dancer, and writer, best known as a stripper in burlesque (b. 1914).

d. Billie Burke, American actress (b. 1885).

d. Arthur Adamov, Russian-born French playwright (b. 1908).

d. Fernand Crommelynck, French-language Belgian playwright (b. 1888).

MUSIC & DANCE

Let It Be, the Beatles' final album and hit single, released after the group had split.

George Harrrison's solo debut album *All Things Must Pass*, including *My Sweet Lord*.

Bridge over Troubled Water, title song of the 1970 Paul Simon–Art Garfunkel album, words and music by Simon; recorded by many others, notably Willie Nelson.

Michael Tippett presented a new opera, to his own libretto, at Covent Garden in London, *The Knot Garden*, opening December 2; he also completed *Songs for Dov* and the choral work *The Shires Suite*.

Sweet Baby James, James Taylor's album, emblematic of the 1960s, including *Fire and Rain*.

Who Cares?, George Balanchine's ballet, music by George Gershwin, first danced February 5, by the New York City Ballet.

The Grateful Dead's albums *Live Dead*, *Workingman's Dead*, and *American Beauty*.

Nicholas Maw's opera *The Rising of the Moon*, premiered at Glyndebourne.

Harrison Birtwhistle's orchestal work *The Triumph of Time* and vocal/instrumental work *Nenia: the Death of Orpheus*.

Natalia Makarova took political asylum in the West while on tour in London.

Pierre Boulez's orchestral work *Éclat/Multiples* and *Cummings ist der Dichter*.

Joni Mitchell's album *Ladies of the Canyon*, including *Big Yellow Taxi* and *Woodstock*.

When Lilacs Last in the Dooryard Bloomed, Roger Sessions's vocal work.

Judy Collins's album *Whales and Nightingales*, including her enormously popular version of *Amazing Grace* and *Farewell to Tarwathie*, accompanied by whale sounds.

Nocturnal Dances, Peter Maxwell Davies's ballet.

The Doors' album *Absolutely Live*.

Gian Carlo Menotti's *Triple Concerto*.

Milton Babbitt's third and fourth string quartets.

Bitches Brew, Miles Davis's album.

Kosmogonia, Krzysztof Penderecki's choral work.

Please to See the King, Steeleye Span's album.

Luciano Berio's avant-garde opera *Opera*.

Stage Fright, The Band's album.

Ain't No Mountain High Enough, Diana Ross's hit.

Sicut umbra, Luigi Dallapiccola's work for solo voice and ensemble.

Cosmo's Factory, Creedence Clearwater Revival's album.

Hugh Masakela's album *Reconstruction*.

Luigi Nono's choral work *Y entonces comprendió*.

Elton John's albums *Elton John* and *Tumbleweed Connection*.

Eric Clapton, his first solo album.

Muddy Waters's album *They Call Me Muddy Waters*.

Neil Diamond's song *Cracklin' Rosie*.

Randy Newman's album *12 Songs*.

Sardakai, Ernst Krenek's dramatic musical work.

György Ligeti's *Chamber Concerto*.

Witold Lutoslawski's *Concerto for Cello*.

Joe Hill, Alan Bush's opera.

First electric piano with steel tines, instead of strings; developed by Harold Rhodes.

d. George Szell, Czech-American conductor (b. 1897).

d. Janis Joplin, American blues singer (b. 1943); the 1980 film *The Rose* was loosely based on her life and death, from a heroin overdose.

d. Jimi Hendrix, American rock guitarist and singer (b. 1942); his death was drink- and drug-related.

d. John Barbirolli, English conductor (b. 1899).

d. Jani Christou, Greek composer (b. 1926).

WORLD EVENTS

American and South Vietnamese forces invaded Cambodia, triggering massive American antiwar protests that quickly forced withdrawal.

Ohio National Guard troops killed four unarmed student Vietnam War protesters at Kent State University.

Prosecuted in the aftermath of the Chicago Democratic National Convention, the Chicago Seven were all found guilty; but in 1972 all convictions were reversed and Judge Julius Hoffman was censured for prejudicial behavior during their trial.

Cambodian leader Norodom Sihanouk was deposed in a military coup led by Lon Nol.

Bengal cyclone killed an estimated 200,000–500,000 people.

Biafra surrendered in the Biafra–Nigerian civil war.

Hafez al Assad seized power in Syria, in a military coup.

Jordan's army fought and defeated PLO forces headquartered in Jordan, and expelled the PLO army.

Black Panther leaders Fred Hampton and Mark Clark were killed by attacking police in Chicago.

Edward Heath became Conservative British prime minister, succeeding Labour leader Harold Wilson.

Terrorist actions increased in Quebec; the Canadian government sent in troops and made mass arrests in the "October crisis."

U.S. Environmental Protection Agency (EPA) was created by the National Environmental Protection Act.

Earthquake in Peru triggered Mount Huascarán avalanche; an estimated 50,000–70,000 died (May 31).

Eve Figes published *Patriarchal Attitudes*, a key theoretical work in the women's liberation movement.

Germaine Greer's *The Female Eunuch*.

Robin Morgan's *Sisterhood Is Powerful*.

Shulamith Firestone's *The Dialectic of Sex: The Case for Feminist Revolution*.

1971

LITERATURE

Pablo Neruda was awarded the Nobel Prize for Literature.

Wallace Stegner's Pulitzer Prize–winning novel *Angle of Repose*.

August, 1914, Alexander Solzhenitsyn's novel.

Song for an Equinox, poetry by St.-John Perse.

The Book of Daniel, E. L. Doctorow's novel, about the Rosenberg case.

Rabbit Redux, John Updike's novel, second in the Rabbit quartet.

The Winds of War, Herman Wouk novel, covering the early portion of World War II, to the Pearl Harbor attack; basis of the 1983 television miniseries; sequel was *War and Remembrance* (1978).

The Towers of Silence, third volume of Paul Scott's *The Raj Quartet*, dramatized as *The Jewel in the Crown*.

Being There, Jerzy Kosinski's novel, basis of the 1979 Hal Ashby film; also Kosinski's novel *Steps*.

Galway Kinnell's poetry *The Book of Nightmares* and *The Lackawanna Elegy*.

Kofi Awoonor's poetry *Night of My Blood* and novel *This Earth, My Brother*.

Love in the Ruins, Walker Percy's novel.

The Underground Man, Ross Macdonald's Lew Archer detective novel.

Ayi Kwei Armah's novel *Are We So Blest*.

Briefing for a Descent into Hell, Doris Lessing's novel.

A. R. Ammons's poetry *Briefings* and *Collected Poems*.

Shirley Ann Grau's novel *The Condor Passes*.

Come Softly to My Wake: The Poems of Christy Brown.

Death of the Fox, George Garrett's Elizabethan novel on Sir Walter Raleigh.

Intensive Care, Janet Frame's novel.

John Gardner's novel *Grendel*.

Sylvia Plath's poetry *Crossing the Water*.

John Knowles's novel *The Paragon*.

Cynthia Ozick's *The Pagan Rabbi and Other Stories*.

The Blood Oranges, John Hawkes's novel.

Denise Levertov's essays *To Stay Alive*.

St. Urbain's Horsemen, Mordecai Richler's novel.

Ferdinand Léopold Oyono's novel *The Big Confusion*.

Jungle Lovers, Paul Theroux's novel.

Robert Creeley's poetry *St. Martin's*.

Ms. magazine was founded, with Gloria Steinem as its first editor (1971–1987).

d. Stevie (Florence Margaret) Smith, British writer and illustrator (b. 1902).

d. George Seferis (Georgios Seferiades), Greek poet (b. 1900).

d. Walter Van Tilburg Clark, American writer (b. 1909).

d. George Lukács, Hungarian literary critic (b. 1885).

d. Ogden Nash, American poet, a popular satirist (b. 1902).

d. August Derleth, American author (b. 1909).

d. Manfred Lee, American mystery writer, with Frederic Dannay the cocreator of Ellery Queen (b. 1905).

FILM & BROADCASTING

The French Connection, Gene Hackman, Roy Scheider, and Fernando Rey starred in the William Friedkin film, a police drama set in the New York drug trade.

The Garden of the Finzi-Continis, the Vittorio De Sica film, about a well-to-do Italian-Jewish family smashed by Fascism; Dominique Sanda, Lino Capolicchio, and Helmut Berger starred.

Sunday, Bloody Sunday, Glenda Jackson, Peter Finch, and Murray Head starred in John Schlesinger's story of complicated and ambiguous sexual relationships.

Klute, Jane Fonda as call girl Bree Daniels and Donald Sutherland starred in the Alan J. Pakula thriller, set in the underside of New York City life.

The Go-Between, Julie Christie, Alan Bates, Dominic Guard, Edward Fox, and Michael Redgrave starred in the Joseph Losey film, set in pre–World War I Britain; Harold Pinter's screenplay was based on the L. P. Hartley novel.

The Last Picture Show, Timothy Bottoms, Jeff Bridges, Cloris Leachman, and Ben Johnson starred in the Peter Bogdanovich film, set in a 1950s Texas town; based on the Larry McMurtry novel.

A Clockwork Orange, the Stanley Kubrick film, starring Malcolm McDowell, based on the 1962 Anthony Burgess novel; withdrawn for circulation in Britain for fear of inciting violence.

Billy Jack, a film directed and cowritten by Tom Laughlin; he also starred as a contemporary Southwestern rebel; there were two sequels (1974, 1977).

Carnal Knowledge, the Mike Nichols film, on 1960s themes; Jack Nicholson, Art Garfunkel, Ann-Margret, and Candice Bergen starred.

The Emigrants, Max von Sydow and Liv Ullmann starred in the Jan Troell film, about 19th-century Swedish immigrants to America; based on the 1949 Carl Moberg novel.

Clint Eastwood starred as *Dirty Harry* in Don Siegel's police action film, first of several.

Clint Eastwood made his directing debut and also starred in *Play Misty for Me*.

Fiddler on the Roof, the Norman Jewison film, based on the 1964 stage musical; Topol starred.

Sean Connery starred in *Diamonds Are Forever*, directed by Guy Hamilton.

McCabe and Mrs. Miller, Warren Beatty and Julie Christie starred in Robert Altman's demythologized saga of the pioneer Northwest.

Happy Birthday, Wanda June, Rod Steiger and Susannah York starred in Mark Robson's screen version of the 1970 Kurt Vonnegut play.

Elizabeth R, Glenda Jackson starred as Elizabeth I of England and Robert Hardy as Leicester in the six-part television miniseries.

Masterpiece Theatre premiere of the television drama anthology series, presented on public television (1971–), hosted by Alistair Cooke through 1992.

McMillan and Wife, the television detective series, starring Rock Hudson (1971–1977).

Peter Falk starred in the television series *Columbo* (1971–1978, and again in the early 1990s).

Carroll O'Connor was bigoted Archie Bunker in the television series *All in the Family* (1971–1983).

Academy Awards for 1971 (awarded the following year): Best Picture: *The French Connection*; Best Director: William Friedkin, *The French Connection*; Best Actor: Gene Hackman, *The French Connection*; Best Actress: Jane Fonda, *Klute*.

d. Paul Lukas (Pal Lukács), Hungarian-American actor (b. 1894).

d. Van Heflin (Emmett Evan Heflin, Jr.), American actor (b. 1910).

VISUAL ARTS

Andrew Wyeth's paintings included *The Kuerners* and *Anna Kuerner*.

Georgia O'Keeffe's paintings included *Black Rock with Red* and *Black Rock wth Blue Sky and White Clouds*.

Pablo Picasso's paintings included *Man Writing, Standing Bather*, and *Flautist*.

Alexander Calder's sculpture *Animobiles*.

Chatham XI: Blue Yellow, Ellsworth Kelly's painting.

Red Grooms's painting *Mr. and Mrs. Rembrandt*.

Claes Oldenburg's sculpture *Three Way Plug, Scale A (Soft)*, *Prototype in Blue*.

Louise Nevelson's welded steel sculpture for the Seagram Building, New York.

I. M. Pei's work included the National Airlines Terminal at J. F. Kennedy Airport, New York, and the Cleo Rodgers Memorial Library, Columbia, Indiana.

Jasper Johns's painting *Decoy*.

Yousuf Karsh's portrait photo collection *Faces of Our Time*.

Gordon Bunshaft designed the Lyndon Baines Johnson Library at Austin, Texas.

Lynda Benglis's sculpture *For Darkness; Situation and Circumstance*.

Helen Frankenthaler's painting *Chairman of the Board*.

John C. Portman designed San Francisco's Hyatt-Regency Hotel.

Ludwig Mies van der Rohe designed Chicago's IBM Building.

Mark di Suvero's sculpture *Il Ook*.

John Johnson designed the Mummer's Theater, Oklahoma City, Oklahoma.

Pier Luigi Nervi's work included the Vatican City Auditorium and the Coliseum, Richmond, Virginia.

Robert Morris's sculpture *Observatory*.

d. Margaret Bourke-White, American photographer (b. 1906).

d. Rockwell Kent, American illustrator and painter (b. 1882).

d. Diane Arbus, American photographer (b. 1923), notably of American grotesques.

d. Coco Chanel, French fashion designer (b. 1883).

THEATER & VARIETY

The House of Blue Leaves, William Atherton and Anne Meara starred in John Guare's play; opened at the Truck and Warehouse Theatre, New York.

Sam Waterston and Michael Moriarty starred in Daniel Berrigan's *The Trial of the Catonsville Nine*.

Jesus Christ Superstar, Andrew Lloyd Webber's rock opera, starred Ben Vereen and Jeff Fenhold; Norman Jewison directed the 1973 film.

Claire Bloom starred in Henrik Ibsen's *A Doll's House* and *Hedda Gabler*.

All Over, Edward Albee's play, starred Jessica Tandy, Colleen Dewhurst, George Voskovec, and Betty Field.

Long Day's Journey into Night, Eugene O'Neill's play, starred Robert Ryan, Stacy Keach, and Geraldine Fitzgerald.

Simon Gray's *Butley*, set in British academe, starred Alan Bates; he also played the role in Harold Pinter's 1975 film.

Stephen Sondheim's *Follies* starred Alexis Smith, Dorothy Collins, Gene Nelson, and Yvonne DeCarlo.

Godspell, Stephen Schwartz's musical, opened at the Cherry Lane Theatre, New York, May 17.

How the Other Half Loves, Alan Ayckbourn's play, starred Phil Silvers and Sandy Dennis.

No, No, Nanette, Vincent Youmans's musical, starred Ruby Keeler, Helen Gallagher, Patsy Kelly, and Jack Gilford.

Old Times, Harold Pinter's play, starred Robert Shaw, Mary Ure, and Rosemary Harris.

James Earl Jones starred in *Othello*.

Lee Grant and Peter Falk starred in *The Prisoner of Second Avenue*; the Neil Simon comedy opened at the Eugene O'Neill Theatre, New York.

Brian Bedford starred in Richard Wilbur's translation of Molière's *School for Wives*.

Sticks and Bones, David Rabe's play, starred Tom Aldredge.

The Basic Training of Pavlo Hummel, David Rabe's play, opened at the Public Theatre, New York.

The Changing Room, David Story's play, set in a rugby milieu.

Ola Rotimi's *Ovonramwen Nogbaisiz*.

Robert Anderson's *Solitaire/Double Solitaire*.

Wole Soyinka's play *Madmen and Specialists*.

Peter Handke's *Der Ritt über den Bodensee*.

Guillaume Oyono-Mbia's *Our Daughter Will Never Get Married*.

Peter Nichols's play *Forget-Me-Not Lane*.

The Story of a Humble Christian, Ignazio Silone's play.

Paul Zindel's play *And Miss Reardon Drinks a Little*.

West of Suez, John Osborne's play.

d. Tyrone Guthrie, British director and actor (b. 1900).

d. Gladys Cooper, English actress (b. 1888).

d. Dennis King, British-American actor and singer (b. 1897).

d. Jean Vilar, French actor, manager, and director (b. 1912).

MUSIC & DANCE

George Harrison inspired the Bangladesh benefit concert, and oversaw the film and Grammy-winning record made from it.

Imagine, John Lennon's solo album, with its haunting title song.

Paul McCartney founded the group Wings.

Always on My Mind, Willie Nelson's hit song and album; words and music by Johnny Christopher, Mark James, and Wayne Thompson.

The Goldberg Variations, Jerome Robbins's ballet, to the music of Johann Sebastian Bach, first danced May 27 by the New York City Ballet.

Anastasia, Kenneth MacMillan's ballet premiered at the Royal Ballet, London, July 22, with Lynn Seymour in the title role.

Owen Wingrave, Benjamin Britten's opera, libretto by Myfanwy Piper, based on the Henry James story; televised on BBC May 16.

James Taylor's album *Mud Slide Slim and the Blue Horizon*, and his hit version of Carole King's *You've Got a Friend*.

Krzysztof Penderecki's *Actions* for 14 jazz instruments; *Partita* for harpsichord; *Praeludium* for woodwind and double bass; and choral/orchestral work *Utrenja*.

The Eagles (1971–1981) was formed, by Bernie Leadon, Glenn Frey, Randy Meisner, and Don Henley.

Harrison Birtwistle's vocal/instrumental work *Meridian* and *An Imaginary Landscape*, for orchestra.

Help Me Make It Through the Night, Kris Kristofferson's popular song.

Tempus destruendi—Tempus aedificanci, Luigi Dallapiccola's choral work.

John Denver's hit song, *Take Me Home, Country Roads*.

The Most Important Man, Gian Carlo Menotti's opera.

Blue, Joni Mitchell's album, featuring *My Old Man*.

Ravi Shankar's first sitar concerto.

Judy Collins's album *Both Sides Now*.

Alvin Ailey's dance work *Cry*.

Antikhthon, Iannis Xenakis's ballet.

Bonnie Raitt, her first album.

Beatrix Cenci, Alberto Ginastera's opera.

Pendulum, Creedence Clearwater Revival's album.

Leonard Bernstein's theater piece *Mass*.

Randy Newman's album *Live*.

Elliott Carter's third string quartet.

Every Picture Tells a Story, Rod Stewart's album.

The Man Who Sold the World, David Bowie's album.

Der Besuch der alten Dame, Gottfried von Einem's opera.

Cahoots, the Band's album.

Agnus, Luciano Berio's vocal work.

L.A. Woman, the Doors' album.

The Grateful Dead album.

B. B. King's album *Live in Cook County Jail*.

Benjamin Britten's fourth canticle.

Tapestry, Carole King's album, with *It's Too Late*.

American Pie, Don McLean's album.

Occasional Variations, Milton Babbitt's tape work.

I'm Still Waiting, Diana Ross's album.

Melodien, György Ligeti's orchestral work.

Coat of Many Colors, Dolly Parton's autobiographical album.

Hugh Maskela and the Union of South Africa, Hugh Masakela's album.

Ein Gespenst geht um in der Welt, Luigi Nono's choral work.

Pierre Boulez became conductor of the New York Philharmonic (1971–1978).

American Musical Instrument Society founded.

d. Igor Stravinsky, Russian composer (b. 1882).

d. Louis "Satchmo" Armstrong, American trumpeter, cornettist, singer, and bandleader (b. 1901).

d. Lil Armstrong (Lillian Hardin), American jazz pianist, singer, and bandleader (b. 1898), first wife of Louis Armstrong; she played with King Oliver and then the Hot Five and Hot Seven, before going on her own.

d. Thomas Beecham, British conductor, founder of the New Symphony Orchestra, National Opera Company, London Philharmonic, and Royal Philharmonic (b. 1869).

d. Jim Morrison, lead singer of the rock group the Doors (b. 1943), whose career was profiled in the 1991 film *The Doors*; his Paris death was drug-related.

WORLD EVENTS

Pakistani forces attacked India on December 3, and were defeated in a two-week war that ended on December 16 when the Indians took Dacca and 90,000 Pakistani prisoners. The Bangladesh War of Independence also ended, with Bangladesh establishment of an Indian-backed independent nation, with Mujibur Rahman its first president.

Soviet *Salyut 1* became the world's first space station.

American space probe *Mariner 9* went into orbit around Mars (November).

American–Soviet Nuclear Accidents Agreement, an attempt to limit the possibility of nuclear war arising from misunderstanding.

Attica Prison riot: 1,500 police stormed and took the prison, killing 28 inmates and 9 hostages, caught in police crossfire (September 9).

Saddam Hussein took full power in Iraq.

Guerrilla warfare began in Rhodesia, then growing into the long Zimbabwe–Rhodesia civil wars (1971–1984).

Idi Amin seized power in Uganda.

United Nations ratified the Biological Warfare Ban Treaty.

Marcian (Ted) Hoff developed the computer microprocessor (chip).

Man's World, Woman's Place, Elizabeth Janeway's key work for millions of women then moving into a wider world.

Roy Medvedev's *Let History Judge*, on the crimes of the Stalin period; Roy and Zhores Medvedev's *A Question of Madness*.

d. Lin Biao, Chinese Communist leader (b. 1907), Mao Zedong's heir-apparent, in a plane crash, said by the Chinese government to have occurred while he was fleeing after a failed coup attempt.

1972

LITERATURE

Gabriel García Márquez's *Innocent Eréndira and Other Stories*.

Heinrich Böll was awarded the Nobel Prize for Literature.

Maurice, E. M. Forster's novel on homosexual themes, first published; written in 1913–1914 and published posthumously.

The Wanderers, Ezekiel Mphahlele's novel, set in the black South African experience.

The Optimist's Daughter, Eudora Welty's Pulitzer Prize–winning novel.

The Man Died: Prison Notes of Wole Soyinka.

Burr and *Myron*, Gore Vidal's novels.

Maxine Kumin's Pulitzer Prize–winning *Up Country; Poems of New England*.

Chimera, John Barth's National Book Award–winning collection of short fiction.

John Gardner's novel *The Sunlight Dialogues*.

Nadine Gordimer's short stories *Livingstone's Companions*.

Scars on the Soul, Françoise Sagan's novel.

From the Diary of a Snail, Günter Grass's novel.

Sylvia Plath's poetry *Winter Dreams*.

Daughter Buffalo, Janet Frame's novel.

Nikki Giovanni's poetry *My House*.

The Queen of a Distant Country, John Braine's novel.

Denise Levertov's essays *Footprints*.

Eugenio Montale's poetry *Xenia*.

Love Affair, Wright Morris's novel.

Robert Creeley's poetry *A Day Book*.

Ira Levin's novel *The Stepford Wives*.

d. Edmund Wilson, American writer, critic, and editor (b. 1895).

d. Ezra Pound, American writer, critic, and translator, a major modern poet whose life was adversely colored by his Fascism, anti-Semitism, and broadcast support of the Fascist cause during World War II (b. 1885).

d. Yasunari Kawabata, Japanese writer (b. 1899).

d. Marianne Moore, American poet (b. 1887).

d. John Berryman, American poet (b. 1914), a suicide.

d. Kenneth Patchen, American poet (b. 1911).

d. Betty Smith, American novelist (b. 1904).

d. Mark Van Doren, American writer and critic, brother of Carl Van Doren (b. 1894).

FILM & BROADCASTING

Charles Chaplin was awarded a special Academy Award for his work, and returned to the United States to accept it, his first visit since his blacklisting during the McCarthy years.

The Godfather, Marlon Brando starred as Don Vito Corleone, with Al Pacino, Robert Duvall, James Caan, and Diane Keaton, in the Francis Ford

Coppola Mafia story, screenplay by Coppola and Mario Puzo, based on the Puzo novel. Coppola did two sequels (1974, 1991).

Ingmar Bergman directed *Cries and Whispers*, starring Harriet Andersson, Ingrid Thulin, and Liv Ullmann.

The Discreet Charm of the Bourgeoisie, the Luis Buñuel satire, set at a French dinner party; Fernando Rey, Delphine Seyrig, Stephane Audran, Bulle Ogier, and Jean-Pierre Cassel starred.

James Garner, Katharine Ross, and Hal Holbrook starred in *They Only Kill Their Masters*, directed by James Goldstone.

Cabaret, Liza Minnelli, Michael York, and Joel Grey starred in the Bob Fosse film, set in Weimar Berlin; based on the 1966 Fred Ebb–John Kander musical, itself based on John Van Druten's 1951 play, *I Am a Camera*, from Christopher Isherwood's 1939 *Goodbye to Berlin*.

Jesus Christ Superstar, Ted Neeley and Carl Anderson starred in Norman Jewison's screen version of the 1971 Andrew Lloyd-Webber rock opera, with lyrics by Tim Rice.

Sounder, Kevin Hooks, Paul Winfield, and Cicely Tyson starred as the African-American farm family in Depression-era Louisiana in Martin Ritt's drama; based on the Lonnie Elder novel.

Man of La Mancha, Peter O'Toole as Cervantes and Don Quixote and Sophia Loren starred in the screen version of the 1965 Dale Wasserman stage musical.

Play It Again, Sam, the Herbert Ross film, adapted by Woody Allen from his 1969 play; Allen again starred, opposite Diane Keaton.

Robert Redford starred in *Jeremiah Johnson*, directed by Sydney Pollack.

Laurence Olivier and Michael Caine starred in *Sleuth*, directed by Joseph L. Mankiewicz.

State of Siege, the Constantin Costa-Gavras film, a political thriller set in Uruguay; Yves Montand starred.

Robert Redford and Melvyn Douglas starred in *The Candidate*, directed by Michael Ritchie.

The New Land, Max von Sydow and Liv Ullmann starred in the Jan Troell film, about 19th-century Swedish immigrants to America; based on the 1952 and 1963 Carl Moberg novels.

The Sound and the Fury, Yul Brynner, Joanne Woodward, and Margaret Leighton starred in Martin Ritt's film from William Faulkner's 1929 novel.

A Day in the Death of Joe Egg, Alan Bates and Janet Suzman starred in Peter Medak's film version of Peter Nichols's 1967 black comedy.

Lina Wertmuller directed *The Seduction of Mimi*.

*M*A*S*H*, Alan Alda and Wayne Rogers starred in the television series, based on the 1970 Robert Altman film (1972–1983).

The Streets of San Francisco, the television series starred Karl Malden and Michael Douglas (1972–1976).

The Waltons, Richard Thomas, Ralph Waite, Michael Learned, and Will Geer starred in the television drama series, set in the 1930s South (1972–1981).

Academy Awards for 1972 (awarded the following year): Best Picture: *The Godfather*; Best Director: Bob Fosse, *Cabaret*; Best Actor: Marlon Brando, *The Godfather* (refused); Best Actress: Liza Minnelli, *Cabaret*.

d. Miriam Hopkins (Ellen Miriam Hopkins) American actress (b. 1902).

d. George Sanders, British actor (b. 1905).

d. William Dieterle, German actor and director (b. 1893).

d. John Grierson, British documentary filmmaker (b. 1898).

d. Asta Nielsen, Danish actress (b. 1883).

d. William Boyd, American actor (b. 1898).

VISUAL ARTS

London's Tate Gallery bought a piece of modernist Carl Andre's "land art," in the form of unjoined stacks of bricks, setting off a notable 20th-century "Is it art?" controversy.

Michelangelo's *Pietà* in St. Peter's basilica was badly damaged by a deranged man with a 12-pound hammer.

Christo wrapped one million square feet of the Australian coastline in plastic sheeting, as an artwork.

Edward Durell Stone designed the John F. Kennedy Center for the Performing Arts, Washington, D.C.

Pablo Picasso's paintings included *Musician* and *The Embrace*.

Andrew Wyeth's paintings included *Bale* and *Nogeeshik*.

Georgia O'Keeffe's painting *The Beyond*.

Slate Grey Statement, Robert Goodnough's painting.

Robert Mangold's painting *Incomplete Circle No. 2*.

The *Assassin* series of pictures by William Glackens (1972–1973).

Henri Cartier-Bresson's photo collection *Faces of Asia*.

Louis I. Kahn designed the Kimball Art Museum, Fort Worth, Texas.

Thomas Hart Benton's painting *Turn of the Century Joplin*.

Tony Smith's sculpture *Gracehoper*.

James Rosenquist's 86-foot-long painting *F-111*.

Edward Larrabee Barnes designed the Crown Center, Kansas City, Missouri.

H. C. Westermann's sculpture *American Death Ship on the Equator*.

Jules Olitski's painting *Willemite's Vision*.

Graduate School of Design, Harvard University, designed by Andrews, Anderson, and Baldwin.

Louise Nevelson's painting *Night Presence IV*.

One Liberty Plaza, New York, and One Shell Plaza, Houston, designed by Skidmore, Owings, and Merrill.

d. Cristóbal Balenciaga, Spanish fashion designer (b. 1895).

THEATER & VARIETY

Colleen Dewhurst starred in Eugene O'Neill's *Mourning Becomes Electra*.

Ingrid Bergman starred in George Bernard Shaw's *Captain Brassbound's Conversion*.

That Championship Season, Richard Dysart, Paul Sorvino, Charles Durning, Walter McGinn, and Michael McGuire starred in Jason Miller's play, set at a high school basketball team reunion; opened at the Public Theatre, New York, May 2. Miller adapted and directed the 1982 film version.

Grease, the Jim Jacobs–Warren Casey musical, opened at the Eden Theatre, New York.

Moon Children, Michael Weller's play, starred James Woods, Kevin Conway, and Edward Herrmann.

Jack Albertson and Sam Levene starred in *The Sunshine Boys*; Neil Simon's play opened at the Broadhurst Theatre, New York, December 20.

The Country Girl, the Clifford Odets play, starred Jason Robards, Maureen Stapleton, and George Grizzard.

Pippin, Stephen Schwartz's musical, opened at the Imperial Theatre, New York, October 23.

Vivat! Vivat Regina!, Robert Bolt's play, starred Claire Bloom and Eileen Atkins in New York.

Ralph Richardson starred in *Lloyd George Knew My Father*.

Sizwe Bansi Is Dead, Athol Fugard's play.

The Creation of the World and Other Business, Arthur Miller's play, starred Zoë Caldwell and George Grizzard.

6 Rms Riv Vu, Bob Randall's play, starred Jerry Orbach and Jane Alexander.

Julie Harris starred in James Prideaux's play *The Last of Mrs. Lincoln*.

Absurd Person Singular, Alan Ayckbourn's play.

Eric Russell Bentley's *Are You Now Or Have You Ever Been . . . ?*

Hanoch Levin's *Hefetz*.

I, Claudius, John Mortimer's play.

Jumpers, Tom Stoppard's play.

The Old Ones, Arnold Wesker's play.

d. Margaret Webster, British actress and director (b. 1905), a leading director of Shakespeare in the United States; daughter of actor Ben Webster and actress May Whitty.

d. Padraic Colum, Irish playwright and man of letters (b. 1881).

d. Henri de Montherlant, French writer and playwright (b. 1896).

MUSIC & DANCE

George Balanchine created three new ballets to music by Igor Stravinsky: *Stravinsky Violin Concerto*, *Symphony in Three Movements*, and *Duo Concertant*, the first two premiering June 18, the third June 22, all with the New York City Ballet.

The City of New Orleans, Steve Goodman's folk-rock classic, written during the 1972 presidential campaign, was popularized by both Judy Collins and Arlo Guthrie, in his album *Hobo's Lullaby*.

Twilight, Hansvan Manen's ballet to music by John Cage, first danced June 20, by the Dutch National Ballet, Amsterdam.

The Rise and Fall of Ziggy Stardust and the Spiders from Mars, David Bowie's second album, promoted with an extravagantly staged American tour.

Harrison Birtwistle's vocal/instrumental works *The Fields of Sorrow* and *La Plage*; orchestral work *The Triumph of Time*; and tape work *Chronometer*.

Bette Midler became a star with her Grammy-winnning solo debut album *The Divine Miss M.*

Taverner, Peter Maxwell Davies's opera on the life of 16th-century composer John Taverner, debuted at Covent Garden.

Stevie Wonder released two new albums, *Music of My Mind* and *Talking Book*, including the hits *Superstition* and *You Are the Sunshine of My Life.*

Tales of Hoffman, Peter Darrell's ballet, music by Jacques Offenbach, first danced April 6, by the Scottish Ballet, in Edinburgh.

The Rolling Stones' album *Exile on Main Street*, including *Tumbling Dice* and *Sweet Virginia.*

Krzysztof Penderecki's choral work *Canticum canticorum Salomonis*; vocal work *Ecloga VIII*; and *Cello Concerto No. 1.*

Joni Mitchell's album *For the Roses*, with *You Turn Me On, I'm a Radio.*

I'd Like to Teach the World to Sing, William Backer, Roger Cook, and Roger Greenaway's song, which started as a Coca-Cola commercial.

Saint Louis, Darius Milhaud's opera.

Virgil Thomson's opera *Lord Byron* and his *Symphony No. 3.*

Maria Muldaur's albums *Maria Muldaur* and *Mud Acres.*

Luciano Berio's vocal work *E vo'* and dramatic musical work *Recital I.*

Hugh Masakela's album *Home Is Where the Music Is.*

Letter to the 30th Century, Dmitry Kabalevsky's choral work.

Rod Stewart's album *Never a Dull Moment.*

Michael Tippett's *Third Symphony.*

Twyla Tharp's dance work *The Bix Pieces.*

Steeleye Span's album *Below the Salt.*

Bonnie Raitt's album *Give It Up.*

Vivian Fine's *Missa brevis.*

The Eagles' album *Eagles.*

Paul Simon, his first solo album.

Randy Newman's album *Sail Away.*

Ornette Coleman's *Skies of America.*

Ylem, Karlheinz Stockhausen's chamber music.

You're So Vain, Carly Simon's number-one hit.

György Ligeti's *Double Concerto* for flute, oboe, and orchestra.

Como una ola de fuerza y luz, Luigi Nono's vocal work.

Olivier Messiaen's *La Fauvette des jardins*, for piano.

d. Bronislava Nijinska, Russian dancer and choreographer, sister of Vaslav Nijinsky (b. 1972).

d. Maurice Chevalier, French singer and actor (b. 1888).

d. José Limón, American dancer and choreographer (b. 1908).

d. Rudolph Friml, Czech-American composer and pianist (b. 1879).

d. Mahalia Jackson, American gospel singer (b. 1911).

d. Helen Traubel, American soprano (b. 1889).

d. Ted Shawn, American dancer and choreographer (b. 1891).

d. Robert Casadesus, French pianist (b. 1899), known for his piano duos with his wife Gaby Casadesus; his son Jean Casadesus (1927–1972) was also a noted pianist.

WORLD EVENTS

President Richard M. Nixon won a second term, defeating Democrat George McGovern.

President Richard M. Nixon's "opening to China," a February visit that opened relations closed since the Korean War.

Watergate scandal (1972–1974) began with the June 17 arrest of five burglars ("plumbers") in Democratic national headquarters.

American–Soviet Strategic Arms Limitation Agreements (SALT I) set limits on the use and deployment of antiballistic missile systems (ABMs) and intercontinental ballistic missiles (ICBMs).

DDT, an extraordinarily toxic insecticide, was banned in America; many threatened species began to make comebacks in the following decades.

Bloody Sunday in Northern Ireland (January 30); British troops killed 13 unarmed Catholic demonstrators in Londonderry, and guerrilla war grew. British direct rule was imposed in March.

Black September terrorists murdered 11 Israeli athletes at the Munich Olympics (September).

Austrian diplomat Kurt Waldheim became the fourth secretary-general of the United Nations (1972–1982).

Ferdinand Marcos took dictatorial power in the Philippines, ruling under martial law.

Willy Brandt became West German chancellor (1972–1974).

After the the failed Hutu rebellion of 1972 in Burundi, the Tutsi-dominated Burundi army massacred an estimated 100,000–250,000 Hutus.

Andrew Young became the first African-American Congressman from Georgia since Reconstruction.

Juan Perón returned to Argentina and was reelected to the presidency (1973–1974).

Managua, Nicaragua, earthquake killed an estimated 5,000 and destroyed the city center.

Soviet space probe *Venera 8* made the first soft landing on Venus.

Allan MacLeod Cormack and Godfrey N. Hounsfield invented the CAT (computerized axial tomography) scan.

Phyllis Chesler published *Women and Madness*.

1973

LITERATURE

Alexander Solzhenitsyn's novel *The Gulag Archipelago* (three vols., 1973–1975), his exposé of the Soviet prison system.

Patrick White was awarded the Nobel Prize for Literature; and his novel *The Eye of the Storm* was published.

Allen Ginsberg's National Book Award–winning *The Fall of America: Poems of These States 1965–1971*.

The Dolphin, Robert Lowell's Pulitzer Prize–winning poems.

Gravity's Rainbow, Thomas Pynchon's National Book Award–winning novel.

Rubyfruit Jungle, Rita Mae Brown's mainly autobiographical radical lesbian novel.

Wole Soyinka's novel *Season of Anomy*.

Pentimento, Lillian Hellman's autobiographical work.

Fear of Flying, Erica Jong's novel.

Christy Brown's poetry *Background Music*.

Group Portrait with a Lady, Heinrich Böll's novel.

India Song, Marguerite Duras's play; basis of her 1975 film.

Ayi Kwei Armah's *Two Thousand Seasons*.

John Gardner's novel *Nickel Mountain*.

Octavio Paz's essays *Alternating Current*.

Small Changes, Marge Piercy's novel.

Theophilus North, Thornton Wilder's novel.

Bernard Malamud's short stories *Rembrandt's Hat*.

Derek Walcott's *Another Life*.

Brian W. Aldiss's novel *Frankenstein Unbound*.

St. Jack, Paul Theroux's novel.

Life Is Elsewhere, Milan Kundera's novel.

Lionel Trilling's essays *The Mind of the Modern World*.

Meyer Levin's novel *The Obsession*.

The Honorary Consul, Graham Greene's novel.

Sula, Toni Morrison's novel.

Yehuda Amichai's poems *Songs of Jerusalem and Myself*.

Touch the Water, Touch the Wind, Amos Oz's novel.

Robert Bly's poetry *Sleepers Joining Hands*.

Balzac, V. S. Pritchett's biography.

d. W. H. (Wystan Hugh) Auden, British-American writer, a leading 20th-century poet (b. 1907).

d. Pablo Neruda (Ricardo Neftali Reyes Basualto), Chilean poet (b. 1904).

d. J. R. R. (John Radford Reuel) Tolkien, British writer, creator of Middle Earth and the hobbits (b. 1892).

d. Elizabeth Bowen, Anglo-Irish writer (b. 1899).

d. Pearl Buck, American author (b. 1892).

d. Arna Bontemps, American author (b. 1902).

d. Carl Moberg, Swedish writer (b. 1898).

d. Conrad Aiken, American writer (b. 1889).

d. John Creasey, British mystery writer; his work included more than 500 novels.

FILM & BROADCASTING

The Sting, Paul Newman and Robert Redford starred as Prohibition-era Chicago con men in George Roy Hill's film, to the music of Scott Joplin.

Amarcord, Federico Fellini's semiautobiographical work, set in Fascist Italy during the 1930s.

The Way We Were, Barbra Streisand and Robert Redford starred in Sidney Pollack's look at life, art, and politics from the late 1930s through the McCarthy period.

Scenes from a Marriage, Liv Ullmann and Erland Josephson starred in Ingmar Bergman's study of a failing marriage; originally a television miniseries.

Day for Night, the François Truffaut film about the making of a film; Jacqueline Bisset, Jean-Pierre Léaud, Valentina Cortese, Jean-Pierre Aumont, and Truffaut starred.

American Graffiti, the George Lucas film evoking small-town America in the early 1960s and starring Richard Dreyfuss, Ron Howard, Paul Le Mat, and Charlie Martin Smith; *More American Graffiti* (1979) was a sequel.

Last Tango in Paris, Marlon Brando as the demoralized American and Romy Schneider starred in

Bernardo Bertolucci's sexually explicit and therefore then-controversial film.

Mean Streets, Robert De Niro and Harvey Keitel starred in the Martin Scorsese film, set in New York City's Little Italy.

Paper Moon, Ryan O'Neal and his daughter, Tatum O'Neal, starred as the con man and the young girl in Peter Bogdanovich's 1930s "road film" period piece.

George Segal and Glenda Jackson starred in *A Touch of Class*, directed by Melvin Frank.

A Delicate Balance, Katharine Hepburn and Paul Scofield starred in Tony Richardson's film version of the 1966 Edward Albee play.

Robert De Niro and Michael Moriarty starred in *Bang the Drum Slowly*, a baseball film based on the 1956 Mark Harris novel, directed by John Hancock.

Soylent Green, Richard Fleischer's film about a desperately hungry and overcrowded future humanity, based on Harry Harrison's novel *Make Room! Make Room!*; starring were Charlton Heston and Edward G. Robinson, in his last role.

The Day of the Jackal, Edward Fox starred as the assassin in the Fred Zinneman film, about an attempt to murder Charles De Gaulle; based on a Frederick Forsyth novel.

The Exorcist, the William Friedkin film, based on William Peter Blatty's demonic possession novel; Linda Blair, Ellen Burstyn, Jason Miller, Max von Sydow, and Lee J. Cobb starred.

The Glass Menagerie, Katharine Hepburn, Sam Waterston, and Joanna Miles starred in the Anthony Harvey film version of the 1945 Tennessee Williams play.

The Iceman Cometh, Lee Marvin as Hickey, Fredric March, and Robert Ryan starred in John Frankenheimer's film version of the Eugene O'Neill play.

Under Milk Wood, Richard Burton, Elizabeth Taylor, and Peter O'Toole starred in Anthony Sinclair's screen version of the 1954 Dylan Thomas play.

Satyajit Ray directed *Distant Thunder*.

Lina Wertmuller directed *Love and Anarchy*.

Werner Herzog directed *Aguirre, the Wrath of God*.

Kojak, Telly Savalas starred in the television series title role.

Academy Awards for 1973 (awarded the following year): Best Picture: *The Sting*; Best Director: George Roy Hill, *The Sting*; Best Actor: Jack Lemmon, *Save the Tiger*; Best Actress: Glenda Jackson, *A Touch of Class*.

d. John Ford (Sean Aloysius O'Feeney), American film director (b. 1895).

d. Robert Ryan, American actor (b. 1909).

d. Edward G. Robinson (Emmanuel Goldenberg), American actor (b. 1893).

d. Anna Magnani, Italian actress (b. 1908).

d. Laurence Harvey (Lauruska Mischa Skikne), South African actor (b. 1928).

d. Betty (Elizabeth Ruth) Grable, American actress (b. 1916), the quintessential World War II "pin-up girl."

VISUAL ARTS

Jasper Johns's painting *Two Flags*.

David Hockney's painting *The Weather Series: Sun*.

Boston Public Library Wing, designed by Philip Johnson and John Burgee.

Jim Dine's painting *Untitled Tool Series*.

Robert Rauschenberg's sculpture *Untitled*.

Saul Steinberg's cartoon collection *The Inspector*.

Marcel Breuer designed the Murray Lincoln Center, University of Massachusetts, Amherst.

Richard Artschwager's painting *Interior*.

Al Held's painting *South Southwest*.

Robert Smithson's sculpture *Amarillo Ramp*.

I. M. Pei designed the 88 Pine Street Building, New York.

Brice Marden's sculpture *Grove Group, I*.

American Institute of Architects, Washington, D.C., designed by the Architects Collaborative.

Christopher Wilmarth's sculpture *My Divider*.

IDS Center, Minneapolis, designed by Johnson and Burgee.

James Bishop's painting *Untitled, No. 2*.

Sam Francis's painting *Untitled #7*.

d. Edward (Edouard Jean) Steichen (b. 1879), American photographer, a landmark figure in the history of photography.

d. Jacques Lipchitz (Chaim Jacob Lipschitz), Lithuanian Jewish sculptor (b. 1891), a central figure in the development of modern sculpture.

d. Pablo Ruiz Picasso, Spanish artist (b. 1881), for seven decades a tremendously prolific key figure in the 20th century.

d. Philip Evergood, American painter (b. 1901).

d. Chic (Murat Bernard) Young, American cartoonist

(b. 1901); creator of Blondie and Dagwood.

d. Walt Kelly, American cartoonist, who created Pogo (b. 1913).

THEATER & VARIETY

Colleen Dewhurst and Jason Robards, Jr., starred in Eugene O'Neill's *A Moon for the Misbegotten*.

Hot l Baltimore, Lanford Wilson's play, starring Trish Hawkins and Judd Hirsch, opened at the Circle in the Square Theatre, New York, March 22.

Glynis Johns, Len Cariou, and Hermione Gingold starred in *A Little Night Music*; Stephen Sondheim's musical, based on the 1955 Ingmar Bergman film *Smiles of a Summer Night*, opened at the Shubert Theatre, New York, February 25 (Harold Prince directed the 1978 screen version).

Angela Lansbury starred as Rose in a Broadway revival of *Gypsy*.

Da, Barnard Hughes as Da and Brian Murray as his son starred in Hugh Leonard's play, set in Ireland; Matt Clark directed the 1988 screen version.

The River Niger, Douglas Turner Ward starred in the Negro Ensemble Company production of the Joseph A. Walker play; opened at the Brooks Atkinson Theatre, New York, March 27.

Finishing Touches, Jean Kerr's comedy starred Barbara Bel Geddes; opened at the Plymouth Theatre, New York, February 8.

Irene Papas starred in the title role of Euripides's *Medea*.

Peter Hall became director of Britain's National Theatre.

Raisin, the Judd Woldin and Robert Brittan musical, based on *Raisin in the Sun*, starred Virginia Capers and Joe Morton.

Seesaw, the Cy Coleman and Dorothy Fields musical, starred Michele Lee, Ken Howard, and Tommy Tune.

John Lithgow starred in David Storey's *The Changing Room*.

The Contractor, David Storey's play, starred Kevin O'Connor and George Taylor.

Brian Friel's *The Freedom of the City* opened in London and Dublin.

James Earl Jones starred in Eugene O'Neill's *The Iceman Cometh*.

The Women, play by Clare Booth (Luce), starred Dorothy Loudon, Myrna Loy, Kim Hunter, and Rhonda Fleming.

George C. Scott, Nicol Williamson, Julie Christie, and Lillian Gish starred in Anton Chekhov's *Uncle Vanya*.

In the Boom Boom Room, David Rabe's play.

The Island, Athol Fugard's play.

The Norman Conquests, Alan Ayckbourn's play.

d. Noël Coward, British writer, actor, composer, and director (b. 1899).

d. William Inge, American playwright (b, 1913).

d. Katina Paxtinou (Katina Constantopoulos), Greek actress, director, and translator (b. 1900), a leading figure in the Greek theater.

d. S(amuel) N(athaniel) Behrman, American playwright (b. 1893).

d. Jack MacGowran, Irish actor (b. 1918).

MUSIC & DANCE

Scott Joplin's ragtime music had a revival after its use in the score to the film *The Sting*; his 1903 song *The Entertainer* was a hit single in Marvin Hamlisch's piano performance,

Death in Venice, Benjamin Britten's opera, libretto by Myfanwy Piper based on Thomas Mann's 1912 story, opened June 16 at the Aldeburgh Festival.

Remembrances, Robert Joffrey's ballet to music by Richard Wagner, premiered October 12 at the City Center, New York.

As Time Goes By, Twyla Tharp's ballet, first danced by the Joffrey Ballet October 24 at New York's City Center Theater.

Send in the Clowns, Stephen Sondheim's song from *A Little Night Music*; a 1975 hit for Judy Collins on her album *Judith*.

Voluntaries, Glen Tetley's ballet, music by Francis Poulenc, first danced by the Stuttgart Ballet.

Sydney's Opera House, home of the Australian Opera, opened with a production of Sergei Prokofiev's *War and Peace*.

Academy of Ancient Music, English ensemble named after the old Academy of Ancient Music, founded by Christopher Hogwood to perform Baroque and Classical music on period instruments.

Pete Townshend's rock opera *Quadrophenia*, a double-record album for the Who.

Art Garfunkel's first solo album *Angel Clare*, named after the character in Thomas Hardy's *Tess of the D'Urbervilles*.

Olivia Newton-John's albums *Let Me Be There* and *If You Love Me, Let Me Know*.

Michael Tippett's third sonata for piano and third string quartet.

There Goes Rhymin' Simon, Paul Simon's album.

Patterns, piano work by Haim Alexander.

The Dark Side of the Moon, Pink Floyd's album.

Harrison Birtwistle's *Grimethorpe Aria*, for brass band.

Bonnie Raitt's album *Taking My Time*.

Greetings from Asbury Park, N.J., Bruce Springsteen's debut album.

Tamu-Tamu, Gian Carlo Menotti's opera.

Touch Me in the Morning, Diana Ross's album.

De temporum fine comoedia, Carl Orff's dramatic musical work.

My Tennessee Mountain Home, Dolly Parton's album.

Eridanos, Iannis Xenakis's orchestral work.

Eric Clapton's Rainbow Concert album.

Desperado, the Eagles' album.

Krzysztof Penderecki's *Symphony No. 1*.

Closing Time, Tom Waits's album.

Honkytonk Heroes, Waylon Jennings's album.

Houses of the Holy, Led Zeppelin's album.

Killing Me Softly with His Song, Roberta Flack's hit.

Siamo la gioventù del Vietnam, Luigi Nono's vocal work.

György Ligeti's choral work *Clocks and Clouds*.

d. Pablo Casals, Spanish cellist, composer, and conductor (b. 1876).

d. Otto Klemperer, German conductor, a leading figure in classical music for more than six decades.

d. John Cranko, British dancer, choreographer, and ballet director (b. 1927).

d. Kid Ory (Edward Ory), American bandleader and jazz trombonist (b. 1886).

d. Lauritz Melchior (Lembricht Hommel), Danish tenor, a leading Wagnerian singer (b. 1890).

d. Gene Krupa, American drummer and bandleader, a leading drummer of the big-band era (b. 1909).

d. Gian Francesco Malipiero, Italian composer (b. 1882).

d. Mary Wigman, German dancer, a seminal modern dance teacher (b. 1886).

d. Vaughan Monroe, American singer, bandleader, and trombonist (b. 1911).

WORLD EVENTS

Watergate scandal unfolded after the indictment and guilty pleas of the Watergate burglars and E. Howard Hunt and G. Gordon Liddy, as judicial and Congressional investigations, and the Robert Woodward–Carl Bernstein *Washington Post* investigation all proceeded. Several key Nixon aides resigned. In October, the Watergate tapes revealed Nixon's complicity, and his attempts to withhold tapes and documents ultimately destroyed his credibility.

Vice-President Spiro Agnew resigned on October 10, after pleading no contest to income tax evasion.

Paris Peace Accords (January 27), negotiated by Henry Kissinger and Le Duc Tho, provided for American withdrawal from Vietnam, a prisoner return, and North–South truce; American withdrawal followed.

Yom Kippur War (Fourth Arab–Israeli War, October 6–24) began with successful surprise attacks by Egyptian, Syrian, Iraqi, and Jordanian forces on Israel on Yom Kippur. But Israeli forces, with air superiority, within a week had won the war, and were threatening to destroy the Egyptian Third Army, which nearly brought direct Soviet Union armed action and a sharp American warning to the Soviets. A United Nations–mediated ceasefire ended hostilities.

Organization of Petroleum Exporting Countries (OPEC) oil embargo generated an October 1973–March 1974 massive worldwide oil shortage.

d. Chilean President Salvador Allende Gossens (b. 1908), killed during the course of the September 11 military coup that deposed him; General Augusto Pinochet led the coup, which was followed by a reign of terror.

In *Roe v. Wade*, the U.S. Supreme Court established the right of pregnant women to make their own choices as to abortion, a fundamental right reaffirmed in the decades that followed.

Afghan revolution: Mohammad Zahir Shah (king 1933–1973) was deposed by the forces of his cousin, Sardar Mohammed Daud Khan.

Greek dictator George Papadopoulos was toppled by a military coup.

American Indian Movement (AIM) occupied the Wounded Knee Massacre site in South Dakota.

Richard Nixon–Leonid Brezhnev summit meeting in Washington (June) had few concrete results, but further fostered detente.

Laotian Civil War ceasefire (February); coalition government formed.

American orbital space station *Skylab* was launched on May 14.

American space probe *Pioneer 10* passed within 81,000 miles of Jupiter.

1974

LITERATURE

If Beale Street Could Talk, James Baldwin's novel.

Gather Together in My Name, Maya Angelou's novel.

Eyvind Johnson and Harry Martinson shared the Nobel Prize for Literature.

All the President's Men, Watergate scandal book by *Washington Post* reporters Robert Woodward and Carl Bernstein. Robert Redford played Woodward and Dustin Hoffman played Bernstein in the 1976 Alan J. Pakula film.

Tinker, Tailor, Soldier, Spy, John le Carré's spy thriller, first novel of the George Smiley trilogy; basis of the 1977 television miniseries.

J. I. M. Stewart's *A Staircase in Surrey* (1974–1978); his five Oxford novels, beginning with *The Gaudy*.

Jaws, Peter Benchley's thriller about a massive killer shark and its hunters; basis of the 1975 Steven Spielberg film.

John Fowles's novel *The Ebony Tower*.

Andrey Sinyavsky's *A Voice from the Chorus*.

Something Happened, Joseph Heller's novel.

Carrie, Stephen King's horror novel.

John Knowles's novel *Spreading Fires*.

Mongo Beti's novel *Perpetua*.

A Shadow on Summer, Christy Brown's novel.

The Abbess of Crewe, Muriel Spark's novel.

Philip Larkin's poetry *High Windows*.

The Sacred and Profane Love Machine, Iris Murdoch's novel.

The Conservationist, Nadine Gordimer's novel.

Robert Creeley's poetry *Thirty Things*.

Alice Adams's novel *Families and Survivors*.

Shirley Ann Grau's novel *Evidence of Love*.

The Black House, Paul Theroux's novel.

A. R. Ammons's poetry *Sphere: The Form of a Motion*.

The War Between the Tates, Alison Lurie's novel.

Alejo Carpentier's novel *Reasons of State*.

The Story, Elsa Morante's novel.

d. Pär Lagerkvist, Swedish writer (b. 1891).

d. Cecil Day Lewis, British poet and novelist (b. 1904); he wrote his mystery novels as Nicholas Blake; father of actor Daniel Day-Lewis.

d. Miguel Angel Asturias, Guatemalan novelist (b. 1899).

d. Anne Sexton, American poet (b. 1928), a suicide.

d. Cyril Connolly, British literary critic (b. 1903).

d. John Crowe Ransom, American writer and critic (b. 1888).

FILM & BROADCASTING

The Godfather, Part II, Al Pacino, Robert De Niro, Diane Keaton, Robert Duvall, John Cazale, and Lee Strasberg starred in Francis Ford Coppola's second Corleone family Mafia story, the sequel to his 1972 *The Godfather*; screenplay again by Coppola and Mario Puzo, based on the Puzo novel.

Auntie Mame, Lucille Ball starred as Mame in the film version of the 1966 Broadway musical, directed by Gene Saks.

Blazing Saddles, the Mel Brooks Western film satire, starring Cleavon Little, Gene Wilder, Madeleine Kahn, and Brooks.

Chinatown, Jack Nicholson, Faye Dunaway, and John Huston starred in the Roman Polanski film about financial corruption and incest in 1920s Southern California; screenplay by Robert Towne.

Conversation Piece, Burt Lancaster, Silvana Mangano, and Helmut Berger starred in the Luchino Visconti film.

Death Wish, the first of the Charles Bronson vigilante films; directed by Michael Winner.

Harry and Tonto, Art Carney starred in the Paul Mazursky film, on later-life themes.

Alice Doesn't Live Here Anymore, Martin Scorsese's film, starring Ellen Burstyn as the widowed Alice, Jodie Foster as her child, and Kris Kristofferson; basis for the television series *Alice*, starring Linda Lavin.

The Front Page, Jack Lemmon and Walter Matthau starred in the Billy Wilder film, based on the 1928 Ben Hecht–Charles MacArthur play about Chicago newspaper people.

Murder on the Orient Express, Albert Finney as Hercule Poirot, John Gielgud, Richard Widmark, Lauren Bacall, Ingrid Bergman, Sean Connery, and Wendy Hiller led a celebrity cast in Sidney Lumet's screen version of the Agatha Christie novel.

Steppenwolf, Max von Sydow and Dominique Sanda starred in the Fred Haines film, based on the 1927 Hermann Hesse novel.

The Apprenticeship of Duddy Kravitz, Richard Dreyfuss starred in Ted Kotcheff screen version of the 1959 Mordecai Richler novel, set in Montreal's Jewish-Canadian community.

Gene Hackman starred in *The Conversation*, directed by Francis Ford Coppola.

The Great Gatsby, Robert Redford and Mia Farrow starred in the Jack Clayton film, set in newly rich Long Island circles in the 1920s; adapted by Francis Ford Coppola from the 1925 F. Scott Fitzgerald novel.

Werner Herzog directed *The Mystery of Kaspar Hauser*.

Alain Resnais directed *Stavisky*.

Robert Bresson directed *Lancelot of the Lake*.

Michelangelo Antonioni directed *The Passenger*.

The Autobiography of Miss Jane Pittman, Cicely Tyson starred in this television film, the fictional biography of a century-old Southern black woman, once a slave.

Little House on the Prairie, Michael Landon starred in the television series, based on the Laura Ingalls Wilder children's story (1974–1983).

The Rockford Files, James Garner starred in the television detective series (1974–1980).

Academy Awards for 1974 (awarded the following year): Best Picture: *The Godfather, Part II*; Best Director: Francis Ford Coppola, *The Godfather, Part II*; Best Actor: Art Carney, *Harry and Tonto*; Best Actress: Ellen Burstyn, *Alice Doesn't Live Here Anymore*.

d. Vittorio De Sica, Italian director and actor (b. 1902), a major figure in world cinema from his post–World War II creation of *Shoeshine* and *The Bicycle Thief*.

d. Anatole Litvak (Michael Anatol Litwak), Soviet-American director and producer (b. 1902).

d. Jack Benny (Benjamin Kubelsky), American comedian, a radio and television star for decades (b. 1894).

d. Samuel Goldwyn (Samuel Goldfish), American producer (b. 1882).

d. Bud Abbott (William B. Abbott), American comedian (b. 1895).

VISUAL ARTS

Sydney, Australia, Opera House was completed (1958–1974); Danish architect Jørn Utzon had won the competition for the design, but was removed before completion; the main outlines remained, however, and it became Australia's best-known structure.

Museum openings included the J. Paul Getty Museum in Malibu, California; the Hirshhorn Museum and Sculpture Garden, Washington, D.C.; and the Neuberger Modern Art Museum, State University of New York, Purchase.

Gordon Bunshaft designed the Hirshhorn Museum at Washington, D.C.

Sears Tower, Chicago, opened, becoming the world's tallest building, at 1,450 feet.

Alexander Calder's *Universe* was installed in the Sears Tower, Chicago.

Hoarfrost, a series of assemblages by Robert Rauschenberg (1974–1975).

Frank Stella's painting *Pratfall, York Factory*.

Helen Frankenthaler's painting *Savage Breeze*.

Richard Serra's sculpture *Ollantoyambo*.

Air and Space Museum, Washington, D.C., was designed by Hellmuth, Obata, and Kassabaum.

Robert Morris's sculpture *Labyrinth*.

Carl Andre's sculpture *Decks*.

Richard Estes's painting *Woolworth's America*.

Chuck Close's paintng *Robert/104,072*.

Fairfield Porter's painting *The Cliffs of Isle au Haut*.

Richard Artschwager's painting *Rockefeller Center*.

Joel Shapiro's sculpture *Untitled*.

Lynda Benglis's sculpture *Victor*.

Ralph Goings's painting *McDonald Pickup*.

Michael Heizer's sculpture *The City, Complex One*.

d. Alexander Young Jackson, Canadian painter (b. 1882), a member of the Group of Seven.

d. David Alfaro Siqueiros, Mexican painter (b. 1896), especially known for his murals.

d. Louis Kahn, American architect (b. 1901); among his final works was the Yale Center for British Art, completed after his death.

d. Adolph Gottlieb, American painter (b. 1903).

THEATER & VARIETY

Equus, Anthony Hopkins as the psychiatrist and Peter Firth as the disturbed boy starred in the Peter Shaffer play; Sidney Lumet directed the 1977 film version.

Sizwe Banzi Is Dead and *The Island*; both Athol Fugard plays starred John Kani and Winston Ntshona.

The Norman Conquests, Alan Ayckbourn's trilogy of plays, about the same events from different perspectives, including *Table Manners*, *Living Together*, and *Round and Round the Garden*.

Travesties, Tom Stoppard's play, set among writers and revolutionaries in Zurich in 1917.

Jumpers, Tom Stoppard's play, starred Brian Bedford and Jill Clayburgh.

Liv Ullmann starred in Henrik Ibsen's *A Doll's House*.

Absurd Person Singular, Alan Ayckbourn's play, starred Richard Kiley, Geraldine Page, and Sandy Dennis.

Henry Fonda premiered his one-man show as Clarence Darrow.

Zero Mostel and Fionnuala Flanagan starred in Marjorie Barkentin's *Ulysses in Nighttown*.

Cat on a Hot Tin Roof, the Tennessee Williams play, starred Elizabeth Ashley and Keir Dullea.

Rex Harrison, Julie Harris, and Martin Gabel starred in Terence Rattigan's *In Praise of Love*.

Lorelei, the Jule Styne and Leo Robin musical, starred Carol Channing and Dody Goodman.

The Magic Show, the Stephen Schwartz musical, opened at the Cort Theatre, New York, May 28.

Peter Nichols's *The National Health* starred Rita Moreno and Leonard Frey.

Lynn Redgrave and George Rose starred in Charles Laurence's *My Fat Friend*.

Anne Baxter, Hume Cronyn, and Jessica Tandy starred in *Noël Coward in Two Keys*.

The Dance of Death, the August Strindberg play, starred Robert Shaw and Zoë Caldwell.

The Wager, Mark Medoff's play, starred Kristoffer Tabori.

Peter Nichols's play *Chez Nous*.

Life Class, David Story's play.

Eric Russell Bentley's *Expletive Deleted*.

William Douglas Home's *The Dame of Sark*.

d. Katharine Cornell, American actress–manager (b. 1893).

d. Marcel Pagnol, French writer, director, and producer (b. 1895).

d. Austin Clarke, Irish poet, playwright, and novelist (b. 1896).

d. George Edward Kelly, American playwright (b. 1887).

d. Marcel Achard, French playwright (b. 1899).

MUSIC & DANCE

Jerome Robbins choreographed a new ballet, *Dybbuk Variations*, to music by Leonard Bernstein, first danced May 15 by the New York City Ballet.

Mikhail Baryshnikov took political asylum in the West while on tour in Canada.

Mstislav Rostropovich and Galina Vishnevskaya left the Soviet Union; they would not return until 1990.

Elite Syncopations, Kenneth MacMillan's ballet, to the music of several ragtime composers, first danced October 7 by the Royal Ballet, London.

Bruce Springsteen's *The Wild, the Innocent and the E Street Shuffle*, including *Rosalita*, *New York Street Serenade*, and *Sandy*.

Le Tombeau de Couperin, George Balanchine's ballet, music by Maurice Ravel, first danced May 29 by the New York City Ballet.

Manon, Kenneth MacMillan's ballet, music by Jules Massenet, first danced March 7 by the Royal Ballet, London.

Court and Spark, Joni Mitchell's album, including *Help Me* and *Twisted*.

Krzysztof Penderecki's choral work *Magnificat* and orchestral work *The Dream of Jacob*.

Iannis Xenakis's choral work *Cendrées* and orchestral work *Erikhthon*.

Now We Are Six, Steeleye Span's album, with David Bowie making a guest appearance.

Karlheinz Stockhausen's chamber music *Herbstmusik* and orchestral work *Inori*.

I Will Always Love You, Dolly Parton's hit song, revived strongly by Whitney Houston in 1992.

Luciano Berio's vocal works *Calmo* and *Cries of London*; and his ballets *Linea* and *Per la dolce memoria de quel giorno*.

Heart Like a Wheel, Linda Ronstadt's album, with *I Can't Help It if I'm Still in Love with You*.

Piano Man, Billy Joel's autobiographical song.

Heart of Saturday Night, Tom Waits's album.

John Denver's hit songs *Sweet Surrender* and *Annie's Song*.

Des canyons aux étoiles. . . . , Olivier Messiaen's orchestral work.

Jolene, Dolly Parton's album, with its hit title song.

Elliott Carter's *Brass Quintet* and *Duo* for violin and piano.

Waitress in a Donut Shop, Maria Muldaur's album.

Benjamin Britten's fifth canticle.

Randy Newman's album *Good Old Boys*.

San Francisco Polyphony, György Ligeti's orchestral work.

Rod Stewart's album *Smiler*.

Arie da capo, Milton Babbitt's ensemble work.

This Time, Waylon Jennings's album.

Streetlights, Bonnie Raitt's album.

Philip Glass's *Music in Twelve Parts*.

Wrap Around Joy, Carole King's album.

A Man and a Woman, Dionne Warwick's album.

Für Paul Dessau, Luigi Nono's tape work.

d. Duke (Edward Kennedy) Ellington, American composer, pianist, and orchestra leader (b. 1899).

d. Darius Milhaud, French composer (b. 1892).

d. David Oistrakh, Soviet violinist, a world figure (b. 1908); father of violinist Igor Oistrakh (b. 1931).

WORLD EVENTS

On August 9, facing imminent impeachment, Richard M. Nixon resigned. He was pardoned by President Gerald Ford in September.

Patricia "Patty" Hearst, granddaughter of newspaper magnate William Randolph Hearst, was kidnapped on February 5 in San Francisco by members of the Symbionese Liberation Army (SLA), and on April 15 participated in a San Francisco bank robbery. She went into hiding after police killed six SLA members, and was captured and sentenced to a seven-year prison term in 1976.

Portuguese Armed Forces movement ended Portuguese dictatorship in a bloodless coup, restored democracy at home, and freed Portuguese colonies.

An army coup led by Haile Mariam Mengistu deposed Emperor Haile Selassie I of Ethiopia.

Moscow: Richard Nixon–Leonid Brezhnev summit meeting in June continued dialogue, without specific achievements.

Gerald Ford–Leonid Brezhnev summit meeting in

Vladivostok (August) produced some forward movement on Salt II arms limitation agreement.

Turkish armed forces invaded and partitioned Cyprus.

Valéry Giscard d'Estaing became president of France (1974–1981).

Helmut Schmidt became chancellor of West Germany (1974–1982).

Mariner 10 went into orbit around Mercury.

U.S. Freedom of Information Act opened some previously secret government files.

America ratified the Biological Warfare Ban Treaty.

d. Karen Gay Silkwood, American atomic worker (b. 1946), who died under disputed circumstances while working on an atomic safety hazards exposé. She was memorialized in the 1983 film *Silkwood*.

1975

LITERATURE

Ragtime, E. L. Doctorow's turn-of-the-century novel; basis of the 1981 Milos Forman film.

Eugenio Montale was awarded the Nobel Prize for Literature.

Heat and Dust, Ruth Prawer Jhabvala's novel, set in modern India, with a parallel story set in the 1920s; she adapted it into the 1983 James Ivory film.

The Autumn of the Patriarch, Gabriel García Márquez's novel.

Denise Levertov's poetry collections *Here and Now* and *The Freeing of the Dust*.

Legs, first novel of William Kennedy's Albany trilogy.

Shogun, James Clavell's story of an Englishman in medieval Japan; basis of the 1980 television miniseries.

A Division of the Spoils, fourth volume of Paul Scott's *The Raj Quartet*, dramatized as *The Jewel in the Crown*.

Robert Bly's poetry collections *Old Man Rubbing His Eyes* and *The Morning Glory*.

Humboldt's Gift, Saul Bellow's Pulitzer Prize–winning novel.

In the Realms of Gold, Margaret Drabble's novel.

The Dead Father, Donald Barthelme's novel.

Kay Boyle's novel *The Underground Woman*.

Terra Nostra, Carlos Fuentes's novel.

Maxine Kumin's poetry *House, Bridge, Fountain, Gate*.

Kenneth Koch's poetry *The Art of Love*.

Guerrillas, V. S. Naipaul's novel.

Morley Callaghan's novel *A Fine and Private Place*.

A. R. Ammons's poetry *Diversifications*.

Nikki Giovanni's poetry *The Women and the Men*.

Picture Palace, Paul Theroux's novel.

R. W. B. Lewis's Pulitzer Prize–winning biography, *Edith Wharton*.

Rainbow's End, James M. Cain's novel.

Salem's Lot, Stephen King horror novel.

The Great Railway Bazaar, Paul Theroux's travel book.

Vicente Aleixandre's poetry *Diálogos del concímiento*.

d. St.-John Perse ([Marie-René] Alexis Saint-Léger Léger), French poet and diplomat (b. 1887).

d. Thornton Wilder, American novelist and playwright (b. 1897).

d. Carlo Levi, Italian writer and painter (b. 1902).

d. Ivo Andric, Yugoslav writer (b. 1892).

d. Rex Stout, American mystery writer, who created Nero Wolfe and Archie Goodwin (b. 1886).

d. Lionel Trilling, American writer and critic (b. 1905).

d. P. G. (Pelham Grenville) Wodehouse, British writer (b. 1881), the creator of Jeeves.

d. Vincent Sheean, American writer (b. 1899).

FILM & BROADCASTING

One Flew over the Cuckoo's Nest, Jack Nicholson and Louise Fletcher starred in Milos Forman's film version of the 1962 Ken Kesey novel, about life inside an insane asylum.

Nashville, Robert Altman's country music world film, featuring a large cast led by Lily Tomlin, Ronee Blakley, Henry Gibson, Keith Carradine, and Barbara Harris.

Butley, the Harold Pinter film, based on the 1971 Simon Gray play set in British university life; Alan Bates recreated his stage role.

John Hurt appeared as Quentin Crisp in the television film *The Naked Civil Servant*.

Robert Redford and Faye Dunaway starred in *Three Days of the Condor*, directed by Sydney Pollack.

Dog Day Afternoon, Al Pacino, John Cazale, and Charles Durning starred in Sidney Lumet's bank robbery–hostage thriller.

Farewell, My Lovely, Robert Mitchum and Charlotte Rampling starred in the Dick Richards film, based on the 1940 Raymond Chandler mystery novel.

Gene Hackman and Jennifer Warren starred in *Night Moves*, directed by Arthur Penn.

Gene Hackman and Fernando Rey starred in *The French Connection II*, directed by John Frankenheimer.

Funny Lady, the Herbert Ross film musical, a sequel to *Funny Girl* (1968); Barbra Streisand again starred, here opposite James Caan.

Derzu Uzala, Akiro Kurosawa's film, a Japanese-Soviet coproduction.

Jaws, Roy Scheider and Richard Dreyfuss starred in Steven Spielberg's special effects horror film, about a killer shark and its hunters; based on the 1974 Peter Benchley novel. There were three sequels (1978, 1983, 1987).

Katharine Hepburn and John Wayne starred in *Rooster Cogburn*, directed by Stuart Millar.

Love Among the Ruins, Katharine Hepburn and Laurence Olivier starred in George Cukor's telefilm version of the 1953 Evelyn Waugh novel.

Warren Beatty, Julie Christie, and Goldie Hawn starred in *Shampoo*, directed by Hal Ashby.

Michael Caine and Sean Connery starred in *The Man Who Would Be King*, directed by John Huston, based on a Rudyard Kipling story.

Isabelle Adjani and Bruce Robinson starred in *The Story of Adele H.*, directed by François Truffaut.

Saturday Night Live, the antic, long-running late-night comedy series (1975–).

Pennies from Heaven, British television miniseries scripted by Dennis Potter, starring Bob Hoskins; basis for the 1981 film.

Sony introduced the first videocassette recorder (VCR).

Academy Awards for 1975 (awarded the following year): Best Picture: *One Flew over the Cuckoo's Nest*; Best Director: Milos Forman, *One Flew over the Cuckoo's Nest*; Best Actor: Jack Nicholson, *One Flew over the Cuckoo's Nest*; Best Actress: Louise Fletcher, *One Flew over the Cuckoo's Nest*.

d. Fredric March (Ernest Frederick McIntyre Bickel), American actor (b. 1897).

d. Pier Paolo Pasolini, Italian director and writer (b. 1922).

d. George Stevens, American director and producer (b. 1904).

d. Susan Hayward (Edythe Marrener), American actress.

d. William Wellman, American director (b. 1896).

VISUAL ARTS

I. M. Pei designed the Herbert F. Johnson Museum, Cornell University.

Louise Nevelson's work included the sculpture *Transparent Horizon*.

Jammer, a series of assemblages by Robert Rauschenberg.

Claes Oldenburg's sculpture *Geometric Mouse—Scale A*.

Richard Estes's painting, *Central Savings*.

Philip Johnson designed the Crystal Court, IDS Center, Minneapolis, Minnesota.

Richard Serra's sculpture *Sight Point*.

Frank Stella's painting *Grodno (1–7)*.

Jasper Johns's painting *Scent*.

Lynda Benglis's sculpture *Bravo 2*.

Willem de Kooning's painting *Whose Name Was Writ in Water*.

Sheila Hicks's sculpture *Communications Labyrinth*.

Larry Le Va's sculpture *Center Points and Lengths (through Tangents)*.

Franklin Court, Philadelphia, designed by Venturi and Rauch.

Bill Beckley's painting *Hot and Cold Faucets with Drain*.

INA Tower, Philadelphia, designed by Mitchell and Guirgola.

Jackie Winsor's sculpture *Fifty-five*.

Carl Andre's sculpture *Twenty-Ninth Copper Cardinal*.

Penzoil Plaza, Houston, designed by Philip Johnson and John Burgee.

d. (Jocelyn) Barbara Hepworth, British sculptor (b. 1903).

d. Thomas Hart Benton, American painter (b. 1889).

d. Moses Soyer, American painter (b. 1899); twin brother of painter Raphael Soyer.

d. Philip Evergood, American painter, social realist, and fantasist (b. 1901).

THEATER & VARIETY

No Man's Land, Harold Pinter's play, its two central characters memorably played by John Gielgud and Ralph Richardson.

A Chorus Line, a backstage musical directed and choreographed by Michael Bennett, opened at the Public Theatre, New York, April 15; basis of the 1985 Richard Attenborough film. Originally starring Robert LuPone and Donna McKechnie, it would run on Broadway for 15 years.

Maggie Smith and Brian Bedford starred in Noël Coward's *Private Lives*.

John Cullum starred in *Shenandoah*; the John Kander–Fred Ebb–Gary Geld musical opened at the Alvin Theatre, New York, January 7.

Alan Bates starred in Simon Gray's *Otherwise Engaged*.

Alan Ayckbourn's *The Norman Conquests* starred Barry Nelson, Ken Howard, Estelle Parsons, Richard Benjamin, and Paula Prentiss in New York.

Ellen Burstyn and Charles Grodin starred in *Same Time, Next Year*; Bernard Slade's comedy opened at the Brooks Atkinson Theatre, New York.

Deborah Kerr and Frank Langella starred in Edward Albee's *Seascape*.

Diana Rigg and Alec McCowen starred in Molière's *The Misanthrope*.

The Ritz, Terrence McNally's play, starred Rita Moreno, Jack Weston, and F. Murray Abraham; opened at the Longacre Theatre, New York.

Chicago, the John Kander and Fred Ebb musical, starred Gwen Verdon, Jerry Orbach, and Chita Rivera.

Habeas Corpus, Alan Bennett starred opposite Donald Sinden in his own play.

Michael Hordern played a judge in Howard Barker's *Stripsell*.

Wole Soyinka's *Death and the King's Horseman*.

The Merchant, Arnold Wesker's play.

Fanshen, David Hare's play.

Michael Frayn's *Alphabetical Order*.

Bedroom Farce, Alan Ayckbourn's play.

d. R. C. (Robert Cedric) Sherriff, British playwright and novelist (b. 1896).

d. Marie Lohr, Australian-born actress (b. 1890).

d. Pamela Brown, English actress (b. 1917).

MUSIC & DANCE

The Houston Opera mounted the first full production of Scott Joplin's 1911 folk opera *Treemonisha*; Joplin was awarded a posthumous Pulitzer Prize.

Tommy, Ken Russell's screen version of Peter Townshend's 1969 rock opera, starring rock figures Roger Daltrey, Elton John, Tina Turner, and Eric

Clapton, with film stars Ann-Margret, Jack Nicholson, and Oliver Reed.

Born to Run, Bruce Springsteen's album, including *Thunder Road*, *Jungleland*, and *Night*, followed by three years of marathon live concerts.

Isadora, Yuari Gregorovich's ballet, music by Sergei Prokofiev, first danced February 20 by the Bolshoi Ballet in Moscow.

Redheaded Stranger, Willie Nelson's album, including his hit song *Blue Eyes Cryin' in the Rain* (words and music by Fred Rose, 1945).

Four Schumann Pieces, Hans van Manen's ballet to music by Robert Schumann, first danced January 31 by the Royal Ballet, London.

Rod Stewart's *Atlantic Crossing* album included his signature song *Sailing*.

Milton Babbitt's tape works *Philomena*, with voice, and *Reflections*, with instruments.

The Sex Pistols were formed by Johnny Rotten, Paul Cook, Steve Jones, and Glen Matlock.

The Horseman (*Ratsumies*), Aulis Sallinen's opera; libretto by Paava Haavikko, premiered July 17 at the Savonlinna Festival, Finland.

Still Crazy After All These Years, Paul Simon's album, including *50 Ways to Leave Your Lover* and *My Little Town* (with Art Garfunkel).

Pierre Boulez's chamber music *Messagesquisse* and orchestral work *Rituel*.

I'm Easy, Keith Carradine's song, from *Nashville*.

Luciano Berio's vocal work *A-ronne* and dramatic musical work *Diario immaginario*.

That's the Way of the World, Earth, Wind, and Fire's album.

A Mirror on Which to Dwell, Elliott Carter's vocal and ensemble work.

Wish You Were Here, Pink Floyd's album.

Benjamin Britten's third string quartet.

Northern Light–Southern Cross, the Band's album.

Andrew Lloyd Webber's *Requiem Mass*.

Red Octopus, the Jefferson Starship's album.

Nighthawks at the Diner, Tom Waits's album.

Home Plate, Bonnie Raitt's album.

Barry Manilow's album *Trying to Get the Feeling*.

Judith, Judy Collins's album, with *Send in the Clowns*.

Parson Weems and the Cherry Tree, Virgil Thomson's ballet.

Prisoner in Disguise, Linda Ronstadt's album.

Musik im Bauch, Karlheinz Stockhausen's chamber music.

Simple Things, Carole King's album.

James Taylor's album *Gorilla*.

Emmylou Harris's album *Pieces of the Sky*.

Études australes, John Cage's piano work.

Eric Clapton's album *461 Ocean Boulevard*.

Art Garfunkel's album *Breakaway*.

Al gran sole carico d'amore, Luigi Nono's dramatic musical work.

Natalie Cole's debut album *Inseparable*.

d. Dmitri Shostakovich, Soviet composer (b. 1906).

d. Josephine Baker, U.S.-French singer, dancer, and actress, who became a major cabaret star in France in the 1920s and 1930s (b. 1906). She died after 14 performances of the show *Josephine '75*, celebrating her 50 years in Paris.

d. Cannonball (Julian Edwin) Adderly, American jazz saxophonist and composer (b. 1928).

d. Noble Sissle, American singer, composer, and bandleader (b. 1899).

d. Arthur Bliss, English composer (b. 1891).

d. Luigi Dallapicolla, Italian composer (b. 1904).

WORLD EVENTS

Saigon fell to the North Vietamese on April 30, ending the Vietnamese Civil War. American air evacuation occurred as North Vietnamese troops approached the city.

Phnom Penh fell to the Khmer Rouge, and American forces withdrew from Cambodia; the Khmer Rouge then perpetrated the Cambodian Holocaust, which resulted in the the deaths of an estimated 2–3 million Cambodians (1975–1978).

Angolan Civil War began when MPLA, led by Augustinho Neto, announced formation of the Soviet-backed People's Republic of Angola, with himself as president, cutting out the FNLA and UNITA, which immediately went to war.

American merchant ship *Mayaguez* was seized by a Cambodian gunboat in international waters on May 12; American attacks on Cambodia caused Cambodians to free the crew on May 14.

International Lockheed scandal developed when Congressional investigation exposed worldwide pattern of massive Lockheed bribes of public figures; Japanese Prime Minister Kakuei Tanaka resigned when implicated.

President N'Garta (François) Tombalbaye of Chad was assassinated during a failed military coup, fol-

lowed by Libyan intervention; the long Chad Civil War began (1975–1987).

President Mujibur Rahman of Bangladesh was assassinated, with his wife and five children, on August 15, during a failed army coup.

Australian Liberal party leader Malcolm Fraser became prime minister of the Liberal-National Country coalition government (1975–1983).

Guerrilla war in Lebanon intensified in April, with heavy Phalange–PLO Beirut fighting, which soon became a full-scale multiparty civil war.

Helsinki Accords (August 1) supported civil liberties and freedom of expression, but were nonbinding and in many nations a nullity from the beginning.

South African minister and freedom movement leader Desmond Mpilo Tutu became the first Black Anglican dean of Johannesburg and the general secretary of the South African Council of Churches.

Soviet dissenter Andrei Sakharov won the Nobel Peace Prize.

Soviet space probes *Venera 9* and *10* transmitted the first pictures of the surface of Venus.

First personal computer (PC) appeared, the Altair.

Edward Osborne's *Sociobiology: The New Synthesis*.

Susan Brownmiller issued *Against Our Will: Men, Women and Rape*.

d. Francisco Franco, Spanish general (b. 1892), leader of insurgent forces during the Spanish Civil War, and Spanish dictator (1939–1975).

1976

LITERATURE

Roots, Alex Haley's Pulitzer Prize–winning novel, based upon his own family's African and African-American history; basis of the 1977 and 1979 television miniseries.

Saul Bellow was awarded the Nobel Prize for Literature.

Andrei Voznesensky's poetry *The Master of Stained Glass*.

Scoundrel Time, Lillian Hellman's autobiography, focusing on the impact of McCarthyism on the lives of her and Dashiell Hammett.

Wole Soyinka's poetic works *Ogun Abibiman* and *Myth, Literature and the African World*.

Derek Walcott's *Sea Grapes*.

Christopher and His Kind, Christopher Isherwood's autobiography.

Singin' and Swingin' and Gettin Merry Like Christmas, Maya Angelou's novel.

Cyprian Ekwensi's novel *Survive the Peace*.

The Blue Hammer, Ross Macdonald's Lew Archer detective novel.

Woman on the Edge of Time, Marge Piercy's novel.

Geography III, Elizabeth Bishop's 10-poem cycle.

The Zodiac, James Dickey's poetry collection.

The Farewell Party, Milan Kundera's novel.

John Gardner's novel *October Light*.

Meridian, Alice Walker's novel.

Saville, David Story's novel.

Trinity, Leon Uris's novel.

Peter Benchley's novel *The Deep*.

QB VII, Leon Uris's novel.

The Widower's Son, Alan Sillitoe's novel.

Wild Grow the Lilies, Christy Brown's novel.

Robert Creeley's poetry *Away*.

A Soldier's Tale, M. K. Joseph's European war novel.

The Childwold, Joyce Carol Oates's novel.

The Shining, Stephen King's horror novel.

d. André Malraux, French writer (b. 1901).

d. Agatha Christie, British novelist (b. 1890).

d. Eyvind Johnson, Swedish writer (b. 1900).

d. José Lezama Lima, Cuban writer (b. 1910).

FILM & BROADCASTING

All the President's Men, Robert Redford and Dustin Hoffman starred as *Washington Post* reporters Robert Woodward and Carl Bernstein in this Watergate-scandal film based on their book; directed by Alan J. Pakula.

1900, Burt Lancaster, Robert De Niro, Gerard Depardieu, Donald Sutherland, and Dominique Sanda starred in Bernardo Bertolucci's multigenerational epic.

The Memory of Justice, Marcel Ophüls's classic documentary, in which he reviews and compares the Nuremberg Trials, French actions during the Algerian war, and American actions on Vietnam.

Taxi Driver, Robert De Niro in the title role, Jodie Foster as the teenage prostitute, and Cybill Shepherd starred in Martin Scorsese's study of fringe New York City life.

Network, William Holden, Faye Dunaway, and Peter Finch starred in Sidney Lumet's television-world

fantasy, a bitter satire that prefigured much of what was soon to come.

A Star Is Born, Kris Kristofferson as the fading movie star and Barbra Streisand as his much younger protégée and wife starred in Frank Pierson's remake of the 1937 William Wellman film.

Bound for Glory, David Carradine starred as Woody Guthrie in Hal Ashby's biofilm, based on the folksinger's autobiography; cinematography by Haskell Wexler.

Sissy Spacek and Piper Laurie starred in *Carrie*, directed by Brian De Palma.

Lina Wertmuller directed *Seven Beauties*, starring Giancarlo Giannini and Fernando Rey.

Rocky, Sylvester Stallone wrote and starred as the ultimately victorious boxer in the John G. Avildsen film; Stallone directed the first three of the four sequels, Avildsen the fourth (1979, 1982, 1985, 1990).

The Man Who Fell to Earth, the Nicholas Roeg film, starring David Bowie.

The Sailor Who Fell from Grace with the Sea, Sarah Miles and Kris Kristofferson starred in the Lewis John Carlino film, based on the 1965 Yukio Mishima novel.

Jeanne Moreau wrote, directed, and starred in *Lumière*.

Nagisa Oshima directed *In the Realm of the Senses*.

Eleanor and Franklin, television film of Eleanor and Franklin Delano Roosevelt, played by Jane Alexander and Edward Herrmann, directed by Daniel Petrie; based on Joseph Lash's biography; followed by a sequel (1977).

The Muppet Show featured Jim Henson's Muppet puppets, led by Kermit the Frog and Miss Piggy (1976–1981).

Academy Awards for 1976 (awarded the following year): Best Picture: *Rocky*; Best Director: John G. Avildsen, *Rocky*; Best Actor: Peter Finch, *Network*; Best Actress: Faye Dunaway, *Network*.

d. Luchino Visconti, Italian director (b. 1906).

d. Jean Gabin (Jean-Alexis Moncorgé), French actor (b. 1904).

d. Roger Livesey, British actor (b. 1906).

d. Busby Berkeley, American choreographer and director (b. 1895), premier Hollywood choreographer of the 1930s.

d. Alistair Sim, Scottish actor (b. 1900).

d. Carol Reed, British director (b. 1906).

d. Rosalind Russell, American actress (b. 1908).

d. James Wong Howe, Chinese-American cinematographer (b. 1899).

VISUAL ARTS

Liberty Bell Pavilion, Living History Center, Philadelphia, designed by Mitchell and Giurgola.

Christo's sculpture *Running Fence*, a long fence in California.

Duane Hanson's sculpture *Couple with Shopping Bags*.

Claes Oldenburg's sculpture *Inverted Q*.

Jim Dine's painting *Four Robes Existing in This Vale of Tears*.

Cube Structure Based on Nine Modules, Sol Lewitt's sculpture.

Frank Stella's painting *Wake Island Rail*.

Red Grooms's painting *Ruckus Manhattan*.

Jasper Johns's painting *Corpse and Mirror, End Paper*.

Willem de Kooning's painting *Untitled VI*.

Isabel Bishop's painting *Recess #3*.

Chuck Close's painting *Linda no. 6646*.

Jackie Winsor's sculpture *Cement Piece, #1 Rope*.

Lee Krasner's painting *Present Perfect*.

Occupational Health Center, Columbia, Indiana, designed by Holzman and Pfeiffer.

Philip Guston's painting *Wharf: Source*.

Richardson-Merrell Headquarters, Wilton, Connecticut, designed by Roche and Dinkeloo.

d. Alexander Calder, American sculptor and painter (b. 1898); son and grandson of sculptors Alexander Stirling Calder (1870–1945) and Alexander Milne Calder (1846–1923).

d. Alvar Aalto (Hugo Alvar Henrick Aalto), Finnish architect and furniture designer (b. 1898).

d. Man Ray, American photographer, filmmaker, and painter, and early dadaist and then surrealist (b. 1890).

d. Max Ernst, German painter (b. 1891).

d. Paul Strand, American still photographer and documentary filmmaker (b. 1890).

d. Jean Paul Getty, American oil magnate and art collector, founder of the Getty Museum (b. 1892).

d. Jo Mielziner, leading American 20th-century stage designer (b. 1901).

d. Josef Albers, German painter, designer, and teacher (b.1888).

d. Mark Tobey, American artist (b. 1890).

THEATER & VARIETY

Stephen Sondheim's *Pacific Overtures* starred Mako, Yuki Shimodo, and Sab Shimono.

George C. Scott, Robert Preston, and Jack Gilford starred in Larry Gelbart's *Sly Fox*.

Streamers, David Rabe's play, opened at the Mitzi E. Newhouse Theatre, Lincoln Center, New York.

Katharine Hepburn starred in Enid Bagnold's *A Matter of Gravity*.

Bubbling Brown Sugar, the African-American musical, starred Avon Long and Josephine Premice.

Neil Simon's comedy *California Suite* starred Barbara Barrie, George Grizzard, Tammy Grimes, and Jack Weston.

For Colored Girls Who Have Considered Suicide When the Rainbow Is Enuf, Ntozake Shange's African-American play, starred Trazana Beverley.

Knock Knock, Jules Feiffer's comedy, starred Lynn Redgrave, John Heffernan, and Charles Durning; opened at the Biltmore Theatre, New York.

Long Day's Journey into Night, Eugene O'Neill's play, starred Jason Robards, Michael Moriarty, Zoë Caldwell, and Kevin Conway.

Julie Harris appeared as Emily Dickinson in William Luce's *The Belle of Amherst*.

Vanessa Redgrave and Pat Hingle starred in Henrik Ibsen's *The Lady from the Sea*.

John Lithgow, Jonathan Pryce, and Milo O'Shea starred in Trevor Griffiths's *The Comedians*.

Jane Alexander and Richard Kiley starred in Ruth Goetz's *The Heiress*.

The Old Glory, Roscoe Lee Browne starred in the Robert Lowell's play.

Your Arms Too Short to Box with God, Alex Bradford's African-American musical, starred Delores Hall and William Hardy, Jr.

A Texas Trilogy, Diane Ladd starred in the Preston Jones plays; opened at the Broadhurst Theatre, New York, September 21.

Who's Afraid of Virginia Woolf?, Edward Albee's play, starred Colleen Dewhurst and Ben Gazzara.

d. Lee J. Cobb (Leo Jacoby), American actor (b. 1911); he created the Willy Loman role in *Death of a Salesman*.

d. Edith (Mary) Evans, British actress (b. 1888).

d. Margaret Leighton, English actress (b. 1922).

d. Sybil Thorndike (Agnes Sybil Thorndike), British actress (b. 1882).

MUSIC & DANCE

Wanted! The Outlaws, album featuring Willie Nelson, Waylon Jennings, Tompass Glaser, and Jessi Colter; the first country music album to sell over a million copies; Nelson and Jennings also teamed on the hit single *Good Hearted Woman*.

A Month in the Country, Frederick Ashton's ballet, to music by Frédéric Chopin, first danced February 12 by the Royal Ballet, London.

Farewell concert of the Band, at San Francisco on Thanksgiving Day; subject of Martin Scorsese 1978 film *The Last Waltz*.

Push Comes to Shove, Twyla Tharp's ballet, music by Joseph Lamb and Haydn, first danced January 9, by the American Ballet Theater, in New York, with Mikhail Baryshnikov.

Chaconne, George Balanchine's ballet, to music by Christophe Gluck, first danced January 22 by the New York City Ballet, Lincoln Center.

Einstein on the Beach, Philip Glass's opera, premiered at Avignon and the Metropolitan Opera; it was the first of his "portrait opera" trilogy.

Requiem, Kenneth MacMillan's ballet, music by Gabriel Fauré, first danced by the Stuttgart Ballet.

Gian Carlo Menotti's *Symphony No. 1*; *Fantasia* for cello and orchestra; cantata *Landscapes and Remembrances*; and operas *The Hero* and *The Egg*, for children.

The Union Jack, George Balanchine's ballet, music by Hershy Kay, first danced May 12 by the New York City Ballet.

Harrison Birtwistle's percussion work *For O, For O, the Hobby-horse is Forgot* and *Melencolia I*, for clarinet, harp, and strings.

Peter Maxwell Davies's *Symphony No. 1* and his choral work *Westerlings*.

Judy Collins's album *Bread and Roses*, with the title song and *Salt of the Earth*.

Elliott Carter's *A Symphony of Three Orchestras*.

Rod Stewart's album *A Night on the Town*.

The Sisters, Dmitry Kabalevsky's operetta.

Led Zeppelin's album *Presence*.

We Come to the River, Hans Werner Henze's opera.

Linda Ronstadt's album *Hasten Down the Wind*.

Milton Babbitt's *Concerti*, for tape with instruments.

Maria Muldaur's album *Sweet Harmony*.

Stevie Wonder's album *Songs in the Key of Life*.

Coro, Luciano Berio's vocal work.

The Jefferson Starship's album *Spitfire*.

Fleetwood Mac's album *Rumours*.

Bette Midler's album *Songs for a New Depression*.

Earth, Wind, and Fire's album *Spirit*.

d. (Edward) Benjamin Britten, British composer (b. 1913).

d. Paul Robeson, African-American actor and singer, a world figure (b. 1898).

d. Gregor Piatigorsky, Russian cellist (b. 1903).

d. Lotte Lehmann, German soprano, later naturalized American (b. 1888).

d. Johnny Mercer, American lyricist and composer (b. 1909).

d. Lily Pons (Alice Josephine Pons), French soprano (b. 1898).

d. Dean Dixon, African-American conductor (b. 1915).

d. Roland Hayes, American tenor, an African-American singer who became a world figure, despite pervasive discrimination in the United States.

d. Rosina Lhévinne, teacher at Juilliard School (b. 1880).

d. Walter Piston, American composer (b. 1894).

WORLD EVENTS

Democrat Jimmy (James Earl) Carter, Jr., defeated incumbent Republican President Gerald R. Ford to become 39th president of the United States (1977–1981).

d. Mao Zedong (Mao Tse-tung), leader of Chinese Communism (b. 1893). After his death, his wife Jiang Qing, Zhang Chunqiao, Wang Hongwen, and Yao Wenhuan were arrested and charged as the "Gang of Four," accused of a plot to take power; all were subsequently convicted. Deng Xiaoping emerged as Chinese Communist head.

Argentina's military government began a campaign of state terrorism against all dissidents, the "dirty war" that saw the murders of tens of thousands, the *desaparacios* (disappeareds).

Barbara Jordan was the keynote speaker at the Democratic national convention.

Israeli commandos rescued 98 hostages taken June 27 in an Air France hijacking and held at Uganda's Entebbe airport by Idi Amin (July 4).

In *Gregg v. Georgia*, the U.S. Supreme Court reinstated the right of states to enforce the death penalty, and the killing of prisoners was soon resumed.

South African government's attempt to force use of Afrikaans as official language triggered massive riots in Soweto and then throughout the country; at least 600 Blacks and other non-Whites died.

Direct Syrian intervention in the Lebanon civil war led to a partial autumn ceasefire, but the war continued.

Former Chilean Allende government official Orlando Letelier del Solar was assassinated by Chilean secret police agents in Washington, D.C.

German terrorist Ulrike Meinhof was found dead in prison, in questionable circumstances.

Portuguese democratic leader Mario Lopez Soares became prime minister of Portugal.

Massive Tangshan, China, earthquake reportedly killed 242,000 people and injured 164,000.

Guatemala City earthquake caused massive damage in central Guatemala; an estimated 20,000–25,000 people died.

World's first regularly scheduled supersonic airliner service began, on the *Concorde*.

American spacecrafts *Viking 1* and *2* landed on Mars.

d. Zhou Enlai (Chou En-lai), first premier of the People's Republic of China (1949–1976), and chief spokesperson, diplomat, and negotiator of Chinese Communism (b. 1886).

1977

LITERATURE

The Thorn Birds, Colleen McCullough's multigenerational Australian novel; basis for the 1983 television minisereies.

Vicente Aleixandre was awarded the Nobel Prize for Literature.

A Book of Common Prayer, Joan Didion's novel.

A Place to Come To, Robert Penn Warren's novel.

The Turning Point, Arthur Laurents's novel; basis of the 1977 Herbert Ross film.

The Women's Room, Marilyn French's novel, about a woman's journey to independence.

The Honorable Schoolboy, John le Carré's spy thriller, second novel of the George Smiley trilogy.

A. R. Ammons's poetry collections *Highgate Road* and *The Snow Poems*.

The Persian Boy, Mary Renault's novel.

Song of Solomon, Toni Morrison's novel.

The Ice Age, Margaret Drabble's novel.

Falconer, John Cheever's novel.

Christy Brown's poetry *Of Snails and Skylarks*.

In Patagonia, Bruce Chatwin's travel book.

Dannie Abse's *Collected Poems*.

Hortense Calisher's novel *On Keeping Women*.

Lancelot, Walker Percy's novel.

Houseboat Days, John Ashbery's poetry collection.

Robert Bly's poetry *This Body Is Made of Camphor and Gopherwood*.

Morley Callaghan's short stories *Close to the Sun*.

The Painter of Signs, Rasipuram Narayan's novel.

Richard Wright's autobiographical work *American Hunger*.

S. J. Perelman's *Eastward Ha!*

Robert Lowell's poems *Day by Day*.

Susan Sontag's essays *On Photography*.

Petals of Blood, novel by Ngugi Wa Thiong'O.

Turgenev, V. S. Pritchett's biography.

d. Anaïs Nin, American writer (b. 1903).

d. Robert Lowell (Traill Spence, Jr.), American poet (b. 1917).

d. Vladimir Nabokov, Russian-American writer (b. 1899).

d. James Jones, American author (b. 1921).

d. James M. Cain, American writer (b. 1892).

d. Konstantin Fedin, Soviet writer (b. 1892).

d. Louis Untermeyer, American writer and editor (b. 1885).

d. MacKinley Kantor, American writer (b. 1904).

FILM & BROADCASTING

Roots, the record-breaking 12-hour television miniseries, based on the 1976 Alex Haley book, which explored his family's African and African-American history, with a cast led by Louis Gossett, Jr., LeVar Burton, and Ben Vereen; a 12-hour sequel was broadcast in 1979.

Julia, Jane Fonda as Lillian Hellman, Jason Robards as Dashiell Hammett, and Vanessa Redgrave starred in Fred Zinneman's film, set in the American and Europe in the 1930s; based on Hellman's autobiographical *Pentimento* (1973).

Close Encounters of the Third Kind, Steven Spielberg's science fiction and special effects film; Richard Dreyfuss, Melinda Dillon, François Truffaut, and Cary Guffey starred.

Annie Hall, Woody Allen wrote and directed this romantic comedy, also starring opposite Diane Keaton.

Black and White in Color, the Jean-Jacques Annaud film, set in colonial Africa at the start of World War I.

Star Wars, Mark Hamill, Harrison Ford, Carrie Fisher, and Alec Guinness starred in George Lucas's interstellar war special effects film.

Equus, Richard Burton as the psychiatrist and Peter Firth once again as the disturbed boy starred in Sidney Lumet's screen version of the 1973 Peter Shaffer play.

Diane Keaton, Richard Kiley, and Tuesday Weld starred in *Looking for Mr. Goodbar*, directed by Richard Brooks.

Madame Rosa, Simone Signoret as the compassionate prostitute starred in the Moshe Mizrachi film.

Robert Mitchum starred as Philip Marlowe in a remake of *The Big Sleep*.

Fernando Rey and Carole Bouquet starred in *That Obscure Object of Desire*, directed by Luis Buñuel.

Richard Dreyfuss and Marsha Mason starred in *The Goodbye Girl*, directed by Herbert Ross.

Anne Bancroft and Shirley MacLaine starred in *The Turning Point*, directed by Herbert Ross.

Andrzej Wajda directed *Man of Marble*.

Tinker, Tailor, Soldier, Spy, Alec Guinness starred as George Smiley in the television miniseries, based on the 1974 John le Carré spy thriller.

The Pallisers, Philip Latham, Susan Hampshire, Roland Culver, Roger Livesey, Barbara Murray, Donal McCann, and Anna Massey led a huge cast in the 22-part British television serial, based on several Anthony Trollope novels.

Eleanor and Franklin, the White House Years, sequel to *Eleanor and Franklin* (1976), again starring Jane Alexander and Edward Herrman as Eleanor and Franklin Delano Roosevelt.

The Lou Grant Show, Ed Asner starred as the Los Angeles city editor in the socially aware television series, with Mason Adams, Nancy Marchand, Linda Kelsey, Jack Bannon, Robert Walden, and Daryl Anderson (1977–1982).

I, Claudius, beginning of the celebrated British television series, based on Robert Graves's 1934 novel.

Academy Awards for 1977 (awarded the following year): Best Picture: *Annie Hall*; Best Director: Woody Allen, *Annie Hall*; Best Actor: Richard

Dreyfuss, *The Goodbye Girl*; Best Actress: Diane Keaton, *Annie Hall*.

d. Charlie (Charles Spencer) Chaplin, British actor, director, writer, composer, and producer (b. 1899).

d. Roberto Rossellini, Italian director who created *Open City* (1945) and *Paisan* (b. 1906).

d. Groucho Marx (Julius Henry Marx), American actor and comedian (b. 1890).

d. Howard Hawks, American director, writer, and producer (b. 1896).

d. Joan Crawford (Lucille Fay Le Sueur), American actress (b. 1904).

d. Peter Finch (William Mitchell), Australian actor (b. 1916).

d. Michael Balcon, British producer (b. 1896).

VISUAL ARTS

Minoru Yamasaki and Emery Roth designed New York's World Trade Center.

Yale University Center for British Art, New Haven, opened; designed by Louis I. Kahn before his 1974 death.

Alexander Calder's aluminum mobile was placed in the National Gallery of Art, Washington, D.C.

Louise Nevelson's sculpture *Mrs. N's Place*.

William Jensen's painting, *Heaven, Earth*.

Yousuf Karsh's *Karsh Portraits*.

Ellsworth Kelly's painting *Blue Panel I*.

Benjamin Thompson designed the restored Faneuil Hall Marketplace, Boston.

Red Grooms's painting *Quick Elysées*.

Richard Estes's painting *Ansonia*.

John Portman designed the Renaissance Center, Detroit.

Frank Stella's painting *Sinjerli Variations*, *Steller's Albatross*.

Agnes Martin's painting *Untitled No. 11, No. 12*.

Alice Aycock's sculpture *Studies*.

Audrey Flack's painting *Marilyn*.

Hugh Stubbins designed the Citicorp Center, New York.

Dan Flavin's sculpture *Untitled (for Robert with Fond Regards)*.

Lehman Wing, Metropolitan Museum of Art, designed by Roche and Dinkeloo.

Nicholas Africano's painting *The Cruel Discussion*.

Luccio Pozzi's sculpture *Four Windows*.

Philip Guston's painting *Cabal*.

Thanksgiving Square, Dallas, designed by Johnson and Burgee.

d. William Gropper, American cartoonist and painter of social concerns (b. 1897).

THEATER & VARIETY

Neil Simon's *Chapter Two* starred Judd Hirsch and Anita Gillette; opened at the Imperial Theatre, New York, December 4.

Side by Side by Sondheim, Stephen Sondheim's musical, starred Millicent Martin, Julie McKenzie, and David Kernan.

Hume Cronyn and Jessica Tandy starred in *The Gin Game*; D. L. Coburn's play opened at the John Golden Theatre, New York, October 6.

Otherwise Engaged, Simon Gray's play, starred Tom Courtenay.

Liv Ullmann starred in Eugene O'Neill's *Anna Christie*.

Annie, Andrea McArdle as Annie, Dorothy Loudon, and Reid Shelton starred in the Martin Charnin–Charles Strouse musical, based on the *Little Orphan Annie* comic strip; opened at the Alvin Theatre, New York, April 21.

Dracula, Frank Langella starred in the Hamilton Deane and John L. Balderston play.

Geraldine Fitzgerald, Jason Robards, and Milo O'Shea starred in Eugene O'Neill's *A Touch of the Poet*.

Sylvia Sidney starred in Tennessee Williams's *Vieux Carré*.

American Buffalo, David Mamet's play, starred Robert Duvall and John Savage; opened at the Ethel Barrymore Theatre, New York, February 16.

Lily Tomlin starred in her one-woman show *Appearing Nightly*.

A Life in the Theatre, David Mamet's play, starred Ellis Rabb and Peter Evans.

Caesar and Cleopatra, George Bernard Shaw's play, starred Rex Harrison and Elizabeth Ashley.

Anne Bancroft starred in William Gibson's *Golda*, about Israeli premier Golda Meir.

Gemini, Albert Innaurato's play, starred Danny Aiello.

Estelle Parsons starred in Roberto Athayde's *Miss Margarida's Way*.

Lynn Redgrave starred in George Bernard Shaw's *St. Joan*.

The Basic Training of Pavlo Hummel, David Rabe's play, starred Al Pacino.

The Cherry Orchard, Anton Chekhov's play, starred Irene Worth and George Voskovec.

The Elephant Man, Bernard Pomerance's play, set in 19th-century London, based on the life of John Merrick; basis of the 1980 David Lynch film.

Geraldine Fitzgerald, Lawrence Luckinbill, and Simon Oakland starred in Michael Cristofer's *The Shadow Box*; opened at the Morosco Theatre, New York, March 31.

Rosemary Harris, Tovah Feldshuh, and Ellen Burstyn starred in Anton Chekhov's *The Three Sisters*.

The Landscape of the Body, John Guare's play.

d. Zero Mostel (Samuel Joel Mostel) American actor and comedian (b. 1915); blacklisted in the 1950s, he came back to star on stage and screen.

d. Carl Zuckmayer, German playwright (b. 1896).

d. Edward Loomis Davenport, American actor (b. 1815).

MUSIC & DANCE

Margot Fonteyn and Rudolf Nureyev danced the leads in *Romeo and Juliet*, Kenneth MacMillan's new choreography to the 1938 Sergei Prokofiev score, first performed February 9 with the Royal Ballet, Covent Garden.

Vienna Waltzes, George Balanchine's ballet; music by Johann Strauss, Jr., first danced June 23, by the New York City Ballet.

The Ice Break, Michael Tippett's opera to his own libretto, opened at Covent Garden, London.

Harrison Birtwistle's music-theater work *Bow Down*; and his orchestral works *Silbury Air* and *Carmen arcadiae mechanicae perpetuum*.

Peter Maxwell Davies's opera *The Martyrdom of St. Magnus* and orchestral work *A Mirror of Whitening Light*.

Nobody Does It Better, Carly Simon's hit song from *The Spy Who Loved Me*; words by Carole Bayer Sager, music by Marvin Hamlisch.

A Flock Descends into the Pentagonal Garden, Toru Takemitsu's orchestral work.

Marvin Gaye Live at the London Palladium, album with the hit song *Got to Give It Up*.

Don't Stop (Thinkin' About Tomorrow), Fleetwood Mac's hit song, words and music by Christine McVie.

Sting, Stewart Copeland, and Andy Summers founded the Police.

Leonard Bernstein's overture *Slava!* and *Sonfest*.

Sweet Forgiveness, Bonnie Raitt's album.

Michael Tippett's *Fourth Symphony*.

James Taylor's album *J.T.*, including *Handy Man*.

Foreign Affairs, Tom Waits's album.

The Royal Hunt of the Sun, Iain Hamilton's opera.

Dolly Parton's album *New Harvest . . . First Gathering*.

George Crumb's *Star-child*, for voice and orchestra.

Olivia Newton-John's album *Totally Hot*.

Jonchaies, Iannis Xenakis's orchestral work.

Pink Floyd's album *Animals*.

Jubiläum, Karlheinz Stockhausen's orchestral work.

Randy Newman's album *Little Criminal*.

Ornette Coleman organized the "Prime Time" jazz group.

Linda Ronstadt's album *Simple Dreams*.

Low, *Heroes*, David Bowie's album.

Earth, Wind, and Fire's album *All 'n All*.

d. Elvis Presley, American singer and actor (b. 1935), the first rock-and-roll star to become a world figure.

d. Bing (Harry Lillis) Crosby, American singer and actor (b. 1904), widely popular singer, nicknamed the Crooner, the Groaner, and (by Germans during World War II) Der Bingle.

d. Leopold Stokowski, British-American conductor (b. 1977).

d. Maria Callas (Maria Kalogeropoulos), American soprano (b. 1923).

d. Ethel Waters, American singer and actress, a breakthrough African-American star (b. 1896).

d. E(dward) Power Biggs, British-American organist (b. 1906).

WORLD EVENTS

AIDS (Acquired Immune Deficiency Syndrome) cases began to be reported in America.

Mohammad Zia Ul-Haq led a military coup that seized power in Pakistan, imprisoning Prime Minister Zulfikar Ali Bhutto, murdered in 1979.

Leonid Ilyich Brezhnev formally became secretary-general of the Communist party and president of the Soviet Union.

Somali forces invaded the disputed Ogaden region of Ethiopia, beginning the Somali–Ethiopian War

(1977–1978). Early Somali successes did not hold, as Soviet and Cuban forces backed Ethiopia against their former ally Somalia, which then broke relations with the Soviets in favor of the Americans.

West German commandos successfully rescued 86 hostages aboard a Lufthansa passenger plane held by the terrorist Baader-Meinhof group at Mogadishu airport (October 18).

Amnesty International won the Nobel Peace Prize.

German terrorist Andreas Baader found dead in prison, in questionable circumstances.

America and Panama renegotiated the Canal Zone treaties.

PCBs (polychlorinated biphenyls) were understood to be cancer causing, and their production was banned in America.

Southgate, Kentucky, Supper Club fire killed 162 people (May 28).

Two Boeing 707s collided on the ground and caught fire at Tenerife airport, killing 576 people.

American space probes *Voyager 1* and *2* flew by Jupiter, sending back many pictures and much data.

British gynecologist–obstetrician Patrick Steptoe delivered the first successful "test-tube baby," conceived by *in vitro* fertilization.

1978

LITERATURE

John Cheever's Pulitzer Prize–winning short-story collection *The Stories of John Cheever*.

The World According to Garp, John Irving's novel; basis of the 1982 George Roy Hill film.

Isaac Bashevis Singer was awarded the Nobel Prize for Literature.

James Michener's novels *Chesapeake* and *The Covenant*.

Adrienne Rich's poetry *The Dream of a Common Language*.

Son of the Morning, Joyce Carol Oates's novel.

Susan Sontag's essays *Illness as Metaphor*.

The Human Factor, Graham Greene's novel.

Rumpole of the Bailey, first of John Mortimer's Rumpole novels; basis of the television series.

The Far Pavilions, M. M. Kaye's novel, set on India's northern frontier in the 19th century; basis of the 1984 television miniseries.

Alice Adams's novel *Listening to Billie*.

Nikki Giovanni's poetry *Cotton Candy on a Rainy Day*.

The Sea, The Sea, Iris Murdoch's novel.

Maxine Kumin's poetry *The Retrieval System*.

Brian W. Aldiss's novel *Enemies of the System*.

Kofi Awoonor's poetry *House by the Sea*.

My Michael, Amos Oz's novel.

Robert Creeley's poetry *Later*.

The seventh volume of Anaïs Nin's diary was published.

Robert Penn Warren's poetry *Now and Then*.

d. F. R. (Frank Raymond) Leavis, English critic (d. 1895).

d. James Gould Cozzens, American writer (b. 1903).

d. Sylvia Townsend Warner, British writer (b. 1893).

d. Léon Gontran Damas, French Guianese author (b. 1912).

d. Phyllis McGinley, American author of light verse (b. 1905).

d. Hugh MacDiarmid (pseudonym of Christopher Murray Grieve), Scottish poet and critic (b. 1892).

FILM & BROADCASTING

The Deer Hunter, Robert De Niro, Christopher Walken, Meryl Streep, John Savage, and John Cazale starred in Michael Cimino's Vietnam War film.

Coming Home, Jane Fonda, Jon Voight, and Bruce Dern starred in Hal Ashby's post–Vietnam War film; screenplay by Waldo Salt and Robert C. Jones.

Ingmar Bergman directed *Autumn Sonata*, starring Ingrid Bergman and Liv Ullmann.

Stevie, Glenda Jackson as poet Stevie Smith; Mona Washbourne, Trevor Howard, and Alec McCowen starred in Hugh Whitemore's film version of his play.

La Cage aux Folles, the Edouard Molinaro farce, based on Philip Poiret's play; Ugo Tognazzi and Michel Serrault starred as the gay couple.

Jill Clayburgh, Alan Bates, and Michael Murphy starred in *An Unmarried Woman*, directed by Paul Mazursky.

A Little Night Music, Elizabeth Taylor and Len Cariou starred in the Harold Prince screen version of the 1973 Stephen Sondheim stage musical.

Burt Reynolds, Sally Field, and Jan-Michael Vincent starred in *Hooper*, directed by Hal Needham.

Get Out Your Handkerchiefs, Carol Laure and Gerard Depardieu starred in the film comedy, written and directed by Bernard Blier.

Grease, John Travolta and Olivia Newton-John starred in the Randal Kieser musical, set in the 1950s; based on the 1972 stage musical.

E. G. Marshall, Geraldine Page, Maureen Stapleton, and Diane Keaton starred in *Interiors*, directed by Woody Allen.

Superman, Christopher Reeve starred as Superman in the Frank Donner film; there were three sequels (1980, 1983, 1987).

The Buddy Holly Story, Gary Busey played Holly in the Steve Rash biofilm.

Warren Beatty produced, wrote, and codirected *Heaven Can Wait*, costarring with Julie Christie, James Mason, Dyan Cannon, and Jack Warden; based on the 1941 film *Here Comes Mr. Jordan*.

Dallas, the television series saga of the Texas Ewing family; Larry Hagman, Barbara Bel Geddes, Jim Davis, Patrick Duffy, Victoria Principal, Charlene Tilton, and Linda Grey originally starred.

Holocaust, the television miniseries, story of a German-Jewish family and of the German mass murders of millions of Jews; the cast was led by Sam Wanamaker, Michael Moriarty, and Meryl Streep.

Centennial, the 24-part television series (1978–1980), set in the expanding American West, based on the 1974 James Michener novel; Robert Conrad, Richard Chamberlain, Gregory Harrison, and Lynn Redgrave starred.

Academy Awards for 1978 (awarded the following year): Best Picture: *The Deer Hunter*; Best Director: Michael Cimino, *The Deer Hunter*; Best Actor: Jon Voight, *Coming Home*; Best Actress: Jane Fonda, *Coming Home*.

d. Charles Boyer, French actor (b. 1897).

d. Edgar Bergen, American ventriloquist and actor (b. 1903), creator of the puppet Charlie McCarthy; father of actress Candice Bergen.

VISUAL ARTS

I. M. Pei designed the East Building, National Gallery of Art, Washington, D.C.; and the Dallas City Hall.

The Dinner Party, Judy Chicago's construction, on feminist themes.

Isamu Noguchi's portal for Cleveland's Justice Center.

Roy Lichtenstein's painting *Razzmatazz*.

Ralph Goings's painting *Still Life with Sugars*.

Audrey Flack's painting *Bounty*.

Duane Hanson's sculpture *Woman Reading a Paperback*.

Richard Long's sculpture *Cornish Stone Circle*.

Jennifer Bartlett's painting *Summer Lost at Night (for Tom Hess)*.

Louise Bourgeois's sculpture *Confrontation, Structure III—Three Floors*.

Edward Larrabee Barnes designed the Purchase Campus, State University of New York.

Willem de Kooning's painting *Untitled III*.

Elizabeth Murray's painting *Children Meeting*.

Michael Graves designed Moorehead Cultural Bridge, Fargo, North Dakota.

Philip Guston's painting *Tomb, The Ladder*.

Alice Neel's painting *Geoffrey Hendricks and Brian*.

Susan Rothenberg's painting *For the Light*.

William Tucker's sculpture *Arc*.

d. Giorgio De Chirico, Italian painter (b. 1888).

d. Edward Durell Stone, American architect (b. 1902).

d. Charles Eames, American designer (b. 1907), creator of the Eames chair.

d. Norman Rockwell, American artist (b. 1894), a leading magazine illustrator.

d. Richard Lindner, American painter (b. 1901).

d. W. Eugene Smith, American photographer (b. 1918).

THEATER & VARIETY

The Fifth of July, William Hurt starred in Lanford Wilson's play; opened at the Circle Theatre, New York, April 27.

Henry Fonda and Jane Alexander starred in the Jerome Lawrence and Robert E. Lee play *First Monday in October*.

Rex Harrison and Claudette Colbert starred in William Douglas Home's *The Kingfisher*.

Ain't Misbehavin', Nell Carter and Andre De Shields starred in the jazz musical, based on the work of "Fats" (Thomas) Waller; opened at the Longacre Theatre, New York, May 9.

Da, Hugh Leonard's play, starred Barnard Hughes.

Bob Fosse choreographed and Ann Reinking starred in *Dancin'*; opened at the Broadhurst Theatre, New York, March 27.

The Best Little Whorehouse in Texas, Carol Hall's musical, opened at the Entermedia Theatre, New York, April 17.

Deathtrap, Ira Levin's play, starred John Wood and Marian Seldes; opened at the Music Box Theatre, New York, February 26.

Gregory Hines starred in *Eubie!*, based on the work of Eubie Blake and others.

On the 20th Century, John Cullum, Kevin Kline, and Madeline Kahn starred in the Betty Comden–Adolph Green musical.

The Crucifer of Blood, Glenn Close and Paxton Whitehead starred in Paul Giovanni's play.

Alec McCowen's one-man reading of *St. Mark's Gospel*.

Jay O. Sanders and Jacqueline Brookes starred in Sam Shepard's Pulitzer Prize–winning *Buried Child*; opened at the Theatre de Lys, New York.

Albert Finney starred as *Macbeth* at the National Theatre.

L'Amour, Georges Feydeau's play, starred Louis Jourdan and Patricia Elliott.

Man and Superman, George Grizzard starred in the George Bernard Shaw play.

Tammy Grimes starred in Simon Gray's *Molly*.

Once in a Lifetime, the Moss Hart and George S. Kaufman play, starred John Lithgow.

Meryl Streep and Raul Julia starred in Shakespeare's *The Taming of the Shrew*.

Theodore Bikel starred in Nikolay Gogol's *The Inspector General*.

Jack Lemmon starred in Bernard Slade's *Tribute*.

Joking Apart, Alan Ayckbourn's play.

Night and Day, Tom Stoppard's play.

Protest, Václav Havel's play.

d. Micheál MacLiammóir, Irish actor, designer, and playwright (b. 1899).

d. Fay Compton, English actress (b. 1894).

d. Jökull Jakobsson, Icelandic novelist and playwright (b. 1933).

MUSIC & DANCE

Willie Nelson released a widely admired album of old standards, *Stardust*, and another pairing with country star Jennings, in *Waylon and Willie*, including the Grammy-winning song *Mammas Don't Let Your Babies Grow Up to Be Cowboys*.

Mayerling, Kenneth MacMillan's ballet, to music by Franz Liszt, first danced February 15 by the Royal Ballet, London.

Lear, Aribert Reimann's opera, libretto by Claus Henneberg, based on Shakespeare's play, premiered in Munich, July 9, with Dietrich Fischer-Dieskau in the title role.

Superscope-Marantz of the United States introduced the *Pianocorder*, combining old player-piano ideas with modern computers and tape cassettes, allowing composers to score pieces unlimited by a human player's 10 fingers, sometimes with chords of 30 notes or more.

Kammermusik No. 2, George Balanchine's ballet, music by Paul Hindemith, first danced January 26 by the New York City Ballet.

Bruce Springsteen's album *Darkness on the Edge of Town*, including *Badlands* and *The Promised Land*.

Le Grand Macabre, György Ligeti's opera, libretto by Ligeti and Michael Meschke, opened in Stockholm April 12.

The Red Line, Aulis Sallinen's opera to his own libretto based on the Ilmari Kianto novel, opened in Helsinki November 30.

Billy Joel's Grammy-winning album *52nd Street*, with *My Life*.

The Who's album *Who Are You*.

Linda Ronstadt's album *Living in the U.S.A.*

The Trial of the Gypsy, Gian Carlo Menotti's children's opera.

Bob Dylan's Grammy-winning song *Gotta Serve Somebody*.

B. B. King's album *Midnight Believer*.

Hans Abrahamsen's *Walden*, for wind quintet.

Maria Muldaur's album *Southern Winds*.

Peter Maxwell Davies's ballet *Salome*.

Saturday Night Fever film soundtrack album.

The Jefferson Starship's album *Earth*.

John Cage's *Etudes Borealis*, *Freeman Etudes*.

Muddy Waters's album *I'm Ready*.

Charles Wuorinen's *Fast Fantasy*.

Our Love, Natalie Cole's hit single.

Grease, film sound track album.

Krzysztof Penderecki's opera *Paradise Lost*.

Zubin Mehta became director of the New York Philharmonic Orchestra (1978–1990).

d. Aram Khachaturian, Armenian composer (b. 1903).

d. Tamara Platonovna Karsavina, celebrated Russian dancer (b. 1885), who as prima ballerina created many of the great roles with Sergei Diaghilev's Ballets Russes company.

d. Carlos Chávez, Mexican composer and conductor (b. 1899).

d. Jacques Brel, French cabaret singer (b. 1929).

d. Ruth Etting, American torch singer (b. 1903).

d. William Grant Still, African-American composer (b. 1895).

WORLD EVENTS

President Jimmy Carter mediated the September 17 Camp David Accords, in which Anwar Sadat and Menachim Begin agreed on the terms of an Egyptian–Israeli peace treaty and Israel agreed to withdraw from the Sinai Peninsula.

Polish priest Karol Wojtyla, archbishop of Kraków, became Pope John Paul II.

South African freedom movement leader Desmond Mpilo Tutu won the Nobel Peace Prize, and became the Anglican bishop of Johannesburg.

War began between invading Vietnamese and Kampuchean (Cambodian) forces; the Vietnamese occupied Cambodia, driving Pol Pot's Khmer Rouge forces to Thailand bases and ending the Cambodian Holocaust, as guerrilla warfare continued.

Israeli forces invaded Lebanon in March, setting up a "buffer zone" garrisoned by Christian Lebanese militia; the long Lebanon wars continued.

U.S. Congressman Leo Ryan and four others in his investigative party were murdered by followers of People's Temple cult leader Warren "Jim" Jones, at Jonestown, Guyana. Jones then caused the death of 909 of his followers, most of them suicides by cyanide, the others murdered; Jones then committed suicide.

San Francisco ex-supervisor Dan White murdered gay San Francisco Supervisor Harvey Milk and Mayor George Moscone on November 27.

Sandinista guerrilla war in Nicaragua grew into the Nicaraguan Civil War (1978–1988).

In *Regents of the University of California v. Bakke*, the U.S. Supreme Court invalidated many preferential admissions programs, the "quota system."

U.S. Supreme Court upheld the right of American Nazis to march at Skokie, Illinois.

Abscam (Arab scam), an FBI operation, caught and convicted a U.S. senator and five congressmen ready to accept bribes; the conviction of one other congressman was reversed on appeal.

An April Afghan coup toppled the Sardar Mohammed Daud Khan government. The new government introduced massive changes, soon generating armed *mujahedin* resistance.

Somali forces were decisively defeated at Diredawa-Jijiga (March 2–5), ending the Somali–Ethiopian War with Somali withdrawal from the Ogaden.

Italian Red Brigades assassinated former Italian Prime Minister Aldo Moro.

Shiite fundamentalist arsonists set fire to a theater in Abadan, Iran, killing 350–400 people.

Supertanker *Amoco Cadiz* broke up in a storm off Brittany on March 9, generating a massive oil spill and environmental disaster.

Chlorofluorocarbons (CFCs) in aerosol sprays were banned in America.

Mary Daly's *Gyn/Ecology: The Metaethics of Radical Feminism.*

1979

LITERATURE

Sophie's Choice, William Styron's novel about a concentration-camp survivor; Alan J. Pakula directed the 1982 film version.

The Nobel Prize for Literature was awarded to Odysseus Elytis.

The Morning of the Poem, James Schuyler's Pulitzer Prize–winning collection.

Shikasta, first novel in Doris Lessing's science fiction *Canopus in Argos* series.

Norman Mailer's Pulitzer Prize–winning *The Executioner's Song.*

The Book of Laughter and Forgetting, Milan Kundera's novel.

Robert Bly's poetry *This Tree Will Be Here for a Thousand Years.*

The Old Patagonian Express, Paul Theroux travel book.

The Twyborn Affair, Patrick White's novel.

The Ghost Writer, Philip Roth's novel.

A Bend in the River, V. S. Naipaul's novel.

Burger's Daughter, Nadine Gordimer's novel.

And Again, Sean O'Faolain's novel.

RETA E. KING LIBRARY
CHADRON STATE COLLEGE
CHADRON, NE 69337

Safety Net, Heinrich Böll's novel.

Ayi Kwei Armah's novel *The Healers*.

W. H. Auden's *Selected Poems*.

The White Album, Joan Didion's novel.

Brian W. Aldiss's novel *A Rude Awakening*.

Dubin's Lives, Bernard Malamud's novel.

The Strength of Fields, James Dickey's poetry collection.

John Knowles's novel *A Vein of Riches*.

Living in the Maniototo, Janet Frame's novel.

Joseph Brodsky's poems *A Part of Speech*.

Kenneth Rexroth's poetry *The Morning Star*.

Muriel Rukeyser's *Collected Poems*.

Old Love, Isaac Bashevis Singer's novel.

Peter Benchley's novel *The Island*.

Vasily Aksyonov's novel *The Steel Bird*.

d. Eric (Honeywood) Partridge, New Zealand–born British lexicographer (b. 1894).

d. James Farrell, American writer (b. 1904).

d. Elizabeth Bishop, American poet (b. 1911).

d. Jean Rhys, British feminist writer (b. 1894).

d. S. J. (Sidney Joseph) Perelman, American humorist (b. 1903).

d. Jean Stafford, American writer (b. 1915).

d. Konstantin Simonov, Soviet writer (b. 1915).

d. I. A. (Ivor Armstrong) Richards, English critic and poet (b. 1893).

FILM & BROADCASTING

The China Syndrome, Jane Fonda, Jack Lemmon, and Michael Douglas starred in the James Bridges film, about a nuclear near-meltdown.

Kramer vs. Kramer, Dustin Hoffman and Meryl Streep starred as the well-to-do New York City divorced parents in a custody case in the Robert Benton film.

Norma Rae, Sally Field as Norma Rae, Ron Liebman, and Beau Bridges starred in Martin Ritt's textile union organizing story, set in the South.

The Corn Is Green, Katharine Hepburn and Ian Saynor starred in George Cukor's film version of the 1938 Emlyn Williams play.

The Tin Drum, David Bennant starred as the dwarf in Volker Schlondorff's screen version of the Günter Grass novel, sharply criticizing the German response to Nazism.

Apocalypse Now, Francis Ford Coppola's anti–Vietnam War film, was loosely based on Joseph Conrad's story *Heart of Darkness*; Martin Sheen, Marlon Brando, and Robert Duvall led a large cast.

Manhattan, Woody Allen, Diane Keaton, Michael Murphy, Mariel Hemingway, and Meryl Streep starred in Allen's film about a set of affluent, quasi-intellectual young people.

Being There, the Hal Ashby film, starring Peter Sellers, Shirley MacLaine, and Melvin Douglas; Jerzy Kosinski adapted his own 1971 novel.

William Holden, Marthe Keller, and José Ferrer starred in *Fedora*, directed by Billy Wilder.

All That Jazz, the Bob Fosse film autobiography, a musical starring Roy Scheider, Jessica Lange, Ann Reinking, and Ben Vereen.

Hair, Milos Forman's film, based on the 1967 stage musical, screenplay by Michael Weller; John Savage, Treat Williams, and Beverly D'Angelo starred.

Rainer Werner Fassbinder directed *The Marriage of Maria Braun*.

Werner Herzog directed *Wozzeck*.

Ike, The War Years, Robert Duvall as Dwight D. Eisenhower and Lee Remick as Kay Summersby starred in the television miniseries.

Roots: The Next Generations, television miniseries, sequel to the 1977 *Roots*, also based on the 1976 Alex Haley novel, with a multistar cast led by James Earl Jones as Haley.

I Know Why the Caged Bird Sings, Ruby Dee and Diahann Carroll starred in the television film adaptation of Maya Angelou's 1970 autobiography.

Academy Awards for 1979 (awarded the following year): Best Picture: *Kramer vs. Kramer*; Best Director: Robert Benton, *Kramer vs. Kramer*; Best Actor: Dustin Hoffman, *Kramer vs. Kramer*; Best Actress: Sally Field, *Norma Rae*.

d. Mary Pickford (Gladys Marie Smith) American actress (b. 1893), the silent-screen star who became "America's Sweetheart."

d. John Wayne (Marion Michael Morrison), American actor (b. 1979).

d. Jean Renoir, French film director (b. 1894), son of Impressionist painter Pierre-Auguste Renoir.

d. Darryl F. Zanuck, American producer (b. 1902).

d. Joan Blondell, American actress (b. 1909).

d. George Brent (George Brendan Nolan), Irish-American actor (b. 1904).

d. John Cromwell, American actor, director, and producer (b. 1888).

VISUAL ARTS

I. M. Pei designed the John F. Kennedy Library, Dorchester, Massachusetts.

The Obstacle Race: The Fortunes of Women Painters and their Work, Germaine Greer's book.

Christopher Wilmarth's sculpture, *The Whole Soul Summed Up, Insert Myself within Your Story*.

Robert Rauschenberg's painting *Barge*.

Alice Adams's sculpture *Three Arches*.

Jim Dine's painting *Jerusalem Nights, In the Harem*.

Ellsworth Kelly's painting *Diagonal with Curve 9*.

Richard Diebenkorn's painting *Ocean Park 105*.

Susan Rothenberg's painting *Pontiac*.

Frank Stella's painting *Guadalupe Island, Kastüra*.

Richard Serra's sculpture *Left Corner Rectangles*.

Ida Applebroog's painting *Sure, I'm Sure*.

Robert Rauschenberg's painting *Barge*.

Deere West Building, Moline, Illinois, designed by Roche and Dinkeloo.

Hans Haacke's painting *Thank You, Paine Webber*.

Jack Beal's painting *The Harvest*.

Boettcher Concert Hall, Denver, Colorado, designed by Holzman and Pfeiffer.

Julian Schnabel's painting *Procession for Jean Vigo*.

Vito Acconci's sculpture *The People Machine*.

d. Al Capp, American cartoonist, creator of L'il Abner (b. 1909).

d. Hale Woodruff, African-American artist (b. 1900).

d. Peggy Guggenheim, modern art collector (b. 1898).

d. Pier Luigi Nervi, Italian engineer and designer (b. 1891).

THEATER & VARIETY

Sweeney Todd, the Demon Barber of Fleet Street, Len Cariou as lethal barber Sweeney Todd and Angela Lansbury starred in the Steven Sondheim musical; opened at the Uris Theatre, New York.

On Golden Pond, Ernest Thompson's play, starred Frances Sternhagen and Tom Aldredge; opened at the New Apollo Theatre, New York, February 28.

The Elephant Man, Bernard Pomerance's play, starred Philip Anglim, Carole Shelley, and Kevin Conway.

Tom Conti and Jean Marsh starred in Brian Clark's *Whose Life Is It Anyway?*

Mickey Rooney and Ann Miller starred in the Ralph Allen–Harry Rigby musical *Sugar Babies*.

They're Playing Our Song, the Marvin Hamlisch–Carole Bayer Sager–Neil Simon musical opened at the Imperial Theatre, New York, February 11.

Evita, Patti Lupone starred in the Andrew Lloyd Webber–Tim Rice musical, based on the life of Eva Perón.

Kevin Kline, Roxanne Hart, and Jay O. Sanders starred in *Loose Ends*; Michael Weller's play opened at the Circle in the Square, New York.

A Month in the Country, Tammy Grimes and Farley Granger starred in the Turgenev play.

Michael Gough starred in Alan Ayckbourn's *Bedroom Farce*.

Ian McKellen starred in Martin Sherman's *Bent*.

Samuel Beckett's *Happy Days* starred Irene Worth and George Voskovec.

I Remember Mama, Liv Ullmann starred in the Richard Rodgers and Martin Charnin musical.

Maggie Smith starred in Tom Stoppard's *Night and Day*.

Romantic Comedy, Bernard Slade's play, starred Mia Farrow and Anthony Perkins.

True West, Sam Shepard's play.

Constance Cummings starred in Arthur Kopit's *Wings*.

d. Cornelia Otis Skinner, American actress (b. 1902).

d. Emmett Kelly, American circus clown (b. 1898); he was Weary Willie.

d. Eric Portman, English actor (b. 1903).

d. Joyce Irene Grenfell, English diseuse (b. 1910).

d. Beatrix Lehmann, English actress (b. 1903).

d. W. A. Darlington, English dramatic critic and playwright (b. 1890).

MUSIC & DANCE

Lulu, Alban Berg's complete opera, received its first full staging February 24, in Paris; part had been produced in 1937.

La Fin du Jour, Kenneth MacMillan's ballet, to music by Maurice Ravel, first danced March 15 by the Royal Ballet, London.

Bob Marley's album *Survival*, regarded as his master-

piece; his song *Zimbabwe* was begun during a benefit for African freedom fighters.

Michael Tippett's *Concerto* for violin, viola, and cello; and his fourth string quartet.

Off the Wall, Michael Jackson's first highly successful album, product of his new collaboration with producer Quincy Jones.

Gian Carlo Menotti's operas *La loca* and (for children) *Chip and his Dog*; also his *Missa O pulchritudo*.

Mingus '79, Joni Mitchell's album in homage to jazz great Charles Mingus, their intended collaboration ended by his death.

David Del Tredici's *In Memory of a Summer Day*, first performed in St. Louis.

Milton Babbitt's *Images*, for tape with instruments, and *Paraphrases*, for nine winds.

Fleetwood Mac's album *Tusk*.

Samuel Barber's *Oboe Concerto*.

Willie Nelson's album *Willie and Family Live*.

Solstice of Light, Peter Maxwell Davies's choral work.

Stevie Wonder's album *Journey Through the Secret Life of Plants*.

Orpheus, Hans Werner Henze's ballet.

A Little More Love, Olivia Newton-John's hit single.

William Bolcomb's *Second Sonata for Violin and Piano*.

Amanda, Waylon Jennings's country hit.

Krzysztof Penderecki's *Te Deum*.

Bad Girls, Donna Summer's album.

Led Zeppelin's album *In Through the Out Door*.

Diana Ross's album *The Boss*.

Gunther Schuller's *Sonata Serenata*.

The Wall, Pink Floyd's two-disk album.

Roaratorio, John Cage's electronic work.

Randy Newman's album *Born Again*.

Anémoessa, Iannis Xenakis's choral work.

Eat to the Beat, Blondie's album.

d. Richard Rodgers, American composer (b. 1902), a major musical theater figure, notably in collaboration with Oscar Hammerstein II and Lorenz Hart.

d. Arthur Fiedler, American conductor and violinist (b. 1894), long head of the Boston Pops Orchestra.

d. Charles Mingus, American jazz composer and bandleader (b. 1922).

d. Gracie Fields (Grace Stansfield), British singer, comedian, and actress (b. 1898).

d. Leonid Massine, Russian dancer and choreographer (b. 1895).

d. Nadia Boulanger, French teacher and conductor (b. 1887).

d. Roy Harris, American composer (b. 1898).

WORLD EVENTS

Losing control of his country, Iranian Shah Mohammed Reza Pahlevi fled Iran; he was succeeded by National Front leader Shahpur Bakhtiar, quickly deposed by the fundamentalist Islamic forces of Ayatollah Ruhollah Khomeini, who then ruled Iran until his death in 1989.

Iran hostage crisis: Khomeini's new Iranian government seized 66 Americans and several other hostages in Tehran on November 14, ultimately holding 52 Americans for 444 days. The crisis greatly damaged President Jimmy Carter; all would be released on January 21, 1981, the day he left office.

Sandinista victory in the Nicaraguan revolution generated a civil war, as American-backed former government forces in the north became *Contra* (Against) guerrillas, as did dissident Sandinistas in the south.

Three Mile Island nuclear accident (March 28) brought a reactor close to meltdown, released radioactive material into air and water, and greatly heightened public fear of nuclear energy.

Massive Soviet intervention in the Afghanistan civil war (December 25) turned it into the long Soviet–Afghan war (1979–1989).

Ugandan dictator Idi Amin was deposed after Tanzanian victory in the Uganda–Tanzania war. Milton Obote again became president of Uganda, then instituting yet another reign of terror and generating a civil war in which an estimated 200,000 people died.

Low-level mid-1970s El Salvador guerrilla insurgency grew into full-scale civil war (1979–1991).

At the June Vienna Summit, President Jimmy Carter and Soviet Premier Leonid Brezhnev signed the SALT II arms limitation agreements.

Conservative leader Margaret Thatcher became Britain's first woman prime minister (1979–1990).

British art historian and former Soviet spy Anthony Blunt was publicly exposed, with great publicity; he then lost his knighthood and some other positions and honors.

Reverend Jerry Falwell founded the Moral Majority, an ultraconservative political organization.

Saint Lucia became an independent state and Commonwealth member.

Ixtoc 1 oil well blew out in the Gulf of Mexico; at 600,000 tons, the largest recorded oil spill.

Nawa El Saadawi published *The Hidden Face of Eve: Women in the Arab World.*

d. Zulfikar Ali Bhutto (b. 1928), founder of Pakistan People's party (1967) and prime minister of Pakistan (March–July 1977). Deposed and jailed, he was executed by the military government of General Mohammad Zia ul-Haq after being falsely convicted of murder.

d. Park Chung Hee, South Korean dictator (b. 1917); assassinated October 26 by the head of his own Central Intelligence Agency.

d. Louis Mountbatten, diplomat and soldier (b. 1900), a member of the British royal family; assassinated by Irish Republican Army terrorists on August 28, off the Irish coast.

1980

LITERATURE

A Confederacy of Dunces, John Kennedy Toole's Pulitzer Prize–winning novel, published 11 years after its author committed suicide over his artistic failure.

Smiley's People, John le Carré's spy thriller, final novel of the George Smiley trilogy; basis of the 1982 television miniseries.

Czeslaw Milosz was awarded the Nobel Prize for Literature.

Tom Wolfe's *The Right Stuff*, on the early days of American space flight.

The Clan of the Cave Bear, first of Jean Auel's Earth's Children novels.

Thy Neighbor's Wife, Gay Talese's exploration of adultery in modern life.

Robert Penn Warren's *Being Here: Poetry 1977–1980.*

The Transit of Venus, Shirley Hazzard's novel.

The Collected Stories of Eudora Welty.

Ridley Walker, Russell Hoban's novel.

Loon Lake, E. L. Doctorow's novel.

Setting the World on Fire, Angus Wilson's novel.

Rites of Passage, William Golding's novel.

Joyce Carol Oates's novel *Bellefleur.*

Creation, Gore Vidal's novel.

Falling in Place, Ann Beattie's novel.

Nadine Gordimer's short stories *A Soldier's Embrace.*

Vance Bourjaily's novel *A Game Men Play.*

Cosmos, Carl Sagan.

Plains Song, Wright Morris's novel.

James Merrill's poetry *Scripts for the Pageant.*

The Second Coming, Walker Percy's novel.

Galway Kinnell's poetry *Mortal Arts, Mortal Words.*

Howard Nemerov's poetry *Sentences.*

The Covenant, James Michener's novel.

Princess Daisy, Judith Krantz's novel.

Firestarter, Stephen King's horror novel.

Man in the Holocene, Max Frisch's novel.

Waiting for the Barbarians, J. M. Coetzee's novel.

Wole Soyinka's *The Critic and Society.*

Alice Adams's novel *Rich Rewards.*

Devil on a Cross, Ngugi Wa Thiong'O's novel.

Anthony Burgess's novel *Earthly Powers.*

Cyprian Ekwensi's novel *Divided We Stand.*

Eudora Welty's short stories *Moon Lake.*

Joshua Then and Now, Mordecai Richler's novel.

d. Jean-Paul Sartre, French writer and philosopher, chief popularizer of existentialism; the companion of Simone de Beauvoir (b. 1905).

d. Marshall McLuhan, Canadian communications essayist who popularized the term "global village" (b. 1911).

d. Katherine Anne Porter, American writer (b. 1890).

d. C. P. (Charles Percy) Snow, British novelist and scientist (b. 1905).

d. Henry Miller, American author (b. 1891).

d. Roland Barthes, French literary critic (b. 1915).

d. Alejo Carpentier, Cuban novelist (b. 1904).

d. Romain Gary (Roman Kacew), French writer (b. 1914).

d. Camara Laye, Guinean writer (b. 1928).

d. Louis Kronenberger, American drama critic (b. 1904).

d. Muriel Rukeyser, American writer (b. 1913).

FILM & BROADCASTING

Raging Bull, Robert De Niro starred as fighter Jake LaMotta in the classic Martin Scorsese biofilm.

Ordinary People, Donald Sutherland, Mary Tyler Moore, and Timothy Hutton starred as the troubled family in Robert Redford's film of Judith Guest's novel, adapted by Alvin Sargent.

Kagemusha, Tatsuya Nakadai, Tsutomu Yamazaki, and Kenichi Hagiwara starred in Akira Kurosawa's feudal epic.

The Elephant Man, John Hurt, Anthony Hopkins, Wendy Hiller, John Gielgud, and Anne Bancroft starred in the David Lynch film, based on the 1977 Bernard Pomerance play.

François Truffaut directed *The Last Metro*, starring Catherine Deneuve.

Coal Miner's Daughter, Sissy Spacek starred as country singer Loretta Lynn in the Michael Apted film.

Atlantic City, the Louis Malle film, screenplay by John Guare, starring Burt Lancaster as an aging gangster; Susan Sarandon and Robert Joy costarred.

Berlin Alexanderplatz, Rainer Werner Fassbinder's television miniseries, based on the 1929 Alfred Döblin novel; Hanna Schygulla and Gunther Lamprecht starred.

Jane Fonda, Lily Tomlin, and Dolly Parton starred in *Nine to Five*, directed by Colin Higgins.

Moscow Does Not Believe in Tears, Irina Muravyova, Raisa Ryazonova, and Natalie Vavilova starred in Vladimir Menshev's unsentimental look at modern Moscow life, signaling a new realism in Soviet films.

Woody Allen wrote, directed, and starred opposite Charlotte Rampling in *Stardust Memories*.

The Empire Strikes Back, Irvin Kershner's sequel to *Star Wars* (1977); Mark Hamill, Carrie Fisher, Harrison Ford, and Billy Dee Williams starred.

The Rose, Bette Midler starred as a self-destructive rock singer, reputedly modeled on Janis Joplin, in the Mark Rydell film.

Lee Remick starred as actress Margaret Sullavan in the television biofilm *Haywire*.

Playing for Time, Vanessa Redgrave, Jane Alexander, Shirley Knight, and Marisa Berenson starred in Daniel Mann's telefilm version of the Fania Fenelon book, about her time as a prisoner in the German mass murder camp at Auschwitz.

Shogun, Richard Chamberlain and Toshiro Mifune starred in the story of an Englishman in medieval Japan; based on the 1975 James Clavell novel.

The Thorn Birds, Richard Chamberlain, Rachel Ward, Barbara Stanwyck, and Jean Simmons led a large cast in the television miniseries based on Colleen McCullough's 1977 multigenerational Australian novel.

Academy Awards for 1980 (awarded the following year): Best Picture: *Ordinary People*; Best Director: Robert Redford, *Ordinary People*; Best Actor: Robert De Niro, *Raging Bull*; Best Actress: Sissy Spacek, *Coal Miner's Daughter*.

d. Alfred Hitchcock, British director and producer, notably of thrillers (b. 1899).

d. Barbara Stanwyck (Ruby Stevens), American actress (b. 1907).

d. Peter Sellers (Richard Henry Sellers), British actor (b. 1925).

d. Lewis Milestone, a major director during Hollywood's Golden Age (b. 1895).

d. Raoul Walsh, American director and actor (b. 1887).

d. Alf Sjoberg, Swedish director (b. 1903).

VISUAL ARTS

More than 1.5 million people visited the Pablo Picasso centenary retrospective at the Museum of Modern Art in New York.

Roy Lichtenstein's painting *American Indian Theme II*.

Jasper Johns's painting *Dancers on a Plate*.

Kenzo Tange designed the Union Bank building, Singapore.

Nancy Holt's sculpture *14 Concrete Discs and Fragments*.

"American Light: The Luminist Movement," exhibition at Washington's National Gallery of Art.

Jim Dine's painting *A Tree That Shatters the Dancing*.

Willem de Kooning's painting *Untitled I*.

Richard Meier designed the Atheneum Center, New Harmony, Indiana.

Gunnar Birkerts designed the Corning Museum of Glass, Corning, New York.

Ellsworth Kelly's painting *Dark Blue Gray; Violet; Red-Orange*.

Jeff Koons's sculpture *New Hoover Deluxe Shampoo Polisher*.

Benjamin Thompson designed Baltimore's Harborplace.

Helen Bonfils Theater, Denver, designed by Roche and Dinkeloo.

Robert Irwin's sculpture *Running Fence*.

Michael Heizer's sculpture *This Equals That*.

Whitney Museum mounted a major Edward Hopper retrospective exhibition.

d. Oskar Kokoschka, Austrian artist (b. 1886), a leading Art Nouveau and then expressionist painter.

d. Cecil Beaton, British photographer and film, theater, opera, and ballet designer (b. 1904).

d. Graham Sutherland, British painter (b. 1903).

d. Marino Marini, Italian sculptor (b. 1901).

d. Philip Guston, American artist (b. 1913).

THEATER & VARIETY

Children of a Lesser God, Phyllis Frelich and John Rubinstein starred in Mark Medoff's play, about a deaf student and her voice teacher; opened at the Longacre Theatre, New York, March 30.

Athol Fugard's *A Lesson from Aloes* starred James Earl Jones, Harris Yulin, and Maria Tucci.

A Life, Hugh Leonard's play, starred Roy Dotrice and Pat Hingle.

Agnes of God, John Pielmeier's play about a nun accused of killing her baby, starred Amanda Plummer, Elizabeth Ashley, and Geraldine Page.

Paul Scofield as Salieri and Ian McKellen as Mozart starred in Peter Shaffer's *Amadeus*; basis of the 1984 Milos Forman film.

Talley's Folly, Judd Hirsch and Trish Hawkins starred in Lanford Wilson's Pulitzer Prize–winning play, the second of the Talley family series; opened at the Brooks Atkinson Theatre, New York, February 20.

42nd Street, Jerry Orbach, Wanda Richert, and Tammy Grimes starred in the musical, based on the 1933 film, with music by Harry Warren; opened at the Winter Garden Theatre, New York.

Jim Dale and Glenn Close starred in the Michael Stewart and Cy Coleman musical *Barnum*.

Blythe Danner, Roy Scheider, and Raul Julia starred in Harold Pinter's *Betrayal*, in which the scenes are in reverse chronological order.

E. G. Marshall and Irene Worth starred in Henrik Ibsen's *John Gabriel Borkman*.

Morning's at Seven, Paul Osborne's play, starred Teresa Wright, Maureen O'Sullivan, and Nancy Marchand.

The American Clock, Arthur Miller's play, starred William Atherton, Joan Copeland, and John Randolph.

A Day in Hollywood/A Night in the Ukraine, the Dick Vosburgh and Frank Lazarus musical, starred Priscilla Lopez, Stephen James, and David Garrison.

Irene Papas starred in Euripides's *The Bacchae*.

d. Alfred Lunt, American actor (b. 1892), often costarring with his wife Lynn Fontanne.

d. Harold Clurman, American director and theater critic, in 1931 a founder of the Group Theater (b. 1901).

d. Marc (Marcus Cook) Connelly, American writer and director, best known for *The Green Pastures* and *Merton of the Movies* (b. 1890).

d. Jimmy (James Francis) Durante, American variety entertainer (b. 1893).

d. Mae West, American actress and writer (b. 1892).

d. Ben Travers, English playwright, writer of farce (b. 1886).

d. Ernst Busch, German actor (b. 1900).

d. Robert Ardrey, American playwright (b. 1908).

MUSIC & DANCE

d. John Lennon, British musician, member of the Beatles (b. 1940); he was murdered by crazed fan Mark Chapman in New York City, on December 8. Earlier that year, he and Yoko Ono had released their album *Double Fantasy*.

Mikhail Baryshnikov became artistic director of the American Ballet Theatre (1980–1989); he also danced the lead in *Rhapsody*, Frederick Ashton's ballet, music by Sergei Rachmaninoff, first danced August 4 by the Royal Ballet, London.

The Rose, Bette Midler's sound-track album from the 1979 Mark Rydell film.

Plácido Domingo and Renata Scotto were seen in over 20 countries via satellite in the Metropolitan Opera production of *Manon Lescaut*.

Frank Sinatra's *New York, New York*, theme from the otherwise forgotten film of that name.

Gloria, Kenneth MacMillan's ballet, music by Francis Poulenc, first danced March 13 by the Royal Ballet, London.

Harrison Birtwistle's *Clarinet Quintet* and *On the Sheer Threshold of the Night*.

Hotter Than July, Stevie Wonder's album, with *Master Blaster (Jammin')* and *Happy Birthday*, his tribute to Martin Luther King, Jr.

On the Road Again, Willie Nelson's song, which he introduced in the film *Honeysuckle Rose*.

Where the Wild Things Are, Oliver Knussen's opera,

libretto by Maurice Sendak from his children's book, opened in Brussels November 28.

Satyagraha, Philip Glass's opera, part of his "portrait opera" trilogy, premiered in Rotterdam.

Glass Houses, Billy Joel's album, with *It's Still Rock 'n' Roll to Me* and *You May Be Right*.

Peter Maxwell Davies's *Symphony* and opera *The Lighthouse*.

Bruce Springsteen's album *The River*, with *Hungry Heart*.

Steve Reich's *Variations for Winds, Strings and Keyboards*.

Krzysztof Penderecki's *Symphony No. 2*.

Coward of the County, Kenny Rogers's hit single.

Leonard Bernstein's *Fanfare* and *Divertimento*.

Damn the Torpedoes, Tom Petty and the Heartbreakers' album.

Ned Rorem's *Santa Fe Songs*.

Against the Wind, Bob Seger and the Silver Bullet Band's album.

Witold Lutoslawski's *Double Concerto* for oboe, harp, and strings.

Diana Ross's album *Diana*.

William Schuman's *Three Colloquies*.

Eric Clapton's album *Another Ticket*.

Henry Brant's *The Glass Pyramid*.

In the Heat of the Night, Pat Benatar's album.

Michael Tippett's *Wolf Trap Fanfare* for six brass.

Linda Ronstadt's album *Mad Love*.

Pierre Boulez's *Notations*, orchestral work.

Sails of Silver, Steeleye Span's album.

Elliott Carter's *Night Fantasies* for piano.

Prince's album *Dirty Mind*.

WORLD EVENTS

American mission to rescue hostages held by Iran failed.

Responding to the 1979 Soviet invasion of Afghanistan, America boycotted the 1980 Moscow Olympics and embargoed American grain shipments to the Soviet Union.

Republican Ronald Wilson Reagan defeated President Jimmy Carter's bid for a second term, becoming the 40th president of the United States (1981–1989).

Iraq attacked Iran, claiming the Shatt al-Arab waterway between Iraq and Iran in violation of a 1975 treaty, and beginning the Iran–Iraq War, which cost more than one million lives (1980–1988).

In *Diamond v. Chakrabarty*, the U.S. Supreme Court ruled that genetically engineered biological organisms could be patented.

German Green party was founded, the first and most successful of many throughout the world.

Powerful Mount St. Helens, Washington, volcanic eruption killed 40–60 people (May 18).

Rhodesia became the new Republic of Zimbabwe; Robert Mugabe was its first prime minister.

Solidarity (Independent Self-Governing Trade Union Solidarity) quickly grew into a 10-million-strong labor confederation in Poland.

Yoweri Musaveni took power in Uganda, winning the Ugandan Civil War (1979–1980).

American space probes *Voyager 1* and *2* flew by Saturn.

d. Tito (Josip Broz), Yugoslav Communist leader (b. 1892), World War II partisan leader and ruler of Yugoslavia (1945–1980).

1981

LITERATURE

Midnight's Children, Salman Rushdie's Booker Prize–winning novel.

Elias Canetti was awarded the Nobel Prize for Literature.

Chronicle of a Death Foretold, Gabriel García Márquez's novel.

The Name of the Rose, Umberto Eco's medieval mystery novel; basis of the 1986 Jean-Jacques Annaud film.

Rabbit Is Rich, Pulitzer Prize–winning John Updike novel, third in the Rabbit quartet.

The Heart of Woman, Maya Angelou's novel.

Tar Baby, Toni Morrison's novel.

Wole Soyinka's autobiographical *Aké: The Years of Childhood*.

Zuckerman Unbound, Philip Roth's novel.

Marguerite Yourcenar became the first woman member of the French Academy.

Russell Baker's Pulitzer Prize–winning biography *Growing Up*.

The Second Stage, essays on women's rights and feminism by Betty Friedan.

A Good Man in Africa, William Boyd's first novel.

A. R. Ammons's poetry *A Coast of Trees*.

Chirundu, Ezekiel Mphahlele's novel of the black South African experience.

A Start in Life, Anita Brookner's novel.

The Rebel Angels, Robertson Davies's novel.

The Mosquito Coast, Paul Theroux's novel.

Cujo, Stephen King's horror novel.

Derek Walcott's *The Fortunate Traveller*.

Dannie Abse's poetry *Way Out in the Centre*.

Funeral Games, Mary Renault's novel.

Noble House, James Clavell's novel.

Sylvia Plath's *Collected Poems*.

Robert Bly's poetry *The Man in the Black Coat Turns*.

Shadow Train, John Ashbery's poetry collection.

Under the North Star, Ted Hughes's children's poems.

Taylor Caldwell's novel *Answer as a Man*.

The Immigrants, Howard Fast's novel.

The Testament, Elie Wiesel's novel.

d. William Saroyan, Armenian-American writer (b. 1908).

d. A. J. (Archibald Joseph) Cronin, British writer (b. 1896).

d. Christy Brown, Irish poet and novelist (b. 1932), whose lifelong cerebral palsy afforded him only the use of his left foot, as depicted in the 1989 film *My Left Foot*.

d. Mao Dun, Chinese novelist (b. 1896).

d. Meyer Levin, American author and journalist (b. 1905).

d. Nelson Algren, American writer (b. 1909).

FILM & BROADCASTING

Chariots of Fire, Hugh Hudson's film, screenplay by Colin Welland, set around the 1924 Olympics; Ben Cross, Ian Charleson, Nigel Havers, Ian Holm, Alice Krige, and Cheryl Campbell starred.

Reds, Warren Beatty as John Reed and Diane Keaton as Louise Bryant led a large cast in Beatty's Bolshevik Revolution epic, set in Europe and the United States.

d. Abel Gance, French film director (b. 1889), whose 1927 silent film epic *Napoléon*, a landmark work in the history of film, was reconstructed by Kevin Brownlow and shown in 1981 restored, unabridged, and with a new score.

On Golden Pond, Henry Fonda, Katharine Hepburn, and Jane Fonda starred in the later-years drama; based on the Ernest Thompson play.

Paul Newman and Sally Field starred in *Absence of Malice*, directed by Sydney Pollack.

S.O.B., William Holden, Julie Andrews, Robert Preston, and Richard Mulligan starred in Blake Edwards's Hollywood satire.

Ragtime, Howard E. Rollins, Jr., James Cagney, Elizabeth McGovern, and Mary Steenburgen starred in Milos Forman's film version of the 1975 E. L. Doctorow novel.

Mel Gibson and Mark Lee starred in *Gallipoli*, directed by Peter Weir.

Mephisto, Klaus Maria Brandauer starred in Istvan Szabo's film, as a German actor who works with the Nazis for career gains; based on the Klaus Mann novel.

André Gregory and Wallace Shawn starred in *My Dinner with André*, directed by Louis Malle.

Pennies from Heaven, Herbert Ross's film, based on Dennis Potter's 1978 television miniseries.

Raiders of the Lost Ark, Harrison Ford as Indiana Jones starred in Steven Spielberg's special effects adventure film; sequels followed (1984, 1989).

Rich and Famous, Jacqueline Bisset and Candice Bergen starred as the lifelong, incompatible friends in George Cukor's film, a remake of *Old Acquaintance* (1943), itself based on the John Van Druten play.

The French Lieutenant's Woman, Meryl Streep and Jeremy Irons starred in the Karel Reisz film; screenplay by Harold Pinter, based on John Fowles's 1969 novel.

The Postman Always Rings Twice, Jack Nicholson and Jessica Lange starred in Bob Rafelson's film version of the 1934 James M. Cain novel, about a woman and a man who kill her husband for money.

Hill Street Blues (1981–1987), the highly textured minority-neighborhood television police series; Daniel J. Travanti, Veronica Hamel, and Michael Conrad led a large cast.

Walter Cronkite retired as CBS television news anchor (1962–1981); succeeded by Dan Rather.

Academy Awards for 1981 (awarded the following year): Best Picture: *Chariots of Fire*; Best Director: Warren Beatty, *Reds*; Best Actor: Henry Fonda, *On Golden Pond*; Best Actress: Katharine Hepburn, *On Golden Pond*.

d. William Holden (William Franklin Beedle), American actor (b. 1918).

d. William Wyler, German-American director (b. 1902), a leading director of Hollywood's Golden Age and beyond.

d. Robert Montgomery (Henry Montgomery, Jr.), American actor and director (b. 1904), father of actress Elizabeth Montgomery.

d. Melvyn Douglas (Melvyn Edouard Hesselberg), American actor (b. 1901).

d. Natalie Wood (Natasha Gurdin), American actress (b. 1938).

d. René Clair, French writer and director (b. 1898).

d. Allen Dwan (Joseph Aloysius Dwan), American film director (b. 1885).

d. René Clément, French director (b. 1913).

d. Edith Head, leading American film industry costume designer (b. 1907), from the 1940s through the early 1970s.

VISUAL ARTS

Picasso's *Guernica* was returned to the Prado after 42 years at New York's Museum of Modern Art; Picasso had ordered that it not be returned until Spain had a democratic government.

Joseph Hirshhorn left his collection and a large bequest to Washington's Hirshhorn Museum and Sculpture Garden.

Louise Nevelson's sculptures included *Moon-Star III* and *Moon-Star Zag XIII*.

d. Joseph Herman Hirshhorn, American art collector (b. 1899), founder of Washington's Hirshhorn Museum and Sculpture Garden.

d. Marcel Lajos Breuer, Hungarian architect and designer (1902).

d. Theodore Roszak, American sculptor, printmaker, and painter (b. 1907).

d. George Drysdale, Australian painter (b. 1912).

d. Ilya Bolotowsky, American abstract painter (b. 1907).

d. Wallace Harrison, American architect (b. 1895).

THEATER & VARIETY

Crimes of the Heart, Beth Henley's Pulitzer Prize–winning play, starred Mary Beth Hurt and Mia Dillon; opened at the John Golden Theatre, New York, November 4.

Barnard Hughes starred in Brian Friel's *Translations*.

The Life and Adventures of Nicholas Nickleby, Roger Rees had the title role in David Edgar's marathon play, based on the Dickens novel; music and lyrics by Stephen Oliver.

Soldier's Play, Charles Fuller's play, starred Adolph Caesar; opened at the Theater Four, New York.

Al Pacino starred in David Mamet's *American Buffalo*.

Michael Bennett choreographed and directed *Dreamgirls*; the Tom Eyen–Henry Krieger musical opened at the Imperial Theatre, New York.

Gregory Hines starred in Duke Ellington's musical *Sophisticated Ladies*.

Katharine Hepburn and Dorothy Loudon starred in Ernest Thompson's play *The West Side Waltz*.

Lauren Bacall starred in Fred Ebb and John Kander's musical *Woman of the Year*.

Ronald Harwood's play *The Dresser* starred Tom Courtenay and Paul Rogers.

Linda Ronstadt, Kevin Kline, and Estelle Parsons starred in Gilbert Sullivan's *The Pirates of Penzance*.

Joanne Woodward starred in George Bernard Shaw's *Candida*.

Elizabeth Taylor, Maureen Stapleton, and Tom Aldredge starred in Lillian Hellman's *The Little Foxes*.

Love Letters on Blue Paper, Arnold Wesker's play.

Peter Nichols's *Passion Play*.

d. Lotte Lenya (Karoline Blamauer), Austrian actress and singer (b. 1900); the original Pirate Jenny in *The Three Penny Opera*.

d. Helene Wiegel, Austrian actress (b. 1901), a leading figure in Weimar Germany and from 1933 Bertolt Brecht's wife; together they founded the Berliner Ensemble in 1949.

d. Paddy Chayefsky (Sidney Chayefsky), American writer (b. 1923).

d. Enid Bagnold, English author (b. 1889).

d. Jessie Matthews, British actress, singer, and dancer (b. 1907).

d. Paul Green, American playwright (b. 1894).

MUSIC & DANCE

Donnerstag aus Licht (*Thursday from Light*), the first completed of Karlheinz Stockhausen's projected seven-evening opera *Licht*, premiered March 15 in Milan; Stockhausen also premiered *Jubilee*.

The Wild Boy, Kenneth MacMillan's ballet, with

Natalia Makarova and Mikhail Baryshnikov, premiered at the American Ballet Theatre.

Paradise Theater, Styx's album built around an old Chicago playhouse, including *The Best of Times* and *Too Much Time on My Hands*.

Mozartiana, George Balanchine's ballet, to Peter Ilich Tchaikovsky's *Fourth Suite for Orchestra*, first danced June 4, by the New York City Ballet.

Somewhere in England, George Harrison's album, including *All Those Years Ago*, his tribute to the murdered John Lennon.

The Police's album *Ghost in the Machine*, including *Every Little Thing She Does Is Magic*.

Diana Ross and Lionel Richie had a big hit single, *Endless Love*; Ross also released the album *Why Do Fools Fall in Love?*

Ned Rorem's *Double Concerto in 10 Movements for Cello and Orchestra* premiered in Cincinnati.

Isadora, Kenneth MacMillan's ballet, music by Richard Bennett, first danced April 30 by the Royal Ballet, London.

John Cage's *30 Pieces for 5 Orchestras* and his 12-hour work *Empty Words*.

Ravi Shankar's second sitar concerto.

Elliott Carter's vocal and ensemble composition *In Sleep, In Thunder*.

B. B. King's album *There Must Be a Better World Somewhere*.

John Harbison's *Violin Concerto*.

Leonard Bernstein's *Halil* and piano work *Touches*.

Bette Davis Eyes, Kim Carnes's Grammy-winning single.

Peter Maxwell Davies's *Symphony No. 2*.

Olivia Newton-John's album and hit title song *Physical*.

David Del Tredici's *All in the Golden Afternoon*.

Ars combinatoria, Milton Babbitt's orchestral work.

Twyla Tharp's dance, *The Catherine Wheel*.

Ned Rorem's *Winter Pages*.

Johan Adams's composition *Harmonium*.

Hi Infidelity, REO Speedwagon's album.

Roger Sessions's *Concerto for Orchestra*.

Back in Black, AC/DC's album.

Robert Starer's *Violin Concerto*.

Nekuia, Iannis Xenakis's choral work.

Crimes of Passion, Pat Benatar's album.

The Pointer Sisters' hit *Slow Hand*.

Erza Laderman's *Symphony No. 4*.

Voices, Daryl Hall and John Oates's album.

Face Value, Phil Collins's first solo album.

Harrison Birtwistle's *Pulse Sampler*.

Barbican Arts and Conference Centre opened in London.

d. Hoagy (Howard Hoagland) Carmichael (b. 1899), American composer and musician, who wrote *Stardust*, *Georgia on My Mind*, and many other popular standards.

d. Lotte Lenya, Austrian-born singer and actress (b. 1898); the original "Pirate Jenny" in *The Threepenny Opera*.

d. Samuel Barber, American composer (b. 1910).

d. E. Y. (Edgar Yip) Harburg, American lyricist (b. 1898), who wrote *Brother, Can You Spare a Dime?*

d. Bob (Nesta Robert) Marley, Jamaican singer, songwriter, and guitarist (b. 1945), a key figure in the popularization of reggae.

d. Howard Hanson, American composer and conductor (b. 1896).

d. Harry Warren (Salvatore Guaragna), American songwriter (b. 1893).

d. Evgeny Brusilovsky, Soviet composer (b. 1905).

WORLD EVENTS

American hostages were released by Iran on January 20, President Ronald Reagan's inauguration day.

President Ronald Reagan and three others were shot and wounded (March 30) in Washington, D.C., by John W. Hinckley, Jr., later judged insane.

Judge Sandra Day O'Connor was appointed to the U.S. Supreme Court, the first woman justice.

Egyptian leader Anwar Sadat was assassinated by Islamic fundamentalists in Cairo (October 6); succeeded by Hosni Mubarak.

AIDS (Acquired Immune Deficiency Syndrome) was recognized as a new disease in the United States.

An estimated 114,000 people were allowed to leave Cuba, through the port of Mariel; therefore called the "Mariel boat people."

Solidarity was outlawed by the Polish government, going underground (December).

Tamil–Sinhalese civil war broke out in Sri Lanka, over demands for an autonomous Tamil area.

William Joseph Casey became director of the Central Intelligence Agency (CIA), quickly introducing many covert operations.

Doctor Gro Harlem Brundtland became the first woman prime minister of Norway.

First American space shuttle was launched, the *Columbia* (April 12).

French socialist political leader François Mitterand was elected president of France.

Andreas Papandreou became premier of Greece.

Indonesian ship *Tampomas 2* caught fire in the Java Sea storm (January 27); ship sank, killing 580 people.

Two interior walkways at the Kansas City Hyatt Regency Hotel collapsed on July 17, killing 113 people.

Beginning of worldwide "nuclear freeze" movement to freeze the number of nuclear weapons at current levels.

1982

LITERATURE

The Color Purple, Alice Walker's Pulitzer Prize–winning novel; basis of the 1985 film.

Gabriel García Márquez was awarded the Nobel Prize for Literature.

John Cheever's posthumous novel *Oh What a Paradise It Seems*.

Anne Tyler's novel *Dinner at the Homesick Restaurant*.

Jean M. Auel's novel *The Valley of Horses*; second of the Earth's Children novels.

Bech Is Back, John Updike's novel.

Saul Bellow's novel *The Dean's December*.

Space, James Michener's novel.

Mary Oliver's Pulitzer Prize–winning poetry *American Primitive*.

Providence, Anita Brookner's novel.

William Wharton's novel *A Midnight Clear*.

A Perfect Peace, Amos Oz's novel.

A. R. Ammons's poetry *Worldly Hopes*.

Gail Godwin's novel *A Mother and Two Daughters*.

Amos Tutuola's novel *The Witch-Herbalist of the Remote Town*.

An Ice-Cream War, William Boyd's novel.

Cynthia Ozick's *Five Fictions*.

Bobbie Ann Mason's *Shiloh and Other Stories*.

Denise Levertov's poetry *Candles in Babylon*.

God's Grace, Bernard Malamud's novel.

John Gardner's novel *Mickelsson's Ghosts*.

Pinball, Jerzy Kosinski's novel.

Marge Piercy's poetry collection *Circles in the Water*.

On the Black Hill, Bruce Chatwin's novel.

Peter Benchley's novel *The Girl of the Sea of Cortez*.

Robert Creeley's *Collected Poems*.

Don DeLillo's novel *The Names*.

Judith Krantz's novel *Mistral's Daughter*.

d. John Cheever, American writer (b. 1912).

d. John Gardner, American author (b. 1933).

d. Archibald MacLeish, American poet (b. 1892).

d. Louis Aragon, French writer, an early surrealist who became a pillar of the French Communist party (b. 1897).

d. Ayn Rand, Russian-American writer (b. 1905).

d. Babette Deutsch, American poet (b. 1895).

d. Eugenio Montale, Italian poet (b. 1896).

d. Djuna Barnes, American writer (b. 1892).

d. Ngaio Marsh (Edith Ngaio Marsh), New Zealand mystery writer and theater producer, creator of Roderick Allyn (b. 1899).

d. Dwight Macdonald, American writer and editor (b. 1906).

d. Frederic Dannay, American mystery writer, with Manfred Lee the cocreator of Ellery Queen (b. 1905).

d. Kenneth Rexroth, American writer, critic, and translator (b. 1905).

d. William Riley Burnett, American writer (b. 1899).

FILM & BROADCASTING

Sophie's Choice, Meryl Streep, as the concentration-camp survivor in the postwar United States, starred with Kevin Kline and Peter MacNicol, in Alan J. Pakula's film version of the 1979 William Styron novel.

Victor/Victoria, Julie Andrews as the male impersonator, Robert Preston, and James Garner starred in Blake Edwards's musical, a comedy set in Paris in the 1930s.

Gandhi, Ben Kingsley starred as Mohandas K. Gandhi in Richard Attenborough's epic biofilm, with Edward Fox, Candice Bergen, John Mills, and John Gielgud.

Missing, Jack Lemmon and Sissy Spacek starred as family members seeking a victim of the Chilean dictatorship in the Constantin Costa-Gavras political thriller.

Fanny and Alexander, the Ingmar Bergman film, set in early 20th-century Sweden; Erland Josephson, Harriet Andersson, Jarl Kulle, and Gunn Wallgren starred.

Tootsie, Dustin Hoffman as the female impersonator, with Jessica Lange, Charles Durning, Teri Garr, and Bill Murray in the Sidney Pollack film.

The World of Apu, Soumitra Chatterjee, Sharmila Tagore, and Shapan Mukerjee starred in the third film of Satyajit Ray's "Apu" trilogy; music by Ravi Shankar.

E.T., Steven Spielberg's science fiction special effects film, about peaceful alien first contact; Henry Thomas, Dee Wallace, Drew Barrymore, Henry MacNaughton, and Peter Coyote starred.

Moonlighting, Jeremy Irons, Eugene Lipinski, Jiri Stanislav, and Eugeniusz Haczkiewicz starred in the Jerzy Skolimowski film, about illegal Polish workers in Britain.

Richard Gere and Debra Winger starred in *An Officer and a Gentleman*, directed by Taylor Hackford.

The World According to Garp, Robin Williams, Glenn Close, John Lithgow, Mary Beth Hurt, Swoosie Kurtz, Jessica Tandy, and Hume Cronyn starred in George Roy Hill's screen version of the 1978 John Irving novel.

The Year of Living Dangerously, Mel Gibson, Linda Hunt, and Sigourney Weaver starred in Peter Weir's film, set in politically unstable 1960s Indonesia.

The Grey Fox, Richard Farnsworth starred in the Philip Borsos film, set in the Canadian northwest and based on the later life of stagecoach and train robber Bill Minor.

Smiley's People, Alec Guinness starred as George Smiley in the television miniseries, based on the 1980 John le Carré spy thriller.

Brideshead Revisited, John Mortimer's 11-part television adaptation of the 1945 Evelyn Waugh novel; Jeremy Irons, Anthony Andrews, Laurence Olivier, Claire Bloom, and Diana Quick starred.

Cagney and Lacey, the American television series, starring Tyne Daly and Sharon Gless as police officer partners (1982–1989).

Cheers, Shelley Long, Ted Danson, Rhea Perlman, and later Kirstie Alley starred in the television situation comedy series (1982–1993).

Academy Awards for 1982 (awarded the following year): Best Picture: *Gandhi*; Best Director: Richard Attenborough, *Gandhi*; Best Actor: Ben Kingsley, *Gandhi*; Best Actress: Meryl Streep, *Sophie's Choice*.

d. Henry Fonda, American actor (b. 1905).

d. Ingrid Bergman, Swedish actress (b. 1915).

d. Grace Kelly, American actress (b. 1928).

d. Henry King, American director (b. 1888).

d. Jacques Tati (Jacques Tatischeff), French mime and director (b. 1908).

d. Kenneth More, British actor (b. 1914).

d. King Vidor, American film director (b. 1894).

d. Rainer Werner Fassbinder, German director (b. 1946).

d. Alberto Cavalcanti, Brazilian director, writer, and documentary filmmaker (b. 1897).

VISUAL ARTS

Maya Lin's Vietnam Veterans Memorial opened at Washington, D.C., immediately becoming a major American national monument that drew millions of visitors.

The Michael C. Rockefeller Wing opened at New York's Metropolitan Museum of Art, its core collection the Rockefeller bequest of ethnic ("primitive") art.

I. M. Pei designed the Fragrant Hills Hotel, Peking.

Louise Bourgeois's sculpture *Femme Couteau*.

Robert Motherwell's painting *The Dedalus Sketchbooks*.

Jasper Johns's painting *Perilous Night*.

Edward Larrabee Barnes designed the IBM Building, New York City.

Robert Rauschenberg's painting *Kabal American Zephyr Series*.

Jim Dine's painting *The Apocalypse*.

Kenzo Tange designed the Saudi Arabian royal palace.

Philip Johnson and John Burgee designed the Peoria Civic Center, Peoria, Illinois.

Frank Stella's painting *Thruxton*.

Richard Meier designed the Hartford Seminary, Hartford, Connecticut.

THEATER & VARIETY

Athol Fugard's *"Master Harold" . . . and the Boys* starred Zakes Mokae, Danny Glover, and Lonny Price.

Torch Song Trilogy, Harvey Fierstein starred in his own three one-act plays, on homosexual themes; opened at the Actors Playhouse, New York.

Cats, the Andrew Lloyd Webber–Trevor Nunn musical, based on T. S. Eliot's 1939 *Old Possum's Book of Practical Cats*.

Lanford Wilson's play *Angels Fall*, with Fritz Weaver and Barnard Hughes.

Cher and Sandy Dennis starred in Ed Graczyk's *Come Back to the 5 & Dime, Jimmy Dean, Jimmy Dean*.

Ellen Burstyn starred in Helen Hanff's *84 Charing Cross Road*.

Judith Ivey starred in Nell Dunn's *Steaming*.

Jessica Tandy and Hume Cronyn starred in *Foxfire*, written by Susan Cooper, Jonathan Holtzman, and Cronyn.

Fay Dunaway starred in William Alfred's *The Curse of an Aching Heart*.

William Mastrosimone's play *Extremities*, with Susan Sarandon.

Zoë Caldwell and Dame Judith Anderson starred in the revival of *Medea*.

James Earl Jones, Christopher Plummer, and Dianne Wiest starred in Shakespeare's *Othello*.

The Wake of Jamey Foster and *Am I Blue*, two Beth Henley plays.

A Map of the World, David Hare's play.

The Real Thing, Tom Stoppard's play.

d. Lee Strasberg, American director and actor (b. 1901), who took a leading role in introducing Stanislavsky-based "method" acting into the United States, as artistic director of the Actors Studio; father of actress Susan Strasberg.

d. Celia Johnson, British actress (b. 1908); she starred on screen in the classic *Brief Encounter*.

d. Stanley Holloway, British actor and variety artist (b. 1890); he was Alfred P. Doolittle in *My Fair Lady*.

d. Peter Weiss, German writer, longtime resident of Sweden (b. 1916).

d. Cathleen Nesbitt, English actress (b. 1888).

d. Heinar Kipphardt, German playwright (b. 1892).

MUSIC & DANCE

Thriller, Michael Jackson's phenomenally popular album, produced by Quincy Jones, generated numerous hits, most notably *Billie Jean* and *Beat It*.

Compact disks (CDs) were introduced, quickly coming to dominate over long-playing records and tape recordings.

Gian Carlo Menotti created two children's operas, *The Boy Who Grew Too Fast* and *A Bride from Pluto*; a cantata *Muero porque no muero*, and *Notturno*.

Bruce Springsteen released his personal, pensive, brooding, virtually homemade album *Nebraska*, with *Mansion on the Hill* and *Johnny 99*.

Billy Joel's album *The Nylon Curtain*, with *Allentown* and *Goodnight Saigon*.

Peter Hall's production of *Macbeth*, with Renata Scotto at the Metropolitan Opera, was booed by audience.

Ebony and Ivory, Paul McCartney and Stevie Wonder's single.

John Phillips, Mackenzie Phillips, Dennis Doherty, and Elaine McFarlane formed a second the Mamas and the Papas folk band.

Iannis Xenakis's choral work *Pour la paix* and orchestral work *Pour les baleines*.

Luciano Berio's vocal work *Duo* and dramatic musical work *La vera storia*.

Midnight Love, Marvin Gaye's album, including *Sexual Healing*.

Milton Babbitt's fifth string quartet and vocal work *The Head of the Bed*.

The Tempest, Rudolf Nureyev's ballet.

Vangelis's single *Chariots of Fire*, theme from the film.

Krzysztof Penderecki's *Violin Concerto No. 2*.

I'm So Excited, the Pointer Sisters' hit song.

The Mask of Time, Michael Tippett oratorio.

Carole King's album *One to One*.

Steve Reich's composition *Vermont Counterpoint*.

The Man with the Horn, Miles Davis's album.

Rolling Stones' album *Tattoo You*.

Philip Glass's *Glassworks*.

Dionne Warwick's album *Friends in Love*.

Janet Jackson, her debut solo album.

Sinfonia concertante, Peter Maxwell Davies's orchestral work.

Fleetwood Mac's album *Mirage*.

Foreigner's album *4*.

Henry Brant's composition *Meteor Farm*.

J. Geils Band's album *Freeze-Frame*.

John Cage's *Postcard from Heaven*.

American Fool, John Cougar's album.

Joseph Schwantner's *Daybreak of Freedom*.

Kissing to Be Clever, Boy George's album.

Loverboy's album *Get Lucky*.

Survivor's single record *Eye of the Tiger*.

The Go-Gos's album *Beauty and the Beat*.

Asia's album *Asia*.

Wynton Marsalis's album *The Young Lions*.

d. Artur Rubinstein, Polish pianist, later American (b. 1887); one of the 20th century's finest pianists, especially admired for his playing of Beethoven, Brahms, and Chopin.

d. Carl Orff, German composer (b. 1895), best known for his *Carmina Burana*.

d. Glenn Gould, Canadian pianist (b. 1932), most noted for his interpretations of Bach.

d. Sam "Lightnin'" Hopkins, American country blues singer, composer, and guitarist (b. 1912).

d. Thelonius Sphere Monk, American pianist and composer (b. 1919).

d. Kara Karayev, Azerbajani composer (b. 1918).

d. Maria Jeritza, Czech soprano (b. 1887).

d. Mario Del Monaco, Italian tenor (b. 1915).

WORLD EVENTS

Israeli forces invaded Lebanon in June, quickly driving Syrian forces into the Bekaa valley, and encirclng PLO and Syrian forces and forcing them out of Beirut. Israeli forces allowed or encouraged Phalangist massacres of Muslims at the Beirut Sabra and Shatilla refugee camps in September.

Lebanese Maronite Christian commander Bashir Gemayel, president-elect of Lebanon, was assassinated.

Iraq sought to end the Iran–Iraq war, but Iran instead invaded Iraq, soon stalling and producing a World War I–style war of attrition.

Argentine troops occupied the Falklands (Malvinas) on April 2: Britain responded with a seaborne expeditionary force, which retook the islands; Argentina surrendered and its government fell.

Cyanide inserted into nonprescription Tylenol capsules killed seven people in Chicago; many copycat poisonings followed.

Team of surgeons led by William De Vries made the first permanent implant of a mechanical heart.

First genetically engineered commercial product, human insulin, approved by the U.S. Food and Drug Administration.

First space satellite launched, from the space shuttle *Columbia*.

Iraqi army defeated Muslim Brotherhood–led insurrection at Hama; thousands died.

Huge nuclear-freeze rally drew 500,000–1,000,000 people at New York's Central Park (June 12).

Manuel Noriega became head of the Panamanian armed forces, and effectively ruler of Panama.

Peruvian diplomat Javier Pérez de Cuéllar became the fifth secretary-general of the United Nations.

Moderate Socialist Felipe Gonzalez Marquez became prime minister of Spain.

Wayne B. Williams of Atlanta was convicted of two of the 28 Atlanta mass murders (1979–1981).

d. Leonid Ilyich Brezhnev, Soviet president (b. 1906); succeeded by Yuri Andropov.

1983

LITERATURE

Ironweed, William Kennedy's Pulitzer Prize–winning Depression-era story of two alcoholics, set in Albany, New York; Hector Babenco directed the 1984 screen version.

William Golding was awarded the Nobel Prize for Literature.

Shame, Salman Rushdie's novel.

Murder in the Dark, Margaret Atwood's novel.

A Tiger for Malgudi, Rasipuram Narayan's novel.

Ancient Evenings, Norman Mailer's massive novel.

Elizabeth Bishop's posthumously published *The Complete Poems, 1927–1979*.

The Little Drummer Girl, John le Carré's spy thriller.

Outrageous Acts and Other Rebellions, essays by Gloria Steinem.

Amy Clampitt's poetry *The Kingfisher*.

Gary Snyder's poetry *Axe Handles*.

Carolyn Kizer's Pulitzer Prize–winning poetry *Yin*.

The Anatomy Lesson, Philip Roth's novel.

Cynthia Ozick's novel *The Cannibal Galaxy*.

W. S. Merwin's poetry *Opening the Hand*.

Shalimar, Kamala Markandaya's novel.

Donald Barthelme's novel *Overnight to Many Distant Cities*.

Frederick Barthelme's novel *Moon Deluxe*.

James Merrill's poetry *The Changing Light at Sandover*.

Lynne Sharon Schwartz's novel *Disturbances in the Field*.

Mark Helprin's novel *Winter's Tale*.

Raymond Carver's short-story collection *Cathedral*.

Stephen King's horror novels *Christine* and *Pet Semetary*.

Walter Tevis's novel *The Queen's Gambit*.

Poland, James Michener's novel.

Yehuda Amichai's poetry *Great Tranquility*.

Sailing Through China, Paul Theroux's travel book.

Vasily Aksyonov's novel *The Island of Crimea*.

d. Mary Renault (Mary Challans), British historical novelist (b. 1905).

d. Ross Macdonald (Kenneth Millar), American writer, creator of the Lew Archer detective novels (b. 1915).

d. Rebecca West (Cicely Isabel Fairfield), British writer and critic (b. 1892).

d. Arthur Koestler, Hungarian-British writer (b. 1905).

d. Gabrielle Roy, French-Canadian writer (b. 1909).

d. Jerzy Andrzejewski, Polish writer (b. 1909).

FILM & BROADCASTING

Terms of Endearment, Shirley MacLaine, Debra Winger, and Jack Nicholson starred in James L. Brooks's screen version of the 1975 Larry McMurtry novel.

The Big Chill, Tom Berenger, Glenn Close, Jeff Goldblum, William Hurt, Kevin Kline, Mary Kay Place, Meg Tilly, and JoBeth Williams starred as the 1960s college classmates reunited at a funeral in Lawrence Kasdan film.

Heat and Dust, Julie Christie, Greta Scacchi as her parallel-story grandmother, Shashi Kapoor, and Mahdur Jaffrey starred in the James Ivory film, set in modern India, adapted by Ruth Prawer Jhabvala from her own 1975 novel.

Meryl Streep, Kurt Russell, and Cher starred in *Silkwood*, directed by Mike Nichols, about the suspicious death of nuclear plant employee Karen Silkwood.

Robert Duvall starred in *Tender Mercies*, directed by Bruce Beresford.

Howard E. Rollins, Jr., starred in *A Soldier's Story*, directed by Norman Jewison.

Albert Finney and Tom Bourtenay starred in *The Dresser*, directed by Peter Yates.

Mark Hamill, Harrison Ford, and Carrie Fisher starred in the *Star Wars* sequel *Return of the Jedi*, directed by Richard Marquand.

Sally Field and John Malkovich starred in *Places in the Heart*, directed by Robert Benton.

Michael Douglas and Kathleen Turner starred in *Romancing the Stone*, directed by Robert Zemeckis.

Harrison Ford starred in Steven Spielberg's *Indiana Jones and the Temple of Doom*.

Woody Allen's film *Zelig*, starring Allen and Mia Farrow.

The Winds of War, the television miniseries on the early years of World War II, to Pearl Harbor, based on Herman Wouk's 1971 novel; Robert Mitchum as Pug Henry led a very large cast, also in the 1989 sequel, *War and Remembrance*.

The Day After, the post-nuclear war television film; Jason Robards, JoBeth Williams, John Lithgow, John Cullum, Steve Guttenberg, and Amy Madigan starred.

Academy Awards for 1983 (awarded the following year): Best Picture: *Terms of Endearment*; Best Director: James L. Brooks, *Terms of Endearment*; Best Actor: Robert Duvall, *Tender Mercies*; Best Actress: Shirley MacLaine, *Terms of Endearment*.

d. Gloria Swanson (Gloria Josephine Swenson), American actress (b. 1897), silent film star, with a comeback the classic *Sunset Boulevard* (1950).

d. David Niven (James Graham David Niven), British actor (b. 1909).

d. George Cukor, American director (b. 1899).

d. Luis Buñuel, Spanish director and writer (b. 1900).

d. Norma Shearer (Edith Norma Shearer), Canadian actress (b. 1900), a star in silent films and then of Hollywood's Golden Age; wife of producer Irving Thalberg.

d. Raymond Massey, Canadian-British actor and director (b. 1896), father of Daniel and Anna Massey.

d. Arthur Godfrey, American entertainer (b. 1903).

d. Robert Aldrich, American director and producer (b. 1918).

VISUAL ARTS

Philip Johnson and John Burgee designed the American Telephone and Telegraph building, New York City, a key postmodernist structure.

Roman Vishniac's *Vanished Worlds*, a collection of his European ghetto photographs of the interwar period.

Jenny Holzer's work of performance art *Unex Sign #1*.

Christo's sculpture *Surrounded Islands*, Biscayne Bay, Florida.

Frank Stella's paintings included *Mellieha Boy* and *Valle Lunga*.

Jennifer Bartlett's painting *Shadow*.

Jim Dine's sculpture *The Crommelynck Gate with Tools*.

Edward Larrabee Barnes designed the Dallas Museum.

Harry Cobb designed the Portland Museum, Portland, Maine.

Willem de Kooning's paintings included *Morning* and *The Springs*.

Jasper Johns's paintings included *Between the Clock and the Bed* and *Ventriloquist*.

Henri Cartier-Bresson's photo collection *Photoportraits*.

I. M. Pei designed the Indiana University Art Museum, Bloomington.

Lucas Samaras's sculpture *Box #110*.

Philip Pearlstein's painting *Two Models with a Library Ladder*.

d. Joan Miró, Spanish artist (b. 1893).

d. (Richard) Buckminster Fuller, American designer and inventor (b. 1895), who developed and popularized the geodesic dome.

d. Bill Brandt, British photographer (b. 1905).

THEATER & VARIETY

Kathy Bates and Anne Pitoniak starred in *'Night, Mother*; the Marsha Norman play opened at the John Golden Theatre March 31.

Neil Simon's *Brighton Beach Memoirs* starred Matthew Broderick, Joyce Van Pattten, and Elizabeth Frantz; opened at the Alvin Theatre, New York, March 27.

Tommy Tune and Twiggy starred in George and Ira Gershwin's musical *My One and Only*.

Jerry Herman's musical *La Cage aux Folles*, based on the Jean Poiret play, starred George Hearn and Gene Barry.

Jerry Herman's musical *Mame*, based on the Patrick Dennis book *Auntie Mame*, starred Angela Lansbury in the title role.

Alec McCowen starred in his solo *Kipling*.

Lanford Wilson's *Angels Fall* starred Fritz Weaver and Barnard Hughes.

Michael Frayn's *Noises Off* starred Dorothy Loudon and Brian Murray.

Elizabeth Taylor and Richard Burton starred in Noël Coward's *Private Lives*.

The Caine Mutiny Court-Martial, Herman Wouk's play, starred Michael Moriarty, John Rubinstein, and Jay O. Sanders.

You Can't Take It with You, the Moss Hart and George S. Kaufman play, starred Colleen Dewhurst, Jason Robards, Jr., and Elizabeth Wilson.

Anthony Quinn in the title role and Lila Kedrova starred in the John Kander and Fred Ebb musical *Zorba*, based on the Nikos Kazantzakis novel.

Sean Penn and Kevin Bacon starred in John Byrne's *Slab Boys*.

Al Pacino starred in David Mamet's *American Buffalo*.

Tennessee Williams's *The Glass Menagerie* starred Jessica Tandy, Bruce Davidson, Amanda Plummer, and John Heard.

Heartbreak House, George Bernard Shaw's play, starred Rex Harrison and Rosemary Harris.

Simon Gray's *Quartermaine's Terms* starred Remak Ramsey.

Arthur Miller's *A View from the Bridge* starred Tony Lo Bianco, Saundra Santiago, and James Hayden.

Natalia Makarova and Dina Merrill starred in the Richard Rodgers and Lorenz Hart musical *On Your Toes*.

Savannah Bay, Marguerite Duras's play.

d. Tennessee Williams (Thomas Lanier Williams), leading American playwright; a world figure (b. 1911).

d. Ralph Richardson, one of the leading British actors of his time (b. 1902).

d. Lynn Fontanne (Lillie Louise Fontanne), British-American actress, stage partner and wife of Alfred Lunt (b. 1887).

MUSIC & DANCE

d. George Balanchine (Georgi Melitonovich Balanchivadze), Russian-American dancer, choreographer, and ballet director (b. 1904); choreographer of Sergei Diaghilev's Ballets Russes and founder of the New York City Ballet.

Eurythmics, the pop duo of Annie Lennox and David Allan Stewart, released their album *Sweet Dreams (Are Made of This)*, with the hit title song and *Love Is a Stranger*.

Glass Pieces, Jerome Robbins's ballet to Philip Glass's music, first danced by the New York City Ballet.

Twyla Tharp introduced her new ballet *Once Upon a Time*, with Mikhail Baryshnikov.

St. Francis of Assisi (*Saint François d'Assise*), Olivier Messiaen's opera.

Colour by Numbers, Culture Club's album featuring Boy George, with *Karma Chameleon*, *Church of the Poison Mind*, and *Victims*.

György Ligeti's *Piano Concerto* and choral works *Drei Phantasien* and *Hungarian studies*.

The Police's album *Synchronicity*, with their hit *Every Breath You Take*.

Milton Babbitt's *Canonical Form* for piano and ensemble work *Groupwise*.

Vivian Fine's *Drama for Orchestra* premiered in San Francisco.

Lionel Richie's album *Can't Slow Down*, and hit single *All Night Long*.

George Antheil's *Violin Sonata No. 1* premiered in Buffalo, New York.

A Quiet Place, Leonard Bernstein's opera.

Paul Simon's album *Hearts and Bones*.

Elliott Carter's ensemble piece *Triple Duo* premiered in New York.

Wynton Marsalis's album *Think of One*.

Krzysztof Penderecki's *Viola Concerto*.

Randy Newman's album *Trouble in Paradise*.

The Mask of Orpheus, Harrison Birtwhistle's opera.

Billy Joel's single *Tell Her About It*.

Witold Lutoslawski's *Third Symphony*.

Carole King's album *Speeding Time*.

The English Cat, Hans Werner Henze's opera.

Madonna's albums *Madonna* and *Like a Virgin*.

Gian Carlo Menotti's *Double Concerto*.

Def Leppard's album *Pyromania*.

Bonnie Tyler's hit *Total Eclipse of the Heart*.

Michael Tippett's *Festal Brass with Blues*, for brass band.

Men at Work's album *Business as Usual*.

The English Cat, Hans Werner Henze's opera.

Iannis Xenakis's choral works *Chant des soleils* and *Shar*.

Jacob Druckman's composition *Vox Humana*.

Let's Dance, David Bowie's album and single.

Lukas Foss's *Percussion Quartet*.

Prince's album *1999*.

d. William Walton, British composer (b. 1902).

d. Earl "Fatha" Hines, American jazz pianist, bandleader, and songwriter (b. 1903).

d. Ira Gershwin, American lyricist, brother of George Gershwin (b. 1896).

d. Eubie Blake (James Hubert Blake), American composer and pianist (b. 1883).

d. Muddy Waters (McKinley Morganfield), American blues singer, guitarist, and bandleader (b. 1915).

d. Adrian Boult, English conductor (b. 1889).

d. Alberto Ginastera, Argentinian composer (b. 1916).

WORLD EVENTS

Philippines opposition leader Benigno Aquino was assassinated, probably by government agents, as he returned from exile (August), starting the train of events that led to the Philippine Revolution.

As the Lebanese civil war continued, American forces in Beirut, Iran-backed Hezbollah guerrillas, the PLO, Syria, and several Christian and Muslim Lebanese militia all were drawn into multiple armed clashes.

Muslim guerrillas in Beirut drove explosives-laden trucks into American and French peacekeeping-force barracks, killing 241 Americans and 58 French.

Korean Airlines Flight 007 was shot down by Soviet planes near Soviet Sakhalin; 269 people died.

President Ronald Reagan developed the Star Wars (Strategic Defense Initiative) nuclear defense theory, pouring resources into research.

American forces invaded and took lightly defended Grenada, installing a new government to replace the Cuban-oriented government.

After lost Falklands War, Raúl Alfonsin Foulkes became president of Argentina, quickly moving to restore democracy and the economy.

Australian Labour party leader Bob Hawke became prime minister, then pursuing an unaligned path and anti-nuclear weapons international policy.

Nowruz oil-field blowouts generated a massive oil spill in the Persian Gulf during the Iran–Iraq war.

U.S. Environmental Protection Agency bought all the homes in dioxin-contaminated Times Beach, Missouri, and evacuated the town.

Vanessa Williams, the first African-American Miss America, was forced to resign her crown after *Penthouse* magazine publicized some early nude photographs.

Yitzhak Shamir succeeded Menachem Begin as prime minister of Israel (1983–1984).

Astrophysicist Sally K. Ride became the first Amer-

ican woman astronaut in space, on the second flight of the space shuttle *Challenger.*

Guion Bluford, Jr., became first African-American astronaut, in the third *Challenger* flight.

First genetic markers were found, for Duchenne muscular dystrophy and Huntington's disease.

Dian Fossey published *Gorillas in the Mist,* the story of her work with mountain gorillas in Zaire.

1984

LITERATURE

The Unbearable Lightness of Being, Milan Kundera's novel, set in then-communist post–Soviet invasion Czechoslovakia; basis of the 1988 Philip Kaufman film.

The Nobel Prize for Literature was awarded to Jaroslave Seifert.

The War of the End of the World, Mario Vargas Llosa's novel.

Love in the Time of Cholera, Gabriel García Márquez's novel.

Hotel du Lac, Anita Brookner's Booker Prize–winning novel.

The Witches of Eastwick, John Updike's novel, basis of the 1987 George Miller film.

Larry McMurtry's Pulitzer Prize–winning novel *Lonesome Dove;* basis for a television miniseries.

Tough Guys Don't Dance, Norman Mailer's novel; basis of his 1987 film.

Father Come Home, Ezekiel Mphahlele's novel, set in the black South African experience.

Jay McInerney's novel *Bright Lights, Big City.*

Louise Erdrich's novel *Love Medicine.*

Lincoln, Gore Vidal's novel.

Alison Lurie's Pulitzer Prize–winning novel *Foreign Affairs.*

Saul Bellow's *Him with His Foot in His Mouth and Other Stories.*

Helen Hoover Santmyer's *". . . And Ladies of the Club."*

Eudora Welty's *One Writer's Beginnings.*

The Lover, Marguerite Duras's novel.

The Paper Men, William Golding's novel.

John Ashbery's poetry *A Wave.*

Joseph Heller's novel *God Knows.*

E. L. Doctorow's novel *Lives of the Poets.*

Down from the Hill, Alan Sillitoe's novel.

Ellen Gilchrist's novel *Victory over Japan.*

Henry Taylor's Pulitzer Prize–winning poetry *The Flying Change.*

Stephen King's and Peter Straub's best-seller *The Talisman.*

Jayne Anne Phillips's novel *Machine Dreams.*

Padgett Powell's novel *Edisto.*

Philip Kenny's poetry *The Evolution of the Flightless Bird.*

Sharon Olds's poetry *The Dead and the Living.*

Dr. Seuss's *The Butter Battle Book.*

Steve Katz's *Stolen Stories.*

Ted Hughes's poetry *River.*

Tess Gallagher's poetry *Willingly.*

Democracy, Joan Didion's novel.

Fly Away Home, Marge Piercy's novel.

Ted Hughes became Britain's poet laureate, succeeding John Betjeman.

The Two of Us, John Braine's novel.

Dr. Slaughter, Paul Theroux's novel.

d. Vicente Aleixandre, Spanish poet (b. 1898).

d. Truman Capote, American author (b. 1924).

d. Mikhail Sholokov, Soviet writer (b. 1905).

d. J. B. (John Boynton) Priestley, British writer and critic (b. 1894).

d. Liam O'Flaherty, Irish writer (b. 1896).

d. Chester Himes, American writer (b. 1909).

d. Ignazio Silone (Secondo Tranquilli), Italian writer (b. 1900).

d. Irwin Shaw, American writer (b. 1913).

FILM & BROADCASTING

A Passage to India, Alec Guinness, Judy Davis, Victor Bannerjee, James Fox, Peggy Ashcroft, and Nigel Havers led a large cast in David Lean's epic film, set in India; based on the sensitive, small-scale 1924 E. M. Forster novel.

Amadeus, the Milos Forman film version of the 1980 Peter Shaffer play, starred F. Murray Abraham as Salieri and Tom Hulce as the young Wolfgang Amadeus Mozart.

The Killing Fields, Sam Waterston and Haing S. Ngor starred in the Roland Joffe film, based on Sidney Schanberg's reportage of the end of the Cambodian Civil War and the beginning of the Cambodian Holocaust.

Ironweed, Jack Nicholson and Meryl Streep starred as two down-and-out Depression-era alcoholics in

Hector Babenco's screen version of the 1983 William Kennedy novel.

1984, John Hurt and Richard Burton starred in Michael Radford's film version of the 1949 George Orwell satirical novel, an always-timely satirical attack on the bureaucratic state.

Dangerous Moves, Michele Piccoli, Liv Ullmann, Leslie Caron, Michel Aumont, and Alexandre Arbatt starred in Richard Dembo's thriller, set during world chess championship play.

Greystoke, The Legend of Tarzan, Lord of the Apes, Hugh Hudson's Tarzan film; Christopher Lambert, Ralph Richardson, Cheryl Campbell, Ian Holm, and Ian Charleson starred.

Satyajit Ray directed *The Home and the World*.

Woody Allen and Mia Farrow starred in Allen's *Broadway Danny Rose*.

Murder, She Wrote, Angela Lansbury as mystery writer Jessica Fletcher starred in the television series, set largely in fictional Cabot Cove, Maine (1984–).

The Cosby Show, Bill Cosby's very popular television situation comedy (1984–1992).

The Jewel and the Crown, the television miniseries, set in India 1942–1947, on the eve of independence; based on Paul Scott's tetralogy of novels (1966–1973); Art Malik, Susan Wooldridge, Tim Piggott-Smith, Geraldine James, Charles Dance, and Peggy Ashcroft starred.

The Far Pavilions, Ben Cross and Amy Irving starred in the television miniseries, based on the M. M. Kaye novel, set on India's northern frontier in the 19th century.

Academy Awards for 1984 (awarded the following year): Best Picture: *Amadeus*; Best Director: Milos Forman, *Amadeus*; Best Actor: F. Murray Abraham, *Amadeus*; Best Actress: Sally Field, *Places in the Heart*.

d. François Truffaut, French director and critic (b. 1932).

d. William Powell, American actor (b. 1892).

d. James Mason, British actor (b. 1909).

d. Walter Pidgeon, Canadian actor (b. 1897).

d. Joseph Losey, American director (b. 1909); blacklisted during the McCarthy period, he became a leading British director.

d. Jackie (Jack Leslie) Coogan, American actor (b. 1914), a child star.

d. Richard Basehart, American actor (b. 1914).

VISUAL ARTS

The Museum of Modern Art reopened, after a four-year-long renovation that more than doubled its size.

Forty-five Renaissance "masterworks" at the Metropolitan were discovered to have been forgeries.

Isamu Noguchi's sculptures included *Lightning Bolt* and *Memorial to Ben Franklin*.

Frank Stella's sculpture *St. Michael's Counterguard*.

Roy Lichtenstein's painting *Landscape with Figures*.

Jasper Johns's painting *Racing Thoughts*.

Marisol's sculpture *Self-Portrait Looking at the Last Supper*.

Julian Schnabel's painting *King of the Wood*.

Richard Meier designed the High Museum of Art, Atlanta, Georgia.

Kenny Scharf's painting *When Worlds Collide*.

Kevin Roche's and John Dinkeloo designed the General Foods Corporation headquarters, Rye, New York.

Philip Johnson designed the Center for the Fine Arts, Miami.

Red Grooms's painting *Chance Encounter at 3 a.m.*

Venturi, Rauch, and Scott Brown designed Gordon Wu Hall, Princeton University, Princeton, New Jersey.

d. Ansel Adams, American photographer and conservationist (b. 1902), who became the foremost landscape and nature photographer of the modern American West.

d. Brassaï (Gyula Halász), French photographer (b. 1899).

THEATER & VARIETY

August Wilson's *Ma Rainey's Black Bottom* starred Theresa Merritt and Charles Dutton; directed by Lloyd Richards.

Tom Stoppard's *The Real Thing* starred Jeremy Irons and Glenn Close; directed by Mike Nichols.

Me and My Girl, Robert Lindsay and Maryann Plunkett starred on Broadway in a notable revival of the 1937 Noel Gay musical.

Dustin Hoffman as a memorable Willy Loman, Kate Reid, John Malkovich, and Stephen Lang starred in Arthur Miller's *Death of a Salesman*.

Two notable solo performances: *Ian McKellen Acting Shakespeare*, and Alec McCowen in Brian Clark's *Kipling*.

Two one-woman star vehicles: *Shirley MacLaine on Broadway* and *Whoopi Goldberg*.

Mandy Patinkin and Bernadette Peters starred in Stephen Sondheim's *Sunday in the Park with George*.

David Mamet's Pulitzer Prize–winning play *Glengarry Glen Ross*, starring Robert Prosky and Joe Mantegna, opened on Broadway on March 25, after a run at Chicago's Goodman Theater.

David Rabe's play *Hurlyburly* starred William Hurt, Harvey Keitel, Ron Silver, Judith Ivey, and Sigourney Weaver.

Fred Ebb's and John Kander's musical *The Rink* starred Liza Minelli and Chita Rivera.

Derek Jacobi starred in the title role of Anthony Burgess's translation of *Cyrano de Bergerac*.

Noël Coward's *Design for Living* was revived in New York, with Jill Clayburgh, Frank Langella, and Raul Julia in the leads; George C. Scott directed.

Barnard Hughes, Linda Hunt, and John Shea starred in Arthur Kopit's *End of the World*, directed by Harold Prince.

Irene Worth, Stockard Channing, and Jeff Daniels starred in A. R. Gurney's *The Golden Age*.

George Bernard Shaw's *Heartbreak House* starred Rex Harrison and Amy Irving.

Derek Jacobi and Sinead Cusack starred in Shakespeare's *Much Ado About Nothing*, directed by Terry Hands.

d. Richard Burton (Richard Walter Jenkins), Welsh-British actor (b. 1925).

d. Lillian Hellman, a leading American playwright for three decades (b. 1905).

d. Ethel Merman (Ethel Zimmerman), American singer and actress (b. 1909).

d. William Douglas Home, British writer and actor (b. 1912).

d. Brooks Atkinson, American journalist (b. 1894), chief drama critic for the *New York Times* (1925–1960).

d. Eduardo de Filippo, Italian actor and playwright (b. 1900).

d. Flora Robson, British actress (b. 1902).

Music & Dance

Band Aid, an international rock music relief effort, to aid victims of the Ethiopian famine, organized by Bob Geldof of the Boomtown Rats; it generated a benefit record, *Do They Know It's Christmas?*

Sammerstag aus Licht (*Saturday from Light*), the second completed of Karlheinz Stockhausen's projected seven-evening opera *Licht*, premiered May 25 in Milan.

I Just Called to Say I Love You, Stevie Wonder's song, from the film *The Woman in Red*.

Akhnaten, Philip Glass's opera, libretto by Glass and others, opened in Stuttgart March 24; part of his "portrait opera" trilogy.

George Crumb's orchestral work *A Haunted Landscape* premiered in New York.

The Judds—Wynonna and Naomi and *Why Not Me*, the first albums of the daughter-and-mother recording duo (1984–1992).

Harrison Birtwistle's orchestral works *Secret Theatre* and *Still Movement*.

Julio Iglesias and Willie Nelson's duet *To All the Girls I've Loved Before*.

What's Love Got to Do with It?, hit from Tina Turner's album *Private Dancer*.

Leontyne Price sang her farewell performance in *Aïda*, at the Metropolitan Opera, New York.

Bruce Springsteen's massive hit album *Born in the U.S.A.*

Michael Tippett's fourth piano sonata.

Four Play, Milton Babbitt's ensemble work.

Purple Rain, Prince and the Revolution's album.

Billy Joel's album *An Innocent Man*.

Prometeo, Luigi Nono's vocal work.

Cindy Lauper's album *She's So Unusual*.

A Collection of Rocks, John Cage's orchestral work.

Madonna's hit singles *Crazy for You* and *Borderline*.

Mario Davidovsky's composition *String Quartet No. 4*.

Duran Duran's album *Seven and the Ragged Tiger*.

Ellen Zwilich's composition *Celebration for Orchestra*.

Terry Riley's *The Harp of New Albion*.

Exile's single record *I Don't Wanna Be a Memory*.

Branford Marsalis's album *Scenes in the City*.

Hans Werner Henze's *Seventh Symphony*.

Dream Street, Janet Jackson's album.

Stephen Albert's *RiverRun*.

Wynton Marsalis's album *Hot House Flowers*.

A Truly Western Experience, k. d. lang's first album.

Erick Hawkins's *The Joshua Tree*.

Huey Lewis and the News' album *Sports*.

Van Halen's album *1984*.

Roger Reynolds's *Transfigured Wind II.*

d. Count Basie (William Allen Basie), American pianist and bandleader, a big-band standout leader from the late 1930s (b. 1904).

d. Alberta Hunter, American blues singer (b. 1895).

d. Jan Peerce (Jacob Pincus Perelmuth), American tenor (b. 1904).

d. Marvin Gaye, American singer (b. 1939).

WORLD EVENTS

Republican President Ronald Reagan won a second term, defeating Democratic candidate Senator Walter Mondale.

Sikh fundamentalist Jarnail Singh Bhindranwale and an estimated 1,000 of his followers, using the Sikh Golden Temple as haven and headquarters, were killed by Indian army troops who assaulted the temple.

Indian Prime Minister Indira Gandhi was assassinated by two Sikh members of her personal guard; she was succeeded by her son, Rajiv Gandhi.

Deadly methyl isocyanate gas leaked at Union Carbide plant in Bhopal, India, causing a toxic cloud that killed more than 3,500 people and injured an estimated 200,000.

Famine and accompanying disease in Ethiopian and Eritrea, then at war, killed an estimated one million people.

Iraq reportedly used chemical weapons against Iranian forces during the Iran–Iraq war, and did so for the balance of the war, also against Iraqi dissidents, most notably the Kurds.

Canadian Progressive Conservative party leader Brian Mulroney became prime minister (1984–1993).

Los Angeles Olympics were boycotted by the Soviet Union, responding to 1980 Western boycotts of the Moscow games in response to the Soviet invasion of Afghanistan.

Luc Montagnier and Robert Gallo independently identified the AIDS virus; who discovered what first became a matter of controversy.

Carl Sagan and others put forward the "nuclear winter" theory.

d. Yuri Vladimirovich Andropov (b. 1914), head of the Soviet KGB (1967–1982) and leader of the Soviet Union (1982–1984); succeeded by Konstantin Ustinovich Chernenko.

1985

LITERATURE

Old Gringo, Carlos Fuentes's novel, set in revolutionary Mexico; basis of the 1989 Luis Puenzo film.

The Nobel Prize for Literature was awarded to Claude Simon.

Jean M. Auel's *The Mammoth Hunters*, third of her Earth's Children novels.

Peter Taylor's Pulitzer Prize–winning novel *A Summons to Memphis.*

Rita Dove's Pulitzer Prize–winning poetry *Thomas and Beulah.*

Anne Tyler's novel *The Accidental Tourist.*

Raymond Carver's poetry *Where Water Comes Together with Other Water.*

Adventures in the Alaskan Skin Trade, John Hawkes's novel.

Robert Penn Warren became the first U.S. poet laureate.

The Succession: A Novel of Elizabeth and James, second of George Garrett's Elizabethan novels.

Bobbie Ann Mason's novel *In Country.*

Carolyn Chute's novel *The Beans of Egypt, Maine.*

Galway Kinnell's poetry *The Past.*

What's Bred in the Bone, Robertson Davies's novel.

Keri Hulm's New Zealand novel *The Bone People.*

Marge Piercy's *My Mother's Body.*

E. L. Doctorow's novel *World's Fair.*

Zuckerman Bound, Philip Roth's novel.

Isaac Bashevis Singer's short stories *The Image.*

Elmore Leonard's novel *Glitz.*

Grace Paley's novel *Later the Same Day.*

Russell Banks's novel *Continental Drift.*

June Jordan's poetry *Living Room.*

Italo Calvino's novel *Mr. Palomar.*

James Michener's *Texas.*

Louise Glück's poetry *The Triumph of Achilles.*

Robert Coover's novel *Gerald's Party.*

Seamus Heaney's poetry *Station Island.*

Stephen King's novel *Skeleton Crew.*

William Gaddis's novel *Carpenter Gothic.*

Stars and Bars, William Boyd's novel.

The Fifth Son, Elie Wiesel's novel.

Dictionary of American Regional English began publication with its first volume, edited by Frederic G. Cassidy for the American Dialect Society.

d. Robert Graves, British writer (b. 1895),

d. Elsa Morante (b. 1912), Italian writer, wife of writer Alberto Moravia.

d. Philip Larkin, British poet (b. 1922).

FILM & BROADCASTING

A *Room with a View*, Maggie Smith, Helena Bonham Carter, Denholm Elliott, and Daniel Day-Lewis starred in the James Ivory film, adapted for film by Ruth Prawer Jhabvala from the 1908 E. M. Forster novel.

Agnes of God, the Norman Jewison film, about a nun accused of killing her baby; adapted by John Pielmeier from his 1980 play, it starred Meg Tilly, Jane Fonda, and Anne Bancroft.

Out of Africa, Meryl Streep as Isak Dinesen and Robert Redford starred in Sidney Pollack's screen version of Dinesen's 1937 story of her years in Africa.

Prizzi's Honor, Jack Nicholson, Kathleen Turner, and Anjelica Huston as Maerose Prizzi starred in John Huston's Brooklyn Mafia family comedy, based on the 1982 Richard Condon novel.

Ran, Tatsuya Nakadai, Satoshi Terao, Jinpachi Nezu, Daisuke Ryu, and Mieko Harada starred in Akiro Kurosawa's epic Japanese adaptation of Shakespeare's *King Lear*.

A *Chorus Line*, the Richard Attenborough film, based on the 1975 Michael Bennett stage musical; Michael Douglas starred.

Peter Masterson's film *The Trip to Bountiful*, with Geraldine Page.

Ron Howard's film *Cocoon*, with Don Ameche, Jessica Tandy, and Hume Cronyn.

Peter Weir's film *Witness*, with Harrison Ford and Kelly McGillis.

Shoah, Claude Lanzmann's powerful Holocaust documentary.

Plenty, Meryl Streep, Charles Dance, and John Gielgud starred in the Fred Scepisi film version of the 1978 David Hare play.

The Color Purple, Whoopi Goldberg starred in Steven Spielberg's screen version of the 1982 Alice Walker novel.

The Kiss of the Spider Woman, Raul Julia and William Hurt starred as the prisoners sharing a cell in the Hector Babenco film, based on the Manuel Puig novel.

The Official Story, Norma Aleandro, Analia Castro, and Hector Alterio starred in Luis Penzo's exposé of military rule in Argentina.

The Oprah Winfrey Show, her television talk show (1985–).

Woody Allen's film *The Purple Rose of Cairo*, with Mia Farrow, Jeff Daniels, and Danny Aiello.

Academy Awards for 1985 (awarded the following year): Best Picture: *Out of Africa*; Best Director: Sydney Pollack, *Out of Africa*; Best Actor: William Hurt, *Kiss of the Spider Woman*; Best Actress: Geraldine Page, *The Trip to Bountiful*.

d. Orson Welles (George Orson Welles) American director, actor, writer, and producer (b. 1915).

d. Rock Hudson (Roy Scherer), American actor (b. 1925).

d. Simone Signoret (Simone Kaminker), French actress (b. 1921).

d. Louise Brooks, American actress and dancer (b. 1906).

d. Yul Brynner, Russian-American actor and director (b. 1915).

d. Sergei Gerasimov, Russian actor and director (b. 1906).

VISUAL ARTS

I. M. Pei's Charles Shiptman Payson Building, Portland Museum of Art.

The Birth Project, Judy Chicago's painting, on feminist themes.

Kohn Pederson Vox designed the Procter & Gamble Building, Cincinnati.

Richard Serra's sculptures *Pasolini* and *Clara-Clara*.

Mark DiSuvero's sculpture *Huru*.

Sherrie Levine's *Golden Knots* series of paintings.

Michael Graves designed the Humana Building, Louisville, Kentucky.

Philip Taafe's paintings *Brest* and *Homo Fortissimus Excelsius*.

San Francis's painting *Fast and Dark II*.

d. Marc Chagall, Russian-Jewish painter (b. 1887).

d. André Kertész, Hungarian photographer (b. 1894); a leading European photojournalist of the 1920s and 1930s.

d. Jean Dubuffet, French artist (b. 1901).

d. Arthur Rothstein, American photographer (b. 1913), a leading Farm Security Administration photographer of the 1930s.

d. Chester Gould, American cartoonist (b. 1900), who created *Dick Tracy*.

THEATER & VARIETY

James Earl Jones starred in August Wilson's *Fences*, on African-American themes; Lloyd Richards directed.

Athol Fugard directed his own *Blood Knot* and starred opposite Zakes Mokae.

Herb Gardner's *I'm Not Rappaport* starred Judd Hirsch and Cleavon Little.

Hugh Whitemore's *Pack of Lies* starred Rosemary Harris and Patrick McGoohan.

Neil Simon's autobiographical *Biloxi Blues* starred Matthew Broderick and Brian Tarantina.

Lily Tomlin made a notable solo appearance in Jane Wagner's *The Search for Signs of Intelligent Life in the Universe*.

Michael Frayn's *Benefactors* starred Glenn Close, Sam Waterston, and Mary Beth Hurt.

Twyla Tharp directed the Betty Comden–Adolph Green stage adaptation of the film musical *Singin' in the Rain*, starring Don Correia, Peter Slutsker, and Mary D'Arcy.

Roger Miller's musical *Big River: The Adventures of Huckleberry Finn* starred Daniel Jenkins, Ron Richardson, Rene Auberjonois, and Bob Gunton.

Yul Brynner starred in the Richard Rodgers and Oscar Hammerstein II musical *The King and I*.

Rex Harrison, Claudette Colbert, Lynne Redgrave, and Jeremy Brett starred in Frederick Lonsdale's *Aren't We All?*

Jim Dale and Stockard Channing starred in Peter Nichols's *Joe Egg*, directed by Arvin Brown.

Glenda Jackson, Edward Petherbridge, and Tom Aldredge starred in Eugene O'Neill's *Strange Interlude*.

Jason Robards and Barnard Hughes starred in Eugene O'Neill's *The Iceman Cometh*.

George Rose and Betty Buckley starred in Rupert Holmes's *The Mystery of Edwin Drood*.

Linda Hunt starred in Wallace Shawn's *Aunt Dan and Lemmon*.

Talley and Son, fourth of Lanford Wilson's Talley family plays.

The Debutante Ball, Beth Henley's play.

Largo Desolato, Vaclav Havel's play.

Pravda, David Hare's play.

Larry Kramer's play *The Normal Heart*.

d. Michael Redgrave, one of the leading British actors of his time (b. 1908); the husband of Rachel Kempson, and father of Vanessa, Lynn, and Corin Redgrave.

d. Isabel Jeans, English actress (b. 1891).

MUSIC & DANCE

Live Aid, 16-hour-long simultaneous rock benefit concerts in Philadelphia and London's Wembley Stadium; a followup to the 1984 Band Aid relief effort.

American A. for Africa (American Band Aid) produced the single *We Are the World*, written by Lionel Richie and Michael Jackson, with numerous celebrities taking part, and contributing songs to the associated album.

Dancing in the Street, the Rolling Stones and David Bowie's hit song for Band Aid.

No Jacket Required, Phil Collins's album, with its Grammy-winning song *Against All Odds*.

Bruce Springsteen & The E Street Band: Live, 1975–1985, the best-selling five-record set.

Porgy and Bess was presented at the Metropolitan Opera, New York, with Grace Bumbry and Simon Estes.

Toru Takemitsu's *Piano Concerto* premiered in Los Angeles.

Frank Zappa's album *The Perfect Stranger and Other Works*.

Henry Brant's *Desert Forests* premiered in Atlanta.

Rockin' with the Rhythm, the Judds' album.

William Schuman's composition *On Freedom's Ground*.

Peter Maxwell Davies's *Violin Concerto*.

Washington Square, Rudolf Nureyev's ballet.

Eric Clapton's album *Just One Night*.

Penthode, Elliott Carter's five instrumental quartets.

Sting's *The Dream of the Blue Turtle*.

Behold the Sun, Alexander Goehr's opera.

Milton Babbitt's *Piano Concerto*.

Wham's album *Make it Big*.

George Perle's *Wind Quintet IV*.

Lionel Richie's single *Say You, Say Me*.

Thallein, Iannis Xenakis's orchestral work.

Bryan Adams's album *Reckless*.

John Harbison's *Variations*.

Billy Ocean's album *Suddenly*.

Ralph Shapey's *Symphonic Variations*.

James Levine was named artistic director of the Metropolitan Opera Company.

d. Efrem Zimbalist, Russian-American violinist; father of actor Efrem Zimbalist, Jr.

d. Emil Gilels, Soviet pianist (b. 1916).

d. Eugene Ormandy, Hungarian-American conductor; longtime conductor of the Philadelphia Orchestra (1938–1980).

d. Roger Sessions, American composer (b. 1896).

WORLD EVENTS

d. Konstantin Ustinovich Chernenko, Soviet Communist party general secretary (b. 1911)

Mikhail Gorbachev became general secretary of the Soviet Communist party and leader of the Soviet Union, and quickly began the reforms that would transform the Soviet Union, break up the Soviet empire, and end the cold war.

Mikhail Gorbachev and American President Ronald Reagan met at Geneva in November, beginning the sequence of summit meetings and events that would transform the entire world situation.

Iran–Contra Affair: Reagan Administration sale of arms to Iran in return for the release of Lebanon hostages began; profits from such sales were used to illegally arm the Nicaraguan Contras.

Associated Press Middle East correspondent Terry Anderson was kidnapped in Lebanon on March 15, becoming a hostage; he would be held 2,454 days, until December 4, 1991.

Beirut CIA station chief William Buckley, taken hostage in Lebanon in 1984, was murdered by his captors.

Both sides in the Iran–Iraq war began missile attacks on enemy cities.

French agents sank the Greenpeace antinuclear ship *Rainbow Warrior* in Auckland harbor, New Zealand, killing one person; two agents were convicted of manslaughter.

Full-scale civil war returned to the Sudan, bringing mass starvation and emigration.

Haitian dictator Jean-Claude Duvalier was toppled by a revolution and fled the country in 1986.

Islamic Jihad (Holy War) terrorists hijacked a TWA airliner, holding 153 people on the ground at Athens and then Beirut (June 14–30) and murdering one passenger.

Palestinian terrorists hijacked the Italian cruise ship *Achille Lauro* off the Egyptian coast, murdering an American passenger. They were taken when American fighters forced an airliner carrying them to land in Sicily.

An Air India 747 exploded over the Irish Sea, killing 329 people.

Philadelphia police bombing of MOVE organization killed 11 people and triggered a major fire.

Mexican earthquakes killed 5,000–10,000 people and destroyed much of the center of Mexico City (September 19–20).

Ozone hole over Antarctica was first reported by British scientific team.

1986

LITERATURE

The Handmaid's Tale, Margaret Atwood's futurist novel on feminist themes; basis of the 1990 Volker Schlondorff film.

Toni Morrison's Pulitzer Prize–winnng novel *Beloved*.

Wole Soyinka was awarded the Nobel Prize for Literature.

The Old Devils, Kingsley Amis's Booker Prize–winning novel.

The Nature of Passion, Ruth Prawer Jhabvala's novel.

William Meredith's Pulitzer Prize–winning poetry *Partial Accounts*.

Ernest Hemingway's novel *The Garden of Eden* posthumously published.

Tama Janowitz's short-story collection *Slaves of New York*.

Derek Walcott's *Collected Poems, 1948–1984*.

John le Carré's novel *A Perfect Spy*.

Reynolds Price's novel *Kate Vaiden*.

Sue Miller's novel *The Good Mother*.

Pat Conroy's best-seller *The Prince of Tides*.

Matigari, Ngugi Wa Thiong'O's novel; and his *Decolonising the Mind: The Politics of Language in African Literature*.

John Updike's novel *Roger's Version*.

Adrienne Rich's poetry *Your Native Land, Your Life*.

J. M. Coetzee's novel *Foe*.

Ishmael Reed's novel *Reckless Eyeballing*.

Larry Heinemann's novel *Paco's Story*.

Richard Ford's novel *The Sportswriter*.

Ronald Sukenick's fiction *The Endless Short Story*.

Edwin Denby's *The Complete Poems*.

Donald Hall's poetry *The Happy Man*.

Charles Simic's poetry *Unending Blues*.

Jane Kenyon's poetry *The Boat of Quiet Hours*.

Karl Shapiro's *New and Selected Poems 1940–86*.

Lao She's *Crescent Moon and Other Stories*.

O-Zone, Paul Theroux's novel.

d. Jorge Luis Borges, Argentinian writer (b. 1899), a key figure in 20th-century Latin American literature.

d. Simone de Beauvoir, French writer, philosopher, and leading feminist; longtime companion of Jean-Paul Sartre (b. 1908).

d. Bernard Malamud, American writer (b. 1914).

d. Christopher Isherwood, British writer (b. 1904).

d. Frank Herbert, American science fiction writer, creator of *Dune* (1965), and its sequels.

d. John Gerard Braine, British writer (b. 1922).

FILM & BROADCASTING

Children of a Lesser God, Marlee Matlin and William Hurt starred in the Randa Haines film, based on the 1980 Mark Medoff play, about a deaf student and a teacher.

The Name of the Rose, Sean Connery starred in the Jean-Jacques Annaud film, based on Umberto Eco's medieval mystery novel.

Manon of the Spring and *Jean de Florette*, Yves Montand and Gérard Depardieu starred in Claude Berri's screen version of Marcel Pagnol's plays.

Crimes of the Heart, Diane Keaton, Jessica Lange, and Sissy Spacek starred in Bruce Beresford's screen version of the 1981 Beth Henley play.

Platoon, Charlie Sheen, Tom Berenger, and Willem Dafoe starred in Oliver Stone's angry anti–Vietnam War film.

Blue Velvet, a film written and directed by David Lynch; set in the underside of American small-town life; Kyle MacLachlan, Dennis Hopper, Isabella Rossellini, and Laura Dern starred.

Kathleen Turner and Nicolas Cage starred in *Peggy Sue Got Married*, directed by Francis Ford Coppola.

Woody Allen wrote, directed, and starred in *Hannah and Her Sisters*, with Michael Caine, Mia Farrow, Dianne Wiest, Barbara Hershey, and Carrie Fisher.

Sigourney Weaver starred in the science fiction monster film *Aliens*, directed by James Cameron.

Paul Newman and Tom Cruise starred in *The Color of Money*, set in the seedy world of the pool hall; Martin Scorsese directed.

Nick Nolte and Bette Midler starred in *Down and Out in Beverly Hills*, directed by Paul Mazursky.

Paul Hogan starred as the Australian bush ranger in the title role of *Crocodile Dundee*, directed by Peter Faiman.

Round Midnight, Dexter Gordon starred in Bernard Tavernier's story of a jazz great winding up his life and career in 1950s Paris.

The Story of English, Robert MacNeil's television series.

L.A. Law, Harry Hamlin and Jill Eikenberry led a large cast in the television drama series, set in a Los Angeles law firm (1986–).

Academy Awards for 1986 (awarded the following year): Best Picture: *Platoon*; Best Director: Oliver Stone, *Platoon*; Best Actor: Paul Newman, *The Color of Money*; Best Actress: Marlee Matlin, *Children of a Lesser God*.

d. Cary Grant (Archibald Alexander Leach), British actor (b. 1904).

d. Otto Preminger, Austrian-American director, producer, and actor (b. 1899).

d. James Cagney, American actor (b. 1896).

d. Robert Preston (Robert Preston Meservey), American actor (b. 1918).

d. Ray Milland (Reginald Truscott-Jones), British actor (b. 1905).

d. Dalton Trumbo (James Dalton Trumbo), American writer (b. 1905), blacklisted in 1947, who continued working under pseudonyms until openly resuming his career in the 1960s.

d. Vincente Minnelli, American director, father of Liza Minelli (b. 1910).

d. Elisabeth Bergner, Austrian actress (b. 1900), who had been a star in Weimar Germany before fleeing the Nazis in 1933.

d. Broderick Crawford (William Broderick Crawford), American actor (b. 1908), son of actress Helen Broderick.

d. Lee Marvin, American actor (b. 1924).

d. Sterling Hayden (John Hamilton), American actor (b. 1916).

d. Mervyn LeRoy, American director (b. 1900).

d. Andrei Tarkovsky, Soviet director (b. 1932).

d. Blanche Sweet, silent film star (b. 1895).

d. Brian Aherne, British actor (b 1902).

VISUAL ARTS

Andrew Wyeth unveiled the "Helga" pictures, 240 hitherto-unknown paintings and drawings of his neighbor Helga Testof, many of them major works.

Equitable Life opened its New York City building, designed by Edward Larrabee Barnes; it included Roy Lichtenstein's *Mural with Blue Brushstroke*.

Andy Warhol's paintings included *Mercedes Benz S125 (1937)* and his *Last Self-Portrait*.

Isamu Noguchi's sculptures included *Ojizousama* and *Slide Mantra*.

Arata Isozaki designed the Los Angeles Museum of Contemporary Art.

Jasper Johns's painting *The Seasons*.

Robert Motherwell's painting *Work in Progress (The Golden Bough)*.

Cesar Pelli designed the Cleveland Clinic Foundation Building and Herring Hall at Rice University, Houston.

Gregory Gillespie's painting *Studio Corner*.

Herbert S. Newman designed the Battell Chapel at Yale University, New Haven.

Judy Pfaff's sculpture *Supermercado*.

Richard Artschwager's sculpture *Organ of Cause and Effect III*.

I. M. Pei designed the IBM Building at Purchase, New York.

d. Georgia O'Keeffe, American artist (b. 1887).

d. Henry Moore, British sculptor (b. 1898).

d. André Masson, French painter, a leading surrealist (b. 1896).

THEATER & VARIETY

John Guare's *The House of Blue Leaves* starred Swoosie Kurtz, Stockard Channing, and John Mahoney; Jerry Zaks directed.

Neil Simon's autobiographical *Broadway Bound* starred Jason Alexander, Linda Lavin, and Phyllis Newman; Gene Saks directed.

Jack Lemmon, Kevin Spacey, Bethel Leslie, and Peter Gallagher starred in Eugene O'Neill's *Long Day's Journey into Night*.

Jessica Tandy and Hume Cronyn starred in *The Petition*, directed by Peter Hall.

Amanda Plummer and Uta Hagen starred in George Bernard Shaw's *You Never Can Tell*.

Debbie Allen starred in the title role of the Cy Coleman, Dorothy Fields, and Neil Simon musical *Sweet Charity*, choreographed and directed by Bob Fosse.

Michael Frayn's *Wild Honey*, adapted from Anton Chekhov, starred Ian McKellen, Kate Burton, and Kathryn Walker.

Jean Stapleton and Polly Holliday as the homicidal sisters and Abe Vigoda starred in Joseph Kesselring's *Arsenic and Old Lace*.

George C. Scott and John Cullum starred in Bernard Sabath's *The Boys in Autumn*; Theodore Mann directed.

Richard Thomas and John Lithgow starred in Ben Hecht and Charles MacArthur's *The Front Page*; Jerry Zaks directed.

Zoë Caldwell starred in her solo *Lillian*, based on the Lillian Hellman autobiographies; Robert Whitehead directed.

Alec Baldwin, Zoe Wanamaker, and Charles Keating starred in Joe Orton's *Loot*.

d. Siobhan McKenna, Irish actress (b. 1923), a leading figure on the Irish stage known best abroad for her leads in Shaw's *St. Joan* and Synge's *The Playboy of the Western World*.

d. Cheryl Crawford, American director, producer, and actress (b. 1902), a founder of the Group Theater, the American Repertory Theater, and the Actors Studio.

d. Alan Jay Lerner, American writer and lyricist (b. 1918), half of the Lerner and Loewe musical theater team.

d. Jean Genet, French writer (b. 1910).

d. John William Sublett, Bubbles of the vaudeville team "Buck and Bubbles" (b. 1902).

MUSIC & DANCE

Whitney Houston debuted with a Grammy-winning album, *Whitney Houston*, including the hit singles *Didn't We Almost Have It All*, *The Greatest Love of All*, *Saving All My Love for You*, *How Will I Know*, and *You Give Good Love*.

Carole Bayer Sager and Burt Bacharach had two major hit songs: *On My Own*, sung by Patti LaBelle and Michael McDonald, and *That's What Friends Are For*, a major hit for the ad-hoc group Dionne Warwick, Elton John, Gladys Knight, and Stevie Wonder, with funds going to AIDS research.

Vladimir Horowitz returned to play in the Soviet Union, after decades of exile and then self-imposed exile.

Gian Carlo Menotti's opera *Goya*, premiered in Washington, D.C., with Plácido Domingo.

The Mask of Orpheus, Harrison Birtwistle's opera, libretto by Peter Zinovieff, opened at the English National Opera May 21.

Harrison Birtwistle's opera *Yan Tan Tethera* and orchestral work *Earth Dances*.

Graceland, Paul Simon's acclaimed album fusing American and African musical styles.

Elliott Carter's fourth string quartet and *A Celebration of Some 100 × 500 Notes*.

Back in the High Life, Steve Winwood's album, with *Higher Love*.

The Black Mask (*Die schwarze Maske*), Krzysztof Penderecki's opera.

Michael Jackson began his solo career.

Cinderella, Rudolf Nureyev's ballet.

Hugh Masakela's album *Waiting for the Rain*.

Barbra Streisand's *The Broadway Album*.

Quiet City, Jerome Robbins's ballet.

Madonna's album *True Blue*.

James Taylor's album *That's Why I'm Here*.

William Bolcom's *Symphony No. 4*.

Diana Ross's album *Chain Reaction*.

John Harbison's *The Flight into Egypt*.

Joni Mitchell's album *Dog Eat Dog*.

Angel with a Lariat, k. d. lang's album.

Mr. Mister's album *Welcome to the Real World*.

Patti LaBelle's album *Winner in You*.

Van Halen's album *5150*.

Prince and the Revolution's single record *Kiss*.

Ralph Shapey's composition *Symphonie Concertante*.

Steeleye Span's album *Back in Line*.

Charles Wuorinen's composition *The W. of Babylon*.

d. Peter Pears, British tenor, longtime musical colleague and companion of composer Benjamin Britten.

d. Robert Murray Helpmann, Australian-born dancer, actor, choreographer, and director (b. 1909).

d. Antony Tudor, British dancer and choreographer (b. 1909).

d. Benny Goodman (Benjamin David Goodman), American clarinetist and bandleader (b. 1909).

d. Erik Bruhn (Belton Evers), Danish dancer (b. 1928).

d. Harold Arlen (Hyman Arluck), American songwriter and composer, whose popular songs included *Over the Rainbow*, *Stormy Weather*, and *Blues in the Night* (b. 1905).

d. Kate Smith, American singer (b. 1907); her signature song was *God Bless America*.

d. Rudy (Hubert Prior) Vallee, American singer and actor (b. 1901).

d. Sonny Terry (Saunders Terrell), American harmonica player and singer (b. 1911); partner of Brownie McGhee.

d. Serge Lifar, Russian-French dancer, choreographer, ballet director, and writer (b. 1905).

WORLD EVENTS

Core meltdown, with explosion and fire, caused a massive nuclear disaster at the Chernobyl nuclear plant, near Kiev, in the Ukraine (April 26–May 1). Huge nuclear cloud spread throughout Europe and the Northern Hemisphere. Hundreds died within a few days of the blast, thousands more were seriously damaged by radiation, and more than 300,000 were evacuated for long terms; hundreds of square miles were contaminated.

At the Reykjavik summit (October), American President Ronald Reagan and Soviet Premier Mikhail Gorbachev seemed to make no progress; but it ultimately proved only a prelude to massive agreements just ahead.

Iran–Contra scandal broke in October and November, as arms-for-hostages sales to Iran and the illegal arming of Nicaraguan contras were exposed. On November 25, Oliver North was fired from his White House national security post and John Poindexter resigned as national security advisor, as multiple investigations began.

Corazon Aquino won the February 7 Philippine presidential election, defeating incumbent Ferdinand Marcos; but Marcos made a false count and claimed victory. Massive demonstrations followed, and then defections by key figures and major portions of the armed forces. Marcos fled into exile on February 25.

All seven astronauts aboard the American space shuttle *Challenger* died when the craft exploded just after takeoff (January 28).

Gramm–Rudman Act unsuccessfully attempted to reduce America's soaring national deficit and develop a balanced budget.

American warplanes and ships carried out air and sea attacks on Libyan targets.

Former United Nations secretary-general Kurt Waldheim became president of Austria, amid controversy about his World War II activities.

Mohammad Najibullah took full power in Afghanistan.

Mozambiquan guerrilla General Joaquim Alberto Chissanó became president of Mozambique.

Peter Kilburn, Beirut American University librarian, a hostage in Lebanon since 1984, was murdered.

Lake Nios, Cameroon, toxic cloud killed 1,700 people.

Soviet *Mir* (Peace) space station became the first permanent space station.

American space probe *Voyager 2* passed Uranus.

d. Olaf Palme, Swedish Social Democratic party leader (b. 1927), premier (1969–1976); assassinated in Stockholm on February 28, by unknown assailants.

1987

LITERATURE

Tom Wolfe's novel *The Bonfire of the Vanities*.

The Nobel Prize for Literature was awarded to Joseph Brodsky.

The Rat, Günter Grass's novel.

The Book and the Brotherhood, Iris Murdoch's Booker Prize–winning novel.

Anne Tyler's Pulitzer Prize–winning novel *Breathing Lessons*.

Richard Wilbur's Pulitzer Prize–winning *New and Collected Poems*.

A Sport of Nature, Nadine Gordimer's novel.

All God's Children Need Traveling Shoes, Maya Angelou's novel.

Cristobal Nonato, Carlos Fuentes's novel.

Philip Roth's novel *The Counterlife*.

Empire, Gore Vidal's novel.

Saul Bellow's novel *More Die of Heartbreak*.

A Black Box, Amos Oz's novel.

Derek Walcott's *The Arkansas Treatment*.

Walker Percy's novel *The Thanatos Syndrome*.

Cynthia Ozick's novel *The Messiah of Stockholm*.

Stephen King's novels *The Tommyknockers* and *Misery*.

Chinua Achebe's novel *Anthills of the Savannah*.

A Friend from England, Anita Brookner's novel.

Garrison Keillor's *Leaving Home*.

The Songlines, Bruce Chatwin's novel.

Denise Levertov's poetry *Breathing the Water*.

James McElroy's novel *Women and Men*.

Scott Turow's novel *Presumed Innocent*.

T. Coraghessan Boyle's novel *World's End*.

Marge Piercy's novel *Gone to Soldiers*.

Serenissima, Erica Jong's novel.

Christopher Logue's poetry *War Music*.

William Snodgrass's *Selected Poems 1957–1987*.

Amy Clampitt's poetry *Archaic Figure*.

The White Man's Burden, Paul Theroux's novel.

d. James Baldwin, a leading African-American novelist and essayist of the 1950s and 1960s (b. 1924).

d. Erskine Caldwell, American writer (b. 1903).

FILM & BROADCASTING

Empire of the Sun, Steven Spielberg's film set in Shanghai early in World War II; Christian Bale, John Malkovich, Nigel Havers, and Miranda Richardson starred.

Martin Scorsese directed the controversial film *The Last Temptation of Christ*, starring Willem Dafoe and Harvey Keitel, based on Nikos Kazantzakis's 1955 novel.

The Dead, John Huston's last film, based on a James Joyce story set in Dublin; Anjelica Huston and Donal McCann starred.

The Last Emperor, Jon Lone as Pu Yi, last of the Manchu Chinese emperors, Joan Chen, and Peter O'Toole starred in Bernardo Bertolucci's epic film.

Babette's Feast, Stephane Audran, Gudmar Wivesson, Bibi Andersson, and Jarl Kulle starred in the Gabriel Axel film, based on the Isak Dinesen short story.

Hope and Glory, John Boorman's autobiographical film, set in World War II London; David Hayman, Sarah Miles, Sammi Davis, and Ian Bannen starred.

Gardens of Stone, Francis Ford Coppola's film, set in army life at home during the Vietnam War; James Caan, James Earl Jones, and Anjelica Huston starred.

Cry Freedom, Richard Attenborough's film, set in South Africa; Denzel Washington starred as murdered black leader Steven Biko, opposite Kevin Kline.

William Hurt and Holly Hunter starred in *Broadcast News*, directed by James Brooks.

Sigourney Weaver starred in *Gorillas in the Mist*, directed by Michael Apted.

Melanie Griffith, Harrison Ford, and Sigourney Weaver starred in *Working Girl*, directed by Mike Nichols.

Wall Street, Michael Douglas and Charlie Sheen starred in Oliver Stone's fictional film exposé of 1980s financial market corruption.

Cher and Nicolas Cage starred in *Moonstruck*, directed by Norman Jewison.

The Witches of Eastwick, Jack Nicholson, Cher, Susan Sarandon, and Michelle Pfeiffer starred in George Miller's screen version of the 1984 John Updike novel.

Susan Sarandon, Kevin Costner, and Tim Robbins starred in *Bull Durham*, directed by Ron Shelton.

The Glass Menagerie, Paul Newman, Joanne Woodward, and John Malkovich starred in Newman's film version of the 1945 Tennessee Williams play.

Woody Allen wrote, directed, and starred opposite Mia Farrow in *Radio Days*.

Academy Awards for 1987 (awarded the following year): Best Picture: *The Last Emperor*; Best Director: Bernardo Bertolucci, *The Last Emperor*; Best Actor: Michael Douglas, *Wall Street*; Best Actress: Cher, *Moonstruck*.

d. Fred Astaire (Frederick Austerlitz) American dancer and actor, who became the world's leading dancer in film (b. 1899).

d. John Huston, American director, actor, and writer, the son of actor Walter Huston and the father of actress Anjelica Huston (b. 1906).

d. Fritz Lang, Austrian director, a leading film figure in Weimar Germany (b. 1890).

d. Jackie Gleason (Herbert John Gleason), American actor and comedian (b. 1916).

d. Randolph Scott (Randolph Crane), American Western star (b. 1903).

d. Rita Hayworth (Margarita Carmen Cansino), American actress (b. 1918).

d. Lorne Greene, Canadian actor (b. 1915); he was Ben Cartwright in *Bonanza*.

d. Madeleine Carroll (Marie-Madeleine Bernadette O'Carroll), British actress (b. 1906).

d. Danny Kaye, American actor and comedian (b. 1913).

d. Joan Greenwood, British actress (b. 1921).

d. Pola Negri (Apollonia Chalupiec), Polish actress, a star in silent films (b. 1894).

d. Rouben Mamoulian, Armenian-American director (b. 1898).

VISUAL ARTS

Harlem Renaissance: Art of Black America, exhibit at New York's Metropolitan Museum of Art.

Lila Acheson Wallace Wing opened at New York's Metropolitan Museum of Art, designed by Kevin Roche and John Dinkeloo.

Jim Dine's painting *For Margit van Leight-Frank*.

Richard Serra's sculpture *My Curves Are Not Mad*.

Charles W. Moore and Chad Floyd designed the Hood Museum of Art, Dartmouth College.

Robert Mangold's painting *Brown Frame/Gold Ellipse*.

Cesar Pelli designed Battery Park City, New York.

Gwathmey Siegel designed the Dartmouth College Gymnasium.

Melissa Meyer's painting *My Father's Sketch Pad*.

Hardy Holzman Pfeiffer designed the Robert O. Anderson Building, Los Angeles County Museum of Art.

Peter Haley's painting *Cell with Smokestack*.

Philip Johnson and John Burgee designed 190 South La Salle Street, Chicago.

Renzo Piano designed the Menil Collection, Houston.

Richard Long's sculpture *Vermont Georgia South Carolina Wyoming Circle*.

Venturi, Rauch, and Scott designed the Lewis Thomas Laboratory, Princeton University.

d. Andy Warhol (Andrew Warhola), American pop artist and filmmaker (b. 1928?).

d. Raphael Soyer, Russian-born American painter (b. 1898); twin brother of painter Moses Soyer.

THEATER & VARIETY

Sole Woyinka wrote and directed *Death and the King's Horseman*, starring Earle Hyman and Eric LaSalle.

John Malkovich and Joan Allen starred in Lanford Wilson's *Burn This*, directed by Marshall Mason.

Harvey Fierstein starred in his own trailblazing *Safe Sex*.

Bernadette Peters and Tom Aldredge starred in the musical *Into the Woods*, music and lyrics by Stephen Sondheim, written and directed by James Lapine.

Les Misérables, the Claude-Michel Schönberg and Herbert Kretzmer musical, adapted and directed by Trevor Nunn and John Caird from the Victor Hugo novel.

Allan Rickman and Lindsay Duncan starred in Christopher Hampton's *Les Liaisons Dangereuses*, based on the Choderlos de Laclos play; Howard Davies directed.

Dreamgirls, the Henry Krieger and Tom Eyen musical, starred Alisa Gyse, Susan Beaubian, and Arnetia Walker; Michael Bennett directed.

Starlight Express, the Andrew Lloyd Webber and Richard Stilgoe musical, starred Greg Mowry and Robert Torti; Trevor Nunn directed.

Jason Robards, Jr., starred in Bob Larbey's *A Month of Sundays*, directed by Gene Saks.

Mary Tyler Moore and Lynn Redgrave starred in A. R. Gurney's *Sweet Sue*.

Peter O'Toole as Henry Higgins, Amanda Plummer as Eliza Doolittle, and John Mills starred in George Bernard Shaw's *Pygmalion*.

Blythe Danner, Richard Chamberlain, Judith Ivey, and Geraldine Page starred in Noël Coward's *Blithe Spirit*.

Derek Jacobi starred in Hugh Whitemore's *Breaking the Code*.

Harry Groener and Jeff DeMunn starred in John Harris's *Stepping Out*.

Mahabharata, Peter Brooks marathon nine-hour version of the Indian epic.

Kenneth Branagh founded Britain's Renaissance Theatre Company.

d. Geraldine Page, American actress (b. 1924).

d. Bob Fosse, American dancer, choreographer, and director (b. 1927).

d. Ray Bolger, American dancer and actor, a theater performer best known as the Scarecrow in the 1939 film *The Wizard of Oz*.

d. Clare Boothe Luce, American playwright and actress (b. 1903).

d. Anna Neagle (Marjory Robertson), British actress (b. 1904).

d. Clarence Brown, American director (b. 1890).

d. Colin Blakely, Irish-born actor (b. 1930).

MUSIC & DANCE

Cloud Nine, George Harrison's album, including the hit song *Got My Mind Set on You*.

Standard Time, the first of three collections of jazz standards, by Wynton Marsalis on trumpet and his father, Ellis, on piano (1987, 1990, 1991).

Whitney Houston's second album, *Whitney*, with the hit single *I Wanna Dance with Somebody (Who Loves Me)*.

Franco Zeffirelli's production of *Turandot* at the Metropolitan Opera, New York, with Eva Marton and Plácido Domingo.

John Harbison's *Symphony No. 2* first performed in San Francisco.

Bruce Springsteen's album *Tunnel of Love*, with *Brilliant Disguise*.

Endless Parade, Harrison Birtwistle's work for trumpet and orchestra.

Trio, Linda Ronstadt, Dolly Parton, and Emmylou Harris's album.

Donald Martino's *The White Island* first performed in Boston.

Bad, Michael Jackson's album.

Milton Babbitt's *Transfigured Notes*.

Harry Connick, Jr., his debut album.

Nixon in China, John Adams's opera.

Bon Jovi's album *Slippery When Wet* and hit single *Livin' on a Prayer*.

Heartland, the Judds' album.

Nicholas Thorne's composition *Revelations*.

Madonna's album *You Can Dance*.

Sting's album *Nothing Like the Sun*.

U2's album *The Joshua Tree*.

Beastie Boys' album *Licensed to Ill*.

Genesis's album *Invisible Touch*.

Huey Lewis and the News' album *Fore!*

Stevie Wonder's album *Characters*.

Nothing's Gonna Stop Us Now, Starship's hit single.

d. John Hammond, American record producer (b. 1910), who discovered and recorded Bessie Smith, Billie Holiday, Aretha Franklin, Bob Dylan, Bruce Springsteen, and others.

d. Jascha Heifetz, Russian-American violinist, a world figure for eight decades, from early days as a child prodigy.

d. Andrés Segovia, Spanish classical guitarist (b. 1893).

d. Woody (Woodrow Charles) Herman, American bandleader, clarinetist, and singer, a leading figure of the big-band era (b. 1913).

d. Jacqueline Du Pré, English cellist (b. 1945), forced by multiple sclerosis to retire in 1973.

d. Dmitry Kabalevsky, Russian composer (b. 1904).

d. Liberace (Wladziu Valentino Liberace), American pianist and variety entertainer (b. 1919).

d. Sammy Kaye, American bandleader and composer (b. 1910).

WORLD EVENTS

At the Washington Summit (December 8), President Ronald Reagan and Premier Mikhail Gorbachev signed the landmark Intermediate Nuclear Forces (INF) Treaty, for the first time agreeing to destroy a whole class of nuclear weapons.

Costa Rican President Oscar Arias Sánchez offered his Nicaraguan peace plan, the "Arias Plan," which provided much of the basis for the peace that followed; he was awarded the 1987 Nobel Peace Prize.

American stock market crashed on Black Monday (October 19), with Dow-Jones industrial average decline of 508.32, on 604.33 million shares traded.

Tower Commission report on the Iran–Contra affair was highly critical of the Reagan administration.

A surprise and apparently erroneous Iraqi missile attack in the Persian Gulf killed 37 sailors aboard the U.S.S. *Stark* (May 17).

British Anglican church hostage negotiator Terry Waite was himself kidnapped and became a Lebanon hostage on January 20.

Chadian forces defeated Libyan forces in Chad, invaded Southern Libya.

Collision of Philippines ferry *Dona Paz* and oil tanker *Victor* killed 2,000–3,000 people (December 20).

Liberal reformer Zhao Ziyang, a protégé of Deng Xiaop'ing, became general secretary of the Chinese Communist party (1987–1989). Chinese Communist leader Li Peng succeeded Zhao Ziyang as premier.

Nazi war criminal Klaus Barbie, the "Butcher of Lyon," was sentenced to life imprisonment in France; he had been captured in Bolivia in 1983.

New Zealand declared its territorial waters a nuclear-free zone, triggering a major dispute with the United States on the issue.

Pro-Khomeini Iranian pilgrims and Saudi Arabian police clashed at Mecca's Grand Mosque on July 1; hundreds died, including many bystanders.

Television evangelist Jim Bakker resigned, after accusations of a 1980 sexual relationship with Jessica Hahn; he was convicted and jailed on 24 fraud and conspiracy counts.

d. William Joseph Casey, director of the Central Intelligence Agency (CIA) (b. 1913). He had resigned on February 2 due to illness, while being investigated as to his role in the Iran–Contra affair.

1988

LITERATURE

The Satanic Verses, Salman Rushdie's novel, a worldwide best-seller after fundamentalist Muslims generated murders, riots, and book burnings, and Ayatollah Ruhollah Khomeini proclaimed a "death sentence" on Rushdie for alleged anti-Islamic slurs in the work. Rushdie was forced into hiding.

The Nobel Prize for Literature was awarded to Naguib Mahfouz.

Umberto Eco's novel *Foucault's Pendulum*.

Billy Bathgate, E. L. Doctorow's novel, basis of the 1991 film.

Oscar Hijuelos's Pulitzer Prize–winning novel *The Mambo Kings Play Songs of Love*.

Riding the Iron Rooster: By Train Through China, Paul Theroux's travel book.

The Lyre of Orpheus, Robertson Davies's novel.

Utz, Bruce Chatwin's novel.

Octavio Paz's *The Collected Poems*.

Thomas Flanagan's novel *The Tenants of Time*.

Picture This, Joseph Heller's novel.

A Far Cry from Kensington, Muriel Spark's novel.

J. F. Powers's novel *Wheat That Springeth Green*.

Raymond Carver's short-story collection *Where I'm Calling From*.

Don DeLillo's novel *Libra*.

Pete Dexter's novel *Paris Trout*.

Richard Powers's novel *Prisoner's Dilemma*.

Harold Brodkey's *Stories in an Almost Classical Mode*.

William Kennedy's novel *Quinn's Book*.

Jay Cantor's book *Krazy Kat*.

Michael Chabon's novel *The Mysteries of Pittsburgh*.

Donald Hall's poetry *The One Day*.

James Schuyler's *Selected Poems*.

Alaska, James Michener's novel.

Joseph Brodsky's poetry *To Urania*.

Czeslaw Milosz's *Collected Poems*.

Wayfarer, James Dickey's poetry collection.

Richard Wilbur's *New and Collected Poems*.

The Western Lands, William Burroughs's novel.

Oxford English Dictionary first became available on a computer disk (CD-ROM).

d. Malcolm Cowley, American editor and writer (b. 1898), much of whose work memorialized the "lost generation."

d. Robert Anson Heinlein, American science fiction writer (b. 1907).

d. Sacheverell Sitwell, British writer, the brother of Edith and Osbert Sitwell (b. 1897).

d. Alan Paton, South African writer (b. 1903).

d. Bhabani Bhattacharya, Indian novelist writing in English (b. 1906).

d. Yuli Daniel, Soviet writer (b. 1925), a leading dissident of the late Soviet period.

FILM & BROADCASTING

Pelle the Conqueror, Max von Sydow and Pelle Hvenegaard starred in the Bille August film about poor workers in early 20th-century Denmark; based on the Martin Anderson Nexo novel.

Rain Man, Dustin Hoffman as an autistic man and Tom Cruise as his brother starred in Barry Levinson's film.

Jodie Foster and Kelly McGillis starred in *The Accused*, directed by Jonathan Kaplan; based on an actual rape case.

Louis Malle wrote and directed the autobiographical film *Au Revoir Les Enfants*, starring Gaspard Manesse, set in World War II France.

The Unbearable Lightness of Being, Daniel Day-Lewis, Juliette Binoche, Lena Olin, Derek de Lint, and Erland Josephson starred in Philip Kaufman's screen version of the 1984 Milan Kundera novel, set in post–Soviet invasion Czechoslavakia.

Hotel Terminus, The Life and Time of Klaus Barbie, the Marcel Ophüls documentary on Barbie, the Holocaust, the complicity of many, and collective guilt.

Mississippi Burning, Gene Hackman and Willem Dafoe starred in Alan Parker's fact-based story of the 1964 Neshoba County, Mississippi, murders of civil-rights activists James Chaney, Andrew Goodman, and Michael Schwerner.

Shirley MacLaine starred in *Madame Sousatzka*, directed by John Schlesinger; screenplay by Ruth Prawer Jhabvala and Schlesinger.

Da, Barnard Hughes, once again as Da, and Martin Sheen as his son starred in Matt Clark's screen version of the 1973 Hugh Leonard play.

Robert Redford directed and produced *The Milagro Beanfield War*.

Glenn Close and John Malkovich starred in *Dangerous Liaisons*, directed by Stephen Frears.

Torch Song Trilogy, Harvey Fierstein starred in Paul Bogart's screen version of Fierstein's three 1982 one-act plays.

Jeff Bridges as automobile designer Preston Tucker starred in *Tucker, The Man and His Dream*, directed by Francis Ford Coppola.

A Very British Coup, Ray McAnally as Labour prime minister and Alan MacNaughtan starred in the British television miniseries, directed by Mick Jackson.

After the War, the television miniseries, based on the Frederic Raphael novel.

Roseanne, the American television series, starring Roseanne Arnold and John Goodman (1988–).

War and Remembrance, the television miniseries, sequel to *The Winds of War* (1983); Robert Mitchum, Victoria Tennant, and John Gielgud starred.

Academy Awards for 1988 (awarded the following year): Best Picture: *Rain Man*; Best Director: Barry Levinson, *Rain Man*; Best Actor: Dustin Hoffman, *Rain Man*; Best Actress: Jodie Foster, *The Accused*.

d. John Carradine (Richmond Reed Carradine), American classical actor (1906), best known for his role in the film *The Grapes of Wrath*; father of actors David, Keith, and Robert Carradine.

d. Emeric Pressburger, British director, producer, and writer (b. 1902), long partnered with Michael Powell.

d. Trevor Howard, British actor (b. 1916).

d. Edward Chodorov, American writer, director, and producer (b. 1904); his career was cut short by political blacklisting in 1953.

d. Hal Ashby, American director and film editor (b. 1936).

VISUAL ARTS

American Museum of the Moving Image opened at Astoria, New York; and the British Film Institute's Museum of the Moving Image opened in London.

Ellsworth Kelly's painting *Red Black*.

Larry Rivers's painting *Seventy-Five Years Later: Sienna*.

Rebecca Horn's sculpture *The Hot Circus*.

Ted Wesselmann's sculpture *Blonde Vivienne*.

Benjamin Thompson designed the remodeled Union Station, Washington, D.C.

Julian Schnabel's painting *Flaubert's Letter to His Mother*.

Chuck Close's painting *Susan*.

Figg and Muller designed the Sunshine Skyway Bridge, St. Petersburg–Bradenton, Florida.

Jeff Koons's paintings included *Popples* and *Serpents*.

Thomas Beeby designed the Chicago Art Institute Wing.

d. Isamu Noguchi, American sculptor and designer (b. 1904).

d. Louise Nevelson (Louise Berliawsky), American sculptor (b. 1899).

d. Charles Addams, American cartoonist (b. 1912), creator of *The Addams Family*.

THEATER & VARIETY

M. Butterfly, John Lithgow and B. D. Wong starred in David Henry Hwang's play, a new twist on themes from *Madame Butterfly*; John Dexter directed.

The Heidi Chronicles, Joan Allen as Heidi starred in Wendy Wasserstein's Pulitzer Prize–winning play.

The Piano Lesson, Charles S. Dutton and S. Epatha Merkerson starred in August Wilson's Pulitzer Prize–winning play, about a 1930s Pittsburgh African-American family; Lloyd Richards directed.

Athol Fugard's *The Road to Mecca* starred Yvonne Bryceland and Amy Irving.

August Wilson's *Joe Turner's Come and Gone* starred Ed Hall, Delroy Lindo, and Mel Winkler; Lloyd Richards directed.

Phantom of the Opera, the Andrew Lloyd Webber and Charles Hart musical based on the Gaston Leroux horror novel, starred Michael Crawford and Sarah Brightman; Harold Prince directed.

The Gospel at Colonnus, the Bob Telson and Lee Breuer musical, based on the Sophocles play, starred Isabell Monk and Morgan Freeman; Breuer directed.

Ain't Misbehavin', the Fats Waller musical, starred Nell Carter, Armelia McQueen, Charlaine Woodard, and Ken Page; Richard Maltby, Jr., directed.

Lee Blessing's *A Walk in the Woods* starred Robert Prosky and Sam Waterston.

Vanessa Redgrave starred in Peter Hall's production of Tennessee Williams's *Orpheus Descending*.

Sarafina!, the Mbongeni Ngema and Hugh Masakela South African musical; Ngema directed.

Joe Mantegna, Ron Silver, and Madonna starred in David Mamet's *Speed-the-Plow*.

A. R. Gurney's *The Cocktail Hour* starred Nancy Marchand.

Avery Dean starred in Philip Hayes Dean's *Paul Robeson*.

Neil Simon's *Rumors* starred Christine Baranski, Ron Liebman, and André Gregory.

Michael Weller's *Spoils of War* starred Kate Nelligan and Jeffrey de Munn.

Christopher Walken and Irene Worth starred in *Coriolanus*.

Juno and the Paycock starred Donald McCann and John Kavanagh; Joe Dowling directed.

Jason Robards and Colleen Dewhurst starred in Eugene O'Neill's *Long Day's Journey into Night*.

Christopher Plummer and Glenda Jackson starred in *Macbeth*.

Erland Josephson and Brian Dennehy starred in Anton Chekhov's *The Cherry Orchard*.

d. John Houseman (Jacques Haussman), British-American producer, actor, writer, and director (b. 1902); he and Orson Welles cofounded the Mercury Theater in 1937.

d. Frederick Loewe, Austrian-American composer (b. 1904), long partnered with Alan Jay Lerner.

d. Joshua Logan, American director (b. 1908).

d. Beatrice Lillie, Canadian-British actress and singer (b. 1894).

d. John Clements, British actor–manager (b. 1910); from 1943, he often costarred on stage with his wife, Kay Hammond.

MUSIC & DANCE

Folk-rock legends Bob Dylan, George Harrison, Tom Petty, Jeff Lynne, and Roy Orbison formed the Traveling Wilburys, their first eponymous album winning a Grammy for "best new group."

Forever Your Girl, Paula Abdul's highly popular debut

album, with the title single, *Straight Up*, and *(It's Just) The Way That You Love Me.*

Philip Glass completed two new operas, *The Making of the Representative for Planet 8* and *One Thousand Airplanes on the Roof.*

The Comfort Zone, Vanessa Williams's album, with *Save Your Best for Last* and *Work to Do.*

Tracy Chapman, her acclaimed debut album, including *Freedom Now*, about then-jailed Nelson Mandela.

Bobby McFerrin's Grammy-winning album and title song *Don't Worry, Be Happy.*

Elliott Carter's *Remembrance*; also his *Oboe Concerto* was first performed, in New York.

Linda Ronstadt's album *Canciones de Mi Padre* (*Songs of My Father*).

Wendy Chambers's *Symphony of the Universe.*

K. T. Oslin's country album *Hold Me.*

Guns N' Roses album *Appetite for Destruction.*

Stephen Paulus's *Violin Concerto.*

Shadowland, k. d. lang's album.

Vanessa Williams's album *The Right Stuff.*

Def Leppard's album *Hysteria.*

Karlheinz Stockhausen's opera *Montag.*

George Michael's album *Faith.*

INXS's album *Kick.*

Joni Mitchell's album *Chalk Mark in a Rain Storm.*

Keith Whitley's country album *When You Say Nothing at All.*

Harry Connick's album *20*, for his 20th birthday.

Roger Reynolds's composition *Whispers Out of Time.*

Dirty Dancing film sound track album.

d. Frederick William Ashton, British dancer, choreographer, and ballet director, a central figure in the development of British ballet (b. 1904).

d. Robert Joffrey (Abdullah Jaffa Anver Khan), American dancer, choreographer, and founder of the Joffrey Ballet (b. 1930).

d. Roy Orbison, American rock singer and composer (b. 1936).

WORLD EVENTS

At the May Moscow summit, Soviet Premier Mikhail Gorbachev and American President Ronald Reagan continued the process of settling remaining cold-war matters.

United Nation Secretary-General Javier Pérez de Cuéllar mediated an August ceasefire in Iran–Iraq War, essentially ending the war. Iraq then moved against rebelling Kurds, using poison gas to kill thousands of civilians.

Republican George Herbert Walker Bush defeated Democrat Michael Stanley Dukakis, becoming the 41st president of the United States.

Oliver North, John Poindexter, Albert Hakim, and Richard V. Secord were indicted in connection with the Iran–Contra scandal. North and Poindexter were later convicted, their convictions then being reversed on appeal.

Palestinian Intifada (Uprising) began on the West Bank of the Jordan River and the Gaza Strip.

Pakistani dictator Mohammad Zia Ul-Haq was killed in an August 17 airplane crash; he was succeeded by Benazir Bhutto, daughter of murdered Prime Minister Zulfikar Ali Bhutto.

Angola, Cuba, and South Africa peace agreement provided for Namibian and Angolan ceasefire, withdrawal of Cuban and South African forces, and Namibian independence.

American Lieutenant Colonel William Higgins, head of the United Nations Lebanon truce team, was kidnapped and murdered by Muslim terrorists.

Massive student demonstrations in Burma forced general Ne Win to resign, bringing a "Burmese Spring," and a democratic govenment led by U Nu. But the army took power again, killing hundreds of people and reinstating the military dictatorship.

Nicaraguan Civil War was effectively ended by a March ceasefire.

Panamanian dictator Manual Noriega was indicted in Florida on drug-trade-related charges, on which he was tried when later captured.

U.S.S. *Vincennes* mistakenly attacked an Iranian passenger plane over the Persian Gulf, killing 290 people; reparations were later paid.

Bomb planted by Islamic terrorists on America-bound Pan Am 747 exploded over Lockerbie, Scotland, killing 259 people on board, 11 on the ground; responsibility was later placed on Libya.

After a two-year investigation, Drexel Burnham Lambert was charged by the federal government with huge, multiple securities law violations, most generated by its "junk bond" dealings, run by Michael Milken; years of litigation followed.

In Burundi, a failed Hutu rebellion was followed by massacres of Hutus by the military, controlled by Tutsis; more than 5,000 people died.

Japanese Recruit stock scandal involved many in Japanese government and financial elites, and forced resignation of Prime Minister Noboru Takeshita.

Soviet Armenia earthquakes killed 55,000 people, left 500,000 homeless (December 7).

Explosions and fire destroyed *Piper Alpha* oil rig in North Sea, killing 167 (July 6).

Stephen William Hawking's *A Brief History of Time*.

1989

LITERATURE

The General in His Labyrinth, Gabriel García Márquez's novel.

The Nobel Prize for Literature was awarded to Camilo José Cela.

The Message to the Planet, Iris Murdoch's novel.

The Storyteller, Mario Vargas Llosa's novel.

John le Carré's novel *The Russia House*.

Stephen Hawking's *A Brief History of Time*.

Vineland, Thomas Pynchon's novel.

Amy Tan's novel *The Joy Luck Club*.

John Casey's novel *Spartina*.

T. Coraghessan Boyle's novel *If the River Was Whiskey*.

Russell Banks's novel *Affliction*.

Cynthia Ozick's novel *The Shawl*.

Allan Gurganus's novel *The Oldest Living Confederate Widow Tells All*.

Mary Gordon's novel *The Other Side*.

Brad Leithauser's novel *Hence*.

Alice Walker's *The Temple of My Familiar*.

Robert Haas's poetry *Human Wishes*.

Adrienne Rich's poetry *Time's Power*.

Philip Larkin's poetry *Collected Poems*.

Fire Down Below, William Golding's novel.

Hollywood, Gore Vidal's novel.

Susan Sontag's essays *AIDS and Its Metaphors*.

d. Samuel Beckett, Irish writer (b. 1906).

d. Robert Penn Warren, American writer and critic (b. 1905).

d. Bruce Chatwin, British writer (b. 1940).

d. Daphne Du Maurier, British writer (b. 1907), author of *Rebecca*; daughter of actor–producer– writer George Du Maurier.

d. Donald Barthelme, American writer (b. 1931).

d. Georges Simenon, Belgian-French writer, the creator of Inspector Maigret (b. 1903).

d. Mary McCarthy, American writer and critic (b. 1912).

d. Nicolás Guillén, Cuban poet (b. 1902).

d. Owen Lattimore, American writer (b. 1900).

d. Irving Stone, American writer (b. 1903).

FILM & BROADCASTING

My Left Foot, Daniel Day-Lewis starred as writer and artist Christy Brown, afflicted with cerebral palsy, in Jim Sheridan's biofilm.

Driving Miss Daisy, Jessica Tandy, Morgan Freeman, and Dan Aykroyd starred in the Bruce Beresford film, based on the Robert Uhry play.

Born on the Fourth of July, Tom Cruise starred as Ron Kovic in Oliver Stone's anti–Vietnam War film; screenplay by Stone and Kovic, based on Kovic's autobiographial book.

Field of Dreams, the Phil Alden Robinson baseball fantasy film; Kevin Costner, Ray Liotta, James Earl Jones, Amy Madigan, and Burt Lancaster starred.

Glory, Matthew Broderick, Denzel Washington, and Morgan Freeman starred in the Edward Zwick film, set in the Civil War, about the African-American Massachusetts 54th Regiment.

Henry V, Kenneth Branagh directed and starred in his film version of Shakespeare's play, with Derek Jacobi, Ian Holm, Judi Dench, Paul Scofield, Emma Thompson, Robbie Coltrane, and Alec McCowen.

Spike Lee wrote and directed *Do the Right Thing*, starring Danny Aiello, Ruby Dee, Ossie Davis, and Lee.

Jacqueline Bisset starred in *Scenes from the Class Struggle in Beverly Hills*, directed by Paul Bartel.

Old Gringo, Gregory Peck and Jane Fonda starred in the Luis Puenzo film, based on the 1985 Carlos Fuentes novel, set in revolutionary Mexico.

Woody Allen wrote, directed, and starred opposite Mia Farrow in *Crimes and Misdemeanors*.

Stephen Spielberg directed *Always*, starring Richard Dreyfuss and Holly Hunter.

Robin Williams starred in *Dead Poets' Society*, directed by Peter Weir.

Pauline Collins and Tom Conti starred in *Shirley Valentine*, directed by Lewis Gilbert.

Milos Forman directed *Valmont*, another version of *Dangerous Liaisons*, this one starring Colin Firth, Annette Bening, and Meg Tilly.

Billy Crystal and Meg Ryan starred in *When Harry Met Sally . . .*, directed by Rob Reiner.

Batman, Michael Keaton played the title role and Jack Nicholson was the Joker in Tim Burton's film version of the cartoon series.

Murphy Brown, American television series starring Candice Bergen (1989–).

Academy Awards for 1989 (awarded the following year): Best Picture: *Driving Miss Daisy*; Best Director: Oliver Stone, *Born on the Fourth of July*; Best Actor: Daniel Day-Lewis, *My Left Foot*; Best Actress: Jessica Tandy, *Driving Miss Daisy*.

d. Lucille Ball, American actress (b. 1911), "Lucy" to tens of millions of television viewers worldwide.

d. Bette Davis (Ruth Elizabeth Davis), American actress (b. 1908).

d. Joris Ivens (George Henri Anton Ivens), Dutch documentarian (b. 1898).

d. Sergio Leone, Italian filmmaker (b. 1921), largely of "spaghetti Westerns."

d. Ray McAnally, Irish actor and director (b. 1926).

d. Cesare Zavattini, Italian screenwriter (b. 1902).

d. Franklin J. Schaffner, American director (b. 1920).

VISUAL ARTS

I. M. Pei's Pyramid opened at Paris's Cour Napoléon, entrance to the courtyard leading to the Louvre.

I. M. Pei's work included the CAA Building, Beverly Hills, and the Morton H. Meyerson Symphony Center, Dallas.

Maya Lin designed the Civil Rights Memorial, Montgomery, Alabama.

Claes Oldenburg and Coosje Van Bruggen's sculpture *Knife Slicing Wall*.

Nam June Paik's sculpture *Fin de Siècle II*.

Kevin Roche designed the Morgan Building, New York City.

Frank Stella began his *Moby-Dick* sculpture series.

Ellsworth Kelly's painting *Dallas Panels*, at the Dallas Symphony Hall.

Hartman-Cox designed the Chrysler Museum, Norfolk, Virginia.

Joan Mitchell's painting *Mountain*.

Peter Eisenman and Richard Trott designed the Wexner Center for the Arts, Ohio State University, Columbus.

Kenneth Noland's painting *Curtains 1988–1989*.

Cesar Pelli designed the Norwest Center, Minneapolis.

Richard Serra's sculpture *Blackmun and Brennan*.

Leon Golub's paintings included *Night Scenes* and *The Prisoner*.

Nam June Paik's sculpture *Fin de Siècle II*.

Folger Shakespeare Library, Washington, D.C., designed by Hartman and Cox.

Richard Meier designed the Bridgeport Center, Bridgeport, Connecticut.

Sherrie Levine's painting *Untitled Mr. Austridge: 3; 5*.

Romaldo Giurgola designed the Kimball Museum extension, Fort Worth, Texas.

d. Salvador Dali, Spanish painter, a leading surrealist from the 1920s (b. 1904).

d. Robert Mapplethorpe, American photographer and filmmaker (b. 1947), a victim of and notable campaigner against AIDS; his sexually explicit work became the center of an anticensorship fight after his death.

THEATER & VARIETY

John Cullum starred in *Shenandoah*, a Gary Geld and Peter Udell musical directed by Philip Rose.

Grand Hotel, a musical directed and choreographed by Tommy Tune, based on the Vicki Baum novel, as was Edmund Goulding's 1932 film; book by Luther Davis, score by Robert Wright and George Forrest.

Robert Morse starred in *Tru*, written and directed by Jay Presson Allen.

Pauline Collins starred in Willy Russell's *Shirley Valentine*, directed by Simon Callow.

Dustin Hoffman starred as Shylock in Shakespeare's *The Merchant of Venice*, directed by Peter Hall.

City of Angels, the Cy Coleman, David Gippel, and Larry Gelbart musical, starred James Naughton.

Claudio Segovia and Héctor Orezzoli's musical revue *Black and Blue* starred Ruth Brown, Linda Hopkins, and Carrie Smith.

Sweeney Todd, Stephen Sondheim's revival of the musical, starred Bob Gunton and Beth Fowler.

Jerome Robbins's musical revue *Jerome Robbins' Broadway* starred Jason Alexander and Charlotte d'Amboise.

Jerry Sterner's play *Other People's Money* starred Kevin Conway and Mercedes Ruehl.

Jean Stapleton starred in Harold Pinter's *The Birthday Party*.

Hugh Martin and Ralph Blane's musical *Meet Me in St. Louis* starred George Hearn, Betty Garrett, and Donna Kane.

Blair Brown and Mary Beth Hurt starred in *The Secret Rapture*, written and directed by David Hare.

Gypsy, Tyne Daly starred as Rose in the Jule Styne, Stephen Sondheim, and Arthur Laurents musical; Laurents directed.

Sting, Georgia Brown, and Nancy Ringham starred in the Kurt Weill and Bertolt Brecht musical *The Threepenny Opera*; John Dexter directed.

Len Cariou and Kate Burton starred in Shakespeare's *Measure for Measure*.

Rex Harrison, Stewart Granger, and Glynis Johns starred in *The Circle*.

d. Laurence Olivier, British actor, director, and producer (b. 1907), the most celebrated actor of the latter 20th century.

d. Samuel Beckett, Irish writer (b. 1906), who worked largely in French, a leading 20th-century playwright who also worked in several other forms.

d. Anthony Quayle, British actor, director, and producer (b. 1913).

d. Harry Andrews, British classical actor best known for his character roles on screen (b. 1911).

d. Maurice Evans, British-American actor (b. 1901).

MUSIC & DANCE

Bonnie Raitt and her comeback album *Nick of Time* swept the Grammy awards with best album, best female rock vocal, and best pop vocal; she also shared a Grammy with John Lee Hooker for their revival of his 1951 hit song *I'm in the Mood*, from his album *The Healer*.

Paul McCartney began an enormously successful world tour, his first in 13 years, which in 1990 resulted in the live album *Tripping the Live Fantastic*.

Crossroads, Tracy Chapman's second album; she also toured for Amnesty International, and her song about Nelson Mandela, *Freedom Now*, was banned in South Africa.

When Harry Met Sally . . . , Harry Connick, Jr.'s film sound track album, which first brought him wide audiences.

Bette Midler's Grammy-winning album and song *Wind Beneath My Wings*, theme from the film *Beaches*.

Mariah Carey, her hit debut album, including *Someday* and the Grammy-winning *Vision of Love*.

Oh Mercy, Bob Dylan's album and world tour began his comeback.

George Perle's *String Quartet No. 8* was first performed in New York.

Rhythm Nation: 1814, Janet Jackson's hit album and tour.

Jacob Druckman's *Brangle* was first performed in Chicago.

Back on the Block, Quincy Jones's Grammy-winning album.

Stephen Paulus's *Night Speech*, first performed in Spokane.

Madonna's album *Like a Prayer*.

Bobby Brown's album *Don't Be Cruel*.

Philip Glass's opera *Mattogrosso*.

Traveling Wilburys' single *End of the Line*.

Bon Jovi's album *New Jersey*.

Diana Ross's album *Workin' Overtime*.

Eleanor Cory's composition *Hemispheres*.

Fine Young Cannibals' album *The Raw and the Cooked*.

Guns N' Roses' album *Appetite for Destruction*.

Janet Jackson's single record *Miss You Much*.

Mel Powell's composition *Duplicates*.

New Kids on the Block's album *Hangin' Tough*.

William Albright's composition *Chasm*.

Aerosmith's hit single *Janie's Got a Gun*.

Black Velvet, Alannah Myles's hit.

Anita Baker's *Compositions*.

d. Vladimir Samoylovich Horowitz, Soviet-American pianist (b. 1904), one of the world's leading pianists from his 1921 debut.

d. Irving Berlin (Isadore Baline), American songwriter (b. 1888), one of the leading popular composers of the century.

d. Herbert von Karajan, Austrian conductor (b. 1908), a leading figure in German music during the Nazi period, and long director of the Berlin Philharmonic (1954–1989).

d. Alvin Ailey, American dancer, choreographer, and director (b. 1931).

d. Roy Eldridge (David Roy Eldridge), American jazz musician (b. 1911).

d. Sammy Fain (Samuel Feinberg), American composer (b. 1902).

d. Virgil Thomson, American composer and critic (b. 1896).

WORLD EVENTS

d. Hu Yaobang (Hu Yao-pang), Chinese Communist reformer (b. 1915).

Chinese student demonstrations began as parting tribute to reformer Hu Yaobang, and became massive nationwide pro-democracy demonstrations, their center at Beijing's Tiananmen Square. Ultimately, Chinese troops massacred hundreds there and perhaps thousands, while literally the whole world watched. Mass arrests followed.

American forces invaded and in four days took Panama, deposing General Manuel Noriega, who took refuge in the Vatican embassy. After his surrender on January 3, 1990, he would be taken to America to stand trial on existing drug-related charges.

Iranian Ayatollah Ruhollah Khomeini offered a $1 million reward to whoever would murder British author Salman Rushdie, for his 1988 novel *The Satanic Verses*, which had generated worldwide Islamic fundamentalist protests.

African-American Barbara Clementine Harris was consecrated in Boston (February 11) as the first woman bishop of the Episcopal church and of the worldwide Anglican Communion.

Exxon Valdez grounded in Prince William Sound, off Alaska, spilling massive amounts of oil and causing extensive environmental damage.

Collision of two packed trains on the Soviet Trans-Siberian railway at Chelyabinsk killed 600–650 people (June 3).

House of Representatives Democratic majority leader James Claude Wright, Jr., was forced to resign in June, because of alleged financial irregularities while in office; no prosecutions followed.

Paraguayan dictator Alfredo Stroessner was deposed by a military coup, and went into Brazilian exile.

The labor group Solidarity was legalized in Poland.

Soviet disengagement in Afghanistan concluded in February.

d. Ayatollah Ruhollah Khomeini (Ruhollah Kendi) (b. 1900), Shiite fundamentalist Islamic ruler of Iran (1979–1989).

d. Nicolae Ceausescu (b. 1919), Romanian dictator, and Elena Ceausescu, his wife and coruler (b. 1918; both executed by revolutionaries on December 25.

1990

LITERATURE

Carlos Fuentes's novel *La Campaña*, set in the 19th-century Argentinian independence movement.

Octavio Paz was awarded the Nobel Prize for Literature.

Wole Soyinka's autobiographical *Isarà: A Voyage Around the Essay*.

George Garrett's *Entered from the Sun*, the third of his Elizabethan novels, this one focusing on the murder of Christopher Marlowe.

William Styron's autobiographical *Darkness Visible: A Memoir of Madness*.

Joyce Carol Oates's novel *Because It Is Bitter, and Because It Is My Heart*, set in the late 1950s and early 1960s.

Haroun, Salman Rushdie's book of children's stories.

Scott Turow's novel *The Burden of Proof*.

Muriel Spark's novel *Symposium*.

Kingsley Amis's novel *The Folks That Live on the Hill*.

Brian Moore's *Lies of Silence*, set in the northern Ireland civil war.

Larry McMurtry's novel *Buffalo Girls*.

The World Doesn't End, Charles Simic's Pulitzer Prize–winning poetry.

The Plains of Passage, fourth of Jean Auel's Earth's Children novels.

Obabakoak, by Basque writer Bernardo Atxaga, a novel built of linked tales.

Jean-Paul Sartre's youthful fiction and essays were published in *Écrits de jeunesse*.

Simone de Beauvoir's letters to Jean-Paul Sartre were published.

Pauld de Castilho's novel *Fora de Horas*, story of two Portuguese "on the road" in the United States.

I Shall Not Be Moved, poetry by Maya Angelou.

Beryl Bainbridge's novel *An Awfully Big Adventure*.

East Is East, T. Coraghessan Boyle's novel.

Anne Beattie's novel *Picturing Will*.

Dr. Seuss's *Oh, the Places You'll Go!*

The King, Donald Barthelme's novel.

V. S. Pritchett's *The Complete Short Stories*.

Body, Harry Crews's novel.

Brian Moore's novel *Lies of Silence*.

Collected Stories of Wallace Stegner.

Almeida Faria's novel *Conquistador*.

Derek Walcott's long poem *Omeros*.

Four Past Midnight, Stephen King's novellas.

Kurt Vonnegut's novel *Hocus Pocus*.

Above the River, James Wright's complete poems.

Killing Mister Watson, Peter Matthiessen's novel.

Lac, Jean Echenoz's novel.

Jean Rouaud's novel *Les Champs d'honneur*.

Mordecai Richler's novel *Solomon Gursky Was Here*.

Natural Selection, Frederick Barthelme's novel.

Joseph Brodsky's poetry collection *Edification*.

Donald Hall's *Old and New Poems*.

Philip Roth's novel *Deception*.

Amy Clampitt's poetry *Westward*.

Eric Jong's novel *Woman's Blues*.

Camille Paglia's essays *Sexual Personae: Art and Decadence from Nefertiti to Emily Dickinson*.

d. Patrick White, Australian writer (b. 1912).

d. Walker Percy, American author (b. 1916).

d. Lawrence Durrell, Anglo-Irish writer (b. 1912).

d. Alberto Moravia (Alberto Pinchale), Italian writer (b. 1907), the husband of writer Elsa Morante.

d. Hugh MacLennan, Canadian novelist (b. 1907).

d. Rosamond Lehmann, British writer (b. 1903).

d. Morley Callaghan, Canadian-born author (b. 1903).

FILM & BROADCASTING

Kevin Costner starred as the Western frontier soldier who ultimately joined the Sioux nation in the Oscar-winning *Dances with Wolves*; Michael Blake adapted his own novel.

Bernardo Bertolucci's *The Sheltering Sky* starred Debra Winger and John Malkovich; Mark Peploe's screenplay was based on the Paul Bowles book.

Akira Kurosawa wrote and directed *Akira Kurosawa's Dreams*, starring Akira Terao and Martin Scorsese.

Jeremy Irons, Glenn Close, and Ron Silver starred in *Reversal of Fortune*, directed by Barbet Schroeder; Nicholas Kazan's courtroom drama was based on the Alan Dershowitz book about the Claus von Bülow case.

Barry Levinson wrote and directed *Avalon*, starring Aidan Quinn, Armin Mueller-Stahl, and Joan Plowright.

Robert De Niro starred in *Awakenings*, directed by Penny Marshall.

Philippe Noiret and Jacques Perrin starred in *Cinema Paradiso*, written and directed by Giuseppe Tornatore.

Home Alone, Macaulay Culkin was the child who foiled the bad guys, played by Joe Pesci and Daniel Stern; Chris Columbus directed.

Warren Beatty directed and starred in the title role in *Dick Tracy*, based on the Chester Gould comic strip; Madonna, Glenne Headly, and Dustin Hoffman costarred.

Goodfellas, Robert De Niro, Ray Liotta, Paul Sorvino, and Joe Pesci starred in the Martin Scorsese film, about a group of New York City criminals and hangers-on.

Hamlet, Mel Gibson, Glenn Close, and Alan Bates starred in Franco Zeffirelli's version of the Shakespeare play.

James Caan, Kathy Bates, and Lauren Bacall starred in Rob Reiner's *Misery*; William Goldman's screenplay was based on the Stephen King novel.

Spike Lee wrote and directed *Mo' Better Blues*, starring Denzel Washington, Lee, Joie Lee, and Cynda Williams.

Meryl Streep and Shirley MacLaine starred in *Postcards from the Edge*, directed by Mike Nichols; Carrie Fisher's screenplay was based on her novel.

Alan J. Pakula directed and cowrote *Presumed Innocent*, based on Scott Turow's novel; Harrison Ford, Raul Julia, Bonnie Bedelia, and Paul Winfield starred.

Brian De Palma directed *The Bonfire of the Vanities*, starring Tom Hanks, Bruce Willis, and Melanie Griffith; Michael Cristofer's screenplay was based on the Tom Wolfe novel.

The Civil War, Ken Burns's 11-hour television documentary.

The Freshman, Marlon Brando and Matthew Broderick starred in Andrew Bergman's spoof of *The Godfather*.

Francis Ford Coppola directed *The Godfather Part III*, starring Al Pacino, Diane Keaton, Talia Shire, and Andy Garcia, with screenplay by Mario Puzo and Coppola.

Volker Schlöndorff directed *The Handmaid's Tale*, starring Natasha Richardson, Robert Duvall, and Faye Dunaway; Harold Pinter's screenplay was based on the Margaret Atwood novel.

Sean Connery, Alec Baldwin, Scott Glenn, and

James Earl Jones starred in *The Hunt for Red October*, directed by John McTiernan; based on Tom Clancy's novel.

Fred Schepisi directed *The Russia House*, starring Sean Connery, Michelle Pfeiffer, and Roy Scheider; Tom Stoppard's screenplay was based on the John Le Carré novel.

Academy Awards for 1990 (awarded the following year): Best Picture: *Dances with Wolves*; Best Director: Kevin Costner, *Dances with Wolves*; Best Actor: Jeremy Irons, *Reversal of Fortune*; Best Actress: Kathy Bates, *Misery*.

d. Greta Garbo (Greta Louise Gustafsson), Swedish actress (b. 1905).

d. Jim Henson (James Maury Henson), creator of the Muppets (b. 1937).

d. Ava Gardner, American actress (b. 1922).

d. Irene Dunne, American actress (b. 1901).

d. Ian Charleson, British classical actor (b. 1949), best known for his film role in *Chariots of Fire*.

d. Martin Ritt, American director (b. 1919).

d. Michael Powell, British director, producer, and writer (b. 1905), long partnered with Emeric Pressburger.

d. Aldo Fabrizi, Italian actor and director (b. 1905).

VISUAL ARTS

Performance artist Karen Finley was denied a National Endowment for the Arts (NEA) grant for a work on sexual abuse, on the grounds that it was obscene, creating a cause célèbre.

Monet in the 90's: The Series Paintings was the largest international Monet exhibition ever mounted; it was shown at Boston's Museum of Fine Arts, the Art Institute of Chicago, and at London's Royal Academy.

After 10 years of work, the Sistine Chapel restoration was unveiled.

With the cold war over, cultural interchanges grew between the countries of the former Soviet bloc and the rest of the world; one notable show, seen at New York's Metropolitan Museum of Art, was *From Poussin to Matisse: The Russian Taste for French Painting: A Loan Exhibition from the U.S.S.R.*

Humboldt Library by American architects Moore Ruble Yudell in the West Berlin suburb of Tegel, part of the Tegel Harbor development.

I. M. Pei designed the Bank of China building.

Goran Mansson and Marianne Dahlback's *Vasa* museum opened in Stockholm, housing the 17th-century Swedish ship raised in 1961.

Tokyo—The Sight of a City was the first exhibition at the opening of the Tokyo Museum of Photography.

Washington's National Gallery of Art mounted a substantial exhibition of the landscape paintings of Frederic Edwin Church.

New York's Metropolitan Museum of Art mounted the first major United States Canaletto exhibition.

Substantial international Frans Hals exhibition was shown at Washington's National Gallery of Art, London's Royal Academy, and Haarlem's Frans Halsmuseum.

Renzo Piano designed the planned Osaka, Japan, airport.

d. Gordon Bunshaft, American architect (b. 1909).

d. Roman Vishniac, Russian photographer (b. 1897).

d. Eliot Porter, American photographer and conservationist (b. 1901).

d. Hans Hartung, German modernist painter (b. 1904), an anti-Nazi who fought with the French during World War II and later became a French citizen.

d. Lewis Mumford, American writer and architectural theorist (b. 1895).

d. Sidney Janis, New York City art dealer (b. 1896).

THEATER & VARIETY

Frank Galati adapted and directed John Steinbeck's *The Grapes of Wrath*, starring Gary Sinise, Lois Smith, and Terry Kinney.

August Wilson's *The Piano Lesson* opened on Broadway, starring Charles S. Dutton and S. Epatha Merkerson; Lloyd Richards directed.

Stockard Channing, John Cunningham, and Courtney Vance starred in John Guare's *Six Degrees of Separation*; Jerry Zaks directed.

Jane Alexander and Nigel Hawthorne starred in William Nicholson's *Shadowlands*.

Kathleen Turner and Charles Durning starred in Tennessee Williams's *Cat on a Hot Tin Roof*, directed by Howard Davies.

Aspects of Love, the Andrew Lloyd Webber, Don Black, and Charles Hart musical, starred Michael Ball, Ann Crumb, Kevin Colson, and Kathleen

McAllen; Trevor Nunn directed.

Richard Nelson's *Some Americans Abroad* starred Kate Burton, Frances Conroy, Henderson Forsythe, and Nathan Lane.

Paul Hipp, Fred Sanders, and David Mucci starred in *Buddy . . . The Buddy Holly Story*, based on Holly's life and music; Rob Bettinson directed.

Peter Pan, the Moose Charlap and Carolyn Leigh musical, based on the James M. Barrie book, starred Cathy Rigby and Stephen Hanan; Fran Soeder directed.

Craig Lucas's *Prelude to a Kiss* starred Barnard Hughes, John Dossett, and Ashley Crow; Norman René directed.

Maggie Smith and Margaret Tyzack starred in Peter Shaffer's *Lettice and Lovage*, directed by Michael Blakemore.

Ian McKellen starred in the title role of *Richard III* at the Royal National Theatre; Richard Eyre directed.

Glenda Jackson starred in Bertolt Brecht's *Mother Courage*.

Topol starred in *Fiddler on the Roof*, the Jerry Bock and Sheldon Harnick musical.

Felicity Kendal and Peter Barkworth were directed by Simon Gray in his *Hidden Laughter*.

Estelle Parsons starred in *Miss Margarida's Way*, written and directed by Roberto Athayde.

Ivan Menchell's *The Cemetery Club* starred Eileen Heckart, Elizabeth Franz, and Doris Belack.

Philip Bosco, Carole Shelley, and Mia Dillon starred in Molière's *The Miser*; Stephen Porter directed.

Oh Kay!, the George and Ira Gershwin musical, starred Brian Mitchell and Angela Teek; Dan Siretta directed.

d. Mary Martin, American singer and actress who originated several classic musical theater roles; mother of actor Larry Hagman (b. 1913).

d. Rex (Reginald Carey) Harrison, British actor (b. 1908).

d. Sammy Davis, Jr., American singer, dancer, and actor (b. 1925).

d. Paulette Goddard (Marion Levy), American actress (b. 1911).

d. Gordon Jackson, British actor (b. 1923).

d. John Dexter, English director (b. 1925).

d. Friedrich Dürrenmatt, Swiss playwright and novelist (b. 1921).

d. Bernard Miles, English actor and director (b. 1907).

MUSIC & DANCE

Mstislav Rostropovich and Galina Vishnevskaya returned to the Soviet Union, in Moscow leading the Washington Symphony Orchestra first in Peter Ilich Tchaikovsky's *Symphony No. 6*, the *Pathétique*, the last work he had conducted before leaving in 1974. Many other émigrés also returned to Eastern Europe and the Soviet Union.

Kurt Masur became musical director of the New York Philharmonic Orchestra.

Madonna released two albums, *I'm Breathless* and *The Immaculate Collection*, plus a video, *Justify My Love*, and began her "Blond Ambition" international concert tour, basis for the 1992 documentary film *Truth or Dare: In Bed with Madonna*.

Mikhail Baryshnikov and ultramodern dancer–choreographer Mark Morris formed the White Oak Dance Project, touring America and later Europe.

Maurice Béjart's created *Ring Around the Ring*, a dance version of Richard Wagner's *Der Ring des Nibelungen*, first danced by his Ballet Lausanne (Switzerland) in Berlin.

Philip Glass premiered a new opera, *The Hydrogen Jukebox*, created in collaboration with poet Allen Ginsberg and visual artist Jerome Sirlin, originally a cantata based on Ginsberg's antiwar poem *Wichita Vortex Sutra*.

Waylon Jennings, Willie Nelson, Kris Kristofferson, and Johnny Cash were on the road again as the Highwaymen.

Hammer became the first major rap artist to successfully cross over to popular music, with his album *Please Hammer Don't Hurt 'Em*.

Mario Davidovsky's *Concertante for String Quartet and Orchestra* premiered by the Philadelphia Orchestra with the Guarneri String Quartet.

Pacific Music Festival debuted at Art Park in Sapporo, Hokkaido, intended to be a Japanese Tanglewood; guests included Leonard Bernstein, Michael Tilson Thomas, and the London Symphony Orchestra.

Rudolf Nureyev premiered Flemming Flindt's *The Overcoat*, created for him, at the Edinburgh Festival.

The new Bastille Opera in Paris opened with the city's first-ever complete production of Hector Berlioz's *Les Troyens*.

Chicago Symphony Orchestra premiered Andrzej Panufnik's *Symphony No. 10*; Ezra Laderman's *Cello Concerto*; Ned Rorem's *Goodbye My Fancy*, an oratorio to texts by Walt Whitman; and John Corigliano's *Symphony No. 1*, honoring friends lost to AIDS.

Harry Connick, Jr.'s albums *Lofty's Roach Souffle* and *We Are in Love*.

Love Will Never Do (Without You), Janet Jackson's hit single.

Garth Brooks's debut album *No Fences*.

Music from Mo' Better Blues, Branford Marsalis's album.

Paul Simon's album *The Rhythm of the Saints*.

Twyla Tharp's *Brief Fling* for American Ballet Theatre.

Bob Dylan's album *Under the Red Sky*.

Absolute Torch and Twang, k. d. lang's album.

Paul Taylor's evening-length allegory, *Or Bright Blue Birds and the Gala Sun*, for his own company.

Violin Concerto by Elliott Carter, premiered by the San Francisco Symphony.

d. Aaron Copland, American composer (b. 1900).

d. Leonard Bernstein, American composer, conductor, and pianist (b. 1918).

d. Pearl Bailey, American singer, dancer, and actress (b. 1918).

d. Dexter Gordon, American jazz saxophonist (b. 1923).

d. Johnny Ray, American singer, popular in the 1950s (b. 1927).

WORLD EVENTS

Iraqi forces invaded and quickly took Kuwait. American forces began a huge military buildup in the Persian Gulf, as President George Bush led in the formation of the worldwide alliance that would move against Iraq.

East and West Germany quickly moved toward unification as Soviet opposition to a united Germany disappeared. The final settlement between the two Germanies and the Allies was signed on September 12, with unification on October 3.

Mikhail Gorbachev continued to resist the dismemberment of the Soviet Union, while pushing openness and democracy forward, as the forces he had let loose began to tear his country apart; he

won the 1990 Nobel Peace Prize. He and Boris Yeltsin, who in May was elected president of the Russian Federation, continued their struggle for dominance. The Baltic republics demanded freedom, war began between Azerbaijan and Armenia, and dissolution of the Soviet Union began to seem a proximate possibility.

With the February 11 release of Nelson Mandela by the government of Frederik Willem De Klerk, a new period began in South African history. The African National Congress–government agreements of August 7 brought a full ceasefire, release of many other political prisoners, and the beginning of the end of apartheid.

John Major succeeded Margaret Thatcher as British prime minister.

Civil war in Angola resumed, as the 1989 ceasefire failed to hold.

Lech Walesa won election as the president of Poland.

Namibian independence was achieved; Sam Nujoma became the first president of the new country.

1991

LITERATURE

John Updike's Pulitzer Prize–winning novel *Rabbit at Rest*, the final volume of his Rabbit quartet.

A Thousand Acres, Jane Smiley's novel.

Nadine Gordimer was awarded the 1991 Nobel Prize for Literature.

Time's Arrow, Martin Amis's novel.

The Journals of John Cheever were published, edited by Robert Gottlieb.

The Rise of Life on Earth, Joyce Carol Oates's novel; also her *Heat: And Other Stories*.

Manuel Vázquez Montalbean's detective novel *El laberinto griego*, featuring his series character Pepe Carvalho.

Alice Walker's *Her Blue Body Everything We Know: Earthling Poems 1965–1990 Complete*.

Margaret Drabble's novel *The Gates of Ivory*, set among refugees in Cambodia.

Joseph Brodsky was named American poet laureate.

Adrienne Rich's *An Atlas of the Difficult World: Poems 1988–1991*.

Margaret Atwood's novel *Wilderness Tips*.

Alexandra Ripley novel *Scarlett: The Sequel to Mar-*

garet Mitchell's *Gone with the Wind.*

Daughters, Paule Marshall's story, on Caribbean African-Amercan history and current themes.

Pierre Combescot's Prix Goncourt–winning novel *The Daughters of Calvary.*

Timothy Mo's novel *The Redundancy of Courage*, set in Indonesian-occupied East Timor, betrayed by Western powers.

Sandra Cisneros's *Woman Hollering Creek: And Other Stories.*

Alan Massie's novel *The Sins of the Father.*

Object Lessons, Anna Quindlen's novel.

Almanac of the Dead, Leslie Marmon Silko's novel.

Ben Okri's novel *The Famished Road*, set in Nigeria.

Saint Maybe, Anne Tyler's novel.

Robertson Davies's novel *Murther & Walking Spirits.*

Marianne Wiggins's story collection *Bet They'll Miss Us When We're Gone.*

The Alchymist's Journal, Evan S. Connell's novel.

The Kitchen God's Wife, Amy Tan's novel.

Doris Grumbach's essays *Coming into the End Zone.*

Something Happened Here, Norman Levine's new collection of short stories.

Dan Franck's novel *La Séparation.*

John Barth's novel *The Last Voyage of Somebody the Sailor.*

WLT: A Radio Romance, Garrison Keillor's novel.

The MacGuffin, Stanley Elkin's novel.

Flow Chart, John Ashbery's poetry.

Norman Mailer's CIA novel *Harlot's Ghost.*

Arthur Danto's essays *Encounters and Reflections.*

Claude Lévi-Strauss's essays *Histoire de lynx.*

Cynthia Macdonald's poetry *Living Wills.*

Philip Levine's *New Selected Poems.*

Scum, Isaac Bashevis Singer's novel.

Robert Creeley's *Selected Poems.*

Norman Rush's National Book Award–winning novel *Mating.*

The Runaway Soul, Harold Brodkey's novel.

Ann Beattie's *What Was Mine: Stories.*

Taeko Kohno's novel *The Strange Story of a Mammy Hunt.*

d. Graham Greene, British writer (b. 1904).

d. Dr. Seuss (Theodor Seuss Geisel), American children's author, artist, and filmmaker (b. 1904).

d. Isaac Bashevis Singer, Jewish-Polish-American writer (b. 1904).

d. Angus Wilson, British writer and critic (b. 1913).

d. Jerzy Kosinski, Polish-American writer (b. 1933).

d. A. B. Guthrie (Alfred Bertram Guthrie), American writer (b. 1901).

FILM & BROADCASTING

Jodie Foster and Anthony Hopkins starred in *The Silence of the Lambs*, directed by Jonathan Demme; Ted Tally's screenplay was based on the Thomas Harris novel.

Kevin Costner, Gary Oldman, Tommy Lee Jones, Sissy Spacek, and Jay O. Sanders starred in *JFK*, Oliver Stone's version of the John F. Kennedy assassination.

Susan Sarandon and Geena Davis starred in *Thelma and Louise*, directed by Ridley Scott.

Barbra Streisand directed and starred opposite Nick Nolte in *The Prince of Tides*, based on the Pat Conroy novel.

Akira Kurosawa wrote and directed *Rhapsody in August*, starring Richard Gere, Sachiki Murase, and Hisashi Igawa.

Jessica Tandy and Kathy Bates starred in *Fried Green Tomatoes*, directed and cowritten by John Avnet.

Robin Hood, Prince of Thieves, Kevin Costner starred in the title role, opposite Morgan Freeman, Christian Slater, Alan Rickman, and Mary Elizabeth Mastrantonio; Kevin Reynolds directed.

John Singleton wrote and directed *Boyz N the Hood*, starring Ice Cube, Cuba Gooding, Jr., Morris Chestnut, Larry Fishburne, and Angela Bassett.

Jeff Bridges, Robin Williams, and Mercedes Ruehl starred in *The Fisher King*, directed by Terry Gilliam.

Warren Beatty starred opposite Annette Bening in the title role of *Bugsy*, directed by Barry Levinson.

Cape Fear, Robert De Niro, Nick Nolte, and Jessica Lange starred in Martin Scorsese's redo of the 1962 film; Gregory Peck and Robert Mitchum this time took small roles.

Kenneth Branagh directed and starred opposite Emma Thompson and Derek Jacobi in *Dead Again.*

Dustin Hoffman, Bruce Willis, and Nicole Kidman starred in Robert Benton's *Billy Bathgate*; Tom Stoppard's screenplay was based on the E. L. Doctorow book.

Al Pacino and Michelle Pfeiffer starred in *Frankie and Johnny*, directed by Garry Marshall; based on Terrence McNalley's play.

Hook, Robin Williams, Dustin Hoffman, Julia Roberts, and Bob Hoskins starred in Steven Spiel-

berg's film version of James M. Barrie's *Peter Pan*.

Jeremy Irons and Theresa Russell starred in *Kafka*, directed by Steven Soderbergh.

Jodie Foster directed and starred opposite Dianne Wiest, Adam Hann-Byrd, and Harry Connick, Jr., in *Little Man Tate*.

Gregory Peck and Danny DeVito starred in *Other People's Money*, directed by Norman Jewison; Alvin Sargent's screenplay was based on the Jerry Sterner play.

Martha Coolidge directed *Rambling Rose*, starring Laura Dern, her mother Diane Ladd, and Robert Duvall; Calder Willingham adapted his own book.

Paul Mazursky's *Scenes from a Mall* starred Bette Midler and Woody Allen.

The Addams Family, based on Charles Addams's cartoon and television characters, starred Anjelica Huston, Raul Julia, and Christopher Lloyd; Barry Sonnenfeld directed.

Christopher Walken and Natasha Richardson starred in Paul Schrader's *The Comfort of Strangers*; Harold Pinter's screenplay was based on the Ian McEwan novel.

William Hurt and Elizabeth Perkins starred in *The Doctor*, directed by Randa Haines.

William Hurt, Sam Neill, and Max von Sydow starred in *Until the End of the World*, directed by Wim Wenders.

Academy Awards for 1991 (awarded the following year): Best Picture: *The Silence of the Lambs*; Best Director: Jonathan Demme, *The Silence of the Lambs*; Best Actor: Anthony Hopkins, *The Silence of the Lambs*; Best Actress: Jodie Foster, *The Silence of the Lambs*.

d. Frank Capra, American director (b. 1897).

d. Yves Montand (Ivi Livi), French actor and singer (b. 1921).

d. Fred MacMurray, American actor (b. 1908).

d. Joseph Cotten, American actor (b. 1905).

d. Jean Arthur (Gladys Georgianna Greene), American actress (b. 1905).

d. Gene Tierney, American actress (b. 1920).

d. Ralph Bellamy, American actor (b. 1904), a notable Franklin Delano Roosevelt in *Sunrise at Campobello*.

d. Lee Remick, American actress (b. 1935).

VISUAL ARTS

Robert Venturi's Sainsbury Wing opened, at London's National Gallery in Trafalgar Square, generating much controversy as a major work of the postmodernist movement which Venturi began and led.

The Astronauts Memorial opened at Cape Canaveral, Florida, designed by Holt, Hinshaw, Pfau, and Jones as part of the Kennedy Space Center's Spaceport USA.

Arata Isozaki designed Barcelona's Sant Jordi Sports Hall, the stadium for the 1992 Olympic Games.

Thomas Beeby designed Chicago's newly completed Harold Washington Library Center.

Hans Hollein designed Frankfurt's Museum of Modern Art.

Cesar Pelli designed New York City's Carnegie Hall Tower.

Henry Cobb designed the Los Angeles First Interstate World Center.

Montreal's Canadian Centre for Architecture opened its new sculpture garden, designed by Melvin Charney.

Richard Meier designed what was to be the large and very expensive Getty Center, in West Los Angeles.

Charles W. Moore and the Urban Innovations Group designed the Oceanside, California, Civic Center.

Further cultural interchanges proceeded in the wake of the cold war; one such was the exhibition *The Twilight of the Tsars: Russian Art at the Turn of the Century*, at London's Hayward Gallery.

A dissenting view of the American frontier, emphasizing genocidal white racism, was seen in the exhibition *The West as America: Reinterpreting Images of the Frontier*, at the National Museum of American Art.

Washington, D.C.'s Market Square was designed by Hartman Cox.

d. Giacomo Manzù, Italian sculptor (b. 1908).

d. Rufino Tamayo, Mexican painter (b. 1899), who with Clemente Orozco, Diego Rivera, and David Alfaro Siquieros created the Mexican Renaissance.

d. Robert Motherwell, American modernist painter (b. 1915), a key abstract expressionist.

d. Berenice Abbott, American photographer (b. 1898).

d. Robert Gowing, British painter and art historian (b. 1918).

THEATER & VARIETY

Maryann Plunkett, Martin Sheen, Fritz Weaver, and Michael York starred in Arthur Miller's *The Crucible*, first production of the National Actors Theatre, founded by Tony Randall; Yossi Yzraely directed.

Neil Simon's *Lost in Yonkers* starred Mark Blum and Mercedes Ruehl; Gene Saks directed.

Miss Saigon, the Claude-Michel Schönberg, Alain Boublil, and Richard Maltby, Jr., musical opened on Broadway after substantial disputes about the casting of Asian-Americans in key roles; Jonathan Pryce and Lea Salonga starred, Nicholas Hytner directed.

Jason Robards, Jr., and Judith Ivey starred in Israel Horovitz's *Park Your Car in Harvard Yard*, directed by Zoe Caldwell.

The Will Rogers Follies, the Cy Coleman, Betty Comden, and Adolph Green musical, starred Keith Carradine in the title role; Tommy Tune directed.

Peter Hall directed a revival of Harold Pinter's *The Homecoming* in London, with Warren Mitchell in the lead, while Pinter directed a revival of his own *The Caretaker*, with Donald Pleasance recreating the leading role.

Lindsay Crouse, Roy Dotrice, Daniel Gerroll, and Jonathan Hogan starred in a New York revival of Pinter's *The Homecoming*, directed by Gordon Edelstein.

Brian Friel's *Dancing at Lughnasa*, originally at Dublin's Abbey Theatre and then at the Royal National Theatre, opened on Broadway.

David Hare's *Murmuring Judges*, an attack on the British legal system, opened at the Royal National Theatre.

Paul Rudnick's *I Hate Hamlet* starred Nicol Williamson, Evan Handler, and Celeste Holm.

Julie Harris starred in William Luce's *Lucifer's Child*, based on several Isak Dinesen works.

Paul Osborn's *On Borrowed Time* starred George C. Scott, Conrad Bain, Nathan Lane, and Teresa Wright; Scott directed.

Timberlake Wertenbaker's *Our Country's Good* starred Tracey Ellis, Richard Poe, and Peter Frechette; Mark Lamos directed.

Alan Ayckbourn's *Taking Steps* starred Jane Summerhays, Christopher Benjamin, and Jonathan Hogan; Alan Strachan directed.

Tracey Ullman starred in Brooke Allen and Jay Presson Allen's *The Big Love*.

The Secret Garden, the Marsha Norman and Lucy Simon musical, starred Mandy Patinkin, Daisy Eagen, and Rebecca Luker; Susan H. Schulman directed.

Steve Tesich's *The Speed of Darkness* starred Len Cariou, Stephen Lang, and Lisa Eichhorn; Robert Falls directed.

d. Joseph Papp (Joseph Papirovsky), American producer and director (b. 1921), founder of New York's Public Theater and Shakespeare in the Park.

d. Eva Le Gallienne, British-American actress and director, founder in 1926 of the Civic Repertory Theater (b. 1899).

d. Peggy Ashcroft (Edith Margaret Emily Ashcroft), British actress (b. 1907); she was Juliet alternately to John Gielgud and Laurence Olivier, Desdemona to Paul Robeson, Hedda Gabler, and far more.

d. Colleen Dewhurst, American actress (b. 1926).

d. Tony Richardson (Cecil Antonio Richardson), British director and producer (b. 1928); father of actress Natasha Richardson.

MUSIC & DANCE

Dangerous, Michael Jackson's album, spinning off hit singles such as *Remember the Time*, *In the Closet*, *Jam*, *Black or White*, and *Heal the World*, sung on his accompanying world tour.

Rudolf Nureyev danced the role of Aschenbach in Flemming Flindt's *Death in Venice*, based on the Thomas Mann story; premiered at the Verona (Italy) Ballet.

Liverpool Oratorio, Paul McCartney's first classical work, written with Carl Davis, was presented by the Royal Liverpool Philharmonic at the Liverpool Anglican Cathedral.

Natalie Cole combined new and old in her Grammy-winning album *Unforgettable*, in which she sang many of the old standards made famous by her father, Nat "King" Cole, including the electronically engineered duet with him on the title song.

Blue Light, Red Light, Harry Connick, Jr.'s album.

For My Broken Heart, Reba McEntire's hit album, with *Is There Life Out There?* and *The Greatest Man I Never Knew*.

Just for the Record, Barbra Streisand's four-CD collection of old and new songs.

Love Can Build a Bridge, the Judds' Grammy-winning single.

Love Hurts, Cher's album and tour.

Mr. Lucky, John Lee Hooker's album.

Paula Abdul's album *Spellbound* and her following "Under My Spell" tour.

Ropin' the Wind, Garth Brooks's Grammy-winning hit album.

Soul Cages, Sting's album and Grammy-winning title song; Sting and Eric Clapton also had a hit single *It's Probably Me* from the sound track of *Lethal Weapon 3*.

Willie Nelson released his *Who'll Buy My Memories (The I.R.S. Tapes)*, the title referring to tax problems caused by bad investments.

Bicentenary of Mozart's death.

Centenary of Sergei Prokofiev's birth (April 23); productions of his vast opera *War and Peace* by the Kirov Opera and by the San Francisco Opera.

Danish choreographer Flemming Flindt created *Caroline Mathilde*, a royal tragedy out of Danish history, with much-admired original music by British composer Peter Maxwell Davies.

John Corigliano's *Ghosts of Versailles* premiered at New York's Metropolitan Opera.

Kirov Ballet (renamed the St. Petersburg Ballet) visited Washington, D.C., and took productions of *Boris Godunov*, *Khovanshchina*, and *Le Coq d'Or* to Paris.

Ned Rorem's *Swords and Plowshares*, for four solo voices and orchestra, premiered with the Boston Symphony Orchestra.

John Adams's new opera *The Death of Klinghoffer*, based on the 1985 hijacking of an Italian cruise ship, premiered in Brussels; libretto by Alice Goodman.

Harrison Birtwistle's *Gawain* premiered at the Royal Opera, Covent Garden.

The Chicago Symphony Orchestra's centenary celebrations included the premiere of Michael Tippett's *Byzantium*.

The newest blockbuster from Maurice Béjart was his *Ring Around the Ring*, a metamorphosis of the four Wagner operas into four acts of multimedia choreography.

Ullysses Kay's *Frederick Douglass* (New Jersey State Opera).

d. Lawrence Welk, American bandleader (b. 1903).

d. Margot Fonteyn (Peggy Hookam), British dancer (b. 1919).

d. Martha Graham, American choreographer and dancer, a leading figure in the development of modern dance (b. 1893).

d. Rudolf Serkin, Austrian-American pianist, a world figure (b. 1903); father of pianist Peter Serkin.

d. Miles Davis (Miles Dewey Davis, Jr.), American jazz trumpeter and bandleader (b. 1926).

d. Tennessee Ernie (Ernest Jennings) Ford, American country singer (b. 1919).

WORLD EVENTS

Allied forces began a massive aerial attack on Iraq on January 17, followed by a ground offensive that began with a quick armored envelopment of Iraqi forces that destroyed much of Iraq's armor and forced a disorganized retreat. Allied forces did not follow up, leaving Saddam Hussein in control of Iraq and with enough air power and armor to subsequently defeat internal enemies.

During the Persian Gulf War, a deliberate and massive Iraqi oil spill at the Sea Island Terminal, other deliberate Iraqi oil spills into the Persian Gulf, and Iraqi setting of many hundreds of oil-well fires in Kuwait caused a massive environmental disaster.

On August 19, an abortive right-wing coup began in the Soviet Union; Mikhail Gorbachev was placed under house arrest while vacationing in the Crimea and coup leaders announced that they had taken power. But massive resistance quickly developed, centered around Boris Yeltsin at the Russian Federation White House. Capital military units supported Yeltsin, dooming the coup, which collapsed on August 21. Soon so did the Soviet Union and the Gorbachev government; Yeltsin took power in Russia and the Soviet Union was disbanded in December, replaced by the Commonwealth of Independent States.

Remaining American and British Lebanon hostages were freed; the last was Terry Anderson, freed on December 4, after 2,454 days of captivity.

Civil war between Inkatha and African National Congress forces grew in South Africa, impeding progress toward the development of an interracial democracy; but ANC–government negotiations

continued. Winnie Mandela was found guilty of kidnapping and of being an accessory to assault.

Supreme Court Justice Thurgood Marshall resigned. Long Senate Judiciary Committee hearings on the nomination of Judge Clarence Thomas had nearly been completed when Anita Faye Hill's sexual harassment charges against him were made public. Thomas was ultimately confirmed, but Hill's treatment by an all-male Senate Judiciary Committee before a massive worldwide television audience helped trigger a new stage in the fight for women's rights.

Ethiopian civil war ended with defeat of government forces; dictator Haile Mariam Mengistu resigned and fled the country on May 21, rebel forces then taking Addis Abbaba.

All Iran–Contra charges against Oliver North and John Pondexter were dropped.

d. Rajiv Gandhi, Indian prime minister (b. 1944); assassinated in a bombing while on a campaign swing; he was the son of assassinated Indira Gandhi and the grandson of Jawaharlal Nehru.

1992

LITERATURE

West Indian poet and playwright Derek Alton Walcott was awarded the Nobel Prize for Literature.

Salman Rushdie remained in hiding for a fourth year, as Islamic fundamentalists continued to try to murder him; the paperback version of The Satanic Verses was published in 1992.

Mona Van Duyn won the Pulitzer Prize for Near Changes, her seventh volume of poems.

Gore Vidal's bitterly satirical novel Live from Golgotha and several essay collections.

Carlos Fuentes's The Buried Mirror, a long essay on the genesis and development of Hispanic cultures in Europe and the Americas.

William Kennedy's Very Old Bones, another in his series of Albany novels, the third book in the history of the Phelan family.

Gabriel García Márquez's short-story collection Doce cuentos peregrinos.

James Michener's The World Is My Home: A Memoir; Mexico, his once-lost novel; and his My Lost Mexico, describing the process of writing the novel.

Stephen King's novels Gerald's Game and Doris Claiborne, both continuing to explore horror themes.

John Updike's 15th novel, Memories of the Ford Administration.

Michael Ondaatje's novel The English Patient, set in postwar Italy; he shared Britain's Booker Prize with Barry Unsworth, whose novel, Sacred Hunger, was about the history of the slave trade.

Muriel Spark's autobiography Curriculum Vitae.

Jakuco Setouchi won Japan's Tanizaki Prize for her novel Ask the Flowers.

Ken Kesey's Sailor's Song, a 30-years-later sequel to his One Flew Over the Cuckoo's Nest, like the earlier work a celebration of nature as an antidote to humanity-destroying technology.

Jay McInerney's fourth novel, Brightness Falls, his failed protagonists signaling the end of the 1980s New York big-money life and of his own 1980s.

Günter Grass's satirical novel Unkenrufe.

Hayden Carruth's Collected Shorter Poems 1946–1991.

Elizabeth Macklin's poetry collection A Woman Kneeling in the Big City.

P. J. O'Rourke's satirical essays Give War a Chance: Eyewitness Accounts of Mankind's Struggle Against Tyranny, Injustice, and Alcohol-Free Beer.

Camille Paglia's essays, Sex, Art, and American Culture.

C. K. Williams's poetry collection A Dream of Mind.

Elena Poniatowska's historical novel Tinísima.

d. Alex Palmer Haley, African-American writer (b. 1921).

d. Isaac Asimov, American writer (b. 1920).

d. Eve Merriam, American feminist poet (b. 1916).

d. Pietro di Donato, Italian-American writer (b. 1911).

d. Frederick Exley, American novelist (b. 1929).

d. William Andrew Swanberg, American biographer (b. 1907).

d. Kay Boyle, American writer (b. 1903).

d. Allan Bloom, American essayist and teacher (b. 1930).

d. Fritz Lieber, American fantasy and science fiction writer (b. 1910).

d. Max Lerner, American essayist (b. 1892).

d. Frank Yerby, American novelist (b. 1916).

FILM & BROADCASTING

Vanessa Redgrave, Emma Thompson, Helena Bonham Carter, and Anthony Hopkins starred in *Howards End*, directed by James Ivory, with screenplay by Ruth Prawer Jhabvala, based on E. M. Forster's 1910 novel.

Clint Eastwood directed and starred in *Unforgiven*, costarring Gene Hackman and Morgan Freeman.

Satyajit Ray wrote and directed his final film, *The Stranger*, starring Utpal Dugg, Deepankar De, and Mamata Shankar.

Tim Robbins led a celebrity cast in *The Player*, Robert Altman's hard, satirical look at Hollywood.

Penny Marshall directed the women's baseball story *A League of Their Own*, starring Geena Davis, Tom Hanks, Lori Petty, and Madonna.

Malcolm X starred Denzel Washington in the title role; Spike Lee directed and cowrote the screenplay with Arnold Perl; based on *The Autobiography of Malcolm X*.

Robert Redford directed *A River Runs Through It*, starring Tom Skerritt and Craig Sheffer.

Aladdin, John Musker and Ron Clements wrote and directed the animated film, with Alan Menken's score.

Sharon Stone and Michael Douglas starred in the psychosexual thriller *Basic Instinct*, directed by Joe Eszterhaus.

Catherine Deneuve starred in *Indochine*, directed and cowritten by Regis Wargnier.

Samuel Froler, Pernilla August, and Max von Sydow starred in *The Best Intentions*, its autobiographical screenplay written by Ingmar Bergman; Bille August directed.

Kevin Costner and Whitney Houston starred in *The Bodyguard*, screenplay by Lawrence Kasdan; Mick Jackson directed.

A Brief History of Time, documentary by Errol Morris, based on the Stephen Hawking book and featuring Hawking.

Neil Jordan wrote and directed *The Crying Game*, starring Stephen Rea, Jaye Davidson, and Forest Whitaker.

Miranda Richardson, Joan Plowright, Josie Lawrence, and Polly Walker starred in *Enchanted April*, directed by Mike Newell.

Louis Malle directed *Damage*, starring Jeremy Irons and Miranda Richardson; David Hare wrote the screenplay.

Meryl Streep, Goldie Hawn, and Bruce Willis starred in *Death Becomes Her*, directed by Robert Zemeckis.

Tom Cruise, Jack Nicholson, and Demi Moore starred in *A Few Good Men*, adapted from his own play by Aaron Sorkin; Rob Reiner directed.

Jack Nicholson starred as Teamsters union boss Jimmy Hoffa in the biofilm *Hoffa*; Danny DeVito directed and costarred.

Woody Allen wrote, directed, and starred opposite Mia Farrow in *Husbands and Wives*.

The Last of the Mohicans, Daniel Day-Lewis starred in the newest screen version of the James Fenimore Cooper novel; Michael Mann directed.

Al Pacino and Chris O'Donnell starred in *Scent of a Woman*, directed by Martin Brest.

Academy Awards for 1992 (awarded the following year): Best Picture: *Unforgiven*; Best Director: Clint Eastwood, *Unforgiven*; Best Actor: Al Pacino, *Scent of a Woman*; Best Actress: Emma Thompson, *Howards End*.

d. Marlene Dietrich, German actress (b. 1901), who became an international star.

d. Satyajit Ray, Indian director, a leading figure in world cinema (b. 1921).

d. Arletty, French actress (b. 1898); she was Garance in *Les Enfants du Paradis*.

d. Paul Henreid (Paul George von Hernreid), Austrian-American actor and director (b. 1908); he was Victor Laszlo in *Casablanca*.

d. Hal Roach, pioneer American filmmaker (b. 1892).

d. Dana Andrews, American actor (b. 1909).

d. Chuck Connors, American actor (b. 1921), the "Rifleman" in television.

d. Anthony Perkins, American actor (b. 1930).

d. Freddie Bartholemew, a leading child actor of the 1940s (b. 1924).

d. Rudolph Ising, pioneer American film animator (b. 1910).

VISUAL ARTS

New York's Guggenheim Museum reopened, as redesigned by Gwathmey Siegel, with a new 10-story wing and a complete interior renovation. The first exhibition was *The Guggenheim Museum and the Art of This Century*.

At the Louvre, Paolo Veronese's restored painting *Marriage at Cana* (1563) was unveiled; some protested that the restoration had removed portions of the original work.

Britain's Charles, Prince of Wales, founded an institute of architecture bearing his name, aimed at creating a new kind of modern architecture that incorporated classical forms, that would "become a kind of crucible in which the architecture of the 21st century can be forged."

Major Henri Matisse retrospective at New York's Museum of Modern Art included many works on loan from Russian museums, long unseen abroad. Russian contemporary art was also on view on loan at the Guggenheim.

Some reviewers were shocked by the exhibition *Helter Skelter: L.A. Art in the 1990s*, at the Los Angelese Museum of Contemporary Art.

Barcelona Olympics structures included Arata Isozaki's Olympic Stadium; Isozaki also designed a new Nara, Japan, convention center.

Stuart Davis retrospective at New York's Metropolitan Museum of Art.

Santiago Calatrava designed Seville's Alamillo Bridge.

Nicholas Grimshaw designed the British pavilion for Seville's Expo '92.

Robert Venuri and Denise Scott Brown's Seattle Art Museum opened.

Alberto Giacommeti retrospective at Paris's Museum of Modern Art.

Charles Correa designed the Jaipur, India, crafts museum.

Norman Foster's Century Tower opened in Tokyo, composed of two office buildings and a joining atrium.

Bloomington, Indiana's huge Mall of America opened; designed by Jerde Partnership.

Oriole Park opened in Baltimore; the ballpark was designed by Hellmuth, Obata, and Kassenbaum.

Phase One of London's Canary Wharf development was completed, but financial problems threatened completion of the Docklands project of which it was part.

Renzo Piano's renovation of Genoa Harbor continued.

Vittorio Gregotti designed a new soccer stadium for Genoa.

Moshe Safdie designed a new Vancouver, British Columbia, main library.

Rafael Moneo's Seville airport terminal opened for the city's Expo '92.

If We Had Shadows, David Bailey's photography collection.

Eurodisney was completed, a major "theme park" group of buildings at Marne-la-Vallée, near Paris.

New York City's Whitehall Ferry Terminal was designed by Venturi, Scott, and Brown.

d. Francis Bacon, British artist (b. 1909).

d. Sidney Robert Nolan, Australian artist (b. 1917).

d. Joseph Schuster, American cartoonist (b. 1914), the cocreator of Superman.

d. James Frazer Stirling, British architect (b. 1926).

d. John Bratby, British painter and writer (b. 1928).

d. Samuel Brody, American architect (b. 1926).

d. John Piper, British artist, critic, and designer (b. 1903).

d. Emilio Pucci, Italian fashion designer (b. 1914).

THEATER & VARIETY

Judd Hirsch starred in Herb Gardner's play *Conversations with My Father*, directed by Daniel Sullivan.

August Wilson's *Two Trains Running* starred Larry Fishburne and Roscoe Lee Browne; Lloyd Richards directed.

Glenn Close, Richard Dreyfuss, and Gene Hackman starred in the Broadway version of Ariel Dorfman's play *Death and the Maiden*, directed by Mike Nichols.

Jessica Lange, Alec Baldwin, and Amy Madigan starred in Tennessee Williams's *A Streetcar Named Desire*; Gregory Mosher directed.

Jake's Women, Neil Simon's play, starred Alan Alda; Gene Saks directed.

Stockard Channing and James Naughton starred in John Guare's *Four Baboons Adoring the Sun*, with music by Stephen Edwards; Peter Hall directed.

Gregory Hines starred in *Jelly's Last Jam*; the George C. Wolfe musical about the life and music of Jelly Roll Morton.

Falsettos, Michael Rupert and Chip Zien starred in William Finn's musical, with music and lyrics by Finn, and book by Finn and James Lapine, who directed.

Lynn Redgrave, Tony Randall, Maryann Plunkett, and Rob Lowe starred in Georges Feydeau's *A Little Hotel on the Side*; Robert Moore directed.

Earle Hyman and Madeleine Potter starred in

Henrik Ibsen's *The Master Builder*; Tony Randall directed.

Hector Elizondo and Debra Mooney starred in Arthur Miller's *The Price*; John Tillinger starred.

Al Pacino starred in Oscar Wilde's *Salome*; Robert Allan Ackerman directed.

Tyne Daly, Jon Voight, and Maryann Plunkett starred in Anton Chekhov's *The Seagull*; Marshall Mason directed.

Alec McCowen and Stephen Rea starred in Frank McGuinness's *Someone Who'll Watch over Me*; Robin Lefévre directed.

Richard Nelson's *Two Shakespearean Actors* starred Brian Bedford and Victor Garber; Jack O'Brien directed.

Jane Alexander and Harris Yulin starred in Friedrich Dürrenmatt's *The Visit*; Edwin Sherin directed.

Harry Groener and Jodi Benson starred in the George and Ira Gershwin musical *Crazy for You*, directed by Mike Ockrent.

Nathan Lane and Faith Prince starred in the Frank Loesser musical *Guys and Dolls*, with book by Jo Zwerling and Abe Burrows, directed by Jerry Zaks.

Raul Julia and Sheena Easton starred in a revival of Mitch Leigh's musical *Man of La Mancha*.

d. Judith Anderson (Frances Margaret Anderson), Australian actress (b. 1898) who played many of the great roles, among them her very notable 1947 *Medea*.

d. Morris Carnovsky, American actor (b. 1897).

d. Shirley Booth (Thelma Booth Ford), American actress (b. 1907).

d. Stella Adler, American actress and teacher (b. 1901).

d. Denholm Mitchell Elliott, British actor (b. 1922).

d. Yvonne Bryceland (Yvonne Hellbuth), South African actress (b. 1924).

d. Georgia Brown (Lillie Klot), British singer and actress (b. 1933).

d. Jose Ferrer, American actor (b. 1912).

d. Laura Liddell Kendal, British actress, mother of Felicity and Jennifer Kendal (b. 1908).

d. Robert Morley, British actor and writer (b. 1908).

d. Molly Picon, Jewish-American actress (b. 1898).

MUSIC & DANCE

Philip Glass's opera *The Voyage*, libretto by David Hwang, commissioned by the Metropolitan Opera to commemorate the 500th anniversary of the Columbus voyage, premiered at the Met.

Paul Simon took his "Born at the Right Time" tour to South Africa, becoming the first major foreign artist to appear after the lifting of antiapartheid sanctions.

Whitney Houston had a major hit with her version of Dolly Parton's 1974 song *I Will Always Love You*, sung for her film *The Bodyguard*.

Mikhail Baryshnikov toured Europe and America with his and Mark Morris's White Oak Dance Project, Baryshnikov introducing Morris's solo ballet *Three Preludes*; he also toured with Twyla Tharp, the two of them premiering her new ballet *Cutting Up*.

Don't Stop (Thinkin' About Tomorrow), Fleetwood Mac's 1977 hit song was heard everywhere, as the Bill Clinton campaign theme.

William Bolcom's opera *McTeague* premiered at Chicago's Lyric Opera, as did his clarinet concerto at the New York Philharmonic.

Baroque Duet, classical album by Wynton Marsalis and Kathleen Battle, the subject of a PBS documentary.

Billy Ray Cyrus achieved instant celebrity with the success of his album *Some Gave All*, especially his hit single *Achy Breaky Heart*.

Body Count, the debut album by Ice-T (Tracy Marrow) and his hardcore metal band Body Count caused major controversy with their song *Cop Killer*, with lyrics such as "I've got my 12-gauge sawed off . . . I'm 'bout to dust some cops off . . . die, pig, die."

Bruce Springsteen released two new albums: *Human Touch*, with the hit single *57 Channels (and Nothin' On)*, and *Lucky Town*, with *Better Days* and *Leap of Faith*.

John Tavener's opera *Mary of Egypt* premiered at the Aldeburgh Festival.

For All We Know, Barbra Streisand's hit single from the sound track of *The Prince of Tides*.

In This House on This Morning, Wynton Marsalis's composition blending several gospel music and jazz styles and themes, premiered May 27 at Lincoln Center's Avery Fisher Hall; Marsalis's jazz septet also issued *Blue Interlude*, and toured widely, seeking a classic jazz revival.

John Harbison's *Oboe Concerto* premiered at the San Francisco Symphony.

Anthony Davis's opera *Tania*, based on the Patty

Hearst kidnapping, premiered at Philadelphia's American Music Theater.

k. d. lang moved from country music to mainstream cabaret style with her album *Ingenue*, with the songs *Miss Chatelaine*, *Constant Craving*, and *The Mind of Love*.

Robert Moran's opera *Desert of Roses* premiered at the Houston Grand Opera.

Emotions, Mariah Carey's second album.

Erotica, Madonna's album, single, and music video.

d. Olivier Messiaen, French composer, a major figure in 20th-century music (b. 1908).

d. John Cage, American composer (b. 1912).

d. Roy Claxton Acuff, American country music singer, fiddler, bandleader, and composer (b. 1903).

d. Hanya Holm (Johanna Eckert), German-American dancer, choreographer, and teacher (d. 1898).

d. Kenneth MacMillan, British choreographer (b. 1929).

d. Stan Getz, American jazz saxophonist (b. 1927).

d. Claudio Arrau, Chilean pianist (b. 1903).

d. Alfred Drake, American singer and actor (b. 1914).

d. Dorothy Kirsten, American lyric soprano (b. 1910).

d. Nathan Milstein, Russian-American violinist (b. 1903).

d. Paul Haakon, Danish dancer and choreographer (b. 1914).

WORLD EVENTS

Bill Clinton defeated incumbent President George Bush and independent candidate H. Ross Perot to become the 42nd American president.

War continued and expanded in what had been Yugoslavia, as Serbian forces besieged Sarajevo and other Muslim-held areas, and initiated "ethnic cleansing," seen worldwide as the kind of genocidal brutality practiced by Germany in World War II.

In *Planned Parenthood of Southeastern Pennsylvania v. Casey*, the Supreme Court upheld the right of a woman to choose to have an abortion, the essence of *Roe v. Wade*, but permitted state restrictions.

Massive April 30–May 2 race riots occurred in south-central Los Angeles, following the acquittal of several police officers charged in the March 1991 beating of motorist Rodney King, recorded on videotape by a bystander.

At the June 16–17 Russian–American Washington summit meeting, presidents Boris Yeltsin and George Bush agreed on further large nuclear weapons cuts, signing a formal treaty on January 3, 1993. In Russia, a power struggle continued between Yeltsin and the conservative opposition. The Azerbaijan–Armenian war continued, as did the civil war in Georgia.

Yitzhak Rabin became Israeli prime minister after Labor victory in the June elections, and stalled Arab–Israeli peace talks resumed.

Nazi rioting spread in Germany, as "neo-Nazis" generated antiforeign riots; anti-Nazi Germans responded with massive demonstrations.

Civil war ended in El Salvador with a January peace treaty, which held; the war formally ended in December.

The June 3–14 Rio de Janeiro United Nations–sponsored "Earth Summit" was the largest such meeting ever held; but major disagreements sharply limited its direct effectiveness.

President Alberto Fujimori of Peru took dictatorial power. Government forces captured Abimeal Reynose Guzmán; the civil war continued.

Hurricane Andrew devastated much of southern Florida.

European Community members debated the question of unity, as the process of ratification of the 1991 Maastricht Treaty proceeded.

Panamanian General Manuel Noriega was convicted and sentenced in Florida on American drug-related charges.

American forces, with United Nations approval, intervened in Somalia, attempting to end the mass starvation and disease that had caught world attention; they were soon joined by forces from other nations.

RETA E. KING LIBRARY
CHADRON STATE COLLEGE
CHADRON, NE 69337